The
ISLE of THANET
COMPENDIUM

by Bob Cawthorne

The Isle of Thanet Compendium

by Bob Cawthorne

Copyright © 2007

First published in 2007 by Scribble and Doodle Books ©
e-mail: scribbleanddoodle@btinternet.com
By post: PO Box 321 Broadstairs CT10 1XY

A catalogue record for this book is available from the British Library

ISBN 978-0-9557062-0-2

Printed and bound in Great Britain by Thanet Press, Margate

Bob Cawthorne has lived all his life in Kent. He and his wife live happily in Thanet. Most mornings he and his dog walk on the cliffs and beaches. The rest of the day he ponders at how long he has survived without having a proper job. Proceeds from this book will go towards maintaining this lifestyle.

Front Cover Photographs (left to right):
Top row: Droit House, Margate Harbour; lamp, Margate seafront; Hugin figurehead; lifeboat memorial, Margate; North Foreland lighthouse.
Middle row: lighthouse, Ramsgate Harbour; Scotsman, Broadstairs Harbour; St Peter's village sign; Clock Tower, Margate; Birchington village sign.
Bottom row: Botany Bay; boats at Broadstairs Harbour; lighthouse, Margate Harbour.

PREFACE

Some of the Isle of Thanet's history is well known, other parts almost forgotten. I have lived in Thanet on and off, man and boy, for over thirty years (aye, and it were all green hills in them days, it only ever rained at night, and strawberries had some flavour!). On returning to live in the area I wanted to refresh my local knowledge and add to my smallish library (alright, bookshelf) on the subject. Apart from books of old postcards, with some showing then-and-now comparisons, which are good as far as they go, there was virtually nothing available. So I wrote one. Now, you may well read this book and find it littered with errors, for which I can only apologise in advance; if I knew where they were I would have corrected them! In this book there are over 2,200 entries that include thousands of pieces of information and I would be astounded if there are no errors. You may find some of the inclusions unwarranted, or you may feel that there are serious omissions, but this is not an encyclopedia, it is a compendium of the information that I found.

I have included, where I can, short biographies because I hate it when books say 'Charlie Farley lived here' as if you are meant to know who Charlie Farley was! I have also tried to find some more obscure details about the characters we come across along the way. So, even if you already know who Charlie Farley was, you might find out something new about him. (Now I need to find out who Charlie Farley was. Was he one of the Ramsgate Farleys?)

INTRODUCTION

Thanet is an area steeped in history. Apart from Britain's main cities, Margate, Ramsgate and Broadstairs probably have more history in them than any other area of the country. It has been in the front line of two World Wars and has seen our armed forces leave and return from various conflicts for centuries. It has attracted poets, novelists, artists, politicians, tycoons and entertainers. If there was this much history in any other area there would be open-top bus tours, guides with large colourful umbrellas leading numerous historical walks and merchandise would be sold to visitors eager to soak up the history of the area – but I should stop before I really get going, and instead convince you by letting you read on . . .

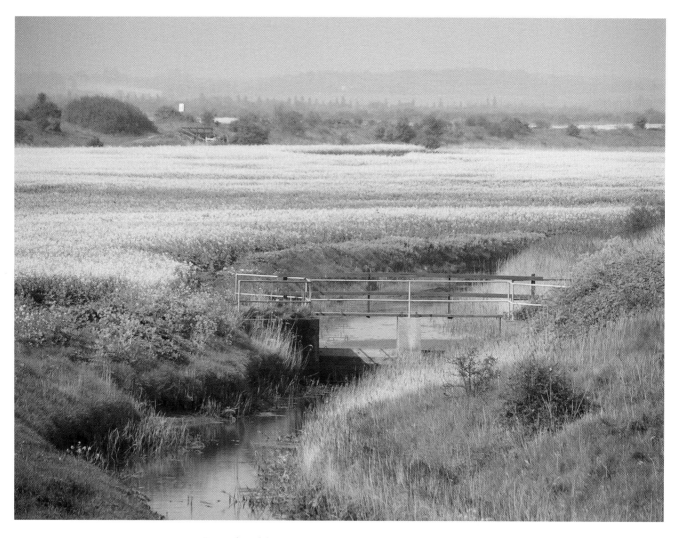

Farmland between Birchington and Reculver

Minnis Bay, Birchington

A

ABBOT'S HILL, Ramsgate

Previously called Clover Hill, it was eventually re-named Abbot's Hill after the man who farmed the land around Albion Place, William Abbot.

Mount Zion Chapel, now flats, stood near the junction with Camden Road. On the other corner The Carpenter's Arms opened in 1813 but was called the Prince Albert Inn when it was closed in 1909.

On the corner of Abbot's Hill and King Street in the nineteenth century was a blacksmith called Underdown.

Rammell's grocery store was on the corner with King Street. Between Rammell's and the pub was a small passageway leading down to a skittle alley, which much later was the site of a record shop. Rammell's later became a furniture shop. There was a footpath next to it leading past Joad's bakehouse and a candle factory to the clifftop.

The philosopher Karl Marx, suffering from his recurring carbuncles and his usual insomnia, stayed at 16 Abbot's Hill alone from the middle of April until 5th May 1874 but in spite of the 'marvellous air', and plenty of walking, swimming and watching his diet, he told a daughter in a letter that *'my condition was even worse than in London'*.

Karl Marx, letter, 19th April 1874:

16 Abbot's Hill – vis-à-vis Mme Williams – that is the address of the 'cliff' where I have lodgings. But never mind! There was no price fixed for it either. The landlady first asked for £1 and then came down to 12 shillings. They are incidentally perfectly decent 'folk'; the man, a coach builder, seems also to dabble in art. He has painted, and not just daubed, a very idealised and rather enigmatic figure who stands guard at the entrance to a certain place, And in the middle of the front-garden there is a Tom-Thumb-sized clay figure of Napoleon I, standing on a brick pedestal, dressed in black, yellow and red, etc., A very manly man, and well done. The landlady has a number of children, including a six-week-old baby who often makes his presence felt in a very disagreeable manner. The air here is delightful, but despite all the walking I do, I have not yet managed to get a good night's sleep.

The place is not quite deserted, but it is the home brewed people who are most in evidence, as yet.

His grandson, by his daughter Jenny, died later that year and Marx brought her to stay with his friend and collaborator, Friedrich Engels, to help her recover from her loss.

Engels stayed at number 11 from mid July to mid August 1876 and again in August 1877, when Marx, along with his second daughter and her husband, made a day trip to Ramsgate to visit him and apparently thoroughly enjoyed himself in spite of his ill health.

SEE Adelaide Gardens/ Bathing/ Engels, Friedrich/ Farms/ King Street, Ramsgate/ Marx, Karl/ Ramsgate

Harold ABRAHAMS

Born Bedford 15th December 1899
Died Enfield 14th January 1978

A sprinter and long jumper, he won an Olympic gold medal for the 100 metres at the 1924 Paris Olympics, as well as a silver in the 4x100 m relay team. An injury to his foot cut short his athletics career and he worked as an athletics journalist for forty years and also commentated for BBC radio.

SEE Carlton Hotel/ Chariots of Fire/ Liddell, Eric/ Radio/ Sport

ACCOMMODATION

The 1957 edition of Kelly's Directory of The Isle of Thanet listed 934 places to stay in Thanet. There were 396 guest houses, as well as 261 hotels (11 in Birchington; 36 in Broadstairs; 145 in Margate; 1 in Minster; 39 in Ramsgate; 29 in Westgate) and 277 boarding houses (19 in Broadstairs; 204 in Margate; 43 in Ramsgate; 11 in Westgate).

In the 1960s there were 236 hotels and boarding houses in Cliftonville.

In 2005, there were 28 guest houses and 36 hotels listed, a total of just 64 in the whole of Thanet.

SEE Birchington/ Boarding Houses/ Broadstairs/ Cliftonville/ Hotels/ Margate/ Minster/ Ramsgate/ Westgate-on-Sea

ACOL

In 1347 the Black Plague wiped out most of the population of Acol – the Black Death was so named because it turned your skin black and then you died, horribly. It killed about one in eight of the country's population, but was not called the Black Death until the sixteenth century. Whatever they were calling it, Acol was burnt to the ground to stop any spread of the disease and, just to make sure, the village was re-built in a new location. The old site is where the Shottendane Road meets the Manston Road, called either Kemp's Corner or, sometimes Sparrow Castle.

The name of the village has changed over the years as well; it has been Millborough, Ville in the Oaks, Ville in the Woods, Ville of Woods, Woodchurch, Acholt, Ocholte Acoll and now Acol, which is Saxon for a settlement near an oak thicket.

Acol suffered a two-year long famine from 1621 during which the Church collectors saw that *'corn was fetched for the poor'* and there was *'pease for the people of Acol'*.

Birchington also suffered this famine.

Kelly's Directory of The Isle of Thanet 1957:
Acol (or Wood) is a liberty and chapelry and a member of the Cinque Port liberty of Dover. It is situated 4 miles south-east from Margate and 70 from London, is in the rural district of Eastry, Isle of Thanet parliamentary division of the county, hundred of Ringslow, lathe of St Augustine, county court district of Margate, rural

deanery of Thanet, archdeaconry and diocese of Canterbury.

The church of St Mildred was erected in 1876. The vicar is the Rev. Christopher W Donaldson BD who is also vicar of All Saints, Birchington, where he resides. There is also a Methodist Chapel.

The hill, close to the Thanet Institution, is called King William's Mount.

At Quex is also the Smuggler's Leap, famous in 'Ingoldsby Legends.'

Under the County of Kent Review Order, 1935, part of this parish was transferred to the Borough of Margate.

Population in 1951, 204, area, 533 acres.

Post & Telephone Call Office, Acol street.- Mrs S E Chilton, sub-postmistress. Postal address, Acol, Birchington, Kent. The nearest money order and telegraph office is at Birchington, 1 mile distant.

There are said to be just over 100 houses in Acol, but I cannot confirm this as I have not counted them all.

SEE All Saints, Birchington/ Birchington Hall/ Captain Swing/ Churches/ Cinque Ports/ Crown and Sceptre/ Fascists/ Nest of the Sparrowhawk/ Plague/ Population, Acol/ Quex estate/ Shottendane Road/ Smuggler's Leap/ St Nicholas-at-Wade

The ACORN INN
Park Lane, Birchington

Isaac Williams was in the 1802 rates book at *'the Sign of ye Acorn'*, and by 1810 George Duffell was running the Acorn Public House. The rear room was a tiny flint cottage reputed to be 500 years old.

Although an 1840 map has it marked as a cottage it appears to have always been a public house.

SEE Birchington/ Park Lane/ Pubs

ACTORS

SEE Adams, Tony/ Aitken, Jonathan/ Anderson, Lindsay/ Arlis, George/ Barkworth, Peter/ Bascomb, AW/ Berkeley, Ballard/ Blethyn, Brenda/ Bouchier, Arthur/ Braithwaite, Dame Lilian/ Brown, June/ Campion, Gerald/ Chaplin, Charlie/ Colman, Ronald/ Cooper, Dame Gladys/ Cortez, Leon/ Coward, Noel/ Craig, Gordon/ Davenport, Bromley/ De Bar, Benedict/ Dors, Diana/ Entertainers/ Fairbanks, Douglas/ Fawcett, John/ Films/ Fox, Angela/ Fuller, Leslie/ Germaine, Louise/ Greet, Ben/ Hanley, Jimmy/ Hicks, Sir Seymour/ Howard, Trevor/ Irving, Sir Henry/ Jordan, Mrs/ Kean, Edmund/ Landen, Dinsdale/ Langtry, Lillie/ LeMesurier, John/ Lonsdale, Frederisck/ Mathews, Charles/ Matthews, Jesse/ Morley, Robert/ Pickford, Mary/ Richard, Eric/ Robinson, Bruce/ Roc, Patricia/ Savage, Dominic/ Secombe, Harry/ Siddons, Mrs Sarah/ Smith, C Aubrey/ Spall, Timothy/ Suchet, David/ Sullivan, Barry/ Television/ Terriss,

William/ Theatre Royal/ Thomas, Terry/ Toole, JL/ Vanbrugh, Dame Irene/ Warner, Jack/ Williams, Kenneth

Tony ADAMS
Born 11th December 1940
The actor who, from 1978, played Adam Chance in the TV soap 'Crossroads', lived for a while on a boat moored in Ramsgate Harbour.
SEE Actors/ Harbour, Ramsgate

Lord ADDINGTON
Born London, 30th May 1757
Died Richmond, Surrey, 15th February 1844
Formerly Henry Sidmouth, a friend of both George IV and Sir William Curtis, he was prime minister between 17th March 1801 and 10th May 1804. He became friends with Pitt the Younger as a child when his father, a prominent physician, treated Pitt the Elder (the Earl of Chatham). He entered parliament as MP for Devizes in 1783 and was elected as Speaker of the House in 1789, a post he retained until William Pitt the Younger resigned as Prime Minister in 1801 over Catholic Emancipation (he had been PM since 1783, and would be PM again 1804-06). As Prime Minister Addington instructed his Foreign Secretary Lord Hawkesbury (later to become Lord Liverpool) to negotiate the Peace of Amiens with France on 25th March 1802 – it did not work as fighting started again in 1803. He was unpopular as PM and thought to be fairly mediocre and resigned to make way for Pitt. A popular jingle was 'Pitt is to Addington, as London is to Paddington'. In 1805 he became Viscount Sidmouth and held several cabinet posts, most notably as Home Secretary from 1812 to 1821, a period in which he suspended the Habeous Corpus Act (Latin for '[that] you have the body' – it was designed to stop arbitrary imprisonment), as well as introducing other measures to combat the Luddite rioters of the time. The Peterloo Massacre also occurred in this period (1819).
SEE Addington Place, Ramsgate/ Addington Road, Ramsgate/ Addington Street, Ramsgate/ Australian Arms/ Curtis, Sir William/ George IV/ Liverpool, Lord/ Obelisk/ Peterloo/ Prime Ministers

ADDINGTON PLACE, Ramsgate
Named after Lord Addington.
The area to the west was an enclosed military camp during the Napoleonic Wars. The two main gates were in Addington Place.
In 1814 the Queen's Bay Regiment were ordered to march from Ramsgate to Deal where they would then go on to join the Duke of Wellington at Portsmouth. The day before they were due to go, Private George Gregory was found drunk and a little bit loud in the barracks. Major Gordon ordered that the man be put under the rear guard as a prisoner. As his detachment passed by, the major realised that the rear guard was not keeping up so he went to investigate. As he did so Gregory came towards him and demanded to know why he was being treated as a prisoner. When he was told that it was because he was drunk, Gregory got abusive and refused to ride his horse any further. The major took Gregory's sword and thwacked the rear of the horse to get the animal moving but before he could hand the weapon back to Gregory the horse reared up and turned into the major's horse causing Gregory to be stabbed through the ribs with his own sword. He died within seconds and Major Gordon was said to be horrified. At a subsequent inquiry the death was deemed to be manslaughter and Major Gordon was convicted of this after a two-day trial. His punishment was a £50 fine.
SEE Addington, Lord/ Napoleonic Wars/ Ramsgate

ADDINGTON ROAD, Ramsgate
Named after Lord Addington.
Addington Road Post Office was gutted when a fire caused by an oil stove killed the Post Master, on 5th November 1948.
SEE Addington, Lord/ Duke of York/ Fires/ Ladysmith, relief of/ Ramsgate

ADDINGTON STREET, Margate
Named after Lord Addington.
In 1828 Addington Street was called Brooke's Place. It was later called Prince's Street and by 1885 it was Addington Street.
Where Hawley Square meets Addington Street there are four houses that date from the turn of the eighteenth century.
SEE Addington, Lord/ Fountain Inn/ Friend to All Nations/ Hawley Square/ Houchin, Alan/ London Tavern/ Margate/ Theatre Royal

ADDINGTON STREET, Ramsgate
Named after Lord Addington.
Originally this whole area was a large military camp for troops involved in the Napoleonic Wars. The Duke of York pub evolved from an army canteen at the barracks here.
It was originally used as an occupation road by the workmen involved in the building of Nelson Crescent Road and was then split into three sections. The section nearest the sea was known as St George's Fields; the section at the other end had a row of Flint Cottages, later the site of a garage, and was known as Flint Row; and the section in the middle was Addington Place.
Various pubs have been in this street, including the Queen Charlotte, The Paragon Inn and the Royal Harbour.
Princess Victoria is said to have bought her coal from Grants at number 52 when she stayed at West Cliff House in 1828.
At the turn of the twentieth century, Mr Fox, who ran a chemists in Addington Street appointed himself the conduit for all news regarding the Boer War. He claimed to be the first person in Ramsgate to receive the news of the relief of Ladysmith, which caused much celebrating in the street outside his shop.
In April 1916, Richard Softley of 48 Addington Street, Ramsgate, was fined £15, or he was offered six weeks in prison, for 'having in his possession without the permission of the Postmaster-General certain apparatus' – which to you and me was a wireless that could both transmit and receive messages.
On 17th June 1917 areas near to Addington Street were badly damaged in the Dump Raid.
In August 1922, Edith May Hodgman, of 2 Addington Street, Ramsgate, was fined £2 'for selling a tin of condensed milk at a price in excess of the maximum prices order'.
From a 1920s advertisement:
Ramsgate's Coming Business Centre
When shopping, visit Addington Street, the thoroughfare of enterprise.
Every want supplied at lowest rates. Give a fair trial order to
The Traders of Addington Street
East Side
At No 4 - S Wilson - 'The Patriotic Baker' Established 1892
At No 6 - R King – High class baker and confectioner Established 1822
At No 12 - C Tilbury – Fruiterer & greengrocer – best quality goods
? ? ? Pure beer, malt & hops only – find it in Addington Street ! ! !
At No 20 - W Andrews – THE Fishmonger – phone Ramsgate 87
At No 28 - J K Chandler fruiterer, greengrocer & dairyman –new laid eggs, genuine new milk
At No 36 - F Wellard jun –Dairyman –milk from own farm
At No 34 - W H Starie – newsagent, tobacconist and confectioner
At No 36 - Harry Hodgman – furniture dealer – furniture bought sold and exchanged
At No 50&52 - R Grant & Co Ltd – Coal merchants Established 1839. Phone Ramsgate 106
West Side
At No 23 - The Duke of York Host R C Prockter
At No 27 - R J Yare – hairdresser, hosier, outfitter
At No 31 - W Hunt – Stationer & bookseller
At No 33 - W Hogbin – best quality meat only
At No 35 - C J Fox – Prescriptions dispensed at the West Cliff Pharmacy
At No 37 - C J W Andrews – Fruiterer, greengrocer, florist, stationer, etc.
At No 41 - E A Head – Fruiterer & greengrocer – The quality shop
At No 43 - Mrs E Smith - newsagent, tobacconist and stationer
At No 45 - J Deverson – Boot repairs of every description
At No 49 - Geo. Mence Smith – Every description of household requisite
At No 53 - 'APB' – Originators of this advertisement
At No 57 - Queen Charlotte – Proprietor J E Miller
Royal Harbour – noted house for spirits – Mrs E Holgate proprietress
At No 79 - G E Lovett – grocer and provision merchant
At No 81 - The Paragon Inn – Host E J Besley
At No 87 - The Addington Street Post Office – Haberdashery and stationery

Following an air raid on 20th March 1940, number 69 collapsed and Mr and Mrs Crompton suddenly found themselves in the cellar of their house.
SEE Addington, Lord/ Brockman, Sarah/ Crescent Road/ Duke of York/ Dump Raid/ Falstaff Inn/ Farms/ Garages/ Ladysmith, relief of/ Linscott/ Napoleonic Wars/ Pubs/ Ramsgate/ Victoria

ADDISCOMBE ROAD, Margate
A woman and child were injured at number 21 in the Hurricane Bombardment in World War I.
SEE Hurricane Bombardment/ Margate/ World War I

Queen ADELAIDE
Born Meiningen, Germany 13th August 1792
Died Middlesex 2nd December 1849
Princess Adelaide of Saxe-Meiningen was born Adelheid Amalie Luise Theresa Carolin, the daughter of George I, the Duke of Saxe-Meiningen. On 13th July 1818 she married Prince William, the Duke of Clarence, and the third son of George III, at Kew Palace in Surrey. It was a double marriage with William's brother Edward, Duke of Kent, marrying Victoria of Saxe-Coburg-Saalfeld at the same time. Adelaide was 26 and William was 52 and despite it beginning as a marriage of convenience it went on to be a very happy one.
However, although Adelaide had four, or possibly five, pregnancies they all ended in heartbreak. Their first child Charlotte was born prematurely on 21st March 1819 and only lived one day. Her second pregnancy ended in a miscarriage in Calais whilst they were travelling to England so the child could be born on British soil. Princess Elizabeth was born on 10th December 1820 but died on 4th March 1821. Later, twin boys were born stillborn on 23rd April 1822.
Had any of their children lived, then Victoria would not have become Queen. These tragedies, along with Adelaide's modesty and charity work, caused her to be loved by the British public.
When George IV died in 1830, William became monarch and the couple was crowned at Westminster Abbey on 8th September 1831.
Adelaide outlived William by 12 years and was buried at St. George's Chapel, Windsor.
Adelaide, the capital of South Australia, was named in her honour.
SEE Adelaide Gardens/ George III/ George IV/ Royalty/ Victoria/ William IV

ADELAIDE GARDENS, Ramsgate
Adelaide Gardens was named after King William IV's wife, Queen Adelaide.
The Walmer Castle public house is another pub now converted to residential use.
SEE Adelaide, Queen/ Engels, Friedrich/ Pubs/ Ramsgate/ Stray pony/ West Cliff Tavern/ William IV

ADMIRAL FOX public house
Grange Road, Ramsgate
This public house, built in 1860, is named after Rear Admiral William Fox.

SEE Fox, Rear Admiral William/ Grange Road/ Pubs/ Ramsgate

ADMIRAL HARVEY public house
Harbour Parade, Ramsgate

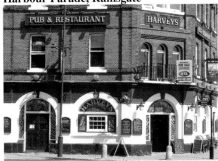

The original building extended to the harbour wall in the 1790s when its next door neighbour was Dyason's Royal Clarence Baths where the Duke of Clarence, later King William IV, was a regular visitor.
The landlord, who held the licence for 90 years in the nineteenth century, was a Napoleonic War veteran, Thomas Parnell.
In 1903 a road-widening scheme meant the old building was demolished and the present one built. The landlord then was Jules Richieux whose children went on to be heavily involved in the theatre world of London's West End. His daughter Blanche married the music hall legend George Robey and his sons Prince Littler and Sir Emile Littler (the latter was born in the pub in 1903) became impresarios. Nowadays the pub is called Harveys Crab and Oyster House.
SEE Harbour, Ramsgate/ Harvey, Admiral Henry Harvey/ Napoleonic Wars/ Pubs/ Ramsgate/ Robey, Sir George/ William IV

ADMIRALS
SEE Austen, Jane/ Beresford/ Clarence, Duke of/ Cochrane/ Effingham/ Fitzalan/ Fitzroy/ Fox/ Harvey/ Jervis/ Kieth/ Nelson/ Rodney/ William IV

AFRICA
There is another Margate - also a seaside resort - on the south coast of KwaZulu-Natal, in South Africa.
SEE Australia/ Margate/ USA

William Harrison AINSWORTH
Born 4th February 1805
Died 3rd January 1882
The historical novelist who wrote 'Rookwood' (1834) (which gave an idealized version of the Dick Turpin story), 'Jack Shepherd' (1839), 'The Tower of London' (1840), 'Guy Fawkes' (1841), 'Old St Paul's' (1841) and 'Windsor Castle' (1843) often visited Ramsgate.
SEE Authors/ Ramsgate

Jonathan AITKEN
Born Dublin, 30th August 1942
His parents were the Conservative MP Sir William Aitken and Penelope, the daughter of John Maffey, 1st Baron Rugby. His great-uncle was Lord Beaverbrook the newspaper magnate who told Jonathan, 'Your father is a good man, but a dull one. You must make mischief'. While we are at it, his sister is the

actress Maria Aitken and the actor Jack Davenport is his nephew. Well that's the family out of the way.
He attended Eton and Christ Church, Oxford where he read law. He was a war correspondent in Biafra and Viet-Nam in the 1960s. He has also written A Short Walk on the Campus (1966), The Young Meteors (1967), Land of Fortune: A study of Australia (1969), Officially Secret (1970) and Richard Nixon: A life (1993).
In 1974 he became MP for Thanet East. He served on the back-benches under Margaret Thatcher, allegedly because he ended his relationship with her daughter, Carol.
Away from politics he was involved with TV-AM and there was talk of his dealing in arms with Saudi Arabia.
Under John Major he was appointed Minister of State for Defence Procurement in 1992 and Chief Secretary to the Treasury in 1994.
'I thought of him as a very able, intelligent and articulate MP, someone who had very considerable experience and who was always thought of as potential ministerial calibre' Sir Malcolm Rifkind
He resigned in 1995 due to his involvement in court cases regarding the accusation that his stay at the Paris Ritz was paid for by an Arab businessman – a violation of the ministerial rules. Before the libel action he took against The Guardian newspaper and Granada Television he famously said, 'If it falls to me to start a fight to cut out the cancer of bent and twisted journalism in our country with the simple sword of truth and the trusty shield of British fair play, so be it.'
In May 1997 he lost the Thanet East seat that he had held for 23 years and the next month The Guardian found new evidence that forced the trial to collapse.
At the subsequent trial Mr Justice Scott Baker said, 'For nearly four years you wove a web of deceit in which you entangled yourself and from which there was no way out unless you were prepared to come clean and tell the truth. Unfortunately you were not.'
In June 1999 he was found guilty of perjury and perverting the course of justice and sentenced to 18 months in jail on both charges to be served concurrently. He served seven. Whilst in prison he leant Greek and rediscovered the Bible. He has since written two autobiographical works, 'Pride and Perjury' and 'Porridge and Passion' as well as 'Psalms for People under Pressure' (what is it about words beginning with 'p'?).
He had three daughters by his first wife, Locacia, and another by Soraya Kashoggi. He married his second wife, Elizabeth Harris in June 2003.
SEE Actors/ Election results/ Politics

ALBERT MEMORIAL
Kensington Gardens, London
This memorial to Prince Albert has connections to two Ramsgate men. It was designed by Sir George Gilbert Scott, who was such a fan that he insisted a figure of Pugin was included as one of the greats of Britain in the friezes.

SEE London/ Pugin, Augustus/ Ramsgate/ Scott, Sir George Gilbert

ALBERT ROAD, Ramsgate

The architecture of numbers 3 to 13 Albert Road are attributed to Edward Welby Pugin. They were built in 1872.

There was a fire at 41 Albert Street on 23rd June 1914 when a passing policeman (not a phrase we use often these days) saw the house ablaze. With the help of a neighbour, the occupants, Mr and Mrs Arnett and their invalid son, were rescued from an upstairs bedroom with the aid of a ladder. The whole house was gutted.

Four houses were destroyed in Albert Road in the Dump Raid in 1917, killing Jonathon and Mrs Hamlyn and Benjamin Thouless.

SEE Dump Raid/ Fires/ Pugin, Edward Welby/ Ramsgate/ Zeppelin

ALBERT STREET, Ramsgate

In 1916 Mrs Millie Woodhall of 39 Albert Street was prosecuted for being in Harbour Parade with a flash lamp that was *'unobscured and visible from the sea'*.

Zeppelin raids on 16th-17th June 1917 reduced cottages to rubble in Albert Street killing three people and injuring sixteen. The premises, at number 40, of Mr W M Houghton, builder and decorator who employed around 45-50 men was partially demolished .

SEE Dump Raid/ Harbour Parade/ Ramsgate/ Zeppelin

ALBERT TERRACE, Margate

This area was virtually destroyed by the great storm of January 1808 and explains its former name of Hazardous Row.

Overlooking the clock tower, the gardens are built on land reclaimed from the sea. It was renamed Albert Terrace in 1868, after Prince Albert.

SEE Hodges, Captain Frederick/ Margate/ Storms

ALBION

Albion means Britain or England, the connection coming from 'albus' being the Latin for white, in this case referring to the white cliffs of Dover.

SEE Without Prejudice

ALBION GARDENS, ALBION HILL and ALBION PLACE, Ramsgate

The building of Albion Hill and Albion Place began around 1789-90, and gave access to Albion Place from Harbour Street. By 1792 twenty-six houses had been completed. The land was owned by Stephen Heritage who had the largest rates bill in town at £178 – I don't know what band his house was in! William Abbot grazed his cattle until 1816 in what became Albion Gardens, and residents had to have a stout fence to stop the cattle from trying to get their milk back. A flight of steps replaced a rough path up to Albion Place in 1818 and were then named Kent Steps.

Albion Hill was damaged in the same Zeppelin raid (17th May 1915) that destroyed the Bull and George pub in the High Street, and the Imperial Bazaar (it sold toys, trinkets and Gosse china) injuring Mr France. The same bazaar was wrecked again on 17th June 1917 – not that the attacks were personal, but they must have wondered!

SEE Albion/ Bull & George/ Destiny/ Dump Raid/ Harbour Street, Ramsgate/ Port & Anchor pub/ Ramsgate/ World War I/ Zeppelin

ALBION HOUSE
Albion Place, Ramsgate

Mr Simmons, an Alderman of Canterbury, built the house in 1790.

In October 1835, after Princess Victoria and her mother accompanied her uncle, King Leopold (King of Belgium) and Queen Louisa to Dover, where the latter sailed to Belgium, they returned to stay at Albion House. Victoria, who had been complaining of being ill for a couple of days, was diagnosed with typhoid. She spent the next three months recovering from the disease at Albion House. She *'took quinine at 7.30am and had nothing but potato soup for luncheon, a little boiled mutton, rice and orange jelly for dinner, no occupation but knitting.'* She also lost so much of her hair that she was *'literally bald'*.

Ironically in future years it would be typhoid that Prince Albert died from. Victoria stayed here on more than one occasion.

Ramsgate Borough Council bought the house on 22nd November 1900 and until 1974 it was used as the seat of the Council.

SEE Albion/ Leopold Street/ Ramsgate/ Victoria

ALBION INN
St Peter's Road, Broadstairs

It was built in 1860 on the site of an even older inn and is sometimes referred to as Little Albion to avoid confusion with the Albion Hotel.

The Albion Inn is reputed to be haunted.

SEE Albion/ Broadstairs/ Pubs/ St Peter's Road, Broadstairs

ALBION PLACE, Ramsgate

An air raid on 17th May 1916 damaged Albion Place

SEE Albion/ Albion Gardens, Hill & Place/ Mansfield Park/ Ramsgate

ALBION ROAD, Birchington

From 1869 until 1892, behind the verger's house and adjoining the Birchington Institute, there was an Infants School established by the trustees of the Crispe Charity. In 1926 the school moved to the old Primitive Methodist Chapel in Albion Road. Bartletts Cottages were next to the Old Primitive Chapel but were demolished to leave what is now called an 'open space'.

SEE Albion/ Birchington/ Morrison Bell House/ National School/ Primitive Methodist Chapel/ Schools

ALBION ROAD, Cliftonville

On 13th September 1915, a German seaplane dropped bombs here. Kate Bonny, aged 27, of Brooklyn Lodge, was hit and died four days later in hospital. A nurse holding a child on a garden path was injured by shrapnel and the horses pulling a cab were blown up.

SEE Albion/ Cliftonville/ Harold Road/ Schools

ALBION ROAD, Ramsgate

John Marshall, who built Mount Albion House in 1798, also built a windmill where the end of Albion Road is now. Well, I say 'he' built it, but it was his company, Messrs Marshall & Joad, Corn Factors, who spent £3,000 on a state of the art, if that was the phrase they used then, windmill. They bought their first load of wheat for 120 guineas but after manufacturing the flour were so disappointed with the small profit that by 1810 they had pulled the mill down. It was re-erected on the west-cliff.

SEE Albion/ Ramsgate/ Mount Albion House/ Windmills

ALBION STREET, Broadstairs

Dickens first visited Broadstairs in 1837, with his family and mother-in-law. They rented a small two-storey wooden house overlooking the High Street about three minutes from the sea. He got to know the landlord of Ballard's Hotel which overlooked the sea. He often walked along the seashore to Ramsgate and joined the subscription library there. He liked Broadstairs so much that he and his family spent most of their late summers/early autumns here for the next fourteen years.

On one of his trips to Thanet he was unable to find suitable accommodation in Ramsgate and instead rented 40 Albion Street in Broadstairs.

Charles Dickens in a letter to John Forster in September 1839: *There were no lodgings at Ramsgate (thank Heaven!) and after spending a night at an Hotel we came on here, and with great difficulty established ourselves for a month.*

. . . Take a Ramsgate boat from London Bridge Wharf at 9 precisely…If the weather should be so rough that the boat can't come off (not probable) go on to Ramsgate and return – 2 miles- per fly.

Whilst staying at No. 40 Albion Street whilst Dickens finished writing 'Nicholas Nickleby' which must have gone well because it prompted him to write, *'We enjoy this place amazingly'*.

It was here that his cook *'got drunk – remarkably drunk – on Tuesday night, was removed by constables, lay down in front of the house and addressed the multitude for some hours.'*

It is now No.12, part of the Albion Hotel.

The street numbers have been changed over the years and it is not easy to locate exactly, but Dickens spent at least three holidays, during the early 1840's at number 37, and records the events in many of his letters.

SEE Albion/ Albion Hotel/ American Notes/ Balmoral Hotel/ Barfield House/ Broadstairs/ Dolphin Inn/ High Street, Broadstairs/ Libraries/ Martin Chuzzlewit/ Nicholas Nickleby/ Old Curiosity Shop/ Ramsgate/ Rose Inn/ Royal Albion Hotel/ Shrine of Our Lady

ALEXANDER HOUSE SCHOOL
Broadstairs

William Green opened this school in 1920 at the top of the High Street. In 1930 the girls moved to Hilderstone, now the adult

education college, and the boys to Claringbold in St Peter's Road. William and Marjorie (his wife, they married in 1936) ran the boys' school, and Lovey, William's sister, ran the girls'. During World War II the schools were evacuated to Gloucestershire. After the war, both boys and girls attended the Claringbold site. William died in 1954, but Marjorie and Lovey continued to run the school until it closed in 1964.

The building was sold and demolished to make way for an estate of bungalows.

In the introduction to 'Welsh Fairy-Tales and Other Stories' collected and edited by P H Emerson (April 1894), the author gives his address as Claringbold, Broadstairs.
SEE Broadstairs/ High Street, Broadstairs/ St Peter's Road, Broadstairs/ Schools

Princess ALEXANDRA
Born 1st December 1844
Died 20th November 1925

After coming from Denmark to marry Prince Edward (the future King Edward VII) she was Princess of Wales from 1863 until 1901, the longest anyone has held that title. She was Queen Consort to King Edward VII from 1901 until 1910 when he died. Thereafter she did not use the term Queen Mother, but was called Her Majesty, Queen Alexandra.

Very good looking, she led the fashion for wearing high necklines and high choker necklaces; although most people did not know that she wore them to disguise a scar on her neck.
SEE Alexandra Philanthropic Homes/ Denmark/ Royal Yacht/ Royalty

ALEXANDRA ARMS public house
Ramsgate
SEE Blazing Donkey/ Pubs/ Ramsgate

ALEXANDRA PHILANTHROPIC HOMES, Tivoli Road, Margate
Originally built in 1865-67, the site had 26 dwellings in 1881 and 32 by 1891.
SEE Margate/ Royal Yacht/ Tivoli Road

ALEXANDRA ROAD, Margate
A Gotha air raid on the night of 30th September 1917 caused damage to Alexandra Road.

On 18th December 1917, Margate was again attacked by German Gothas three times between 6 and 8 o'clock in the evening. There was only one injury, a cut arm, but around 150 houses were damaged in Alexandra Road as well as in Addington Road, Glencoe Road, Dane Road, Upper Grove, Clifton Terrace, Victoria Road, and Carraways Place
SEE Alexandra Road, Cliftonville/ Gotha raid/ Margate

ALEXANDRA ROAD, Ramsgate
Named after Princess Alexandra of Denmark, the wife of the future King Edward VII, Alexandra Road was built, along with the other streets in this area, in the period between 1876 - when St Luke's Church opened - and 1890.
SEE Denmark/ Ramsgate/ St Luke's Church

ALFRED COTTAGES, Ramsgate
SEE Ramsgate/ Slum Clearance

ALL SAINTS SERVICE STATION
All Saints Avenue, Westbrook
It was situated on the corner of All Saints Road and in later years became an office supplies firm. The building is now demolished and houses have been built on the site.
SEE Westbrook

ALL SAINTS' CHURCH
The Square, Birchington

Kelly's Directory, 1951: The Parish Church of All Saints, in the centre of the village, is an ancient structure, containing several good brasses and monumental tablets; its registers, among the oldest in Thanet, are in good preservation. The three chapels are of the 12th century and the nave of the 13th. The Rossetti window and tomb are objects of interest.

Overlooking The Square, All Saints Church is said to have the same dedication as the old 'lost' All Saints Church at Shuart (a sister village to Sarre of which no trace remains today although in 1978 archaeologists excavated its medieval church. It has been suggested that the Black Death of 1348 was responsible for the demise of both Shuart and Woodchurch as villages. All Saints Church at Shuart was over 100 feet long). Stones in the south wall of All Saints are thought to come from the old church at Shuart or from the ancient church that was at Gore End. The Tower and chancel are from around 1250AD. The church was built with Kentish cobbles on the outside. The nave is 94 feet long and the aisles 47 feet wide which makes it a pretty big and impressive church. It started life as the Chapel to the Manor of Monkton and the Church of St. Mary Magdalene and it was not until the local towns grew with the popularity of the Victorian seaside resorts that the church had a curate assigned to it in the later nineteenth century. From around 1863-73 there were extensive additions and renovations; the roof timbers were replaced in 1863 (there was a gable in the roof to let in light up until this point); the box pews were replaced with the existing seats (1863) and

the south aisle was probably added then. The Eastern Chancel Window, representing the Crucifixion, and depicting Saints and notable figures from East Kent, such as St Augustine, Queen Bertha, St Mildred, King Ethelbert etc., designed by Mr Beasley and painted by N H J Westlake is also Victorian and was finished in 1883. These characters re-occur in the carved oak Altar Rails which date from 1938. The pulpit dates from the seventeenth century and on the wall in the chancel there is a 16th century brass showing Sir John Heynys.

Inside is the tomb of Sir Henry Crispe and Katherine, his wife, dating from 1575.

Behind the church was a tithe barn now pulled down and taken to New Barnet where it became a museum.

The Wax House that made all the candles for the church was behind the church near the Powell Inn.

A clock was almost put up on the church tower in 1812, but the cost was too high. In 1848 Mr Powell offered a clock to the village that was at first accepted but then turned down. In 1887 to commemorate Queen Victoria's jubilee, a clock was finally erected. Major Morrison Bell gave £110 and 15 shillings to cover the cost of the clock and Mrs Gray of Birchington Hall gave £100 to restore the tower. Well, while they were up there. . .

When the church was restored in 1958 the bells of the clock were recast, the face re-gilded and the clock overhauled. When the spire was re-shingled in 1968 the clock was re-gilded again with 22 carat gold leaf. You see, while they were up there . . .

The cottages near the church in Birchington were '*very thickly inhabited and have nowhere to throw their refuse but on the highway*' and '*the want of proper sanitary arrangements causes a great nuisance*'.
SEE Birchington/ Birchington Churchyard, Rossetti sonnet/ Churches/ Dog Acre/ Landy, Jimmy/ Lollipop Man/ Monkton/ Old Bay Cottage/ Powell Arms/ Square, The/ Shuart/ Victoria

ALL SAINTS' CHURCH, Birchington
Rossetti's burial, grave and window
The Bungalows of Birchington, by W.L.C., The Art Journal, 1886: *It was here that on Easter Day, his spirit took its flight. His grave nestles under the south-west porch of the church, which, says Mr Hall Caine, in his 'Recollections,' 'is an ancient and quaint Early Gothic edifice, somewhat rejuvenated, however, but with ivy creeping over its walls. The prospect to the north is sea only: a broad sweep of landscape so flat and so featureless that the great sea dominates it. As we stood there, with the rumble of the rolling waters borne to us from the shore, we felt that though we had little dreamed that we should lay Rossetti in his last sleep here, no other place would be so fit. It was, indeed, the resting place for a poet.'*
. . . . The old church is in itself an important feature in 'the village,' standing in what, but for the absence of petty merchants and merchandise, would be the market-place. It is but a short walk from the station, and on

the road to Margate, which lies some four miles to the east. It is worth a visit, and contains a well-painted reredos, and an old black letter Bible (which since an enterprising Vandal cut out a large initial letter is kept locked) that will repay inspection. No greater contrast could perhaps possibly be found between this quiet churchyard where Rossetti 'must, at length, after weary years of sleepiness, sleep the only sleep that is deep and will endure,' and the desolate and dreary old house in Cheyne Walk, where so much of his life was spent.

Outside by the south door is the grave of the painter and poet Dante Gabriel Rossetti, which alone attracts many visitors.

On the white sandstone Irish Cross that marks his grave his brother William wrote the inscription: Here sleeps Gabriel Charles Dante Rossetti honoured under the name of Dante Gabriel Rossetti Among painters as a painter and among poets as a poet Born in London of parentage mainly Italian 12th May 1828 Died at Birchington 9th April 1882

On the rear it says: This cruciform monument bespoken by Dante Rossetti's mother was designed by his life long friend Ford Maddox Brown executed by his brother William and Sister Christina Rossetti

At the point where the cross intersects is a representation of the Garden of Eden, with the upper part of the serpent taking the form of a woman. Underneath shows the spiritual marriage of Dane and Beatrice. The patron saint of painters, St Luke, is on the stem of the cross, and the emblem of the evangelist, the ox, is above that.

There were complaints in 1893, in the Morning Post, and in 1900, in letters to The Times, and letters from William and Christina to the vicar, regarding the state of neglect of the grave. This prompted an iron railing to be put around the grave and today it looks in remarkably good condition.

There were also complaints that the grave was too near the church door and even doubts as to whether he was buried there at all.

Keble's Gazette, 22nd April 1882: The remains of Mr Dante Gabriel Rossetti, poet and painter, were on Friday afternoon quietly and without ceremony interred in the Churchyard here. At half past three the cortège consisting of the hearse and five ordinary mourning coaches left the sea-side cottage where Mr Rossetti had been staying during the past six weeks in company with his old friend Mr Hall Caine. The deceased was followed to his grave by his mother, his sister, Miss Christina Rossetti, his brother, Mr William Rossetti, Mrs W M Rossetti, Mr Theodore Watts, Mr Hall Caine and others. It had been at first intended to have a public funeral at Highgate where his wife and father were interred but for family reasons this idea was abandoned. At the Churchyard wicket, the procession was met by the vicar, the Rev J Alcock, and the coffin, which was covered with flowers, was carried along the pathway to the Church. It was of polished oak with brass fittings and bore the inscription, 'Dante Gabriel Rossetti, born at

London, May 12, 1828, died at Birchington-on-Sea, April 9, 1882.' The Burial Service was read by the Vicar after which the coffin covered with flowers was lowered into the grave. At the time of his death, Mr Rossetti was engaged on a study of 'Joan of Arc'. Following the funeral, Christina and her mother remained in Birchington for nine weeks to oversee the completion of the stained glass windows at the Church to the west of the south door. Christina dealt with the correspondence involved and her mother paid for them.

The left window reproduces Rossetti's painting of the Passover described by Christina:

Our Lord holds the basin of blood from which the lintel is being struck with hyssop by Zacharias. One side post has already been struck close to Christ's head. His foot is being shod by St John the Baptist kneeling, allusive to 'I am not worthy to stoop down and unloose –'. The Blessed Virgin culls bitter herbs for the Paschal Supper for which Joseph in the background brings the lamb, being met by St Elizabeth. Our Lord is turned in the direction of a dove settled on brickwork near a table on which stand the vessels for supper. A vine grows up the house. A few forget-me-knots grow beside a well with a bucket drawing water.

Rossetti's friend Frederick Shields designed the right window which represents Jesus healing the blind man outside the gates of Bethsaida.

Letter to Christina Rossetti from Frederick Shields: The moment is after our Lord has first touched the blind man's eyes and questions him if he sees ought – I desired in him to express the eager longing awakened by the partial gift of sight for perfect vision. Out of the city the Lord leads him upward – under the low arched street. Pharisee and Disciple, the disciple attracted to the Lord – the Rabbi – warning him not to be led after a false Prophet – above his head, a camel – 'ye blind guides that strain at a gnat and swallow a camel.' By the side of the gate growling at the passing Saviour, a dog – emblem of unholy men – teachers and persecutors – suckling her litter of blind cubs – an echo of Spiritual blindness in which the children of the world are born – the thistle grows beside them. Over our Lord's head a flight of seven doves – the fullness of the Spirit. The shepherd folding the sheep and lambs – they flocking to him over the green pastures – bulked in the light of the setting son. The Lake of Galilee beyond – dotted with fishing craft and the crescent moon rising. Rossetti's badge and motto, 'Frangas non Flectus' (You shall break, you shall not bend) is above the picture.

Two thieves broke into the church in 1902 by smashing the lower light of the window. They were caught and Frederick Shields and William Rossetti ensured the window was repaired.

SEE Birchington Churchyard -Rossetti sonnet/ Rossetti

ALL SAINTS' CHURCH WAR MEMORIAL
All Saints Avenue, Westbrook

The metal figure of Christ on a teak crucifix was dedicated by Lord Harris in 1921 to those who died in World War I.

SEE Churches/ Westbrook/ World War I

Viscount ALLENBY

Born 23rd April 1861
Died 14th May 1936

Field Marshall, the Right Honourable, the Viscount Allenby, GCB was made a freeman of the Borough of Ramsgate for his services in World War I – he led the Egyptian Expeditionary Force to conquer Palestine and Syria. Jack Hawkins played him in 'Lawrence of Arabia' (1962).

SEE Ramsgate/ World War I

ALMA

There are Alma Roads in Margate and Ramsgate, as well as an Alma Place in Ramsgate and they are all named after a small river called Alma in the Crimea, where 45,000 (with 600 cavalry) French, under Marshal Armand de St-Arnaud, and British, under the command of Lord Fitzroy James Raglan, defeated the 40,000 Russians (with 6,000 cavalry) on 20th September 1854 in the Crimean War. Of those who died 5,700 were Russians, 2,000 British and 550 French.

SEE Russia

ALMA ROAD, Margate
ALMA PLACE, Ramsgate

SEE Alma/ Margate/ Ramsgate

ALMA ROAD, Ramsgate

Alma Road suffered casualties in the Hurricane Bombardment that occurred on 27th April 1917. John Hobday, aged 61, at number 32 was killed. Close by, Jessie Giles and John Belsey, aged 57, was hit by shrapnel and seriously wounded.

East Kent Times, 22nd May 1918: How many potatoes can you plant in an hour? Allotment holder Mr James Stone of 35 Alma Road, Ramsgate thinks he has established a record of planting ten acres in 64 hours.

OK, who wants to have a go at beating his record? . . and ten acres? That was some allotment!

SEE Alma/ East Kent Times/ Hurricane Bombardment/ Ramsgate/ World War I

'AMERICAN NOTES'
by Charles Dickens

In 1842 Charles Dickens, whilst writing 'American Notes' at his lodgings in Albion Street, Broadstairs, watched his young son Charley through the window, 'digging up the sand on the shore with a very small spade, and compressing it into a perfectly impossible wheelbarrow'

SEE Albion Street/ Broadstairs/ Dickens, Charles

Hans Christian ANDERSEN

Born Odense, Denmark 2nd April 1805
Died near Copenhagen 4th August 1875

The man who brought to the world fairy stories like 'The Snow Queen', 'The Ugly Duckling', 'The Little Mermaid',

'Thumbelina' and many more. When it was published in 1835, his book of fairy tales, ('Eventyr' in Denmark) made him well known internationally. He stayed with Charles Dickens at Fort House (it later became known as Bleak House) and described the *'narrow little house, but pretty and neat The windows facing the Channel, the open sea rolling in almost underneath them; while we were eating the tide went down, the water ebbed at an amazing speed, the great sandbanks. . . rose mightily up, the lighthouse was illuminated'* the following morning the two of them walked to Ramsgate where Hans caught a steam boat to Copenhagen.

However, it is also said that he spent his last night in England at the Royal Oak, Ramsgate before returning to Denmark. He had spent the previous ten weeks in Britain and had been treated as a bit of a star, more so than in his home country. Charles Dickens came to see him off and waved until the ship disappeared over the horizon.

'. . . arrived at the Royal Oak; got a bad room with a good view. The whole hotel was full . . .' Monday 30th August 1847
'Awoke early. Up at 7 o' clock. Waited for the barber, annoyed. A very bad hotel. I was cheated every which way. I exchanged some sovereigns, and they came and said there had been a napoleon d'or among the coins I had given them – which is impossible, since I didn't have any. That's how I lost five francs.' Tuesday 31st August 1847

Dickens *'had walked from Broadstairs to say goodbye to me; and was in a green scotch dress and gaily coloured shirt, extremely smart English. He was the last person to shake my hand in England. . . .'*

Incidentally Hans was embarrassed by his weak, concave chest so he would stuff newspapers under his shirt to build it up!

He always carried a piece of rope with him so that he could escape any building that was alight because he was terrified of being killed in a fire.

Some have conjectured that Dickens based the character of Uriah Heep in 'David Copperfield' on Andersen.
SEE Authors/ Bleak House/ Broadstairs/ Denmark/ 'David Copperfield'/ Fort House/ Ramsgate/ Royal Oak Hotel

Lindsay ANDERSON
Born India, 17th April 1923
Died of a heart attack, Angouléme, France, 30th August 1994
A film director ('If' (1968), 'O Lucky Man!' (1972) etc) and actor, he was Master of Caius in 'Chariots of Fire'. In 1952 he was approached to co-direct a 20-minute film about the Royal School for the Deaf. Richard Burton narrated, without any fee, and the film won an Oscar. While he was here Anderson had the idea to do a 10 minute film called 'O Dreamland'.
SEE Actors/ Chariots of Fire/ Dreamland/ Films/ Royal School for the Deaf

ANDERSONS CAFÉ
Victoria Parade, Broadstairs

The building is over two centuries old. It was Nuckells Assembly Rooms (c1880); a private house, then the Broadstairs Club and Andersons Café. It is now part of the Charles Dickens public house.

SEE Broadstairs/ Pubs/ Victoria Parade

ANGLICAN CHURCH of St THOMAS
Minnis Road, Birchington
In 1924 Mrs Haidee Kearnes donated the land and £2,000 to pay for the building of the church. The actual cost was £2,804 when it was built in 1932.
SEE Birchington/ Churches/ Minnis Road

Princess ANNE
Born 15th August 1950
Amongst her numerous visits, she opened the Manston MOD fire training school in 1992 and returned for a second visit in 2004.
SEE Blythe, Chay/ Manston airfield/ Royalty

'ANY QUESTIONS'
An edition of the BBC radio programme was broadcast from the Theatre Royal on 5th September 2003.
SEE Politics/ Radio/ Theatre Royal

'A PASSAGE in the LIFE of
Mr WATKINS TOTTLE'
by Charles Dickens
'You didn't go, of course?' said Watkins Tottle.
'Didn't I? - Of course I did. There she was, with the identical housemaid in perspective, in order that there might be no interruption. We walked about, for a couple of hours; made ourselves delightfully miserable; and were regularly engaged. Then, we began to 'correspond' - that is to say, we used to exchange about four letters a day; what we used to say in 'em I can't imagine. And I used to have an interview, in the kitchen, or the cellar, or some such place, every evening. Well, things went on in this way for some time; and we got fonder of each other every day. At last, as our love was raised to such a pitch, and as my salary had been raised too, shortly before, we determined on a secret marriage. Fanny arranged to sleep at a friend's, on the previous night; we were to be married early in the morning; and then we were to return to her home and be pathetic. She was to fall at the old gentleman's feet, and bathe his boots with her tears; and I was to hug the old lady and call her 'mother,' and use my pocket-handkerchief as much as possible. Married we were, the next morning; two girls - friends of Fanny's - acting as bridesmaids; and a man, who was hired for five shillings and a pint of porter,

officiating as father. Now, the old lady unfortunately put off her return from Ramsgate, where she had been paying a visit, until the next morning; and as we placed great reliance on her, we agreed to postpone our confession for four-and-twenty hours. My newly-made wife returned home, and I spent my wedding-day in strolling about Hampstead-heath, and execrating my father-in-law. Of course, I went to comfort my dear little wife at night, as much as I could, with the assurance that our troubles would soon be over. I opened the garden-gate, of which I had a key, and was shown by the servant to our old place of meeting - a back kitchen, with a stone-floor and a dresser: upon which, in the absence of chairs, we used to sit and make love.'
SEE Dickens, Charles/ Ramsgate

ARCHBISHOP of CANTERBURY
SEE Churches/ Holy Trinity Church, Broadstairs/ San Clu Hotel/ Tait, Archibald Campbell/ Temple, William/ Tunnels, Ramsgate

ARCHWAY HOUSE
Fort Road, Broadstairs

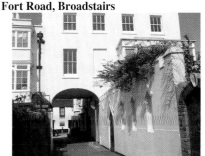

When Dickens stayed here, it was called Lawn House and was separated from the sea by a cornfield. In 1840, he worked here for five weeks on 'The Old Curiosity Shop'. Although he was trying to get a lease on Fort House, he still declared this house *'a most brilliant success - far more comfortable than we have had'*. He also wrote part of 'Barnaby Rudge' here.
SEE Barnaby Rudge/ Broadstairs/ Dickens, Charles/ Lawn House, Broadstairs/ Old Curiosity Shop

Baron ARKLOW
Born 27th January 1773
Died 21st April 1843
The title of Baron Arklow was created on 25th November 1801, as a subsidiary title for the Duke of Sussex, Prince Augustus Frederick, the sixth son of George III.
SEE Arklow Square/ George III/ Mount Albion House

ARKLOW SQUARE, Ramsgate
It is named after Baron Arklow.
Ann Gillham had a home here after she became a widow.
SEE Arklow, Baron/ Coleridge/ Gillham/ Fry, Elizabeth/ Mount Albion House/ Ramsgate

George ARLISS
Born London 10th April 1868
Died 5th February 1946
He was an actor who learnt his trade from Sarah Thorne at the Theatre Royal, Margate. He found fame on screen in Hollywood. He

was nominated for an Academy Award for 'The Green Goddess' (1930) and won the award for 'Disraeli' (1930), a re-make of a film he had made in 1921.
SEE Actors/ Disraeli/ Theatre Royal

ARMADA
The Spanish intended to conquer England by landing at Margate and working their way westwards, but we beat them before they could get here.
After the defeat of the Spanish Armada in 1588 the English fleet anchored off Margate and many wounded were brought ashore. Some reports say that the battle took place off the coast of Margate but in fact they were nearer to the French coast. Charles, Lord Howard of Effingham, Lord Admiral of the fleet wrote, *'Sickness and mortality begins wonderfully to grow amongst us; and it is a most pitiful sight to see, here at Margate, how men, having no place to receive them into here, die in the streets. I am driven myself, of course, to come a-land, to see them bestow'd in some lodging; and the best I can get is barns and such outhouse; and the relief is small that I can provide for them here. It would grieve a man's heart to see them that have served so valiantly to die so miserably.'*
SEE Beacon Road/ Effingham/ Lighthouse, North Foreland/ Margate/ Ships

ARMISTICE DAY
The message that the First World War was to cease at 11am on 11th November 1918 was sent from Dover to the naval base at Ramsgate Harbour at 9.45am that morning. The townspeople were informed by ships' sirens, fog horns and whistles all making one a hell of a din!
SEE Harbour, Ramsgate/ Ramsgate/ World War I

Matthew ARNOLD
Born 24th December 1822
Died 15th April 1888
The English poet once said, *'Margate: that brick-and-mortar image of English Protestantism.'*
SEE Margate/ Poets

Robert ARNOLD
Born 1931
Died 2003
He played PC then DC Swain in the BBC television series Dixon of Dock Green and was born in Manston. He was also in an episode of Fawlty Towers ('The Anniversary'). He was married to actress June Brown who plays Dot Cotton in Eastenders.
SEE Eastenders/ Fawlty Towers/ Manston

ARTHUR ROAD, Cliftonville
It had three Victorian schools; all boys boarding schools at Herne House (numbers 1-7), Arthur House (number 8) and Cliftonville College.
SEE Cliftonville/ Schools

ARTILLERY ARMS public house
Westcliff Road, Ramsgate
The bow windows suggest it was built in the Regency or Georgian eras. It first appears on an 1849 map as Albert Cottage, and does not become the Artillery Arms until 1872.
It also has great leaded-glass windows that show Napoleonic soldiers and guns – as in artillery.
It won The Thanet CAMRA Pub of the Year in 1999, 2002 and 2003.
SEE Napoleonic Wars/ Pubs/ Ramsgate

ARTILLERY ROAD, Ramsgate
This was, at one time, the entrance to the estate of Lady D'Ameland, with an avenue of trees leading to Mount Albion House. The estate was purchased by Edward Pugin in 1865/7 and it was he who re-named it Artillery Hill (it had previously been Portland Place) in a ceremony with speeches, most notably from the Rev A Whitehead. He said that the new name would commemorate the success of the local artillery corps on their achievements and the peaceful victories the corps had gained at Shoeburyness. (Pugin was Captain of a team that won a target shooting competition.) He also hoped that the purchasers of the estate would be successful, and that beautiful villas, terraces, and crescents of houses would spring up.
Karl Marx came to Ramsgate in 1880 to visit his daughter Jenny who lived at 6 Artillery Road. Marx's grandson, Edgar, was born there in August 1879. When Karl Marx' wife, also Jenny (she was four years Karl's senior and they had married in June 1843 after a 7 year engagement) was terminally ill, she passed the last summer of her life with her daughter in Ramsgate, and she died on 2nd December 1881. Jenny, his daughter died 11th January 1883, swiftly followed by Karl, who died in London 14th March 1883 largely destroyed by the bereavements.
SEE Marx, Karl/ Ramsgate

ARTISTS
SEE Dearden's Picture Gallery/ Dyce, William/ Emin, Tracey/ Fildes, Sir Samuel Luke/ Frith, William Powell/ Mauzan/ Moore, Henry/ Morland, George/ Orchardson, Sir WQ/ Orpen, William/ Rossetti/ Sala, George/ Sickert, Walter/ Siddal, Elizabeth/ Tissot/ Turner/ Van Gogh/ Wain, Louis

ARUNDEL ROAD, Cliftonville
Number 11 was destroyed on the morning of Saturday 7th July 1917, by a lone German Gotha plane, killing James Marks and his wife, along with Miss A M Cooper, Mrs Marks' lady companion. Crawford Gardens and Northdown Road (See also Princes Gardens) were also hit and even though anti aircraft guns fired over 100 rounds at the plane, it escaped unharmed.
SEE Cliftonville/ Gotha/ Northdown Road

4th Earl of ARUNDEL
SEE Fitzalan, Richard

ARX ROUCHIM

Standing on the cliff top overlooking Kingsgate Bay, this folly was a replica of the fort built at Deal by Henry VIII. It is also meant to be the burial place of Vortigern.
There was once a tower upon which there was an inscription:
Arx Rouchim
Secundum Rv, et admodum ornatum
Et eruditum virum, Cornelius Willes
Tempore principis Vortigern,
Annum circiter CCCCXLVIII
Edificata
I know you don't need it translated, but some people, well . . .
Roman's Tower, according to the opinion of the very accomplished and learned Rev Cornelius Willes, was built in the time of King Vortigern, about the year 448.
They were having a bit of a laugh, because it is a folly. The central chalk tower was a victim of erosion.
SEE Holland, Lord/ Kingsgate

ASHBURNHAM ROAD, Ramsgate
There was a jam factory marked on the 1907 map at the south eastern end of Ashburnham Road.
SEE Ramsgate

Arthur ASKEY
Born Liverpool, 6th June 1900
Died 16th November 1982
'Hello Playmates - Big Hearted Arthur that's me – Before your very eyes - Ay thang yew!'
He was a small (5ft 2in tall) bespectacled comedian who started out in a touring concert party in 1924. For four years from 1926 he was part of Fred Wilton's Entertainers at The Oval in Cliftonville. He became a huge radio star in The Bandwagon, with Richard Murdoch and Lewis the goat, which ran for three series from 5th January 1938 until 2nd December 1939. He was a popular pantomime dame and was also famous for his silly songs, 'The Bee Song' being his most famous.
In 1975, he returned to Margate to do the summer season at the Winter Gardens along with the comedian Jimmy Tarbuck.
SEE Entertainers/ Oval, The/ Radio/ Tarbuck, Jimmy/ Winter Gardens

Cynthia ASQUITH
Born 1887
Died 1960
She was married to the Prime Minister's son. During World War I, she became private secretary to J M Barrie (the author of Peter Pan) while her husband was away on active service. She also wrote herself, including three volumes of reminiscences, a book of short stories, children's books, ghost story anthologies, royal biographies and two novels 'The Spring House' (1936) and 'One Sparkling Wave' (1943). She and her husband owned Marylands in Marine Drive, (overlooking Botany Bay) and used it as a holiday home. It was here that she first met and became a fan and friend of D H Lawrence on 20th July 1913 – a relationship that endured until his death.
SEE Lawrence, D H/ Marine Drive, Broadstairs/ Prime Ministers

ASSEMBLY ROOMS
Cecil Square, Margate

In the 1770s the well-to-do visitor was entertained at The Assembly Rooms and Royal Hotel built in 1769, which stood on the corner of Hawley Street and Cecil Square, where the library is now situated.

The Margate and Ramsgate Guide in Letters to a Friend (1797): *The subscription is . . . half-a-guinea to the assembly-room for the season. . . Balls, during the season, are twice a week, with public tea-drinking, every Thursday. A band of music attends and plays every day, Sundays and Wednesdays excepted, from twelve till one in the assembly-room, for the entertainment of the subscribers.*

The Grand Ballroom measured 90 feet x 40 feet and Masquerade Balls and concerts were held here, mostly between May and September.

'The Beauties of England and Wales; or Original Delineations, Topographical, Historical, and Descriptive of Each County' (1808) by Edward Wedlake Brayley: *The Assembly Rooms (are) a handsome building of the Ionic order, with Venetian windows. . . On the ground floor is a good Billiard and a Coffee-room, several Dining-parlours, and a Piazza, supported by a range of duplicated Doric columns. On the first-floor are the Tea and Card-rooms, and the Ball-room; the latter is a very elegant apartment. . . The walls are tastefully ornamented with various stuccoed compartments, and festoons of flowers encircling. . . mirrors; at the west end of the room is a handsome orchestra, with wings for the accommodation of spectators; and five large and elegant glass chandeliers are suspended from the ceiling.*

George III attended a ball here in 1811 and it was where the then Prince of Wales (1762-1830 later King George IV) first met his future wife Caroline of Brunswick.

The building was destroyed by a fire in 1882 and was replaced by the Grand or New Theatre; the name was changed to the Hippodrome in 1905. In the 1920s, there was a mixture of live shows and silent films. In 1929 it opted to become solely a cinema for talkies (one of the first shown was 'Bulldog Drummond') but after the initial interest, it reverted to Variety shows. By May 1931 the films returned but competition from the Regal next door put an end to films once and for all. The Hippodrome as a cinema closed 13 months before the Regal was bombed. After the war, films returned in 1946 and Cinemascope was installed in 1955. The owners, Allwood Theatres, closed it in 1957 as it was unprofitable and the whole company went bust the following year. The Council purchased the site, demolished it and built the Library and Council Chambers in 1970.

SEE Fires/ George III/ George IV/ Libraries/ Margate/ Meeting of George & Caroline

ASSEMBLY ROOMS
High Street, Ramsgate

Lady Emma Hamilton attended a ball at the Rooms on the 11th August 1804. The Assembly Rooms eventually became the Albion Hotel.

SEE Clarence, Duke of/ Hamilton, Lady/ High Street, Ramsgate/ Ramsgate

ASTORIA CINEMA, Cliftonville

On the junction of Northdown Road and Wyndham Avenue, once stood the Palladium Garage. In just 14 weeks it was converted by the architect, E A Stone, into the Astoria Cinema. The outside was faced in Croft stone and the entrance hall was richly patterned in terrazzo. In the auditorium there was an 18' stage and a Compton organ played by Leslie Lawrence and on the balcony stairs there was a café. The only design fault seemed to be that the screen and projection box were hung from the same beam and the traffic outside caused them to vibrate in unison!

The grand opening on 4th August 1934, was attended by the actress Jessie Matthews who, along with an audience of 1,305, watched her film 'Evergreen'.

Just 2 years and one month after opening, business was poor; possibly due to a lack of passing trade at that end of town. The organ was shipped off to the Savoy in Stoke Newington and ABC Cinemas took over in June 1937. It was forced to close after it was bombed on 20th July 1940. The Nazis obviously didn't like this particular cinema because they bombed it three more times! After the war the damage was so severe that it could not be re-built and it returned to being a garage.

SEE Cliftonville/ Garages/ Matthews, Jessie/ Northdown Road

King ATHELSTAN

A Child's History of England by Charles Dickens: *Athelstan, the son of Edward the Elder, succeeded that king. He reigned only fifteen years; but he remembered the glory of his grandfather, the great Alfred, and governed England well. He reduced the turbulent people of Wales, and obliged them to pay him a tribute in money, and in cattle, and to send him their best hawks and hounds. He was victorious over the Cornish men, who were not yet quite under the Saxon government. He restored such of the old laws as were good, and had fallen into disuse; made some wise new laws, and took care of the poor and weak. A strong alliance, made against him by Anlaf a Danish prince, Constantine King of the Scots, and the people of North Wales, he broke and defeated in one great battle, long famous for the vast numbers slain in it. After that, he had a quiet reign; the lords and ladies about him had leisure to become polite and agreeable; and foreign princes were glad (as they have sometimes been since) to come to England on visits to the English court.*

When Athelstan died, at forty-seven years old, his brother 'Edmund', who was only eighteen, became king.

SEE Athelstan Road/ Dickens, Charles

ATHELSTAN ROAD, Cliftonville

The plans for Athelstan Road were drawn up in 1864 – it is named after King Athelstan.

At the end of the nineteenth century, Athelston House, a boarding school for girls, was at 1 Athelstan Road.

SEE Athelstan/ Cliftonville/ Schools

AUGUSTA STAIRS, Ramsgate

The stairs from the Mount Albion Estate to the sands were named Augusta Stairs.

SEE Albion Gardens, Albion Hill & Albion Place/ Ramsgate

Jane AUSTEN

Born, near Basingstoke, 1775
Died 18th July 1817

Author of 'Pride and Prejudice' (rejected by a publisher 1797, finally published 1813), 'Sense and Sensibility' (written 1797-98, published 1811), 'Persuasion' (started 1798, published posthumously 1818), 'Northanger Abbey' (written 1798-99, published posthumously 1818), 'Mansfield Park' (written 1811, published 1814), and 'Emma' (written 1814, published 1816).

She once wrote to a friend that she thought moving to live at Ramsgate would be in *'bad taste'*. Her brother, Frank, was in charge of the 'Sea Fencibles' – a group of volunteers he had been ordered to form and command to repel any French invasion – and she came to visit him at Ramsgate in the autumn of 1803. Frank went on to marry a local girl, Mary Gibson, and he became Admiral Francis Austen.

SEE Admirals/ Albion Place, Ramsgate/ Authors/ Mansfield Park/ Pride and Prejudice/ Radcliffe, Ann/ Ramsgate

AUSTRALIA

There are two more Margates there; a small town in Tasmania; and also a little village on the Redcliffe peninsula, Queensland.

SEE Africa/ Bellevue Road, Ramsgate/ Burton, Alfred Henry/ LeMesurier, John/ Margate/ South Africa/ Town of Ramsgate/ Transportation/ USA/ Vogel, Julius

AUSTRALIAN ARMS
Ashburnham Road, Ramsgate

It changed its name to the Addington Arms for a while but reverted to its original name in 2000.

SEE Addington/ Pubs/ Ramsgate

AUTHORS/ WRITERS

SEE Andersen, Hans Christian/ Ainsworth, WH/ Austen, Jane/ Ballantyne, RM/ Barcynska, Countess/ Barham, Richard Harris/ Bowen, Elizabeth/ Bryher/ Buchan, John/ Buckeridge, Anthony/ Bulwer-Lytton, Edward/ Burges, George/ Burnand, Sir Francis/ Caxton, William/ Cobbett, William/ Coleridge, Samuel Taylor/ Collins, Wilkie/ Corelli, Marie/ Defoe, Daniel/ Dickens, Charles/ Doyle, Sir Arthur Conan/ Durrell, Gerald/ Eliot, George/ Eliot, T S/ Fleming, Ian/ Galsworthy, John/ Gray, Thomas/ Grossmith, George & Weedon/ Hamilton, Charles/ Hardy, Thomas/ Henley, WE/ Jerrold, Douglas/ Johnson, Lionel Pigot/ Jones, HA/ Lamb, Charles/ Lawrence, DH/ Lear, Edward/ Lonsdale, Frederick/ Mansfield, Katherine/ Muir, Frank/ Orczy, Baroness/ Parker, Richard/ Pepys, Samuel/ Radcliffe, Ann/ Richards, Frank/ Russell, William Clark/ Sala, George/ Scott, Clement/ Shaw, George Bernard/ Shelley, Mary/ Sheridan, Richard/ Sheridan, Thomas/ Simpson, Dorothy/ Stone, David Lee/ Thackeray, William

Makepeace/ Tonna, Mrs/ Twain, Mark/ Waite, Arthur/ Wheatley, Dennis/ Wilde, Oscar

B

The BACHELORS
In 1964 this hugely successful vocal trio had more top ten hits than The Beatles. They went on to have hits not only here but in Australia and in the USA where 'Charmaine' got to number 2. Their other hits included 'Diana' and 'I Believe'.
SEE Winter Gardens

BAGSHAW'S DIRECTORY and GAZATEER
In 1845, it listed 32 private schools, 6 libraries, 27 grocers, 13 blacksmiths, 4 foreign consuls (representing 24 countries), and 5 straw hat makers in Ramsgate!
SEE Grocers/ Libraries/ Ramsgate/ Schools

BALDOCK
Queen Street, Ramsgate
Advertisement, c1900:
> *Harry J Baldock, 12, Queen Street*
> *Noted shop for millinery.*
> *Millinery a speciality.*
> *All hats trimmed free of charge.*
> *Ribbons, blouses, laces, gloves,*
> *underclothing, corsets, dresses, silks,*
> *sheetings, calicoes, flannelettes, curtains,*
> *blankets, etc.*

SEE Queen Street, Ramsgate/ Ramsgate/ Shops

R M BALLANTYNE
Born Edinburgh, 24th April 1825
Died Rome 8th February 1894
Robert Michael Ballantyne's father was a friend of Sir Walter Scott. His first novel was 'The Young Fur Traders' (1856) based on his first job, at the age of 16, with the Hudson Bay Fur Company. His best-known novel today is The Coral Island (1858) but after it was published - in fact quite a long time after - it was pointed out that his description of 'cocoanuts' did not include anything about the fibrous outer part. I particularly like the bit: *'So be it, captain, go ahead,' cried Peterkin, thrusting the* [cocoa]*nuts into his trousers pocket.* Perkins must have been a big lad! Ballantyne said that he *'had always laboured to be true to fact and to nature, even in my wildest flights of fancy'* and he became very conscientious in his research thereafter. Before starting 'The Lifeboat' he came to Ramsgate and got to know the coxswain of its lifeboat, and spent a fortnight on the Goodwin Sands lightship before writing 'The Floating Light', as well as sailing on the steam tug 'Aid' that towed the Ramsgate lifeboat, whose coxswain was the famous Isaac Jarman.
He wrote around 90 books, nearly all of which were adventure yarns.
He died in Rome, on 8th February 1894. Having been in feeble health for some time, he had accepted an invitation to spend the winter with friends at Tivoli; and he died on the homeward journey.
SEE Authors/ Battles of the Sea/ 'Floating Light of The Goodwin Sands'/ Goodwin Sands/ Lifeboats/ Ramsgate

William BALLANTINE
Born London 3rd June 1812
Died Margate 9th January 1887
The son of a police-magistrate, he became a serjeant-at law. Educated at St Paul's School, he was called to the bar in 1834. With his forceful character and wide circle of acquaintances, he soon built up a large successful practice. He excelled at cross examining in criminal cases and the biggest cases of his career included his successful prosecution of Franz Muller for murder in 1864; his defence of the Tichborne claimant in 1871, and his defence of the Gaekwar of Baroda, India, in 1875 – for which he received one of the largest fees ever known at the time but his bohemian lifestyle meant he spent all the money he earned!
SEE Margate

BALMORAL HOTEL
Albion Street, Broadstairs
Built in 1850, it ceased to be a hotel in 1946 when the rooms became flats and the dining rooms were converted into shops (Albion bookshop and Gem shop). The tap became the Balmoral Bar which then became Bombers in the 1990s but has since reverted to being the Balmoral Wine Bar. The gardens opposite were once the hotel's tea gardens.
SEE Albion Street/ Broadstairs/ Hotels

B&Q
Ramsgate Road, Margate
Named after Richard Block and David Quayle who opened their first store in Southampton in 1969.
SEE Margate/ Ramsgate Road

Edward BANCROFT
Born Westfield, Missouri, 9th January 1744
Died Margate, 8th September 1821
During the American War of Independence he was the Secretary to the American Commissioners in France but was spying for the British, telling them the movements of Benjamin Franklin (born 17th January 1706 – the fifteenth child of seventeen – died 17th April 1790) between 1777 and 1783 and also details of movements of ships and troops from France to America. Britain deliberately gave him information to give to the Americans to convince them he was spying for them. On one occasion they even pretended to arrest him. In 1783 he moved to Britain to preserve his British citizenship and to collect his pension from the British government. He continued to correspond with his old mate Franklin who had no idea he had spied against him. It would not be until seventy years after Bancroft's death that his role as a spy would become public knowledge. Along the way he also found time to invent a process for dyeing textiles and was made a Fellow of the Royal Society.
SEE Margate

BANDSTANDS
SEE Beach Entertainment/ Paragon/ Sea View Terrace, Margate/ Wellington Crescent, Ramsgate - bandstand

BANDSTAND - Broadstairs
It was built by McFarlands in 1895 and originally stood quite near to the Victoria Parade and Oscar Road junction. Ten years later it was moved nearer to the centre of the promenade where it stood until 1952.
SEE Broadstairs/ Victoria Parade

BANGER'S ORIGINAL ESSENCE & POTTED SHRIMP FACTORY, Ramsgate
This firm once stood opposite the Bellevue Tavern. From around 1840, Shrimp paste was sold in china pots with lids that had views of Pegwell and Ramsgate on them. These pots can now be quite valuable.
SEE Bellevue Tavern, Pegwell

BANKS
SEE Barclay's Bank/ Lloyds Bank/ Madeira Walk, Ramsgate/ Midland/ National Provincial/ NatWest

BAR 26, Marine Terrace, Margate
Formerly a restaurant, this bar opened in May 2001.
SEE Margate/ Marine Terrace/ Pubs/ Restaurants

BAR BARCELONA
Marine Gardens, Margate
Numbers 3 and 4 Marine Gardens were built in 1885 as two houses. In 1909, one was the local Conservative Party office and the other a tailors. Over the years they were many different types of shop including a fruiterer, tobacconist and a wardrobe dealer, until they were combined as Jarman's ladies outfitters in 1935. It later became Jarman's restaurant and was bought by a Mr Achilles after the war who kept the same name until it re-opened in 1975 as the Achilles Heel free house and steak bar. In 1999 it became a tapa bar/restaurant called Bar Barcelona.
SEE Margate/ Marine Gardens/ Pubs/ Restaurants

Thomas BARBER
A local carpenter, he built the first seawater bath in 1736 and it is in this year that it is said Margate, as a seaside resort, was born.
The Kentish Post, or Canterbury News Letter, Wednesday 14th July to Saturday 17th July 1736: *'Whereas Bathing in Sea-Water has for several Years, and by great Numbers of People, been found to be of great Service in many Chronical Cafes, but for want of a convenient and private Bathing Place, many of both Sexes have not cared to expofe themfelves to the open Air; This is to inform all Perfons, that Thomas Barber, Carpenter at Margate in the Ifle of Thanett, hath lately made a very convenient Bath, into which the Sea Water runs through a Canal about 15 Foot long. You defcend into the Bath from a private Room adjoining to it. N.B. There are in the fame Houfe convenient Lodgings to be Lett.'*
SEE Bathing/ Margate

BARCLAYS BANK

John Freame founded a bank in Lombard Street, London in 1692. James Barclay joined as a partner in 1736 and subsequently married Freame's sister.

The branch on the corner of Queen Street and Cavendish Street in Ramsgate opened in 1922.

SEE Banks/ Cavendish Street, Ramsgate/ Queen Street, Ramsgate/ Ramsgate

Countess BARCYNSKA

Born 1894

Died 1964

Marguerite Florence Helene Jervis Evans, nee Marguerite Barclay, used both Countess Hélène Barcynska (over 50 titles) and Oliver Sandys (over 80 titles) as pen names for her best selling novels.

Her first marriage was to Count Barcynska and she kept the name because she liked the sound of it. Her second husband was the Welsh writer Caradoc Evans whom she married in 1933.

Her books were often turned into films in the 1920s. 'A Plaything of Destiny' was published in 1923, filmed as a silent movie called 'Tesha' in 1928 and was so popular that a soundtrack was added in 1929.

She lived in Broadstairs in the late 1920s

SEE Authors/ Broadstairs

BARFIELD HOUSE
Albion Street, Broadstairs

SEE Albion Street/ Broadstairs/ Libraries

Richard Harris BARHAM

Born 6th December 1788, at 61 Burgate Canterbury; the house was destroyed in World War II

Died 17th June 1845

He was a descendant of one of the great families of Kent, the de Berhams and his father bequeathed him the Manor of Tappington when he was six years old. (I think I got a train set, but I'm not bitter). In 1814 he married Caroline, the daughter of Captain Smart of the Royal Engineers. He became vicar of Warehorne and Snargate, on Romney Marsh, around 1818. Late at night he would often bump into the Aldington Gang of smugglers, who used his church at Snargate to store their contraband. Barham reckoned he could find his way there in the dark by the smell of tobacco. They did not harm him and he pretended he knew nothing about their activities; thus everyone was happy.

When he was a minor canon at St Paul's Cathedral he found that he had enough free time to have a career in writing amusing, narrative verses which were published in, amongst others, Bentley's Miscellany, a magazine edited by Charles Dickens, who, along with Thackeray and Hook, became a friend of Barham.

He is best known as the author of the 'Ingoldsby Legends' (1840) based partly on his own experiences and partly on local legends. In the case of The Smuggler's Leap, one of the best known, it involves Exciseman Anthony Gill and his Customs men chasing Smuggler Bill and his gang, along with their contraband lace and gin. Such is Gill's obsession with catching Bill that he inadvertently makes a deal with the Devil and ends up on the Devil's horse. The Chase finally ends when both men plunge to their deaths in a chalk pit at Acol (now near the end of the runway at Manston airport). Two bodies are found but only one horse. The place became so popular that there was a thriving trade in horse and traps bringing tourists from Margate pier for a *'three shilling drive'* to have *'a peep at that fearful chalk pit'*

'[Margate is] *the least aristocratic of all possible watering places'*, Richard Harris Barham

SEE Acol/ Authors/ Captain Swing/ Dickens, Charles/ Ingoldsby House/ Ingoldsby Road/ Manston Airport/ Margate/ Minster/ Smuggler's Leap/ Thackeray, William Makepeace

Peter BARKWORTH

Born Margate, 14th January 1929

Died 21st October 2006

He is probably most fondly remembered for his role as Mark Telford, a senior banking executive who steps down to become a branch manager in Dover, in the 1980s BBC TV series 'Telford's Change'. The series was based on an idea of Barkworth's and co-starred Hannah Gordon and Keith Barron. He appeared in many other series from 'The Avengers' to 'Colditz' and 'Maigret' as well as films from his first, 'A Touch of Larceny' in 1951, to his last, 'Wilde' in 1997, and included 'Where Eagles Dare' in 1968.

SEE Actors/ Margate

'BARNABY RUDGE'
by Charles Dickens

This much under-rated novel was partly written by Dickens at Broadstairs. Charles Dickens, writing in 1841: *'I am hideously lazy - always bathing, lying in the sun, or walking about. I write a No. [edition of Barnaby Rudge] when the time comes, and dream about it beforehand on cliffs and sands - but as to getting in advance!'*

SEE Bathing/ Books/ Broadstairs/ Dickens, Charles

BARNABY RUDGE public house,
Albion Street/Harbour Street, Broadstairs

It was re-named in the late 1960s after the Charles Dickens novel that was partly written at Archway House. The pub started out as the British Tar in 1849 and in 1930 it became The George.

SEE Broadstairs/ Harbour St, Broadstairs/ Pubs

BARNACLES, King Street, Ramsgate

Overlooking the harbour, it was once the Royal Albion Hotel's lounge bars. In the 1980s the bar was rebuilt and it became Barnacles; the hotel's letting rooms became flats and the bar area was rebuilt. It was featured in the film 'Last Orders'.

SEE King Street, Ramsgate/ Last Orders/ Pubs/ Ramsgate

BARNETT'S RADIO & ELECTRICAL SERVICES, Ramsgate

It was situated on the corner of Cavendish Street and Queen Street. There was a big fire here on 7th July 1958.

SEE Cavendish Street, Ramsgate/ Fires/ Queen Street, Ramsgate/ Ramsgate/ Shops

BARRICADES

Many of the old bathing machines were used in the barricades built to block the roads in and out of Thanet in case of invasion during World War II.

SEE Bathing machines/ Thanet/ World War II

BARTHOLOMEW'S GATE

It was the original name for Kingsgate Bay, named after St Bartholomew, one of the twelve apostles, because it was on St Bartholomew's Day (24th August) that the work to dig out access through the cliff to the beach was completed.

SEE Kingsgate Bay

BARTRAM GABLES, Broadstairs

On 30th May 1910, iron buckles, spearheads and knives as well as the remains of 3 women and 4 men signified that it had been the site of an Anglo Saxon cemetery. Pottery from the Iron Age meant that there had also, probably, been an Iron Age settlement here. Built as Valetta House in 1909 in 13 acres of grounds overlooking Dumpton Gap. The headmistress was Janet Bartrum and when she left in 1916, the name was changed in her honour. A later headmistress and a driving force in the school was Mrs Crittal and when she left, it is said that it never was as good again. The former girls' finishing school Bartram Gables closed in 1951 and is now the Bradstow Residential School – motto 'Living and learning together' – which cares for, and educates, 50 children between the ages of 5-19 who have autism or other severe learning difficulties.

SEE Broadstairs/ Dumpton Gap/ Dumpton Park Drive/ Roc, Patricia/ Schools

A W BASCOMB

He was an actor who learnt his trade from Sarah Thorne at the Theatre Royal, Margate, and went on to appear in 'The Good Companions' with John Gielgud and Jesse Mathews.

SEE Actors/ Mathews, Jesse/ Theatre Royal

BATH CHAIRS

In 1910 there were thirty-five licensed bath chair attendants in Margate.

SEE Margate/ Phillpott, Thomas

BATHING / SWIMMING

In the nineteenth century, byelaws prevented boats going within 30 yards of where the ladies bathed and another law stated that the ladies and gentlemen's machines had to be at least 100 yards apart. They really knew how to practise safe sex in those days. To be fair, everyone knew that the segregation laws were ridiculous and Margate was the first town to abolish them in 1901. An illustrated newspaper of the time, The Graphic, said, *'It seems rather absurd to employ a man, a horse and a great house on wheels to enable a British human creature to dip himself in the sea.'*

In Victorian times it was considered bad manners to swim in the sea after 1pm.

In Ramsgate, the motion, on 27th March 1907, was *'that this Chamber urge the Corporation, now that it has control of the sands, to make provision for mixed bathing'*. You will be relieved to know that at the subsequent meeting on 17th April 'The Mixed Bathing Resolution' was passed!

SEE Abbot's Hill/ Barber, Thomas/ 'Barnaby Rudge'/ Bathing machines & bathing rooms/ Beale, Benjamin/ Boating pool & paddling pool/ Churchill Tavern/ Cinque Port Arms/ Clifton Baths/ Cliftonville/ Development of Thanet/ Engels, Friedrich/ Hasted, Edward/ Hawley Square/ Holiday Romance/ Isabella Baths/ Jerrold, Douglas/ Lee shore/ Lido/ Margate/ Margate Marine Bathing Pavilion/ Marina Bathing Pool/ Marx, Karl/ Nelson/ Paragon/ Pegwell Bay Reclaimation Co/ Pettman, Thomas/ Plains of Waterloo/ Queen's Highcliffe Hotel/ Ramsgate/ Ramsgate Song/ Royal Adelaide/ St Peter's Court Prep School/ Smuggler's Leap/ Steam Packets/ Thomson, Dr/ Veiled Lodger/ Walpole Bay/ West Ham Convalescent Home/ Westbrook Bathing Pavilion/ White Hart/ Without Prejudice

BATHING MACHINES

A Tour through the Isle of Thanet and some other Parts of East Kent (1793), by Zachariah Cozens: *That sea bathing may be attainable with the strictest decency, there are near forty machines employed in a season. . . .In the course of more than thirty years experience, hardly any improvement has been made upon them: they consist of a carriage similar to that of a coach, but more simple, much stouter and considerably higher, that it may resist the waves in blowing weather; the wheels are high and strong, and . . . stand at right angles with the axles; in the front is a platform, from which you have admittance into the machine, which forms a neat dressing room, 6½ feet long, 5 wide, and 6½ high, with a bench on either side for the bathers to undress upon; the*

sides and top are framed, and covered with painted canvas; at the back opens a door, and, by means of a flight of steps attached to the machine, the bathers descend into the water, concealed from public view by a large umbrella of canvas stretched on hoops, which is let down by the driver, by means of a rope which comes to the front of the machine, until it touches the water, and forms a bath 10 feet long and 6 wide. There is a horse to each machine, and the proprietors employ very careful drivers, under whose guidance the machines are drawn out to the depth the bather may require: it is a pleasing sight to behold between 30 and 40 of these curious machines in a morning hovering on the surface of the water. . . continually revolving in their course either returning with their cleansed guest, or going out with a freight of perhaps, jolly citizens preparing to wash off the dust and care of six months attendance to their counting houses.

Margate's first guidebook was written in 1763 by John Lyons, a local schoolmaster, and cost one shilling *and entitled* 'A Description of the Isle of Thanet, and particularly of the town of Margate', it included:

EXPLANATION of the Structure of the Machine (the letters A, B and C referred to an illustration not included here)

A. The Bathing-Room, to the steps of which the Machine B is driving, with its umbrella drawn up.

C. A back view of the Machine, shewing its steps, and the folding doors which open into a Bath of eight feet by thirteen feet, formed by the fall of the umbrella.

D. The Machine, as used in Bathing, with its umbrella down.

The entrance into the Machine is through a door, at the back of the driver, who sits on a moveable bench, and raises or lets fall the umbrella by means of a line, which runs along the top of the Machine, and is fastened to a pin over the door. This line is guided by a piece of wood of three feet in length, which projects, pointing a little downward, from the top of the back part of the Machine, through which it passes, in a sloping direction. To the end of this piece is suspended a cord, for the Bather to lay hold on if he wants support.

The umbrella is formed of light canvas, spread on four hoops. The height of each of which is seven feet, and each is eight feet wide at its axis.

The last hoop falls to an horizontal level with its axis, from whence depends the curtain.

The pieces which support the hoops, are about six feet in length; they are fastened to the bottom of the Machine, but are extended, by a small curve, about one foot wider than the body of it on each side. The hoops move in grooves in these pieces. The distance of the axis of the first hoop is more than two feet from the Machine; of the rest from each other, something more than one foot; but no great exactness is required in these proportions, as scarce and two of them are built alike.

SEE Barricades/ Graffiti/ Hasted, Edward/ Margate/ Martin Chuzzlewit/ Robey, George/ Shabby Genteel Story/ Tivoli Road/ Wellington Crescent/ Willsons Road/ Without Prejudice/ Yoakley, Michael

BATHING MACHINES & BATHING ROOMS

Bathing rooms were very popular in the High Street, Margate, at the end of the eighteenth century and beginning of the nineteenth, with six warm water marble baths, filled with sea water and heated to whatever temperature that you liked. It would cost you 3/6, or if seven of you got in together it would set you back a guinea. Shower, sulphur and douche baths were added in later years.

It wasn't cheap to use a machine. For a lady to use a machine with a guide was 1/3; two ladies or more sharing with a guide was a shilling each; 2 or more children with a guide, 9d each; gentlemen, with a guide 1/6; 2 or more gents with a guide, 1/3 each; and 2 or more gents with no guide, 9d each. A ticket for the season cost 3/6 and allowed you to read the daily morning and evening papers for free. Other attractions at these establishments included the use of telescopes, pianos and books. Jellies and sherbet were offered as refreshments.

The government of the time caught on to the popularity of the bathing machines and an Act of Parliament in 1799 stated that the owner of every bathing machine using the harbour at Margate, *'or the bay thereunto adjoining'* should pay, for each machine, a duty of half a crown on 1st September. In 1809 this went up to 7/6 per machine and by 1812, 10/6 was due every 10th October.

In 1808 a great storm washed most of the bathing rooms away (the same thing happened again in 1870) but were replaced with better facilities.

The law at this time said that you could not bathe after 10 o'clock on Sunday mornings.

Mr Phillpott ran the bathing rooms in the High Street for many years and spent a lot of money on improving them, even adding steam power to get sea water pumped up any time he wanted. The High Street was nearer the sea or, more correctly, before the construction in 1878 of the promenade linking the harbour and Marine Terrace, the sea could get much closer to the High Street. The bathing rooms were so popular that there was a rush first thing in the morning to reserve the machines on the reservation slates. This was before the Germans had thought of using towels.

In 1870 another bathing room, with a reading room attached, was set up on Marine Terrace.

In 1887 a newspaper reckoned that Margate was *'the only spot in Britain where you can be taken for a 20 minute ride in a bathing machine without getting into more than 3 feet of water'*.

By 1900 it was illegal to bathe without using a machine after 8am, although when the Corporation took over the foreshore rights in 1919, this changed.

In various guises the machines continued in use until World War I, when changes in

social attitudes meant they were no longer required. People just became shameless, it was the beginning of the end, standards started to slip and they've just never stopped. God knows where it will all end.

The bathing rooms at the bottom of the High Street were only one storey high because a covenant restricted the height so that the houses on the other side of the street, for the gentry, could have an uninterrupted view of the sea. When Marine Drive was built in 1878 the houses were built tall so the covenant had no real value (the buildings there are still only one storey high). The bathing machines moved their trade westwards to Marine Sands and to Clifton's Baths and Pettman's Bathing Platform at Cliftonville.
SEE High Street, Margate/ King's Head, Margate/ Margate/ Marine Drive/ Marine Terrace/ Ramsgate/ Storms

BATTERIES

The Kingsgate Battery, North Foreland Battery, Chandos Battery (in front of the Chandos Square area) and the North Cliff Battery (in front of Bleak House) were all built as defences in the Napoleonic Wars.
SEE Bleak House/ Kingsgate/ Napoleonic Wars/ North Foreland

BATTLE of BRITAIN 1940

There were four main phases to the battle. 'Kanalkampf' (10th July – 11th August) with the main action taking place in the Channel; 'Adlerangriff' (12th August – 23rd August) the coastal airfields were attacked; from 24th August until 6th September the German attack switched to other airfields and finally from 7th September until 31st October, British towns and cities came under attack.

Being a coastal airfield, RAF Manston was knocked out of action early in World War II but remained a vital dispersal field for returning bombers later in the war.
SEE Manston airport/ World War II

BATTLE of BOTANY BAY

The famous Battle of Botany Bay took place early one March morning in 1769 between the Revenue men and a gang of smugglers. The leader of the smugglers was Joss Snelling, then aged about 28. The Revenue men hid in the long grass and watched as Snelling signalled to the Lark, an armed lugger. Once the boat had received the signal, it dropped anchor and a small boat was lowered and loaded up with brandy, lace, tea and more. Six men then rowed it to shore where, in the dark, they whistled to the smugglers who responded with another coded whistle – it was exciting wasn't it? – and then led down their pack horses to be loaded with contraband. The Revenue men, who had been tipped off, waited until they had almost finished, then the officer in charge bellowed out 'Halt in the name of the King!' He was interrupted by a keg of brandy crashing against his leg, thrown by one of the men from the Lark. Now, the story goes that a smuggler shouted back, 'Fire and be damned!' but I think it may have been a

somewhat earthier phrase. Whatever he said, pandemonium broke out. Shots were fired, one of the smugglers fell dead into the sea and cutlasses, knives and boathooks were used in the ensuing battle, and some men were injured by the stampeding horses. You can imagine the carnage; well, you can if you supported Millwall in the 1970s. Snelling and four of his gang managed to flee up Kemp Stairs but were confronted by a Revenue man who ordered them to stop. So they shot him. The smugglers managed to escape to Reading Street. The wounded Revenue man was taken after the battle to the Captain Digby where he died. The remaining Revenue men carried out a house-to-house search of Reading Street and found one of their men dead and another dying in Rosemary Cottage. The gang of smugglers had worse casualties than the Revenue men, with ten of them killed. The eight who were captured were tried, found guilty and taken to Gallows Field in Sandwich, where they were hung.

Within a year, and despite the heavy losses, Joss Snelling formed a new gang that was twice the size of the old one.
SEE Botany Bay/ Reading Street/ Sandwich/ Smuggling/ Snelling, Joss

BATTLE of the NORTH FORELAND

Also known as the St James's Day Battle or the Battle of Orfordness it lasted from 4th to 5th August 1666. St James Day is 25th July in the old Julian calendar, in use in England at the time, or 4th August in the Gregorian calender that was adopted in 1752.

It quickly followed the Four Days' Battle in June which had only stopped when both sides ran out of ammunition, and they each claimed victory. For a while, the Dutch controlled the English Channel until the English won a decisive victory off North Foreland. Our 54 ships beat their 80. Unfortunately, Charles II could not build upon the victory as his funds got used up dealing with both the Great Plague and the Fire of London – it was a busy time!

'If a man faint under the burden of such tediousness as usually attendeth upon warlike designments, he is no way fit for enterprise' George Monck, Duke of Albemarle (1608-1670), commander of the English fleet.

It was not until 29th July (Julian calender) that Samuel Pepys, who was working at the Navy Office, heard of the victory, as he recorded in his diary: 'The Resolution burned; but as they say, most of her men and commander saved. This is all; only, we keep the sea; which denotes a victory, or at least that we are nor beaten. But no great matters to brag on, God knows. So home to supper and bed.'

In the weeks that followed the battle corpses, dressed in their Sunday best, were washed up on the shore around Thanet. These were men who had been going off to church when the press gang dragged them off to serve in the navy.
SEE Pepys, Samuel

'BATTLES OF THE SEA'
by R M Ballantyne
There is a Fund connected with the Broadstairs Lifeboat which deserves passing notice here. It was raised by the late Sir Charles Reed, in 1867, the proceeds to be distributed annually among the seamen who save life on that coast. The following particulars of this fund were supplied by Sir Charles Reed himself: - 'Eight boatmen of Broadstairs were interested in a lugger - the Dreadnought - which had for years done good service on the Goodwins. One night they went off in a tremendous sea to save a French barque; but though they secured the crew, a steam-tug claimed the prize and towed her into Ramsgate Harbour. The Broadstairs men instituted proceedings to secure the salvage, but they were beaten in a London law court, where they were overpowered by the advocacy of a powerful company. In the meantime they lost their lugger off the coast of Normandy, and in this emergency the lawyers they had employed demanded their costs. The poor men had no means, and not being able to pay they were taken from their homes and lodged in Maidstone Gaol. He (Sir Charles) was then staying in Broadstairs, and an appeal being made to him, he wrote to the 'Times', and in one week received nearly twice the amount required. The bill was paid, the men were liberated and brought home to their families, and the balance of the amount, a considerable sum, was invested, the interest to be applied to the rewarding of boatmen who, by personal bravery, had distinguished themselves by saving life on the coast.'
SEE Ballantyne, R M/ Broadstairs/ Floating Light of the Goodwin Sands/ Harbour, Ramsgate

The BAY

The imaginative name for the main bay at Margate. It can't be long before a focus group suggests a re-branding.
SEE Bays/ Beaches/ Margate

BAYS

Starting from Birchington, and travelling east there are nine bays on the north coast of Thanet: Minnis Bay, Grenham Bay, Epple Bay, Westgate Bay, St Mildred's Bay, Westbrook Bay, The Bay, Walpole Bay and Palm Bay.

Broadstairs has seven bays and, from north to south, they are Botany Bay, Kingsgate Bay, Joss Bay, Stone Bay, Viking Bay, Louisa Bay and Dumpton Gap.

South of Ramsgate there is Pegwell Bay.
SEE Beaches/ Bay, The/ Botany Bay/ Broadstairs/ Dumpton Gap/ Epple Bay/ Grenham Bay/ Joss Bay/ Kingsgate Bay/ Louisa Gap/ Minnis Bay/ Palm Bay/ Pegwell Bay/ St Mildreds Bay/ Stone Bay/ Thanet/ Viking Bay/ Westbrook Bay/ Westgate Bay/ Walpole Bay

BEACH AVENUE, Birchington

SEE Beresford Hotel/ St Mary's Convalescent Home

BEACH ENTERTAINMENT

Margate: Sandcastle competitions were once very popular with children and adults.

Whole areas of the beach were roped off and cash prizes were offered; one 1912 prize was a not inconsiderable £20 and was presented by the music hall star Marie Lloyd. Sand pictures were also popular, carved out in the sand with a spoon or dining fork and embellished with seaweed, shells or pebbles. Often, children from orphanages raised funds for their homes by spending hours creating pictures in the sand and getting passers by to hand over their money. When they returned home it was not uncommon for local kids to take their place and pocket any money for themselves. This practice was known as 'grotto-ing' and continued until the last war.

Keep-fit classes were also held on the beach with sometimes a couple of hundred participants.

Holiday makers did not dress informally, they wore their Sunday best!

In time Nigger Shows (it was a less enlightened era) were gradually replaced by slightly more sophisticated Pierrot shows, which were performed upon a small wooden stage under a roof on the beach. The performers were dressed in almost clown-like suits with large hats and floppy baggy white blouses and trousers with large black pom-pom buttons. They sang popular songs to the accompaniment of a piano.

These shows evolved into the concert party, where the stage was larger and the performers were dressed in straw hats, loud stripy blazers, spotted bow ties and also sang songs. The shows were basically a more sophisticated version of the old Pierrot shows. There was a Margate concert party called 'The Yachtsmen' which adopted a dress code of peaked caps and nautical blazers. Harry Gold arrived in a concert party at Margate in 1903 and within four years had concert parties not only in Margate but also in Ramsgate, Cleethorpes, Skegness, Wales and Scotland. He introduced dressing rooms for the performers and electric lighting to the stages; it was only World War II that stopped his career. He died in 1946.

As the concert parties and their stages were cropping up on the beaches, bandstands were starting to appear on land. In 1909 Margate had an impressive five bandstands at Westbrook, Dane Park, Queens Lawns, the Oval and Fort Green; the latter was the oldest having been built in 1868. Military bands all dressed up in their best dress uniform and led by the bandmaster had a weekly roster of performing at Kent and Sussex resorts. As well as military bands, there were also groups of performers with a piano singing the popular songs of the day and comedians telling jokes and performing amusing sketches.

In 1910 it became clear to the Fetes Committee that a large permanent venue was required as a place of entertainment. The Winter Gardens was the result.

SEE Dandy Coons/ Lloyd, Marie/ Margate/ Orphanages/ Uncle Bones/ Uncle Frank/ Westbrook/ Winter Gardens

Ramsgate: Entertainment on the sands has included Punch and Judy shows, knife throwers, bands from Germany and Italy, performing canaries, equestrian monkeys, minstrels, guinea pigs and rabbits, beach photographers, E Tucker selling ice cream from a barrow and hurdy gurdy men. In later years, Harry Gold's Pierrots performed.

Keble's Penny Guide to Margate 1871-2: *Walk to Ramsgate – don't forget the sands – listen to the Niggers with their 'yah, yah massa', the hurdy-gurdies; German bands; Equestrian Monkees; Performing Canary Birds; Guinea Pigs and Rabbits, a trifle to each and think yourself a cosmopolitan. Before leaving the sands, you can amuse yourself with a game of 'Aunt Sally'. All this will cost you 6d.*

SEE Beach entertainment, Margate/ Ice Cream/ Ramsgate/ Yachtsmen

BEACHES

Thanet has 17 beaches and bays along 26 miles of coastline.

SEE Bays/ Foreness Point/ Thanet/ West Beach, Ramsgate

BEACON ROAD, Broadstairs

A windmill called Reading Street Mill is first recorded on a 1683 map and was used by ships as a seamark. When it was removed, it was replaced by a beacon built of red bricks and became known as the Red Beacon. It was situated behind Tower Cottage in Beacon Road – hence the names of both. Subsidence meant that it had to be demolished in 1931.

Warning lights were lit at Beacon Road at the time of the Armada. Captain Henry Crispe (probably a member of the Quex family) commanded a company of 250 trained officers and men to defend the island. He was paid £169/15/6 to *'keep them at the ready'* for 22 days.

SEE Armada/ Broadstairs/ Quex/ Reading Street

Benjamin BEALE

Born c.1717
Died 16th May 1775

The credit for the first bathing machine is still argued about today because there is a print of Scarborough dating from 1735 which shows a small beach hut on wheels being taken down to the edge of the sea. Now, to the connoisseur, especially if he comes from Kent and not Yorkshire, this was not a true bathing machine. It was a young Margate Quaker, Benjamin Beale, the son of Thomas Beale (1690-1747) a glover, and a glover and breaches maker himself, (he married Elizabeth Bindlock from Canterbury in 1740) who perfected the horse-drawn bathing machine which played a major role in the development of Margate as a seaside resort. It allowed mixed bathing to be respectable and thus, in turn, ensured the success of all the other British seaside holiday resorts as they all eventually embraced Beale's design for the fully-fledged machines which took bathers right out into the sea. They were in use at Margate from about 1750 onwards and possibly earlier. Bathers paid about 2 shillings, the equivalent of 2 days wages for an ordinary working man, and entered the machines by steps at the back of the bathing houses built at the bottom of the west side of the High Street (or where Albert Terrace backs onto the High Street today). These buildings balanced precariously on timber piles on the cliff face, and this, combined with the regular storm damage they suffered, contributed to the area soon becoming known as Hazardous Row. Trading in a street with a name like that it's surprising he got any business at all, but business boomed. At its rear, the machine had a hinged and hooped canvas screen which, once the machine had been driven into position, the driver operated a pulley to lower the screen and form a tent over the water. The occupant would then go down the steps of the machine and bathe in complete privacy from onlookers. They were also in complete privacy from the sun and sky and, combined with the all-covering predominately blue bathing suits that both sexes wore, formed a sort of early, and 100% effective, sun block. This was still in the era when a suntan was not fashionable. Also, as very few people owned a bathing suit, you would hire one while you were here.

The machines were hugely popular and contemporary guidebooks gave them rave reviews - *by means of this very useful contrivance both sexes may enjoy the renovating waters of the ocean, the one without any violation of public decency, and the other safe from the gaze of idle or vulgar curiosity.*

Almost every resort in Britain, as well as the East and West Indies and virtually everywhere else in the world where the British sense of decency had spread, imported the machines, or at any rate copied them.

Sadly, Benjamin Beale eventually lost all his money when storm after storm wrecked his bathing rooms and machines. I told you that having a business address in Hazardous Row was a bad omen but poor old Benjamin obviously thought it didn't apply to him. The local people, but primarily Sir John Shaw, Bart., and Dr Hawley, kindly organised a public subscription to assist him financially, with lots of 'I tried to tell him, but he had to know best' probably being whispered behind his back, like people do. Obviously, you and I wouldn't, but you know the type I'm talking about. He died a pauper aged 58 years and was buried at Draper's Hospital on St. Peter's Road. His wife died aged 92 in 1806 and is buried next to him.

He knew the area because he had taken over Draper's Farm in 1751.

Prior to his bathing machine career he operated a passenger service to Canterbury in a light carriage he designed himself. Once, when he was driving his cart along a turnpike he met a cart coming the other way which would not get out of the way. The devout Quaker lost his temper, jumped down and grabbed the other man's horse to move the cart. Within seconds there was a brawl between him and the other driver and his passengers. A case of turnpike rage. Nothing is new.

SEE Albert Terrace/ Bathing/ Bathing machines/ Farms/ High Street, Margate/ Hoy, The/ Margate

The BEATLES

They were a pop group (comprising John Lennon, Paul McCartney, George Harrison and Ringo Starr) who were quite popular in the 1960s.
SEE Bachelors, The/ Music/ Rolling Stones/ Winter Gardens

Venerable BEDE

The Venerable Bede, 'Historia Ecclesiastica Gentis Anglorum' (AD731) (Ecclesiastical History of the English People): *A.D. 449. This year Marcian and Valentinian assumed the empire, and reigned seven winters. In their days Hengest and Horsa, invited by Wurtgern, king of the Britons to his assistance, landed in Britain in a place that is called Ipwinesfleet [Ebbsfleet]; first of all to support the Britons, but they afterwards fought against them. The king directed them to fight against the Picts; and they did so; and obtained the victory wheresoever they came. They then sent to the Angles, and desired them to send more assistance. They described the worthlessness of the Britons, and the richness of the land. They then sent them greater support. Then came the men from three powers of Germany; the Old Saxons, the Angles, and the Jutes. From the Jutes are descended the men of Kent, the Wightwarians (that is, the tribe that now dwelleth in the Isle of Wight), and that kindred in Wessex that men yet call the kindred of the Jutes. From the Old Saxons came the people of Essex and Sussex and Wessex. From Anglia, which has ever since remained waste between the Jutes and the Saxons, came the East Angles, the Middle Angles, the Mercians, and all of those north of the Humber. Their leaders were two brothers, Hengest and Horsa; who were the sons of Wihtgils; Wihtgils was the son of Witta, Witta of Wecta, Wecta of Woden. From this Woden arose all our royal kindred, and that of the Southumbrians also. (A.D. 449. And in their days Vortigern invited the Angles thither, and they came to Britain in three ceols, at the place called Wippidsfleet.)*
A.D. 455. This year Hengest and Horsa fought with Wurtgern the king on the spot that is called Aylesford. His brother Horsa being there slain, Hengest afterwards took to the kingdom with his son Esc.
A.D. 457. This year Hengest and Esc fought with the Britons on the spot that is called Crayford, and there slew four thousand men. The Britons then forsook the land of Kent, and in great consternation fled to London.

Anglo-Saxon Chronicle

So Augustine, strengthened by the encouragement of St. Gregory, in company with the servants of Christ, returned to the work of preaching the word, and came to Britain. At that time Ethelberht, king of Kent, was a very powerful monarch. The lands over which he exercised his suzerainty stretched as far as the great river Humber, which divides the northern from the southern Angles. Over against the eastern districts of Kent there is a large island called Thanet which, in English reckoning, is 600 hides in extent. It is divided from the mainland by the river Wantsum, which is about three furlongs wide, can be crossed in two places only, and joins the sea at either end. Here Augustine, the servant of the Lord, landed with his companions, who are said to have been nearly forty in number. They had acquired interpreters from the Frankish race according to the command of Pope St. Gregory. Augustine sent to Ethelberht to say that he had come from Rome bearing the best of news, namely the sure and certain promise of eternal joys in heaven and an endless kingdom with the living and true God to those who received it. On hearing this, the king ordered them to remain on the island where they had landed and be provided with all things necessary until he had decided what to do about them. Some knowledge about the Christian religion had already reached him because he had a Christian wife of the Frankish royal family whose name was Bertha. He had received her from her parents on condition that she should be allowed to practise her faith and religion unhindered, with a bishop named Liudhard whom they had provided for her to support her faith.
Some days afterwards the king came to the island and, sitting in the open air, commanded Augustine and his comrades to come thither to talk with him. He took care that they should not meet in any building, for he held the traditional superstition that, if they practised any magic art, they might deceive him and get the better of him as soon as he entered. But they came endowed with divine not devilish power and bearing as their standard a silver cross and the image of our Lord and Saviour painted on a panel. They chanted litanies and uttered prayers to the Lord for their own eternal salvation and the salvation of those for whom and to whom they had come. At the king's command they sat down and preached the word of life to himself and all his gesiths there present. Then he said to them: 'The words and the promises you bring are fair enough, but because they are new to us and doubtful, I cannot consent to accept them and forsake those beliefs which I and the whole English race have held so long. But as you have come on a long pilgrimage and are anxious, I perceive, to share with us things which you believe to be true and good, we do not wish to do you harm; on the contrary, we will receive you hospitably and provide what is necessary for your support; nor do we forbid you to win all you can to your faith and religion by your preaching.' So he gave them a dwelling in the city of Canterbury, which was the chief city of all his dominions; and, in accordance with his promise, he granted them provisions and did not refuse them freedom to preach. It is related that as they approached the city in accordance with their custom carrying the holy cross and the image of our great King and Lord, Jesus Christ, they sang this litany in unison: 'We beseech Thee, O Lord, in Thy great mercy, that Thy wrath and anger may be turned away from this city and from Thy holy house, for we have sinned. Alleluia.'
As soon as they had entered the dwelling-place allotted to them, they began to imitate the way of life of the apostles and of the primitive church. They were constantly engaged in prayers, in vigils and fasts; they preached the word of life to as many as they could; they despised all worldly things as foreign to them; they accepted only the necessaries of life from those whom they taught; in all things they practised what they preached and kept themselves prepared to endure adversities, even to the point of dying for the truths they proclaimed. To put it briefly, some, marvelling at their simple and innocent way of life and the sweetness of their heavenly doctrine, believed and were baptized. There was near by, on the east of the city, a church built in ancient times in honour of St. Martin, while the Romans were still in Britain, in which the queen who, as has been said, was a Christian, used to pray. In this church they first began to meet to chant the psalms, to pray, to say mass, to preach, and to baptize, until, when the king had been converted to the faith, they received greater liberty to preach everywhere and to build or restore churches.
At last the king, as well as others, believed and was baptized, being attracted by the pure life of the saints and by their most precious promises, whose truth they confirmed by performing many miracles. Every day more and more began to flock to hear the Word, to forsake their heathen worship, and, through faith, to join the unity of Christ's holy Church. It is related that the king, although he rejoiced at their conversion and their faith, compelled no one to accept Christianity; though none the less he showed greater affection for believers since they were his fellow citizens in the kingdom of heaven. But he had learned from his teachers and guides in the way of salvation that the service of Christ was voluntary and ought not to be compulsory. It was not long before he granted his teachers a place to settle in, suitable to their rank, in Canterbury, his chief city, and gave them possessions of various kinds for their needs.
SEE Ebbsfleet/ Hengist and Horsa/ Thanet/ Wantsum Channel

BEDFORD INN public house
Westcliff Road, Ramsgate

The terrace of buildings that this pub stands in dates from about 1808. It was called the Jolly Farmer in the mid-nineteenth century, but from around 1874 it became the Bedford Hotel.
SEE Pubs/ Ramsgate

BEECHING, MOSES and Co, Ramsgate

In March 1902 from the boat-building yard of the *'progressive and wide awake firm of Messrs Beeching, Moses and Co. of Ramsgate a new Smack named in spite of these stirring times 'Peace''*.
SEE Ramsgate/ Shipbuilding

BELGIAN SOLDIERS

The first wounded Belgian soldiers landed at Ramsgate on 10th October 1914.
SEE Lewis, Hyland and Linom/ Ramsgate/ Refugees/ Royal Sailors' Rest/ World War I

BELL INN
The Street, St Nicholas-at-Wade

The building, originally Tudor, was in existence before it was a pub and it has been selling beer since 1715 or even earlier. It was briefly the Hare and Hounds in the late eighteenth century. Francis Cobb of the Cobb Brewery having leased it for thirty four years bought it off the Bridges family in 1798.

All that Messuage or Tenement called or known by the name of The Bell (sometimes called or known as The Hare and Hounds), and the Kitchen, Necessary House or House of Easement and the buildings heretofore used as a Dog Kennel, yard, garden and ground ...
SEE Cobbs/ Pubs

BELLEVUE GARAGE, Ramsgate

Even though mechanics at Bellevue Garage had taken precautions (including removing the petrol tanks) before welding a car, firemen had to contend with collapsing walls, explosions and the danger of gas cylinders exploding as they worked for three hours to stop a fire reaching dozens of homes which had to be evacuated on 10th September 1996.
SEE Fires/ Garages/ Ramsgate

BELLEVUE HILL, Ramsgate

Born at 12 Belle Vue Hill, Samuel Stead (1846-1921 the son of John Sandwell Stead 1808-1882), emigrated to Sydney, Australia with his two elder brothers in 1862. They left for Plymouth and sailed on the Hotspur on 31st March 1862. The journey took 110 days.
SEE Ramsgate

BELLEVUE ROAD, Ramsgate

It was originally Belle Vue Place and named because it had a good view, before it was blocked by the building of Wellington Crescent. It was also where Samuel Taylor Coleridge spent his last holiday in Ramsgate with the Gillmans, at number 4 (3rd – 27th July 1833).

Thirty people were injured here when two trams collided on 27th May 1903. Amazingly, exactly two years later to the day, on 27th May 1905, another accident occurred when tram 47 ran out of control into Vye's grocery shop. The manager's seven year-old daughter was badly injured, as was the tram driver and conductor.

Another tramway accident in Belle Vue Road. East Kent Times 31st May 1905
The Iron Duke pub is currently being renovated after being a bit of an eyesore for many years.
SEE Coleridge/ Donkeys/ East Kent Times/ Mount Albion House/ Ramsgate/ Trams/ Vye and son

BELLE VUE TAVERN
Northdown Road, Cliftonville

Once at Belgrave Terrace, and now at 159 Northdown Road, it dates back, as a hotel, to the 1850s. Around 1935 it was extended to include a large lounge bar.

In 1940 a bomb exploded over the road outside the bank and caused some damage but the pub continued to trade. The actor Jack Warner was a regular visitor and apparently enjoyed a game of snooker here.
SEE Cliftonville/ Northdown Road/ Oxford hotel/ Pubs/ Warner, Jack

BELLEVUE TAVERN, Pegwell

This tavern dates from around 1785. This was once both a very popular tavern and tea garden, well known for its shrimp teas. Princess Victoria once visited here and when she became Queen the landlord, John Cramp, was granted the warrant of *'Purveyor of Essence of Shrimps in Ordinary to her majesty the Queen'*. Horse-drawn carriages brought many people here to enjoy their shrimp teas whilst watching the shrimpers working in the bay below. Before the Second World War the fare was 4d each way.
SEE Banger's Original Essence and Potted Shrimp Factory/ Pubs/ Victoria

BELMONT HOUSE, Ramsgate

Built for a trader of the East India Company in 1795, it was subsequently owned by an Irish absentee landlord and an unmarried but wealthy trader who let the property out to various notables like the Duchess of Kent and her daughter Princess Victoria. A popular feature of the property then was a secret garden. In later years the house was a girls' school but World War II saw this close and the army take over the property. Later it became a hotel and a nursing home and in 2004 was turned into apartments.
SEE Ramsgate/ Schools/ Victoria/ World War II

BELMONT ROAD, Ramsgate

The Hurricane Bombardment of 27th April 1917 caused damage to Belmont Road.
The Belmont Road Pentecostal Church opened on 23rd October 1965 and closed in November 1984.
SEE Churches/ Hurricane Bombardment/ Ramsgate/ World War I

BELMONT ROAD, Westgate

Two German seaplanes attacked Westgate on 16th March 1917 dropping 13 bombs – most of the damage was centred on Belmont Road, although the bandstand on the seafront was also damaged.
SEE Westgate-on-Sea/ World War I

BELMONT STREET, Ramsgate

In the mid-nineteenth century Belmont Street was called Regent Place and was the home of Austen's Regent Brewery from 1850, having moved from Broad Street. Part of the building was converted into a pub that became the Golden Ball Inn with an entrance in Union Street.

In 1927 Gardener's of Ash bought the brewery and eight years later demolished it. The Golden Ball Inn was re-built and remained open until the 1960s. Part of the old brewery became a hall holding dances and concerts. The whole area, including many terraced houses, was cleared for redevelopment in the 1960s.
SEE Breweries/ Broad Street/ Ramsgate

BELVEDERE HOUSE
Dundonald Road, Broadstairs

Now separated into three properties including the Dundonald House Hotel, it was built for Admiral Thomas Cochrane, 10th Earl of Dundonald,
Lord Sidmouth, when he was Home Secretary, first heard news of the Peterloo massacre whilst he was staying here.
SEE Addington, Lord/ Broadstairs/ Cochrane, Admiral Thomas/ Peterloo/ Sidmouth, Lord

BENJAMIN BEALE public house
Fort Hill

SEE Beale, Benjamin/ Hoy, The

BEMBON BROTHERS

They were from the Netherlands and took over Dreamland Amusement Park in 1983. They introduced the concept of a 'one payment admission charge' instead of paying to get on each ride.
SEE Dreamland

Sir Richard Rodney BENNETT
Born: Broadstairs 29th March 1936.

Although born in Broadstairs he was brought up in the West Country during the war. His mother had been a pupil of Gustav Holst (1874-1934). Bennett is world-renowned as a composer of symphonies, jazz, operas and ballets but he is probably best known for his film soundtracks, which he has created for over 40 films including 'Far from the Madding Crowd', 'Lady Caroline Lamb', 'Four Weddings and a Funeral' and 'Murder on the Orient Express' for which he was nominated for an Oscar and won a BAFTA. He was knighted in 1977 and now lives in semi-retirement in New York.
SEE Broadstairs/ Films/ Music

BENSONS ASSEMBLY ROOMS

These were attached to the Royal Hotel in Cecil Square and were a very fashionable place to visit in the period around 1799. The gentry could take tea or coffee, or play billiards here.
SEE Cecil Square

Admiral Charles William De La Poer BERESFORD (GCVO, KCB)

Born 10th February 1846
Died 6th September 1919
The second son of the 4th Marquis of Waterford, he joined the Royal Navy as a cadet in 1859. By 1874 he was a lieutenant. A man who liked a bit of publicity, he was a John Bull type figure, even down to having a bulldog with him, and was known to the public as 'Charlie B'. Still in the navy, and

now a commander, he accompanied the Prince of Wales (the future Edward VII) to India as his aide-de-camp (1875-76). He was also Conservative MP for Waterford from 1875 until 1880. He married Mina Gardner in 1878 and they had two children, Kathleen and Eileen Theresa Lucy.

He was second-in-command of the Royal Yacht HMS Osborne (1878-81). In 1882 he became captain of HMS Condor, a gunboat that during the 1882 Egyptian War, he took close in to shore to bombard the Egyptian batteries which made him very popular with the British public. He also captained HMS Sophia up the Nile as part of the expedition to relieve Lord Wolsey in 1884.

He was MP for Marylebone in 1885 and got re-elected in the general election the following year but he resigned in 1888 protesting at what he saw as a lack of expenditure on the navy. This built up public pressure on the issue and as a consequence the Naval Expenditure Act was passed in 1889. He captained HMS Undaunted (1889-93) in the Mediterranean Fleet. In 1897 he became a Rear-Admiral and an MP again, this time for York, which must have been difficult as he was representing the Associated Chambers of Commerce in China for much of the time. In 1900 he was no longer an MP but second-in-command of the Mediterranean Fleet. He was back in Parliament from 1902 as MP for Woolwich but gave it up in 1906 when he became an Admiral and Chief of the Channel Fleet. He then commanded the Mediterranean Fleet from 1905-07. He had a very public and acrimonious row with Jackie Fisher, the First Sea Lord, because he did not agree with his reforms. He swopped being in command of the Channel Fleet for being MP for Portsmouth in 1909, left the navy in 1911, and stopped being an MP in 1916.
SEE Admirals/ Beresford Gap, Birchington

BERESFORD GAP, Birchington
This man-made gap in the cliffs is named after Admiral Charles William De La Poer Beresford.
SEE Birchington/ Beresford, Admiral Charles

BERESFORD HOTEL
Beach Avenue, Birchington
John Pollard Seddon designed this very classy 5-star hotel that was hugely popular up until the 1960s but it was sadly demolished in the 1970s. It was a very luxurious affair furnished in a Japanese style with a ballroom and a room described as 'Oak and pewter'.

It was named after Major Morrison Bell, who lived here when it was originally called Thor and Haun. At the very end of the nineteenth century Admiral Lord Charles William de la Poer Beresford used it as his seaside retreat – it had six acres of grounds - and entertained here on a very grand scale. It became Beresford Lodge but was a British Red Cross Hospital in World War I. It returned to its former glory when it became the Beresford Hotel (5-stars, obviously). John Betjeman (1906-1984) stayed there briefly in the early

part of 1929 when he accompanied his then employer, the former agricultural expert, Sir Horace Plunkett, who was writing a book. Betjeman most probably took a trip to Westgate during this time as it is the subject of one of his earliest published poems 'Westgate-on-sea'.

Other guests here included everyone from Harold Wilson to Diana Dors (not at the same time, we don't want to start any gossip – although . .), The Beatles and Petula Clark. Times changed, and the glory days became a memory and the old place closed in 1967, and in 1971 the site was sold for housing.
SEE Beresford, Admiral/ Beresford Gap/ Betjeman, Sir John/ Birchington/ Dors, Diana/ Home School for Girls/ Hotels/ Seddon, John Pollard/ Westgate-on-Sea/ World War I

Ballard BERKELEY
Born Margate 6th August 1904
Died London 16th January 1988
An actor who made his professional stage debut in 1928, he made many films in his career ranging from 'In Which We Serve' (1942) to 'The Wildcats of St. Trinian's' (1980) and just his voice in the cartoon 'The BFG' (1989). On television he appeared in episodes of 'Dixon of Dock Green' (from 1956-61 & 1969); 'The Adventures of Robin Hood' (1955, 58 & 60); 'Fresh Fields' (1984), 'Terry and June' (1982 & 87), 'Hi-de-hi!' (1983), 'Are You Being Served?' (1983), 'To the Manor Born' (1981), 'The Goodies' (2 episodes in 1980), 'Just William' (1977), 'Bless This House' (1972), 'Sherlock Holmes' (1965 & 68), 'Maigret' (1963) and most famously, he was Major Gowen ('Papers arrived yet Fawlty?') in 'Fawlty Towers' (1975).
SEE Actors/ Fawlty Towers/ Margate

BERKELEY ROAD, Birchington
Sea Point Private School moved here from Elfin Cottage, Station Approach, but closed at the outbreak of World War II.
SEE Birchington/ Schools

Queen BERTHA
Born 539
Died c612
The wife of King Ethelbert.
SEE Ethelbert/ Queen Bertha's School

BETHESDA STREET, Ramsgate
The Particular Baptist Chapel was here in 1829 and was still standing until the 1950s. Bethesda, from the Greek kolumbethra, 'swimming bath' is mentioned in The Bible, John 5:2 *Now there is at Jerusalem by the sheep market a pool, which is called in the Hebrew tongue Bethesda, having five porches.*
SEE Bible/ Churches/ Ramsgate/ St Georges School

Sir John BETJEMAN
Born Highgate 28th August 1906
Died Trebetherick 19th May 1984
The poet, broadcaster, conservationist and architectural historian became Poet Laureate in 1969.

Up until World War II, his name was spelt 'Betjemann' but he removed the second 'n' because he thought it would look less Germanic.

Towards the end of his life, when he was wheelchair-bound and suffering from Parkinson's Disease, he was asked if he had any regrets; he said that he wished that he'd had more sex.
SEE Beresford Hotel/ George V Avenue/ 'Margate 1940' by Sir John Betjeman/ Poets/ 'Westgate on sea' by Sir John Betjeman

BETSEY TROTWOOD
This character in 'David Copperfield' by Charles Dickens was based on Miss Mary Pearson Strong who lived in the house now called Dickens House on Victoria Parade in Broadstairs. She had an aversion to people riding their donkeys in front of her house and Dickens would apparently persuade people to do it just so that he couild watch her reaction!

Janet had gone away to get the bath ready, when my aunt, to my great alarm, became in one moment rigid with indignation, and had hardly voice to cry out, 'Janet! Donkeys!'
Upon which, Janet came running up the stairs as if the house were in flames, darted out on a little piece of green in front, and warned off two saddle-donkeys, lady-ridden, that had presumed to set hoof upon it; while my aunt, rushing out of the house, seized the bridle of a third animal laden with a bestriding child, turned him, led him forth from those sacred precincts, and boxed the ears of the unlucky urchin in attendance who had dared to profane that hallowed ground.
To this hour I don't know whether my aunt had any lawful right of way over that patch of green; but she had settled it in her own mind that she had, and it was all the same to her. The one great outrage of her life, demanding to be constantly avenged, was the passage of a donkey over that immaculate spot. In whatever occupation she was engaged, however interesting to her the conversation in which she was taking part, a donkey turned the current of her ideas in a moment, and she was upon him straight. Jugs of water, and watering-pots, were kept in secret places ready to be discharged on the offending boys; sticks were laid in ambush behind the door; sallies were made at all hours; and incessant war prevailed. Perhaps this was an agreeable excitement to the donkey-boys; or perhaps the more sagacious of the donkeys, understanding how the case stood, delighted with constitutional obstinacy in coming that way. I only know that there were three alarms before the bath was ready; and that on the occasion of the last and most desperate of all, I saw my aunt engage, single-handed, with a sandy-headed lad of fifteen, and bump his sandy head against her own gate, before he seemed to comprehend what was the matter. These interruptions were of the more ridiculous to me, because she was giving me broth out of a table-spoon at the time (having firmly persuaded herself that I was actually starving, and must receive nourishment at first in very small quantities),

and, while my mouth was yet open to receive the spoon, she would put it back into the basin, cry 'Janet! Donkeys!' and go out to the assault.
SEE Broadstairs/ 'David Copperfield'/ Dickens, Charles/ Dickens House/ Donkeys/ Victoria Parade

BETTISON'S CIRCULATING LIBRARY
On the corner of Hawley Square and Cecil Street, Bettison's Circulating Library opened in 1786 attracting *'officers and gentry of rank and fashion'* until it closed in 1843. They were attracted by the musical evenings, raffles and card playing. The same corner was the site of the Thanet School of Art that opened in 1931. The building became the Hilderstone Adult Education Centre in the 1960s.
SEE Libraries/ Hawley Square/ Schools

BEVIN BOYS
Named after Ernest Bevin (1881-1951), the Minister of Labour and National Service in World War II and devisor of the scheme whereby, depending on the last digit of their call-up number, 21,000 men were sent down the mines rather than join the armed forces.
'One will say: 'I was a fighter pilot'; another will say: 'I was in the Submarine Service'; another 'I marched with the Eighth Army'; a fourth will say: 'None of you could have lived without the convoys and the Merchant seamen', and you, in your turn, will say, with equal pride and equal right: 'We cut the coal'. Winston Churchill, 22nd April 1943.
Mr George Buckman, of Kings Road, Birchington, and Mr Kennety Field, of Canterbury Road, were two eighteen year old Bevin Boys who, in 1944, walked out of Chislet Colliery after working five days on the coal face. They said they felt bad about it but would prefer to go into the services - I can't say I blame them!
SEE Birchington/ World War II

The BIBLE
SEE Aitken, Jonathan/ Bethesda Street/ Blinkos's Book Shop/ Churches/ Fry, Elizabeth/ Mausoleum/ Van Gogh, Vincent

BICYCLE
The following from the Kentish Post and Canterbury News Letter (26th June 1770) is thought to refer to an early form of bicycle:
To the CURIOUS
To be seen gratis at Margate in the Isle of Thanet.
A Machine of a very neat construction, in which the ingenious Mr Moore of Cheapside, was lately conveyed from London to Margate in the course of nine hours without the aid of horses.
The above machine may be seen by applying to Mr Kitchener at the New-Inn in Margate, at any time of the day, till Friday next, when it will be had back again to London by order of the proprietor
SEE East Cliff Lodge/ Kingfisheries fishing tackle shop/ Margate/ Motor Museum/ Orczy, Baroness/ Priestley's Cycle & Machine Stores/ Royal York Hotel/ Sea Breeze Cycle Factory/ Sea Wall/

Transport Viking Coastal Trail/ Westbrook Cycle Store

Ronnie BIGGS
Born 8th August 1929
The Great Train Robber: *'My last wish is to walk into a Margate pub as an Englishman and buy a pint of bitter.'*
SEE Margate/ Pubs

'BILLERICAY DICKIE'
A song by Ian Dury on his 'New Boots and Panties!!' album that mentions the Isle of Thanet. He maintains, in the lyrics, that he had an affair with a certain Janet, apparently just outside the Isle of Thanet.
SEE Dury, Ian/ Music/ Thanet

BILLY BUNTER
The character of Billy Bunter was an amalgamation of Frank Richards' sister Una who *'peered over her glasses like an inquisitive owl'*; his brother Alex, who was always expecting a cheque; and Lewis Ross Higgins, an art critic for Punch and the editor, from 1914, of Chuckles, who apparently *'overflowed his chair'* and who died aged 34 in 1919 after suffering from a glandular disorder.
The first illustrator of the books was Hutton Mitchell who used his sons, Alan, Bruce and Alexander to model for him with pillows stuffed down their trouser legs. Many think that Port Regis Retirement Home in Convent Road, Broadstairs, is the model for Greyfriars School and he mentions Roman Well and Hengist Stone in these stories
''My esteemed chums,' murmured Hurree Jamset Ram Singh. 'This is not an occasion for looking the gift horse in the mouthfulness.'' Bunter's Last Fling
The first Billy Bunter story was written in 1899 but was rejected by a publisher who *'shook a sage head over him.'* The stories ran in The Magnet up until the Second World War. Between 1946 and 1961, a total of 39 Bunter books were published. Here goes then, take a big breath and don't forget to put your anorak on: 'Billy Bunter of Greyfriars School' (1947); 'Billy Bunter's Banknote'; (1948); 'Billy Bunter's Barring Out' (1948); 'Billy Bunter in Brazil' (1949); 'Billy Bunter's Christmas Party' (1949); 'Bessie Bunter of Cliff House School' (1949); 'Billy Bunter's Benefit' (1950); 'Billy Bunter Among the Cannibals' (1950); 'Billy Bunter's Postal Order' (1951); 'Billy Bunter Butts In' (1951); 'Billy Bunter and the Blue Mauritius' (1952); 'Billy Bunter's Beanfeast' (1952); 'Billy Bunter's Brainwave' (1953); 'Billy Bunter's First Case' (1953); 'Billy Bunter the Bold' (1954); 'Bunter Does His Best' (1954); 'Billy Bunter's Double' (1955); 'Backing Up Billy Bunter' (1955); 'Lord Billy Bunter' (1956); 'The Banishing of Billy Bunter' (1956); 'Billy Bunter's Bolt' (1957); 'Billy Bunter Afloat' (1957); 'Billy Bunter's Bargain' (1958); 'Billy Bunter the Hiker' (1958); 'Bunter Out of Bounds' (1959); 'Bunter Comes for Christmas' (1959); 'Bunter the Bad Lad' (1960); 'Bunter Keeps it Dark' (1960); 'Billy Bunter's

Treasure Hunt' (1961); 'Billy Bunter at Butlins' (1961); 'Bunter the Ventriloquist' (1961); 'Bunter the Caravaner' (1962); 'Billy Bunter's Bodyguard' (1962); 'Big Chief Bunter' (1963); 'Just Like Bunter' (1963); 'Bunter the Stowaway' (1964); 'Thanks to Bunter' (1964); 'Bunter the Sportsman' (1965); and 'Bunter's Last Fling' (1965).
SEE Books/ Broadstairs/ Campion, Gerald/ Richards, Frank/ Schools

BIOSCOPE
A bioscope was an early form of travelling cinema, before they were installed in their own buildings. They would travel around the country and show films in a tent similar to those used by a circus.
SEE Cinemas/ Forresters Hall, Union Crescent

Eugenius BIRCH
Born 20th June 1818, Gloucester Terrace, Shoreditch
Died 8th January 1884, Hampstead
The most famous names in pier engineering - which is, I grant you, a limited area of expertise - are Joseph Wilson, J and A Dawson, James Brunlees, and lastly, possibly the best, but certainly the most prolific, Eugenius Birch. His father, John, was a corn dealer and his mother was Susanne. They had an elder son, John Brannis Birch, born in 1813, who would work with his brother in later years. Eugenius went to school, first in Brighton, and then Euston Square, London and showed both great artistic and mechanical talent from a very young age. He was spellbound watching the Regent's Canal being cut. He even sent in a model of a railway carriage to the Greenwich Railway Company who adopted his idea of having the wheels under the carriage instead of on the sides (Brunel was in favour of having the more efficient large wheels taller than the carriages and passengers would look out the windows through the spokes of the wheel). When he was 16, Eugenius started work at Bligh's engineering works in Limehouse. Following this he joined the Mechanic's Institute. The boy did good: in 1837, his drawing of a steam engine won the Society of Arts Silver Isis Medal; in 1838 his drawings of Huddert's rope machinery won a silver medal; in 1839 the Institution of Civil Engineers elected him a graduate and in 1863, he became a member. By 1845 the Birch brothers had opened an office at 3 Cannon Row, Westminster which they had until 1856. From 1858 until 1864 they were based at 43 Parliament Street.
In 1863, he and his brother went into partnership and the expansion of railways saw them build railways, bridges, and viaducts including Nottinghamshire's Stockwith and Kelham bridges. He even got involved in projects as far away as India where they worked on the Calcutta – Delhi railway line. John Brannis Birch died aged 51 in 1864, and Eugenius' offices moved to 7 Westminster Chambers, Victoria Street, London.
In all this talk of railways, I have overlooked the thing that Eugenius (what a great name -

everytime someone called to him, it was a compliment!) Birch is most famous for, seaside piers. In 1853, Margate businessmen commissioned Eugenius to design a new pier for the town. He went on to design fourteen across the country over the next thirty-one years. His time in India very often influenced the designs. The startling new marine engineering development that the Margate design included was his 'screwed piling' technique. Quite simply, he added a screw blade onto the end of the iron piles and simply screwed them into the ground. This method was so successful that when, 125 years later following a storm in 1978, an attempt was made to dismantle the pier, dynamite could not dislodge the piles! In time, Birch's new technique was copied and improved on by James Branlees who pumped water down the hollow pile to ease its passage through sand or shingle. Anyway, Margate's pier was a success in three ways. It made Margate more popular; after a slow start, it made pleasure piers more popular - 18 were built between 1862 and 1872 - and it made Eugenius Birch more popular. His new method was used in most of the other thirteen that he built:

BLACKPOOL NORTH, opened 21st May 1863 and still survives.

DEAL, opened autumn 1864 at 1100 feet long. It was badly damaged in January 1940 when a Dutch ship, Nora, hit a mine, lost control and crashed into the pier. It was replaced In 1957 by a concrete structure (costing £250,000) making it the only post-war pier in the country. (Trivia alert –Deal pier and the Titanic were the same length 882 feet and 9 inches)

ABERYSTWYTH, opened on Good Friday 1865, at 800 feet long but was damaged in storms in 1938 and is still partly closed.

LYTHAM, opened 17th April 1865. It was Lytham's first pleasure attraction. A fire in 1928 caused great damage and it was eventually demolished in 1960.

SCARBOROUGH, opened c1866 but it is now gone.

BRIGHTON WEST, opened 5th October 1866, costing £30,000, at 1,115' long and was considered to be Birch's masterpiece. It closed in 1975 but it remains the only Grade I listed pier in the country.

BIRNBECK, WESTON-SUPER-MARE, opened 6th June 1867, at 1,350 feet long, being the tenth longest pier and the only pier linking the mainland to an island – Birnbeck. It is Grade II listed but is on the English Heritage list of buildings at risk.

NEW BRIGHTON, opened 7th September 1867 and long used by the Mersey ferry. It was demolished in 1977.

EASTBOURNE, opened 13th June 1870 at 1,000 feet long; it still survives.

HASTINGS, opened 5th August 1872' Repeatedly repaired and replaced it closed on 13th October 1999 although there are plans to restore and re-open it.

BOURNEMOUTH, opened 11th August 1880 at 838 long; it still survives today.

HORNSEA, opened in 1880. A ship, the Earl of Derby, destroyed some of it the same year

following a collision, and the rest was demolished in 1897.

PLYMOUTH, his last pier, opened 29th May 1884, but was a casualty of the last war.

Around 55 piers remain in the country.

His other projects included the West Surrey waterworks, Devon and Somerset railway, Exmouth docks, and Ilfracombe harbour.

Away from his engineering work, he was a talented artist and in the winter of 1874 to 1875, he painted over one hundred watercolours on a tour of Italy, Egypt and Nubia. It was probably somewhat of a honeymoon as, in 1874, at 56 years old, he had married the daughter of Charles Gent, a Moss Side, Manchester manufacturer. They had no children and Eugenius died just ten years later on the 8th January 1884 at Hampstead before his last pier, at Plymouth, had opened.

SEE Pier/ Titanic

BIRCHINGTON

Meaning, in Saxon, a farmstead near a hill where birch trees grow, it is recorded as Bichilton in 1240; Berchinton or Bercheton in 1254; Birchelton in 1254; Bercelton in 1264; Birchinton in 1270 and Byrchington in 1610. At other times, it is recorded as Birchiton, Bircheton, Brunchington or Burchington; it has been spelt many different ways, although I like Brunchington the best, it conjures up images of freshly brewed coffee and toasted teacakes - but that's just me, and I am overdue a tea break.

There is a long history of human habitation in the Minnis Bay, Grenham Bay and Quex Park areas. Neolithic flint tools, Roman urns and Saxon coins have all been found, and it is well worth visiting the Quex Park Museum to view many of these items.

Medieval Birchington was a limb of Dover and therefore one of the Cinque Ports.

The deputy of Birchington, James Stone, arrested a *'silly man who was cracht in his brains, Robert Wood.'* for vagrancy in 1633.

In 1876, at a cost of £3 9s 8d each, twenty one gas lamps were purchased to light Birchington for the first time.

The Parish Council set a speed limit of 8mph through Birchington in 1910.

Kelly's Directory, 1957: *The area comprises 1,674 acres of land, 1 of water and 312 of foreshore.*

SEE Accomodation/ Acol/ Acorn Inn/ Albion Road/ All Saint's Church/ Anglican Church of St Thomas/ Barham, Richard Harris/ Beresford Gap/ Beresford Hotel/ Berkeley Road/ Bevin Boys/ Bothers of Birchington/ Bungalows/ Bungalows of Birchinton/ Bush, Kate/ Canterbury Road/ Canute Road/ Captain Swing/ Carmel Court/ Churches/ Cinemas/ Cinque Ports/ Coleman's Stairs Road/ Court Mount/ Cooper, Dame Gladys/ Coward, Noel/ Cross Road/ Dads Army/ Dearmer, Geoffrey/ Devon Gardens/ Dog Acre/ Edward VII/ Epple Bay/ Epple Bay Road/ Epple Road/ Fountain/ Fox, Angela/ Great Brooks End Farm/ Green Road/ Grenham Bay/ Grenham House School/ Grenham Road/ Grove House/ Hasted/ Home School for Girls/ Hotels/ Iles, JH/ Ingoldsby Road/ Kent Gardens/ Kidnapping/ King Ethelbert School/ Laburnham House/ Landy, Jimmy/ LeMesurier, John/ Lollipop man/ Lonsdale, Frederick/ 'Margate 1940'/ Mill Lane/ Minnis

Bay/ Minnis Bay Hotel/ Minnis Bay Parade/ Minnis Coastguard Cottages/ Minnis Road/ Morrison Bell House/ National School/ New Inn/ Old Bay Cottage/ Ocean Close/ Orchardson, Sir William Quiller/ Park Lane/ Parade, The/ Perfects Cottage/ Pewter Pot/ Plague/ Pond/ Population/ Powell Arms/ Primitive Methodist Chapel/ Pubs/ Queen Bertha's School/ Queen's Head/ Quex/ Railway Footbridge/ Roman Catholic Church/ Rossetti/ St James' Terrace/ St Mary's Convalescent Home/ Sea Breeze Cycle Factory/ Sea Point Private School/ Sea View Hotel/ Sea Wall/ Seddon, JP/ Shakespeare Road/ Station Road/ Smuggler restaurant/ Smuggling/ Spurgeon's Homes/ Square, The/ Station Road/ Stocks/ Tea Clipper Houses/ Temperance Hotel/ Thicket Convalescent Homes/ Traffic jams/ Twinning/ United Reform Church/ V1 & V2 rockets/ VAD Hospitals/ Wesleyan Methodist Church/ 'Westgate-on-Sea'/ Wheatley, Dennis/ Windmills/ Without Prejudice/ Woodford House School/ 'World of Waters'/ Yew Tree Close

BIRCHINGTON BAPTIST CHAPEL
Crescent Road, Birchington
It was built in 1925 on land donated by the Church Secretary, W H Cooper. The Upper Hall was added in 1971.
SEE Churches

BIRCHINGTON BAY ESTATE COMPANY
The founder of the Birchington Bay Estate Company was a London stockbroker, Mr A R Rayden, who along with a Mr C R Haig's assistance did a lot to develop the Minnis Bay area following the arrival of the railway. He built an Exhibition Building in the grassy dip which attracted great numbers.
SEE Minnis Bay/ (The) Parade, Birchington

BIRCHINGTON CHURCHYARD –
A Rossetti sonnet
A lowly hill which overlooks a flat,
Half sea, half country side:
A flat-shored sea of low-voiced creeping tide
Over a chalky weedy mat.
A hill of hillocks, flowery and kept green
Round Crosses raised for hope,
With many-tinted sunsets where the slope
Faces the lingering western sheen.
A lowly hope, a height that is but low,
While Time sets solemnly,
While the tide rises of Eternity,
Silent and neither swift nor slow.

SEE Churches

BIRCHINGTON CINEMA
Station Road, Birchington
On the 24th October 1910 the Public Hall Cinema opened at 33 Station Road. You don't remember it? Well you might have known it as The Princess, between August

and November 1918; or maybe as The Select until September 1933. In July 1923, whilst on holiday in Birchington with the actress Gladys Cooper and her sister Doris, Ivor Novello visited the cinema to see his own film 'Call of the Blood'. Just as people were getting used to the name, it became The Regent, but on the 26th January 1936, it became The Ritz for a while and then on 9th April 1958, The Bengal; until, all names exhausted, it closed as a cinema on the 14th August 1961.

It was not the largest of cinemas, only holding about 300, and apparently ventilation was sometimes a bit of a problem. At first, bouquets of flowers were stacked up to the ceiling to solve the problem and in a further attempt to remove the smoke and general fug, the usherettes would liberally spray a product called 'June' around the auditorium. Audiences could leave via a small yard to the side, from where the film was projected, but they had to use prisms to prevent the picture being distorted on the screen. A projectionist once fell through the roof void onto the seats. Mr R H Field owned the cinema from 1941 until 1961 and made alterations which meant that films no longer had to be projected onto the back of the screen.

It became a bingo club for a while and then Trader Pink's Night Spot, Sand's Cabaret Club and eventually came snooker and bingo in the Birchington Club.
SEE Cinemas/ Station Road, Birchington

BIRCHINGTON HALL
Canterbury Road, Birchington
A house called Skottestoen stood hereabouts as far back as 1278.
By the eighteenth century, the Friend family were living in Birchington Hall (it has also been Birchington Place), a very large twelve bedroomed farmhouse, with one lodge for the coachman and another for the gardener of the large grounds.
Thomas Gray and his wife who lived here in the 1870s gave generously to many local causes including St Mildred's Church at Acol and All Saints Church. It was a very nice place to live in then, with sea views and around 30 acres of grounds which were used for village celebrations like the coronation of Edward VII.
SEE Acol/ Churches/ Farms

BIRCHINGTON-on-SEA RAILWAY STATION
The station, named Birchington-on-Sea, was built at the same time as the railway line - they knew how to organise things then - and the line opened on 3rd September 1863, although no passengers could use it until 2nd October – probably leaves on the line. At the time, the area between the station and the sea was being developed, and the architects of many of the houses, J P Seddon and John Taylor, are said to have designed the Station House. There were two signal boxes, one on the down line, and one on the up line (demolished in 1929) which backed onto the old Bungalow Hotel.

There was a crossing, then a wooden bridge and fairly soon the brick bridge that is there now. If you wanted to go to Margate in 1867, a third-class ticket would have cost you 3d. If you were more adventurous and wanted to go to London Victoria then a ticket, third class again – yeah, like you were going to go first class – would have cost 6s 2d, or about 31p. It was not until the arrival of the railway that Birchington grew, but Birchington, like Westgate, made no attempt in Victorian and Edwardian time, to attract the holiday trade, in case it lowered the tone of the towns.
From c1817 until c1900 just - and I mean just - north of the railway bridge there used to be The Seed Mill, formerly a windmill.
SEE Railway/ Windmills

BIRMINGHAM DAILY GAZETTE
Birmingham Daily Gazette, 24th July 1874: *'The lisping wag who conjectured the Isle of Thanet was so called because its air was 'tho thanitory' had at least reasonable grounds for hazarding the opinion. How thousands of our hard-working citizens would get through the toil of the year without their annual refresher at Margate it would be difficult to imagine.'*
SEE Margate/ Thanet

BIRDS
These attract a great many visitors to coastal resorts. Ornithologists are also attracted.
The Collared Dove was once a rare visitor from the Balkans to Britain until the 1930s when it was seen feeding on grain being unloaded off sailing barges at Military Road, Ramsgate Harbour. Now, it is a common British bird. It must have been good grain.
Curlews, those long-legged, long-necked, long-beaked wading birds, can be seen at Pegwell Bay.
Buzzards and sparrow-hawks were killed as vermin, for financial reward, in the 18th century.
Partridges and quails, both members of the pheasant family, were plentiful in Thanet in the first half of the 18th century as were nightingales. A constant spring visitor, it was said that it was not unusual to see fifty or more on an evening walk.
East Kent times, 22nd July 1914: *Wild nature lovers will be interested to know that a grey linnet has built a nest in a fuchsia alongside a public path in Ellington Park. It has laid a clutch of eggs and hatched out four.*
SEE Curling family/ East Kent Times/ Ellington Park/ Harbour, Ramsgate/ Military Road/ Parakeets/ Pegwell Bay/ Ramsgate Harbour/ Thanet

BIRDS AVENUE, Garlinge
SEE Garlinge/ Hengrove

Sir Henry Rowley BISHOP
Born London 1786
Died 30th April 1855
He was the composer of 'Angelina' which was first performed in Margate in 1804. He was the first musician to be knighted. Although successful he died virtually impoverished.
SEE Margate/ Music

BLACK & WHITE MINSTRELS
Les Want, one of the Black and White Minstrels for over a quarter of a century, used to live in Broadstairs.
SEE Broadstairs/ Entertainers

BLACK HORSE INN, Margate
Next door to the White Hart, on the corner of Duke Street and The Parade, was the Black Horse Inn where Thomas Barber got up one day and decided that it would be a good idea to cut a 15' long canal across The Parade to the harbour (try getting planning permission for that these days). When the tide came in it filled a bath in the basement of the tavern, which could be heated to a nice warm temperature. Crazy, you're thinking, but you'd have been wrong. The next year, April 1837, business is so good that he has to build *'another Bath much larger and more commodious'*, and it wasn't a five minute wonder because in 1769 he has to build a stable next door to accommodate sixty horses. The advert said *'Lodging Rooms. Dressing Rooms. . a handsome large sash'd Dining Room* (and) *a Summer House . . which affords a pleasant prospect out to Sea.'*
SEE Margate/ Pubs

BLACKBURN'S
York Street, Broadstairs
The furniture, beds and carpet store started business in 1840 with a main shop in Ramsgate and a smaller one in Broadstairs. The Blackburn family owned, amongst others, the old Cannon Brewery and the St Paul's School Buildings in King Street, Ramsgate. In the 1920s they supplied at 6/11 each, fifteen hundred deck chairs to the Ramsgate Borough Council (that's £518 and 15 shillings – in case you were wondering); they also re-upholstered the seats in the Royal Victoria Pavilion.
'Ramsgate', by J S Rochard, c1900:
Mr W P Blackburn, Upholsterer, Cabinet Maker, Paperhanger, Undertaker, House Agent and Appraiser.
69, 71 & 73 King Street
This highly successful business was founded about 54 years ago in a comparatively small way by Mr Blackburn's father. There are numerous excellent specimens of high-class furniture and cabinet work exhibited in the large show windows. There are extensive stores and workshops at the rear and Mr Blackburn has large warehouses in Cavendish Street and timber sheds in Hereson. Mr Blackburn was a member of the old Local Board and one of the improvement Commissioners. He became a Councillor when the town received its Charter and afterwards became an Alderman. He was elected Mayor on three occasions.
The Ramsgate shop closed in the 1950s and in 1968 a retired London accountant, Miss James, who had a home in Broadstairs, bought the business as an interest for her retirement. In time, the business passed to Mr Alwyn Williams who runs it today. Its small frontage in York Street belies its huge interior spread over three floors.

BLAGDON COTTAGES
Tippledore Lane, St Peters
These brick and flint buildings originally housed the toilets and wash houses of the servants from the nearby Hibernia Cottage built 1790-1800. Its name was later changed to Blagdon House.
SEE Broadstairs/ St Peter's/ Tippledore Lane

'BLAKE'S 7'
An episode, entitled 'Bounty', of the BBC sci-fi series was partly filmed at Waterloo Tower in Quex Park.
SEE Quex Park/ Television

The BLAZING DONKEY public house
Ramsgate
Built on the corner of Alexandra Road and St Luke's Avenue, Ramsgate in 1880, it was originally called The Alexandra Arms after Princess Alexandra and found itself as one of two pubs with the same name; the other was at Harbour Parade. There is some confusion over why it changed its name to The Blazing Donkey.
One version is that when a driver came out of the pub after enjoying a drink, his donkey refused to move. His method of persuasion was to light some straw underneath the animal, which apparently had the desired effect.
Another version is that in the 1890s an old man kept a donkey in a shed to the rear of the pub and when the straggly hair of the donkey's coat needed a trim he used a lighted taper instead of a blade. Inevitably, one day the poor old donkey caught alight and pub customers had to come to its rescue.
A third version is that the name comes from the heraldry term 'blazon' and that an ass, meaning patience, was used as part of the pub sign when it was the Alexandra Arms. In time the pub was referred to as the blazoned donkey, and eventually the blazing donkey. Whichever version is true, it should be noted that there are quite a few pubs with the same name in the south east.
A guy known as Black Sam was a regular for many years. He claimed that he had been rescued from the Indian Chief ship in 1881 and, for many years, his photograph hung in the bar.
On 27th April 1917, The Alexandra Arms was wrecked during the Hurricane Bombardment.
SEE Donkeys/ Harbour Parade/ Hurricane Bombardment/ Indian Chief/ Pubs/ Ramsgate

'BLEAK HOUSE'
by Charles Dickens
It is the tenth novel by Charles Dickens.
It is the hottest long vacation known for many years. All the young clerks are madly in love, and according to their various degrees, pine for bliss with the beloved object, at Margate, Ramsgate, or Gravesend. All the middle-aged clerks think their families too large. All the un-owned dogs who stray into the Inns of Court and pant about staircases and other dry places seeking water give short howls of aggravation. All the blind men's dogs in the streets draw their masters against pumps or trip them over buckets. A shop with a sun-blind, and a watered pavement, and a bowl of gold and silver fish in the window, is a sanctuary. Temple Bar gets so hot that it is, to the adjacent Strand and Fleet Street, what a heater is in an urn, and keeps them simmering all night.
Fort House, in Fort Road, Broadstairs, was renamed Bleak House even though it is not the house described in the novel.
SEE Books/ Broadstairs/ Dickens, Charles/ Fort House/ Margate/ Ramsgate

Brenda BLETHYN OBE
Born Ramsgate 20th February 1946
Brenda Ann Bottle was one of nine children. She trained to be a secretary and worked for British Rail. Amateur dramatics had only been a hobby but after splitting from her husband, Mr Blethyn, she studied at the Guildford School of Acting before appearing at the National Theatre for several seasons. In 1980 she won the London Critics' Circle Theatre Award for Best Supporting Actress for the play 'Steaming'. That same year she appeared in the Mike Leigh TV play 'Grown Ups' (now I don't want to have to get another of my hobby horses out but why don't they repeat it? It was excellent. Alright I've got it out of my system - for now). Again for the DDC, she played Cordelia in 'King Lear' and Joan of Arc in 'Henry VI'. She was also in the Radio 4 series 'Dial M for Pizza', and in some episodes of 'Yes, Minister', 'Alas Smith and Jones' as well as the under-rated Simon Callow sitcom 'Chance in a Million'. She is possibly best known for the ITV comedy-drama series 'Outside Edge'.
On the big screen she has played Brad Pitt's mum in 'A River Runs Through It' (1992). Working again with Mike Leigh she was nominated for an Academy Award for her role in 'Secrets & Lies' (1996) – she would be nominated again for 'Little Voice' (1998). She has also been a voice in the animated films 'Pooh's Heffalump Movie' (2005) and 'The Wild Thornberrys Movie' (2002).
SEE Actors/ Granville Theatre/ Radio/ Ramsgate

BLINKO'S BOOK SHOP
Queen Street, Ramsgate
BLINKO'S BOOK SHOP
Come and look round: ALWAYS SOMETHING NEW AND INTERESTING
Bible Warehouse – New Books Every Day – Fountain Pens, Eversharp pencils, Leather Goods, Newest Stationery.
UP-TO-DATE LIBRARY SINGLE BOOKS LENT
See our own series of Postcard Pictures of Picturesque Thanet
Agents for Ordnance Survey Maps
25/27 QUEEN STREET, RAMSGATE
It became Geering's Thanet Ltd in 1963. Today the shop is Homebasics.
SEE Libraries/ Queen Street/ Ramsgate/ Shops

BLIZZARD
On 18th January 1881 there was a huge blizzard - back when the word actually meant 'a blinding storm of wind and snow' and not just a few snowflakes. Only one train reached Margate that day.
SEE Margate/ Railway/ Weather

The BLOODLESS BATTLE of HARBOUR STREET, Ramsgate
In 1838 a new law prevented the exposure of raw meat and fish on sale, and you could be fined £2 if you were caught. Many stallholders failed to comply, arrests were made and because they refused to pay the fines some were carted off to Sandwich jail. Consequently, there were protests that turned into violence and damage to property in the area. Members of the 10th Hussars were brought in from Canterbury and the violence subsided. A whip-round also paid the fines of those in prison. Thus, with no blood spilt the 'battle' got its name.
SEE Harbour Street/ Market/ Ramsgate/ Sandwich

Buster BLOODVESSEL
Born Stoke Newington, London 1958
Born Douglas Trendle, he was brought up by his great-aunt and great-uncle and thought his Auntie Lily was his mother until, at the age of seven, he overheard that he was adopted. *'Yeah, it hurt. A real strange feeling went through my body. . .Yeah. I wet the bed.'* He never met his birth father.
A big man, he weighs about 25 stone, with a shaved head and a large tongue, he was a memorable front man to the ska band Bad Manners – a band that he and his mates formed in 1976, despite none of them being able to play an instrument. They were quickly a success, getting a recording deal – without ever recording a demo tape - and a string of hit singles followed: 'NE NE NA NA NA NA NU NU' (No. 28 in March 1980), 'Lip Up Fatty' (No. 15 in June 1980), 'Special Brew' (No. 3 September in 1980), 'Lorraine' (No. 21 December in 1980), 'Just A Feeling' (No. 13 in March 1981), 'Can Can' (No. 3 in June 1981), 'Walkin In The Sunshine' (No. 10 in September 1981), 'Buona Sera' (No. 34 in November 1981), 'Got No Brains' (No. 44 in May 1982), 'My Girl Lollipop' (No. 9 in July 1982), 'Sampson And Delilah' (No. 58 in October 82), and 'That'll Do Nicely' (No. 49 in May 1993).
The band broke up in 1988. They were known for their live work and toured all over the world appearing at festivals and clubs alike. Buster was very much the face of the band and got publicity in a variety of ways. He ate thirty Big Macs in one sitting; did a moonie on stage in Italy unaware that the Pope was in the audience (I thought he would have preferred All Saints, or Charlotte Church, but you can never tell) and was consequently banned from Italy for ten years; he appeared on Top of the Pops with his head painted red - '*I didn't think the make up artist would actually do it*' - resulted in another ban.

His connection with Margate includes buying a hotel here for people of a similar stature as himself, 'Fatty Towers', that had reinforced beds and '2,000 calories in every bite' breakfasts. It has since closed down.

A few seasons ago, via a sponsorship deal between Link Music and Margate Football Club, the name 'Bad Manners' was emblazoned across the team's shirts and Buster was regularly in the crowd at the matches, even though he is an Arsenal supporter! During this time he was voted Margate's sexiest man!

He has also acted, in 'Sammy and Rosie Get Laid' and 'Out of Order', as well as in TV commercials - one poking fun at how broke he was.

Married with two children, he still tours with both a reformed Bad Manners and another band, Buster All Stars.

SEE Entertainers/ Margate/ Margate Football Club/ Music

Gebhard Leberecht von BLÜCHER

Born 16th December 1742
Died 12th September 1819
He was the Prussian Field Marshall at Waterloo. He was known amongst the ranks as Field Marshall Forward (well Marschall Vorwärts in Prussian, or Polish – look, 'O' level French beat me, what chance do I stand with Polish or Prussian?) because of his style of warfare. He also gave his name to 'bluchers' - strong leather half-boots.

SEE Blucher Villas/ Prussia/ Waterloo

BLUCHER VILLAS, Ramsgate

Named after von Blücher.
SEE Blücher, Gebhard Leberecht von/ Ramsgate

BLUE PLAQUES

The first nine blue plaques were put up around Margate in early 2004. They were dedicated to Richard Barham, George Moreland, Eric Morecombe, Prince Frederick, George IV, Duke of Cumberland, Walter Sickert, Francis Cobb, and J M W Turner whose plaque was the first to go up on 19th January 2004.

Frances Coleman, a local artist, helped to design the plaques. The fish that appears on them is a sturgeon.

SEE Barham, Richard/ Broughton, Phyllis/ Cobbs/ Cumberland, Duke of/ Fish/ George IV/ Grand Old duke of York/ Margate/ Morecombe, Eric/ Moreland, George/ Sickert, Walter/ Turner J M W

Chay BLYTHE

Born 14th May 1949
In 1966, whilst still serving in the army, he and Captain John Ridgeway rowed, in an open dory just 20 feet long, across the Atlantic in 92 days. He was awarded the British Empire Medal.

In 1971, he was the first person to sail non-stop around the world westwards. It took him 392 days. He was subsequently awarded the CBE. He was the skipper of the successful yacht Great Britain II, crewed by paratroopers, in the 1973 Whitbread Round the World Yacht Race. Aboard the yacht Great Britain IV, he won the 1978 Round Britain Race. He was knighted in 1997.

Princess Anne once named a new yacht for Chay Blythe at Ramsgate Harbour.
SEE Anne, Princess/ Harbour, Ramsgate/ Ramsgate

BOARDING HOUSES

SEE Accommodation/ Cameo Cinema/ Cliff House/Cranbourne Alley/ Crowds/ Fox, Sydney/ Garlinge/ Isabella Baths/ Margate Marine Bathing Pavilion/ Marine Terrace/ Northdown Road/ Smack Boys' Home/ Trinity Square/ Warwick Road/ Wellington Crescent/ Zion Place

BOATHOUSE, Broadstairs Harbour

Also used as the Harbour Master's office, the boathouse is well over three centuries old, although it may be like that old joke about the worker in the warehouse who had swept the floor for forty years using the same broom that he had been issued with on his first day - just 28 new heads and 12 new handles! So all the building materials may not be original but, looking at how it has settled into its spot, it has been there a long time. I don't think there is a wall that is perpendicular!

The two figureheads gracing the exterior are The Scotsman and Hercules. Above Hercules are two rib bones from a 70 ton whale that was washed ashore here on 2nd February 1762. It was 'cut into steaks by the people of Bradstow and sold for 30 guineas to the citizens of Deal'.

Why did they sell it? Herman Melville offers a clue in 'Moby Dick' (1851): 'The fact is, that among his hunters at least, the whale would by all hands be considered a noble dish, were there not so much of him; but when you come to sit down before a meat-pie nearly one hundred feet long, it takes away your appetite. Only the most unprejudiced of men like Stubb, nowadays partake of cooked whales; but the Esquimaux are not so fastidious. We all know how they live upon whales, and have rare old vintages of prime old train oil. Zogranda, one of their most famous doctors, recommends strips of blubber for infants, as being exceedingly juicy and nourishing. And this reminds me that certain Englishmen, who long ago were accidentally left in Greenland by a whaling vessel - that these men actually lived for several months on the mouldy scraps of whales which had been left ashore after trying out the blubber. Among the Dutch whalemen these scraps are called 'fritters'; which, indeed, they greatly resemble, being brown and crisp, and smelling something like old Amsterdam housewives' dough-nuts or oly-cooks, when fresh. They have such an eatable look that the most self-denying stranger can hardly keep his hands off. '

SEE Broadstairs/ Hercules/ Lifeboat/ Scotsman/ Whales

BOATING AND PADDLING POOL
The Parade, Margate

The Boating and Paddling Pool by the harbour which remained full at low tide, was built here in 1920, with paddle boats driven by hand becoming very popular with children. As late as the 1960s, children could hire canoes to paddle around in the pool. Now it has been largely covered by sand.

SEE Bathing/ Margate/ Parade, The

BOBBY'S DEPARTMENT STORE

Bobby's department store was opened in Cecil Square in 1887 by Mr F J Bobby. He later opened other stores in Leamington (1904), Folkestone (1906), Eastbourne (1910), Cliftonville (1913), Torquay (1913) and Bournemouth (1915). The stores were eventually bought by Debenhams in the 1970s.

SEE Cecil Square/ Margate/ Shops

BOBBY'S DEPARTMENT STORE
Northdown Road, Cliftonville

'Bobby and Co.'s Cliftonville Enterprise. Some details of the splendidly equipped premises opened today' was how Bobby's department store announced itself in June 1913. This was a magnificent purpose-built department store with a tower in the corner topped by a large flag waving in triumph. Its Palm Court Restaurant held tea dances with an orchestra and singers right up until 1939. After the war, morning coffee and afternoon teas were introduced in 1950 but the world had moved on. With strong competition from Canterbury's department stores, Bobby's finally closed in January 1973. The whole block was converted into smaller shops. Fads, selling wallpaper and other home decorating goods were on the corner for many years. You can still get a glimpse of its past grandeur by looking up at the top half of the building.

SEE Cliftonville/ Northdown Road/ Restaurants/ Shops/ Walpole Bay

BODYSNATCHER

The Devil's Dictionary, Ambrose Bierce: Body-snatcher, n. a robber of grave-worms. One who supplies the young physicians with that with which the old physicians have supplied the undertaker. The hyena.

In the early nineteenth century, doctors and surgeons, both as individuals and through hospitals, needed corpses from which to learn the detailed anatomical knowledge of the human body then not available in books (now of course they would have bought 'Surgery for Dummies' – I thought I would check if there was such a book and was surprised to find that 'Cosmetic Surgery for Dummies' does exist!). They would buy recently deceased bodies that grave robbers would then dig up from graveyards, usually during the night after they were buried – they had a very short sell-by date.

In the Midlands, the term used for this type of tradesman was a 'diggum-upper'! Eventually, the Anatomy Act was passed in

1832 to regulate the way corpses were supplied to hospitals, but grave robbing continued, albeit to a lesser extent, for a good decade or more after.
SEE Crouch, Ben

BOER WAR
The First Boer War between Britain and the Transvaal Boers was fought between 1880 and 1881; the Second Boer War between Britain and the Orange Free Stae and the south African Republic, or the Transvaal Republic, was between 1899 and 1902.
SEE Addington Street/ Ladysmith, relief of

BOHEMIA
High Street, Broadstairs

On the corner of Prospect Road and Broadstairs High Street and formerly called The Lawn, a tree-lined open air venue, was re-named Bohemia after The Bohemians Concert Party was employed from 1895 by the Balmoral Hotel in Albion Street. One of the posts that was put up to hold the 'Bohemia' sign in 1895 is still there - on the pavement in front of the estate agents.
SEE Broadstairs/ High Street, Broadstairs

Betty BOLAINE
Born 1723
Died 1805
A notorious miser who lived in St Lawrence, she left £20,000 in her Will when she died, aged 82, choking on a dry crust of bread.
SEE St Lawrence

Harry BOLENO
In 1860 the then very famous Drury Lane clown Harry Boleno retired to become the landlord of The Albion Hotel. 'Mr Harry Boleno and his troupe' had appeared at The Royal Alhambra Palace, on the east side of Leicester Square, 'This evening at 8 o'clock in the grand ballet Pierrot.' He often entertained the clientele with his spur-of-the-moment clowning and on one occasion, whilst out walking, he astounded his party by unexpectedly leaping across Jesus Gap.
SEE Entertainers/ Royal Albion Hotel

BOND, James BOND 007
Spy. Fictional spy.
SEE Die Another Day/ Fleming, Ian/ Goldfinger/ Moonraker

BOOKS
SEE Barnaby Rudge/ Billy Bunter/ Bleak House/ By Sheer Pluck/ David Copperfield/ Diary of a Nobody/ Dombey & Son/ Domesday Book/ Dracula/ Edwin Drood/ Eva Trout/ Fallen Leaves/ Floating Light of the Goodwin Sands/ Goldfinger/ Haunted Man/ Holiday Romance/ Jennings & Darbishire/ Jorrock's Jaunts & Jollities/ Kenelm Chillingly/ Last Orders/ Law and the Lady/ Lifeboat, The/ Mansfield Park/ Martin Chuzzlewit/ Miss Morris and the Stranger/ Moonraker/ Murder Makes an Entrée/ Nest of the Sparrowhawk/ Nicholas Nickleby/ Old Curiosity Shop/ Oliver Twist/ Our English Watering Place/ Over the River/ Pair of Blue Eyes, A/ Parade, The/ Passage in the Life of Mr Watkins Tottle/ Paying Guest/ Pickwick Papers/ Poor Miss Finch/ Pride and Prejudice/ Prince of the Captivity, A/ Quarantine Island/ Second Stain/ Shabby Genteel Story, A/ Sheltering Tree/ Sketches by Boz/ Sword of Ganelion/ Tale of Two Citiea/ Thirty Nine Steps/ Three Men in a Boat/ Tom Tiddler's Ground/ Tuggses of Ramsgate/ Veiled Lodger/ War of the Worlds/ Waste Land/ Without Prejudice/ With Wolfe in Canada/ Woman in White/ Women in Love/ World of Waters

Cherie BOOTH
Born Bury 23rd September 1954
The wife of the Prime Minister, Tony Blair, she unsuccessfully contested the North Thanet constituency in the 1983 General Election – the same election that saw Tony Blair become an MP.
SEE Election results/ Politics/ Prime Ministers/ Thanet

General William BOOTH
Born 10th April 1829
Died 20th August 1912
General William Booth, 1887: It is still the painful truth, that during the busy summer months, religion is almost forgotten by multitudes of persons residing in health resorts unless it is absolutely forced upon their attention.
General Booth, the founder of the Salvation Army, made his first visit to Ramsgate in 1905 to be greeted by huge crowds as he travelled throught the town in a car, following a Salvation Army band in a lorry.
Keble's Gazette: General Booth visited Ramsgate on Wednesday [2nd August 1905] and was accorded a reception representative of all classes of the community. He addressed a crowded assembly at the Royal Victoria Pavilion, and was received by Mayor Councillor K Dowling. Other council members also greeted the General, as did the Vicar of Ramsgate, Reverend C L J White-Thomson, and representatives of the Free Churches.
SEE Ramsgate/ Royal Victoria Pavilion/ Salvation Army Citadel

BOOTS THE CHEMISTS
Boots are named after Jesse Boot (1850-1931), a Nottingham chemist, who, after he had taken over his father's medicinal herb shop, built up a business dealing in patent medicines and also the manufacture of drugs. When he died, he had a chain of over 1,000 shops nationwide.
SEE John Bayly's Tea Dealership & Cheesemonger's shop/ Shops/ Timothy Whites

BORN OUT OF WEDLOCK
A 1966 survey found that 1 in 8 babies in Thanet were born out of wedlock.
In 2000, Thanet had the highest teenage pregnancy rate in Kent. I blame the sea air.

SEE Thanet

BOTANY BAY, Broadstairs

The bay is around 200 metres wide with no promenade.
It is said that Botany Bay is so-called because those found in possession of smuggled goods here were deported to the other Botany Bay in Australia.
The old border between Margate and Broadstairs councils used to run just to the west of Botany Road. In 1933 Broadstairs and St Peter's Urban District Council paid £2,000 for the foreshore of Botany Bay, Whiteness and Kingsgate to prevent Margate from getting hold of them and attracting day-trippers.
Pigot's 1936: In 1932 the Council acquired Kingsgate Bay and the foreshore at Botany Bay on the Broadstairs and Margate boundary. The late Lord Northcliffe's North Foreland Estate was purchased by the council in 1935. The Estate comprises some 263 acres and includes the North Foreland Golf Course and the foreshore from Broadstairs Pier to Hackemdown Point.
Excellent examples of chalk stacks, a feature of coastal erosion, can be found at Botany Bay.
SEE Battle of Botany Bay/ Broadstairs/ Hackemdown Point/ Kingsgate/ Margate

BOTTLE LIGHT SIGNAL
Back in the age of smuggling, this signal was concealed in the wall of 26 High Street, St Peter's (now gone) and would signify whether or not Revenue men were about in the area. You had to know where the signal was because it was not obvious and had to be viewed from a particular angle.
SEE Broadstairs/ High Street, St Peter's/ St Peter's/ Smuggling

Arthur BOUCHIER
He was an actor who learnt his trade from Sarah Thorne at the Theatre Royal, Margate. He famously played Shylock, and claimed that Shakespeare 'wrote his plays in the hope that some day they would be acted and staged better than they could be acted and staged in his own time.' He is said to haunt the Garrick Theatre in London, where he was manager from 1910-15, walking with the takings back to his office which he enters through a wall!
SEE Actors/ Shakespeare/ Theatre Royal

BOUNCING BOMB
SEE Dambusters/ Gibson, Guy/ Wallis, Barnes

BOUNDARY ROAD, Ramsgate
It got the name because it marked the old boundary of the town, but was originally called Boundary Place.
The Hurricane Bombardment of 27th April 1917, caused some damage to Boundary Road.
SEE Fire Station, Ramsgate/ Forester's Arms/ Gas Works, Ramsgate/ Hurricane Bombardment/ King of Denmark, Ramsgate/ Ramsgate/ Richardson, Alan/ Sharps Dairies/ Thunderstorm/ Tunnels, Ramsgate

BOUNTY
Originally called the Alston, a replica of the Bounty was moored in Ramsgate Harbour in the late 1940s and operated as a floating restaurant. It was not a success and was taken away in 1951, after which it was broken up in Essex.
SEE Harbour, Ramsgate/ Ramsgate/ Restaurants/ Ships

BOURNES DEPARTMENT STORE
35&37 High Street, Ramsgate
20th January 1984:
BOURNES CLOSES FOR GOOD: In 1839 Humphrey Bourne started a drapery business in Ramsgate. It is claimed that Queen Victoria used the shop on visits to the town and for many years her insignia adorned the front of the shop. In the twentieth century the shop was extended on several occasions. It closed during the war but reopened in 1945. The shop is set to close again, this time for good. Many of the staff have worked there for years including Phyllis Coughlan who has worked there for 32 years. Old fashioned drapers it may have been but there will be many folk in East Kent who will mourn the passing of Bournes.*
*As the Ramsgate Millennium Book points out *'Queen Victoria only visited Ramsgate once after 1836 and stayed only for an afternoon'*.
SEE High Street, Ramsgate/ Ramsgate/ Shops/ Victoria

Elizabeth BOWEN
Born Dublin, 7th June 1899
Died (lung cancer) Hythe 22nd February 1973
Her father was an Irish lawyer and landowner, and her real name was Elizabeth Dorothea Cole. The Irish novelist attended Downe House School between 1914 and 1917 and lived in various parts of Kent as a child so she knew this area well. Her last novel was 'Eva Trout'.
SEE Authors/ Eva Trout

David BOWIE
'The Lower Third' – originally 'Oliver Twist and the Lower Third' - were a band formed in Margate in 1963 comprising Les Mighall on drums, Graham Rivens on bass guitar and Denis Taylor on lead guitar. Their enduring claim to fame is that a young David Bowie joined them in April 1965 – OK, not actually in Margate I grant you, but a link between Margate and Bowie nonetheless.
SEE Entertainers/ Margate/ Music

BOWKETTS BAKERY
Built in the 1930s on the north western corner of the Westwood roundabout, was Bowketts Bakery. It was architecturally typical of the age and had very modern facilities including six continuous brick ovens.
SEE Shops/ Westwood

BOWLER'S ARMS
SEE Cliftonville Hotel/ Frank's

BRACEY'S public house
King Street, Ramsgate
It was once called Swiss Cottage.
SEE King Street, Ramsgate/ Pubs/ Ramsgate

BRADSTOW
Broadstairs was known in Saxon times as Bradstow (Bradsteow in Saxon meant 'a broad place'), a name that referred to a broad flight of steps cut into the cliff face at the start of the 15th century. It is also mentioned as Brodsteyr Lynch in 1434, Brodsteyr in 1479, Broadstayer in 1565, Brod styrs in 1610.
SEE Broadstairs

BRADSTOW HOUSE
Serene Place, Broadstairs
Back in 1864, Bradstow House was a high-class grocery shop, although the owner only sold smuggled tea - not that he advertised the fact. Each September, tea clippers could be seen sailing past Broadstairs and North Foreland with the new crop from China. He would watch the clippers go by, wait three days, the time it took to transport it down from London, and then advertise it as this year's consignment. It was worth his while to sell smuggled tea because tea cost eight shillings a pound plus another eight shillings duty on top of that. He got his comeuppance when he claimed he was selling tea from the tea clipper Chufoo. Unfortunately, there had been a yellow fever scare and all the tea from Chufoo had been impounded. (I like that name, Chufoo, so I keep using it – it sounds like a swear word, you stupid chufoo. However, now that a sensible tablet has kicked in, I can tell you that Chufoo was the town in China where the philosopher, Confucius (551-479BC), lived)
SEE Bradstow/ Broadstairs/ Serene Place/ Shops

BRADSTOW MILL public house
High Street, Broadstairs
Previously The Claredon Hotel and before that The Railway Hotel, it became the Bradstow Mill in 1979.
SEE Broadstairs/ High Street, Broadsairs/ Pubs

BRADSTOW NURSERIES
R E & L M Everett were market gardeners and pig farmers at Bradstow Nurseries Bradstow Way, Broadstairs in 1936.
SEE Broadstairs/ Farms

BRADSTOW RESIDENTIAL SCHOOL
SEE Bartram Gables/ Broadstairs/ Schools

BRADSTOW WAY
SEE Bradstow Nurseries/ Broadstairs

Dame Lilian BRAITHWAITE
Born Ramsgate 9th March 1873
Died London 17th September 1948
The Rev John Braithwaite of St George's Church, Ramsgate had four sons and a daughter, Florence Lilian Braithwaite. Her acting career began in various amateur theatre companies. She made her professional debut in George Lawrence's Shakespeare Company's 1897 production of The Merchant of Venice. She married George Lawrence and they had a daughter in 1898 - Joyce Carey, also an actress, she was the snooty woman who ran the buffet in 'Brief Encounter').
Away from Shakespeare, Lilian excelled in the role of Abby Brewster in 'Arsenic and Old Lace'.
On the screen, she appeared in 18 films, both silent movies ('The World's Desire', 1915) and talkies ('A Man About the House', 1947). For services to the stage she was made a Dame in 1943.
When the critic James Agate congratulated Lilian on being the second-best actress in London, she countered it by saying how much that meant coming from the second-best critic.
SEE Actors/ Ramsgate/ St Georges Church/ Shakespeare

BRASS MONKEY
A folk band. Track 10 on their 'Sound and Rumour' album is 'Auretti's Dutch Skipper/ An Adventure in Margate/ The Spirit of the Dance'.
SEE Margate/ Music

BREWERIES
Ramsgate once had 6 breweries and 118 public houses.
SEE Belmont Street/ Blackburn's/ Broad Street/ Bull & George/ Cliff Street/ Cobbs/ Cottage/ East Kent Arms/ First and Last/ Imperial Hotel/ King Edward VII pub/ Lord Byron pub/ Love Lane/ Margate ales/ Northdown Ales/ Prince Coburg pub/ Ramsgate/ Red Lion Hotel/ Spencer Square/ Sun Inn/ Tomson & Wotton/ Victoria pub/ Wastall/ Ye Olde Charles

The BRITANNIA public house
Fort Hill, Margate

Situated at the top of Fort Hill, it occupies an unusual location for a pub, next door to the police station. Partly because of its unusual hexagonal shape, it is thought that this may originally have been the Cobb family's recreational or hunting lodge – but probably

more of the former than the latter. They would have had a fantastic view of the harbour and the Cobb brewery was close by. It was a Cobb house from around 1820 until 1968. A single storey extension was added around the late 1800s or early 1900s. There is thought to be a tunnel, now blocked off that led to the Margate caves and was the entrance to the World War I air raid shelters. Soldiers were billeted here after Dunkirk in World War II. In the many attempts to blow up the pier in 1978, a rivet shot through a bedroom and penetrated four inches into the wall!

SEE Cobbs/ Dunkirk/ Margate/ Pier/ Pubs/ Tunnels/ World War I/ World War II

BRITISH EXPEDITIONARY FORCE

During World War I, a supply base for the British Expeditionary Force in France was located at Richborough (it continued in operation for around two years after the end of the war),

SEE Richborough/ World War I

BROAD STREET, Margate

There were three cottages in the middle of the road and thus, it was a broad street. The cottages were knocked down in 1862 when the road was widened.

On 5-6th December 1917 thirty bombs were dropped by the Germans on Margate during which Broad Street suffered damage.

SEE Crown, The/ Margate/ Old Margate

BROAD STREET, Ramsgate

Austen's Brewery started brewing in Broad Street in c1795 but may well have been in business before then. They moved to Belmont Street in 1850 and the premises here were taken over by Fleet's Brewery.

Fleet's Brewery, a family run business, took over the old Austen's Brewery in Broad Street and remained there until into the twentieth century. They made stouts, porter, bitter and mild ales. The hops and malt were supplied by farms owned by the Fleets and delivered all over Thanet by their own drays. Next door to the brewery was the manager's house, and next door to that was The Victorian Temperance Hotel!

The Conservatory Restaurant used to be the St James Theatre.

SEE Belmont Street/ Breweries/ Farms/ Hops/ Ramsgate/ Restaurants

BROADSTAIRS

Ramsgate (The Kent Coast at its best) Pictorially Presented, by A H Simison 1930s: '[Broadstairs developed] *always with a consistent policy of retaining those characteristics for which it has for so long been renowned.*'

SEE Accomodation/ Albion Inn/ Albion Street/ Alexander House School/ 'American Notes'/ Andersen, Hans Christian/ Andersons Café/ Archway House/ Balmoral Hotel/ Bandstand/ Barcynska, Countess/ Barfield House/ 'Barnaby Rudge'/ Barnaby Rudge pub/ Bartram Gables/ 'Battles of the Sea'/ Bays/ Beacon Road/ Belvedere House/ Bennett, Sir Richard Rodney/ Betsey Trotwood/ Billy Bunter/ Black & White Minstrels/ Blackburn's/ Blagdon Cottages/ 'Bleak House'/ Boathouse/ Bohemia/ Botany Bay/ Bottle

light signal/ Bradstow/ Bradstow House/ Bradstow Mill pub/ Bradstow Nurseries/ Bradstow School/ Broadway/ Brown Jug Inn/ Buchan, John/ Buckmaster House/ Buffs Cottages/ Bulwer-Lytton, Edward/ 'By Sheer Pluck'/ Callis Court/ Canadian Military Hospital/ Carlton Hotel/ Carson, Lord/ Catholic Church of Our Lady/ Chandos Place/ Chandos Square/ 'Chariots of Fire'/ Charles Dickens pub/ Charles Dickens School/ Chess Board Estate/ Cinemas/ Clarendon Road/ Claremont Mill/ Cliff Railway/ Cochrane, Admiral/ Collins, Wilkie/ Copperfield Court/ Crampton, Thomas/ Crampton Tower/ Dane Court/ Dane Court Gardens/ Dane Court Road/ Dane Court School/ Darwin, Charles/ David Copperfield restaurant/ 'David Copperfield'/ David Potton Menswear/ 'Diary of a Nobody'/ Dickens, Charles/ Dickens House/ Diggin' It/ Doherty brothers/ Dilphin Inn/ 'Dombey & Son'/ Dull/ Dumpton Gap/ Dumpton Park Drive/ Dundonald, Earl of/ Dundonald House Hotel/ Dundonald Road/ Eagle House/ East Cliff Lodge/ East Kent Times/ Eastern Esplanade/ Edge End Road/ Edward VII/ Electric Tramways Co/ Eliot, George/ Elmwood Cottage/ Elmwood Cottages/ Elmwood House/ Fair Street/ Fairfield House/ 'Fallen Leaves'/ Farm Cottage/ Fascists/ Faversham & Thanst Co-op/ 1566/ Fig Tree Inn/ Fishing/ Fitzroy, Admiral/ Fitzroy Avenue/ Five Tuns/ Flint & Chalk construction/ Flint Cottage/ 'Floating Light of the Goodwin Sands'/ Forresters Hall/ Fort House/ Fort Road/ Friend to all Nations/ Galland, William/ Gladstone Road/ Gloucester, Duke of/ Grand Hotel/ Green, Napoleon/ Grosvenor Road/ Haddon Dene School/ Half Man Half Biscuit/ Harbour/ Harbour Street/ Harrington's/ 'Haunted Man'/ Heath, Edward/ Henrys/ Hercules/ Hereson School/ Heseltine, Philip/ High Street/ Hildersham House School/ Hilderstone/ Holy Trinity Church/ Hops/ Hugin/ Humane Society/ Jewel of Thanet/ Johnson, Lionel Pigot/ Johnson, Rob/ Joss Bay/ Josse family/ Jubilee Clock Tower/ Kenelm Chillingly/ King George VI Park/ Kingsgate/ Lanthorne pub/ Lanthorne Road/ 'Law and the Lady'/ Lawn House/ Libraries/ Lichfield, Lord/ Lifeboat, Broadstairs/ Lift/ Lloyds Bank/ Lonsdale, Gordon/ Lord Nelson pub/ Louisa Gap/ Lusitania/ Marchesi's/ Marine Drive/ 'Martin Chuzzlewit'/ Mary White/ Mason, David/ Masons Rise/ Milton Place/ Montefiore College/ Morelli's/ Moseley, Sir Oswald/ Mott/ Munro, Harold/ 'Murder Makes an Entrée'/ Nelson Terrace/ Neptune's Hall/ Newfoundland/ 'Nicholas Nickleby'/ Northern Belle/ 'Ode to Broadstairs'/ Old Crown pub/ Old Curiosity Shop/ 'Old Curiosity Shop'/ 'Oliver Twist'/ Osborne Road/ 'Our English Watering Place' Parade, The/ Pavilion/ 'Paying Guest'/ Pear Tree Cottage/ Percy, Major/ Perseverance/ 'Pickwick Papers'/ Pierremont Avenue/ Pierremont Hall/ Pierremont Mill/ Population/ Post bx/ Poster/ Postgate, Oliver/ Preacher's Knoll/ Prince Albert pub/ 'Prince of Captivity'/ Promenades/ Prostitutes/ Punch & Judy/ Punch magazine/ 'Quarantine Island'/ Railway Hotel/ Ramsgate Airport/ Ramsgate Road/ Rectory Road/ Restaurants/ Rhodes, Gary/ Richardson, Geoffrey/ Robinson, Bruce/ Roc, Patricia/ Rose Inn/ Royal albion Hotel/ Royal Oak Hotel/ Rumfields Road/ St George's Hotel/ St George's School/ St Mary's Convalescent Home/ St Peter's/ St Peter's Road/ Salisbury Avenue/ Scanlon, Lord/ Scotsman/ Scott, Clement/ Sea angling/ Seapoint Road/ Serene Place/ Seven Stones/ Shaw, George Bernard/ Shipbuilding/ Shrine of our Lady, Bradstowe/ Siouxsie & the Banshees/ Sky Sports/ Smuggling/ Snelling, Joss/ Sound Location/ South Cliff Parade/ South East in Bloom/ Stanley Road/ Stone Bay/ Stone Farm/ Stone House/ Stone Road/ Tartar Frigate pub/ Tesco/ Thanet Place/ Thanet Technical College/ Thatched House/ 'Thirty Nine

Steps'/ Three Tuns pub/ Tom Thumb Theatre/ Trams/ Trinity Square/ Tunis Row/ Twain, Mark/ Uncle Bones/ Uncle Mac/ Union Square/ Upton Primary School/ VAD Hospitals/ Vale, The/ Vere Road/ Vestey, Sir Edmund/ Victoria Parade/ Viking Bay/ Vye & Son/ Waite, Arthur/ 'War of the Worlds'/ Wardour Close/ Warner, Jack/ Waterloo Steps/ Wellesley House School/ West Cliff Road/ West Dumpton Lane/ Western Esplanade/ 'Without Prejudice'/ Westlife/ Whales/ Wilde, Oscar/ Windsor Cinema/ Wishing well pub/ 'With Wolfe in Canada'/ 'Woman in White'/ 'World of Waters'/ World War I/ World War II/ Wrotham Arms/ Wrotham Road/ Yarrow, Sir Alfred/ Yarrow Close/ Yarrow Home/ Yeomenry/ York Gate/ York Street/ Zeppelin raid

BROADSTAIRS and St PETER'S MAIL

A local newspaper, The Broadstairs and St Peter's Mail, once had their office at 13 The Broadway.

SEE Broadway, The/ Newspapers/ St Peter's

BROADSTAIRS DICKENS FESTIVAL

Started in 1937, it is held each June in Broadstairs. Many local people dress up as Dickens' characters or in costumes of that time and wander around the town the whole week. They also parade en masse down to the sea front. Various other activities occur including a fair and a stage version of one of the novels.

SEE Dickens, Charles

BROADSTAIRS FOLK FESTIVAL

Held every August in Broadstairs, it started in 1965 when its sole location was a stage in Pierremont Park. Now over 100 different acts perform in around 500 different events at various locations.

SEE Music

BROADSTAIRS RAILWAY STATION

Although the railway came to Broadstairs in 1863 the present station was built in the 1920s.

SEE Railway

BROADSTAIRS ROAD, Broadstairs

Relatively new as a route into Broadstairs, it was opened on 14th July 1929 by the MP for Thanet, Captain H H Balfour, and the

chairman of the council, Councillor Bing, as a traffic by-pass for St Peter's village.

In the early hours of Monday 10th July 1944, a German flying bomb exploded in the back of a house called Pelhamdale (now 30 Broadstairs Road). It took the whole of the back wall off the house, leaving all the rooms exposed. Mr and Mrs Herbert Hughes and their daughter Betty were asleep in the front bedrooms and amazingly escaped injury. The house had to be re-built. Virtually all the houses in this road suffered some damage that night and tiles, slates and glass littered the street in the morning.
SEE Catholic Church of Our Lady Star of the Sea/ Charles Dickens School/ Dane Court School/ St Peter's/ Tippledore Lane

BROADSTAIRS SAILING CLUB
Their clubhouse in Harbour Street was once the Chinese Lantern Café where a murder took place. It is said to be haunted as a result.
SEE Harbour Street, Broadstairs/ Murder/ Sport

BROADSTAIRS WATER COMPANY
Formed in 1859 by Thomas Crampton, it provided a supply to local houses until 1901 when it was taken over by the local council who sank wells at Rumfields to provide a greater volume for the growing population.
SEE Crampton, Thomas/ Crampton Tower

BROADSTAIRS WATER GALA
Broadstairs Water Gala in August has been a part of the summer calendar since the late nineteenth century.

In 1888, the first Water Sports was held and from around 1900, the Battle of the Water was introduced which involved the local millers from the many windmills in the town against the sweeps. This allowed one side to throw white powder, and the other side to throw back black powder and create a huge mess. The battle was 'refereed' by the local constable who usually ended up in the water.
From 1924 the event was organised by local tradesmen and shopkeepers and explains why to this day it is held on a Wednesday, the town's half day closing.

In 1930, the event was re-named the Broadstairs Water Gala and events, still popular today, like the tug-of-war and the greasy pole, were introduced.
SEE Harbour, Broadstairs/ Viking Bay

The BROADWAY, Broadstairs
This parade of shops were built in 1903.
SEE Broadstairs/ Broadstairs and St Peter's Mail/ Osborne Road/ Shops/ World War II

Sarah BROCKMAN
Sarah Brockman, a middle-aged widow who lived at number 24 Seafield Road in Ramsgate, was murdered there in the early evening of 18th February 1914. Her attractive daughter, Alice, 21, had been going out with William, or Will, Hearne Pitcher, 22, of Church Road, Ramsgate for about two years. He was an unemployed bricklayer living with his parents, and Sarah did not like him, nor did she think that he was suitable for her daughter. She had told him this, and she had told her daughter as well.

Knowing that Alice was out and would not be returning home until later, Pitcher called at her house. It is not known whether he forced his way in or if Sarah was happy to let him in, but at some point it got very nasty. He beat her ferociously with a dining chair, leaving splinters from the chair leg embedded in Sarah's hat. Using rope, he bound and gagged her. A piece of her waterproof apron was stuffed in her mouth, and two lengths of material were tied tightly around her mouth and face, so that only the area around her eyes were not covered. The post mortem gave the cause of death as 'suffocation aggravated by severe shock and multiple injuries to the head'. He than dragged the trussed up Sarah upstairs to her bedroom and threw her on the floor at the foot of her bed.

Picher was arrested, made a full confession, and appeared at Kent Assizes at Maidstone on Monday, 21st June 1914. He was charged with the wilful murder of Mrs Brockman. Very composed he entered a plea of 'Not guilty', the jury members were then sworn in and he burst into tears. He spent most of the trial with his head in his hands, sometimes sobbing, but showing little interest in the proceedings.

At the trial, Alice said that she had returned home at exactly 8.15, 'When I found the front door locked, I thought it rather strange; I called out to my mother through the letter box but as there was no reply I went round to the back door. The kitchen was in darkness and as I opened the back door, I called out to her again. [pause] Suddenly, a man sprang out from behind the door and I was scared to death as he pushed me to the floor – I can't remember if I screamed or not and although I knew a man had attacked me, I couldn't see who it was.

. . . I started to struggle as I was so frightened when this man wrapped a paraffin soaked piece of rag round my mouth and then tied my hands behind me. At the same time, he placed a pillow over my face. I tried to scream but it was impossible. Then he sat on my knees, held one hand on the pillow and started to light a lamp with his other hand. It was only when the pillow slipped from my face that I saw who it was. I said, 'Good gracious, Will, I didn't think it was you, what on earth are you doing?' He replied by pulling me to my feet by the rope which tied my hands; it was then I was able to ask him where my mother was. He said, 'She has gone down Addington Street and you must come upstairs.' 'I will not.' I shouted at him and he replied, 'If you don't, I will murder you.'

. . . Then he dragged me upstairs with one hand, carrying the lamp in his other hand; he threw me on the bed and assaulted me.' (the word 'rape' was not used, although one newspaper did report it as such) I told him my brother would be home about quarter past nine and again I asked him where my mother was. He said she was asleep. At the same time I saw that he had pulled stockings over his boots and he pulled them off when he saw me looking.' Pitcher then untied her

and took her back downstairs. 'He told me that he had murdered my mother. I was so shocked I don't think I said anything. Then he hauled me back upstairs and showed me the body of my mother in her bedroom. Then he had the nerve to calmly light a cigarette as he said, 'There's your mother, she won't be opening her mouth again'. After taking me back to the kitchen he asked me if I would go away with him but he hadn't got any money. For some strange reason he went to the front door and started to unlock it and then I saw my chance to run through the kitchen and out the back door. I was so terrified that I went straight to the Larkin's' house and blurted out my story; they must have informed the police. As I knocked on the door, I heard Will shout out, 'Goodnight Alice'.'

The police arrived at the scene and at the trial Constable Champion said that he had been on duty outside the house, and had seen Pitcher smoking a cigarette. He went over to Pitcher who then asked the policeman, 'Has something serious happened here then?' The policeman replied, 'Why do you ask?' and was surprised when Pitcher told him, 'Because I'm the one you want.' Still not able to believe his luck, the copper asked him, 'What for?' and was told, 'For killing that old woman in number twenty-four.' The policeman continued, 'What are you talking about?' and thankfully Pitcher phrased it in the way that policemen have understood down the years, 'All right then, I done it.' The policeman then arrested him - it was touch and go for a minute there - and took him into the house and explained the situation to Chief Inspector Paine. It was Paine, not Champion, who cautioned Pitcher who, just in case a policeman of the rank of Chief Inspector did not understand the situation, stated again, 'There is nothing more to say, I am guilty.' On his way out of the house he pointed to the frames of some pictures, and said, 'I don't suppose I shall make any more of them for her.' Mailbags possibly, but not picture frames.

At the trial, where remember he had pleaded not guilty, despite telling Paine and Champion repeatedly that he had committed the crime, Mr Thorne Drury, for the defence, asked the Chief Inspector if he recalled a similar incident involving Pitcher's sister. She was a domestic servant, and had been tied, gagged and assaulted, although not sexually, by a man, but the sketchy description she had given was not enough to identify him. Paine agreed that the two assailants could be the same man. In his summing up, Mr Thorne Drury explained that there was a history of mental illness in the Pitcher family, alright not close family, but there was someone related to Will currently at Chartham Lunatic Asylum, and the Chief Medical Officer of that institution, Dr Fitzgerald, testified that, due to the mental history of the family, he was quite sure that Pitcher was insane when he committed the crime. You may lower your eyebrows whenever you want to. Pitcher displayed no signs of madness whilst held at the same

asylum in the period before the trial. However, Mr Thorne Drury was not finished in his quest for a 'guilty but insane' verdict, *'One of the prisoner's sisters is an epileptic and of course she is mentally defective'* – those eyebrows have gone up again, haven't they? Well keep them there – the judge, Sir Charles Darling, checked with Dr Fitzgerald, *'These epileptic people suffering from a sort of mania – are they sometimes guilty of violence?'* The doctor explained, *'They are capable of doing dangerous things and are sometimes homicidal'*, and *'epileptics can be quite sane just before and just after the commission of a crime. The attacks come and go quite suddenly.'* It is to their credit that some members of the public audibly gasped at this, it was a pity they were only witnessing the proceedings. Finally, the judge told the jury, *'If you come to the conclusion that the prisoner killed the old woman but at the time he killed her, he was insane and did not know he was doing wrong, then you should say he was insane when he did it.'*

Shortly after, the jury, who had obviously got the judge's hint, delivered a guilty but insane verdict, to which the judge announced that, *'The order of this court is that the prisoner should be detained as a criminal lunatic until His Majesty's pleasure be known.'* No majestic pleasure was ever known and Pitcher spent the next sixty-five years or so, until his death, at Broadmoor.
SEE Addington Street/ Murders/ Ramsgate

BRONZE AGE
Thanet is said to have more Bronze Age burial sites than anywhere else in the country.
SEE Garlinge/ Thanet

'BROTHERS of BIRCHINGTON'
Richard Harris Barham who wrote the 'Ingoldsby Legends' which included the 'Brothers of Birchington', from which this is an excerpt:
You may see, some half way
'Twixt the pier at Herne Bay
And Margate, the place where you're going to stay,
A village call'd Birchington, fam'd for its 'Rolls,'
As the fishing-bank, just in its front, is for Soles.
SEE Barham, Richard Harris/ Birchington/ Margate

Lord BROUGHTON
Recollections of a Long Life by Lord Broughton. 31st July 1820: *Went in the London Engineer steam yacht to Margate – 270 people on board – a magnificent spectacle altogether. A few years ago I recollect laughing at the notion of applying steam to these purposes.* 28th July 1820
Set out at eight in the Eclipse steam yacht. . . We arrived by this extra-ordinary mode of making progress at Tower Stairs, quarter to four in the afternoon, passing by all sailing boats as if they were at anchor. . . In six hours and a half – 88 miles by water.
SEE Margate/ Steam packets

Phyllis BROUGHTON
Born 1862
Died 1926
The famous gaiety girl lived at India House in Hawley Street, Margate. Gaiety girls were named after the old Gaiety Theatre in London that stood in the Strand – now part of the Aldwych area - between 1864 and 1903. The Strand Theatre (1864) was rebuilt as The Old Gaiety in 1868 but was demolished to make way for the Aldwych/Strand road widening. The New Gaiety opened in 1903 but was demolished in 1956. There is a branch of Citibank there now.
She was a very successful actress in the West End as a showgirl, appearing in musicals, Gilbert and Sullivan operettas and ballets. She appeared in 'The Earl and the Girl, the minuet', as Kevin, King of the Fairies in a ballet at the Canterbury Music Hall, Westminster Bridge Road, London (now demolished) in 1879, 'Marjorie' at the Prince of Wales theatre 1889 and in 'Joan of Arc' in the 1890s at the Gaiety.
Postcards of her dressed in corsets and bloomers were a big seller of the day.
While in her late sixties and living at India House she married a doctor from The Limes surgery next door.
SEE Blue Plaque/ Entertainers/ India House/ Margate

BROWN JUG INN
Ramsgate Road, Broadstairs
It dates from the eighteenth century and is reputed to be haunted.
SEE Broadstairs/ Ghosts/ Pubs/ Ramsgate Road, Broadstairs

John Collis BROWNE
Born 1819
Died 1884
Mount Albion House had a famous resident in the shape of John Collis Browne; in fact he died there. A plaque was unveiled on 8th May 1973. Dr N M Goodman had this poem printed in The Lancet:
'In England Now'
A crowd there was in Ramsgate town
To honour Dr Collis Browne
Whose chlorodine saved countless chaps
From having untoward mishaps
And many another skilled invention
He made too numerous to mention.

So Collis Browne deserves his plaque
Which mayor, mayoress and town clerk
With friends and kinsmen by the score
(although he died in eighty-four)
unveiled and thus gave him his mead
which he (or she) who runs may need.

As you have probably spotted, Dr Collis Browne was the inventor of the medicine chlorodine. In 1847 he joined the Army Medical Service as an assistant surgeon and was posted to India. In Bengal he had to deal with a *'desperate visitation'* of cholera. The main way to combat the disease seemed to be to keep the patient as calm as possible. Collis Browne initially combined chloroform,

morphia, Indian hemp and Prussic acid – imagine the street value today. The name for his invention came from combining chloroform and anodyne in 1848. When he returned to England he licensed the manufacture and sale of the compound chlorodine to a chemist called J T Davenport. Cholera was also a problem back in Britain, there were 26 fatal cases in Maidstone in 1849 alone. When chlorodine was used to treat 154 patients in County Durham in 1854, all but one survived. Originally, the medicine was recommended for virtually everything from a cold to cancer! It certainly was popular with British troops in India as a remedy for Delhi belly.
'J COLLIS BROWNE'S COMPOUND – None genuine without the name of J Collis Browne'
A version is still available today, without the morphine and opium; the mixture is calcium carbonate (200mg), kaolin light (750mg) and morphine hydrochloride (0.35mg) and is a relief for diarrhea – 36 tablets will cost you around £5.
Collis Browne was a keen yachtsman and that is what first brought him to Ramsgate. His first address was 15 Nelson Crescent. He was also a designer and inventor, coming up with mechanisms to lower boats into the sea; an unusual type of propeller and a new design of bow enabling faster passage through the water.
He died at Mount Albion House and was buried at St Laurence churchyard.
SEE Mount Albion House/ Poems/ Ramsgate/ St Laurence Church

Duke and Duchess of BRUNSWICK
The Duchess was a grand-daughter of Queen Victoria. Their daughter, Frederica, attended North Foreland Lodge Boarding School in 1934.
SEE North Foreland/ Schools/ Victoria

BRYHER
Born Margate 2nd September 1894
Died Vevey, Switzerland 28th January 1983
The daughter of a British shipping magnate, Sir John Ellerman, Annie Winifred Ellerman, took the pen name Bryher (it was her favourite Isle of Scilly) and became a popular novelist, poet and critic. She co-founded and co-edited a journal of silent films called 'Close Up'. Amongst her books are 'Film Problems of Soviet Russia', as well as critically acclaimed historical novels 'Beowolf' (1948), 'The Fourteenth of October' (1952), 'The Player's Boy' (1953), 'Ruan' (1960), 'The Roman Wall' (1954), and 'The Coin of Carthage' (1963).
SEE Authors/ Margate/ Poets

John BUCHAN
Born Scotland 28th August 1875
Died 11th February 1940
The son of a Calvinist Presbyterian minister, he went to Oxford and read the classics and although he aimed for the Bar, he never actually practised as a barrister. He had a varied career; at the end of the Boer War he was an administrator for the government in

South Africa; he was a war correspondent for The Times; he edited The Spectator; he was a director of a publishing house and of Reuters; and was MP for the Scottish Universities in 1927. In 1935, when he was appointed Governor General of Canada he was made a Baron. He was a very popular Governor General and travelled extensively across the whole country. It was his signature that brought the Canadians into the Second World War.

'But for the bold experiment of Fascism the decade has not been fruitful in constructive statesmanship.' John Buchan, Morning Post, 31st December 1929

It is as a writer that he is probably best remembered. He wrote more than a hundred books, over half of them non-fiction – biographies, historical and even accountancy books! His best-known work of fiction is 'The Thirty Nine Steps' the title of which was inspired by the steps which lead down to the beach from North Foreland where he was living at the time. He and his wife, Susan, and daughter, Alice, stayed at St Ronan's Guest House in Stone Road, Broadstairs for a holiday in the summer of 1914. Six-year old Alice was recuperating from a mastoid operation and John himself would soon develop a duodenal ulcer which would cause him problems for the rest of his life. Susan's cousin's family were staying at St Cuby, often thought to be Trafalgar Lodge (situated on the Ruff in The 39 Steps), on the junction of Anne's Road and Cliff Promenade. While staying with them, a story about a spy having been arrested locally, combined with a staircase in the cliff, inspired John Buchan to write 'The Thirty Nine Steps'.

Whilst shaving on 11th February 1940, Buchan suffered a brain haemorrhage and died aged 64.

SEE Authors/ Broadstairs/ Prince of the Captivity, A/ Stone Road/ Thirty Nine Steps/ Thirty Nine Steps - films

BUCKINGHAM ROAD, Margate

A Gotha raid on the night of 30th September 1917 killed Mrs Alice Coleman at 36 Buckingham Road.

The road suffered further damage on 5-6th December 1917 when the Germans dropped thirty bombs on Margate.

SEE Gotha raid/ Margate/ Princess of Wales/ Uncle Bones

Anthony BUCKERIDGE

Born London 20th June 1912
Died 28th June 2004

His father died when he was 4 years old, *''I always had leanings towards the Left. My father was killed in 1917 at Bullecourt, near Arras; he'd been half an hour at the Front. He died needlessly, just bolstering up the reputations of Haig and the generals. I felt bitter about the politics of war, joined an anti-war group when I was at London University in the 1930s, and became a socialist.'*

His father had written poetry but also worked in a bank and consequently the Bank Clerks' Orphanage charity paid for Anthony to attend Seaford College Boarding School in

Sussex so that his mother *'could earn a living'*. He later recalled it as *'not a very nourishing experience. No music, no drama, no art, nothing of that sort, and I remember always being hungry'* – apart from the lack of food the boys shared washing water and had to use buckets as toilets.

During the war, he and his mother moved to Ross-on-Wye where his grandparents lived but after the war he and his mother moved back to London. When his grandfather died he and his mother moved to Welwyn Garden City where his mother was employed promoting the new city.

When he left school he got a job with the same bank in which his father had worked, but after two years decided that it was not for him. He was briefly an actor in weekly rep (he also had an uncredited part in the 1931 film 'Tell England') but decided that he wanted to become a teacher.

By now he had married Sylvia Brown and enrolled at University College London where he was involved in many socialist and anti-war groups (in later years he was an active member of CND and marched at Aldermaston). After failing Latin he did not take his degree, but now with two children, he soon got a job teaching in Suffolk and Northamptonshire.

In World War II his anti-war beliefs saw him serving as a fireman in the National Fire Service.

Between 1944 and 1949 he was head of English at St Lawrence College, Ramsgate and it could be said that the college was responsible for the Jennings stories as they began as bedtime stories told in the dormitories *'Finish up your prunes and custard in 30 seconds flat and I'll tell you a story'.*

Between 1953 and 1961 he wrote four 'Rex Milligan' books set in a state school but they were nowhere near as popular.

In 1962 he met Eileen Selby, the woman he described as the true love of his life and she became his second wife and with whom he had another child.

When he retired to Sussex, the acting bug returned and he often *'walked on'* in non-singing roles with the nearby Glyndebourne Opera.

After a period of ill health, Anthony Buckeridge died at the age of 92 in 2005.

SEE Authors/ Jennings and Darbishire/ Ramsgate/ St Lawrence College

BUCKMASTER HOUSE
residential home
Western Esplanade, Broadstairs

Built in 1895 but until 2003 it was for ladies only!

Pigot's 1936: *The Buckmaster Memorial Home for ladies in reduced circumstances is situated on the West Cliff.*

SEE Broadstairs/ Western Esplanade

BUENOS AYRES, Margate

For many years Buenos Ayres marked the western extremity of Margate with open countryside beyond this point.

[Trivia alert: Buenos Aires is the capital of Argentina and means 'good breezes' – although the city's full name is Nuestra Senora Santa Maria de los Buenos Aires - 'Our Lady St Mary of the favourable winds'.]

SEE Margate

BUFFALO BILL'S WILD WEST SHOW

Born Scott County, Iowa 26th February 1846
Died 10th January 1917

Buffalo Bill was a guide, scout and showman whose real name was William Frederick Cody. His family moved to Kansas in 1854 but not long after, his father died. He attended school just briefly in 1859 but at the age of 14 he became a rider with the newly-formed Pony Express. In 1863, in the American Civil War, he was a scout with the Seventh Kansas Cavalry.

When the war ended in 1865, he worked for the Kansas Pacific Railroad to supply bison meat to feed the railroad workers building the line. He claimed to have killed 4,000 bison, or buffalo, in 18 months, earning the nickname of Buffalo Bill. He did another stint as an army scout from 1868-1872 and was awarded the Congressional Medal of Honor in 1872 by the government who then took it off him in 1916 when they realised he was not actually in the army but was a civilian working for them!

Buffalo Bill appeared as a character in popular novels by Ned Buntline and Cody's career as a showman started when he appeared as himself in Buntline's melodramas between 1872 and 1883.

He also worked in the west guiding cavalry, raising cattle and fighting in the 1876 Sioux War.

He formed his Wild West Show in 1883. It showed life on the plains to audiences who had only read about it. He toured the USA and Europe. His show included the legendary Indian leader Sitting Bull and the sharpshooter Annie Oakley.

Cody formed, and became president of, the Cody Military College and International Academy of Rough Riders on his land in Wyoming in 1901. He even has a town named after him, Cody in Wyoming.

'Every Indian outbreak that I have ever known has resulted from broken promises and broken treaties by the government.'

SEE Entertainers/ Queen's Gate Road

BUFFS COTTAGES, Broadstairs

Pigot's 1936: *The Buffs Cottages at Rumfields, St Peter opened in 1906, consist of four cottages, erected to the memory of the officers and men of 2nd Battalion The Buffs (East Kent Regiment) who fell in the South African War and are for disabled members of that regiment.*

Built on land donated by Mr Friend, the cottages cost £600 each to build and were dedicated to the memory of the German Prince Christian (who died in action fighting for the British). Two cottages were built in 1902 to house the wounded or disabled men of the East Kent Regiment (The Buffs). Two more cottages were added in 1903, this time

dedicated to Lieutenant Colonel Brian Francis Holmes of The Buffs, who died in 1902 in Burma, and the privates and non-commissioned officers of The Buffs who died in South Africa 1899-1902. Although The Buffs Regiment was disbanded in 1961 (they were amalgamated into the Princess of Wales Royal Regiment in 1992), the upkeep of the cottages was funded by the Regimental Association of the Queen's Own Buffs. The cottages were handed over to Haig Homes (the UK's largest ex-serviceman's housing association) in June 2003.

All residents get a life tenancy, and are either members of the regiment, or married to an ex-Buff.

SEE Broadstairs/ Rumfields Road

BULL AND GEORGE HOTEL
High Street, Ramsgate

Before 1800 it was the Bull Inn and was kept by the 'widow Elizabeth Stone' until 1817. During the Napoleonic Wars cavalry quartered behind it, using the stables there.

The town pump is said to have been at the entrance to the stables and carriers would transport water to those who did not have a supply. Hooper's Brewery stood near to the Bull Inn in the eighteenth century and used water from the nearby well that fed the pump.

The inn was subsequently owned by the Hudson family, and then John Hayward.

It was very badly damaged in the first Zeppelin raid of World War 1 on 17th May 1915 (Erich Linnarz led, in Zeppelin number LZ38, if you want to bear a grudge). Just after midnight, the Zeppelin drifted over the town at about 2,000 feet, a British Avro aircraft armed with two incendiary bombs and two grenades piloted by Flight Sub-Lieutenant R H Muluck from Westgate attacked it but it rose higher and out of reach. It then dropped 52 bombs onto the town. Two people died; one of them was 42-year old John Smith who had been staying at the Bull & George Hotel (where Woolworth's stands now). The clock on the outside of the building stopped when the bomb went off. At the inquest, Herbert Grey, the head boots at the hotel, gave evidence, as did Chief Inspector Paine of Ramsgate police who told how he had found Mr John Smith lying in the cellar beneath the dining room. Mr Smith and his wife both died in the raid. A verdict against the Kaiser of wilful murder was returned! Kate Moffat, a barmaid, had just got out of bed when the bomb went straight through it! (In the same raid, Bell Cottages, to the rear of the High Street, were hit by two bombs.)

The damaged property was later sold at auction in 1916 for £4,500. It is the present day site of Woolworth's (it opened here in 1920) and Littlewoods.

SEE Albion Gardens/ Breweries/ Chapel Road/ High Street, Ramsgate/ Hotels/ Littlewoods - Ramsgate/ Napoleonic Wars/ Ramsgate/ Star Cinema/ Westgate-on-Sea/ Woolworths/ World War I/ Zeppelin

BULLS HEAD public house
Market Place, Margate

There has been a pub called The Bulls Head in Market Place since at least 1732 (there is a reference to 'a sale at the Bull's Head'), before the market started in 1776. There was a large coach house, extensive stabling and sixteen rooms to let; later reduced to eight. After their marriage at St John's Church, Margate, on the 11th December 1952, Eric Morecambe (died 29th May 1984 during a charity show at Tewkesbury) and his wife, Joan, who had been Miss Kent in 1951, had their wedding reception in the upstairs function room - her dad was the landlord and she met Eric when Morecambe and Wise stayed there on tour. There is a blue plaque there to commemorate the event.

In the 1980s five separate bars were converted into one lounge bar.

SEE Blue Plaque/ Margate/ Pubs/ St John's Church

Edward BULWER-LYTTON
Born 25th May 1803
Died 18th January 1873
The novelist, dramatist and politician spent part of 1824 in Broadstairs.

SEE Authors/ Broadstairs/ Kenelm Chillingly/ Politics

BUNGALOWS

Just to the east of the garden walk area in Westgate was the site of England's first bungalow built by the architect John Taylor in 1867 for Sir Erasmus Wilson, the son of a Dartford doctor. They were based on single storey tea planters homes he had seen whilst in Bengal, India, hence Bengalos, later corrupted to bungalows. It was obviously a success as he then built a whole bungalow estate in Birchington.

'There are English bungalows at Birchington and on the Norfolk coast near Cromer.'
Brewer's Dictionary of Phrase & Fable, 1894

SEE Birchington/ Westgate-on-Sea

BUNGALOW HOTEL, Birchington
SEE Cooper, Dame Gladys/ Hotels

'BUNGALOWS OF BIRCHINGTON'
by W.L.C., The Art Journal, 1886
Birchington differs from any other of the many pleasure resorts that stud this breezy coast, in that it is new without being garish. After a first whiff of the sea at Whitstable with its numerous oyster-dredgers, and passing by Herne Bay, the train draws up at an altogether insignificant station; one's baggage is quietly shouldered by a porter, and a trudge of a quarter of a mile brings us to 'Rossetti,' as the last home of the painter-poet is now called. Should one arrive at night, there is but time to notice that this building is a study in brown and red, low-pitched, and surrounded by a dwarf wall of the familiar Kent flint, ere one is in the centre of a long corridor, lighted ship-fashion by swinging lamps, with doors opening on either side and each end. Everything is of wood, match-boarded within and clinker-built without, and one's first feeling is of surprise at the absence of snakes! Everything suggests the tropics, from the cool colour of the painted woodwork to

the suffused light of the hanging lamps. A wonderful view of the ever-changing sea greets one upon issuing forth in the morning. Immediately in front, at a distance of about a mile, the sun-lit ocean spreads its length and breadth to the horizon, studded with every kind of craft, from the three-masted steamer making for the Nore to the sailing-barge hugging the coast and waiting for high water to discharge its cargo. Away to the right the main group of Bungalows nestle close to the edge of the low-lying cliff, and Westgate-on-Sea, the home of Mr Orchardson R.A., lies a little further on. To the left the 'Birchington Brothers' [Reculver Towers] stand out clear against the morning sky. These, although known to have been many miles inland in Roman times, are now sheer on the seaboard. Midway, and far enough off to be comparatively inoffensive, lies the new 'quarter' of Birchington Bay, built with all the reckless unpicturesqueness of the modern builder. From the other side of the bay, however, 'the Reculvers,' with the intervening expanse of sea, varying in its tints of blue from light to dark as the deep water or the sand-bars predominate – quite after the heart of Mr Brett – forms a capital subject; and behind them the landscape is broken and wooded, with an occasional glimpse of a venerable, grey or ivy-mantled, church tower. All round Birchington, a few miles inland, the massive Norman churches with their backings of fresh foliage afford many a paintable subject for the artist, and the churches themselves are full of historical and architectural interest. . . .

The new 'quarter' of Birchington Bay, with its asphalt 'parade,' its tennis-ground, and its 'desirable villas,' may be rendered necessary if the neighbourhood continues to grow as steadily in public estimation in the future as it has done during the past few years, but it cannot claim to deserve any large degree of attention from the visitor allured there either by the fame of the Bungalows or by Rossetti associations. In its want of architectural beauty it contrasts unfavourably with Westgate-on-Sea. Returning therefore towards Margate, and once more passing over the threshold of 'Rossetti,' we find ourselves in the drawing room or studio, a large and comfortable room with two bays and an entrance into a conservatory. Taking short walks on the cliff or round the road that winds about the churchyard, and subsequently lying in the 'studio' on one of the curiously contrived couches, in constructing which the architect, Mr Taylor, expended much ingenuity, Dante Gabriel Rossetti spent most of the last nine weeks of his life, reading, or, latterly, being read to by Miss Rossetti, and occasionally, when strong enough, painting.

oOo

The public interest in Birchington certainly had its birth with the bungalow which Mr Taylor built. From his original plan the others have sprung, and so flourished that there is no danger of the original designer being forgotten. This, however, is not our concern. 'Rossetti,' which, after the hotel, is

the first bungalow come to, is different from the rest in many respects, chiefly because it is built entirely of wood on brick foundations; and, secondly, because the builders of subsequent bungalows have improved the original plan almost out of recognition. There is little difference between the exteriors of Mrs Joan Wood's summer residence, or Mr Martin's 'Orion,' for instance, and 'Rossetti,' but the ground plan is very different. Instead of the long corridor in the one with the rooms opening on either side on to the passage, and all on one floor, the rooms of Mrs Wood's bungalow lead from one into the other, and 'Orion' has a charming room on the first floor. Interior decoration, too, contributes much to emphasize the distinction, for whereas 'Rossetti' is wonderful in its simplicity, 'Dilkoosha' (or 'Heart's Delight) is decorated and furnished with all the lavish elegancies of a 'high-art' firm, and 'Orion' derives its name from the astronomically correct representation of that constellation in a blue-and-gold morning room. It would be invidious to express any final opinion respecting the two methods of treatment, but the happy simplicity of 'Rossetti' is, perhaps, more in character with the spirit of a 'bungalow.' The other bungalows which lie between 'Dilkoosha' and 'Orion,' differ but little from those just described, except in that they are either larger or smaller, and some of them of substantial brick. The coach-houses, too, of those in the centre are decorated with sgraffito work by Mr Frampton, a late Academy student of promise. The method is simple; two layers of different coloured plaster or cement are superimposed and the artist works his design on the second layer until he comes to the first, thus leaving his figures in relief. It is effective on a small scale but easily overdone.

A curious instance of the portability of a small wooden bungalow was afforded by the action of Mr Martin, a Hereford architect, who has become much identified with the Birchington bungalows. Having some difficulty with the local authorities respecting a right of way, he took the unusual course of removing his structure one night, by the aid of rollers and two powerful traction engines which were on the estate, and planting it, by the time the surveyor arrived the next day, over the disputed way – a course of action which was effectual as it was unique.

Outside its bungalows, Birchington has attractions which should not come amiss to the artist or the visitor. The village is quaint, and the walks abroad full of paintable subjects.

. . . The sea, too, has its attractions for the marine artist, and altogether this new Thanet watering place is by no means devoid of interest. It is rapidly growing in public estimation, and as one of the nearest 'lungs' to London on this part of the coast, it is a welcome addition to that class of summer resorts which commends itself by its surroundings rather by the quantity of its visitors.

SEE Birchington/ Churches/ Rossetti/ Westgate-on-Sea

George BURGES
Born India, 1786
Died Ramsgate 11th January 1864
He went to Cambridge University, and became a highly-regarded Greek scholar, although not always on good terms with other scholars. After some bad investments he fell into financial hardship but managed to obtain a civil list pension that saved him. His works include 'Euripides Troades' (1807), 'Phoenissae' (1809), 'Aeschylus Supplices' (1821), 'Eumenides' (1822), 'Prometheus' (1831), 'Sophocles Piloctetes' (1833), and 'Hermesianactis Fragmenta' (1839).
SEE Authors/ Ramsgate

James BURKE
Born Derry, 22nd November 1936
The science historian, author and TV presenter – most notably Tomorrows World, The Burke Special (1972-76), Connections, Connections 2 and Connections 3 – worked, early on in his working life, as a teacher at the Regency Language School in St Augustine's Road, Ramsgate.
SEE Ramsgate/ Television

Sir Francis BURNAND
Born 29th November 1836
Died 21st April 1917
He was the editor of Punch from 1880 until 1906. He also wrote burlesques, including 'The Colonel' (1881); he adapted French farces, and wrote an operetta 'Cox and Box' with music by Sullivan. Whilst convalescing in the town, he grew fond of Ramsgate and bought a house here, telling anyone who would listen how good the bracing climate was. He died at 18 Royal Crescent and was buried in the Abbey churchyard next to St Augustine's Church.
SEE Authors/ Ramsgate/ Royal Crescent/ St Augustine's

Alfred Henry BURTON
Born Leicester c1833-5
Died Dunedin, New Zealand 2nd February 1914
John Burton and his wife Martha Neal had four sons, Alfred being the eldest. John was the founder of John Burton and Sons, a chain of printing and photographic shops across the Midlands including branches in Leicester, Birmingham, Derby and Nottingham. In 1856, Alfred spent three years in New Zealand and three more in Australia before coming back to manage the Nottingham branch of the family firm. It was at this time that he married Lydia Taylor in Ramsgate on 15th November 1864. His brother Walter, who had married three weeks earlier, invited him to join them in New Zealand and work in a photography firm that would become Burton Brothers - they sold fancy goods, newspapers and were dealers in Masonic clothing and jewels. In time the photographic side of the business came to the fore with a huge demand for portraits to send home and views of the country being in demand. Alfred travelled all over the country taking photographs. The business was a success but the two brothers had their differences and the partnership broke up in 1877; the two of them barely saw each other again. Alfred kept the firm going and the youngest brother, John, worked with him from 1877-1880.
Alfred continued to travel and photographed Maoris and the natives in Fiji, publishing 'The Maori at Home' and 'Through the King Country with the Camera: a Photographer's Diary' (1885). He trained his son Harold to become a photographer and they travelled extensively together until, in 1890, as a result of a gunshot wound, he lost an arm; the cameras then were so bulky two arms were needed to operate them.
Alfred retired from photography in 1898 and became an elocution teacher for sixteen years.
SEE New Zealand/ Ramsgate

Kate BUSH
Born 30th July 1958
There has long been a link between Birchington and the singer Kate Bush who is reputed to own property and/or live in the area. Further fuel for the theory is the name of the Editor of the first seven editions of The Kate Bush Fan Club newsletter, Nicholas Wade, but thought to be Kate herself. Another name linked to her coterie is a Jeremy Birchington.
SEE Birchington/ Music

BUTCHERS
In the 1957 Kelly's Directory there were 85 listed in Thanet. In 2005 there were 15 (excluding supermarkets).
SEE Coal/ Dairy Farms/ Greengrocers/ Grocers/ Ice Cream/ Shops/ Thanet

BUTCHERS BROOM
A member of the lily family, it grows to about 30inches (or 75cm) and was once used for making brooms, although not necessarily exclusively for butchers. It grows in Mockett's Wood.
SEE Mockett's Wood

Sir Billy BUTLIN
Born 1899
Died 12th July 1980
His first holiday camp opened near Skegness, Lincolnshire, on an old sugar-beet field, on Easter Saturday, 11th April, 1936. His holiday camps developed into virtually self-contained holiday centres offering all sorts of amenities and entertainment within the site. The original site is still going although it is now called Butlins Funcoast World.
SEE Butlins/ Queen's Highcliffe Hotel

BUTLINS
In 1955 the four hotels owned by Butlins in Cliftonville received 25,000 enquiries.
SEE Butlin, Sir Billy/ Cliftonville/ Hotels/ Queen's Highcliffe Hotel

Charles BYRNE (aka O'Brien)
Born 1761
Died 1783
He was born in Ireland close to the border of Tyrone and Derry to *normal parents* -

whatever they are - and grew *'like a cornstalk'* to be 7 feet 10 inches tall (7 feet 7 inches and 8 feet 4 inches are also quoted in other reports) which the local villagers reckoned was because he was born on top of a high haystack. In 1909, long after his death, advances in medicine enabled the mystery of Byrne's height to be solved: a pituitary adenoma produced a growth hormone which accounted for his height and poor health generally – I still prefer the haystack theory myself.

Soon, the well-dressed and well-mannered Charles started earning money as a star attraction in freak-shows and in Edinburgh he startled nightwatchmen when he lit his pipe from a streetlamp.

'Tall men walk considerably under his arm, but he stoops, is not well-shaped, his flesh loose, and his appearance far from wholesome . . an ill-bred beast'

In April 1782, he ended up in London. Had it been 220 years later he would have won Freak Idol (*'I've seen bigger freaks on the judging panel'* Simon Cowell) and become a star and then forgotten a few months later. Well, apart from the Freak Idol bit, that is what happened.

'However striking a curiosity may be, there is generally some difficulty in engaging the attention of the public; but even this was not the case with the modern living Colossus, or wonderful Irish Giant; for no sooner was he arrived at an elegant apartment at the cane-shop, in Spring Garden-gate, next door to Cox's Museum, than the curious of all degrees resorted to see him, being sensible that a prodigy like this never made its appearance among us before: and the most penetrating have frankly declared, that neither the tongue of the most florid orator, or pen of the most ingenious writer, can sufficiently describe the elegance, symmetry, and proportion of this wonderful phenomenon in nature, and that all description must fall infinitely short of giving that satisfaction which may be obtained on a judicious inspection.' Newspaper report 6th May 1782

When, inevitably, the public moved on to something else, Charles turned to drink:

'The Irish Giant a few evenings since, taking a lunar ramble, was tempted to visit the Black Horse, a little public-house facing the King's-mew; and before he turned to his own apartments, found himself a less man than he had been the beginning of the evening, by the loss of upwards of £700 in bank notes, which had been taken out of his pocket.' Newspaper report 23rd April 1783

As Charles's health deteriorated, a Dr Hunter took a great interest in him. *'The sight of him is more than the mind can conceive, the tongue express, or pencil delineate, and stands without parallel in this or any other country'*

During his career as an anatomist, lecturer and physician, Dr John Hunter (1728-93) *'met temptation in a rollicking spirit – with a wine bottle in his hand and a doxy on his knee'* but treated Sir Joshua Reynolds, Thomas Gainsborough, Benjamin Franklin,

Lord Byron and was Surgeon Extraordinary to George III. He is also thought by some to be the inspiration for Robert Louis Stevenson's Dr Jekyll and Mr Hyde. The word on the street was that he did very good business with body-snatchers. He also had a fascination with what he referred to as 'monsters', or freaks of nature. He collected them or their remains after death and the 14,000 items he had accumulated became the Hunterian Collection.

Aware that Byrne did not have much longer to live, Hunter wanted his skeleton for his collection and even went to him to pay him in advance for it. The ex-freakshow star was duly freaked out. Hunter even employed a man to follow Charles around in case he dropped dead in the street. He began to live in fear. Well, you would.

Knowing that his health was failing, Charles arranged with some fishermen that he would be taken to Margate and buried at sea in a lead coffin.

Charles died at his rather elegant home in Cockspur Street on 1st July 1783.

'The whole tribe of surgeons put in a claim for the poor departed Irish Giant, and surrounded his house just as Greenland harpooners would an enormous whale. One of them has gone so far as to have a niche made for himself in the giant's coffin, in order to his being ready at hand, on the 'witching time of night, when church-yards yawn.'' Newspaper report 5th June 1783

Another newspaper followed that:

'Since the death of the Irish Giant, there have been more physical consultations held than ever were convened to keep Harry the Eight in existence. The object of these Esculapian deliberations is to get the poor departed giant into their possession; for which purpose they wander after his remains from place to place, and mutter more fee, faw, fums than ever were breathed by the whole gigantic race, when they attempted to scale heaven and dethrone Jupiter!' Newspaper report 5th June 1783

It seems that the lead coffin was buried but the corpse was not in it. Reports vary but Hunter either bribed the undertaker, or the fishermen, or just got the fishermen drunk, or managed to get some body snatchers to raise the body, but either way he got the body and boiled it in a giant iron kettle to get the skeleton. In time it duly entered the Hunterian Collection at the Royal College of Surgeons of England at Lincoln's Inn Fields, London WC2 – the collection is still open, Charles Byrne's skeleton is still on display and the admission is free!

The novel 'The Giant' by Hilary Mantel is based on Byrne's life.

SEE Bodysnatcher/ Crouch, Ben/ George III/ Margate

Lord BYRON

Born 22nd January 1788
Died 19th April 1824

George Gordon Byron, 6th Baron, went to Dulwich, Harrow and Trinity College, Cambridge. Authorities still cannot decide which foot was the club foot but whichever

one it was, he had to suffer very painful and very unsuccessful operations on it all through his childhood.

His father, Captain John Byron of the Coldstream Guards, known as 'Mad Jack', married a Scottish heiress, Catherine Gordon, and promptly squandered her fortune. He left her soon after and died when Byron was 3 years old. Young Byron was brought up by his mercurial mum and a Calvinist nurse, May Grey, who got into the 9-year old Byron's bed at night and sexually abused him - *'playing tricks on his person'* as he later put it.

Whilst at Cambridge he was forbidden to keep a dog as a pet so, instead, he kept a bear. A tutor described him as *'a young man of tumultuous passions'*. He left without a degree but with a large debt.

His 'Cantos I and II of Childe Harold's Pilgrimage' was published in 1812 and these and his subsequent writings made him famous and much better off.

Accused of *'every monstrous vice'* in 1816 he left this *'tight little Island'* of Britain and spent the rest of his life on the continent. The vices included debauchery, incest, paedophilia, homosexuality, rape, sodomy – feel free to add any I may have missed. According to Byron, *'pleasure's a sin, and sometimes sin's a pleasure'*. Lady Caroline Lamb famously described him as *'mad, bad, and dangerous to know'* although she wasn't speaking from a position of strength herself.

Byron died in Missolonghi, Greece, and his body was returned to London where he had expected to be buried in *'a marble tomb in Westminster Abbey'*. The dean of Westminster refused on the grounds that Byron had been far too notorious to be included in Poet's Corner! So, on 12th July 1824, he was laid to rest in the family vault under Hucknall Parish Church, at Hucknall Torckard, near Newstead, along with 15 other Byrons. In 1852 the vault was opened again to allow in the coffin of his daughter, 38 year-old Augusta Ada, Lady Lovelace, whose mother was Byron's wife Annabella. The vault remained closed until the evening of 15th June 1938. The local vicar, the Rev Canon T G Barber, wanted *'to clear up all doubts as to the poet's burial place and compile a record of the contents of the vault'*. Forty witnesses were there for the opening of the vault but, in a nice sexist gesture, only the males went down into the vault. Of these, only four actually saw Byron's corpse in its lead casket. A wooden lid was raised, followed by a lead one, and another lead one. The church warden, A E Houldsworth, noted, *'. . . we were able to see Lord Byron's body which was in an excellent state of preservation. No decomposition had taken place and the head, torso, and limbs were quite solid. The only parts skeletonised were the forearms, hands, lower shins, ankles and feet, though his right foot was not seen in the coffin.* (Houldsworth later wrote to Elizabeth Longford that *'his right foot was detached from his leg and lay at the bottom of the coffin'*) *The hair on his head, body, and limbs was intact, though grey. His sexual*

organ showed quite abnormal development. *There was a hole in his breast and at the back of his head, where his heart and brains had been removed. These are placed in a large urn near the coffin.'*
The next morning the coffin was closed and the vault sealed once more.
You may easily suppose that the English don't seek me, and I avoid them. To be sure, there are but few or none here, save passengers. Florence and Naples are their Margate and Ramsgate, and much the same sort of company too, by all accounts, which hurts us among the Italians. Letter sent by Byron from Venice to Mr Moore 11th April 1817
SEE Byron Road/ Char-a-banc/ Lord Byron public house/ Margate/ Poets/ Ramsgate

BYRON ROAD, Margate
This and the other roads in its vicinity were named after poets. This one is named after the poet Lord Byron.
In the nineteenth century this was a particularly rough area where the coppers went around in twos, and where men were men, and some of the women were too (alright I made that last bit up, just in case your great granny lived there).
On the night of 5th December 1917 Byron Road suffered damage in a Gotha Raid.
SEE Cowper Road/ Gotha Raid/ Margate/ Milton Avenue/ Poets' Corner

'BY SHEER PLUCK: A TALE OF THE ASHANTI WAR' by G A Henty
'I am afraid we are,' Frank said; 'but there is nothing to do but to keep on rowing. The wind may lull or it may shift and give us a chance of making for Ramsgate. The boat is a good sea boat, and may keep afloat even if we are driven out to sea. Or if we are missed from shore they may send the lifeboat out after us. That is our best chance.'

oOo

At this moment there was a shout to leeward, which was answered by a scream of joy from those on board the wreck, for there, close alongside, lay the lifeboat, whose approach had been entirely unseen. In a few minutes the fifteen men who remained of the twenty-two, who had formed the crew of the wreck, and the four boys, were on board her. A tiny sail was set and the boat's head laid towards Ramsgate.
'I am glad to see you, Master Hargate,' the sailor who rowed one of the stroke oars shouted. He was the man who had lent them the boat. 'I was up in the town looking after my wife, who is sick, and clean forgot you till it was dark. Then I ran down and found the boat hadn't returned, so I got the crew together and we came out to look for you, though we had little hope of finding you. It was lucky for you we did, and for the rest of them too, for so it chanced that we were but half a mile away when the ship fired her first gun, just as we had given you up and determined to go back; so on we came straight here. Another ten minutes and we should have been too late. We are making for Ramsgate now. We could never beat back to

Deal in this wind. I don't know as I ever saw it blow much harder.'
These sentences were not spoken consecutively, but were shouted out in the intervals between gusts of wind. It took them two hours to beat back to Ramsgate, a signal having been made as soon as they left the wreck to inform the lifeboat there and at Broadstairs that they need not put out, as the rescue had been already effected. The lads were soon put to bed at the sailors' home, a man being at once despatched on horseback to Deal, to inform those there of the arrival of the lifeboat, and of the rescue of the four boys who had been blown to sea.
SEE Books/ Broadstairs/ Ramsgate

C

CAFFYNS GARAGE
The business started in Eastbourne in 1903. Caffyns bought the A and B Garage, Grange Road, Ramsgate in 1973.
SEE Garages/ Grange Road/ Ramsgate

CALLIS COURT COTTAGE
SEE Broadstairs/ Farm Cottage

CALLIS COURT or CALLIS GRANGE Broadstairs
Situated roughly where Grange Road crosses Callis Court Road, hence the name for both roads.
It was probably built in the 15th century although replacing an earlier building from the 12th or 13th century. It once stood in a 39 acre estate. When the architect John P Seddon visited the house in 1874 he thought that: *'The original building consisted of little more than one large room open from the ground to the roof, but when the house was re-modelled in the 17th century the tie beams and octagonal kingposts were enclosed from view by the bedrooms.'*
He also thought that the building had been *'much altered in recent years.'*
There was also a large pond in front that was filled in when the building was demolished.
The name originated out of the surnames of the Caley, Calisun, or Caleson family. There is also a story that in 1596 the Spaniards were planning to capture Calais and use it as a base to invade England. Lord Howard, who was living at Cleve Court near Minster at the time; Robert Devereux, the Earl of Essex and Sir Walter Raleigh were sent as leaders of a task force to capture Cadiz as a spoiling tactic. At the time, Cadiz was called Cales and it was therefore called the Cales Expedition. It was a success - assuming you were English - and the plunder included the Bishop of Faro's library which became the Bodlean Library, Oxford. Also, almost anyone involved was put up for a knighthood – Queen Elizabeth I was not happy when the Earl of Essex came up with sixty names – and the resulting knighthoods, with no

attached land or wealth were thought to be somewhat common.
A Knight of Cales
A Nobleman of Wales
A Laird of the North Country
But a Yeoman of Kent with half a year's rent
Will buy them all out
It is possible that one of the resulting Knights of Cales lived here. For a time it was referred to as Calais Court.
Cromwellian soldiers were said to have been billeted here after the Battle of Worcester (3rd September 1651) on the look out for fleeing Royalists.
The Rev George Lovejoy – once a headmaster of King's School, Canterbury – leased the Grange in 1684. He died a year later and his widow continued to live here until she died in 1694.
In 1783 members of the 13th Light Dragoons, brought in to combat smuggling, were billeted at the Fig Tree Inn, but they were also quartered here. There were caves underneath the house that officially stored farm produce but were used unofficially by the smugglers.
In 1829, Princess Victoria and her mum, the Duchess of Kent, sheltered from a thunderstorm in a barn here.
Harry Hanoel Marks (born London 9th April 1855) who was both MP and JP for Thanet and the owner and editor of the Financial News, bought Callis Court, as a holiday home, from Richard Potter in 1889. After his wife's death, it was sold at auction in 1916. The old farmhouse had got very ramshackle and had been demolished.
Some of the materials were used in the building of a preparatory school called St Edwards which become Wychdene Nursing Home.
SEE Broadstairs/ Cleve Court/ Farms/ Lovejoy School/ Minster/ Politics/ Victoria

Marquess CAMDEN
Born 11th February 1759
Died 8th October 1840
The 1st Earl's only son, his full name and titles were John Jeffreys Pratt, the 2nd Earl and 1st Marquess Camden.
He attended Trinity College Cambridge, and in 1780, at the age of 21, became MP for Bath. Subsequently, he was Teller of the Exchequer, a position that was very well paid and, although he gave up the salary in 1812, he kept the position until he died. In William Pitt's cabinet he was a Lord of the Admiralty and a Lord of the Treasury.
He became the 2nd earl when his father died in 1794 and the following year he was appointed Lord Lieutenant of Ireland. He and his policies were not popular there and following the suppressing of the 1798 rebellion, he resigned.
In 1804 he became Secretary of State for War and the Colonies and the following year Lord President of the Council, a position he held again from 1807-12. In 1812 he was made Earl of Brecknock and Marquess Camden and it is this latter title that inspired the naming of Camden Square.
SEE Camden Arms/ Camden Square

The CAMDEN ARMS public house
La Belle Alliance Square, Ramsgate

The pub was built in 1833 and Mrs Buckmaster was its first landlady. A later landlord, Hugh Crawford Hunter, held the licence for fifty years, although he had to close the place for a while in August 1940, after it was damaged in the blitz.

SEE Camden, Marquess/ La Belle Alliance Square/ Pubs/ Ramsgate

CAMDEN SQUARE, Ramsgate

Friedrich Engels stayed at number 11 from 24th July until 1st September 1876.

SEE Adelaide Gardens/ Camden, Marquess/ Engels, Friedrich/ Ramsgate

CAMEO CINEMA
Northdown Road, Cliftonville

Two houses, including a twin-gabled former boarding house, and gardens were partially demolished in 1912 to make way for Cliftonville's first cinema, the Lounge Cinema - a 550-seat cinema with a foyer that was decorated in a French conservatoire style. It opened at 127/129 Northdown Road on 22nd January 1912 and was described at the time as 'cool and cosy'. In some respects it was a bit on the small side; there was no room for a stage and the ceiling of the box, sited over the entrance, was so low that there was no room to stand up. Sound was installed on 16th November 1929 but the Hippodrome had beaten them by 3 weeks and won also beating them in trade, as well. It closed on 28th September 1935 and became the Cameo News Theatre in 1936 but, on 5th July 1937, soon reverted to showing feature films and became The Cameo. Requisitioned for the war, it re-opened on 27th May 1946 and continued until 23rd December 1969. It then became three shops.

SEE Assembly Rooms/ Boarding Houses/ Cliftonville/ Cinemas/ Northdown Road

CAMERA OBSCURA

They project through lenses, a 360-degree live panorama of the surrounding area onto a horizontal flat screen.

There were two at Ramsgate: one on the Iron Marine Pier, destroyed in World War I and the other on the west pier of the harbour between around 1827 and 1966.

There were also two at Margate: between Fort Point and Second Point, from around 1821 at the landward end of the jetty, up until about 1937; and the other one was first noted in 1809. The camera obscura stood in an eight-sided hut at the entrance to the jetty. Pictures of Margate and its Vicinity, 1821, W C Oulton: *At the top of the flight of steps, in the ROAD LEADING TO THE FORT, on the left hand, is a small wooden building, used as a camera obscura which, by reflection, commands most delightful views of the harbour and surrounding scenery. After the storm of 1808 this camera obscura was removed from the pier; and its present situation is exceedingly favourable.*

SEE Harbour, Ramsgate/ Margate/ Pier/ Ramsgate/ Stone House/ World War I

Gerald CAMPION
Born 23rd April 1921
Died July 2002

An actor who played Billy Bunter in the television series that started on 19th February 1952. Although the books author, Frank Richards, didn't approve of it the show ran for 120 episodes. In 1958 there was even a Greyfriars play at the Victoria Palace in London with Gerald Campion still playing the part of Billy Bunter.

Gerald Campion was over 30 when he started playing the schoolboy Billy Bunter; he stopped playing the character when he was 40. As an extra piece of trivia, he also played the part of one of the Ministers in the film of 'Chitty Chitty Bang Bang'. He retired from acting and became a successful restaurateur and even employed a young Ronnie Corbett behind the bar at Gerry's in Shaftesbury Avenue, London, before retiring to France.

SEE Actors/ Billy Bunter/ Richards, Frank

CANADA

Thanet Children for Canada: *Twenty bright-eyed children trooped into Ramsgate Police Court on Tuesday. They were children from Thanet Cottage Homes at Manstone and they appeared before Magistrates to state their willingness to go to Canada.* 22nd March 1905

SEE Manston/ Ramsgate/ Thanet

CANADIAN MILITARY HOSPITAL

Last Kent Times, 29th August 1917.

CANADIANS GOING – LOSS TO
RAMSGATE AND BROADSTAIRS
Departures hastened by Gotha raid

By the end of this week the whole of the Canadian Hospital patients at Ramsgate and Broadstairs will have left the district.

The official intimation has been secured by an EKT representative from the Officer Commanding the Canadian Special Hospitals, Lieut-Col Clarke. It will cause the greatest regret in both towns.

Following an air raid on Ramsgate it was hinted some time ago that the question of the removal of the Canadian patients from Ramsgate was being considered, but little attention was paid to by the residents. The raid by Gothas on 22 August, however, has hastened the decision of the authorities, and, as indicated no time is being lost in carrying out the removal.

As there has been no time to secure other suitable buildings, or on another portion of the coast difficult for the approach of enemy aircraft, the patients are being distributed pro tem among other hospitals and convalescent institutions throughout the country.

No doubt when the work of the specialist hospitals is recommenced elsewhere, the men will once more be transferred. Inasmuch as there are no other electro therapeutic Canadian Special Hospitals in the British Isles, it is obviously essential that the good work carried out here for so long should be continued and no time is likely to be lost in the transfer of the equipment when suitable buildings have been found.

The staff of the hospitals, we understand, will remain in charge and assist in the ultimate removal of equipment and apparatus.

The Granville Hospital, which was opened in October 1915, has accommodation for 600 patients, and the staff comprises 250 officers, nurses, NCOs and men.

Chatham House School was opened as an annexe to the hospital in March 1916 and accommodated 250 patients with a staff of over 100.

Two months later, Townley Castle School adjoining Chatham House, was used for the accommodation of patients to the number of about 50 and a staff numbering a score (20).

A fourth building was taken over later in the year this time at Broadstairs when Sir A Yarrow place Yarrow Home at the disposal of the Canadian authorities, and patients were taken there in October. In that building were 150 beds while the staff was composed of 100. Subsequently it was converted for the use of officers in place of the NCOs and men who were originally treated.

At the end of the year, the departure of the pupils of St Lawrence College, Ramsgate, resulted in the conversion of that building into a hospital named 'Princess Patricia's' which accommodated 800 patients and a staff of 200.

The last building to be taken over was the Grand Hotel at Broadstairs early this year. It has since been used for the convalescent officers, and is capable of holding 300 beds. The staff there totals 150.

Expressing to our representative his regret at the pending departure, Lieut-Col Clarke remarked that Ramsgate and Broadstairs were ideal places under normal conditions for hospitals. The air, he said, was splendid. It was due to the men who had been wounded in France, however, to be put in a safe place when they came back to England.

SEE Broadstairs/ Chatham House School/ Convalescent Homes/ East Kent Times/ Gotha/ Grand Hotel/ Ramsgate/ St Lawrence College/ Townley Castle School/ Yarrow Home

George CANNING
Born 11th April 1770
Died 8th August 1827

In 1809 he had a long dispute with Lord Castlereagh, the Secretary of State for War, which resulted in the two of them fighting a duel. Canning had never fired a gun in his life so consequently missed with his shot, but received a wound in his thigh from Castlereagh. I bet nobody moaned that politics was boring back then.

He was married to Joan and they had four children, but it was rumoured that he had an affair with Queen Caroline, the wife of the new King George IV.

He was Prime Minister from 10th April to 8th August 1827, succeeding Lord Liverpool. He died in office and holds the record for being Prime Minister for the shortest period of time, 119 days.

SEE Pier/ Liverpool, Lord/ Politics/ Prime Ministers

CANNON ROAD, Ramsgate

Cannon Road was originally a ropewalk, one of two in Ramsgate; the other being where George Street is now sited. In the Napoleonic Wars, cannon were parked here, hence the name.

A Mr Austen lived in a seventeenth century house between Monkton Court and Cannon Road. Austen was a shipping agent, banker and large scale ropemaker employing a lot of men to make and repair ropes and cables at his business sited where Cannon Street is now situated.

Oast houses next to The Maltings are evidence of a history of beer brewing in the area.

SEE Blackburns/ George Street/ Knowler/ Napoleonic Wars/ Priory School/ Ramsgate/ Tunnels, Ramsgate

CANTERBURY ROAD, Birchington

A section to the east of Birchington Square was known as Margate Road at one time.

Old Cottages stand opposite the churchyard of All Saints and were once part of Street Farm which covered part of what is now the churchyard. In 1688, John Bridges, a gentleman from Canterbury, owned several Thanet farms including Church Hill Farm here. These cottages were all part of what was once one cottage and belonged to that farm. Sun Alliance Fire Mark (No. 537003) is on one of the cottages, referring to the policy that William Grigg, a miller, took out in 1787.

Church Hill Farm was opposite the All Saints churchyard from about 1680 until 1970. Only some cottages now remain.

Ferndale Court was the site of Church Hill Farm and Homestead which dated back to the 1680s. The house was built in the Flemish style – Flemish bond brickwork, but was demolished in 1970 when Ferndale Court, flats for the elderly, was built.

SEE All Saints' Church, Birchington/ Birchington/ Court Mount/ Farms/ King Ethelbert School/ Lollipop man/ Pond/ Queen Bertha's School/ Spurgeon's Homes/ Yew Tree Close

CANTERBURY ROAD, Westbrook

In 1927 the estate agents Wright, Tanton and Co put up a clock outside their office. When they moved next door from 143 to 145 in 1953 it took a while for the clock to be put up again – you know what it's like when you've just moved – and some locals were not happy about it - there were complaints!

Montrose House was a boarding school for around 30 girls until the late 1880s at 5 and 6 Royal Terrace on the Canterbury Road. Just down the road, at number 4, at the same time was a smaller establishment for boys.

SEE Dog & Duck/ Goodwins/ Royal Sea Bathing Hospital/ Schools/ Shakespeare pub/ Trams/ Westbrook/ Westbrook Cycle Store/ Westbrook Day Hospital

CANTERBURY ROAD, Westgate

Torrential rain caused flooding in 1973 drowning 77 year-old Victoria Scott. Her body was found in the garden of her Canterbury Road home, after neighbours heard her screaming as the water rushed into her home and rose to within a foot of the ceiling.

SEE Flooding/ Hawtrey's Field/ Read Court/ St Augustine's/ Westgate-on-Sea

King CANUTE

Or to spell it in the modern way 'Cnut', which I am sure will soon be the brand name of a range of trendy clothing. It is probably a bit late to apply for the job of King Canute's PR man but the whole business of him attempting to hold back the waves of the sea, for which he is now remembered, was engineered to reprimand his sycophantic courtiers for their belief that he had the power, when he knew that he did not. It has been misunderstood ever since.

SEE Canute Road, Birchington/ Royalty/ Sweyn, King

CANUTE ROAD, Birchington

Named after King Canute.

SEE Birchington/ Canute, King

CAPTAIN DIGBY
public house and restaurant, Kingsgate

A terrible storm in 1813 removed - and what it did not remove had to be demolished - most of a bede house (a form of almshouse) leaving only the stables which is now the Captain Digby.

SEE Battle of Botany Bay/ Eva Trout/ Harley's Tower/ Holland, Lord/ Kingsgate/ Northern Belle/ Restaurants/ Thirty Nine Steps

CAPTAIN SWING

Not an individual, but a generic term for the rebels. In 1830 a combination of events caused East Kent farm workers to rebel: huge taxes were imposed to pay for the French Wars; falling farm prices; the introduction of the workhouse as replacement for the old Poor Law; the particularly bad winter of 1829/30; wages that did not pay enough to feed a family (wages were typically 7 shillings a week and it cost 6 shillings to feed a man, if he only ate bread and water); and the invention of machinery that replaced jobs of farm workers.

On 17th October the first threatening letter from 'Captain Swing' was sent out at Ramsgate.

On 15th November 'General' Moore of Garlinge led a mob of men who had blackened their faces to St Nicholas, Monkton and Shuart where they destroyed threshing machines. That same month there were fires in Birchington and at Alland Grange (near Manson airport) two threshing machines belonging to George Hannam were damaged. Other machines were damaged at Chambers Wall, Shuart and Minster. At St Johns, Margate, one man from the parish of St John's, another from Monkton and the rest from Acol and Birchington, were tried and convicted of 'unlawfully maliciously and feloniously breaking a certain threshing machine in November 1830 in the parish of St John's Margate to the value of ten pounds the property of Hills Rowe, farmer of [Vincent Farm] Margate.' Amongst those sentenced and convicted at the General Sessions of the Peace at Dover was an illiterate, 25-year old son of a Birchington butcher who had no trade, Richard Oliphant; Stephen Bushell (28) from Monkton; William Bushell (17) from St John's; William Hughes (21) from Acol, who could read but not write; illiterate William Brown who had married Sarah Miles in Birchington church in 1819 and had six children; Thomas Hepburn, or Heborn, from Acol who had married Elizabeth at Birchington and had two children. They were all transported on the convict ship 'Eliza', carrying 224 convicts, in a voyage that began on 2nd February 1831 from Portsmouth and arrived in Hobart, Tasmania, then called Van Diemans Land, in May. Elizabeth received help from the Overseers of the Poor for the Ville of Wood (Acol). Thomas Hepburn got a free pardon in 1836 and was joined later by his wife and children. They had three more children, and Thomas died a 'gentleman' in 1879, Elizabeth having passed away in 1854.

On 9th November Elizabeth Studham (she had been baptised in 1814 which gives an idea of her age) helped to burn down the workhouse at Birchington. She was said to be of 'bad behaviour' and also transported to Van Diemans Land, on the convict ship 'May'. According to the ship's register she was well behaved on the journey but said to have loose morals - and probably quite popular! After arriving in Hobart on 19th October 1831 she knocked up – possibly a poor choice of phrase for her – ten offences, including two for theft, but the others were mainly for bad language. In 1846 she received a conditional pardon.

When Irish labour, who were escaping starvation from their own country, were brought in at Margate Harbour to bring in the harvest at St Johns they got a very hostile reception.

The rebellion continued but around eight years later it had ended, savagely put down. The last hurrah was at Blean with the Mad Tom Courtneys

He grew gouty, dyspeptic, and sour,
And his brow, once so smooth and so placid,
Fresh wrinkles acquired every hour,
And whatever he swallow'd turn'd acid
The neighbours thought all was not right,
Scarcely one with him ventured to parley,
And Captain Swing came in the night,
And burnt all his beans and his barley.
R H Barham, Ingoldsby Legends,
Babes in the Wood 1840

SEE Acol/ Barham, RH/ Birchington/ Farms/ Fires/ Garlinge/ Harbour, Margate/ Margate/ Minster/ Monkton/ Ingoldsby Legends/ Politics/ Ramsgate/ Shuart/ Transportation/ Workhouse

CARLTON CINEMA
St Mildred's Road, Westgate

The first films at what was originally the Town Hall Cinema were shown in May 1912, but by the war the name had changed to the Westgate Cinema. Hugely popular during World War I, the audience, many having to stand, faced the opposite direction than those of today, towards a transparent screen on to which the film was projected from the rear. Films were displaced in the

1920s by dances, skating, whist drives and even the occasional opera! Before World War II, two shillings would have got you into a whist drive that included refreshments.

The Carlton Cinema opened in 1932 accommodating audiences of up to 490 for the new talkies. It was the only cinema in Thanet not to close in World War II. The screen was moved to the other end of the auditorium in 1957 when Cinemascope was also installed. In 1982, Mike Vicker and Barry Kavanagh spent a small fortune on Dolby stereo sound, placing the screen slightly higher up (prior to this if anyone left to buy popcorn or go to the loo their silhouette went across the film), hanging curtains all around the walls, laying 600 yards of carpet, and installing 300 luxury seats. It won an award around this time as the best independent cinema in the country, and is still a great place to see the latest films – well, I like it!

SEE Cinemas/ St Mildred's Road/ Town Hall Building/ Westgate-on-Sea

CARLTON HOTEL
Victoria Parade, Broadstairs

Built in 1899, on the corner of Oscar Road and Victoria Parade it overlooks the seafront. In 1924, the entire British Olympic Team including Harold Abrahams and Eric Liddell of Chariots of Fire fame, stayed here whilst they trained for that year's games.

SEE Abrahams, Harold/ Broadstairs/ Chariots of Fire/ Hotels/ Liddell, Eric/ Victoria Parade

CARMEL COURT
Spencer Road, Birchington

Built in 1895 as a replica of a villa at Mount Carmel in Palestine. There was a fountain at the front and steps inside led down to a Roman bath. It was demolished in 1964 to be replaced by a block of flats.

SEE Birchington/ Spencer Road, Birchington

Andrew CARNEGIE

Born Dunfermline 1835
Died Massachusetts 11th August 1919
He moved to America in 1848 and got a job as a bobbin boy in a cotton mill in Pennsylvania before becoming a messenger in a Pittsburgh telegraph office. He learnt telegraphy and worked his way up to become a private secretary, a telegrapher and then a superintendent in what would later become the Pullman Company. His fortune, or at least the beginnings of it, stemmed from the financial interest he took in that company. He also invested in oil - a shrewd move.
During the American Civil War, he worked for the War Department on both the telegraph service and military transport. When the war was over, he formed a

company to make iron railway bridges, which led to (geddit?) a steel mill. By the time he was 33, in 1868, he was earning $50,000 a year and said, *'Beyond this never earn, make no effort to increase fortune, but spend the surplus each year for benevolent purposes.'*
In 1899 he controlled a quarter of the USA's iron and steel production and two years later retired after selling his company for $250,000,000.
He donated the money for Ramsgate's library and in total donated the money for almost 1,700 libraries in Britain and the USA. *'I choose free libraries as the best agencies for improving the masses of the people, because they give nothing for nothing. They only help those who help themselves. They never pauperize. They reach the aspiring and open to these chief treasures of the world, those stored up in books. A taste for reading drives out lower tastes.'*
Carnegie also paid for the Peace Palace at The Hague (it is now the International Court of Justice). All told, in his lifetime, he gave away $350,000,000 to a variety of peace, cultural or educational projects and institutions.
'A man dies disgraced if he leaves millions of dollars which he could have used in his life time for the benefit of Mankind.' – I quite agree, just give me the millions and I'll prove it.

SEE Library, Ramsgate/ Ramsgate

Princess of Wales, CAROLINE of Brunswick-Luneburg

Born Germany, 17th May 1768
Died London 7th August 1821
She married her cousin George, the Prince of Wales on 8th April 1795.
She spent the summer of 1803 at East Cliff Lodge.

SEE East Cliff Lodge/ Meeting of George & Caroline/ George IV/ Obelisk

The CAROLINE

A three-masted lugger bought jointly by Augustus Pugin and Alfred Luck for £70.
SEE Pugin, Augustus/ Luck, Alfred/ Royalty

Lord Edward Henry CARSON

Edward Henry Carson was born on the 4th February 1854 at 4 Harcourt Street, Dublin, into a Protestant family. He was brought up and educated in the South of Ireland and on holidays at Dungarvan, County Waterford, he played on the beach with another boy, Oscar Wilde.
Later he attended Trinity College Dublin and came 7th out of 10 successful candidates in his law exams in April 1877 and was called to the Irish Bar that Easter. One of his contemporaries at Trinity College was Oscar Wilde who later recollected that he and Carson would walk around arm-in-arm, or with their arms around each others' shoulders. Carson would have no such recollection.
On 19th December 1879, Carson got married to Annette Kirwan in Monkstown Parish

Church and they subsequently honeymooned in London. They had four children, William Henry Lambert, Aileen Seymour, Gladys Isabel and Walter Seymour.
His career in law was going well when he started a parallel career in politics being appointed Irish Solicitor General in 1892. In a busy year he was also elected as a University burgess for Trinity College to the British House of Commons. He moved to London transferring to the English Bar where he continued to be successful and became a Queens Counsel in 1894.
His most famous trial occurred in 1895 when he defended the Marquess of Queensbury (the one who wrote the rules of boxing) against Oscar Wilde's libel charges after the Marquess presented him with a card stating that Wilde was *'posing as a sodomite'*. When Wilde learned of the opposing legal team he initially did not fear him and nonchalantly said, *'I'm going to be cross examined by old Ned Carson'*, but he also added that *'No doubt he will perform his task with the added bitterness of an old friend'*. Carson did not want the case at first, it being against a fellow Irishman and having attended the same university. He soon overcame his reluctance, wanting the challenge of a case that at first seemed very weak, but out of a three-day trial, Carson relentlessly cross-examined Wilde for two. (Carson, then aged 41, was surprised that his ex university contemporary had only reached the age of 39 in the same period.) Referring to Walter Grainger, a servant, Carson asked, *'Did you ever kiss him?'*
Wilde, *'Oh, dear no. He was a peculiarly plain boy. He was, unfortunately, extremely ugly. I pitied him for it.'*
Carson, *'Was that the reason why you did not kiss him?'*
Wilde, *'Oh Mr Carson, you are impertinent and insolent.'*
Carson, *'Why, sir, did you mention that this boy was extremely ugly?'*
Wilde, *'For this reason. If I were asked why I did not kiss a door-mat, I should say because I do not like to kiss door-mats. I do not know why I mentioned that he was ugly, except that I was stung by the insolent question you put to me and the way you have insulted me through this hearing. Am I to be cross-examined because I do not like it?'*
Carson continued on the subject, and finally Wilde said, *'You sting me and insult me and try to unnerve me; and at times one says things flippantly when one ought to speak more seriously. I admit it.'*
Carson came forward with more evidence and witnesses that Wilde had not envisaged. Two of the boys that could have given evidence against Wilde hid in Broadstairs at the time of the trial. Carson won his case and the judge subsequently sent him a letter:
Dear Carson,
I never heard a more powerful speech nor a more searching crossXam. I congratulate you on having escaped the rest of the filth.
Yrs ever
R Henn Collins

Wilde then faced prosecution charges himself and was convicted for gross indecency and served two years in prison. Michael MacLiammoir commented *'Yes, that would explain it all. Oscar probably upset Edward's sandcastle.'*

During the short period after his release from jail, Wilde was accidentally knocked into the gutter by a man walking in the opposite direction, the man turned round to apologise. It was Carson.

Edward Carson became Sir Edward Carson in 1900 when he was knighted by the Prince of Wales. It was another busy year because he was also appointed Solicitor General to the Government. He went on to be a Cabinet Minister and was First Lord of the Admiralty for some of the First World War.

He became leader of the Irish Unionists in the Commons in the House of Commons on 21st February 1910 and fought against the third Home Rule Bill. In 1912 he and other leaders signed a covenant opposing it, and in 1913 he set up a private army, with weapons supplied from Germany, as well as a provisional government in Belfast, ready should home rule be imposed. The British government subsequently conceded that the Irish northern counties would remain part of the UK. Carson was made a life peer in 1912 and served as a Lord of Appeal until 1929.

Sadly, his wife Annette suffered a stroke and died in 1913. On the 18th September 1914 Sir Edward married his second wife, Ruby Frewen.

Sometimes known as 'Carson's Army', The Ulster Volunteers were formed in 1914.

After serving as MP for Trinity College for 26 years, he became in 1918 the Unionist MP for the new Belfast seat of Duncairn,

Edward had a fifth child, his first with Ruby, on the 17th February 1920, a son, also named Edward. The same year, with a new family, and following all the stresses and strains of the recent turbulent Irish politics, with semi retirement in mind he bought Cleve Court near Minster.

In 1921 Carson stood down as the leader of the Ulster Unionists and became Lord of Duncairn in the House of Lords.

In 1935 Dr E G Moon, from Broadstairs, visited his patient, Lord Carson, at Cleve Court. As he was leaving, the doctor realised that he had forgotten to give Carson's nurse some information. As he stood by the front door he noticed that not only had his car disappeared, along with the yew hedge that had been next to it, but the driveway had turned into a muddy path on which, about a 100 feet away, a man wearing a 19th century type coat and several capes, and carrying a rifle-type gun, was looking straight at him as he walked towards him. The doctor turned to go back into the house to speak to the nurse, but realising what he had seen he looked again and everything was back to normal.

Sir Edward Carson lived to the ripe old age of 81, which probably surprised him as he had suffered from poor health for most of his life. He died at Cleve Court on the 22nd October 1935. His coffin was taken on a gun carriage through Belfast to St. Anne's

Cathedral, where soil from the six counties of Ulster and Londonderry were scattered on it.

Lady Carson continued to live at the house until she died nearly 30 years later in 1966.
SEE Broadstairs/ Cleve Court/ Politics/ Punch magazine/ Wilde, Oscar

CARTOON
A snob in a 1820 cartoon says, *'Lord, Madam, you can never think of going to Margate, it is so common.'*
SEE Margate

CATHOLIC CHURCH of OUR LADY STAR of the SEA, Broadstairs

Situated on Broadstairs Road, Broadstairs, near to Edge End Road, it was opened and dedicated on 10th September 1931 by the Right Reverend Peter E Amigo, the Bishop of Southwark. The western end had to wait until 1963 before it was completed.

A bomb landed in the grounds on 3rd August 1941.
SEE Broadstairs/ Broadstairs Road/ Churches

CAVALRY
Cavalry horses were tethered on iron rings in the walls of the East Pier at Ramsgate Harbour prior to embarking on their journey to the Napoleonic Wars. The rings are still there, although a bit rusty now.
SEE Napoleonic Wars/ Harbour, Ramsgate/ Ramsgate

CAVENDISH BAPTIST CHURCH
Cavendish Street, Ramsgate
James Mortlock Daniel was the minister who acquired the site and erected the church in 1840.

The most well-known minister here was Thomas, or Tommy, Hancocks (born London 1854 – died 1940). He spent his early life in Birmingham but after leaving Spurgeon's College in 1877, he became a church minister in Kent for the rest of his life; first in Tonbridge (1877-84), then at the Zion Baptist Church, Chatham (1884-92); and finally in Ramsgate. He was a founder of the Ramsgate Evangelical Nonconformist Association, later to become the slightly snappier entitled Ramsgate Free Church Council. After 1896 he became a leading member of the Ramsgate United Sand Services, part of the Ramsgate Free Church Council. As the numbers attending the church were growing he decided that the

church needed improving, particularly its layout. The pulpit was moved from under the Effingham Street window, which meant that the seating would need re-organising and he wanted a new schoolroom. In 1899, Hancock had a quote for the work of £4,200 but had only £2,800 in the coffers. He set an opening date for six weeks later and had printed on the invitation:
'Before that silver key can be turned in the lock, the last penny must be given, and I dare to prophesy that all will be ready before 3 o'clock that day.'

Not only did he get the last penny, but he got another £200 on top. Stone tablets in the church and outside the school stated:
The adjoining schools are a witness to the Living God, who gave over £4,410, thus enabling His people to do the impossible and open them free of debt on September 13th 1900. The last £2,400 was given in ten months. 'Ask and it shall be given'.

The church also paid thanks *'despite bad times caused by three wars, many war Funds, and a late and wet season, and a serious rise in the cost of everything . . .* [and] *for no accident to the men employed'.*

By 1903 there were 354 baptised believers. Many boys from Fegan's Homes for Boys regularly attended the services and, in later years would write letters of thanks to Hancocks some from their new homes far away in Canada.

In World War I, Hancocks' house was damaged in three air raids before being destroyed in a fourth. The cellars of the church and new schoolrooms were regularly used by 250 people as air raid shelters. There was also a canteen run by one of Hancocks' daughters — he and his wife had eight children - that, in two years, saw 100,000 servicemen pass through it. Many wrote letters of thanks, including the odd poem:
There is a canteen in Cavendish Street
Where soldiers throng to sit and eat
Air Force men; Engineers
Bombardiers and Fusiliers
Find right here a haven of rest
And food whose quality is the best

Hancocks was also the chaplain at RAF Manston where the commanding officer described him as *'the best helper I have'* and *'the best influence on the station'.*

In 1922 the Mayor of Ramsgate came *'to place on record my high appreciation of your long association with our borough during these 30 years, the earnestness of your work and your fine citizenship.'*

Some 400 people came to celebrate the Hancocks' Golden Wedding Anniversary in 1924, *'I am absolutely taken aback. That which you have said about me is quite a good description of the man I want to be! With regard to my wife, I can honestly say I do not think that she could be any better.'*

In 1928, part of the land belonging to the church was sold to the Ramsgate Corporation who built the Police Station upon it.

In January 1931 Hancocks held a huge Lifeboatmen's Tea attended by all manner of seafaring folk. Hancocks was also known as the Fisherman's Pastor.

Following a 41-year ministry, Hancock resigned in 1933 at the age of 76. He was given a big send off, a *'worthy close to the greatest chapter in the history of the Cavendish'.*
He died in 1940. The tablet in the church was engraved with: *Thomas Hancocks . . . for 56 years a minister of Jesus Christ, 41 of which he was the honoured Pastor of Cavendish Baptist Church. A man greatly loved. He walked with God in peace and equity, and did turn many away from iniquity. Malachi 2.6'*
Currently, Cavendish Baptist Church lies empty.
SEE Cavendish Street/ Churches/ Manston Airport/ Poems/ Ramsgate/ Schools/ World War I

CAVENDISH STREET, Ramsgate
SEE Barclays Bank/ Barnett's/ Blackburns/ Cavendish Baptist Church/ Fine Fare/ George & Dragon pub/ Guildford Lawn, Ramsgate/ Library, Ramsgate/ One way system/ Police Station, Ramsgate/ Queens Court/ Ramsgate/ Richardson, Alan/ Tuckshop murder mystery

CAVES
SEE Coves, St Peters,The

William CAXTON
Born Kent c1422
Died c1491
William Caxton, England's first printer, wrote, and printed, *'Thanatos, that is Tenet, a ylonde besides Kent and hath the name Thanatos of deth of serpents, for ther ben none. Ther is a noble corn lond and fruitful.'*
He referred to a legend that says no reptile can live on Thanet and if you take earth from Thanet and pour it on a reptile it will die.
SEE Authors/ Caxton Road/ Thanet

CAXTON ROAD, Garlinge
Named after Willam Caxton.
SEE Caxton, William/ Garlinge

CECIL SQUARE, Margate
It was originally laid out in 1769. The Assembly Rooms were the fashionable place to go and such was their importance that the houses on the northern side of Cecil Square could not be too tall because it would spoil the view from the Assembly Rooms.
SEE Assembly Rooms/ Benson's Assembly Rooms/ Bobby's Department Store/ Centre, The/ Cumberland, Duke of/ Harbour Area/ Hippodrome/ Hospital/ Howe's Royal Hotel/ Keble's Gazette/ Margate/ Post Office/ Regal Cinema/ Sickert, Walter Richard/ Theatre Royal/ Yates' Wine Lodge

CECILIA ROAD, Ramsgate
Originally it was called Cemetery Road because it leads to the cemetery but the name was so disliked by the inhabitants, they asked for it to be changed. They could have had Graveyard Grove, Deadbody Drive, Cadaver Close, or even Stiffs Street, but they said no, they wanted something that did not refer to the burial ground. In the end, Cecilia Road was chosen. I do not know why that name was chosen but St Cecilia is the patron saint of music, composers, musicians, musical instrument makers and martyrs.

'While the profane music of her wedding was heard, Cecilia was singing in her heart a hymn of love for Jesus, her true spouse.' The Acts of Cecilia.
St Cecilia's day is 22nd November.
SEE Cemetery/ Ramsgate

Madame CELESTE
Born Paris, 16th August 1815
Died Paris, 12th February 1882
She started her career as a dancer and when visiting America in 1834, such was her popularity that a huge crowd removed the horses from her carriage, pulled it themselves, and carried her on their shoulders. Different people were carrying out each act you understand. She returned to England a wealthy woman and switched to being an actress, appearing at Drury Lane and the Haymarket. The third phase of her career was as manager of the Lyceum. She left there in 1861 and returned to America (1865-68) before retiring in 1870.
She appeared at Margate's Theatre Royal.
SEE Theatre Royal

CEMETERIES
The word 'cemetery' comes from the Greek word for dormitory, 'koimeterion', thus it is a place for sleep.
A Jutish cemetery was found at Ozengell - Jutes believed that you could take it with you, so they were buried with their belongings.
SEE Cemetery, Margate/ Jutes/ Ozengell

CEMETERY, Margate
Seven crewmembers of a German Gotha aircraft died during an air raid over Kent on Wednesday, 22nd August 1917. They are buried here, on the edge of the RAF section, and their graves are still well tended. The wreckage of their aircraft was sold at auction in the Town Hall with the money going to war charities.
SEE Chatham House School/ Friend to all Nations memorial/ Gotha/ Hengrove/ Margate/ Military Road, Ramsgate/ Phillpott, Thomas/ Picton Road, Ramsgate/ Sanger's graves/ Wain, Louis/ Walpole Bay

CEMETERY, Ramsgate
Ramsgate Cemetery was consecrated in March 1871. It was purchased at a public auction of the Newlands Farm Estates by the Ecclesiastical Commissioners in 1869.
There are said to be an example of every tree in England in this cemetery.
SEE Cecilia Road/ Farms/ Ramsgate

The CENTRE
The shopping area in Margate that links Cecil Square, Queen Street and the top half of the High Street, was built in 1971.
SEE Cecil Square/ High Street, Margate/ Margate/ Queen Street, Margate/ Shops

CERVIA – moored in Ramsgate Harbour
The 240-ton Empire Raymond was built by Alexandra Hall and Company in Aberdeen for the Ministry of War Transport in 1945-6. She first saw service assisting the Queen Elizabeth when she went aground on

Brambles Bank in Southampton Water in April 1947. After changing her name to Cervia (a small Italian town) she served in the North Sea and the Channel until she sank in fog in a towing accident in 1954 when five people died. When water poured in through a two-inch hole in July 2003 it took fireman four hours to pump it out.
SEE Harbour, Ramsgate/ Ramsgate/ Ships

Frederick CHAMBERS (MD JP)
Born in 1801, he studied at the London Hospital in Whitechapel Road and for many years travelled the world as a naval surgeon. Eventually, he settled in Margate and was instrumental in the setting up of Margate's Local Board of Health. He did much to make the town a healthier place, working hard to close down the local slaughterhouses. He was less successful in improving what he considered to be unsanitary piggeries. Visiting a local man, he tried to explain to him that it was dangerous to his health to have his pig live in the parlour. Chambers was told that the pig had not had a day's illness in its life!
The doctor was a staunch Roman Catholic at a time of great religious intolerance in the town. A local low preacher and coachbuilder, Mr Watson, who employed quite a few big lads, took great delight each year on Guy Fawkes Night in going around the town with a pipe and fife band, and a cart carrying effigies of the Pope, Dr Chambers and anyone else whom he disliked. They caused as much noise as possible, particularly when they went by Dr Chambers' house! The whole thing ended up with a huge bonfire on the beach at Marine Terrace. Rubbish from all over town was burnt on the bonfire, so it served a useful purpose as well.
Chambers lived at one point at Vicarage Crescent, Margate (by the railway bridge over the Ramsgate Road) and objected strongly to the new railway embankment that the London, Chatham and Dover Railway were planning near his house. It was sorted out when the railway company bought him out.
He also lived for many years in Eaton Road, at St Mary's Cottage.
SEE Eaton Road/ Margate/ Marine Terrace/ Ramsgate Road

CHAMBERS JOURNAL
1853: *We leave Ramsgate, then, with its 'stuckupishness' and stiff and formal society.*
SEE Ramsgate

CHANDOS PLACE, Broadstairs
SEE Broadstairs/ Dickens, Charles

CHANDOS SQUARE, Broadstairs
SEE Batteries/ Broadstairs/ Eliot, George/ Post box

CHAPEL BOTTOM
The Chapel of Dene was built here at Chapel Bottom, just west of Margate Cemetery, in 1230. A farmer removed the foundations in 1868.
SEE Cemetery, Margate/ Farms/ Margate

CHAPEL PLACE, Ramsgate

In 1788-9 John Fagg gave land and five other gentlemen donated money for a chapel to be built to cater for the expanding population. It was originally a rough track that led through open farmland to the Chapel, hence the name, Chapel Place.

This was once Ramsgate's Harley Street with many doctors and dentists practising from here.

Built in 1789 and known at the time as Ramsgate Chapel, it had to wait until 1791 to be consecrated by Archbishop John Moore. By 1866 it was a chapel of ease to St George's and then dedicated to St Mary, it thus became St Mary's Church. It closed in 1940 for the duration of the war, but was bombed the following year and the year after that. The remains were completely demolished in 1955 and it is now the site of Apollo House Social Services. St Mary's church altar became the altar in the St Nicholas Chapel within St George's Church.

The mock Tudor house with blue coloured windows that is currently part of the adult education centre was once St George's Church Vicarage.

SEE Bull and George/ Churches/ Farms/ Foresters Hall, Chapel Place/ Ramsgate/ St George's Church/ Zeppelin

CHAPEL ROAD, St Lawrence

Named after a chapel that closed on 30th July 1989. Near to St Laurence Church was once an ancient chantry chapel, Holy Trinity. Later a Chapel Cottage was built on the site. Six bombs fell on Chapel Road in the same Zeppelin raid (17th May 1915) that destroyed the Bull and George pub in the High Street.

SEE Bull & George/ Churches/ Ramsgate/ St Laurence Church/ Zeppelin

Charlie CHAPLIN

Born 16th april 1889
Died 24th December 1977
The actor, mime, clown, writer and director was possibly the biggest star in the world in the first half of the twentieth century. *'All I need to make a comedy is a park, a policeman and a pretty girl'*. At the age of 75, he appeared at the Theatre Royal, Margate in January 1964.

SEE Actors/ Entertainers/ Theatre Royal

CHAR-A-BANCS

The word charabanc comes from the French 'char-à-bancs' meaning a horse-drawn carriage with benches. Lord Byron mentions them in his journal of September 1816 and the word became anglicised about ten years later. We English chose to pronounce the word 'sharabang', because clearly, we know better. When the motor vehicle variety, a forerunner of the coach, first appeared in 1907, the speed limit was 12mph. They had solid tyres giving a bumpy ride; pneumatic tyres were not introduced until 1924. Virtually the same design continued until the 1930s. Many a works outing to Thanet was had on a chara! Many were later converted into local buses.

SEE Byron, Lord/ Transport

'CHARIOTS OF FIRE'

The 1981 British film directed by Hugh Hudson tells the story of Harold Abrahams (played by Ben Cross) and Eric Liddell's (played by Ian Charleson) involvement in the 1924 Olympics. It won 4 Academy Awards (Best Picture - David Puttnam, producer; Original Music Score – Vangelis; Writing Original Screenplay - Colin Welland; and Costume Design - Milena Canonero). In addition, Ian Holm was nominated for Best Supporting Actor; Hugh Hudson for Directing and Terry Rawlings for Film Editing.

The film's title is taken from a line from William Blake's poem:

And did those feet in ancient time
Walk upon England's mountains green?
And was the Holy Lamb of God
On England's pleasant pastures seen?
And did the countenance divine
Shine forth upon our clouded hills?
And was Jerusalem builded here
Among these dark satanic mills?
Bring me my bow of burning gold!
Bring me my arrows of desire!
Bring me my spear! O clouds, unfold!
Bring me my chariots of fire!
I will not cease from mental fight,
Nor shall my sword sleep in my hand,
Till we have built Jerusalem
In England's green and pleasant land.

In 1999 it was ranked 19th in the British Film Institute's Top 100 British films. Kenneth Branagh, Stephen Fry and Ruby Wax can be seen as extras in crowd scenes.

The scene where the athletes are training on the beach, with Vangelis' music pumping out, was filmed in Scotland – St Andrews golf club is in the background but in real life they trained on Broadstairs beach.

Likewise the 'Carlton Hotel, Broadstairs, Kent' was filmed at the 18th hole of the St Andrews Golf Club.

SEE Abrahams, Harold/ Anderson, Lindsay/ Broadstairs/ Carlton Hotel/ Liddell, Eric/ Poems

Prince CHARLES, the Prince of Wales

Born 14th November 1948
He visited St Augustine's Abbey in November 2004 to look at the restoration of the Grange.

SEE Grange, The/ Royalty

CHARLES DICKENS public house
Victoria Parade, Broadstairs

SEE Andersons Café/ Broadstairs/ Dickens, Charles/ Pubs/ Victoria Parade, Broadstairs

CHARLES DICKENS SCHOOL
Broadstairs Road, Broadstairs

It was opened by Philip Charles Dickens, the grandson of the old fella, on Monday 12th September 1955.

The first headmaster was Les Warren and the first day for pupils was 1st September 1955 when 605 started school even though originally it was only supposed to take 450.

SEE Broadstairs/ Broadstairs Road/ Dickens, Charles/ Schools

CHARLOTTE COURT, Ramsgate

Ramsgate Police Station was once sited here.
SEE Horse and Groom pub/ Police, Ramsgate/ Ramsgate/ St Laurence Church

CHARLOTTE PLACE, Margate

Miss Emma Boys, ironically, ran a ladies' school, Danesbury House, here in the 1860s. The George and Dragon public house dating back to the early nineteenth century was at 11 Charlotte Place.

SEE Liverpool Arms/ Margate/ Post Office/ Quart in a Pint Pot pub/ Schools

Thomas CHARNOCK

Born 1524 or 1526
Died 1581
He was a great alchemist who worked in the Salisbury and Oxford areas and once wrote to Queen Elizabeth in 1565 saying that if he could not make gold she could behead him! Now, there's confidence. It is said by most scholars that he was born in Faversham, but a few say he was born in Thanet, and obviously we should side with them!

SEE Thanet

CHAS and DAVE

The singers/songwriters had a hit with 'Down to Margate', which got to number 46 in the charts in July 1982.

Hurry up will ya Grandad come on we're
going,
Chorus
Down to Margate, don't forget you're buckets
and spades and cossys and all,
Down to Margate, we'll have a pill of jellied
eels at the cockle stall,
Down to Margate, we'll go on the pier and
we'll ave a beer aside of the sea.
Down to Margate, you can keep the Costa
Brava, I'm telling ya mate I'd rather have a
day down Margate with all me family

Along the promenade we spend some money,
And we find a spot on the beach that's simply
sunny,
The kids will all enjoy themselves digging up
the sand, collecting stones and winkle shells
to take back home to Nan
Behave yourself Grandad, or you won't be
going,
Chorus
You can keep the Costa Brava and all that
palaver, rather have me a day down Margate
with all me family
Written by Hodges & Peacock.

SEE Entertainers/ Margate/ Music

CHATHAM HOUSE SCHOOL
Chatham Street, Ramsgate

Dr William Humble established Chatham House School for day pupils and boarders at

5 Love Lane in 1797. Inevitably the pupils got the nickname 'Humble's bees'.

Thomas Whitehead bought the school in 1810 and as headmaster insisted on there being 99 boarders, but definitely not 100! Day pupils had to be at school by 5.40am and did not leave until after prayers at 8.20pm! (Youngsters today, eh? – don't know they're born!)

His son took over as head and had a son Alfred.

The buildings were added to in 1824.

Queen Victoria and Prince Albert visited the school in 1842.

During the headmastership of the Rev E Gripper-Banks who was head between 1873 and 1882, the old buildings made way for those that exist today - built between 1879 and 1882.

Mr A J Hendry was the headmaster between 1900 and 1917. In time it became Kent Education Committee's Chatham House County Grammar School for Boys.

During World War I it was used as a Canadian Military Hospital. It was bombed during Easter 1915, and again during the worst daylight bombing raid in Thanet on 22nd August 1917. A squadron of Gothas dropped 28 bombs on the town killing 8 and injuring many more. One bomb passed through the roof of the school, the top floor chapel (in later years it became the school library), the dormitory below, the recreation room – from where, fortunately, 200 wounded Canadians had just run out to watch an enemy aircraft come down in flames – and then on into the basement where it killed the staff butcher and injured several other men.

In the same raid Townley Castle, next to Chatham House, was badly damaged.

Towards the end of the war, prisoners of war were interred here.

When the Canadians moved out, a regiment of the Highland Light Infantry moved in and when the war ended, the Royal Army Medical Corps used the buildings as a warehouse.

In 1917, because of the war, pupil numbers declined, the school buildings were damaged and the school closed. During the school's first incarnation it produced a prime minister of France; an Archbishop of Rupertsland, Canada; 62 members of the clergy, including a bishop; and Sir Seymour Hicks.

The school was evacuated to two locations during World War II, Stafford and Uttoxeter, both in Staffordshire. The headmaster at the time was the Rev B V F Brackenbury who retired soon after the school's return to Ramsgate.

Along with other secondary schools in the area, Chatham House pupils (250 of them – although within a year there would be nearer 450) returned on 9th September 1944 - the same date that it opened for juniors.

William Pearce took over as headmaster in 1946 and continued in the role until 1969 when he was replaced by Mr Potton.

Chatham house's most famous ex-pupil is Edward Heath.

In 1969 Chatham House Grammar School's team got to the final of the TV series Top of the Form (all together now: Da-daa da. Da-daa da. Da-da-da d-d-d-da da-da-d. . .c'mon, you remember the tune!) and lost by 5 points.

The cream of British high jumpers took part in a thrilling competition at Chatham House on Saturday. It was however one of the school's old boys, 6 ft 8 ins Geoff Parsons, who stole the show. He just failed to beat his own British outdoor record. 27th May 1988

Amongst state schools, Chatham House has the sixth highest number of entries in Who's Who.

SEE Canadian Military Hospital/ Chatham Street/ Gotha/ Heath, Edward/ Hengrove/ Hicks, Sir Seymour/ Kerly, Sean/ Military Road, Ramsgate/ Picton Road, Ramsgate/ Ramsgate/ Schools/ Townley Castle/ Victoria Walpole Bay/ Whitehead, Alfred North/ World War II

CHATHAM HOUSE SCHOOL SONG
Words by J W Mann BA,
Music by T Haigh MusD
Here where the feet of Englishmen first stood on English soil,
And marched in strong battalions on the foe,
There far off sons attentive catch the clamour of their arms
And feel their hearts within responsive glow
For though their deeds are hidden in the shrouding mists of time
And down the ages shrills the message yet
Of men who braved the terrors that wrapped an unknown shore
And reached the goal on which their hearts were set
Chorus:
Then these be our patterns, our models, our heroes
Who wrote the first page of our islands fair fame
Strength never faltering pluck never swerving
This shall we make us and keep us a name

Here where the sainted herald came and preached a gentler law
That sweetened human joys and earthy pain
That taught our sires the moulding of their might to nobler ends
And showed the purer heights they could attain
We to will bend our passions we too rejoice to know
An inward strength in conscious virtue bold
so shall we piece with clear set eyes the faithless shams of life
and glimpse the distant hope that years enfold
Chorus
Then this be our effort our aim, our endeavour
To guard as our fathers our islands fair name
Steadfast in purpose noble in nature
Thus shall we make us and keep us a name.
I am only sorry that I do not have the technology to allow you to hear me singing the song for you. It is a stirring tune.
SEE Music

CHATHAM PLACE, Ramsgate

The Duke of Wellington stayed at 1 Chatham Place during part of the Napoleonic Wars.
SEE Chatham Street/ Napoleonic Wars/ Ramsgate/ Wellington, Duke of

CHATHAM STREET, Ramsgate
Originally called Love Lane, it was a narrow street – *'two handcarts could not pass'* - that led to a mill and some farmhouses before James Townley bought the land. He built a cul-de-sac with stables at the end, re-named it Chatham Place and lived at number one whilst Townley House, which his wife designed, was built in 1792.
SEE Chatham House/ Chatham Place/ East Kent Arms/ Farleys/ Farms/ Railway Tavern/ Ramsgate/ Townley House/ Whitehead, Alfred North

CHERRY BLOSSOM SHOE SHINE
SEE Mason, Daniel

CHESS BOARD ESTATE, Broadstairs
The avenues of this small area off Stone Road are named after pieces on a chess board: Bishops Avenue, Kings Avenue, Knights Avenue, Queens Avenue, and Castle Avenue. There are no pawns around here.
SEE Broadstairs/ Stone Road

CHEYNE WALK, London
SEE Fleming, Ian/ London/ Rossetti/ Turner, J M W

CHILDREN'S SOCIETY
SEE East Court

CHILTON
From 'Childs ton', the Saxon for 'farm of the child' referring to Gavilkind.
Chilton Farm House was built in 1713. An earlier one stood opposite, behind The Chilton Tavern until around 1800.
Chilton Primary School opened in 1975.
SEE Chilton Primary School/ Curling family/ Farms/ Gavilkind/ Schools

CHIPPY HOUSE
SEE Chips

CHIPS
No, not the ones soaked in salt and vinegar, although now you've mentioned them, I am a bit peckish, but no vinegar on mine, thank you. Back in the seventeenth and eighteenth century, if you worked in a shipyard or on the docks, then you could take away any waste timber, just as long as it was under six feet long (do not try to do the same in the DIY store). These were referred to as chips. The bits that were about 5'11' were used to build houses with.
SEE Chippy House

CHOCOLATE
Dowlings was a chocolate manufacturer listed in Eaton Road, Margate in 1936.
SEE Eaton Road/ Food/ Margate/ Queen Street

CHRIST CHURCH
Vale Square, Ramsgate
Caen stone comes from Caen in Normandy. I know - my specialist subject, if ever I am on Mastermind, will be 'stating the bleeding obvious' – but it was important to William

Saxby (who had built the Congregational Church in Meeting Street) when he started to build Christ Church out of Caen stone and Kentish ragstone, with oak shingles on the spire; to give you all the details. The Caen stone had to be unloaded at Ramsgate Harbour and you need quite a bit to build a church - between three and four hundred tons. The architect was George Gilbert Scott. John Pemberton Plumtree MP laid the foundation stone on 14th August 1846 and it was consecrated on 4th August 1847. Previously, £8,000 had been raised locally for the project.

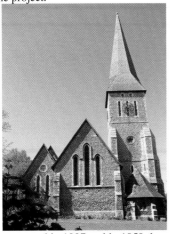

It was restored in 1907 and in 1950 the organ was repaired (a larger one had replaced the original in 1869) along with some re-decoration. The gallery was removed in 1965 at the same time as a lighting system was installed.

The Diocesan Pastoral Committee decided that the church should be declared redundant in 1977 and the parish hall was sold (a meeting room, kitchen and cloakroom were built in the north aisle around the same time). They were to be proved wrong and the church continued as a place of worship. It is now a Grade II listed building, despite another Diocesan Committee referring to it as a *'building with no notable features'*.
SEE Albert Memorial/ Churches/ Harbour, Ramsgate/ Listed buildings/ Meeting Street/ Ramsgate/ Scott, Sir George Gilbert/ Smack Boys' Home/ Vale Square, Ramsgate

CHRIST CHURCH SCHOOL
London Road, Ramsgate
28th June 1996:
CHRIST CHURCH SCHOOL
ON THE MOVE
Former pupils of Christ Church School have made an emotional final visit before the school moves to new premises in London Road. The oldest visitor on the open day was William Holladay who attended the school between 1912 and 1919. The school's current building was built in 1849 and is now in a poor state. There will be nine classes in the new school for 270 youngsters.
SEE London Road/ Ramsgate/ Schools

CHURCH ROAD, Ramsgate
It is named after the church – St George's - you can't miss it, it's huge – but it only became Church Road after the church

opened in 1827. Before that it was Bethel Place, after the Bethel Chapel.
SEE Brockman, Sarah/ Ramsgate/ St George's Church

CHURCH STREET, St Peter's
The Liptons supermarket was built in 1970, the chain that bought out Vye and Son. In the Napoleonic wars, troops were stationed in a barn on this site. A later barn on the same spot burned down and the present building was designed to look barn-like.
The Mockett family gave the Village Green in front to St Peter's in 1970.
The Old Farmhouse was built in 1682 by Richard and Sarah Mockett - 'SMR 1682' is carved above the doorway. The Lych Gate is a 2002 addition and has won awards.
The Mocketts built Hopeville in 1704. For 4 years from 1934 Walter Richard Sickert (1860-1942) lived there.
George Appleton took over The Forge, which used to be behind number 26, during World War I and up until its closure in 1974, it remained in the same family.
SEE Farms/ Mockett/ Napoleonic Wars/ Rediffusion/ Shops/ St Peter's/ Shops/ Sickert, Walter Richard/ Vye and Son

CHURCHES
There were advertisements in local papers showing the times of services for 26 places of worship in Ramsgate in 1901.
SEE Acol/ All Saints' Church War Memorial/ All Saints' Church, Birchington/ Anglican Church of St Thomas/ Belmont Road, Ramsgate/ Bethesda Street/ Birchington churchyard–sonnet/ Birchington Baptist Chapel/ Birchington Hall/ Bungalows of Birchington/ Catholic church of our Lady/ Cavendish Baptist Church/ Chapel Place, Ramsgate/ Chapel Road, Ramsgate/ Christ Church Ramsgate/ Church Road, Ramsgate/ Church Services/ Congregational Church, Ramsgate/ Crampton, Thomas Russell/ Garlinge Methodist Church/ Gore End/ Great Storm, The, 1703/ Holy Trinity Church, Broadstairs/ Holy Trinity Church, Margate/ Holy Trinity Church, Ramsgate/ Leopold Street, Ramsgate/ Methodist Church, Northwood/ Methodist Church, Ramsgate/ Methodist Hall/ Monkton/ Newington Free Church/ Osborne Road, Broadstairs/ Preachers' Knoll/ Primitive Methodist Chapel/ Pugin, Augustus/ Pugin, Edward Welby/ Pugin, Peter Paul/ Queen Street, Ramsgate/ Ramsgate/ Reculver/ Richborough/ Roman Catholic Church of our Lady/ Sailors' Church/ Sarre/ Shallows, the/ Shrine of Our Lady, Bradstowe/ Shuart/ St Andrew's Church, Reading Street/ St Augustine's Abbey/ St Christopher's Church Newington/ St Ethelbert & St Gertrude Church/ St George's Church, Ramsgate/ St Giles Church, Sarre/ St James' Church, Garlinge/ St John's Church/ St Laurence Church, Ramsgate/ St Luke's Church, Ramsgate/ St Mark's Church/ St Mary's Church, Minster/ St Mary's Church, Northdown/ St Mary's Church, Ramsgate/ St Mildred's Church, Acol/ St Mildred's Church, Westgate/ St Nicholas at Stonar Church/ St Nicholas-at-Wade Church/ St Paul's Church, Ramsgate/ St Peter's Baptist Church/ St Peter's Church/ St Peter's Footpath/ Stonar/ Synagogue/ United Reform Church, Birchington/ Weslyan Church, Westgate/ Wesleyan Methodist, Birchington

Sir Winston CHURCHILL
Born 30th November 1874
Died 24th January 1964

When, as prime minister, Winston Churchill visited the Ramsgate Tunnels in 1940, he was told by A B C Kempe that smoking was not allowed down there. Apparently, Churchill threw his cigar away saying *'there goes a goodun'*. If e-bay had existed then you could have bid for it the next day.
He had a dog named Margate.
SEE Kempe, A B C/ Margate/ Marsh, Sir Edward/ Prime Ministers/ Ramsgate/ Seven Stones/ Tunnels, Ramsgate

CHURCHILL TAVERN, Ramsgate
Originally the Isabella Baths (*'sea and freshwater bathing!'*) when it was built in 1816, it has in turn been the Paragon Hotel, the Van Gogh pub, Steptoes and is now The Churchill Tavern.
SEE Bathing/ Paragon/ Pubs/ Ramsgate

CINEMAS
In 1957 there were twelve cinemas in Thanet.
Broadstairs had the Odeon; Birchington had the Ritz; Westgate had the Carlton; Cliftonville had the Cameo; Margate had the Classic, Dreamland, and Plaza; Ramsgate had the King's Theatre, New Picture House, Odeon, Palace Theatre and the Ramsgate Picture House.
Ramsgate has had the Palace Cinema 1883; The Pav 1904; Kings Cinema 1910; Queens Cinema 1911; Marina Electric Theatre 1909; Star Cinema 1911; Ramsgate Picture House 1920; Odeon then Classic 1935; Granville Theatre.
SEE Astoria/ Bioscope/ Cameo/ Carlton/ Classic/ Dreamland/ Granville/ Kings/ Marina Theatre/ Odeon/ Plaza/ Queens/ Ramsgate/ Regal/ Riviera Gardens/ Star/ Windsor

CINQUE PORTS
From the Norman French for five ports, the original towns were Hastings, New Romney, Hythe, Dover, and Sandwich. In addition there were the 'antient towns' of Rye and Winchelsea as well as 'Limbs' of the main towns. Lydd was a Limb of New Romney; Tenterden was a Limb of Rye; Folkestone, Faversham, Gore End, Acol, St Peters and Margate were Limbs of Dover; and Deal, Stonar, Reculver, Sarre and Ramsgate were Limbs of Sandwich.
The Cinque Ports were formed for trade and military purposes. In return for supplying ships and men for the crown, they were given exemptions from taxes, and a blind eye was given to the area which meant that smuggling became rife.
In 1229 Margate became a limb of the Cinque Port of Dover even though it did not have a harbour until 1320.
SEE Acol/ Birchington/ Cobbs/ Crest & Motto/ Dane Park/ Gore End/ Granville Hotel/ Guildford, Earl of/ Jetty/ Jolly Sailor Inn/ Harbour/ Margate/ Obelisk/ Ramsgate/ Reculver/ Richmond Road/ St Augustine's Cross/ St George's Church/ St Peters/ Sarre/ Stonar/ Tomson & Wotton/ Wantsum Channel/ Wellington Hotel/ Yeomenry

CINQUE PORT ARMS HOTEL
Marine Terrace, Margate
The Cinque Port Arms, with ten rooms to let, dated back to the 1820s first at 39 Lower

Marine Terrace and then at 52-53 Marine Terrace - it didn't move but the street names changed. On one side there was a bathing house which, in the nineteenth century, was virtually next door to the Margate Sands Railway Station. The hotel was either named after the Cinque Ports or it was a jokey reference to the five doors that led to the five bars. Since 1996 it has been called the Punch and Judy.
SEE Bathing/ Cinque Ports/ Hotels/ Margate/ Margate Sands Railway Station/ Marine Terrace/ Oxford Hotel/ Punch & Judy pub

Duke of CLARENCE
Born 21st August 1765
Died 20th June 1837
The future King William IV was a regular visitor to Ramsgate. He apparently proposed marriage four times to a Miss Long of Ramsgate - she said 'no' four times.
Whilst Admiral of the British Fleet patrolling the Downs, he held a ball and supper to which 200 members of the nobility were invited in October 1811 at The Assembly Rooms in Ramsgate.
SEE Admirals/ Assembly Rooms, Ramsgate/ Downs, The/ Dyason's Royal Clarence Baths/ Fox, Rear Admiral/ Jordan, Mrs/ Ramsgate/ William IV

4th Earl of CLARENDON
Born 12th January 1800
Died 27th June 1870
He was plain old George William Frederick Villiers to his mum, but became the Foreign Secretary under Palmerston, Russell and Gladstone.
SEE Clarendon Road/ Gladstone

CLARENDON GARDENS, Ramsgate
Before this street was built, the area was known as Spurgeon's Field because it was owned by a butcher by the name of - go on, have a guess. Yes! Mr Spurgeon. You can pick any prize off the top shelf.
SEE Clarendon, 4th Earl of

CLARENDON HOUSE SCHOOL
Elms Avenue, Ramsgate
It was built in what used to be the garden of Rear Admiral William Fox's house which was situated in Effingham Street.
SEE Clarendon, 4th Earl of/ Effingham Street/ Elms Avenue/ Fox, Rear Admiral William/ Ramsgate/ Ramsgate County School/ Schools

CLARENDON ROAD, Broadstairs
On 1st March 1916 a German FF29 attacked Thanet, crashed into the sea and was subsequently picked up by the French. In Clarendon Road one of its bombs cut through a chain that was keeping a dog to its kennel, enabling the dog to escape. Do you think it was a German Shepherd? (What's the matter with that?)
SEE Broadstairs/ Clarendon, 4th Earl of/ Gladstone Road/ Grosvenor Road/ King Edward Avenue/ Norfolk Road/ Percy Avenue

CLARENDON ROAD, Cliftonville
At 3 Clarendon Villas, there was, at the end of the nineteenth century, a small boarding school for girls.
SEE Clarendon, 4th Earl of/ Cliftonville/ Schools

CLAREMONT MILL, Broadstairs
SEE Broadstairs/ Pierremont Mill/ Clarendon, 4th Earl of

CLARKS SHOES
When Clark's shoes ran their 'Life is Just One Big Catwalk' campaign in 2004, slogans included 'Preston is My Paris', 'Norwich is My New York' and 'Margate is My Milan'. I do not know if a reciprocal campaign was ever run in Italy!
SEE Margate

The CLASH
Classic punk band. 'Wild man of Ramsgate' is a track on their 'Maximum Clash' album.
SEE Music/ Ramsgate

CLASSIC CINEMA
King Street, Ramsgate
Wallis's Farm stood here for half a century, and then, from 1793 onwards, the Fowler family operated a coach house and stables from here using a stagecoach called Royal Sovereign, driven from the seafront to London everyday by Mr Wattson and his two sons. Fowler's also had a 'fish run' where the local catches were nipped up to the capital in a fast, light carriage pulled by two horses.
The last cinema to be built in Ramsgate was built on this site and opened in September 1936 as the Odeon. Odeons were so named by the owner, Oscar Deutsch (1893-1941), partly because his initials formed part of the word and partly because 'odeion' is Greek for a building that presents musical performances.
In May 1954, it was discovered that Benjamin Trowse, the doorman at the Odeon Cinema, held both the Distinguished Service Medal and the Imperial Service Order.
After many alterations in the 1970s the upstairs became the Classic Cinema and the downstairs a bingo hall, only to be turned back into a cinema a few years later. The Classic was sold in August 1987 to be demolished and replaced with Iceland, a frozen food store, at 20 King Street, in 1990.
SEE Cinemas/ Farms/ King Street, Ramsgate/ Odeon/ Ramsgate

CLEOPATRA'S NEEDLE, London
Nothing to do with Thanet I know but I'm going to tell you about it anyway. Erasmus Wilson has a strong connection with Thanet through the Royal Sea Bathing Hospital and part of his earlier curriculum vitae included bringing Cleopatra's Needle to London. It was made originally in 1460BC, or 1475BC, or 1500BC (different sources, different dates) for Pharaoh Thotmes (or Thutmose) III in Heliopolis, and later was transferred to Alexandria, Cleopatra's royal city. That is the only connection to Cleopatra that the needle has, but the marketing men could not have sold the name of Thotmes's needle nearly as well!
It had lain buried in the sand of the desert for centuries before it was found on 29th January 1801. Mohammed Ali (no, not that one) presented it to Britain in 1819 as a memorial to Nelson and Abercromby. In 1878, the

public, or the government - you choose - wanted something tangible to celebrate our victory over Napoleon some 63 years earlier. So, obviously, a 68ft 6in Egyptian obelisk given to the nation nearly 60 years earlier was everyone's first choice. The public were duly tapped up for, or they subscribed – again, your choice - £15,000 to pay for it and Erasmus apparently wrote out a cheque for a good deal more, in fact for £10,000, to pay for the transportation costs. The obvious problem was getting all 180 tons of it here. No Eurotunnel then, so a slow-moving lorry with an 'abnormal load' sign on the back of it going across Europe's motorways was a non-starter. A special cigar-shaped metal container ship, 93ft x 15ft, called The Cleopatra, was built at a cost of around £10,000 (paid for by Erasmus, and designed by John Dixon) to contain the obelisk which would then be towed by another ship, The Olga. Everything went fine until they reached the Bay of Biscay, off the coast of France, when, during a huge storm and concerned for their safety, the captain of The Olga asked for six volunteers to row to the Cleopatra and take off it's crew of five. The volunteers all drowned and The Olga managed to come alongside and rescue Cleopatra's crew. They set the Cleopatra adrift but she sank, taking The Olga down with her. It was another five days, before the Cleopatra was discovered floating off the north coast of Spain. Another ship, The Anglia, was then sent out to tow her in, and in January 1878 huge crowds watched as it sailed up the Thames accompanied by an artillery salute. In September 1878 the needle was winched into position, where it can still be seen close to Embankment tube station and Waterloo Bridge. The names of the crew members who drowned are commemorated on a plaque on the plinth. The Cleopatra was sold for scrap.
SEE London/ Royal Sea Bathing Hospital/ Wilson, Sir Erasmus

CLEVE COURT, near Minster
Cleve Court is a part Tudor, part Elizabethan house built, because of the spectacular views of the surrounding countryside, upon King Williams Mount between Minster and Acol. Over the years it has had some famous and infamous residents.

Cleve Court Estate, near Minster
a Valuable Freehold Property known as CLEVE COURT including a Most Attractive Residence. . . beautiful Pleasure Gardens and Grounds. . . also Two very valuable farms known as CLEVE COURT and ACOL FARMS, together with several cottages and accommodation land covering a total of about 310 acres.
Messrs. Daniel Smith, Oakley & Garrard will offer the above Properties for Sale by Auction at the Royal Fountain Hotel, Canterbury, on Saturday, 29th May, 1920.
Lord and Lady Carson heard footsteps and other strange noises in the house. Somebody tapped on their bedroom door when they were alone in the house and a guest heard drawers opening and closing in the room

above her, even though she was actually on the top floor. Lord Carson put it all down to the house settling, as houses do, but Lady Carson believed in a more paranormal explanation. When he was aged 5, Edward, their son, informed his mum that he did not like the lady that walked outside his bedroom at night. At a later date, the Carson's 4 year-old niece stayed in the same room as her cousin and told Lady Carson about a lady who not only stood by her bed, but was in the corner of the room as they were speaking. The child got angry when Lady Carson could not see the woman herself. Another child saw the Grey Lady, as she became known, a few years later in the bedroom and the drawing room, and was concerned that no-one would tell her who she was. No adult had seen anything, but the family dogs were reluctant to go in the bedroom. The first adult to see the Grey Lady was Edward junior's wife in 1949. One night she had a bath, after everyone else had gone to bed, and when she left the bathroom she heard the footsteps of someone coming towards her down the corridor and then passing by her. Months later, in the middle of the night, her dog needed to go out. As she walked through the Georgian part of the house she accidentally knocked the light switch, turning the light off. As there was enough light to see by she left it off, and continued down stairs. At the bottom the dog refused to go any further so Lady Carson put the light back on, and saw a young woman in a grey skirt and cape with a white ribbon in her hair come down the stairs and turn into the Elizabethan part of the house. The air was freezing cold and she admitted to being scared stiff – or whatever word ladies used in those circumstances. The story was picked up by the newspapers and that December someone calling themselves 'EC' wrote to The Times saying she had worked there as an under-housemaid when she was 15 and had been preparing a bedroom as a nursery for the arrival of a guest's child when she unexpectedly saw the Grey Lady in the room. She went to leave but the ghost waved to her to carry on. There is a theory that the Grey Lady is the ghost of Farrer's wife, a previous resident.
SEE Acol/ Callis Court/ Carson, Lord/ Farms/ Farrer, Josias Fuller/ Minster/ Orczy, Baroness

CLIFF HOUSE, Ramsgate
In the middle of the nineteenth century, Messrs Sacketts and Fuller's Marine Library and music warehouse did exactly what it said on the tin, plus a bit more. There were evening promenade concerts and a boarding house over the top of the library that had a good view of the sea and the lovely gardens of the villa belonging to Sir William Curtis. Part of Cliff House managed to survive until 1973 as Ramsgate's Courthouse.
SEE Boarding houses/ Curtis, Sir William/ Libraries/ Ramsgate

CLIFF RAILWAY, Broadstairs
Built by the Waygood Company Ltd in 1910, it had a single passenger car that could transport up to 12 passengers along a 5 feet 3

inch wide track up a 45 degree tunnel from the beach to the back garden of 14 Albion Street. The counterweight travelled in a separate brick-lined tunnel. Waygoods ran the service through a subsidiary company, Cliff Lifts Ltd, until the lease was purchased by a Mrs Wilson of Broadstairs in the 1920s. She was the first of around half a dozen leaseholders until the Broadstairs Hotel and Guesthouse Association formed the Broadstairs Lift Company and took it over in 1977. They took this step because they saw the Railway as an important local attraction and were afraid of its imminent closure. They managed to keep it in operation for 14 years despite many periods of closure for essential maintenance and repair. The local council had to help with grants and the railway never made a profit or broke even. Just when a major restoration looked likely, a massive thunderstorm in 1991 caused yet more damage to both the structure and the electrical equipment. Efforts have been made to raise funds to restore it to its former glory but it still remains closed.

SEE Broadstairs/ Lifts

CLIFF STREET, Ramsgate
Mr Austen of the local Austen's Brewery died when he fell over the cliffs here in 1840. The cliffs were subsequently fenced off to avoid another tragedy.
SEE Breweries/ Marine library/ Obelisk/ Ramsgate/ WVS

CLIFFS - Ramsgate
Ramsgate's East Cliff and West Cliff were called North Cliff and South Cliff respectively until the eighteenth century.
SEE Ramsgate

CLIFFS END HALL, Cliffsend
The history of the old hall can be traced back to before the Dissolution of the Monasteries, but we join the story in 1750 when James Petley bought the old manor house/farm house and farmed the extensive lands.
The Petley family sold the property to Colonel Whitehead for £4,000 which, together with land he bought from Earl Granville, gave him a luxurious country house in 27 acres.
In subsequent years, Cliffs End Hall, as it had become known, was owned by Miss Derry, of the famous Kensington department store, Derry and Toms. She planted up the gardens with trees from all over the world. In 1921 Colonel Sceales and his wife bought it, created a lake and sunken garden and opened the gardens to the public. Mrs

Sceales bred St Bernard dogs that won prizes at Crufts.
During World War II servicemen were billeted here. The son of the family was killed in Italy in 1945 and Cliffs End Hall never returned to its pre-war glory.
'Cliffsend Hall, which for at least 400 years has been Thanet's most elegant home has finally caught the eye of the planners and developers.'
In the 1970s the lake was filled in and most of the trees uprooted as houses were built. Just the Gardener's Lodge and the Cottington Road entrance survived.
Over the years many of the rich and famous visited here, most notably Haile Selassie.
SEE Derry & Toms/ Farms/ Haile Selassie/ Ramsgate/ World War II

CLIFTON ARMS public house
Clifton Street, Cliftonville
The Clifton Arms was established around 1830 as a beer shop in the parlour of a terraced house. In 1845 it became a pub. It had a landlord in the 1880s who doubled as a stonemason. A games room was later built on what had been a beer garden.
SEE Cliftonville/ Pubs

CLIFTON BATHS, Cliftonville
Clifton Baths had a wooden drill hall that advertised films as early as 19th October 1910; first as the Electric Cinema and then the Clifton Cinema. It also held concerts by military bands and, unusually for the times, you could read news agent wires on the stereoscopic daylight screen.
'The only theatre in Thanet using the stereoscopic screen, assuring steadiness and brilliancy' 1912
'A fine new sunbrite screen, the largest and brightest pictures in town' 1920
With the advent of talkies it was thought uneconomical to convert to sound and it closed in 1929.
By 1936 the Clifton Baths consisted of The Basque Café, The Bathing Pool, The Cliff Bar, Cliff Café, Clifton Baths (Margate) Ltd swimming baths, Clifton Concert Hall, The French Bar, The Jolly Tar Tavern and The Normandie Café. There was also a cinema, a funicular cliff railway and a Joywheel ride.
SEE Bathing/ Cliftonville/ Lido

CLIFTONVILLE
There is a school of thought that says Cliftonville is named after the Cliftonville Hotel, not the other way around, and that the hotel was named after Clifton Road with a poncey foreign sounding 'ville' added to the end. I don't know what came first, but then I've always had trouble with the chicken and the egg. Another school of thought says that it may have been named after Clifton, the then very fashionable area of Bristol. Basically, if you see a theory you like, feel free to take it.
As Margate's popularity with Londoners increased, it got correspondingly noisier and raucous. A more genteel resort was therefore needed and Cliftonville expanded from Ethelbert Road to Harold Road. Guest houses

of a high standard were built in streets set at right angles to the sea front. Promenades and sea walls were built as well as first class hotels and bandstands. At this time, mixed bathing was a very definite no-no and a bell was rung to tell men to get out of the sea when the ladies were approaching for their dip. Strangely, sales of telescopes were high. The large lawns in front of the hotels on the cliff top were the social centre of the area. It was the place to see and be seen. Men wore hat, collar and tie, jacket and waistcoat (alright, trousers as well) – whatever the weather. If it was hot they wore a straw hat - you know how that can cool you down. Women would arrive with 40 to 60 dresses for the Cliftonville season. A day-tripper would wear their Sunday best - just like today!

SEE Accomodation/ Albion Road/ Arthur Road/ Arundel Road/ Astoria Cinema/ Athelstan Road/ Bathing/ Belle Vue Tavern/ Bobby's Department Store/ Butlins/ Cameo Cinema/ Clarendon Road/ Clifton Arms/ Clifton Baths/ Dalby Square/ Dane Valley Arms/ Dearden's Picture Gallery/ East Cliff Hotel/ Eastern Esplanade/ Edgar Road/ Eliot, TS/ Endcliffe Hotel/ Ethelbert Road/ Ethelbert Terrace/ Foreness Point/ Frank's/ Fuller, Leslie/ Godwin Road/ Good Intent pub/ Gordon Road/ Gouger's windmills/ Grand Hotel/ Hades/ Harold Road/ Hartsdown Park/ Hodges' Flagstaff/ Honiton House/ Hooper's Hill House/ Howard, Trevor/ Ice Cream/ King Edward VII pub/ Laleham School/ Lewis Crescent/ Lido/ Lovelys/ 'Margate 1940'/ Margate Caves/ MFI/ Munro Cobb/ Newgate Gap/ Norfolk Hotel/ Norfolk Road/ Northdown pub/ Northdown Ale/ Northdown House/ Northdown Park/ Northdown Road/ Northumberland Road/ Oval, The/ Padgets/ Palm Bay/ Palm Bay Primary School/ Parakeets/ Peel, Sir Robert/ Pettman, Thomas/ Price, Dr/ Princes Gardens/ Princes Walk/ Queen's Highcliffe Hotel/ Queens Promenade/ Riviera Gardens/ Rowe, AW/ St George's Hotel/ St George's Lawns/ St Paul's Road/ Sea View Terrace/ Sir Francis Drake pub/ Spall, Timothy/ Suffragettes/ Sunbeam Photos/ Surrey Road/ Sweyn Road/ Takaloo/ Tom Thumb Theatre/ VAD Hospitals/ W H Smith/ Walpole Bay/ Walpole Bay Hotel/ Warwick Road/ Wheatley, Dennis/ Wilderness Hill/ Ye Olde Charles pub/ Zion Place

CLIFTONVILLE AVENUE, Ramsgate
Although this avenue appears on a 1907 map very little housing had yet developed.
SEE Ramsgate

CLIFTONVILLE HOTEL, Cliftonville
Luxurious and impressive hotels were built as Cliftonville developed in the 1860s including the Cliftonville Hotel, the Grand Hotel, the Queens and the Highcliffe Hotel. First was The Cliftonville Hotel built in 1867/8 in Ethelbert Crescent and Dalby Square - and a pretty swish place it was in its day. At that time it was surrounded by corn fields. Not only were plush rooms available for the affluent guests but another section of the hotel was set aside to accommodate their servants. Even their carriages were given a garage for their stay. At the front of the hotel was a large ornamental lawn with statues and a croquet lawn. Near the entrance was a palm court where an orchestra played to entertain the guests when the weather was bad.

'The Cliftonville Hotel is the largest hotel in the town of Margate. . . The entire area occupied by the Hotel, steam laundry, stabling and house for the servants is about six acres. It has 300 rooms including a Grand Dining Room, a Drawing Room, a Reading Room, a Billiard Room. . . Sitting rooms with private balconies overlooking the sea with Bedrooms en suite, seven Bath Rooms and every modern Convenience. The sanitary arrangements are perfect. . . The rooms are all lofty, spacious and healthy, and most of them command a view of the sea and grounds belonging to the Hotel. . . BOARD TERMS: HALF-A-GUINEA PER DAY including a 3s Bedroom, Attendance and full board' Guide to the Isle of Thanet and a Souvenir of The Cliftonville Hotel (Margate, 1890-91)

So sumptuous was it, that, in 1906, it was stated that, 'Lords and Ladies visiting here might fancy themselves at Cannes'.

World War II left the building without proper maintenance for six years and this, along with the changing demand for this old-style accommodation, led to it being converted into apartments.

There was a major fire here on 4th March 1952 which needed seventy men and their engines from Canterbury, Folkestone and Maidstone. Sixty-three residents of the apartments there were evacuated to Greylands Hotel.

In 1956, the building was demolished.

The site is now largely occupied by a bowling alley and nightclub that originally opened in February 1963.

It was replaced by a pub known, in turn, as The Bowler's Arms, the Sir Francis Drake and Thorley's Tavern which opened in 1982 and held a disco each evening in the 1930s art-deco style lounge.
SEE Dalby Square/ Fires/ Garages/ Hotels

CLOCK HOUSE
Ramsgate Harbour

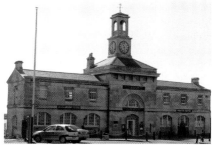

In 1805 the engineer to the harbour, Samuel Wyatt, was given the job of coming up with a plan for a watchhouse and a clock house to be situated in the harbour where it would give the best view over the harbour. By 1809 Wyatt's successor, John Rennie, modified the design to create storerooms and added a top floor. The cellars were used to deposit resin, pitch tar and so on. Eventually the clock house was completed on 28th July 1817.

The turret clock was replaced in 1848, by an eight-day tunnel clock that had four gas illuminated, 5ft diameter dials. The clock struck on the hour and the quarter hours. The mechanism was in the same room as the 4.5

metre-long brass meridian line which had been established in 1819 and set in the floor running north-south. On Monday 18th November 1822, John Woodward, the harbour master, changed his journal from nautical time to Ramsgate meantime which continued until 1st November 1848 when Greenwich Meantime was adopted.
SEE Harbour, Ramsgate/ Ramsgate

CLOCK TOWER, Margate

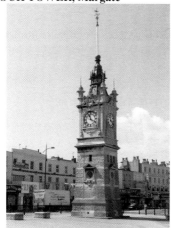

Probably Margate's best known landmark, it was built in 1887 to commemorate Queen Victoria's Golden Jubilee and was handed over to Margate Corporation on 24th May 1889. The clock came from Potts of Leeds and originally had 5 hemispherical bells that were replaced in 1908 by Gillett & Johnson when they overhauled the clock.

In 1975 the clock tower was one of only two buildings in Thanet to appear in a list of seventy-five buildings of special excellence in Kent as part of European Architectural Heritage Year. The other was the farmhouse and barns at Sevenscore, Minster-in-Thanet.
SEE Farms/ Margate/ Minster/ Victoria

Edward CLODD
Born 1840
Died 1930
His father was the captain of a brig that traded between the north and Margate. Edward Clodd lived the very early part of his life in Queen Street, Margate, until his family moved to Suffolk when he was still a young child. He educated himself in science and religion by attending lectures and using free libraries. He was an agnostic, anthropologist and a banker joining the London Joint Stock Bank as a clerk in 1872, but worked his way up until he became secretary, finally retiring in 1915.

He was a great admirer of Darwin and went on to write 'The Story of Creation' (1888), 'Jesus of Nazareth', and 'The Childhood of the World' – most of his work is still in print. Whilst living at Aldeburgh in Suffolk, Leslie Stephen (English critic, biographer and philosopher – and Virginia Woolf's dad!), T H Huxley (British biologist, and a staunch supporter of Darwin), and Thomas Hardy (who wrote a few novels, apparently) were regular visitors. His circle of friends was a remarkable one, as it included most of the more liberal-minded religious thinkers of the age. He was a great one for clubs and

societies, joining the Century Club (1877), the Folk-Lore Society (1878) and helped to found the Johnson Club (1884), and the Omar Khayyám Club (1892).
SEE Hardy, Thomas/ Margate/ Pair of Blue Eyes

COAL
In 1957 there were 18 coal and coke merchants listed in Thanet. In 2005 there were none.
SEE Butchers/ Dairy Farms/ Greengrocers/ Grocers/ Ice Cream/ Thanet

COASTGUARD STATION - Ebbsfleet
There was a Coastguard Station listed at Ebbsfleet in 1936.
SEE Ebbsfleet

COASTGUARD STATION
Victoria Parade, Ramsgate

The Ramsgate Coastguard service was established near Augusta Steps in 1817 just one year after the service was established elsewhere in the country. When the railway station was built below the cliffs in 1863 it made sense to move the station to Victoria Parade where it can be seen today. On Friday 11th February 1881, Prince Alfred, the Duke of Edinburgh, visited and presented medals to the coxswain and crew of the lifeboat for their part in the rescue of the crew of the Indian Chief. After over a century of service, Ramsgate lost its East Cliff coastguards in November 1955.
SEE Railway/ Ramsgate/ Victoria Parade

COASTGUARDS
SEE Coastguard Station, Ebbsfleet/ Coastguard Station, Ramsgate/ Dane Park/ Epple Bay/ Epple road/ Fig Tree Inn/ Friend to All Nations/ Hartsdown/ Hood, Thomas/ Kingsgate/ Minnis Bay & Gore Rnd/ Minnis coastguard cottages/ Minnis Road/ Northern Belle/ Pegwell Bay/ Pier, Margate/ Plum Pudding Island/ Smuggling/ United Reform Church/ Westgate-on-Sea

COASTLINE
Thanet has 17 beaches and bays along 26 miles of coastline.
SEE Bays/ Thanet

William COBBETT
Born 9th March 1763, Farnham
Died 18th June 1855
The man who took his famous series of 'Rural Rides' in the 1820s was taught to read by his innkeeper father (who was also a farmer). He worked as a farm labourer until, in 1783, he went to London and got a job as a clerk. The following year he joined the Army and became a corporal. When he was in Canada with his regiment, he realised that the quartermaster was stealing army funds but when the recently married Cobbett brought the matter to light he was accused of being a troublemaker. He and his wife ran off to France and after seven months he ended up teaching English to French refugees in the

USA. Whilst there, a visit from the scientist and radical, Joseph Priestley, started Cobbett's writing career. Convinced that Priestley was a traitor, Cobbett wrote the first of twelve diatribes against the American democracy over the next twelve years. After having to pay a large fine in a libel case, the man who had been nicknamed Peter Porcupine returned to England in 1799.
In 1802, Cobbett started his newspaper the 'Political Register' and over the next few years his opinions became more radical especially so when he criticised the use of German troops to quell a mutiny in Ely. The government tried him for sedition and sentenced him to two years in Newgate prison.
In 1815 a heavy tax duty of 4d per paper was imposed on newspapers resulting in only the well-off being able to afford the cover price of 6 or 7d. Cobbett was just about managing to sell 1,000 copies a week of his 'Political Register'. In a very ingenious move, he, in modern parlance, re-branded his publication as a pamphlet, thus avoiding the tax duty. As a result he began selling 40,000 copies a week at 2d a copy, and the 'Political Register' became the main read of the working class. This success, once again, made Cobbett unpopular with the government and after the rumblings of a further charge of sedition grew deafening, Cobbett, not wanting to return to Newgate, instead returned to America.
He lived on a Long Island farm and wrote 'Grammar of the English Language' managing to continue publishing the 'Political Register' with help from his friend William Benbow in London. Following the Peterloo Massacre, Cobbett returned to England, joined up with other Radicals, and over the following two years his attacks on the government caused him to be charged with libel three times.
In 1821, by now in his fifties, Cobbett began his rides on horseback across southern England to glean information for a series of articles on the state of rural England for 'Cobbett's Weekly Political Register' (it came out in book form in 1830). The period following the Napoleonic Wars was a bad time for the agricultural labourer who not only had to put up with sudden changes in the price of wheat, but also landowners who were either dishonest, inept, or both. Combine this with starvation wages and crippling taxes and you can understand why Cobbett was very sympathetic to the labourer's position. He arrived in East Kent in September 1823 and although he was very taken by the fertility of the land, he could not bear to enter Margate because he said that it epitomised everything that was wrong with the agricultural economy.
'When I got upon the corn land in the Isle of Thanet, I got into a garden indeed. There is hardly any fallow; comparatively few turnips. It is a country of corn. . .
I left Ramsgate to my right about three miles, and went across the island to Margate; but that place is so thickly settled with stock-jobbing cuckolds, at this time of

year, that, having no fancy to get their horns stuck into me, I turned away to my left when I got within about half a mile of the town. . .
All was corn around me. Barns, I should think, two hundred feet long; ricks of enormous size and most numerous . . .
As he left Thanet he saw a sign that read, *'Paradise Place. Spring guns and steel traps are set here.'*
In 1831 he wrote an article in support of the Captain Swing Riots and promptly got charged with seditious libel. At the trial he so successfully conducted his own defence that the jury found him not guilty.
In an attempt to change things from within, he tried again to become an MP, having tried unsuccessfully to become MP for Honiton twenty years earlier. He lost in Preston (1826) and Manchester (1832), but following the Reform Act of 1832 he won the seat in Oldham at the age of 69. Once in Parliament, he spent most of his time attacking corruption within the government, and the workings of 1834 Poor Law, but he did not find the routines and nocturnal workings of Parliament easy.
He is a chained house-dog who falls with equal fury on every one whom he does not know, often bites the best friend of the house, barks incessantly, and just because of this incessantness of his barking cannot get listened to, even when he barks at an actual thief. Therefore the distinguished thieves who plunder England do not think it necessary to throw the growling Cobbett a bone to stop his mouth. This makes the dog furiously savage, and he shows all his hungry teeth. Poor old Cobbett! England's watch-dog!
Heinrich Heine (1797-1856)
William Cobbett died of influenza on 18th June 1835.
This place [Cheltenham] *appears to be the residence of an assemblage of tax-eaters. These vermin shift about between London, Cheltenham, Bath, Bognor, Brighton, Tunbridge, Ramsgate, Margate, Worthing, and other spots in England.* Rural Rides, 1821, by William Cobbett
SEE Authors/ Captain Swing/ Crown & Sceptre/ Acol/ Farms/ Keble, TH/ Margate/ Napoleonic Wars/ Peterloo/ Politics/ Ramsgate

COBBS BANK and BREWERY, Margate
Francis Cobb (1727-1802) was the founder of Cobbs Bank and the first of three generations to oversee this bank and the Cobbs empire, for it encompassed more than just banking. Francis was succeeded by Francis Cobb (1759-1831), his youngest son, and he by Francis William Cobb (1787-1871).
The savings bank was in existence from 1818-1827 and 1839-1863, but between them the Cobbs held many positions in Margate and could be said to have laid the foundations for the town's later prosperity. At one point their bank was said to be trusted more than the Bank of England. But they were more than just bankers. They owned ships and were shipping agents; they were coal merchants and chandlers, sold insurance and were experts on salvage. They also

owned a brewery and had various public houses. The troops at the Battle of Waterloo drank beer from the Cobbs Brewery.

The Cobbs also held various positions of note and were involved in various philanthropic and charitable actions. One or more of them represented Thanet for the Cinque Ports, held Vice-Consulships to many countries, was the Commander of the Local Volunteers and Sea Fencibles, and held the position of town constable, deputy mayor, magistrate, pier warden, coroner, and pavement commissioner!

They were churchmen, involved in the founding of the Royal Sea Bathing Hospital, and were largely responsible for replacing the pier after the previous one was destroyed in 1808.

A blue plaque now commemorates that Francis Cobb brewer, banker and *'King of Margate'* lived at 23 King Street, Margate. Numbers 29 and 31 King Street were once the offices of Cobbs brewery, and one of them bears the date 1683.

SEE Blue plaques/ Breweries/ Cinque Ports/ Hawley Square/ Hodges' flagstaff/ Jetty/ King Street, Margate/ Margate/ 'Misadventures at Margate'/ Pubs/ Red Lion, Stonar/ Rodney

Admiral Thomas COCHRANE
10th Earl of Dundonald,
Born Lanarkshire 14th December 1775
Died 13th October 1860
The son of Lord Archibald Cochrane and Anne Gilchrist, he had a remarkable career.
It anyone is looking around for an idea for a film, then consider this man's story - and consider my finder's fee as well!

During the Napoleonic Wars, he served with distinction in the Royal Navy. In his first command as Lieutenant of the sloop, Speedy, which had a crew of 92 and carried 14 four-pounder guns, he captured fifty ships, 535 prisoners and 122 guns. This haul also included the capture on 6th May 1801 of the Spanish 32-gun frigate, El Gamo. He cheated by hoisting the American flag to confuse them so that he could get close enough, and then fired on the unsuspecting Spaniards. Finally, the Spanish fired a broadside but missed. Cochrane returned fire, killing the Spanish captain. Cochrane left his surgeon on board Speedy, and the remaining 91 crew members stormed the El Gamo. They pulled down the Spanish colours and the 319-strong Spanish crew surrendered to them. Cochrane was soon promoted; well you would hope so wouldn't you?

As Post-Captain he commanded the frigate, Pallas, and then the Imperieuse and was such a pest to Napoleon along the French and Spanish coasts that he referred to Cochrane as the Sea Wolf.

He also became an MP in 1806 how did he find the time?

In 1808 he attacked Valencia and captured a few ships - as you do - one of them American – stop cheering. Now almost forgotten, the Battle of Basque Roads in 1809 could have been remembered with the same reverence as the Battle of Trafalgar. Cochrane used explosive vessels and fire-ships to cause panic in the French squadron who, just to add to their woes, ran aground. Stop smirking. With the fleet just waiting to be destroyed, all Cochrane's Commander-in-Chief, Admiral Lord Gambier, had to do, was to send in the rest of the English fleet and the work was done; but he dithered and the opportunity was lost. Incensed, Cochrane refused to support a motion of thanks to Gambier in the House of Commons, so Gambier insisted on a court martial to clear his name. Can you hear toys being thrown from the pram? You will not be surprised to hear, that the establishment closed ranks around Gambier who was acquitted. The knives began to be turned upon Cochrane. In 1812, Cochrane presented a novel plan for gas warfare to the Admiralty which, although technically achievable, was thought to be inhuman. I may have to be with the Admiralty on this one.

Cochrane's enemies in the establishment were powerful and numerous and his campaign to eradicate much of the corruption in the Navy, whilst necessary, was not increasing the number of Christmas card lists that he was on. In 1814 he was charged with stock exchange fraud and after a dodgy trial was dismissed from Parliament and the Navy and sent to prison. The next year however, he escaped! (Actually, forget the film, we may need a mini-series.) He was soon released but on the outside came under immense pressure, both political and financial, such that he soon thought 'blow this for a game of sailors' and in 1817, left the country.

So there he was, aged 42, at the employment agency, discussing his options for a future career with an adviser half his age. 'Apart from winning sea battles, what other work skills do you have? What courses have you been on? Would you consider re-training? What about working in a DIY store?' - Alright, what actually happened was that he worked for the Chilean Navy. In 1820 with just 300 Chilean troops he captured the Spanish fortress of Valdivia, and destroyed the Esmerelda, the flagship of Spain's South American fleet while it was in the port of Callo.

He then went on to work his magic with the emergent Brazilian Navy with whom he captured the Portuguese garrison at Bahia, and forced the fortress at Maranhao to surrender to him.

Like today's football managers, he swiftly moved his allegiances on again to a different country to work for the Greek Navy.

With a new king, William IV, and a new government, Whig, he was reinstated to the Royal Navy in 1832 where he remained until he became Commander-in-Chief of the North American and West Indies Station in 1847. Such was his reputation for coastal warfare, that the government openly discussed using Cochrane in the Crimean War (1953-56). The Russians spotted that this was a direct threat to their coastal port of St Petersburg. Even in his late 70s he could make countries afraid without even doing anything!

He died in 1860 aged 85 and was buried in Westminster Abbey.

Locally, Dundonald Road, Broadstairs, is named after him.
SEE Admirals/ Belvedere House/ Broadstairs/ Napoleonic Wars/ Russia/ William IV

COCK FIGHTING
I know, it is wrong, on so many levels, today, but in the nineteenth century, if pay-per-view channels had been available, then two male chickens fighting would have been over subscribed.
SEE Rumfields Road

COCKNEY RHYMING SLANG
Both 'Ramsgate sands' and 'Margate sands' were Cockney rhyming slang for 'hands' in the early part of the twentieth century.
Ambrose Bierce 'The Devil's Dictionary':
Hand: a singular instrument worn at the end of a human arm and commonly thrust into somebody's pocket.
SEE Margate/ Ramsgate

Sir Christopher COCKERELL
Born 4th June 1910
Died 1st June 1999
Sir Christopher Cockerell CBE was made an honorary freeman of the Borough of Ramsgate on 6th April 1971 in recognition of his invention of the hovercraft.
SEE Hovercraft/ Ramsgate

CODRINGTON ROAD, Ramsgate
The even-numbered houses, up to number 20, are thought to have been designed by Edward Pugin, and built around 1869.
SEE Pugin, Edward/ Ramsgate

The COFFEE POT
Margate Road, Ramsgate
This was a windmill; two more windmills stood near to where Hudsons Mill stands today.
SEE Margate Road/ Ramsgate/ Windmills

COKE RIOT, Ramsgate
No, it has nothing to do with changing the recipe of a fizzy drink. It was about the hard residue that is left after coal has been distilled, and used as fuel.
In August 1920, with World War I only over by 20 months or so, Ramsgate Corporation decided to sell around 1,000 tons of locally produced coke to Denmark. The problem was that they gave the job to two German ships. A huge police presence was needed at Ramsgate Harbour to keep a large and angry crowd from preventing the loading of the cargo and extra police were brought in from London. The riot actually started in Hardres Street. One officer suffered from concussion, and another was stabbed in the neck by a woman with her hat pin. Six men and one woman were subsequently jailed.
SEE Denmark/ Harbour, Ramsgate/ Police/ Ramsgate

COLD HARBOUR, Margate
This was an area between the Fort Arcade and the Hotel Metropole. At times of crisis local troops mustered here.
SEE Margate/ Metropole

COLEMAN'S SCHOOL, Margate

The artist, J M W Turner (1775-1851), attended Thomas Coleman's School on the corner of Love Lane and Hawley Street, Margate, from 1785 to 1788. The building has long since been demolished but a blue plaque commemorating Turner's schooling can be found on the building that sits on the school's old site.

SEE Hawley Street/ Love Lane/ Margate/ Schools/ Turner, J M W

COLEMAN'S STAIRS ROAD
Birchington

Originally, this, and Albion Road, was just a track that led to the sea. The Coleman family lived in a farmhouse – now The Smugglers – and farmed land in this area, as did Mr A Richard Wilson in the 1800s hence, another former name, Wilson's Road. It was also called Pig Lane but you can come up with the reason for that yourself.

SEE Birchington/ Farms/ Smugglers, The

Samuel Taylor COLERIDGE
Born Ottery St. Mary, 21st October 1772
Died 25th July 1834

Although his birthday was 21st October he always celebrated it the day before - and I bet he opened his Christmas presents early too; I hate that.

His father, John Coleridge, was a minister and his mother, Ann Bowden Coleridge, had already borne nine children before Samuel turned up. He was always called Col, or Coleridge, and in later life he generally signed his works 'S.T.C.' or 'Estese', although his wife did call him Samuel - and a few other things I expect.

What do you do when you are seven years old, the youngest of ten kids, and the butt of the taunts of the next youngest in the family, Frank? Well, you run away from home, but Col, unfortunately for him, was found by a neighbour the next day and brought back.

When, at age 9, his father died, Col was sent to a charity school for children of the clergy in London, staying with his uncle John – his mum's brother – whom Col accompanied to the local taverns. While John got drunk, Col was involved in the debates in the bar. The boy, who was devouring books, was well versed in many subjects and was regarded as a bit of a prodigy by the drinkers. I don't know how often he got his round in though.

He had to deal with more grief when, in 1790, his brother Luke died, followed the next year by his sister Ann prompting Col to write one of his first poems in which he likens himself to Thomas Chatterton, a starving poet who committed suicide aged 17. Grief counselling was some way off back then.

By the time he went to Cambridge on a scholarship in 1791 his addiction to laudanum had begun. Although he originally took laudanum to combat illness, it did not take long before he was addicted to opium, alcohol and women, and was £150 in debt - but at least he had no student loan to worry about. So - and here is a novel idea for getting out of trouble - he joined the army as

Silas Tomkyn Comberbache (now, you would have thought that the recruiting officer would have guessed it was a made up name, but no), and it was only his inability to ride a horse that stopped him from being sent straight to France to fight. When his family found out they were far from happy, and not just because of the stupid name, but maybe it was not that stupid after all as it enabled his brother to get him out of the army on the grounds of insanity. Perhaps his original plan to apprentice himself to a shoemaker was a good one after all.

Back at Cambridge, he became friends with Robert Southey and together they had 'Pantisocracy', their own Utopian-style anti-monarchy society (their toast to the King was 'May he be the last.') that involved their moving to America.

Robert was engaged to Edith Fricker and introduced Col to Edith's sister, Sara Flicker (now there is a name that lends itself to romantic poetry). Col did not hang around; within weeks he was engaged to her, and in October 1795 they married. Robert's family convinced Col to give up on Utopia and become a lawyer. Robert introduced him to William Wordsworth, who, in turn, introduced him to Sara Hutchinson (Wordsworth was to marry her sister) (I know it's confusing having all these Saras around, and it's going to get worse) with whom Col fell immediately in love, putting an extra strain on his already iffy marriage.

He needed to earn money and managed to cobble together an income of £120pa through tutoring and getting people to give him money. Something he was good at. The Wedgwoods, the sons of the makers of bone china, gave him an annuity. In 1797 he had some poems published and they did rather well.

His first big hit, as it were, was 'The Rime of the Ancient Mariner' in 1798 – a poem that has given at least three phrases or metaphors to the language, albeit they are usually mis-quoted:

1. Water, water everywhere but not a drop to drink, comes from

> Water, water, every where,
> And all the boards did shrink;
> Water, water, every where,
> Nor any drop to drink.

2. A sadder and wiser man:

> He went, like one that hath been stunn'd
> And is of sense forlorn:
> A sadder and a wiser man
> He rose the morrow morn.

3. An albatross around your neck:

> Ah wel-a-day! what evil looks
> Had I from old and young;
> Instead of the Cross the Albatross
> About my neck was hung.

Coleridge became a father in September 1796 to a son David Hartley Coleridge, who was followed by Berkeley Coleridge in May 1798 – both were named after his favourite philosophers. His third son was born in September 1800 and named Derwent after the river near his home. Southey asked, 'Why will he give his children such heathenish names? Did he dip him in the

river and baptize him in the name of the Stream God?' In fairness, his daughter, born 1802, was called plain old Sara. Berkeley died whilst still a baby after a bad reaction to the new smallpox vaccination while Col was away in Germany. He was not the most attentive of fathers. Friends and relatives had to pay for David Hartley's education and Col once went eight years without seeing his kids, although he did help to nurse David through an attack of typhoid in 1822.

His daughter Sara took after him both in temperament and intellect and even became an opium addict as well.

Col also suffered with many illnesses that he blamed on the Lake District's damp weather and in 1804 he left to live in Malta where he was officially the temporary Public Secretary but did a bit of spying, because Britain wanted Malta as a port.

In 1806 he returned to England and asked his wife for a legal separation. Although not happy about it, she agreed.

Whilst living on Exmoor, Coleridge took some opium, 'in consequence of a slight indisposition' read a book and fell asleep in his armchair. During the hours of 'profound sleep' he composed 2-300 lines of poetry. When he woke up he wrote down 54 lines of 'Kubla Khan' (1798), but was interrupted by a 'person from Porlock', so that when he returned to his desk, could recall no more of the poem.

> In Xanadu did Kubla Khan
> A stately pleasure-dome decree:
> Where Alph, the sacred river, ran
> Through caverns measureless to man
> Down to a sunless sea.

In an effort to break his drug addiction he moved into the Highgate home of the apothecary James Gillman in April 1816. He did however keep an alternate supply available to him. He lived with the Gillmans for the rest of his life and it was probably Gillman's recommendation that Col came to Ramsgate most years, often with the Gillmans. He was never cured of his addictions but the Gillmans did seem to calm Col's mental state.

In order to earn money he also became a reviewer and was probably, at the time, as famous for that as he was for his poems. He was still short of money though and the situation only worsened when his only secure income, his pension from the Royal Society of Literature was lost due to a government re-organisation.

Apart from his poems he is attributed with introducing the word 'aesthetic' to the English language, and coined the word 'selfless'.

- When a woman asked him if he believed in ghosts, Coleridge replied, 'No, madam, I have seen too many to believe in them.'
- Coleridge – 'A huge pendulum attached to a small clock' Ivan Panin, Russian critic
- 'A weak, diffusive, weltering, ineffectual man. . . a great possibility that has not realised itself. Never did I see such apparatus got ready for thinking, and so little thought. He mounts scaffolding, pulleys, and tackle, gathers all the tools in the

neighbourhood with labour, with noise, demonstration, precept, abuse, and sets – three bricks.' Thomas Carlisle, Scottish historian and essayist.

During one of his stays in Ramsgate Coleridge took an excursion in a donkey trap to Kingsgate.

SEE Authors/ Donkeys/ Dumpton Gap/ Dyason's Baths/ Kingsgate/ Plains of Waterloo/ Poets/ Ramsgate/ Ramsgatize/ Sion Hill/ Snuff/ Wellington Crescent

COLLEGE ROAD, Margate

Named after a college, the road has lasted longer than the college did. The small single-storey building that is the carpet office was Norman and Sons Corn Merchants in 1936 – the remains of the painted sign are still visible on the side of the building – it's something to look at while you are waiting for the traffic lights to change.

SEE Margate/ St Peter's Footpath, Margate/ Schools

Wilkie COLLINS

Born London, 8th January 1824
Died London, 23rd September 1889

William Wilkie Collins was the eldest son of a fashionable painter of both landscapes and portraits, William Collins, RA, and named after Sir David Wilkie RA a friend of the family, and Wilkie's godfather.

His parents brought Wilkie Collins and his brother to Ramsgate for the first time when he was four years old and they stayed at Sion Hill, although it was called Sion Row then. They returned five years later and stayed at 4 Plains of Waterloo.

At school, possibly because of his appearance – 5ft 6in tall, with small hands but large shoulders and a large head with a forehead that had a prominent bulge on its right side – he quickly learned to become a proficient storyteller to placate the dormitory bully. He left school in 1841 and was apprenticed to Antrobus & Co., tea merchants in the Strand, or as he called it, 'the prison on the Strand'. During this time he wrote 'The Last Stage Coachman' and it was published in the August 1843 Illuminated Magazine. He became a law student at Lincoln's Inn in May 1846 and was called to the bar in 1851 although he never practised. He himself had a painting exhibited in the Royal Academy in 1848. The year after his father's death, his book 'The Memoirs of the Life of William Collins, Esq., R.A.' got good reviews, and encouraged by this, four novels followed: Antonina or The Fall of Rome (1850), Basil (1852), Hide and Seek (1854) and The Dead Secret (1857).

Wilkie Collins was 27 and Charles Dickens 39 when they first met. A mutual friend, Augustus Egg, enlisted Collins into Dickens' amateur theatrical company. Dickens wrote to Collins on 4th March 1851 and they met on the 12th. 'Wilkie Collins became for all the rest of the life of Dickens one of his dearest and most valued friends.' The Life of Dickens by John Forster, 1873.

Collins often stayed with Dickens both at his home and at his holiday addresses - which included Broadstairs and the Albion Hotel there. He enjoyed the Dickens family life, being popular with the children and he stayed friendly with both Charles and his wife after they separated.

Collins health declined from the mid 1850s. His Bohemian lifestyle and love of good food and wine may well have contributed. 'Neuralgia' or 'rheumatic gout' severely affected his eyes and either, his mistress Carrie Graves or his lifelong friend and doctor, Frank Beard, acted as his secretary. Having tried everything from quinine to hypnotism to baths (both Turkish and electric) to health spas, Beard prescribed opium, in the form of laudanum. Wilkie built up such a tolerance over the years that he took it every day and it was said that he took 'more laudanum than would have sufficed to kill a ship's crew or company of soldiers'.

Wilkie spent August 1858 in Broadstairs recovering from another of his spells of poor health.

'The Woman in White' came out in 1860 and Wilkie's brother, Charles, married Dickens daughter, Kate, in July of that year.

The financial rewards of 'The Woman in White' enabled Wilkie to leave the staff of All The Year Round in January 1861 – he had worked on Dickens' periodicals for the past five years,

Dickens wrote to him, 'I am very sorry that we part company (though only in a literary sense) but I hope we shall work together again one day.' Wilkie blamed his liver for the pain he experienced down his left side and came to Broadstairs to recover in July 1861. He also began to write his follow up, 'No Name' - the story of a woman's attempts to get her family fortune back. It dealt with illegitimacy and the inheritance laws of the day.

'I came here, last Friday, and propose staying till next Thursday the 18th - when I must get back to London for a week or so to collect all my literary goods and chattels for the writing of my new book. You will be glad to hear that I tried the outline of this said story upon Dickens, that he was immensely struck by it, and that he gave such an account of it to Wills in my absence, that the said Wills's eyes rolled in his head with astonishment when he and I next met at the Office. If I can only write up to my design, I think I can hold the public fast, with an interest quite as strong as in The Woman In White, and with a totally different story.

Sometimes I think of staying here - sometimes, of going to Scarborough - sometimes of exploring the unknown Suffolk coast, and resting quietly at Lowestoft. When I next write to you, or see you, I suppose I shall have settled something.' 11th July 1861, Wilkie Collins, letter to his mother Harriet

Dickens serialized 'No Name' in 45 instalments from March 1862, and that September wrote, 'I have gone through the Second Volume at a sitting and I find it wonderfully fine. It is as far before and beyond The Woman in White as that was

beyond the wretched common level of fiction-writing.'

Despite Wilkie suffering from gout all year, 'No Name' was published in book form in December 1862. He sent a copy to Dickens who wrote back, 'Many thanks for the book, the arrival of which has created an immense sensation in this palatial abode. I am delighted (but not surprised) to hear of its wonderful sale.'

Collins longest novel, 'Armadale' was published in 1866 and tells the complex history of the Armadale family over two generations featuring murder, the supernatural, and a beautiful red-headed female villain.

Gout had left him bed-ridden, forcing him to dictate virtually all of 'The Moonstone'. It was serialized in All The Year Round in 1867.

'It is prepared with extraordinary care, and stands every chance of being a hit. It is in many respects much better than anything he has done.' Dickens, in a letter to Wills, June 1867

'I quite agree with you about 'The Moonstone'. The construction is wearisome beyond endurance, and there is a vein of obstinate conceit in it that makes enemies of readers.' Dickens, in a letter to Wills, 1868

'The first and greatest of English detective novels'. T S Eliot, describing The Moonstone It was so popular that crowds formed outside the publisher's offices in Wellington Street, London to get the next instalment as soon as possible.

In 'Man and Wife' (1870), he attacked the marriage laws of the era. 'The Law and the Lady' (1875), had a female detective, and attacked the Scottish 'not proven' verdict.

In 'Jezebel's Daughter' (1880) a melodramatic novel which includes poisoning, he appealed for the humane treatment of lunatics. 'Heart and Science' (1883) makes the case against vivisection.

His health continued to decline, his heart problems caused breathing difficulties and he regularly took amyl nitrate and hypo-phosphate. Being thrown from a cab when it was involved in a collision in January 1889 did not help, and soon after he developed severe bronchitis followed by a stroke on 30th June. Further complications followed and he died on 23rd September 1889.

He wrote 25 novels, more than 50 short stories, at least 15 plays, and more than 100 non-fiction pieces. At one point he was the highest-paid author of his time. Both 'The Moonstone' and 'The Woman in White' have never been out of print and the latter has recently been made into a Lloyd-Webber musical.

Now you have been patient, and I know that what you really want is the dirt on his private life. Alright then, there were two women in his life, Caroline Graves and Martha Rudd, but neither of them made it to the altar with him.

Caroline Graves, known as Carrie, was a widow from Gloucestershire with a daughter, Harriet Elizabeth, when she met Wilkie in

the spring of 1856. They lived together from 1858.

In 1864 Wilkie, now aged 40, met 19 year-old Martha Rudd and four years later she was living at 33 Bolsover Street, just around the corner from his grander residence at 90 (now 65) Gloucester Place, London. He had three children with Martha.

Wilkie and Martha called themselves Mr and Mrs William Dawson and their three children, Marian, Harriet and Charley, took Dawson as their surname. Whether it was the relationship with Martha, or Wilkie's 'commitment issues' (possibly he had too much commitment rather than too little), he refused to marry Caroline who abruptly married someone else, Joseph Crow (sometimes Clow), in 1868. Wilkie was at the wedding at Marylebone Parish Church, as was Carrie and Frank Beard. Caroline returned to live at Gloucester Place in April 1871 and they lived together until Wilkie's death. She died six years later in 1895 and was buried in the same grave as him in Kensal Green Cemetery.

Now I know what you want to know: what happened when they all went on holiday? Well, I'll tell you. He came to Ramsgate most years, sometimes for two or three months at a time, and he and Caroline Graves stayed at 14 Nelson Crescent (they were there in 1861) along with her grandchildren and his children by Martha Rudd. At the same time he and Martha, under the name of Mr and Mrs Dawson, stayed at 27 Wellington Crescent.

He had been keen on sailing since boyhood and joined a local yacht club sailing either out to sea or along the coast, He also enjoyed walking, and fishing, as well as writing; many of his novels were, at least partially, written in Ramsgate, and some include Ramsgate as their setting.

He continued to visit here until the year before his death.

He said of Broadstairs: *'this little town will always hold my affection.'*
SEE Authors/ Broadstairs/ 'Fallen Leaves'/ Gout/ Law and the Lady, The/ Miss Morris and the Stranger/ Nelson Crescent/ North Foreland Lighthouse/ Plains of Waterloo/ Poor Miss Finch/ Ramsgate/ Ramsgate Road, Broadstairs/ Royal Albion Hotel/ Wellington Crescent/ Woman in White

Ronald COLMAN
Born 9th February 1891
Died 19th May 1958
He started in rep at The Theatre Royal, Margate and went on to appear in the films, 'A Tale of Two Cities' (1935), 'Lost Horizon' (1937), 'The Prisoner of Zenda' (1937), 'Random Harvest' (1942) and 'Around the World in 80 Days' (1956).
SEE Actors/ Films/ Theatre Royal

COMPTON ORGAN
Dreamland Cinema's Compton organ was restored by the Medway Theatre Organ Trust in 1975 and concerts were held on Sundays (latterly by another society). In 1985 Lewis Gerard, the organist in the instrument's heyday, was invited back from his retirement in California to play.
SEE Dreamland Cinema

CONCERT PARTIES
Up until World War II, huge crowds gathered to watch concert parties on the sands at Marine Terrace, Margate. Through the years they evolved from minstrels, Pierrots, and Harry Gold's Concert Parties. On a stage facing the promenade approximately opposite Arlington House, the beach would be crowded as well as drawing a big crowd watching from the promenade. Nowadays, the entertainment consists of bouncy castles, swings and trampolines.
SEE Beach Entertainment/ Margate/ Marine Terrace

CONCHOLOGY
This is the posh word for shell-collecting. Somehow it makes it a more repectable hobby when it has a posh name.
SEE Jerrold, Douglas

CONGREGATIONAL CHURCH
Meeting Street, Ramsgate
It is probably the site of Ramsgate's oldest church, as a building has been here since 1662. The present building was built in 1838 but the church closed in 1978.
SEE Christ Church/ Churches/ Ramsgate

Billy CONNOLLY
Born 24th November 1942
The comedian appeared at the Granville Theatre, with the Albion Dance Band as support, on 19th May 1977.
SEE Entertainers/ Granville Theatre/ Ramsgate

CONVALESCENT HOMES
Between 1870 and 1914 there were at least 48 convalescent homes in Thanet.
SEE Canadian Military Hospital/ Harold Road, Cliftonville/ Morrison Bell House/ Orphanages/ St Mary's Convalescent Home/ St Mary's Convalescent Home for Children/ Shottendane House/ Tatnell's Clifton Tavern/ Thanet/ Thanet Technical College, Ramsgate/ Thicket Convalescent Home/ West Ham Convalescent Home, Cliftonville/ Wilderness Hill, Cliftonville/ Working Mens Club, Reading Street/ Yarrow Home, Broadstairs

Marquis of CONYNGHAM
SEE Effingham Street/ Pettman, Thomas/ Sailor's Church/ Smack Boys' Home/ Thanet Technical College

CONYNGHAM SCHOOL, Ramsgate
This opened with 120 pupils on 8th January 1964 at a cost of £141,000 – the first school to be built in the area since 1911. It was named after the Marquis of Conyngham and opened by his son the Earl of Mount Charles. The school later changed its name to The Ramsgate School.
SEE Ramsgate/ Schools

Dame Gladys COOPER
Born Lewisham 18th December 1888
Died Henley-on-Thames 17th November 1971
The Bungalow Hotel, Birchington, now long replaced by Bierce Court flats, was a popular holiday retreat for the actress Gladys Cooper, later Dame Gladys Cooper. She also stayed at houses owned by Frederick Lonsdale, the playwright, including one in Alpha Road. She also rented a couple of houses in 1925 and 1926 with Gerald du Maurier (father of Daphne du Maurier), and it was not unusual for them to nip down by train for the day.

One of the most beautiful actresses of her day, aged 19 in 1908, she married a 26 year-old Boer War veteran soldier. Their daughter Joan, had a son well-known to most as the actor Robert Morley, and indeed his son Sheridan Morley is a well-known theatre critic. Gladys died in 1971 whilst touring with 'The Chalk Garden'. Probably her most enduring role is that of Henry Higgins' (Rex Harrison) mum in the film version of 'My Fair Lady'.
SEE Actors/ Birchington/ Bungalow Hotel/ Lonsdale, Frederick/ Morley, Robert

Tommy COOPER
Born 19th March 1921
Died 15th April 1984
Comedian and magician: (now put on your fez and do the voice - come on, you know you want to), *'I was in Margate last year for the summer season. A friend of mine said, 'You want to go to Margate, it's good for rheumatism.' So I did, and I got it! - Just like that! Thankyouverymuch!'*
SEE Entertainers/ Flag and Whistle/ Margate/ Winter Gardens

COPPERFIELD COURT
Eastern Esplanade, Broadstairs
It stands on the old site of the Clevedon Hotel, which was the Invalid Children's Aid Association for many years.
SEE Broadstairs/ David Copperfield/ Eastern Esplanade, Broadstairs

Marie CORELLI
Born 1st May 1855
Died 21st April 1924
Mary Mackay wrote melodramatic romantic novels 'Barabbas' (1893), 'The Sorrows of Satan' (1895) and 'The Mighty Atom' (1896) under the pseudonym of Marie Corelli. The critics hated them, the public loved them, and for a while she was the best read author in the land. Her fans included Gladstone, Wilde, Randolph Churchill and Queen Victoria herself. In time, the public tired of her extravagant style and began to ridicule it, although she is probably smiling somewhere because her books are still in print today.

In Cockney rhyming slang a 'telly' is a 'Marie' as in Marie Corelli – telly. In her novel 'A Romance of Two Worlds' she predicted x-rays, radio and television.

When the tomb of Tutankhamen was opened in 1922, she claimed that an early Arabic text that she owned foretold that curses would follow any opening. This claim pretty much got the whole 'Curse of Tutankhamen' going.

She was a huge fan of the Margate Shell Grotto thinking it, *'one of the most beautiful,*

fantastic and interesting relics of the ancient days that exist in England or anywhere else.'
Her description of a visit to Margate in 'Cameos' (1896): *There is something not exactly high-class in the name of Margate. Sixpenny teas are suggested, and a vulgar flavour of shrimps floats unbidden in the air. . . But there is something at Margate beside the air, the sands and the sea: something that calls for recognition from students, antiquarians, lovers of romance and savants of all classes and nations: something that, just because it is at plebeian Margate, has escaped the proper notice and admiration it so strongly deserves. If the curious and beautiful subterranean temple. . . existed anywhere but at Margate, it would certainly be acknowledged as one of the wonders of the world, which it undoubtedly is.*
SEE Authors/ Margate/ Radio/ Shell Grotto/ Victoria

Leon CORTEZ
An actor who appeared in 'Dads Army', and 'Dixon of Dock Green'. He died on New Years Eve, 1970.
SEE Actors/ San Clu Hotel

The COTTAGE
High Street, Margate
This public house dates back to 1760, a time when port wine was imported into Portugal House, and the front of the building still remains. Now, when I say imported, that also includes smuggling and there is a legend indicating that there was, or is, a tunnel that connected the cellar of the pub to St Johns Church.
A Ramsgate wine importer and brewer, E G Wastall, took over in the nineteenth century and ran an off-licence at the front and a wine lodge in a rear extension.
A 'benign lady in white' is said to haunt the upstairs restaurant. It became a free house in 1969, later becoming an Italian restaurant, Island Taverna, but is now The Cottage once more.
SEE Breweries/ High Street, Margate/ Margate/ St John's Church/ Pubs/ Restaurants/ Tunnels/ Wastall

COTTAGE ROAD, Ramsgate
When the military used the area now called Wellington Crescent, one of the footpaths leading to it was from Clover Hill, through what is now Cottage Road.
SEE Ramsgate

Billy COTTON
Born 6th January 1899
Died 25th March 1969
He was a bandleader whose famous catchphrase was, *'Wakey-wakey! Rise and shine!'*
SEE Entertainers/ Lynn, Vera/ Shakespeare public house

COURT MOUNT
Canterbury Road, Birchington
Parts of the rear of the building date back to the fifteenth and sixteenth century, and the front to the late eighteenth or early nineteenth century. It was once the farmhouse of South End Farm.
In 1933 the pond in front, near the side of Canterbury Road, was filled in.
SEE Birchington/ Canterbury Road, Birchington/ Farms

COURTS FURNITURE STORE
Queen Street, Ramsgate
On 24th November 1966, in what was Ramsgate's biggest fire since the war, Courts three-storey furniture store in Queen Street was gutted causing £150,000 worth of damage - £35,000 worth of stock can make a lot of flames. Seventy firemen from brigades from all over Kent were called in, and local residents warned of imminent evacuation. At 5.30 in the morning an official went on duty at the harbour, a quarter of a mile away – *'Flames leapt up 30 or 40 feet higher than the Yacht Club buildings. The whole harbour was lit up as if the illuminations were on.'* Sparks were flying into the harbour and the safety of the boats was in danger for a while. After the fire was brought under control, it became apparent that the walls of the building were unsafe.
The chain of 88 stores closed in 2004.
SEE Fires/ Queen Street, Ramsgate/ Ramsgate/ Shops

COVELL'S ROW, Margate
SEE Lawrence, Carver/ Margate

The COVES
High Street, St Peter's
A private house, the building dates from 1769 and includes some Queen Anne features (Queen Anne lived 1665-1714, reigned 1702-1714; she was pregnant 18 times, all but one either ended in miscarriage or a still birth and the one that did survive died aged 11 – all irrelevant to The Coves I know) and was once the last building in the High Street. In its grounds were several large caverns (hence the name) used for smuggling and later as shelters. They stretch as far as the old site of Sowell Farm, near the Albion Road junction.
SEE Farms/ High Street, St Peter's/ St Peter's

Noel COWARD
Born 16th December 1899
Died 26th March 1973
The writer, actor, playwright, producer and composer stayed on more than one occasion at a bungalow called Delmonte in Spencer Road, Birchington.
SEE Actors/ Birchington/ Don't Put Your Daughter on the Stage, Mrs Worthington/ Fox, Angela/ Music/ Spencer Road, Birchington

Christopher COWDREY
Born Farnborough, Kent 20th October 1957
He played cricket for Kent (and Glamorgan for one season) and captained the England team in the fourth test against the West Indies in 1988. His father, Colin Cowdrey, had also been the England captain and they became only the second father and son to achieve this double. The first to achieve the feat were Frank and George Mann. After retiring from cricket, Christopher pursued a successful career in broadcasting.
SEE Cricket/ Wellesley House School

William COWPER
Born Great Berkhamstead, Hertfordshire 20th November 1731
Died 25th April 1800
God moves in a mysterious way,
His wonders to perform;
He plants his footsteps in the sea,
And rides upon the storm.
'Light Shining out of Darkness' from Olney Hymns (1779)
Cowper (pronounced Cooper) was very interested in the pleasures of rural living, and also human suffering. What started as depressing tendencies got worse after he took a legal exam for a government post. On the day before the exam he tried to poison himself, stab himself and then hang himself! – and you thought you'd had exam nerves. He lived and got out of taking the exam. After this, he suffered from long periods of deep depression, spending time in an asylum because he convinced himself that he had committed an unpardonable sin. When he was discharged, he lived with an evangelical cleric, Morley Unwin and Morley's wife Mary in Huntingdon. Morley died in 1767 and Cowper moved with Mary and her children to Buckinghamshire. The depression returned in 1773 and he tried hanging himself again, due to religious doubts. Mary looked after him and encouraged him to write poetry and gradually he recovered, although he did have one last go at hanging himself in 1787. His best known works are 'The Diverting History of John Gilpin' (1783) a humorous ballad, and 'The Task' (1785), a poem written in a conversational style of blank verse praising rural life. He never married Mary Unwin, but they were engaged, and moved again in 1786 to Weston Underwood where William continued to write, including one poem called 'To Mrs Unwin'.
When Mary died, his depression returned and his last completed work was 'The Castaway' which clearly showed his torment. He died in 1800 of natural causes, and his last words were, *'What does it signify?'* Let's hope he found out.
He visited Margate in August 1763 and stayed until the autumn, just shortly before he sat his legal exam.
But you think Margate more lively – So is a Cheshire Cheese full of Mites more Lively than a Sound one, but that very Liveliness only proves its Rottenness. I remember too that Margate tho' full of company, was generally filled with such Company, as People who were Nice in the choice of their Company, were rather fearfull of keeping Company with. The Hoy went to London every Week Loaded with Mackarel & Herrings, and return'd Loaded with Company. The Cheapness of the Conveyance made it equally commodious for Dead Fish and Lively Company...
I remember taking a Walk upon the Strand at Margate where the Cliff is high &

perpendicular. At long Intervals there are Cartways cut thro' the rock down to the Beach, and there is no other way of Access to it, or of Return from it. I walk'd near a mile upon the Water Edge, without observing that the Tide was rising fast upon me. When I did observe it, it was almost too late. I ran every Step back again, and had much ado to save my Distance. I mention this as a Caution, lest you should happen at any time to be surprized as I was. It would be very unpleasant to be forced to cling like a Cat to the Side of a Precipice, & perhaps hardly possible to do it for 4 Hours without any Respite.
SEE Margate/ Poets

COWPER ROAD, Margate
Named after the poet, William Cowper.
SEE Cowper, William/ Margate

COXSWAIN
The word 'coxswain', meaning helmsman, was formerly spelt 'cockswain', and came from swain, or the man in charge, of a cockboat. This can be traced back to the Latin 'caudica' meaning dug-out canoe, which, in turn, – are you keeping up? – comes from 'caudex' meaning tree-trunk.
SEE Coxswain, The/ Mary White

The COXSWAIN public house
Marine Terrace, Margate
Built as part of the Arlington House development in 1963, it became Millennium Bar II and Millennium Sports Bar for a while, but is now closed.
SEE Coxswain/ Margate/ Marine Terrace/ Pubs

CRADLECAR & CO –
baby carriage manufacturers
A business listed in Whitehall Road, Ramsgate in 1957.
SEE Ramsgate/ Whitehall Mineral Water

Edward Gordon CRAIG
Born 16th January 1872
Died 29th July 1966
Usually known as Gordon Craig, he was an actor, producer and scene designer who learnt his trade from Sarah Thorne at the Theatre Royal, Margate. His mother was Ellen Terry, of whom he later wrote a biography, and with whom he acted in Sir Henry Irving's company.
SEE Actors/ Irving, Sir Henry/ Theatre Royal

Norman CRAIG
East Kent Times 8th January 1910: *The Suffragettes and suffragists of Thanet are all forlorn. . . neither of the candidates will espouse their cause. . . nevertheless the ladies are determined not to be left out in the cold. . . they are attending the meetings in large numbers. At one of the meetings many of the male electors had to be content with standing room. Some of them could not even obtain that.* The candidates were the Liberal Mr Weigall, father of Miss Weigall, who ran the anti-suffrage group, and Norman Craig, Conservative. As soon as Norman Craig was elected MP, he changed his mind and became a supporter of votes for women.

Thanet's Member of Parliament at the time, had booked, and paid for, tickets on the Titanic and was going to have a holiday in New York (nowadays he would have claimed the money on expenses and said it was a fact-finding mission). A sixth sense told him to cancel, go on a later date, and instead attend the Home Rule bill debate in the House of Commons. After the boat sank on the 14th-15th April 1912, he was congratulated on his lucky escape by everyone he met.
East Kent Times 16th July 1913*: Mr Norman Craig replies to suffragists... he says he detested the excesses and outrages into which a few of its overzealous advocates have been betrayed. 'Untold injury has been done to the cause of women's suffrage by the wanton crimes of the militant extremists.'*
In World War I, many urged that he be appointed Minister responsible for air defence but he could not be considered because he had given up his highly-paid work to serve on dangerous sea patrols in the English Channel.
SEE East Kent Times/ Election results/ Politics/ Suffragettes/ World War I

Thomas Russell CRAMPTON
Born Broadstairs 6th August 1816
Died Westminster 19th April 1888
It is a strange thing that his achievements are more recognised abroad, than they are in England, or even in his home town of Broadstairs.
His parents, John and Mary, lived at Prospect Cottage near the Albion Road/ Dickens Walk area (I know it was not called Dickens Walk then!). His dad was a plumber and architect and also ran the Vapour and Medicated Baths at Eldon Place. Charles Dickens wrote in a letter to his daughters in 1859 that he used the facilities here because the sea was too cold.
Thomas married Louisa and they had eight children, two girls and six boys. Their first child, Ada Sarah, died at just four years old and in her memory Crampton paid for a stained glass window at St Peter's Church, some of it is still to be seen in the Belfry Tower. Their second daughter, Louisa, married the ambassador to the Netherlands, Sir Horace Rumbold.
As far as his career is concerned he served his articles between 1831 and 1839 in London with a well known engineer of the period, John Hague.
From 1839 until 1844 he was assistant to Brunel, (Isambard's dad), and then Daniel Gooch and was responsible for the drawings for the Great Western Railways' first locomotive 'Firefly'. In 1843 he also patented the Crampton Engine which had a low centre of gravity and big wheels. Within a few years it was used by the Compagnie du Nord and continued to be used on the rail networks of North and Eastern France. Napoleon III made him an Officer of the Legion of Honour in 1855; thirty years later he was honoured again when he was made a knight.

Back home, he recommended that the railway companies adopt the narrow-gauge. They would not agree and years later what did we end up with? Narrow gauge.
From 1844 he worked for John and George Rennie building the Liverpool locomotive, an improvement on his old Crampton. A powerhouse of a machine it was the strongest of its time able to carry 180 tons at 50 mph. It won a gold medal at the Great Exhibition in 1851.
In 1848 he set up in business on his own making a dozen engines for use on Britain's railways. By 1878 every express train in Eastern France had been built by Crampton. Six of his engines were also used by the Prussian Eastern Railways and in 1856 he had been elected to the Prussian Order of the Red Eagle.
'In 1851, Mr Crampton succeeded, under exceptionally difficult circumstances, in laying the first successful cable for a submarine telegraph between Dover and Calais. He undertook the whole engineering responsibility in his first practical step in submarine telegraphy. . . Mr. Crampton may therefore be fairly considered as the father of submarine telegraphy'. Obituary in The Times
His cable enabled the prices from Paris Bourse (stock exchange) to be received on the same day in London for the first time on 13th November 1851. Crampton put up half the costs of this new cabling venture, and although it involved a huge risk, it worked and he did rather well out of it.
It was not just engines that he was involved with; he also built the tracks for some of them, in Bulgaria and Turkey, and closer to home between Sevenoaks and Swanley, Strood and Dover, and Herne Bay and Faversham. These became part of the London Chatham and Dover Railway network (OK not the Turkish or Bulgarian ones).
Crampton also invented machinery for use in the manufacture of the matchbox, road building, cement, iron and steel industries. He owned brickworks and lime businesses in Otford and Sevenoaks. He also invented a machine to tunnel under the Channel, for a project that took another century and a half to actually get going – again he was ahead of his time!
With Sir Charles Fox, he constructed the Berlin Waterworks. He was also responsible for the Broadstairs' gas works.
After his wife Louisa's death, Thomas remarried in 1881, but after a period of failing health he died in 1888.
SEE Broadstairs/ Broadstairs Water Company/ Crampton Tower/ Holy Trinity Church/ Prussia/ St Peter's Church/ Louisa Gap

CRAMPTON TOWER, Broadstairs
Designed by Thomas Crampton for his own company, the Broadstairs Water Company, it still stands today near the Railway Station and The Broadway. Built in 1859, it is 80 feet tall and the water was pumped up from wells by a gas engine under the reservoir

floor; the reservoir itself could hold 83,000 gallons.

It opened as the Crampton Museum in 1978.

SEE Broadstairs/ Crampton, Thomas Russell

CRANBOURNE ALLEY, Margate

Close to St Johns Church, it was a row of old-fashioned shops selling virtually everything in its time.

Churchfield House was in Cranbourn Alley and was a preparatory and boarding school for young gentlemen for most of the eighteenth century; by 1936, Mrs A Strand was running it as a boarding house.

Cranbourne Alley was included in the demolition of several old streets and alleyways in this area in the 1960s which enabled roads to be widened and allowed easier access by car to the town centre.

The Walmer Castle public house was demolished in 1968.

SEE Boarding Houses/ Margate/ Pubs/ St John's Church/ Schools/ Shops

CRECY

Around 160 mariners sailed in 15 ships from Margate Harbour to fight with King Edward III's campaign for Crecy and Calais.

The battle took place on 13th August 1346 – we won.

SEE Edward III/ Harbour, Margate/ Margate

CRESCENT ROAD, Ramsgate

There were casualties in this area in the 1917 Dump Raid.

On the 28-29th January 1918, an aerial torpedo, one of seven fired on Ramsgate that night, left the Rev Thomas Hancock with an outside bathroom on the first floor of his house on the corner – in fact the whole of the back of the house was lost.

SEE Addington Street/ Albert Road/ Dump Raid/ Harbour/ Ramsgate/ Southwood Road

CREST AND MOTTO - Ramsgate

The motto on the Ramsgate town crest is 'Salus nauf racis salus aegris', which means 'Safety for the shipwrecked and health for the sick'.

Two supporters, a lifeboatman and a sailor, were added in 1934 and they hold the crest which is split into four. The top left quarter has the Invicta white horse representing Kent

on a red background; the top right has a blue background with the front half of a lion joined to the back half of a ship, the symbol for the cinque ports (Ramsgate is a Limb of Liberty to Sandwich); the bottom left has a dolphin on a blue background, representing the importance of fishing to the town - a cod may have been more accurate; and the bottom right has a red background with a single-masted galley, or Golden Lymphad, representing the value of sea trade over the years.

SEE Cinque Ports/ Ramsgate/ Sandwich

CRICKET

SEE Cowdrey, Christopher/ Goodwin Sands – cricket match/ Iles, J H/ Jordan, Sir William Joseph/ Margate College/ MCC/ Oval, The/ St George's Lawns/ Smith, Sir C Aubrey/ Sport/ Wellesley House School

Dr CRIPPEN

Born 1862

Died 23rd November 1910

At 39 Hilltop Crescent, Holloway, London (it's now council flats) Dr Hawley Harvey Crippen murdered his wife Cora, an unsuccessful music hall performer, and hid the headless body in the coal hole behind some loose bricks. The reason for the murder is still not known for certain. He told his friends and neighbours that she had died whilst visiting family in America. Had he left it at that, he may well have gotten away with it. When his secretary, Ethel Le Neve, was seen wearing his wife's jewellery and clothes, he told the police that his wife had run off with her lover and he had made up the story of her death to avoid embarrassment. The police accepted his story. Crippen, however, panicked and ran off to the USA on board the SS Montrose with Ethel. The police searched the house and found nothing but on a second search they managed to find the body parts and the hunt for Crippen began. The Captain of the SS Montrose became suspicious of the two who came aboard as Mr and Master Robinson and using a Marconigram wireless he notified the police via the North Foreland radio station. The police promptly got on a faster vessel, caught up with the SS Montrose and arrested the couple. It was the first time that radio had helped capture a criminal.

Dr Crippen was visited in his cell at Pentonville, before his execution in 1910, by W S Gilbert, the librettist half of Gilbert and Sullivan, to research for what would be his final play 'The Hooligan'. Crippen was hung at Pentonville in November 1910.

Crippen's house in Holloway was opened as the Crippen Museum after it was bought for £100 by Sandy McNabb, a Scottish comedian. Almost a century later, fresh evidence came to light which put Crippen's guilt in question.

SEE Murder/ North Foreland Radio Station

CRITICAL MASS

This was a pressure group, formed in Ramsgate in 1984 that opposed Margaret Thatcher and supported the National Union

of Mineworkers. They also opposed the rules that prevented local unemployed from living in the numerous empty hotels in the area desperate for business. Red Herrings was a BBC2 documentary on the subject in 1985.

SEE Miners/ Politics/ Ramsgate

CROSS ROAD, Birchington

Cross Road is named after Dr Cross of the Thicket Convalescent Home.

SEE Birchington/ Thicket Convalescent Home

Ben CROUCH

He was the son of a London hospital caretaker and was probably the most notorious of all bodysnatchers.

He was, at one time, a member of the Borough Gang which operated in London between 1802 and 1825, along with Joseph Naples who kept a diary.

Tuesday 24th. At twelve at midnight a party went to Wyngate got 3 small, came back and got 2 large at Newington, came home and settled with Ben, each man's share £8, 16s. 8d, at home all night.

Friday 27th. Went to look out, came home met Ben and Dan at 5 o'clock, went to Harps, got 1 large

Saturday 28th. At 4 o'clock in the morning got up, with the whole party to Guy's and St. Thomas's crib (burial ground), got 6 took them to St. Thomas. Came home and met at Thomas's again, packd up 3 for Edinbro

Monday 10th. Met. went to St. James. got 9 large & 1 small, took them to Dur thol.

Tuesday 11th. Went to Barthol. Moved the things. Home all night.

He started up on his own but was far from a one-man band, running an organisation between 1809 and 1813 that Al Capone would have been proud of. His gang ensured that they had a virtual monopoly on corpses in London, and with St Barts Hospital in particular, but his empire extended into the south-east and the Midlands. If anyone else stole from what he and his gang considered as their graveyards, they had a variety of responses. Beating up their rivals was always good for gang morale.

Shopping them to the police was another, although a somewhat lazier response. It did enable Ben, who was a huge fan of boxing, to take his gang members off to prize fights and all work stopped on these days. Ben liked to tell people that he was a bit useful in the ring himself and when his gang was standing behind him few argued with him.

A stranger response to rivals was to go and dig up the corpses and then leave them out in the open so they would decompose quicker and therefore become worthless. If a hospital or doctor decided to go to another supplier, then Ben and his gang would go into the hospital, beat up the staff and rip the dead bodies to shreds. He did not try to hide his activities and became well-known to both magistrates and the press.

There are records of bodies being sold for up to 15 guineas, and of one resurrectionist being paid, in one night, £144 for 12 bodies, out of which he gave £5 to each of his gang.

So there was money to be made and Crouch certainly made it.

It seems he lived for a while at The Crown and Anchor in Zion Place and in 1823 he seems to have invested some of his money in two houses here, one of which, The Randolph Hotel, he converted into a billiard room.

The following, from Chambers' Book of Days 1869, refers to Crouch, but not by name: *Another Resurrectionist, after a long and active career, withdrew from it in 1817, and occupied himself principally in obtaining and disposing of teeth. As a licensed suttler, in the Peninsula and France, he had drawn the teeth of those who had fallen in battle, and had plundered the slain: with the produce of these adventures, he built a large hotel at Margate, but his previous occupation being disclosed, his house was avoided, and disposed of at a very heavy loss: he was subsequently tried, and imprisoned for obtaining money under false pretences, and was ultimately found dead in a public-house near Tower-hill.*

It is possible that he was recognized by a survivor of the battlefields where he had learned his trade.

There is a record of a Benjamin Crouch marrying Anne Cannaby at St Johns Church, Margate in 1828 but whether it is him is not certain. Would he, or could he have returned to the area?

It is understood that Charles Dickens based the character of Jerry Cruncher in 'A Tail of Two Cities' on Ben Crouch. There is even a tavern named after him in London.
SEE Price, Dr David/ Margate/ St John's Church/ Zion Place

CROW HILL, Broadstairs
SEE Eagle House/ Hops/ Pear Tree Cottage/ Percy, Major

CROWDS
There was a ninety degree heat wave on the August Bank Holiday weekend of 1908. The crowds poured in on every conceivable type of transport; there was not an empty bed to be had in any hotel or boarding house and many people slept on the beach each night.

On 2nd August 1921, a Bank Holiday, there were huge crowds again in Margate. Trains arrived every ten minutes, and there were traffic jams caused by people trying to get into Margate.

At Easter 1933, there were 10,000 more visitors than the previous Easter but the traders complained that *'the people had no money to spend'*. By Whitsun though, it needed nineteen special trains to bring the crowds down.

During the August Bank Holiday of 1955, it is said that every bed in every hotel, boarding house and guest house in Thanet was booked with thousands, yes thousands, arriving unable to find a place to sleep.
SEE Boarding houses/ Hot weather/ Margate/ Thanet

The CROWN public house, Margate
At number 2 Broad Street, it dates back to the early nineteenth century, certainly before

1823, and possibly replaced the Old Crown (1792).
SEE Broad Street, Margate/ Margate/ Pubs

CROWN & SCEPTRE public house, Acol
Now they do say that there were a Crown and Sceptre at the bottom of Margate Hill from the 1640s, around the time of the Civil War – I lapsed into some sort of country yokel voice in my head for a moment but I am back to normal now. Well, as near as I get. The Holloway family owned two adjacent properties from around 1670. Eventually Mrs Ann Holloway sold them around a century later to John Friend of Birchington, and it later ended up under the ownership of the Cobb Brewery of Margate until 1968. It is probably where William Cobbett stopped for breakfast:
But could get no corn for my Horse, and no Bacon for myself.
The labourers' houses, all along through this island, beggarly in the extreme. The people dirty, poor-looking; ragged, but particularly dirty.. . . It is impossible to have an idea of anything more miserable than the state of the labourers in this part of the country.
Invariably have I observed, that the richer the soil, and the more destitute of woods; that is to say, the more purely a corn country, the more miserable the labourers . The cause is this, the great, the big bull frog grasps all. In this beautiful island every inch of land is appropriated by the rich.'
SEE Acol/ Cobbett, William/ Cobbs

CROWN & SCEPTRE public house Ramsgate Road, Margate
A pub at Chapel Hill which dated back to the 1830s. It belonged to the Chapel Hill Estate (C D Hayes esq. lived there in 1840) and it consisted of a small cottage built from flint with stabling and a forge next door. John Strattford was the landlord in 1840. Possessing its own 58' deep well it was able to produce cider. Also underground are thought to be two tunnels. One to Fleete, and the other to Salmestone Grange as an escape route for persecuted Catholics. It was superbly placed for all traffic between Margate and Ramsgate. Legend has it that the Sabbatarians had such a grip on Garlinge at one time, that pubs there had to remain closed on Sundays, so the villagers trooped here for their Sunday pint. At around 1900 the then owners Tomson and Wotton changed the name to The Orb. The landlord in the 1960s was quite a character, keeping an optic for spirits in his private loo! He also proudly stocked 100 different whiskies, a choice of 45 alternative brandies, and 165 brands of cigarettes. At different times The Orb has been a Rigden of Faversham, a Whitbread, and a Shepherd Neame pub.
SEE Garlinge/ Margate/ Pubs/ Ramsgate Road, Margate/ Tunnels

CROWN & THISTLE public house Northdown Hill, St Peter's
It has now been replaced by Crown Cottages and, you've guessed it, Thistle Cottages.
SEE Northdown Hill, St Peter's/ Pubs/ St Peter's

CROWN and THISTLE public house High Street, St Peter's
It was a Thomson and Wotton pub that closed in 1954. The building was demolished in 1960 and replaced by two shops set further back from the road than the old pub had been.
SEE High Street, St Peter's/ Pubs/ St Peter's

CROWN BINGO Marine Terrace, Margate
It opened on Marine Terrace in 1963 and has been Margate's largest bingo hall for many years. Badly water-damaged after the huge fire next door in 2003 it underwent a huge refurbishment.
SEE Bingo/ Fires/ Margate/ Marine Terrace

CROWN INN, Sarre

It dates from the 15th century when it was a posting inn. It is probably better known as the Cherry Brandy House. The recipe was introduced here over three centuries ago by a Huguenot landlord and handed down over the years. The 17th century French Huguenots brought the cherry brandy recipe to Kent when they fled from religious persecution by Louis XIV of France – and you thought asylum seekers were a new thing!

It has had a few names over the years; in 1696 it was The Plough Inn; by 1719 it was the Hare and Hounds; in 1785 the Halfway House; and, in 1800 it became the Crown Inn.

The names of its most famous customers are displayed outside: Charles Dickens, Cruickshanks, Rudyard Kipling, Lord Carson, Viscount Rothermere, Ellen Terry, Lady Wyndham, Sir John Hare, W H Berry, Lionel Brough, Jack Payne, Herman Finck, A B Payne, Col Elliott Roosevelt, Norman M Scott, G R Sims, F C Burnard, The Pickwick Coaching Club, Betty Balfour, Sir George Robey, Binney Hale, George Graves, Evelyn Laye, Olga Lindo, Nelson Keyes. Bransby Williams, Claud Allister, Sir Seymour Hicks, Eddie Calvert.
SEE Carson, Lord/ Dickens, Charles/ Hicks, Sir Seymour/ Pubs/ Robey, Sir George

Leslie CROWTHER
Born 6th February 1933
Died 29th September 1986
This English comedian appeared on 'Crackerjack' between 1960 and 1968; hosted 'The Price is Right' and also the first three series of 'Stars in Their Eyes'.
SEE Entertainers/ Granville Theatre

CULTURE CLUB
Pop band fronted by Boy George (born 14th June 1961) who had nine Top 10 singles including 'Do you really want to hurt me?'

(1982), 'Time (clock of the heart)' (1982) and 'Karma Chameleon' (1983). They were called Culture Club as a reference to the diverse make up of the band personnel, which included an Englishman, a Jamaican-Briton, a Jew and a transvestite.

Joan Rivers: *'Boy George is all England needs - another queen who can't dress.'*

SEE Music/ Winter Gardens

Duke of CUMBERLAND

Born 27th Novemebr 1745
Died 18th September 1790

Henry was the sixth son of Frederick, Prince of Wales and Augusta of Saxe-Gotha. George III was his elder brother and he himself was third in line to the throne.

On 4th March 1767, he married a commoner, Olive Wilnot, in a secret ceremony and subsequently had a daughter Olivia (1772-1834) although whether the marriage actually took place, and who was Olivia's father were both much debated.

Olivia became a novelist and landscape painter who married John Thomas Serres (1759-1825), but later gave herself the title of Princess Olivia of Cumberland.

Lady Anne Houghton (sometimes spelt Horton) (1743-1808) was, strictly speaking, also a commoner although she was the daughter of Simon Luttrell, the Earl of Carhampton, and the widow of Christopher Horton of Catton Hall. She also had a bit of a reputation *'the Duke of Grafton's Mrs Houghton, the Duke of Dorset's Mrs Houghton, everyone's Mrs Houghton.'* There were probably lots of jokes about her needing a Y-shaped coffin when she died. You know the sort of thing. Yes you do.

Despite her track record, the Duke of Cumberland married her on 2nd October 1771 and they immediately ran off to Margate to avoid the paparazzi. They lived in a house in Cecil Square, Margate (there is a blue plaque on the Nat West Bank).

It was this marriage that brought about the Royal Marriages Act 1772 which forbade any of George II's descendents from marrying without the monarch's permission.

The Duke once enjoyed the company of Samuel Foote, a Cornish playwright, wit and a superb mimic of the establishment figures of the day. *'Mr Foote, I swallow all the good things you say.'* Foote replied, *'Do you? Then your Royal Highness has an excellent digestion, for you never bring any of them up again.'*

SEE Blue plaques/ Cecil Square/ George III/ Margate

CUMBERLAND ROAD, Ramsgate

Karl Marx's final visit to Ramsgate was in 1880 when he and his family stayed at 10 Cumberland Road through August to 13th September. Again, he and his wife were in poor health - she had terminal cancer of the stomach - but by all accounts it was a happy family holiday with his daughters and their husbands.

SEE Engels, Friedrich/ Marx, Karl/ Ramsgate

CURLING FAMILY

An old family of Chilton, thought to have taken their name from the Curlews that can often be seen at Pegwell Bay.

SEE Birds/ Pegwell Bay

Sir William CURTIS

Born 1752
Died 1829

An alderman and MP, he was the son of a baker of ship's biscuits, a business that he and his brother, Timothy, inherited in 1771. They expanded the business into the shipping and whaling trades and in due course Curtis got incredibly wealthy and William earned his nickname, Sir Billy Biscuit. William was involved in the development of London's East End docks; he also became a City banker - establishing the Robarts, Curtis, Were, Hornyold, Berwick & Co Bank (later taken over by Coutts). He became an alderman for Tower Ward at the age of 33; Sheriff in 1788; Lord Mayor 1795-6; and Tory MP for the City from 1790-1818 and 1820-26, at which point he was known as the 'Father of the City'.

Although he was virtually illiterate and his way of speaking was clumsy and at times unintentionally amusing it hardly held him back. He is said to be the originator of the phrase *'the three Rs – reading 'riting and 'rithmatec'.*

He moored his sumptuously fitted-out yacht 'Emma' – he raced it at Cowes - at Ramsgate Harbour and bought Cliff House, a villa on Sion Hill, overlooking it.

He married Anne Constable (born 9th January 1757) in 1776.

For years, his portly figure was a gift to caricaturists, particularly George Cruickshank. After William died, aged 77, on Sunday 18th January 1829 at Cliff House, every shop in town closed for the day of the funeral. Huge crowds followed his funeral cortege as far as the second mile stone on the Canterbury Road, that took his body to the crypt of St Mary's in Wanstead, Essex. He left a mourning ring to each member of the Court of Aldermen, and £300,000, mostly to his friend Lord Sidmouth.

There is a memorial to Sir William at St George's Church.

SEE Addington, Lord/ Harbour, Ramsgate/ Obelisk/ Politics/ Ramsgate/ St George's Church/ St Laurence Church/ Sion Hill/ Walcheren Expedition

Lord CURZON

He had a house built for himself in Kingsgate.

SEE Kingsgate

D

Mike D'ABO

Born Betchworth, England 1st March 1944

He left the Band of Angels to become the vocalist with Manfred Mann in 1966. Their hits included 'Just like a woman' (it got to

number 10 in the charts), 'Semi-detached suburban Mr James' (number 2), 'Ha! Ha! Said the clown' (number 4), 'Mighty Quinn' (number 1), and 'My name is Jack' (number 8). He went solo in 1969.

As a songwriter he wrote 'Build Me Up Buttercup' for The Foundations, and 'Handbags & Gladrags' which has been a hit for Chris Farlowe, Rod Stewart and the Stereophonics, as well as the song in the 'Finger of Fudge' TV advert where, apparently, *'a finger of fudge, is just enough, to give your kids a treat'* – you'll be humming it all day now!

He has a band called Mike d'Abo & His Mighty Quintet and hosts a radio show, Late Night West, in the West Country.

SEE Music/ Radio/ Wellesley House School

'DADS ARMY'

It has been suggested that the fictional Walmington-on-sea in the classic BBC TV comedy is actually based on Birchington-on-sea. Not only are the names similar, but Walmington has Eastgate as its neighbour, and Birchington is next to Westgate. Hey, I've heard worse conspiracy theories.

SEE Birchington/ LeMesurier, John/ Television

DAILY MAIL

Alfred Harmsworth, later Lord Northcliffe, took his cue for the style of The Daily Mail from that of American papers. The Daily Mail went through 65 dummy runs, at a cost of £40,000, at Carmelite House on the junction of Carmelite Street and Tallis Street in the City of London, before the first edition, at a cost of a halfpenny for eight pages, was issued on 4th May 1896. It used the slogans 'A Penny Newspaper for One Halfpenny' and 'The Busy Man's Daily Newspaper'. This paper had banner headlines across the whole page, the stories were shorter and more readable, and it was the first paper to include a women's page dealing with cookery and fashion. It had serials with dramatic opening episodes of around 5,000 words followed by a series of 1,500-2,000 words each day – Harmsworth personally supervised these stories. It was also the first paper to give a rate per thousand sales to advertisers, as well as audited sales figures. Circulation soon went up to 500,000 and, with interest in the Boer War in 1899, this doubled. Harmsworth told his readers that the paper stood *'for the power, the supremacy and the greatness of the British Empire'*. Lord Salisbury said it was *'a journal produced by office boys for office boys'*.

The US newspaper magnate, Joseph Pulitzer, was so impressed by Harmsworth's achievements that he invited him to be the guest editor of his 'New York World' on the first day of the twentieth century. Harmsworth decided to print it in a smaller size and the tabloid size was born.

In 1897, G W Stevens was sent to Germany by Harmsworth to write a 16-part series called 'Under the Iron Heel'. In 1900 when Harmsworth wrote a Daily Mail editorial predicting that Britain would be beaten by

Germany in a war, he was regarded as a warmonger.

Our type is set by machinery, and we can produce many thousands of papers per hour cut, folded and if necessary with the pages pasted together. It is the use of these new inventions on a scale unprecedented in any English newspaper office that enables the Daily Mail to effect a saving of from 30 to 50 per cent and be sold for half the price of its contemporaries. That is the whole explanation of what otherwise appears a mystery. The Daily Mail (4th May, 1896)

The New Journalism had arrived, and the Daily Mail under Alfred Harmsworth for whom I worked was its founder and pioneer. There were violent critics of this new type of journalism. They thought it vulgar, trashy, and lacking altogether in the dignity of the old-time Press. But Alfred Harmsworth knew what he was doing, and did it with genius. He knew that a public had grown up which took an intelligent interest in things not previously considered part of newspaper chronicles. Food; fashions; the drama of life in low places as well as high; sport of all kinds; the human story wherever it might be found; the adventure of science as it affected everyday life. Harmsworth knew that women's interests had been left out mainly from the old fashioned newspapers, and he knew that here was an enormous field for increasing circulation. Philip Gibbs, a journalist who started working for the Daily Mail in 1902.

Desperate to make his paper the official paper of the British Army, Harmsworth ensured that 10,000 copies of the Daily Mail were delivered by military cars to the Western Front. In August 1914 he also offered to pay front line soldiers to write articles on their experience.

Lord Kitchener has starved the army in France of high-explosive shells. The admitted fact is that Lord Kitchener ordered the wrong kind of shell - the same kind of shell which he used largely against the Boers in 1900. He persisted in sending shrapnel - a useless weapon in trench warfare. He was warned repeatedly that the kind of shell required was a violently explosive bomb which would dynamite its way through the German trenches and entanglements and enable our brave men to advance in safety. This kind of shell our poor soldiers have had has caused the death of thousands of them. Lord Northcliffe, The Daily Mail (21st May, 1915)

This attack on a national hero caused the circulation of the Daily Mail to plummet from 1,386,000 to 238,000 overnight. A banner stating *'The Allies of the Huns'* was hung over the Daily Mail nameplate, and even 1,500 members of the Stock Exchange passed a motion against *'venomous attacks of the Harmsworth Press'* and then burnt copies of the paper. Herbert Asquith, the leader of the government, joined in and accused both Northcliffe and his newspapers of disloyalty, but then privately agreed there was a problem and appointed David Lloyd George to the new position of Munitions Minister.

The Gallipoli campaign, which had began on 12th April 1915, caused yet more criticism, *'forty thousand killed, missing or drowned; three hundred millions of treasury thrown away. . . To win this war, the German line itself must be broken'.*

Northcliffe continued attacking Horatio Herbert Kitchener, Lord Kitchener, and when he was lost at sea on 5th June 1916, whilst travelling on the cruiser, Hampshire, which struck a mine and sank, remarked, *'The British Empire has just had the greatest stroke of luck in its history.'*

Following Kitchener's death Northcliffe turned his attention to getting Herbert Asquith removed, claiming that he was inactive and that Germany was afraid of David Lloyd George becoming prime minister.

The daily losses in the war, on ordinary days, where there is no attempt to advance, are about 2,000, according to official casualty lists. We are growing callous about the size of the daily lists of killed, wounded and missing. Very few people read even the headings of them, comparatively few grasp the fact that after vast losses we are just where we were six months ago on our little line in the Franco-Belgian Frontier. Thousands of homes are mourning today for men who have been needlessly sacrificed. Lord Northcliffe, The Daily Mail, 23rd August, 1915

The most decisive success at the Dardanelles would settle nothing in Flanders and would hardly affect the German resolve. To win this war, the German line must itself be broken and the German masses hurled back. Upon that task we must concentrate all our strength and not dissipate it in half a dozen different directions. Lord Northcliffe, The Daily Mail, 3rd September, 1915

Every article that is received from you is submitted to me; but the censor 'kills' an immense amount of matter. The articles from you are 'killed' I put before important members of the Cabinet, either verbally or in your writing, so that nothing is wasted. Lord Northcliffe, letter to Hamilton Fyfe, who was reporting on the Eastern Front for the Daily Mail, 1917

When the War was over, Northcliffe returned to his interest in new technology and the Daily Mail sponsored the world's first wireless concert.

Once before the Daily Mail stirred the national imagination to realise the vital importance of flying. It has now taken the lead in private wireless experiments with the object of cultivating national receptivity for the new science and of bringing minds in train for achievements to come.

The appeal of wireless to human interest is that it seems magical and yet is real. In attempting the control of electrical energy we begin to get on terms with the world-force on which the future of mankind - for construction or destruction - will depend. The objective of such (wireless) experiments as the Daily Mail has initiated and intends to continue is to enable this country to take the

lead. The only safe place is in front. Lord Northcliffe, The Daily Mail, 16th June, 1920
SEE Harmsworth, Alfred/ Hugin/ Newspapers/ St Peter's village sign/ Thatched House

DAILY MIRROR

In 1903 Alfred Harmsworth put Kennedy Jones in charge of his next project at 2 Carmelite Street, off Fleet Street, London - The Daily Mirror: *'the first newspaper for gentlewomen'* written by women and edited by a woman. A total of £100,000 was spent on publicity, including a free gift of gilt and enamel mirrors. (Incidentally, why is it always a 'free gift'? What other type of gift is there?). The news was condensed into very brief paragraphs and into single sentence captions in the 'Today's News at a Glance' box.

Came down to the Mirror office and found Kennedy Jones in full swing, and after the usual pangs of childbirth produced the first copy at 9.50 p.m. It looks a promising child, but time will tell if we are on a winner or not. Alfred Harmsworth, diary entry (1st November, 1903)

It was a monumental failure. On the first day, 2nd November 1903, circulation was at 276,000, but dropped to 24,000 in January 1904, by which time he was losing £3,000 a week.

He sacked his female editor Mary Howarth, *'women can't write and don't want to read'.*, replacing her with Hamilton Fyfe, and in January 1904 it was re-launched as the Daily Illustrated Mirror with photojournalists sent all over the world.

I was shown into a small room where an extremely pretty girl sat typing letters. Then I saw that in the doorway stood a youngish man, rather heavily built, with fair hair that swept in a wave over his forehead, massive features, and penetrating blue eyes. Just now his eyes were smiling. 'Come in,' he said, his tone was friendly.

For a few minutes we talked about the Advertiser. He seemed to know that I had little money to spend, that my relations with the Board were strained. After this he looked hard at me. 'How would you like to come on to one of my papers?' he asked.

Suppressing an impulse to take his hands, lift him out of his chair, and whirl him in a wild dance round the room, I said quietly: 'That depends on what arrangement we could make.' He pressed a bell. A small boy in uniform appeared. 'Ask Mr. Kennedy Jones to come down for a moment,' Harmsworth said. We went on talking, and I succumbed at once to the fascination he was to exercise over me for nearly twenty years.

Kennedy Jones came in. A totally different type of man, no charm of manner or expression - until he smiled. Coarsely moulded features, stiff black hair, rather a lazy way of moving, but a man who directly he spoke radiated acute intelligence. He shook hands in an uninterested sort of way, and sprawled on the Chesterfield lounge. Harmsworth frowned. 'I want somebody to take over the Daily Mirror,' he said, and showed that he had to make an effort to say

it. His failure, the first bad one he had known, hurt him. 'It won't do as a paper for women,' Harmsworth went on. 'It's taught me two things - that women can't write and don't want to read. But we've got to do something with it. I should like to see what you can do.' Hamilton Fyfe, November 1903, after Alfred Harmsworth invited Hamilton Fyfe, editor of the Advertiser, to meet him at Carmelite House.

Hamilton Fyfe set about changing it into a picture paper for both men and women. Sales multiplied by seven within a month.

On 2nd April 1904 Fyfe tried publishing a whole front page of photographs of Edward VII and his children Henry, Albert and Mary. The newspapers' and the public's fascination with the Royal family thus began. Harmsworth's papers started to sponsor events. The Daily Mirror paid D M Weigal to drive a 20 horse power Talbot car on a 26,000 mile journey in June 1904. In July they offered a 100 guinea prize to the first person to swim the Channel.

Owing to much good luck and many loyal co-workers, the Daily Mirror is, up to the present, the only journalistic failure with which I have been associated.

Disaster may often be changed to triumph by alteration in tactics. The faculty of knowing when you are beaten is much more valuable than the faculty of thinking you are not beaten when you are. I had for many years a theory that a daily newspaper for women was in urgent request, and I started one. The belief cost me £100,000. I found out that I was beaten. Women don't want a daily paper of their own.

It was another instance of the failures made by a mere man in diagnosing women's needs. Some people say that a woman never really knows what she wants. It is certain she knew what she didn't want. She didn't want the Daily Mirror. I then changed the price to a halfpenny, and filled it full of photographs and pictures to see how that would do. It did. Alfred Harmsworth, in an article in The Daily Mirror (27th February, 1904)

The first 'exclusive' appeared in the Daily Mirror in August 1905; an interview with the new Viceroy of India, Lord Minto. This and similar exclusives increased the circulation to 350,000 by the end of the year.
SEE Harmsworth, Alfred/ Mods and Rockers/ Newspapers

DAIRY FARMS
In 1957 there were 7 dairy farms listed in Thanet. In 2005 none are listed.
SEE Coal/ Farms/ Sharps Dairy/ Thanet/ Thanet Farm Dairy

DALBY SQUARE, Cliftonville
Alderman Thomas Dalby Reeve was a local businessman and this square was developed and laid out by him in 1865. It was originally to be called Montpelier Square but in the end was named after him.
New College, a boarding school for boys, was situated at 16 Dalby Square in the late nineteenth century, but in 1936 it was listed as the Cliftonville Club.

The Cliftonville Hotel was built in 1868 at Ethelbert Crescent and Dalby Square.
In an air raid on 1st June 1943 Warrior House in Dalby Square suffered a direct hit killing several soldiers that were billeted there.
The Dalby Square Project was launched in 2002. Within 18 months, £137,000 had been raised. A combination of fund-raising; successful lottery grant applications; monies from the Thanet Community Development Trust and hard work meant that by 2006, £500,000 enabled plants, benches and railings to transform a community garden, as well as providing recycling facilities and a children's playground.
SEE Cliftonville/ Cliftonville Hotel/ Schools/ Wheatley, Dennis

DAMBUSTERS
In contrast to its usual tranquility, Reculver was used in April 1943 for the testing of the dambuster bombs. Kent police received the order to cordon off a square mile to the east of Reculver Towers at the end of March, and the first trial took place on Friday 11th April 1943. A few Lancaster bombers practised dropping an experimental bouncing bomb that would skim along the water and explode when it hit the wall of the dam. They were observed by some top brass from the RAF, Wing Commander Guy Gibson (who was going to lead the raid), Bob Hay (617 Squadron's bombing leader), and Dr Barnes Wallis, the inventor of this bouncing bomb, who had been inspired whilst watching his sons skim stones across the sea. Police patrolled the perimeter area, but no more than thirty people knew of the plan. Reculver's twin towers were the release point for the bombs, as they were similar to the towers at Moehne. They would be a crucial landmark in navigating the area and in targetting where to drop the bomb in the final approach.
On this first trial when the bomb hit the water, instead of bouncing, it broke up. Gibson and Hay returned to their base in Lincolnshire. Along the way, however, whilst flying at 3,000 feet over Margate, the engine in their Miles Magister failed and the plane hit a tree as it crash-landed. Amazingly, they were both unhurt but a local doctor who checked them over commented, *'It's a shame they make you fellows fly so young'*. Now you're probably worried about what happened to the poor bomb aren't you? Well, like Humpty Dumpty, they picked up the pieces and took them back to a heavily-guarded hangar at Manston, where, amongst lots of head scratching, two things were altered. The outside casing was strengthened and the height at which it was to be dropped was lowered from 150 feet to just 60 feet. Test two took place, with two Lancaster bombers flying from the east, one with the bomb and the other with a slow-motion camera. Fragments still came off the bomb, but it did bounce. Wallis was still not satisfied though.
Wallis improved the bomb for the third trial on Thursday 29th April so that it spinned as it left the aircraft. Shorty Longbottom (there's

a name to treasure!) was the pilot who flew the Lancaster at 250mph and saw the bomb successfully bounce through the marker buoys that represented the dam. As he swung around he saw an excited Barnes Wallis jumping up and down and waving his hat in the air. It was not the only time he was seen dancing up and down. One bomb went slightly astray, hit a breakwater, flew over the heads of those watching and landed by the Roman ruins. Gibson then had a go, before he left with two other pilots for Manston where they ran some more tests.
The last trial here was at seven o'clock on the morning of 16th May 1943 and the actual raid took place, successfully, later that night. Led by Guy Gibson, 617 Squadron left from Scampion in Lincolnshire for the target.
'Wing Commander Gibson, whose personal courage knew no bounds, was quickly recognised to be an outstanding operational pilot and leader. He served with conspicuously successful results as a night bomber pilot and also as a night fighter pilot, on operational tours. In addition, on his 'rest' nights he made single-handed attacks on highly defended objectives such as the German battleship Tirpitz. Wing Commander Gibson was then selected to command a squadron formed for special tasks. Under his inspiring leadership this squadron executed one of the most devastating attacks of the war - the breaching of the Moehne and Eder dams. Wing Commander Gibson personally made the initial attack on the Moehne dam. Descending to within a few feet of the water, he delivered his attack with great accuracy. He then circled very low for thirty minutes, drawing the enemy fire and permitting as free a run as possible to the following aircraft. He repeated these tactics in the attack on the Eder dam. Throughout his operational career, prolonged exceptionally at his own request, he has shown leadership, determination and valour of the highest order.' The London Gazette, 27th May 1943
The raid involved 19 Lancaster bombers with only 8 returning and the loss of 53 out of the 133 crew. The dams that the busters bust were the Eder, Moehne and Sorpe concrete dams (although the latter remained intact). It took five attempts to bust the Moehne dam, which caused thirty miles of the Western Ruhr valleys to be flooded with 300 million tons of water. To put this into perspective, if you took all the water that passes down the Thames in a day and multiplied that by thirty, that represents how much water poured out, destroying 125 factories, 25 bridges, coalmines and 3,000 hectares of arable farming land. Also, 1,294 people were drowned. After the raid, Barnes Wallis cried at the loss of life his bomb had caused.
The film of these events 'Dambusters', starring Richard Todd, opened in London on 16th May 1955. On the 60th anniversary of the raid it was estimated that a crowd of about 10,000 watched from the coastline as the last Lancaster bomber flew a fly-past tribute.
Some of the bombs used in the tests at Reculver were cleared away using an

American Jolly Green Giant Helicopter in May 1982. You can't rush these things
SEE Gibson, Guy/ Manston Airport/ Reculver/ Wallis, Barnes/ World War II

DAME JANET JUNIOR SCHOOL
Newington Road, Ramsgate
Named after its benefactor, it was opened by the Ramsgate Mayor, Alderman Florence Dunn JP, on 29th September 1933.
SEE Drays/ Newington Road/ Ramsgate/ Schools/ Stancomb-Wills, Dame Janet

Lady D'AMELAND
She was King George III's daughter-in-law, being married to Augustus, Duke of Sussex, and lived at Mount Albion House, Ramsgate.
SEE George III/ Mount Albion House

DANDY COONS
The 'Dandy Coons' were a troupe that performed on Margate beaches around a century ago. They were white men who blackened their faces with burnt cork, and then performed as black minstrels. The forming of a modern-day tribute band is unlikely.
SEE Beach Entertainment, Margate/ Entertainers/ Margate

DANE COURT, Broadstairs
Kent's Topographer by W H Ireland 1828:
Dane Court, situated in a valley, a short distance west of the church of St Peter, was once accounted a manor, where, in early times, stood a gentleman's seat; this estate giving to that mansion and a family the name of Dane. The custom of gavilkind, however, having divided this estate between two branches, one having an only daughter, Margaret, married to John Exeter, about the close of the reign of Henry IV, she, in her own right, being a widow, held this manor at her death, in the 4th of Henry VI, after which the fee became vested in Nicholas Underdowns, who died possessed of it, in the 2d of Richard III AD1484. Having left two sons, Nicholas and Richard, to the former he devised this manor, which one of his descendants, in the time of Henry VIII sold to Richard Norwood, who, as well as his successors, resided here. In the reign of Charles II, Richard Norwood, a descendant of the above, devised this manor to his second son Paul, who, in 1666, alienated it to Richard Smith, from whom it descended to his nephew Robert, who, in 1686, sold it to John Hammond, of Deal. This latter possessor having several sons, they being his heirs in gavelkind, joined in the conveyance of the manor to Peter Bridger, who, having two daughters, Dane Court was devised to the elder, when it was enjoyed by her husband, Gabriel Neve, until he sold it to Richard Sacket of Northdowne, who, by will, devised it to his granddaughter Sarah, wife of Robert Tomlin, when the latter gentleman became owner of the same.
Dane Court Manor House was the home of many of the major families of Thanet: Norwood (Northwood), Sackett and Tomlin.
It had a Georgian exterior although the building dated back 900 years, evolving from

a Saxon settlement. When Dane Court was let in 1860 the advert said *'WCs both upstairs and downstairs'* - a very 'mod con' at the time. The old house and the new school did overlap in existence for a few years, but house developers demolished it in 1959.
SEE Broadstairs/ Dane Court Gardens/ Northwood/ St Peter's Church

DANE COURT GARDENS, Broadstairs
It was built on the site of the old Dane Court estate; Little Court was on the edge of it.
SEE Broadstairs/ Dane Court

DANE COURT ROAD, St Peter's
Runs from the roundabout junction with Westwood Road, Broadstairs Road and Vicarage Street at the Broadstairs end, and continues on from St Peter's Road at the Margate end. At the point where the roads change name is the old border between Margate and Broadstairs which also ran along Sloe Lane footpath on the Margate side and Broadley Road on the Dane Valley side.
SEE Broadstairs/ Sacketts Hill Farm/ St Peter's/ St Peter's Road, Margate

DANE COURT SCHOOL
Broadstairs Road, Broadstairs
It was opened in 1957 at a cost of £189,000 by Dame Dorothy Black. It was originally separated into a girls' and a boys' school called the Dane Court Technical High School, and placed emphasis on teaching the science subjects.
The school badge incorporates part of the crest of the Northwood family who once owned the Dane Court estate. The Dane Court Manor House, in which grounds Dane Court Gardens are now situated, was pulled down a couple of years later but did overlap in existence, albeit briefly. Now it is known as Dane Court Grammar School.
SEE Broadstairs/ Broadstairs Road, Broadstairs/ Dane Court, Broadstairs/ Northwood/ Schools

DANE PARK, Margate
We need to get into the time machine for this bit. It's alright, you can remain where you are, it works a bit like Neverland in that all you have to do is believe in it, and you will go there - I sense that there are non-believers out there, but we're going anyway.
We need to travel back to Wednesday 1st June 1898 and land outside Margate Railway Station where a huge crowd is gathering. Inside, are the Mayor of Margate, Councillor G F Brown JP, looking splendid in his robe and chain, the Lady Mayoress, the Town Clerk, the Borough Recorder, the aldermen, the other councillors, and John Woodward, a member of an old Margate family, who bought 33 acres of farmland at auction in 1895 and presented the Borough with the land for use as a public park the following year. After two years of landscaping the great and the good are now congregated in the waiting room that has been decorated and carpeted especially for the occasion. As a special train pulls into the station they walk through the main area of the station, also carpeted for the day, so that they can greet

the day's guest of honour, the Lord Mayor of London, Colonel H D Davies MP. He has brought with him his Lady Mayoress, and officials including the Sheriff, City Marshall, Sword Bearer, and Mace Bearer. The band of the Royal Marines, a detachment of the 10th Hussars is also there. Stepping out onto the carpeted platform decorated with ferns, the band of the No.7 Company (Margate), 1st Cinque Ports Artillery Volunteers are playing 'The March of Scipio', and the rest of the men of that company form a guard of honour and present arms. The big wigs then get into a state carriage drawn by four bays, and will be followed by thirty other carriages, as well as the troops of soldiers, as they leave for Dane Park. The whole route is decorated. Every few yards banners are hung from scarlet-coloured Venetian masts with gilt spiked tops; ornamental shields hold five flags just above head height, and bunting is festooned from pole to pole. Virtually every house and business along the route has been decorated; some with the City of London motto, 'Domine Dirige Nos', and others 'Welcome to Margate the queen of health resorts'. The coastguard flagstaff opposite the station is richly decorated with flags up to the top and back down again, and flags and shields are hung from the clock tower. Along Marine Drive, Margate Fire Brigade use various ladders to form an arch decorated with flags, with firemen all over it to greet the procession as it passes beneath.
At Dane Park there is a crowd of 7,000 to see a pond over which was a rustic bridge, a lodge, cricket pavilion, a bandstand where the Band of the Scots Fusiliers played, a summer house, tennis courts, lakes and rockeries.
In future years the outer grass track was used for cycling and trotting. There was a fete held every year, regular firework displays and plays performed on an open-air stage. The popularity of the park was short-lived and by the beginning of World War I most of the entertainments had been moved to other sites in Margate; by the 1930s the refreshment rooms and the bandstand had been demolished.
Margate Bowling Club's new green opened in here 1909.
In 1911 the peacocks in the park were evicted for making too much noise (this was before ASBOs).
Three bombs landed in Dane Park during the Gotha raid on the night of 30th September 1917.
Just after the war some of the park was given over to allotments; in 1960 the lake was filled in, and twenty years later the Dane Park Café was demolished.
SEE Cinque Ports/ Coastguards/ Farms/ Gotha raid/ Houchin, Alan/ Margate/ Marine Drive/ Parks

DANE VALLEY ARMS public house
Dane Valley Road, Cliftonville
In 1929, after the success of the King Edward public house down the road, Thompson and Son Ltd of Deal (the name is still in the bar windows) invested £10,000 on a brand new pub called the Station Hotel

because they thought that a new railway station to be called Cliftonville Halt was going to be built nearby. How they must have laughed when they discovered it was not. So, with the letting rooms upstairs totally redundant and then virtually surrounded by open farmland, The Dane Valley Arms opened probably more in hope than anything else. It was not until after the war that the housing estate was built, although by the time trade got going, it had become a Charrington pub. It was renovated in 1980. If the railway station had been built the whole area would certainly be very different than it is today.

SEE Cliftonville/ Farms/ King Edward VII public house/ Pubs

Charles DARWIN
Born 12th February 1809
Died 19th April 1882
He was the naturalist who accompanied Admiral Fitzroy on The Beagle.

The Life and Letters of Charles Darwin, Voyage of the 'Beagle' – 27th December 1831 to 2nd October 1836, Charles Darwin: *On returning home from my short geological tour in North Wales, I found a letter from Henslow, informing me that Captain Fitz-Roy was willing to give up part of his own cabin to any young man who would volunteer to go with him without pay as naturalist to the Voyage of the 'Beagle'. . . I will here only say that I was instantly eager to accept the offer, but my father strongly objected, adding the words, fortunate for me, 'If you can find any man of common sense who advises you to go I will give my consent.' So I wrote that evening and refused the offer. On the next morning I went to Maer to be ready for September 1st, and, whilst out shooting, my uncle [Josiah Wedgwood.] sent for me, offering to drive me over to Shrewsbury and talk with my father, as my uncle thought it would be wise in me to accept the offer. My father always maintained that he was one of the most sensible men in the world, and he at once consented in the kindest manner. I had been rather extravagant at Cambridge, and to console my father, said, 'That I should be deuced clever to spend more than my allowance whilst on board the 'Beagle';' but he answered with a smile, 'But they tell me you are very clever.'*

Next day I started for Cambridge to see Henslow, and thence to London to see Fitz-Roy, and all was soon arranged. Afterwards, on becoming very intimate with Fitz-Roy, I heard that I had run a very narrow risk of being rejected, on account of the shape of my nose! He was an ardent disciple of Lavater, and was convinced that he could judge of a man's character by the outline of his features; and he doubted whether any one with my nose could possess sufficient energy and determination for the voyage. But I think he was afterwards well satisfied that my nose had spoken falsely.

Fitz-Roy's character was a singular one, with very many noble features: he was devoted to his duty, generous to a fault, bold, determined, and indomitably energetic, and

an ardent friend to all under his sway. He would undertake any sort of trouble to assist those whom he thought deserved assistance. He was a handsome man, strikingly like a gentleman, with highly courteous manners, which resembled those of his maternal uncle, the famous Lord Castlereagh, as I was told by the Minister at Rio. Nevertheless he must have inherited much in his appearance from Charles II., for Dr. Wallich gave me a collection of photographs which he had made, and I was struck with the resemblance of one to Fitz-Roy; and on looking at the name, I found it Ch. E. Sobieski Stuart, Count d'Albanie, a descendant of the same monarch.*

Fitz-Roy's temper was a most unfortunate one. It was usually worst in the early morning, and with his eagle eye he could generally detect something amiss about the ship, and was then unsparing in his blame. He was very kind to me, but was a man very difficult to live with on the intimate terms which necessarily followed from our messing by ourselves in the same cabin. We had several quarrels; for instance, early in the voyage at Bahia, in Brazil, he defended and praised slavery, which I abominated, and told me that he had just visited a great slave-owner, who had called up many of his slaves and asked them whether they were happy, and whether they wished to be free, and all answered 'No.' I then asked him, perhaps with a sneer, whether he thought that the answer of slaves in the presence of their master was worth anything? This made him excessively angry, and he said that as I doubted his word we could not live any longer together. I thought that I should have been compelled to leave the ship; but as soon as the news spread, which it did quickly, as the captain sent for the first lieutenant to assuage his anger by abusing me, I was deeply gratified by receiving an invitation from all the gun-room officers to mess with them. But after a few hours Fitz-Roy showed his usual magnanimity by sending an officer to me with an apology and a request that I would continue to live with him.

His character was in several respects one of the most noble which I have ever known.

. . . That my mind became developed through my pursuits during the voyage is rendered probable by a remark made by my father, who was the most acute observer whom I ever saw, of a sceptical disposition, and far from being a believer in phrenology; for on first seeing me after the voyage, he turned round to my sisters, and exclaimed, 'Why, the shape of his head is quite altered.'

. . . On September 11th (1831), I paid a flying visit with Fitz-Roy to the 'Beagle' at Plymouth. Thence to Shrewsbury to wish my father and sisters a long farewell. On October 24th I took up my residence at Plymouth, and remained there until December 27th, when the 'Beagle' finally left the shores of England for her circumnavigation of the world. We made two earlier attempts to sail, but were driven back each time by heavy gales. These two months at Plymouth were the most miserable which I

ever spent, though I exerted myself in various ways. I was out of spirits at the thought of leaving all my family and friends for so long a time, and the weather seemed to me inexpressibly gloomy. I was also troubled with palpitation and pain about the heart, and like many a young ignorant man, especially one with a smattering of medical knowledge, was convinced that I had heart disease. I did not consult any doctor, as I fully expected to hear the verdict that I was not fit for the voyage, and I was resolved to go at all hazards.*

Letter from Charles Darwin, to J.D. Hooker, Norfolk House, Shanklin, Isle of Wight, August 1858: *You speak of going to the sea-side somewhere; we think this the nicest seaside place which we have ever seen, and we like Shanklin better than other spots on the south coast of the island, though many are charming and prettier, so that I would suggest you're thinking of this place. We are on the actual coast; but tastes differ so much about places.*

If you go to Broadstairs, when there is a strong wind from the coast of France and in fine, dry, warm weather, look out, and you will PROBABLY (!) see thistle-seeds blown across the Channel. The other day I saw one blown right inland, and then in a few minutes a second one and then a third; and I said to myself, God bless me, how many thistles there must be in France; and I wrote a letter in imagination to you. But I then looked at the LOW clouds, and noticed that they were not coming inland, so I feared a screw was loose. I then walked beyond a headland, and found the wind parallel to the coast, and on this very headland a noble bed of thistles, which by every wide eddy were blown far out to sea, and then came right in at right angles to the shore! One day such a number of insects were washed up by the tide, and I brought to life thirteen species of Coleoptera (beetle); not that I suppose these came from France. But do you watch for thistle-seed as you saunter along the coast . .

SEE Broadstairs/ Fitzroy, Admiral Robert

Bromley DAVENPORT
Born Warwickshire, 29th October 1867
Died London, 15th December 1946
He was an actor who learnt his trade from Sarah Thorne at the Theatre Royal, Margate. He made over seventy films including 'Old Mother Riley's Ghosts' (1941) and 'Jamaica Inn' (1939).

SEE Actors/ Theatre Royal

DAVID COPPERFIELD restaurant
Westwood Road, Broadstairs
This Brewers Fayre pub/restaurant, opened in March 2002.

SEE Broadstairs/ Pubs/ Restaurants

'DAVID COPPERFIELD'
by Charles Dickens
Much of this novel by Charles Dickens was written in Broadstairs.

I had not walked out far enough to be quite clear of the town, upon the Ramsgate road, where there was a good path, when I was

hailed, through the dust, by somebody behind me. The shambling figure and the scanty great-coat, were not to be mistaken. I stopped, and Uriah Heep came up.
SEE Andersen, Hans Christian/ Betsey Trotwood/ Books/ Broadstairs/ Copperfield Court/ Dickens House/ Dickens, Charles/ Donkeys/ Fort House/ Ramsgate

DAVID GREIG
This was a family-run butchers and then a supermarket chain that virtually collapsed when several elderly members died in quick succession incurring heavy death duties.
SEE Sausages/ Shops

DAVID POTTON MENSWEAR
High Street, Broadstairs
Following the death of the owner in December 2003, the David Potton menswear shop closed in 2004 after 30 years in business.
SEE Broadstairs/ High Street, Broadstairs/ Shops

Jim DAVIDSON
Born London 13th December 1953
Stand-up comedian and one-time host of the BBC series 'The Generation Game', he is almost as famous for being married four times as he is for his work.
SEE Entertainers/ Winter Gardens

Edmund DAVIS
A millionaire financier, he lived at St Peter's Cottage in Sowell Street, St Peter's. He paid for the gardens to be laid out in front of the Granville Hotel, Ramsgate. Both he and the cottage are, however, long gone.
SEE East Cliff Promenade/ Ramsgate/ St Peter's/ Sowell Street/ Westgate-on-Sea

Benedict DE BAR
Born London 5th November 1812
Died St. Louis, Missouri, 14th August 1877
He made his stage debut at the Theatre Royal, Margate, in 1832, but found his fame and fortune in America as an actor manager and theatre owner in New York and New Orleans.
SEE Actors/ Theatre Royal

DEAL CUTTER public house
King Street, Ramsgate
Deal Cutters were boats built and designed in Deal, famed for their strength and ability to stand up to the worst weather. There was fierce rivalry between the owners of these boats and the local Ramsgate boats, so it is somewhat surprising to find a pub with this name in Ramsgate. The Deal Cutter pub dates back to the early part of the 18th century and the original building stood about five feet further back (see the shop fronts on the King Street-Brunswick Street corner). The ghost of Isaac Jarman, coxswain of the Ramsgate lifeboat (from 1860-70) and a former landlord, has apparently appeared in the cellar. Mysteriously, a jug with 'D.O.L.F.I.' inscribed on it and containing foul-tasting orange-brandy, once appeared in the cellar.
SEE King Street, Ramsgate/ Lifeboat, Ramsgate/ Pubs/ Ramsgate/ Shipbuilding

DEARDEN'S PICTURE GALLERY
Northdown Road, Cliftonville
The gallery closed after more than half a century, when Bill Dearden retired at the age of 88 in February 2000. The shop once held the world's largest stock of Lowry, Russell Flint and other artists' limited edition prints. He produced the 'Dearden List' that was used by collectors of limited editions.
SEE Artists/ Cliftonville/ Northdown Road/ Shops

Geoffrey DEARMER
Born 21st March 1893
Died 18th August 1996
He fought in France and Gallipoli in World War I, and was a war poet. His brother died at Gallipoli in 1915, and his mother, who was a nurse, died in Serbia, also in 1915. Having survived the First World War he lived to the ripe old age of 103 and died in Birchington.
He became the Poetry Society's oldest member and in his memory The Geoffrey Dearmer Prize for poetry was established in 1997.
SEE Birchington/ Poets/ World War I

DECKCHAIRS
Deckchairs were introduced in 1900 although chairs on the beach were not unheard of beforehand. In the 1890s, the local chair lady, Ester Kenny together with her neighbours, brought down hard wooden seats from their kitchens and bedrooms and hired them out to visitors for 1d each. During this time Edwin Atkins brought six deckchairs with him when he came down on holiday. He was a chair maker in London who supplied deckchairs to the P&O liners which sailed from Tilbury. When he returned home he left the chairs with his landlady in Eaton Road, Margate. Such was their popularity that the next year he came back with another hundred he had made in his factory.
Later, a local entrepreneur called Perkins built up a deckchair empire to 2,000 which he hired out for 1d for 2 hours. His operation continued to grow, but in 1919 the local authority decided they would like this lucrative business and without giving any compensation to Perkins, they took over the foreshore rights!
SEE Eaton Road/ Margate/ Thomas, Terry

Daniel DEFOE
Born 1660
Died April 1731
He was plain old Daniel Foe, the son of a candle merchant, until he was about forty years old at which time he added the then trendy 'de' prefix to his surname.
Daniel Defoe 1723: *'Bradstow is a small fishing hamlet of some 300 souls, of which 27 follow the occupation of fishing, the rest would seem to have no visible means of support! I am told that the area is a hot bed of smuggling. When I asked if this was so, the locals did give me the notion that if I persisted in this line of enquiry some serious injury might befall my person.'*

Daniel Defoe, 'Tour Through the Whole Island of Great Britain' (1724-6): *Ramsgate, a small port, the inhabitants are mightily fond of having us call it Roman's-Gate; pretending that the Romans under Julius Caesar made their first attempt to land here, when he was driven back by a storm.*
SEE Authors/ Bradstow/ Ramsgate/ Smuggling

Alfred DELLER
Born 1912
Died 1979
The famous counter tenor was born in Margate and began as a chorister at St John's Church before singing in Canterbury Cathedral. In 1943, Michael Tippet (born 2nd January 1905; died 8th January 1998, England's foremost composer of the twentieth century) launched his singing career when he invited Alfred to sing in London. He was famous for singing the works of Purcell, and for creating the role of Oberon in Britten's opera 'A Midsummer Night's Dream' in 1960.
SEE Margate/ Music/ St John's Church

DENMARK
SEE Alexandra, Princess/ Alexandra Road/ Andersen, Hans Christian/ Coke Riot/ Droit/ Fry, Elizabeth/ Hugin/ Jutes/ King of Denmark/ Lifeboat, Ramsgate/ Pugin, EW/ San Clu Hotel/ Sweyn/ Twinning/ Voss, Capt

DENT-de-LION, Garlinge
There are various ways to spell its name, including Daundelyon, and a John Daundelion was buried at Margate's St Johns Church in 1445. One of the bells there had the inscription, *'John de Daundelion with his dog, brought over this bell on a mill-cog'.*
Dent de Lion (it means 'lion's teeth' in French – that's why they used the French version) was a small fortified manor with battlements, built of brick and flint dating from the 14th century.
There was a windmill at Dent-de-lion in 1610. 'Dandelion' was the site of the Dandelion pleasure gardens in Garlinge, renowned for its bowling green, dancing music and public breakfasts.
In the early 19th century Dent-de-lion Pleasure Gardens was popular with visitors who travelled there in horse brakes. In 1804 The Times reported a gathering of 700 people - today that would be described as a rave. At one stage the estate was owned by Charles James Fox.
Pigots 1840: *The remains of 'Dandelion' a fortified mansion of a family of that name in the reign of Edward I, stand about a mile and a half to the south west of the town* (Margate)*; the gate house flanked with four towers is still in good preservation.*
By the 1850s most of it had been turned back into farmland. The gatehouse is all that remains today after a fire destroyed the mansion and farm buildings that surrounded it in 1888.
In April 1943 during World War II, as part of the D-day preparations tanks were stationed in the wooded area of Dent-de-lion.
SEE Farms/ Fires/ Fox, Charles James/ Garlinge/ Hops/ Lawrence, Carver/ St John's Church/ Tales

of the Hoy/ Tanks/ Windmills/ Wolcot, John/ World War II

DERBY ARMS HOTEL
Margate Road, Ramsgate
Named after the 14th Earl of Derby, Edward George Stanley, an MP who liked his horseracing. The earliest mention of the hotel is in 1849.

It was once run by Frank Muir's grandparents, Charles and Margaret; Frank was born here and spent much of his childhood here. In March 2006 a plaque was put up in the bar to commemorate Frank Muir.

SEE Hotels/ Margate Road, Ramsgate/ Muir, Frank/ Pubs/ Ramsgate

DERRY & TOMS department store
99-121 Kensington High Street
Joseph Toms and his brother-in-law Charles Derry ran this large department store in London. At the height of its popularity, they employed over 2,000 staff who lived on the premises. In 1920 it was acquired by John Baker and Company Ltd who left the name unchanged. It continued in business until 13th January 1972, since when the building has housed Biba, Marks and Spencer and British Home Stores.

Derry and Toms was also famous for its roof garden which covered one and a half acres; had 500 trees and shrubs; a stream and pink flamingos. Every year 38,000 bedding plants and 15,000 bulbs were planted.

Miss Derry, a descendent of Charles, owned Cliffs End Hall at Cliffsend.

SEE Cliffs End Hall/ London/ Shops

Mademoiselle D'ESTE
The D'Este family lived at Mount Albion House, Ramsgate.

SEE D'Este Road, Ramsgate/ Mount Albion House/ Holy Trinity Church

D'ESTE ROAD, Ramsgate
Named after the D'Este family.

SEE Mount Albion House/ Ramsgate

DESTINY, Albion Gardens, Ramsgate
This partially-clad female figure was designed and sculpted by Gilbert William Bayes. Dame Janet Stancomb-Wills presented it to the town and it was unveiled on 17th December 1920 in Albion Gardens, Ramsgate, just above the waterfall, as the Town 'Peace' Memorial to all the people and

animals who died in World War I. Bayes said that although her eyes are closed, she is looking *'beyond to a greater vision of the future'*. Wags at the time said she was watching the trams go by.

In 1968 vandals shattered it. Thanks, however, to the combined efforts of Thanet Council, the Ramsgate Society, East Court School, Ramsgate Charter Trustees, English Heritage, and Friends of the War Memorials it was restored and re-unveiled on the anniversary of its original unveiling over 80 years before.

SEE Albion Gardens/ Ramsgate/ Stancomb-Wills Dame Janet/ World War I

DEVELOPMENT of the
ISLE of THANET
The development of the Isle of Thanet came from the emergence of seaside holidays in the 1750s when Dr John Russell claimed, through a published work, that seawater cured ailments. He suggested either bathing in the sea or drinking it. Only one of these was to have a long-lasting appeal or any appeal at all. With the advent of improved roads and better and more frequent shipping links between London and Thanet, wealthy patients suddenly became keen to start visiting the extensive sandy beaches and so the Isle of Thanet became more popular.

The Margate and Ramsgate Guide in Letters to a Friend (1797): *'Streets, squares, and rows of houses, in different directions, are now to be seen, where, a few years since, the farmer sowed his corn.'*

SEE Bathing/ Farms/ Thanet

DEVON GARDENS, Birchington
Bedlam Cottage stood here from around 1600 until the late 1930s. Gilbert Hooker was listed as a fruiterer here in 1936.

SEE Birchington

'DIARY OF A NOBODY'
by G & W Grossmith
It is the fictional diary of Charles Pooter, an office clerk who has a higher opinion of himself than do those around him. During the course of the book Charles, his wife Carrie and their delightfully-named son, Lupin, take their holiday in Broadstairs, and socialize with the Cummings and the Gowings.

July 31. Carrie was very pleased with the bangle, which I left with an affectionate note on her dressing-table last night before going to bed. I told Carrie we should have to start for our holiday next Saturday. She replied quite happily that she did not mind, except that the weather was so bad, and she feared that Miss Jibbons would not be able to get her a seaside dress in time. I told Carrie that I thought the drab one with pink bows looked quite good enough; and Carrie said she should not think of wearing it. I was about to discuss the matter, when, remembering the argument yesterday, resolved to hold my tongue.

I said to Carrie: 'I don't think we can do better than 'Good old Broadstairs.'' Carrie not only, to my astonishment, raised an objection to Broadstairs, for the first time; but begged me not to use the expression, 'Good old,' but to leave it to Mr Stillbrook and other gentlemen of his type. Hearing my 'bus pass the window, I was obliged to rush out of the house without kissing Carrie as usual; and I shouted to her: 'I leave it to you to decide.' On returning in the evening,

Carrie said she thought as the time was so short she had decided on Broadstairs, and had written to Mrs. Beck, Harbour View Terrace, for apartments.

August 2. Mrs. Beck wrote to say we could have our usual rooms at Broadstairs. That's off our mind. Bought a coloured shirt and a pair of tan-coloured boots, which I see many of the swell clerks wearing in the City, and hear are all the 'go.'

August 11. Although it is a serious matter having our boy Lupin on our hands, still it is satisfactory to know he was asked to resign from the Bank simply because 'he took no interest in his work, and always arrived an hour (sometimes two hours) late.' We can all start off on Monday to Broadstairs with a light heart. This will take my mind off the worry of the last few days, which have been wasted over a useless correspondence with the manager of the Bank at Oldham.

August 13. Hurrah! At Broadstairs. Very nice apartments near the station. On the cliffs they would have been double the price. The landlady had a nice five o'clock dinner and tea ready, which we all enjoyed, though Lupin seemed fastidious because there happened to be a fly in the butter. It was very wet in the evening, for which I was thankful, as it was a good excuse for going to bed early. Lupin said he would sit up and read a bit.

August 14. I was a little annoyed to find Lupin, instead of reading last night, had gone to a common sort of entertainment, given at the Assembly Rooms. I expressed my opinion that such performances were unworthy of respectable patronage; but he replied: 'Oh, it was only 'for one night only.' I had a fit of the blues come on, and thought I would go to see Polly Presswell, England's Particular Spark.' I told him I was proud to say I had never heard of her. Carrie said: 'Do let the boy alone. He's quite old enough to take care of himself, and won't forget he's a gentleman. Remember, you were young once yourself.' Rained all day hard, but Lupin would go out.

August 15. Cleared up a bit, so we all took the train to Margate, and the first person we met on the jetty was Gowing. I said: 'Hulloh! I thought you had gone to Barmouth with your Birmingham friends?' He said: 'Yes, but young Peter Lawrence was so ill, they postponed their visit, so I came down here. You know the Cummings' are here too?' Carrie said: 'Oh, that will be delightful! We must have some evenings together and have games.'

I introduced Lupin, saying: 'You will be pleased to find we have our dear boy at home!' Gowing said: 'How's that? You don't mean to say he's left the Bank?'

I changed the subject quickly, and thereby avoided any of those awkward questions which Gowing always has a knack of asking.

August 16. Lupin positively refused to walk down the Parade with me because I was wearing my new straw helmet with my frock-coat. I don't know what the boy is coming to.

August 17. Lupin not falling in with our views, Carrie and I went for a sail. It was a relief to be with her alone; for when Lupin irritates me, she always sides with him. On our return, he said: 'Oh, you've been on the 'Shilling Emetic,' have you? You'll come to six-pennorth on the 'Liver Jerker' next.' I presume he meant a tricycle, but I affected not to understand him.

August 18. Gowing and Cummings walked over to arrange an evening at Margate. It being wet, Gowing asked Cummings to accompany him to the hotel and have a game of billiards, knowing I never play, and in fact disapprove of the game. Cummings said he must hasten back to Margate; whereupon Lupin, to my horror, said: 'I'll give you a game, Gowing—a hundred up. A walk round the cloth will give me an appetite for dinner.' I said: 'Perhaps Mister Gowing does not care to play with boys.' Gowing surprised me by saying: 'Oh yes, I do, if they play well,' and they walked off together.

August 19, Sunday. I was about to read Lupin a sermon on smoking (which he indulges in violently) and billiards, but he put on his hat and walked out. Carrie then read me a long sermon on the palpable inadvisability of treating Lupin as if he were a mere child. I felt she was somewhat right, so in the evening I offered him a cigar. He seemed pleased, but, after a few whiffs, said: 'This is a good old tup'ny - try one of mine,' and he handed me a cigar as long as it was strong, which is saying a good deal.

August 20. I am glad our last day at the seaside was fine, though clouded overhead. We went over to Cummings' (at Margate) in the evening, and as it was cold, we stayed in and played games; Gowing, as usual, overstepping the mark. He suggested we should play 'Cutlets,' a game we never heard of. He sat on a chair, and asked Carrie to sit on his lap, an invitation which dear Carrie rightly declined.

After some species of wrangling, I sat on Gowing's knees and Carrie sat on the edge of mine. Lupin sat on the edge of Carrie's lap, then Cummings on Lupin's, and Mrs. Cummings on her husband's. We looked very ridiculous, and laughed a good deal.

Gowing then said: 'Are you a believer in the Great Mogul?' We had to answer all together: 'Yes—oh, yes!' (three times). Gowing said: 'So am I,' and suddenly got up. The result of this stupid joke was that we all fell on the ground, and poor Carrie banged her head against the corner of the fender. Mrs. Cummings put some vinegar on; but through this we missed the last train, and had to drive back to Broadstairs, which cost me seven-and-sixpence.

SEE Books/ Broadstairs/ Grossmith, George & Weedon/ Margate

Charles DICKENS
Born 7th February 1812
Died 9th June 1870
England's finest novelist described Broadstairs as *'one of the freshest and freest little places in the world'* and explains why it was his favourite holiday resort. He stayed here with his family for a minimum of one month every summer, bar two years, from 1837, when he was becoming established as a successful writer, through until 1851. In the two years he missed he went abroad, but was still nostalgic for Broadstairs. In Italy, in 1844 he said it had, *'never so fine a sunset'* and in Switzerland in 1846 he missed Broadstairs' *'good, old, tarry, salt, little pier'*.

1837: stayed at 12, now 31 High Street
1839: 40 Albion Street
1840: 37 Albion Street/Lawn House
1841: 37 Albion Street/Lawn House
1842: 37 Albion Street/Lawn House
1843: (probably) at 40 Albion Street
1845: Albion Hotel, previously 40 Albion Street
1847: 1 or 6 Chandos Place
1848: 1 or 6 Chandos Place
1849: Albion Hotel, previously 40 Albion Street
1850: Fort House
1851: Fort House
1859: Albion Hotel (he stayed alone)

In a letter to John Maclise, 2nd September 1840, he wrote: *You know that we know that Fletcher didn't go into the Sea that day at Ramsgate? Well - I had good corroborative evidence yesterday. Seeing me go into one of the Machines he plucked up and said he'd have another. He had the next one. I undressed, went in, waited, still no Fletcher. Determined that he should not escape, I waded under the hood of his bath and seeing him stand with only his coat off, urged him to make haste. In about five minutes more he fell heavily into the water, and feeling the cold, set up a scream which pierced the air! You never heard anything so horrible! And then he splashed like a fleet of Porpoises, roaring most horribly all the time, and dancing a maniac dance which defies description.*

SEE Albion Hotel, Broadstairs/ Albion Street, Broadstairs/ Andersen, Hans Christian/ Andersons Café, Broadstairs/ Archway House, Broadstairs/ Athelstan/ Authors/ Barnaby Rudge/ Barnaby Rudge pub/ Betsey Trotwood/ Bleak House/ Broadstairs/ Charles Dickens pub/ Charles Dickens School, Broadstairs/ Collins, Wilkie/ Crampton, Thomas Russell/ David Copperfield/ David Copperfield, restaurant/ Dickens Festival, Broadstairs/ Dickens House, Broadstairs/ Dombey and Son/ Edwin Drood/ Fildes, Sir Samuel Luke/ Fort House, Broadstairs/ Halfmile Ride/ Haunted Man, The/ High Street, Broadstairs/ Holy Trinity Church, Broadstairs/ Lawn House, Broadstairs/ Luttrell, Henry/ Martin Chuzzlewit/ Nicholas Nickleby/ Old Crown pub, Broadstairs/ Old Curiosity Shop/ Oliver Twist/ Our English Watering Place/ Passage in the Life Of Mr Watkins Tottle, A/ Pickwick Papers/ Prostitutes/ Punch magazine/ Ramsgate/ Ramsgate Road, Broadstairs/ Royal Oak Hotel, Ramsgate/ Sketches by Boz/ Smugglers - Dickens/ South Cliff Parade, Broadstairs/ Tale of Two Cities/ Tartar Frigate, Broadstairs/ Ternan, Nelly/ Toole, J L/ Tuggses of Ramsgate, The/ Without Prejudice/ Weller, Sam/ Woman in White, The/ York Street

DICKENS HOUSE
Victoria Parade, Broadstairs
Originally a small Tudor building, it was extended and re-modelled in Victorian times.

Betsey Trotwood, the donkey-hating character in 'David Copperfield' was based on Miss Mary Pearson Strong, who once lived here. According to Dickens' son, also Charles, she was a charming old lady who often fed him tea and cakes but did have a hysterical reaction to donkeys crossing the grassy area in front of her cottage. In the novel, the location of her cottage is moved to Dover, possibly to save Miss Strong's blushes.

The house was named Dickens House at the end of the 19th century. In 1919 The Tattam family bought it and when Mrs Dora Tattam died in 1952, she left the house to her friend Gladys Walterer, who, when she died, left instructions for it to be turned into a Dickens museum. The council became the owners in 1971 and the museum duly opened on 16th June 1973. The museum currently has around 8-9,000 visitors a year.
SEE Betsey Trotwood/ Broadstairs/ David Copperfield/ Dickens, Charles/ Donkeys/ Victoria Parade, Broadstairs

'DIE ANOTHER DAY'
RAF Manston was used as the location for a North Korean Airbase in this 2002 James Bond film starring Pierce Brosnan.
SEE Bond, James/ Films/ Manston airfield

DIGGIN' IT
Some of this Disney TV series was filmed at Broadstairs Harbour on 27th June 2003.
SEE Broadstairs/ Harbour, Broadstairs/ Television

DINKY TOYS
SEE Rovex/Hornby

Benjamin DISRAELI
Born 21st December 1804
Died 19th April 1881
The politician and novelist changed his name from D'Israeli to Disraeli. He was twice prime minister (1868 and 1874-80) and became a close friend of Queen Victoria. He once said that *'Everyone likes flattery; and when you come to Royalty you should lay it on with a trowel'*. When he was on his death bed, Queen Victoria offered to visit him. Disraeli apparently said, *'No, it is better not. She would only ask me to take a message to Albert'*.
SEE Arliss, George/ Gladstone/ Old White Hart Hotel/ Politics/ Prime Ministers/ Victoria

DOG ACRE, Birchington
Dog Acre is the small, triangular, green area of park land between Alpha Road and Station Road opposite the library.

This area used to stretch as far as Butt Acre or, as it was called back in Tudor times, The Buttys which was situated further up what is now Station Road. The old village was centred more around the church and local men practised their archery here.

Its present name derives from an era when more people were engaged in agricultural work and virtually everyone kept a dog to assist them, and which went pretty much everywhere with them, even to church. The good ones would curl up under the pews, but others would display what would nowadays be referred to as 'behavioural problems'; like running around, or howling along with the hymns! To combat this, a Dog Whipper was employed by the church (8 shillings a year in 1622) who would use large wooden tongs to remove any unruly dogs, and boys if necessary, from the congregation and put them outside – and they wonder why church attendances have fallen, bring back the entertainment! I know what you're thinking; Dog Acre is a long way from the church. Well, in later years, part of the Dog Whipper's remuneration was an acre of land and this green was part of that land, although the dimensions have changed over the years. This remaining bit of land was owned by the church until 1921 when it sold it for £390 6s 9d. At one point a Post Office and Sorting Office was to be built on it but fortunately it did not go ahead.
SEE All Saints' Church, Birchington/ Birchington/ Station Road Birchington

The DOG AND DUCK public house
44 Canterbury Road, Westbrook
It was named after an old blood sport – thankfully, no longer popular - in which a dog was sent into a pond after a duck which had been fettered (just to make it even more unfair), and spectators would win or lose their wagers depending on how long the poor old duck survived. Established at 6 Westbrook (Terrace) around 1830 the pub's attractions included a pleasure garden, a Bowling Green and '*the largest hog in England*'. The latter was apparently a huge draw until the poor chap died in 1866, after which, it was stuffed and put into a glass display case with a plaque that stated: '*Mammoth pig. Born 1857. Died 1866. The largest pig ever seen in Kent.*' This survived for virtually one hundred years until the 1960s when it was vandalised, and the landlord subsequently burnt it. The hotel closed in the 1950s but it continued as a pub and in 1986, it was treated to a massive modernisation – an old fashioned term for a makeover – but it is now closed and currently boarded up, and could become flats, in time.
SEE Canterbury Road, Westbrook/ Pubs/ Westbrook

DOGGETT, COAT and BADGE
public house, Market Street, Margate
This pub dates back to around the 1780s and has existed right through the nineteenth century when it was The Kings Arms, a hotel with stabling.

It had a major re-fit in the 1970s and became The Doggett, Coat and Badge because an ex-landlord had won the 1953 annual Thames' Lightermans Race (sculling, for the uninitiated). The winner became a Queen's Waterman and received an ornamental coat with a badge that was originally donated in 1716 by a Mr Thomas Doggett, an actor who was grateful for the waterman's services. They apparently were not universally popular because of their bad language and general vulgarity. The race is still run between London Bridge and Cadogan Pier, Chelsea – there is a pub of the same name by Blackfriars Bridge in London. The ornamental coat was proudly displayed in the pub until the landlord moved to Kents in Ramsgate.

SEE Margate/ Old Margate/ Pubs

The DOHERTY BROTHERS
Reginald Doherty:
Born Wimbledon Surrey, 14th October 1872
Died 29th December 1910
Hugh Laurence Doherty:
Born Wimbledon Surrey, 8th October 1875
Died 21st August 1919
The popular brothers, both with centre parted dark wavy hair, attended Trinity College, Cambridge, and were very successful tennis players. Hugh, known as Laurie or Little Do, was 5ft 10in; the right-handed and probably the slightly better player; his brother Reggie, or Big Do, was 6ft 1in, weighed just 10 stone, and often suffered poor health due to digestive problems. Whilst considered the lesser of the two brothers it did not stop Reggie winning four consecutive Wimbledon Singles titles (1897-1900), beating his brother in the 1898 final, 6-1 in the fifth set. It is Laurie, though, that has the connection with Broadstairs. He won five Wimbledon singles (1902-06) and partnering his brother, won a record eight Wimbledon men's doubles (1897-1901 and 1903-05 they lost the 1902 final). He holds the record for the most mens Wimbledon titles, 13, and won the 1900 Olympic gold medal for the men's singles, and men's doubles with his brother and was the first foreigner to win the US Open in 1903. As a doubles team, the brothers were the first to introduce the tactic or formation whereby the partner of the receiver stands at the net, with the receiver

joining him at the net once he has returned the serve – are you still with me? In 1903, they were members of the first British team to win the Davis Cup which they won four times in total, with Laurie winning five doubles, seven singles and losing no Davis Cup matches. He died at Broadstairs on 21st December 1919 aged 44. Reggie was just 38 when he died.
SEE Broadstairs/ Sport

DOLPHIN INN
Albion Street, Broadstairs
It dates back to the 16th century and is the oldest pub in the town. It was refurbished in 1999.
SEE Albion Street/ Broadstairs/ Pubs

'DOMBEY AND SON'
by Charles Dickens
This novel by Charles Dickens was partly written in Broadstairs.
SEE Books/ Broadstairs/ Dickens, Charles

'DOMESDAY BOOK'
Thanet appears in the 1086 Domesday Book as Tenet.
SEE Books/ Thanet

DOMNEVA - the legend of
At the court of Egbert, King of Kent, in 670AD, according to legend, two brothers, his cousins, were murdered. As was customary at the time, their sister Ermenburga, or Domneva, Queen of Mercia, was expected to come and collect the 'weregild' or blood money. Unexpectedly, she asked to be given land on which to build a convent. The area of land was to be bound by the course of her pet deer. The deer was set free in what is now Westgate and it ran. Then it ran it bit more. Then it really got into its stride and ran, although not in a straight line, up to Salmestone before heading south-ish. Egbert had an evil counsellor (this is your chance to hiss and boo) by the name of Thunor, who by now had gone right off this deal, so he tried to stop the deer and was immediately swallowed up by the earth. The deer continued running right across the island to Sherrifs Hope.
SEE Westgate-on-Sea

DONKEYS
Now you may think that Margate today is some sleepy backwater, but in days gone by it was cutting edge. One of the pioneering introductions to the British seaside tradition, which occurred in the early 1800s, began at Margate. It was the first seaside resort to offer, and popularise, donkey rides on the beach.
There were about 60 donkeys based in the High Street at Bennett's Asinarium or Donkey Stud from whence they would parade down to the sands each morning accompanied by the local bands' trumpets and drums. The ever patient donkeys were described as '*bearing angels by day and spirits by night*' a reference to their forefathers' involvement in smuggling. In the 20th century the business was run by 'Donkey' Brown and his family.

*DONKEY MEN WALK THROUGH
LONDON*

*Probably the oldest 'donkey boy' in
Ramsgate is Mr Aaron Todd, who lives at 44
Bellevue Road, son of the renowned John
Todd, who ran donkeys on the sands for 60
years, Aaron continued that business until
three years ago. Today he runs two pony
chaises – a Cinderella coach and a
governess cart – on Harbour Parade. Before
he left school he was operating a goat chaise
on the sands.*

*Mr Todd well remembers an occasion just
after the First World War when he and his
father went to the Caledonian Market in
London to buy some donkeys. They
purchases six and then decided upon another
two – but ran out of cash. 'It was a case of
walking home or leaving the donkeys there'
he said. 'We decided to walk, and left the
market at four in the afternoon. We reached
Ramsgate at nine o'clock the following
night.'*

SEE Bathing Machines/ Bellevue Road/ Betsey
Trotwood/ Blazing Donkey pub/ Coleridge/
Deckchairs/ Dickens House/ Fallen Leaves/ Goats/
Harbour Parade, Ramsgate/ High Street, Margate/
Hood, Thomas/ Jerrold, Douglas/ Margate/
Newcastle Hill/ Newcastle Hill/ Pierremont Hall/
Ramsgate/ Ramsgate Song/ Royal Adelaide/
Southwood House/ Steam Packets/ Tuggses of
Ramsgate/ Uncle Bones/ Without Prejudice

**'DON'T PUT YOUR DAUGHTER on the
STAGE, Mrs WORTHINGTON'**
Song by Noel Coward.
*Don't put your daughter on the stage, Mrs.
Worthington,*
Don't put your daughter on the stage.
*She's a bit of an ugly duckling, you must
honestly confess,*
*And the width of her seat would surely defeat
her chances of success.*
On my knees, Mrs. Worthington,
Please, Mrs. Worthington,
Don't put your daughter on the stage.
SEE Coward, Noel/ Fox, Angela/ Music

DOODLEBUGS
SEE V1 rockets/ World War II

Diana DORS
Born 23rd October 1931
Died 4th May 1984
A glamorous British actress. *'They asked me
to change my name. I suppose they were
afraid that if my real name, Diana Fluck,
was in lights and one of the lights blew. . .'*
She once stayed at the Beresford Hotel in
Birchington.
SEE Actors/ Beresford Hotel

'DOUBLE YOUR MONEY'
A television game show of the sixties hosted
by Hughie Green, where, when contestants
answered each question correctly the prize
money, er, doubled. The 'Who Wants to be a
Millionaire' of its day.
SEE Green, Hughie/ Television/ Winter Gardens

DOVER CASTLE INN, Ramsgate

It existed as far back as 1724, and possibly
earlier, and stood on the site later to be used
by the Castle Hotel which was built in the
1880s.
SEE Pubs/ Ramsgate

DOVER STEPS
SEE Victoria Steps

The DOWNS
The stretch of the English Channel between
the Kent coast and the Goodwin Sands.
SEE Clarence, Duke of/ Dumpton Gap/ East Cliff
Lodge/ 'Floating Light of the Goodwin Sands'/
Goodwin Sands/ Hercules/ Libraries/ Pepys/
Ramsgate/ Royal Hotel/ Smuggling/ West Cliff
Hall

Sir Arthur Conan DOYLE
Born 22nd May 1859
Died 7th July 1930
The novelist who created Sherlock Holmes.
SEE Authors/ Old Oak Cottage/ Second Stain/
Sherlock Holmes/Veiled Lodger

'DRACULA' by Bram Stoker
*2 August, midnight. Woke up from few
minutes sleep by hearing a cry, seemingly
outside my port. Could see nothing in fog.
Rushed on deck, and ran against mate. Tells
me he heard cry and ran, but no sign of man
on watch. One more gone. Lord, help us!
Mate says we must be past Straits of Dover,
as in a moment of fog lifting he saw North
Foreland, just as he heard the man cry out. If
so we are now off in the North Sea, and only
God can guide us in the fog, which seems to
move with us, and God seems to have
deserted us.*
SEE Books/ North Foreland

DRAPERS HOSPITAL
SEE Yoakley, Michael

DRAPERS MILL, Margate
One of Thanet's only two surviving
windmills - the other is at Sarre – is situated
near the school of that name, was saved from
demolition in the sixties by the late
headmaster of the school and a group of
enthusiasts.

THIS PLAQUE IS IN MEMORY OF
MR R M TOWES
HEADMASTER OF DRAPERS MILLS
SCHOOL
FROM 1949-1974
WITHOUT WHOSE INSPIRATION AND
DEDICATION THIS MILL WOULD NOT
BE STANDING TODAY

It is a smock mill built by John Holman in
1847 to replace an earlier one that had been
moved here from the Nayland Rock area
around 1805. The present mill has been
known as Old Mill and had Little Drapers
Mill as a companion (hence the plural in the
Drapers Mills). This mill was moved here
from Barham and remained here from c1870
until 1929 when it was dismantled, although
the base was not removed until 1954. Also
here, from c1874, was the Pumper, owned by
Margate Corporation Waterworks. Severely
damaged by a strong wind in 1894 it was
subsequently pulled down.

SEE Margate/ Schools/ Windmills

DRAYS, Ramsgate
This florist and greengrocers was probably
the oldest retail business in Ramsgate when it
closed on 23rd January 1993. William Dray
set up the firm in Harbour Street in 1826,
before it moved to 17 Queen Street, and then
to York Street in 1964. The business passed
to Dray's son, another William and his
children: Dorothy, known as Doff, who ran
the shop, and William and John who ran the
nursery in Newington Road (now the
grounds of Dame Janet School). Dorothy
handed over to her daughter Muriel Apps,
and her husband Ken in 1973. By the time it
closed, Muriel had clocked up 46 years of
service before retiring in 1991.
SEE Dame Janet School/ Harbour Street,
Ramsgate/ Newington Road/ Queen Street,
Ramsgate/ Ramsgate/ Shops

DREAMLAND, Margate
Under the ownership of John Henry Iles, the
Hall by the Sea became the Dreamland Hall
in 1919 and was named after an amusement
park in New York. The entertainment
included a small orchestra, touring variety
acts and the popular silent films of the day.
Through the 1920s the old Hall by the Sea
was gradually transformed. What had been a
genteel, relaxed garden complete with statues
and a river became the hugely successful
amusement park - and probably Margate's
biggest attraction. To come to Dreamland
meant that you and your family could chose
from attending dances and musical teas,
visiting a zoo or an amusement park, the star
of which was the Scenic Railway.
Many people came here on organised trips;
companies and factories would bring their
staff here on dozens of trains, coaches and
charabancs, for their works outing – they
didn't call it bonding then – and this led to
the creation of an enormous catering
operation. It was said that Dreamland was
the country's largest caterer in the 1930s.
The Garden Café (an old World War I
aircraft hangar brought here in kit form)
could seat up to 1,200 people, but in all, the
seven or eight places to eat here could hold a
combined total of 3,500. Each year, over
125,000 were fed from three kitchens, a
butchery and a bakery that also produced

loaves for Thanet's shops. All ice cream was made on site.

Just to show that this was a different era, the photos of the Garden Cafe at the time show the tables covered with tablecloths - there is not a wipe-clean surface in sight – and they are laid with china plates. Food did not arrive in cardboard or polystyrene boxes. Cutlery was used – nobody ate with their fingers, and napkins were made of fabric, not paper. Consequently, there were no bins full of litter at the end of each day - but we've progressed since then!

On 1st September 1934, a miniature Brooklands attraction opened at Dreamland. It was a bit like bumper cars but the cars looked more like the Grand Prix cars of the era and raced around an oval track.

As late as 1939, troupes of midgets, people with deformities and performing animals were used in shows at Dreamland. In 1937, a troupe called The Royal Coronation Midgets performed here.

In 1940, Dreamland became a government repository, and after Dunkirk, troops were temporarily billeted here.

After suffering damage in the war Dreamland quietly re-opened on the 1st July 1946, although staff were still busy doing repairs. The amusement park continued to be a massive draw to holiday makers across the country and many would say that Margate was Dreamland and vice versa. What caused the demise of Margate as a top resort also saw Dreamland's fortune wane, cheaper foreign holidays and competition from newer, and more technically advanced, amusement parks.

The Caterpillar Ride was a very popular original ride at Dreamland, although it had come from Germany. It was a ride that went round on circular rails but transformed itself into a caterpillar when a green awning came across the seats and covered everyone – it was a much simpler era then, alright?

The big wheel at Dreamland Amusement Park was sold to a park in Mexico.

In 2002 Dreamland was the UK's fifth most visited free entry amusement park with 680,000 people visiting. Whilst these figures are good, compare them with the 2,000,000 that visited as recently as the 1980s when it was amongst the UK's 10 most visited tourist attractions.

SEE Anderson, Lindsay/ Bembon Brothers/ Dreamland Cinema/ Dreamland fires/ Dreamland Theatre/ Flea Circus/ Hall by the sea/ Ice Cream/ Iles, John/ Great Storm 1953/ Lido/ Margate/ Margate Football Club/ Model Village/ Mods and Rockers/ Only Fools and Horses/ Squash club/ Sunshine Rooms/ Topspot/ World War I/ Wrestling

DREAMLAND CINEMA, Margate

The old Palais de Dance had its chandeliers removed and giant mirrors concealed before the original 900-seater Dreamland cinema with a screen measuring 275ft x 55ft, opened in this hall on 17th May 1923. By 1929 the cinema had a 2-manual 17-unit straight Moterman organ.

Although a fire badly damaged the amusement park in 1931, it did not affect the cinema. However, in the rebuilding, a sunshine café and bars were built on Marine Terrace and a 90ft corridor to the cinema was built. On 22nd September 1934, the old cinema was pulled down.

J R Leathart and W F Granger were in charge of the overall design, and J B Iles (J H Iles son) did the interior decoration of the new one. When it was built, it was the largest cinema in the country outside of London. The very thirties-style design still looks good today, with a central display fin, and it is said to have influenced the subsequent designs of cinemas, especially the Odeons. Down the corridor you got your tickets at a 30ft high booking rotunda. There was a Greek key design on the ceiling. Upstairs was a stalls foyer measuring 72ft x 44ft, at one end of which was the entrance to the ballroom, together with a bar and tea room, and stairs up to the circle. There were 1,328 seats in the stalls and 722 in the circle; tickets were 7d, up to 2/-. The auditorium was decorated in Australian walnut and had an oak dado displaying sea gods and nymph decorations recycled from the previous cinema. The new Compton organ cost a small fortune - £4,850 - enough to buy five or six houses at the time although some pipes from the old Moterman organ were re-used. Lewis Gerard was the resident organist. There was free car-parking and staff would even look after your dog while you were in the cinema - now try asking for that at a modern multiplex. No, I mean it, try.

The new cinema was officially opened on 22nd March 1935, with the mayor, Alderman Pettman and Captain Balfour MP in attendance. The showman Harold Finch, took over from Jack Binns as manager of the ballroom and the cinema, and on the cinema's first birthday he had a 500lb cake baked for the audience. Just a thought, but the 75th anniversary will be on 22nd March 2010, and plans may well be in place for all I know, but it would be a nice gesture to repeat the act. If I have to choose I would go for a chocolate cake, but don't feel you have to, but like I said, it would be nice . . .

In 1938 John Henry Iles, at the age of 66, gambled his fortune on the future of the British film industry and lost the lot.

As was the case with many cinemas in the 1970s, Dreamland converted the stalls into a theatre and bingo hall and the circle into two, 'twin', cinemas; one with 376 seats, the other with 378. One of the bars was also converted into a small 60-seater video screen mini-cinema. These opened on 22nd April 1973.

The cinema and the bingo hall were both refurbished in 1992/3.

SEE Cinemas/ Compton organ/ Dreamland/ Hawkwind/ Marine Terrace

DREAMLAND, Margate - FIRES

There have been a few fires at Dreamland including a fire in September 1930 which destroyed some rides causing around £20,000 worth of damage. It attracted a crowd of around 5,000 at the height of the inferno, just before midnight, and the flames were reported as being 120ft tall.

Another fire in August 1937 caused damage to various staff areas and workshops and a fire in 1949 damaged the scenic railway.

On 8th August 1950, fire engines were called in from all over Kent to combat a huge fire that caused around £75,000 worth of damage. Police marksmen stood by with rifles in case lions escaped from their cages.

The Queen Mary (a building replicating the luxury liner) was damaged by a fire in September 1963.

On Sunday 30th November 2003, a fire destroyed the Waltzer roundabout and left a big hole along Margate's seafront.

SEE Dreamland/ Fires/ Margate/ Scenic railway

DREAMLAND THEATRE, Margate

It opened with a sold-out Dick Emery Show in 1973, but was followed by an ill-judged production of 'The Bed' for the summer season that year. With a cast of one man and six girls, it was a farce about a man with a bed incorporating various gadgets – you can probably guess the rest. Anyway, the idea was, I think, to titillate the local audience, but instead the attendant publicity seemed to offend them; it was not a production to which parents were going to take their children. Either that or John Inman was not the right choice for the lead.

The following summer the comedy play 'No Sex Please We're British' was on offer with Charles Hawtrey, Pip Hinton (a replacement for the unwell Jessie Matthews) and the stars of the hit television comedy 'Please Sir', Peter Denyer and Carol Hawkins.

The New Seekers also appeared here in concert.

SEE Matthews, Jessie/ Theatre Royal

DROIT

(French for 'right', from Latin 'direclus', straight), a legal title, claim or due; a term used in English law in the phrase droits of admiralty, certain customary rights or perquisites formerly belonging to the lord high admiral, but now to the crown for public purposes and paid into the exchequer. These droits consisted of flotsam, jetsam, ligan, treasure, deodand, derelict, within the admirals jurisdiction; all fines, forfeitures, ransoms, recognizances and pecuniary punishments; all sturgeons, whales, porpoises, dolphins, grampuses and such large fishes; all ships and goods of the enemy coming into any creek, road or port, by durance or mistake; all ships seized at sea, salvage, &c., with the share of prizes such shares being afterwards called tenths; in imitation of the French, who gave their admiral a droit, de dixime. The droits of admiralty were definitely surrendered for the benefit of the public by Prince George of Denmark, when lord high admiral of England in 1702. Encyclopedia Britannica, 1911

SEE Denmark/ Droit House

DROIT HOUSE, Margate Harbour

The building where droits were dealt with was built in 1829 near the entrances of the

Pier and Jetty; it replaced the original Customs House on the Fort Steps.

A German Heinkel HE111 dropped twelve 55-pound bombs across the harbour in the first few minutes after midnight on 14th July 1941 hitting Droit House, the stone pier and Zion Place. The damage was so severe that Droit House had to be re-built in 1948 as an exact replica of the original; nevertheless, it is a listed building. It became the offices of the Margate Pier and Harbour Company.

SEE Droit/ Margate/ Pier

DRUIDS ARMS public house, Margate

It was at 7 (later 14) St John's Street, off Churchfields, in the early 1800s.
SEE Margate/ Pubs

DUKE OF EDINBURGH, public house
Milton Avenue,
Margate

It was once the smallest pub in town. Not only did you have to walk through the landlady's kitchen to get to the loo, but the public bar, the snug and the 'bottle and jug' took up a combined floor space of 13ft x 12ft. It was extended in 1985, well over a century after it opened in the 1870s, and named after a ship - not after the fella who married the Queen. Now closed, the building is to be converted into flats.
SEE Margate/ Milton Avenue/ Oxford Hotel/ Pubs

DUKE OF YORK public house
Addington Street, Ramsgate

This pub evolved from an army canteen at the barracks situated here in the Napoleonic wars.
SEE Addington Street/ Napoleonic Wars/ Pubs/ Ramsgate

DUKE STREET, Margate

To avoid the brick tax in the eighteenth century, two houses in this street were faced with mathematical tiles that looked like bricks but were not taxable.

The Queens Arms, a hotel and pub, was once in Duke Street and dated back to the late eighteenth century.

The Neptune or Neptune's Hall was at 3 Duke Street in the early to mid-nineteenth century.
SEE Margate/ Old Margate

DULL

'Margate is pronounced Margitt and the same applies to Ramsgate. Broadstairs is frequently pronounced 'dull'.' A trader in 1862
SEE Broadstairs/ Margate/ Ramsgate

DUMP RAID

Ramsgate's Dump Raid occurred on the night of 16-17th June 1917. German aircraft en route to attack London turned back because of bad weather and instead decided to attack Dover and Ramsgate. Two aerial torpedoes were dropped at around two o'clock in the morning: the first disappeared into the sea, but the second hit the ammunition dump that was in a converted fish market in the harbour. The resulting explosion was immense, creating not just one big bang, but a continuous supply of exploding ammunition for a couple of hours. Further inland, because of the red glow in the sky, people were convinced that Ramsgate had been completely destroyed; it very nearly was. A total of 660 houses were damaged that night, and it was estimated that 10,000 sheets of glass were smashed, but remarkably only 16 people were injured and the death toll was three. Normal activities in the town stopped for days whilst everybody cleared up – the public were kept out of around one third of the town.

The destruction of the fish market all but destroyed Ramsgate's fishing fleet and meant the end of Ramsgate's fishing industry.
SEE Addington Street/ Albert Road/ Crescent Road/ Ivy Lane/ Ramsgate/ Southwood Road/ Zeppelin

DUMPTON

The name Dumpton comes from Dudeman's farmstead. It is referred to as Dudemeiton in 1186, Dodeminton in 1270, Dodmanton in 1332 and Dodemayton in 1348.

Thomas Relf of Dumpton was bound over in the sum of 5 pounds for threatening to kill his wife. East Kent Times 7th July 1909
SEE East Kent Times/ Electric Tramways Co/ Evacuation/ Farms/ Heath, Edward/ Petit/ Tunnels, Ramsgate/ West Dumpton Lane/ Without Prejudice

DUMPTON GAP

This is now the name given to the area between Broadstairs and Ramsgate and, strictly speaking, refers to the gap in the cliff that allows access to the beach.

The bay is around 150 metres wide and a promenade links it with Louisa Bay.

During the Napoleonic Wars, a French ship, being a bit daring, nipped through the Downs and tried to dash past Ramsgate Harbour and escape towards home. Impertinent Froggy, eh?! Anyway, there were two cruisers in Ramsgate Harbour at the time, and the captain of one, Captain Bayly, wanted both of them to go and attack the French ship. The other captain said no, so Bayly went on his own. The French vessel being larger, outgunned him, and he was captured and taken out to sea. Bayly and his crew were put in a boat off Dumpton and put ashore. Now, just as Johnny Foreigner was beginning to feel a bit smug, another British cruiser turned up – OK, you can start the cheering now – and captured the French ship and brought it into Ramsgate Harbour. The French crew was then sent off to Maidstone, or Sheerness, or somewhere – but do we care? What is important is that we captured the surrender monkeys! I'm sorry – could someone check whether I have taken my medication?

Whilst waiting for the smuggling gang led by George Snelling, and including his son Jim, on 16th September 1817, seven Revenue men were standing under a cliff at Dumpton Gap, when a chalk fall buried one of them. While his colleagues were attempting to get him out, a second chalk fall buried all except one of them. When more help arrived it was discovered that all had died. Reports put the number of deaths between five and twelve. The smugglers came ashore to find seven saddled, but rider-less, horses at the top of the cliff.

Having been walking along this stretch of beach one day in February 2004, I can testify to how terrifying a big chalk fall can be. My wife, dog and I were just yards away when a large section crashed down beside us, blocking the entrance to a cave, and we all discovered the hitherto unknown laxative property of chalk. My dog refused to walk anywhere near the cliff for about ten days.

Dismounting from my steed I'll stray
Beneath the cliffs of Dumpton Bay,
Where Ramsgate and Broadstairs between,
Rude caves and grated doors are seen:
(For Fancy in her magic might
Can turn broad day to star less night!)
When lo! Methinks a sudden band
Of smock-clad smugglers round me stand.
Denials, oaths, in vain I try,
At once they gag me for a spy,
And stow me in a boat hard by.
Delinquent Travellers (1824)

Coleridge became a regular bather at Ramsgate, but on his first trip in 1819 he bathed at Dumpton Gap and left his clothes in a cave while he went for a swim.

I have been miserably unwell and in an increasing ratio of pains and sickliness for the last three days – but last night passed a tolerably good night, and now am still better – having had a glorious tumble in the waves – though the water is still not cold enough for my liking. The weather, however, is evidently on the change, and we have now a succession of flying April showers, and needle rains. My Bath is about a mile and a quarter from the Lime Grove – a wearisome Travail by the deep crumbly sands, but a very pleasant breezy walk along the Top of the cliff, from which you descend thro' a deep steep Lane cut thro' the chalk rocks - the Tide comes up to the end of the Lane, and washes the Cliff; but a little before or after high Tide there are nice clean seats of Rock with foot-baths, and then an expanse of sand greater than I need, and exactly a hundred of my Strides from the end of the Lane there is a good roomy arched Cavern, with an Oven or cupboard in it where one's clothes may be put free from the sand. Letter to James Gillman, c. 19th August 1819

An international cable was laid from Dumpton Gap in September 1927.
SEE Bartram Gables/ Bays/ Broadstairs/ Coleridge, Samuel/ Crampton, Thomas Russell/ Downs, The/ Harbour, Ramsgate/ Law and the Lady, The/ Louisa Gap/ Napoleonic Wars/ Promenades/ Ramsgate/ Snelling, George/ South Cliff Parade

DUMPTON GREYHOUND TRACK
Hereson Road, Ramsgate
With a railway station and two bus routes passing by, it was an ideal site. Dumpton Greyhound Track opened on 26th May 1928 and was soon known as 'the Ascot of Greyhound Racing' because of its beautiful trees, lawns and flower beds which all enhanced the overall grandeur of the place. It offered all-year racing for the first time in February 1968. Northern Sports Ltd took over Dumpton Greyhound Track in 1976 and invested around £2,000,000 to modernise the facilities. After sixty years, Greyhound racing stopped in March 1996 when Northern Sports went into receivership. Around 100 jobs were lost but the other activities on site continued. Now the dogs have gone, and the market has moved on. Housing and a garden centre have taken their place.
SEE Dumpton Market/ Dumpton Park Leisure Centre/ Iles, John Henry/ Newington Greyhound Track/ Sport

DUMPTON MARKET
It opened at the Dumpton Greyhound Track on 23rd May 1969 *to change local shopping habits overnight'*. Within a year it was described as *'the best in southern England'* by one of its 500 traders.
SEE Dumpton Greyhound Track/ Dumpton Park Leisure Centre/ Iles, John Henry/ Market, Ramsgate/ Market Place, Margate/ Sole, The

DUMPTON PARK
This was the Assembly Point for evacuation from Thanet in World War II.
See Evacuation/ Thanet/ World War II

DUMPTON PARK DRIVE, Broadstairs
On the afternoon of 9th February 1916, the Germans dropped 12 bombs on Broadstairs and 4 on Ramsgate, from a Hansa-Brandenburg NW and a Friedrichshafen FF33e. Bartram Gables School alone received 7 of them – the housemaid and a 9-year old pupil were injured. At Tenerife, also in Dumpton Park Drive, one person was cut in the face
SEE Bartram Gables/ Broadstairs/ Ramsgate/ Roc, Patricia/ Skating Rink

DUMPTON PARK LEISURE CENTRE
Hereson Road, Ramsgate
The Dumpton Park Leisure Centre opened in September 1982 at a cost of £600,000. It included a luxury 160-seater restaurant from where you could watch the greyhound racing, 4 squash courts, 4 snooker tables, a gym, cabaret club and disco.
SEE Iles, John Henry/ Dumpton Greyhound Track/ Dumpton Market/ Restaurants

DUMPTON RAILWAY STATION
It was built in 1926.
SEE Railways

DUNCAN ROAD, Ramsgate
On 22nd February 1957 it was reported that the Queen had bought for her private collection a portrait of her father by Henry Rayner of Duncan Road, Ramsgate. It became the fifth picture she owned of his in her collection.
SEE Ramsgate/ Richardson, Alan

Earl of DUNDONALD
(Admiral Lord Cochrane)
He stayed at Belvedere House, now Belvedere Place, Broadstairs.
SEE Broadstairs/ Cochrane, Admiral Lord/ Dundonald House Hotel

DUNDONALD HOUSE HOTEL
Dundonald Road, Broadstairs
It was named after the Admiral Lord Cochrane, Earl of Dundonald.
SEE Belvedere House/ Broadstairs/ Cochrane, Admiral Lord/ Dundonald, Earl of/ Hotels

DUNDONALD ROAD, Broadstairs
It was named after the Admiral Lord Cochrane, Earl of Dundonald.
SEE Broadstairs/ Cochrane, Admiral Lord/ Dundonald, Earl of

DUNDONALD ROAD, Ramsgate
On Sunday 26th September 1942, Mrs Clarissa Stokes of 10 Dundonald Road celebrated her 104th birthday.
SEE Ramsgate

DUNKIRK
The evacuation of Dunkirk (Dunkerque) on the coast of France lasted from 27th May to 4th June 1940. About a fortnight after Churchill became Prime Minister, following the German breakthrough to the Channel, British and Allied troops had to be rescued from the beaches in and around Dunkirk. On 27th May, 1,000 civilians died in air raids on Dunkirk.
A fleet comprising 41 destroyers, patrol craft, 36 minesweepers, 77 trawlers and any other vessels (including pleasure craft) that could be found and crewed, were sent to Dunkirk.
The Navies of Belgium, France, Holland and Norway had boats in the fleet. In total 933 boats were in the fleet (not including the numerous small, private craft), of which 236 were sunk and another 91 were put out of action.
While British and French units fought to keep the German troops back from the coast, their comrades were waiting to be picked up from the beach, under a continuous barrage of bombs and shells.
By 4th June, a total of 338,226 British, French and Belgian soldiers had been rescued and ferried back to England. This total comprised 98,780 that were picked up from the beach and 239,446 who were rescued from the harbour and 'mole' - a wooden breakwater. Around 140,000 of the total picked up were French - another 40,000 French soldiers had been taken prisoner by the Germans.
Their equipment had to be left behind and the Germans found themselves the new owners of 76,000 tons of ammunition, over 20,000 motorcycles, over 63,000 vehicles, and almost 2,500 guns.
Six destroyers had been sunk (Wakeful was struck and sank within 15 seconds with the loss of 600 lives) and nineteen damaged, as had many of the smaller boats which had gone to assist. A total of 126 merchant seamen died.
The Dunkirk Spirit was a huge morale booster and this, combined with the experienced troops that were saved, meant that Britain could continue with the war.
SEE Dunkirk – Margate/ Ships/ Sundowner/ Wherry

DUNKIRK - Margate
In total, 46,722 soldiers were landed at Margate from Dunkirk.
'The manner in which the Margate lifeboat crew brought off load after load of soldiers under continuous shelling, bombing and aerial machine gun fire, will be an inspiration to us all as long as we live.'
Letter to RNLI, from the Commander of HMS Icarus
Seventy-five trains were used to transport troops from Margate after they were rescued from Dunkirk.
SEE Britannia public house/ Dreamland/ Dunkirk/ Golden Eagle/ Lynn, Dame Vera/ Parker, Edward Drake/ Steam Packets/ Sundowner/ Wherry/ Winter Gardens

DUNKIRK – Prudential lifeboat
With a crew of eight, the Prudential lifeboat (which had been the Ramsgate lifeboat since 1926, and Ramsgate's first motor lifeboat) left Ramsgate at 2.20pm on 30th May 1940, accompanied by eight small boats, manned by eighteen naval men, in tow. When they arrived at Dunkirk it was their job to collect British servicemen from the beach and ferry them to larger ships waiting for them out at sea. For the next thirty hours (they were at sea for around forty consecutive hours – a whole working week in one shift effectively) until 1.30am on the morning of 1st June, they were under constant fire from the Germans, but during that time rescued 2,800 men from the beaches. Coxswain Howard Knight received the Distinguished Service Medal for gallantry and determination. The RNLI flag that was flown by the lifeboat throughout the forty hours was given to, and hung in St George's church.
SEE St George's Church/ Kent Place, Ramsgate

DUNKIRK, Ramsgate
From Ramsgate Harbour 4,200 ships left to rescue troops from Dunkirk and 80,000 men were brought back to safety in Ramsgate. Of these, 42,783 men left on 82 special trains from Ramsgate. Only Dover dealt with more, sending about 180,000 on 327 trains.
On the 60th anniversary of Dunkirk, Dame Vera Lynn unveiled a plaque at Ramsgate Harbour to commemorate Thanet's role in the Dunkirk evacuation. Unfortunately within a few years it had to be refurbished because it could not cope with the weather, but it is now back and looking good!
SEE Harbour, Ramsgate/ Lynn, Dame Vera/ Ramsgate

4th Earl of DUNMORE
Born Scotland c1732
Died Ramsgate 25th February or 5th March 1809
John Murray, 4th Earl of Dunmore, Viscount of Fincastle, Lord Murray of Blair, Moulin and Tillemot, was Governor of New York in 1770 and Virginia in 1771. The ensuing American Revolution saw him dissolve the Virginia Assembly in 1772, 73 and again in 1774 - the same year that he had a war named after him! Lord Dunmore's War was against the Shawnee, a Native American tribe. In April 1775, he scarpered out to sea and attacked Hampton, and burned Norfolk on 1st January 1776. The Americans forced him from Gwynn's Island in Chesapeake Bay and he took his fleet to the West Indies before returning to England. From 1787 until 1796, he was governor of the Bahamas. He died in Ramsgate.
His daughter was Lady Augusta Murray.
SEE Mount Albion House/ Ramsgate

E R DUNN
Queen Street, Ramsgate
Advertisement c1900:
E R DUNN, 90 Queen Street. Telephone No 100.
Telegrams: 'EDMUND DUNN, RAMSGATE
Quality Sanitary Inspector.
Registered Plumber, Decorator, etc
Sanitary surveys and reports. Drains tested.
Work we do: Sanitation, Drainage, Heating, Ventilating, Smith's work, Decorating, Distempering, Paper-hanging, Structural alterations, etc.
Goods we fix and supply: Ranges, Stoves, Baths, Geysers, Lavatories, Closets, Electrical and Gas fittings, Wall Decorations, Globes, Chimneys, Mantles, etc.
SEE Queen Street, Ramsgate/ Ramsgate/ Shops

DUNN & SONS
Queen Street, Ramsgate
Advertisement c1900:
R G DUNN & SONS, 63, 67 & 92 Queen Street, Ramsgate, Telephone 41
House Furnishers and Removal Contractors
Departments: Furniture, Bedsteads & Bedding, Carpets & Linoleum, Curtains, China & Glass, Furnishing drapery, Furnishing Ironmongery, Bamboo & Wicker Goods, Speciality : Carpets
The most comprehensive and up-to-date stock in Kent.
Experienced Workmen for all departments.
Inspection and comparison solicited.
SEE Queen Street, Ramsgate/ Ramsgate/ Shops

Gerald DURRELL
Born 7th January 1921
Died 30th January 1995
He was the founder of Jersey Zoo (in 1959) and author of 'My Family and Other Animals'. In 1951 he was a relief keeper at the Lido's mini zoo.
SEE Authors/ Lido

Ian DURY
Born Upminster 12th May 1942
Died 27th March 2000
He was a very English rock and roll singer, of Ian Dury and the Blockheads fame.
SEE Billericay Dickie/ Muisc

DUTCH TEA HOUSE, North foreland
It was also known as the North Foreland Tea House, where, at the end of the nineteenth century, you could stop for refreshment in your horse-drawn brake.
SEE North Foreland

DYASON'S ROYAL CLARENCE BATHS,
Ramsgate Harbour
Next to Admiral Harvey was Dyason's Royal Clarence Baths built out of wood in 1790. Isaac Dyason drew water from the harbour into baths that blocked the street to carriages. A 5ft gap was left for pedestrians – mostly passengers disembarking at the harbour with their luggage - before building his main premises in 1855. It got the name after the Duke of Clarence visited and when he became King a notice was put up that read:
Patronised by His Majesty King William the Fourth
Royal Clarence Warm Sea Water and Cold Sea Water, Shower and Douse Baths
The warm bath cost three shillings or you could have eight for a guinea – or 'buy seven get one free' in today's terminology – the cold shower baths with warm footbaths set you back 1/6 each. Dyason went to great pains to stress that the water was pumped up at great expense from the inner harbour – into which the town's sewage was pumped - right under the Admiral Harvey pub - he tended not to stress that bit very much.
In 1855 the baths were removed and a new lot built next to the Royal Hotel, which had previously been the King's Head and dated back to the 1600s. In Napoleonic times it was used as the Customs House, and was also the place where deals were done between captains of vessels and local merchants.
Samuel Taylor Coleridge took a bath at this establishment in what was his last holiday here in 1833.
SEE Coleridge, Samuel Taylor/ Duke of Clarence/ Harbour, Ramsgate/ Napoleonic Wars/ Ramsgate

William DYCE
Born 19th September 1806
Died 14th February 1864
The Scottish painter and art administrator was also seen as the instigator of the pre-Raphaelite movement in English painting. Possibly his most well-known painting is called 'Pegwell Bay, Kent - A Recollection of October 5th 1858' which currently hangs in the Tate Gallery. The date of 5th October 1858 is significant because it was the day Donati's Comet could be seen. The comet, seen in the painting, signifies the enormity of space and the cliffs signify the vastness of time, apparently.
SEE Artists/ Pegwell Bay

EAGLE CAFE, Ramsgate
Situated at the end of the East Pier, Ramsgate, it was built by local building firm Grummant Brothers, at a cost of £6,000. Ultra modern in design at the time, it was opened by the Mayor of Ramsgate, Alderman W T Smith, in July 1938. Nowadays it is called Harbour Lights.
SEE Harbour, Ramsgate/ Ramsgate

EAGLE HILL, Ramsgate
Once called Windmill Hill because of the post mill that was here from before 1596 (the date of the map it appears on). In 1828, there was a post mill and a smock mill where Chatham Court flats are now. The mills disappeared when the Ramsgate Town railway station was built.
SEE Ramsgate/ Windmills

EAGLE HOUSE, Broadstairs

Situated next to the Pavilion on Broadstairs beach, this building was originally known as Station House, and was part of the naval signalling system to warn of invasion from France during the Napoleonic wars. The signal went from Eagle House to Crow Hill in Broadstairs, then on to St Peter's Church tower in Broadstairs (even now, St Peter's Church still has the right, on special occasions, to fly the White Ensign), and then on through the county to London. This system could get a message from Broadstairs to London in just under 2 minutes (quicker than some e-mails can take, nearly 200 years later).
It is now called Eagle House because Major Henry Percy presented the resident Port Admiral with the captured French Eagle standard when he landed at Broadstairs with news of Wellington's victory at the Battle of Waterloo.
SEE Broadstairs/ Crow Hill/ Napoleonic Wars/ Percy, Major Henry/ St Peter's Church/ Waterloo, Battle of/ Wellington

EAGLE INN, High Street, Ramsgate
Originally three small cottages, it is the oldest pub in the High Street dating from 1763. It is said to be named to commemorate the shooting here of an eagle as a huge flock flew over the town. It was originally called the Spread Eagle.
SEE High Street, Ramsgate/ Layard, Sir Austen Henry/ Pubs/ Ramsgate

EARL of the ISLE of THANET

The first Earl of the Isle of Thanet was Sir Nicholas Tufton - Charles I made him a peer on 6th August 1628. The Earl of Thanet's seat was at Skipton Castle in Yorkshire. The earldom is now extinct, but should I ever be asked . . .

Aldersgate Street [London] *preserves the remains of a noble town-house, erected by Inigo Jones for the Earls of Thanet; its name soon changed to Shaftesbury House, by which it is best known.* Chambers' Book of Days 1869
SEE Thanet

EARL St VINCENT public house
King Street, Ramsgate

It is named after Earl St Vincent, John Jervis (1735-1823) an Admiral of the Fleet. Nelson served under him at the battle off Cape St Vincent in 1797.

The pub dates back to around 1814 and has expanded over the years, taking over what had been a corner shop next door.
SEE Jervis, John/ King Street, Ramsgate/ Pubs/ Ramsgate

EARTHQUAKE

At 9:20am on 22nd April 1884, an earthquake in Essex was felt all along the north Kent coast and it caused the church bells to ring at Westgate.

In its time, St Nicholas Church has also been damaged by an earthquake, and cracks in the tower of St Peter's Church, Broadstairs are said to have been caused by an earthquake in 1580 when the church was just 510 years old!
SEE St Peter's Church/ St Nicholas-at-Wade/ Westgate-on-Sea

EAST CLIFF HOTEL
Northdown Road, Cliftonville

Dating from 1874, or possibly slightly earlier, it was established by the Cobb Brewery. It took over a neighbouring carpet shop when it was extended and refitted in the 1970s and had another refit in the 1990s. It is now known as The Eastcliffe at 130 Northdown Road.
SEE Cliftonville/ Cobbs/ Northdown Road/ Hotels

EAST CLIFF LODGE
Broadstairs/Ramsgate border

Benjamin Bond Hopkins Esq. (born 1762 – died 1838) built East Cliff Lodge in 1794 as his 13 acre country seat - I must get round to getting one of those. He was one of five children, three boys and two girls, and his father was that rare combination, a turkey merchant and banker. Benjamin was a director of the East India Company and was married to Sarah Cowley. They had three children. They also had a grandson, Charles John, who died when he fell off a penny farthing - one of the more unusual causes of death that you come across.

The lodge was designed by Mr Boncey of Margate in the form of a quadrangle; its paved central courtyard had its own well of fine water, and with its embattled summits it was considered a '*good specimen of modern gothic'* with fine views of the channel and the coast of France.

When Hopkins died, the estate was subsequently owned by Nathaniel Jefferys, James Symes, and then James Strange.

The Princess of the Wales, the future Queen Caroline, spent the summer of 1803 here (Other royal guests have included George IV).

In 1804, Admiral Lord Kieth, later the Viscount Elphinstone, bought the property. He was responsible for building tunnels down to the beach, and a jetty under the cliff to enable him to sail out to his fleet anchored in the channel defending the Downs.

In 1815, the Lodge was sold to a Russian merchant, Patrick Cummings, whose wine cellars were said to be famous throughout England. Cummings later leased the property to the Marquis Wellesley, the Duke of Wellington's brother, who came to stay here. After first renting the property in 1822, Sir Moses Montefiore bought it for £5,500 on 6th April 1831 following the death of Patrick Cummings the previous year. After the death of Sir Moses, the property passed to Sebag Montefiore and remained in the Montefiore family until 1935.

David Nathan was the last person to occupy the place before Ramsgate Borough Council bought the property in 1938. The army occupied the whole place in World War II right up until 1945.

In March 1944 there was a proposed £830,000 development plan to turn it into a health centre. In 1952 the estate was sold to the Borough of Ramsgate, and in July 1953 the Lodge was demolished as there were plans to build a road through the grounds to link Ramsgate with Broadstairs. The only reason that the greenhouse and stable block were not demolished was because the road was not going through that part of the estate. The grounds are now the King George VI Memorial Park.

The gatehouse still exists and is a Grade II listed building.
SEE Bicycle/ Broadstairs/ Caroline, Princess of Wales/ Downs, The/ George VI/ Italianate Greenhouse/ Keith, Admiral Lord/ King George VI Park/ Listed buildings/ Montefiore, Sir Moses/ Ramsgate/ Tunnels/ Russia/ Wellesley/ Wellington/ Without Prejudice

EAST CLIFF PROMENADE, Ramsgate

First, the land behind the cliffs was farmland belonging to the Truro Estate; then the hotels, baths and concert hall arrived and, to complete the set, gardens were laid out. They were paid for by Edmund Davis, a financier who lived in St Peter's. Back in the nineteenth century, you had to pay a small charge at the kiosk before entering through a turnstile.
SEE Davis, Edmund/ Farms/ Granville Hotel/ Ramsgate/ Tollgate Kiosk

EAST COURT
Victoria Parade, Ramsgate

Designed by the London architects, Sir Ernest George and Harold Peto (they built many of the fashionable Chelsea and Kensington town houses of the era) for Sir William Henry Wills in 1889 (his initials are on the front of the house).

In 1933 the house was bought by the cigarette and alcohol hating 80 year old widower, Sir John Bayley who lived there until he died, aged 99, in April 1952. Obviously the sea air did him good. He had been the Vice-President of the non-conformist British and Foreign School Society. He founded Wrekin College, a public school, in 1880 and was its headmaster for 40 years. He became a knight in 1935. As Lloyd George was a great friend of his, it is possible he may have visited here. Mrs Butler, Bayley's sister-in-law, frugally ran the East Court household for him.

Opened by Princess Alice, the Duchess of Gloucester, and dedicated by the Bishop of Dover, Alfred Roase, from 1953 until 1982, East Court was used initially as a nursery for 24 babies, aged between 6 weeks and 2 years, by the Church of England's Children's Society. In 1970 it became a mixed home for children between 3 and 16.

In 1983 it became the East Court School for Dyslexic Children catering for around 60 children, aged between 8 and 13, some of whom are boarders.
SEE Holy Trinity Church/ Ramsgate/ Schools/ Stancomb-Wills, Dame Janet/ Wills, W D & H O/ Wills, Lady Elizabeth/ Wills, Sir William Henry

EAST KENT ARMS
Chatham Street, Ramsgate

It dates back to 1884 when the East Kent Brewery of Sandwich owned it.
SEE Breweries/ Chatham Street/ Pubs/ Ramsgate/ Sandwich

EAST KENT ROAD CAR Co

The East Kent Road Car Co started its bus service on the 27th March 1937.
SEE Transport

EAST KENT TIMES

Check out your old chest of drawers for a copy of it because it is thought that only one copy of the first issue remains, and that is in the British Museum.

*The Kent Coast Times
and Ramsgate and Margate Observer
circulated in Ramsgate Margate Broadstairs
Minster St Peters Sandwich Herne Bay
Whitstable
No 1 Thursday 17th May 1866 Price
Three-halfpence*
Printed, and published at his printing works in Hardres Street and Broad Street, Ramsgate, by Edwin Bligh. He wrote in it that, '*The Kent Coast Times will grow in merit and in favour and we hope, be a household word and a common household guest in these parts for generations to come.*' It did thrive as did many other newspapers of the time. In 1884 there were four local papers to choose from in Ramsgate: The Advertiser, The Argos and The Echo being the others. When Edwin Bligh died, his widow, Mary Anne Bligh, sold the paper and the new owners changed the name to the East Kent Times. In 1902 they also started to publish the Broadstairs and St Peter's Mail. The East Kent Times Limited Company was formed in London in 1904, the original directors being Robert Stacey, owner of the St Cloud Hotel; William E Duckett, the editor; and Henry George Holloway. The paper had a circulation of around 20,000 homes, and a great deal more readers, at its peak. It closed in 1980.
SEE Alma Road, Ramsgate/ Bellevue Road/ Birds/ Broadstairs/ Broadstairs & St Peter's Mail/ Canadian Military Hospital/ Craig, Norman/ Dumpton/ Fishing Fleet/ Forresters Hall, Margate/ Forresters Hall, Ramsgate/ Garlinge/ Green, Napoleon/ Hart, Dr/ HMS Thanet/ Infant deaths/ Lewis, Hyland & Linom/ Margate Sands Railway Station/ Mayor's Chain/ Mouth organs/ Muir Road/ National Union of Suffragettes/ Newspapers/ Pankhurst, Christabel/ Pankhurst, Emmeline/ Paragon/ Pethick-Lawrence, Emmeline/ Pond, Birchington/ Post box/ Promenade Pier/ San Clu Hotel/ Sausages/ South Eastern Road/ Square, Birchington The/ Suffragettes/ Summers, Henry/ Television advertising/ Tulips/ U-boat/ White slave trade

EASTENDERS
A popular soap opera that started on BBC on 19th February 1985. Twenty years later over 3,100 episodes have been broadcast. If you had watched every one of them back to back, and allowing for eight hours sleep each day, then it took up the equivalent of fourteen weeks of your life!
The former Eastenders star Jack Ryder turned on the Margate Christmas lights in 2004.
SEE Arnold, Robert/ Margate/ Televison

EASTERN ESPLANADE, Broadstairs
The local Conservative candidate in the 1904 election. F E McCormick Goodhart lived at Langley Lodge. The house later became Cliffcoombe Nursing Home, and in 1933, Dolly, the widow of Sir Henry Irving, died there.
SEE Broadstairs/ Copperfield Court/ Irving, Sir Henry/ St Mary's Convalescent Home for Children

EASTERN ESPLANADE, Cliftonville
This is the main road along the sea front between Newgate Gap in the west, and Hodges Gap in the east.
Ravensworth High Class School for Girls, Cliftonville was a boarding school at 3 Eastern Esplanade around the 1890s.
SEE Cliftonville/ Eliot, T S/ Grand Hotel/ Hodges Gap/ Lewis Crescent/ Newgate Gap/ Norfolk Hotel/ Queens Promenade/ St George's Hotel/ Schools/ Surrey Road/ Tom Thumb Theatre

EATON ROAD, Margate
Alresford House was a boys' boarding school situated at 7 Grosvenor Terrace in Eaton Road in the 1880-90s. There was also a girls' boarding school at number 8, Northcote School.
SEE Chambers, Frederick/ Chocolate/ Deckchairs/ Margate/ Schools

EBBSFLEET
Ebbsfleet is the area to the west of Cliffsend south of Ramsgate.
'*It is with the landing of Hengist and his war-band at Ebbsfleet on the shore of the Isle of Thanet that English history begins.
No spot in Britain can be so sacred to Englishmen as that which first felt the tread of English feet*' John Richard Green
SEE Bede, Venerable/ Coastguard Station, Ebbsfleet/ Gregory, Pope/ Lavender/ Pegwell Bay/ St Augustine's Cross/ St Mildred/ Hengist and Horsa/ Thanet

EDGAR ROAD, Cliftonville
There were four schools in this road at the end of the nineteenth century. Marion House was a girls' boarding school, and Napier Lodge was a boarding school for boys; as was Surrey House and Stafford House the latter being at number 2
SEE Cliftonville/ Schools

EDGE END ROAD, Broadstairs
About 100 years ago, a circus set up camp in a field at Edge End, Broadstairs, and their elephants walked all the way down the High Street so that they could have a paddle in the sea – they were supervised, obviously.
Unfortunately the name of the circus is not known for certain, but it in all probability it was the famous Barnum & Bailey's.
SEE Broadstairs/ High Street, Broadstairs/ Upton Primary School/ Woodward, James

EDITH ROAD, Ramsgate
Roman urns and pottery have been found in the area between Edith Road and St Mildred's Road.
SEE Ramsgate

King EDWARD III
Born 13th November 1312
Died 21st June 1377
He became king when his father, Edward II, died on 25th January 1327. The coronation was on 1st February 1327.
SEE Crecy/ Royalty

King EDWARD VII
Born 9th November
Died 6th May 1910
As a young man he often stayed at St Peter's as the guest of the vicar.
When he became king on 22nd January 1901 he was 59 years old, and the second oldest man to become the king. The oldest was William IV at the age of 64.
The Coronation of King Edward VII took place at Westminster Abbey on 9th August 1902, although Thanet was too busy with its summer season to have a proper celebration like the rest of the country.
At Margate, Ramsgate and Broadstairs the decorations are extremely effective, but as it is the height of the holiday season, business has not been suspended and there is an absence of festivities. Kentish Express
In 1907 Edward VII visited Birchington by rail – a giant archway was erected on the road near the railway station for him to pass through. He was attending a shooting party at Quex House.
SEE Alexandra, Princess/ Beresford, Admiral/ Birchington Hall/ Broadstairs/ King Edward VII pub/ Margate/ Quex/ Ramsgate/ Royalty/ St Peter's/ Wesleyan Methodist Church

'The Mystery of EDWIN DROOD'
by Charles Dickens
Charles Dickens' final but unfinished novel.
SEE Books/ Tartar Frigate

EFFINGHAM:
Charles Howard, 1st Earl of Nottingham, 2nd Lord Howard of Effingham
Born 1536
Died 14th December 1624
Elizabeth Howard, his father's sister, was the mother of Anne Boleyn who, in turn, was the mother of Elizabeth I. As a youth he served at sea with his father but when Elizabeth became queen his connections, abilities, and apparently, his good looks did wonders for his promotion chances. He was sent to France to congratulate Francis II on his accession in 1559 and, in 1569, he served under the Earl of Warwick suppressing the Roman Catholic rebellion in the north. In 1570 he was commander of a squadron of ships sent to watch the Spanish fleet that was accompanying the Queen of Spain to Flanders. He forced them to '*vail their bonnets for the queen of England*'.
In both 1563 and 1572, he represented Surrey in parliament. On 29th January 1573 he succeeded to his father's titles; on 24th April 1574 he became a Knight of the Garter and was made Lord Chamberlain of the Household, only giving up the honour when he was made Lord High Admiral of England in May 1585.
He also found the time to be High Steward of Kingston-upon-Thames, and Lord Lieutenant of Surrey. He was also one of the commissioners at the trial of the Babbington Plot conspirators and that of Mary, Queen of Scots. Some said it was his influence that caused Elizabeth to sign Mary's death warrant.
In December 1587, he was issuing stern warnings to the Queen: *For the love of Jesus Christ, Madam, awake thoroughly and see the villainous treasons round about you, against your Majesty and your realm . . . draw your forces round about you like a*

mighty prince to defend you. Truly, Madam, if you do so, there is no cause for fear.

As the Spanish Armada approached, on 6th July 1588, Howard described his forces: *I have divided myself here into three parts, and yet we lie within sight of one another, so as if any of us do discover the Spanish fleet we give notice thereof presently the one to the other and thereupon repair and assemble together. I myself do lie in the middle of the channel with the greatest force. Sir Francis Drake hath 20 ships and 4 or 5 pinnaces which lie beyond Ushant and Mr Hawkins with as many more lieth towards Scilly.*

By launching an attack on the San Lorenzo, off Calais, he was late turning up for the big battle off Gravelines for which he has been much criticized. Not only did he contribute to the naval expenses, but he also put his hand in his own pocket to assist the many seamen who had been poisoned by bad food and had to be landed at Margate.

In 1596, he and the Queen's favourite, Essex, commanded the expedition to Cadiz. Howard was content to destroy the enemy's fleet, which they did (a squadron was destroyed and two ships brought back intact), but Essex decided that he wanted to land, tear apart Cadiz and destroy the fort. As part of Howard's duty was to protect Essex, he reluctantly had to go along with him.

On 22nd October 1596 Howard was created Earl of Nottingham.

When Essex led a rebellion, Howard played a major part in its suppression, and was a commissioner at his trial in February 1601.

It was to Howard that Elizabeth spoke on her death bed, naming James as her successor. Howard remained Lord High Admiral under the new king until he was appointed ambassador to Spain in 1605. He was also involved in the trial over the Gunpowder Plot.

SEE Admirals/ Armada/ Effingham Street/ Margate

EFFINGHAM STREET, Ramsgate

It was originally known as Brick Street in 1730 (pre-dating the first records of 1748) either because (I wanted some of this book to be multiple choice) there was a brickfield here, or the houses here were amongst the first to be built of brick (by the same logic, roads on new estates these days should be called Breezeblock Row). By 1785 it was Effingham Place, re-named after Effingham House that was built here in the 1760s, and was looked upon as *'the most eligible place for persons desirous of retirement'*.

In the eighteenth century residents included Lord Verney, Lady Westmoreland, Sir David Lindsay and Lord Conyngham.

Until three steps leading up into George Street were removed in 1839 it was not a through road.

Rear Admiral Fox, who died at the age of 77 in 1810, lived in a house on the site of the Fire Station. There is a plaque marking the opening of the Fire Station in 1905.

The wine merchants Gwyn and Company, had premises on the site of a livery stable owned by Mr Worger.

There was once a Unitarian Chapel at number 9.

The Rising Sun has been there since 1822, prior to that it was called The Sun.

There are listed buildings here in some quantity, including numbers 10 and 12 dating from the early 19th century; number 24, Pine Lodge dating from the late 18th century although some of the rear of the property is from the 17th or earlier; numbers 35 and 39 are from the early 19th century; and 32, 34 and 36 are also listed.

Number 3 was recently on Thanet's eyesores list and was due to be demolished.

SEE Clarendon House School/ Conyngham/ Effingham/ Fire Station/ Fox, Rear Admiral/ George Street/ Ramsgate/ Rising Sun

ELECTION RESULTS

1885
King-Harman (Conservative) 3,381
E F Davis (Liberal) 2,670
Majority 711

1886
King-Harman (Conservative) 3,399
Banks (Liberal) 1,311
Majority 2,088

1888
Lowther (Conservative) 3,457
Knatchbull-Hugesson (Liberal) 2,889
Majority 568

1892
Lowther (Conservative) 3,901
Hart (Liberal) 2,857
Majority 1,044

1895
Lowther (Conservative) unopposed

1900
Lowther (Conservative) unopposed

1904
Marks (Conservative) 4,048
King (Liberal) 3,666
Majority 382

1906
Marks (Conservative) 5,154
King (Liberal) 3,961
Goodhart (Independent Conservative) 925
Majority 1,193

1910 January
Norman Craig (Conservative) 6,892
Weigall (Liberal) 3,410
Majority 3,482

1910 December
Norman Craig (Conservative) unopposed

1918
Norman Craig (Conservative) unopposed

1919
Harmsworth (Conservative) 9,711
West (Liberal) 7,058
Majority 2,653

1922
Harmsworth (Conservative) 16,116
Suenson-Taylor (Liberal) 10,226
Majority 5,890

1923
Harmsworth (Conservative) 13,821
Rait (Liberal) 13,773
Majority 48

1924
Harmsworth (Conservative) 21,130
Luxmore (Liberal) 6,779
Aman Labour) 4,202

Majority 14,351

1929
Balfour (Conservative) 22,595
Suenson-Taylor (Liberal) 15,648
Plaisted (Labour) 4,490
Majority 6,947

1931
Balfour (Conservative) 33,173)
Phillips (Liberal) 11,517
Majority 21,656

1935
Balfour (Conservative) unopposed

1945
Carson (Conservative) 15,023
Boyd (Labour) 12,075
Willmett (Liberal) 3,732
Majority 2,948

1950
Carson (Conservative) 31,345
Boyd (Labour) 20,522
Wrong (Liberal) 4,561
Majority 10,823

1951
Carson (Conservative) 33,551
Shaw (Labour) 20,892
Majority 12,659

1953 By-election
Rees-Davies (Conservative) 25,261
Woodbridge (Labour) 15,935
Majority 9,326

1955
Rees-Davies (Conservative) 31,270
Jones (Labour) 18,981
Majority 12,289

1959
Rees-Davies (Conservative) 29,453
Fountain (Labour) 17,555
Macdonald-Jones (Liberal) 6,998
Majority 11,898

1964
Rees-Davies (Conservative) 27,870
Wistrich (Labour) 20,520
Norrington (Liberal) 9,979
Majority 7,350

1966
Rees-Davies (Conservative) 29,302
Bishop (Labour) 24,416
Redman (Liberal) 7,952
Majority 4,886

1970
Rees-Davies (Conservative) 33,434
Bishop (Labour) 21,709
Gates (Liberal) 7,176
Josephs (Independent) 2,136
Majority 11,725

In **1970** Thanet was split into two constituencies

1974 February: Thanet East
Aitken (Conservative) 17,944
Bean (Labour) 11,347
Cox (Liberal) 8,997
Majority 6,597

1974 February: Thanet West
Rees-Davies (Conservative) 16,880
Tiltman (Labour) 9,220
Ramage (Liberal) 7,969
Majority 7,660

1974 October: Thanet East
Aitken (Conservative) 15,813
S M Barlett (Labour) 11,310
C Hogarth (Liberal) 6,472
K Munson (National Front) 708

Majority 4,503
1974 October: Thanet West
Rees-Davies (Conservative) 13,763
C J Smith (Labour) 8,655
I G Tiltman (Lib) 7,935
Majority 5,108
1979: Thanet East
Aitken (Conservative) 20,367
Kilberry (Labour) 10,128
Hesketh (Liberal) 4,755
Dobing (National Front) 376
Majority 10,239
1979: Thanet West
Rees-Davies (Conservative) 18,122
Little (Labour) 8,576
Payne (Liberal) 6,017
Majority 9,564
Thanet was split into two different constituencies
1983: Thanet North
Gale (Conservative) 26,801
Macmillan (SDP) 12,256
Booth (Labour) 6,482
Dobing (BNP) 324
Majority 14,545
1983: Thanet South
Aitken (Conservative) 24,512
Josephs (Liberal) 10,461
Clarke (Labour) 8,429
Majority 14,501
1987: Thanet North
Gale (Conservative) 29,225
Cranston (SDP) 11,745
Bretman (Labour) 8,395
Condor (GP) 996
Majority 17,480
1987: Thanet South
Aitken (Conservative) 25,135
Pitt (Liberal) 11,452
Wright (Labour) 9,763
Majority 13,683
1992: Thanet North
Gale (Conservative) 30,867
Bretman (Labour) 12,657
Philips (LibDem) 9,563
Dawe (GP) 873
Majority 18,210
1992: Thanet South
Aitken (Conservative) 25,253
James (Labour) 13,740
Pitt (Liberal) 8,948
Peckham (GP) 871
Majority 11,513
1997: Thanet North
Gale (Conservative) 21,586
Johnson (Labour) 18,820
Kendrick (LibDem) 5,576
Chambers (Referendum) 2,535
Haines (UKIP) 438
Majority 2,766
1997: Thanet South
Ladyman (Labour) 20,777
Aitken (Conservative) 17,899
Hewett-Silk (LibDem) 5,263
Crook (UKIP) 631
Wheatley (Green) 418
Majority 2,878
2001: Thanet North
Gale (Conservative) 21,050
Laing (Labour) 14,400
Proctor (LibDem) 4,603
Moore (UKIP) 980

Shortt (Independent) 440
Holmes (National Front) 395
Majority 6,650
2001: Thanet South
Ladyman (Labour) 18,002
MacGregor (Conservative) 16,210
Voizey (LibDem) 3,706
Baldwin (Independent) 770
Eccott (UKIP) 502
Franklin (National Front) 242
Majority 1,792
2005: Thanet North
Gale (Conservative) 21,699
Johnson (Labour) 14,065
Barnard (LibDem) 6,279
Stocks (UKIP) 1,689
Majority 7,634
2005: Thanet South
Ladyman (Labour) 16,660
MacGregor (Conservative) 15,996
Voizey (LibDem) 5,431
Farage (UKIP) 2,079
Green (Green) 888
Kinsella (Independent) 188
Majority 664
SEE Aitken, J/ Booth, C/ Craig/ Harmsworth/ Politics/ Thanet

The Isle of Thanet ELECTRIC TRAMWAYS AND LIGHTING COMPANY Ltd
(You wouldn't have wanted the job of answering the phone at that firm!) The company opened a tram service between Ramsgate, Broadstairs and Margate on 4th April 1901, and another between Margate, Dumpton and Ramsgate three months later. In 1901 a tramcar careered down Fort Hill ending up outside the Crown Hotel in Market Place, Margate.
SEE Broadstairs/ Dumpton/ Margate/ Ramsgate/ Thanet/ Trams

ELEPHANT
SEE Edge End Road/ Lucy the Margate Elephant/ Mechanical Elephant/ Van Amburgh, Isaac/ USA

ELEPHANT & CASTLE public house Hereson Road, Ramsgate
Once a terraced house built in 1834, by 1849 it was a pub. Over the years it has expanded into adjacent properties.
SEE Hereson Road/ Pubs/ Ramsgate

George ELIOT
Born 22nd November 1819
Died 22nd December 1880
Mary Ann (later changed to Marian) Evans, better known by her pen name of George Eliot, came with Herbert Spencer in 1852 for one of their '*discreet holidays together in Broadstairs*'. They stayed at Chandos Cottage on the corner of Chandos Square and Oscar Road and in letters to friends she wrote:
May 1852: '... *I am getting as haggard as an old witch under London atmosphere and influences . .*'
4th July 1852: *Broadstairs is perfect, and I have the snuggest little lodgings conceivable with a motherly good woman and a nice little damsel of 14 to wait on me.*

. . . I have a sitting-room about 8 feet by 9 and a bedroom a little larger, yet in that small space there is almost every comfort.
. . . I pay a guinea a week for my rooms, so I shall not ruin myself by staying a month unless I commit excesses with coffee and sugar.
. . . I warn you against Ramsgate, which is a strip of London come out for an airing.
14th July 1852: *…. this is the nicest sea place I have seen – so quiet and full of natural beauty.*
15th July 1852: *I am imbibing its* (Broadstairs) *peaceful beauty and dignity and half determining never to go back to that human world with its jealousies and unrest.*
16th July 1852: *If you could see me in my quiet nook! I am half ashamed of being in such clover both spiritually and materially while some of my friends are on the dusty highways without a tuft of grass or a flower to cheer them.*
19th August 1852: *Providence, seeing that I needed weaning from this place, has sent a swarm of harvest-bugs and lady birds to bite my legs.*
Between 1851 and 1854, Mary was the sub-editor of 'The Westminster' owned by John Chapman. Previously, she had lodged with him, his wife and their children's governess and also Mr Chapman's mistress. Ironically, Mary lived there for only ten weeks because she could not stand the jealousy of the other two women in the household who were convinced, wrongly, that she was Mr Chapman's new mistress. It was at one of John Chapman's numerous literary parties that she met the sub-editor of 'The Economist' Herbert Spencer, whose book 'Social Statics' had been published in 1851 by - you've guessed it - John Chapman. The hot gossip of the time was that the two of them were engaged, but they never were. Our Herbert did however introduce Marian, as she had now become, to both her future husbands. The first was George Henry Lewes, a journalist, who had founded the radical weekly 'The Leader' with Thornton Leigh Hunt in April 1850. George was married to Agnes Jervis, and two weeks after the first issue of 'The Leader', she gave birth to a son; only it was Thornton who was the father. George, being a very liberal man, accepted the situation and registered the boy as his own son, remaining friendly with both Agnes and Thornton. However, Agnes and Thornton also remained more than friendly with each other, and, in October 1851, the same thing happened again. This time George wasn't going to take it lying down - unlike Agnes - and he ceased to regard her as his wife, suing for divorce; but he was not permitted to do so because by accepting the first boy as his son he had condoned the adultery. It was at this point in his life that he met Marian and they lived together openly and extremely happily.
It was during this time that Marian wrote and published 'Adam Bede' (1859), 'The Mill on the Floss' (1860), 'Silas Marner' (1861), 'Middlemarch' (1871-2), and 'Daniel Deronda' (1876). Meanwhile, Agnes had

four children in total by Thornton, the last being born in 1857, all registered with George as the father. Poor old George ended up paying for their schooling in Switzerland, as well as paying Agnes £100 a year, which was to continue until her death in 1902. After George's death on 30th November 1878, Marian was heartbroken and for months refused to see anyone except George's son Charles Lee Lewes. For many years their financial affairs had been handled by John Walter Cross (1840-1924), a banker introduced to them by our old friend John Chapman. Cross's mother had died only a week after Lewes and sympathy and advice led to affection and on 6th May 1880 they married. He was 40, she was 60, but sadly just seven months later, on the 22nd December, she died.

'Broadstairs is perfect.' George Eliot
SEE Authors/ Broadstairs/ Ramsgate

T S ELIOT
Born 26th September 1888
Died 4th January 1965
He is probably best remembered today for his book of childrens' verse 'Old Possum's Book of Practical Cats' (1939), later adapted by Andrew Lloyd Webber into his musical 'Cats'.

In October 1921, his employers, Lloyds Bank, gave Thomas Stearns Eliot three month's sick leave to convalesce and recover from nervous exhaustion. The first three weeks were spent at the Albemarle Hotel, 47 Eastern Esplanade, Cliftonville. In a letter to a friend, his wife wrote, *'he looks already younger, and fatter and nicer. . . being out in this wonderful air all day!'* While he was here, he completed the third section of 'The Waste Land' and sent off the manuscript with the £16 hotel bill attached!

'I have done a rough draft of part III, but do not know whether it will do - I have done this while sitting in a shelter on the front – as I am out all day except while taking rest. But I have written only some fifty lines, and have read nothing, literally – I sketch the people, after a fashion, and practise scales on the mandoline.'

> *On Margate Sands.*
> *I can connect*
> *Nothing with nothing.*
> *The broken fingernails of dirty hands.*
> *My people humble people who expect*
> *Nothing.*

SEE Authors/ Cliftonville/ Eastern Esplanade, Cliftonville/ Margate/ Music

ELLINGTON ARMS public house
Hillbrow Road, Ramsgate
Named after the Ramsgate Yeomanry based at what is now Ellington Park. It was a spit and sawdust pub in what was then a tough area referred to as the Blue Mountain district of Ramsgate. Now closed, it has been converted into two houses.
SEE Pubs/ Ramsgate/ Yeomanry

ELLINGTON PARK, Ramsgate
The original Ellington manor house was lived in by the Ellington family, who farmed the area to the west of the present park back in the thirteenth century. Over the years with different owners, it has been added to and changed. The Ellingtons were replaced by the Thatchers in the late fifteenth century. In the latter half of the sixteenth century the Sprackling family took over.

The Troward family bought Ellington house in the mid-eighteenth century. Mr W Troward of Manston Green died without issue in 1767 and subsequently the estate had several owners. Eventually the one time tenant, John Garrett (captain of the Thanet Troops), ended up able to leave the estate and manor house to his nephew who then set about making various improvements.

For a long time people were convinced that the place was haunted but it transpired that the things that went bump in the night were noises from the stables echoing around the chalk caves under the old house – or so they said . . .

The trustees of the Garrett family sold off the estate in 1866 for building purposes, with the exception of Ellington House and 12 acres of land which were bought by Edward Wilkie.

When Wilkie died in 1892, Ramsgate Corporation bought it for £12,000 and created Ellington Park. It opened on 7th September 1893 without the mansion house which was by now demolished. The new park was a magnificent sight at the time and was laid out by Cheal & Sons, nursery gardeners from Crawley. Military bands played in the bandstand, and there was a fountain containing goldfish, as well as an aviary housing peacocks, rabbits and guinea pigs (it wasn't an exclusive aviary – not being able to fly did not bar you), there was also a rustic bridge over the reed-lined lake. Gymkhanas, concerts, fetes and the Battle of the Flowers have all been held here.

A fountain was presented to the town in 1894 by Mrs Barber in memory of her son. The fountain has gone now as well.

A flower show in August 1911 was held in temperatures up in the 90s.

Thanet Advertiser, 10th March 1906:
Benjamin Todd, 20, was sent to Chartham Lunatic Asylum for indecently exposing himself in Ellington Park.

Ramsgate children celebrated Empire Day on 25th May 1908 in Ellington Park, and in 1913 there were 4,800 children gathered to watch the Mayoress raise the Union Jack (aye, they used to make their own entertainment then).

In 1934 the Ramsgate Pageant was held from 16th to 21st July to celebrate the town's 50th anniversary as an independent borough. Over 4,000 people dressed up as figures from history.

As part of the George V Silver Jubilee celebrations, 5,000 children were addressed here by the Chairman of the Education Committee. They all went home with either a commemorative mug or beaker.

Ellington Park was damaged in the same Zeppelin raid (17th May 1915) that destroyed the Bull and George pub in the High Street. In total, five bombs landed on the park in World War I and one, weighing 500kg,

uprooted trees and damaged about 50 houses nearby.

A bowling green was created just after the war.

A mini railway opened on 18th August 1971 with a track that was over 500 feet long and had taken two years to build.
SEE Birds/ Bull and George/ Farms/ Ramsgate/ Sprackling, Adam/ Parks/ Thanet/ Zeppelin

ELMS AVENUE, Ramsgate
The almshouses of the parish of St George were *'built, endowed and dedicated to the poor . . .by the will of Frances Barber'* and a lovely building it is too. So the next time you are whizzing down Elms Avenue to go shopping at Waitrose pause to enjoy it. Only remember to 'mirror, signal, manoeuvre' before you stop!
SEE Clarendon House/ Elms public house/ Ramsgate

ELMS public house
Richmond Road, Ramsgate
The Tomson estate was once enclosed by elm trees and the name of the pub reflects this. It was a pub dating from 1870 but is now closed and soon to be converted into a residential property.
SEE Pubs/ Ramsgate/ Tomson & Wotton

ELMWOOD COTTAGE, Broadstairs
The earliest Sun Insurance plaque, No 115253 dated 1748, is on the side of this cottage. Back then a cooper from Herne, John Rumney, was the owner.

At the invitation of Alfred Harmsworth, Douglas Fairbanks (Senior) and Mary Pickford spent part of their secret honeymoon in Elmwood Cottage.
SEE Broadstairs/ Elmwood House/ Harmsworth/ Honeymoon

ELMWOOD COTTAGES
Callis Court Road, Broadstairs
Now demolished, Elmwood Cottages, opposite Elmwood House were part of Josse Farm – later Elmwood Farm, part of the Northcliff Estate.
SEE Broadstairs/ Farms/ Josse family/ Northcliff

ELMWOOD HOUSE, Broadstairs
The house, Tudor built, on the junction of Elmwood Avenue, Callis Court Road, and Reading Street was home to Sir James Fisher from 1801, when it was built. Its most famous resident was Alfred Harmsworth who bought it in 1889 but spent two years having it modernised before moving in, during 1891. He is said to have kept a pet alligator here, either in the lake or the conservatory, according to the season, or the story, involved.

The five gardeners it took to look after the gardens were housed in a cottage in the grounds called the Bothey. It is now called Gardenia Cottage.

When Harmsworth was Propaganda Minister in World War I, the Germans tried to assassinate him. At 11.15pm on 25th February 1917, a German destroyer, G.85, fired a shot at Elmwood House but missed and hit the cottage instead, killing a woman

and her two children. The destroyer was subsequently sunk by HMS Broke. Harmsworth set up a relief fund for the bereaved family. The hole made by the shell was turned into a window.
SEE Broadstairs/ Harmsworth, Alfred/ Honeymoon/ Thatched House/ World War I

Paul ELUARD
Born St Denis, nr Paris 14th December 1895
Died 18th November 1952
The poet and surrealist (Paul Eluard was a nom de plume, his real name was Eugene Grindel) visited his fifteen-year old daughter, who was staying in Ramsgate, in August 1933. Her mother Gala was divorced from Paul and was Salvador Dali's mistress.
SEE Poets/ Ramsgate

Tracey EMIN
Born 3rd July 1963
Famous for being *'the most outrageous artist on the contemporary scene',* Tracey Emin was born in London in 1963 (she has a twin brother, Paul), but brought up in Margate (Fort Crescent – and she went to Holy Trinity School, Trinity Square, and King Ethelbert School), and refers to herself as *'Mad Tracey from Margate'.*
Her work includes 'Every Part of Me Is Bleeding', 'You Forgot to Kiss My Soul' (the words are in neon within a neon heart-shape), 'My Bed' her unmade bed which Saatchi famously paid £150,000 for (he can have mine for a straight £100,000), and 'Everyone I have Ever Slept With' a tent displaying all the names of people she has ever slept with – a very small ridge tent and a very large marker pen is all most people need. It should be stressed though, that it is everyone she had ever shared a bed with, not just everyone she has had sex with, it was more about intimacy than sex - a distinction often ignored by her critics.
The first thing she bought when she started to make some money was medical insurance, *'because I get run down and I have very bad herpes'.*
A fire at a warehouse on 24th May 2004 destroyed much of her work.
Her 40th birthday party was held in Kingsgate and at the Walpole Hotel in Cliftonville.
SEE Artists/ Fort Crescent/ King Ethelbert School/ Kingsgate/ Margate/ Topspot/ Trinity Square/ Walpole Bay Hotel

ENDCLIFFE HOTEL, Cliftonville
The Endcliffe Hotel was gutted by fire in April 2005.
SEE Cliftonville/ Fires/ Hotels

Friedrich ENGELS
Born 28th November 1820
Died 5th August 1895
The German philosopher who collaborated with Karl Marx. 'The Communist Manifesto' (1848) and 'Das Kapital' (1867-94) were probably their two greatest hits, popular in Eastern Europe in their day, but not so big now. They also had Ramsgate in common, convinced of the health benefits of the sea and the sea air. Friedrich stayed in Ramsgate

at least ten times between 1871 and 1880, often with Lizzie Burns, his mistress. Marx strongly disapproved of Engel's choice of mistress because she was too common!
Engels had lived with her sister Mary until she had died, aged 41, in 1863 and then Lizzie (Lydia) got the job. He came twice for a few days in September and October 1871, the second time with Karl Marx and his wife. He returned with Marx *'to relax a little for a few days at the seaside'* in July 1872. The following year he spent several weeks here in August and September with Lizzie for her health. They returned again and stayed at 11 Abbot's Hill from the middle of July 1874 for about a month. Engels noticed that as Ramsgate got more popular with *'the lower English middle-classes',* the visitors became *'less respectable'.*
From the middle of August until 22nd September 1875 they again stayed in Ramsgate; the following year, between 20th May and 2nd June 1876 they stayed at 3 Adelaide Gardens, but returned to stay at 11 Camden Square from 24th July until 1st September. This time Marx's wife Jenny stayed with them and Engels wrote to a friend about the *'very idle life'* and *'the excellent bottled beer',* oh and the weather was good as well. It must have been terrible for them.
At this moment Ramsgate is populated almost exclusively by small greengrocers and other quite small shopkeepers from London. These people stay here a week, for as long as the return ticket is valid, and then make way for others of the same ilk. It's the former day-trip public which now takes a week off. At first sight one would think they were working men, but their conversation immediately betrays the fact that they are rather above that and belong to quite the most disagreeable stratum of London society – they're the kind who, in speech and manner, are already preparing themselves, after the inevitably pending bankruptcy, for the no less inevitably impending career of costermonger. Engels, in a letter to Marx, 25th August 1876
From 11th July until 28th August 1877 he brought Lizzie to 2 Adelaide Gardens to help with her poor health but he told Marx in a letter that, *'the magic powers of sea bathing have failed her for the first time'.* He eventually married Lizzie on her deathbed in 1878. He did not come back to Ramsgate until 1880 when he stayed with the Marx family for a few days at 10 Cumberland Road, but otherwise he took his holidays elsewhere. From Bridlington he wrote to Marx's son-in-law that it differed from Ramsgate in that it was *'more provincial'* and there were *'no 'Arrys'*!
SEE Abbot's Hill/ Adelaide Gardens/ Bathing/ Camden Square/ Cumberland Road/ Marx, Karl/ Ramsgate

ENTERTAINERS
Many showbiz stars have performed, or had a connection with Thanet, the following is just a small selection.

SEE Actors/ Askey, Arthur/ Beach entertainment/ Black & White Minstrels/ Bloodvessel, Buster/ Boleno, Harry/ Bowie, David/ Broughton, Phyllis/ Buffalo Bill's Wild West Show/ Chaplin, Charlie/ Chas & Dave/ Connolly, Billy/ Cooper, Tommy/ Cotton, Billy/ Crowther, Leslie/ Dandy Coons/ Davidson, Jim/ Films/ Flea circus/ Granville Theatre/ Grayson, Larry/ Green, Hughie/ Hill, Benny/ Hill, Vince/ La Rue, Danny/ Laurel & Hardy/ Lido/ Lion Tamer/ Lloyd, Marie/ Lynn, Dame Vera/ Matthews, Jesse/ Mills, Annette/ Morecambe and Wise/ Murray, Al/ Norton, Graham/ Pallo, Jackie/ Robey, Sir George/ Sanger/ Secombe, Harry/ Tarbuck, Jimmy/ Theatre Royal/ Thomas, Terry/ Tyrwhitt-Drake, Sir Garrard/ Uncle Bones/ Uncle Frank/ Uncle Mac/ Van Amburgh, Isaac/ Wagram, Miss/ Warner, Jack/ Winter Gardens/ Winters, Mike & Bernie/ Woodward, James/ Zavaroni, Lena

EPPLE BAY, Birchington
There once was a coastguard station here, well two, if you count the 'old' and the 'new' that replaced it.
At the end of May in 2000 a 25 year old man fell into a 30ft hole caused by subsidence as a result of torrential rain; well, it was the Bank Holiday weekend. He suffered injuries to his head and leg and was trapped for an hour before firemen could rescue him.
SEE Bays/ Birchington/ Coastguards/ 'Nest of the Sparrowhawk'

EPPLE BAY ROAD, Birchington
Horace Valentine Payne, an employee of Kraft Food, was given the MBE by King George VI on 13th June 1946. He had the bungalow at Number 10 Epple Bay Road, Birchington built.
The property at 81 Epple Bay Road was on Thanet's eyesore list. At the time of writing, there are plans to refurbish the building as a nursing home.
A school for girls and boys under nine was established at Mildmay, Epple Bay Road in the 1920s but soon moved to Station Approach.
SEE Birchington/ George VI/ Thicket Convalescent Home/ Sea Point Private School/ Schools

EPPLE ROAD, Birchington
Originally Epald Road, it led to the Coastguard Houses, but the gap has been filled in and its original route has been altered.
SEE Birchington/ Coastguards

King ETHELBERT
King Ethelbert was married to a Christian but refused to see Augustine when he arrived in 597. I know how he felt. I refuse to meet those people who want me to change my utility company, or convert to another 'energy supplier'. In the end, he did agree to meet, but only in the open air, where he thought he would be safe from Augustine's spells. Augustine and his party were not as bad as the King was expecting (but I'm still not going to change my supplier) and they were invited up to Canterbury. Augustine became the first Archbishop of Canterbury. He died in 604.
SEE Jerrold, Douglas/ Royalty/ St Augustine

ETHELBERT ROAD, Cliftonville

The Ethelbert Hotel was at 36 Ethelbert Road, Cliftonville, in the late nineteenth century.
SEE Cliftonville/ Hotels

ETHELBERT TERRACE, Cliftonville

SEE Cliftonville/ Gotha raid

King ETHELRED

Born 968
Died 23rd April 1016
During King Ethelred's reign (978-1013 and 1014-1016) the spectre of smuggling emerged, possibly as a by-product of his having levied a tax on the Thames Boatmen in London for any cargo landed. They had to pay a halfpenny on a boat without a sail, and a penny if it had a sail. Boatmen soon took to unloading away from the docks and transporting their goods by horse.
SEE Royalty/ Smuggling

EUROJET

Eurojet, or EUjet, started commercial flights from what is now called London Manston Airport. The first flight left at 6.15am on 1st September 2004 to Amsterdam Schipol. It was hoped that there would be 60 flights in and out each day to 27 destinations including Barcelona, Dublin and Milan. Half a million passengers were hoped for in the first year, and by 2007 it was hoped it would rise to 2,000,000. However, by July 2005 they had gone out of business.
SEE Manston Airport

'EVA TROUT' by Elizabeth Bowen

Novel published in 1969
The Anglia . . . quickened on entering open air - passing the lighthouse, they swooped down the loops of the road to Kingsgate Bay. One grade above sea-level, two great white-painted lions outside a great white closed house looked across, watching the tide go out. Not a ship in sight - and the road, in the bright boundless chill of the salty evening, was vacant also. Even the wind had gone. The outgoing water sucked and dragged at the wetted edge of the beach, but you could not hear. Some way ahead, to the east, like a kind of beacon, the Captain Digby crowned the sawn-off headland terminating the bay. Now, building and cliff were one in an hallucinatory afterglow: B-A-R was able to be deciphered. Eva . . . was trailing a look through the back window at what they were leaving behind them: Kingsgate Castle. The crenellated mock fortress, flint-hard in silhouette, rode forward over the waters towards France.
SEE Books/ Bowen, Elizabeth/ Captain Digby/ Kingsgate Castle

EVACUATION

On the alarm signal (two maroons) take two days' provisions, lock up your house and proceed to the place of Assembly (Dumpton Park). Take no household goods with you. The Police will look after your house. By order of the Mayor, for the Naval and Military Authorities. Evacuation Orders for Ramsgate 1914.
Once assembled, you would march all the way to a camp called Stonehaven at Plucks Gutter!
In June 1940 over two thousand Thanet schoolchildren were evacuated (Ramsgate children went mainly to the Stafford area) on three trains, containing 700, 689 and 697 children respectively.
SEE Dumpton/ Ramsgate/ Schools/ Thanet/ World War I/ World War II

F

FAIR STREET, Broadstairs

Hops were once grown in this area at Fair Street Farm.
SEE Broadstairs/ Farms/ Hops

Douglas FAIRBANKS Snr.

Born Denver 23rd May 1883
Died 12th December 1939
Douglas Elton Ulman (his real name) was an American actor, screenwriter, director, and producer, most noted for his swashbuckling roles in films like 'The Mark of Zorro' (1920), 'The Three Musketeers' (1921), 'Robin Hood' (1922), 'The Thief of Bagdad' (1924) and 'The Black Pirate' (1926).
He married Anna Beth Sully, the daughter of a wealthy industrialist, in 1907 and they had a son, Douglas Fairbanks, Jr.. He met Mary Pickford whilst on a war bonds drive with Charlie Chaplin and the two fell in love. He and Beth were divorced in 1920, and on 28th March 1920 Fairbanks and Pickford married and became 'Hollywood Royalty', entertaining lavishly at their Pickfair estate.
He and Mary separated in 1933 and were divorced three years later. On 7th March 1936, Douglas married Sylvia Ashley. He lived in retirement in Santa Monica, California but died in his sleep of a heart attack in 1939.
SEE Actors/ Honeymoon/ Pickford, Mary

FAIRFIELD HOUSE OPEN AIR RESIDENTIAL SCHOOL
Fairfield Road, Broadstairs

The Fairfield House Open Air Residential School was a 'Save the Children' school, and the then President of that charity, Countess Mountbatten of Burma, visited it on Saturday 16th September 1950. It was home to girls between seven and eleven years old. It had been closed during World War II, when it was used by the fire brigade, but was re-opened by the wife of the Prime Minister, Clement Attlee in 1947 who told the crowd 'I think your home is lovely'.
The house became a retirement home in the 1980s.
SEE Broadstairs/ Prime Ministers/ Schools

'The FALLEN LEAVES'
by Wilkie Collins

In 'The Fallen Leaves' (1879) old Mr Ronald (he's 50!) follows his young wife to Ramsgate, where she is staying for the sake of her daughter's health (well that's what she told him . . .) but Broadstairs also gets a mention in the story:
Mr. Ronald walked mechanically to the end of the row of houses, and met the wide grand view of sea and sky. There were some seats behind the railing which fenced the edge of the cliff. He sat down, perfectly stupefied and helpless, on the nearest bench. . . . He leaned back on the bench, and fixed his eyes on the sea, and wondered languidly what had come to him. Farnaby and the woman, still following, waited round the corner where they could just keep him in view.
The blue lustre of the sky was without a cloud; the sunny sea leapt under the fresh westerly breeze. From the beach, the cries of children at play, the shouts of donkey-boys driving their poor beasts, the distant notes of brass instruments playing a waltz, and the mellow music of the small waves breaking on the sand, rose joyously together on the fragrant air. On the next bench, a dirty old boatman was prosing to a stupid old visitor. Mr. Ronald listened, with a sense of vacant content in the mere act of listening. The boatman's words found their way to his ears like the other sounds that were abroad in the air. 'Yes; them's the Goodwin Sands, where you see the lightship. And that steamer there, towing a vessel into the harbour, that's the Ramsgate Tug. Do you know what I should like to see? I should like to see the Ramsgate Tug blow up. Why? I'll tell you why. I belong to Broadstairs; I don't belong to Ramsgate. Very well. I'm idling here, as you may see, without one copper piece in my pocket to rub against another. What trade do I belong to? I don't belong to no trade; I belong to a boat. The boat's rotting at Broadstairs, for want of work. And all along of what? All along of the Tug. The Tug has took the bread out of our mouths: me and my mates. Wait a bit; I'll show you how. What did a ship do, in the good old times, when she got on them sands - Goodwin Sands? Went to pieces, if it come on to blow; or got sucked down little by little when it was fair weather. Now I'm coming to it. What did We do (in the good old times, mind you) when we happened to see that ship in distress? Out with our boat; blow high or blow low, out with our boat. And saved the lives of the crew, did you say? Well, yes; saving the crew was part of the day's work, to be sure; the part we didn't get paid for. We saved the cargo, Master! and got salvage!! Hundreds of pounds, I tell you, divided amongst us by law!!! Ah, those times are gone. A parcel of sneaks get together, and subscribe to build a Steam-Tug. When a ship gets on the sands now, out goes the Tug, night and day alike, and brings her safe into harbour, and takes the bread out of our mouths. Shameful - that's what I call it - shameful.'
SEE Books/ Broadstairs/ Collins, Wilkie/ Donkeys/ Goodwin Sands/ Ramsgate

FALSTAFF INN
Addington Street, Ramsgate
Originally only half of its current size and occupying the equivalent of one terraced house in the newly built Addington Street of 1840 the pub soon expanded into the house next door. Apt really, because the Shakespearean hero after which it is named was both jovial, had an expanding waistline and enjoyed a drink.

Falstaff appears in Shakespeare's play 'Henry IV' parts I and II (1597) and, apparently at the request of Queen Elizabeth who loved the character, he returned in 'The Merry Wives of Windsor' (1600) and his death is described in 'Henry V' (1598).

SEE Addington Street/ Ramsgate/ Shakespeare/ Pubs

Joseph FARINGTON
Born 1747
Died 1821
The diarist and topographical artist *'Left Margate at 5 in the Coach, Miss Glover with me. We breakfasted at Canterbury, where two other passengers joined us. We got to London at 7 in the evening.'* According to his diary entry for 27th August 1804.
SEE Margate/ Transport

FARLEYS, Chatham Street, Ramsgate
James Farley opened a cobbler's and shoe repairers in 1928 but soon started to sell second-hand furniture. The business passed to his sons Norman and Harold and developed into the biggest carpet and furniture shop in East Kent occupying 21,000 square feet of floor space. Part of the building where the shops operates is Grade I listed.

A plaque outside reads: *Here Boxer lies after years of faithful service. He came to an untimely end April 19th 1850.* Boxer is thought to be a dog that belonged to a former housekeeper of Townley House.
SEE Chatham Street/ Ramsgate/ Shops/ Townley House

FARMS
Once, grain was in abundance in Thanet but from the early 1900s broccoli, cauliflower, spring cabbage and early potatoes took over. Now the main food crops are green vegetables and potatoes.

There were 57 farmers listed in Kelly's Directory of the Isle of Thanet, 1957.

Thanet now has 15,000 acres of farmland.

SEE Abbot's Hill/ Addington Street/ Beale, Benjamin/ Birchington Hall/ Bradstow Nurseries/ Broad Street/ Callis Court/ Canterbury Road, Birchington/ Captain Swing/ Cemetery, Ramsgate/ Chapel Bottom/ Chapel Place/ Chatham Street/ Chilton/ Church Street, St Peter's/ Classic Cinema/ Cleve Court/ Cliffs End Hall/ Clock Tower/ Cobbett, William/ Coleman's Stairs Road/ Court Mount/ Coves, The/ Dairy Farms/ Dane Park/ Dane Valley Arms/ Dent-de-lion/ Development/ Dumpton/ East Cliff Promenade/ Ellington Park/ Elmwood Cottages/ Fair Street/ Farm Cottage/ Ferndale Court/ Garlinge/ Granville Hotel/ Great Brooks End Farm/ Hardres Street/ Hereson/ Hollicondane/ Holy Trinity School, Broadstairs/ Honeysuckle Inn/ Hops/ Jackey Bakers/ Jersey Cabbage/ Joss Bay/ Josse family/ Kingsgate Castle/ Lavender/ Lloyds Bank/ Manston/ Margate/ Market, Ramsgate/ Minnis Bay & Gore End/ Monkton Road Farm Cottages/ Mulberry Tree/ Mutrix/ Nethercourt Farm/ Northdown Road/ Old Bay Cottage/ Petit, JC/ Pierremont Mill/ Poultry Farms/ Queens Court/ Ramsgate Airport/ Reculver/ Roman Catholic Church, Birchington/ Sacketts Hill Farm/ St Andrew's Church/ St Peter's Court Prep School/ Shallows, The/ Sharps Dairy/ Smugglers, The/ Smuggler's Leap/ Sowell Street/ Spur Railway Line/ Stag Hunt Extraordinary/ Stone Farm/ Sun Inn/ Temperance Hotel/ Thanet/ Tivoli Road/ Tomson & Wotton/ Trams/ Tyrrel's Farm/ United Reform Church/ Vale, The/ Westbrook/ Westgate-on-Sea/ Whitehall Farm/ White Stag/ Yeomanry

FARM COTTAGE
Lanthorne Road, Broadstairs
Joss Snelling (a well-known smuggler) lived at Farm Cottage in Lanthorne Road, although then it was called Callis Court Cottage, and Snelling's gang was called the Callis Court Gang.

'This cottage was of late occupied by a bold man of smuggling notoriety whose illicit pursuits we mention but to condemn.' The Pocket Companion to Margate, 1831

The ubiquitous smugglers' tunnel led to the beach and was so large that in 1954 a 2-ton bulldozer fell into it.

In 1821 Snelling sold the cottage to E M Harrison who set up a dairy farm which kept going until 1955. Blue Dutch tiles – they repel flies you know - were used to line one room.

Mr H H Marks has also lived here. He was involved with the Financial News and presented Broadstairs with the Jubilee Clock Tower.

SEE Broadstairs/ Farms/ Jubilee Clock Tower/ Lanthorne Road/ Snelling, Joss/ Tunnels

Josias Fuller FARRER
He was only a child when he inherited around £100,000 from his father in 1762. Although Farrer was married with a son, he turned his Cleve Court home into a den of iniquity. Guests, mostly male, were offered almost unlimited alcohol, as well as a harem of women to 'pleasure' them, in a sort of early version of the Playboy mansion. The place, not surprisingly, was popular but even with a fortune as large as Farrer's, his partying mates, in time, eroded it. Farrer locked his wife in the bedroom most nights because the sights outside were just not suitable! Her only comfort was their young son who was locked in with her.
SEE Cleve Court

FASCISTS
In the 1930s, The British Union of Fascists held meetings in Acol and Minster and had their headquarters at 74 High Street Broadstairs. There was a rumour that the German Foreign Secretary, von Ribbentrop, often visited the town as the representative of a German champagne company. In March 1936, a Margate magistrate fined five Blackshirts, three BUF members and two sympathisers, a total of £14 for 'Jew-baiting', which involved painting the word 'Jew' on the windows of Jewish-owned shops (a swastika was also painted on one) in order to make the people of Margate 'Jew conscious', telling them *'We don't want this sort of conduct in Margate'*. One of the five was Stanley G Verrall the local district officer at the Broadstairs HQ.
SEE Acol/ Broadstairs/ High Street, Broadstairs/ Lord Haw Haw/ Margate/ Minster/ Moseley, Oswald/ Politics/ Tester, Dr Arthur

FAUNA
Although you will be lucky to see them now, badgers, foxes and otters were not unknown in Thanet in the 18th Century. Also at that time polecats, stoats and weasels were killed as vermin, for financial reward.

Rabbits and hares were plentiful in Thanet in the first half of the 18th century.
SEE Birds/ Thanet

FAVERHAM & THANET CO-OPERATIVE SOCIETY Ltd
This was a chain of grocery, butchery and bakery shops in the mid-twentieth century. In Ramsgate there were shops at King Edward Road, 112 Newington Road, Southwood Road, 69-73, 157 and 159 King Street, 128-130-132 High Street, and 24 Grange Road.

In Margate they were at 168 Canterbury Road, 81/85 and 115/117 High Street, 107/109 Ramsgate Road, and Ventnor Lane.

In Broadstairs there were branches at 27 Beacon Road, St Peters, and 18 St Peter's Park Road. Elsewhere, 42 Station Road, Birchington and 51 High Street Minster also had branches.
SEE Broadstairs/ High Street, Margate/ King Street, Ramsgate/ Margate/ Minster/ Newington Road/ Ramsgate/ Ramsgate Road, Margate/ Shops/ Southwood Road/ Station Road, Birchington

John FAWCETT
Born 1768
Died 1837
The son of an actor of the same name, he was a playwright and actor in his own right. At the age of 18 he ran away from school and ended up appearing as Courtall in 'The Belles Stratagem' on the stage at Margate. He went on to be a very successful actor in London with parts written specifically for him. He retired in 1830.
SEE Actors

FAWLTY TOWERS
Comedy series written by John Cleese and Connie Booth. There were only twelve episodes made.
SEE Arnold, Robert/ Berkeley, Ballard/ Television

FEENEY'S, Ramsgate
SEE North Pole/ Pubs/ Ramsgate

Sebastian Ziani de FERRANTI
Born Liverpool 1864
Died 1930
He was the British electrical engineer who promoted the installation of large electrical generating stations and alternating current distribution networks in England, without whom there would possibly not have been the national grid. He attended St Augustine's

College in Ramsgate, and took out 176 patents for his ideas between 1882 and 1927.
SEE Ramsgate/ St Augustine's College

5TH AVENUE NIGHTCLUB
SEE Marina Theatre

1566
In 1566 Margate had 108 houses, and 8 vessels - employing 60 men - carrying coal and used for fishing.
Broadstairs had 98 houses and 8 vessels - employing 40 men - carrying coal, and used for fishing.
Ramsgate had 125 houses, 14 vessels - employing 60 men - carrying coal and used for fishing.
SEE Broadstairs/ Fishing/ Margate/ Ramsgate

FIG TREE INN, Broadstairs
Back in the eighteenth century this was a local centre for smuggling. William Pitt, the Prime Minister, ordered the 13th Light Dragoons to Thanet in 1783 to assist the coastguards in combating the rampant smuggling going on here. They were billeted at the Fig Tree Inn from 1783 until 1784 and became a common site in their blue and buff uniforms, either on foot or patrolling on horseback, with their sabres at the ready. Part of their orders was to go to Deal and burn the boats on the beach. Despite the landlord using a pigeon to send a warning message to his brother who was the landlord at Deal, the boats were eventually burnt.
The Fig Tree Inn became Fig Tree Cottage.
SEE Broadstairs/ Coastguards/ Prime Ministers/ Pubs

Sir Samuel Luke FILDES
Born Liverpool 3rd October 1843
Died 27th February 1927
This famous artist was adopted by his grandmother, Mary Fildes, a political activist - she was a speaker at the meeting in Manchester that turned into the Peterloo massacre – and a leading member of the Female Chartists. In the 1840s she ran the Shrewsbury Arms in Chester.
At 17, Samuel became a student at the Warrington School of Art, before moving to the South Kensington Art School. He shared his grandmother's interest in the plight of the poor and in 1869 started work for the Graphic Illustrated magazine – edited by the social reformer, William Luson Thomas – where they hoped that visual images showing injustice and poverty would prompt charitable acts, both collective and individual. The first issue came out in December 1869 and Fildes' engraving, 'Houseless and Hungry', showing a queue of homeless people waiting for a bed at a workhouse, was used to accompany an article on the Houseless Poor Act. It was brought to the attention of Charles Dickens who then commissioned him to do the illustrations for 'The Mystery of Edwin Drood' – the book left unfinished at Dickens' death. It was a good time for Fildes' career, as he was able to leave the Graphic and turn his attentions to oil painting, many of his pictures reflected social issues.

In 1874 he married another artist, Fanny Woods, the sister of Henry Woods, also a painter.
During the following decade, he became a portrait painter and was amongst the most successful painters of the time. In 1890 Henry Tate commissioned him (£3,000 - a huge amount at the time- even though Fildes reckoned he would have earned more painting portraits) to paint a picture for his then new National Gallery of British Art. The result was 'The Doctor' which showed a dying child being watched over by a concerned physician. The painting, based on the death of Fildes' own son, became one of the Victorian era's best-selling engravings – a doctor told his students *a library of books would not do what this picture has done and will do for the medical profession in making the hearts of our fellow men warm to us with confidence and affection.'.*
At the turn of the century, Fildes was the top portrait painter in the country, his subjects included many members of the royal family such as Edward VII, Queen Alexandra and King George V - these now hang in Buckingham Palace. During this time, he lived for many years at Holland House in Kingsgate.
The realism in his portraits did not always meet with the subject's approval. Cecil Rhodes, who came to Holland House to sit for his portrait, sent a note claiming *'as soon as it arrives I will burn it'*. Fildes kept the painting and refused the cheque.
He was knighted in 1906. He and his wife both died in the same year, 1927.
SEE Artists/ Dickens, Charles/ Holland House/ Peterloo/ Rhodes, Cecil

FILMS
SEE Actors/ Bennett, Sir Richard Rodney/ Chariots of Fire/ Colman, Ronald/ Die Another Day/ Gypo/ Last Orders/ Last Resort/ Thirty Nine Steps/ Topspot/ Withnail & I

FINE FARE SUPERMARKET
High Street, Ramsgate
The Fine Fare chain of supermarkets became part of the Gateway empire, which in turn became part of Somerfields.
When Fine Fair opened on the former site of the Palace Theatre in Ramsgate in 1961, part of its opening offer included giving away 7,000 chickens. This caused queues right round into Cavendish Street. Argos now occupies most of the site.
SEE Cavendish Street/ High Street, Ramsgate/ Palace Theatre/ Ramsgate/ Shops/ Tesco

FIRES
SEE Addington Road, Ramsgate/ Albert Road, Ramsgate/ Assembly Rooms, Margate/ Barnett's/ Bellevue Garage, Ramsgate/ Captain Swing/ Cliftonville Hotel/ Courts Furniture Store/ Crown Bingo/ Dent-de-lion/ Dreamland fires/ Endcliffe Hotel, Cliftonville/ Fort Brewery Tap, Margate/ Frank's, Cliftonville/ Gouger's windmills, Cliftonville/ Grange, The, Ramsgate/ High Street, Ramsgate/ Holy Trinity School, Ramsgate/ Library, Ramsgate/ Metropole Hotel, Margate/ Monkton/ Norfolk Road, Cliftonville/ Palace Theatre, Ramsgate/ Paragon/ Pier, Margate/ Promenade Pier, Ramsgate/ Queen's Highcliffe Hotel, Cliftonville/ Queen's Promenade,

Cliftonville/ Ramsgate Sands Railway Station/ Red Lion Hotel, Ramsgate/ Rose Hill, Ramsgate/ Royal Albion Hotel, Margate/ Royal Hotel, Ramsgate/ Royal Victoria Pavilion, Ramsgate/ St John's Church, Margate/ St Nicholas-at-Wade/ Salmestone Grange/ San Clu Hotel/ Scenic Railway/ Shaftesbury House, Margate/ Staner Court, Ramsgate/ Theatre Royal/ World's Wonder/ Ye Foy Boat Inn, Margate/ Zeppelin Raid

FIRE BRIGADE, Margate
On their way to a fire in January 1900, they crashed their fire engine into the local doctor's carriage. They were subsequently accused by the councillors of showing off after they had to fork out £50 in damages.
SEE George Medal/ Margate/ Phoenix, The

FIRE STATION, Ramsgate
Originally under the control of the police the Ramsgate Fire Brigade dates right back into the 1800s, and was based in York Street, with a second station at St Lawrence (this closed in 1915).
After rejecting a site in Boundary Road for the town's new station, Ramsgate's watch committee decided in August 1904 on a plot of land that was once Admiral Fox's garden in Effingham Street. It was opened by the Mayor on 17th October 1905 amongst great pomp and ceremony with games, drills and a parade. In the evening, before a musical concert, there was a big supper consisting of turbot, beef, mutton, veal, and ham, followed by apple tart!
In the first year, 17 calls were answered (in case you are wondering, these days the number is a staggering 900 and there are 45 firemen stationed there).
It is the oldest building in the country still being used as a fire station.
Dame Janet Stancomb-Wills donated the town's first fire engine called Lord Winterstoke. The second was called Dame Janet.
Ramsgate Fire Brigade became part of the Kent fire Brigade in 1948.
SEE Boundary Road/ Effingham Street/ Fox, Admiral/ Ramsgate/ Rose Hill/ Stancomb-Wills, Dame Janet

The FIRST AND LAST public house
Ramsgate Road, Margate
The pub opened in 1817, although it was much smaller than it is now, and earned its name because it was the first building people encountered when entering Margate and therefore the last when they left. Stagecoaches pulled up here with both horses and passengers gasping for a drink. At this time there was even a small brewery at the rear. Various tunnels ran underneath particularly to both St Johns Churchyard and over the road to 4 Ramsgate Road. All the tunnels were used by smugglers to hide their contraband. Mary Castle was the landlady in 1840.
Due to changes in the road names, its address changed over the years. It was at Vicarage Place, Margate from the 1830s; it became 18 & 19 Ramsgate Road in the 1860s; 19 Vicarage Place at the end of the century, and finally it was back in Ramsgate Road again.

It is thought to have originally been the Customs House.

A poignant part of its history is the story of how at 10 o'clock one autumn evening in 1914, many of the young regulars downed a last pint before going off to war; sadly not all would return.

There are two curiosities that are peculiar to this pub. One, is the stuffed five-legged lamb that once decorated the bar. The other, is the blind landlord that ran the place in the 1960s. It is also said to be the site of slightly spooky goings on over the years. If you smell gin and you are not drinking it, then it could be that Henry the ghost is around. He won't do any harm, but he likes to lock and unlock doors, move things around, and turn lights on and off - you can insert your own spirit joke here. It is now closed and a bit of a sad sight. Henry must be quite depressed.

SEE Breweries/ Margate/ Pubs/ Ramsgate Road, Margate/ St John's Church/ Tunnels

FISH

Tudor Ramsgate prospered on cod fishing and ship-building.

In Victorian times, Dover Sole was extremely popular and very expensive. One Ramsgate fishing skipper made £20,000 a year from Dover sole alone and managed to retire rich, and more importantly, young.

Lobster, Shrimp and prill (a flatfish, apparently delicious) were all previously fished from the sea by Thanet fishermen as was mullet - there are around 95 different types of mullet so make sure you ask the fishmonger for the correct one!

SEE Fishing Fleet/ Grunt fish/ Ramsgate/ Thanet

FISH AND CHIPS

This dish became popular from the 1850s onwards and its popularity is sometimes credited with creating the wealth of the fishing fleets around Britain which included the one at Ramsgate.

SEE Fishing fleet/ Ramsgate

FISHING

As a fishing village, the ninety families that lived in Broadstairs at the end of the 18th century were employed in the Icelandic cod industry. Cod liver oil was brought ashore in casks. Herring and mackerel were caught closer to home.

SEE Broadstairs/ Kingfisheries/ Sea angling/ Soper's Yard

FISHING FLEET

Fourteen fishing boats operated from Ramsgate in 1556, when the town consisted of just 25 houses, so you can see that this was the main industry back then. As the fishing industry grew, so did the town, and by 1870/90 it boasted one of the largest fishing fleets in the country with a fleet of around 185 boats registered here. Added to that number were boats from the West country, Lowestoft, Deal and Rye that brought the total of craft fishing from here to over 300, and all drawn by the lack of any dues payable on their catch and a prosperous local market for their catch.

The West Country fishermen also brought with them large ketch-rigged craft called smacks which would eventually be preferred by the local men who had been using two or three masted luggers.

The fishing trade only began to see some decline in the early 1900s.

On the night of 30th September 1911, one of the most violent storms ever known in this area caused devastation to the Ramsgate fishing fleet. The whole fleet was out that night, and the next morning the boats struggled back, damaged and beleaguered. The fishing smacks named Progress, which was fishing off the Dutch coast, Idessa, and Criterion, both fishing off Lowestoft, never returned; people prayed for their return for over a week. The widows and children were provided for by the Royal Provident Fund for Sea Fishermen who gave the widows 5 shillings a week for four years, and 1 shilling per week for each child under fourteen. The local Fisherman's Accident Fund paid a grant of £10 to each family.

East Kent Times, 9th December 1914: *The Admiralty order issued a few days ago that local fishing boats will not be permitted to fish off the coast between Cromer and Portland Bill has come as a bombshell to the fishing community at Ramsgate. For some time the fishing industry here has been practically at a standstill.*

The effects of the complete cessation of the trade at Ramsgate would be very wide, for there are many people who rely on the fish market for their daily bread and if the smacks are definitely forbidden, the port market will automatically close.

Before World War I, there were 150 boats in the Ramsgate fishing fleet, of which the Germans sunk around 41 (14 fishermen were killed). Thereafter, for safety reasons, many boats relocated to other ports. By the end of the war the fleet totalled just 4.

The last survivor of the Ramsgate fishing fleet, 'Jack and Eve', left Ramsgate in 1956.

SEE Dover Sole/ East Kent Times/ Fish/ Harbour, Ramsgate/ Ramsgate/ Shrimp/ World War I

FISHMONGERS

There were 32 fishmongers listed in Kelly's Directory of the Isle of Thanet, 1957.

SEE Shops/ Thanet

Diane FISHWICK

A North Foreland Golf Club member, nineteen year-old Diane Fishwick, won the British Ladies Open Championship at Formby in May 1930 (by 4&3 over 36 holes), and during the celebration dinner at the Savoy Hotel in London, Douglas Fairbanks presented her with a silver tray.

She also won the Pearce Cup in 1926; and the Whitsuntide Cup in 1926, 1928 and 1929. She appeared on a Wills's Gold Flake Cigarette Card, in a series showing sportsmen and women.

I have assumed she is one of the Fishwicks who lived at 'Durban' in Reading Street.

SEE North Foreland Golf Club/ Sport

Richard FITZALAN

Born 1346

Died 1397

In 1387 Richard Fitzalan, the 4th Earl of Arundel, who was at the time the Admiral of the West and South, gained a victory over the French and their allies in a sea battle off the coast of Margate.

SEE Admirals/ Margate

John Patrick FITZGERALD

Born Ireland c1815

Died Ramsgate 8th January 1897

He studied medicine in Glasgow, the Royal College of Surgeons in London, and in Dublin, and was Surgeon Superintendent on the Oriental, belonging to the New Zealand Company. He arrived in New Zealand on 31st January 1840, and subsequently held numerous positions (including consulting physician, coroner and health officer) initially in the Wellington area. Whilst there, he did find time to marry the daughter of a Dublin solicitor, Eliza Sarah Christian - on 14th November 1842. He became surgeon to the Wellington Militia, and (on 15th September 1847) became the Superintendent of Wellington's public hospital – just 16 patients on two storeys – he had to assist '*the jail, the police, the natives, pauper Europeans, and in fact all to whom the government may be desirous of affording medical attendance*'.

His new modern methods attracted some fierce criticism. Until the arrival of Father Jeremiah O'Reily in 1843, Fitzgerald was also the head of the local Catholic community, and even here came under fire. He was found guilty on 10th December 1850 of, amongst other things, giving Catholic priests extra visiting privileges.

On 26th March the following year, he was charged with 'gross quackery' and the fraudulent use of medical qualifications. After an investigation, the authorities decided that actually, he was qualified – good of them really.

Five weeks after the birth of their fifth child, tragedy occurred on 4th April 1852 when his wife died, and the baby girl was found to be suffering from a heart complaint. The following year, Fitzgerald managed to survive cholera. He then asked for two years leave. Bear in mind that he had worked for fifteen years with no leave at all. They laughed at him. So he asked for a shorter amount of time. They laughed. He shortened the time again. They laughed again. He resigned on the 21st July 1854, and returned

to Britain where the provincial council said he was guilty of dereliction of duty! He didn't laugh.

In 1856, he became Superintendent of Grey Hospital, King William's Town, Cape Colony, New Zealand where he stayed until 1888. When he returned to England again he settled in Ramsgate, where he died on 8th January 1897.

SEE New Zealand/ Ramsgate

Mrs FITZHERBERT

A mistress of George III, she spent the autumn of 1794 in Margate.

SEE George III/ Margate/ Mistress

Admiral Robert FITZROY

Born Suffolk, 15th April 1805
Died 30th April 1865

One of the many historical figures to spend seasonal holidays in Broadstairs. He lived temporarily at Holland House, near where Fitzroy Avenue is now in Kingsgate.

The 'Fitz' part of the name Fitzroy, means son, and the 'roy' is king in old French; thus, it was a name given to the illegitimate sons of kings. Robert Fitzroy was a descendant of Charles II, who had a son, Henry Fitzroy (1863-1690), by his mistress, Barbara Villiers.

At the age of 14, Fitzroy joined the Navy, serving both in the Mediterranean and off South America, rising up through the ranks until, in 1828, he was appointed Captain of the 240-ton brig HMS Beagle - a three masted brig, just 100ft long with room for 74 people and 10 cannons. Well, I say room, but it's estate agent speak for 'bloody cramped'. In this, he surveyed the South American coast between Patagonia and Tierra del Fuego arriving back in England in 1830.

At the end of the following year on December 27th 1831, he set sail from Portsmouth (well, at least he had Christmas before he went) with the naturalist Charles Darwin on board. The ship was so cramped that the two of them, both in their twenties, had to share a cabin. Fitzroy had chosen Darwin as much for his ability to be a good dining companion as for any other reason - the captain could not possibly dine with the riff-raff of the crew. In fact, Darwin was his second choice. The two of them had many rows as well as good conversations and after five years they could have assumed they knew each other pretty well. At the end of the voyage, Fitzroy immediately married the girl to whom he had been engaged for years before the voyage, but at no time had he mentioned her.

They travelled to the Cape Verde Islands, the South American coast, through the Strait of Magellan, the Galapagos Islands, Tahiti, New Zealand, Australia, The Maldives and Mauritius and returned to England on 2nd October 1836. Imagine the cost of that cruise today!

Three years later, Fitzroy published two volumes of *Narrative of the surveying voyages of his majesty's ships Adventure and Beagle between the years of 1826 and 1836, describing their examination of the southern shores of South America, and the Beagle's circumnavigation of the globe'*. It had to be two volumes because they could not fit the title on just one volume. Charles Darwin took note and called his book *'The Voyage of the Beagle'*. Guess which one was the bestseller? Not only has it got a snappier title, but it also appealed to dog lovers, who might not know what it was actually about until they got it home. He kept the same theme going when he published 'The Origin of the Species'. The phrase 'survival of the fittest' is not Darwin's; it comes from Herbert Spencer who wrote 'Principles of Biology'.

Fitzroy became MP for Durham in 1841 and was appointed Governor of New Zealand in 1843. However, he was recalled two years later because he quite reasonably agreed with the Maoris, and believed that claims to their own land were as valid as those of the settlers. What was he thinking, eh? He had also spotted many unscrupulous dealings between the settlers and the natives and consequently became very unpopular. He was made Superintendent of the Dockyard at Woolwich in 1848.

He retired from active duty in the navy, partly due to ill health, in 1850, and four years later became a devoted meteorologist. He devised what he referred to as a weather warning system, or what we now call a weather forecast (it was probably wrong then as well) and was effectively the founder of the Met Office. He published 'The Weather Book' in 1863, and invented the first mercury barometer that could be mass-produced.

In later life he suffered with mental problems brought on, in part, by the responsibility that he felt for the safety of ships' crews who used his weather forecasts. His role in assisting Darwin greatly troubled him, and he was present at the famous debate in Oxford in 1860. He heckled Huxley, brandishing The Bible and shouting, *'Here is the truth - in here!'* He was escorted from the building. He committed suicide at his home in Upper Norwood, London, by cutting his throat on 30th April 1865. At the inquest, overwork was deemed to be the reason behind the suicide. It is interesting to note that his uncle, Viscount Castlereagh (1769-1822), the Chancellor of the Exchequer, had committed suicide by the same method (Lord Byron wrote of Lord Castlereagh

'Posterity will ne'er survey
A nobler grave than this;
Here lie the bones of Castlereagh;
Stop, traveller, and piss.')

and that the previous captain of The Beagle had shot himself in the head.

The settlement of Fitzroy in the Falklands is named after him as is a South American conifer (Fitzroya cupressoides) and, in 2002, the Finisterre area off the coasts of Spain and Portugal, a location often heard in the shipping forecast, was renamed Fitzroy in his honour.

SEE Admirals/ Broadstairs/ Darwin, Charles/ Fitzroy Avenue/ Holland House/ Kingsgate/ New Zealand

FITZROY AVENUE, Broadstairs

SEE Broadstairs/ Fitzroy, Admiral Robert

FIVE POUND NOTE

Elizabeth Fry, who once lived in Ramsgate, became only the second female (the first was Florence Nightingale, on a £10 note) to appear on the back of an English banknote when she replaced George Stephenson on the reverse of a fiver on 21st May 2002. It showed her face and a scene of her reading to the prisoners in Newgate prison, where, in recognition of her work, she was given a key to the prison. The key is used within the design on the note.

SEE Fry, Elizabeth/ Ramsgate

FIVE TUNS
Union Square, Broadstairs

The name of an old smuggling inn once situated in Union Square. Not the place for a quiet drink apparently. There is an old story of the Revenue men searching these premises for over an hour and finding nothing. Having worked up a thirst, one of the men ordered a drink and decided to sit outside on the dog kennel to drink it. The roof of the kennel collapsed and eighty pounds of tobacco were found in it.

After the inn was demolished in 1912, it became a fisherman's yard.

SEE Broadstairs/ Pubs/ Tartar Frigate/ Three Tuns, The/ Tobacco/ Union Square

FLAG & WHISTLE public house
Station Road, Margate

Not long after the North Kent Railway Company opened the Margate Station in 1863, Tomson and Wotton opened the Station Hotel. In the 1950s, the hotel side of the business was doing less well, and the name seemed inappropriate. A competition was held with a prize of five guineas to whoever could come up with the best new name. Ironically an ex-railwayman won with the name 'The Flag and Whistle'. One famous customer was the comedian Tommy Cooper.

SEE Cooper, Tommy/ Margate/ Pubs

FLEA CIRCUS

There was a flea circus performing in a kiosk at Dreamland in the 1950s and 1960s. The human fleas (apparently animal fleas are too thick) could perform tricks like walking tightropes or riding bikes but they had to be quick learners as they only live for a week. You viewed the show through a magnifying glass.

The good old days. Proper clean entertainment, not like today eh?

SEE Dreamland/ Entertainers

Ian FLEMING

Born 28th May 1908
Died 12th August 1964

He was the novelist who created James Bond.

SEE Authors/ Cheyne Walk/ Moonraker/ Goldfinger

FLETE

Margate Corporation Reservoirs was listed at Flete in 1936.
SEE Margate

FLINT & CHALK CONSTRUCTION

Most houses built in Broadstairs prior to the 1860s were constructed using these two cheap materials that could be collected from the beach. Flint is a very durable material for the walls, and the chalk, cut into blocks, was good for foundations because it prevented rising damp.
SEE Broadstairs

FLINT COTTAGE, Broadstairs

Alfred Harmsworth and Mary Milner had their first Broadstairs home at Flint Cottage opposite Holy Trinity Church.
SEE Broadstairs/ Harmsworth Alfred/ Holy Trinity Church/ Elmwood

'The FLOATING LIGHT of The GOODWIN SANDS' by R M Ballantyne

Ramsgate is mentioned 79 times in this 1870 novel. Here are just a few:

It was a chill November evening, when this light arose, in the year - well, it matters not what year. We have good reasons, reader, for shrouding this point in mystery. It may have been recently; it may have been 'long, long ago.' We don't intend to tell. It was not the first time of that light's appearance, and it certainly was not the last. Let it suffice that what we are about to relate did happen, sometime or other within the present century. Besides being cold, the evening in question was somewhat stormy - 'gusty,' as was said of it by a traveller with a stern visage and remarkably keen grey eyes, who entered the coffee-room of an hotel which stood on the margin of Ramsgate Harbour facing the sea, and from the upper windows of which the light just mentioned was visible.

'It is, sir,' said the waiter, in reply to the 'gusty' observation, stirring the fire while the traveller divested himself of his hat and greatcoat.

'Think it's going to blow hard?' inquired the traveller, planting himself firmly on the hearth-rug, with his back to the fire, and his thumbs hooked into the armholes of his waistcoat.

'It may, sir, and it may not,' answered the waiter, with the caution of a man who has resolved, come what may, never to commit himself. 'Sometimes it comes on to blow, sir, w'en we don't look for it; at other times it falls calm w'en we least expects it. I don't pretend to understand much about the weather myself, sir, but I shouldn't wonder if it was to come on to blow 'ard. It ain't an uncommon thing at Ramsgate, sir.'

The traveller, who was a man of few words, said 'Humph!' to which the waiter dutifully replied 'Yessir,' feeling, no doubt, that the observation was too limited to warrant a lengthened rejoinder.

The waiter of the Fortress Hotel had a pleasant, sociable, expressive countenance, which beamed into a philanthropic smile as he added, -

'Can I do anything for you, sir?'

'Yes - tea,' answered the traveller with the keen grey eyes, turning, and poking the fire with the heel of his boot.

'Anything with it, sir?' asked the waiter with that charmingly confident air peculiar to his class, which induces one almost to believe that if a plate of elephant's foot or a slice of crocodile's tail were ordered it would be produced, hot, in a few minutes.

oOo

Ere long the lights of the shipping in the Downs were hung out, and one by one the lamps on shore shone forth - those which marked the entrance of Ramsgate Harbour being conspicuous for colour and brilliancy - until the water, which was so calm as to reflect them all, seemed alive with perpendicular streams of liquid fire; land and sea appearing to be the subjects of one grand illumination.

oOo

It was afterwards ascertained that a mistake had been made in reference to the vessel that had signalled. Some one on shore had reported that the guns and rockets had been seen flashing from the North sandhead vessel, whereas the report should have been, 'from the vessel at the South sandhead.' The single word was all-important. It had the effect of sending the steam-tug Aid (which always attends upon the Ramsgate lifeboat) in the wrong direction, involving much loss of time. But we mention this merely as a fact, not as a reproof. Accidents will happen, even in the best regulated families. The Ramsgate lifeboat service is most admirably regulated; and for once that an error of this kind can be pointed out, we can point to dozens - ay, hundreds - of cases in which the steamer and lifeboat have gone, straight as the crow flies, to the rescue, and have done good service on occasions when all other lifeboats would certainly have failed; so great is the value of steam in such matters.

oOo

We turn now to a very different scene - the pier and harbour of Ramsgate. The storm-fiend is abroad. Thick clouds of a dark leaden hue drive athwart a sky of dingy grey, ever varying their edges, and rolling out limbs and branches in random fashion, as if they were fleeing before the wind in abject terror. The wind, however, is chiefly in the sky as yet. Down below there are only fitful puffs now and then, telling of something else in store. The sea is black, with sufficient swell on it to cause a few crested waves here and there to gleam intensely white by contrast. It is early in the day, nevertheless there is a peculiar darkness in the atmosphere which suggests the approach of night. Numerous vessels in the offing are making with all speed for Ramsgate Harbour, which is truly and deservedly named a 'harbour of refuge,' for already some two dozen ships of considerable size, and a large fleet of small craft, have sought and found shelter on a coast which in certain conditions of the wind is fraught with danger. About the stores near the piers, Trinity men are busy with buoys, anchors,

and cables; elsewhere labourers are toiling, idlers are loafing, and lifeboat - men are lounging about, leaning on the parapets, looking wistfully out to sea, with and without telescopes, from the sheer force of habit, and commenting on the weather. The broad, bronzed, storm-battered coxswain of the celebrated Ramsgate lifeboat, who seems to possess the power of feeding and growing strong on hardship and exposure, is walking about at the end of the east pier, contemplating the horizon in the direction of the Goodwin Sands with the serious air of a man who expects ere long to be called into action.

The harbour-master - who is, and certainly had need be, a man of brain as well as muscle and energy, to keep the conflicting elements around him in order - moves about actively, making preparation for the expected gale.

oOo

'Only last night,' continued Queeker to himself, still standing bolt upright in a frenzy of inspiration, and running his fingers fiercely through his hair, so as to make it stand bolt upright too - 'only last night I heard old Durant say he could not make up his mind where to go to spend the autumn this year. Why not Ramsgate? why not Ramsgate?

'Its chalky cliffs, and yellow sand,
And rides, and walks, and weather,
Its windows, which a view command
Of everything together.
'Its pleasant walks, and pretty shops,
To fascinate the belles,
Its foaming waves, like washing-slops,
To captivate the swells.

'Its boats and boatmen, brave and true,
Who lounge upon the jetty,
And smile upon the girls too-
At least when they are pretty.
'Oh! RAMSGATE, where in all the earth,
Beside the lovely sea,
Can any town of note or worth
Be found to equal thee?

oOo

He did not forget Broadstairs; here are some scenes set here:

'Lifeboat close alongside, sir. Didn't see her till this moment. She carries no lights.'

The Weltons, father and son, sprang out of their bunks a second time, and, minus coat, hat, and shoes, scrambled on deck just in time to see the Broadstairs lifeboat rush past before the gale. She was close under the stern, and rendered spectrally visible by the light of the lantern.

'What are you firing for?' shouted the coxswain of the boat.

'Ship on the sands, bearing south,' roared Jack Shales at the full pitch of his stentorian voice.

There was no time for more, for the boat did not pause in her meteor-like flight. The question was asked and answered as she passed with a magnificent rush into darkness. The reply had been heard, and the

lifeboat shot, straight as an arrow, to the rescue.

oOo

On their way, a dark object was seen to sweep past them across their stern as if on the wings of the wind. It was the Broadstairs lifeboat, which had already done good service that night, and was bent on doing more.

oOo

'Ay, there be many more besides these saved last night, miss,' remarked a sturdy old boatman who chanced to be standing beside her. 'All along the east coast the lifeboats has bin out, miss, you may be sure; and they don't often shove off without bringin' somethin' back to show for their pains, though they don't all 'ave steamers for to tug 'em out. There's the Broadstairs boat, now; I've jist heerd she was out all night an' saved fifteen lives; an' the Walmer and Deal boats has fetched in a lot, I believe, though we han't got particklers yet.'

oOo

At any other time the boy would have refused; but his recent disappointment in regard to the angelic nature of Katie still rankled so powerfully in his breast, that he swung round and said - 'Get along, then - I'm your man - it's all up now - never say die - in for a penny in for a pound,' and a variety of similar expressions, all of which tended to convince Mr Jones that Billy Towler happened to be in a humour that was extremely suitable to his purpose. He therefore led him towards his boat, which, he said, was lying on the beach at Broadstairs all ready to shove off.

The distance to Broadstairs was about two miles, and the walk thither was enlivened by a drunken commentary on the fallacy of human hopes in general on the part of Mr Jones, and a brisk fire of caustic repartee on the part of Master Towler.

A close observer might have noticed that, while these two were passing along the beach, at the base of the high cliffs of chalk running between Ramsgate and Broadstairs, two heads were thrust cautiously out of one of the small caverns or recesses which have been made in these cliffs by the action of the waves. The one head bore a striking resemblance to that of Robert Queeker, Esq., and the other to that of Mr Larks.

How these two came to be together, and to be there, it is not our business to say. Authors are fortunately not bound to account for everything they relate. All that we know is, that Mr Queeker was there in the furtherance, probably, of his secret mission, and that Mr Larks' missions appeared to be always more or less secret. At all events, there they were together; fellow-students, apparently, of the geology or conchology of that region, if one might judge from the earnest manner in which they stooped and gazed at the sands, and picked up bits of flint or small shells, over which they held frequent, and, no doubt, learned discussions of an intensely engrossing nature.

It might have been also noticed by a close observer, that these stoopings to pick up

specimens, and these stoppages to discuss, invariably occurred when Mr Jones and Master Billy chanced to pause or to look behind them. At last the boat was reached. It lay on the beach not far from the small harbour of Broadstairs, already surrounded by the rising tide. About the same time the geological and conchological studies of Messrs. Queeker and Larks coming to an end, these scientific men betook themselves suddenly to the shelter of a small cave, whence they sat watching, with intense interest, the movements of the man and boy, thus proving themselves gifted with a truly Baconian spirit of general inquiry into simple facts, with a view to future inductions. 'Jump in, Billy,' said Jones, 'and don't wet your feet; I can easily shove her off alone.' Billy obeyed.

'Hallo! wot have 'ee got here?' he cried, touching a large tarpaulin bag with his foot.

'Only some grub,' answered Jones, putting his shoulder to the bow of the boat.

'And a compass too!' cried Billy, looking round in surprise.

'Ay, it may come on thick, you know,' said Jones, as the boat's keel grated over the sand.

'I say, stop!' cried Billy; 'you're up to some mischief; come, let me ashore.'

Mr Jones made no reply, but continued to push off the boat. Seeing this, the boy leaped overboard, but Jones caught him. For one instant there was a struggle; then poor Billy was lifted in the strong man's arms, and hurled back into the boat. Next moment it was afloat, and Jones leaped inboard. Billy was not to be overcome so easily, however. He sprang up, and again made a leap over the gunwale, but Jones caught him by the collar, and, after a severe struggle, dragged him into the boat, and gave him a blow on the head with his clenched fist, which stunned him. Then, seizing the oars, he pulled off. After getting well away from the beach he hoisted a small lug-sail, and stood out to sea.

All this was witnessed by the scientific men in the cave through a couple of small pocket-telescopes, which brought the expression of Jones's and Billy's countenances clearly into view. At first Mr Queeker, with poetic fervour, started up, intent on rushing to the rescue of the oppressed; but Mr Larks, with prosaic hardness of heart, held him forcibly back, and told him to make his mind easy, adding that Mr Jones had no intention of doing the boy any further harm. Whereupon Queeker submitted with a sigh. The two friends then issued from the cave, shook hands, and bade each other goodbye with a laugh - the man with the keen grey eyes following the path that led to Broadstairs, while the lawyer's clerk returned to Ramsgate by the beach.

SEE Ballantyne, R M/ Battles of the Sea/ Books/ Broadstairs/ Downs, The/ Goodwin Sands/ Harbour, Ramsgate/ Lifeboat/ Ramsgate

FLOODING

Kent suffered from terrible flooding in March 1949. The high tide on the 1st caused

flooding between Margate and Crayford after a tidal surge down the North Sea reached fifteen miles up rivers. There was a four-day long siphon, and a seventy mile per hour gale causing incredible spring tides which themselves caused immense damage. It was so difficult to tell where one bit of flood damage ended and another started that flooding in Dover, Margate, Herne Bay, Whitstable, Sittingbourne, Faversham, Sheerness, Gravesend, Upnor, Strood, Rochester and Chatham were deemed to be one incident.

SEE Canterbury Road, Westgate/ George Hotel/ Great Storm 1953/ Hall by the Sea/ Margate/ Phoenix/ Sea Wall/ Theatre Royal/ Tyrrel's Farm

FLORA ROAD, Ramsgate

Samuel Henson, 58, was a foreman ganger of 14 Flora Road who tried to murder his wife by taking explosives, which he claimed he did not know had a fuse and detonator attached, into the house. Instead of murdering his wife though, the explosion demolished the house, killed his 20-year old son, William, (a bricklayer and well-known local footballer) and seriously injured himself, his wife, the lodger and his mother (who also displayed a cut that police believed had been caused by a knife). At the trial in February 1903, he was found guilty and sentenced to be hanged. A petition for leniency was successfully launched on the grounds that he was insane, backed up by the fact that his second suicide attempt was to bang his head repeatedly against his cell wall. Instead of hanging he was sent to an asylum - hopefully with padded walls.

SEE Football/ Murder/ Ramsgate

FLYING HORSE public house
Park Road, Ramsgate

The original pub was built in 1884 but the present building dates from 1928.

SEE Pubs/ Ramsgate

FOOD

SEE Chocolate/ Fish & Chips/ Ice Cream/ Restaurants/ Sausages

FOOTBALL

SEE Flora Road/ Lowther, James/ Margate Football Club/ Pallister, Gary/ Ramsgate Football Club/ Salgado, Míchel/ Sky Sports/ Sport

Thomas FORDRED

Mary Ann Bridger, 27, lived with her parents at Luton Road, Margate. At five o'clock on a cold 8th January 1867, she left there with just a shawl to keep her warm over her blouse and skirt, to meet her 48 year-old boyfriend, labourer Thomas Fordred in the Liverpool Arms. They had been going out for three years and he was known to beat her up, even hitting her once in front of her mother. On this night, however, he was being affectionate to her, describing her as his 'old daisy'. Later on, he was heard to tell her that he would 'knock her brains out if she went off with another man'. Mary's parents had joined them for a beer and a rum in the pub for part of the evening. Thomas had suggested to Mary that they go back to his

house, and they were seen by her parents (for the last time it transpired) in Victoria Road where they were buying groceries. Having seen Thomas swearing as he was picking up some potatoes he had dropped on the pavement, a policeman, thinking they were drunk, told them to move along. He last saw the couple heading off towards Salmestone Farm. Ann Emptage, of Salmestone Farm Cottage, heard a man shout 'I'll do for you' as a man walked into her house. On the wash room floor, a few minutes later Ann found Mary's torn shawl with both snow and blood on it. Her husband, George, worked in the stables and she next saw Thomas, with blood on his coat and face, go there where he asked George to help him get Mary because '*she's lying on the bank, drunk*'. Two minutes later, the two men carried the virtually naked Mary into the barn, before George left.

Later, Thomas decided to go to the police station. On the way he told a friend that Mary had killed herself and the blood was from where he had carried her. He told the police that Mary had fallen down several times and he had fallen on top of her. It was only in the barn that he realised she was dead and her clothes had fallen off only when he had picked her up.

According to the surgeon who examined Mary's body, there were marks on her chest and two large wounds on the back of her head. Police also found a handful of her hair when they discovered the groceries in the street. The jury took a quarter of an hour to find Thomas guilty of murder at the Maidstone Spring Assizes in March 1868. Thomas continued to insist it was an accident and even convinced several lawyers, the prison governor at Maidstone, and the under sheriff who all said he should have been charged with manslaughter. He was hanged on 4th April 1867, his last words were '*Don't choke me*', but he struggled for several minutes before he died.
SEE Liverpool Arms/ Margate/ Murder/ Salmestone

FORENESS POINT, Cliftonville
A German spy was captured here on 5th December 1917 and during the ensuing struggle a soldier died after he was thrown from the cliff. The spy was subsequently executed.
A walk eastwards along the beach from Palm Bay passing Foreness Point, the most northerly part of Thanet, will take you along one of the island's best beaches towards Botany Bay. On a sunny day, at any time of the year, when the tide is out, the beach is vast. It always reminds me of a recent television advertisement for the Welsh tourist board, where two locals are enjoying a pint in the garden of a pub and one remarks that a mate of theirs is going abroad for his holiday. The other one incredulously wants to know why and the camera then pans across a vast unspoilt beach very similar to this one.
SEE Beaches/ Cliftonville

FORESTERS ARMS public house
Boundary Road, Ramsgate

A pub since the mid-nineteenth century, it re-opened in 1999 after being closed for a while.
SEE Boundary Road/ Pubs/ Ramsgate

FORRESTERS HALL
Union Crescent, Margate
The Forresters Hall in Union Crescent, now the Salvation Army Citadel, was one of the earliest places to host the new Bioscope.
East Kent Times, 7th May 1913:
Margate Suffrage society... meeting at Foresters Hall. About 200 ladies and gentlemen were present.
SEE Bioscope/ East Kent Times/ Margate/ Salvation Army Citadel/ Union Crescent

FORRESTERS HALL
Chapel Place, Ramsgate
14th January 1914 East Kent Times:
RAMSGATE SUFFRAGISTS
THE YEAR'S WORK:
At the AGM of Ramsgate NUWSS at Foresters Hall, Mrs Chaning Pearce said that new ground had been broken with the new branches opening at Margate, Broadstairs and Minster. This of course meant the loss of members from the Ramsgate branch but even with that the membership had still risen, and now stood at 190, and the new 'Friends of Women's Suffrage' numbered 53.
SEE Broadstairs/ Chapel Place/ East Kent Times/ Margate/ Minster/ Ramsgate/ Suffragettes

FORT BREWERY TAP public house
Fort Road, Margate
The Fort Brewery Tap stands on the site of Webb's Brewery and dates back to around 1830 when it was known as the Fort Castle Inn. The Webb brewery was a rival of the Cobb's. Webbs refused to sell their sixteen pubs to Cobbs and they were bought instead by Russel of Gravesend. Their Shrimp Brand Ales (which were still advertised in the bar windows until the bar closed) were brought down by barge to the harbour and then carried on tracks through a tunnel to a depot next door. Russel was acquired by Trumans after the war, but this pub became a free house in the 1980s although it is now derelict. Following a fire in October 2003, it was discovered that the derelict pub had been turned into a cannabis factory with hundreds of plants growing there.
SEE Cobbs/ Fires/ Margate/ Tunnels

FORT CRESCENT, Margate
Crescent House was a late eighteenth century ladies school at 8 Aldby Place in Fort Crescent.
SEE Emin, Tracey/ Margate

FORT HILL, Margate
Roman remains have been found at Fort Hill. In 1938-9 the present open sweep of Fort Road was created by demolishing a whole host of buildings on the seaward side of the road which didn't get completed until 1946 - some excuse about a war or something. Previously a whole warren of ramshackle buildings had sprung up and been added to, and in the previous century, the land at the

end of the jetty was probably the heart of the town with large numbers of goods and visitors all entering the town at this point.
In 1883 you would have found the Seamen's Institute and Observatory, a library, refreshment rooms, jewellers, confectioners, a toy shop, fruiterer, fancy goods, and a tropical shell shop amongst them.
In 1870, a man was found guilty of driving a pony and trap at 11mph down Fort Hill.
SEE Libraries/ Margate

FORT HOUSE, Broadstairs

Fort House was built in 1801 for Captain Gooch who commanded the fort in front of the house.
Charles Dickens stayed there and in the study planned and wrote (sometimes for eight hours at a time) parts of 'Bleak House', 'Our English Watering Place' and 'David Copperfield'.
Charles Dickens had long admired the house and leased it for the summer of 1850 to finish writing David Copperfield. On the morning of 16th August, his wife gave birth to their daughter Dora Annie Dickens (named after the character in David Copperfield) at their London home and in the afternoon, Charles and the rest of the family travelled down to take up their summer residence, a not unusual occurrence in Victorian times. Dickens does write to his wife ' . . I still have Dora to kill – I mean the Copperfield Dora'. I bet she treasured that little note.
In those days, Fort House was well away from the town and had a cornfield between it and the harbour. The house was renamed Bleak House by a later owner, claiming it to have been the house in the novel of the same name, even though that is in Hertfordshire.
A bronze bust or plaque of Charles Dickens was placed on the wall of Bleak House in 1905.
The house was castellated and extended almost beyond recognition by another owner, Mr Barry, who was bankrupt within four years.
One later owner of Bleak House, Mr A Batchelor, landed his Autogiro Cierva C.30P on the lawn of Bleak House in 1934. Earlier that year, he had been the first to land at Ramsgate airport in his monoplane.
SEE Batteries/ Bleak House/ Broadstairs/ David Copperfield/ Dickens, Charles/ Ramsgate Airport/ Without Prejudice

FORT HOUSE CASTLE public house
Margate
It was situated at Fort Road, Margate, in the early nineteenth century, before becoming Fort Castle, and then towards the end of the

century, it became the Sheppards Hotel, named after its owner.
SEE Margate/ Pubs

FORT PAVILION
SEE Winter Gardens

FORT ROAD, Broadstairs
Just off Harbour Street, at the entrance to Fort Road is Archway House. Fort Road used to lead to a fort.
SEE Archway House/ Bleak House/ Broadstairs/ Fort House/ Harbour Street, Broadstairs

FORT ROAD, Margate
Fort Road was not always a through road. At one time it was called Pump Road because the freshwater pump was located in a recess here. The water was reputed to have been the best in town.
The Fort Road Hotel in Fort Hill is currently in a sad state of repair and awaiting the outcome of the Margate Masterplan before a long-term use is decided upon.
SEE Margate/ Old Margate

Stephen FORWARD
Illustrated London News, 19th August 1865:
Southey, shortly after having killed three children at Starr's Coffee House, London, proceeded to Ramsgate where, some years ago, he had left behind, deserted his wife and children. He was known by the name of Stephen Forward, which, in fact, seems to be his real name.
At what precise time he went to Ramsgate does not appear but on Wednesday he found out his wife and daughter there and had an interview with them in the house of Mr Ellis a dyer in King Street.
On Thursday morning he was again allowed to see them and while the interview continued Mr Ellis heard two rapidly succeeding reports of firearms. Rushing upstairs he found wife and daughter shot dead. The murderer at once gave himself up stating that he was also the murderer of the three children in London.
The prisoner is a man who has long been at war with society. His history shows a strange combination of morbidity and hypocrisy. Of late years he appears to have followed gambling as a means of livelihood, to have frequented the watering places where he came in contact with many gentlemen of position at the billiard table. Among them was the honourable Dudley Ward from whom Southey asserts that he won 1100 pounds at billiards. Southey called on the Earl of Dudley and represented the matter to him but his lordship refused to pay the claim. Mrs White, the woman who lived with Southey, then called upon the earl and was so pertinacious that she had to be removed with some force. A summons by Southey against the earl was the result, which was dismissed. Since that time the man has more than once figured in the police reports and has lived by betting, gambling and begging. Earl Russell on one occasion sent him 5 pounds after learning that he was nearly starving.

The inquest was held yesterday week upon the bodies of the murdered woman and girl and a verdict of wilful murder was brought against Southey alias Forward, who was thereupon committed for trial upon the coroner's warrant. On Saturday he was finally examined before the magistrates at Ramsgate and committed to Sandwich Gaol for trial on the charge of having murdered his wife and daughter. He conducted himself with violence of manner during the examination and spoke loudly of the interests of justice that were being violated in his case.
SEE King Street, Ramsgate/ Ramsgate/ Sandwich

Herbert FOSTER
Herbert Foster had a shop selling fishing gear. When he moved to Ramsgate he was an apprentice in the merchant navy, but suffered so badly from seasickness, so wisely chose to work on land. His shop was where Tesco later had their store – OK that has gone too, it is now Wilkinson's – but when his shop was demolished a secret stash of guns and ammunition was discovered!
SEE Ramsgate/ Shops/ York Street

FOUNTAIN
The Square, Birchington

There was a meeting of rate payers in October 1896 to discuss a fitting way in which to commemorate the forthcoming jubilee. Easy, a lamp in the middle of The Square. Two months later, in another meeting they decided on a drinking fountain instead. Great idea, everybody for it. Who is going to pay? Lots of people checking how many buttons they have. Result, no fountain. Fast forward to 1900, when the brother of a great benefactor of the village, Major Morrison Bell, offered to put up a drinking fountain in The Square as a memorial to him. A letter of thanks was sent to him, and 511 voting cards were sent to the parishioners to get their opinion. 'No' said just 15 (3%), 166 (32%) could not be bothered to return their cards, but 330 (65%) said 'Yes'. Well that was all sorted then. No, too straightforward. Two councillors, Pemble and Pointer, were totally unreceptive to the idea, even suggesting that mothers would not send their children to school because the fountain

would cause such congestion in The Square it would be dangerous to get across it. A resolution was passed with only Pemble and Pointer voting against. By the time that the application had been to the County Council and the Eastry Rural District Council, it was the following March and Pemble and Pointer must have had smug grins on their faces. A fountain, they said, would be a hazard in The Square. Mr Bell wrote to the Parish Council saying that he would now be giving the money he had set aside for the fountain to the Royal Sea Bathing Hospital instead. The whole thing had caused a bit of a furore all around. The Parish Council elections took place less than a week later with eleven candidates after nine positions. Questions regarding the fountain were either not allowed or evaded. Pointer said that if he were elected he would stand down and make way for his son - now that is democracy in action. He came fifth and promptly failed to resign - possibly the quickest break of a politician's promise!
Alderman Grant, who lived at Fernleigh, Canterbury Road, gave the present fountain to the village, in memory of his wife, and it was opened by the vicar of Birchington, the Rev H A Serres, on 2nd June 1909, about thirteen years after it was first suggested. *'Gratefully accepted by the inhabitants of Birchington from Alderman Grant'* is inscribed on it. Originally, it was in the middle of The Square and usually on Saturdays, market stalls were set up around it, but in 1916 it was moved nearer to the Powell Arms, and moved again to its present location in the 1930s.
SEE Birchington/ Canterbury Road, Birchington/ Powell Arms/ Pubs/ Square, The

FOUNTAIN INN
King Street, Margate
The Fountain Inn dates back to the late eighteenth century. It changed its name periodically to the Fountain Hotel, Fountain Tap, and just The Fountain; also its address changed through the nineteenth century from 1 King Street to 6 Fort Road.
This inn has one of the longest histories in the town: its deeds go back to 1681. As a coaching inn, stagecoaches left here for Canterbury, and it was also Margate's first permanent theatre. There had been a stage set up in a barn in the Dane a few years before, but from 1771, a stable behind the inn played host to travelling players. Charles Mate, a suitably-named retired sea captain, rented the theatre for £20 a year, and then built a theatre on the site that cost him £200. He also had a theatre in Dover. Charles Mate's last season here was in 1785 when Sarah Baker arrived from Dover, having asked permission from Mr Cobb to build and open a theatre. He said no but she built one anyway, at a cost of £500. She became the first female theatre owner in the country and her theatre was in direct competition to Mate's.
After three months, Charles Mate went back to Dover, for a while, a beaten man. Cobb did not like Sarah Baker and he persuaded 900 locals to sign a petition that was sent to

parliament resulting in the 'Margate Playhouse Bill' and a Royal Charter which strangely had lots of advantages for Cobb. For a start, he could send Sarah Baker back to Dover, stop anyone else opening a theatre here, allow the licensee to put on performances between May and September and sell drink 24 hours a day. Oh, and it was valid for 125 years!

With Sarah Baker gone, Charles Mate decided to make a comeback, and with Thomas Robson, a Covent Garden singer, as his partner, the old theatre was re-opened as the Theatre Royal. At the end of 1786 it closed, with Mates and Robson planning to build a new theatre on the corner of Addington Street and Hawley Square. If you are worried about Sarah's wooden theatre, it was later dismantled and shipped off to Faversham.

In 1810, it was rebuilt with the inn extending down to the corner of King Street, and Cobb also built 'a new and elegant room for town meetings'. For the whole of the 19th century, not only was it one of the leading inns in the town, but a corn market was also held here.

Cobb's Bank took the corner site over in 1882. The bank later became part of Lloyds in 1891.

The Fountain Inn, next to Lloyds Bank was demolished in 1971.

SEE Addington Street, Margate/ Hawley Square/ King Street/ Margate/ Pubs/ Theatre Royal

Angela FOX

She was the daughter of Frederick Lonsdale married to Robin Fox (an impresario and agent) and mother to the actors Robert, James and Edward Fox. Angela Fox was the illegitimate daughter of Glitters Worthington, the wife of a Birchington doctor who brought all her children up as his own. Mrs Worthington went to Noel Coward regarding Angela's early ambitions to become an actress. His reply is, allegedly, immortalized in the song 'Don't put your daughter on the stage, Mrs Worthington'.

SEE Actors/ Coward, Noel/ Birchington/ Don't put your daughter on the stage, Mrs Worthington/ Lonsdale, Frederick

Charles James FOX

Born 1746
Died 1806
A friend of Byron, Macauley and Rogers.
When his father, Lord Holland, confronted Fox over the huge debts he had run up, he asked him how he could sleep at night, to which Fox replied, *'Your Lordship need not be in the least surprised. Your astonishment ought to be how my creditors can sleep.'*
SEE Byron, Lord/ Holland, Lord

Sydney FOX

Sydney Fox was a 29-year old petty criminal who moved from hotel to hotel living off stolen cheques. He charmed people into believing he was an independent farmer and gave the impression of being well-educated although he had actually received a very elementary education.

In 1927, he was having an affair with a married woman. He insured her life for £6,000 and then tried, unsuccessfully, to gas her. He was arrested, found guilty and given fifteen months. Not that the prison sentence taught him much. He left prison in March 1929 and went to Portsmouth where his mother, Rosaline, who had Parkinson's disease, was in hospital. With a combined income of eighteen shillings a week (she had a pension of ten shillings, and he had eight shillings from a service pension) they travelled to France to visit his brother's war grave at Arras. They travelled light; Rosaline had two dresses, a coat and a pair of shoes, and Sydney, although always impeccably turned out, had just the one suit which he kept clean by dabbing any stains with lighter fuel (presumably he was a non-smoker). On arriving back in England they stayed in Canterbury and Folkestone before arriving at Margate, where Sydney booked them into the exclusive Metropole Hotel on the 16th October 1929. This was their second visit to Margate that year, having been here in the July. They did not return to the same hotel because, like virtually every other place they had stayed in since he left prison, they had left without paying the bill. To impress the Metropole management and to deflect attention away from their lack of luggage, Sydney asked them to store a large parcel in the safe. He got the management to change his mother's room to number 66 which had a gas fire and an inter-connecting door to his own to further reinforce the image of the devoted son looking after his invalid mother. That April he had paid the arrears on an insurance policy taken out on his mother's life. He also took out various policies with Royal Cornhill, Eagle Star and Ocean insurance companies for amounts up to £2,000 against the disablement, injury or death of his mother. On some of these policies, he did not keep up the payments, but others he made sure he re-newed.

On 22nd October, he gave the staff at the hotel a large tip and asked them to look after his mother while he went to London on business. The business to which he had to attend involved extending a Royal Cornhill policy for £2,000 by 36 hours. It had been due to expire at midnight on 23rd October. He also took out an additional one-day policy with Ocean Accident for £1,000. Just to finish off his trip to London, he spent the night with a male lover and borrowed a pound off him to buy his mum some flowers and a bottle of port.

On the 23rd, he returned to the Metropole and asked for the bill to be made up as they would be leaving the following day. He put his old mum to bed having ensured that she had drunk enough of the port to make her sleep soundly, and at 11:40 (talk about leaving it until the last minute) he ran down the corridor shouting 'My Mummy is trapped'. Smoke was billowing from the room and another guest, Samuel Hopkins, crawled into the room and dragged Rosaline out but she was already dead. The cause of death was recorded as shock and smoke inhalation. Sydney kept up his performance as the devoted son, pretending that he was distraught; the manager's wife consoled him by hugging him and stroking his hair.

The following day it was thought that Rosaline had put some papers and her clothes on an armchair that was too close to the fire, and the inquest declared death by misadventure. Rosaline clearly did not suspect that her son would murder her. She had changed her will ensuring that Sydney received everything, not that she had much. To her other son, the one that was not intending to murder her, she left the sum of one farthing.

Sydney left the Metropole, without paying the bill, went to the funeral in Norfolk on 29th October, and then claimed on his insurance policies.

The landlady of a Margate boarding house realised that Fox and his mother were the two that had left without paying earlier in the summer and she went to the police. The manager of the Metropole was not happy about the unpaid bill and he also went to the police. The manager's wife could not work out why, when she had been hugging him to console him, Sydney's hair had left the smell of smoke on her hands, when he had not been in the blazing room, and she too went to the police. Whether it was the fact he had tried it before, the amount for which he had insured her life, the number of policies he held, or because his mother died just 20 minutes before a policy expired, the insurance companies got suspicious (well, we don't really need Miss Marple on this one do we?) and his mother's body was exhumed. Meanwhile Sydney was arrested for obtaining credit whilst an undischarged bankrupt. The famous pathologist, Sir Bernard Spilsbury (1877-1947), who also gave evidence at the trial of Dr Crippen, and at the Brides in the Bath trial, discovered that Rosaline had been strangled. Sydney was charged with murder.

On 20th March 1930, at the nine-day trial (it started on 12th March), the jury was told that a can of petrol had been discovered in his hotel room. He said that he used it for cleaning his suit. The prosecution said that he had deliberately stacked up her belongings on the chair and put a can of petrol under the chair. He had not tried to rescue his mother and had even shut the door after he had pretended to discover the fire. Sydney claimed that he had closed the door to stop the fire spreading, but, not surprisingly, he was found guilty. Mr Justice Rowlett passed the death sentence and Fox was hung at Maidstone prison on 8th April 1930. He was the first man in over fifty years to have the death penalty for matricide. At the inquest that followed the execution the coroner hoped that it would be the last time *'such a distasteful business would be necessary within these walls'*.

SEE Boarding houses/ Crippen/ Margate/ Metropole Hotel/ Murder

Rear Admiral William FOX

He lived in Effingham Street, Ramsgate, and married the aunt of local brewer, Richard Tomson.

He died aged 77 in 1810 and is buried in St Laurence Churchyard. A few months after the funeral, his old friend the Duke of Clarence (who became King William IV) visited his grave.

SEE Admiral Fox/ Admirals/ Breweries/ Clarendon House School/ Effingham Street/ Ramsgate/ St Laurence Church/ Tomson & Wotton/ William IV

William FOX-PITT
Born Dorset 2nd January 1969
He attended Wellesley House School, and as a professional Event Rider won a silver medal in the Three Day Event at the 2004 Olympics.
When talking about his horse Tamarillo, William Fox-Pitt said, '*He's obsessed with his looks and would love a diamond earring*'.
SEE Wellesley House School

FOY/FOYING
Foying was the term used to describe the occupation of going out to boats to supply them with provisions or to help them when they were in distress. The word 'foy' is also thought to derive from the boats used to carry out these functions that originally came from Fowey.
SEE Foy Boat Inn/ Ships/ Ye Foy Boat Inn

FOY BOAT INN, Ramsgate
Probably frequented by the early foyers, and hovellers, as they had a good view of the sea and could not only easily spot a vessel in distress, but quickly get down Jacob's Ladder into the harbour to their own boats. The original inn, built on the site of a watch house, was destroyed on 7th September 1941, and the current building was built just after the war.
Advertisement, c1900:
Foy Boat Hotel and Boarding Establishment opposite the Tidal Ball, West Cliff, Ramsgate. Fine sea view, immediately overlooking the Royal Harbour. All rooms facing the sea. Finest section of Wines and all Spirits of best quality. Bass's and all best London and Burton Brewers Beers. Terms moderate. Proprietors – Mr and Mrs Holloway.
SEE Foy-Foying/ Pubs/ Ramsgate/ Ye Foy Boat Inn

FRANK'S
Ethelbert Crescent, Cliftonville
It was originally built on the site of the Cliftonville Hotel after it was damaged by fire. In its time, it has been the Bowler's Arms, the Sir Francis Drake, and in 1982 Thorley's Free House. Frank's Nightclub opened upstairs in August 2001, and in May 2003 the whole place re-opened as Frank's Nightclub.
SEE Cliftonville/ Cliftonville Hotel/ Fires/ Pubs

Prince FREDERICK
SEE Grand Old Duke of York

FRIEND TO ALL NATIONS
On 6th April 1850 a steamer from Dublin, called Royal Adelaide, was wrecked on the Tongue Sand, off Margate. All 250 on board died. Subsequently, the boatmen in the town decided that they would organise a lifeboat to assist in any future incidents. More accurately, it should be described as a surfboat and was designed to operate in shallow waters near the coast. Its main function was not to save lives but to earn a living for the crew by 'hovelling', i.e. giving assistance to ships in difficulty, helping crews with sails or providing replacement anchors. The bulk of the income came from the salvaging of wrecks. Each crew member paid his share of the operating costs into a fund, and at the end of that year any excess money was split between them. The safety of any ship's crew was always a surfboat crew's priority, the salvaging and money earned from selling items to ships came second.

Obviously, this was a major undertaking and it was not until November 1857 that the first of the Surfboats, 'Friend of all Nations' was operational. In the busy waters between the Thames Estuary and the English Channel she was kept very busy. On one occasion in January 1866, the crew had to be rescued after somehow managing to survive for 85 minutes in the freezing water after their boat capsized going to the aid of a ship in trouble. In the Great Storm of November 1877, she was kept very busy even by her standards. After saving the lives of 38 men from 6 different vessels she was wrecked herself.

The replacement surfboat cost £230 (a fund had been set up) in July 1878; it was given almost the same name as its predecessor, being 'Friend to All Nations'. It was 32ft long by 8ft 1in, needed a twelve man crew and proved to be as busy as its predecessor.

In December 1890, under appalling conditions, the surfboat saved 6 men from the crew of half of a tank ship, 'Ville de Calais', which was being towed to London for repairs. The other half had sunk in a blizzard following an explosion on board which had broken her in two.

The north coast of Kent has always been susceptible to great tides from the north that gain huge power and momentum as they head south. There was a particularly vicious one on 29th November 1897. A great tidal surge combined with a cyclonic disturbance created a force of hurricane-like strength which hit Herne Bay, Whitstable, and Birchington. The promenade at Westgate-on-sea was destroyed, Margate's Marine Palace was smashed and the pier, jetty, and Droit office were seriously damaged. The sea wall eroded causing cracks to appear in the cliff face. The Metropole Hotel near the harbour was also damaged, as were many other buildings set back from the sea where you would have thought they would be safe. The sea breached the pier at Broadstairs, and then the colonnade at Ramsgate, which had only been built 24 years earlier.

'The havoc wrought by wind and sea presents a melancholy testimony of their overwhelming power. Not even that useful and unveracious person the oldest inhabitant possessed memories of a tempest which has brought such widespread ruin. Although the storms of 1808 and 1846 were destructive they were trivial compared to this and it is hardly an exaggeration to say that the face of Margate has been changed forever. Through the mist of the spray, huge masses of water could be seen rising mountain-like, their created summits roaring in a majestic splendour high above their prey and in the thunders of sea and wind the work of the rain went on until the ebbing of the tide stayed their pitiless fury.' Keble's Margate and Ramsgate Gazette

By nightfall on the Sunday, the north-north-west wind was up to hurricane force and did not abate on the Monday. Consequently, there was no ebb tide. High tide was at 3.35pm but because it had not gone out, double the volume of water crashed into the coast causing all the damage. Marine Palace and other buildings were thought to be protected by a defensive sea wall built from stone blocks weighing up to fifteen tons, in front of them. However, the waves were so tall that they went over the wall, into the compound, bounced off the cliff and rebounded with such force that the huge stone blocks were shifted as if they were mere pebbles.

The crew of 'Friend to All Nations' was a very close-knit group, including both friends and families. The Coxswain was William Philpott Cook who had lived previously at 3 Cold Harbour Lane but was now at Beaumont's Cottage in Union Square. Married to Anne, they had one daughter, Sarah, and four sons, John and George, and William and Robert who were part of the surfboat's crew.

Anne Cook's sister, Ellen, was married to Henry Brockman and lived at 6 Sydney Place, Margate, with their daughters Florence, Annie, Alice and Jane, and sons Robert and Henry (known as Harry). The latter was part of the crew. Sharing the house was Harry's cousin Henry Brockman also a member of the crew. Ironically the brother of the two sisters Anne and Ellen, Alfred Ansell was married to Ellen's husband's sister Charlotte (don't worry there's not a test at the end).

Two brothers were also part of the crew, George and Robert Ladd. George lived at 3 White Hart Court and was married to Mary and had five children. Robert was married to Minnie and they lived at 33 Brockley Road.

The other crew members were Edward Crunden, one of Harriet Crunden's three sons. She lived at 3 Sollys Court; John Dike (possibly Dyke) who was married to Charlotte, had three children and lived at 5 Charles Square; Joey Epps, who had lived at 41 King Street with his wife, Sarah, five sons, Sarah's dad and a domestic servant, but now that the children had grown up and moved out, had moved to 10 Paradise Street; John Gilbert, who had been married to Sophia at 3 Spellers Court and had two sons and two daughters, although Sophia was now bringing up their children alone. One of their sons, also called John, was a member of the crew; and William Gill, who with his wife Emily, shared a house at 4 Belgrave Cottages with another married couple.

The Superintendent of the Margate Ambulance Corps was Charles Edward Troughton and he often went out to sea with the crew of the surfboat to help the injured off wrecks. He was the son of a Ramsgate man Charles Skinner Troughton, and was born on 5th March 1857 in Belvedere, North Kent. His first job was with a ship builder and coal merchant in Ramsgate, Mr Charles Perry. He then worked in his Broadstairs branch, but an accident at work had kept him off work for many weeks. At the age of 30 he moved to 46 Addington Street Margate, boarding with Mr Charles J Buck and his son, Francis, and daughters, Edith and Ethel, and Mr Buck's sister-in-law, Annie Branston. He got a job as a Brewers Clerk with Cobb & Co., Bankers and Brewers in King Street. At the time, his landlord was also a Brewers Clerk. Mr Buck was promoted to Brewery Manager, and Charles Troughton transferred to the Banking side of the business becoming a Bankers Clerk. In time, he got promoted to the position of Bank Cashier.

On the night of the tragedy he had gone to fetch a parent from Westgate to take them to the bedside of their dying child in the Cottage Hospital. On the way to the harbour he called into the Police Station and told them *'If anything happens, you know where to find me – 21 Union Crescent! Don't forget to call out if you want any help!'*

At 5am on 2nd December 1897, the coastguard on duty at the pier and Mr Grant, the lamplighter, working at the harbour, saw distress signals from a 1,532 ton iron sailing ship, The Persian Empire, on the other side of the sands. An hour later, the lifeboat Quiver assisted the Margate surfboat Friends to All Nations in attempting to rescue the stricken ship.

The Persian Empire was in trouble just off the Nayland Rock, having collided with a steamer. At the tiller of the surfboat was the Coxswain, 54-year old William Cook Snr who steered a course intending to clear both the Nayland Rock and the heavy rollers of waves. He was unable to keep to it, however, and whilst desperately trying to steer and in order to avoid a giant wave which 62-year old crewmember Joey (Joseph) Epps would later describe as a *'monster'* was nevertheless struck by the wave on the starboard quarter which immediately capsized the surfboat. Next to Joey was 28-year old William Cook Jnr who said *'Oh dear! Oh Lor! She's going!'* They were his final words. Forty-year old Charles Troughton was beside Joey but he was swept away before he could utter a sound. Joey survived because he was between the seats (thwarts) and managed to wedge his elbows and keep his chin above the water as the boat was washed ashore at Westbrook, and he was rescued. Charles Troughton was the first body washed ashore. Although a very strong swimmer, he was weighed down by his heavy oilskins and boots in the stormy sea, and was unable to save himself. The Coxswain, William Cook Snr, was found next, along with 38-year old George Ladd.

They were taken directly to the mortuary. At 9 o'clock the next morning, the body of 50-year old Henry Richard Brockman was washed ashore, and very soon after John Dyke (41), followed by William Gill (36) both of whom were badly disfigured having been smashed against the rocks. At around noon, Edward Crunden was brought in, and an hour later Bob Cook, just 26 years old. He too was badly disfigured. The bodies of the Coxswain's two sons William Jnr (28) and Robert (26) were pulled from the sea in the afternoon. Henry John Brockman Jnr, Robert Ladd (40), John Gilbert and Joey Epps all survived.

'One of the most lamentable and disastrous events which has overtaken Margate for many years, occurred in the early hours of Thursday morning (2nd December) by the passing of the Margate surfboat Friends to all Nations. Out of a full complement of 13 men, including Mr C E Troughton, superintendent of the Margate ambulance corps, who invariably accompanied one or other of the boats on their errands of mercy, only four were saved. No such shocking and appalling catastrophe has happened at Margate since the eventful 5th January 1857 when the lugger Victory was lost with her crew of nine hands. The sad event following on only three days after the great storm and accompanying destruction of property made this week in the year 1897 one that will be long remembered in the history of Margate.

How the accident happened was scarcely known to the survivors, and what really caused this usually staunch little craft to turn turtle is to a great extent a matter of conjecture. It was stated, on the authority of one of the survivors, that the sail was being lowered when a sudden squall struck them 'all of a heap', filled the bulging sail with water and, in that way, brought about this most deplorable accident' Keble's Margate and Ramsgate Gazette.

If you were wondering what happened to the 'Persian Empire', it drifted, badly holed, towards the Goodwin Sands, before the lifeboat 'Quiver' managed to get men on board and, in time, with the assistance of some tug boats, the ship made it safely to Folkestone. It had aimed for Dover, but it was that sort of night. It was repaired and continued in service until 1904.

Crowds estimated at 20,000 lined the route 5 or 6 deep from Margate Harbour to St John's Church to watch the horse-drawn hearses carry the victims to their subsequent funerals on 12th December 1897.

The four black horses for the surfboat's trolley that carried eight coffins had been loaned by Captain Hatfield of Hartsdown. Troughton's body was on an ambulance litter conveyed by members of the Margate Ambulance Corp.. Most houses in the town lowered their blinds in a show of respect, as did the shops and businesses, which closed at noon that day.

On the morning following the tragedy there was a meeting, chaired by the mayor Councillor G F Brown, at the Town Hall, which announced that a committee was to be formed to raise money, both locally and nationally, for the families of the deceased. The Daily Telegraph gave £1,400, the RNLI £1,000, and the Stock Exchange £1,000. Queen Victoria wrote a very nice letter and gave some money as well. We must remember that it's the thought that counts, and it was still a tidy sum in those days, but the Queen of the United Kingdom of Great Britain and Ireland, and Empress of India etc gave the princely sum of £35. Thankfully hundreds of other people sent money in and in the end there was a fund of £9,921 to help the dependants, with an additional £354 for a statue. Mr T P O'Connor MP wrote *'The whole nation will be disgraced if a single woman or child, deprived of their breadwinner by this catastrophe, is allowed to want for anything'.*

As is so often the case with funds that try to help the victims of tragedies, it all turned a bit sour. It was suggested that a row of five almshouses to house the five widows and fourteen fatherless children should be built. It was obviously far too sensible a suggestion and it was rejected. In fairness, the widows were to be paid 15/- a week and the orphans 2/6 until they reached working age. The fund paid the £50 bonds necessary for apprenticeships for three of the orphaned boys, and young Arthur Ladd was found an apprenticeship with the South Eastern Railway Works. Quiver Magazine produced a book called 'The Loss of Nine Gallant Lives' and the proceeds from it funded the purchase of a marble clock and a silver medal inscribed to each of the four survivors, which were then presented to them by the mayor. Mr Grant, the lamplighter, was given a medal and some money.

There are two memorials to this event in the town, one at the cemetery, the other on the seafront.

There were many complaints about how the appeal dealt with the funds, and the rumblings continued for many years, and in time many of these seemed to have been justified. About a year after the tragedy, Charlotte Dyke, John's widow, was in such financial straits that she had to apply to a local charity, the Kidman Bounty, for help.

Friend to All Nations was repaired and put back into service. On the 24th/25th November 1877 in a storm 20 vessels were driven ashore between Westgate and Westbrook. Friends of All Nations saved 130 people. Keble's Gazette, *'the scene of devastation and ruin is so complete that the only parallel is in a nightmare'*

She was lost in December 1898, while under tow to a vessel reported in distress. Although she was recovered off Suffolk she never returned to Margate and a new Friend to All Nations was put on station in September 1899. This, like her two predecessors, was an open rowing and sailing boat and her crew were completely open to the elements. In 1906, a crewman died in the boat as a result of exposure, a hazard routinely faced by the men.

One of her most notable services was to the sailing ship Marechal Suchet, aground off

Margate, when she saved 26 people. In 1922 the boat was motorised following public donations, thus becoming the first motor lifeboat at Margate. She was requisitioned for service in World War Two and eventually sank off Ostend in 1957 when she was a houseboat.

During their many years of voluntary service, the Margate Surfboats rescued countless vessels as well as saving over 500 lives.

SEE Addington Street/ Cemetery/ Cobbs/ Coastguards/ Goodwin Sands/ Harbour, Margate/ Hospital, Margate/ Keble's Gazette/ King Street, Margate/ Lifeboat/ Lifeboat memorial/ Margate/ Marine Palace/ Ramsgate/ St John's Church/ Union Crescent/ Shipbuilding/ Victoria/ Westbrook/ Westgate-on-Sea

FRIEND to all NATIONS DISASTER MEMORIAL, Margate Cemetery

The striking and impressive stone memorial complete with anchor, lifebelt and weeping woman, is surrounded by a very low white wall on which each of the victims has his own dedicated inscription on small raised blocks, to mark the single grave where all the victims are buried. It was carved out of a ten ton block of Carrara marble by J Whitehead & Sons. Nobody checked whether the local roads could take such a weight, before they ordered such a heavy monument, and in order to transport it the roads had to be specially strengthened. The original cost soared and went into four figures. Where did the extra costs get paid from? Go on, have a guess. Yes, you're right! They took it from the fund for the dependants! The inscription reads: *In memory of nine heroic men who lost their lives by the capsizing of the Margate surfboat Friend of all Nations in attempting to assist a vessel in distress. 2nd Dec. 1897*

SEE Broadstairs/ Cemetery, Margate/ Friend to all Nations Disaster/ Friend to all Nations Disaster Fund/ Lifeboat Memorial/ Storms

William Powell FRITH

Born 19th January 1819
Died 9th November 1909

Frith was an artist who painted contemporary scenes of English life, including 'Ramsgate Sands – a Day at the Seaside' (1854) which was apparently inspired by a holiday here in 1851. The critics said it was *a tissue of vulgarity*' but Queen Victoria bought it for 1,000 guineas and it is now at either Windsor Castle or Buckingham Palace - the next time I get an invite I will check.

SEE Artists/ Ramsgate/ Victoria

Elizabeth FRY

Born Norwich 21st May 1780
Died 2nd Sunday October 1845

Elizabeth Fry lived in Arklow House in Arklow Square. What do you mean, 'Never heard of her'? Chances are you carry her picture with you (it's alright don't worry who might find it) because, at present, she appears on the back of the five pound note. Elizabeth Gurney Fry was one of seven daughters of Quaker parents – her mother was a descendant of Robert Barclay the Apologist (23rd December 1648- 3rd October1690 a

famous Scottish Quaker - no he didn't keep saying sorry).

She married Joseph Fry when she was twenty years old and moved to London where they had eleven children. A turning point in her life came in 1813 when the plight of women and children imprisoned in damp, filthy cramped conditions in Newgate prison came to her notice. It was another three years before she really started on her prison reform work and in 1817 'An Association for the Improvement of the Female Prisoners in Newgate' was formed by her and eleven other members of the Society of Friends. They tried to provide not only clothing but work as well as reading the Holy Scriptures to them. Her work then expanded to incorporate an interest in the conditions faced by female prisoners who were being transported. The last port of call before New South Wales was very often Ramsgate. Between 1818 and 1843 Elizabeth Fry took an interest in 12,000 convicts, and went on board 106 ships; it was only illness that eventually stopped these visits. The British Society of Ladies aimed to give each prisoner a bag of useful things. This included a Bible, clothing, toiletries, and cutlery. Manchester's Quaker drapery merchants donated the materials to make a patchwork quilt: 100 needles, an ounce of pins, 9 balls of thread (different colours), a thimble, scissors, and even a pair of spectacles, oh and I nearly forgot, 2 pounds of patchwork pieces. There were very often former seamstresses, dressmakers, tailoresses, on board who could supervise or teach the women on their long voyage. The quilt could be used by the maker, or sold when the ships stopped off at Rio de Janerio (the going rate was a guinea) or on arrival at Sydney.

Does Capital punishment tend to the security of the people? – By no means. It hardens the hearts of men, and makes the loss of life appear light to them; and it renders life insecure, inasmuch as the law holds out that property is of greater value than life. Elizabeth Fry, from her journal.

Elizabeth travelled extensively in Denmark, Holland, Germany and Ireland, visiting prisons and hospitals. One of her greatest achievements was the removal of shackles from female convicts; previously they had spent the whole journey wearing them.

Punishment is not for revenge, but to lessen crime and reform the criminal. Elizabeth Fry, from her journal

The house in Arklow Square was rented from Edward Syrett, a local draper.

SEE Arklow Square/ Denmark/ Five pound note/ Ramsgate/ Transportation

Stephen FRY

Born 24th August 1957

In 2005 the writer, broadcaster and comedian visited the Margate Museum, tracing his family tree for the BBC2 programme 'Who Do You Think You Are?'

SEE Margate/ Television

Leslie FULLER

Born Hackney, London 1889

Died Margate, March 1948

He appeared in concert parties before World War I and was a keen cyclist. During the war, he was a Second Lieutenant in the Huntingdonshire Cycling Battalion, when he was asked to form a Battalion Concert Party which he called, naturally enough, The Ped'lers. After the War, he kept the concert party going, first at Whitby but by 1919 he had arrived in Margate where they performed in a marquee next to the Clifton Baths, with the audience sitting in deckchairs. They were a success and by 1925 were performing in the new Clifton Concert Hall. During the winter, they performed in London, at the Alhambra and the Coliseum amongst others, but in the summer it was back to Margate. The concert party grew to include three-act productions that took up half the programme. Amongst their repertoire was 'The Foreign Legion', 'Virginia', 'The Bellamy Pearls' and 'Some Journeys End' including songs and plenty of comedy, Fuller was known as a 'rubber faced comic'.

John Henry Iles, who had been involved in Fuller's career since he arrived in Margate, and Fuller, decided to try their luck in the film industry and Fuller soon had a contract with the Gaumont British Corporation who produced the first few films under the British International Pictures banner. Fuller made 14 films: 'When Sailors Leave Home' (1930), 'Old Soldiers Never Die' (1930), 'Poor Old Bill' (1931), 'Not So Quick on the Western Front' (1931), 'Kiss Me Sergeant' (1931), 'Tonight's the Night' (1932), 'Old Spanish Customers' (1932), 'A Political Party' (1933), 'The Pride of the Force' (1933), 'The Outcast' (1934), 'Doctor's Orders' (1934), 'One Good Turn' (1935), 'The Stoker' (1935), 'Captain Bill' (1936), 'Two Smart Men' (1940), 'The Last Coupon' (1940), 'The Middle Watch' (1940), 'My Wife's Family' (1941) and 'Front Line Kids' (1942). Such was Fuller's success that the local paper reported in 1934 that *Leslie will earn at the very least £20,000 a year.'* Fuller and Iles formed Leslie Fuller Pictures Ltd but it was not all a success: Iles was nearly bankrupt within a few years.

After World War II, The Ped'lers returned in 1946 to The Lido.

Aside from his entertainment career, Fuller was married and had two sons and twin daughters born in 1934. He was also elected as an independent councillor for the Cliftonville ward in 1945 and was then elected onto the Entertainment Committee.

He died in March 1948 aged 57 after a short illness.

SEE Actors/ Cliftonville/ Films/ Margate

William Erskine Kirkland GALLAND

William's father had been a wealthy shipping magnate who had moved to Cliff Promenade

and had unfortunately gone mad; William himself turned into a local eccentric. He was a tall bearded man who lived like a recluse, but was always friendly to anyone he did come into contact with. He preferred to go out at night to avoid people and his chauffeur would drive him to Folkestone or Dover. He went out with a bag of half crowns, and if anyone said hello to him he gave them one of the coins. The windows of his house were blown out in World War II and, being a frugal man, he never replaced them. His 100 or so cats slept in the house, while William often slept in his car. When it snowed he was seen rolling in it on his lawn and was often seen throwing buckets of sea water over himself in Broadstairs Harbour. When he died in 1973 he left £183,000.

SEE Broadstairs/ World War II

GALLOWS POND
Near where Haine Road and Manston Road cross Gallows Pond. Despite the connotations of the name, it was a favourite Victorian picnic site until a coaching accident resulted in two women drowning there.

John GALSWORTHY
Born 14th August 1867
Died 31st January 1933
The author of The Forsyte Saga.
SEE Authors/ Over the River

GARAGES
SEE Addington Street, Ramsgate/ Astoria Cinema/ Bellevue Garage/ Caffyns/ Cliff Hotel/ Garden Electric/ Grove House/ Jubilee Clock Tower/ Kings Head, Sarre/ Northwood/ San Clu/ Trafalgar Hotel/ West Ham Convalescent Home/ World War II

GARDEN ELECTRIC, Margate
Whitehead's laundry on the east side of Fort Road, Margate had a wooden shed where they showed films in 1910. They also used the garden outside, prompting its name, Garden Electric. It closed in 1914, becoming Fort Road Garage in 1925 and after that Richmond Motors.
SEE Cinemas/ Fort Road/ Garages/ Margate

GARLINGE
The open fields that once surrounded the old village have been developed over the years, so that Garlinge is now situated between Westgate to the west and Westbrook to the north and east, although it remains relatively open to the south.
Lewis's 'History of Thanet' described a kit of Roman soldier's tools that was found at Garlinge; in fact the tools were palstaves, or a kind of axe head dating from the Bronze Age.
In 1791 Garlinge was a hamlet of 20 houses. In 1825 the village consisted of 25 houses. The only business listed for 1840 in Garlinge is that of Thomas Munns who was a builder.
In 1871 the population was 360, of these 47 (1 in 8) were labourers, 30 were maids, servants or domestic servants, 14 were laundresses (no piped water, but don't worry, there were 23 pumps and wells!), 6

carpenters, 4 bakers, 4 gardeners, 3 publicans, 2 blacksmiths, 1 boot maker and 2 teachers teaching 134 pupils on the school roll – that's one teacher per 67 pupils. Remember that, when the teacher pupil ratio is next being discussed!
In the 1911 Census there were 1480 inhabitants and the village had grown to 322 houses, although 50 of them stood empty.
East Kent Times, 2nd July 1913: *Miss Griffith Jones addressed an open-air meeting at Garlinge on Monday.* – she was campaigning for votes for women.
The large number of laundries in business here a century or so ago serviced the numerous Margate and Cliftonville hotels and boarding houses.
On 25th February 1917, many of the residents were evacuated due to fear of a bombardment from the sea; it was open farmland between Garlinge and the sea in those days.
The Old School Hall was requisitioned by the Army in 1939.
Garlinge's most recent claim to fame is that it has the same name as an Ikea mattress. Following a recent spate of celebrities naming their offspring after the place where they were conceived, who knows, it may become a popular name for children.
SEE Birds Avenue/ Boarding houses/ Bronze Age/ Captain Swing/ Caxton Road/ Crown & Sceptre/ Dent-de-lion/ East Kent Times/ Farms/ Glebe Gardens & Road/ Hengrove/ High Street, Garlinge/ Hussar/ Mutrix/ Old Crossing Road/ Rodney pub/ St James Church/ Schools/ Suffragettes/ Trams/ Tyrrel's Farm/ Westbrook/ Windmills/ World War I

GARLINGE JUNIOR SCHOOL
Westfield Road, Garlinge
(the Infants School is in Caxton Road) Opened 8th September 1930 with 304 pupils, the foundation stone was laid on 31st October 1929.
SEE Schools

GARLINGE METHODIST CHURCH
In 1936, on what is now the site of the modern Garlinge Methodist Church, there stood a coal merchants at number 2 High Street and, at number 4, a market gardener.
SEE Churches/ High Street, Garlinge

GARNER'S LIBRARY, Margate
Garner's Library was at the bottom of the High Street, No. 158, on the corner of Marine Drive and High Street.
It was replaced by the Globe Inn which was demolished in about 1875 and replaced with The Imperial Hotel.
SEE High Street, Margate/ Imperial Hotel/ Libraries/ Margate/ Marine Drive/ Pubs

Walter William GARWOOD
He was the architect who designed the Granville Theatre and helped to design the Newington Estate in Ramsgate.
He died at his Winterstoke Way, Ramsgate, home aged 82 in 1998 (he received the OBE in 1974).
SEE Granville Theatre/ Newington Estate/ Ramsgate

GAS WORKS, Margate
In the 1920s colliers came four times a week from the North-East to deliver coal to feed the gas works in King Street, Margate. Lorries and trailers shuttled back and forth.
At its peak, the gasworks in King Street used 50,000 tons of coal per year, which came in through the port of Margate. With the advent of North Sea gas supplies however, the gasworks closed in May 1958.
SEE Harbour, Margate/ King Street/ Margate

GAS WORKS, Ramsgate
Following an Act in 1824, the Thanet towns were to be gas-lit. The gas works at the bottom of Hardres Street were built under Mr Hedley's supervision.
Having been moved from Hardres Street, the Ramsgate Gas and Water Undertaking was opened on 17th February 1900 on the former site of Boundary Road Cottages. On 31st October 1917 it was bombed by the Germans. In the first blitz of the Second World War the gasworks were again severely damaged on 24th August 1940 when, in six raids, 2 soldiers and 29 civilians were killed. The gas works were out of action for the next 12 days.
SEE Boundary Road/ Hardres Street/ Ramsgate/ Thanet

GAVILKIND
This is the Kentish custom of dividing inheritance equally between all male children instead of leaving it all to the eldest.
SEE Chilton

Louise GERMAINE
Born 1971
The actress who has appeared in the TV series 'Lipstick on my Collar', 'Frank Stubbs Promotes', 'Sharpe's Company' and 'Bramwell', comes from Margate.
SEE Actors/ Margate

King GEORGE I
Born 28th May 1660
Died 11th June 1727
(1 marriage, 1 son, 1 daughter) died on a Saturday; succeeded by his son, George II.
SEE George II/ George IV/ Royalty/ Tudor House

King GEORGE II
Born 10th November 1683
Died 25th October 1760
(1 marriage, 3 sons, 5 daughters) The last British king to lead his troops in battle, at Dettingen.
On 25th October 1760, King George II had hot chocolate for his breakfast (there has to be some perks to being a king) and then went to the bathroom. His German valet standing outside heard a thump, quickly entered and found the king had suffered a stroke, fallen off the toilet and dropped dead on the floor. He died on a Saturday and was succeeded by his grandson.
SEE George III/ George IV/ Royalty/ St Laurence Church

King GEORGE III
Born 4th June 1738
Died 29th January 1820

(1 marriage, 9 sons, 6 daughters) died on a Saturday; succeeded by his son, George IV.

George the Third
Ought never to have occurred.
One can only wonder
At so grotesque a blunder
Edmund Clerihew Bentley, British poet and radical, 'England in 1819'
SEE Adelaide, Queen/ Arklow, Baron/ Assembly Rooms, Margate/ Byrne, Charles/ Cumberland, Duke of/ D'Ameland, Lady/ Fitzherbert, Mrs/ George IV/ Grand Old Duke of York/ Holland, Lord/ Horse and Groom/ Meeting of George and Caroline/ Mount Albion House/ Obelisk/ Pegwell Cottage/ Poems/ Royal Sea Bathing Hospital/ Royal York Hotel/ Royalty/ William IV/ Wolcot, John

King GEORGE IV
Born 12th August 1762
Died 26th June 1830
(1 marriage, 1 daughter), died on a Saturday.

I sing the Georges Four
For Providence could stand no more.
Some say that far the worst
Of all the four was George the First.
But yet by some 'tis reckoned
That worser still was
George the Second.
And what mortal ever heard
Any good of George the Third?
When George the Fourth from earth descended
Thank God the line of Georges ended.
Walter Savage Landor, British poet, Epigram, the Atlas, 1855

Apparently, everytime George IV slept with a woman, he cut a lock of her hair and put it into an envelope. When he died, over 7,000 such envelopes were found.
SEE Addington, Lord/ Adelaide, Queen/ Assembly Rooms/ Blue Plaques/ Canning, George/ Caroline of Brunswick, Princess/ East Cliff Lodge/ George III/ Grand Old Duke of York/ Meeting of George & Caroline/ Obelisk/ Poems/ Prince's Street, Ramsgate/ Royal Harbour, Ramsgate/ Royal Sea Bathing Hospital/ Royalty/ Snob/ Van Amburgh, Isaac/ William IV

King GEORGE V
Born 3rd June 1865
Died 20th January 1936
In the East End of London some graffiti described the king as 'Lousy, but Royal'. Hopefully, he would have found it amusing as he is reported to have had a sense of humour. At the end of 1935, when talking to Anthony Eden about the recent resignation of Samuel Hoare as Foreign Secretary he recalled, '*I said to your predecessor: 'You know what they're all saying, no more coals to Newcastle, no more Hoares to Paris.' The fellow didn't even laugh*'.
At his Jubilee he is said to have remarked, '*I can't understand it. I'm really quite an ordinary sort of chap.*' On another occasion after hearing the life story of a Mr Wheatley, he said, '*Is it possible that my people live in such awful conditions? . . . I tell you, Mr Wheatley, that if I had to live in conditions like that I would be a revolutionary myself.*'
As a constant companion he had a pet parrot called Charlotte.

'*Born into the ranks of the working class, the new king's most likely fate would have been that of a street-corner loafer*'. James Keir Hardie, Labour Party leader.
When told by his doctor that he would be well enough to visit Bognor Regis, it is said that his response was, '*Bugger Bognor*'; it is claimed that this was also his response to the town's request to rename itself in honour of its recuperative effect on the king.
'*I feel I am getting a down on George V just now. He is all right as a gay young midshipman. He may be all right as a wise old king. But the intervening period when he was just shooting at Sandringham is hard to manage or to swallow. For seventeen years he did nothing at all but kill animals and stick in stamps*' Harold Nicholson, George V's biographer.
'*I don't like abroad. I've been there.*'
Two years after his Jubilee, he was dead, prompting John Betjeman to write:
'*Spirits of well-shot woodcock, partridge, snipe.*
Flutter and bear him up the Norfolk sky'.
After his death, his body lay in state at Westminster Hall. A total of 568,387 people, including 306,686 in one day, passed his coffin, in a queue that was eight abreast, 3 miles long and stretched back along the banks of the Thames over two of its bridges. Three million people lined the route on the day of the funeral.
SEE George V Avenue/ Royalty

King GEORGE VI
Born 14th December 1895
Died 6th February 1952
The father of Queen Elizabeth II.
SEE Epple Bay Road/ King George VI Memorial Park/ Paragon/ Royalty/ Theatre Royal/ St Peter's village sign

GEORGE & DRAGON public house, Cavendish Street, Ramsgate
This old pub was converted into residential properties in 2005.
SEE Cavendish Street/ Pubs/ Ramsgate

GEORGE STREET, Ramsgate
George Street was a ropewalk belonging to George Joad, hence the name, although it was George Place originally. The ropewalk led to Brimstone's Gardens, Spurgeon's fields and Friend's Builder's yard.
In 1839, three steps were removed to allow Effingham Street to open into George Street.
St George's Hall was home to a cinema, Stanley's Electric Theatre, but soon changed its name to the Star Cinema. It was damaged in the same air raid that destroyed the Bull and George pub in the High Street – well the bomb bounced off the roof and a chicken house in the next door garden caught fire. Later, the building (the cinema not the chicken house, although the chickens needed counselling, obviously) became a store selling furniture.
SEE Bull and George/ Effingham Street/ Guildford Lawn/ Ramsgate/ Star Cinema

GEORGE V AVENUE

A turning off Canterbury Road next to a large triangular green containing some trees and with a footpath running across it. At one end of the green there is a small concrete wall on which there is a blue tiled inscription: *This Avenue was ordered by the Margate Town Council to be named George V Avenue and planted with trees to commemorate the Silver Jubilee of the reign of his most gracious Majesty King George V. Alderman F L Pettman CC JP Mayor 6th May 1935*

SEE George V/ Hartsdown Technical College

GEORGE HOTEL, Margate
The George, later The George Inn, goes back to the mid-eighteenth century and has been at 38 and then 44 King Street, and, by the end of the century, Hawley Street. It was the flagship pub of the Cobb brewery being situated opposite the brewery entrance. A proper old coaching inn with adjoining coachhouse and stabling, at one time, it had twenty rooms to let.
On 3rd June 1943, it suffered damage from a German bomb which removed the reception area on the corner of King Street. After which, an old bay window was turned into the new entrance. A room above the bar is said to have the ghost of a middle-aged woman dressed in 1940s fashion, even though there is no record of a death there in that period. As recently as 1953, the sea has flooded as far inland as The George Hotel. The hotel was refurbished in the 1980s.
SEE Cobbs/ Flooding/ Hotels/ King Street/ Margate

GEORGE MEDAL
In 1940, the George Medal was awarded to both Fireman Frederick Watson and Chief Officer Albert Twyman. On 22nd August, low-level bombing caused immense damage at Manston airfield and the fire brigade was called out to assist. Without any breathing apparatus, Albert Twyman led his men into a burning building and formed a human chain saving all the valuable equipment from the flames. In spite of an unexploded bomb close by, Frederick Watson refused to stop using the pumps from an underground tank. The rest of the crew, Herbert Evens, Arthur Harrison, Gabriel Nye, Donald Setterfield, Albert Watson and Michael Wicks, all received commendations for gallantry. However, their experiences at Manston did not end there. Two days later they were back there to deal with another raid. Fireman Herbert Evens, '*As we tried to get a clear view of the blazing buildings, we saw a number of enemy aircraft return. We dived into a slit trench and crouched in terror as*

they headed straight for us, released their bombs and fired machine guns and cannon bombs. We were lucky, we escaped without casualties. A GPO man who had been working at the top of a telegraph pole before the second attack was still there and still working. He had ignored the raiders. The damage to the airfield was vast. The hangars had gone, there were craters everywhere and most of the auxiliary buildings were either completely devastated or severely damaged. The airfield was now out of action.'

SEE Fire Brigade, Margate/ Manston Airport/ Norton, Peter

Prince GEORGE – Duke of Kent

Born 20th December 1902
Died 25th August 1942
The son of George V.
SEE Royalty/ St Peter's Court Prep. School

GHOSTS

SEE Brown Jug/ Cleve Court/ Deal Cutter/ First & Last/ George Hotel/ Lord of the Manor/ Nero's/ Northern Belle/ Old Oak Cottage/ Pillow Talk/ Royal Victoria Pavilion/ Royal York Hotel/ Theatre Royal/ Wheatsheaf

GIBBETS

The sight of recently executed criminals hung on gibbets in the Port of London *'excites feelings of disgust in the breasts of numerous voyagers to Ramsgate, Margate, France, the Netherlands, et cetera, et cetera.'* Letter from William Sykes to Robert Peel

SEE Margate/ Peel, Sir Robert/ Ramsgate

Guy GIBSON

Born 12th August 1918 in Simla, India
Died 19th September 1944
His family returned to England when he was three years old and, in time, he went to St Georges Preparatory School in Folkestone, and then onto St Edwards School in Oxford. His family also lived in Cornwall at Porthleven. In 1936 he joined the RAF. In the eleven months prior to beginning work on the Dambuster raid, he had led 106 Squadron in 172 sorties. That is about one every other day - just the thought of one frightens the life out of me!

After the Dambusters raid, for which he was awarded the Victoria Cross on the 28th May 1943 (in addition to the DFC, awarded on 9th July 1940, bar DFC awarded on 16th September 1941, DSO awarded on 20th November 1942, Bar to DSO awarded on 2nd April 1943) he remained in the RAF but left the squadron. He wrote a book, 'Enemy Coast Ahead', after he had travelled to the USA with Winston Churchill. Desperate to fly again however, he pestered the ministry to release him from his desk job and eventually they agreed. He flew a Mosquito with 627 Squadron, and after finishing a bombing raid on a factory near the Ruhr, out of Woodhall Spa, he and his navigator, Squadron Leader J.B Warwick, returned to check on the position of anti-aircraft artillery. They crashed and were both killed on 19th September 1944. He was just 26 years old. Subsequently, the Dutch put up a sign on the

spot where he died which was then a field, but is now an industrial estate, in Steenbergen. It reads:
Guy Gibson, Wing Commander RAF.
Bearer VC for his main part in the 'bounce bombardment' on the Ruhrdams 16-05-43.
Crashed near this street and killed 19-9-1944.
Except that it is in Dutch, so I thought I would give you the English translation - there's no extra charge. The street now occupying that spot is named Gibson Street, after Guy and Warwick is similarly remembered with Warwick Street. There is also a Lancaster Street and a Mosquito Street. Also, the West Malling airfield, west of Maidstone, where he spent a lot of time, is now the Kingshill Estate. One of its main thoroughfares has been named Gibson Drive in his honour.

SEE Dambusters/ Wallis, Barnes

James GILLRAY

Born 13th August 1757
Died 1st June 1815
James Gillray (sometimes spelt Gilray) was a caricaturist who, in 1807, lived 150 yards from Margate beach: *Packet just arrived. People just landed from ye packet. Fatigued and faded – some Sick and Invalid wrapped up in Great Coats with their Bags and Baskets of Provisions. High wind. Ladies Petticoats blowing over their heads.*

SEE Margate/ Steam Packets

GIRL GUIDES

The Chief Guide, Lady Baden Powell, visited Ramsgate on 24th October 1942.
SEE Ramsgate

Mr G GLACCO

Born 1866
Died unknown
He was the son of an Austrian Army Major, and in 1907, in a specially constructed glass-fronted house (built by Charles Collins of York Street) in the Royal Victoria Pavilion, he fasted for 38 days, and lost 42lb in weight. David Blaine achieved a similar feat in 2003, when he fasted for 44 days, lost 56lb and got worldwide publicity - Ramsgate was almost a century ahead of him!

SEE Ramsgate/ Royal Victoria Pavilion

William Ewart GLADSTONE

Born Liverpool, 29th December 1809
Died Hawarden, Flintshire, 19th May 1898
The son of John Gladstone, a prosperous Scottish merchant, William Ewart Gladstone was Prime Minister four times (1868-1874, 1880-1885, 1886, and 1892-1894) and a major force in Victorian Britain. His family was devoutly Christian, virtually evangelical, and religion played a large part throughout his life, resulting in him writing several books on religion and reading the Bible every day. He spent four years at Eton College, and then distinguished himself at Christ Church, Oxford University, where he came close to pursuing a career in the church, but instead chose politics. He entered

parliament as a Tory (Conservative) MP in 1832 and for the next decade or so, he opposed any reform; in fact, his very first speech was to defend slavery in the West Indies.

Gladstone married Catherine Glynne, to whom he was a devoted husband, in 1839, and they had eight children – I said he was devoted!

He once said, *'Man has 32 teeth, therefore he should chew each mouthful 32 times'.*

In Sir Robert Peel's Tory Cabinet, he became President of the Board of Trade in 1843. When Peel repealed the Corn Laws which taxed imported grain, in 1846, both the Tory party and the government collapsed. Regarded as a Peelite, Gladstone was cast adrift politically for the next 13 years although he did hold some cabinet posts in that time. It was during this period that his views changed. William's father was a slave owner in America and there is a theory that William's guilty conscience about this was what drove his political ambition.

He supported Italian unity and nationalism; and also supported Jews being accepted into Parliament. Despite previously opposing Palmerston's foreign policy - too aggressive for Gladstone - he joined the Liberals (Whigs) under the leadership of Lord Palmerston as Chancellor of the Exchequer in 1859, a post he held until 1866. He became popular with the lower classes, particularly when the Reform Act of 1867 following amendments from him, gave the vote to around one million urban workers. From 1867 he was leader of the Liberal Party, and known as a great reformer. The following year, Victoria, despite disliking him – *'He speaks to me as if I was a public meeting'* - invited him to form a government after Disraeli had resigned as Prime Minister. In 1868 he declared that his mission was to 'pacify Ireland'. During what proved to be just his first term in office, he introduced a system of education, albeit elementary, supported by the state; secret ballots; the abolition of the purchase of army commissions; and declared that entry into the civil service was to be based on competition. Disraeli replaced him in 1874, causing Gladstone to condemn what he saw as his aggressive foreign policies. His great speeches during the 1879-1880 Midlothian campaign appealed to the morality of voters and he was back in power again. The Reform Act of 1884 extended the vote, this time to many rural voters. This term also saw married women gain greater control over their property, and he sought to eliminate electoral corruption. Much of his time was spent on two major areas: the British Empire and Ireland. After being forced to intervene in Egypt, he lost much popularity in 1882, when having sent him against the Mahdi, he failed to rescue Charles George Gordon from Khartoum. He attempted to end Irish unrest with the Land Act of 1881 giving tenant farmers greater rights to the land they were farming, but realised the need for Home Rule, a matter that dominated his third spell as Prime Minister in 1886, when the Home

Rule bill split the Liberal party, and his fourth term, 1892-1894, when a second Home Rule bill (1893) was passed by the Commons but rejected by the Lords. His cabinet did not support him in his fight for Home Rule and as a consequence he resigned and retired in 1894, aged 85. He died of cancer at home in Hawarden, Flintshire, aged 88, and was buried in Westminster Abbey.
SEE Clarendon, Earl of/ Disraeli/ Gladstone Road, Broadstairs/ Old White Hart Hotel/ Peel, Sir Robert/ Politics/ Prime Ministers/ Victoria/ 'Woman in White'

GLADSTONE ROAD, Broadstairs

Named in honour of the former Prime Minister; an accolade that no longer seems to be bestowed. There is no Wilson Road, Thatcher Avenue or Blair Crescent, although we do get Major roadworks!
On 1st March 1916*, a German FF29 attacked Thanet, the top half of a house in Gladstone Road was destroyed.
SEE Broadstairs/ Clarendon Road*/ Gladstone, William Ewart/ Haddon Dene School/ Wellesley House School

GLEBE ROAD and GLEBE GARDENS
Garlinge

Glebe is the name for a field attached to a church.
SEE Garlinge

Prince Henry, Duke of GLOUCESTER

Born 31st March 1900
Died 10th June 1974
He was the third son of George V and along with his mum (Queen Mary to you and me) and his sister Princess Mary, he stayed at Broadstairs in 1910.
SEE Broadstairs/ George V/ St Peter's Court Prep. School

GOATS

Apart from donkey rides on Ramsgate sands, there was a time when you could get a ride in a cart pulled by a goat!
SEE Donkeys/ Ramsgate

GODWIN

Born c1001
Died 15th April 1053
The name Godwin is an old English one. 'Wine' means friend, so Godwin means friend of God.
A powerful Anglo-Saxon chief, Godwin was an Earl of Kent. Although Edward the Confessor was the king of England, Godwin was in effect leader of the opposition, against the Normans, and in reality ruled much of the kingdom. He went with Canute in 1019 on an expedition against Sweden, where Canute was so impressed with him; he not only gave him large tracts of land, but one of his relations for a wife! When Canute died Godwin sided with Hardicanute against Harold, but later reversed his support. He was charged with the murder of one of Ethelred II sons, Alfred, but managed to convince everyone of his innocence. After Hardicanute's death he sided with Edward the Confessor - who became his son-in-law – but then rebelled against him, lost, and had to

flee to Flanders, where he got some fresh forces together and sailed with them up the Thames, throwing the country, and the King, into a bit of a tizzy. The King negotiated a peace deal with him and restored his estates to him. In 1053, he died suddenly whilst dining with the King at Winchelsea

GODWIN ROAD, Cliftonville

In the late nineteenth century, 26-32 Godwin Road (on the corner of Albion Road) was Albion House, a boarding school for about three dozen boys. At 58-60 was Montrose House for around 4 dozen girls. Sea View Lodge was a similar but much smaller girl's boarding school, and Southwell House School was a boarding school for about 20 boys.
On 13th September 1915 just as the sun was setting, a German seaplane dropped ten bombs on Cliftonville; four landed harmlessly on the beach, but a house called Malabar along with a few of its neighbours, were badly damaged. Two women were injured in the top floor of number 14.
SEE Cliftonville/ Gotha raid - Margate/ Riviera Gardens/ Schools

GOLDEN EAGLE

A steamship built by Brown's of Clydebank, for the General Steam Navigation Company in 1909. In the First World War it was a troop carrier.

The General Steam Navigation Co. Ltd
Commencing May 31st.
Season ends Sept. 15th.
DAILY SAILINGS
(Sundays included)(Fridays excepted)
(Weather and other circumstances permitting)
during summer season 1924 by the
GOLDEN EAGLE and/or EAGLE
At Cheap Fares between GREENWICH, NORTH WOOLWICH
SOUTHEND and MARGATE and RAMSGATE PIERS
Calling at TILBURY Pier (for Gravesend etc) connecting with Special Trains to and from Fenchurch Street and intermediate Stations. Through Booking at combined Fares. CIRCULAR TICKETS are issued at Greenwich and North Woolwich Piers. Out by boat and home by Southern Railway co. from Ramsgate or Margate, available for 15 DAYS. Children under 12 years Half Prices.
FREQUENT CHEAP TRIPS TO SEA (about 2 hours duration) from MARGATE to varied points of interest. For fares and further particulars see Hand Bills obtainable from the Co.'s Offices:- The Jetty, Margate or Pier Yard Ramsgate. W J Admans, Agent, May, 1924
The Golden Eagle was converted to oil in 1934, turned into an anti-aircraft ship in 1939 and rescued 1,751 men at Dunkirk in 1940. In 1951 she was sold for breaking after a very hard 42 years.
SEE Dunkirk/ Margate/ Ramsgate/ Ships/ World War I

GOLDFINGER

In this James Bond novel, Ian Fleming refers to 'Goldfinger-land-Reculver'.
SEE Books/ Fleming, Ian/ Moonraker

GOLF

'Golf is the equivalent of crack for middle-aged white men.' Mike Barnicle
There was once a golf course at Hengrove, off the Shottendane Road.
SEE Fishwick, Diane/ Hengrove/ North Foreland Golf Course/ Shottendane Road/ Sport

The GOOD INTENT public house
Bath Road, Cliftonville

It opened as a beer shop around 1845, became a pub in 1859 and was named after a Margate sailing lugger which pre-dated the lifeboat. It was very popular with the American servicemen stationed locally in World War II.
SEE Cliftonville/ Lifeboat/ Pubs

GOODWINS
Canterbury Road, Westbrook

The ironmongers first opened in 1938 selling big pots and pans to the hotel trade. During World War II, the engine of a Mosquito plane crashed into the shop.
It is now run by the third generation of Goodwins.
SEE Canterbury Road, Westbrook/ Shops/ Westbrook/ World War II

GOODWIN SANDS

A 10-mile long line of shoals in the English Channel which have been a danger to shipping for centuries. The area between the Sands and the coast is known as the Downs, and provides shelter and safety for shipping.
The state papers of King James I contain the first recorded rescue from Goodwin Sands: *'Two ships of Horne in Holland cast away on the Goodwin Sands; one saved by the Ramsgate boatmen.'*
'The Merchant of Venice', Act 3, Scene 1, by William Shakespeare: *'The Goodwins, I think they call the place; a very dangerous flat, and fatal, where the carcases of many a tall ship lie buried.'*
'Moby Dick' by Herman Melville: *In what census of living creatures, the dead of mankind are included; why it is that a universal proverb says of them, that they tell no tales, though containing more secrets than the Goodwin Sands;*
SEE Ballantyne, RM/ Downs, The/ 'Fallen Leaves'/ 'Floating Light of the Goodwin Sands'/ Friend to all Nations/ Grange, The/ Harbour, Ramsgate/ Indian Chief/ 'Lifeboat, The'/ Lifeboat, Ramsgate/ Mary White/ Ramsgate/ Royal Hotel/ St Luke's area/ Scotsman/ Shakespeare/ South Cliff Parade/ Turner, JMW/ U-boat

GOODWIN SANDS – cricket match

Ramsgate's Harbour Master, Captain K. Martin, organised the first cricket match on Goodwin Sands in the summer of 1824.
SEE Cricket/ Harbour, Ramsgate

GORDON ROAD, Cliftonville

In 1891, at number 39, the House of Rest for Christians had one guest/ customer/ inmate – delete as you think appropriate.

A German seaplane dropped a bomb here on 13th September 1915 and Agnes Robins, aged 40, who ran a lodging house at number 26, was killed.
SEE Cliftonville/ World War I

GORE END

'Gore' means a wedged-shape piece of cloth - aptly reflecting the shape of the inlet - and 'gara' in Old English is a similarly shaped piece of land. The name probably also reflected the shape of the north-east corner of Thanet at that time. Gore End was a Non-Corporate Limb of the Cinque Ports and is supposed to have had a church that was destroyed by the '*fall of cliffs, it standing near the sea.*'
Dover Chamberlain's Accounts, 1365-67: '*Xs received from the men of Goreshende in full receipt until the feast of Easter.*'
SEE Churches/ Cinque Ports/ Minnis Bay/ Thanet

GOTHA

Gotha bombers were enormous German aircraft, introduced in June 1917, with a wingspan of 78ft, two Mercedes engines and a bomb load of three hundred pounds.
SEE Canadian Military Hospital/ Chatham House School/ Gotha Raid/ Manston Airport/ Military Road/ Picton Road/ Walpole Bay/ World War I

GOTHA RAIDS

One particular Gotha raid, on the night of 30th September 1917, killed eleven people in Margate after dropping 13 incendiary bombs and 13 high explosive bombs. Damage was done to Sweyn Road, Trinity Square, St Pauls Road, Buckingham Road, Dane Park, Godwin Road, Ethelbert Terrace, Alexandra Road, Helena Avenue, and Marlborough Road.
SEE Cemetery, Margate/ Gotha/ Margate/ Marlborough Road/ Sweyn Road/ Trinity Square/ Walpole Bay

GOUGER'S WINDMILLS, Cliftonville

The south side of Northdown Road was once open fields with three Gouger's Windmills (between Wilderness Hill and Clarendon Road, approximately where Woolworths stands today) worked from 1800 to 1836. In February 1836 they were set on fire by smugglers who wanted to bring some contraband ashore at Palm Bay, to act as a warning beacon. They did leave Daniel Gouger, the mill owner, a bag of gold on his doorstep as compensation for the loss of one of his mills, but he nevertheless offered a £500 reward for information to catch the culprits. Carver Lawrence was prosecuted and subsequently transported.
The windmills stood empty until they were demolished in 1875.
SEE Cliftonville/ Fires/ Lawrence, Carver/ Northdown Road/ Transportation/ Woolworths

GOUT

A disease which occurs when there is too much uric acid in the blood. The symptoms include swollen, painful, joints – usually the toe but any joint of the arm or leg can be affected. A diet which includes too much wine, malt or protein can trigger an attack but does not actually cause it.
Wilkie Collins suffered from gout but: '*Ramsgate cured me. I stayed there five weeks – and felt better and better every day*'.
Wilkie Collins, letter to a friend, November 1872
SEE Collins, Wilkie/ Ramsgate

Janey Lee GRACE

One of the co-presenters of Radio 2's 'Steve Wright in the Afternoon' and the author of 'Imperfectly Natural Woman', she has a holiday home in Margate.
SEE Radio

GRAFFITI

Graffiti reportedly found inside one of the women's bathing machines at Margate:
> *Though oft' have I been*
> *In a bathing machine*
> *I never discovered till now*
> *The wonderful art*
> *Of this little go-cart*
> *'Tis vastly convenient, I vow*
> *A peg for your clothes,*
> *A glass for your nose,*
> *and, shutting the little trap door*
> *You are safe from the ken*
> *O those impudent men*
> *Who wander about on the shore.*

Today's graffiti will be less fondly remembered. For a start it rarely rhymes.
SEE Bathing machines/ Margate

GRAND FALCONER

Kentish Gazette, 21st September 1810: *An event, alarming at the moment but unattended by any fatal consequences, occurred about three o'clock on Sunday morning last off Hearn Bay. 'The Grand Falconer' Margate packet on her passage from London, in consequence of a sudden squall when carrying too much canvas, lost her main mast Providentally the passengers, about forty in number, were below deck at the time two gentlemen excepted who narrowly escaped being crushed by the fall of the mast. The accident happened during the night occasioned much distress on board. The anchor was immediately cast and as soon as the dawn of day appeared a lugger put off from Hearn Bay and took the passengers and their luggage on board, but it being low water, when they reached the main the passengers were obliged to be shifted into smaller boats and eventually brought on shore on boatmen's backs from whence many delicate females and children were conveyed in carts to their destination at Margate.*
The boatmen, as a recompense for their labour, made a reasonable demand of five shillings a person but it would seem that there were four persons who (without doubt undesignedly) left the place without contributing their share of the expence.
SEE Margate/ Ships/ Steam Packets

GRAND HOTEL
Queens Gardens, Broadstairs

Now the Grand Mansions, it was built in 1882 for Mr John Butterfield.
SEE Broadstairs/ Canadian Military Hospital/ Hotels

GRAND HOTEL
Eastern Esplanade, Cliftonville

It was built by Thomas Richard Higgins in 1904 as the Cliftonville Hydro at a cost of £15,000. It became the Grand Hotel in 1920 when Isle of Thanet Hotels owned it.
Major chess tournaments were held here in the 1930s.
In 1939 the boxer Benny Lee bought it and the National Union of Teachers and the Labour Party held conferences here.
There were plans to convert the place into flats in 1946.
From 1954 until July 1999 the Grand was part of the Butlin's empire. Grand Hotel Group then became the owners when it acquired similar hotels in Brighton, Blackpool, Llandudno and Scarborough.
In January 2004, much publicity was given to the 266-bedroom hotel only having 30 guests in it.
Demolished in 2005, the hotel was replaced by McCarthy and Stone retirement flats named Dickens Court.
SEE Cliftonville/ Eastern Esplanade, Cliftonville/ Hotels/ Norfolk Hotel, Cliftonville

The GRAND OLD DUKE of YORK

Born St James's Palace 16th August 1763 – Died Arlington St, London 5th January 1827
Prince Frederick Augustus was, from 1804, Duke of York and Albany and Earl of Ulster, the second child and second '*dearest son*' of George III. He was also number one son, George's, favourite brother. He taught him to drink and gamble and ensured that he was '*thoroughly initiated into the debaucheries of this metropolis*'.
He was made Prince-Bishop of Osnabrück in Lower Saxony when he was 6 months old, which is still a record!
He spent much of his early life in Hanover.
He was the popular, if not always successful, commander-in-chief of the British Army and is the Grand Old Duke of York in the nursery rhyme:

> *The grand old Duke of York,*
> *He had ten thousand men.*
> *He marched them up to the top of the hill*
> *And he marched them down again.*
> *And when they were up, they were up.*
> *And when they were down, they were down.*
> *And when they were only halfway up,*
> *They were neither up nor down.*

In 1787 there was a rumour that he was to become King of the United States!
He married Princess Frederica Charlotte of Prussia, his cousin, on 29th September 1791 at Charlottenburg, Berlin, and again at Buckingham Palace on 23rd November 1791 - the things people will do to get more wedding presents. The new Duchess of York was well received in London but the couple split up soon after and, not surprisingly, there were no children. Frederick is thought to have had one probable and one possible illegitimate son.

On 25th March 1809, he resigned as commander-in-chief of the army due to a scandal. It was alleged that his mistress, Mary Anne Clarke, was using her position - if you know what I mean - to sell army commissions. The House of Commons later acquitted him by 278 votes to 196, and on 29th May 1811, he was reappointed and held the post until he died.

When he died at 63 he was heir to the throne (being the younger brother of George IV) and had he lived just another 3 years or so he would have been king.

In 1834 soldiers in the British Army gave up one day's pay to pay for The Duke of York Column on The Mall, London. Frankly, the money could have been used to offset the man's debts because he died owing around £700,000, which equates to c£35,000,000 today.

He lived for a while at the York Mansions in Margate and this is commemorated by a blue plaque.

SEE Blue plaque/ George III/ George IV/ Margate/ Prussia/ William IV

GRAND TURK

A fine tall ship that is a frequent visitor to Ramsgate Harbour and has starred in the TV series Hornblower (as HMS Indefatigable and the French Papillion) and Longitude.

Commissioned by Michael Turk in 1996, and built in Turkey at a cost of around £2,000,000, it is a replica of the sixth rate frigate, Blandford, built in 1741.

Its length is 152ft, beam 34ft, the main mast is 117ft above the water, the yards are 60ft across with 12 sails giving an area of 1,050 square metres, and it has a permanent crew of 16 and 2 engines (this is where it differs from the Blandford!).

On 28th June 2005, it stood in for HMS Victory at the International Fleet Review, off Portsmouth, to commemorate the Battle of Trafalgar.

SEE Harbour, Ramsgate/ Ramsgate/ Ships

The GRANGE, Ramsgate

It was built in 1843-44 by Augustus Pugin as a home for himself and he referred to it as 'my own child'. He worked from the library overlooking the sea although, judging from the vast amount of work he got through in his life, I do not know when he had time to look up and enjoy the view. Nonetheless he did and he would look out onto the Goodwin Sands for any ships that might have gone aground. If he saw any, he would send out his boat, The Caroline, a wrecker that he owned and kept on the beach below The Grange (he did not want to pay any harbour dues). He would rescue the crew and cargo and pocket the salvage money he thus gained.

Much of the interior of the Houses of Parliament were designed here.

After Pugin's death, the house was rented out for the next decade.

Pugin's will was not properly witnessed so he died intestate and the property and contents were sold off as part of his estate.

In 1862 Edward Pugin, Augustus's son, came and lived in the house with Augustus's widow, Jane and other family members. Edward added the long pentice, or covered walk-way; he also made various additions including a bathroom and a conservatory.

The Thanet Advertiser, 28th May 1904:

SERIOUS FIRE AT THE GRANGE.

A most serious outbreak of fire and one which caused a considerable amount of damage occurred at The Grange, the residence of Mrs Pugin, on Thursday evening. The Grange, a building of considerable architectural pretentions, for many years the residence of the late Mr E Welby Pugin, is owned by Mrs Pugin – an octogenarian lady well-known and much respected in the town, and who resides at St Edwards, adjoining – and is a strikingly noticeable building.

The fire, believed to have been caused by a lightning strike, was first noticed by some people walking along Grange Road. Later, flames were seen coming from the parapet of the roof facing the sea. The police and fire services were called and Capt West immediately sent round for horses. The fire was brought under control after three hours. Major damage was caused to the roof and seven rooms on the top floor. Much of the ground floor was damaged due to the immense quantity of water which poured through the upper rooms. The staircase was partly destroyed and the fine panelled ceiling damaged beyond repair. Some of the furniture and bric-a-brac were also totally or partially destroyed.

When the building was re-built, two attic rooms were included.

When Edward's brother, Cuthbert, died in 1928, monks from St Augustine's Abbey turned The Grange into a boys' school (the school moved to Westgate in the 1970s).

In the 1990s a developer bought it but it remained empty for a few years.

Finally The Landmark Trust bought the, by now dilapidated, building in 1997 for £240,000. Over £2.5 million from the Lottery, English Heritage, Thanet District Council and various others was needed to carry out the restoration.

Prince Charles, a patron of the Landmark Trust, visited The Grange on 10th November 2004 to see the works.

SEE Charles, Prince/ Fires/ Goodwin Sands/ Pugin, Augustus/ Pugin, Edward/ Ramsgate/ Schools

GRANGE ROAD, Ramsgate

Named after The Grange in St Augustine's Road, it was formerly called Liberty Boundary.

Augustus W N Pugin once lived at Ellington Cottage (number 188) with his wife, Louisa, and their son, Edward, was born while they were living there.

In January 1965 a London couple moving into their retirement home at 56 Grange Road, Ramsgate, found an 18-inch long live bomb with its detonating pin half out.

SEE Caffyns Garage/ Grange Road Windmill/ Grange, The/ Hotel de Ville/ Lavender/ Pugin, A W N/ Pugin, Edward/ Ramsgate/ Self service

grocery shop/ Sharps Dairy/ St Augustine's College/ Suffragettes

GRANGE ROAD WINDMILL, Ramsgate

The Grange Road Windmill once stood where a row of shops now exist between Mill Cottages and Cannonbury Road. It stood here until 1930 and was replaced by shops and flats called Windmill Parade.

It is popularly thought that it was the windmill that had previously stood on the East Cliff and been moved here. At the time it would have been the only building in the area with a clear run between the windmill and the cliffs.

SEE Grange Road/ Ramsgate

GRANVILLE CINEMA, Ramsgate

The Granville Theatre was converted into a cinema at a cost of around £220,000 in 1998 by Brian Stout who also owned the Windsor Cinema in Broadstairs. The upper circle became screen one with around 300 seats and the stalls became screen two.

Local girl, Brenda Blethyn, visited here on 8th September 2000 for a function to raise money for the St Georges Church fund appeal.

SEE Blethyn, Brenda/ Cinemas/ Granville Theatre/ St George's Church/ Windsor Cinema

GRANVILLE HOTEL
Victoria Parade, Ramsgate

Edward Welby Pugin (1834-1873) built a block of private houses here in 1862, but six years later changed his mind and decided to convert the building into a hotel. The then Lord Warden of the Cinque Ports, the 2nd Earl Granville, agreed to have the place named after him and thus the Granville Hotel was born. Connected to the hotel were stables, a farm and even a mineral water company. It may be strange to imagine it today, but the Granville Hotel was once one of the most impressive hotels in Europe – it even had its own train, and it ran on time – I know, unbelievable. The London, Chatham and Dover Railway Company ran the Granville Special Private Express every day from Victoria arriving at Ramsgate Sands Station. So, you get off the train, arrive at your room and ask for a bath – a straightforward request you would think – but they could offer you a choice of twenty five different types! The large tower, once one of Ramsgate's landmarks, held both fresh water and sea water that had been pumped up through the cliffs so that, if you wanted to bathe in sea water, you could avoid the inconvenience of actually having to go into the sea. Amongst the other types of bath on offer - because I know you are interested - was Turkish, iodine or seaweed – not so keen now, are you?

Edmond F Davis bought the Granville Hotel soon after it opened and set about expanding the enterprise into the Granville Estate, St Lawrence. He wanted to have a road going down to the sea, which obviously necessitated the digging of tunnels, and an ornamental garden. What must have been such a good and straightforward idea at the time turned into a massive undertaking that

needed 370 men to dig out 80,000 tons of chalk and load it all onto 1,000 trucks. It was obviously worth it because by the turn of the century and throughout the Edwardian era, The Granville Hotel was attracting wealthy guests who had previously gone to Algiers or Nice. During World War I, it was used as a military hospital but afterwards never really regained its pre-war business strength. Again, in World War II, it was a military hospital. The gable on the western end of the building was destroyed by a bomb in World War II (it was restored in 2004). The place has now reverted to private dwellings and the age of luxury hotels has long gone.

THE GRANVILLE HOTEL
LARGEST & LEADING HOTEL IN RAMSGATE
The most bracing and invigorating seaside resort in England
Complete system of Baths in the Hotel, including Turkish, Ozone, Douche, Russian, Spray, &c.
CUISINE UNEXCELLED
The Granville Express leaves Victoria at 3.25 daily, arriving 5.28
Carl G Grünhold Manager
Advertisement

A gymkhana was held on Ramsgate sands on 6th July 1925 during which a young boy wandered onto the course. Mr W G Arkwell, the manager of the Granville Hotel, tried to rescue him but died. At the inquest, held on 5th August, the jury thought that horse racing on the sands was too dangerous and should be banned.
SEE Cinque Ports/ East Cliff Promenade/ Farms/ Hotels/ Pugin, Edward/ Ramsgate/ Tunnels/ Victoria Parade/ World War I/ World War II

GRANVILLE LIONS, Ramsgate

There are two lions on the promenade in front of the old Granville Hotel, and they have another couple of brothers on the very top of the building. They also have some cousins on the piers of the gate to The Grange in St Augustine's Road.
SEE Granville Hotel/ Grange, The/ Ramsgate

GRANVILLE THEATRE, Ramsgate

Built as a temporary building (!) into the chalk cliff, it opened on 25th June 1948, and was designed by Ramsgate architect, Walter William Garwood.
In the 1950s you could, in fact you may well have, enjoyed 'The Ice Spectacular' here.

On 14th July 1961, Dinah Sheridan switched on the Ramsgate Festival of Light illuminations that stretched from the Granville Theatre all the way to the West Cliff. A crowd of 100,000 came to watch.
John Mills made a personal appearance here for the opening of 'Sky High' presented by the RAFA.
In the 1970s, Bill Maynard, Leslie Crowther and Lena Zavaroni all performed here.

SEE Blethyn, Brenda/ Connolly, Billy/ Crowther, Leslie/ Garwood, Walter William/ Granville Cinema/ Ramsgate/ Newington Estate/ Winterstoke Way/ Zavaroni, Lena

Thomas GRAY

Born London 26th December 1716
Died 30th July 1771
This poet is considered the forerunner of the Romantic poets.
Educated at Eton and Cambridge, he became Professor of history and modern languages at Cambridge University in 1768. He travelled extensively around the country in search of ancient monuments and picturesque scenery. He also worked on a history of English poetry but it was never published.
His best known work is 'Elegy written in a Country Churchyard' (1751) which he sent to his friend, the author Horace Walpole, who insisted it be published. It was an immediate success. In 1757 he turned down the job of Poet Laureate.
In June 1766 while staying with a friend at Denton, (midway between Folkestone and Canterbury), he visited Margate but you would not consider him a fan.
I took the opportunity to go into the Isle of Thanet, saw Margate (which is Bartholomew-Fair by the seaside)
This was a reference to Smithfield's extremely unruly annual fair which gives an idea of what the town was like at this time.
On a later visit to the area in June 1768, he wrote his verses 'On Lord Holland's Seat'. Gray, along with most of the public at the time, disapproved of Lord Holland, regarding him as a thief who had put his hand deep into the government coffers when he was Paymaster General of the Forces. Gray wrote about Kingsgate Castle, '*Here Holland took the pious resolution to smuggle a few years.*'
Following Holland's retirement to Kingsgate, then just a fishing hamlet, he spent a fortune building a grand house, Holland House, to live in. It was modelled on Cicero's villa on the Appian Way, and included mock ruins, or follies in the grounds, and it is these that Thomas Gray mocks in his verses.
Old and abandon'd by each venal friend
Here H. took the pious resolution
To smuggle some few years and strive to mend
A broken character and constitution.
On this congenial spot he fix'd his choice,

Earl Godwin trembled for his neighbouring sand,
Here Seagulls scream and cormorants rejoice,
And Mariners tho' shipwreckt dread to land,
Here reign the blustring north and blighting east,
No tree is heard to whisper, bird to sing,
Yet nature cannot furnish out the feast,
Art he invokes new horrors still to bring.
Now mouldring fanes and battlements arise,
Arches and turrets nodding to their fall,
Unpeopled palaces delude his eyes,
And mimick desolation covers all.
SEE Authors/ Kingsgate Castle/ Margate/ Poets

Larry GRAYSON

Born Banbury, 21st August 1923
Died 7th January 1995
Camp comedian and Generation Game host, famous for his rambling stories about Fagash Lil and Everard, and catchphrases like '*Shut that door*', '*What a gay day*', '*Look at the muck in 'ere!*', '*Seems like a nice boy*' and '*What are the scores on the doors?*'
SEE Entertainers/ Winter Gardens

GREAT BROOKS END FARM
Birchington

A German Junkers 188 bomber crashed and disintegrated at the farm killing the three crew members on 15th October 1943 after a Mosquito from 85 Squadron shot it down.
SEE Birchington/ Farms

The GREAT STORM of 1703

'*A great wind from the west-south-west*' on Friday 26th to Saturday 27th November 1703 was the worst storm recorded in Britain – until the 1987 hurricane. Every major building and every church in Thanet was damaged. The following day at Reading Street, a cow was found up a tree – it was blown up there; it didn't climb up because of fear - obviously you understood, but some people . . .
SEE Churches/ Reading Street/ Storms/ Thanet

The GREAT STORM 1953

'*The greatest sea-flood disaster in the history of the country has brought havoc, ruin, unparalleled damage and immeasurable misery to the Garden of England. The north Kent coastline is permanently altered, hundreds of Kent people have been rendered homeless, great works are at a standstill and many public services are working on an emergency basis.*
It was on the night of Saturday-Sunday that a fantastically huge and powerful wall of water, whipped by a 100mph gale hit the coastline, smashing man's puny defences of wall and quay and surging on relentlessly over roads and promenades, shattering and destroying all that lay in its path.
About 50,000 acres of land in the country was flooded. Of this, 40,000 acres is agricultural. It is estimated that 1,200 cattle and 10,000 sheep were lost.'
Kent Messenger

In Margate, the storm water swept into the Classic Cinema making walking along Marine Drive impossible.

Despite the huge waves and horrendous weather outside, a dance at Dreamland carried on until dawn because it had its own generators. The rest of the town was blacked out.

SEE Dreamland/ Flooding/ Margate/ Marine Drive/ Storms

Hughie GREEN
Born 2nd February 1920
Died 3rd May 1997
A TV personality and presenter, his two most successful shows were Opportunity Knocks and Double Your Money – a sort of forerunner of Who Wants to Be a Millionaire.
After his death it transpired that he was the biological father of Paula Yates.
He used to keep a boat in Ramsgate Harbour.
SEE Double Your Money/ Entertainers/ Harbour, Ramsgate/ Opportunity Knocks/ Princess of Wales pub/ Ramsgate/ Winter Gardens

Napoleon GREEN
East Kent Times, 26th August 1955:
Napoleon Green, the coloured American who shot 12 people at Manston air base last week [Wednesday 24th], had sworn to kill his enemies. Yet the first to die from his bullets was one of his closest friends. Ninety minutes after the shooting Green lay dead on the rocks at Broadstairs. Green had been pursued and cornered by civil, RAF and American service police after commandeering another American's car at gun-point, forcing the driver to take him to Margate and then to Broadstairs.
Chicago-born Napoleon Green was a 21 year-old 2nd class airman at the USAAF base at Manston. He was due to be questioned about the slashing of a girl's throat and the theft of some money. Whilst he and a colleague were cutting grass, he suddenly left, went to the gun room and armed himself with a .30 carbine and a .45 service revolver, leaving a note that said 'Today I die'. Immediately, the duty officer told his sergeant who called the air police. Green was looking for Captain Ader, and burst into the air police billet telling everyone to get out by 10 o'clock. Airman 2nd Class Nelson Gresham got in his way so he shot him dead, and injured another man. Green then fired nine bullets at a Morris Minor, hitting a front tyre, the driver's window and nicking the back of the leg of the camp tailor, Aubrey Easto from Ramsgate, who was driving. Thankfully, the other bullets did no further damage.
Green then went into the accounts office and at around 9.15, shot dead 33 year old Master Sergeant Lawrence Valesquez (who was married with four children, and lived at Cliftonville). He then ran along Halley Road shooting indiscriminately and grabbed Margaret Hull, a secretary. While she struggled, 22 year-old RAF policemen, Corporal Peter Grayer, came along on his bike. Green shot him; he died later of multiple haemorrhages and shock.
Green then headed for a lorry that was blocking the road, but on coming face-to-face with a 14 year-old boy, amazingly, did not shoot him, instead turning to the main gates where he shot first at the driver of a van and his passengers; then Ian Yeomans, a 24 year-old cashier from Ramsgate, taking the American Express car he was driving; next Miss Wendy Cockburn from Birchington; Miss Anne Cockburn from Broadstairs; Peter Hewitt and Mr Kemp, a driver with the Air Ministry, were all hit by bullets.
Green then ordered Master Sergeant McDaniels to drive him in a Ford Popular to Margate. They drove along Shottendane Road and then into Nash Road where he let McDaniels out of the car. Green also got out of the car and walked in front of Bert Bridgeland's house. He then got back in the car and shortly after, Police Constable Bridgeland was also in pursuit of Green, along with three jeep-loads of armed Air Force Police. By the time he got to Broadstairs Harbour, fifteen more policemen had joined in the chase. By the Tartar Frigate, he leapt out of the car and as he ran past a 70 year-old car park attendant, informed him that they would have to come and get him if they wanted him. At Stone Bay, holiday makers were ordered from the beach and American Air Force Police arrived with guns. After a short gun battle, in which Green was hit many times, he walked into the sea and shot himself in the chest.
SEE Broadstairs/ East Kent Times/ Margate/ Manston Airport/ Murder/ Shottendane Road/ Stone Bay/ Tartar Frigate

GREEN ROAD, Birchington
Originally called Green Lane, it was a track that led to the cliffs at what was called Lime Kiln Gap where there was a beacon.
SEE Birchington

GREENGROCERS
There were 114 greengrocers and fruiterers listed in Thanet in 1957. There were 9 listed in 2005 (excluding supermarkets).
SEE Coal/ Dairy Farms/ Grocers/ Thanet

Sydney GREENSTREET
Born on 27th December 1879
Died 18th January 1954
He was born in Sandwich and made his stage debut in 'Sherlock Holmes' as a murderer called Craigen in 1902 at the Marina Theatre. At the age of 62 he made his film debut as Kasper Guttman in 'The Maltese Falcon,' (1941) starring Humphrey Bogart.
SEE Films/ Marina Theatre/ Sandwich

Ben GREET
He was an actor who learnt his trade from Sarah Thorne at the Theatre Royal, Margate. He had his own Ben Greet's Pastoral Players which included Dame Sybil Thorndike in the early 1900s.
SEE Actors/ Theatre Royal

Pope GREGORY
Pope Gregory was visiting a slave market in Rome one day when he saw some English, or more accurately Angle, boys for sale and asked where they came from. They were Angles he was told, and he responded that they were not Angles but angels because of their fair hair. It had an effect on him though, because he decided to send St Augustine (although he was not yet a saint) to England. He duly landed at Ebbsfleet with forty monks hoping to convert the country to Christianity.
SEE Ebbsfleet/ St Augustine

GRENHAM BAY, Birchington
Also known as White Bay, it is between Beresford and Minnis Bay.
A 50ft long whale was washed up here in 1914 and the bones were taken away to form an archway in the garden of the Sea View Hotel.
The sea wall, built here in the 1980s to stop the cliff erosion, was built well away from the base of the cliffs.
SEE Bays/ Birchington/ Minnis Bay/ Sea View Hotel/ Whales

GRENHAM HOUSE SCHOOL
Grenham Road, Birchington
Messrs B V C Ransome MA JP and H E Jeston MA founded the school at a house in Minnis Bay before building premises with a swimming pool, chapel and playing fields, in Grenham Road in 1910. In 1987 the building was converted, and became Homeblitch House; Hunting Gate Estate was built on the playing fields.
The character actor, John LeMesurier, went to school at Grenham House School which was still going many years after World War II.
SEE Birchington/ Grenham Road/ LeMesurier, John/ Minnis Bay/ Schools/ Suchet, David and John

GRENHAM ROAD, Birchington
David and John Suchet stayed at Sheltwood while they were attending Grenham House School.
SEE Birchington/ Grenham House School/ Suchet, David and John

GREYHOUND RACING
SEE Dumpton Greyhound Track/ Newington/ Sport

GROCERS
There were 178 grocery shops listed in Thanet in 1957.
In 2005 there were 18 convenience stores and grocers listed (excluding supermarkets).
SEE Bagshaw's Directory and Gazateer/ Coal/ Greengrocers/ Shops/ Thanet

George & Weedon GROSSMITH
George Grossmith
Born 9th December 1847
Died 1st March 1912
Weedon Grossmith (known as Wee-Wee, the poor soul)
Born 1854
Died 1919

Of the two brothers, it was George who had the more successful literary career, but they wrote their most successful venture, 'The Diary of Nobody' (1896), together.
SEE Authors/ Diary of a Nobody

GROSVENOR PLACE, Margate
There was once a girls' boarding school called Charlotte House here.
SEE Margate/ Schools

GROSVENOR ROAD, Broadstairs
On 1st March 1916 a German FF29 dropped a bomb on the playground of an infant's school in Grosvenor Road smashing nearly all the windows and injuring a teacher.
SEE Broadstairs/ Clarendon Road/ Schools/ World War I

GROTTO-ING
SEE Beach Entertainment

GROVE HOUSE
The Square, Birchington
Probably two houses originally, it is Dutch in style with Flemish brickwork gables at each end: the north one including the initials IM and the south one has IC on the end of iron tie rods. The two houses were joined together early in their history, probably in the second half of the seventeenth century. The blacksmith's forge was next door and was run by Mary East in 1678. It was later a car repair garage, but is now closed.
SEE Birchington/ Garages/ Square, The

GRUNDY HILL, Ramsgate
It is named after Thomas Grundy who built the old Ramsgate Town Hall.
SEE Market, Ramsgate/ Ramsgate

GRUNT FISH
It is a snapper-like fish but has weaker teeth and is so named because of the pig-like noises it produces with its throat teeth. It is one of about seventy-five species of marine fishes that make up the families Banjosidae and Pomadasyide. The latter are then split into pigfish, sweetlips, tomtate, and Margate (Latin name Haemulon album) which is a, usually, pearl-grey species of the West Atlantic, thus, it is named after Margate City USA.
SEE Fish/ Margate/ USA

GUIDEBOOK
In 1955, Margate sent out 6,000 more copies of its guidebook than the previous year. The trend towards Spanish holidays had started quietly by the late fifties, and that quantity of guides was never requested again.
SEE Margate

Earl of GUILDFORD
As Frederick North, Lord North, he was Lord Warden of the Cinque Ports from 1778 until 1792. He was 2nd Earl of Guildford from 1790.
SEE Cinque Ports/ Guildford Lawn

GUILDFORD LAWN, Ramsgate
Originally called Brimstone's Gardens, it was found at the end of a ropewalk (now George Street). The gardens were later re-named after the Earl of Guildford.
The houses were built here by William Saxby in 1842 and the area was once the fashionable place to live in Ramsgate. Edwardian villas were later built on the gardens.
Karl Marx's daughter once stayed here.
SEE Cavendish Street/ George Street/ Guildford, Earl of/ Lawn Villas/ Library, Ramsgate/ Marx, Karl/ Ramsgate

GWYN'S CLOCK
Queen Street, Ramsgate
You do know it; you just don't know its name. It is the clock that sticks out of the tower of the building currently occupied by Miles and Barr estate agents. It is named after a former Ramsgate mayor, Alderman Gwyn, and dates back to the nineteenth century. Around 1990, it fell into disrepair and looked very poorly until, with the help of the Ramsgate Society, Miles and Barr and others, it was restored in 2004.
SEE Queen Street/ Ramsgate

GYPO
A film, originally entitled 'After Eight' starring Rula Lenska, Paul McGann and Pauline McLynn and filmed in Margate and Ramsgate. It is the story of a Czech asylum seeker.
SEE Films/ Margate/ Ramsgate

GYPSY ROSE LEE
Her real name was Mrs Urania Boswell, and she was the acknowledged leader of the Lees and Boswells, the last two great families of the Romany tribe. Her mother was Gypsy Rose of Brighton, and they were both famous all over the country for reading palms and telling fortunes. Their clientele included dukes and lords. She was married to Levi Boswell who had been king of his clan, but had died in 1924. She lived in a small bungalow at Willow Walk in Farnborough for six months each year, but spent the other half of the year in Ramsgate and Margate; she owned property all over the place. She died aged 81, forecasting her death the previous day, telling her brother that she would say goodbye to the world at six or seven o'clock the next day - a real conversation-stopper, that one! Fifteen thousand people, standing four deep on the pavements, and hanging out of windows and off telegraph poles, turned out for her funeral in April 1933 in Farnborough.
SEE Margate/ Ramsgate

H

HACKEMDOWN POINT
This promontory is between Kingsgate Castle and Joss Bay.
SEE Botany Bay/ Kingsgate Castle

HADDON DENE SCHOOL

Gladstone Road, Broadstairs
It was opened by Miss Olive Vyse as a boarding and day school for girls in 1929; boys were accepted in 1933.
SEE Broadstairs/ Gladstone Road/ Schools

HADES
A discotheque – that term alone dates it – opened in August 1971 at the Lido in Cliftonville. Aimed at the over 20 age group it was open every Thursday, Friday, Saturday and Sunday from 9pm until 2am.
An unfortunate reputation for being a bit rough (it was called Hades and people did not behave properly – what a surprise!) prompted the name to be changed to the Colonel Bogey Discotheque in the early 80s.
SEE Cliftonville/ Lido

HAILE SELASSIE
Born 23rd July 1892
Died 27th August 1975
He was Emperor of Ethiopia from 1930 until 1974. He visited Cliffs End Hall.
SEE Cliffs End Hall

HAINE ISOLATION HOSPITAL
Haine Isolation Hospital opened on 16th June 1902. Part of the Westwood Cross shopping centre now stands on the site.
SEE Hospitals/ Lowther, James

HALF MAN HALF BISCUIT
The song 'She's in Broadstairs' appears on this band's 2002 album 'Cammell Laird Social Club'.
SEE Broadstairs/ Music

HALFMILE RIDE, Margate
This track starts between the local dump (alright, the re-cycling centre) and the cemetery, and runs across fields to Nash Road, Margate. It may look like a dirt road now, but it was used as a horse racing course in Victorian times, attracting everyone from the riff-raff to the gentry (Charles Dickens attended some meetings) to a variety of races; some ridiculous, and others that were taken very seriously.
SEE Margate/ Sport

HALL BY THE SEA, Margate
On the site of what is now the Dreamland Cinema, the 'Hall by the Sea' was built on marshland and meadow for use as a railway station, but it never got planning permission. It was converted in 1867 by Spiers and Pond, the railway catering concessionaires, who opened it up as a dancehall capable of accommodating 2,000 people. Despite being possibly the largest dance hall in the country it was not a success. Unfortunately, it still looked like a railway station, despite all efforts to disguise it and the Assembly Rooms in Cecil Square were a more popular venue.
Alderman Thomas Dalby Reeve bought the hall in 1872 for £3,750 from Spiers and Pond. The purchase also included some allotments and a railway embankment, totalling around 20 acres in all, although it was land that was prone to flooding because

of the dyke that ran through it towards the harbour.

In 1873, Reeve's son, Arthur, married Lord George Sanger's daughter, Harriett. The two dads decided to develop the Hall by the Sea. Sanger set to work in April 1874 and in June the same year there was a grand opening. Arthur Reeve ran the hall as a restaurant by day and a dancehall by night.

Sadly, Thomas Dalby Reeve died in April 1875 and Sanger bought the freehold of the land.

In July 1898 a new building replaced the old hall. Designed by Richard Dalby-Reeve, Arthur's brother, it could seat 1,400 for concerts or accommodate 3,000 for dances, with top bands coming down from London.

On the land behind the hall there was a medieval abbey - OK it was a folly - surrounded by shrubberies, rockeries and ponds with fountains, statues, a lake (fed by the dyke) and summerhouses. Macaws and cockatoos flew around the site adding a touch of exotica!

Lord Sanger kept his menagerie here, from 1874, in 23 cages housing bears, baboons, wolves, leopards, tigers and lions – in an age before foreign travel for the masses, this was exciting stuff.

Lord Sanger had a female South African baboon named Margate. It was huge, and rode round the circus ring on a horse! Well, were you going to tell it not to?

Sanger's brother, William, had a waxworks and the beginnings of a funfair sprang up with a roundabout, cocoanut shy and an archery range.

In April 1893, an 8,000 square feet, ivory maple roller skating rink was opened. An aquarium and aviary were also added.

The Hall by the Sea was one of the first places to have electric lighting, which may, or may not, have cheered up the poor blokes who previously had to attend to the lanterns that illuminated the place at night.

The menagerie was closed in 1905.

An act that appeared at the Hall by the Sea around about 1900 was Leone Clerkes with *'her happy Family of 170, made up from a total of 50 educated cats, 50 educated mice, 50 educated rats and 20 educated canaries'* You got the bit about them being educated did you? What they did I have no idea, but can you imagine the mess? I don't know about educated, but it would certainly teach you a lesson about keeping that many animals. I shudder to think what the animal rights movement would have to say if anyone were to revive the act today.

A cinema began to take shape here starting with a programme of a few short films. By the end of 1912, these had been padded out to become a 3-hour programme.

Following George Sanger's death in 1911, Arthur and Harriet Reeve became the new owners, but time caught up with them and they retired in 1919. The place was sold to John Iles for £40,000. He arrived, looked around, agreed the purchase, and wrote out a cheque, all within two hours. If only selling a house could be that quick today.

SEE Assembly Rooms/ Dreamland/ Flooding/ Iles, John/ Lion tamer/ Margate/ Restaurants/ Sanger family

Charles HAMILTON
Born 1876
Died 24th December 1961
Charles Harold St. John Hamilton was the sixth of eight children. He began writing stories when he was seven, and had his first story published in 1893 earning him 5 guineas, but when the agent discovered his age it was reduced to 4 guineas! Charles went on to be the most prolific author of all time, writing an estimated eighty million words in his career. His output increased dramatically when he learnt to type in 1901. He wrote for The Gem and The Magnet.

Every time he created a new school story he adopted a different pen-name, amongst them were Michael Blake, Clifford Clive, Gordon Conway, Harry Clifton, Martin Clifford, Owen Conquest, Sir Alan Cobham, Winston Cardew, Frank Drake, Freeman Fox, Hamilton Greening, Cecil Herbert, Prosper Howard, Gillingham Jones, Robert Jennings, T. Harcourt Llewelyn, Clifford Owen, Hilda Richards, Raleigh Robbins, Ralph Redway, Ridley Redway, Robert Rogers, Eric Stanhope, Robert Stanley, Peter Todd, Nigel Wallace, Talbot Wynyard and his most famous one and the name under which he wrote the 'Billy Bunter of Greyfriars School' stories, Frank Richards (Richard was the name of one of his brothers, and by adding an 's' he got a new surname).

He travelled extensively from around 1909, gambling in Monte Carlo *'I had a long session there once. I had to stick my editor for cheques in advance. When I'd paid my bills, there was just enough to escape into Italy!'* He got engaged to an American girl in 1913 but broke it off because he did not like being organised! Travelling back from Italy in 1914 when World War I broke out, he was arrested by Germans in Austria. On returning to England he rented a house at Hawkinge in Kent for several years, where he met Edith Hood who became his housekeeper and companion until his death.

Charles bought Roselawn, at 131 Percy Avenue, Kingsgate, in 1926 and lived there enjoying his daily brisk walks along the seashore and cliffs, until his death on Christmas Eve 1961. Earlier that year he described himself as being *'Blind. Completely blind'*.

There is now a Blue Plaque on the house.
SEE Authors/ Billy Bunter/ Blue Plaques/ Kingsgate

Lady HAMILTON
Born 26th April 1761 (or 1765 in some reference books)
Died 15th January 1815
Now if ever there was a woman who had it all and lost it, it was her.
Born in Swan Cottage Ness, as plain Amy Lyon, she was the daughter of a Cheshire blacksmith who died soon afterwards. In her teens she was sent away to be a nursery maid and later a dresser, backstage in a London theatre, becoming the mistress of Sir

Harry Featherstonhough of Uppark, Sussex. The affair ended when she got pregnant and he abandoned her. She then had a child by a naval officer.

She worked as an attendant or *'living illustration'* at Dr Graham's 'Temple of Health' in Pall Mall, a very dodgy place purporting to be a medical establishment. Dr Graham invented the *'medico-magnetico-musico-electrical bed'* which apparently would *'insure the removal of barrenness'* and *'improve, exalt, and invigorate the body and through them, the mental faculties of the human species'*. Measuring 12ft by 9ft, it stood under a mirrored dome, on 28 glass pillars, and had a mattress stuffed with the hair from the tails of English stallions. Throughout the bed were 1,500 pounds of lodestones *'so as to be continually pouring forth in an ever-flowing circle inconceivable and irresistibly powerful tides of the magnetic effluxion, which is well-known to have a very strong affinity with the electric fire'*. Dr Graham, in fact, guaranteed the bed would help produce *'strong, beautiful, brilliant, nay, double-distilled children'*. The bargain price was £150 but, as an optional extra, you could have a sexual stimulant - Amy would perform erotic dances in the nude around it.

By the age of 16 she was living with Charles Francis Greville and had changed her name to Emily Hart. Her remarkable beauty inevitably led her to become a model (some things never change the they?) for many artists most notably George Romney, who painted her portrait many times.

Charles had an uncle, Sir William Hamilton (born 13th December 1730) whose father had been the governor of Jamaica; he had joined the army in 1747 but left 11 years later to marry a Welsh heiress. In 1764 he was appointed British envoy to the Kingdom of Naples, and knighted in 1772. When his wife died in 1782 he inherited her Swansea estate.

In 1786, Charles, either because he needed to find a wife, or because he is deep in debt (there are two different versions around) made an agreement that in exchange for the 56 year-old William paying off his debts, he would send the beautiful 25 year-old Emily to be William's mistress. Emily knows nothing of this arrangement, believing she is going on holiday and is subsequently shocked when she finds out the truth. Not a bad deal by the old fella, and clearly smitten, William and Emma, as she had now become, were married on the 6th September 1791.

Lady Emma Hamilton, as the blacksmith's daughter had now become, was hugely popular in Neapolitan society and became great friends with Queen Maria Carolina of Naples (the sister of Marie Antoinette who was guillotined in October 1793) acting as a good intermediary between her and her husband. She played a huge part in Admiral Nelson's preparation for the Battle of the Nile on 1st August 1798 by getting Neapolitan permission for his fleet to obtain stores and water in Sicily. Lady Hamilton and Lord Nelson (he was only 5ft 2in tall! – any smaller and he would have been a half-

nelson – I'm sorry) had met in 1793 and became lovers after the battle of the Nile (not immediately after you understand, he would have been tired) despite Nelson being married to Frances. A marriage that ended in 1801, a few weeks before Emma gave birth to Horatia, the first of two daughters she had by Nelson, of whom only one survived infancy.

In 1800 the British government recalled Hamilton, and Nelson accompanied him and Emma, who apparently wandered around looking very pleased with herself. Ironically it was William who wanted to end the ménage à trois because he got fed up with Emma - her excessive drinking had caused her to become loud and fat – but he did not want to upset Nelson (incidently, 'The Ménage à trois' is an anagram of 'a giant threesome').

After William died on 6th April 1803, in Emma's arms and holding Nelson's hand, Emma lived with Nelson at Merton in Surrey, until his death at the Battle of Trafalgar on 21st October 1805.

She inherited money from both men but promptly squandered the lot. Between 1813 and 1814 she was imprisoned for debt and died in impoverished exile on 15th January 1815 in Calais. Had it not been for some of Nelson's friends however, she would have died in the debtor's prison.

SEE Assembly Rooms/ Mistress/ Nelson/ Northern Belle

Jimmy HANLEY
Born 22nd October 1918
Died 13th January 1970
A popular actor who appeared in dozens of British films as diverse as 'Henry V' (1944), 'The Blue Lamp' (1949) and 'The Huggetts Abroad' (1949). He was married twice; first to Dinah Sheridan (1942-52) and second to Margaret Avery (1955-1970). He had three children with each of them.
SEE Actors/ San Clu Hotel/ Warner, Jack

HARBOUR, Broadstairs
Originally there was just a track to the sea here. Then, in 1440 an archway was built over it, and the first wooden jetty was built in 1460. A newer, stronger version replaced it in 1538. The jetty was severely damaged in a great storm in 1767 causing major problems to the thriving fishing industry.
The jetty was destroyed in the storm of 1897. The old iron capstan, still there, was used to pull the lifeboats up after their missions. Well, I say it was used; many men had to push and strain to use it. It was later used as the spot where Uncle Mac entertained visitors.
SEE Broadstairs/ Diggin' it/ Stone Bay/ Storms/ Uncle Mac/ Without Prejudice

HARBOUR, Margate

From around 1700, when Margate was just a fishing village, there was a pub here called The Ship. *'To be sold the house of Robert Ladd in Margate, known by the name of Sign of the 'Ship': the said public house lying at the Pier and well situated for business'* (1761).

There would have been crowds of passengers pouring off the sailing ships and later, the steamships which arrived every day. Next door to the Ship was another pub called The Hoy and both of them in time became hotels, such was the demand for accommodation. There was another pub, called The Victoria Inn, briefly in trade around 1845.
After World War II the area had a major redevelopment and the Ship and the neighbouring Metropole Hotel were demolished. The present Ship Inn at The Rendezvous stands on the site of the original Ship Inn and was built in 1965.
Margate Harbour was once the hub of the town with every commodity that the town needed coming through it. At least twice in the nineteenth century there were plans drawn up to build a proper harbour here, similar to the one at Ramsgate, but nothing came of it.
Cement, wood and beer continued to come into Thanet via the harbour as late as the 1950s.
The routes of many local buses used to stop at the harbour but when the terminus moved to Cecil Square, businesses in this area suffered.

SEE Captain Swing/ Crecy/ Friend to all Nations/ Gasworks/ Margate/ Lighthouse, Margate/ Rennie, John/ Rose in June pub/ Turner J M W/ Voss, Captain/ Zion Place

HARBOUR, Ramsgate
Roman bricks, tiles and coins were discovered during building of the main slipway in the nineteenth century suggesting that Romans used this area as a refuge from storms.
Back in the thirteenth century there was a small harbour here consisting of just a curved pier approximately where the present Pier Yard is now.
In November 1703, there was such a huge storm that it wiped out a naval fleet sheltering between the coast and the Goodwin Sands. People began to ask why there wasn't somewhere better to shelter along that part of the coast, and so, in 1749 (what's 46 years when there are lives at stake?) work began on the harbour at such a rate that it was only another 43 years before it was finished in 1792.
In 1761 a seemingly insurmountable problem arose. The harbour kept silting up and it was feared that the whole project would be a complete failure. Smeaton confirmed his reputation as a great engineer by coming up with the solution of making the inner harbour

a 'pent' that trapped the water at high tide, but scoured away the silt when it was released at low tide.
For many years from the mid-nineteenth century to the First World War (the fishing fleet numbered 143 fishing smacks at that point), the inner harbour was so busy that it was genuinely possible to walk from one side to the other by walking across the decks of the boats that were moored there.
On 26th May 1917 while all the men were at breakfast, a torpedo went off in Torpedo Boat 4 in Ramsgate Harbour, killing naval men and sinking the boat. A large crowd lined the route of the subsequent funeral.
Over the years though, the inner harbour had become a fairly empty site until it was turned into a yachting marina in 1976.
SEE Adams, Tony/ Admiral Harvey pub/ Armistice Day/ 'Battles of the Sea'/ Birds/ Blythe, Chay/ Bounty/ Camera Obscura/ Cavalry/ Cervia/ Christ Church, Ramsgate/ Clock House/ Coke Riot/ Curtis, Sir William/ Dumpton Gap/ Dunkirk, Ramsgate/ Dyason's Royal Clarence Baths/ Eagle Café/ Fishing fleet/ 'Floating Light of the Goodwin Sands'/ Goodwin Sands/ Goodwin Sands, cricket/ Grand Turk/ Green, Hughies/ Harvey's/ Hovercraft/ Indian Chief/ Jacobs ladder/ 'Lifeboat, The'/ Lifeboat, Ramsgate/ Lighthouse, Ramsgate/ Miners/ Naval Memorial/ Obelisk/ Old Customs House/ Ramsgate/ Ramsgate Harbour Police/ Richardson, Alan/ Royal Sailors' Rest/ Royal Temple Yacht Club/ Sally the Viking Line/ Shackleton, Sir Ernest/ Sharp's Dairy/ Smeaton's Dry Dock/ Smuggling/ Tall Ships/ Thanet Weed/ Tissot, James/ Torpedo/ Town of Ramsgate pub/ Trams/ Tunnels, Ramsgate/ Turner, J M W/ Victoria Steps/ Von Rintelen, Capt/ Vye and Son/ Walcheren Expedition/ Walkway disaster/ West Cliff Hall/ Without Prejudice/ Woodward, James/ World War I

HARBOUR LIGHTS, Ramsgate
SEE Eagle Cafe/ Ramsgate

HARBOUR PARADE, Ramsgate
The Kings Head hotel which dated back to c1670 was once here. In time it became The Exchange, a place where masters of ships did their trading and dealing with the local merchants. In 1842 The Royal Hotel was built to replace it, but was itself replaced by a smaller version in 1938.
The Alexandra Hotel was previously The Dukes Head, and was owned by Tom Hodgman. He changed its name, to commemorate the wedding of Prince Edward and Princess Alexandra in 1863. It was later re-built further back from the road.
SEE Albert Street/ Blazing Donkey/ Donkeys/ Jazz Room/ Queen's Head/ Ramsgate/ Tissot

HARBOUR STREET, Broadstairs
SEE Barnaby Rudge pub/ Broadstairs/ Broadstairs Sailing Club/ Fort Road, Broadstairs/ Laking, Sir Francis/ Lawn House/ Neptune's Hall pub/ Old Curiosity Shop/ Percy, Major Henry/ Windsor Cinema/ York Gate

HARBOUR STREET, Ramsgate
It was probably the original route to the sea, dug out of the chalk, and runs from the harbour to The Sole, or junction of King Street, Queen Street and High Street, and was originally known as 'South End' until c1800. Records exist of businesses here in

1717; the earliest date for which records were kept. Many of the premises on the eastern side necessitated further excavations into the chalk. Premises on the western side were enlarged in the 1860s.

The oldest building in the street is number 15, which is currently a hairdressers, where the old timbers of the ceiling are still visible.

SEE Albion Gardens, Ramsgate/ Bloodless Battle of Harbour Street/ Drays/ High Street, Ramsgate/ King Street, Ramsgate/ Lewis, Hyland and Linom/ Market, Ramsgate/ Mayor's chain/ One way system/ Pearks' Stores/ Ramsgate/ Ship Inn, Harbour Street/ Sole, The/ Timothy Whites

HARDRES STREET, Ramsgate
Thomas Hardres, the Sergeant-at-law in 1669, owned a large amount of land including nearby Ramsgate Farm where Hardres Street is now. He was part of the family who, between the sixteenth century and 1764, when the last baronet died, were Lords of the Manor of Hardres, near Canterbury.

At one point the whole street had fine buildings on either side of it.

Following an Act in 1824, the Thanet towns were to be gas-lit and the gas works at the bottom of Hardres Street were built under a Mr Hedley's supervision.

Number 29, on the corner of Brunswick Street, was built as a Regency shop. In the roof timbers is carved the date 1806. The first known business here was a bakers and confectioners, when T S Parker opened here in 1823. So it either stayed empty for a long time, which would not have been unusual, or there are some records missing!

Karl Marx stayed at 46 Hardres Street in the summer of 1864, suffering from a very nasty carbuncle (but what other type is there?)

Karl Marx, in a letter to Engels, 25th July 1864: *Your philistine on the spree lords it here as do, to an even greater extent, his better half and his female offspring. It is almost sad to see venerable Oceanus, that age-old Titan, having to suffer these pygmies to disport themselves on his phiz, and serve them for entertainment.*

While suffering from sciatica Marx, with his family, returned to Hardres Street, this time at number 36, from 9th to 31st August 1870. Marx left complaining of the cost and the high number of people around.

SEE Farms/ Gasworks/ H Street & Co/ Marx, Karl/ Ramsgate/ Richardson, Alan/ Sussex Street/ Victoria Hotel

Thomas HARDY
Born 2nd June 1840
Died 11th January 1928
The poet and author of novels set mainly in Wessex, including, 'Tess of the D'Urbavilles', 'The Mayor of Casterbridge' and 'Jude the Obscure'.
SEE Authors/ Clodd, Edward/ Pair of Blue Eyes, A/ Poets

HARE AND HOUNDS public house
Margate Road, Northwood
On a 1907 map, The Hare and Hounds is virtually the only building on this stretch of the Margate Road. The Hare and Hounds

was listed under St Lawrence in 1847, St Peter's in 1867, and as Hare and Hounds Inn, in Margate Road 1881 and Northwood in 1890.
SEE Margate Road, Ramsgate/ Northwood/ Pubs/ St Peter's

Georgina HARLAND
An ex-pupil of Wellesley House School, she won a bronze medal in the Modern Pentathlon in the 2004 Olympic Games in Athens.
SEE Sport/ Wellesley House School

HARLEY'S TOWER
Sited about 100 yards from the Captain Digby, Harley Tower, built in 1768, had a square base with a turret at each corner; all four had a stone eagle carved into the stone. On top was a round tower, around 35ft high, built of chalk and flint and included a circular metal staircase with four slit windows to give light, leading to a room containing four round windows that enabled the whole of the surrounding area to be seen. There were two Latin inscriptions that I can give to you, at no extra cost, in their English translations:
On the base:
This Tower was built to the honour of Thomas Harley, Lord Mayor of London, in the year of our Lord 1768.
This man, in conscious virtue bold, Who dares his secret purpose hold, Unshaken hears the crowd's tumultuous noise.
On the tower:
The magistracy shows the man.
The tower, also referred to as the Candlestick, was in a state of disrepair by 1805 and was restored by John Roberts who had inherited the Kingsgate Estate from his father William in 1805.
Lord Holland, when Paymaster of the Forces, was described as *'the public defaulter of unaccounted millions'* by the people of London in a petition to the king, and there were demands from Holland's enemies for an inquiry into his accounts which would have been a disaster for him. Harley was the man who decided against an inquiry, hence Holland's monument to him, although he wrote later, *'My tower in honour of Mr Harley, is built, I believe more for my own private amusement than from public spirit; for he is really the only man that has not been a coward'.*
In World War II, the army sited anti-aircraft guns here. Unfortunately, one of them, in the middle of an air raid, managed to bring down the tower instead of an aircraft. What was left was too dangerous to leave standing and it was pulled down. Most of the rest of it was removed in 1959, although golfers may find the odd bit of the foundations poking through the grass.
SEE Captain Digby/ Holland/ Kingsgate/ Lord/ World War II

Alfred HARMSWORTH
(later Lord Northcliffe)
Born Chapelizod, near Dublin 15th July 1865
Died August 1922

The son of an English barrister, Alfred attended a small private day school in St John's Wood, London. Although he was not a great scholar and did not learn to read until he was seven, he did go on to edit the school magazine. This proved useful after he left school and began working on a magazine, owned by the Illustrated London News, called Youth. In 1886 he went to edit Bicycling News owned by Edward Iliffe, but it was the success of the Tit-Bits magazine – it was selling 900,000 copies a month – that was to inspire him.

Alfred Harmsworth, in a letter to Max Pemberton (1884): *The Board Schools are turning out hundreds of thousands of boys and girls annually who are anxious to read. They do not care for the ordinary newspaper. They have no interest in society, but they will read anything which is simple and is sufficiently interesting. The man who has produced this 'Tit-Bits' has got hold of a bigger thing than he imagines. He is only at the very beginning of a development which is going to change the whole face of journalism. I shall try to get in with him. We could start one of these papers for a couple of thousand pounds, and we ought to be able to find the money. At any rate, I am going to make the attempt.*

Two years later, with his brother Harold Harmsworth, he launched a similar publication called 'Answers to Correspondents', telling readers that every question sent in would be answered. Within four years he was selling a million copies a month. They used the profits to finance 'Comic Cuts', a children's paper, and 'Forget-Me-Nots', a woman's magazine. By 1894, he had his eyes on newspaper publishing and bought the almost bankrupt 'Evening News' for £25,000. Helped by Kennedy Jones he made major changes to the paper; the tradition of the time was for newspapers to have seven columns of text; he retained this style but advertisements were reduced in size and placed in the left-hand column. The news was reported in a punchier style with headlines such as 'Hypnotism and Lunacy and Killed by a Grindstone', 'Was it Suicide or Apoplexy?' 'Another Battersea Scandal', 'Bones in Bishopgate' – he's got your attention, even now, hasn't he? - He also added pictures to punctuate the text.

On 16th November he claimed that the readership of 394,447 was a world record for a newspaper, and that if he had more printing presses he could sell half a million copies. By 1896 the circulation was 800,000 with yearly profits of £50,000.

His next projects were The Daily Mail, and then The Daily Mirror.

Harmsworth used his papers to promote all manner of new inventions and fads: electric light, the telephone, aircraft, photography, motor bikes and motor cars – he once banned the editor of the Daily Mail from reporting any car accidents! – and the wholemeal loaf claiming *'better teeth, stronger bones, steadier nerves and a greater natural immunity against disease, particularly consumption, will be found if the people of*

England will discard the present white loaf for a more wholemeal bread'.

Having already turned down a knighthood because he said he wanted to become a baronet - and had also once stated that *'when I want a peerage I will buy one'* - when he did became Lord Northcliffe, the youngest ever peer of the realm at 39, on 23rd June 1904, many assumed he had indeed got his chequebook out.

In 1905 he bought the Sunday Observer.

In 1906 he offered £1,000 to the first airman to cross the channel from Calais to Dover, and another £1,000 for the first completed flight from London to Manchester. Thinking the whole thing ludicrous, Punch magazine promptly offered £10,000 for the first trip to Mars. Both Harmsworth's prizes were won by Frenchmen within four years. On a more serious note, he was one of the first to understand the effect aircraft would have in a war.

Lord Northcliffe, in a letter to Winston Churchill (11th May, 1908): *A man with a heavier-than-air machine has flown. It does not matter how far he has flown. He has shown what can be done. In a year's time, mark my words, that fellow will be flying over here from France. Britain is no longer an island. Nothing so important had happened for a very long time. We must get hold of this thing, and make it our own. I will think out what is best to be done.*

Harmsworth realised that Britain could be bombed but despite a letter to the Secretary of War, Richard Haldane, nobody was listening.

The Socialist editor of the 'Clarion', Robert Blatchford, was employed by Harmsworth in October 1909 to visit Germany and write a series of articles on the danger Germany was becoming to Britain. Blatchford wrote, *'I believe that Germany is deliberately preparing to destroy the British Empire'.*

The Star newspaper's editor claimed that *'Next to the Kaiser, Lord Northcliffe has done more than any living man to bring about the war'* just after the outbreak of the First World War.

Harmsworth attacked the army, the war, Lord Kitchener, and the Prime Minister, Asquith, through his newspapers. Eventually, Asquith resigned in December 1916, and the new prime minister was David Lloyd George who promptly realised that it would be easier to have Northcliffe in his cabinet - something about tents and the direction of his pee. Northcliffe turned the offer down as he had twigged that he would no longer be able to criticise the government. It must have been galling for Lloyd George to make the offer as he hated Northcliffe. He wrote to his Parliamentary Private Secretary, *'Northcliffe is one of the biggest intriguers and most unscrupulous people in the country.'*

In March, 1918, Lord Beaverbrook, the owner of the Daily Express and the new Minister of Information, approached Northcliffe who agreed to join the cabinet to take charge of all propaganda directed at enemy countries. Northcliffe organised the dropping of 4,000,000 leaflets behind enemy lines. He resigned from the cabinet on Armistice Day.

David Lloyd George refused to accept a list of people whom Northcliffe thought should be in his government and in the 1918 General Election Northcliffe refused to support Lloyd George. In the campaign, Northcliffe did call for the Kaiser to be hanged and Germany to suffer severe financial penalties.

Hannen Swaffer 1921: *His vitality had gone, his face was puffy. His chin was sunk, and his mouth had lost its firmness. He lost his temper during a speech, because someone dropped a plate or something. He was a different man. The fires that burned within him had burned too fiercely all those years. People who heard him knew it was the end.*

Suffering from an infection of the bloodstream, streptococcus, that attacks the heart and liver, Northcliffe's health deteriorated rapidly in 1921 and he died in August 1922. To each of his 6,000 employees he left the equivalent of three months' salary, a total of £533,000. By the time he died he had created the largest publishing house in the world.

Now I know what you're wondering – where did he get the paper from? And how much did he use? Well, it's been worrying me as well. In Newfoundland, he owned 3,000 acres of forest; waterfalls that provided 20,000 horse power of hydro-electric power; and private railroads. All this combined to supply the 50,000 tons of paper he got through each year.

Alfred Harmsworth was involved in the first motor accident. Driving at speed, his chauffeur had to swerve to avoid a horse and managed to turn the car over. Harmsworth suffered temporary paralysis but recovered.
SEE Daily Mail/ Daily Mirror/ Elmwod Cottage/ Elmwood House/ Politics/ Thatched House Times, The

Alfred HARMSWORTH, (Lord Northcliffe) and George Bernard SHAW

There was a famous exchange between the vast figure of Northcliffe and the slim, vegetarian George Bernard Shaw, *'The trouble with you, Shaw, is that you look as if there were a famine in the land.'* - *'The trouble with you, Northcliffe, is that you look as if you were the cause of it.'*
SEE Shaw, George Bernard

Alfred HARMSWORTH (Lord Northcliffe)
Quotes about Lord Northcliffe:
• Anonymous, History of the Times: 1912-1948: *The creator of Answers (1888), Comic Cuts (1890), Sunday Companion (1894), Home Chat (1895), the Daily Mail (1896), and the Daily Mirror (1903), the restorer of the Evening News, and the saviour of The Times, was unquestionably the greatest popular journalist of his time. To begin with, his technical capacities ranged widely. He had performed all the work of the editorial, advertising or layout man, and knew the uses and costs of copy, type, ink, paper and*

binding. Northcliffe was not an illiterate proprietor. He began as a writer, always liked writing, and was writing within six weeks of his death. Alfred Harmsworth was a journalist at the age of sixteen, a proprietor at twenty-two, a baronet at thirty-eight, a baron at forty, and a viscount at fifty.

• C. P. Scott, in a letter to Henry Nevinson, 7th September, 1927: *Will you kindly write us a signed review of this book about Northcliffe. He would be important if only because his rise is the rise of the vast popular press. The tragedy of his life seems to me to lie in the fact that though he knew how to create the instruments not only of profit but of power he had not the least idea what to do with his power when he got it*

• Kingsley Martin, The New Statesman, January 1932: *Every newspaper lives by appealing to a particular public. It can only go ahead of its times if it carries its public with it. Success in journalism depends on understanding the public. But success is of two kinds. Northcliffe had a genius for understanding his public and he used it for making money, not for winning permanent influence. He became a millionaire because he was his own most appreciative reader; he instinctively appealed in the most profitable way to the millions of men and women whose tastes and prejudices were the same as his own. He lived by flattering. He did not educate or change his public in any essential; he merely induced it to buy newspapers.*

• David Lloyd George, The Truth About the Peace Treaties, 1938: *Lord Northcliffe wielded great power as the proprietor of the most widely-read daily paper and also as the owner of the most influential journal in the kingdom. He was inclined to exercise and to demonstrate that power. When he did so, most politicians bowed their heads. He was one of the most outstanding figures in his generation. He was far and away the most redoubtable figure of all the Press barons of my time. He created the popular daily, and the more other journals scoffed at it and the populace derided it at every political gathering of all parties, the more popular it became. He owed no allegiance to any party, so that every genuine party man deplored his paper.*

• A G Gardner, on Lord Northcliffe: *'This democracy knows you as the prisoner of the streams of human intercourse, the fomenter of war, the preacher of hate, the unscrupulous enemy of human society.'*

Alfred HARMSWORTH, (Lord Northcliffe)
Quotes by Lord Northcliffe:
• *'It is hard news that catches readers. Features hold them.'* Lord Northcliffe, 'My Northcliffe Diary' by T Clarke
• *'It was necessary to get a paper talked about before the public would take any interest in it. There were only two reasons, I saw, for the purchase of papers. One was Curiosity, the other Habit.'* Lord Northcliffe, 'Northcliffe, an Intimate Biography' by Hamilton Fyfe

- *'I'm sure you must be a Jew; you've got such a Scotch name.'* Lord Northcliffe to Stewart Hamilton, 'Northcliffe, an Intimate Biography' by Hamilton Fyfe
- To remind his staff of their public's reading age, Northcliffe had signs in his offices that said, *'They are only ten.'*

Esmond Cecil HARMSWORTH,
Born 29th May 1898
The son of Lord Northcliffe, he was elected MP for The Isle of Thanet at the age of 21 years and 170 days, on 15th November 1919.
SEE Election results/ Harmsworth, Alfred/ Politics

HAROLD ROAD, Cliftonville
On the corner of Harold Road there once stood, at the end of the nineteenth century, Stanley House a boarding school for over three dozen boys.
There were also other schools in Harold Road: Claremont, a boarding school for girls; Lorne House and Tygwin, both mixed.
At 33 Harold Road in the 1880s was The Convalescent Home for Children (around 20 of them) and around 1890 The Haverstock Hill Convalescent Home existed with 5 patients, or inmates as they liked to call them - nowadays it would be customers or guests.
SEE Albion Road, Cliftonville/ Cliftonville/ Convalescent Homes/ 'Margate, 1940' by Sir John Betjeman/ Schools

HARRINGTON'S
York Street, Broadstairs
Broadstairs oldest shop is Harrington's general ironmonger. It was established in 1890 - so the rumour that Noah bought his nails there is not true. The business has been owned by the Fairley brothers since 1958. It has never been altered or modernized and seems to stock virtually anything that an ironmongers should.

I remember that just after the 1987 hurricane, I wanted a log splitter – a wedge shaped piece of iron you hit with a sledgehammer to split logs, hence the name – and after trawling around every large modern DIY centre only to be met with a 'no' or a blank look from mystified school-age employees, I eventually ended up in Harrington's. 'Do you sell log splitters?' I asked. Silently, the man, dressed in a brown warehouseman's coat, descended a wooden ladder through the wooden floor into the cellar, he returned, placed three log splitters on the counter and asked, 'Small, medium or large?' My selection was then wrapped up in a brown paper parcel. I still have it, although it is well battered now.
SEE Broadstairs/ Shops/ York Street

HARRY POTTER
He lived at number 63 St Luke's Avenue, Ramsgate, in 1936! Well, maybe not that Harry Potter.
SEE Books/ Jennings and Darbishire/ Ramsgate/ Rovex-Hornby/ St Luke's Avenue, Ramsgate

Dr Heber HART
East Kent Times, 5th June 1912: *Dr Heber Hart, who was liberal candidate for Thanet in 1895, has written a book called 'Women's Suffrage'. In it, he describes it as a 'national danger' and that the 'race must fall and the state must fall' if women get the vote.*
SEE East Kent Times/ Politics/ Suffragettes

HARTSDOWN, Margate
There once was a coastguard station here.
SEE Coastguards/ Margate

HARTSDOWN MANSION, Margate
The original owner of Hartsdown House (built in 1897) in Hartsdown Park, Margate, owned all the land between the house and the sea and was therefore able to control the development and not spoil his view. In 1929, Margate Borough Council bought the house and park for £23,000 from Mrs Hatfield a local JP and former mayor and it opened as a public park on 5th September 1929.
SEE Hartsdown Park

HARTSDOWN PARK, Margate
The park is for the use of the people in perpetuity. Originally, Hartsdown Mansion was to be dressing rooms, café and an arts centre (and you thought an arts centre was a new idea!). I can remember a drinking fountain at the front of the house in the 1970s. It would probably not get past the health and safety rules these days (all those germs - how come we all survived?), but it was a very popular and welcome refreshment after playing football, tennis or cricket in the park.
On the Whitsun Bank Holiday in 1933 the Margate Catering Company (based at Marine Terrace, and with a parcel office at Sweyn Road, Cliftonville) erected the largest marquee in England at Hartsdown Park. They employed 400 waitresses for the day, 200 of which had to be brought down in a special train from London. The occasion was the annual 'do' for the 3,000 staff and guests of Carreras (who made Black Cat cigarettes) who also came down by special trains. It was held in the park because there was no building in the town that could accommodate them. I hope they had a good lunch. On the same day the Garden Café was host to 900 employees of Pye Radio from Cambridge (they needed 3 special trains that arrived at 8:30 am).
The English Schools Athletic Inter-County Finals were held at Hartsdown Park in 1936 with both boys and girls competing from all over the country.
Cliftonville Hockey Club played here after the last war, and more recently the Reebock Cross-Country Challenge has been held here. The house was no longer used by the council and in later years a leaky roof caused

considerable damage. It was duly repaired but a subsequent lack of ventilation caused more decay internally and it was sold for £100,000 (the auction guide price had been £125,000). It was purchased by Fire Technology Ltd (a Margate-based firm) in late 2000 who undertook to restore it and use it as a Fire Training School.
The house looks good these days.

I particularly like the terra cotta hunting lodge motifs in the gables.

SEE Cliftonville/ Hartsdown Manson/ Margate/ Marine Terrace/ Parks/ Radio/ Schools/ Sweyn Road

HARTSDOWN PARK FOOTBALL GROUND, Margate
The first game played by Margate Football Club at this new ground, was on Saturday 31st August 1929; a friendly against Folkestone - then a Southern League club – which Margate lost 2-1.
SEE Margate/ Margate Football Club

HARTSDOWN ROAD, Westbrook
An air raid on 5-6th December 1917 caused damage to Hartsdown Road.
SEE Westbrook/ World War I

HARTSDOWN TECHNICAL COLLEGE
George V Avenue, Margate
It originally opened in 1958 as Hartsdown Secondary Modern School.
SEE George V Avenue/ Margate/ Schools

Admiral Henry HARVEY
Born 1732
Died 1810
Henry was the younger brother of Richard Harvey, who was the first vicar of St Lawrence Church. The Admiral patrolled the Channel in the Royal Sovereign and gave his name to the Admiral Harvey pub at Harbour Parade.
SEE Admirals/ Admiral Harvey/ St Laurence Church

HARVEY'S public house
Ramsgate Harbour
Formerly the Admiral Harvey.
SEE Admiral Harvey/ Harbour, Ramsgate/ Pubs/ Ramsgate

Edward HASTED
Born London, 31st December 1732
Died Wiltshire 1812
The Kent historian became a lawyer after training at Lincoln's Inn before moving to Sutton-at-Hone near Dartford. In July 1755 he got married to Anne Dorman who was the daughter of one of his neighbours. They briefly moved to Canterbury but soon returned to Sutton-at-Hone, living at St John's, a manor house that had once been the home of the Knights Hospitallers during King John's reign. They spent a small fortune on improving the place and when it was finished, Edward started many years research and wrote a 'History and Topographical Survey of the County of Kent' which was a resounding success. He was on the West Kent Quarter Sessions' bench (Maidstone); he attended church regularly and took an interest in the affairs of his local parish. He and Anne had two daughters and five sons. They moved back to Canterbury where he spent nineteen years serving as a justice in East Kent.

Then, from a state in which everything in the garden was rosy, he somehow, in 1789, found his financial affairs in utter confusion. Although he sold off his estates, he got deeper and deeper in debt and the following year left his wife and ran off with another woman to France. A combination of the war and Napoleon drove him back and he was arrested, spending seven years in a debtors' prison. The Earl of Radnor, a descendant of the Canterbury Hugenots, made him the master of a small charity hospital that Lady Hungerford had endowed, in Corsham, Wiltshire. He died penniless in the lodge house there, aged 79.

Hasted's History of Kent, 1800: *Northward from Minfter lise the parifh of Birchington, adjoining to the fea. It is faid to have been antiently called, fometimes Birchington in Gorend, and at other times Gorend in Birchington, from a place called Gorend, in this parifh, where it is reported the church formerly flood, though the most ufual name was always, as it is at prefent, Birchington only.*

In the eighteenth century he described Margate as *'a poor fishing town'*, but in 1810 he wrote *'when it came to be known that the shore here was so well adapted to bathing, being an entire level and covered with the finest sand, which extends for several miles on either side of the harbour, and the easy distance from the metropolis, with the convenience of so frequent a passage by water, it gave Margate a preference before all others, to which the beauty and healthiness of it and the adjoining country contributed still more', 'near the harbour there are several commodious bathing rooms, out of which the bathers are driven in the machines, any depth along the sands into the sea; at the back of the machine is a door, through which the bathers descend a few steps into the water, and an umbrella of canvas dropping over conceals them from the public view. Upwards of 40 of these machines are frequently employed'*
SEE Bathing/ Bathing machines/ Birchington/ Margate/ Minster/ St Giles Church, Sarre/ St Peter's

HASTINGS AVENUE, Margate
Mrs L J Lenton at 16 Hastings Avenue was one of thousands of women who had to wait months to find out if their men-folk were safe or not during World War II. She had a son, Flight Lieutenant Reginald Lenton, who had played hockey for the county before the war, who had been reported missing. After eight awful months of waiting, she finally found out in July 1942 that he had been captured the previous November. He had escaped and lived with bandits in the hills for several months to avoid being recaptured, before stealing a fishing boat and setting sail for Europe, where he was found safe and well in a European port and ready to return home.
SEE Margate/ Sport/ World War II

John Liptrot HATTON
Born Liverpool, 12th October 1809
Died Margate, 20th September 1886
He was a composer who started out as an organist and actor in Liverpool, before joining Macready's Drury Lane company. He wrote operas that were performed in Vienna, toured as a pianist and singer and worked in America as a conductor before returning to England where he continued to be successful.
SEE Margate/ Music

'The HAUNTED MAN'
by Charles Dickens
This short story – the fifth and last of his Christmas stories - was partly written in Broadstairs.
SEE Books/ Broadstairs/ Dickens, Charles

HAWKWIND
A rock band – you must remember their single, 'Silver Machine' - it sold a million copies. No? Well, do you remember Stacia who used to dance topless? All coming back to you now is it? They appeared at Dreamland Ball Room on 24th March and 4th August and at Dreamland Cinema on 8th December, all in 1972.
Founder member Nik Turner (vocals/ saxophone) grew up in Margate and Bob Calvert (1945-1988) (vocals/ poet/ writer) died of a heart attack at his home in Margate on 14th August 1988.
SEE Dreamland Cinema/ Margate/ Music

HAWLEY SQUARE, Margate
The land on which Hawley Square is built was once owned by a baronet, Sir Henry Hawley. The gardens in the middle had serpentine paths going around flower beds. It was a popular place for visitors to promenade after bathing in the sea.
Around 1890, at number 13, was The Creche run by the matron, Miss Carrier.
At number 45 was the Home for Motherless Girls.

The London Hotel & Livery Stables was a Cobb Brewery house situated at 19 Hawley Square from around 1790 until the late nineteenth century when it was turned into Margate Ladies College.
SEE Addington Street, Margate/ Bathing/ Bettison's Circulating Library/ Cobbs/ Fountain Inn/ London Tavern/ Margate/ Methodist Hall/ Nelson, Lord/ Northern Belle/ Schools/ Shabby Genteel Story, A/ Theatre Royal

HAWLEY STREET, Margate
Waterloo House was a school in Hawley Street from the 1830s to the 1850s.
SEE Coleman's School/ India House/ Limes, The/ Margate/ Margate College/ Post Office – Margate/ Turner, J M W/ Schools/ Waterloo

HAWTREY'S FIELD, Westgate
On the corner of St Mildred's Road and Canterbury Road in Westgate, it was the scene of a gala buffet dance followed by a firework display in 1953.
A crowd of 2,000 attended a gymkhana here as part of the Westgate carnival.
In the 1960s, I can remember (just!) an annual six-a-side football tournament here every year for local junior schools.
SEE Canterbury Road, Westgate/ St Mildred's Road/ Schools/ Westgate-on-Sea

HAZARDOUSE ROW, Margate
SEE Albert Terrace/ Margate

Sir Edward HEATH
Born St Peters, 9th July 1916
Died Salisbury 17th July 2005
Edward Richard George Heath, was the elder of two brothers whose father was a builder and carpenter, and mother was a former ladies' maid. Edward won a scholarship to Chatham House Grammar School in Ramsgate, and went on to Balliol College Oxford supported by his mother's life savings.
When he was a student he attended a Nuremburg rally in 1937 and saw Adolph Hitler - *'his shoulder brushed mine'* – and at an SS cocktail party he met Goering, Goebbels and Himmler, the latter he described as *'the most evil man I have ever met'*. He is probably one of the last world leaders to have seen Hitler in the flesh. He was a stern anti-appeasement Tory and consequently backed Churchill against Chamberlain. He was the last prime minister to have fought in a war. As an artillery officer in Germany after D-day, he was mentioned in dispatches. On de-mobilisation from the Army in 1946, he had achieved the rank of lieutenant-colonel. He was also awarded an MBE that year.
He was a civil servant at the Ministry of Civil Aviation between 1946 and 47, and a member of a merchant banking firm.
He was adopted as the Tory candidate for Bexley, Kent, in 1947, and entered parliament on 23rd February 1950, having won his seat with a majority of just 133. He occasionally toasts the memory of a communist called Job who got 481 votes. Who knows where those 481 votes would have been cast if Job had not stood.

'I owe everything to my mother' (1950)
From February 1951, he served Churchill as Deputy Chief Whip (Churchill gave him two paintings as gifts) and, as Chief Whip, served under Eden, in the Suez crisis of 1956. From October 1959 until July 1960 he was Minister of Labour, then Lord privy seal with Foreign Office responsibility. In October 1963, he became Secretary of State for Trade and Industry.

After the Conservative defeat to Harold Wilson in the October 1964 general election (Labour 317, Conservatives 304, Liberals 9) he became a major opposition figure. Following Sir Alec Douglas-Home's resignation, there was a ballot on 28th July 1965, and he became Conservative Party leader on 2nd August 1965, the first 'working class' leader of the Tories. He lost the 1966 general election (Labour 364, Conservatives 253, Liberals 12, others 1), and then, in 1968, sacked Enoch Powell from his shadow cabinet for his 'rivers of blood' anti immigration speech.

'This would at a stroke, reduce the rise of prices'- a line from a Heath press release during the 1970 General Election campaign
In the biggest upset since 1945, he won the June 1970 election (Conservatives 330, Labour 288, Liberals 6, others 6) and became Prime Minister at 53 years and 335 days old. Outside No 10 Downing Street the next day, a woman threw red paint over him.

During his term of office he negotiated Britain's entry into the EEC (January 1973). Speaking in 1984, he described as *'the most enthralling episode in my life'*.

He also had to deal with the conflict in Northern Ireland, including Bloody Sunday, imposing direct rule from London in 1972.

It was also a time of economic problems with high unemployment, inflation and strikes.

'It is the unpleasant and unacceptable face of capitalism.'

In a Commons statement on the Lonrho affair in 1973, he said, *'Our problem at the moment is a problem of success.'* Six weeks later the three-day week began.

The, probably unnecessary, 'Who governs Britain?' election of 28th February 1974 was fought on the issue of the coal strike. Enoch Powell had urged people to *'Vote Labour'.*

It resulted in a hung parliament (Labour 301, Conservatives 297, Liberals 14, others 23 seats). There were desperate attempts to do a deal with Jeremy Thorpe's Liberals and form a coalition government. They were unsuccessful and Heath left Downing Street after 3 years and 259 days. Harold Wilson became Prime Minister on 4th March.

A second election in the same year was also won by Labour (Labour 319, Conservatives 277, Liberals 13, others 26 seats), thus Heath has the unfortunate record of losing two general elections in one year. On 4th February 1975 he phoned his dad, who lived in Dumpton Gap Road, to tell him that he had lost the ballot for the party leadership. Margaret Thatcher, formerly his education secretary took over as leader on 11th February 1975. He refused to serve under her. *'They have made a grave mistake*

choosing that woman'. When Margaret Thatcher resigned in November 1990 he said, *'Rejoice! Rejoice!'*

In 1990 he flew to Baghdad to talk with Saddam Hussein and brought home 33 British hostages. *'He [Saddam Hussein] is not mad in the least. He's a very astute person, a clever person.'*

He was knighted in 1992.

When William Hague became Conservative leader in 1997 he claimed that it was *'A tragedy for the party. He's got no ideas, no experience and no hope.'*

On the BBC's Newsnight (19th February 1997), he was paying tribute to China's dead dictator, Deng Xiaoping, when the presenter Jeremy Paxman said: *'He killed a lot of people on Tiananmen Square [1989].'* Health replied *'Well, of course, this is just like the British, it's the only thing you can bring up and we are the only country which does bring it up. What happened was that for a month, there was a crisis in which the civil authority had been defied. They [the Chinese authorities] took action about it. We can criticise it in the same way people criticise Bloody Sunday in Northern Ireland, but that isn't by any means the whole story. Why can't we also look at the rest of his achievements?'*

In October 1998 his memoirs, 'The Course of My Life', were published.

When Heath stood down from the House of Commons at the 2001 general election, he had been an MP for 51 years. Neither Tony Blair nor William Hague, the party leaders at the time, was born when he was first elected.

In his time, he knew Charles de Gaulle, Richard Nixon, Khrushchev and Chairman Mao but the magazine Private Eye always referred to him as The Grocer, reflecting an odd fixation Heath had with the fortune of British apples. They also portrayed him as the managing director of Heathco Ltd..

Outside of politics, he was a successful yachtsman, and had a love of classical music, regularly returning to Broadstairs to conduct the annual Christmas Carol concert.

Blue Heather was the name of Edward Heath's Snipe class racing dinghy that he kept at Broadstairs in the 1960s. His name was E R Heath and to reflect the colour of the political party that he led, the boat was called Blue Heather.

Apparently, at the end of an interview held in a hotel room, Heath asked the interviewer if he would like a cup of tea. He said yes, so Heath picked up the phone and ordered, *'Tea for one and a bottle of champagne for me'.*
SEE Broadstairs/ Chatham House/ Politics/ Prime Ministers/ Ramsgate/ St Peter's Village Hall

Heinrich HEINE
Born 13th December 1797
Died 17th February 1856
One of Germany's greatest poets, he spent part of two summers in Ramsgate.
SEE Poets/ Ramsgate

HELENA AVENUE, Margate
During the Gotha raid on 30th September 1917 Helena Avenue suffered damage.
SEE Gotha raid/ Margate/

HENGIST and HORSA
They may have actually existed or they may be purely mythical. Hengist (sometimes Hengest) is the word for stallion in both German and Dutch; Hors meant horse in Anglo-Saxon. The Kent Invicta symbol – a white horse - derives from Hengist; he had it on his banners. They are also thought to have been Jutes, from Jutland, but they could just as easily have come from the Rhineland area. So, now that is all as vague as possible, their story can begin.

In 449AD Vortigern, the King of Kent, invited the chieftains Hengist, and his brother, Horsa, over to see off the Picts and Scots who were harassing his borders. It suited Hengist to see off Vortigern's enemies, and he was re-paid by Vortigern who gave him Ruim (the name by which the Celts knew the isle, although the Saxons called it Thanet) and also gave them all the clothing and provisions they required while fighting his enemies. More warriors from Jutland were sent for, and more clothing and provisions were asked for, until the Brits were no longer able to keep up the supply. Vortigern's council decided that Hengist and his boys should be given notice to leave, thank you very much and all that, but really they could take it from there. Hengist's boys explained to them, with a bit of a snarl, that they were not going anywhere and, if anything, they would send home for some more of their mates. They would also step out of Thanet and spread a bit further inland if they wanted to - and what was the council going to do about it? OK, I wasn't there but that was about the size of it.

Vortigern was having trouble elsewhere in his kingdom and so Hengist said he could get more warriors and help him in these other areas. Vortigern was in no position to do anything but say yes, and fairly soon fifteen ships full of fellas you wouldn't want to annoy turned up, as well as Hengist's daughter Rowena. Vortigern wanted to marry her and told Hengist he could have anything he wanted in return. He got Canterbury.

Hengist then came up with another proposition for Vortigern. He would send for his brother and some more men and defeat the Scots, who were still plaguing Vortigern. Once defeated, Hengist would have all the land north of the wall. Vortigern was probably at the 'Yeah, whatever you want, mate' stage and another load of warriors duly turned up; this time, forty boat-loads of them, under the leadership of Octa (Hengist's son), and Ebissa (Hengist's brother).

By now, Hengist was very confident of his position and complained about the provisions again, and this time, Hengist's mob did more than snarl. It was said that they plundered towns from the western sea to the eastern sea. The Britons asked the Gauls for assistance; the Gauls looked a bit awkward, counted the toggles on their tunics and mumbled something about being busy.

There followed a series of battles that ended in Hengist overthrowing his father-in-law and becoming King of Kent himself. You

thought you had trouble with your in-laws! The Britons fought back and in 452 they did prevent Hengist and Horsa from taking London. Vortigern's son, Vortimer, managed to push Hengist's men back as far as Richborough and then across the Wantsum into Thanet. Not long after however, Vortimer died. The battle of Aylesford (or Agaelesthrep, or Set Thirgabail to the two battling parties) occurred in 455 where Categirn, another of Vortigern's sons, died, as did Horsa - some said that was a bit convenient, but I'm not one to gossip. Finally, in around 456/7, following the battle at Crayford (Crecganford), on the river Darent the Britons left Kent.

Now Hengist made Vortigern an offer of peace. Vortigern said yes, and he and his mates in the council went off to the ceremony to ratify the peace treaty. I feel the need to shout out 'look behind you!' to poor old Vortigern at this point. In all, including elders, noblemen and the military, there were three hundred in Vortigern's party, and exactly the same number in Hengist's. Vortigern's mob mingled, had a few drinks, some nibbles, a few more drinks, and talked about what company chariot they were driving – how many miles to the bucket of fodder they were getting – then had a few more drinks until they were suitably tipsy. Alright, they were pissed. Each of Hengist's three hundred men pulled out a dagger and killed one of the Council apiece, except for Vortigern; he saved his life by handing over the provinces of South, East and Middlesex.

Hengist took possession of Kent. The Brit population was either murdered in their thousands, fled to London, starved in the ensuing famine, or gave themselves up to be slaves to avoid death.

Hengist ruled until his death in 488. It was reported that since the battles, many of the cities in his kingdom had lain desolate for decades.

Meanwhile, Vortigern had built a castle, Cair Guothergirn, on the River Towy in the kingdom of Dimetae, in Wales, and had married his own daughter. Social Services were round like a shot and he was placed on a register – well, today maybe, but back then it was not an uncommon practice. Anyway, they had a son, but a fire fell from heaven - as they do (although you would think that fires would rise up from Hell, but no matter) totally destroying the castle and everyone within, including Vortigern, Hengist's daughter Rowena, and all his other wives.

Allegedly, Rowena is the same 'fair Rowena' that Ivanhoe marries in Walter Scott's 1819 novel.

SEE Jutes/ Pegwell Bay/ Thanet/ Wantsum Channel

HENGROVE

This area is on the Shottendane Road, south of Garlinge.

In the fields, between the top of Birds Avenue and the old Hengrove Golf Links, a German Gotha was brought down on 22nd August 1917, with the loss of the three crewmen.

Thanet Golf Club (Links) was listed as being here in the 1936 Kelly's Directory.

SEE Chatham House School/ Garlinge/ Golf/ Gotha/ Military Road, Ramsgate/ Picton Road, Ramsgate/ Shottendane Road/ Sport/ Walpole Bay

William Ernest HENLEY
Born Gloucester, 23rd August 1849
Died 11th July 1903

He was a critic, editor and poet. He attended the Crypt Grammar School, Gloucester, where the headmaster, Thomas Edward Brown - a poet himself - inspired and encouraged him to write. While still a teenager, Henley contracted tubercular arthritis, resulting in his left leg being amputated below the knee. In 1872, when he was in his twenties, there was a danger that he might also lose his right foot, so he ended up at the Royal Sea-Bathing Infirmary in Margate, which specialised in treating bone and joint tuberculosis. He thought it was 'so gaunt and cheap and business-like it looked' and reminded him of a workhouse. He wrote to a friend in March 1873, 'Here I am and I intend making the best of it.' He got friendly with another patient, a 'bold and athletic young bricklayer' who had a tubercular hip and Henley wrote, 'He had hoisted me over walls, to the end that we might sit in daring and in state in unlawful gin parlours'.

Despite excellent treatment, and the gin, the foot got worse and the following summer he went of to see the then controversial Joseph Lister at Edinburgh who was using strange knew antiseptic methods. Not only was his foot saved, but he met and formed a long friendship with Robert Louis Stevenson who based Treasure Island's Long John Silver on Henley.

In a letter to Henley in May 1883, Stevenson wrote: 'I will now make a confession. It was the sight of your maimed strength and masterfulness that begot John Silver in Treasure Island. Of course, he is not in any other quality or feature the least like you; but the idea of the maimed man, ruling and dreaded by the sound, was entirely taken from you.'

Which is the perfect excuse for when you are next walking past the old Sea Bathing Hospital, to say, in a very loud pirate-like voice 'That's where me old shipmate Long John Silver was a patient!' – I will be listening out for it.

Henley would later collaborate with Stevenson on four plays, 'Deacon Brodie' (1880), 'Admiral Guinea' (1884), 'Beau Austin' (1884), and 'Macaire' (1885). Henley's own poetry books include 'A Book of Verses' (1888), 'In Hospital' (1903), and 'For England's Sake' (1900); the latter a particularly jingoistic work, as are his most well-known poems 'England, My England' and 'Invictus', which ends with the famous lines,

'I am the master of my fate;
I am the captain of my soul'.

The 'Dictionary of Slang and Its Analogues' (1894-1904) was a collaboration with J. S. Farmer; he also helped popularize the works of American painter James Abbott McNeill Whistler, Rudyard Kipling and Irish poet W B Yeats.

SEE Authors/ Margate/ Poets/ Royal Sea Bathing Hospital

HENRYS
Henrys have had shops in Thanet since the early 1930s. In 2004 it was announced that Henrys, the photographic store, would close after 30 years in Broadstairs High Street.

SEE Broadstairs/ High Street, Broadstairs/ Shops

HERCULES

The figurehead on the outside of the Boathouse in Broadstairs Harbour is of Hercules, not Samson or Jason (as in Jason and the Golden Fleece). It came off the Hercules, a Spanish brig that came to grief on the Downs on 16th January 1844.

SEE Boathouse/ Broadstairs/ Downs, The/ Scotsman/ Ships

HERESON, Ramsgate
Once upon a time, a sheep farmer lived near the Honeysuckle Inn. On a freezing, dark, winter's night, the farmer, fearing the weather was getting worse, sent his son to gather the sheep in from the hills at the back of the town. It did get worse, and his son did not return, so he went to look for him. By now, the snow was falling thick and fast and the farmer could barely see, so he began shouting out, 'Here, son! Here, son!' His son heard him, but he, too, could not see through the snow. He could not tell where his father was, so he shouted, 'Holler again! Holler again!' (It was a family trait that they said everything twice, everything twice). When the farmer eventually found his son it was too late. He had frozen to death. This is how Hereson and Hollicondane got their names.

It is said that some old cottages around Honeysuckle Lane date back to the 1440s and formed what became the village of Hereson - which was separate from Ramsgate until well into the nineteenth century.

SEE Farms/ Ramsgate

HERESON MILL, Ramsgate
A windmill that once stood near the site of the synagogue.

SEE Ramsgate/ Synagogue/ Windmills

HERESON ROAD, Ramsgate
SEE Elephant & Castle pub/ North Pole pub/ Racing Greyhound/ Ramsgate/ St Ethelbert's and St Gertrude's Church/ Synagogue

HERESON SCHOOL, Ramsgate
Hereson School was at Lillian Road for 91 years until it moved on 21st July 2000 to the old Holy Cross School in Broadstairs next to Thanet College. Sixteen terraced houses in

Lilian Road now occupy the former site of the school.
SEE Broadstairs/ Ramsgate/ Schools

HERMIT of DUMPTON CAVE
SEE Dumpton/ Petit, Joseph Croome

HERMS FOR PERMS
14 Trinity Hill, Margate
Herms' ladies' hairdressers was at 14 Trinity Hill, Margate, and Gustav Herms' sign was still painted on the side wall as recently as 2004. The shop has now been turned into a house.
SEE Margate/ Shops

HERTFORD STREET, Ramsgate
SEE Ozonic Mineral Water Co/ Ramsgate/ Slum Clearance

Philip HESELTINE / Peter WARLOCK
Born 30th October 1894
Died 17th December 1930
He used his real name of Heseltine when he was working as music critic but used a pseudonym 'Peter Warlock' when he worked as a composer of classical music.
He attended Stone House School in Broadstairs between 1904 and 1908.
SEE Broadstairs/ Music/ Stone House

Sir Seymour HICKS
Born St. Hélier, Jersey, 30th January 1871
Died Hampshire 6th April 1949
He went to school in Bath, and at the age of 9 made his stage debut as Buttercup in HMS Pinafore by Gilbert and Sullivan. The course of his life was then set and he became a professional actor at 16, and by 18 was touring America, where he not only learnt how to act but also how to run a theatre company. After returning to England, he married a beautiful actress, Ellaline Terriss, in 1893, and they toured and appeared together on stage for the next fifteen years, including touring America in 1895. He was a top actor in serious, light comedy or musical roles. Hicks also started to write, often with a partner, and was a success. 'The Runaway Girl', 'With Flying Colours', 'Bluebell in Fairyland', were all his. All his success made him wealthy, and he was able to commission two theatres in London, The Aldwych, which opened in 1905, and The Seymour Hicks Theatre which opened in 1907. The latter was re-named The Globe in 1909 and since 1994 it has been The Geilgud Theatre. An early production at The Aldwych was 'The Beauty of Bath' (1906), written by Hicks and Jerome Kern, and P G Wodehouse who also worked on 'The Gay Gordons' (1907).
In later years, he performed in a Shakespeare play ('Richard III') for the first time, and toured South Africa in his own Company. He was even awarded the French Croix de Guerre, and was the first actor to appear in France after the outbreak of World War I. After the war he presented comedies and farces, some of which were adapted from French farces.
The Theatre World, 1925: *What an amazing man is Hicks! He can move on to laughter or tears as easily and as quickly as he pleases.*

His versatility is remarkable; so is his activity, mental and physical. Only recently he was acting eight times a week in The Man in Dress Clothes, rehearsing two plays, and superintending a huge charity matinée. How good it was to see him as Scrooge in the latter - undisputed proof that he is a great actor, when he chooses. . .
Everything that Seymour Hicks says and does may be traced down to the fact that he simply bubbles over with life. He is always up and doing. Some imp of energy keeps him perpetually on the move.
He appeared in a silent film version of 'Scrooge' (1913) and 'A Prehistoric Love Story' (1915). In 1923, he formed Seymour Hicks Productions and made 'Always Tell Your Wife', during which he fell out with the director and said to a young man nearby, *'Let you and me finish this thing by ourselves'* which they did. The young man went on to direct more films. He was Alfred Hitchcock. Hicks directed two more films, wrote eleven and starred in nineteen. In 1935 he re-made 'Scrooge' as a talkie, directed by Hugh Croise, the man he had fallen out with when making Always Tell Your Wife.
For promoting French drama on the English stage he was awarded the Legion of Honour in 1931. He was knighted in 1934. In 1939 he got a second Croix de Guerre being the MC at the first concert given in France by the newly formed Entertainment National Service Association (ENSA) on 12th November 1939.
He continued to act until his death in 1949 aged 79.
Off stage he was noted for his wit: *'A man does not buy his wife a fur coat to keep her warm, but to keep her pleasant.'*
It is almost a cliché now, but it was new when he said it: *'You will recognize, my boy, the first sign of old age: it is when you go out into the streets of London and realise for the first time how young the policemen look.'*
My favourite quip from Seymour is when he and some friends were sitting around, feeling a bit sleepy after a particularly heavy lunch, and from nowhere he said, *'Things seem a bit dull. Let's change teeth.'*
SEE Actors/ Chatham House School/ Films/ Shakespeare/ Theatre Royal

HIGH SEA
Charles Dickens wrote in a letter: *Strange as it may appear to you, the sea is running so high that we have no choice but to return by land. No steamer can come out of Ramsgate, and the Margate boat lay out all night on Wednesday with all her passengers on board…We cannot open a window, or a door; legs are of no use on the terrace; and the Margate boats can only take people aboard in Herne Bay!*
SEE Dickens, Charles/ Margate/ Ramsgate/ Storms

HIGH STREET, Broadstairs
Charles Dickens wrote part of The Pickwick Papers here. The original building is now gone, but there is a plaque on its

replacement, currently the premises of Sound House.
On 16th August 1941 a 110lb bomb fell on Alexandra Mansions. At the time it was the temporary sleeping quarters for fire officers. Fifteen men managed to escape, but five, including the Chief Officer, Arthur Bates (aged 61) died.
SEE Albion Street/ Alexander House School/ Bohemia/ Bradstow Mill/ Broadstairs/ David Potton Menswear/ Dickens, Charles/ Edge End Road/ Fascists/ Henrys/ Lloyds Bank/ Milton Place/ Moseley, Oswald/ Old Crown/ Oliver Twist/ Pickwick Papers/ Pierremont Hall/ Pierremont Mill/ Prince Albert pub/ Railway Hotel/ Serene Place/ Tesco/ Vye & Son/ World War II

HIGH STREET, Garlinge
Canterbury Road was just a reasonably wide country lane until the increased use of cars in the 1930s forced it to be widened,. After that, the housing developed on either side of Canterbury Road and the population increased to sustain a thriving High Street containing 28 businesses in 1936. Now it barely gets in to double figures.
SEE Garlinge/ Garlinge Methodist Church/ Old School Hall, Garlinge/ Canterbury Road/ Rodney pub/ Tyrrel's Farm

HIGH STREET, Margate
A Mr Z Cozens described the High Street in 1793 as *'a long dirty lane* [riddled with] *malt houses, herring hangs and poor little cottages of fishermen'.*
Argyle House, a day and boarding school, was situated in the High Street and Vicarage Place in the 1830-50s.
This street appears to have been a popular location for pubs over the years. In 1817 a publican in Margate High Street, hung up a sign that read:
> Who buys good land, buys many stones,
> Who buys good meat, buys many bones,
> Who buys good eggs, buys many shells,
> Who buys good ale, buys nothing else
The Elephant and Castle dated from the early nineteenth century, and became the Elephant Hotel in the 1840s. Due to the re-numbering of the street it was at No. 132 and later, No. 84.
For the same reason, The Royal Oak, dating back to the 1830s, was at No. 61, and then No. 143 and.
The Hope and Anchor was at No. 71 in the 1840s and by the 1890s, was at Nos. 173-5.
The Bell closed around 1840.
The Jolly Sailor existed from the very late 1700s to the mid-nineteenth century.
The Star was at No. 68, then at No. 161 from 1839.
The Tailors Arms was at No. 42 in 1839, No. 41 in 1847, and No. 43 in 1851.
The Prince of Wales was at No. 126, No. 108 and then Grosvenor Place in buildings that dated back to 1761. It remained a pub throughout the nineteenth century.
The Railway Hotel existed at No. 29 from 1846 for about 30 years.
The Man of Kent was a short-lived temperance hotel run by Robert Dunthorne at

186 and 188 High Street in the 1880s. He went on to have a hotel on the sea front.

Picture of Margate and Its Vicinity (1821) by W C Oulton:

HIGH STREET AND GARNER'S LIBRARY,
FROM THE MARINE PARADE
This part of the High-Street, opposite the Marine Parade, consists also of lodging houses, commanding extensive views of the sea, of the Isle of Sheppey, and of Reculver, with its sister-spires. . . . For the mental gratification of the tenants, there is the New Marine Library, which is a rotunda, occupied by Mr Garner, provided with a choice collection of books, periodical publications, newspapers, etc. A shaded gallery projects from this library over the sea, where subscribers may enjoy the full use of their telescopes. The shop adjoining the library contains a great variety of jewellery, plated goods, cutlery, etc; and, for the amusement of the company, there is a single card loo every evening . . . Mr Garner is the senior proprietor of a library in Margate.

The High Street suffered damage in a German raid on 5-6th December 1917 when thirty bombs were dropped on Margate.

On the 1st June 1943, in a surprise air-raid, twelve Focke-Wulfs dropped fourteen high-explosive bombs on Margate; one of which caused a roof to cave in and an ARP warden who was in a bar was killed.

Hawker Typhoons of 609 Squadron from Manston chased them away and Flight Lieutenant Wells shot two of them down; one of the pilots baled out too low for his parachute to open.

The raid lasted only one minute but bombs were dropped on the High Street, St Peter's Street and Thanet Road. In total, nine civilians died and four more were seriously injured. Three people were killed at 13 High Street, and elsewhere a butcher's errand boy was killed when the blast from a bomb blew him off his bike.

SEE Bathing Machines & Bathing Rooms/ Beale Benjamin/ Centre, The/ Cottage, The/ Donkeys/ Faversham & Thanet Co-op Soc./ Garner's Library/ Imperial Hotel/ John Bayly's Tea Dealership/ Keble's Gazette/ Kings Head/ Kings Head Hotel/ Lester's Bar & Restaurant/ Libraries/ Man of Kent/ Manston Airport/ Margate/ Marine Parade/ Marks & Spencer/ Mill Lane/ Mods and Rockers/ Plaza/ Post Office/ Pubs/ Saracen's Head/ Schools/ Shabby Genteel Story/ Six Bells/ Woolworths

HIGH STREET, Ramsgate
At one time it was known as the 'North End'. The Albert public house was converted from a house in 1847 and was named after Queen Victoria's other half.

On the corner of the High Street and Queen Street once stood Burgess and Hunts library (it was demolished in 1866); a bank, and later on, the town's first Post Office. From 1875, various jewellers were in business here and in 1926 this part of the road was widened.

On 4th January 1941, ten bombs were dropped on the town by a lone German aircraft. One of them exploded on Dewhurst the butchers. Inside was Miss Edna Holness

(who lived at 20 Church Road) who had run into the shop to shelter, and the shop manager, Albert Victor Dennis (who lived at 54 Bloomsbury Road) who had tried to help her into the shop. Edna died almost immediately, and Albert died that night in hospital.

The Central Commercial Hotel at 30 High Street was replaced by Henekeys Bar, which in turn was replaced by new shops.

A row of shops, including The Magpie's Collection pet shop, and flats were destroyed by fire on 13th June 1999 and became one of Thanet's eyesores –they have now been spruced up very nicely!

The buildings on the corner of Chapel Place were once houses with front gardens until the shop fronts were added in 1913.

SEE Assembly Rooms/ Bournes/ Bull & George/ David Greig/ Eagle Inn/ Faversham & thanet Co-op Soc/ Fine Fare/ Fires/ Harbour Street/ Libraries/ Littlewoods/ Marks & Spencer/ Obelisk/ One way system/ Palace Theatre/ Post Office/ Pubs/ Queen Street/ Ramsgate/ Richardson, Alan/ St George's Church/ Salvation Army Citadel/ Sausages/ Sole, The/ Superdrug/ Thanet Technical College/ Welch/ Wellden/ Wright/ Wrightson

HIGH STREET, St Lawrence, Ramsgate
The street has been widened, most notably in 1938, so that today it is a very different thoroughfare from that of the past. Parts of the street are about three times the width they once were.
SEE Ramsgate/ Umbrella makers/ Wheatsheaf/ White Horse Inn

HIGH STREET, St Peter's
SEE Bottle Light Signal/ Coves/ Crown & Thistle/ Nuckell's Almshouses/ Plane Crash/ St Peter's

HIGHCLIFFE HOTEL
SEE Queen's Highcliffe Hotel

HILDERSHAM HOUSE SCHOOL
St Peter's Road, Broadstairs
Oscar Wilde's son, Vyvyan Wilde, later to be changed to Vyvyan Holland (born 5th November 1886 - died 10th October 1967), started at Hildersham House School in 1894.
SEE Broadstairs/ St Peter's Road, Broadstairs/ Schools/ Wilde, Oscar

HILDERSTONE
SEE Alexander House School/ Broadstairs/ Schools

Benny HILL
Born 21st January 1924
Died c20th April 1992
Comedian whose 'Benny Hill Show' was seen in over 140 countries.
SEE Entertainers/ San Clu Hotel

Sir Rowland HILL
He is famous for introducing the Penny Post in 1840. Whilst staying in Thanet in 1815, he noted that *'It is surprising to see how most people are prejudiced against this packet'*.
SEE Packets/ Thanet

Vince HILL
Born Coventry 16th April 1937

When the singer was 15, his mum entered him for a talent contest at The Prospect Inn near Minster. He won but could not accept the prize of a two-week engagement because he was too young to enter the contest, let alone win!
SEE Entertainers/ Minster/ Music/ Prospect Inn

Richard HILLARY
Born 20th April 1919
Died 8th January 1943
He was the grandson of Sir William Hillary. On 3rd September 1940, his Spitfire was shot down in flames by three Messerschmitts and he crashed into the sea off North Foreland. He was rescued by the local lifeboat, but suffered terrible burns to his face and hands.

Thanks to the Guinea Pig Club (the pioneering plastic surgery unit at East Grinstead Hospital) and three months of painful surgery, he recovered sufficiently to persuade, some say bully, his commanding officers into allowing him to return to flying duty – it was alleged by members of his officers' mess that he could not hold a knife and fork.

He was killed, along with his radio operator, three years later after volunteering for a dangerous night training mission although some questioned whether he was sufficiently recovered to control the plane.

He was 24 when he died.

He wrote a book, 'The Last Enemy' about his experiences in the Battle of Britain.
SEE Hillary, Sir William/ North Foreland/ Spitfire

Sir William HILLARY
Born 4th January 1770
Died 5th January 1847
An aristocrat and distinguished lifeboat man from the Isle of Man, his motto was 'With courage, anything is possible'. He wrote an appeal to the nation, as a result of which The National Institution for the Preservation of Life from Shipwreck was formed on 4th March 1824. In 1854, the name was changed to the Royal National Lifeboat Institution (RNLI) - a good thing really as the original name would probably have had the modern acronym of NIPLS which may, or may not, have affected fund raising.
SEE RNLI

HIPPODROME, Cecil Square
SEE Assembly Rooms

HMS FERVENT
The name given to the World War II Naval Base that was at Ramsgate Sands Railway Station.
SEE Ramsgate/ Ramsgate Sands Railway Station/ Ships

HMS THANET
A destroyer of the H&S class, it was launched on 5th November 1919 bearing a crest, suggested by Margate's mayor W Booth-Reeve, of the North Foreland lighthouse.
The christening of the destroyer HMS Thanet was celebrated on Saturday in Ramsgate.
East Kent Times, 17th December 1919.

It was adopted by the people of Thanet during the government's Adopt a Warship Week. Unfortunately, it was lost in action against the Japanese early in 1942. Thanet towns promised to raise £400,000 to replace it.

SEE East Kent Times/ North Foreland lighthouse/ Ramsgate/ Ships/ Thanet

HODENING

A Christmas revel, or, more accurately, a tradition of the winter solstice, that possibly originated in a Saxon/Pagan festival. It involves a man dressed up as a horse, complete with fake horse's head, which is accompanied by bell ringers, going from house to house carrying torches 'demanding' cakes, beer and small change. There is also a school of thought that says the revel derives from the Scandinavian custom of sacrificing a horse to Odin every winter solstice in return for his help in any future battles, and that Odining, as it was known, was corrupted into Hodening.

The custom of Hodening continued in Sarre and Birchington until the mid 19th century when it seemed to become less popular, although it has been regularly revived over the years.

SEE Birchington/ Sarre

Captain Frederick HODGES

Born c1830
Died – unknown

Strictly speaking, he was Friedrich as he was a German, and he attended the University of Munich. He subsequently came to England, becoming the owner of the Lambeth Distillery, and is rumoured to be the originator of Old Tom gin although there are other contenders for that honour:

Old Tom: Cordial gin. Thomas Norris, one of the men employed in Messrs. Hodges' distillery, opened a gin palace in Great Russell Street, Covent Garden, and called the gin concocted by Thomas Chamberlain, one of the firm of Hodges, 'Old Tom' in compliment to his former master. E Cobham Brewer, Dictionary of Phrase and Fable, 1898.

A fire at the distillery in 1851 began Hodges' lifelong interest in fire fighting and fire extinguishing and soon after the fire, he set up a fire brigade complete with all the latest kit. He was not just interested in the theoretical side of things, but also the practical, attending many fires, most notably that of the Surrey Music Hall in 1861 (it was later re-built) and the Cotton's Wharf, Tooley Street fire (23rd June 1861 – a huge fire, said to be the biggest peacetime fire at the port of London, it took two weeks to finally put out). Both the Duke of Sutherland and King Edward VII took a keen interest in Hodge's work.

Hodge lived for a while at Bramfield House on Albert Terrace in Margate, and was soon a well known character, partly because of the number of flagpoles he erected on the roof of his house, and partly due to the fun he had warming up penny coins, throwing them to youngsters below his house and then watching them burn their hands when they picked the coins up – and people ask what fun was to be had before television came along.

In 1861 he rented some land at Palm Bay and erected a huge flagpole at the spot that immediately became known as Hodge's Flagstaff.

He was a regular contributor to the letters page of the local paper; he entertained the Margate public by driving his 'steam carriage' along the seafront, and, for four years, paid for a firework display on Lower Marine Parade. He also founded the local fire brigade and would lead the team in their training which involved using the Holy Trinity Church as target practice for the hose – I bet it kept it clean though.

He returned to Munich, or 'land of brains' as he called it, but wrote regularly to Mr Adams the proprietor of the Koh-i-Noor cafe.

SEE Albert Terrace/ Hodges' Flagstaff/ Holy Trinity Church/ Koh-i-Noor/ Margate/ Marine Parade/ Newgate Gap

HODGES' FLAGSTAFF, Cliftonville

In 1861 Captain Frederick Hodges rented some land at Palm Bay from a Mr Willats (who had it on lease from Mr Taddy Friend, for £5 a year) and decided to erect a huge flagpole on the spot. It immediately became known as Hodge's Flagstaff because it was the only identifiable thing along that part of the coast at that time. The original flagstaff was 128ft tall and the flags (the Union Jack was 50ft x 25ft, and the White Ensign was 60ft x 30ft) could be seen all over Thanet. There were some that referred to it as Hodges' Folly.

It became a place to which people walked for their constitutional and from where they would then sit and enjoy the sea views on the benches that Hodges also provided, before their return journey.

The area containing Hodge's Flagstaff was auctioned by T U & J Reeve, held at the spot, on Monday 5th September 1870:

660 feet of good iron fencing; 7 small guns with carriages and wheels; 1 carronade 4¾ inch bore; 1 large 12-pounder 4¾ inch bore; 1 18-pounder 5¼ inch bore; 1 12-pounder 4½ inch bore; 1 carronade 5 inch bore; 2 piles of shot; the noble flagstaff, with lower and top-mast, winch for hoisting top-mast, light 1¼ inch wire shroud top-mast rigging, four 3inch shroud wire rigging to lower mast, about 340 feet of running chain signal haulyards; 16 ornamental cast-iron chairs, 5 feet in length.

It was bought by a Mr Pitt, whose father had taken his constitutional there every day, but he immediately gave the place to the town.

On Friday 9th September, a subscription list was opened at Cobb & Co.'s Bank for the necessary repairs and re-decoration (don't you just love those gifts that cost you money?). Among those who signed up were the auctioneers, the Worshipful Mayor, Mr John Bayly, Mr Keble, and, of course, Mr Pitt who headed the team.

A brass plaque was put up: *'Borough of Margate. Flint, Mayor. This flagstaff, seats,* guns and fences, erected in 1861 by F Hodges, Esq., were purchased and presented by George Pitt, of Mitcham, Surrey, to the Town Council for the use of the visitors and inhabitants, as a tribute to the memory of my father, who was much attached to this spot. October, 1870.'

The cannons that looked out to sea remained there until World War II when they were buried on site (and I thought we needed all the guns we could get hold of) and as far as anyone knows they are still down there.

SEE Cliftonville/ Cobbs/ Hodges, Captain Frederick/ Newgate Gap/ World War II

HODGES' GAP

SEE Eastern Esplanade, Cliftonville/ Hodges' Flagstaff

HODGMAN

Advertisement, c1900:

A D HODGMAN, Job Master, Livery, Bait, and Commission Stables,
Order Offices – 78 Queen Street and 30 King Street. Telephone – 55.
Telegrams –'Hodgman, Contractor, Ramsgate'
King's Street Mews, Granville Mews, Albert Mews, Market Place, Wilson's Road, Albert Street, Smith's Yard, King Street, Ramsgate.
Broughams, Victorias, Landeaus, Waggonettes, Private Busses, Pair and Four-horse Brakes, Dog Carts and Saddle Horses, by the Hour, Day, Week, or Job. Orders punctually attended to for Carriages to or from the Rail. Horses jobbed for all purposes.

SEE King Street/ Queen Street/ Ramsgate

'HOLIDAY ROMANCE'
by Charles Dickens

Boldheart now took his mother down into the great cabin, and asked after the young lady with whom, it was well known to the world, he was in love. His mother replied that the object of his affections was then at school at Margate, for the benefit of sea-bathing (it was the month of September), but that she feared the young lady's friends were still opposed to the union. Boldheart at once resolved, if necessary, to bombard the town. Taking the command of his ship with this intention, and putting all but fighting men on board 'The Family,' with orders to that vessel to keep in company, Boldheart soon anchored in Margate Roads. Here he went ashore well-armed, and attended by his boat's crew (at their head the faithful though ferocious William), and demanded to see the mayor, who came out of his office.

SEE Bathing/ Books/ Dickens, Charles/ Margate/ Schools

HOLLAND

Pennant, writing in the 18th century: *The passage from England to Holland was often made from this place* [Margate].'

SEE Low Coutries/ Margate

Lord HOLLAND

Born London 1705
Died 1774

Born plain old Henry Fox, he entered parliament in 1735 and soon became a protégé of Sir Robert Walpole, the Whig prime minister, holding a variety of ministry posts over a thirty year period. He employed those useful tactics of persuasion, intimidation and bribery to get the 1763 Treaty of Paris approved. As a reward he was raised to the peerage. During the Seven Years War he was Paymaster General of the armed forces and due to some creative accounting amassed a sizable personal fortune. In 1765 he was forced to resign, and although charges were brought, they were stayed by George III. He was a swindler but, in his defence, was damned good at it!

He was married to the daughter of the Duke of Richmond and Charles James Fox was their son.

He had two homes called Holland House, one in London that was at the hub of society, and the other at Kingsgate.

SEE Arx Rouchim/ Fox, Charles James/ George III/ Harley's Tower/ Kingsgate

HOLLAND HOUSE, Kingsgate Bay

Holland House was built by Lord Holland in 1761 in the gothic fashion of the times, imitating an Edward I castle, and concealing a practical purpose – Kingsgate Castle was Lord Holland's stables. He surrounded it with Gothic ruins and follies such as The Captain Digby, and Neptune's Tower, Arx Rouchim, just to the north of the Captain Digby.

The Picturesque Pocket Companion to Margate Ramsgate & Broadstairs & the parts Adjacent by William Kidd, 1831: *In this picturesque and delightful valley, the late Henry Lord Holland, under the direction of Sir Thomas Wynne, afterwards Lord Newborough, built a splendid seat, in imitation of Tully's Formian villa on the coast of Baia. The saloon and many of the apartments in this house were of a very handsome character, and the Roman Doric portico in front, was of noble dimensions and appearance: indeed the whole building was constructed with such an accurate knowledge of the useful and elegant, as to reflect the highest credit upon the noble architect, and to render it a most desirable and convenient summer retreat. Here were many ancient and valuable marble columns, busts, vases, statues and paintings, purchased in Italy by Lord Holland, and brought from thence at a very enormous expense; but when this estate passed into the possession of Mr Powell, they were all removed, and the noble mansion dismantled and converted into three separate dwellings, which are however still protected and adorned by the portico in front. At the upper end of the garden, which was once well stored with the choicest plants and flowers, both native and exotic, stands a beautiful black marble column, erected in the memory of the Countess of Hilsborough, and now called Countess' Pillar: upon which is the following inscription 'This pillar is erected in the honour of Margaret of Kildare, Countess of Hilsborough: and alas!*

In memory too of that most amiable woman, who died at Naples anno 1767.'

In 1820 the original portico of Holland House was removed to front the Royal Sea Bathing Hospital in Westbrook, Margate.

William Cowper (1731-1800) in a letter to a friend in July 1779, referred to his visit 16 years previously: *There was not at that Time, much to be seen in the Isle of Thanet besides the Beauty of the Country & the fine Prospects of the Sea. . . One Sight however, I remember engaged my Curiosity & I went to See it. A Fine Piece of Ruins built by the late Lord Holland at a great Expence, which the Day after I saw it, Tumbled down for Nothing. Perhaps therefore it is still a ruin, and if it is I would advise you by all Means to Visit it, as it must have been much improved by this fortunate Incident. It is hardly possible to put Stones together with that Air of Wild & Magnificent Disorder which they are sure to acquire by falling of their own Accord.*

Admiral Robert Fitzroy lived for a period at Holland House.

SEE Fitzroy, Admiral/ Kingsgate Castle/ Royal Sea Bathing Hospital

HOLLICONDANE, Ramsgate

This area was called Holicon Dale in Georgian times, when it was just a cluster of farm buildings.

SEE Farms/ Hereson/ Ramsgate

HOLLICONDANE public house
Ramsgate

SEE Petit, Joseph Croome/ Pubs/ Ramsgate

HOLY TRINITY CHURCH, Broadstairs

It was built of flint and stone as a chapel-of-ease to St Peter's in 1829, for £300, on land previously owned by Fort House. A committee was formed and at the first meeting they raised twenty-five contributions. The Duchess of Kent, Queen Victoria's Mum, *'during her residence at Pierremont House, gave a liberal contribution'* – 'liberal' being £25. A piece of land near the present day entrance to Queens Road was offered as a site for the church by Edward Fletcher but it was turned down. The owner of Fort House, Captain Gooch offered some land to the north-west of his house and this time the committee said yes.

The chapel was 55ft long, 45ft wide and the walls were 35ft high. Originally, it was meant to hold 616 people but this was upped to 1,000 although, in reality, only 800 could fit in and be comfortable. It was altered to allow in more people in 1857. The architect,

David Barnes, was given a budget of £2,000 and decided to spend it on the construction rather than the design. It must have been good as not a single crack was found in the walls or roof when alterations were made in 1915. Archbishop William Howley dedicated the chapel on 15th April 1830.

Dickens did not think much of its architecture and in Our English Watering Place wrote: *'We have a church, by the bye, of course – a hideous temple of flint, like a petrified haystack. Our chief clerical dignitary, who, to his honour, has done much for education both in time and money, and has established excellent schools, is a sound, shrewd, healthy gentleman, who has got into little occasional difficulties with the neighbouring farmers, but has had a pestilent trick of being right. Under a new regulation, he has yielded the church of our watering-place to another clergyman. Upon the whole we get on in church well. We are a little bilious sometimes, about these days of fraternisation, and about nations arriving at a new and more unprejudiced knowledge of each other (which our Christianity don't quite approve), but it soon goes off, and then we get on very well.'*

The Rev John Hodgson was the clergyman Dickens referred to, and the outside walls and doors of the church had been damaged by the horns of cattle as they were driven up what is now Church Road to pasture.

A tower, designed and paid for by Thomas Crampton, was added in 1862 for the cheap price of £300, but because it was fairly weak - I told you £300 was cheap - it was pulled down again in 1925 when the church was enlarged. Thomas Crampton also gave a clock.

The Rev L L Edwards was largely responsible for the enlargement of the church that was undertaken in the winter of 1914-15 at a cost of £4,000. A new organ and a further enlargement at the west end occurred in 1925, this time costing £9,000.

A new Shrine of St Mary was added in 1980. The land for the Rectory was bought in 1868 and it was built in 1871 but was replaced in 1979.

To celebrate the church's 175th anniversary, the Archbishop of Canterbury, Rowan Williams, visited the church in April 2005.

SEE Broadstairs/ Churches/ Crampton, Thomas/ Farms/ Our English Watering Place/ Schools/ St Peter's Church/ Shrine of Our Lady/ Victoria

HOLY TRINITY CHURCH, Margate

Holy Trinity Church was built in 1829. It was damaged in an air raid on the 1st June 1943.

SEE Churches/ Hodges, Captain Frederick/ Margate/ Trinity Square

HOLY TRINITY CHURCH
Bellevue Avenue/Road, Ramsgate

There was once a Holy Trinity Chapel in Ellington Place after which this church was named. The plot of land on which this Holy Trinity Church was built, was a gift from Mademoiselle D'Este.

The church was built, at a cost of £3,000, by Stevens and Alexander of London, for whom

W E Smith worked a lot with Edward Pugin. W E Smith also designed St Catherine's Church in Manston and St Luke's Church in Ramsgate.

There were 770 seats, 300 free for the poor! Mr Warre laid the foundation stone on 29th August 1844, and the consecration took place on 11th June 1845 by the Archbishop of Canterbury, Dr William Howley who also brought the Canterbury Cathedral choir to sing at the service.

The first vicar was Rev Thomas Clark Whitehead, and the first treasurers were J Warre and the Rev G W Sicklemore (the vicar of St Laurence). The wood carving, notably on the pulpit, is by James Lock-Beverbridge and dates from 1868. The organ with 3 manuals and 1,532 pipes was installed in 1871 by Messrs Bridley and Forster. It was re-built by F H Brown and Son of Canterbury in 1963. The organ blower, Newington, was given a pension of 2/- (10p) a week in 1882.

The east window is a memorial to Lady Elizabeth Wills, wife of Sir W H Wills – later Lord Winterstoke.

In October 1995 the Church received a bequest of £300,000 from Miss Caroline Clayson, aged 92, who died that August and had lived at the San Clu Hotel.

SEE Churches/ D'Este, Mademoiselle/ East Court/ Manston/ Mount Albion House/ Pugin, Edward/ Ramsgate/ San Clu Hotel/ Warre/ Wills, Sir W H

HOLY TRINITY SCHOOL, Ramsgate

The nineteenth century Holy Trinity School was destroyed by a fire that had to be fought by 40 firemen in the early hours of Wednesday 25th February 1987. A total of 171 pupils were given a three day holiday. The school re-opened after three years in June 1990 at a cost of £750,000 and could accommodate 210 pupils.

SEE Fires/ Ramsgate/ Schools

HOME SCHOOL for GIRLS
Spencer Road, Birchington

It was a boarding and day school at a house called Portpool from the early 1900s until the mid 1930s. (see also Shakespeare Road). When it closed, the building was taken over by the Beresford Hotel and is now Spencer House.

Gwynant was once used as part of Home School for Girls, in Spencer Road.

SEE Birchington/ Schools/ Spencer Road, Birchington

HONEYMOON

Douglas Fairbanks and Mary Pickford had both been married before when they came to Europe for their honeymoon in 1919 and were unsure of their welcome. They need not have worried. They were mobbed. It is often said that they spent their honeymoon at Elmwood House, but it was just part of their European tour of a honeymoon. In London, women pulled Mary from their limousine to shake her hand – they had remembered the two years she had spent selling war bonds. They could not sleep in Paris because crowds below their hotel room would serenade them. They went to a party in Amsterdam and were

mobbed by the other guests. Fairbanks carried Pickford on his shoulder through a window to escape! When they did get some peace and quiet in Hamberg it was because their films had not been shown in Germany due to World War I, but that prompted Mary to say 'Doug I'm sick of this. Let's go back to one of those countries where they mob us'.

SEE Elmwood House/ Fairbanks, Douglas/ Pickford, Mary

HONEYSUCKLE INN
Honeysuckle Road, Ramsgate

The inn was converted from a farmhouse in 1789 and is supposed to sit on a warren of tunnels leading to the harbour and to East Cliff Lodge. It was described in Police records in 1880 as a 'disorderly house of ill repute' - I once entered a similar sounding pub in London that had a sign on the wall that read: 'Please do not drop lighted cigarette butts on the floor as it burns the hands and knees of our customers as they leave'.

SEE Farms/ Pubs/ Ramsgate/ Tunnels

HONITON HOUSE SCHOOL
Cliftonville

After 56 years in business it announced its closure in 2005.

SEE Cliftonville/ Schools

Thomas HOOD
Born 23rd May 1799
Died 3rd May 1845

A poet who, in his time, was well known for his serious poems and was admired by Dickens for his poem 'The Song of the Shirt' (1843) which was an attack on worker exploitation. Nowadays he is best remembered for his satirical and comic verses which used his gift for pun-making. He worked on magazines like Hood's Own, Hood's Magazine, or The Comic Annual, as their founder, editor or contributor. Hard work and a perpetually poor financial situation led to ill health and he stayed in Ramsgate twice to recuperate.

Thomas Hood, in a letter to his infant daughter, 26th May 1833: 'Ever since Pa and Ma have been at Ramsgate they have wished all day long for their own little Bobe, - for the little children run about the sands & ride upon donkeys & seem as happy & as merry as larks. There are a great many ships & boats sailing about & splashing through the waves & great smoking steamers paddling along, - when Toby is a little older & bigger she shall go to Ramsgate in a steamer too & we will have fine fun with the waves & the donkeys & the boats. – Every morning Pa & Ma go down the sands to pick up shells for our Fanny & we have got some very pretty ones which we will bring home in a little basket. There are some like cups which Toby will like very much. Pa will bring her too some of the curious leaves & flowers that grow in the sea under the water but the waves come jumping one after another & throw the shells and seaweeds onto the ground for little Bobe. As today is Sunday all the ships and boats have got their flags flying*

of all manner of colours - & they are very pretty indeed.'

Thomas Hood, in a letter to a friend, 1833: The weather is so fine you will be a great Pump if you do not come here sooner than you propose. When you talk of the middle of the week you may as well embrace the waste of the week & come down here at once by Tuesday's Margate steamer. Every hour will do you good – so don't stick Thursday, obstinately, on your back like an ass ridden by Day [a jockey in the Derby]. Seriously I shall look for you - & my doctor says all disappointments will throw me back. Mind, - while you are on board have a crust & good Cheshire and bottled porter [ale] for a lunch. . . . even Annie Porter [a friend of theirs] is improved by crossing the channel. Don't forget the pigtail – that is the porter - & sit, not with your back to the bulwark, on acct of the tremor of the engine. The sound is as of a perpetual gallopade, performed by sea-horses. – just go to the chimney & listen. – There was no illness whatever when I came down, at least human sickness. The only symptom I saw was the heaving of the lead [measuring the depth of the water].

Thomas Hood, in a letter to John Leech, 11th September 1843 (John Leech was an illustrator who contributed to Punch, and at the time was on holiday in Ramsgate): I suppose you are at Ramsgate. It is a nice place. If you shut your eyes you can walk right over the Pier – or bang against the cliffs, or off them, whichever you like. You may treadmill yourself for exercise up & down Jacob's Ladder - & if you relish such sea insects – peg well at the shrimps. On a clear day, if you understand French, you can see their coast: and it may concern you to know that a vast number of leeches are imported from France … some curious people ascend the Pharos [lighthouse] on the pier, but it is light-headed - & therefore, like a monomaniac, ought not to be trusted. …Many persons are very ill on the sea-voyage, & if you were sick in going down you may be sure of sickness coming up. A coach and horses is the best preventive. NB. Talking of the Preventive [coastguard] – the Coast Blockade is not for drawing on – as you may imagine: but there is a great Bank called the Goodwin which you may draw on, if you have any cash in it – the head partner is Mr.David Jones.

SEE Coastguards/ Donkeys/ Margate/ Poets/ Ramsgate/ Steam Packets

HOOPER'S HORIZONTAL MILL

Captain Stephen Hooper built three of these horizontal mills, at Battersea, Sheerness and in Zion Place, Margate (on the north side just to the west of Capital House office block) in 1795. The horizontal wheel was on top of a two storey tower. The design never caught on and it was demolished in c1827.

SEE Hooper's Hill House/ Tales of the Hoy/ Windmills/ Zion Place

HOOPER'S HILL HOUSE, Cliftonville

A house built by Sir Thomas Cavaler at the same time as his mill in 1795 and was thus

named Hoopers Hill House, and allegedly had '*the finest wine cellars in the whole of Kent'*. The house was demolished in 1960. It is now the site of Margate Caves, are they the old wine cellars?

SEE Cliftonville/ Hooper's Horizontal Mill/ Margate Caves/ Price, Dr David

HOPE AND ANCHOR

SEE Lester's Bar and Restaurant

Benjamin Bono HOPKINS

SEE East Cliff Lodge

HOPS

Hops were grown at Dent-de-lion, Garlinge, in the late nineteenth century.

These were also grown in Broadstairs in the areas at the top of The Vale, Crow Hill and Elmwood Farm. There were 18 Oast Houses (where the hops were dried out) in Thanet in 1859, and as a rough rule of thumb, you needed one Oast House for every five acres of hops. The crop was not that successful in Thanet mainly because it does not like strong winds - I think I may have been a hop in a previous life!

SEE Broad Street/ Broadstairs/ Crow Hill/ Dent-de-lion/ Farms/ Northdown Ale/ Thanet

HORNBY

SEE Rovex/Hornby

Richard Henry HORNE

Born London 1st January 1803
Died Margate 13th March 1884

He attended Sandhurst, but did not receive a commission in the army, and ended up joining the Mexican navy – he probably saw an advert on the web, the next thing you know . . . anyway, he fought against the Spanish, got involved in a mutiny and was shipwrecked! He had a right old adventure before returning to London to become a journalist, and was editor of 'The Monthly Repository' (1836-37). In 1837 he wrote 'Cosmo de Medici' and 'The Death of Marlowe', both tragedies, and in 1841 a 'History of Napoleon'. In 1843 'Orion', an epic, allegorical poem came out, costing a farthing, and selling incredibly well.

T'is always morning somewhere in the world. Orion (1843)

Edgar Allan Poe was one of many admirers of 'Orion', and the poem was even compared to Keats 'Endymion'.

'A New Spirit of the Age' came out in 1843, written with Elizabeth Barrett (who later became Elizabeth Barrett Browning upon her marriage). He also contributed to the magazines edited by Charles Dickens.

From 1852 until 1869 he lived in Australia and from 1874 received a Civil List Pension. After such a busy life he died, aged 81, in Margate, where he is buried.

SEE Margate/ Poets

HORSE and GROOM public house
Charlotte Court, Ramsgate

Originally built as a house in 1830, it was put up for sale as such on 20th January 1840, at which time a Mr Danton occupied the two sitting rooms, four bedrooms, two kitchens,

an enclosed yard and '*convenient domestic offices*' that it comprised. The property was bought by Mr John Meager who opened it as The Royal Arms pub in 1841. However, due to the proximity of the Sackett's Livery Yard at the back of the property, the name was very soon changed to the Horse and Groom. Mrs Harriet Tomson and Mr Thomas Wotton took over the lease in 1865 and the freehold in 1869. When Thomas Wotton was made a partner in Tomson and Wotton in 1867, it was the birth of what was to become the oldest brewery in Britain.

Named after the wife of King George III, Charlotte Cottage next door was included, along with part of the old livery stable yard, in an extended Horse and Groom in 1960. During the works, a roman coin was found within the bricks and mortar of the cellar, and a 1733 farthing was found behind a wooden window seat in the old cottage.

SEE Charlotte Court/ George III/ Pubs/ Ramsgate/ Tomson & Wotton

HOSPITAL
Victoria Road, Margate

It is amazing to look back to 1875 and realise that as big as the town was getting and the increasing number of rich people who were living or visiting the area, that there was no hospital in the town. Quite frankly, people were dying, and some of them unnecessarily so, particularly as a consequence of accidents. At the meeting that was held on the 14th October 1875, the Mayor and his cohorts decided to acquire Thanet Cottage and its garden in Victoria Road. The sale was completed the following year at a cost of £800. The Cottage Hospital opened soon afterwards with Mr W Knight Treves as the first medical superintendent.

In its first year, 12 patients were treated. The building was spacious enough, but it was difficult to manoeuvre on the stairs, and some rooms had low pitched ceilings. At the time of Queen Victoria's jubilee in 1887, an enlargement of the hospital was suggested. In the end though, it was decided to build the clock tower instead - shame about the sick people who couldn't get into the hospital – but at least they would know what the time was!

Ten years later – and it seems that only a jubilee could induce an improvement to the hospital - it was suggested by Bertram Thornton, a surgeon at the hospital, in January 1897, that any money raised to celebrate the Queen's diamond jubilee could be used to improve the hospital. The idea gathered pace and a committee was duly formed although their initial thought was that they wouldn't get much more than the

£1,000 which was roughly the amount that had been raised ten years before. In fact, the appeal did so well that major improvements were made. The original building was pulled down leaving the operating room and the Lucas and Wilcox wards. On the site of the original building and part of the front garden a larger hospital was built, costing £1,600. It was opened on 19th January 1899 by Thanet's MP, James Lowther. Lloyds Bank endowed a bed in the Lucas ward in memory of their chief cashier, Charles Edward Troughton, who had died in the 1897 surf boat disaster.

In 1897 both the Queen Victoria Ward, and as an acknowledgement to the superintendent's work, Treve's Ward were opened.

In 1913 the hospital was further extended, and the King Edward memorial extension was opened by Princess Alexander of Teck on 22nd July. It was extended both to the north and south. The Wilcox ward for women went from 4 to 9 beds, and Treve's ward for men had 10 beds.

By 1926 there was growing support to build a general hospital. Following a meeting on 1st March 1926 at the Town Hall an appeal was started, and virtually every society and organisation in the area set about raising funds to pay for it. £1,328 was raised. By 1928 the site at St Peter's Road was chosen and a tender of £56,301 was accepted. The Lord Mayor of London, Sir Charles Batho, laid the foundation stone on 25th September 1928. After a lot of hard work by the whole community, the new hospital was opened on 3rd July 1930 by Prince and Princess Arthur of Connaught. The total cost, including equipment was £70,000. By 1948 the hospital was absorbed into the new National Health Service. In the old hospital's final year, it saw 4,204 patients (both in-patients and out-patients).

Sadly, the building stood vacant for some time, until the library moved here in 1932. The library moved on to its present location in Cecil Square in the 1960s and the old cottage hospital building has now been converted into flats.

SEE Friend to All Nations/ Hospitals/ Libraries/ Margate/ St Peter's Road, Margate/ Victoria

HOSPITALS

SEE Hospital, Margate/ Margate General Hospital/ QEQM/ Ramsgate Hospital/ Thanet Hospital/ Westbrook Day Hospital

HOT WEATHER

On 9th August 1911, in Canterbury, the temperature reached ninety-eight degrees, the highest ever recorded. It had snowed in April, but from May all the way through to August it was hot. Crops burnt and fruit shrivelled on the trees, but the tourist trade in Thanet loved it. It was estimated that on August Bank holiday, there were four thousand people on Margate's beach.

There was another very hot and dry summer in 1921. June had virtually no rain at all Only 9.29in (236mm) fell in the whole year! (I bet there wasn't a hose-pipe ban though).

In 1933, the temperature reached a peak of 94F (34C).

The Bank Holiday on 5th August 1935 had such fantastic sunny weather that crowds flocked to Thanet. It was reckoned that there were so many people on the beach you couldn't see the sand.
SEE Crowds/ Margate/ Weather

HOTEL DE VILLE
Grange Road, Ramsgate
Inquests were held here in the 1900s.
John LeMesurier was a regular in the bar here. One previous owner was Lord George Sangar – two former landlords committed suicide here!
SEE Grange Road/ Hotels/ LeMesurier, John/ Ramsgate

HOTELS
SEE Accommodation/ Balmoral Hotel, Broadstairs/ Beresford Hotel, Birchington/ Bull & George Hotel, Ramsgate/ Bungalow Hotel, Birchington/ Butlins/ Carlton Hotel, Broadstairs/ Carlton Hotel, Margate/ Central Commercial Hotel, Ramsgate/ Cinque Port Arms Hotel, Margate/ Cliftonville Hotel/ Derby Arms Hotel, Ramsgate/ Dundonald House Hotel, Broadstairs/ East Cliff Hotel, Cliftonville/ Endcliffe Hotel, Cliftonville/ Ethelbert Road, Cliftonville/ George Hotel, Margate/ Grand Hotel, Broadstairs/ GrandHotel, Cliftonville/ Granville Hotel, Ramsgate/ Hotel de Ville, Ramsgate/ Howes Royal Hotel, Margate/ Imperial Hotel, Margate/ Kent Hotel, Margate/ Metrolpole Hotel, Margate/ Minnis Bay Hotel, Broadstairs/ Nayland Rock Hotel, Margate/ New Shipwrights Hotel, Ramsgate/ Norfolk Hotel, Cliftonville/ Old White Hart Hotel, Margate/ Oxford Hotel, Margate/ Paragon House Private Hotel, Ramsgate/ Pubs/ Queen's Highcliffe Hotel, Cliftonville/ Railway Hotel, Broadstairs/ Red Lion Hotel, Ramsgate/ Royal Albion Hotel, Broadstairs/ Royal Albion Hotel, Margate/ Royal Hotel, Ramsgate/ Royal Oak Hotel, Ramsgate/ Royal York Hotel, Margate/ St George's Hotel, Cliftonville/ San Clu Hotel, Ramsgate/ Sea View Hotel, Birchington/ Temperence Hotel, Birchington/ Trafalgar Hotel, Ramsgate/ Victoria Hotel, Ramsgate/ Walpole Bay Hotel, Cliftonville/ Wellington Hotel, Margate/ Wright's York Hotel, Margate/ York Hotel, Margate

Alan HOUCHIN
He was a 27 year-old mechanic from London, who, in the summer of 1965, was staying at the Croydon Guest House in Addington Street, Margate, otherwise known as the 'mad-house' because of the drinking, drug-taking and less savory activities that went on there. On 22nd August a former pupil of Lausanne School, 16 year-old Shona Berry, a waitress, had gone with Houchin to Dane Park, where she had rejected his advances and had then been strangled by him. Her virtually naked body was later found in the park and Houchin was soon arrested. At the trial in Maidstone, he denied murder, claiming that he had only shaken her by the shoulders because she had been teasing him. The jury took 55 minutes to come to a guilty verdict.
SEE Addington Street/ Dane Park/ Margate/ Murder/ Schools

HOVELLING

The supplying of anchors and chains to ships in storms.
SEE Ships

HOVELLING BOAT INN, Ramsgate
There was once an inn called the Hovelling Boat Inn in York Street.
SEE Pubs/ Ramsgate/ York Street, Ramsgate

HOVERCRAFT
The world's first international service, from the Swedish firm Hoverlloyd Ltd, was formed in November 1965 and in 1966 a hovercraft service started operating from Margate's main beach. It lasted until the Pier Company noticed that an 1812 Act allowed them to collect a levy for every passenger. Other locals were concerned that the noise - and they were NOISY - would frighten the donkeys – a sort of Mrs Patrick Campbell, I don't mind what they do as long as they don't do it on the beach and frighten the donkeys. So, on 10th February 1966, the hovercraft service moved to Ramsgate Harbour, and then onto the Hoverport at Pegwell Bay which opened in May 1969. That is now closed as well and there is no hovercraft service in Thanet.

The Westland SRN6 hovercraft could carry 38 passengers, but was superceded by the SRN4 which could carry 200.
SEE Cockerell, Sir Christopher/ Harbour, Ramsgate/ Hoverport/ Margate/ Pegwell Bay/ Ramsgate/ Transport

HOVERPORT, Pegwell Bay
The Hoverport was opened by the Duke of Edinburgh in May 1969 and closed in October 1981.
The trip from Pegwell Bay to Calais took 40 minutes, and in peak season there were up to 28 crossings a day.
SEE Hovercraft/ Pegwell Bay

HOVIS
Smith's Patent Germ Bread first appeared in 1887, but even the manufacturers agreed it was not the snappiest name for a product – 'I'm just nipping out for a loaf of Smith's Patent Germ Bread' doesn't work does it? So they held a competition to come up with a better name in 1890 and it was won by Herbert Grime who took the Latin for 'strength of man', hominis vis, and shortened it to Hovis. Although for many years, in a more grammatically correct age, it was spelt Hōvis, with a tilde over the 'o', to denote that it was an abbreviation. The Hovis Bread Flour Company was formed in 1898, but by 1918 this too was shortened (no tilde this time) into Hovis Ltd.
SEE Hudson's Mill, Ramsgate

Trevor HOWARD
Born Cliftonville, 29th September 1916
Died Hertfordshire, 7th January 1988
The actor appeared on stage at Stratford and at the Criterion in 'French Without Tears' (1936-38). During World War II, he was a paratrooper but was given a medical discharge in 1943. He starred in 'Brief Encounter' (1945) which was his third film, as well as 'The Third Man' (1949), 'The

Heart of the Matter' (1953), 'The Key' (1958) (for which he got a British Academy Award), 'Sons and Lovers' (1960) 'Mutiny on The Bounty' (1962), 'Charge of the Light Brigade' (1968), and 'Gandhi' (1982).
SEE Actors/ Cliftonville/ Films

HOWES ROYAL HOTEL
Cecil Square, Margate
Margate Delineated; or A Guide to the Various Amusements, Public Libraries, Buildings, Improvements, etc of that celebrated Watering Place (1829): *Howes Royal Hotel in Cecil Square is a splendid and well arranged establishment, possessing billiard-tables, a card-room, and a magnificent ball-room. The landlord of the tap belonging to the Hotel is in possession of a dog, who is found useful in fetching home the pewter-pots whenever he sees them standing at the doors of his master's customers. Weekly concerts are established here, and on Sundays there is a selection of sacred music.*
SEE Cecil Square/ Hotels/ Margate

HOY
A flat-bottomed sailing boat that transported both goods and passengers quite cheaply. They were superseded by steam packets from around the 1820s.
The Hoys, which still every tide from Billingsgate, are (still) cheap, and sometimes agreeable and rapid conveyances . . . A passage in the Margate-hoy . . . is frequently so replete with whim, incident and character, that it may be considered as a dramatic entertainment on the stage of the ocean. The fare being only five shillings for the common cabin, and half-a-guinea for the best, is a strong inducement for numbers to prefer this mode of travelling, though it cannot be recommended to persons of nice delicacy. . . Not less than 20,000 persons annually sail to and from this port. . . In consequence of this profitable trade, Margate has risen from insignificance to wealth and consequence. A Guide to all the Watering and Sea-Bathing Places (1803)
SEE Hoy, The/ Margate/ Ships

The HOY public house, Margate
Named after the boats of the same name, The Hoy public house was at Bankside, before it was renamed Marine Parade, and, in the late eighteenth century, at 4 The Parade.
The 'Old Captain's Room' (later to become a restaurant and function room) was where an old sea salt lived who eventually hung himself. Meals were cooked for the restaurant in the kitchen which was located in the cellar, which, during World War II, was the operations room for a plan to blow up the pier, jetty and harbour in the event of a Nazi invasion. How successful this plan would have been will have to be imagined, but the wooden jetty put up a huge resistance when they tried to blow it up in the 1980s.
In the 1950s, the pub was renamed The Benjamin Beale - ironic as he was a strict Quaker, or to use their correct title, Religious

Society of Friends. A group who, ironically, are teetotal. It is currently closed.
SEE Beale, Benjamin/ Hoy/ Margate/ Marine Parade/ Pubs/ Restaurants/ World War II

H STREET & Co.
Advertisement c1900:
6 Hardres Street & Broad Street
Upholsterers, Cabinet Makers & House Furniture
Furniture Repaired, Re-covered & Re-polished at Low Prices.
Carpets taken up, beaten and re-laid.
Furniture carefully removed.
SEE Shops

HUDSON'S MILL
Margate Road, Ramsgate
The two lower storeys were designed by Edward Pugin in 1865.
The mill has also been called the Rank Hovis Flour Mills. It is Grade II listed and its closure was announced in 2006.
SEE Coffe Pot/ Hovis/ Listed buildings/ Margate Road, Ramsgate/ Ramsgate/ Windmills

HUGIN

Hugin is Norse for 'raven', and in Norse legend, the god Odin sends a black raven to report on mankind's affairs. The Hugin in question here is a replica Viking longboat, based on the type of craft used by them between the 5th and 9th centuries. It was built in ten weeks by craftsmen in Frederikssund, near Copenhagen, using oak planks and copper nails. It weighs 15 tons, and is 71ft long, 18ft wide and 40ft to the top of the mast. It had 64 shields in different colours down the sides and a red and white vertically-striped sail. It was launched on 1st July 1949 by Mrs Hedtoft, the wife of Denmark's then Prime Minister.
It sailed, or more accurately, was rowed, by a crew of around 50, all aged between nineteen and twenty four years of age, from Esbjerg, Denmark, to commemorate 1500 years since Hengist and Horsa had made a similar trip. Teams of 16 rowers each took turns to row across the North Sea. They all had to grow beards for the occasion, and live and dress as the Vikings did, eat simple meals cooked on board, and sleep on wooden boards, but no drinking or smoking was allowed – like the Vikings were noted for not drinking and they had not even thought about the fags! Raping and pillaging was banned as well!
A crowd of around 30,000 greeted the ship when it arrived at Main Bay in Broadstairs at around 2.15pm on 28th July 1949. The crew, led by Erik Suell Kiersgaard, was met by Prince Georg of Denmark, the Archbishop of Canterbury, Dr Geoffrey Fisher, and the

chairman of the council. There was a banquet at the Grand Hotel and a firework display in the evening.
The Main Bay at Broadstairs was subsequently re-named Viking Bay in its honour.
The next day, the boat was rowed to Ramsgate where 10,000 people met it, and the day after that it went to Margate where 40,000 turned out. Eventually it made its way to London where a reception was held at County Hall and the crew was toasted with sherry – the authentic Viking lifestyle had obviously been dropped by then.
The Daily Mail announced that they had bought the Hugin for £5,000 and would present it to the towns of Broadstairs and Ramsgate. Margate was a bit miffed. A year later, following a tour of other British coastal resorts, Prince Georg was back again for the formal handover at the site it now occupies overlooking Pegwell Bay.
In December 2004 the Hugin was sent off to Gloucester for extensive restoration work costing around £250,000 partly paid for by Thanet District Council and partly with money from the EC. The Hugin returned six months later and an unveiling ceremony was held on 22nd June 2005 at which a red and white sail was raised.
SEE Broadstairs/ Daily Mail/ Denmark/ Margate/ Pegwell Bay/ Ramsgate/ Stranglers, The/ Viking Bay/ Vikings

HUMBERS MILL
For most of the eighteenth century a windmill, known as Humbers Mill, stood at Lydden.
SEE Windmills

HUMANE SOCIETY
On 1st February 1908 two men were cut off by the sea at the base of the 60ft high cliffs at Broadstairs. William Bishop subsequently won the Royal Humane Society Bronze Medal for being lowered down to save them.
SEE Broadstairs

HURRICANE BOMBARDMENT
The Hurricane Bombardment occurred on 27th April 1917 when in just two minutes, the German Navy fired 300 shells on Margate, Ramsgate and Manston causing extensive damage.
SEE Addiscombe Road, Margate/ Alma Road, Ramsgate/ Belmont Road, Ramsgate/ Blazing Donkey/ Boundary Road, Ramsgate/ Manston Airfield/ Margate/ Nash Road, Margate/ Ramsgate/ Southwood Road, Ramsgate/ Upper Dumpton Park Road, Ramsgate

HUSBANDS' BOAT
This regularly arrived at Margate pier from London each weekend in the 1830s. It was the quickest way to make the journey before the days of railway. Mum and the kids would have had the whole week at the seaside, Dad would have spent the week working as usual and come down and meet up with the rest of the family for the weekend. This prompted many ribald comments and innuendo from the crowds who thronged around the area to

meet the boat. Obviously, I have no idea what sort of things they would have shouted.
SEE Margate/ Pier/ Royal Adelaide/ Ships

The HUSSAR public house
Canterbury Road, Garlinge
Originally a brick and flint Dent-de-lion estate cottage was converted into a pub in the mid 19th century. In the 1890s, it was the Hussar Inn and Tea Gardens as it was thought to be part of Westgate. In 1926, the Canterbury Road was widened, and the houses that backed onto the Hussar were demolished and the pub rebuilt further back. In 1975, the hotel side of the business closed, although the pub continues.
SEE Garlinge/ Pubs/ Westgate-on-Sea

HYPERMARKET
The Co-op sold their Westwood hypermarket to Tesco in July 2000. It was subsequently demolished and replaced with a new store.
SEE Shops/ Tesco/ Westwood

I

ICE CREAM
The Kent Pure Ice and Kent Coast Ice Cream Co's Ltd were listed in Bath Place, Cliftonville, in 1936 and 1957 as *'Ice cream manufacturers, ice merchants & cold storage'*.
There were 7 ice cream manufacturers listed in Thanet in 1957. There were none in 2003.
SEE Beach Entertainment/ Cliftonville/ Coal/ Dreamland/ Food/ Greengrocers/ Grocers/ Morellis/ Standing Stones/ Thanet

John Henry ILES
Born Clifton, Bristol, 17th September 1871
Died Birchington 29th May 1951
He played cricket for Gloucestershire (1890-91), became a showman with a funfair in Austria and then came to Margate to open Dreamland Amusement Park. Later, he wanted to add the new sport of greyhound racing to the attractions on offer but the Margate authorities said no. Already a success in the USA, the first British greyhound track opened at Manchester's Belle Vue in 1926, and following the success there, Glasgow and London opened tracks. Undeterred, Iles opened a track at Dumpton instead. With a railway station and two bus routes passing by, it was an ideal site and a huge success.
He also founded the national brass band contest in this country.
SEE Birchington/ Cricket/ Dreamland/ Dumpton Greyhound Track/ Dumpton Park Leisure Centre/ Dumpton market/ Hall by the Sea/ Margate

ILLEGITIMACY
A survey in 1966 showed that 1 in every 8 babies in Thanet were born out of wedlock.
SEE Infant deaths/ Teenage pregnancy/ Thanet

IMPERIAL HOTEL, Margate
The Imperial Hotel used to be at the bottom of the High Street on the corner of Marine Drive and at 158 High Street.
During the twentieth century it had a very large illuminated 'Bass' (the name of the brewery that owned it) on the outside and the place was heaving with passengers who had arrived on the steamers from London. It closed in the 1960s and in the 80s became Imps (the old name shortened – geddit?) bar/disco. In 1996 the whole place was refurbished and converted into a nightclub with penthouse-suites.
SEE Breweries/ High Street, Margate/ Hotels/ Garner's Library/ Margate/ Marine Drive

INDIA HOUSE,
Hawley Street, Margate
On the corner of Hawley Street and New Street, Margate, this house dates from Georgian times and was built in 1767. It was lived in by John Gould, a retired tea merchant of the East India Company. In 1759, he was a Commissioner for Restitution after the siege of Calcutta. India House is said to be modelled on his house there. He returned to England in 1766 and when he died in 1784, he left the house to his son. It was used as an office for the East India Company.
Later, the premises were used by a Mr Green, a wine merchant.
Phyliss Broughton also lived here.
In 1920, the solicitors Boys and Maughan bought India House for use as their offices.
SEE Broughton, Phyllis/ Hawley Street/ Margate

INDIAN CHIEF
SEE Alexandra Arms/ Goodwin Sands/ Harbour, Ramsgate/ Lifeboat/ Lifeboat, Ramsgate/ Ramsgate

INFANT DEATHS
The infant mortality rate in Thanet in 1851 was 14.6%. In 2001 it was 0.4%.
• *Miss R Pattenden was committed to trial at the assizes for concealing the birth of a child conceived when she was 15, and letting it die.*
• *The body of a new-born child was found in Margate. It had been strangled with a bootlace.* East Kent Times 18th July 1912
SEE East Kent Times/ Illegitimacy/ Margate/ Teenage pregnancy/ Thanet

Sir William INGLIS
Born 1764
Died Ramsgate 29th November 1835
A great soldier, he joined the army in 1781 and served ten years in America. He was then sent to Flanders before taking part in the capture of St Lucia (1796) in the Caribbean; the Battle of Busaco (1810) and the first siege of Badajoz (1812) - both in Portugal under the command of Wellington. His most famous moment came at Albuera when, commanding the 57th regiment, they were in an exposed but vital position. Within minutes Colonel Inglis, as he was at the time, had his horse shot from under him – this happened to him twice in his career – but he stayed where

he was commanding his troops on foot, before being badly wounded. He refused to be taken away for treatment, telling his men to, *'Die hard, 57th! Die hard!'*. Which they did. Out of 579 men, 438 (23 officers, and 415 rank and file) were killed or wounded.
E'en as they fought in files they lay,
Like the mowers grass at dawn of day,
When his work is o'er on the levelled plain,
Such was the fall of the foremost slain!
Byron
He received the thanks of Parliament for his actions. He was made lieutenant-general in 1825, subsequently knighted, made Governor of Kinsale, and Cork, and was appointed as the colonel of the 57th in 1830.
SEE Ramsgate

INGOLDSBY ROAD, Birchington
There was once a brick yard at the end of Ingoldsby Road that supplied bricks for some of the houses locally.
SEE Barham, Richard Harris/ Birchington

INGOLDSBY HOUSE, Margate
Barham wrote the Ingoldsby Legends at what is now called Ingoldsby House. It was a gentleman's outfitter in 1998.
'Twas in Margate last July, I walk'd upon the pier.
I saw a vulgar boy – I said 'What make you here?'
'The Ingoldsby Legends,
Misadventures at Margate'
by Rev Richard Harris Barham
SEE Barham, Richard Harris/ Margate/ 'Misadventures at Margate'

INVICTA AIRWAYS
Passenger flights started in March 1965 from Manston airport, but when the firm merged with BR Midland in 1972, passenger flights stopped and only flights from Invicta International Freight continued.
SEE Eurojet/ Manston Airport

Sir Henry IRVING
Born Somerset, 6th February 1838
Died 13th October 1905
The great Victorian actor Sir Henry Irving's real name was John Henry Brodribb.
SEE Craig, Edward/ Eastern Esplanade, Broadstairs/ Vanbrugh, Dame Irene

ISABELLA BATHS, Paragon, Ramsgate
Originally, the Isabella Baths (*sea and freshwater bathing!*) when it was built in 1816/7, it became, in around 1850, the Royal Kent Baths (named after the Duchess of Kent). After this business failed the building was replaced by the present one which was originally Mr and Mrs Rose's Boarding House, before it became the Paragon Hotel including some shops, a restaurant and the Paragon Corner House (a high-class tea room), before eventually becoming the Van Gogh pub, Steptoes and now The Churchill Tavern. Another Baths were built in the cliffs in 1868 and lasted until the beginning of World War I.
SEE Bathing/ Boarding houses/ Paragon/ Ramsgate/ Restaurants

ISLE OF THANET GAZETTE
Local newspaper originally founded by Thomas Harman Keble.
SEE Keble's Gazette/ Mods and Rockers/ Newspapers/ Thanet

ITALIANATE GARDENS
These were once to be found at the Paragon in Ramsgate, before a concert hall was built upon them - the West Cliff Hall - which in turn became the Motor Museum, which has now closed.
SEE Italianate Greenhouse/ Motor Museum/ Paragon/ Ramsgate/ West Cliff Hall

ITALIANATE GREENHOUSE
King George VI Memorial Park,
Ramsgate
It is one of the few remaining 19th century conservatories left in the country and was built in 1805, by Lord George Kieth to impress Queen Caroline. The first vine came from Corsica, so that he – well, his staff - could grow grapes of which she was fond.
Restoration became necessary because of vandalism and neglect. Towards this, The Historic Building Council gave a grant of £8,134, The Ramsgate Society gave £625, Kent County Council gave £500, and Thanet District Council gave £7,000, plus a further £4,250 for a fence to protect the structure; the greenhouse was officially re-opened on 27th January 1981.
However, in July 2004, the greenhouse was on English Heritage's register of buildings at risk. Thanet Council gave nearly £100,000, and a grant of £28,000 was given by English Heritage so that restoration work could begin again (is anyone else spotting a cyclical pattern to all this?) and in December 2005 the scaffolding came down and the old greenhouse was again looking very smart!
SEE Caroline/ King George VI Memorial Park/ Ramsgate

IVOR the ENGINE
A popular TV cartoon from the sixties.
SEE Postgate, Oliver/ Tlevision

IVY LANE, Ramsgate
Part of it was badly damaged in the 17th June 1917 Dump Raid.
SEE Dump Raid/ Ramsgate

JACKEY BAKERS SPORTS GROUND
Highfield Road, Northwood
It is named after Jackey Baker's farm that once stood there and was donated in 1929 to Ramsgate by Dame Janet Stancomb Wills who also paid for the land to be flattened and partially turfed, and also for a Ladies' Pavilion.
On 22nd July 1955, lightning struck a boys' camp at Jackey Bakers Sports Ground,

killing a 16 year-old boy and injuring 8 others.
SEE Farms/ Northwood/ Sport/ Stancomb-Wills, Dame Janet/ Sport

JACK THE RIPPER
This was the pseudonym of the murderer of five prostitutes in Whitechapel, London in 1888; crimes which still remain unsolved.
SEE Murder/ Prostitutes/ Sickert, Walter Richard/ Warren, Sir Charles

JACKSON'S WHARF public house
York Street, Ramsgate
Formerly The Crown Inn, and Crown Hotel, it was Ramsgate's oldest pub until it became a café style bar.
SEE Pubs/ Hotels/ Ramsgate/ York Street

JACOB'S LADDER, Ramsgate

To enable access from the cliff top to the harbour works, when Ramsgate Harbour was being built in 1753 or 1754, a timber-staircase (apparently named `Jacob's Ladder' after the carpenter, Jacob Steed, or Stead, who built it) was put at the end of the west pier. When, in 1823, the timber needed replacing, the present stone staircase was built slightly to the west of the original, but the name remained.
SEE Harbour, Ramsgate/ Ramsgate

JARVIS'S LANDING-PLACE, Margate
The first pier or jetty in Kent was Jarvis's Landing-Place at Margate in 1800. It was 1,120ft long, made of oak (English, obviously), cost £8,000 and could only be used at low tide because when the tide came in, it was covered - you've spotted the flaw in the design already haven't you?
The Picturesque Pocket Companion to Margate, Ramsgate, Broadstairs and the Parts Adjacent 1831: *Passengers are* (by this means) *enabled to reach the shore, when the water is too low for vessels to enter the harbour. This useful work* (cost) *£8,000. . . borne by the company of pier proprietors, from whom it must therefore be regarded as a munificent gift to the public. It is constructed of English oak, measures 1,120 feet in length, and at low and half tide, is deservedly considered one of the most inviting marine walks which fancy can imagine, or experience realise.*
Pigot's 1840: *Great difficulty having existed in landing passengers from the steam vessels at low water, in 1824 a wooden pier was constructed, which is carried one thousand and sixty two feet into the sea; it is eighteen feet wide, and has been found perfectly suitable to the purposes of its erection: it is named 'Jarvis's landing-place', in*

compliment to Mr. JARVIS, a resident gentleman of Margate, at whose suggestion this beneficial improvement was undertaken.
By 1855 Jarvis' jetty, or pier, needed replacing, as it had started to sag in the middle - and people who used piers didn't particularly like that quality in a pier.
SEE Margate/ Pier

JAZZ ROOM
Harbour Parade, Ramsgate
Previously the Waterfront Bar and Shipwrights Arms.
SEE Harbour Parade/ Pubs/ Ramsgate

J G JEBB
SEE Kingfisheries fishing tackle shop/ Shops

JEDI
From Star Wars, the Jedi are a peacekeeping monastic organisation.
There is no emotion; there is peace.
There is no ignorance; there is knowledge.
There is no passion; there is serenity.
There is no chaos; there is harmony.
There is no death; there is the Force.
According to the 2001 census, Thanet was home to 972 Jedi, all of whom had quietly turned up in the preceding ten years, because they didn't declare themselves in the 1991 census. So, one in every 120 people here is a Jedi. Just remember that, the next time you look around your packed supermarket on a Saturday morning. If your neighbour seems to return home with what you have assumed to be more replacement fluorescent tubes than the average household would normally require, think again, things may not be as they seem.
SEE Films/ Population/ Thanet

JENNINGS and DARBISHIRE
'You pre-historic clodpoll',
'You gruesome specimen',
'newt-brained shrimp-wit'
'Fossilised fish-hooks',
'Petrified paintpots!',
'Hide, Jennings!' gasped Darbishire. `Oh, don't talk such dehydrated eyewash,' Jennings answered impatiently. `Honestly, Darbi, I've met some bat-witted clodpolls in my time, but I reckon you win the silver challenge cup for addle-pated beetle-headedness against all comers.'
Jennings was a character created by Anthony Buckeridge who was a teacher at St Lawrence College in Ramsgate. Some of the story lines were said to have been inspired by events there!
Jennings appeared in a radio play before the books came out. 'Jennings Learns the Ropes' was broadcast on 16th October 1948 and there were more than 61 broadcasts until the last one in March 1962.
Written by Anthony Buckeridge there are 25 Jennings books:
'Jennings Goes to School' (1950);
'Jennings Follows a Clue' (1951);
'Jennings' Little Hut' (1951);
'Jennings and Darbishire' (1952);
'Jennings' Diary' (1953);
'According to Jennings' (1954);

'Our Friend Jennings' (1955);
'Thanks to Jennings' (1957);
'Take Jennings, for Instance' (1958);
'Jennings, as Usual' (1959);
'The Trouble with Jennings' (1960);
'Just Like Jennings' (1961);
'Leave it to Jennings' (1963);
'Jennings, Of Course!' (1964);
'Especially Jennings!' (1965);
'A Bookfull of Jennings' (1966);
'Jennings Abounding' (1967);
'Jennings in Particular' (1968);
'Trust Jennings!' (1969);
'The Jennings Report' (1970);
'Typically Jennings!' (1971);
'Speaking of Jennings!' (1973);
'Jennings at Large' (1977);
'Jennings Again!' (1991);
'That's Jennings (1994)'.
John Christopher Timothy Jennings, the son of a businessman in the stockbroker belt near Haywards Heath, attends Linbury Court Preparatory School, a boys-only boarding school (79 pupils aged between 8 and 14) in a former Elizabethan manor house in the village of Linbury (fictitious) near the market town of Dunhambury (fictitious) near Brighton (real). His best friend is Charles Edwin Jeremy Darbishire, the son of the Reverend Percival Darbishire, both father and son are often quoting proverbs and a bit pompous. Other pupils include his class mates and fellow boarders who were Venables, Atkinson, Bromwich (Head Newt Keeper) and Temple who is known as Bod (his name is Charles A Temple, thus CAT, which became 'Dog', 'Dogsbody' which got shortened to just 'Bod'). Pettigrew and Marshall were day pupils; Binns Minor and Blotwell were first formers whom Jennings and his cohorts looked down upon, like you do.
On the staff were the disciplinarian headmaster 'The Archbeako' (Mr M. W. B. Pemberton-Oakes); Jennings' housemaster Mr Michael Carter - said to be based on Anthony Buckeridge himself – a patient man who seemed to be able to detect any upcoming misbehaviour; 'Old Wilkie' aka Mr L P (Lancelot Phineas) Wilkins, Jennings' form master who had a huge temper and no patience but a good heart!; and there was the Matron who could be kind but was also able to weed out the malingerers – she also had a large ginger cat called George the Third. There was also Old Nightie and Old Pyjamas, Hawkins the night watchman and Robinson the odd job man, PC Honeyball, Farmer Arrowsmith and Lieutenant General Sir Melville Merridew DSO MC Bart the retired general and old boy of the school whose main role seemed to be giving out half holidays! Jennings also had an absent-minded Aunt Angela, Miss Angela Berkinshaw.
Buckeridge took the name of his main character from a boy, Diarmaid Jennings, who was in the year above him at his own school. `He was a bit of an oddball, I just used his name because it seemed to fit.' The real Jennings had emigrated to New Zealand before his name appeared in print.

He wrote stories about schoolboys because, *'I just happened to get a job at a preparatory school. If I had been an undertaker I would write funny stories about funerals'*

The books have been translated into at least 11 different languages. In France, Jennings is called Bennett, in Germany he is Fredy and in Norway, Stompa! (in Norway, he was so popular that some of the books were turned into films).

In the 1970s `Collins, my first publishers, said the books had had their day' mainly because books about boarding schools were old fashioned but many people drew parallels when the Harry Potter books came along and said that Hogwarts was based on Linbury Court. `The Potter books tell a good story, though I think they have magic instead of humour. But anything that encourages children to read is a good idea.'

SEE Books/ Buckeridge, Anthony/ Harry Potter/ New Zealand/ Radio/ Ramsgate/ St Lawrence College

Douglas JERROLD
Born 1803
Died 1857

This journalist, playwright and wit often stayed in and around Herne Bay for the summer and was subsequently a regular visitor to Margate. The main character in one of his popular domestic melodramas, 'Mrs. Caudle's Curtain Lectures' (1846), tries to show her husband's supposed flaws: *What will I do at Margate? Why, isn't there bathing, and picking up shells; and aren't there the packets* (the steamboats), *with the donkeys; and the last new novel – whatever it is, to read – for the only place where I really relish a book is at the seaside. No, it isn't that I like salt with my reading, Mr. Caudle! I suppose you call that a joke? You might keep your jokes for the day-time, I think.*

After a few days, Mrs Caudle changes her mind and it is somehow her husband's fault for bringing her here.

Other men can take their wives half over the world; but you think it quite enough to bring me down here to this hole of a place, where I know every pebble on the beach like an old acquaintance – where there's nothing to be seen but the same machines – the same jetty – the same donkeys – the same everything.

Jerrold was told by a very thin man, who was boring him, *'Sir, you are like a pin, but without its head or its point.'*

When reading an article in Blackwood's Magazine by A S Smith, of whom he had a low opinion, he noticed that Smith had merely put the initials 'AS' at the end of the article. *'What a pity Smith will only tell two-thirds of the truth.'* said Jerrold.

While on holiday at nearby Herne he visited Reculver:

There, reader, there – where you see that wave leaping up to kiss that big white stone – that is the very spot where Saint Augustine put down the sole of his Catholic foot. If it be not, we have been misinformed, and cheated of our money; we can say no more. Never mind the spot. Is there not a glory lighting up the whole beach?...

And there, where the ocean tumbles, was in the olden day a goodly town, sapped, swallowed by the wearing, voracious sea. At lowest tides, the people still discover odd, quaint, household relics, which, despite the homely breeding of the finders, must carry away their thoughts into the mist of time, and make them feel antiquity. … The village of **Reculvers** *is a choice work of antiquity. The spirit of King Ethelbert tarries there still, and lives enshrined in the sign of a public-house. It would be well for all kings could their spirits survive with such genial associations. . .*

Many of our gentle countrymen – fellow metropolitans – who once a-year wriggle out their souls from the slit of their tills to give the immortal essence sea air, make a pilgrimage to **Reculvers**. *This Golgotha, we have noted it, has to them especial attractions. Many are the mortal relics borne away to decorate a London chimney-piece.*

SEE Authors/ Bathing/ Conchology/ Donkeys/ Ethelbert/ Jetty/ Margate/ Reculver/ Steam Packets

JERSEY CABBAGE

Also known as Waterloo Cabbage, Jersey Kale or Cow Cabbage, they grow on a 'trunk' about 20ft tall. The stalks were used as walking sticks or as rafters in the roofs of thatched cottages! Livestock was fed the leaves, which were 3ft by 2ft; one cabbage could feed five cows or twenty sheep. It was said to improve the quality of the milk, and wool! Try asking for a Jersey Cabbage at the supermarket, and see how far you get – maybe not, you'll be eating the thing for weeks.

Letter from a Revenue Officer, 1811: *Circumstances have bade my person to inform your Majesty's Keeper of Ordnance so that the Tower may send more flint-lock carbines, for we of the service are at a dangerous disadvantage, which is due to smugglers who employ ruffians at two shillings per night to keep watch over the sea-gates when goods are landed without payment of dues. These ruffians are called 'Batmen' from a stout staff they carry called, a 'Bat' which is made from the trunk of a curious plant known hereabouts as Riding Cabbage, and even the lightest blow from which is capable of rendering a man senseless.*

Mr J Fullard grew them at White Swan Cottage in Reading Street, and in 1836 claimed that he had discovered this new phenomenon, although they had been cultivated in England for the previous three decades.

SEE Farms/ Reading Street

John JERVIS
Born Meaford, Staffs 9th January 1735
Died 14th March 1823

He served 73 years in the Royal Navy. This is the inscription on the memorial to him at St Michael's Church, Stone in Staffordshire: *John Jervis, Earl of St. Vincent, Viscount St. Vincent, Baron Jervis of Meaford in the county of Stafford, Knight Grand Cross of* the Order of the Bath, and of the Portuguese Order of the Tower And The Sword, Admiral of the Fleet and General of the Marines.

He was the second and youngest son of Swynfen Jervis of Meaford, Esq. by Elizabeth, daughter of George Parker of Park Hall in the county of Stafford, Esq - being born on the 20th of January 1735.

At the early age of thirteen he entered the Royal Navy, and remained, during a long and active life, one of the brightest ornaments.

In 1759, acting as commander of the Porcupine, he assisted in taking Quebec, and in the conquest of Canada.

In April 1782, when captain of the Foudroyant, he, separately from the rest of the fleet, boarded and captured La Pegase, a ship of 74 guns bearing the flag of a French admiral.

The modest terms in which his despatch was written, were finely contrasted with the glowing eulogy pronounced on him by Admiral Barrington, his commanding officer, and his merit was stamped by the gracious approbation of his sovereign, who created him Knight of the Bath.

Appointed to the command in 1793 of the squadron sent to the West Indies, he affected, in co-operation with General sir Charles Grey, a cordial union of the services, before unexampled, and by their combined efforts the islands of Martinique, Guadeloupe, St. Lucie and Mariegalante were speedily reduced - the gratitude of the nation was expressed by votes of both Houses of Parliament in England and Ireland; and the corporation of Liverpool, peculiarly interested in the prosperity of the west Indies, presented him with their freedom.

In 1795 he was appointed commander in chief in the Mediterranean: during this period a spirit of mutiny disorganised our fleets at home, but was crushed in its infancy in the fleet under his command by his unparalleled discipline.

On the ever memorable 14th of February 1797, he achieved off Cape St. Vincent with a far inferior force, that conquest over the Spanish fleet which carried his renown to the greatest height, and destroyed the effect of one of the most formidable combinations of the enemy ever directed against the power of Great Britain.

Having before this period been, for his former services, raised to the peerage by the title of Baron Jervis - now the joyful acclamations of his countrymen, the expressions of gratitude by numerous corporations which presented him with their freedom, the thanks of each house of the British and Irish legislature, received their triumphant sanction from the act of an approving sovereign, by whom he was promoted to the dignity of Earl and Viscount by the title of the name of the place which formed the scene of his glory.

In 1801 he was appointed first Lord of the Admiralty. By this nomination were realised the advantages which were expected from his experience as a naval captain; and the public interests were protected by the reforms

which as a patriot statesman he effected in the civil departments of the navy.

He instituted the memorable commission of naval enquiry, a measure which drew upon him the hatred and opposition of a host of placemen and pensioners, but which, eminently characteristic of his own purity, integrity, and love of economy, was admirably calculated to detect and prevent fraud, peculation and profusion in the administration of the finances of the country.

In 1806 he was appointed to the Channel fleet, and exercised that command till 1807.

To the last period of his life fresh honours continued to flow on him.

In 1809, Portugal gave him the grand cross of the order of the Tower And The Sword.

In 1814 he was made General of the Marines; and in 1827, seventy-three years after his entrance into the service, he was appointed Admiral of the Fleet.

Having attained his 89th year he expired on the 13th of March 1823: in the full possession of all his faculties.

He married his first cousin, Martha, daughter of the late right honourable Sir Thomas Parker, Knight, Lord Chief Baron of the Exchequer, but left no issue.

His mortal remains are deposited in the adjacent family mausoleum.

He joined the Navy a few days after his fourteenth birthday and his father gave him £20 but afterwards refused any more support. When Jervis became an Admiral he commented that the fleet 'was at the lowest ebb of licentousness and ill discipline'. He told his officers that 'the present indiscipline of the Navy originated with the licentious conduct of the officers'. He set about changing things. He ordered that all decks were to be scrubbed before sunrise, 'so that the ships may seize that favourable moment to get under way, chase and fall suddenly upon an enemy'. He moved his officers from ship to ship to improve the worst ones. He described Sir Charles Knowles, the captain of the Goliath as 'an imbecile, totally incompetent, the Goliath no use whatever under his command.' So he had him swap with Captain Foley of the Britannia. The Britannia got worse and the Goliath got better. He described the Theseus as 'a hotbed of mutiny and intrigue' so he instructed Nelson to take Captain Miller and any other men from the Agamemnom that he wanted saying, 'Nelson and Miller will soon put Theseus to right'. A fortnight later an open letter was found on the deck of the Theseus, 'Success attend Admiral Nelson! God bless Captain Miller! We thank them for the Officers they have placed over us. We are happy and comfortable, and will shed every drop of blood in our veins to support them, and the name of the Theseus shall be immortalized as high as the Captain's. Ship's Company'

Letter to Captain Lord Garlies in 1797: We have had five executions for mutiny and a punishment of 300 lashes given alongside two disorderly line-of-battle ships and the frigate to which the mutineer belonged. He took it all at one time and exhorted the spectators to mind what they were about, for he had brought it upon himself. Two men have been executed for sodomy and the whole seven have been proved to be most atrocious villains, who long ago deserved the fate they met with for their crimes. At present there is every appearance of content and proper subordination.

It should also be pointed out that Jervis did have a sense of humour, albeit a rather grim one, and could show great acts of kindness to his crew. On one occasion when one of his crew, whom he regarded highly, lost his savings of £70 while swimming, Jervis gave the man £70 from his own pocket in front of the whole crew.

When Jervis was replaced as Commander in Chief, Mediterranean, Nelson wrote to him, My dear Lord,

We have a report that you are going home. This distresses us most exceedingly and me in particular; so much so that I have serious thoughts of returning, if that event should take place. But for the sake of our country, do not quit us at this serious momemt. I wish not to detract from the merit of whoever may be your successor; but it must take a length of time to be in any manner a St. Vincent. We look up to you......be again our St. Vincent, and we shall be happy.

His replacement was Admiral Lord Kieth.

Jervis commanded his fleet at the Battle of St Vincent from his flagship Victory and following his victory was created Baron Jervis and awarded a pension of £3,000 a year.

SEE Admirals/ Earl St Vincent public house/ East Cliff Lodge

JETTY (stone)

Now, when I were a lad, the jetty was the stone one and the pier was the wooden one. Nowadays the wooden pier is gone and the stone one gets called the pier and there is a lot of confusion – no? Just me then. Anyway this entry in the book is about the stone one even though it was originally referred to as a pier before the wooden one was built. Hence any references to a pier in this section are referring to the stone jetty that still exists today.

Even as far back as Henry VIII, there is a reference to a pier at Margate (sadly no Candye Flosse, nor 'Thoue must Kisse me Quicke' hattes, are mentioned)

'Margate lyith in St John's paroche yn Thanet, a v miles upward fro Reculver, and there is a village and a peere for shyppes but now sore decayed.' Leland

By the time of Elizabeth I, two pier wardens and their deputies were charging a form of duty on the corn and anything else being brought into the harbour.

In 1662 the Lord Warden of the Cinque Ports, James, Duke of York, received a complaint that the pier and harbour were falling into disrepair; a charge that would continue until an Act was passed in 1715.

In 1776 the Pier wardens, Francis Cobb and John Baker, were granted a licence to hold a market in Margate.

In 1789 Margate Pier was re-built – only later to be damaged in the great storm of 14th January 1808. The replacement was 60ft wide and 900ft long and was built at a cost of £60,000 between 1810 and 1813 by Messrs Rennie and Jessup.

The New Margate, Ramsgate and Broadstairs Guide (1809): Of the many delightful walks in and about Margate, this (jetty) is the most frequented, (being) uncommonly crowded at the coming in or going out of the packets, which is generally termed hoy fair, and on it are frequently to be seen upwards of a thousand persons of all distinctions, indiscriminately blended together; and it can therefore be no wonder, if the humours of such a motley group, welcoming their newcomers, should not now and then occasion such diverting scenes as to baffle all possibility of description.

Pigot's 1840: 'The new pier, the plan of the late Mr Rennie, built of Whitby stone, is nine hundred and one feet long, sixty feet wide in the broadest part, and twenty-six feet high, with a parapet of four feet six inches. The promenade and fashionable evening lounge of the summer visitants, is eight hundred and fifty six feet in length, eighteen feet in width, and elevated seven feet and a half above the level of the pier; it is defended from the sun and rain by canvass awnings; a band of music attends and at night the whole is brilliantly illuminated with gas.'

SEE Cinque Ports/ Cobbs/ Jarvis's Landing Place/ Jerrold, Douglas/ Margate/ Only Fools and Horses/ Reculver/ Steam packets/ Storms

JEWEL of THANET

Broadstairs is often known as the 'Jewel of Thanet'.

SEE Broadstairs

JOHN BAYLY'S TEA DEALERSHIP & CHEESEMONGER'S SHOP, Margate

On the corner of Queen Street and the High Street, where Boots the Chemists now stands, was the site of Margate's oldest shop premises. The original John Bayly's Tea Dealership and Cheesemonger's Shop was said to have been established in 1697, in what was then called the King's Highway, but rebuilt in 1860. In 1881, drainage and sewers arrived! All water came from wells behind the shop until running water, as we know it, was installed in 1890. The redevelopment that resulted in The Centre occurred in 1971.

SEE Boots/ High Street, Margate/ Margate/ Shops

Lionel Pigot JOHNSON

Born Broadstairs 15th March 1867
Died 4th October 1902

He was the son of Captain William Victor Johnson of the 90th Light Infantry, but unlike his brothers, the small frail Lionel did not join the army. He attended Winchester College and New College, Oxford and lived alone (he never married), at Gray's Inn Square, Lincoln's Inn Square, and Clifford's Inn where he wrote poetry and reviews. A devout Catholic, he produced just three books in his lifetime, 'The Art of Thomas Hardy' (1894), 'Poems' (1895), and 'Ireland

and Other Poems' (1897). His 'Birthday Verse' alludes to his Broadstairs origins. He had a drink problem in more ways than one; firstly, he was virtually an alcoholic; and secondly, he died from injuries received after falling off a bar stool.
SEE Authors/ Broadstairs/ Poets

Robb JOHNSON
He gave up a teaching career to become a full-time singer songwriter and his song 'One Broadstairs Morning' is on his album 'The Triumph of Hope Over Experience'.
SEE Broadstairs/ Music

JOLLY FARMER public house
High Street, Manston
It dates back at least as far as 1777. William Davis (1627-90) from Bagshot was a footpad, highwayman or at any rate a thief who earned the popular name of the Golden Farmer. Jolly Farmer is a corruption of that name, and explains the many pubs of that era that carry this name.
This pub had been a popular staging post for the coaches that left and entered Ramsgate, before becoming a popular hostelry for the Battle of Britain aircrews from Manston. Before they were knocked into one in the 1980s, the two bars here were called the Hurricane Bar and the Spitfire Bar.
SEE Manston/ Pubs/ Spitfire

JOLLY SAILOR INN
King Street, Ramsgate
This stood opposite Underdown's forge and was notable for an enormous jug that stood on the roof. It was called the Cinque Ports Arms when it was demolished in 1961.
SEE Cinque Ports/ King Street, Ramsgate/ Pubs/ Ramsgate

Henry Arthur JONES
Born 28th September
Died 1929
The playwright was born in Buckinghamshire but at the age of 12 he was sent to live with his cruel uncle in Ramsgate. His uncle was a stern deacon in a Baptist chapel and for the next 6 or 7 years had Henry working 14-hour days. Henry wrote his first play two years before he had even been in a theatre and became a success with melodramas like 'The Silver King' and 'The Middleman', as well as the comedies, 'The Liars', 'Dolly Reforming Herself', and 'The Case of Rebellious Susan'.
SEE Authors/ Ramsgate

Mrs JORDAN
Born 21st November 1761 (or 1762 or 1752)
Died 3rd July 1816
Born to an Irish father and a Welsh mother, Dorothea (or Dora, or Dorothy) Bland became famous as Dora Jordan, but took the stage name of Mrs Jordan because it was more respectable for a married woman to be on the stage. She was known for her spontaneous charm and was the most famous actress/comedienne of her age. Making her stage debut in 1777, she starred at the Drury Lane for the first time in 1785, and was a huge star for around thirty years. Her favourite venue is said to have been the Theatre Royal, Margate, where her many roles included playing Lady Teazle in 'School for Scoundrels', and Peggy in 'The Country Girl' by David Garrick. She returned here year after year staying at local hotels where she would write to the Duke of Clarence with whom she lived at Bushy House in Middlesex (now the National Physical Laboratory – The UK's National Measurement Laboratory) for twenty years, from around 1790. They had ten children, seven born while they were living at Bushy House (she already had five children before she met the Duke!). One letter home to him said, *'I attend Methodist meetings whenever I can. My favourite preacher is a fisherman who is seeking souls all morning and sending them to the devil in the evening'*. As a star of the theatre she was highly paid and regularly paid the Duke's debts and his household bills. She was under pressure to find a rich wife so that when he thought he was going to marry an heiress, he dumped Dorothea in around 1811 or 1812. The Duke did make a generous financial settlement but the split devastated her. She decided to retire from the stage, and her last performance at Margate was as Violante in 'The Wonder' on 29th July 1815 for which the audience gave her a magnificent send off. By now she had money problems of her own, caused mainly by a son-in-law running up debts in her name. Afraid that she would be arrested for the debts, she went to France using the name Mrs James, where she died, aged 54, alone and virtually penniless in a non-descript lodging house in St Cloud outside Paris and was buried there.
The Duke went on to marry Adelaide of Saxe-Meinengen, a German Princess in 1818, he became King William IV in 1830 – and when he was woken up to be told that his brother had died and he was now the king, he famously said he must return to bed because he *'always wished to sleep with a Queen'*. A strange, even poignant end to the story is that he commissioned a statue of Mrs Jordan in 1831 which ended up in Buckingham Palace. The plaster cast was last seen at the Ashmolean Museum's basement where, to make room for an air raid shelter, it was smashed up during World War II. (see 'Mrs Jordan's Profession' by Claire Tomalin)
SEE Actors/ Margate/ Mistress/ Theatre Royal/ William IV

Sir William Joseph JORDAN
Born Ramsgate, 19th May 1879
Died Auckland, New Zealand, 8th April 1959
He was the son of William Jordan, a fisherman, and his wife Elizabeth Ann Catt. An old boy of St George's School, his family moved to London where he worked as a coach painter and a policeman. He emigrated to New Zealand in 1904 and became a sheep farmer. At the age of 37 he married a draper's assistant, Winifred Amy Bycroft on 30th January 1917, and seventeen days later he joined the army! It was not until March the following year that he saw any action, and within two weeks had been wounded, seriously enough to be transferred to a teaching position – amongst other things he taught beekeeping! Having failed in the 1919 election he was elected to the New Zealand parliament in 1922 and was a successful Labour MP working hard for his constituents. When his party won the 1935 election he was appointed New Zealand High Commissioner in London, a position he held for fifteen years. Returning to his hometown, he was made a freeman of the Borough of Ramsgate on 18th March 1937. He represented New Zealand at the League of Nations between 1936 and 1939, and was president in 1938. He was convinced that world war was inconceivable, and wrote to the New Zealand Prime Minister, M. J. Savage, *'we shall not see war involving our Empire in our lifetime'*, and said as much in a radio interview. Six months later, he said that *'I could not believe that the world was so mad as to go to war'*. Such was his concern for the welfare of New Zealand servicemen and women stationed in London in the war, that he is said to have lent them money, often out of his own pocket. In the 1946 Paris Peace Conference he astonished the world's press when infuriated by the Russian's endless delaying tactics, shouting out, *'Here we sit listening to quack, quack, quack, hour after hour. We are sick of it!'* – we've all been in meetings like that though.
One of his deputies, Major General W. G. Stevens, said of him that he was *'the most unforgetting and unforgiving man I have ever known.'* He despised all clerks, had a vicious temper, and carried on a lengthy feud with Walter Nash, the deputy Prime Minister at the time.
His wife died in 1950, and he asked E. M. Iggulden, his secretary for years, to move in with him. Indignant, she refused, and he effectively turned his back on her. In 1951 he retired to Auckland, where he married Elizabeth Ross Reid, née Riddell, on 1st July 1952. When he died there on 8th April 1959 he was survived by two children from his first marriage together with his second wife.
The Jordan trophy played between England and New Zealand at cricket is named after him.
SEE Cricket/ New Zealand/ Politics/ Radio/ Ramsgate/ St Georges School

'JORROCKS JAUNTS and JOLLITIES'
by Robert Smith Surtees
Aquatics: Mr Jorrocks at Margate:
Well, then, to-morrow at two we'll start for Margate - the most delightful place in all the world, where we will have a rare jollification, and can stay just as long as the money holds out.
SEE Books/ Margate/ Reculver, Jorrocks/ Surtees, RS

JOSS BAY, Broadstairs
Joss Snelling is said to have got his name from the bay, but it is probably named after the Josse family who owned farmland here. In 1933 the Broadstairs and St Peter's Urban District Council paid £20,000 for the foreshore of Joss Bay.

This sandy bay is around 200 metres wide ad is popular with surfers. It has car parking for around 200 cars.

SEE Bays/ Broadstairs/ Farms/ Josse family/ Snelling, Joss/ Sound Location

JOSSE FAMILY

The Josse family owned Josse Farm (later called Elmwood Farm) and the surrounding land in Elizabethan times. They made the gap – Joss Gap - in the cliff so they could collect seaweed to use as fertiliser on the farm.

SEE Broadstairs/ Farms/ Joss Bay, Broadstairs

Richard JOY

Near the front entrance to St Peter's churchyard, in St Peter's, is the tombstone of Richard Joy. He was known as the Kentish Samson because he was able to lift over a ton in weight, pull against the strongest horse, and break ropes that could take 35 cwt of strain. He took to smuggling and got caught, but because the King was so impressed with his strongman party pieces, he was pressed into the navy instead of being hung. While serving on a man-o'-war he asked for a double ration of rum and was told by the captain that he had to do two men's work first. He promptly picked up a large cannon and moved it from the port side of the deck to the starboard side; six men struggled to put it back. He got his double ration. He drowned, aged 67, on 18th May 1742 while smuggling. His tombstone reads:

Herculean hero! Fam'd for strength
At last lies here his breadth and length
See how the mighty man is fall'n!
And the same judgment does befall
Goliath great, as David small.

Daniel Defoe wrote about him although he refers to him as a Ramsgate man:

It was from this town of Ramsgate, that a fellow of gigantic strength, though not of extraordinary stature, came abroad in the world, and was called the English Sampson, and who suffered men to fasten the strongest horse they could find to a rope, and the rope around his loins, sitting on the ground, with his feet straight out against a post, and no horse could stir him; several other proofs of an incredible strength he gave before the king, and abundance of the nobility at Kensington, which no other man could equal; but his history was very short, for in about a year he disappeared, and we heard no more of him since.

SEE St Peter's/ St Peter's Church

JUBILEE CLOCK TOWER, Broadstairs

The Jubilee Clock Tower was built as a gift to the town by H H Marks JP MP in 1897 for Queen Victoria's Diamond Jubilee. To commemorate the landing of the Viking ship Hugin in 1949, a Viking ship weather vane was made by C Hodson of the Reading Street garage. An electrical fault caused the tower to burn down in 1975 but apprentices at Thanet Technical Collage rebuilt it in commemoration of Queen Elizabeth II's Silver Jubilee, which nicely brought its existence full circle.

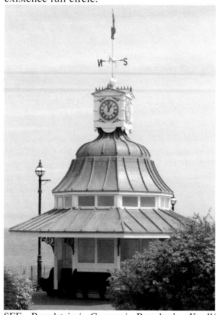

SEE Broadstairs/ Garages/ Preacher's Knoll/ Victoria/ Viking Bay

JUTES

They were a tribe from Denmark and northern Germany. According to the Venerable Bede, they were involved in the 5th century AD conquest of south eastern Britain. Their territory, Jutland, bordered that of the Saxons and the Angles, who combined to force the Britons westwards into Wales. The Jutes soon became assimilated into the population and the term was no longer in use by the 8th century.

SEE Bede/ Cemeteries/ Denmark/ Monkton/ Ozengell/ Sheltering Tree

Edmund KEAN

Born London, 17th March 1787
Died Richmond, 15th May 1833
He was the greatest Shakespearean actor of his day, and his last appearance was on stage with his son, Charles, in Othello at Covent Garden on 25th March 1833. Midway through the play (Act III Scene III, if you want to be specific, just after the line 'Villain, be sure,') he collapsed saying, *'O God, I am dying. Speak to them, Charles'*. He was dying, but it was 15th May before he finally died.

SEE Actors/ Shakespeare/ Theatre Royal

John KEATS

Born Enfield, 31st October 1795
Died Rome 23rd February 1821
His dad was the ostler at the Swan and Hoop Inn and livery stable (today it is called 'The John Keats at Moorgate') and life was good for young John until he was seven and his father fell from a horse, fractured his skull and died. His mum quickly re-married, and just as quickly left her new husband and moved in with John's grandmother. The school he attended taught him to love literature.

In 1810 his mum died of tuberculosis. His grandmother appointed two guardians to look after Keats and his siblings. These guardians, in their infinite wisdom, took John away from the school he liked to become an apprentice to a surgeon. In 1814 an argument with his Gran saw him leave the apprenticeship and become a student at a hospital. In time, he qualified as a licensed pharmacist, but he never actually became one as he had decided instead to be a poet, and thus spent more of his time studying poetry than medicine.

In August and September 1816, aged 20, and accompanied by his brother Tom, John Keats left London in search of mental refreshment and came to a Margate lodging house. Here he wrote a sonnet, three poems, and an Epistle on the pleasures of poetry, to his brother George.

To my Brother George
Many the wonders I this day have seen:
The sun when first he kissed away the tears
That filled the eyes of morn; the laurelled peers
Who from the feathery gold of evening lean;
The ocean with its vastness, its blue green,
Its ships, its rocks, its caves, its hopes, its fears,
Its voice mysterious, which who so hears
Must think on what will be, and what has been...
Of late, too, I have had much calm enjoyment,
Stretched on the grass at my best loved employment
Of scribbling lines for you. These things I thought
While, in my face, the freshest breeze I caught.
E'en now I'm pillowed on a bed of flowers
That crowns a lofty cliff, which proudly towers
Above the ocean-waves. The stalks and blades
Chequer my tablet with their quivering shades.
On one side is a field of drooping oats
Through which the poppies show their scarlet coats,
So pert and useless that they bring to mind
The scarlet coats that pester human-kind.
And on the other side, outspread, is seen
Ocean's blue mantle streaked with purple and green

Soon after, presumably refreshed, he moved to Canterbury where he hoped the spirit of Chaucer would *'set me forward like a Billiard-Ball'*

He moved to the Isle of Wight in 1817. At the same time his brother Tom, of whom he was now taking care, had tuberculosis

In a letter to Leigh Hunt sent from Margate, 10th May 1817, Keats says: *On arriving at this treeless affair I wrote to my Brother George...*

I went to the Isle of Wight - thought so much about Poetry so long together that I could not get to sleep at night - and moreover, I know not how it was, I could not get wholesome food - By this means in a Week or so I became not over capable in my upper Stories, and set off pell mell for Margate, at least 150 Miles - because forsooth I fancied that I should like my old Lodging here, and could contrive to do without Trees.

He finished his epic poem Endymion and went to Scotland and Ireland to hike with his friend Charles Brown. The trip was cut short because Brown showed signs of . . . tuberculosis. When John returned, he found Tom much worse, and in 1818 Tom died. At this point John moved into Charles Brown's house and soon after met, and fell in love with, Fanny Brawne. In later years, the Victorians were shocked (as in, 'that's awful – read me some more') when their letters were published.

The relationship ended when John himself contracted tuberculosis, which, in turn, caused many haemorrhages. Doctors advised that the sunnier climes of Italy would relieve some of his discomfort. He was accompanied by Joseph Severn, an artist, and in November 1820 they arrived in Rome. In December John had a violent relapse that was so severe, he attempted suicide. He constantly asked his doctors, *'When will this posthumous life of mine come to an end? I feel the flowers growing over me'.* The answer was 23rd February. He died in the arms of Severn, who had been his constant companion throughout his illness, *'I shall die easy. Don't be frightened. Thank God it has come.'* He was 26.

He was buried in the Protestant Cemetery in Rome and the inscription on the tomb read, *'Here lies one whose name was writ in water.'*

In his lifetime, his work was savagely attacked by the critics who suggested he give up poetry.

'In my heaven he walks eternally with Shakespeare and the Greeks' Oscar Wilde

The following was written in, and about Minster:

> *Bertha was a maiden fair,*
> *Dwelling in the old Minster-square,*
> *From her fire-side she could see,*
> *Sidelong, its rich antiquity,*
> *Far as the Bishop's garden-wall;*
> *Where sycamores and elm-trees tall,*
> *Full-leav'd, the forest had outstript,*
> *By no sharp north-wind ever nipt,*
> *So shelter'd by the mighty pile.*
> *Bertha arose, and read awhile,*
> *With forehead 'gainst the window-pane.*
> *Again she try'd, and then again,*
> *Until the dusk eve left her dark*
> *Upon the legend of St. Mark.*
> *From plaited lawn-frill, fine and thin,*

> *She lifted up her soft warm chin,*
> *With aching neck and swimming eyes,*
> *And daz'd with saintly imageries.*
> *All was gloom, and silent all,*
> *Save now and then the still foot-fall*
> *Of one returning homewards late,*
> *Past the echoing minster-gate.*

SEE Margate/ Minster/ Poets

Thomas Harman KEBLE

Born 17th October 1814
Died 10th July 1896

An only son, Keble was aged just two when his father died and he was subsequently brought up by his uncle who lived in Sandwich; his father had lived in Eastry.

He married in 1835 and ran a publishing business at 11 Bolt Court, Fleet Street (premises previously occupied by William Cobbett) dealing mainly in elementary school books that were printed at his Margate works. Fed up with commuting, he founded Keble's Margate and Ramsgate Gazette, a forerunner of the Isle of Thanet Gazette.

He was mayor in 1864, and two years later became a magistrate.

SEE Cobbett, William/ Keble's Gazette/ Margate/ Sandwich

KEBLE'S MARGATE AND RAMSGATE GAZETTE

The first issue came out on 3rd March 1870 and consisted of four pages, on each of which were four columns.

It was first printed at Thomas Keble's printing works behind Albert Terrace; handy for Keble because he lived at 72 High Street, so did not have far to go to work.

A year after Keble's son, also named Harman, took over the business and moved it to larger premises at 25 Cecil Square.

SEE Cecil Square/ High Street, Margate/ Keble, Thomas Harman/ Margate/ Newspapers

Michael KELLY

Born Dublin, 25th December 1762
Died Margate 9th October 1826

The eldest boy of 14 children, his father was the master of ceremonies at Dublin Castle and was also a wine merchant, on the side. He noticed in Michael a flair for comedy and a fine singing voice and thus young Michael was educated in Dublin and in Italy (Naples and Palermo). He sang at Vienna's Court Theatre from 1783-87. Emperor Joseph II assumed he was Italian and misunderstood his name; the whole time he was there the emperor referred to him as 'Ochelli'. Here he became a friend of Mozart and sang in the first performance of the Nozze di Figaro in 1786. In Kelly's 'Reminiscences' (1826) he wrote of Mozart: *'He was a remarkable small man, very thin and pale, with a profusion of fine, fair hair, of which he was rather vain...He was remarkable fond of punch, of which beverage I have seen him take copious draughts...He was kind-hearted, and always ready to oblige; but so very particular, when he played, that if the slightest noise were made, he instantly left off...His feeling, the rapidity of his fingers, the great execution and strength of his left hand, particularly, and the apparent*

inspiration of his modulations, astounded me...Mozart was very liberal in giving praise to those who deserved it; but felt a thorough contempt for insolent mediocrity.'

In February 1787, to enable him to see his dying mother, he was given several months leave of absence from Vienna. The Emperor wrote to Rosenberg-Orsini, the opera director, *'It would be a real loss for the Italian opera company, for he is excellent in several roles and never less than good in any of them'.* He never returned to Vienna, but later that year he sang at Drury Lane and was very successful. He became the theatre's principal English tenor and director of music. He also composed operas; his most popular was 'Blue Beard' (1798) which was in the theatre's repertoire for the next twenty-five years. He became the acting-manager of the Kings Theatre in 1793. He wrote songs and was in demand to sing in various concerts. He opened a saloon in Pall Mall in 1801, publishing music and selling wine, although, eventually, the business went bust. His performed for the last time at Drury Lane on 17th June 1808, and in Dublin on 5th September 1811. His retirement was plagued by gout.

He wrote a book, Reminiscences, in 1826 – well, he dictated it, as he was close to death by this time:

At the end of the opera thought the audience would never have done applauding and calling for Mozart; almost every piece was encored, which prolonged it nearly to the length of three operas (it already lasts at least 4 hours!) and induced the Emperor to issue an order on the second representation that no piece of music should be encored. Never was anything more complete than the triumph of Mozart.

His career covered virtually every aspect of theatre and opera, and he died in Margate aged 63.

He was a friend of both Sheridan and of the Prince Regent - it is rumoured that he and the prince shared Mrs Anna Crouch, a singer and actress, as a mistress.

SEE Margate/ Music

A B C KEMPE

Alderman Arthur Bloomfield Courtney Kempe moved to Ramsgate from Devon in 1931 and became a councillor in 1934. When he was elected Mayor of Ramsgate on 9th November 1938, he declared that *'We will make Ramsgate not only the talk of the country but the talk of the world'.* He later remembered that, *'When I was elected mayor I said I would dress like one. I told a young reporter friend of mine, Ken Bindoff, that I intended to wear a top hat and a frock coat.'* He kept his word. An extrovert, almost flamboyant figure, he worked hard on Ramsgate's behalf holding parties on the beach and visiting factories as far away as Coventry to extol the virtues of a holiday in Ramsgate.

He went to Coventry to publicise the £3 17s 6d holiday to Ramsgate that included rail fares, board and lodging as well as entry to

entertainments every night. Not surprisingly, they were a big success.

A tea party on the sands in 1939 attracted 12,000 people, and that same summer the Pearly King of Southwark led over twenty other pearly kings and queens to Ramsgate. The next day the Daily Mirror had a photo of Kempe doing the Lambeth walk with the Pearly Queen of Bethnal Green.

He was host to many celebrities of the time, including Conrad Veidt, Jessie Matthews, and Valerie Hobson.

With war looming, the building of Ramsgate's tunnels came under his ultimate control and he was instrumental in Guildford's 'adoption' of Ramsgate after an air raid on 24th August 1940. He ran a concert party - The Troopers - and became a military welfare officer.

He retired as mayor in November 1941 and on 24th March 1950 was elected an Honorary Freeman of the Borough of Ramsgate.
SEE Kent Place/ Matthews, Jessie/ Ramsgate/ Tunnels, Ramsgate

KENELM CHILLINGLY - HIS ADVENTURES AND OPINIONS
by Bulwer Lytton (Lord Lytton)
Miss Margaret, the eldest, was the commanding one of the three; it was she who regulated their household (they all lived together), kept the joint purse, and decided every doubtful point that arose: whether they should or should not ask Mrs. So-and-so to tea; whether Mary should or should not be discharged; whether or not they should go to Broadstairs or to Sandgate for the month of October. In fact, Miss Margaret was the WILL of the body corporate.
SEE Books/ Broadstairs/ Bulwer Lytton, Edward

KENT CYCLISTS TERRITORIAL FORCE
They held their camp at Callis Court Road in July 1914. All 447 of their members cycled to St George's Church, Ramsgate for Church Parade.
SEE St George's Church/ Sea Wall/ Transport

KENT GARDENS, Birchington
This road was originally just a track that led to Minnis Bay.
SEE Birchington/ Minnis Bay

KENT HOTEL
Marine Terrace, Margate
Mr White built The Kent Hotel in the 1840s at 1 Lower Marine Terrace, later to be re-numbered 15 Marine Terrace. He also had a stake in the Elephant pub up the road and in those days it was open 24 hours a day. In 1852 the Woodruffs took over and in 1885 the Thurstons became the landlords. They had a friend called Mrs Hammond, who called herself Marion, and was a famous local poetess; she wrote a poem about the place which suggests that this is not the original Kent Hotel:

> *The old house stood, forlorn and drear*
> *Twas gone! and, lo! Upon its site*
> *There stood a house so fresh and bright*
> *With plants arranged in dainty row*
> *Upon the new built portico*

It had a reputation as being a rough pub after the war and the diminutive landlady, Ruby Banks, used to have two large Alsatian dogs that followed her around the bar as she restored order. In the 1960s, a photographer plied his trade on the pavement in this area. He had a small monkey for children to hold while he took their photograph. In the 70's and 80's there was a large newspaper stand on the pavement outside. In 1987 it became Flamingos amusement arcade but the Kent Hotel name can still be seen on the side of the building at the very top.
SEE Hotels/ Margate/ Marine Terrace/ Poets

KENT INTERNATIONAL AIRPORT
The airport formerly known as Manston.
SEE Manston Airport/ Transport

KENT PLACE, Ramsgate
The boys of the Forces started to land early one morning. One lady in Kent Place opened her door to fetch the milk in and seeing the lads outside asked them where they had come from. Finding out she immediately brought out her teapot and gave the lads a cup of tea and also the contents of her cupboard. The neighbours soon saw what was happening and they followed suit, and from this small commencement the whole town rallied and shopkeepers were emptying their windows and shelves before many hours had passed.
A B C Kempe on how Ramsgate helped those returning from Dunkirk
SEE Dunkirk/ Kempe, A B C/ Ramsgate

KENT STEPS, Ramsgate
SEE Albion Gardens, Hill and Place/ Ramsgate

Sean KERLY
Born 29th January 1960
He attended Chatham House School and went on to represent England in hockey, winning a Bronze medal at the 1984 Los Angeles Olympics and a gold medal at the 1988 Seoul Olympics.
SEE Chatham House/ Sport

KIDNAPPING
On the 18th July 1657 a boat landed at Minnis Bay, from which Captain Lendell led a mob of around 40 armed men to the Quex Estate, where they broke down the main gates, and marched on to the Mansion. The servants already in shock at this point, watched as next the mob broke down the doors, rounded them up, and forced one of the maids to take them to the rooms of Henry Crispe, who was nearly 80, and his son Nicholas, both of whom they then took prisoner and marched them off to their boat. On the way a deal was done whereby Nicholas was released on the understanding that he would bring £1,000 to the gang in Flanders in 28 days time. He would have to bring another £2,000 for his father's release.

Nicholas wrote to Oliver Cromwell to see whether his father could be exchanged for any Spanish prisoners. Cromwell agreed. For a fee of £1,500 three men went to get Henry out of his prison, but not only did Henry refuse to go with them, he told his captor Captain Lendell of the attempt!

Nicholas still tried to enlist Cromwell's assistance but the latter was suspicious that the exiled Charles II was implicated in the whole story and that it was a ruse to fund his return. Sadly, Nicholas died soon after – he was buried in November 1657 in the Quex Chapel of Birchington Church. His cousin, John Crispe, and his widow, Lady Thomasina, continued to negotiate and eventually, after visiting Bruge six times, Henry gave John permission to sell part of the estate to pay Lendell the ransom. In all, he was held captive for eight months, but in all that time he only learnt one word of his captor's language and that was 'Bonjour'. On his return he was nicknamed 'Bonjour Crispe' by the locals.

Henry was buried in the Quex Chapel on 27th July 1663.
SEE Birchington/ Churches/ Minnis Bay/ Quex

KING EDWARD VII public house
Dane Valley Road, Cliftonville
This building was originally a shop before the brewers, Thompson of Deal, opened the King Edward pub in Dane Valley Road in 1912; two years after the king had died. One landlord was there for thirty-eight years. In later years, it became a Charrington pub and, to avoid confusion with King Edward VIII, was re-named the King Edward VII.
SEE Breweries/ Cliftonville/ Dane Valley Arms/ Edward VII

KING EDWARD AVENUE, Margate
King Edward Avenue was hit by bombs on 1st March 1916.
SEE Clarendon Road/ Margate

KING ETHELBERT SCHOOL
Canterbury Road, Birchington
It opened in 1938 and currently has 750 pupils aged between 11 and 16.
SEE Birchington/ Canterbury Road, Birchington/ Emin, Tracey/ Ethelbert, King/ Schools

KING GEORGE VI MEMORIAL PARK
Ramsgate

The old border between Broadstairs and Ramsgate goes through this park. Previously, it was the site and grounds of East Cliff Lodge. The current George VI Memorial Park covers around 13 acres.
SEE Broadstairs/ East Cliff Lodge/ George VI/ Italianate greenhouse/ Parks/ Ramsgate

KING of DENMARK public house
Boundary Road,
Ramsgate
It opened in the 1860s and was named in honour of the father of Princess Alexandra who had recently married the Prince of Wales, the future Edward VII. It is now a Chinese Restaurant and Noodle Bar.
SEE Alexandra, Princess/ Boundary Road/ Denmark/ Pubs/ Ramsgate/ Restaurants

KING STREET, Margate

SEE Cobbs/ Fountain Inn/ Friend to all Nations/ Gas Works, Margate/ George Hotel/ Kingfisheries/ King's Head, Margate/ Margate/ Phoenix/ Royal albion Hotel, Margate/ Soper's Yard/ Tudor House

KING STREET, Ramsgate

It was originally known as 'East End' and at one point in the nineteenth century there were nineteen licensed premises in King Street.

Opposite the entrance to Broad Street, lived a Mr Cramp, a cobbler, in a thatched cottage with a well in the garden. The house was eventually removed around 1830 but the well often caused the new pavement above it to subside.

SEE Abbot's Hill/ Barnacles bar/ Blackburn's/ Bracey's/ Classic Cinema/ Deal Cutter pub/ Earl St Vincent pub/ Faversham and Thanet Co-op. Coc/ Forward, Stephen/ Harbour Street, Ramsgate/ Hodgman/ Jolly Sailor Inn/ Kings Cinema/ Midland Bank/ National Union of Women's Suffrage Societies/ Odeon Cinema/ Olby/ One way system/ Pilcher Page & Co/ Pointer/ Potatoes/ Ramsgate/ Red Lion Hotel/ Rodway's Dining Romms/ St Paul's Church/ Seaman's Infirmary/ Sole, the/ Vye and son/ York Arms/ York Street

KINGFISHERIES fishing tackle shop
34 King Street, Margate

Previously a slaughterhouse and then a coal store, Kingfisheries fishing tackle shop – often known as Russ's – was opened by J G Jebb in 1903. He had planned to open a bicycle shop but this changed when, on needing materials, he spotted an old tea clipper being scrapped in the harbour. He bought the timber and the masts which still exist as supports at the back of the building. Jebb died in 1949 and his daughter Edith Wilson took over. In 1963, Rene and Tony King took over, and ten years later Russ and Marion replaced them. The memory of J G Jebb still remains in the mosaic on the shop's step.

SEE Bicycle/ Fishing/ Margate/ Shops

KINGS AVENUE, Ramsgate

Although it appears on a 1907 map, very little housing had yet developed at that time.
SEE Ramsgate

KINGS CINEMA, King Street, Ramsgate

In 1910 Ramsgate's first purpose-built cinema was built. The King's Cinema was built on the site of the old stables belonging to The Red Lion. After 71 years it closed in 1981 and is now the home of the King's Fellowship.
SEE Cinemas/ King Street/ Ramsgate

KING'S HEAD public house
High Street, Margate

This dates from at least 1755 and was where auctions were held, attracting custom from the gentry who were visiting the neighbouring bathing rooms. At this point, the sea came right up to the back and the pub had a wooden staircase at the rear leading down to the beach. The eighteenth century artist George Morland, whom we will meet again in King Street and Love Lane, said of the Kings Head, 'a pleasant house, for at high water the sea comes up to the very wall of the house, and if you fell out of the window must surely be drowned'. George had a novel way of settling his bar bill when he was short of cash, and that was to do a quick sketch of the pub that he was in and give it to the landlord instead of cash. He was quite a character, and became a jockey at the popular horse races organised from the Kings Head that were held at Shottendane Road and Mount Pleasant. There were also pig races held there, but the jockeys would have been much smaller than the ones for horses. Anyway, George won his race but managed to infuriate 'four hundred sailors, smugglers, fishermen' who were led by a very unhappy inn keeper. They dragged him from his horse and were going to chuck him into the sea. Fortunately, he was rescued by the landlord of the New Inn, John Mitchener (who, incidently, was later landlord of the Ruby). In the evening after 'three crowns worth of punch' at The King's Head, George and his mates, armed with swordsticks (charming chaps) went off seeking reprisals, and eventually encountered a fairly rotund sailor on the bridge outside the Royal Albion in King Street where, despite outweighing George, the sailor apparently 'got his gruel'!

In 1808, a great storm destroyed much of this area including the bathing houses and machines but the King's Head was left largely intact. A grant from the government paid for a new promenade to be built at the rear of the pub which, in time, allowed the pub to expand. By 1885 The King's Head Hotel was at 46 and 48 High Street. During the following ten years it established a large frontage on Marine Drive. Customers enjoyed the use of stabling (for horses), a smoking room, coffee and billiards (for guests, and any horses good with a cue). In the early part of the twentieth century it was renamed Isaac's Hotel and Fish Restaurant

In 1893, Thomas Pearce, the proprietor, claimed it was the 'oldest family hotel in Margate'.

Since the 1990s it has been called Waverley, after a steamship of the same name.

SEE Bathing machines & Bathing rooms/ King Street, Margate/ Love Lane/ Margate/ Marine Drive/ Morland, George/ Pubs/ Restaurants/ Shottendane Road/ Storms

KINGS HEAD, Sarre

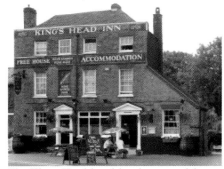

The Kings Head hotel has been an alehouse possibly as far back as 1630. In 1790, John Burtenshaw bought three adjoining houses in Sarre. The following year, Abraham Barnes re-built and enlarged two of them and opened the King's Head with the remaining cottage next to it, although this was demolished within a few years. In 1861 the pub was purchased by Rigden and Delmar.

In the 1900s, there was a garage and Tea Gardens. Between July 1940 and May 1947, the armed forces requisitioned the place.
SEE Garages/ Pubs/ Sarre

KINGSGATE

By a visitor to the area in the early seventeenth century: *This is but a poor fishing hamlet dating from the reign of Queen Elizabeth, it is old built and on the very edge of the sea. In but a few years one might reasonably expect the whole village to be devoured by the inroads of the sea. To halt this evil the locals have erected strong wooden groins, made from timber they have plundered from ships that have been wrecked hereabouts. I am inclined to think that those hovels which remain are so mean as to be not worth saving. The inhabitants are a surly lot and mighty fond of keeping very much to themselves. Tis my opinion that they prefer to fish for that which comes across the water rather than for that which comes out of it. Along this part of the coast I perceived several dragoons, riding officers, and others, armed and on horseback, riding about like huntsmen beating up their game; upon enquiry I found their diligence was employed in the quest for smugglers; I found too, that these patrols were often attacked at night by smugglers in such large and well armed bands, that the soldiers dare not resist, and most stand by whilst the contraband is taken away before their eyes. But I am told that of late many of these desperate fellows have been taken up, and the knots of this illicit industry are now very much broken-up, which is due to the vigilance of the riding officers in these parts.*

The Picturesque Pocket Companion to Margate Ramsgate & Broadstairs & the parts Adjacent by William Kidd, 1831: *Kingsgate is in the parish of St Peter, is one mile from Broadstairs, and three from Margate: it consisted formerly of a group of fisherman's hovels.*

There once was a coastguard station here.

SEE Arx Rouchim/ Batteries/ Broadstairs/ Captain Digby/ Coastguards/ Coleridge/ Curzon, Lord/ Emin, Tracey/ Fitzroy/ Hackemdown Point/ Hamilton, Charles/ Harley's Tower/ Holland House/ Kingsgate Bay/ Lawrence, DH/ Lord Haw Haw/ Louise Alberta, Princess/ Marsh, Sir Edward/ Northern Belle/ Percy Avenue/ Smuggling/ Vere Road/ Whiteness Manor School for Crippled Boys

KINGSGATE BAY

Walking along the beach from Botany Bay, the first glimpse that you get of Kingsgate Bay is of Kingsgate Castle framed by a chalk archway in the cliffs; possibly one of the best views in Thanet. The bay is around 150 metres wide and is probably the most royal part of Thanet. It was known as Bartholomew's Gate until Charles II landed there on 30th June 1683, with his brother the Duke of York, on his way from London to Dover, and promptly renamed it. What

Bartholomew's feelings about this were, history does not recall. Anyway, Mr Toddy of Josse who owned the land, composed a little ditty that was put up on the gate in brass letters:

Olim Porta Patroni Bartholomaei
Nunc, Regis jussu, Regia Porta vocor
Hic exscenderunt Car:Il. R.
Et Ja. Dux Ebor, 30 Junii, 1683

Which translates as (did no one have a classical education round here?):

I once by St Bartholomew was claimed
But now, so bids the King, am Kingsgate named.

And on the eastern side of the gate facing the sea: *God bless Barth'lem's Gate*
A medieval arch and portcullis once defended this ancient gap in the cliffs. It was demolished in c.1830 and rebuilt in the grounds of Port Regis.
A lifeboat was once stationed here and launched down the slipway (the narrow gap in the cliffs) - which must have been quite a white knuckle ride in itself, before they even got out to stormy seas.
Hengist and Horsa are said to have landed here.
SEE Bartholomew's Gate/ Botany Bay/ Hengist and Horsa/ Kingsgate Castle

KINGSGATE CASTLE

A Tudor farmhouse stood on this spot before Kingsgate Castle was built in 1763 by Lord Holland as a folly to be used as servants' quarters and a coach house.
The Picturesque Pocket Companion to Margate Ramsgate & Broadstairs & the parts Adjacent by William Kidd, 1831: *At Kingsgate are a number of fanciful buildings, erected by Lord Holland, to represent ancient ruins and antique edifices, of which the most remarkable is the castle, which in appearance is similar to those built in Wales, by Edward the First, for military stations, after he had conquered that mountainous country: it was originally intended for stables, but is now converted into a comfortable dwelling house.*
Later it became a hotel before conversion to its present use as flats in the 1950's.
SEE Eva Trout/ Farms/ Gray, Thomas/ Hackemdown Point/ Holland, Lord/ Holland House/ Kinggate Bay/ Lubbock, Sir John

Howard Primrose KNIGHT

The Coxswain of 'Prudential', the Ramsgate lifeboat, was awarded the Distinguished Service Medal for *'gallantry and determination when ferrying troops from the beaches of Dunkirk'.*
SEE Coxswain/ Dunkirk/ Lifeboat, Ramsgate/ Ramsgate

KNOWLER

Mr GEORGE KNOWLER, Dairyman and Greengrocer, British and Foreign Fruiterer
2 Cannon Road
'The Elms Dairy and Greengrocery Stores' has been catering for the public requirements for the past fifteen years. Mr Knowler supplies pure English country butter and new laid eggs, procured twice weekly direct from well-known dairy farms, and genuine new milk is delivered regularly twice daily to customers, who may have it sent at any hour to suit their convenience.
Ramsgate, by J S Rochard, c1900
SEE Cannon Road/ Ramsgate/ Shops

KOH-I-NOOR

It is the name of the very large diamond in the Coronation crown but locally was also the name of a Paddle-steamer that brought many visitors from London to Margate.
SEE Margate/ Queens Promenade, Cliftonville/ Ships

L

LA BELLE ALLIANCE

La Belle Alliance is the name of an inn in Belgium. On the morning of 18th June 1815 Napoleon Bonaparte used the inn as his headquarters for the Battle of Waterloo, but, at 9 o'clock that evening, the Duke of Wellington and Blücher were meeting there having just won the Battle. An interesting day for the inn-keeper. Blücher wanted to call the battle 'La Belle Alliance', and it was Wellington who insisted on it being the 'Battle of Waterloo'.
SEE Blucher/ La Belle Alliance Square/ Waterloo

LA BELLE ALLIANCE SQUARE
Ramsgate

The Hill family owned approximately two acres of land near a thoroughfare called Liberty Way but they sold it to a butcher, Thomas Spurgeon, who had borrowed the necessary money from his brother and fellow butcher, Nicholas. Even though the loan was effectively wiped out when Nicholas died in January 1828, Thomas still had financial problems and his property was possessed by his creditors.
Within a year it had passed to a builder, James Crisford, who set about developing the area. In November 1832, Richard Tomson, the brewer, purchased a plot with the condition that roads were built. As part of the development there was to be a pub, the Camden Arms.
Early on 18th January 1990, a man died when a huge explosion, thought to be caused by a gas leak, wrecked Conflans Court in La Belle Alliance Square.
SEE Camden Arms/ La Belle Alliance/ Ramsgate/ Tomson & Wotton

Danny LA RUE
Born 26th July 1927
The female impersonator, entertainer and *'comic in a frock'* stayed at the London Tavern whilst performing at the Theatre Royal in Margate.
SEE Entertainers/ London Tavern/ Secombe, Harry/ Theatre Royal

LABURNHAM HOUSE
Station Road, Birchington

The plot of land on which this house stands was part of the garden of another house that had been built in 1619 and was owned by Thomas Grenefelde, the local curate. It has Dutch shaped gables and was split into two houses in 1698.
Daniel and John Jarvis built the present house in 1765/6 for their widowed mother.
A Riding Officer – an early version of a Customs Officer – named Richard Laurence Bowles lived here in 1771 and the Sun Alliance Insurance Company Fire Mark (No. 283720) on the building tells us with whom he insured the building (for £250) and the contents (for £50).
In the mid-nineteenth century it was called Mulbery House. At the front of the house, where the pavement is now, was either a laburnum or a mulberry tree with a seat built around it. The tree was still there well into the twentieth century.

Nowadays the house is the premises of the Mulberry Tea Rooms.
SEE Birchington/ Station Road, Birchington

The relief of LADYSMITH

Ladysmith is a town in eastern South Africa founded in 1850 by the British and named after the wife of the then governor of the Cape Colony, Sir Harry Smith. In October 1899, Boers surrounded the British forces here until they were relieved by Sir Redvers Buller on 28th February 1900. In that time 3,200 people died from injuries and wounds and also from disease and hunger brought on by the lack of food and medical supplies.
SEE Addington Street/ Boer War/ Warren, Sir Charles

Freddie LAKER
Born 6th August 1922
Died 9th February 2006
Freddie Laker was born in Ramsgate and went to Simon Langton School in Canterbury. He joined Short Brothers in Rochester in 1938 and during the war worked with the Air Transport Auxiliary. He worked for Aviation Traders and then in 1960 joined British United Airways as managing director. Five years later they were Britain's largest independent carrier. On 26th September 1977, he launched his cut-price, no frills, walk on, Sky Train to New York. Tickets were £59, nearly £130 less than the normal fare. The enterprise collapsed on 5th February 1982 leaving 6,000 passengers stranded. Laker accused other airlines of conspiring to force him out of business and

in 1992, in an out-of-court settlement his creditors were paid off and Freddie received £5 million. He then set up Laker Airways, flying to US cities from the Bahamas.
SEE Ramsgate

Sir Francis LAKING
The Royal Physician lived at York Gate House in Harbour Street in 1910.
SEE Harbour Street, Broadstairs/ York Gate

LALEHAM SCHOOL, Cliftonville
The building that is now Laleham School was originally the Montrose Ladies College. In 1957, it was the Laleham School for Delicate Children (Kent Education Committee).
SEE Cliftonville/ Schools

Charles LAMB
Born, London 10th February 1775
Died 27th July 1834
He was educated at Christ's Hospital, where his lifelong friendship with his fellow pupil, and later poet, Samuel Taylor Coleridge began. He began work as a clerk in 1792 in the accounting department of East India House, London. He remained there until 1825 when he retired with a pension. At his office one day a superior inquired,
'What are you about, Mr Lamb?',
'About forty', replied Lamb.
'I like not your answer',
'Nor I your question', and Lamb returned to his task.
In 1796 his sister, Mary Ann Lamb (1764-1847), was seized by the first of her fits of temporary insanity and stabbed their parents, wounding their father and killing their invalid mother. To keep her out of an insane asylum, and despite Charles himself having suffered from a period of insanity when he was 20, he had himself appointed as her guardian. After she was released from three years of care in 1799, Charles looked after her for the rest of his life
Charles also had a literary career, writing plays and poems (he contributed four sonnets to Coleridge's 'Poems on Various Subjects' (1796), 'Blank Verse' (1798) and 'Pride's Cure' (1802)) as well as being a critic – most notably his 'Specimens of English Dramatic Poets who Lived about the Time of Shakespeare' (1808).
His most important work were the essays, personal reflections on life with touches of great humour and pathos, written between 1820 and 1825 under the pseudonym Elia for the London Magazine, and later published as books, 'Essays of Elia' (1823) and 'Last Essays of Elia' (1833). He also wrote for The Morning Chronicle, Morning Post and the The Quarterly Review.
His most enduring work was written in collaboration with his sister (who was a writer herself, particularly for children 'A child's a plaything for an hour', Mary Lamb, Parental Recollections), and published as 'Tales Founded on the Plays of Shakespeare' in 1807, but it was later entitled 'Tales from Shakespeare' and is still in print today. The book was a re-telling of twenty of

Shakespeare's plays for children. Charles was responsible for the tragedies ('Hamlet', 'King Lear', 'Macbeth', and 'Othello'); whilst Mary worked on 'Measure for Measure', 'Cymbeline', 'The Merchant of Venice' and the comedies ('A Midsummer Night's Dream' and 'The Tempest').
The Lambs' first visit to Margate 'for a sea change' was in 1801, and they were visited by Keats' friend Charles Cowden Clarke. In a letter to a friend in September 1801, Charles Lamb wrote: 'Your letter has found me at Margate, where I am come with Mary to drink sea water and pick up shells.'
It appears that Charles enjoyed their trip more than Mary. She told a friend prior to a return trip in 1803: '. . .we shall find the flat country of the Isle of Thanet very dull.'
Charles' 'The Old Margate Hoy' describes many seaside resorts, and shows that Margate was his favourite.
'my cousin contrives to wheedle me once in three or four seasons to a watering place. . . We have been dull at Worthing one summer, duller at Brighton another, dullest at Eastbourn, a third, and are at this moment doing dreary penance at – Hastings!- and all because we were happy many years ago at Margate. . . Can I forget thee, thou old Margate Hoy, with thy weather-beaten, sunburnt captain, and his rough accommodations? - ill-exchanged for the foppery and fresh-water niceness of the modern steam packet? To the winds and waves thou committedst thy gouty freightage. . . With the gales of heaven thou wentest swimmingly; or, when it was their pleasure, stoodest still with sailor-like patience. Thy course was natural, not forced, as in a hot-bed; nor didst thou go poisoning the breath of ocean with sulphureous smoke. . . All this time sat upon the edge of the deck . . . a lad, apparently very poor, very infirm, and very patient. . . we learned that he was going to Margate, with the hope of being admitted into the Infirmary there for sea-bathing. His disease was a scrofula, which appeared to have eaten all over him.'
In another letter, this time in 1821 he wrote: 'I am here at Margate, spoiling my holydays with a review I have undertaken for a friend'.
Whilst here, they were, like the rest of the population, quite excited by a huge whale that was washed up on the seashore.
Having struggled all through his life against poverty (as well as a stutter and his sister's madness) he did keep a sense of humour. His last words were 'My bed fellows are cramp and cough – we three all in one bed'.
All his friends were surprised that Charles left as much as £4,000, about double the amount that anyone expected. His property he left in trust to his sister, with an annuity of £240 a year. Like many people before and after, he put off making a will because he thought the action would bring forward his death. When he finally confronted his fear and made one he wrote as a postscript on it, 'I am not therefore going to die'.
He was also a great conversationalist and letter writer. His circle of friends included many contemporary writers, including his

old friend Coleridge, as well as William Wordsworth, William Hazlitt, Robert Southey Leigh Hunt, Percy Bysshe Shelley, Henry Brougham, Lord Byron, and Thomas Barnes.
The following are some quotes made by Charles Lamb:
- Wordsworth, 'I believe I could write like Shakespeare, if I had a mind to try it.' Lamb, 'Yes, nothing wanted but the mind.'
- 'His face when he repeats his verses hath its damaged glory, an Archangel a little damaged.' Charles Lamb, in a letter to Wordsworth, referring to Coleridge (26th April 1816)
- Samuel Taylor Coleridge had once been a Unitarian minister.
 Coleridge: 'I believe you never heard me preach, Charles?'
 Lamb: 'Yes, I believe I never heard you do anything else.'
- Quoting Coleridge's own phrase in a letter to Coleridge (5th December 1796), 'I could forgive a man for not enjoying Milton; but I would not call that man my friend who should be offended with 'the divine chit-chat of Cowper''
- Someone once asked Lamb how he had become such a keen pipe smoker, 'I toiled after it, sir, as some men toil after virtue'.
- For thy sake, tobacco, I
 Would do anything but die.
 A Farewell to Tobacco.
- Returning to town in the stage-coach which was filled with Mr. Gilman's guests, we stopped for a minute or two at Kentish Town. A woman asked the coachman, 'Are you full inside?' Upon which Lamb put his head through the window and said, 'I am quite full inside; that last piece of pudding at Mr. Gilman's did the business for me.'
 Autobiographical Recollections, Leslie
- 'The scene for the most part laid in a brothel. O tempora, O mores! But as friend Coleridge said when he was talking bawdy to Miss – 'to the pure all things are pure'', Charles Lamb, letter to Southey, July 1798
- 'You are knee deep in clover.' Charles Lamb, letter to C C Clarke (December 1828).
- 'When my sonnet was rejected, I exclaimed, 'Damn the age; I will write for Antiquity!' Charles Lamb, letter to B W Procter (22nd January 1829).
- 'The greatest pleasure I know, is to do a good action by stealth, and to have it found out by accident.' Charles Lamb, 'Table Talk by the late Elia. The Athenaeum' (4th January 1834).
- 'I have had playmates, I have had companions,
 In my days of childhood, in my joyful schooldays,
 All, all are gone, the old familiar faces.'
 Charles Lamb, 'The Old Familiar Faces'
- Your absence of mind we have borne, till your presence of body came to be called in question by it. 'Amicus Redivivus'.
- Martin, if dirt was trumps, what hands you would hold! 'Lamb's Suppers'.

- *'I mean the borrowers of books – those mutilators of collections, spoilers of the symmetry of shelves, and creators of odd volumes'* Charles Lamb, The Two Races of Man

SEE Authors/ Byron, Lord/ Coleridge, Samuel Taylor/ Margate/ Poets/ Shakespeare/ Whales

Dinsdale LANDEN
Born 4th September 1932
Died Fakenham, Norfolk, 29th December 2003
The actor was born in Margate and attended King's School, Rochester. He started his career in repertory theatre and was an accomplished Shakespearean actor with the RSC. He was once nominated for an Olivier Award for his role in Michael Frayn's play, 'Alphabetical Order'. He also appeared at the National Theatre in 'Uncle Vanya'. On television he appeared as the adult Pip in 'Great Expectations' (1959), the mini-series 'The Glittering Prizes' (1976), 'What The Butler Saw' (1987), Edith Wharton's 'The Buccaneers' (1995), 'Mickey Dunne', 'Pig In The Middle' (1977), 'Doctor Who' and 'Lovejoy'. He was also in the films 'Digby, The Biggest Dog in the World', 'Mosquito Squadron', 'Every Home Should Have One' and 'The Steal'.
In 1985, he and his wife, Jennifer Daniel, wrote a book, 'The True Story of HP Sauce'.
He died of cancer.
SEE Actors/ Margate/ Shakespeare

Jimmy LANDY
His real name was James Eastland, and he was buried in Birchington churchyard under the name of Huntley. He was a carpenter, and smuggler, He went to prison once for six months for selling dodgy tobacco and spirits in the Powell Arms. He lived in a cottage near Quex and died aged 82 in 1906.
SEE All Saints' Church, Birchington/ Birchington/ Perfects Cottage/ Powell Arms/ Smuggling/ Quex/ Tobacco

Lillie LANGTRY
Born 13th October 1852
Died 12th February 1929
Born in Jersey as Emily Charlotte le Breton, the daughter of the Dean of Jersey, she later married Edward Langtry. As Lillie Langtry she became world famous and was regarded at the time as the most beautiful woman in the world. She was also the mistress of the Prince of Wales. As an actress she first appeared in 'She Stoops to Conquer' by Oliver Goldsmith in London. She formed her own company and toured the world, performing in plays such as 'Antony and Cleopatra', 'As You Like It', and 'Lady Windermere's Fan' a play especially written for her by Oscar Wilde.
'I would rather have discovered Lillie Langtry than America.' Oscar Wilde
'I resent Mrs Langtry; she has no right to be intelligent, daring and independent, as well as lovely.' George Bernard Shaw.
She retired from the stage in 1914 and died in 1929. Lillie Langtry stayed at a house in Vale Square, Ramsgate, when she was

appearing at the Palace Theatre at the end of the nineteenth century.
SEE Actors/ Palace Theatre/ Ramsgate/ Vale Square/ Shaw, George Bernard/ Wilde, Oscar

LANTHORNE public house, Broadstairs
It was built in 1880 as the Callis Court Hotel. Following a refurbishment in the 1990's, it became the Lanthorne.
SEE Broadstairs/ Pubs

LANTHORNE ROAD, Broadstairs
The word 'lanthorne' derives from lantern – or does lantern derive from lanthorne? – and refers to the lighthouse at North Foreland, to which this road leads.
SEE Broadstairs/ Farm Cottage/ St Peter's Orphanage/ Snelling, Joss/ Stone Farm/ Stone House

'LAST ORDERS' by Graham Swift
This 1996 novel has one of the characters, Jack Dodds, requesting that his ashes be thrown off Margate pier. A film based on the book was made in 2001 and was partly filmed in Margate. It starred Tom Courtney, Michael Caine, Bob Hoskins, David Hemmings, Ray Winston, and Helen Mirren.
SEE Barnacles/ Books/ Films/ Margate

'LAST RESORT'
Commissioned by the BBC, the film 'Last Resort' (2000), a drama directed by Polish-born Pawel Pavilowski, follows Tanya, a Russian refugee, and her son Artyom. Set in the fictional town of Stonehaven it was filmed in Margate.
SEE Films/ Margate/ Russia

LAUDANUM
A solution made from opium that was used originally as a narcotic painkiller, but became a popular recreational drug in the nineteenth century.
SEE Collins, Wilkie/ Rossetti

LAUREL and HARDY
Comedy double act.
SEE Entertainers/ Winter Gardens

LAVENDER
DEFIED THE PARK KEEPER
Report of a remarkable escapade of a Ramsgate girl named Alice Gibbons of Grange Road. She was brought before the Mayor and Justices on Monday with plucking Lavender from a bush in the Park. She was remanded in custody in the Workhouse for a week while a place was found for her in an Industrial School. 17th September 1902
There was once a lavender farm at Great Cliffsend Farm opposite St Augustine's Cross at Ebbsfleet. The crop was distilled and used to make soap and bags which were sold to the holiday makers and day trippers who visited the farm.
SEE Ebbsfleet/ Farms/ Grange Road/ Ramsgate/ St Augustine's Cross/ Without Prejudice/ Workhouse

'The LAW AND THE LADY' by Wilkie Collins
We left the train at Ramsgate.

The favourite watering-place was empty; the season was just over. Our arrangements for the wedding tour included a cruise to the Mediterranean in a yacht lent to Eustace by a friend. We were both fond of the sea, and we were equally desirous, considering the circumstances under which we had married, of escaping the notice of friends and acquaintances. With this object in view, having celebrated our marriage privately in London, we had decided on instructing the sailing-master of the yacht to join us at Ramsgate. At this port (when the season for visitors was at an end) we could embark far more privately than at the popular yachting stations situated in the Isle of Wight.
oOo
After breakfast that morning we had news at last of the yacht. The vessel was safely moored in the inner harbour, and the sailing-master was waiting to receive my husband's orders on board.
Eustace hesitated at asking me to accompany him to the yacht. It would be necessary for him to examine the inventory of the vessel, and to decide questions, not very interesting to a woman, relating to charts and barometers, provisions and water. He asked me if I would wait for his return. The day was enticingly beautiful, and the tide was on the ebb. I pleaded for a walk on the sands; and the landlady at our lodgings, who happened to be in the room at the time, volunteered to accompany me and take care of me. It was agreed that we should walk as far as we felt inclined in the direction of Broadstairs, and that Eustace should follow and meet us on the sands, after having completed his arrangements on board the yacht.
In half an hour more the landlady and I were out on the beach.
The scene on that fine autumn morning was nothing less than enchanting. The brisk breeze, the brilliant sky, the flashing blue sea, the sun-bright cliffs and the tawny sands at their feet, the gliding procession of ships on the great marine highway of the English Channel - it was all so exhilarating, it was all so delightful, that I really believe if I had been by myself I could have danced for joy like a child. The one drawback to my happiness was the landlady's untiring tongue. She was a forward, good-natured, empty-headed woman, who persisted in talking, whether I listened or not, and who had a habit of perpetually addressing me as 'Mrs. Woodville', which I thought a little overfamiliar as an assertion of equality from a person in her position to a person in mine.
. . . .I happened to say that I supposed we must by that time be near the end of our walk - the little watering-place called Broadstairs. 'Oh no, Mrs. Woodville! cried the irrepressible woman, calling me by my name, as usual; 'nothing like so near as you think!'
. . . .My face and manner must have betrayed something of the agitation that I was suffering. Happening to look at me at the end of her next sentence, the old lady started, and said, in her kindly way,

'I am afraid you have overexerted yourself. You are very pale - you are looking quite exhausted. Come and sit down here; let me lend you my smelling-bottle.'

I followed her, quite helplessly, to the base of the cliff. Some fallen fragments of chalk offered us a seat.

. . . In the meantime the old lady was still speaking to me with the most considerate sympathy. She too was fatigued. she said. She had passed a weary night at the bedside of a near relative staying at Ramsgate. Only the day before she had received a telegram announcing that one of her sisters was seriously ill. She was herself thank God, still active and strong, and she had thought it her duty to start at once for Ramsgate. Toward the morning the state of the patient had improved. 'The doctor assures me ma'am, that there is no immediate danger; and I thought it might revive me, after my long night at the bedside, if I took a little walk on the beach.'

I heard the words - I understood what they meant - but I was still too bewildered and too intimidated by my extraordinary position to be able to continue the conversation. The landlady had a sensible suggestion to make - the landlady was the next person who spoke.

'Here is a gentleman coming,' she said to me, pointing in the direction of Ramsgate. *You can never walk back. Shall we ask him to send a chaise from Broadstairs to the gap in the cliff?'*

SEE Books/ Broadstairs/ Collins, Wilkie/ Ramsgate

LAWN HOUSE, Broadstairs

A house at the end of Fort Road, off Harbour Street, Broadstairs, that is now called Archway House.
SEE Archway House/ Broadstairs/ Harbour Street, Broadstairs/ Old Curiosity Shop

LAWN VILLAS, Ramsgate

Originally, the houses of Guildford Lawn all had lawns until a Mr Beer bought them all one by one. He then sold off the houses and built Lawn Villas on the old lawns. He then sold the new houses and probably made a nice profit!
SEE Guildford Lawn/ Ramsgate

Carver LAWRENCE

Gunfire flashes were seen in Margate when there was a bloody battle between the Coast Blockade Service and a band of smugglers on Sunday, 2nd September 1821 at St Mildred's Bay. Thirty or so smugglers had travelled from Canterbury on the Friday night, and then split up; arranging to meet at a hill outside Minster on the Saturday night, by which time their numbers had swelled to around sixty. Stephen 'Carver' Lawrence, a Margate carpenter by day and smuggler by night, was the leader of this gang, and the job that night involved collecting fifteen tubs of gin and brandy, and taking them to the old gatehouse at Dent-de-Lion farm.

When the booty arrived it was spotted by the Coast Blockade Service and Lieutenant Carr fired a shot in the air to summon Lieutenant Barton who lived close by; he never responded. Although heavily outnumbered, the Coast Blockade Service was soon engaged in combat with the smugglers. Carr and his men split into two groups, one either side of the beach, forcing the smugglers to fight two battles. Taking heavy wounds to the head, Carr fought on with his cutlass. Before the Blockade reinforcements arrived, one of their men, Thomas Cook, thought he recognised a local man called Taylor as one of the smugglers. He managed to down two of the smugglers before they retreated and shot him in the hip,

The next day, a warrant was sent to Taylor's home in Covell's Row in Margate. He denied any involvement claiming he had been in bed at the time. There was a rumour that he was going to turn King's evidence, and as a consequence, the home of his solicitor, John Boys, was attacked. Margate constable, John Carthew, arrested nineteen men, many of whom named Taylor as being at the battle, but he was still not arrested. (Nearly eighteen months previously at Herne Bay he had been involved in an incident, but again not arrested, when a Blockade man named Snow had been murdered. At the farce of a trial that followed at the Old Bailey, the six men arrested were acquitted.)

The nineteen men arrested were charged with smuggling, possessing arms, shooting and wounding, or aiding the wounding of the Blockade men at Marsh Bay, and stood trial at Maidstone Assizes on 22nd March 1822. In the trial, which lasted one day, all the men said Taylor was innocent, which was quite true, he was not there – he was smuggling at Margate at the time, so he stood trial for that. He was obviously successful at it as he could afford three attorneys, whilst the nineteen on trial could only afford one between them, and they were all found guilty, with four sentenced to be hung. The remainder, along with Taylor, were transported to Diemen's Land for between 7 and 15 years.

There was a sort of campaign mounted to pardon Taylor, but after the Bow Street Runners gave information about him, it fizzled out. Nine months into his sentence he got 50 lashes for embezzlement.

Strangely, Carver Lawrence was released before the trial, even though he said Taylor was innocent and had admitted his own guilt. He seemed to have had some friends in high places that protected him from justice.
SEE Dent-de-lion/ Gouger's Windmills/ Margate/ Minster/ St Mildred's Bay/ Smugglers/ Transportation

D H LAWRENCE

Born Eastwood, near Nottingham 11th September 1885
Died Vence, France 2nd March 1930

When David Herbert Lawrence was only two weeks old he suffered an attack of bronchitis; when he was a young boy, he developed a nervous hacking cough; when he was 17, he caught pneumonia; at the age of 31, he was told he had tuberculosis, but he took no action; in 1925, his condition was so bad that doctors only gave him a year or two to live; in 1926, he had a bronchial haemorrhage, and a year later had an even more violent hemorrhage (doctors told him that it would have killed an average man). Finally, in 1930 he agreed to enter a sanatorium, and at Ad Astra (a famous TB retreat in the south of France) he had an attack of pleurisy, which was the start of a relapse, and a few days later he died. There are two versions of his last words. They were either, *'I am better now'*, or *'I think it is time for morphine'*. He left £2,500.

He stayed at 28 Percy Avenue for three weeks between the 9th and 29th July 1913 with Frieda Weekly (1879-1956) but before he came he wrote in a letter, *'Oh dear, oh lord, Margate !'*

A somewhat negative view of what he saw as a bourgeois aspect to the area seems to have taken over any initial enthusiasm he may have had. They were visited by Katherine Mansfield, John Middleton Murry and Edward Marsh, who in turn introduced them to Herbert and Cynthia Asquith who were staying at nearby Marine Drive.

Letter 11th July 1913: *We have tumbled into a most jolly little flat. The big bedroom has a balcony that looks across the fields at the sea. Then the house has a tent, and the way-down to the sea is just near, so one can bathe . . . We are quite alone – the folk only let this flat. We do our own work. It is very serene.*

Letter 13th July 1913: *It is a nice flat we have got, but the place bores me. What have I to do with fat fatherly Jews and their motor cars and their tents?*

Lawrence and Weekly left an unpaid bill behind - nice - when they left to go to Bavaria.

Letter to Cynthia Asquith 17th August 1913: *You were awfully nice to us at Kingsgate. But that your Marylands (the Asquiths' house) was such a joy, I might have found myself hurrying over the edge of the cliff in my haste to get away from that half-crystallised nowhere of a place- Kingsgate. Kingsgate – oh God! The last was a pathetic little bill for one and fourpence, the dregs and lees of our housekeeping down there: I believe it was the baker. But it dogged our footsteps and ran us down here. So I made a little boat of it and set it afloat.*

Despite Lawrence's fame for writing erotic novels, most notably 'Lady Chatterley's Lover' (The original title was 'Tenderness'), he would, apparently, only have sex with the light off - and no, I don't know how they know that!

Lawrence and Frieda Weekley invited the future critic and editor of 'The Athenaeum'

and 'The Adelphi' John Middleton Murry (1889 -1957) down to Kingsgate in July 1913. He had just graduated from Oxford and started a relationship with the writer Katherine Mansfield (real name Kathleen Mansfield Beauchamp, born New Zealand 1888 – died 9th January 1923) (they married in 1918). He probably ignored the invitation because he could not afford the train fare but Lawrence wrote back telling them off for not asking for the money! They duly arrived on 26th July 1913 for a short but apparently lively weekend.

John Middleton Murry: *'So this time we went and we bathed all together. Once in the early evening, in the faintly chill dusk, Lawrence darting, like a schoolboy, in and out of the waves as they slipped up the flat broken sand. Katherine Mansfield was a superb swimmer, I a good one. It is the only thing I could even do better than Lawrence did it. There, on the deserted sand, the four of us bathed naked in the half-light, first happy, then shivering. Then we went back and ate a huge supper of fried steak and tomatoes. For some reason those tomatoes gleam very red in my memory'*

It was the start of an intense stormy and turbulent friendship between the two couples. Mansfield and Murry were witnesses at the Lawrence'e wedding, but by 1916 the friendship between Mansfield and the Lawrences had reached crisis point. Kathleen wrote to a mutual friend that the *'dear man* [has become lost in] *the immense German Christmas pudding which is Frieda. And with all the appetite in the world one cannot eat one's way through Frieda to find him.'* She did not always share Lawrence's literary views, recording in her journal *'I shall never see sex in trees, sex in the running brooks, sex in stones & sex in everything. The number of things that are really phallic from fountain pen fillers onwards!'*

The insults went back and forth. Lawrence on Katherine Mansfield and J Middleton Murray: *Spit on her for me when you see her, she's a liar out and out. As for him, I reserve my language. . . .Vermin the pair of 'em!*

Lawrence in a letter to Mansfield: *I loathe you. You revolt me stewing in your consumption. . . The Italians were quite right to have nothing to do with you.*

Lawrence did not take kindly to anyone who did not recognize his talent:
Curse the blasted, jelly-boned swines, the slimy, the belly-wriggling invertebrates, the miserable sodding rotters, the flaming sods, the snivelling, dribbling, dithering, palsied, pulse less lot that make up England today. They've got white of egg in their veins, and their spunk is that watery it's a marvel they can breed. They can nothing but frog-spawn – the gibberers! God, how I hate them!

He was having a bad day.

SEE Asquith, Cynthia/ Authors/ Kingsgate/ Mansfield, Katherine/ Margate/ New Zealand/ Women in Love

Sir Austen Henry LAYARD
Born Paris, 5th March 1817

Died London, 5th July 1894
Some sources say the lawyer and archaeologist was born in Paris, others say Ramsgate, behind the Eagle Inn, in Eagle Cottage. His Ramsgate connections come through his mother's family. Her father was a Ramsgate banker named Nathaniel Austen, and the Austen family was originally from Spain. He was educated in Italy, spending much of his boyhood there, as well as in France, England and Switzerland. He worked for six years as a solicitor in Benjamin Austen's (his uncle) office but six years is probably long enough for anyone and he embarked on a career in the Ceylon civil service - although embark is probably the wrong term as he decided to travel there overland.

He set off in 1839, and after making many detours reached as far as Persia. He enjoyed the journey so much that he gave up on the Ceylon civil service career. In 1842, he ended up in Constantinople, again, where the British ambassador, Sir Stratford Canning, gave him work in various diplomatic missions in Turkey. In 1845, with Canning's help and backing, he set out to explore the ruins of Assyria. It was to be his finest hour. Over the next few years he discovered the ruins of Babylon and Nineveh. At the age of 36 he gave up archaeology and became ambassador of Constantinople.

His career in politics continued in England when he became the Liberal MP for Aylesbury 1852-57, and was briefly the under-secretary for foreign affairs. Following his 1857 defeat, he visited India to investigate the causes of the Indian Mutiny. He became MP for Southwark in 1860, and was under-secretary for foreign affairs again from 1861-66, under Palmerston and Russell. He retired from parliament in 1869 and went to Madrid as 'envoy extraordinary'.

In 1877 he was back in Constantinople as ambassador, where he remained until 1870 retiring from public life, aged 53, to Venice to collect and write about Italian art. He died in London aged 77.

SEE Eagle Inn/ Politics/ Ramsgate

Edward LEAR
Born 12th May 1812
Died 29th January 1880
The writer of nonsense poems such as 'The Owl and the Pussycat' suffered from epilepsy - which he called 'the Demon' - and depression - referred to as 'the Morbids' - throughout his life, starting in childhood. The depression may have been caused by the epilepsy for which, as a child, he was sent to Margate for treatment involving spa water and exercise.

SEE Authors/ Margate/ Poets

LEE SHORE
'Some Peculiar Advantages which Margate pre-eminently Enjoys for the Benefit of Bathing in the Seas', By Philomenia, The Gentleman's Magazine, April 1771: *The town and harbour of Margate are situated on the east side of a clean sandy bay. . . directly open to the northern ocean, (but an)*

advantage peculiar to Margate is, its being a weather shore during the greatest part of the summer, or, in other words, the southern winds, which generally prevail in that season, blow on from the land; by which means the sea is rendered perfectly smooth. . . .whereas most of the places on the sea coast, in the English Channel, from the North Foreland to the Land's End, are on a LEE SHORE during the greatest part of the summer, and are incommoded very much by the southerly winds before-mentioned; for these grateful gales, which produce the warm fine weather, and render Margate a smooth pleasant shore, never fail to occasion at the same time a continual swell and surf of the sea, on the south coast of England, which not only makes the water there foul and thick, but annoys, frightens and SPATTERS the bathers exceedingly.

The bay wherein the Company bathe at Margate. . . has not its equal in this kingdom. . . The surface is a fine clean sand, perfectly free from rocks, stones, sea-weed, and all manner of soil and sullage; and lies on so gentle and regular a descent, (that) the company go into the water in the open ocean with security and ease. . .

For the foregoing, and several other reasons which might be added, Margate has the superiority over every place in England, for the convenience and propriety of bathing in the salt water. (Also) the bathing machines THERE have their merits too; and are universally allowed to be the best contrived of any in the kingdom for convenience, safety, privacy, and expedition of driving into and out of the sea. . .

Wishing success. . . to the town of Margate, and too the bathers.

SEE Bathing/ Margate

John LEMESURIER
Born Bedford 5th April 1912
Died 15th November 1983
The most famous former resident of London Road, Ramsgate, is the actor, **J**ohn LeMesurier. Born John Elton Halliley. He was very young when his family moved to Bury St. Edmunds where his father was a solicitor. He was first educated at Grenham House at Birchington-on-Sea. After failing his entrance exams for the Royal Naval College at Dartmouth he went on to Sherborne, a public school, in Dorset. When he left school, John became an articled clerk at Greene and Greene, a Bury firm of solicitors. Six years later, just before his 21st birthday, realising that the acting bug would not go away and, with his parents' approval, he joined the Fay Compton Studio of Dramatic Art, taking his mother's maiden name, Le Mesurier, as his stage name. Alec Guinness started on the same day. John's first professional engagement was at the Palladium Theatre, Edinburgh, then onto Oldham Rep and Sheffield Rep and then on various tours. He married theatre director June Melville in 1939.

He joined the Royal Armoured Corps at Tidworth on Salisbury Plain and became a Captain, serving both here and at the

Northwest Indian Frontier until he was de-mobbed in 1945. He resumed his acting career and the following year his marriage to the alcoholic June ended and they divorced in 1947.

He met Hattie Jacques, who at the time was a radio star in ITMA, at the Players Theatre in Villiers Street, near Charing Cross, and soon moved in with her. He made his film debut in 'Death in the Hand' (1948). He and Hattie married in April 1952 and had two sons, Kim and Robin (who was a guitarist in Rod Stewart's band and has written songs for Willie Nelson, amongst others). Hattie became a regular in BBC TV's 'Hancock's Half Hour' and John appeared in the first of seven in 1957. He also appeared in a couple of series that Hancock made for ITV and in all but one of his films. They became firm friends.

He declined the part of the next-door neighbour in 'Sykes' (eventually played by Richard Wattis) in which Hattie Jacques played Eric Syke's sister. He went on to appear with Sid James and Peggy Mount in the classic 'George and the Dragon'.

He and Hattie divorced in 1965 after she fell in love with a younger man; at one point the three of them lived together. Brokenhearted, John confided in a friend, Joan Malin (who was twenty years John's junior, and had been married to actor Mark Eden with whom she had a son, David Malin). Their relationship deepened over a period of eighteen months and they married in 1966, living in homes in London and Ramsgate. Six months after their wedding, Tony Hancock moved in to recover following the break-up of his marriage. Within two or three weeks, Joan had fallen in love with Tony and they set up home together. Heartbroken again, John understood and continued to love his wife and his best friend. A year later, Joan could take no more of Hancock's drunken, abusive behaviour and returned to John. Unknown to John however, Joan and Tony re-started their affair although she told Tony that if he remained sober for a year, she would leave John and marry him. Hancock left for Australia to kick-start his flagging career and Joan wrote to him every day. A postal strike meant that no letters arrived for a couple of weeks and as the tour was not going as well as he expected, he thought Joan no longer loved him. It is thought that all these things together caused him to overdose on pills and commit suicide. John took the phone call and had to break the news to his wife and then had to cope not only with the loss of his best friend but also his wife's broken heart. Somehow he coped without showing his own devastation like the typical English gentleman he not only portrayed, but was.

'Dad's Army' came along in 1968 in which John was originally going to play the Captain and Arthur Lowe the Sergeant, but thankfully the roles were reversed. Certainly one of the best ever TV comedy series, it ran for twelve series until 1977 and there was also a film spin-off in 1971. The role of Sergeant Arthur Wilson is the role he will be best remembered for. Just to prove that he could do straight roles as well as comedy, he was awarded BAFTA for Best Actor of the Year in 1971 and the Society of Film and Television Arts 'Best Television Actor' award for his portrayal of Kim Philby in Dennis Potter's play 'Traitor' in 1971. He used the BAFTA as a doorstop in his bedroom.

Other serious roles included 'Brideshead Revisited' and he played Marley's ghost in 'A Christmas Carol' on BBC TV. He made other television appearances in 'The Goodies', 'Doctor at Large', 'The Dick Emery Show' and 'Worzel Gummidge'. He and Arthur Lowe did advertisements for British Airways and his was the voice that told us *Graded grains make finer flour* on the series of Homepride Flour commercials.

He made over 100 films, including 'Private's Progress', 'I'm Alright Jack', 'Brothers in Law', 'Carlton Brown of the FO', 'Our Man in Marrakech', many of the Boulting Brothers films and 'Jabberwocky'. His last film was 'The Fiendish Plot of Dr Fu Manchu' (1980) with Peter Sellers. His last TV appearance was in 'A Married Man' with Anthony Hopkins, and his last radio performance was in a spin-off series from Dad's Army about running a seaside pier 'It Sticks out Half a Mile'. Three days after this, he died from an abdominal illness on 15th November 1983 in Ramsgate hospital.

He loved both jazz and drink and had been a heavy drinker for many years. He also had cirrhosis of the liver and suffered liver failure in 1977; he was advised to stop drinking, which he did. Ironically, instead of his health improving, he wasted away. He gave it a year, and informed his family that as he no longer enjoyed life without alcohol he would start drinking again and take the consequences.

When he died aged 71 years old, virtually his last words to Joan were, *It's all been rather lovely*. He made Joan promise that when he died she would put his obituary in The Times claiming that John had *simply conked out*.

His autobiography, 'A Jobbing Actor' was published in 1984 and in 1994, the Dead Comics Society put up a plaque in his memory at his former flat in Baron's Court.
SEE Actors/ Birchington/ Dads Army/ London Road/ Radio/ Ramsgate

King LEOPOLD I of Belgium
Born 16th December 1790
Died 10th December 1865
Leopold was the brother of Queen Victoria's mother and was widowed after the death of his wife Princess Charlotte, George IV's daughter, shortly after giving birth to a stillborn child. He did re-marry and in 1831, after being elected as the king of the newly independent Belgium, he came for a week's holiday in Ramsgate where he met up with Princess Victoria to whom he gave much advice on how to be a monarch.
SEE Ramsgate/ Royalty/ Victoria

LEOPOLD STREET, Ramsgate
This used to be Farley Place, named after a local shipbuilder who had a yard here. The General Baptist Church opened here in 1724 and was in use for over a century and a half. There was also a shrimp factory here once – not that you can actually manufacture a shrimp – where shrimps were cooked and made into shrimp paste that was very popular at the time.
The street was re-named after King Leopold of Belgium who always arrived in England via Ramsgate.
SEE Churches/ Neptune Row/ Ramsgate/ Shipbuilding

LESTER'S BAR and RESTAURANT
In 1951, the Hope and Anchor public house and off-licence was built at 162 Ramsgate Road and named after a pub of the same name that had recently been demolished in Margate High Street. The building was re-styled and re-named in 1983 when the off-licence was removed becoming The Thomas Telford, after the 18th century Scottish engineer who, incidentally, worked on some of Ramsgate's drainage systems. These days it is Lester's Bar and Restaurant, named after Lester Piggott the jockey (Born 5th November 1935) who was very fast on the horses, but famously once very slow on paying his tax. He was champion jockey 11 times and won the Derby 9 times.
SEE High Street, Margate/ Margate/ Pubs/ Ramsgate/ Ramsgate Road, Margate/ Restaurants

Joseph Moses LEVY
Born London, 15th December 1812
Died Ramsgate, 12th October 1888
He acquired the ownership of The Daily Telegraph and Courier from Colonel Sleigh in settlement of a debt. He shortened the title and it became the first London daily paper to sell for a penny.
SEE Newspapers/ Ramsgate

LEWIS, HYLAND and LINOM
Store in Harbour Street, Ramsgate.
East Kent Times, 9th December 1914:
Ingenious Ruse: Arthur Abley, manager of the outfitting department of Lewis, Hyland and Linom's in Harbour Street told the Court that a man, evidently a foreigner, with his face and neck swathed in surgical bandages asked for a flag. A Union Jack was apparently unsuitable and while the manager went to look for the requested Belgian flag the foreigner stole a cloth cap from a drawer near at hand.
SEE East Kent Times/ Harbour Street, Ramsgate/ Ramsgate/ Sedan chair/ Shops

LEWIS CRESCENT, Cliftonville
This and much of the area now called Eastern Esplanade was built by the Lewis estate.
The large urn here is a memorial to the son of a local councillor who died in World War I. Originally, there were lion heads as well but these have now disappeared.
SEE Cliftonville/ Eastern Esplanade, Cliftonville/ World War I

Jerry Lee LEWIS
Born 29th September 1935
Rock 'n' roller.

'When they look back on me I want 'em to remember me not for all my wives, although I've had a few, and certainly not for any mansions or high livin' money I made and spent. I want 'em to remember me simply for my music. . '
SEE Music/ Winter Gardens

LEYBOURN FAMILY
An old Thanet family that once owned most of the land in the area that is now Westgate.
SEE Old Bay Cottage/ Westgate-on-Sea

LIBRARIES
These were the fashionable places to see and be seen in, back in and around 1800. You gossiped, drank tea – which had probably been smuggled – gossiped, entered raffles, gossiped, listened to lectures, but mostly gossiped. The three main ones in Broadstairs were the Marine Library (or Barnes as it was sometimes known) which finally closed in 1864 and later became Marchesi's; Barfield's, now Barfield House; and Hale's which later became the Omar Restaurant.
The Picturesque Pocket Companion to Margate Ramsgate & Broadstairs & the parts Adjacent by William Kidd, 1831: *Here [Albion Place] are two excellent libraries; the one kept by Mr Barnes, and the other by Mr Hale, both of which command a view of the Downs, and contain a large selection of books; while the respective proprietors strive by assiduity and unremitting attention, to deserve the support of their friends and the summer visitors. Here are also assemblies for dancing and cards, which are held alternately, during the season, at the library of the former, and at the new rooms lately erected by the latter, and adjoining the library.*
SEE Albion Street, Broadstairs/ Assembly Rooms, Margate/ Bagshaw's Directory and Gazateer/ Barfield House/ Blinko's Bookshop/ Broadstairs/ Cliff House/ Downs, The/ Fort Hill, Margate/ Garner's Library/ High Street, Margate/ High Street, Ramsgate/ Hospital/ Marine Library, Ramsgate/ Police Station, Ramsgate/ Post Office, Ramsgate/ Restaurants/ World War II

LIBRARY, Ramsgate
Originally, Ramsgate's library was in Cavendish Street, but, thanks to a grant of £7,000 from the Scottish millionaire Andrew Carnegie, it moved just around the corner to Guildford Lawn and the new library was opened on 13th October 1904 by the Rev L J White-Tomson (the town vicar at the time) and various dignitaries along with the architect, Stanley D Adshead. The ceremony ended in the museum room with afternoon tea.
The children's library opened in 1932, and in 1937 an advertisement described it as *'Ramsgate Library – the poor man's university'*.
Late on the evening of 13th August 2004 a fire gutted the building leaving just the outside walls standing. So severe was the fire that water had to be pumped from the harbour to try and put the flames out. At 11.15pm the hands of the library clock dramatically began to spin around before the clock shot into the fire. It was not until around 1.30 in the morning that the fire was brought under control.
People living in the neighbouring area formed human chains to remove books, archives and artifacts from the basement. Whilst the loss of a town's library is always appalling this was also Ramsgate's museum and although many books can be replaced much of what was lost here cannot.
The fire occurred exactly three months short of the building's 100th birthday.
SEE Carnegie, Andrew/ Cavendish Street, Ramsgate/ Fires/ Guildford Lawn/ Ramsgate/ Stancomb-Wills, Dame Janet

Lord LICHFIELD
Born 25th April 1939
Died 11th November 2005
Formally, he was Thomas Patrick John Anson, the 5th Earl of Lichfield, with an estate at Shugborough, near Cannock Chase in Staffordshire, but, as a highly successful photographer, he was known as Patrick Lichfield. His mother, Anne Bowes-Lyon (1917-1980) was a niece of the Queen Mother. Apart from attending Wellesley House School, Broadstairs, he also went to Harrow and the Sandhurst Military Academy. When he left the army in 1962 he began a career in photography and took the wedding photos for Charles and Diana in 1981.
SEE Broadstairs/ Wellesley House School

Eric LIDDELL
Born Tientsin China 6th January 1902
Died 21st February 1945
The second son of the Rev and Mrs James Dunlop Liddell, missionaries with the London Mission Society in China, he was educated at Eltham College, London where his headmaster described him as *'entirely without vanity'*. He was a rugby international and winner of a gold medal in the men's 400 metres at the 1924 Olympic Games in Paris, where he finished 5 yards ahead of the field and set a new world record of 47.6 seconds, attributing his win to God. As a staunch Catholic, he refused to race on Sundays, and withdrew from his best event, the men's 100 metres, and instead preached a sermon in Paris on the day of the heats. He also won a bronze medal in the 200 metres.
After the Olympics, he returned to China as a missionary from 1925 to 1943. He married Florence Mackenzie, the daughter of Canadian missionaries, and they had three daughters (they all ended up living in Canada). In 1941 the British Government advised British nationals to leave China. Florence and their daughters did but Eric was interned in Weishien Camp, where he suffered a brain tumour and died in 1945.
SEE Abrahams, Harold/ Carlton Hotel, Broadstairs/ Chariots of Fire/ Sport

LIDO, Cliftonville
Outside Venice, facing the Adriatic, is a sandy island named the Lido, from the Latin 'litus', meaning shore. It has long been a fashionable bathing resort, and is the one that all other Lidos are named after.

John Henry Iles bought the old Clifton Baths Estate and built the Cliftonville Lido which opened on 24th June 1927, although it was still called Clifton Baths up until 1938.
Some facts and figures:
- Cost of re-building the facilities: £120,000
- Cost of building swimming pool: £60,000
- 4 sluices let sea water into the pool which was complete with a diving board,
- Pool area: 37,000 square feet.
- Pool dimensions: 250'x150'
- Pool depth 2'-9'
- 1,300 tons of cement, and 10,000 tons of ballast were used in the construction
- There were 400 changing cubicles (later increased to 800)

At the opening ceremony three flares were fired: one for Margate, one for the Mayor of Margate and one for the King of England. The mayor was Cllr Mrs M H S Hatfield and part of the ceremony included pushing a young girl into the pool as the first swimmer. Try that now and you'll have health and safety regulations and social services all over you. The ceremony was even captured in an oil painting – but not the pushing-someone-in-the-pool bit.
The pool stayed open all day and on until midnight in the summer.
Beauty contests were popular here.
As well as the swimming facilities, luxurious hairdressing salons for men and women were established along with 50 private bathrooms boasting marble floors and walls and hot sea water! The bathrooms were replaced by an aquarium and mini zoo in the 1950s where you could see tropical fish, snakes and other reptiles and monkeys!

Themed bars were added in the 1930s. Cliff Café grew from being able to accommodate 80 people to 1,000, all seated. From here you could see the sea and the pool. The Café Normandie was French in style and had dance-bands and orchestras. Café Basque had a rustic stone and wood style to it. The French Bar had a pirate theme, only they were French pirates, obviously. The Jolly Tar Tavern was decorated with fishing gear and ship's 'things' including lobster pot lampshades – because that is exactly what Jolly Tars use as lampshades!
The Cliff Theatre had shows like 'Henry Claxton's Gaytime' (stop it!) and 'Gay

Parade' (I mean it!) and most of the shows here were aimed at the people who would attend every night of their week's holiday, so the same cast would perform six or seven different shows every week.

The storm of 1953 caused damage to all parts of the Lido, but the Café Normandie was worst hit of all when a 20ft concrete slab caused so much damage that it was never re-built. In its place was built the Wild West themed Golden Garter Saloon complete with a Sheriff, showgirls and entertainers called the Vigilantes. This closed in the late 1960s.

The Lido swimming pool closed in 1977 and the pool was filled in. The rest of the complex is now under tarmac with just the old beacon still standing (it was smartened up in 2003) looking a bit incongruous, advertising something that has long since disappeared.
SEE Bathing/ Clifton baths/ Cliftonville/ Dreamland/ Durrell, Gerald/ Entertainers/ Fuller, Leslie/ Hades/ Iles, John Henry/ Lido Theatre/ Savage, Tony

LIDO THEATRE

The Clifton Concert Hall replaced the old cinema in 1930 having 1,500 seats and a sliding roof; it later became the Lido Theatre. In the 1960s and 70s, Bill Maynard, Joan Turner, Reg Varney, Beryl Reid, Benny Hill, Tommy Trinder, Roger de Courcey and Nookie Bear, Charlie Drake, and Norman Wisdom all starred here.

In the 1970s there was 'Carnival on Ice' (1973), 'The Amazing Penny Whistle Show' (1974), 'There'll Always Be An England' and 'The Al Jolson Minstrel Show'.
SEE Lido

'The LIFEBOAT'
by R M Ballantyne (1864)

Guy Foster, clad in a sou'-wester hat and oilskin coat, stood at the end of the pier of Ramsgate Harbour, with his sweet wife, Lucy, clinging to his arm, and a sturdy boy of about four years old, holding on with one hand to the skirts of his coat, and with the other grasping the sleeve of his silver-haired grandsire, Mr Burton.

It was night, and a bitter gale was blowing from the north-east, accompanied by occasional showers, of sleet. Crowds of seamen and others stood on the pier eagerly watching the lifeboat, which was being got ready to put off to sea. Put to sea on such a night! with the waves bursting in thunder on the shore, the foam seething like milk beneath, the wind shrieking like ten thousand fiends above, and the great billows lifting up their heads, as they came rolling in from the darkness of Erebus that lay incumbent on the raging sea beyond.

Ay, a landsman might have said 'madness' with reason. Even a seaman might have said that without much apparent impropriety. But the boatmen of Ramsgate held a different opinion! The signal gun had been fired, the rocket had gone up, a wreck was known to be on the fatal Goodwin Sands, and they were as eager to face the storm as if encountering danger and facing death were pleasant pastime.

As the oars were about to be shipped, one of the crew stumbled, and struck his head so violently against the bollard, that he fell stunned into the bottom of the boat. Guy saw the accident as he stood on the edge of the pier. A sudden impulse seized him. At one bound he passed from the pier to the boat, which was already some half-dozen feet away, and took the seat and oar of the injured man. In the confusion and darkness, the others thought he was one of the supernumerary boatmen, and took no further notice of him. The boat was shoved back, the life-jacket was transferred to Guy, and the boatman was put ashore.
SEE Ballantyne, R M/ Books/ 'Floating Light of the Goodwin Sands'/ Goodwin Sands/ Harbour, Ramsgate/ Lifeboat, Ramsgate/ Ramsgate

LIFEBOAT - Broadstairs

On the Boathouse at Broadstairs Harbour are boards listing the
'*Services Rendered by the Broadstairs Lifeboat of the Royal National Lifeboat Institution*'
Another states:
ROYAL NATIONAL LIFEBOAT INSTITUTION THESE BOARDS ARE ERECTED TO COMMEMORATE THE GALLANT WORK OF THE BROADSTAIRS LIFE-BOAT STATION WHICH WAS ESTABLISHED IN 1868 AND THE LIFEBOATS WHICH FROM THAT DATE UNTIL 1912 RESCUED 275 LIVES FROM SHIPWRECKS THE STATION WAS CLOSED IN 1912 AND THE AREA IS NOW COVERED BY MODERN MOTOR LIFE-BOATS STATIONED AT RAMSGATE AND MARGATE

Broadstairs had five RNLI lifeboats between 1868 and 1912:
1868: the Samuel Morrison Collins (the gift of Mrs Collins) was launched 129 times and saved 84 lives.
1888: the Christopher Ward Bradford (the gift of Mr Ward) was launched 47 times, saving 52 lives.
1896: a temporary lifeboat was used and launched 16 times, saving 13 lives.
1897: the Frances Forbes Barton (a legacy of Miss I Webster) was launched 77 times, saving 115 lives.
1906: a temporary lifeboat was used and launched 7 times, saving 5 lives.
SEE Boathouse/ Broadstairs

LIFEBOAT – Margate

The Margate lifeboat had saved over 1250 lives and been launched 1,644 times by 1987. Two lifeboat slipways were built, in 1898, at the shore end of Margate Pier. The lifeboat house was later built halfway down the pier in 1926.

The lifeboat was trapped in its station on 14th November 1962 because the iron bars used to secure the doors were bent by the ferocity of the waves outside.
SEE Margate/ Pier

LIFEBOAT MEMORIAL, Margate

The bronze statue of a lifeboatman looking out to sea for his fellow crewmen, stands just east of the Nayland Rock Hotel, and commemorates the Friends of All Nations disaster; it was paid for out of the disaster fund that had been set up. Sculpted by Frederick Calcot, and cast at the London foundry of Elking & Co., it was unveiled on 4th October 1899 by the wife of the Sheriff of Kent, Mrs J T Friend, who lived at Northdown House. Throughout the mayor's speech he was interrupted by angry hecklers from the large crowd of locals and boatmen who were far from happy at how the funds were being administered. It almost beggars belief but the organisers - and that's a term that appears to flatter them - did not invite any of the widows to the unveiling ceremony. Originally sited opposite the Marine Sundeck, the statue was moved to its current position in the 1920s. Unusually for a town of this size, it is virtually the only statue in the whole town.

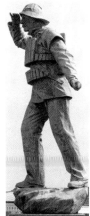

SEE Friend to all Nations Disaster/ Friend to all Nations Disaster Fund/ Friend to all Nations Disaster Memorial/ Margate

LIFEBOAT - Ramsgate

Ramsgate Harbour's trustees bought the first lifeboat from Henry Greathead at South Shields who manufactured boats specifically for that purpose.

William Miller of Ramsgate was awarded the silver medal in 1826 after rescuing, in a private boat, seven people from the 'Eliza and Jane' when it was wrecked on the Goodwin Sands.

Similarly, Captain Edward Gimar was awarded the silver medal in 1829 when he rescued six people, again from a private boat, Auguste, a French brig, off Ramsgate.

The Duke of Northumberland ran a competition for a new type of lifeboat. And James Beeching of Great Yarmouth won the prize for his invention of a self-righting lifeboat. Ramsgate Harbour's trustees ordered one for £250 and in November 1851 it arrived and was named the Northumberland. The new lifeboat's coxswain was John Hogbin and he also won the silver medal in 1857. Following his retirement in 1860, Isaac Jarman took over, and guess what he won – the silver medal, twice, in 1863 and 1870, before he retired in 1870. The Northumberland was in service from 1851 until 1865 and saved at least 400 lives in at least 150 launches. That £250

purchase price equated to around 12/6 (65p) per life saved.

The RNLI took over responsibility for Ramsgate's lifeboats in 1865, and the first four lifeboats were provided by the people of Bradford and were consequently named Bradford.

Bradford I (1866-77)
344 lives saved in 139 launches
Bradford II (1877-87)
405 lives saved in 147 launches
Bradford III (1887-93)
66 lives saved in 44 launches
Bradford IV (1893-1905)
53 lives saved in 121 launches
In total the four Bradfords saved 868 lives in 39 years.

During this time, on 5th January 1881 the Indian Chief, sailing from Middlesborough to Yokohama ran aground on the Goodwin Sands during a ferocious easterly gale. The steam tug Vulcan towed the lifeboat Bradford III for 26 hours because they had to wait all night before they could even find the Indian Chief, and then saved 12 of the 29 man crew. When the boat returned, a crowd of 2,000 had gathered at the harbour to greet them. Every lifeboatman, all eighteen of them, received the RNLI's silver medal and Charles Fish, the coxswain who replaced Isaac Jarman, won the gold medal and became a bit of a national celebrity. (Just to put into perspective the number of medals won that night - and each one is awarded for great bravery - in total, Ramsgate has been awarded two gold, forty silver and one bronze medals since the first one in 1826. Almost half that total were awarded on this one night alone, one gold and eighteen silvers.)

When Charles Fish retired in 1891 (he died aged 75 in 1915), he had helped in the rescue of 877 lives, in 353 launches, having served in the Ramsgate lifeboat for 26 years, 21 as the coxswain. For his incredible service the RNLI awarded him a second gold medal – the only time they did so. He was also awarded a silver medal in 1867 when he was the bowman in a rescue.

Charles Knight was the mate on the Vulcan and his wife was pregnant at the time. The First Officer on the Indian Chief was Howard Primrose Fraser who, despite being rescued, died on the trip back to harbour. Mrs Knight named her baby Howard Primrose Knight and he went on to become coxswain on the Ramsgate lifeboat 'Prudential' that rescued hundreds of men at Dunkirk fifty-nine years later.

Anyway, back in 1905, on the 25th May in fact, Mrs C Stephens of Reading spent £1,635 and presented Ramsgate with their next lifeboat named 'The Charles and Susanna Stephens' replacing Bradford IV. Coxswain William Cooper received the silver medal from the King of Denmark and the following year the crew received the thanks of the German government. After twenty years service, during which the lifeboat saved 294 lives in 163 launches, the Ramsgate sailing lifeboat had its last mission in November 1925. That year also saw the launch of the new, and Ramsgate's first, motor lifeboat named Prudential after the insurance company (Prudential Assurance Co.) that donated her at a cost of £8,417. She was launched by Mrs Home, the wife of the company's deputy chairman. The coxswain was Thomas Read and the boat was in service until 1953 after saving 330 lives in 276 launches as well as the 2,800 she brought off the beach at Dunkirk.

In 1953, a bronze medal was awarded to Coxswain Douglas Kirkaldie following the rescue of the SS Western Farmer.

The Duchess of Gloucester launched the 'Michael and Lily Davis' on 11th June 1954, a day which also commemorated the 150th anniversary of the Ramsgate station. The cost of £28,811 was borne by Mrs Davis, Mrs Halford, Mr Fox and Mrs Greystone who all generously donated it. The coxswain was initially Arthur Verrion, then Thomas Cooper and then Herbert Goldfinch. During the next twenty-three years, 318 launches resulted in 309 lives being saved.

Named after the former commander of the RNLI and his wife, 'The Ralph and Joy Swan' cost £130,000 and was launched by the Duchess of Kent in 1976. The coxswain was Ronald Cannon who, following the rescue of seven people from a French trawler, won the silver medal on 26th December 1985.

SEE Deal Cutter/ Denmark/ Dunkirk/ Goodwin Sands/ Harbour, Ramsgate/ Indian Chief/ Ramsgate

LIFT, Broadstairs

The Millennium Lift, as it is sometimes known, because it was built in 2000, is the newest such construction in the country. At the cliff top it is entered by up to 14 passengers at a time, via a short timber-decked bridge, before it descends to exit direct onto the beach. The structure is fifty three feet tall and has a window almost as tall.
SEE Broadstairs/ Cliff Railway

LIFT, East Cliff, Ramsgate

The passenger lift here was formally opened by the mayor on 5th August 1908. It was owned by Cliff Lifts Ltd (try saying that after six pints) and could carry 20 passengers at a time up to the top of Madeira Walk. It was very popular with passengers who had just arrived at the nearby Ramsgate Marine Railway Station. On 31st March 1919 it was purchased by Ramsgate Council. After falling into disuse in the 1990s it was repaired and refurbished in 1999 and re-opened.

SEE Madeira Walk/ Ramsgate

LIGHTHOUSE - Margate

John Rennie designed the first lighthouse on the end of the stone pier and it was put up between 1812 and 1815. In 1828, the second one, designed by William Edmunds, was put up. The Great Storm of 1st February 1953 damaged the foundations so badly that the lighthouse collapsed. The third and present, concrete lighthouse was built in 1955.
SEE Harbour, Margate/ Great Storm 1953/ Lighthouse, North Foreland/ Lighthouse, Ramsgate/ Margate/ Storms

LIGHTHOUSE - North Foreland

North Foreland is the most south-easterly point of Britain and there has been a lighthouse there in some form since 1499 when it was described as, *ye beecon that lyith at ye hedde of ye cliffe at Beecon Hill.*

During action involving the Spanish Armada, Sir Henry Seymour mentioned the beacon in 1588, *'Verily my heart was filled with thankfulness when ye Rainbow passed ye tower beecon of ye Foreland and we lyith a mile of Margate.'*

During the great sea battle against the Dutch in 1666, an observation post was set up on top of the lighthouse. In 1683 the original wooden structure burnt down, but was obviously re-built as the letter from the patentee to the lighthouse keeper in 1685 shows: *Let ye men at the lighthouses have a strict charge to be diligent about their fires, for wee hiar that ye 'Windsor Castle' is lost upon ye South Sand Head; also, Pray give all my servants at the lighthouse a strict charge to be very diligent in keeping good fires this rumbustious weather that no damage may come by their defaults, ask the Vicar Nicholas White to peep out sometimes before going to bed to see how my lights burn and, if he finds dimness, to reprove the men, the dangers yt ye lighthouse men apprehend themselves to be in from ye Press-masters proceeds I find from themselves and therefore you did very well in charging them to mind ye lights which is their proper business and leave off their fishing otherwise I shall suspect my concern to be neglected and thereby their disadvantage may be greater than their gains by fishing, besides, I don't know how they can be sufficiently watchful after sayling all ye day.*

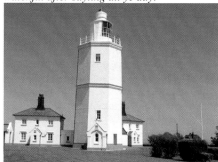

The foundations of the present lighthouse date back to 1691 although the present structure was not built until 1732, with two extra storeys added in 1793. A new lantern and two cottages for the keepers and their families were added in 1860. In 1698 the

lighthouse used 100 tons of coal but in 1790 the original coal-fired light was replaced by a patent oil lamp with reflectors and a magnifying lens. In 1931 the light was converted to electricity and is equal to 175,000 candle-power from a 3.5 Kw 240v lamp. The light is recognised by a group flash 5 times every 20 seconds and is visible up to 20 miles away. Trinity House took over the running of the place in 1832 and on 26th October 1998, Prince Philip as Master of Trinity House ceremoniously switched the operation to an unmanned lighthouse; at the time it was the last manned one in the country.

The cost of automation was £150,000, but it was calculated that this would be regained within five years, and over fifteen years the saving would be £769,000.

It is often said that the lighthouse's stark appearance was what inspired Wilkie Collins to call his novel 'The Woman in White', now the white bit I can see, but stone tower to woman I still can't get.

SEE Armada/ Collins, Wilkie/ HMS Thanet/ 'Quarantine Island'/ Shaw, George Bernard/ Smuggler's Leap/ Tester, Dr Arthur/ Woman in White

LIGHTHOUSE - Ramsgate

There have been three lighthouses at the present site.

The first seems to have had plans drawn up for its construction by John Smeaton in 1783 although there is some dispute as to whether it ever actually got built.

The second (or first!) was built by Samuel Wyatt in 1794. It was 34ft tall and 9ft in diameter.

The third and present one was the John Shaw designed lighthouse built in 1843 which used 1,660 cubic feet of Portland Stone and cost £1,000. The Latin phrase 'perfugium miseris' meaning 'shelter for the distressed' was carved into the stonework.

SEE Harbour, Ramsgate/ Lighthouse, Margate/ Lighthouse, North Foreland/ Ramsgate/ Storms

LILLIAN ROAD, Ramsgate

Bombs just missed The Lillian Road School in an air raid on 9th February 1916.

SEE Ramsgate/ Schools/ World War I

The LIMES, Hawley Street, Margate

This house was built in 1803. Initially, a Mrs Brooke lived there for three years, followed by Robert Brooke (her son?) who was a solicitor. It appears to stay with the Brooke family until 1835 when George Henry Hoffman junior takes over. Another solicitor, Edward Bailey King, was there in 1901; then a naval surgeon, Charles Harnett, is followed by Dr Percy Burgess in 1906 and more medical men: Dr Drummond and Dr Summerfield were GPs here after World War II as well as Paterson, Muir and Muir.

Now more solicitors are here in the form of Boys and Maughan who are also next door at India House.

SEE India House/ Hawley Street/ Margate

LINSCOTT

16 Addington Street, Ramsgate

Ramsgate, by J S Rochard, c1900:

Mr J Linscott, Family Grocer, Wine, Spirit, Bottled Beer and Provision Merchant, 16 Addington Street, West Cliff.

The business was founded nearly half a century ago by Mr Linscott's father-in-law. Mr Linscott has been running the business for some twenty years always enjoying the patronage and recommendation of a number of the best families residing on the West Cliff and elsewhere, as well as the custom of numerous visitors during the season. Mr Linscott also takes a great interest in the repair and manufacture of astronomical telescopes, which instruments he has supplied to scientists in all parts of the world, at prices from £5 to £300.

SEE Addington Street/ Ramsgate/ Shops

LION TAMER

At the Hall by the Sea, Lord Sangar's wife worked as the first female lion tamer. Captain Sadler was also a lion tamer there and had a billing which was taken from a popular song of the time:

He puts his head in the lion's mouth
And keeps it there a while,
And when he takes it out again
He greets you with a smile.
. . . and a look of relief, I suspect.

George Sadler lived in a cottage in the grounds of the Hall by the Sea and was the driving force behind a successful breeding programme for lions. He cared for up to 20 lion cubs in his cottage. Circuses and menageries across Europe had lion cubs from here – many were named Margate.

He also trained lions to do various tricks; one particularly fierce-looking lion was doing his routine of walking across two tightropes above the lake when a firework spooked him and he fell into the lake. The soaked and frightened king of the jungle promptly ran to Sadler's cottage to be comforted!

When Sadler got married in October 1900, he and his new wife, along with some of the braver guests, cut the wedding cake in the lions' cage.

SEE Entertainers/ Hall by the Sea/ Margate/ Van Amburgh, Isaac

LISTED BUILDINGS

Ramsgate has more listed buildings than any other town in the south of England.

SEE Christ Church, Ramsgate/ East Cliff Lodge/ Hudson's Mill/ Margate Railway Station/ Marina Esplanade, Ramsgate/ Old Bay Cottage, Birchington/ Paragon/ Pugin, bust/ Ramsgate/ Royal Sea Bathing Hospital/ St Augustine's, Westgate/ Scenic Railway/ Seven Stones/ Shelter/ Victoria Parade, Ramsgate

LITTLEWOODS

High Street, Ramsgate

John Moores (born 1896) was part of a group that founded a football pools business in Liverpool in 1923 but he called it Littlewoods after the family name of another partner, rather than Moores because he did not want his employers to find out about it. The firm expanded into mail order in 1932, and the chain stores started to appear in 1936.

Prior to Littlewoods opening in Ramsgate in 1938, the area it occupied, next to Woolworths, was a small court of shops: the snappily-named London and Provincial Meat Company (owned by George Munday who took over a fishmongers and poulterers from the grandly named Mr Hippolyte Drincbier), and the Imperial Wine and Spirit Company. In between these stood the businesses of Mr Twigg, a leather merchant, and Mr Spratt, a barber.

SEE High Street, Ramsgate/ Ramsgate/ Shops/ Woolworths

LIVERPOOL ARMS public house

Charlotte Place, Margate

It was at 19 Charlotte Place from around the early 1820s, then at 22 Charlotte Place at the end of the century. The Liverpool Arms closed in the 1950s.

SEE Charlotte Arms/ Fordred, Thomas/ Margate/ Pubs

Lord LIVERPOOL

Born 7th June 1770
Died 4th December 1828

If we are going to be formal, he was The Right Honourable Robert Banks Jenkinson, 2nd Earl of Liverpool, KG, PC, and from 1796 to 1808 was known as Lord Hawkesbury.

He was 42 years and 1 day old when he became Prime Minister. There has been nobody younger than him since – even Tony Blair was 43 when he first took office.

Liverpool was Prime Minister for 14 years and 305 days, from June 1812 to April 1827 the longest-serving Prime Minister of the nineteenth century, but he suffered a stroke on 17th February 1827 causing his resignation, from then until his death, nearly 22 months later, he was barely conscious.

He had previously been Home Secretary (1804-6 & 1807-9) and Foreign Secretary (1801-03) and became Prime Minister after his predessesor, Spencer Percival, was assassinated in May 1812.

He founded the National Gallery and both Liverpool Street and Liverpool Street Station in London are named after him.

SEE Canning, George/ Liverpool Lawn/ Pier/ Prime Ministers

LIVERPOOL LAWN, Ramsgate

It is named after Lord Liverpool.

SEE Liverpool, Lord/ Ramsgate

David LIVINGSTONE

Born 19th March 1813, Blantyre, Scotland
Died c.30th April 1873 Chitambo (Zambia)
He was a doctor and a missionary but started his working life in a cotton-textile factory. After studying medicine and theology in Glasgow, he offered his services to the London Missionary Society after hearing a lecture by the Scottish missionary Robert Moffat (1795-1883). The newly-ordained Livingstone went off to South Africa as a medical missionary. Soon after, in 1841 he reached Kuruman, a settlement established by Moffat, in Bechuanaland (now Botswana). He married Mary Moffat, daughter of Robert, in 1845. The two of them travelled across the continent seeing areas no European had seen before, crossing the Kalahari and seeing Lake Ngami (1849) and the Zambezi River (1851, by now their children were in tow). Whilst following the Zambezi River, in 1855, he became the first European to see the Victoria Falls of the Zambezi. He effectively re-drew the map of Africa, and when he returned to Britain in 1856 his book 'Missionary Travels and Researches in South Africa', published the following year, made him famous.

Following his resignation from the London Missionary Society, he was appointed by the British government to be the British Consul for the east coast of Africa at Quelimane (now in Mozambique) and also the commander of an expedition to explore central and east Africa. During these travels, he became increasingly concerned about the Portuguese and Arab slave traders he saw operating there - a topic he wrote about in 'Narrative of an Expedition to the Zambezi and Its Tributaries' which he wrote when he returned to Britain again in 1865.

Another expedition funded by friends and admirers was to find the source of the Nile, a sort of Holy Grail in Victorian England. He became the first European to see Mweru and Bangweulu lakes on his way to Lake Tanganyika where he arrived in 1869. Back home, the country was getting concerned for him as nothing had been heard of him and eventually a party led by Henry Morton Stanley met him at Ujiji in October 1871 with the famous words, *'Dr. Livingstone, I presume?'*. The two of them then set off and explored the area to the north of Lake Tanganyika, before Livingstone continued alone in his search for the source of the Nile. He was found dead on 1st May 1873 at Chitambo (in modern Zambia). It is probable that he had died the previous day. His followers buried his heart at the foot of the tree where he died and then carried his body to Zanzibar. Although it is also reported that his last words were to his servant Susi who was ministering to his illness, *'Alright, you can go now'*. His body was buried in Westminster Abbey, but his heart, remember, was buried in Tanzania, one of the very few people to be buried in two countries, or even continents.
SEE Livingstone Road, St Peter's

LIVINGSTONE ROAD, St Peter's

It is named after David Livingstone.
Seven German planes dropped 15 bombs between them on this area on the night of 19th May 1916.
SEE Livingstone, David/ St Peter's

Marie LLOYD

Born 12th February 1870
Died 7th October 1922
One of the great music hall entertainers. The songs 'My Old Man Said Follow the Van', 'The Boy I Love is up in the Gallery' and 'A Little of What You Fancy Does You Good' were made famous by her. She was known for the innuendo and double entendre that she could put into what seemed to be the most innocent of songs, 'Come into the Garden Maud' for example. *'They don't pay their sixpences and shillings at a music hall to hear the Salvation Army. If I was to try to sing highly moral songs, they would fire ginger beer bottles and beer mugs at me. I can't help it if people want to turn and twist my meanings.'*
SEE Beach entertainment/ Entertainers/ Salvation Army Citadel

LLOYDS BANK

Lloyds was founded in Birmingham in 1677, by a Welshman (Montgomeryshire), Charles Lloyd (born 1637) who started out as an iron master.
The Broadstairs branch, on the corner of Prospect Road and the High Street, was built on the site of a small farm that had burnt down.
In Ramsgate the premises of jewellers Lewis and Weeks were demolished to make way for the new Lloyds Bank on the corner of Queen Street and the High Street in 1927. Lloyds' previous site on the corner of the High Street and Hardres Street was rented out to the Westminster Bank.
SEE Broadstairs/ Farms/ High Street, Broadstairs/ Queen Street, Ramsgate/ Ramsgate

LOGO

In the 1950s the Ramsgate logo that appeared on all sorts of advertising material was a ram jumping over a gate.
SEE Ramsgate

LOLLIPOP MAN

Plaque on the churchyard wall at Canterbury Road, Birchington:

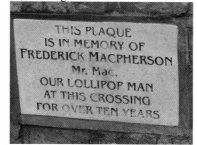

THIS PLAQUE IS IN MEMORY OF FREDERICK MACPHERSON Mr. Mac. OUR LOLLIPOP MAN AT THIS CROSSING FOR OVER TEN YEARS

SEE All Saints' Church/ Birchington/ Canterbury Road, Birchington

LONDON

Margate is approximately 72 miles east of London.

SEE Albert Memorial/ Cheyne Walk/ Cleopatra's needle/ Derry & Toms/ Donkeys/ Margate/ Town of Ramsgate pub

LONDON CHATHAM and DOVER RAILWAY Company

It arrived in Thanet in 1863 but because of various mishaps was known as the Undone, Smash'em and Turnover.
A Ramsgate Town Council meeting on 9th June 1900 discussed the nuisance of smoke from the LCDR Station. It was decided that if the railway people took the trouble, they could control it. Well that sorted the problem didn't it?
SEE Railway/ Ramsgate Sands Railway Station

LONDON ROAD, Ramsgate

In 1795, Joseph Ruse built a house called Belmont. A few years later, he sold it to the Earl of Darnley, but when Thomas Warre bought it in 1817, the name was changed to West Cliff House. It remained owned by the Warres until 1901 and was a holiday home for 12 year-old Princess Victoria in 1831. In 1904 it was owned by the Murray-Smith family. In 1922 it first became the St Winifred's School for Girls, then Stacey's Hotel and then a nursing home run by the Bon Secours Sisters.
SEE Christ Church School/ LeMesurier, John/ Ramsgate/ Schools/ Warre family/ Victoria

LONDON TAVERN public house
Addington Street, Margate

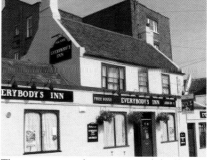

The cottage that was originally the Shakespeare Tavern dated from around the latter part of the eighteenth century. From 1858 it was The London Tavern, a Cobb Brewery house, and a staging point for the London stagecoaches and passengers who could get salted beef, bread and a jug of hot porter for 3d. Single-storey extensions were added either side in the nineteenth century; the extension on the right was for a saloon bar and had 'Billiard and Smoking Room' advertised in the glass of the windows and the other extension replaced the courtyard where the stabling and well had been. A bit like an iceberg, it probably had more working space underground than it had above. The kitchen, harness room and domestic quarters were all subterranean, having been dug out of the chalk. There were also three tunnels. First, there was the almost compulsory smugglers tunnel through which you had to crawl on your hands and knees all the way down to the harbour. Have you seen how far it is? I think I would have walked and paid the excise duty! Second, there was a tunnel to the 'actor's passage' in The Theatre

Royal opposite and third, there was a tunnel complete with storage chambers, leading to the rather swish London Hotel at 19 Hawley Square.

In more recent years, performers at the Theatre Royal have used the London Tavern as digs, perhaps the most famous being Danny La Rue and Harry Secombe. These days it is called Everybody's Inn.
SEE Addington Street/ Cobbs/ Hawley Square/ La Rue, Danny/ Margate/ Pubs/ Secombe, Harry/ Shakespeare/ Theatre Royal/ Tunnels

Frederick LONSDALE
Born St Helier, Jersey, 5th February 1881
Died London, 4th April 1954
In 1919 the film star Gladys Cooper was a houseguest of the playwright Frederick Lonsdale who owned three houses in Birchington between 1913 and 1923; one of them was called Ailsa on the corner of Alpha Road. He wrote many plays – comedies and musicals – and was also a screenwriter. Amongst his plays were, 'The Day after Tomorrow' and 'The Last of Mrs Cheyney'. He was the father of Frances Donaldson and Angela Fox (she married Robin Fox, an impresario and agent), and was grandfather to the actors Robert, James and Edward Fox.
SEE Authors/ Birchington/ Fox, Angela

Gordon LONSDALE
His real name was Konon Trofimovich Molody, but he took the identity of a dead Canadian businessman to hide the fact that he was a Russian spy in the 1950s. He was known locally as a big spending and popular director of a company that manufactured bubble gum machines in Broadstairs. He was sentenced to 25 years in 1961, but was exchanged in 1964 for the British spy, Greville Wyne.
SEE Broadstairs/ Russia

LOOP
The Thanet Loop bus service started in October 2004 and was launched by the then Transport Minister Alistair Darling. There is a bus every ten minutes!
SEE Thanet/ Transport

LORD BYRON public house
Byron Road, Margate
Two terraced houses, built in 1879, were merged by the Webb brewery to form a pub in 1896. It was taken over in 1897 by Russell of Gravesend, who in time became part of Trumans. Between 1896 and 1986 it had just four landlords. In the 1950s The Lord Byron Walking Race, 15 miles to Acol and Minster, was held annually with a trophy presented to the winner by the mayor of Margate. Some said that the walk became a pub crawl but I could not possibly comment. Around the same time the landlord apparently dressed in drag and gave a biscuit to the local carthorse every Sunday when he popped in whilst The Urinal Five played skiffle music in the large games room. The Byron became a freehouse in 1986 when the ex-landlord of the Victoria took it over.
SEE Breweries/ Byron Road/ Byron, Lord/ Margate/ Minster/ Pubs

LORD HAW-HAW
Born Brooklyn USA, 24th April 1906
Died Wandsworth Prison 3rd January 1946
Born William Joyce, he moved to London in 1921, joined the Nazis in 1930s, and before fleeing to Germany in 1939, was a teacher, briefly, at Port Regis School in Kingsgate. Whilst here he visited Dr Tester, the German spy.
In Germany, he was employed by Josef Goebbels, Hitler's Minister of Propaganda. He broadcast throughout World War II from Hamburg as 'Lord Haw-Haw' in an attempt to demoralize British listeners with German propaganda. His opening phrase was always 'Germany calling, Germany calling' and he attracted a sizeable audience.
'Jonah Barrington', Daily Express: *'A gent I'd like to meet is moaning periodically from Zeesen* [site of the German transmitter]. *He speaks English of the haw-haw, damit-get-out-of-my-way variety, and his strong suit is gentlemanly indignation.'* In fact he heard the voice of *'the Sandhurst-educated officer and gentleman'* Baillie-Stewart in September 1939, not Joyce, who had a more nasally voice, but the name stuck.
His last broadcast, during which he was drunk and rambling, was from Hamburg on 30th April 1945, as British troops were entering the city.
Joyce and his wife were arrested on the German/Danish border by British troops who, at first, did not realise whom they had caught, but they soon realised where they had heard that voice before! At the time of the arrest he put his hand in his pocket, and the troops, assuming he was going for a gun, shot him in the leg.
His trial was on 17th September in the Central Criminal Court at the Old Bailey, where he was charged with three counts of treason. Some people argued that he was not a British citizen (he was born in the USA and said he had no British passport, even though he applied and got one on 4th July 1934, and had extended it by one year in August 1939 – thus his earliest broadcasts were made as a British passport holder).
The trial lasted three days, and due to the arguments over whether or not he was British, he was found guilty on only one of the charges.
Various appeals followed that went to the House of Lords but they were rejected. At just after 9am on 3rd January 1946 he was hanged at Wandsworth Prison in London and buried within the grounds of the prison. In August 1976, his remains were exhumed and returned for burial in Ireland. Largely on compassionate grounds his wife, Margaret, was not prosecuted and she died in London in 1972.
SEE Joyce, William/ Kingsgate/ Schools/ Tester, Dr Arthur/ World War II

LORD NELSON public house
Broadstairs
In 1805, local draper and tailor, Richard Norwood, built his house here. He sold it to Robert Lawrence, a seafarer from Ramsgate, who turned it into a coffee house, although there are records of it having been used as a tailors and drapers. In 1815, Richard Tomson bought it for £850 and it became a pub named after Nelson to commemorate his death in the year that it was built. Again, there is a school of thought that says it was named after the occasion when HMS Victory anchored in, but more likely off, what is now Viking Bay on the way back from the Battle of Trafalgar with Nelson's corpse on board. Trips out to the ship were supposed to have been organised so that locals could view the body.
Coins dated 1808 were found when the pub was altered in 1964.
SEE Broadstairs/ Nelson/ Nelson Terrace/ Pubs

LORD of the MANOR, Ramsgate
The £1.4 million road improvement to replace the Lord of the Manor traffic light has been approved by county planners. The junction is Thanet's worst bottleneck. It will be replaced by two roundabouts, one on either side of the railway line and linked by a dual carriageway. About 6 acres will be needed plus 2.8 acres for landscaping. The scheme affects Ozengell Anglo Saxon burial ground, which is a scheduled ancient monument. (29th January 1988)
Various ghostly sightings have been reported in the area including some of monks and a phantom carriage!
SEE Ozengell/ Ramsgate

LOUISA GAP, Broadstairs
This bay is around 150 metres wide and is linked by promenades to both Dumpton Gap and Viking Bay.
It was originally named Goodson's Stairs. In 1873, Thomas Crampton designed, and paid for, a new wrought iron metal bridge to replace an old and dangerous wooden one and named it the Louisa Gap Bridge after his daughter Louisa Crampton. His wife was also named Louisa and she was a singer and a very good friend of Jenny Lind the Swedish opera singer
The gap got unintentionally renamed Louisa thereafter. The old bridge was replaced in 1963.
SEE Bays/ Broadstairs/ Crampton, Thomas/ Dumpton Gap/ Vale, The

Princess LOUISE ALBERTA
Born 18th March 1849
Died 3rd December 1939
The 4th daughter of Queen Victoria, she was generally thought to be the prettiest of all her sisters and was described as being elegant, calm, and ladylike but could be fickle and had volatile moods. She married John Campbell, 9th Duke of Argyll on the 21st March 1871. She had a house in Kingsgate for many years. She died on the 3rd December 1939.
SEE Kingsgate/ Royalty/ Victoria

LOVE LANE, Margate
This was once the home of Dick Ovendon, a nineteenth century smuggler, who lived there with his eighteen children!

The 'fair widow' Sarah Lenham lived in Love Lane. She had the misfortune to lose her husband and eleven children who all died in a period of just three years. She brewed a very popular eight-penny ale from 1825 at 'Aunt Sarah's Brewery', and then Lenham's Love Lane Brewery. It became The Love Lane Hotel (how could it fail with a name like that?) at numbers 6 & 7, from around the 1840s, then the Love Lane Inn which closed in 1973.

George Morland, the eighteenth century artist – who liked a drink - stayed at 8 Love Lane in 1785. He funded his drinking by doing portraits of visitors and selling them the finished product.

SEE Breweries/ Coleman's School/ King's Head/ Margate/ Morland, George/ Old Margate

LOVEJOY SCHOOL, St Peter's

The Rev George Lovejoy had once been headmaster of King's School in Canterbury. In 1684 he leased Callis Grange, or Callis Court. He died the next year but his wife, Elizabeth, continued to live there until she died after a stroke, or apoplexy as it was called then, in 1694. Unfortunately, she had not signed her will and the lawyers had all sorts of fun before deciding that the provisions in the will should stand. The vicar got another £40 per year, and another £20 a year – half what the vicar got – was used to set up and maintain a school within the church to be named the Lovejoy School.

If we fast forward to January 1852, we will find increased pupil numbers have meant that the Rev John Hodgson has to buy the Ranelagh Assembly Rooms, the Steward's Cottage and some land to be used as the new premises for the Lovejoy School. The first master here was Richard Schardau and his cottage is now called Lovejoy Cottage.

SEE Callis Court/ Ranelagh Gardens & Assembly Rooms/ St Peter's/ Schools

LOVELYS, Northdown Road, Cliftonville

E J Lovely opened the art shop Lovelys in 1891 and it is still a family run business.

SEE Cliftonville/ Northdown Road/ Shops

LOW COUNTRIES

During the 18th century, many monarchs and members of the royal family embarked to the Low Countries from the King's Stairs on the Parade, Margate.

SEE Holland/ Margate/ Parade, The

James LOWTHER

Born 16th February 1859
Died - not known

He was the second son of the Earl of Lonsdale and MP for Thanet. On 29th October 1900, he laid the foundation stone of the Haine Hospital for Contagious Diseases. He also donated the Isle of Thanet Football League Trophy for which teams still compete today.

SEE Election results/ Haine Isolation Hospital/ Politics

Sir John LUBBOCK

Born London, 30th April 1834
Died 28th May, 1913

He was the 1st Lord and Baron Avebury (succeeding to the baronetcy when he was 29), and the son of Sir John William Lubbock (1803-1865. He was both an astronomer and mathematician. He also studied the tides and the planets. His mathematic probability theories were used in relation to calculating life insurance policies.) In 1845, John junior went to Eton College and when he left, in 1848, joined his father's bank (well you would, wouldn't you?), becoming a partner when he was 22. In 1879, he was elected the first president of the Institute of Bankers.

His book, 'Pre-historic Times, as Illustrated by Ancient Remains, and the Manners and Customs of Modern Savages' (1865) was possibly the most important archaeological book of the century. He was the man who invented the names Palaeolithic and Neolithic for the Old and New Stone Ages. His other books included 'The Origin and Metamorphoses of Insects' (1873), 'British Wild Flowers' (1875), 'Ants, Bees and Wasps' (1882), 'Flowers, Fruit and Leaves' (1886), 'The Pleasures of Life' (1887), 'The Senses, Instincts and Intelligence of Animals' (1888), 'The Beauties of Nature' (1892), and 'The Use of Life' (1894). He also wrote essays, one of which was 'Tact' a lesson on life! He suggested that we try to win everyone we meet, to meet their desires (steady!) but it is alright to say no. We should not assume everyone is a friend just because they tell us they are, but we must not assume they are our enemies either. Apparently we should not expect to be heard much when we are young, we should sit and listen. OK, there might be a bit of scoffing at that last bit, but he did have some wise words, here are some highlights:

• *I can but think that the world would be better and brighter if our teachers would dwell on the duty of happiness as well as the happiness of duty; for we ought to be as bright and genial as we can, if only because to be cheerful ourselves is a most effectual contribution to the happiness of others.*

• *The important thing is not so much that every child should be taught, as that every child should be given the wish to learn.*

• *A wise system of education will at last teach us how little man yet knows, how much he has still to learn.*

• *Earth and sky, woods and fields, lakes and rivers, the mountain and the sea, are excellent schoolmasters, and teach some of us more than we can ever learn from books.*

• *Happiness is a thing to be practiced, like the violin.*

• *A day of worry is more exhausting than a week of work.*

• *What we see depends mainly on what we look for.*

• *Rest is not idleness, and to lie sometimes on the grass under trees on a summer's day, listening to the murmur of the water, or watching the clouds float across the sky, is by no means a waste of time.*

• *Sunsets are so beautiful that they almost seem as if we were looking through the gates of Heaven.*

• *Your character will be what you yourself choose to make it.*

He was elected MP for Maidstone in 1870 but lost his seat in the 1880 election, although he was immediately elected MP for the University of London (he had been vice-chancellor since 1872). His most lasting achievements as an MP were the Ancient Monuments Act of 1882 and the Bank Holidays Act of 1871.

Up until 1834, bankers had 33 days a year as holidays, mostly saints' days and the main church holidays like Easter and Christmas. In 1834 most of these were taken away and only Good Friday, 1st May, 1st November, and Christmas Day remained as holidays. Now here is a sentence you will not read very often: Some people felt sorry for the bankers (you will note we do not have Solicitor Holidays, or Estate Agent Holidays, I am not passing judgement just making an observation). Sir John Lubbock's Act gave them Easter Monday, Whit Monday, the first Monday in August, and Boxing Day as well. (Scotland got New Year's Day, May Day, the first Monday in August, and Christmas Day). Everyone else looked at these new Bank Holidays (although some wag called them St Lubbock's Days) and thought that they would like to take them as holidays as well, but the original name stuck.

The latter part of his C.V. reads:

1878 appointed a trustee of the British Museum.

1888-92 President of the London Chamber of Commerce.

1889-90 Vice-Chairman, 1890-92 Chairman of the London County Council.

1890 appointed a Privy Councillor;

1891 Chairman of the committee of design on the new coinage.

1884 Founded the Electoral Reform Society (then the Proportional Representation Society).

1900 (January) made Baron Avebury.

In the same year he bought Kingsgate Castle and largely re-built it.

SEE Kingsgate Castle

Alfred LUCK

Alfred Luck was a warehouseman who went on to become a wealthy merchant. He married Clementina Golding and they had seven children. After Clementina died, Alfred, a very religious man who had converted to Catholicism, moved the family to Ramsgate, where he bought the home of Augustus Welby Pugin, and paid for the building of the Benedictine monastery established in 1856.

He lived at 11 Nelson Terrace. He and Pugin bought a lugger together in 1849. He also commissioned Pugin to build a house for him. It was called St Gregory's but has since been demolished.

Alfred became a diocesan priest, as did one of his sons, two of his daughters became nuns, and his sons Francis and John became Benedictines. They both later went to New

Zealand, Francis the younger of the two went two years before John.

Alfred is buried in St Augustine's Church.

SEE Caroline, The/ Luck, John Edmund/ New Zealand/ Pugin, Augustus/ Ramsgate/ St Augustine's Abbey

John Edmund LUCK
Born Peckham, Surrey, 18th March 1840
Died Auckland, New Zealand, 23rd January 1896

The son of Alfred Luck, John studied in Italy, France, Ireland and England until he returned to Ramsgate in 1882. Here he was appointed bishop of Auckland, New Zealand, and was consecrated by Cardinal H. E. Manning on 3rd August that year, before arriving in Auckland in the November.

To bring the story full circle, when he had a new bishop's house built in 1894 it was designed by Augustus Pugin's sons and is said to be the finest example of the Pugin style of architecture in New Zealand.

SEE Luck, Alfred/ New Zealand/ Pugin/ Ramsgate

LUCY THE MARGATE ELEPHANT
Margate City, in New Jersey, USA - downbeach from world famous Atlantic City - is famous for Lucy the Margate elephant, a six-storey building including a restaurant and hotel within, which is literally in the shape of an elephant.

LUCY, THE MARGATE ELEPHANT
Has been designated a
NATIONAL HISTORIC LANDMARK
This site possesses national significance
In commemorating the history of the
UNITED STATES OF AMERICA
National Park Service
United States Department of the Interior

They advertise it as *'the only elephant in the world you can walk through and come out alive.'*

SEE Elephant/ Margate/ Restaurants/ USA

The LUSITANIA
This four-funnelled British steamship was launched on 7th June 1906 and was the first to cross the Atlantic in under five days. Lusitania was the Roman name for Portugal. Before it was built, £78,000 had to be spent on new equipment at the Clydebank shipyard which included the cost of dredging the Clyde to accommodate the ship's size.

Whilst sailing to England from New York, the Lusitania was torpedoed and sunk by a German U-20 submarine off the Old Head of Kinsale, Ireland on 7th May 1915. It took just 18 minutes to sink and 1,201 people died, including 128 Americans, and 3 stowaways. There were 764 survivors. The Germans claimed that she was carrying arms; the British and USA denied it. Nevertheless, the action was a major factor in the USA's decision to enter World War I.

Two of the dead were from Thanet, both seamen, one from Margate and the other from Broadstairs. They were in a lifeboat that washed ashore on the coast of Ireland. The lifeboat was auctioned to raise money for War Charities and was bought by Daniel Mason, a local benefactor and owner of the Cherry Blossom Shoe Polish Company. He presented the lifeboat to Broadstairs and it was placed on the side of the pier for many years.

SEE Broadstairs/ Margate/ Mason, Daniel/ Ships/ Titanic/ World War I

Henry LUTTRELL
Born 1765
Died 1851

Part of the Holland House circle, which included Dickens, Thackeray, Sheridan and Macauley, Henry Luttrell was *'a talker and a diner-out'* and Byron described him as *'the most epigrammatic conversationalist'* he had met. He particularly admired Luttrell's 'Advice to Julia', a poem that included observations of the London society of the time. Like many of his contemporaries, Luttrell had travelled down to Margate by sea which he describes in 'Steamer to Margate':

Now many a city wife and daughter
While on the deck some stretch their legs,
Feels that the dipping rage has caught her.
Some feast below on toast and eggs.
Scarce can they rest upon their pillows,
Cheered by the clarinet and song,
For musing on machines and billows;
Ten knots an hour they spank along,
Or, should they slumber, tis to dream
By Gravesend, Southend, through the Nore,
All night of Margate and of steam;
Till the boat lands them all at four,
Of Steam much stronger than a giant,
Exulting, on the Margate shore!
And, duly conjured, more compliant.
At eight, that bustling, happy hour,
His boat is ready at the Tower.
Embarked, they catch the sound, and feel
The thumping motion of his wheel.
Lashed into foam by ceaseless strokes,
The river roars, the funnel smokes.

SEE Dickens, Charles/ Margate/ Poets/ Steam Packet/ Thackeray, William Makepeace

Dame Vera LYNN
Born 20th March 1917

She was born Vera Margaret Welch and started her singing career in working men's clubs at the age of seven. By 11, she had joined a dancing troupe and at 17, she was singing with local bands and with the Billy Cotton Band. Her first radio broadcast was with the Joe Loss Band in 1935, and she followed this up with an appearance and a record of 'I'm in the mood for love' with the pianist Charlie Kunz.

In 1941 she went solo and had a radio series for servicemen called 'Sincerely Yours' as well as appearing in the revue 'Apple Sauce' at the London Palladium. Two of the biggest hits of the war were hers, 'We'll Meet Again' (1939) and 'The White Cliffs of Dover' (1942). She also entertained the troops in many war zones, some as far away as Burma in 1944 and she soon became known as 'The Forces' Sweetheart' a title she has kept for the rest of her life.

After the war, she appeared in the West End in 'London Laughs' (1952) and developed a TV career in the 1950s. What is often forgotten is her success in America where she had her own radio series, and was the first British female singer to have a number 1 hit there with 'Auf Wiederseh'n, Sweetheart' (1952). Her last UK chart hit was 'Travellin' Home' (1957). In the 1980s her album 'Family Favourites' sold well. She was made a Dame in 1975 and has appeared at many 40th, 50th and 60th anniversaries of D-Day landings and VE Days.

Still the Forces Sweetheart, she has never forgotten them and, clearly, they have never forgotten her.

SEE Cotton, Billy/ Dunkirk/ Entertainers/ Radio/ Winter Gardens

M

MADEIRA WALK, Ramsgate
It was built at a cost of £60,000 by Pulham & Son in 1892 to enable easy access from the east cliff down to the harbour area. The building that housed the old Albion Hotel, the East India Coffee House (which had replaced some cottages) had to be demolished and thousands of tons of chalk dug out of the cliff. In the end there was a small plot left over which the National Provincial Bank (later the NatWest, after merging with the Westminster Bank in 1970) bought at auction.

The rocks that adorn the gardens here are artificial and made from a recipe of cement and secret ingredients known only to Mr Pulham, the end result being called Pulhamite. Just after it opened on 6th April 1895 locals referred to it as the 'ratepayers' tears'.

On 29th April 1901, a tram came away from the line as it climbed Madeira Walk. As it ran back down the hill out of control, one of the passengers, Mr Abrams, panicked, understandably, and jumped from the tram fracturing his arm. Amazingly, he was the only casualty.

On 4th May 1901 another tram went out of control and crashed into the kerb but this time, just to improve on the first incident, while the breakdown gang was sorting things out, another tram went sliding down!

On 3rd August 1905, at just after 11 am - and you are probably ahead of me here – yet another tram, in fact, let me name it as Car 41, flew down the hill, broke through the iron railing and landed at the bottom of the cliff beside the Queen's Head over 30 feet below. Amazingly, the six passengers escaped unhurt – although bruised and understandably shocked - but the driver, Mr L W Lloyd, who had jumped out and landed on the roof of an unused building, had severe injuries to his head. The number injured would probably have been higher had it not been raining on this summers day, thus many holiday makers had not ventured out.

Word of these accidents travelled far and wide and a London newspaper even went so

far as reporting that trams had caused *'no deaths in Ramsgate that week'*.
SEE Lift/ Pulhamite/ Ramsgate/ Royal Victoria Pavilion/ Trams

MAGDALA ROAD, St Peters
In the mid-nineteenth century Emperor Theodore II (sometimes Tewodros II) of Abyssinia (Ethiopia) used the town of Magdala as his base, and later his capital, while he attacked and conquered the surrounding Oromo area. In 1867 he put several British diplomats in prison. Sir Robert Cornelius Napier was sent to rescue them, which he duly did, destroying Magdala and, as a consequence, Theodore II later committed suicide. As a reward for his victory, Napier was made Baron Napier of Magdala. The first journalist to report the news of this was Henry Morton Stanley, he of 'Dr Livingstone, I presume?' fame.
'Dear Me' by Peter Ustinov (1921-2004):
My grandmother, whose Christian name was Magdalena, was born in a tent during the Battle of Magdala, which opposed Ethiopian forces to British ones under Lord Napier . . . My grandmother's youngest sister was still, until recently, a lady-in-waiting at the court of Haile Selassie.'
These events were commemorated by the naming of both Magdala Road and Napier Road in St Peters.
SEE Stanley, Sir Henry Morton

Katherine MANSFIELD
Born 14th October 1888
Died 9th January 1923
T S Eliot, a visitor to Margate, told Ezra Pound that she was *'a dangerous woman'*. He also said she had *'a fascinating personality'* but was *'a thick skinned toady'*
By 1918 she had contracted tuberculosis which, five years later, killed her.
Her work includes 'In a German Pension' (1911); 'Bliss' (1920), 'The Garden Party' (1922), 'The Dove's Nest' (1923) and 'Something Childish' (1924),
'I believe the greatest failing of all is to be frightened.' Katherine Mansfield, in a letter to her husband, John Middleton Murry, 18th October 1920
SEE Authors/ Eliot, T S/ Lawrence, D H

'MANSFIELD PARK'
by Jane Austen
I went down to Ramsgate for a week with a friend last September, just after my return from the West Indies. My friend Sneyd - you have heard me speak of Sneyd, Edmund; his father and mother and sisters were there, all new to me. When we reached Albion Place they were out; we went after them, and found them on the pier. Mrs. and the two Miss Sneyds, with others of their acquaintance. I made my bow in form, and as Mrs Sneyd was surrounded by men, attached myself to one of her daughters, walked by her side all the way home, and made myself as agreeable as I could; the young lady perfectly easy in her manners, and as ready to talk as to listen. I had not a suspicion that I could be doing anything wrong. They looked just the same; both well dressed, with veils and parasols

like other girls; but I afterwards found that I had been giving all my attention to the youngest, who is not out, and had most excessively offended the eldest.
SEE Albion Place/ Austen, Jane/ Books/ Pride and Prejudice/ Ramsgate

MANSTON
The name comes from 'Mann's farmstead'. It was also once known as Manston Green.
SEE Arnold, Robert/ Canada/ Ellington Park/ Farms/ Holy Trinity Church, Ramsgate/ Hurricane Bombardment/ Jolly Farmer/ Mill Lane, Birchington/ St Luke's Church/ Smuggler's Leap/ Tyler, Wat/ World's Wonder

MANSTON AIRFIELD/AIRPORT
The Royal Naval Air Service was stationed at Westgate at the beginning of World War I, but soon moved inland to fields behind Manston for use initially as an emergency landing area, and then as a base, for their attacks on the invading German Zeppelins, Taub and Gotha bombers.
Handley–Page long-range bombers were installed here. Bombs and fuel were brought here via a railway line that ran from Birchington, via Brooksend and Acol.
The Hurricane Bombardment of 27th April 1917 hit RNAS Manston with 37 shells. Ferndale in Manston village was also damaged.
The Royal Naval Air Service and the Royal Flying Corps grew and combined into one. The aerodrome was named Royal Air Force Manston on 1st April 1918.
After the war, up to 4,000 personnel were accommodated in classrooms, hangars and workshops and it became a major training station.
During World War II, being so close to the coast meant that enemy aircraft were soon - on 24th August 1940 to be exact! - able to put it out of action. Later in the war, it served as a dispersal field for our bombers as they returned.
On 12th February 1942, in dreadful weather, part of the German navy including the Gneisenau, Prinz Eugen and the Scharnhorst sailed from Brest up to the Baltic where they would be safe from enemy attack. Lieutenant Commander Eugene Esmonde led six Swordfish aircraft from Manston to attack the fleet. Out of a total of eighteen crew, thirteen died as all six planes were shot down.
In 1943, the airstrip was enlarged to help damaged planes returning from raids on Europe to land – it is the fourth longest runway in the UK.
For a while in the 1950s and 60s it was a USAF base, but with an airstrip that was almost 200 feet wide the RAF used it as a Master Diversion Airfield.
The RAF's first use of jet aircraft was from Manston airport, when Gloster Meteors were stationed and used to bring down V1 flying bombs.
Houses were built for RAF personnel in 1980.
In 1982 it became a Military Emergency Diversion Airfield.
RAF Manston closed on 31st March 1999.

The Allied aircrew figure statue was unveiled by the Queen Mother on 18th July 1997 and the Allied Air Force Memorial Garden was opened on 30th June 2001 when the guest of honour was Dame Vera Lynn who had previously opened the Hurricane Memorial Building on 7th October 1988.

SEE Anne, Princess/ Barham, RH/ Battle of Britain/ Cavendish Baptist Church/ Dambusters/ Die Another Day/ Eurojet/ George Medal/ Gotha/ Green, Napoleon/ High Street, Margate/ Hurricane Bombardment/ Invicta Airways/ Kent International Airport/ Lynn, Dame Vera/ Plane Crash, St Peter's/ Ramsgate Airport/ Roman Catholic Church, Birchington/ Rossetti/ Royal Navy Air Service Station/ Sacketts Hill Farm/ Space Shuttle/ Spitfire/ Spur Railway Line/ Tester, Arthur/ Transport/ Trinity Square/ Tunnels, Ramsgate/ V1&V2 rockets/ Westgate-on-Sea/ World War I/ World War II/ Zeppelin

MANSTON AIR DISPLAY DISASTER
September 1949
The day before the disaster, a Mrs Andrews could not decide whether to take her children to the air display or to Canterbury for a cricket match. She tossed a coin to decide and it came down in favour of the air show. So, with her two year-old son in a carrier on her bike, she, along with her sister and her eleven year-old son, Malcolm, were cycling from Margate to Manston for the display. Flight Lieutenant Geoffrey Hanson was piloting a Mosquito, a twin-engine aircraft, which had been performing low-level aerobatics. He had been told to dive to 200ft, then climb to 500ft and then to do a roll. Whether it was pilot's error or mechanical fault is not known for certain, but when the engine stalled, he was too low to do the manoeuvre and crashed into the queue of traffic waiting to enter the aerodrome, destroying some cars and their occupants completely. Some people were trapped inside their cars and burnt to death and cyclists and pedestrians who were caught in the flames suffered in the same way. Malcolm had cycled ahead and turned round to see the Mosquito *'I went ahead and got there first. I looked back for them and saw an aeroplane diving. Then there was a flash and a sheet of flame'* Malcolm lost his mum, brother and his aunt.

MANSTON COURT

The ancient manor house, Manston Court, was demolished in 1853. The only part to survive was a section of the chapel which went on to have a career as a barn!

MANSTON GATE

In the 1926 re-organisation of the Southern Railway, Manston Gate, the level crossing, was replaced by a new bridge, and the whole of Manston Road was improved.

MARCHESI'S

The same family have owned the restaurant in Albion Street, Broadstairs since Frederico Marchesi opened it in 1886 until it closed in early 2006. The business moved next door to the Royal Albion Hotel (which they bought in 1978), but the Marchesi name is no longer traded under.

SEE Broadstairs/ Libraries/ Restaurants/ Royal Albion Hotel

MARGATE

Originally Margate, or Meregate (meaning marsh gate because, until modern times, the town lay between two tidal creeks, one of which was at the present site of Dreamland and the other at the point where King Street now enters Marine Drive/ Terrace) as it is referred to in 1252 (it appears as Maraget in 1293), was a small fishing hamlet clinging around a wooden jetty, with a separate farming community hugging around St John's Church.

In the early to mid 18th century the town became popular.

Sailing ships or hoys carried Thanet's barley, wheat, fish and cordwood to the London quays. Ships could thus bring patients back to Margate for the curative sea air as recommended by the written works of Sir John Floyer (1722) and Dr Russell (1752).

'The Penny Cyclopedia' by The Society for the Diffusion of Useful Knowledge (1839):

Margate, a seaport town on the coast of Kent, in the parish of St. John, hundred of Ringslaw, and Isle of Thanet, 40 miles east-north-east from Maidstone, and 65 east from London (direct distances). Its name is probably derived from Meregate, signifying an opening or gate into the sea.

Hasted, in his 'History of Kent,' published in 1799, says, 'The town of Margate was till of late years a poor inconsiderable fishing-town, built for the most part in the valley adjoining the harbour, the houses of which were in general mean and low ; one dirty narrow lane called King Street having been the principal street of it.' At present the principal streets of Margate are regularly constructed and well paved, and lighted with gas; and many of the houses and public buildings, including an esplanade, squares, &c, are of a superior description.

The spring-water is excellent and the supply abundant. The shore is well adapted to sea-bathing, and to this circumstance, added to the generally acknowledged salubrity of the air, and the facility of communication with the metropolis by means of steam-vessels, must be attributed to the rapid increase in the population of the parish of St. John, which in 1831 amounted to 10,339.

A handsome new church has been built at Margate within these few years. There is an hospital, called Draper's Hospital, founded in 1709 by Michael Yoakley, a member of the Society of Friends, for the housing and maintenance of decayed housekeepers. The sea-bathing infirmary at West-Brook, near Margate was established by the benevolent Dr. Lettsom in the year 1792, assisted by committees which had been formed both in London and Margate. The object of the founders was to enable poor people to participate in the advantages of sea-bathing. The building consists of a centre building and two wings, and contains wards for the reception of nearly one hundred patients. The national school affords gratuitous instruction to about 400 children of both sexes.

The present stone pier was erected under the superintendence of Messrs. Rennie and Jessop, at an expense exceeding £100,000. It is 900 feet long, and at its extremity is the lighthouse, built from a design of Mr. Edmunds. The erection of this pier has added greatly to the utility of the harbour, which is much exposed to winds from the north-east.

Margate is within the jurisdiction of Dover, one of the Cinque-ports. In the year 1787 the inhabitants thought their town of too much importance to be longer subjected to this jurisdiction, and accordingly applied to the crown for a charter of incorporation; but upon the case being heard before the attorney-general, the opposition of Dover was so strong that their petition was refused, and since then the application has not been renewed.

SEE Accomodation/ Actors/ Addington Street/ Addiscombe Road/ Africa/ Albert Terrace/ Alexandra Homes/ Alexandra Road/ Alma Road/ Armada/ Arnold, Matthew/ Assembly Rooms/ Australia/ Ballantine, William/ B&Q/ Bancroft, Edward/ Bar 26/ Bar Barcelona/ Barber, Thomas/ Barham, RH/ Barkworth, Peter/ Bath chairs/ Bathing/ Bathing machines/ Bay, The/ Beach Entertainment/ Beale, Benjamin/ Berkeley, Ballard/ Bicycle/ Biggs, Ronnie/ Birmingham Daily Gazette/ Bishop, Sir Henry/ Black Horse Inn/ 'Bleak House'/ Blizzard/ Bloodvessel, Buster/ Blue Plaques/ Boating & paddling pool/ Bobby's Department Store/ Botany Bay/ Bowie, David/ Brass Monkey/ Britannia pub/ Broad Street/ 'Brothers of Bitchington'/ Broughton, Lord/ Broughton, Phyllis/ Bryer, Buckingham Road/ Buenos Ayres/ Bulls Head/ Byrne, Charles/ Byron, Lord/ Byron Road/ Camera Obscura/ Captain Swing/ Cartoon/ Cecil Square/ Cemetery, Margate/ Centre, The/ Chambers, Frederick/ Chapel Bottom/ Charlotte Place/ Chas & Dave/ Chocolate/ Churches/ Churchill, Winston/ Cinemas/ Cinque Ports/ Cinque Port Arms/ Clarks shoes/ Clock Tower/ Clodd, Edward/ Cobbett, William/ Cobbs/ Cockney rhyming slang/ Cold harbour/ Coleman's School/ College Road/ Concert Parties/ Cooper, Tommy/ Corelli, Marie/ Cottage, The/ Covell's Row/ Cowper, William/ Cowper Road/ Coxswain pub/ Cranbourne Alley/ Crecy/ Crouch, Ben/ Crowds/ Crown pub/ Crown & Sceptre/ Crown Bingo/ Cumberland, Duke of/ Dandy Coons/ Dane Park/ Deckchairs/ Deller, Alfred/ 'Diary of a Nobody'/ Doggett Coat & Badge/ Donkeys/ Drapers Mill/ Dreamland/ Droit House/ Druids Arms/ Duke of Edinburgh pub/ Duke Street/ Dull/ Dunkirk/ Eastenders/ Eaton Road/ Edward VII/ Effingham/ Electric Tramways/ Eliot, TS/ Emin, Tracey/ Entertainers/ Farington, Joseph/ Farms/ Fascists/ Faversham & Thanet Co-op/ 1566/ Fires/ Fire Brigade, Margate/ First & Last/ Fitzalan, Richard/ Fitzherbert, Mrs/ Flag & Whistle/ Flete/ Flooding/ Football/ Fordred, Thomas/ Forresters Hall, Margate/ Forresters Hall, Ramsgate/ Fort Brewery Tap/ Fort Crescent/ Fort Hill/ Fort House Castle/ Fort Road/ Fountain Inn/ Fox, Sydney/ Friend to All Nations/ Fry, Stephen/ Fuller, Leslie/ Garden Electric/ Garner's Library/ Gas Works/ Germaine, Louise/ George Hotel/ Ghosts/ Gibbets/ Gillray, James/ Golden Eagle/ Golf/ Gotha Raids/ Graffiti/ Grand Falconer/ Grand Old Duke of York/ Gray, Thomas/ Great Storm 1953/ Green, Napoleon/ Grosvenor Place/ Grunt fish/ Guidebook/ Gypo/ Gypsy Rose Lee/ Halfmile Ride/ Hall by the Sea/ Harbour/ Hartsdown/ Hartsdown Park/ Hartsdown Technical College/ Hasted, Edward/ Hastings Avenue/ Hatton, John Liptrot/ Hawkwind/ Hawley Square/ Hawley Street/ Hazardous Row/ Helena Avenue/ Henley, WE/ Herms/ High Sea/ High Street/ Hodges, Captain/ 'Holiday Romance'/ Holland/ Holy Trinity Church/ Hood, Thomas/ Horne, RH/ Hospital/ Hotels/ Hot weather/ Houchin, Alan/ Hovercraft/ Howes Royal Hotel/ Hoy/ Hoy pub/ Hugin/ Hurricane Bombardment/ Husbands' Boat/ Iles, JH/ Imperial Hotel/ India House/ Infant deaths/ Ingoldsby House/ Jarvis's landing place/ Jerrold, Douglas/ Jetty/ John Bayly's Tea Dealership/ Jordan, Mrs/ Jorrocks/ Keats, John/ Keble/ Kelly, Michael/ Kent Hotel/ King Edward Avenue/ King Street, Margate/ Kingfisheries/ King's Head/ Kooh-i-noor/ Lamb, Charles/ Landen, Dinsdale/ 'Last Orders'/ 'Last Resort/ Lawrence, Carver/ Lawrence, DH/ Lear, Edward/ Lee shore/ Lester's Bar & Restaurant/ Lifeboat/ Lifeboat memorial/ Lighthouse, Margate/ Limes, The/ Lion tamer/ Liverpool Arms/ London/ Lord Byron pub/ Love Lane/ Low Countries/ Lucy the Margate Elephant/ Lusitania/ Luttrell, Henry/ Marine Drive/ Marine Gardens/ Marine Palace/ Marine Parade/ Marine Terrace/ Market Place/ Marks & Spencer/ Marlborough Road/ Marx, Karl/ MCC/ Mechanical Elephant pub/ Meeting of George & Caroline/ Methodist Hall/ Metropole Hotel/ Mill Lane/ Milton Avenue/ 'Misadventures at Margate'/ Mods & Rockers/ 'Moonraker'/ Moore, Henry/ Morland, George/ Morley, Robert/ Morning Chronicle/ 'Mr Jericho'/ Mulberry Tree pub/ Napoleon/ Nash Road/ Nayland Rock Hotel/ Nelson/ New Inn/ Newgate Gap/ Newton, Sir Charles/ Noise/ Norfolk Road/ Northern Belle pub/ Norton, Peter/ 'Oh, Margate'/ 'Old Curiosity Shop'/ Old Margate/ Old White Hart Hotel/ 'Only Fools and Horses'/ Orb pub/ Orpen, William/ 'Over the River'/ Oxford Hotel/ Oxford Street/ Paine, Thomas/ Pallo, Jackie/ Pancake ice/ Pankhurst, Christabel/ Parade, The/ Parker, ED/ Passengers by sea/ Pepys, Samuel/ Phillpott, Thomas/ Phoenix pub/ Pier/ Pillow Talk/ Plaza Cinema/ Plucks Gutter/ Poets Corner/ Population/ Post box/ Post Office/ 'Praise of Margate'/ Princess of Wales pub/ Prostitutes/ Pubs/ Punch & Judy/ Punch & Judy pub/ Punch magazine/ Quart in a Pint Pot pub/ Queens Head pub/ Queen's Highcliffe Hotel/ Queens Promenade/ Railway stations/ Ramsgate/ Ramsgate Road/ Recruitment/ Regal Cinema/ Rennie, Richard, Eric/ Rose in June pub/ Rovex/ Rowe, AW/ Royal Adelaide/ Royal Albion Hotel/ Royal Crescent/ Royal School for Deaf/ Royal Sea Bathing Hospital/ Royal Yacht/ Royal York Hotel/ St John's Church/ St Peter's Footpath/ St Peter's Road/ Sala, George/ Salgado, Michel/ Salmestone Grange/ Sanger/ Saracen's Head pub/ Savage, Tony/ Schools/ Sea View Terrace/ 'Second Stain'/ Settlement Acre/ 'Shabby Genteel Story'/ Shaftesbury House/ Shakespeare pub/ Shaw, George Bernard/ Shell

Grotto/ Shelter/ Sheridan, Richard/ Sheridan, Thomas/ Ship Inn/ Shottendane House/ Shottendane Road/ Sickert, Walter/ Six Bells/ 'Sketches by Boz'/ Sloops/ Smuggling/ 'Smuggler's Leap'/ Snob/ Soper's Yard/ South Africa/ Spread Eagle Inn/ Springs/ Squash Club/ Stagecoach/ Standing Stones/ Steam Packets/ Storms/ Suffragettes/ Suicide/ Sunbeam Photos/ Sunsets/ Sunshine Rooms/ Takaloo/ 'Tales of the Hoy'/ Ternan, Nellie/ Terriss, William/ Thackeray, William Makepeace/ Thames Steam Yacht/ Thanet Hospital/ Thatcher, Margaret/ Theatre Royal/ Thomson, Dr/ 'Three Men in a Boat'/ Times, The/ Tivoli Brook/ Tivoli Park/ Tivoli Park Avenue/ Tivoli Road/ Tobacco/ 'Tom Tiddler's Ground'/ Topspot/ Town Hall Building/ Town Mill/ Traffic jams/ Trams/ Trinity Square/ Tudor House/ Turner, JMW/ Twelve Nails/ Twinning/ Tyrwhitt-Drake, Sir Garrard/ Uncle Bones/ Uncle Frank/ Union Crescent/ USA/ VAD Hospitals/ Van Amburgh, Isaac/ 'Veiled Lodger'/ Victoria/ Victoria pub/ Voss, Captain/ Walpole Bay/ 'Wasteland'/ Watt/ Weather/ Weill, Kurt/ Wellington Hotel/ Wesley, John/ Wheatley, Dennis/ Wherry/ White Hart pub/ White slave trade/ Wilde, Oscar/ William & Mary/ Windmills/ Winter Gardens/ 'Without Prejudice'/ 'Women in Love'/ Workhouse/ 'World of Waters'/ World War I/ World War II/ Wrestling/ Yachtsmen/ Yates' Wine Lodge/ Ye Foy Boat Inn/ Yeomanry/ Yoakley, Michael/ Yoakley Square/ York Hotel/ York Mansions

MARGATE ALES
John Evelyn, 1672: *'Meregate consists of brewers of a certain heavy ale, and they deal much in malt.'*
SEE Breweries/ Pepys, Samuel/ Northdown Ales

'MARGATE, 1940'
by Sir John Betjeman
Having first visited Birchington over a decade earlier, he obviously visited the rest of Margate and was able to make a comparison with the wartime town. The poem mentions the Queen's Highcliffe Hotel, Queen's Promenade, Harold Road and Norfolk Road.
SEE Betjeman/ Birchington/ Cliftonville/ Harold Road/ Norfolk Road/ Poems/ Queen's Highcliffe Hotel/ Queens Promenade

MARGATE CAVES
Northdown Road, Cliftonville
They are to be found at the western end of Northdown Road under (where else) the site of the old Holy Trinity Church and current Margate War Memorial.
Francis Forster built a large house and named it after the county of his birth, Northumberland House. A year or two later, around 1798, his gardener was working away - I don't know what he was doing, but I think digging was involved - when he discovered the caves. A new entrance was created and a local artist called Brazier created murals on the walls. Unfortunately, in order to create the paintings, he first smoothed the walls, and in doing so, removed all the old tool marks that would have revealed much about the date of the caves.
The entrance used today was created in 1914 from the cellar of the vicarage.
In 2005, the caves were closed due to safety concerns and while it would have cost £48,000 to re-open the caves, it only cost £26,000 to close them.
SEE Cliftonville/ Holy Trinity Church, Margate/ Hoopers Hill House/ Northdown Road

MARGATE COLLEGE
In 1886, W Leach-Lewis, who owned other schools in Margate, bought the Margate High School for the Sons of Gentlemen in Hawley Street and re-named it Margate College. Highly successful, it was a *'public school in miniature'* and by the early part of the twentieth century it aimed *'to train leaders of men to govern our Empire'*.
The school had about 300 pupils and it regularly entertained the MCC at cricket during the 1920s, in its extensive green and leafy grounds.
A German air raid in September 1941 destroyed the college and the site became a car park, known as College car park, for many years. The present supermarket complex was built in 1986 at a cost of £4million.
SEE Cricket/ Hawley Street/ MCC/ Schools/ Ternan, Nelly/ Union Crescent

MARGATE FOOTBALL CLUB
It was founded as an amateur club in 1896/97 and the team played in black and white shirts on a variety of pitches, including school playing fields.
From September 1912 they played their home games on the Lower Pitch at Dreamland and in 1924/25 they joined the Kent League Division One.
The first trophy that Margate Football Club ever won was The Kent Junior Cup, beating Ashford Park Rangers 2-1 in the final on 1st March 1902.
They moved to Hartsdown in 1929, and at the same time their team colours changed to amber and black.
A link to Arsenal Football Club meant that in 1934 the club became their nursery side and the pitch was laid out in the same dimensions as the one at Highbury - a pity the link cannot be re-established. The club also had a good run in the FA Cup that year, beating both QPR and Crystal Palace before losing 3-1 to Blackpool in the third round.
The team colours changed again in 1949/50 to the present blue and white.
Floodlights were installed and used for the first time on 23rd September 1959, although a match against West Ham (attendance 4,216) was the official opening, or switch on. In 1964 the pylons were replaced.
The same season saw the club play in front of a record 29,300 crowd – alright it wasn't a home match but even so – at Selhurst Park against Crystal Palace in a FA Cup 2nd round replay following a 0-0 draw at Hartsdown on 5th December. Margate lost the replay 3-0 on 9th December (Crystal Palace lost 1-0 away to Scunthorpe in the next round).
Almer Hall was the manager of Margate Football Club for twenty years from 1950. For his testimonial match in 1968, West Ham United, including World Cup winners Bobby Moore, Geoff Hurst and Martin Peters, came to Hartsdown Park. At half-time Margate were 4-2 up but at full-time it finished 6-6. Davie Houston scored five of Margate's goals.
After having beaten Wimbledon 1-0 in the 4th qualifying round of the FA Cup, Margate Football Club lost away to Bournemouth 11-0 on 20th November 1971 - Ted MacDougall scored nine of the goals, and still holds the record for one player in the FA Cup. The attendance was 12,079. Bournemouth's brand new electronic scoreboard proudly displayed the score until goal number ten went in, at which point it became obvious that they had not considered that they would ever get into double figures, because it was promptly switched off! I know this because I was there - and it was a bloody long journey back!
In the FA Cup of 1972/3 season, Margate Football Club beat high-flying Swansea 1-0 at home in round 1 (18th November 1972) and Walton and Hersham 1-0 away in round 2 (9th December 1972), before getting the plum home draw of first division Tottenham Hotspur in the third round on 13th January 1973.
The teams were:
Margate: Chic Brodie, Ray Summers, Alan Butterfield, Norman Fusco, David Paton, Davie Houston, John Baber (Pat Ferry), Eddie Clayton, Kevin Barry, Barry Brown, Bruce Walker
Tottenham: Pat Jennings, Ray Evans, Cyril Knowles, John Pratt, Mike England, Terry Naylor, Alan Gilzean, Steve Perryman (Jimmy Pearce), Martin Chivers, Martin Peters, Ralph Coates
Margate Football Club lost 6-0, the goal scorers were Chivers (2), Knowles, Pearce, Peters and Pratt.
The attendance for the match was 14,169, although this figure has been questioned. Margate's next home match was four days later, a 1-1 draw with Canterbury when the attendance was just 432.
In November 1997, Margate lost 2-1 at home to Fulham (then managed by Kevin Keegan) in the FA Cup 1st round.
On 16th November 2002, Margate drew 1-1 away to Leyton Orient, and won the replay 1-0 ten days later, although not at Hartsdown as the club were ground-sharing at the time. But at least they were giant-killers! They lost 3-0 at 'home' to Cardiff in the next round.
SEE Bloodvessel, Buster/ Football/ Hartsdown Park Football Ground/ Old Crossing Road, Garlinge/ Ramsgate FC

MARGATE GENERAL HOSPITAL
St Peter's Road, Margate
Margate General Hospital was built on corn fields in 1929.
SEE Hospitals/ St Peter's Road, Margate

'MARGATE HOY'
A 'Master Cockney' writing to a friend in London, 1791:

The MARGATE HOY
So soon as we landed at this pretty spot,
As 'twere a fresh dainty from town, piping hot

There came all about us, with bows to the ground,
From all the hotels in the neighbourhood round,
A set of waiters, so frizzed and flour'd,
We seem with civility quite overpowered.
One snatches up the saddle-bags, bearing my best coat,
My yard and a half buckskins and fur-collared waistcoat;
Another my father's portmanteau and many
The pile of band-boxes of Mother and Nanny,
The maid followed after and carried her own
Little bundle containing a clean linen gown.
As thus in procession we went up the beach,
Said I, 'Gentlemen – be so good as to say
If you're all going one, or a different way,
Because you see, Father, Mother and I
Would go to one House as we came in one Hoy'
SEE Ships

MARGATE MARINE BATHING PAVILION

It opened in July 1926, just slightly to the east of the Lifeboat Memorial. It was 214ft long and stood well above sea level, at the same height as the promenade. There was a long wide gangway that linked the two, as well as six sets of stairs down to the beach. It provided hundreds of changing rooms around a central cafe for bathers using the beach - the outdoor pool that was added in 1937 when free bathing from the beach was banned. Around the outside of the Pavilion was a wide promenade that was decked with pitched pine battens that were caulked, creating a huge, dry shelter underneath for sunbathers to scurry to when it rained – which it obviously never did. Probably not planned either were the people who used it as a free campsite for the night – particularly the ones who could not find their way back to their boarding house after a few pints. The contractor was Lionel Snowden and he presented the Mayor with a golden key to open it. The Pavilion was the first of its kind anywhere and was seen as another example of how Margate came to be at the forefront of seaside resorts – '*a further advance by the Municipality in enhancing the amenities of the town'.* In time, it became the home for cafes and then predominantly amusement arcades. The Sun Deck as it became popularly known was demolished in 1990.
SEE Bathing/ Boarding houses/ Walpole Bay

MARGATE ROAD, Ramsgate

SEE Coffee Pot/ Derby Arms/ Hare and Hounds/ Hudson's Mill/ Mouth organs/ Poorhole Lane/ Ramsgate/ Sainsburys/ St Mark's Church/ Shakepseare pub/ Star Inn/ Station Approach Road/ Viaduct/ Vye and Son/ Westwood

MARGATE RAILWAY STATION

The present station was built in 1926 by Southern Railway. It became a listed building in 1987. The magnificent size of the building reflects how busy it was in its heyday.
SEE Listed buildings/ Railways

MARGATE SANDS RAILWAY STATION (South Eastern Railway)

The original railway station was built where the Dreamland and Arlington Arcade now stands, in 1846. Known as Margate Sands Station (which replaced a previous temporary wooden station called Margate SER) it was on the South Eastern Railway line that ran from Charing Cross via Ramsgate. The coming of the railways brought real development to Thanet, but the direct Margate-Ramsgate railway line closed when the towns became part of the Southern Railway. The last train to run from Margate Sands to Ramsgate Town was on 2nd July 1926. When it closed, the present station, then known as Margate West, took over as the sole railway station for the town.
East Kent Times, 21st May 1913: *The 'suffragette bomb hoax' has again been worked in Thanet. On Friday a passenger at Margate Sands Station called Inspector Osborne to a parcel left in the lavatory which turned out to be merely coal dust.*
SEE East Kent Times/ Railways/ Suffragettes

MARGATE WEST RAILWAY STATION (London Chatham and Dover)

It opened on 5th October 1863, on a direct line to Victoria, as the previous route was more circuitous. By 1889, twelve trains were leaving each day from Margate West and eight from Margate Sands. Both stations became part of Southern Railway in 1925 when the direct lines to Ramsgate closed and Margate Sands Station closed.
SEE Blizzard/ Railways

MARINA BATHING POOL, Ramsgate

It was opened on 27th July 1935 by Mr Martin Tomson and Mrs T Wotton of the local brewing firm and the Mayor, Alderman E Dye. It cost £50,000 and could accommodate 2,000 bathers at any one time. There were cafes, bathing terraces and a ten metre diving tower said to be the finest in Europe with 1-and 3-metre spring boards and a 5-metre diving board. The whole pool was described at the time as the most up-to-date and luxurious in the country - one of only a few 50-metre pools as most were 33 yards. It closed during World War II but re-opened in 1946. It is now a car park at the end of Marina Esplanade.
SEE Bathing/ Ramsgate/ Tomson & Wotton

MARINA ESPLANADE, Ramsgate

It was built into the cliff in 1877 and designed by J T Wimperis. The Marina Esplanade was much bigger than can be seen today. There were shops, a photographer's studio – later a restaurant – and a concert hall. It was built to complement the classy Granville Hall that was on the cliff top. Numbers 1-4 are now Grade II listed.
SEE Granville Hotel/ Listed buildings/ Nero's/ Ramsgate/ Restaurants

MARINA THEATRE, Ramsgate

It was opened by the Lord Mayor of London, Earl Sidney, accompanied by the Lord Lieutenant of Kent in 1877. The building was converted into a cinema in 1909 and was known as The Excelsior Animated Picture House. It showed the first moving pictures that Ramsgate saw. In more recent years the building was used as 5th Avenue nightclub.
SEE Cinemas/ Greenstreet, Sydney/ Ramsgate

MARINE DRIVE, Margate

SEE Bathing Machine and Bathing Rooms/ Dane Park/ Garner's Library/ Great Storm 1953/ Imperial Hotel/ King's Head/ Margate/ Marine Parade/ Pillow Talk/ Trams

MARINE DRIVE, Broadstairs

SEE Asquith, Cynthia/ Broadstairs/ Lawrence, DH

MARINE GARDENS, Margate

At number 1 Marine Gardens was Walker and Son, photographer, in 1936. It was also once the Elephant public house and is now the Woolwich Building Society.
SEE Bar Barcelona/ Margate/ Princess of Wales pub/ Shaftesbury House

MARINE LIBRARY, Ramsgate

At the turn of the nineteenth century, Mrs Witherden built a large building at the top of Cliff Street in Ramsgate that was to be the Marine Library.
SEE Cliff House/ Libraries/ Ramsgate

MARINE PALACE, Margate

In 1875, a sea wall was built from Fort Point to the harbour enclosing 3 acres of foreshore. Here were built the Marine Palace and skating rink.
The Marine Palace and Aquarium were swept away by a great storm in November 1897 – the grand piano from the ballroom was found a mile away along the beach.
The site was an eyesore for many years. Eventually the council built a putting green in the 1920s and 30s. From 1950 it has been a car park with a promenade and sea wall in front.
SEE Friend to All Nations/ Margate/ Storms

MARINE PARADE, Margate

In 1809, Marine Parade in Margate was widened and later Marine Drive was built out from the old sea wall.
New Marine Drive, which runs from the station to the jetty, was built in 1878 and opened to the public in 1880 at a cost of £40,000.
SEE High Street, Margate/ Hodges, Frederick/ Hoy pub/ Margate/ Marine Drive/ Old White Hart Hotel/ Parade, The/ York Hotel

MARINE TERRACE, Margate

Two hundred years ago the area that is now Marine Terrace was open marshland. In 1808-10 a road – called at the time New Road - was built across it and soon after a row of terraced houses was built.
In 1883 Marine Terrace – as it had become - was all residential properties, except for the Cinque Port Arms, and the Kent Hotel.
The Carlton Hotel was a boarding house at 7 Marine Terrace, in the late nineteenth century.
In 1891, 6 Marine Terrace was called Shaftesbury House, and was a Seaside Home of the YMCA.

Also in the 1890's, at 9 Marine Terrace, was The Dunthorne Hotel, a private hotel and boarding house.

Margate Delineated; or A Guide to the Various Amusements, Public Libraries, Buildings, Improvements, etc of that celebrated Watering Place (1829): *This Terrace, which comprises an elegant range of new houses on the New Road leading from Margate to Canterbury, is protected from the inroads of the sea by a stupendous stone wall, nearly 1,500 feet in length, reaching from the Blockade station at Westbrook and joining the stone wall heretofore erected contiguous to the Bathing Rooms.*
The lodgings on the Fort and the Marine Terrace are the most expensive; whole houses let at from three to five guineas a week, and upwards, according to the number of beds and other conveniences.
. . . many persons from a principle of economy, or for the pleasure of associating with others, prefer the establishment of a Boarding House, in which comfort and good living are combined, without the care and inconvenience of housekeeping. There are many houses of this description, varying their prices according to the quality of the table kept, from £1 11s 6d to £2 12s 6d a week each person. . . A Boarding House has recently been established on the Upper Marine Terrace, which is highly spoken of, kept by Mrs Willemotte.
SEE Bar 26/ Bathing Machines & Bathing Rooms/ Boarding houses/ Chambers, Frederick/ Cinque Port Arms Hotel/ Concert Parties/ Coxswain pub/ Crown Bingo/ Dreamland/ Dreamland Cinema/ Hartsdown Park/ Kent Hotel/ Margate/ Mechanical Elephant/ Mods & Rockers/ Noise/ Royal Yacht/ Westbrook/ Westbrook Bathing Pavilion

MARKET - Ramsgate
The original site of the market was at The Sole, approximately on the corner of Harbour Street and Queen Street, and had been used by local farmers as a dumping ground for their gleanings, seaweed and flint from the beach – although the largest pieces of flint and rock were used in the subsequent building of the market!
Under the Improvement Act of 1785 a long oblong-shaped Market House was built with a meeting room over the market place, where there were markets for vegetables, meat and fish, along with a cell, with bars at the windows, for any offenders. The first market held here was in September 1788.
This building was replaced at a cost of £1,239 in 1839 by the Ramsgate Town Hall, built by Thomas Grundy; a fairly ugly and unpopular building. Eventually, the fish and meat markets moved to York Street, because people attending the Council meetings could not stand the smell.
Pigot's 1840: *The markets, held on Wednesday and Saturday, frequently present a number of attendants from the French coast, with supplies of eggs, fruit and other commodities.*
When the Town Hall was demolished in 1955, Page's Wine and Spirit went with it. Richard Page started the firm in 1804 and it closed in 1927 – the premises were occupied

by a branch of Burton's the tailors. The Halifax Building Society now occupies the site of the old Town Hall.
The market returned from Dumpton to The Sole as the area was known, in the late 1990s.
SEE Bloodless Battle of Harbour Street/ Dumpton Market/ Farms/ Grundy Hill/ Harbour Street, Ramsgate/ Queen Street/ Sole, The/ York Street, Ramsgate

MARKET PLACE, Margate
Margate market, in Market Place in the old part of town, had 43 licensed stalls in 1821, predominately selling fish, fruit and vegetables. In 1897, the number of stalls was reduced when the municipal offices were built on the site. Trade strangely declined. One family kept a fruit-and-veg stall in business here from 1919 until 1982. A small coffee stall is the last reminder of the market.
SEE Margate/ Old Margate/ Queen's Head pub/ Steam Packets and Steamers/ Wellington Hotel

MARKS & SPENCER
In 1884 a Russian Jewish immigrant, Michael Marks (1859-1907), set up his 'Penny Bazaar' in Leeds market. As the business grew, he took on Thomas Spencer (1852-1905), a cashier from one of his suppliers, as his partner in 1894.
From 1913 until 1931 Marks & Spencer was at 25 High Street, Ramsgate, before transferring to 41-45 High Street. When it closed on 3rd February 1990, it employed 58 people. It is now Peacocks Store.
The Margate High Street branch closed in May 2005 when the new Westwood Cross store opened.
SEE High Street, Margate/ High Street, Ramsgate/ Margate/ Ramsgate/ Shops/ Westwood Cross

MARLBOROUGH ROAD, Margate
Damage was done to Marlborough Road during the Gotha raid on the night of 30th September 1917.
SEE Gotha raid/ Margate

Sir Edward MARSH
Born 1872
Died 1953
He was Sir Winston Churchill's private secretary for 23 years. When he wasn't working he was a noted patron of the arts, giving both advice and money to struggling young writers and artists. He was the editor of the anthology 'Georgian Poetry' (1912-22), publishing many a struggling writer, including D H Lawrence. In July 1913, Marsh sent Lawrence's royalty cheque to his Kingsgate address. As a result, Lawrence invited him down to visit. As Marsh was visiting the Asquiths at Kingsgate anyway, he accepted the invitation and on 20th July introduced them all to each other and thus a friendship started that was to last all of Lawrence's life.
SEE Asquith/ Churchill, Winston/ Kingsgate/ Lawrence, D H/ Poems

MARSH BAY
This was the old name for St Mildred's Bay in Westgate.

Joss Snelling and David Mutton were arrested at Marsh Bay on 23rd April 1830 and charged with smuggling 61 tubs of foreign spirits. They were each fined £100. Huge crowds turned up for the trial to see the famous and popular smuggler, Joss Snelling.
SEE Bays/ Lawrence, Carver/ St Mildred's Bay/ Snelling, Joss/ Westgate-on-Sea

'MARTIN CHUZZLEWIT'
by Charles Dickens
When writing Martin Chuzzlewit (1843), at his lodgings in Albion Street, Broadstairs, Charles Dickens was amused by a bather, '*At one, he disappears, and presently emerges from a bathing machine and may be seen - a kind of salmon-coloured porpoise - splashing about in the ocean*'.
SEE Albion Street, Broadstairs/ Bathing machines/ Books/ Broadstairs/ Dickens, Charles

Karl MARX
Born Trier, Germany 5th May 1818
Died London, 14th March 1883
A revolutionary, sociologist, historian, economist and thinker. He attended the universities at Bonn, Berlin, and Jena before writing an article for the Cologne newspaper Rheinische Zeitung. Soon afterwards he became that newspaper's editor although his views on local social and political conditions were not well received by the local authorities. In 1843, he was pressurised into resigning and soon after the newspaper stopped publishing. Marx moved to Paris where his communist views were further refined. In 1844, Friedrich Engels visited him in Paris and they soon realised that quite independently they had come to the same conclusions. They went on to collaborate for the next four decades until Marx's death.
Because of his revolutionary beliefs, Marx was ordered to leave Paris (they'd had their revolution and they didn't want another one) and he headed off to Brussels where he and Engels organised groups named Communist Correspondence Committees in various European cities. In 1847, these groups consolidated to form the Communist League and Marx and Engels were commissioned to form a set of principles; they duly came up with the Communist Manifesto. The conclusions of the Manifesto were that the capitalist class could be overthrown by a working class revolution and replaced by a classless society. It was translated into many languages, sold millions of copies and was to influence all Communist literature and thought. After it was published, there were revolutions in France and Germany and the Belgian government, fearing that they were next, banished Marx. He went back to Paris, and then onto Cologne where he edited a communist publication, the Neue Rheinische Zeitung. In 1849, he was arrested and tried for inciting armed insurrection. Although acquitted he was chucked out of Germany; France chucked him out, again, and he spent the rest of his life in London. Here, he wrote Das Kapital (volume 1 was published in 1867; volumes 2 and 3 were edited by Engels and published posthumously in 1885 and

1894, respectively; a fourth volume was planned before his death.

Marx suffered from ill health most of his life - a painful liver, abscesses on his lungs, carbuncles, bronchitis, and insomnia – and, as was the vogue at the time, he thought that sea air would help him. Marx suffered from carbuncles so regularly in fact that his family referred to them as *'his old enemies.'* He tried many remedies including arsenic, creosote and seaside holidays. Strangely the latter had better results than the first two. For most of his life Karl Marx also suffered from boils, and he rarely took a bath! Was there a connection between these two facts?

Marx convalesced in Margate between 15th March and 10th April 1866 beginning his stay at the King's Arms but moved to 5 Lansell's Place *'in front of the sea'*. In his letters he wrote about the long walks that he took (he once walked as far as Canterbury), the *'wonderful air'*, and the *'delicious'* sea bathes.

Extract from a letter to his daughter Jenny: *'I arrived here yesterday evening, ¾ past seven. According to your instructions I left my luggage behind me in the cloakroom and was then landed by the omnibus at a small inn called the 'King's Arms'. Having ordered a rump steak, and being shown to the coffee room, which was rather dimly illuminated, I took rather fright, (you know my anxious temper) at a lean, long, stiff sort of man, midway between parson and commis-voyageur, solitarily and motionlessly seated before the chimney. From the vagueness of his glanceless eye, I thought him a blind man. . . . When my supper arrived the man began somewhat to wave, quietly took off his boots and warmed his elephantine feet at the fire. What with this agreeable spectacle, and his supposed blindness, and what with a rump steak, which seemed, in its natural state, to have belonged to a deceased cow, I passed the first Margate evening anything but comfortably.'*

His daughter was to join him later in his visit.

Extract from a letter to his cousin: *'I have been banished, by my medical adviser, to this seaside place, which, at this time of the year, is quite solitary. Margate lives only upon the Londoners, who regularly inundate it at the bathing season. During the other months it vegetates only. For my part right glad I am to have got rid of all company, even that of my books. . . I have become myself a sort of walking stick, running up and down the whole day, and keeping my mind in that state of nothingness which Buddhaism considers the climax of human bliss.'*

'Withdrawing a little from the seaside, and roaming over the adjacent agricultural districts, you are painfully reminded of 'civilisation', because from all sides you are startled by large boards, with governmental proclamations on them, headed: Cattle Disease. The ruling English oligarchs were never suspected to care one farthing for 'der Menscheit ganzes Weh', but as to cows and oxen, they feel deeply.'

For the last eight years of his life, Marx's health was particularly poor and, consequently, his work output was impeded. He died in London aged 64.

Originally, his grave was in a secluded part of Highgate Cemetery in London but his remains were moved to a new site where the present monument was erected in 1956. His bust is on a 12ft granite base, and is inscribed in gold lettering with *'Workers of all lands, unite. The philosophers have only interpreted the world in various ways; the point is to change it'*). He was buried in un-consecrated ground because he was Jewish.
SEE Abbot's Hill/ Artillery Road/ Bathing/ Cumberland Road/ Engels, Friedrich/ Hardres Street/ Margate/ Plains of Waterloo/ Ramsgate

MARY WHITE

Thomas White, a shipwright, presented Broadstairs with a lifeboat in July 1850. It was first used on 6th March 1851 when during a freezing cold northerly gale raining sleet, snow, and hailstones, a brig called Mary White got trapped on the Goodwin Sands.

Coxswain Solomon Holburn, who was also the Harbour Master, got together the crew who then launched the lifeboat from its horsedrawn trailer. Eventually, they managed to get to the brig and cast a line to it. Holburn, and another of the lifeboat crew George Castle, were now aboard the Mary White, and had rescued seven of the crew of ten when the line snapped. The lifeboat was blown away from the Mary White which itself was breaking up. Holburn and Castle pleaded with the brig's Captain White and his two remaining crew, but they refused to leave their ship. The two lifeboatmen then jumped and swam for it. Somehow they made it back to the lifeboat, and the crew then rowed for shore. The eight crew members received the silver medals for gallantry from the RNLI.

The rescue even had a song written about it:
'Song of the 'Mary White'
Come, all you jolly sailors bold, and landsmen too,
attend, I am inclined to sing in praise of those eight gallant men, who
boldly left their native shore as you shall understand,
to save the lives of those poor souls upon the goodwin sand.
[Chorus]: Britons all, both young and old think of those jolly sailors bold.
On Thursday, 'twas March the sixth, the wind blew
from the land which drove the fated 'Mary White' upon the goodwin sands.
The lifeboat's crew from Broadstairs flew, with hearts so light and gay, right gallantly they made the wreck,
those precious lives to save.
[Chorus]
John Crouch, a gallant sailor bold, likewise George Castle too,
George Wales, Richard Crouch, this day, my praise is due to you...
Sol. Holbourn, Sackett Ansel, John Wales, with great delight

so gallantly did venture off to save the 'Mary White'
[Chorus]
Ned Chittingden, 17 your health I drink, I drink with thee, times three
and for your valor my brave men, you shall rewarded be.
[Chorus]
You've done your best, and saved the lives of seven poor souls this day;
may God receive the other three who did get cast away.
[Chorus] (twice)
So to conclude and finish now, my song is at and end,
may God above a blessing give to those eight gallant men!
[Chorus]

As the lifeboat had not only been given by Thomas White, and been built by Thomas and John White, and the ship it had assisted was named Mary White, and her captain had been Captain White – do see a pattern building here? - the as yet unnamed lifeboat was called Mary White and, not long after, John White presented the town with a second Lifeboat named . . . Culmer White.
SEE Broadstairs/ Coxswain/ Goodwin Sands/ Lifeboat, Broadstairs/ Northern Belle/ Music

MASCALL'S MILL

A windmill that once stood near the later site of the Windmill Inn, Newington Road, Ramsgate.
SEE Newington/ Newington Road/ Ramsgate/ Windmills

Daniel MASON

Daniel Mason was the owner of the Cherry Blossom Shoe Shine Company and a local benefactor. He presented Broadstairs with a lifeboat from the Lusitania (that was placed in the Harbour), Christchurch Church, and the Memorial Recreation Ground, all 8 acres of it. Mason's Rise in Broadstairs is named after him.

In about 1886, a small soap factory was set up in Chiswick. By the turn of the century Charles and Dan Mason were running it as the Chiswick Soap Company, selling such products as 'Primrose' and 'Red Poppy' soft soaps and 'Buttercup' metal polish and 'Forget-me-not' furniture polish.

As a by-product of their manufacturing, they were left with loads of bits of tin-plate 5 inches in diameter and needed to come up with a use for them. In 1905, they came up with the idea of manufacturing small tins of shoe and boot polish that would not rub off on people's clothes like the 'blackings' of the day were prone to do. A suitable formula was found and in 1906 Cherry Blossom Boot Polish was launched, amid plenty of advertising and marketing, for 1d a tin. Originally the tins were filled by hand but in 1907 the production was mechanised.

In 1908, for people attending the Franco-British Exhibition at the White City, the place to meet was under the 'Cherry Blossom clock'.

The clock returned, in the form of a replica of the Big Ben clock tower, at the 1911

Exhibition at the Crystal Palace when for one day only, the company took it over and admission was free if you showed a Cherry Blossom lid. As a marketing exercise it was a huge success; 200,000 turned up and the traffic in London was chaotic – a vision of the future.

In 1913, the success of Cherry Blossom led to the formation of a separate Chiswick Polish Company Ltd owned by the Mason brothers and Reckitt & Sons Ltd. The polish was manufactured at Yalding in Kent.

The Mason brothers were ahead of their time in the way they looked after their staff. In 1918 a 5-day 44-hour week was introduced along with rest rooms and medical assistance that included a doctor's surgery, chiropodist and dental clinics; in 1923, a Pension Scheme was introduced; in 1925, they gave their staff a 10 acre sports ground; in 1930, 50 semi-detached houses in Chiswick were provided for the workforce.

If you were wondering when that little 'fish-plate' opener was introduced on Cherry Blossom lids – well, you could pretend you are interested - it was in 1924.
SEE Broadstairs/ Mason's Rise/ Lusitania/ Wardour Close

MASON'S RISE, Broadstairs
This street is named after Daniel Mason.
SEE Broadstairs/ Mason, Daniel

Charles MATHEWS
Born London, 28th June 1776
Died Plymouth, 28th June 1835
A star of the stage in England and in America, he appeared at Margate's Theatre Royal.
SEE Actors/ Theatre Royal

The MATRIX
Adrian and Neil Rayment, twins from Minster in Thanet, played twin#2 and twin#1 respectively in the film 'The Matrix Reloaded' (2003) – a film with 1,943 names in the credits - but I still didn't understand the plot. Too old? – probably.
SEE Films/ Minster

Jessie MATTHEWS
Born 11th March 1907
Died 19th August 1981
She was a singer, dancer and actress and a star, both in the West End and at the cinema. In the 1960s she took over the role of Mrs Dale in the hugely popular radio soap, 'Mrs Dale's Diary' which ran from 1948 until 1967 on the BBC Light Programme which became Radio 2.
SEE Actors/ Astoria Cinema/ Bascomb, WA/ Dreamland Theatre/ Entertainers/ Kempe, A B C/ Radio

MAUSOLEUM,
Hereson
The Mausoleum was copied from The Tomb of Rachel in Bethlehem, which is the third most important Jewish holy site.
Bible: Genesis 35, 16-21: *And they journeyed from Bethel; and there was but a little way to come to Ephrath: and Rachel travailed, and she had hard labour. And it came to pass,*

when she was in hard labour, that the midwife said unto her, Fear not; thou shalt have this son also. And it came to pass, as her soul was in departing, (for she died) that she called his name Benoni: but his father called him Benjamin. And Rachel died, and was buried in the way to Ephrath, which is Bethlehem. And Jacob set a pillar upon her grave: that is the pillar of Rachel's grave unto this day. And Israel journeyed, and spread his tent beyond the tower of Edar.
The Montefiores had seen the Tomb when they travelled to Bethlehem in 1841. Whilst there Sir Moses Montefiore had it renovated and built a dome over the grave markers to give shelter to pilgrims.
SEE Montefiore, Sir Moses

Achille Luciano MAUZAN
Born 1883
Died 1952
He was a painter and sculptor who, between the wars, designed over 1,000 postcards and 2,000 posters.
SEE Artists/ Poster

MAYOR'S CHAIN
On 14th May 1930, The East Kent Times reported that Percy Frank Weeks (MBE), a jeweller at 6 Harbour Street, had made the Ramsgate Mayoral Chain of gold, enamel and platinum. It was paid for from public subscription and was presented to the town in a ceremony at the Town Hall on the Tuesday.
SEE East Kent Times/ Harbour Street, Ramsgate/ Ramsgate

Sir Thomas Malcolm McALPINE
Part of the McAlpine civil engineering empire, he had a house, North Foreland Hall, built in the North Foreland area.
SEE North Foreland

MCC
The initials stand for Marylebone Cricket Club or Margate Cricket Club.
SEE Cricket/ Margate/ Margate College

MECHANICAL ELEPHANT
Marine Terrace, Margate
The Mechanical Elephant pub took over the site of an amusement arcade in May 2001. It is a reference to an actual 6ft 8in tall, 12ft long mechanical elephant weighing 1,400lb that you could ride on for 6d back in the 1950s. It looked like an elephant, it walked like an elephant, and it even swayed its trunk like an elephant! – but there was no need to follow it with a bucket and shovel.
Frank Smith was an inventor and engineer from Morecambe who made the first mechanical elephant out of an Austen 7 engine and four bedsteads and covered it in barrage balloon fabrics – he sounds like a man with way too much free time! – but it worked. After a few improvements he sold the patent for £1,000 to Frank Stuart of Essex who further improved the design to that which took trippers for rides between the Winter Gardens and the Rendezvous car park. The poor old elephant was stored at the old Pleasurama site in Ramsgate, where it

pulled a pumpkin coach for a while – hey, a job's a job.
Nowadays, it is thought to be either in Exmouth or America where, due to excessive insurance premiums, the poor old elephant is now unemployed, and probably depressed. They say an elephant never forgets, but this one never writes, it doesn't phone . . .
SEE Elephant/ Margate/ Marine Terrace/ Pubs

MEETING of GEORGE & CAROLINE
THE PRINCIPAL CHARACTERS:
They were cousins. He was George, the 32 year-old Prince of Wales, a bit of a dandy, refined, well-mannered, immaculate in his appearance and interested in architecture and art. He could spend money like there was no tomorrow, had low morals and was married to Maria Fitzherbert, a twice-widowed Roman Catholic who was older than him. He sent her a note during a dinner party saying that he would not be seeing her again. George's new mistress was the beautiful but domineering Lady Jersey (42), a grandmother and the wife of George Bussey Villiers, the Earl of Jersey (60). Whilst George chose his bride it was Lady Jersey that seemed to have given the final approval of 26-year old Princess Caroline of Brunswick as his bride, possibly because she thought that she would not be any competition to herself.

Caroline had been a very pretty child, but her looks had faded in her twenties. She was kind, carefree, exuberent and at times showed a lack of inhibition and discretion that concerned her parents. She was brought up in almost complete seclusion, watched over by her govenness to such a degree that she even followed her on to the dancefloor! Despite this monitoring, Caroline had received some marriage proposals, and there were rumours that she was not a virgin (where was the governess?). This constant monitoring only made her more wilful and impulsive. Worst of all, it was said that she was kind to those of a lower rank. Well we can't have that can we?

Caroline thought getting dressed quickly was better than dressing well (with her governess maybe she had learned to get dressed quickly). She rarely bathed, and apparently '*smelt like a farmyard*'. She was gauche, short, slovenly, vulgar, flippant, and sarcastic.

Sir James Harris, the Earl of Malmesbury, a friend of George, had met her before and thought that she was well-meaning and good-natured and tried to develop in her '*a strict attention to appearance*' but Caroline was set in her ways. Caroline also knew of George's affair with Lady Jersey. Her mum had told her.
THE PROBLEM:
George's marriage to Maria was valid as far as the Church of England was concerned, but illegal because he had not asked the king's permission to marry and anyone married to a Catholic could not become monarch. George had debts of £630,000 (credit cards, store cards, loans to consolidate the debts, you've seen the adverts).

THE SOLUTION:
The marriage to Maria would be forgotten. In exchange for his debts being paid off, he agreed to marry '*a Protestant and a Princess.*' Princess Caroline of Brunswick was summoned to be his wife. Simple.

THE MEETING:
It was a big moment. The future king about to meet the future queen. They met at the Assembly Rooms in Margate (there is a blue plaque to commemorate the event above the door of the library). Lady Jersey had became a lady-in-waiting to Caroline and she persuaded her to change into a less flattering dress, and overdid her make-up just before she was to meet George.

She was presented to him, knelt before him, but due to her less than svelte figure and a lack of elegance and grace, she fell. The gallant George rushed to help her up. He got his first whiff of her, turned and rushed to the far corner of the room. '*Harris, I am not well. Pray get me a glass of brandy.*' Harris (Malmesbury) replied, '*Sir, had you not better have a glass of water?*' George then swore and said '*No, I will go directly to the Queen*' and left the room. Now Malmesbury does not know what to do, and Caroline said '*My God! Is the Prince always like this? I find him very fat and not nearly as handsome as his portrait.*' Three days later they were married.

THE WEDDING DAY:
They married at St. James's Palace, London on the evening of 8th April 1795. George loved a big occasion, but he was not looking forward to this one. He told his brother that morning, and repeated it in the carriage on the way to the ceremony that, '*I shall never love any woman but Fitzherbert*'. George turned up drunk. His groomsmen, the Duke of Bedford, the Duke of Roxburgh and George Brummell (who was 17) had to help him up the aisle and he '*looked like death*'. He spent the whole ceremony making eyes at Lady Jersey.

The Archbishop of Canterbury gave a meaningful look around the room as he said, '*I am required to ask anyone present who knows a reason why these persons may not lawfully marry, to declare it now*' he looked intently at the king and then at the prince. No one said anything, but many people were counting their buttons. He also felt it necessary to ask George '*Will you love her, comfort her, honour and protect her, and, forsaking all others, be faithful to her as long as you both shall live?*' - twice. The second time George burst into tears before responding, '*I will*'. During the prayer, with everyone's eyes closed, George got up to leave. The king bellowed across the chapel and George sunk to his knees, both physically and metaphorically.

Afterwards, Caroline seemed happy and talkative. George was morose until the end of the evening when he became '*very civil and gracious*'.

The WEDDING NIGHT & HONEYMOON:
George turned up drunk, collapsed in front of the fireplace and slept the whole night there. When he woke up the next morning he consumated the marriage - and they say romance is dead. Later that morning, George went out riding leaving Caroline to entertain the guests that had been invited.

The honeymoon was spent at the Marine Pavilion, Brighton, and the place was full of George's mates. Caroline said that they '*were constantly drunk and filthy, sleeping & snoring in bouts on the sofas*' and the place '*resembled a bad brothel much more than a palace*' (how was she qualified to make such a comparison?). Also amongst George's guests was Lady Jersey so that – do I need to spell it out?

THE MARRIAGE:
The couple never lived together. According to George's letters, they only had sex three times, but enough for Caroline to get pregnant and Princess Charlotte Augusta was born on 7th January 1796, almost exactly nine months after the wedding.

As a bachelor, George had an allowance of £78,000 a year, but when he married he would get £125,000. It was not until after the wedding that he realised that £65,000 plus £13,000 income from the Duchy of Cornwall would be clawed back as part payment of the debt, leaving him with £60,000. Now, he was married to a woman he hated and he was worse off financially.

George took back a pair of bracelets that had been part of his wedding present to Caroline. He gave them to Lady Jersey, who then took great pleasure in wearing them in front of Caroline.

THE SEPARATION:
George left Lady Jersey and went back to Maria Fitzherbert. Just 48 hours after the birth of his daughter, Princess Charlotte Augusta, George wrote a new will leaving everything to his '*beloved and adored Maria Fitzherbert.*' To Caroline, or '*her who is call'd the Princess of Wales*', he left one shilling, and specified that she would have no part in raising Charlotte. The royal couple split up (were they ever together?) in December 1797. Caroline was banished to Blackheath in 1799 where she lived in 'The Pagoda'. She was not allowed to see her daughter. Caroline lived, and spent lavishly. Where the facts end and rumours begin is not clear. George's circle may have made up some stories or embellished some truths. George got newspapers to print the most sordid stories about her. It was said that Caroline had affairs with Sir Sidney Smith (an admiral), George Canning (a politician), her servants and many others, male and/or female. When she adopted a boy it was put about that he was her illegitimate son. She was said to wear revealing, or see through clothing, and dance topless. All inapropriate behaviour for a princess, and a stout princess at that. In 1805 a *Delicate Investigation* was started by the government, but they found no proof of adultery. In 1811, George became Prince Regent and Caroline was excluded from court. From 1814 she lived in Italy and, so the gossips said, had an affair with Bartolomeo Pergami (aka Bergami) her Italian courier.

Princess Charlotte Augusta married Leopold George Frederick on 2nd May 1816, but died in childbirth on 6th November 1817. George now had no heir and Caroline feared that he might have her murdered so that he could marry again. George III died on 29th January 1820 and the new George IV was determined that Caroline would not attend his coronation, so he tried to pay her off. She was determined to be crowned queen and in June 1820 she returned to England, where the British public were on her side.

THE CORONATION:
George persuaded his very reluctant ministers to bring a Bill into the House of Lords '*to deprive Her Majesty, Caroline Amelia Elizabeth, of the Title, Prerogatives, Rights, Privileges, and Exemptions of Queen Consort of this Realm; and to dissolve the Marriage between His Majesty and said Caroline Amelia Elizabeth.*' – it was debated for three months, and Caroline attended what amounted to her trial every day, although she did play backgammon in a side room when it got too boring.

The public followed the proceedings intently and when a group of Caroline supporters confronted the Duke of Wellington he tactfully told them '*Well, gentlemen, since you will have it so, God Save the Queen - and may all your wives be like her.*'

Lady Cowper wrote, '*The Queen has a strange luck in her favour; the worse she behaves, the more it rebounds to her credit. . . She says it is true she did commit adultery once, but it was with the Husband of Mrs Fitzherbert. She is a droll woman.*'

The Bill of Pains and Penalties, as it became known, was defeated by 123 votes to 95, but it was really a draw; there was to be no divorce and there was to be no invitation to the coronation either. Caroline decided to gatecrash. She turned up at Westminster Abbey for the Coronation on 19th July 1821 and went from door to door trying to get it. At least one door was literally slammed shut in her face. She did not get in.

Nineteen days later she died, aged 53, on 7th August 1821 of an intestinal blockage, although poison has been mentioned, '*I know I am dying - they have killed me at last!*'

When George was informed that his greatest enemy had died, he beamed, '*Has she, my God!*', only to be told that it was Napoleon who had died.

George never re-married (are you surprised?) and outlived Caroline by nine years.
SEE Assembly Rooms/ Canning, George/ Caroline, Princess of Wales/ George III/ George IV/ Margate

MEETING STREET, Ramsgate
SEE Christ Church/ Congregational Church/ Ramsgate/ Slum Clearance

MERRIE ENGLAND
SEE Ramsgate/ Ramsgate Sands Railway Station/ WVS

METHODIST CHURCH, Northwood
It opened in 1931 and closed at the end of July 1988. It was later sold and became a synagogue.

SEE Churches/ Northwood

METHODIST CHURCH
Hardres Street, Ramsgate
This Methodist Church was opened on 18th August 1955 by the Rev Dr Leslie Weatherhead, the President of the Methodist Conference. It replaced a previous church that had been built in 1811 at a cost of £5,000 and had been opened by the Rev Thomas Coke, a missionary and close colleague of John Wesley the founder of the Methodist movement. A bomb in February 1941 had left it so damaged and weak that it had to be demolished. The first Methodist School in the area was opened here in 1817. The Methodist Centenary Hall opened in 1911.
SEE Churches/ Hardres Street/ Ramsgate/ Schools/ Wesley, John

METHODIST HALL
Hawley Square, Margate
On the north side of the square is the former Methodist Hall. It was built, with Gothic windows and a stuccoed classical front, in 1896, next to the former Methodist Church, for its congregation to use as a community centre and Sunday school.
SEE Churches/ Hawley Square/ Margate

METROPOLE HOTEL, Margate
This 100-room hotel was built in 1893, opposite the entrance to the Pier and replaced the Grand Hotel which had been destroyed by a fire. The Metropole is most famous for being the scene of the 1929 Sydney Fox matricide. It was demolished after World War II.
SEE Fires/ Fox, Sydney/ Hotels/ Margate/ Ye Foy Boat Inn

MFI
Your starter for ten: What does MFI stand for? If you said Made For Idiots, then you lose ten points. The correct answer is Mullard Furniture Industries, because Mullard was the maiden name of the wife of the firm's founder Donald Searle. It started trading in 1964 and there was a branch in Northdown Road, Cliftonville.
SEE Cliftonville/ Northdown Road/ Shops

MIDLAND BANK - Ramsgate
On the corner of Ramsgate High Street and King Street, Robert Page opened the London Hotel in 1798. It did well in a town that prospered in the Napoleonic Wars. He sold it to Frederick Crow, who then leased it to George and Thomas Rowe. The hotel closed in 1914. In 1922 the Midland Bank opened a branch on the site.
The Midland Bank was originally founded in 1836 in Birmingham as The Birmingham and Midland Bank. When it acquired the Central Bank of London it moved its headquarters to the capital in 1891.
SEE King Street, Ramsgate/ Napoleonic Wars/ Ramsgate

Lord Bernard MILES
Born Uxbridge, 27th September 1907
Died Knaresborough 14th June 1991

In addition to his many film appearances, he had a successful stage career reciting comic monologues, usually in the character of a country yokel:
Ole Miss Piggott what used to play th' organ. I hated the sights of 'er. I couldn't abide 'er. They reckon her dad was a big army gentleman left over from the mutinies. But she was very 'ot on the temperance.
Arr, I mind she seed my barrow stood outside the Rose and Crown one time. I'd been over to get some bean sticks from by the crab tree and I'd stood my barrow outside the Rose and Crown and she seen it stood there.
So I sees her on the Tuesday and she starts off at me.
She says 'I seed your barrow stood outside the Rose and Crown,' she says, 'that's intemperance,' she says. 'Look not upon the wine when it is red,' she says, 'Cos at the last it biteth like a serpent and stingeth like a adder; Proverbs 25, 31 and 32.'
'But,' I said, 'I was never inside the Rose and Crown.' I said, 'I never come near 'er.'
And she said, 'I seed your barrow stood outside. That's intemperance,' she said. 'That's intemperance.'
So I seed it wasn't no good argyfying. I touched me hat and said good arternoon.
About three or four days arterwards I left my barrow outside her door all night. Arr, that 'ad 'er. That 'ad 'er.
His first lead role in a film was in 'In Which We Serve' (1942), but he was also Newman Noggs in 'Nicholas Nickleby' (1947) and Joe Gargery in 'Great Expectations' (1946). He was one of the writer's of the Will Hay comedy 'The Goose Steps Out' (1942), and he co-wrote and co-produced 'Tawny Pipit' (1944). From 1951 he worked hard to establish the Mermaid Theatre in London. He was knighted in 1969, and became Lord Miles in 1978 and is a former resident of St Nicholas.
SEE St Nicholas-at-Wade

MILITARY ROAD, Ramsgate

The ice house in Military Road was built in 1895, to enable the fish caught by the local fleet to be frozen.
Eight German Gotha planes dropped twenty-eight bombs on Ramsgate on 22nd August 1917. Six men - George Baker (71), Alfred Coomber (63), John Debling (44), Walter Melhuish (45), Henry Minter (63), and Walter Spain (57) - who were sheltering outside a store in Military Road, all died.
SEE Birds/ Cemetery/ Chatham House School/ Gotha/ Hengrove/ Military Road, Ramsgate/ Picton Road, Ramsgate/ Ramsgate/ Walpole Bay

MILL LANE, Birchington
There have been at leat four windmills in Birchington. These included a seed mill near

where the Railway Sation now stands, and a post mill near Gore End.
Hudson's Mill stood in what is now Mill Lane but the sails of the mill were so close to the road that horses were often spooked as the sails almost touched them as they swept round. The solution was to move the mill:
Kentish Gazette, Tuesday 11th August 1772:
Yesterday the windmill near Birchington, in the Isle of Thanet, which has been so long complained of as an annoyance to the road between Canterbury and Margate, was removed sixty yards backwards, at the expence of the Hon. Charles James Fox, who is proprietor of the estate. The removal of the Mill was completed in little more than one day, with the utmost ease, and by the assistance of two horses only. Its weight was supposed to be upwards of forty tons, as neither the sweeps or mill stones were taken down. The engineer was Mr Peake, a carpenter at Manstone in St Lawrence parish.
In the 1830s, Zachariah Hudson bought the mill for his son and it remained in the family until C J Hudson sold it in 1891. Hudson moved his operations to the Steam Flour Mills in Ramsgate. The windmill was in Mill Lane until around 1903-04.
SEE Birchington/ Hudsons Mill/ Manston/ Ramsgate/ Windmills

MILL LANE, Margate
This links Cecil Street to the south end of the main shopping area of the High Street and looks a bit different these days with modern buildings everywhere, the most notable being the Jobcentre. There was a windmill here called Mill Lane Mill.
SEE High Street, Margate/ Margate/ Windmills

Annette MILLS
Born 1900
Died 1955
A famous name from post-war Britain, Annette Mills lived at Dumpton Gap. The sister of Sir John Mills, she was an accomplished and successful dancer and singer, and wrote and performed the popular monologue 'I'm an old Norman Castle'.
She was best known for working with a puppet. A famous Punch and Judy puppet maker, Fred Tickner, had made 'Muffin the Mule' in 1934. Years later, another puppeteer, Ann Hogarth, bought him for fifteen shillings from a showman. With Ann manipulating the puppet and Annette singing and playing the piano, Muffin first appeared on BBC television in 1946. Muffin was soon joined by many of his animal friends, all of whom had wonderful names. There was Mr Peregrine Esquire the penguin, Peter the pup, Poppy the parrot, Hubert the hippo, Grace the giraffe, Sally the sea lion, Zebbie the zebra, Monty the monkey, Wally the frog, Willie the worm, Oswald ostrich, Louise the shy lamb, Katy the kangaroo, Kirri the kiwi (not to be confused with the one who sung at Charles and Di's wedding), and my favourites, Maurice and Doris the mice. There were also Prudence and Primrose kitten who had one of the first spin-off TV

shows. Annette's final appearance was on 11th January 1955; sadly, just four days later, she died. Ann Hogarth wrote some Muffin the mule books with various illustrators including Annette's daughter Molly Blake, who had a studio in St Peters.
SEE Dumpton Gap/ Entertainers/ Muffin the mule/ St Peter's Church/ Television

John MILTON
Born London 9th December 1608
Died 8th November 1674
He went to Cambridge University and became a clergyman. A combination of dissatisfaction with the church and a growing interest in poetry saw him leave the church and spend two years, 1635-37, studying the classics at his father's house in Buckinghamshire, and another two years, 1637-39, touring Italy and France meeting the literati of the times.
In 1642, aged 33, he married Mary Powell, who was 17, but she left him within weeks blaming incompatibility. They were reconciled in 1645, but she died in 1652.
He was a supporter of Cromwell and in 1649 was appointed Latin secretary to the Council of State, a position he held until 1660 when Charles II became king. Milton served a period in prison for his ties to the previous administration.
In 1652 he became totally blind and therefore needed the help of an assistant in his work.
'They also serve who only stand and wait', John Milton on his Blindness
In 1656 he married Katherine Woodcock but both she and their newly-born baby died.
In 1663 he got married for the third time, this time to his former nurse Elizabeth Minshull, but this time it was he who died first.
SEE Milton Avenue/ Poets

MILTON AVENUE, Margate
Part of a group of streets named after poets.
SEE Byron Road/ Cowper Road/ Duke of Edinburgh pub/ Margate/ Milton, John/ Poets Corner

MILTON PLACE, Broadstairs
Built by the Culmers in the seventeenth century, it stood opposite Serene Place and was reached via a narrow passage between two shops. It was demolished in 1910 as part of the widening of the High Street.
SEE Broadstairs/ High Street, Broadstairs/ Serene Place

MINERS
Two thousand Kent miners and trade unionists celebrated what they saw as a great victory on 26th March 1972 at the Winter Gardens. After a seven-week dispute that had caused power cuts of up to nine hours, Jack Dunn, the general secretary of the Kent Area of the National Union of Miners said they had, *'fought, not only for a decent living wage, but for a livelihood. We had been told that our labour was no longer necessary for the British economy and pits were to be phased out in this age of oil and nuclear power. The three remaining Kent pits at Betteshangar, Snowdon, and Tilmanstone were among those under threat'.*

'We carried the struggle to unprecedented heights and played our part in history. We took over the NUM offices in London, and in other picketing organisations, we organised flying squads to picket in London and the south coast, we held hundreds of meetings large and small with demonstrations and parades, we have humiliated the Tory government and we have received an offer beyond the realms of optimism of four months ago. Our members, with the support of millions of trade unionists have shattered the Tory wage restraint policy. We have forged a new political and class consciousness throughout Britain'.
The three-day week began in December 1973.
During the National Union of Mineworkers strike of 1984, miners from local collieries blockaded Ramsgate Harbour several times.
Following strike action in March 1985, Snowden colliery never re-opened, Tilmanstone closed in June 1985 and Betteshanger colliery closed on 26th August 1989.
SEE Critical Mass/ Harbour, Ramsgate/ Ramsgate/ Winter Gardens

MINNIS BAY, Birchington
A local guide book in 1905 said *'Many persons eminent in the Church, at the Bar, or on the stage have built or have bought houses here'* and the new estates of large detached houses and bungalows here meant that Birchington now stretched all the way from its beginning around the Square to the sea.
The Minnis Bay Refreshment Pavilion – nowadays The Minnis - had a roof terrace where you could enjoy a meal and a drink.
SEE Bays/ Birchington/ Birchington Bay Estate Co/ Gore End/ Grenham Bay/ Grenham Bay School/ Kent Gardens/ Kidnapping/ Plum Pudding Island/ Sea Wall/ Smuggling, Minnis Bay/ Spur railway line/ Square, The/ Tea clipper houses

MINNIS BAY and GORE END
Although there had been an Iron Age settlement there, Minnis Bay was largely uninhabited apart from the odd farm cottage until the coastguard cottages were built in 1870.
The word 'minnis' meant 'land held in common' in Old English and the first reference to the name Minnis is found in Church Wardens' Accounts in 1531.
It is one of the few beaches with the blue flag status.
John Leland, 1542: *Reculver is now scarce half a mile from the shore but is to be supposed that in times past the se[a] cam[e] hard to Gore-end, a two mile from Northmouth, and at Gore-end is a little straite called Broode Staires to go down the clive [cliff].*
I know; it looks nothing like how he described it, because in the intervening centuries the sea has eroded the cliff at a rate of something like two feet every year until its progress was halted when the sea defences were built. The erosion was worse at the Reculver end of the sea wall due to the differences in soil and geology.

Minnis Bay was formerly Gore End, a sea port in its day although now virtually all traces have disappeared. The port was located approximately in the grassy area between the end of the sea wall and the Minnis Bay Café, where the path runs next to the farmland.
SEE Coastguards/ Farms/ Gore End/ Smuggling

MINNIS BAY HOTEL, Birchington
It was built in 1905, but was replaced by a block of flats.
SEE Birchington/ Hotels

MINNIS BAY PARADE, Birchington

The first shop in this area was the Post Office and general stores built in 1903. The two terraces of shops were built in 1930 – the date is displayed above the shops on one of the terraces - some of the research for this book was easier than others.
SEE Birchington/ Shops

MINNIS COASTGUARD COTTAGES
These cottages were built in the 1870s to the east end of Minnis Road in Birchington. Coastguards lived in them until the turn of the last century when they became privately owned houses.
SEE Birchington/ Coastguards/ Minnis Road

MINNIS ROAD, Birchington
The Bay Hotel was built in 1905 followed, at the end of Minnis Road, by Uncle Tom's Cabin; a hotel decorated to look like a Wild West saloon. It burnt down in 1970. On the site of both buildings, blocks of flats were built.
There once was a coastguard station here.
SEE Anglican Church of St Thomas/ Birchington/ Coastguards/ Minnis Coastguard cottages/ Old Bay Cottage/ Roman Catholic Church/ Sea Breeze Cycle Factory/ Tea Clipper houses/ United Reform Church/ VAD Hospitals

MINSTER
The large chalk-pit, now a nature reserve, is associated with both the Domneva legend and the 'Smugglers Leap' Ingoldsby legend. Minster was once the centre of the Isle of Thanet's community and was given the right to have a market in around 1115 or 1116.
In World War II, to combat the threat from long-range German guns in France firing at us, a gun was installed on a railway carriage on the line near Minster, to fire back.
SEE Accomodation/ Barham RH/ Callis Court/ Captain Swing/ Churches/ Cleve Court/ Clock Tower/ Domneva/ East Kent Times/ Fascists/ Faversham & Thanet Co-op Soc/ Forresters Hall, Ramsgate/ Hasted, Edward/ Hill, Vince/ Keats, John/ Lawrence, Carver/ Lord Byron pub/ Matrix/

MINSTER ABBEY

A nunnery was founded here in 670 by King Egbert of Kent for Ermenburga, Queen of Mercia, who took the name of Eva, as her religious name, and became known as Domneva. She was succeeded as Abbess of the Minster by Mildred, her daughter, later a saint, hence the many St Mildred names locally.

In 840, Vikings attacked, ransacked the area and burnt the abbey down. Thereafter, the abbey was uninhabited until monks from St Augustine's Abbey, Canterbury, rebuilt it as a monastic grange in 1027.

The great South Hall was added shortly after 1066. The dissolution of the monasteries saw the building coming under the crown in 1538. In 1602, James I released the building to private ownership. The nuns of St Walburga's Abbey in Bavaria, fleeing from the Nazis, took over the building in 1936-7.

SEE St Laurence Church/ Salmestone Grange/ Square, Birchington/ Vikings

MINSTER MILLS

These were situated by the Prospect from around 1596. One mill had new sweeps fitted by its owner, T Holman, in 1870 and around the same time, the other one had its wooden wind shaft replaced with a metal one. The one with the new wind shaft burned down five years later and the other one did not last much longer. The owner could not afford the necessary complete renovation that was required in 1880 and soon after, it was pulled down.

SEE Windmills

'MISADVENTURES at MARGATE'

Barham's 'Misadventures at Margate' (1840), tells of a visitor's encounter with *a little vulgar Boy'* whom he meets on the pier. He takes pity on him but discovers later that most of his valuables have gone, along with the boy:

'Twas in Margate last July, I walk'd upon the pier,
I saw a little vulgar Boy - I said, 'What make you here?
The gloom upon your youthful cheek speaks anything but joy;'
Again I said, 'What make you here, you little vulgar Boy?'

He frown'd, that little vulgar Boy, - he deem'd I meant to scoff -
And when the little heart is big, a little 'sets it off;'
He put his finger in his mouth, his little bosom rose, -
He had no little handkerchief to wipe his little nose!

'Hark! Don't you hear, my little man? - it's striking Nine,' I said,
'An hour when all good little boys and girls should be in bed.

Run home and get your supper, else your Ma' will scold - Oh! fie!
It's very wrong indeed for little boys to stand and cry!'

The tear-drop in his little eye again began to spring,
His bosom throbb'd with agony, - he cried like any thing!
I stoop'd, and thus amidst his sobs I heard him murmur - 'Ah!
I haven't got no supper! and I haven't got no Ma'!! -

'My father, he is on the seas, - my mother's dead and gone!
And I am here, on this here pier, to roam the world alone;
I have not had, this live-long day, one drop to cheer my heart,
Nor 'brown' to buy a bit of bread with, - let alone a tart!

'If there's a soul will give me food, or find me in employ,
By day or night, then blow me tight!' (he was a vulgar Boy;)
'And now I'm here, from this here pier it is my fixed intent
To jump, as Mister Levi did from off the Monu-ment!'

'Cheer up! cheer up! my little man - cheer up!' I kindly said,
'You are a naughty boy to take such things into your head:
If you should jump from off the pier, you'd surely break your legs,
Perhaps your neck - then Bogey'd have you, sure as eggs are eggs!

'Come home with me, my little man, come home with me and sup;
My landlady is Mrs. Jones - we must not keep her up -
There's roast potatoes at the fire, - enough for me and you -
Come home you little vulgar Boy - I lodge at Number 2.'

I took him home to Number 2, the house beside 'The Foy,'
I bade him wipe his dirty shoes, - that little vulgar Boy, -
And then I said to Mistress Jones, the kindest of her sex,
'Pray be so good as go and fetch a pint of double X!'

But Mrs. Jones was rather cross, she made a little noise,
She said she 'did not like to wait on little vulgar Boys.'
She with her apron wiped the plates, and as she rubbed the delf,
Said I might 'go to Jericho, and fetch my beer myself!'
I did not go to Jericho - I went to Mr. Cobb
I changed a shilling - (which in town the people call 'a Bob') -
It was not so much for myself as for that vulgar child -

And I said, 'A pint of double X, and please to draw it mild!' -

When I came back I gazed about - I gazed on stool and chair -
I could not see my little friend - because he was not there!
I peep'd beneath the table-cloth - beneath the sofa too -
I said, 'You little vulgar Boy! why what's become of you?'

I could not see my table-spoons - I look'd, but could not see
The little fiddle-pattern'd ones I use when I'm at tea;
 - I could not see my sugar-tongs - my silver watch - oh, dear!
I know 'twas on the mantelpiece when I went out for beer.

I could not see my Macintosh - it was not to be seen! -
Nor yet my best white beaver hat, broad-brimm'd and lined with green;
My carpet-bag - my cruet-stand, that holds my sauce and soy,
My roast potatoes! - all are gone! - and so's that vulgar Boy!

I rang the bell for Mrs. Jones, for she was down below,
'Oh, Mrs. Jones, what do you think? - ain't this a pretty go?
That horrid little vulgar Boy whom I brought here to-night,
He's stolen my things and run away!!' - Says she, 'And sarve you right!!'

Next morning I was up betimes - I sent the Crier round,
All with his bell and gold-laced hat to say I'd give a pound
To find that little vulgar Boy, who'd gone and used me so;
But when the Crier cried, 'O Yes!' the people cried, 'O No!'

I went to 'Jarvis' Landing-place,' the glory of the town,
There was a common sailor-man a-walking up and down,
I told my tale - he seem'd to think I'd not been treated well,
And call'd me 'Poor old Buffer!' - what that means I cannot tell.

That Sailor-man he said he'd seen that morning on the shore,
A son of - something - 'twas a name I'd never heard before,
A little 'gallows-looking chap' - d ear me; what could he mean?
With a 'carpet-swab' and 'muckingtogs,' and a hat turned up with green.

He spoke about his 'precious eyes,' and said he'd seen him 'sheer,'
 - It's very odd that Sailor-men should talk so very queer -
And then he hitch'd his trousers up, as is, I'm told, their use,

- It's very odd that Sailor-men should wear those things so loose.

I did not understand him well, but think he meant to say
He'd seen that little vulgar Boy, that morning, swim away
In Captain Large's Royal George, about an hour before,
And they were now, as he supposed, 'somewheres' about the Nore.
A landsman said, 'I twig the chap - he's been upon the Mill -
And 'cause he gammons so the flats, ve calls him Veeping Bill!'

He said 'he'd done me wery brown,' and nicely 'stow'd the swag,'
 - That's French, I fancy, for a hat - or else a carpet-bag.
I went and told the constable my property to track;
He ask'd me if 'I did not wish that I might get it back?'

I answered, 'To be sure I do! - it's what I'm come about.'
He smiled and said, 'Sir, does your mother know that you are out?'
Not knowing what to do, I thought I'd hasten back to town,
And beg our own Lord Mayor to catch the Boy who'd 'done me brown.'

His Lordship very kindly said he'd try and find him out,
But he 'rather thought that there were several vulgar boys about.'
He sent for Mr. Withair then, and I described 'the swag,'
My Macintosh, my sugar-tongs, my spoons and carpet-bag;
He promised that the New Police should all their powers employ!
But never to this hour have I beheld that vulgar Boy!

MORAL
Remember, then, that when a boy I've heard my Grandma tell,
'Be warn'd in time by others' harm, and you shall do full well!'
Don't link yourself with vulgar folks, who've got no fixed abode,
Tell lies, use naughty words, and say they 'wish they may be blow'd!'

Don't take too much of double X! - and don't at night go out
To fetch your beer yourself, but make the pot-boy bring your stout!
And when you go to Margate next, just stop, and ring the bell,
Give my respects to Mrs. Jones, and say I'm pretty well!
SEE Barham/ Cobbs/ Ingoldsby House/ Margate/ Poets

'Miss MORRIS and the STRANGER' by Wilkie Collins
'Do you come to us from Ramsgate?' I began. He only nodded his head. 'We don't think much of Ramsgate here,' I went on. 'There is not an old building in the place. And their first Mayor was only elected the other day!'
SEE Books/ Collins, Wilkie/ Ramsgate

MISTRESS
A dictionary definition is between mattress and mister.
SEE Collins, Wilkie/ Fitzherbert, Mrs/ Hamilton, Lady/ Jordan, Mrs

MOCKETT'S WOOD, St Peters
The footpath next to number 58 Northdown Road, St Peters, leads into Mockett's Wood and then continues through the wood to the supermarket car park in St Peters. The aptly named Sherwood Mockett planted the woods behind his home in Church Street, St Peters, over a century ago as a Victorian arboretum to provide some shelter from strong winds, and welcome shade in summer. There is a good variety of plants including Butchers Broom. The area was given to the village by the Mockett family and is now looked after by The Friends of Mocketts Wood. It is pleasant to find an area of real woodland within Thanet, so thank you Sherwood, and his Friends.
SEE Butchers Broom/ Church Street, St Peters/ Raneleigh Gardens/ Shallows, The/ Northdown Road, St Peter's

MODEL VILLAGE, Ramsgate
It was opened on 4th March 1954 by the Mayor of Ramsgate, Eddie Butcher, on the West Cliff. The models took three years to make – by a team of craftsmen at Dreamland - to fill the half-acre site.
The name of the miniature village was Castlewolde and Lord Morissey Trowte lived at the largest house, Compton Abbass. You could have a drink – a short presumably – at the Dew Drop Inn, and be healed at Castlewolde General Hospital – with 36 beds – look upon a Greek monument that Lord Morrisey Trowte imported from a miniature Athens, and learn at Seaton Grange College.
Around two million people visited over the years but after half a century it closed in 2004 due to falling attendance and vandalism.
SEE Dreamland/ Ramsgate

MODS and ROCKERS
The period from Sunday 17th May to Bank Holiday Monday 18th May 1964 (called Whitsun, when we still had a Whitsun Bank Holiday) saw the Mods and Rockers have their battles on the beach, along Marine Terrace, at the railway station, up the High Street, in Dreamland and anywhere else they fancied. Police arrived from all over the county to deal with the 'wild ones' as the press referred to them. They mainly arrived on their scooters (Mods) and motorbikes (Rockers) but also came down by train. Many arrests were made and 51 appeared in the magistrate's court on the Monday, chaired by George Simpson who later received over fifty letters from people all over the country praising him for his efforts in dealing with the hooligans. Margate's Mayor asked the press not to report the violence because, apparently, it would give 'these mentally unstable young people some false sense of their own importance'. Well that was going to work wasn't it? Just the thing newspapers don't want to write about. So they all did. It was front page news on the national dailies the next day. The Daily Mirror had 'Wild ones beat up Margate' as their headline. The editor of the Isle of Thanet Gazette said 'Those who believe that a press boycott would put an end to the kind of trouble that has spoilt Margate's holiday weekend are merely skimming the surface of the problem. The heavy fines and sentences imposed by magistrates should be a deterrent to future outbreaks of this kind. The press has a responsibility to report factual events such as this'.
SEE Daily Mirror/ Dreamland/ High Street, Margate/ Isle of Thanet Gazette/ Margate/ Marine Terrace

MONKTON
The name comes from 'Monks of Christ Church'. Queen Edgiva gave them the land. Her sons, Edmund and Eadred, were both kings in 961AD. She must have been so proud.
Some buildings here date back to the fifteenth and sixteenth centuries.
Ramsgate Fire Brigade was called to a fire at Monkton on 9th November 1912. Unfortunately, the horse drawn cart turned over injuring seven firemen of whom 'at least two men owe their lives to the protection afforded by their helmets'.
Pigot's Directory 1936: The church situated at the western end of the village is dedicated to St Mary Magdalene and is described previously. The living is a vicarage net yearly value £373 with residence. It is in the gift of the Archbishop of Canterbury, and has been held since 1924 by the Rev. Hubert C Henham. There is also a Methodist Chapel. The old stocks still exist near the churchyard. Area, 2,371 acres of land, 4 of tidal water and 3 of foreshore; population in 1931, 488.
Kelly's Directory of the Isle of Thanet, 1957: Monkton is a parish on the river Stour, 2 miles north-west from Minster station, 6½ west from Ramsgate and 6½ south-east from Margate, in the Isle of Thanet parliamentary division of the county, hundred of Ringslow, lathe of St Augustine, rural district of Eastry, petty sessional division and county court district of Ramsgate, rural deanery of Thanet and archdeaconry and diocese of Canterbury.
Water is supplied by The Thanet Water Board.
The church, situated at the western end of the village, is dedicated to St Mary Magdalene. The living is a vicarage, with residence in the gift of the Archbishop of Canterbury, and has been held since 1947 by the Rev. Frederick Richard Gower-Smith of Wycliffe Hall, Oxford. There is a Methodist Chapel and a Village Institute. The old stocks still exist near the churchyard.
Monkton Court is the property and residence of H A Smith esq., JP.

Population in 1951, 436, area 2,371 acres.
Post Office.-Percy George Jarvis, sub-postmaster. Postal address, Monkton, Ramsgate, Kent. The nearest money order & telegraph office is at Minster, 2 miles distant. Voluntary Primary School (junior mixed & infants); Miss D Foreman, head mistress.
There is a Jutish cemetery near the A253, where, in 1971, a gold Jutish brooch, called the Monkton Brooch was found.
The Croft at Monkton dates back to 1743.
SEE All Saints Church, Birchington/ Captain Swing/ Churches/ Fires/ Jutes/ Minster/ Royal Exchange Inn, Monkton/ Sarre/ Scarman, Lord/ Schools/ Smuggler's Leap/ Stocks/ Temperence Hotel/ White Stag

MONKTON MARSHES
In the 1870s, the police complained that the train companies were stopping their trains between stations to let up to 2,000 people off so that they could attend prize fights here. Prizes of up to £1,000 were offered, but two people died at one event.

MONKTON MILL
Shipping in the Channel used Monkton Mill (a post type windmill) as a landmark between c1596 and 1769. It was on the same road as the Minster Mills and situated to the north east of the village.
SEE Minster/ Windmills

MONKTON ROAD FARM COTTAGES
Monkton Road Farm Cottages are on the Seamark Road which goes from Brooks End to Monkton. The name of the cottages possibly refers to an older name for this road.
SEE Farms

Lord MONTAGU of BEAULIEU
Born London 20th October 1926
It must have taken an eternity to sew his name tags into his school uniform: Edward John Barrington Douglas-Scott-Montagu, 3rd Baron Montagu of Beaulieu. He became a peer at the age of two when his father died in an accident. He attended St. Peter's Court School (later Wellesley House) and Ridley College in Canada, Eton and New College, Oxford. He served in Palestine with the Grenadier Guards, and when he took his seat in the House of Lords, at the age of 21, he gave his maiden speech on the subject of Palestine.
He opened the National Motor Museum on his Beaulieu (Hampshire) estate in 1952.
In 1954 he was sentenced, along with journalist Peter Wildeblood and Michael Pitt-Rivers, to twelve months in prison for consensual homosexual offences. At the time, there was much concern over what was perceived as an increase in homosexuality and this trial came about to some extent because of that. Montagu protested his innocence and an ensuing backlash against the trial, as well as the Wolfenden Report, led to eventual legalisation of homosexuality. Montagu developed a good reputation in tourism following the opening of his estate to the public. He was Chairman of English Heritage from 1984 to 1992.

SEE St Peter's Court Preparatory School

Sir Moses MONTEFIORE
Descended from an Italian Jewish family who also had Portuguese and Spanish links, Moses was born the eldest son of wealthy merchant, Joseph Elias Montefiore, and Rachel, daughter of Abraham Lumbroso de Mattos Mocatta and moved to England as an infant. He was also the nephew of several well respected London brokers and despite the low status of Jews at the time considered himself born *'with all the advantages'*. His family, on his father's side, had been Jewish merchants who had settled in Ancona and Leghorn back in the 17th century. His grandfather, Moses Haim Montefiore, had then left Leghorn to settle in London in 1758. His relatives got him a job on the London Stock Exchange – one of only 12 Jews allowed to do business but it cost them £200 to buy a licence to allow it!
In 1812 he married Judith, a daughter of Levi Barent Cohen. Her sister was married to Nathan Mayer Rothschild, the head of the Rothschild bank, and Moses's brother, Abraham, married Henrietta Rothschild, a sister of Nathan. If you want to draw a family tree on the back of an envelope, I can wait.
Young Moses, in partnership with Nathan Rothschild, established a bank in Ireland, the Alliance Assurance Company, the South Eastern Railway, and an international gas company. By the time he was 40 in 1824, the 6ft 3in tall Moses was wealthy enough to retire - doesn't it make you want to spit?
His life's passion was the emancipation and betterment of Jews everywhere and his retirement gave him the time to devote to it. In all, he made seven trips to Palestine in 1827, 1838, 1849, 1855, 1857, 1866 and 1875. He wanted to establish agricultural settlements and paid for building supplies, farm implements, livestock and seeds. In England, he joined the United Deputies of British Jews working to end anti-Semitic discrimination in Britain. He became a sheriff of London in 1837, and was the first Jew in modern times to be knighted also in 1837. He was made a baronet on Sir Robert Peel's recommendation, in 1847.
On his visit to Jerusalem in 1838, he took up the cause of some Syrian Jews in Damascus who were accused of, and summarily jailed for the murder of a Capuchin monk and making Passover matzos from his blood. Everyone considered that the charges were ludicrous but the Syrian officials stood firm, and were supported by the French government. Montefiore fought their case obtained their release, got the false charges recanted and received a promise that Syrian Jews would henceforth be protected. When he returned to England he was a hero and his reputation as a defender of Jewish rights grew on visits to Russia in 1846, Italy in 1858, and Romania in 1867 where he had to deal with the government and taunting anti-Semitic crowds. He was even tempted at the age of 98 to go to St Petersburg when he

heard of anti-Semitic violence going on there.
In 1873 the local paper mistakenly printed his obituary: *'Thank God to have been able to hear of the rumour and to read an account of the same with my own eyes, without using spectacles'* was his response to the editor.

During their stay in Ramsgate in the summer of 1835, Montefiore gave Princess Victoria and her mother a golden key to open a private door to which enabled them to use the grounds of East Kent Lodge.
Entry in Montefiore's diary: *A little before seven, I went out in our chariot to the West Cliff, where I had the honour of dining with their Royal Highnesses, the Duchess of Kent and Princess Victoria.'*
Sir Moses Montefiore was talking to a business associate when another Jew passed them. Montefiore's companion made a very uncomplimentary remark about the man's pronounced Jewish features before he remembered to whom he was talking. *'I do beg your pardon. It was stupid of me. Please forgive me. You look angry enough to eat me!'* Sir Moses replied, *'You may rest assured on that account. My religion forbids it.'*
As an orthodox Jew, he ate only kosher meat, never had dairy products and meat at the same meal and fasted for six days of the year. In his nineties, he rested for 14 hours a day. When he was one hundred years old, he told a man of 80, *'Is that all? You have much work before you, sir.'*
On his death in 1885 at the age of 101, Sir Moses Montefiore was laid to rest beside Lady Judith Montefiore (she had died, aged 78, on 24th September 1862) in the Mausoleum at Hereson.
SEE East Cliff Lodge/ King George VI Park/ Mausoleum/ Ramsgate/ Russia/ Sedan chair/ Victoria

MONTEFIORE ARMS public house
Trinity Place,
Ramsgate
Named after Sir Moses Montefiore, it won the Thanet CAMRA Pub of the Year award in 2005.
SEE Pubs/ Ramsgate

MONTEFIORE COLLEGE
It was built by Sir Moses Montefiore as a memorial to his wife and was called the Hebrew Theological College. It was Tudor in style, faced in red brick, and consisted of a central building containing the library and reading room on the ground floor together with a lecture hall above and five houses on either side.

On the afternoon of 9th February 1916, the Germans dropped 12 bombs on Broadstairs and 4 on Ramsgate, some of which fell harmlessly in the grounds of Montefiore College. The building is with us no more.
SEE Broadstairs/ Ramsgate/ Schools

'MOONRAKER' by Ian Fleming
The James Bond novel mentions Margate and North Foreland.
SEE Books/ Fleming, Ian/ Margate/ North Foreland/ Tom Thumb Theatre

Henry MOORE
Born York, 7th March 1831
Died Margate, 22nd June 1895
An artist, he was the 9th son of William Moore. He started out doing paintings of animals and landscapes imitating the style of the Pre-Raphaelite Brotherhood but following a visit to the West Country in 1857, became a sea-painter. His work includes the 'Pilot Cutter' (1866), 'The Salmon Poachers' (1869), 'The Lifeboat' (1876), 'Highland Pastures' (1878), 'The Beached Margent of the Sea' (1880), 'The Newhaven Packet' (1885), 'Catspaws off the Land' (1885), 'Mounts Bay' (1886), 'Nearing the Needles' (1888), 'Machrihanish Bay, Cantyre' (1892), and 'Hove-to for a Pilot' (1893). He died in Margate aged 64.
SEE Artists/ Margate/ Rossetti

MORECAMBE and WISE
Eric Morecambe
Born 14th May 1926
Died 28th May 1984
Ernie Wise
Born 27th November 1925
Died 21st March 1999
Probably television's best comedy duo – you don't need me to explain them to you:
'What do you think of it so far?' - 'Rubbish!'
'More tea, Ern?'
'[He's got] short fat hairy legs'
'You can't see the join!'
'The play what I wrote'
'[cough] Arsenal!'
'He's not wrong, you know!'
'Wahey!'
'There's no answer to that!'
'Pardon?'
'If you want me to be a goner, buy me a record by Des O'Connor'
'I am playing all the right notes... but not necessarily in the right order.'
Eric affectionately slapping Ernie's cheeks; wiggling his glasses; throwing an invisible ball into a paper bag or putting a paper cup over his moth to do a Jimmy Durante impression, 'Sitting at my pianna the udder day ...'
Eric and Ernie both singing, 'Bring Me Sunshine'.
SEE Bulls Head/ Entertainers/ St Johns Church/ Winter Gardens/

MORELLI'S
Victoria Parade, Broadstairs
The ice cream parlour opened in 1932.

SEE Broadstairs/ Ice Cream/ Victoria Parade, Broadstairs

George MORLAND
Born Haymarket, London, 26th June 1763
Died Coldbath Fields London, 19th October 1804
The son of Henry Robert Morland, a painter, and Jenny Lacam, a Frenchwoman, and the eldest of their five children. He was educated at home and soon displayed an artistic gift, copying pictures and plaster casts. By the age of ten, he was exhibiting chalk drawings at the Royal Academy of Arts. In 1777, he was apprenticed for seven years to his father and was soon earning a good living for his father with his copying. It is thought that George was effectively the breadwinner at this time. He had his first picture engraved and published in 1780 and the following year, he had his first painting exhibited at the Royal Academy, where his work continued to be exhibited periodically for the rest of his life. At the Free Society of Works in 1782, he managed to show twenty-six works. Before his apprenticeship had ended George Romney (1734-1802), who, at the peak of his career was a more fashionable society portraitist than both Sir Joshua Reynolds and Thomas Gainsborough, offered him a job in his studio for the next three years at £300 a year. George turned it down. When his apprenticeship ended in 1784, he entered the Royal Academy Schools but within six months had left home and taken lodgings close to a Drury Lane publisher and began painting a large number of paintings for him. In the summer of 1785, he came to Margate where he painted portraits. He also paid a visit to Calais and St Omer in France that summer. The following year, he married Anne Ward. As he loved children, it was sad that they only had the one child who was stillborn. Anne was the sister of Henry Ward, his engraver, and Henry married George's sister.
During the 1780s, he gained a reputation for pictures of childhood, or sentimental scenes but in the following decade his subject matters were more rustic. His contemporaries mainly worked on a commission basis; Morland was unusual in that he sold his work through an agent. He had anything up to five pupils to assist in the production line he had going.
Some have said it was his strict upbringing, others the grind and slog of his apprenticeship, but whatever the reason, he had the deserved reputation of liking his drink and the wild-life. After his marriage and following his success, he spent more time with what was quaintly referred to as

'sporting company' and by 1789 was deeply in debt and hiding from his creditors, despite earning around £1,000 a year. By 1790 he had moved to Paddington but a change of address did not change his lifestyle. By 1793 doctors were warning that his life of debauchery had to change. He, of course, ignored any advice and the following year his increasing debts forced him to keep moving house and produce more work to sell. Returning to his lodgings, now in Vauxhall, from a visit to the Isle of Wight in 1799, he was arrested for his debts and sent to the King's Bench Prison in Southwark. He was finally liberated from there in 1802 but, by 1803, was under the roof of Marshalsea. Again he managed to extricate himself and went back to his old life, in turn, apoplectic and paralysed. On 19th October 1804, he was arrested by a publican and taken to a sponging house. [sponging house: 'A victualling house where persons arrested for debt are kept for twenty-four hours, before lodging them in prison. The houses so used are generally kept by a bailiff, and the person lodged is spunged of all his money before he leaves'. 'The Dictionary of Phrase and Fable', the new and enlarged edition 1894 by E. Cobham Brewer).] There he tried to draw a picture that he could sell to get himself out again. While drawing it he had a fit that turned out to be 'brain fever' and he died on the 29th. When his beautiful wife, who had not shared her husband's lifestyle although still deeply in love with him, was told of his death she went into convulsive fits herself and died herself on 2nd November. They were buried together.
SEE Artists/ Kings Head, Margate/ Love Lane/ Margate/ Royal Albion Hotel, Margate

Robert MORLEY
Born 1908
Died 1992
An actor, director, and playwright, he made his professional stage debut at Margate in 1928.
SEE Actors/ Cooper, Dame Gladys/ Margate

MORNING CHRONICLE
The Morning Chronicle 8th September 1810: '[Margate was] crowded with company and indeed may be considered as London in miniature, being in many circumstances an epitome of that vast metropolis.'
SEE Margate

MORRISON BELL HOUSE
Albion Road, Birchington
Built in 1900 and named after Major Morrison Bell who had died that year, it was a convalescent home for delicate children from London. On 6th August 1941, half of it was destroyed by a bomb. It was subsequently repaired and converted into flats after the war, but was eventually demolished in 1965; houses were then built on the site.
SEE Albion Road, Birchington/ Birchington/ Convalescent Homes/ World War II

Sir Oswald MOSELEY
Born 16th November 1896

Died 3rd December 1980
He was the leader of the British Union of Fascists from 1932 until 1940. His mother, Lady Katherine Moseley, visited Broadstairs for the opening of the party's office in Broadstairs High Street.
'Oswald Moseley was a cross between a demented Terry Thomas and Bill Clinton' David Aaronovitch
SEE Broadstairs/ Fascists/ High Street, Broadstairs/ Politics/ Tester, Dr Arthur

Kate MOSS
The father of model Kate Moss' baby is magazine publisher, Jefferson Winston Hack, who comes from Ramsgate.
SEE Ramsgate/ Walpole Bay Hotel

MOTOR MUSEUM, Ramsgate

Terry Sharpe opened the museum in 1982 and when he died in 2001, his two brothers, Dennis and Alan took the place over. With 65 cars and 50 bikes, there were at least ten exhibits for every decade from the 1900s to the 1960s. These included a penny farthing bicycle, a wooden prototype for a 1904 Arrol Johnston and a blue Ford Anglia, similar to that used in the Harry Potter film. Other vehicles had appeared in 'Those Magnificent Men in Their Flying Machines'. The Motor Museum closed in 2005.
SEE Bicycle/ Harry Potter/ Ramsgate/ West Cliff Hall

MOTT
When the band Mott the Hoople split up, some ex-members formed a new band called Mott. On an album called The Gooseberry Sessions and Rarities there is a track entitled 'Broadstairs Beach' written by Morgan Fisher.
SEE Broadstairs/ Music

MOUNT ALBION HOUSE, Ramsgate
John Marshall, a local miller, built Mount Albion House in 1798 close to his mill, and leased it for a while to the son of the Duke of Hamilton and Brandon. It was in 1817 that Lady D'Ameland came into possession not only of the house but also the surrounding estate. She had been Lady Augusta Murray - her father was the Earl of Dunmore - until she went to Rome in 1792 and not only met King George III's sixth son Frederick Augustus, but married him there a year later. They must have enjoyed it because they had a second ceremony at St Georges in Hanover Square in December 1793 - or maybe the photographs didn't come out. They had a son, Frederick Augustus, in 1794, and a daughter, Ellen Augusta Emma, on 11th August 1801. Then he left her. Apparently, it was the only way that he could take the title of the Duke of Sussex. Lady Augusta took the title of Lady D'Ameland, and the children took the name of D'Este. Lady

D'Ameland died in 1830 and the house and estate passed to her daughter who was then known as Mademoiselle D'Este.
It was put up for sale in 1838, but due to a lack of buyers was eventually divided up and sold off as building plots. In 1844, one plot was given by Mademoiselle D'Este, along with a large financial gift, to enable the building of Holy Trinity Church.
In 1845 she married Sir Thomas Wilde, a former attorney, who later became Lord Truro, and Lord Chancellor. He was also involved in a famous court case to establish whether the estate was within the parish of Ramsgate or St Lawrence. Lord Truro won his case and placed two stones on the corner of Bellevue Road and Truro Road, one engraved with an 'R' and the other 'STL'. Lord Truro died in 1855, and Mademoiselle D'Este, obviously now Lady Truro, died in 1866. The family are remembered today in the names of Truro Road, Augusta Road, and D'Este Road.
With Charles James Scott MA as its principal, Mount Albion House became the Granville College, St Lawrence-on-sea at the end of the nineteenth century. In the years after the Second World War, it was St Hilda's Preparatory School, and in 1964 it became the Hotel Maria, before, in 1972, it was converted into flats.
SEE Albion Road, Ramsgate/ Arklow Square, Ramsgate/ Augusta Road, Ramsgate/ Bellevue Road, Ramsgate/ Browne, John Collis/ D'Este Road, Ramsgate/ D'Este, Mademoiselle/ Dunmore, 4th Earl of/ George III/ Holy Trinity Church, Ramsgate/ Ramsgate/ Schools

MOUTH ORGANS
The East Kent Times, 1916: *Lance Corporal R Collier, a Ramsgate man serving with the Sixth Batallion The Buffs, would be grateful to any kind persons who would send a few mouth organs and jews harps. He said the lads would appreciate these gifts, as they would break the monotony of life at the Front when the hours are passing slowly. Lance Corporal Collier has been wounded. He was formerly employed by Messrs Vye's, Ramsgate and lives at 52 Margate Road.*
SEE East Kent Times/ Margate Road, Ramsgate/ Music/ Ramsgate/ Vye and Son

'Mr. JERICHO'
An Operetta in One Act, with words by Harry Greenbank and music by Ernest Ford, it was first performed at the Savoy Theatre, London, on 18th March 1893 and ran for 45 performances.
In it, the Earl of Margate squanders his money and has to live in a cottage and even tend his own garden! His son, Horace, has to become a bus driver. He crashes the bus and tells his father, at which point they both realise that Horace has no chance now of a romance with Lady Bushey's daughter, Winifred, who often gets on his bus. Mr Jericho is a jam manufacturer.
Horace: *Let me introduce you to Mr. Jericho, father.*
Jericho: *Why, surely this is,—indeed I cannot be mistaken,—this is no other than the Earl of Margate!*

Lady B. and Win: *The Earl of Margate!*
Michael: *Oh! Horace our secret is discovered! This will shake the House of Lords to its very foundations!*
Jericho: *I remember you perfectly. I used to see you in the park regularly every Sunday.*
Lady B: *You have a noble old face, but it bears traces of considerable financial troubles.*
Michael: *No doubt it does. Fortune has dealt hardly with me. The Official Receiver has opened his arms wide and taken me into his bosom.*
Winifred: *Oh! Horace, are you really the son of an Earl?*
Horace: *I regret to say that I am; I have the misfortune to bear the title of Viscount Ramsgate.*
Winifred: *Then I think I love you more than ever! There is something singularly attractive about a nobleman.*
Horace: *Alas! my darling, we are daily sinking in the market of public estimation.*
SEE Music/ Margate/ Ramsgate

MUCKY DUCK public house
SEE Pubs/ White Swan, Reading Street

MUFFIN THE MULE
A puppet; not a crime.
SEE Mills, Annette

Frank MUIR
Born Ramsgate 20th February 1920
Died Thorpe Surrey 2nd January 1998
He attended Chatham House School in Ramsgate but left with no qualifications. He was a successful comedy writer, broadcaster and producer appearing on 'My Music' and 'Call My Bluff', and producing 'Steptoe and Son' and 'Till Death Us Do Part'
Frank Muir and Dennis Norden, BBC comedy series 'Take it From Here': *'What are you – a sorcerer? / Only at home. In company I drink out of the cup.'*
He listed his hobbies as *'collecting books and staring into space'* and I can see nothing wrong with either of those things.
SEE Authors/ Chatham House School/ Derby Arms/ Ramsgate

MUIR ROAD, Ramsgate
East Kent Times, 16th October 1957: *Red Moon seen over Thanet - Russian Satellite travelling at 18,000mph seen with naked eye by Mr & Mrs Brown of 63 Muir Road, Ramsgate and others. Radio signals picked up by the Isle of Thanet Radio Society*
SEE East Kent Times/ Ramsgate/ Russia

MULBERRY TREE public house
Dane Road,
Margate
In the eighteenth century this was a knapped flint farmhouse surrounded by a meadow. Slowly, but surely, the town began to encroach; eventually, around 1830, James Newlove bought the house to start his Dane House Academy for Boys. He had both day pupils and boarders who slept in three bedrooms on the dormer windowed top floor. Mr Bowles, a builder, built Belle Vue Cottage (later to become Rosannah Lodge)

nearby and Mr Newlove decided to lease it in 1835 so that his wife could run a girls school (by the 1890s, when it was at 57 Dane Road, it had become a mixed school, but only had about four pupils). One day, the Newlove's son, Joshua, decided to dig a duck pond, as you do, and there he is digging away in the garden to the rear of the girls' school when, instead of finding an old coin, or a piece of a plate, or even a rusty nail like the rest of us would, he finds a great big shell grotto. His father sees it and pound signs start flashing before his eyes. He gets his son to cover it up and they both presumably sauntered away whistling between their respective teeth, trying to look as nonchalant as posssible. He managed to acquire the freehold from a Mr Bowles in 1837, after which he, no doubt, faked surprise when he discovered the grotto again.

The Cobb Brewery took over the old Dane House School and it became The Mulberry Tree (a throw-back to its farmhouse beginnings), a busy pub with the Grotto's many visitors coming in to quench their thirst. For a while, it changed its name from The Mulberry Tree to The Freemason's Tea Tavern Garden but soon reverted again in the 1840s, but became the Freemasons Tavern Tea Garden and Bowling Green in the 1860s and The Mulberry Tree again in the 1880s.

In 1871 John Feakins, a widower, was the landlord living here with his two teenage sons: one was a tin worker and the other was a pipe maker, (in the 1980s, a quantity of his pipes were discovered in the garden); his three daughters who all worked as domestics; his mother-in-law and a lodger!

In 1940 the mulberry tree, after which the pub was named, was felled because so many customers complained that the fruit left a purple-red stain on their clothes. Bombs dropping everywhere, food rationed, and apparently this is what they complained about!

In the 1950s, the Mulberry operated as a hotel but soon reverted back to being solely a pub with the atmosphere of a country pub or hunting lodge with buffalo horns in the public bar (probably not shot locally), wood panelling, very heavy chairs made from barrel staves and original beams.

A sapling mulberry tree was planted in the beer garden in 1986.
SEE Cobbs/ Farms/ Margate/ Pubs/ Schools

MULBERRY HARBOUR

In World War II, part of the Mulberry Harbour was assembled at Richborough for D-Day.
SEE Richborough/ Stonar/ World War II

Harold MUNRO

Born 1879
Died 1932
The founder of the journal, The Poetry Review in 1911, he also advanced the cause of poetry in this country by opening a poetry bookshop in Devonshire Street in London. An alcoholic, he died in a nursing home in Broadstairs at the young age of 53.
SEE Broadstairs/ Poets

MUNRO COBB furniture store
Northdown Road,
Cliftonville

Leonard Monroe Cobb grew up in Strood, near Rochester and was an apprentice at Maples furniture store in Tottenham Court Road, London. He married and they had a son. Due to his wife's poor health, a move to the seaside was recommended and Cobb moved his family to Margate. Sadly, his wife died two years later. He re-married three years after and two more sons and two daughters followed.

He opened a fairly small furniture shop in Northdown Road in 1904. Four years later he bought a corner plot and moved the shop to its present location, buying adjacent properties as the business expanded.

His son, also Leonard, took over the firm after World War II.

Joseph Hurst ran the business (his family had bought the firm) until his death aged 91 in 2003. His daughters now own it.

Covering five floors, it was the largest shop in Northdown Road before its recent closure.
SEE Cliftonville/ Northdown Road/ Shops

MURDER

To intentionally cause the death of any person. A homicide or assassination. To blow away, blow someone's brains out, bump-off, butcher, dispose of, do-in, do away with, exterminate, kill, knock-off, massacre, put to death, slaughter, slay, take out, waste.
SEE Broadstairs Sailing Club/ Brockman, Sarah/ Crippen, Dr/ Flora Road, Ramsgate/ Fordred, Thomas/ Green, Napoleon/ Houchin, Alan/ Jack the Ripper/ Richardson, Alan/ Stone Bay/ Suicide

'MURDER MAKES AN ENTRÉE –
a Victorian whodunnit'
by Amy Myers

In this novel, Auguste Didier, a French cook who loves English cooking, is preparing a banquet in Broadstairs to celebrate the life of Charles Dickens, when one of the guest dies. Luckily Inspector Rose of Scotland Yard is staying in Ramsgate . . .
SEE Books/ Broadstairs/ Dickens, Charles/ Ramsgate

Al MURRAY

Born 10th May 1968
The comedian Al Murray – the 'pub landlord' – (he has performed at The winter Gardens) is the great great great great grandson of William Makepeace Thackeray.
SEE Entertainers/ Thackeray, William Makepeace/ Winter Gardens

John Middleton MURRY

Born 1889
Died 1957
SEE Lawrence, D H

MUSHROOMS

In 1957, mushroom growers were in business at Coolvale Mushrooms in Sea View Road, Cliffsend, Ramsgate.
SEE Ramsgate

MUSIC

SEE Beatles/ Bennet, Richard Rodney/ Billericay Dickie/ Bishop, Sir HR/ Bloodvessel, Buster/ Bowie, David/ Brass Monkey/ Broadstairs Folk Festival/ Bush, Kate/ Chas and Dave/ Chatham House School Song/ Clash, The/ Coward, Noel/ Culture Club/ D'Abo, Mike/ Deller, Alfred/ Don't Put Your Daughter on the Stage, Mrs Worthington/ Eliot, TS/ Half Man Half Biscuit/ Hatton, JL/ Hawkwind/ Heseltine, Philip/ Hill, Vince/ Johnson, Robb/ Kelly, Michael/ Lewis, Jerry Lee/ Mary White/ Mott/ Mouth organs/ Mr Jericho/ Noise/ Oh Margate/ Ramsgate Song/ Richardson, Geoffrey/ Rolling Stones, The/ Russell, William Clark/ St Nicholas-at-Wade/ Savage, Dominic/ Savage, Tony/ Shapiro, Helen/ Siouxsie & the Banshees/ Sousa, JP/ Status Quo/ Steenhuis, Wout/ Stranglers, The/ Sunshine Rooms/ Weill, Kurt/ Westlife/ Winter Gardens

MUTRIX, Garlinge

The Margate holiday trade used the produce grown by the Garlinge (previously Bethlehem), Dent-de-lion and Mutrix Farms. The latter had land requisitioned by the government in World War I upon which huts and wooden aircraft hangars were hurriedly put up for use as the temporary headquarters of A Flight of No 2 Squadron, comprising Avro 504s, Curtiss JN3s and BE 2Cs. The Mutrix name lives on with Mutrix Road and Mutrix Gardens.
SEE Farms/ Garlinge/ World War I

Jeff MUTTON

A local smuggler captured along with Joss Snelling on 10th August 1803 on the beach at Kingsgate with over sixty kegs of spirits which they claimed they found while they were out for a walk. They were fined £100.
I do not know if he was hard of hearing or not.
SEE Kingsgate Bay/ Smuggling/ Snelling, Joss

NAPIER ROAD, St Peters
SEE Magdala Road, St Peters

Prince Louis NAPOLEON (Napoleon III)

Born Paris 20th April 1808
Died Chislehurst, Kent 9th January 1873
Bonaparte's exiled nephew, Prince Louis Napoleon (born 20th April 1808, Paris, the third and youngest son of King Louis and Queen Hortense of Holland) chartered the steamer Edinburgh Castle, in 1840 as part of his plan to invade France and take power (he had already staged a failed attempt in 1836) . He sailed to Margate, stayed and planned the venture for three days at the Royal York Hotel. His pet eagle stayed in a cubicle in the lobby. The landlord, Edward Wright, was invited to join the Louis group for breakfast on the steamer, but he declined when he saw that they were all dressed in military uniform and not the fishing attire he was expecting. On their arrival in France they were duly arrested and Louis was sentenced to life

imprisonment. Louis escaped from a fortress in Ham in 1846 dressed in the clothes of a workman named Badinguet. Henceforth, his followers were called Badingueux. He went on to rule France between 1852 and 1870 but following defeat in the Franco-Prussian War he was overthrown in Paris on 4th September 1870 and died in exile.
SEE Margate/ Prussia/ Royal York Hotel

NAPOLEONIC WARS (1803-15)
So many troops embarked from Ramsgate to war in Europe during the Napoleonic wars that it became a common sight. The numbers reached the tens of thousands as Ramsgate was a garrison town. It is said that on one particular occasion, the line of troops, six abreast, stretched back as far as Nethercourt as they filed into the harbour to sail away to the continent.
SEE Addington Street, Ramsgate/ Addington Place, Ramsgate/ Admiral Harvey public house/ Artillery Arms/ Batteries/ Bull & George Hotel/ Cannon Road, Ramsgate/ Cavalry/ Chatham Place, Ramsgate/ Church Street, St Peters/ Cobbett, William/ Cochrane, Admiral/ Duke of York public house/ Dumpton Gap/ Dyason's Royal Clarence Baths/ Eagle House/ Midland Bank/ Ramsgate/ Royal Road, Ramsgate/ St Peter's Church/ Star Inn, Westwood/ Thanet Weed/ Townley Castle/ Vale Square, Ramsgate/ Walcheren Expedition/ Waterloo, Battle of/ Wellington Crescent, Ramsgate/ Wellington, Duke of/ West Cliff Hall, Ramsgate/ West Cliff Promenade, Ramsgate/ Windsor Cinema/ York Gate

NASH ROAD, Margate
Nash Road was damaged in The Hurricane Bombardment of 27th April 1917.
SEE Hurricane Bombardment/ Margate/ Stone Bay

NATIONAL PROVINCIAL BANK
Grange Road, Ramsgate
In June 1951, Reginald Coppard was sentenced to 7 years in jail after he had shot and critically wounded Richard Maxwell, 46, a cashier at the National Provincial Bank in Grange Road, Ramsgate.
SEE Banks/ Grange Road/ Ramsgate

NATIONAL SCHOOL
Park Lane, Birchington
John Powell Powell, of Quex, donated land on which to build a school for the poor of Birchington and Acol, together with a residence for the schoolmaster, or schoolmistress. Despite some opposition from parishioners and members of the governors of the Crispe Charity, the school opened on 11th June 1849. It measured just 48ft by 22ft with sixty pupils (that's about an area 4 feet by 4 feet for each pupil), warming themselves on cold winter days beside an open fire. The school was enlarged in 1872 and 1881; a new girls school was built in 1902; and the new Infants School was built in 1926. It replaced the school in Albion Road at the old Primitive Methodist Chapel. In 1935 the three schools became one and the old school was knocked down in 1972, when the newer buildings were put up and the remainder renovated.

In more recent times, it has been called the Birchington Church of England (Controlled) Primary School.
SEE Acol/ Albion Road, Birchington/ Birchington/ Park Lane/ Quex/ Schools

NATIONAL UNION of WOMEN'S SUFFRAGE SOCIETIES
East Kent Times, 22nd January 1910: *This society has opened a committee room in King Street, Ramsgate where a petition lies for the signature of the electors.*
SEE East Kent Times/ King Street, Ramsgate/ Ramsgate/ Suffragettes

NATIONAL WESTMINSTER BANK
The London and Westminster Bank began in 1834 and had two offices: one in Throgmorton Street, London and the other in Waterloo Place, Westminster, hence – well, you've got the idea. The previous year, The National and Provincial Bank was set up in London as a national bank in England and Wales and also had provincial branches. Within two years they had fifteen such branches. In 1970 the Westminster Bank, the National Provincial Bank and the District Bank merged to form the National Westminster, or NatWest, Bank
SEE Banks

NAVAL MEMORIAL
The memorial in Ramsgate Cemetery is dedicated to the 13 men who died after their torpedo boat exploded in Ramsgate Harbour in May 1917.
SEE Cemetery/ Harbour, Ramsgate/ Ramsgate

NAYLAND ROCK HOTEL, Margate
The Nayland Rock Hotel was once a very grand hotel, built on the site of the old Nayland Windmill which was moved to a site near the Draper's almshouses around 1805. The exact opening date is uncertain but the hotel was referred to in an 1885 guide. Probably around 1860, to generate money to build houses here, the Margate Royal Crescent Tontine Company was formed. [Lorenzo Tonti was a seventeenth century Neapolitan banker who moved to Paris and came up with this form of company or will.] Every subscriber invested a sum in the company and as they died the investments were re-allocated between them and their children, until there was just one person left who owned the entire company. The Margate Royal Crescent Tontine Company's prospectus stated, *'When completed, the Royal Crescent will consist of 18 first-class private houses, of very handsome design and elevation with a double frontage. The situation of the whole property is most healthful and beautiful. The seafront possesses a magnificent view from the Nore to the North Foreland, including the town and the bay of Margate, the pier and the new landing stage.'*
Some of the houses were converted into the Nayland Rock Hotel in the 1890s
Mick and Bianca Jagger had a family party here in the 1970s to celebrate their marriage.
SEE Hotels/ Margate/ Rolling Stones/ Windmills

Lord Horatio NELSON
Born 29th September 1758
Died 21st October 1805
England's greatest admiral. He lost the sight of an eye in 1794, but did not lose his eye, nor did he wear an eye-patch. He lost an arm in 1797.
Lord Nelson on Friday came ashore at Margate for the purpose of procuring among the smugglers in that neighbourhood some Pilots particularly acquainted with the French coast. (11th August 1800)
He once went to a ball in Hawley Square with Lady Hamilton and also visited Margate for the bathing in the very early 1800s.
SEE Bathing/ Earl St Vincent pub/ Hamilton, Lady/ Hawley Square/ Jervis, John/ Lord Nelson pub/ Margate/ Nelson Crescent/ Nelson Terrace/ Northern Belle/ Rodney, Admiral/ Tartar Frigate/ Uncle Mac/ William IV

NELSON CRESCENT
West Cliff, Ramsgate
Overlooks Royal Parade and the harbour and was built around 1798-1801.
Alfred Luck lived at number 11.
Wilkie Collins stayed here in 1861 at number 14.
SEE Collins, Wilkie/ Luck, Alfred/ Nelson, Lord Horatio/ Ramsgate/ U-boat/ Wellington Crescent

NELSON TERRACE, Broadstairs
Built around the same time as the Lord Nelson pub. Originally naval officers lived there.
SEE Broadstairs/ Lord Nelson public house

NEPTUNE ROW, Ramsgate
This once linked Princes Street to Leopold Street and the Sandwich Arms public house was situated at the end of it.
SEE Leopold Street, Ramsgate

NEPTUNE'S HALL public house
Harbour Street, Broadstairs
Its unusual claim to fame is that its interior was listed in 1999.
It was built in 1815 and replaced some fishermen's cottages. In the 1920s it was a hotel.
Uncle Mac was a regular here.
SEE Broadstairs/ Harbour Street, Broadstairs/ Pubs/ Uncle Mac

NERO'S
Previously called Marina Hall, *'just a little exclusive'* nightclub opened in 1969 in what was formerly the Supreme ballroom. It cost 7/6 to get in on Wednesdays, and 10/6 on Fridays and Saturdays.
NERO'S
Marina Esplanade, Ramsgate
YOUR WEEK-END ENTERTAINMENT.
Friday and Saturday: On stage we welcome for the first time 'THE PETER PRINCE INTERNATIONAL DISCO SHOW' with top stereo sounds zany games, spot prizes, and the finest lighting effects put on the road today.
Monday. The return of popular radio DJ 'EDDIE AUSTIN'
Details: phone Thanet 52946
From a 1977 advertisement

Various paranormal experiences were reported at the old nightclub, including ghosts of ex-servicemen and strange smells (although are strange smells in a nightclub unusual?) but more remarkable were the reports of timeslips.
SEE Ghosts/ Marina Esplanade/ Radio/ Ramsgate

Gerard NERVAL
Born 1808
Died 1855
A writer of both prose and poetry who travelled extensively both in the east and in Europe, included Ramsgate on his way back from London in July 1846.

De Ramsgate à Anvers (1846)
A cette côte anglaise
J'ai donc fait mes adieux,
Et sa blanche falaise
S'efface au bord des cieux!
Que la mer me sourie!
Plaise aux dieux que je sois
Bientôt dans ta patrie,
O grand maître anversois!
Rubens! à toi je songe,
Seul peut-être et pensif
Sur cette mer où plonge
Notre fumeux esquif.

SEE Poets/ Ramsgate

'The NEST OF THE SPARROWHAWK' by Baroness Orczy
A novel, written in 1913, which was set locally, and included Epple Bay:
The mist had not lifted. It was heavy and dank like a huge sheet of grey thrown over things secret and unavowable. Over the sea it hung, thickest down in the bay, lurking in the crevices of the chalk, in the great caverns and mighty architecture, carved by the patient toil of the billows in the solid mass of the cliffs.
Up above it was slightly less dense: allowing distinct peeps of the rough carpet of coarse grass, of the downtrodden path winding towards Acol, of the edge of the cliff, abrupt, precipitous, with a drop of some ninety feet into that grey pall of mist to the sands below.
. . . A gentle breeze had risen about half an hour ago and was blowing the mist hither and thither, striving to disperse it, but not yet succeeding in mastering it, for it only shifted restlessly to and fro, like the giant garments of titanic ghosts, revealing now a distant peep of sea, anon the interior of a colonnaded cavern, abode of mysterious ghouls, or again a nest of gulls in a deep crevice of the chalk; revealing and hiding again: - a shroud dragged listlessly over monstrous dead things.
SEE Acol/ Books/ Epple Bay/ Orczy, Baroness

NETHERCOURT FARM, Ramsgate
There was a Zeppelin attack on 17th May 1915 at Nethercourt Farm, but there were no casualties or any major damage.
SEE Farms/ Ramsgate/ Zeppelin

NETHERCOURT HOUSE, Ramsgate
The house that was demolished in January 1957 dated from c1702, although it had replaced an earlier one built in 1254. The house has been home to Thomas Garrett, the Colonel who commanded the East Kent Yeomanry Isle of Thanet Troop, and the Rev G W Sicklemore (1836-1880) vicar of St Lawrence.
In World War I there was a VAD hospital at Nethercourt.
SEE Ramsgate/ VAD Hospitals/ Yeomanry

NEW INN, The Square, Birchington
It was the brake house for horse-drawn brakes leaving for Margate and Canterbury. The Inn has also been called the Pewter Pot and dates back well over two and a half centuries.
SEE Birchington/ Pewter Pot, Birchington/ Pubs/ Square, The

NEW INN, New Street, Margate
A coaching inn from 1793. In 1983 it was altered to one bar with an open plan layout. The coach house and stable block are now a private property.
SEE Margate/ Old Margate/ Pubs/ Royal York

NEW SHIPWRIGHTS HOTEL
Ramsgate
Advertisement, c1900:
The 'New Shipwrights' Hotel.
Facing the New Pavilion and harbour.
All the finest brands of wines and spirits stocked.
Comfort, cleanliness and civility my specialities.
Proprieter – J J Flower
SEE Harbour, Ramsgate/ Hotels/ Ramsgate

NEW ZEALAND
SEE Burton, Alfred/ Fitzgerald, JP/ Fitzroy, Admiral/ Jennings & Darbishire/ Jordan, Sir William/ Lawrence, DH/ Luck, alfred/ Luck, JE/ Norfolk Hotel/ Vogel, Julius/ Voss, Captain

NEWCASTLE HILL, Ramsgate
Amongst locals it was referred to as Cassell Hill.
The donkeys used for giving rides to children on the beach lived in stables around here and were looked after by the Todd family who also used to live in this area.
The Wesleyan Mission Hall (late nineteenth to early twentieth century), had previously been an infants' school. The Methodists sold it in the 1950s before it was demolished in the 1960s.
When workmen were laying a new path around Newcastle Hill flats in May 1962, they found 614 gold sovereigns and 116 half sovereigns. Local schoolchildren were asked to come up with names for the two tower blocks in time for the opening on 18th November 1964. The discovery of the coins prompted the name Trove Court. The other was named Kennedy House after the recently assassinated US President.
SEE Donkeys/ Ramsgate/ Schools/ Wesley, John

NEWFOUNDLAND
Broadstairs fishermen went to catch cod off Newfoundland in the late nineteenth century, both for the fish itself and for cod liver oil.
SEE Broadstairs/ Fishing/ USA

NEWGATE GAP, Cliftonville
The original bridge over Newgate Gap was put there by Captain Frederick Hodges to enable people to get to Hodges' Flagstaff. The original bridge had '*Pro bono publico*' (for the public good) inscribed on it and survived until 1907 when it was replaced as part of the 50th Anniversary celebrations of Margate becoming a borough. The replacement bridge had steel girders encased in concrete and faced with carrara marble and cost £1,400.
SEE Cliftonville/ Eastern Esplanade, Cliftonville/ Hodges, Captain Frederick/ Hodges' Flagstaff/ Margate

NEWINGTON ESTATE, Ramsgate
In April 1946, it was announced that 700 dwellings were to be built on the 112 acres of the Newington Estate.
SEE Garwood, Walter William/ Mascall's Mill/ Ramsgate/ Tulips/ Windmill Inn

NEWINGTON FREE CHURCH
Newington Free Church opened in 1963 having cost £4,000 to build; the costs were borne by donations.
SEE Churches/ Ramsgate

NEWINGTON GREYHOUND TRACK
It had a hare that had to be operated by a man pedalling like mad to ensure that the dogs did not catch it! It was also operated outside of the National Greyhound Racing Association's control which meant that owners could race their dogs more often than the twice-a-week limit at Dumpton.
SEE Dumpton Greyhound Track/ Ramsgate

NEWINGTON MILL
The site of Newington Mill was just off Newington Road, opposite Cliftonville and Granville Avenues. It was sold at auction in the Auction Rooms at 36 High Street on 4th May 1899 for £2,000 and the accompanying cottages for £400.
SEE Newington Road/ Ramsgate/ Windmills

NEWINGTON RAILWAY STATION
Including the existing one, Ramsgate has had four railway stations; one was at the other end of Station Approach Road, another at Ramsgate Sands and one at St Lawrence which was situated next to the first road bridge over the railway line in Newington Road. It was the station where tourists could alight for their visits to Pegwell Bay. A re-organisation of Southern Railways in 1926 meant that the station was no longer required. At the same time a new Newington Bridge was built.
SEE Pegwell Bay/ Railway Stations/ Ramsgate/ Station Approach Road

NEWINGTON ROAD, Ramsgate
SEE Dame Janet School/ Drays/ Faversham & Thanet Co-op/ Mascall's Mill/ Newington Mill/ St Lawrence Railway Station/ Windmill Inn

NEWSPAPERS
SEE Daily Mail/ Daily Mirror/ East Kent Times/ Isle of Thanet Gazette/ Keble's Margate & Ramsgate Gazette/ Times, The

155

Sir Charles Thomas NEWTON

Born Herefordshire, 16th September 1816
Died Margate, 28th November 1894

An archaeologist, he started out as an assistant in the Antiquities Department of the British Museum in 1840. In 1852 he quit to become the vice-consul at Mitylene, so that he could explore the coastal areas of Asia Minor. His biggest find was the discovery of one of the seven wonders of the ancient world, the remains of the mausoleum of Halicarnassus.

In 1860, he became the British consul in Rome but almost immediately was tempted to re-join the British Museum to re-organise the Antiquities department. When he left in 1885, he was presented with a bust of himself, which is now on display at the museum. Suffering with poor health in his later years, he died in Margate aged 78.

SEE Margate

'NICHOLAS NICKLEBY'
by Charles Dickens

This novel by Charles Dickens was partly written in Broadstairs. In his diary entry for 20th September 1839, Charles Dickens wrote 'Finished Nicholas Nickleby this day at 2 o'clock and went over to Ramsgate with Fred and Kate to send the last chapter to Bradbury and Evans in a parcel. Thank God that I have lived to get through it happily.'

SEE Albion Street, Broadstairs/ Books/ Broadstairs/ Dickens, Charles/ Ramsgate

NOGGIN the NOG

This was an excellent stop-animated children's television series that ran for five series and 36 programmes from 1959 until 1965 (there was a brief return in 1980) about Noggin the Nog, a very good-natured Norse prince. Each episode began with, 'Listen to me and I will tell you the story of Noggin the Nog as it was told in the days of old.'
Now available on DVD!

SEE Postgate, Oliver/ Television

NOISE

We think that the noise of the seafront with amplified music coming from every bar and amusement arcade is a modern invention. In the 1900s however, there were street singers, musicians, German bands, organ grinders, fiddlers (or scrapers), a town crier or bellman, hawkers with their baskets, licensed porters, cornet players (or blowers) and harpists all along Marine Terrace, Parade and the entrance to the pier and jetty. The noise and nuisance level got so loud that the Margate Corporation issued the following bye-law, 'In case any street musicians shall not depart from the neighbourhood on being requested to do so by an occupier, he shall be fined the sum of £1.'

SEE Margate/ Marine Terrace/ Music/ Pier

NORFOLK HOTEL
Eastern Esplanade, Cliftonville

It shared a similar history to its neighbour the Grand Hotel.
In March 1945, the Norfolk Hotel was one of over thirty hotels in Cliftonville used to billet over eight thousand soldiers from the ANZACS (the second New Zealand Expeditionary Forces) who had previously been captured by the Nazis in Italy and the Middle East and then forced to march across Europe to prisoner-of-war camps. The sea air was deemed to be an important part of their treatment to help them recover from the malnutrition and the general effects of the appalling time they had suffered. It seemed to work because on VJ night. Wednesday 15th August 1945, they stoked the celebratory bonfire near the Grand Hotel.

In May 2004, it was announced that the Grand Hotel was to be replaced by a McCarthy & Stone retirement home containing 73 flats. The Norfolk Hotel was also to be replaced by a block of 73 flats called Darwin Court.

SEE Cliftonville/ Eastern Esplanade, Cliftonville/ Grand Hotel/ Hotels/ New Zealand

NORFOLK ROAD, Cliftonville

On 1st March 1916 a German FF29 dropped 3 high-explosive bombs on Norfolk Road killing a 9-month old boy.
On the night of 5th December 1917, thirty bombs were dropped by the Germans on Margate and Norfolk Road suffered damage. Following a fire, the old Newbury Hotel remained a burnt-out shell until it was compulsory purchased in 2004.

SEE Clarendon Road/ Cliftonville/ Fires/ Margate/ 'Margate, 1940'/ world War I

NORTH FORELAND

This is the most south-eastern part of England.
A couple of hundred years ago, passengers on the steamers from London were not keen on travelling beyond Margate because they were afraid that the ships would perish on the hazardous North Foreland shoreline.

SEE Batteries/ Brunswick, Duke & Duchess/ 'Dracula'/ Dutch Tea House/ Hillary, Richard/ Lighthouse, North Foreland/ McAlpine, Sir Thomas Malcolm/ Moonraker/ Orchardson, Sir WQ/ Pair of Blue Eyes/ Skies

NORTH FORELAND GOLF CLUB

It was opened by Alfred Harmsworth in 1903, and cost him £50,000.
Pigot's 1936: North Foreland Golf Club Ltd established in 1915 has two 18 hole courses (one 6,136 yards and the other 1,752 yards), 1½ miles from Broadstairs and Margate; there are 250 members; subscription 10 and 5 guineas; there are also four en tout cas hard tennis courts.

SEE Harmsworth, Alfred/ Fishwick, Diane/ Northern Belle/ Punch magazine/ Thatched House

NORTH FORELAND RADIO STATION

This was based in a private house at Foreness Point by Guglielmo Marconi who set up a wireless telegraphy station there in 1899. The GPO took it over in 1903 and moved it to a wooden hut next to the lighthouse. In 1923 it was moved across town to Rumfields. Whilst it was here though, it played a part in the arrest of the murderer, Dr Crippen.

SEE Crippen, Dr

NORTH POLE public house
Hereson Road,
Ramsgate

Originally it was two houses in a terrace called North Pole Cottages. It became Feeney's, an 'Irish' type pub, after a refit in the 1990s.

SEE Hereson Road/ Pubs/ Ramsgate

Lord NORTHCLIFFE

The title that Alfred Harmsworth took.
SEE Harmsworth, Alfred

NORTHDOWN

Pigot's 1936: Lies east of Margate. The Whitfield Tower at Northdown marks the highest altitude in Thanet. In the park on the left is Northdown, the mansion of Capt. James Irvine Hatfield Friend O.B.E., M.C., J.P. opposite the entrance gates of which on the main road is a church erected by James Taddy Friend esq. D.L., J.P. and dedicated to St Mary. The church is served by the clergy of the parish church of St John the Baptist, Margate, to which it is attached.

SEE Churches/ St Mary's Church, Northdown/ Thanet

The NORTHDOWN public house
33 Summerfield Road, Cliftonville

It was built in 1969 to satisfy the thirst of those living on the new Palm Bay estate.
SEE Cliftonville/ Palm Bay/ Pubs

NORTHDOWN ALE

Strictly speaking, beer is made from hops and ale is not but the two names can sometimes be interchangeable. It is therefore not certain whether the Margate and Northdown ales that Samuel Pepys referred to were actually ales, especially considering both were made in the hop growing county of the country. The water used came from a then famous well at Grapevine Cottage, in what was then West Northdown. For a time, sales of Northdown Ales brought a fair amount of prosperity to the area but, eventually, ales and beers from northern brewers became more popular.

SEE Breweries/ Cliftonville/ Hops/ Margate Ales/ Pepys, Samuel

NORTHDOWN HILL, St Peters

Thanet's trams had a main depot at the bottom of Northdown Hill. The era of the tram ran from 3rd April 1901 until 24th March 1937.

SEE Crown & Thistle pub/ Trams

NORTHDOWN HOUSE

It still stands in Northdown Park and was built from 1770-90.
SEE Cliftonville/ Northdown Park

NORTHDOWN PARK
Cliftonville

This was originally land owned by the Friend family until it was taken over by the local Corporation (Council) in 1937. The ringed-neck parakeets that are so common across Thanet are said to originate from a pair that bred in Northdown Park.

Hops were grown in an area to the south of the park.

SEE Birds/ Cliftonville/ Northdown House/ Parakeets/ Parks

NORTHDOWN ROAD, Cliftonville

The north side of the section of Northdown Road between Edgar Road and Sweyn Road contains what were the first buildings ever built in Northdown Road. The ten gabled roof tops (originally there were twelve), were the original impressive terrace of houses, called Magala Villas, that overlooked open farmland and woodland (now the site of Dane Park) with just three windmills to spoil their views. To the rear, the view was over cornfields to the sea. Each of the gables was topped with decorative stone pineapples. Many have been lost over the years, presumably falling to the ground as chunks (ouch!). By 1936, these houses had long since become shops.

Much of the housing in Northdown Road was originally built as large Victorian residences for the wealthy and professional classes. Gradually, they were converted into shops with a flat above; the gardens removed; and the road was widened. The original owners moved out to the larger and newer houses being constructed in what had previously been the surrounding fields.

What is now Northdown Road, was originally Northumberland Road which, in turn, led into Alexandra Road (named after Princess Alexandra).

In the late nineteenth century there were eleven schools in Northdown Road; Branscombe House with a couple of dozen pupils, Burleigh House for girls, Cambridge House, Clare House Boarding School for Young Gentlemen, Ditton House Boys Boarding House, Goodwood House for Girls, Llanberris Boys Boarding School, Lynton House for Girls, Northfield Girls School, Seymour House for Boys and Osbourne House School for the Daughters of Gentlemen at 6 Harold Terrace (between Harold Road and Norfolk Road).

SEE Arundel Road/ Astoria Cinema/ Belle Vue Tavern/ Boarding houses/ Bobby's Dept Store/ Dearden's Picture Gallery/ Cameo Cinema/ Cliftonville/ East Cliff Hotel/ Farms/ Gouger's Windmills/ Lovelys/ Margate Caves/ MFI/ Munro Cobb/ Northumberland Road/ Padgets/ Royal Yacht/ Schools/ Trams/ W H Smith/ West Ham Convalescent Home/ Ye Ole Charles

NORTHDOWN ROAD, St Peters

The metal footbridge over the railway line at Northdown Road, St Peters, cost £5,500 and was opened on 1st March 1965.

SEE Mockett's Wood/ Railway

NORTHERN BELLE

The Northern Belle was an American 1,100 ton cargo ship. On 5th January 1857 at 3 o'clock in the morning having set sail from London for New York, it foundered on the rocks at Foreness Point. The coastguards sent for the Mary White and Culmer White lifeboats from Broadstairs. They were each taken to Kingsgate overland on trailers drawn by three horses - it must have been a Herculean effort; the weather was bitterly cold, it was the middle of the night and the roads were not as easily managed as they are these days.

Once there, they then had to launch the boats and row them out across the stormy seas to the stricken ship. The rescued were then taken to the Captain Digby where they were wrapped in blankets, given hot rum and dried out in front of open fires. The second mate of the Northern Belle had English ancestors and apparently boomed out that *'none but Englishmen would have come to our rescue on such a night as this.'*

He wasn't the only one to show his thanks. The 14th US President, Franklin Pierce (1804 – 1869, president 1853-57), ordered 25 silver medals to be struck and awarded to the members of the lifeboat crews. They also received salvage money. Jethrow Miller was awarded a gold medal but he gave it to George Emptage because he thought he deserved it more, George having made three trips out to the Northern Belle that night.

Chambers' Book of Days 1869: *There was the Whitby case of January the 4th, 1857, when one of the boatmen was clearly washed out of the life-boat, over the heads of all his companions, by a raging sea; and yet all were saved, ship's crew and boatmen alike. But most of all do the life-boatmen pleasurably reflect on the story of the Northern Belle, and what they achieved for the crew of that ship. It was a fine vessel, an American trader of 1100 tons. On the 5th of January 1857, she was off the North Foreland struck by a terrible sea, and placed in imminent peril. The Broadstairs boatmen harnessed themselves to their life-boat carriage, and dragged it with the boat a distance of no less than two miles, from Broadstairs to Kingsgate, over a heavy and hilly country. In the dead of a winter's night, amid hail, sleet, and rain, the men could not see where to launch their boat. They waited through the darkness.*

At day-break on the next morning, a distressing sight presented itself: twenty-three poor fellows were clinging to the rigging of the only remaining mast of the Northern Belle, to which they had held on during this appalling night. Off went the life-boat, the Mary White, manned by seven daring boatmen, who braved the raging sea which washed over them repeatedly. They went to the wreck, brought off seven men, and were obliged to leave the rest for fear of involving all in destruction. Meanwhile another life-boat, the Calmer White, was wheeled overland from Broadstairs, then launched, and succeeded in bringing away four-teen of the sufferers. There remained only two others, the captain and the pilot, who refused to leave the wreck so long as a spar was standing. The Calmer White dashed out a second time, rescued these two mariners, and left the hapless ship to its watery grave. How the poor American sailors were warmed and cared for at the little hostelry, the 'Captain Digby,' at Kingsgate; how the life-boats returned in triumphant pro-cession to Broadstairs; and how the quiet heroism of the life-boatmen *was the admiration of all—the newspapers of the period fully told.*

Notice in Illustrated Times, 7th March 1857:

THE BROADSTAIRS BOATMEN

Mr Croskey, the United States Consul at Southampton, has received from the Lifesaving Benevolent Association, New York, a letter enclosing £45 to be distributed among the families of the nine men who perished in the lugger Victory, while endeavouring to rescue the crew of the American ship Northern Belle, wrecked near Ramsgate in the early part of January. The medal of the Association will be sent to each of the men who eventually succeeded in saving the Americans, as soon as a correct list of names shall have been received at New York.

SEE Broadstairs/ Coastguards/ Kingsgate/ Mary White/ Ramsgate/ Walker, Jeremiah

NORTHERN BELLE public house
Mansion Street,
Margate

Converted from two cottages built in 1680 right at the waters edge, The Northern Belle at 4 Mansion Street in Margate dates back to 1689 and at one time could boast that it was the oldest standing pub in the town. Originally called the Waterman's Arms, it had its name changed to the Aurora Borealis, difficult to say at the best of times but even worse when you have had a few. There is a possibly apocryphal, story of a drunk who was in court and told the judge that he had been drinking in the 'Roarer boarer relish' at which the whole court fell about laughing. The landlord decided to change the name to something drunks could pronounce. Another, more likely, reason is that when the Aurora Borealis had closed temporarily in 1857, an American merchant ship called The Northern Belle went aground off North Foreland. Lifeboats went to its rescue and survivors were given aid and comfort at The Captain Digby. They were then put up at the Aurora before going on to London, prompting the landlord to change the name. Incidentally, the wrecked Northern Belle supplied timber in a few local pubs. In this one, the ceiling in the saloon bar is made from its timber, and the counter in the public bar was previously the davit. (A davit, for any landlubbers reading this, is similar to a crane and is used, for example, to raise and lower lifeboats over the side of the ship.)

A ghost of a woman shrouded in white has often been seen in the bar and particularly in the cellars and the smugglers' tunnels that run from under the building to all over the town including Hawley Square where Emma Hamilton once resided. Nelson spoke with smugglers here to ascertain where the French fleet was. The pub closed in the late 1990s but has recently been re-fitted.

SEE Hawley Square/ Hamilton, Lady/ Margate/ Northern Belle/ Old Margate/ Pubs/ Tunnels

NORTHUMBERLAND ROAD
Cliftonville
Many many years ago, Northdown Road was called Northumberland Road. Francis Forster moved to the area from Northumberland at the end of the eighteenth century and built a large brick house which he named Northumberland House after his home county. This name was adopted by the Northumberland Hotel in Northumberland Avenue when it was built in the 1930s. Originally it was destined to be a super de-luxe Jewish hotel, but in the end, the hotel rooms became flats and the restaurant and bar, complete with grand piano, were transformed into a club. In the late 1960s, Trumans took over and it became a pub, The Northumberland Arms. It is now residential properties.

Dane Hill House, a boarding school for boys from the 1840s until the end of the century, was situated in Northumberland Avenue.
SEE Cliftonville/ Margate Caves/ Northdown Road/ Restaurants/ Schools

NORTHWOOD
A windmill once stood near the current site of the bus garage but was demolished in 1961.
SEE Dane Court/ Dane Court School/ Garages/ Hare and Hounds/ Jackey Bakers/ Methodist Church/ Ramsgate Airport/ Rumfields Road/ St Mark's Church/ Vegetarian Society

Graham NORTON
Born 4th April 1963
Actor, presenter, comedian and chat show host. *'Basically, I'm a really bad interviewer. I love meeting celebrities, but then I get a bit bored. Once you meet them you thing, 'really, what an ordinary person'.*
SEE Entertainers/ Winter Gardens

Peter NORTON
Born 1962
Peter Norton was brought up in Margate.
Whilst serving as an Ammunition Technical Officer with the British Army's Royal Logistic Corps in Iraq, he was awarded the George Cross. On 24th June 2005, a United States Army patrol was damaged by an IED (improvised explosive device) and Norton went to check for any further devices. A second device exploded causing him to lose a leg and part of his left arm, and he sustained serious injuries to his lower back and other leg. Suspecting that there were further devices, and in spite of his injuries, he continued to instruct his team and ensure that everyone in the vicinity were aware of the possible danger before he was rmoved from the scene. A further device was found the following day.
SEE George Medal/ Margate

NUCKELL'S ALMSHOUSES
High Street, St Peters
The building started life in 1805 as a Workhouse, replacing an earlier building built in 1753. The new building, able to house 45 people, was paid for by Thomas Brown. Around 1835/6 Mrs Ann Nuckell provided the vicar, the Rev John Hodgson,

with £700 to convert it into Almshouses for ten widows. Nowadays, it comprises six flats, but still retains the very attractive statue above the door.
SEE High Street, St Peter's/ Workhouse

OAK and SHADE public house
SEE Pubs/ Royal Oak Hotel

OAKLANDS COURT, St Peter's
On the corner of Oaklands Avenue in St Peter's is Oaklands Court (or at least it was before a bungalow was built in its garden in 2003/4). When it was originally built, it had an imposing driveway on the left. It was the home of Henry Sheridan before becoming a Boys Preparatory School. It is now flats. To the right of the grounds is one of the entrance archways to the old Ranelagh Gardens.
SEE Ranelagh Gardens/ St Peter's/ Schools

OBELISK, Ramsgate

When King George III died at Windsor in 1820, the wife of the new King George IV, Princess Caroline Brunswick, returned to England via Dover, where the locals gave her a fantastic welcome, *'Multitudes met her on the beach at Dover with loud acclamations, banners and every sign of popular enthusiasm'* which did not go down well with the new King who had refused to allow his estranged wife to become his queen. The following year, he had her locked out of his coronation. He decided that in future, whenever he visited Hanover, where he was also king, he would leave and return via Ramsgate, even though it was quicker via Dover. It also gave him the opportunity of calling in on his old friends Sir William and Lady Curtis who lived in Cliff Street.
The Deputy Mayor, Richard Tomson, together with Sir Thomas Grey, Baron Garrow, Sir William Curtis, and Sir James Lake were all part of the group that met to decide on how the King should be received. Their decision was that the town should be cleaned up – it is amazing how some things

never change – and should be illuminated. Sir William Curtis also wrote and invited the King to stay at his place
The King was due to arrive on 24th September 1821 and that morning many of the locals were up and busy preparing at 7 o'clock. Arches were erected and decorated for him to pass through as far as St Laurence, down the High Street and along Queen Street, and almost every house had boughs of laurel hanging from their windows and many had flags waving.
King George travelled from Carlton Palace through Gravesend and Sittingbourne before stopping for a civic reception at Canterbury. He arrived in Ramsgate around dusk when he was escorted in to the town by the Thanet Cavalry. Unfortunately, the High Street had been covered with sand and gravel that meant it was not entirely conducive to horse-riding, resulting in some soldiers becoming unseated. The King duly stayed overnight with Sir William and probably enjoyed the banquet that was laid on for him. The leading cartoonist of the time, George Cruickshank, soon came up with a drawing showing the King and Lady Curtis together with Sir William keeping a watchful eye over them.
In the morning King George left Cliff House in his open carriage and was met at the harbour entrance by the Civic Deputation, together with thousands of locals and visitors who had arrived for the event. He entered Pier House, now gone, and from the balcony addressed the crowd:
'I receive with great satisfaction the loyal and dutiful Address of the inhabitants and visitors of Ramsgate, as well as the general testimony of attachment and affection from all classes of my subjects. I am leaving my dominions for a short period only, and thank you for your cordial wishes for my return. This is not the first time I have been in this attractive place and, I trust, it will not be the last.'
In the outer harbour was the Royal Sovereign yacht. Outside that was the King's Fleet, including the Active and Liffey frigates; Lee, Hind, and Chameleon, all sloops of war; two cutters and, just in case the wind refused to obey royal commands, Hero, a steam yacht, as a fall back. King George was rowed out to his yacht at around 10.45am and the whole fleet was then followed out of the harbour area by many local boats, for their next stop, Hanover.
The King was due to sail up the Thames upon his return on 8th November, with Sir William following in his own yacht, Emma. At the last minute, the King took a sudden detour towards Ramsgate, so Sir William quickly headed for Margate, landing ahead of the King, hopped in a horse and carriage and managed to arrive at Ramsgate Harbour in time to meet the royal yacht. Now, whether the King was entirely happy at this meeting, I will leave you to conjecture, but it looks to me as if that night at Cliff House, the role of Sir William could have been played by a gooseberry.
Six weeks later and another old friend of the King, Lord Sidmouth (Henry Addington) received a letter from him telling him how

pleased he was at his reception at Ramsgate and had decided to designate Ramsgate a Royal Harbour. Immediately, a committee was formed (that's what you do isn't it? That, or make a cup of tea) to decide what sort of memorial the King's visit warranted. Well let's see what we can come up with: better facilities for the harbour, another lifeboat, generally something useful. The committee came up with an obelisk - and not even an original obelisk. The architect, John Shaw, copied the largest obelisk at the entrance to ancient Thebes. Subscriptions were sought to pay for it. Mr Shaw received £70, the master mason got £40, the chief carpenter pocketed £20 and the actual construction costs swallowed up most of the remaining £600.

Lord Liverpool, the Lord Warden of the Cinque Ports, laid the foundation stone, weighing 11 tons, on 8th November 1822, exactly one year on from the King's return. He also placed some coins of the realm in a hole in the middle; so, if ever it blows over in a storm, you'd better get down there sharpish. The local bigwigs had a slap up do at the Albion Hotel hosted by the Earl of Liverpool that night, but Sir William Curtis did not forget the men who had done the work and sent them several gallons of ale and two whole sheep. The former was probably more welcome than the latter. You can see why convenience food became popular.

The whole memorial, made of Dublin granite and weighing 100 tons, is 52ft high and was unveiled by Lord Liverpool, again, on 19th July 1823. The locals at the time referred to it as the royal toothpick.

At one time, four small bronze cannon said to be from the Royal George, all dated 1732, and signed by the well-known cannon founder Schalch (1692-1776) were situated at the base of the obelisk. Yes, they were bought second-hand, cheap eh? They were later moved to the West Cliff.

There was a proposal to move the obelisk to the end of the East Pier in May 1955, but it was turned down as it was too expensive. Now, this magnificent memorial to an historic grand royal visit that elevated the harbour to royal status and made the whole town proud is just a few short steps from a public toilet. Any nearer and the urinals could have been bolted onto the base.
SEE Addington, Lord/ Caroline, Princess/ Cinque Ports/ Cliff Street/ Curtis, Sir William/ George III/ Harbour, Ramsgate/ High Street, Ramsgate/ Liverpool, Lord/ Queen Street, Ramsgate/ Ramsgate/ Sidmouth, Lord

OCEAN CLOSE, Birchington
This was once the site of a brick field.
SEE Birchington

'ODE TO BROADSTAIRS'
by Walter B Marling
A jumble every street –
What matters!
We hold her even sweet
In tatters

Sun, sea and air, she, best

Physician,
Prescribes and cures – confessed
Magician!

Broadstairs joy-filled, bless her,
Gay of mien;
Nothing can depress her,
Saucy Quean!
SEE Broadstairs/ Poets

PC Jon ODELL
The memorial at the eastern end of Shottendane Road is for PC Jon Odell who died when he was hit by a car whilst carrying out routine speed checks. Originally charged with murder, the driver was convicted of manslaughter and his sentence was reduced on appeal.
SEE Shottendane Road

ODEON CINEMA
King Street, Ramsgate
In May 1954 it was discovered that Benjamin Trowse, the doorman at the Odeon Cinema, held both the Distinguised Service Medal and the Imperial Service Order. The Odeon, or Classic as it became, was sold in August 1987 to be demolished and replaced with a frozen food store.
SEE Cinemas/ Classic Cinema/ King Street, Ramsgate/ Ramsgate/ Regal Cinema

'OH, MARGATE'
The title of a single by Judge Dread and Buster Bloodvessel that was released in 1997.
SEE Bloodvessel, Buster/ Margate/ Music

OLBY
Ramsgate, by J S Rochard, c1900:
MR ALFRED OLBY, Wholesale and Retail Merchant in Lead, Zinc, Iron, Window Glass, Oils, Colours, and Varnishes, etc.
27 King Street;
Paperhanging Warehouse, Hardres Street.
This business was established 20 years ago by the present proprieter, who has made a widespread connection among builders, sanitary and other engineers, glaziers, gas and water fitters, etc. and the general public. The premises comprise a large double fronted shop, with well equipped stores and workshops to the rear, and there is also a spacious warehouse in Hardres Street for the immense stock of paper hangings. The window display in artistic brass goods, gas brackets, lamps etc. is of a superior character, and in the interior the showrooms are fully stocked with all description of plain, ornamental, and tinted glass for general and decorative purposes, besides gas fittings, pendants, chandeliers, and all the necessary tools and materials for gasfitters, plumbers and other purposes. Lead and composition tubes, perforated zinc, block tin and solder, oils, colours, stains, varnishes, japan, etc for painters, decorators, and coach makers; bell fittings, hot and cold water fittings, engineer's steam fittings, etc are also fully represented, as well as pipes and gutters, bath and lavatory fittings, and plumbers goods.

A special feature is made of wall papers, of which a large selection is held in all the latest artistic and sanitary productions of English and French design, the firm always stocking the most recent novelties immediately as they appear. In sanitary appliances, which form a distinct speciality of the business, improved water closets, urinals, bath and lavatory fittings, cisterns, taps, cocks, water waste preventers, etc, there is a large selection, as well as in pumps and similar appliances. The complete glazing of shop fronts and houses is carried out in the best modern style, and polished plate or silvered glass are supplied at wholesale London cash prices. Lead-lights are also made to order in any style. Mr Olby has a very large wholesale and retail trade which is steadily increasing.
The premises occupied by Olby in King street, Ramsgate have been replaced by newer shops.
SEE King Street, Ramsgate/ Ramsgate/ Shops

OLD BAY COTTAGE
Minnis Road, Birchington
Travel back to 1310 and this whole area was farmland owned by Sir William Leybourne of Leybourne Castle near Maidstone. Part fifteenth-century and part-eighteenth century, Old Bay Cottage was the farmhouse of Gore End Farm. It is Grade II listed and has a Sun Alliance Insurance Fire Mark on the outside. It was also - there is a clue in the name - the edge of the old port of Gore End.
SEE Birchington/ Farms/ Leybourn/ Listed buildings/ Minnis Road

OLD BOUNDARY ROAD, Westgate
It was named thus because it marked Westgate's old eastern boundary (It's a good job I'm here to explain everything isn't it?).
SEE Westgate-on-Sea

OLD CROSSING ROAD, Garlinge
The road runs north off Canterbury Road and is named after an old level crossing over the railway line. The crossing closed in 1923. Margate Football Club played their home matches at a ground in Old Crossing Road in the early 1900s.
SEE Garlinge/ Margate Football Club/ Railways

OLD CROWN public house
High Street, Broadstairs
This dates back to the 1830s and Charles Dickens is said to have supped here whilst lodging just up the road.
SEE Broadstairs/ Dickens, Charles/ High Street, Broadstairs/ Pubs

OLD CURIOSITY SHOP, Broadstairs
In the seventeenth century there were two cottages built either side of a well which, in time, became one building. At the end of the nineteenth century the Curio Shop occupied the building, and is now The Old Curiosity Shop and a wishing well.
'The Old Curiosity Shop' by Charles Dickens was not named after this shop.
When renovations were being carried out here a few decades ago, four rotting kegs were found in the chalk around the well,

hidden from the Revenue men and forgotten about.

SEE Broadstairs/ Harbour Street, Broadstairs/ Shops/ Smuggling

'The OLD CURIOSITY SHOP'
by Charles Dickens

'You see, Mr Witherden,' said the old lady, 'that Abel has not been brought up like the run of young men. He has always had a pleasure in our society, and always been with us. Abel has never been absent from us, for a day; has he, my dear?'

'Never, my dear,' returned the old gentleman, 'except when he went to Margate one Saturday with Mr Tomkinley that had been a teacher at that school he went to, and came back upon the Monday; but he was very ill after that, you remember, my dear; it was quite a dissipation.'

'He was not used to it, you know,' said the old lady, 'and he couldn't bear it, that's the truth. Besides he had no comfort in being there without us, and had nobody to talk to or enjoy himself with.'

Much of 'The Old Curiosity Shop' (1840) was written at Albion Street in Broadstairs. Before starting though, Dickens wrote that the *'writing table is set forth with a neatness peculiar to your estimable friend'* and there is *'a good array of bottles on display in the dining parlour closet'*.

One night whilst taking a cliff top walk Dickens saw stars reflected in the sea. This inspired Little Nell's similar vision *'found new stars burst upon her view, and more beyond, and more beyond again, until the whole great expanse sparkled with shining spheres . . .'*

SEE Albion Street/ Archway House/ Books/ Broadstairs/ Dickens, Charles/ Lawn House/ Margate

OLD CUSTOMS HOUSE, Ramsgate
The old one was in the pier yard and the new one – the brick building with a dome on the roof – was built in 1898.

SEE Harbour, Ramsgate/ Ramsgate

OLD MARGATE
When this area behind the harbour comprising Broad Street, Duke Street, Fort Road, Love Lane, Lombard Street, Mansion Street, Market Place, Market Street, White Hart Mansions etc was the busiest area of town in the eighteenth and nineteenth centuries, there were up to forty pubs in business, opening as early as five o'clock in the morning - not long after some of them had shut. Now, there are just four pubs.

SEE Broad Street/ Doggett, Coat & Badge/ Duke Street/ Fort Road/ Love Lane/ Margate/ Market Place/ New Inn/ Northern Belle pub/ Pubs/ Town Hall building/ Wellington Hotel

OLD OAK COTTAGE, Minster
This ten-roomed cottage dates from 1300AD as was once used as guest accommodation for Minster Abbey being linked to it via an underground passage.

There is a story that an Augustan monk, by the name of Aloysius who, possibly fueled by jealousy, accused a fellow monk,

Ambrosia, of having illicit trysts with a nun, Francesca, at Old Oak Cottage. They were punished by being walled in alive. Years later, on his death bed, Aloysius admitted that he had lied and his ghost is said to haunt the cottage. Sir Arthur Conan Doyle, during the period when he was doing extensive psychic research, is said to have come to the cottage to investigate.

SEE Doyle, Sir Arthur Conan/ Ghosts/ Minster/ Minster Abbey

OLD WHITE HART HOTEL, Margate
Overlooking the harbour and on the site of the Lord Nelson at 2 Marine Parade, was the Old White Hart Hotel which opened in January 1748 (although some sources state 1717). It was a top class hotel for almost 200 years until World War II after which it became derelict and was demolished in 1967. Its best known landlord was Mrs W A Fagg who took over in 1846; only her death in 1906, at the age of 84, stopped her completing a sixty-year reign. She welcomed Earl Beaconsfield, Benjamin Disraeli and William Gladstone as guests, but famously turned away Marc Brunel (the father of Isambard Kingdom) when he sailed into town aboard one of his steam packets. She was siding with the local sailing boat owners who saw new and unwelcome competition.

After demolition in 1967, the site, for the next 20 years or more, held six single-storey shops on short leases while the future of the site was decided. The White Hart Mansions now occupy the site.

SEE Disraeli/ Gladstone/ Hotels/ Margate/ Marine Parade

'OLIVER TWIST'
by Charles Dickens
Part of this novel was written when Dickens was staying in lodgings at 12 High Street in Broadstairs.

SEE Books/ Broadstairs/ Dickens, Charles/ High Street, Broadstairs/ Pickwick Papers

ONE WAY SYSTEM, Ramsgate
A new one-way traffic system involving the High Street, Hardres Street, Broad Street, Brunswick Street, and Susssex Street started trials on 1st February 1964.

An experimental pedestrianisation scheme started in June 1981 in part of the High Street and Turner Street resulted in Cavendish Street, York Street and Broad Street becoming one-way; while leaving vehicles with limited access to Queen Street, King Street and Harbour Street.

SEE Cavendish Street/ Harbour Street, Ramsgate/ High Street, Ramsgate/ King Street, Ramsgate/ Queen Street, Ramsgate/ Ramsgate/ Turner Street

'ONLY FOOLS AND HORSES'
The BBC comedy series (with David Jason as Del Boy, and Nicholas Lyndhurst as Rodney) broadcast their 'Jolly Boys Outing' to Margate on Christmas Day 1989 at 4.05pm – attracting 20.1 million viewers. Dreamland and the stone jetty were both featured.

SEE Dreamland/ Jetty/ Margate/ Television

OPPORTUNITY KNOCKS
Opportunity Knocks was a talent show – a sort of forerunner of X-Factor - that started out on the BBC Light Programme in 1949 before transferring to Radio Luxembourg in the 1950s. With the advent of television it was on ITV in 1956 and again from 1961 until 1978 with Hughie Green as the host.

Amongst the acts for whom opportunity knocked were Pam Ayres, Max Boyce, Frank Carson, Bobby Crush, Freddie Davies. Les Dawson, Mary Hopkin, Bonnie Langford, Little and Large, Peters and Lee, Su Pollard, Freddie Starr and Lena Zavaroni.

It was later revived by the BBC from 1987-9 with Bob Monkhouse as the presenter and again in 1990, this time with Les Dawson as the frontman.

SEE Radio/ Television/ Winter Gardens/ Zavaroni, Lena

The ORB public house
Ramsgate Road, Margate
It was the Thanet CAMRA Pub of the Year in 2000.

SEE Crown and Sceptre/ Margate/ Pubs/ Ramsgate Road, Margate

Sir William Quiller ORCHARDSON
Born Edinburgh, 27th March 1835
Died London, 13th April 1910
A painter, he worked in Scotland until 1862, when he moved to London. He married Miss Helen (or Ellen) Moxon in 1873 and was elected to the Royal Academy (full membership) in 1877. That same year, the house he was having built, with a studio and a tennis court in the garden, was finished in what was described then as Westgate-on-Sea but is now Birchington.

His painting 'On the North Foreland' (1890), an oil on canvas (930x780 mm) shows a young lady standing on a windy cliff top, desperately trying to hold her hat on.

He was knighted in June 1907.

'Twenty Years of My Life' by Louise Jopling (1843-1933): *'Sir Quiller Orchardson, the RA, had a most picturesque personality. I don't know what part of Scotland he came from, but, I remember, the first time I heard him speak I thought he was a foreigner.'*

His son, Charles Orchardson, who was also a well-known painter – portraits and landscapes – died in 1917 from wounds he received in World War I.

SEE Artists/ Birchington/ North Foreland/ World War I

Baroness ORCZY
Born 23rd September 1865
Died 12th November 1947
Born in Hungary, educated in Brussels and Paris, Baroness Orczy moved to London aged 15 where she studied painting and started to learn to speak English. With her husband she wrote and illustrated childen's stories before her first novel, 'The Emperor's Candlesticks', was published in 1899. In 1902 she wrote what became her biggest success 'The Scarlet Pimpernel' but not before twelve publishers had rejected it. Set in the French Revolution, the stories involve

the elusive Sir Percy Blakeney, otherwise known as the Scarlet Pimpernel, saving aristocrats from the guillotine.

'We seek him here, we seek him there. Those Frenchies seek him everywhere. Is he in heaven? Is he in hell? That damned elusive Pimpernel?' The Scarlet Pimpernel

A stage version of it was put on in 1903 in Nottingham before it moved to London the following year, becoming a huge success. The book was published the same year.

Other titles followed, 'I Will Repay' (1906), and 'The Elusive Pimpernel' (1908). Although nowhere near as popular as The Scarlet Pimpernel, she also wrote detective novels, 'The Case of Miss Eliot' (1905) and 'Lady Molly of Scotland Yard' (1910).

Between 1908 and 1911 Baroness Orczy, or Mrs Montague Barstow to give her married name, rented Cleve Court, *'a nice old dower house near Minster in Thanet'*, where she seemed to cut rather a dash with the locals! She employed a local man as her coachman and he drove her coach and the five excitable horses that she had brought over from her homeland of Transylvania, through the lanes of Thanet at high speed. They shied at motor cars and forced a local schoolmaster off his bicycle – he may possibly have used language that a schoolmaster should never be heard to use.

She wrote a romantic novel in 1913 set in the Civil War, *'The Nest of the Sparrowhawk'*, and in the dedication she wrote, *'In remembrance of the happy days I spent in Thanet...'* although the Thanet landscape she describes – there are a lot of trees in the book – should, perhaps, be put down to artistic licence.

'The young heroine begins to see Acol Court (Cleve Court) through different eyes in the company of her mysterious foreign lover.

She had hated the grim, bare house at first, so isolated in the midst of the forests of Thanet, so like the eyrie of a bird of prey.

But now she loved the whole place; the bit of ill-kept tangled garden, with its untidy lawn and weed-covered beds, in which a few standard rose-trees strove to find a permanent home; she loved the dark and mysterious park, the rusty gate, that wood with its rich carpet which varied as each season came round.

. . . they walked cautiously through the park, for the moon was brilliant and outlined every object with startling vividness. The trees here were sparser. Close by was the sunk fence and the tiny rustic bridge –only a plank or two- which spanned it.'

'Links in the Chain of Life', Orczy's autobiography, was published in 1947, the year of her death – such good timing.
SEE Authors/ Bicycle/ Cleve Court/ Minster/ Nest of the Sparrowhawk

William Newenham Montague ORPEN
Born 27th November 1878
Died 29th September 1931
He is arguably Ireland's greatest painter – his 'Man from Arran', a 1916 self-portrait, sold for £573,000 in Belfast in 1999. He went to the Metropolitan School of Art, Dublin

(1891–1897) and then the Slade School of Art, London (1897–1899), where his 'The Play Scene' from Hamlet won the composition prize in 1899. He was an ardent student of the Old Masters and visited Paris in 1899 with his friend Augustus John. Orpen became one of Britain's most financially successful and critically acclaimed, portrait painters of the twentieth century, particularly for his portraits of Lloyd George, Ray Lancaster and the wonderfully titled self portrait *'Orpsie Boy, You're Not as Young as You Were, My Lad, Paris 1924'* (1924). He had been appointed the Official War Artist in 1917 and an exhibition of this work was held in London in the spring of 1918. In 1919 he was appointed the official artist to the British Peace Delegation. He left all his war paintings to the nation and they are now with the Imperial War Museum. His wife was the subject of many of his works, including, 'Lady Orpen' (97x86cm) which he painted in 1907, early in their marriage on holiday in Margate with William and Mabel Nicholson and their children. She is wearing a bonnet, scarf, gloves and ostrich feathers – the Orpens and the Nicholsons were all keen on dressing up – and it was a private painting done primarily for their own enjoyment and probably amusement.
SEE Artists/ Margate

ORPHANAGES
Between 1870 and 1920 there were 48 orphanages and convalescent homes in Thanet.
SEE Beach Entertainment, Margate/ Convalescent homes/ St Peter's Orphanage/ Shaftesbury House/ Spurgeon's Homes/ Stone House

OSBORNE ROAD, Broadstairs
Pigot's 1936: *Christ Church (Free Church of England) which was erected as a memorial to Bishop Dicksee D.D. is in Osborne Road.*
SEE Broadstairs/ Broadway/ Churches

'OUR ENGLISH WATERING PLACE'
by Charles Dickens
Originally published as 'Our Watering Place' on 2nd August 1852 in Household Words, a weekly magazine edited by Dickens, it appeared again in 'Reprinted Pieces'. Without being mentioned by name, it was a description of Broadstairs.
'Half awake and half asleep, this idle morning, in our sunny windows on the edge of a chalk cliff in the old fashioned watering place to which we are a faithful resorter, we feel a lazy inclination to sketch its picture.'
. . . 'The place seems to respond. Sky, sea, beach and village, lie as still before us as if they were sitting for the picture. It is dead low water. A ripple plays among the ripening corn upon the cliff, as if it were faintly trying from recollection to imitate the sea. . . .'
SEE Books/ Broadstairs/ Dickens, Charles/ Holy Trinity Church

The OVAL, Cliftonville
It was originally a green surrounded by a rustic fence and a gravel path known as Ragged Road and in the mid-nineteenth

century, boys from local schools used it as a cricket ground.

In 1904 the soil was dug out to form a huge amphitheatre with a very smart bandstand in the centre surrounded by 2,000 seats on terraces.

On 13th September 1915 a German seaplane dropped a bomb here.

The Red Viennese Band regularly played on the green at the Oval which was very popular between the wars. Many people started their careers in showbiz here, the most famous being Arthur Askey who performed here in the mid-1920s as principal comedian. Norman Wisdom has also appeared here.

After the war The Oval did not retain its popularity much beyond the mid-1950s when wrestling and amateur talent nights became the staple fare.

In later years there were many threats of closure and eventually the Cliftonville Residents Association took over the Oval.

In 2005 it was decided that the old underground dressing rooms had fallen into such a state of disrepair that the only viable thing to do was to fill them in with concrete. The bandstand was demolished in April 2006 to make way for a replacement.
SEE Askey, Arthur/ Cliftonville/ Cricket/ Wrestling

'OVER THE RIVER'
by John Galsworthy
'Did you ever know a sadist?'
'Once at Margate. My private school. I didn't know at the time, of course, but I've gathered it since.'
SEE Books/ Galsworthy, John/ Margate/ Schools

OXFORD HOTEL
St Peter's Road, Margate
Built in 1870, it was a seven-bedroomed Cobb Brewery property. In the 1950s and 60s, the landlord was Jimmy Manktelow, a small, slight man who wore glasses, and had a huge sense of humour and fun. If you went in wearing a tie, he would most likely cut it off and hang it up behind the bar. Fireworks might be let off, or the bar might be set on fire. A rivalry developed between The Oxford Hotel and The Duke of Edinburgh, each trying to outdo the other in outrageous acts. The Duke somehow managed to get a Red Indian (this was before they became Native Americans) to ride bareback in their bar. In order to get The Oxford to top this, Jimmy, through a friend of his in the circus, arranged for a baby elephant to come and have a drink in the bar. Unfortunately - some of you are perhaps already ahead of me here - the floor could not take the elephant's weight and it crashed down into the cellar. Somehow, the regulars managed to rescue it but sadly this was before the days of video cameras. In time, Jimmy lost the pub but went on to work in the Belle Vue and the Cinque Ports.

As a mark of respect when he died, a local landlord placed a bottle of whisky on his grave.

The Oxford Hotel also had the nickname 'The Plasterers Arms' at this time because of

161

the large number of workmen who drank there. \
SEE Cinque Ports pub/ Cobbs/ Belle Vue/ Duke of Edinburgh/ Hotels/ Margate/ St Peter's Road, Margate

OXFORD STREET, Margate
During the German bombing on 5/6th December 1917, Mrs A Roberts was killed in the house next to the Oxford pub in Oxford Street.
SEE Margate/ World War I

OZENGELL, Ramsgate
The area more recently known as Lord of the Manor was previously Ozengell or 'The hill of Osian's people' where the Jutes had a burial ground (AD 600-700).
The area is now covered by the railway line and the junction of Haine Road and Canterbury Road.
SEE Cemeteries/ Jutes/ Lord of the Manor/ Ramsgate

OZONIC MINERAL WATER COMPANY
It was a subsiduary of Tomson & Wotton brewery. Their office was in Hertford Street in Ramsgate.
SEE Hertford Street/ Ramsgate/ Tomson & Wotton/ Whitehall Mineral Water Co

P

PADGETS,
Northdown Road, Cliftonville
This ironmongers is virtually the only private firm still in Northdown Road that also existed before World War II.
SEE Cliftonville/ Northdown Road/ Shops

Thomas PAINE
Born Thetford Norfolk, 29th January 1737
Died New York, 8th June 1809
In an early episode of his life, which he rarely mentioned later in life, Thomas set up a stay making business (his father had been a stay maker – it's in the blood you know) in Sandwich which subsequently failed. He and his pregnant young wife of less than a year moved to Margate in the spring of 1760 but following a premature birth, both mother and baby died. He left the area soon after.
He went on to be the radical author of 'Common Sense' (1st January 1776) which had a great influence on American public opinion on the American War of Independence – published anonymously it sold half a million copies. The American government gave him $3,000 together with a farm in gratitude in 1785.
He returned to Europe in 1791, and turned his attention to the French Revolution in 'The Rights of Man' (1791) 'The Age of Reason' (part I in 1794, part II in 1795 and part III in 1807. He served on the National Convention twice; the two occasions interrupted by an eleven month spell in prison after he upset Robespierre. He further upset both sides in French politics and finally becoming disgusted with politics altogether, instead studied finance until 1802.
The US President, Thomas Jefferson, placed a ship at his disposal and he returned to the USA where he lived his last few years pretty well ignored.
SEE Margate/ Politics/ Sandwich

'A PAIR OF BLUE EYES'
by Thomas Hardy
How beautiful was the sunset when they rounded the North Foreland the previous evening!
SEE Books/ Hardy, Thomas/ North Foreland/ Skies

PALACE THEATRE
High Street, Ramsgate
A large house and a row of shops were demolished on the corner of the High Street and George Street in the 1870s. The cleared plot of land was put up for auction. Lord George Sangar bought the land for a good price and built an amphitheatre behind a row of six shops and a pub - which later became Sangar's Hotel – for £30,000. It opened it in 1883.
Sangar's amphitheatre was re-modelled as the Palace Theatre in 1908 as both a theatre and a cinema.
There were eight classical-style statues of women holding lanterns outside, which were copies of those seen by Sangar outside the Paris Grand Opera House in 1883. They cost £50 each to transport but were not popular with the locals. Aldeman Gwyn said that they were *'an eyesore and a disfigurement'* and in 1913, six were re-located to Dreamland, and in 1939, the remaining two were removed – maybe they were called up, I don't know.
The first talking picture to be seen and heard in Ramsgate was shown here - 'The Singing Fool' with Al Jolson was shown here on 15th July 1929.

Palace Theatre, High Street, Ramsgate.
Proprietress: Mrs A Reeve-Sanger
OPEN ALL YEAR ROUND
The Handsomest and most Commodious Theatre on the South Coast.
Visited and Re-visited by all the Leading West End Attractions
Box Office open daily from 10am to 9pm. No extra charge for booking.
Telephone: 31 Ramsgate

The theatre was badly damaged by a fire on 21st June 1946.
Both the Palace Theatre and Sangers Hotel were sold in June 1950 and the theatre was demolished in 1961 to be replaced by Fine Fare supermarket. To see what is left of the old theatre building look at the top of the shop next door.
Argos now occupies most of the site.
SEE Fine Fare/ Fires/ High Street, Ramsgate/ Langtry, Lillie/ Ramsgate/ Sanger circus/ Sanger family/ Theatre Royal

Gary PALLISTER
Born Ramsgate 30th June 1965
After being transferred from Middlesborough Football Club to Manchester United for a then record transfer fee of £2.3 million in 1989 he went on to win the FA Cup three times, the Premiership title four times and a League Cup and a European Cup Winners Cup. He was also capped 22 times for England.
SEE Football

Jackie 'Mr TV' PALLO
Born Islington 12th June 1926
Died 11th February 2006
He was born Jack Ernest Gutteridge (the boxing commentator, Reg Gutteridge, is his cousin) and became one of the most popular wrestlers in the country at a time when the sport was shown every Saturday afternoon on ITV between 4 o'clock and the football results. He started to wrestle professionally in 1949 and by the 1960s was one of the biggest stars in the sport. His rivalry with Mick McManus pulled in big audiences; their fight before the 1963 FA Cup Final was watched by more people than the football match itself. He also appeared in 'The Avengers', 'Emergency Ward 10' and 'Are You Being Served?'
Always a showman, he was as good a wrestler as he was quick-witted. He told one irate old lady who was barracking him that she should move to India because 'You'd be sacred there'. On another occasion a woman shouted out that he was a big-head, and he replied, 'If my head was in your mouth, it would rattle'.
In 1985 he published his autobiography 'You Grunt, I'll Groan'.
He often fought at Thanet venues and lived in Ramsgate up to his death; he was cremated at Margate Crematorium.
SEE Entertainers/ Margate/ Ramsgate/ Sport/ Television/ Wrestling

PALM BAY, Cliftonville
It was formerly known as Palmers Bay.
SEE Bays/ Cliftonville

PALM BAY PRIMARY SCHOOL
It was built on the site of a car park, that at one point was quite overgrown, and a recreation ground and opened in September 1995.
SEE Cliftonville/ Schools

PANCAKE ICE
During the Great Freeze of February 1963, 'pancake ice' formed around the pier at Margate. Pancake ice looks like pancakes! Each piece of ice is about a foot in diameter and around 3 inches thick, with a rim around the edge. Thousands of these can form as the water freezes but the motion of the sea makes these circles rest on slushy ice underneath.
SEE Margate/ Pier/ Weather

PANCAKE RACE
Station Road in Westgate is one of many locations across the country where pancake races are held each year on Shrove Tuesday. 'Shrove' comes from the word 'shrive', meaning to confess your sins, which is what

Christians did - a 'final fling' before Lent which starts the following day, Ash Wednesday.

The ingredients of pancakes are symbolic of the creation (eggs), the staff of life (flour), purity (milk) and wholesomeness (salt). The ingredients were also many of the things that years ago Christians would give up for Lent, and, so that they were not wasted, pancakes became an ideal way of using them all up before it started.

Pancake races are said to date back to the fifteenth century when a woman - not in Thanet I stress - was frying pancakes when she heard the church bell ring. In her haste not to be late for the service, she went running down the road still holding her frying pan and tossing her pancake. Quite what she was going to do with the hot frying pan when she got there I don't know.

Pancake Song by Christina Rossetti
Mix a pancake,
Stir a pancake,
Pop it in the pan.
Fry the pancake,
Toss the pancake,
Catch it if you can.
SEE Rossetti, Christina/ Station Road/ Westgate-on-Sea

Christabel PANKHURST
Born 1880
Died 1958
She was the daughter of Emmeline Pankhurst (1858-1928), the leader of the Women's Social and Political Union that campaigned for voting rights to be given to women on the same basis as they were granted to men.
East Kent Times, 1st July 1910
Miss Christabel Pankhurst at Ramsgate
At the Royal Pavilion on Friday evening the brilliant Suffragette leader addressed a large crowd among whom were a large number of men. Miss F E Macauley was the organising secretary. Miss Pankhurst delivered an inspiring address and expected the cause to be won very soon. 'Women are going to be outlaws no longer' she said. She also defended the militant tactics of the Suffragettes. Another large meeting was addressed on Saturday at the Theatre Royal.
East Kent Times, 27th March 1912:
Miss PANKHURST. . .
IS SHE AT MARGATE?
Interest in the chase for Miss Pankhurst the missing Suffragette leader, has been aroused at Margate owing to a widespread rumour that she is in hiding in the town. A daily paper stated that Police are keeping watch on a house where a heavily veiled woman, said to resemble the missing suffragist arrived a few days ago... Scotland Yard is said to have received more communications as to the supposed whereabouts of Miss Pankhurst than in the case of any other 'wanted' person. It will be remembered that she spoke in Ramsgate and Margate.
Christabel Pankhurst managed to escape to Paris.
SEE East Kent Times/ Margate/ Politics/ Ramsgate/ Royal Victoria Pavilion/ Pankhurst, Mrs Emmeline/ Suffragettes

Mrs Emmeline PANKHURST
On 27th May 1910, The East Kent Times reported on Mrs Pankhurst's visit to the Royal Victoria Pavilion, Ramsgate, where she spoke on women's rights.
SEE Christabel Pankhurst/ East Kent Times/ Politics/ Ramsgate/ Royal Victoria Pavilion/ Suffragettes

The PARADE, Birchington
This area, together with the lawned area behind the road, was an inlet in which ships used to anchor. It was later known as The Lagoon before an earth embankment, and later still, a stone one, replaced it in 1879-80.
SEE Birchington/ Birchington Bay Estate Co.

The PARADE, Broadstairs
The stairs that once descended from the Chapel in Albion Road, were once referred to as Chapel Stairs. When a bridge to the bay was added overlooking the area now occupied by the Pavilion and its Garden on the sands, it was named Bridge Parade, and 3 Eldon Place was once called Bridge House.
SEE Broadstairs/ Shrine of our Lady, Bradstowe

The PARADE, Margate
Richard Barham (1788 -1845) lived at 20 The Parade, Margate for a while, and wrote a humorous 'log' of a journey to Margate that he and his family made in 1841:
August 16
Nine A.M.: Two cabs, three trunks, one band-box, a wife, three girls, two carpet bags, portfolio, and a Dick on the dickey.
Half-past Nine: On board the Royal George; luggage safe stowed, all but the Dick, who quitted. …
Ten: Off she goes; 'Times and Morning Herald'. …
Three: Off Herne Bay, beautiful weather, sea like a duck-pond; gin and water.
Twenty minutes past Four: Landed on Margate Jetty,
Half-past Four: Three bed-rooms and first-floor sitting room at a hatter's on Marine Parade. Don't know whether engaged or not – depends on next post, which comes in at half-past six; old woman, former lodger, to send her answer by it ; have tea there upon speculation.
Five: Very good tea, ditto bread, ditto butter, hurdy-gurdy under window – 'Nix my Dolly'.
Six: Post in, old woman don't come; take the lodgings, three guineas a week, seem very comfortable, … hurdy-gurdy – 'I'd be a butterfly'; fiddler –'College Hornpipe'; bagpipes – 'Within a mile of Edinburgh Town', wish to God they were!
SEE Barham, Richard/ Boating & Paddling Pool/ Books/ Low Countries/ Margate/ Marine Parade

PARADISE, Ramsgate
This street was so-named due to its quiet location and its existence is recorded as far back as 1779. It was a favoured spot to which sea-faring men retired – being just far enough inland to be not able to hear the sea!
SEE Ramsgate

PARAGON, Ramsgate

This street was built in 1816 in an area then known as St George's Fields.
In around 1850, The Royal Kent Baths were at the Paragon.
A fire here at around half past two in the morning of Friday, 26th June 1925, saw Paragon Mansions ablaze. When the fire crews arrived, in an engine donated by Dame Janet Stancomb-Wills, residents of the third and fourth floor flats were screaming to be rescued as their escape route via the stairs was now too dangerous. It took until 4 o'clock that morning for the combined efforts of crews from Margate and Ramsgate to get the fire under control. The basement was gutted and most of the bedrooms damaged with only the frame of the staircase remaining. In all, eight people were rescued, along with a cat, two kittens and a canary, but no-one died.
Gardens have existed here since the 1870s, becoming known as the Italianate Gardens, complete with a bandstand. Then in 1913, the overwhelming need for a Concert Hall was acknowledged and a hall was opened on 2nd August 1914. Not a good time to open as just 48 hours later World War I began!
East Kent Times, 15th May 1958:
DISASTROUS CLIFF FALL AT THE PARAGON.
The huge cliff fall which tore away a large part of the roadway at The Paragon on Monday night, will cost at least £50,000 to repair, but only a proportion of this will come from the local rates. It is expected that the biggest contribution will come from the Ministry of Transport. Kent County Council, which wholly maintains the road, would also be responsible for part of the bill.
With a noise like thunder, and vibration which shook the houses on the opposite side of the road the promenade fell. Tons of chalk crashed on the old swimming baths below, snapping the steel girders like matchsticks. Police cars were used to block the road at either end, and bus drivers were warned of the danger and vehicles were diverted.
Mr M Holmes of 19 The Paragon said 'I had just got up to turn the TV off, when I glanced out of the window and saw the street lights gradually disappearing. I was scared stiff!'
Mrs Harvey of Dovercourt, The Paragon said, 'We were watching television and thought a lorry had gone over the cliff'.
There was no question of people being evacuated but several Paragon residents slept in their back rooms.
In the morning they looked out of their front windows to see the cliff edge had advanced yards towards their front doors.
Possibly the smallest Grade II listed building in the country is in the Paragon, Ramsgate. Designed by Giles Gilbert Scott, the K6 Jubilee (as in the silver jubilee of King George VI and Queen Mary) phone box is now protected!
SEE Churchill Tavern/ East Kent Times/ Fires/ George VI/ Italianate Gardens/ Listed buildings/ Paragon House Private Hotel/ Ramsgate/ Stancomb-Wills/ World War I

PARAGON HOUSE PRIVATE HOTEL
Ramsgate
PARAGON HOUSE PRIVATE HOTEL
Situated on the West Cliff Promenade facing the Sea.
South and West aspects. 60 rooms, of which 40 face the sea.
Sanitary Certificate. For terms apply to Mr & Mrs ROSE, proprietors
SEE Bathing/ Churchill Tavern/ Hotels/ Paragon/ Ramsgate

PARAKEETS
Ring-Necked Parakeets live wild in wooded areas of Thanet and they are thought to descend from a pair that started breeding in Northdown Park, Cliftonville after escaping from captivity. They are also common in King George VI Park in Ramsgate.
SEE Birds/ Cliftonville/ King George VI Park/ Northdown Park/ Ramsgate

PARK LANE, Birchington
Originally this was a very narrow track called Parish Lane.
There were four thatched almshouses down here from around 1805 until 1934.
SEE Acorn Inn/ Birchington/ National School/ Plum Pudding Island

Edward Drake PARKER
He was the Coxswain of 'Lord Southborough', the Margate lifeboat, and was awarded the Distinguished Service Medal for *'gallantry and determination when ferrying troops from the beaches of Dunkirk'.*
SEE Dunkirk/ Lifeboat

Richard PARKER
Born Maidstone 1913
Died Herne Bay 1990
He lived with his wife and children at various locations in and around Herne Bay (including 5 Prospect Hill) after he returned from his Egypt posting during the Second World War (he had been a reporter in London before the war). He therefore knew the marshland that was once the Wantsum Channel well, and used it as the setting for 'The Sheltering Tree', a children's book about nineteenth century smuggling and how it affects a poor family.
He was a prolific author, not only of children's stories but also adult and historical novels. At one point, he and his family emmigrated to Australia but returned to Herne Bay within two years in 1962.
SEE Authors/ 'The Sheltering Tree'/ 'The Sword of Ganelon'/ Wantsum Channel

PARKS
SEE Dane Park/ Hartsdown Park/ King George VI Park/ Northdown Park/ Quex Park/ Tivoli Park

'A PASSAGE In The LIFE Of Mr WATKINS TOTTLE'
by Charles Dickens
A short story by Dickens from 'Sketches by Boz': *Now, the old lady unfortunately put off her return from Ramsgate, where she had been paying a visit, until the next morning; and as we placed great reliance on her, we agreed to postpone our confession for four-and-twenty hours.*
SEE Books/ Dickens, Charles/ Ramsgate/ Sketches by Boz

PASSENGERS BY SEA
In the 35 years between 1812/13 and 1846/47 the number of passengers in and out of Margate by sea was 2,219,364. Yes two and a quarter million! That is an average of over 63,000 per year. The top year was 1835/36 when the number was 108,625. The steamship traffic quadrupled between 1817 and 1835. The owner of the steamships 'Eclipse' and 'Thames' said in 1828 that Margate people *'ought to eulogise. . . Steam Vessels, as the harbingers of their prosperity'.* In years to come no doubt similar success will be had by the Turner Centre, or Turner Contemporary, or whatever name it has by then. Let's hope it can match the number of visitors.
SEE Margate/ Steam packets/ Transport

PAVILION, Broadstairs
The Broadstairs Pavilion opened in 1933 and stands on the site of a bowling green which, in turn, stood on the site of White's Shipyard.
Advertisement, 1909:
> *A MEETING will be held in the*
> *PAVILION, BROADSTAIRS on*
> *TUESDAY JULY 13th at 7.45p.m.*
> *Under the auspices of the*
> *WOMEN'S FREEDOM LEAGUE*
> *Principal speaker is*
> *MRS. HOLMES*
> *Free seats also reserved at 1/-, 6d, 3d*
SEE Broadstairs/ Eagle House/ Parade, Broadstairs/ Shipbuilding

'The PAYING GUEST'
by George Gissing
'Dear Mrs. Mumford, - I know you'll be glad to hear it's all over. It was to have been at the end of October, when our house was ready for us. We have taken a very nice one at Holloway. But of course something happened, and mother and Cissy and I quarrelled so dreadfully that I went off and took a lodging. And then Tom said that we must be married at once; and so we were, without any fuss at all, and I think it was ever so much better, though some girls would not care to go in their plain dress and without friends or anything. After it was over, Tom and I had just a little disagreement about something, but of course he gave way, and I don't think we shall get on together at all badly. My stepfather has been very nice, and is paying for all the furniture, and has promised me a lot of things. Of course he is delighted to see me out of the house, just as you were. You see that I write from Broadstairs, where we are spending our honeymoon. Please remember me to Mr. Mumford, and believe me, very sincerely yours, Louise L. Cobb.'
SEE Books/ Broadstairs

PEAR TREE COTTAGE
Crow Hill, Broadstairs
In the eighteenth century, smugglers used this cottage as a store, but when the Revenue men searched the premises they often did not find anything because a cupboard in the cellar had a false back and that was where the goodies were hidden. It worked well until a cat got locked in there one day and gave the game away. The Revenue men found goods worth about £1,000 in the cupboard.
SEE Broadstairs/ Crow Hill/ Smuggling

PEARCE SIGNS, Westwood
Samuel Pearce's family made their first signs back in the eighteenth century, and were the first of seven generations to run the firm. They moved to the former premises of Steelcase at Westwood in 1961. They became such a fixture that the junction became known as Pearce Signs roundabout. Shortly after leaving the site in March 2004, over forty years later, the company, employing over 200 staff, went into administration. The original landmark building was demolished in September 2005. Homebase opened their new store on the site in July 2006.

PEARKS' STORES, Ramsgate
Advertisement, c1900
> *Pearks' Stores, 19 & 21 Harbour Street*
> *Grocers, wine, spirit and beer merchants*
SEE Harbour Street, Ramsgate/ Ramsgate/ Shops

Sir Robert PEEL
Born 5th February 1788
Died 2nd July 1850
He was Prime Minister twice (1834-1835 and 1841-1846) and also Home Secretary - he formed the world's first police force in London in 1829 – and was the founder of the modern Conservative Party. He died in London as a result of a riding accident.
He owned quite a bit of land in Cliftonville when it was known as New Town – locals soon nicknamed it Peel Town.
SEE Cliftonville/ Gibbets/ Gladstone, William/ Montefiore, Sir Moses/ Prime Ministers

PEGWELL BAY

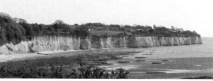

This was allegedly the landing site of Hengist and Horsa at Ebbsfleet and the site of the betrothal of Hengist's daughter Rowena to King Vortigern of Kent.
The sandstone boulders that can be found on the beach led to the bay being originally known as Greystone Bay during the eighteenth century. It has also been called Hopes Bay and Courtstairs, after the Court Baron held at one time at Nether Court.
There once was a coastguard station here.
It was known as a picturesque hamlet and was famous in the 19th century for its shrimps and potted shrimp preserves.
Pegwell Bay was once a famous venue for yacht racing. A typical regatta in 1829 under the patronage of the Earl of Darnley and

Squire Warre started with a race for the larger class of yachts; the prize for he winner being a purse of sovereigns.

At one time Ravenscliff Pier stretched 300 feet out to sea.

Pegwell Bay was heavily fortified in World War II with artillery positioned in concrete defences pointing out to sea.

A secret weapon was successfully developed at Pegwell bay in 1940. It involved oil being pumped onto the sea and then being set alight – more than that I cannot say, as it was secret, but you can probably guess what happened next. It was never used, but had the Germans invaded . . .

The sea has frozen at Pegwell Bay, most notably in 1963.

SEE Bays/ Belle Vue Tavern, Pegwell/ Birds/ Coastguards/ Curling family/ Dickens, Charles/ Dyce, William/ Ebbsfleet/ Greystone Bay/ Hengist & Horsa/ Hovercraft/ Hoverport/ Hugin/ Newington Railway Station/ Tatnell's Clifton Tavern/ 'Tuggses of Ramsgate'/ Van Gogh, Vincent/ Warre/ Weather/ Whales/ Wheatley, Dennis/ World War II

PEGWELL BAY RECLAIMATION COMPANY

This company was formed in 1875 and by 1878 they had built a restaurant, bathing pool and a pier so that visitors could arrive by boat. Unfortunately, not many came, and the venture was a failure.

SEE Bathing/ Piers/ Restaurants

PEGWELL COTTAGE

By the time Sir William Garrow (born 1760 – died 1840) was 33, King George III had made him one of His Majesty's Counsel. He was Attorney General from 1813 until 1817. During this time, he introduced the Stage Coach Bill, which was intended to protect the horses – although it was actually the passengers that he was more concerned about – from the operators who would gallop their horses over rough roads for hours at a time to beat the competition. It was not a success.

He was made Baron of the Court of Exchequer in 1817, around the same time that he built Pegwell Cottage.

William IV made him a Privy Counsellor on his retirement. Whilst here, Lady Garrow became involved with the St Lawrence schools and made a point of inviting local schoolchildren to Sunday lunch each week. Part of the deal though, was that they had to collect the joint of meat from the Pegwell bakehouse on their way, or they went hungry, or became vegetarian!

Garrow died, aged 80 at Pegwell.

Mr and Mrs Littlewood-Clarke lived in the cottage from 1905-1939 and in later years, it was turned into a caravan park.

SEE George III/ William IV

Samuel PEPYS

Born 23rd February 1633
Died 26th May 1703

Probably the most famous diarist in history. The first of the following entries has nothing to do with Thanet, but I included it because I like it!

13th October 1660: *'I went out to Charing Cross, to see Major-General Harrison hanged, drawn and quartered, which was done there, he looking as cheerful as any man could do in that condition.'*

Monday 7th May 1660: *This morning Captain Cuttance sent me 12 bottles of Margate ale. Three of them I drank presently with some friends in the Coach. . . .In the afternoon I lost 5s. at ninepins. After supper musique, and to bed. . . . After I was in bed Mr. Sheply and W. Howe came and sat in my cabin, where I gave them three bottles of Margate ale, and sat laughing and very merry, till almost one o'clock in the morning, and so good night.*

27th August 1660 *This morning comes one with a vessel of Northdown ale from Mr. Pierce, the purser, to me, and after him another with a brave Turkey carpet and a jar of olives from Captain Cuttance, and a pair of fine turtle-doves from John Burr to my wife. These things came up to-day in our smack, and my boy Ely came along with them, and came after office was done to see me. I did give him half a crown because I saw that he was ready to cry to see that he could not be entertained by me here. . . .*

13th September 1660: *Old East comes to me in the morning with letters, and I did give him a bottle of Northdown ale, which made the poor man almost drunk.*

Sunday 23rd September (Lord's day) 1660 : . . . *This afternoon, the King having news of the Princess being come to Margate, he and the Duke of York went down thither in barges to her.*

Friday 26th October 1660: . . *My father and Dr. Thomas Pepys dined at my house, the last of whom I did almost fox with Margate ale. My father is mightily pleased with my ordering of my house. I did give him money to pay several bills.*

1st January 1661: . . . *Then comes in my brother Thomas, and after him my father, Dr. Thomas Pepys, my uncle Fenner and his two sons (Anthony's' only child dying this morning, yet he was so civil to come, and was pretty merry) to breakfast; and I had for them a barrel of oysters, a dish of neat's tongues, and a dish of anchovies, wine of all sorts, and Northdown ale. We were very merry till about eleven o'clock, and then they went away.*

16th June (Lord's day) 1661: . . . *At night resolved to hire a Margate Hoy, who would go away to-morrow morning, which I did, and sent the things all by him, and put them on board about 12 this night, hoping to have them as the wind now serves in the Downs to-morrow night. To-bed with some quiet of mind, having sent the things away.*

13th January 1665: *So to the Hall awhile and thence to the Exchange, where yesterday's newes confirmed, though in a little different manner; but a couple of ships in the Straights we have lost, and the Dutch have been in Margaret* [Margate] *Road.*

SEE Authors/ Battle of North Foreland, The/ Downs, The/ Margate/ Margate Ales/ Northdown Ale/ Pierremont Hall/ Punch and Judy

Major Henry PERCY

Wellington's aide-de-camp, was the Honourable Major Henry Percy. He found that, due to bad weather, he could not land at Dover and instead had to come ashore on Broadstairs beach with the first news of victory at the Battle of Waterloo, news that was going to have far-reaching commercial implications for the country. He stopped at the Station House on the beach, which was the headquarters of the Coast Blockade, and presented the resident Port Admiral with the captured French Eagle standard (crawler) and the building was re-named Eagle House. Immediately afterwards, he broke the news to the clientele of the pubs at the top of Harbour Street; well, you would go straight to the pub wouldn't you? Accounts of the time do not tell us what time of day he landed but it would not have had the same impact bursting into the local bakers. Now this being a once in a lifetime occasion, he was probably treated to a drink by every one he met, so he did what most people would do, and told the people in the next pub as well. Eventually, he was supplied with horses and proceeded on up Crow Hill through St Peter's and on to London. All the way, unsurprisingly, he was greeted with great acclaim and the ride, with so many interruptions, took two full - in every sense of the word - days.

Major Henry Percy, his uniform still dirty, torn and blood-stained from the battle, called first at 16 St James Square in London, the home of Edmund Boehm, a rich merchant, and interrupted the ball that he and his wife were hosting with the Prince Regent as a guest. Mrs Boehm was not happy at the interruption. The Prince was delighted when the French Eagles was laid at his feet. He ordered the ladies from the room, got Lord Liverpool to read the dispatch and promoted Percy to the rank of Colonel on the spot. However, Percy's work was still not done, as he had to continue in an open carriage decorated with four French flags, to the Earl of Harrowby's home at 44 Grosvenor Square, to give the official news of Wellington's victory over Napoleon at the Battle of Waterloo, three days after the battle on 21st June 1815. The British Cabinet was dining there at the time, and the Honourable Henry Percy entered with a despatch for the War Secretary, the Earl of Bathurst.

SEE Broadstairs/ Crow Hill/ Eagle House/ Harbour Street, Broadstairs/ St Peter's/ St Peter's Church/ Viking Bay/ Waterloo, Battle of

PERCY AVENUE, Kingsgate

Two bombs fell in Percy Avenue on 1st March 1916.

SEE Clarendon Road/ Gladstone Road/ Hamilton, Charles/ Kingsgate/ Lawrence, D H/ Vye and Son

PERCY ROAD, Ramsgate

Richard Chandler of 10 Percy Road was the skipper of the fishing smack Progress. In 1910, his son died at sea, and soon after that his wife died. In a massive storm on the night of September 30th, Richard, along with another of his sons and his nephew, died at

sea, leaving a daughter and another small son as orphans.
SEE Ramsgate

PERFECTS COTTAGES
Canterbury Road, Birchington
James Eastland (aka Huntley), who also went by the name of Jimmy Landy, was a carpenter and part-time smuggler, selling his stuff at the Powell Arms. He served six months in Sandwich prison when he was caught smuggling. He died, aged 82, in his home at Perfects Cottages in 1906.
SEE Birchington/ Landy, Jimmy/ Powell Arms/ Quex/ Sandwich

PERSEVERANCE
The name of a pleasure boat based at Broadstairs, that was among those 'little ships' that sailed to Dunkirk. She returned safely and continued to carry visitors from Broadstairs Jetty until the 1960s.
SEE Broadstairs/ Dunkirk

PETERLOO
In a year of high food prices and industrial depression, there had been a series of rallies culminating in a radical meeting held in St Peter's Fields in Manchester on 16th August 1819. Henry Hunt presided over the meeting that was intended to show the public's dissatisfaction and its desire for parliamentary reform. The peaceful, unarmed crowd of 60,000 included a high number of women and children. The size of the crowd made the local magistrate nervous and the largely untrained yeomanry were ordered to arrest the speakers as soon as the meeting began. The cavalry brutally broke up the meeting by charging in waving their sabres. The chairman of the bench of magistrates then ordered the 15th Hussars and the Cheshire Volunteers to join in. Ten minutes later, the field was clear, but around 500 had been injured and eleven killed – although both sides disputed the figures. The speakers had been arrested and after being tried, were found guilty; Hunt was sentenced to two years in prison. Peterloo became a symbol amongst the radicals for the Tories' tyranny and callousness.
In the same way that every political scandal these days ends in 'gate' – Cheriegate, Camillagate etc - after Watergate, it was named Peterloo after the name of the field where the meeting took place, St Peter's Fields, and 'loo' in reference to the recent Battle of Waterloo (1815).
SEE Addington, Lord/ Belvedere House/ Cobbett, William/ Fildes, Sir Samuel Luke/ Sidmouth, Lord/ Waterloo, Battle of

Emmeline PETHICK-LAWRENCE
Born 1867
Died 1954
Pethick was her maiden name and when she married Frederick Lawrence (1871-1961) in 1901 they both took the double-barrelled name of Pethick-Lawrence. They were senior members of the women's suffrage movement. Emmeline was a great public speaker and fundraiser, and their London home was even used as the Union's office

for a few years. She was imprisoned on five occasions for militant actions; in particular, in March 1912, Emmeline and Frederick were among the leaders arrested for conspiracy after suffragettes had broken many windows as part of their campaign. They had to pay the trial costs and damages and were each sentenced to nine months in prison but were released early.
East Kent Times, 15th July 1911:
Woman Suffrage Meeting at Ramsgate.
The speaker was Mrs Pethick Lawrence [the well-known feminist]. She thanked Ramsgate council for passing a resolution to beg Parliament to pass the Conciliation Bill into law. She said that when men had wanted the vote they had 'done some very shocking things indeed. They had destroyed life, injured people and destroyed property to the value of hundreds of thousands of pounds. Women have to pick a tiny leaf out of the men's book.
SEE East Kent Times/ Ramsgate/ Suffragettes

Joseph Croome PETIT
In 1823, Joseph Croome Petit lived in a cave behind a farmhouse near the Hollicondane Public House and was known as the Hermit of Dumpton Cave.
SEE Dumpton/ Farms

Thomas PETTMAN
As an employee of the Clifton Baths, Thomas Pettman realised that the development of Cliftonville meant a whole new clientele for bathing. He therefore leased some of the foreshore from the Marquis of Conyngham and after cutting out some of the rocks to form a bay at Newgate Gap, he opened a bathing station with his own bathing machines. When he died, his son and daughter took over until Mrs Charlotte Pettman eventually took sole charge. It grew even more popular, the machines were improved and bathing saloons became an added luxury.
In 1864, at the base of the cliff, a wooden platform was built called Pettman's Bathing Platform. It was a mile long running parallel to the cliff and offered facilities *'being distinctly select and decidedly superior to others on the coast'*, including over one hundred bathing machines and cabins and deckchairs in which customers could rest. Locals referred to it as Pettman's splashboard.
The local Corporation eventually purchased the whole foreshore for £3,000 and leased Pettman's bathing area back to them. The development of Cliftonville owes a lot to the Pettmans.
A side effect of World War II was the absence of any maintenance of the platform. Such was the deterioration, that it was demolished and replaced by a promenade.
SEE Bathing/ Clifton/ Cliftonville/

PEWTER POT public house
The Square, Birchington
It was originally named the New Inn, although the Powell Arms has also been known as the New Inn in its history. It is

another Birchington property with Dutch gable ends and dates back to the reign of William III (1689-1702). In Victorian times it had livery stables to the rear. It was updated in 1999 and, more recently, the name has changed to the Three Legged Toad and Saxby's.
SEE Birchington/ New Inn, Birchington/ Pubs/ Square, The/ William III

Thomas PHILLPOTT
For 43 years from 1814 until he died on 15th April 1857 at the age of 83 Thomas was Margate's town crier and lived in a cottage in Lombard Street (now a shop). He was short, very popular with the local children who often followed him around the town, and famous for telling the latest news in rhyme! When he got too old and frail he was pushed around town in a bath chair. The locals paid for a stone to mark his grave at Margate cemetery.
SEE Bath chairs/ Cemetery, Margate/ Margate

The PHOENIX public house
King Street, Margate
Originally at 28, later re-numbered 68, King Street, the pub dates back to 1764 and was once under the Tomson and Wotton brewery banner, unusual in this Cobb brewery heartland. In the nineteenth century the town's fire brigade used the Phoenix as their local - quite apt considering the name - as the fire station was opposite.
The Phoenix has always been liable to flooding because it was built in a former river valley. After the great flood of 1st February 1953, a permanent record was preserved on the side of the bar to record the 3ft 6in depth to which the bar was under water. For many years a poltergeist was said to appear in the pub and it was once featured on a television programme. It refuses to do interviews now and later landlords have had no problems with it.
SEE Cobbs/ Fire Station/ Flooding/ King Street, Margate/ Margate/ Pubs/ Tomson & Wotton

Mary PICKFORD
Born Toronto 8th April 1892
Died 29th May 1979
Although she was born Gladys Louise Smith in Canada, she became Hollywood's biggest film star and was known as 'America's Sweetheart' and 'the girl with the curl'. Successful in both the silent and talkie eras - *'Adding sound to movies would be like putting lipstick on the Venus de Milo'* - she was the first actress to earn over a million dollars a year. She won an Academy Award for Best Actress in 1929 but four years later retired after it became obvious that the public would not accept her as anything other than a teenage heroine. *'I left the screen because I didn't want what happened to Chaplin to happen to me. When he discarded the little tramp, the little tramp turned around and killed him.'*
Her first husband was the actor Owen Moore (1886-1939); they married on 7th January 1911 but divorced in March 1920. Her second husband was Douglas Fairbanks, Sr. (1883-1939). The marriage took place on 28th

March 1920 and the two of them became 'Hollywood Royalty' entertaining lavishly at their Pickfair estate. They divorced in January 1936 and in 1937 she married another actor, 'America's Boy Friend' Charles 'Buddy' Rogers (1904-1999). He later became a bandleader. When Mary was told of Fairbanks death in 1939 she apparently wept in front Rogers saying, 'My darling is gone'. I bet that went down well.

A very astute businesswoman she, along with Douglas Fairbanks Sr., Charlie Chaplin, and D W Griffith, founded United Artists and she was its first vice president in 1936.

She suffered from alcoholism for around fifty years and lived at Pickfair until she died.

SEE Actors/ Fairbanks, Douglas/ Honeymoon

'PICKWICK PAPERS'
by Charles Dickens

Partly written (notably part 18) when Dickens was staying in lodgings at 12 High Street in Broadstairs.

SEE Books/ Broadstairs/ Dickens, Charles/ High Street, Broadstairs/ Oliver Twist/ Weller, Sam

PICTON ROAD, Ramsgate

Eight German Gotha planes dropped twenty eight bombs on Ramsgate on 22nd August 1917. Three children and a draper, J Wright, were injured in Picton Road.

Another Gotha raid on 28th January 1918 also bombed Picton Road demolishing the Rev Thomas Hancocks' (Baptist Pastor) house.

Pamela Williams of Picton Road was Miss Ramsgate in 1958. Ten years later she stood trial for murdering her three children aged 5, 3, and 4 months. She was found not guilty due to insanity.

SEE Cemetery, Margate/ Chatham House School/ Gotha/ Hengrove/ Military Road/ Ramsgate

PIER, Margate

Designed by Eugenius Birch, the iron and wood pier was built between 1853 and 1857. To give steamers an easier berth, a large hexagonal extension was started in 1875, and opened by the Lord Mayor of London, Sir John White on May Day 1877. A total of 40,000 people - tickets were 2d each – used the pier in the peak holiday weeks, the last week in July and the first week in August.

Entry to the pier was through turnstiles, before a long walk to an area at the end where there was a bandstand, dining room and 'what the butler saw' type slot machines. Paddle steamers arrived and departed.

On 2nd January 1877, Margate pier was damaged by a storm. Well, the storm wrecked a ship, the wreck cut the pier in half and 40-50 people attending a New Year party at the far end were trapped all night; just them and the un-drunk booze. You're not so sympathetic now, are you? The stone pier and Droit House was severely damaged in the storm as well.

Very popular here, in the 1920s, was a 'guess your weight' stall, a camera obscura at the entrance and a profusion of cockle and whelk stalls.

Passing ships that were fifteen miles out to sea, on 8th November 1964, kept phoning the coastguards because they were convinced there was a ship on fire. In fact, it was the pier. The pavilion was also badly damaged and a crowd of hundreds watched from the promenade as fireman, assisted by forty members of the Royal Engineers who had been enjoying a night out, fought to control the blaze that was being fanned by a strong easterly wind. Lifeboatmen had to quickly remove rockets and explosives from their lifeboat in the harbour.

In 1976 the pier was deemed to be unsafe and two years later, on 11th-12th January 1978, it was destroyed by a storm. A severe northerly 80mph gale whipped up a tidal surge that was almost as bad as that of 1953. East Kent took the full force with winds of around 80mph.

The combination of the wind and waves was too much for the 123 year-old iron pier, which broke into 3 sections; most of it is now beneath the sea. The main end section, and the lifeboat house, which had stood halfway down it, were now marooned but thankfully the lifeboat was out at sea. It was this same storm that prompted the building of the Thames Flood Barrier as a disastrous flooding of London was only just avoided – the Thames getting to within 19 inches of the retaining walls.

In the aftermath of this storm, Tudor bricks and parts of the old sluice that drained the area up until the middle of the nineteenth century were discovered on the beach.

It took another 20 years for the remains of the pier to be removed.

Alexander Mitchell came up with a technique of screwing each pile ten feet into the chalk that was so effective, that after a great storm in 1978 that virtually destroyed the pier it took the best part of twenty years of trying to get the things out again!

SEE Birch, Eugenius/ Britannia pub/ Camera Obscura/ Coastguards/ Fires/ Husbands Boat/ Lifeboat/ Margate/ Pancake ice/ Storms/ Wesleyan Methodist Church/ Without Prejudice

PIER, Ramsgate

Having just had his daily swim, Samuel Taylor Coleridge bumped into the Prime Minister (Lord Liverpool) and the Foreign Secretary (George Canning) on Ramsgate pier.

Coleridge, in a letter to James Gillman on 10th November 1822: *On Wednesday, as Mrs. G. & I were on the Pier, whom should I see but Lord Liverpool & Mr. Canning, with Lords Bentinck & Howard de Warden. Lord L. did not recognize me – nor Mr Canning – till I took off my Hat (by Mrs. G's desire as if to dry my locks, I having just returned from the Machine) – he then looked at me & I advanced & addressed him. He received me very cordially - & called out – Liverpool! Here is Mr. Coleridge – and so I walked arm in arm with them, down the Pier, thro' the town, and up to the cliff, to see the Wellington Crescent &c – and they seemed pleased to have me.*

SEE Canning, George/ Coleridge, Samuel Taylor/ Liverpool, Lord/ Pegwell Bay Reclaimation Co/ Promenade Pier/ Ramsgate/ Wellington Crescent

PIERREMONT AVENUE, Broadstairs

The lower gatehouse of the Pierremont Hall Estate was removed in 1898 to make way for the development of Pierremont Avenue.

SEE Broadstairs/ Pierremont Hall

PIERREMONT HALL
High Street, Broadstairs

The name Pierremont derives from the French for St Peter's Mount, and the name precedes the building.

Pierremont Lodge (later to become Pierremont Hall) was designed by Samuel Pepys Cockerell (1754-1827), a descendent of Samuel Pepys, and was built in 1785 as a country seat for Thomas Forsyth. The grounds covered 30 acres between Pierremont Avenue, The Vale, York Street and Ramsgate Road. The materials for the house had to come by sea - the age of the DIY superstore not yet having dawned. Forsyth only intended to stay at the place for a few weeks each year and Lady Fitzherbert got the credit for nicknaming it 'Forsyth's Folly'.

Within a few years, Mr T W Payler bought Pierremont Lodge and saw out his days there. Edward Fletcher was the next owner and he added a coach house and stables as well as a cottage for his gardener - and this was a gardener worthy of his own cottage. He grew rare fruits, a grape vine and lemon trees in hot houses and in the gardens there was a good population of nightingales nesting alongside the Japanese pheasants and peacocks that wandered around. There was also a gatekeeper's lodge in York Street and another where the war memorial now stands. Fletcher rented out the hall for 25 guineas a week for three months at a time to the Duchess of Kent and her eight year-old daughter Princess Victoria. They stayed at Pierremont Hall from 27th July to 3rd November 1827. When she went on the beach she had her own white donkey, Dicky, who had been a present from the Duke of York. Her party must have been quite a sight on the beach as she was usually accompanied by three more donkeys, three ponies and seventeen horses – and hopefully a man carrying a shovel and a big bucket. The small building, separated from the hall, that was used by Victoria for her music lessons later became the Council Planning Office,.

When Fletcher died in 1846, Mr E F Maitland bought the place for £4,428, but it was sold again in 1854 to Edmond and Samuel Grimshaw, although the price had gone up to £7,550. For the ten years following Edmond Grimshaw's death in 1875, the estate was placed in trust before it was sold to J B Arnold who paid £9,900 for it in 1895, and then a schoolmaster named L

W Poznett paid £3,500 for it in 1896. This lower price is connected to William Copping having bought some of the land which he then developed as 'Royal Pierremont Park Estate.

Poznett then leased the house for the next 21 years, at £220 p.a., to three brothers named Farnfield; they founded Pierremont College private school in 1907.

Daniel Mason paid £4,500 for the house in 1917 but sold it five years later for £5,500 to a syndicate comprising of H Bing, Dr Frank Brightman, Major H T Gulliver, and Mrs Louisa Nook. The buying and selling ended in 1927 when Broadstairs and St Peter's Urban District Council paid £5,500 for it.

The upper gatekeeper's lodge was removed in 1923 and replaced the same year by the Broadstairs War Memorial.

Jo-Ann's Court was built in 1966 and replaced the old stables.

SEE Broadstairs/ Donkeys/ High Street, Broadstairs/ Mason, Daniel/ Ramsgate Road, Broadstairs/ Schools/ Victoria

PIERREMONT MILL
High Street, Broadstairs
Old maps show a mill here as far back as 1596. A new mill was built in 1827, owned by a Mr T Hodgman. He sold it in 1874 to William Hills who had to fork out £62 in 1881 on a new brake-wheel. The mill had 'run away' and caused a bit of damage!

Between c1815-c1845 there was a second smock mill here to keep it company.

Pierremont Mill stopped being used in the early 1900s and was demolished in 1909, the site became Mill Stores and then Pierremont Stores until 1975. Mill Cottage and Old Mill Terrace were built in 1910.

Just up the road was Claremont, or Clairmont, Mill owned by R Goodson of Upton Farm, but it was replaced in 1852 by Claremont House. The old mill was put on a wagon and sent off to Canterbury; Pierremont Mill then became known as Broadstairs Mill.

SEE Broadstairs/ Farms/ High Street, Broadstairs/ Windmills

PILCHER PAGE & Co.
King Street, Ramsgate
Ramsgate, by J S Rochard, c1900:
Messrs PILCHER PAGE & CO. Wholesale and Family Grocers, Agents for Messrs W & A Gilbey, King Street. Telephone Number 17 There is probably no other house in town that can make an equally attractive display of goods, for the high-pitched well-lighted, and spacious shop with mahogany counters is admirably suited for the purpose. The premises contain almost everything known to the trade, yet the shop is quite free from any appearance of overcrowding. Customers calling for the first time are enabled readily to select and compare their purchases. Here are splendid home-cured hams, Harris's Wiltshire bacon, fresh laid eggs, choice dairy butters, a fine selection of cheese, tinned and potted delicacies, preserved fruits, ginger, jams, marmalades, and an excellent variety of all kinds of comestibles. The warehouse and cellars are enormous in extent. The spacious cellarage affords a very ample storage for wines and spirits, of which, as agents for the well known firm W & A Gilbey, a very full stock is held.
SEE King Street, Ramsgate/ Ramsgate/ Shops

PILLOW TALK
Marine Drive, Margate
The sex shop opened in 1980 and stands on the site of an old brothel. The ghost of a former prostitute is reputed to haunt the building.
SEE Ghosts/ Margate/ Marine Drive/ Prostitutes/ Shops

PLAGUE, Birchington
As far back as the mid-1300s the Black Death has caused many deaths here.

An attack from June 1544 to March 1545 killed around 50, or about one in eight of the villagers. The village also suffered a similar fate in 1603, 1604, and 1615-19.

In 1625 a traveller brought an unwelcome visitor with him to the village. It was the plague. In the next 12 months, although the village had 32 baptisms it also had 72 funerals. By comparison the figures for the period 1564-1600 were 598 baptisms, 478 funerals, and 189 weddings.

At the time, it was suggested that the cause of the Plague was due to the unsanitary state of the village! Thought to be? Rats, who carried the plague, loved it in those days when rubbish was just thrown outside into the road – dust carts had not yet been invented, and re-cycling was unheard of.

The down side of being a rat, well there are plenty when I think about it, but the particular one I am referring to is the price on their heads. In 1773 - after the plague years, I grant you, but memories were obviously long - one halfpenny was paid out on each tail; presumably, you could do what you wanted with the rest of the rat, a pie possibly. That year, the total reward money paid out came to £8 12 shillings and 4½ pence, or 4,137 rats.

God's heavy hand visited again in 1637, 1644, and 1669 (again about 1 in 8 died in a population of around 400, although it seems to have been the last outbreak). Birchington avoided 1665's Great Plague of London, however, knowing the suffering that was involved, there were five generous collections of money in the village sent to help those in need in London. They were probably terrified of getting a thank you note in case it was germ ridden.
SEE Acol/ Birchington

PLAINS of WATERLOO, Ramsgate
Samuel Taylor Coleridge spent part of October and November on holidays in Plains of Waterloo with the Gillmans in 1822, 1823 (at No. 8), 1824 (at No. 1), 1825 (at No. 8), 1826 (at No 8) and 1828 (at No 9).

Whilst staying here in the autumn of 1823, Samuel Taylor Coleridge was working so hard that he was *'merely allowing myself two hours for Bathing and Exercise'*.

Wilkie Collins stayed at number 4 as a child and Pugin wrote part of 'The True Principles of Pointed or Christian Architecture' at what was then number 19, when he stayed here *'for the benefit of my children'* in the winter of 1841.

Karl Marx was on holiday on Jersey in 1879 with Eleanor, his youngest daughter, when he had to rush to 62 Plains of Waterloo, where Jenny, his eldest daughter, was nursing her very frail new baby. Marx, his wife, his daughter and her baby were all in poor health at the time.

On 26th May 1905, the number 47 tram ran out of control down the hill and thumped into Vye's the grocers with such a force that it could not be removed until the front of the building was shored up. The crew of the tram and the shop manager's seven-year old daughter were badly injured but there were no fatalities.
SEE Bathing/ Coleridge, Samuel Taylor/ Collins, William Wilkie/ Marx, Karl/ Ramsgate/ Trams/ Vye and Son/ Waterloo, Battle of

PLANE CRASH, St Peters
On Sunday 27th April 1952, the vicar of St Peters, the Reverend L C Sargent was giving his sermon and, as is not unusual, it went on a bit, overrunning by about ten minutes. Although many of the congregation may have sworn at the time, his waffling on, or his extra wisdom, depending on your point of view, saved the lives of many at church that morning, because had he finished on time, they would have been walking down St Peter's High Street just as an American F84 Thunder Jet crashed and demolished the sub-branch of Lloyds Bank and the neighbouring ironmongers shop, at the junction with Ranelagh Grove. The Manston-based pilot, Captain Clifford Fogerty, died. He had begun his military career during World War II in 1944 and died at the height of the cold war. He was married with a daughter. The 79 year-old ironmonger, William Read, and his wife, Evelyn May, 55, were found dead in the cellar beneath the shop and the bank. Ellen Collier, a widow, also died in the tragedy. The St Peter's Village Tour commissioned a memorial and it was unveiled in April 2003 by Lt Col Ron Bernal, the Marine attache at the US Embassy in London, and Hazel Pindr-White the Mayoress of Broadstairs and St Peters. The memorial was made by Andrews and Elliot Stonemasons who had once had premises on the same spot.

Opposite the crash site, The Cottage Tea Room was opened by Miss Ann Hayter and Miss Ball soon after.
SEE High Street, St Peter's/ Manston Airport/ St Peter's/ St Peter's Church

PLAZA CINEMA, High Street, Margate
A laundry was on the site before the Plaza Cinema was built. It is now the New Life Christian Fellowship Centre.
SEE Cinemas/ High Street, Margate/ Margate

PLEASURAMA, Ramsgate
An amusement park, built in what was formerly the Ramsgate Marine Railway Station.
SEE Ramsgate/ Ramsgate Sands Railway Station

PLUCK'S GUTTER

This is located where the B2046 now crosses the river Stour via a bridge, although originally there was a ferry here. When the bridge was being built in the nineteenth century, the landlord of the Dog and Duck, a Mr Pluck, ferried the men building it across the river, and it was they who named this stretch of the river Pluck's Gutter. On some old maps from the early part of the 19th century it is shown as Plux Gutter.

It was also on part of the route of the North Kent Gang who would walk the best part of fifteen miles from their base to Marsh Bay where they would earn their living from smuggling.

In the event of a German invasion during World War I, the bridge was to be the escape route for the Margate population, with all other roads, as well as the railway line, being reserved for the military.

SEE Margate/ World War I

PLUM PUDDING ISLAND

This is located behind the sea wall between Reculver and Minnis Bay. It is not an island, nor is there any plum pudding to be seen.

This was part of the coastal blockade, and the first Coastguard Station was situated near Plum Pudding Island in around 1818. The children of the coastguards attended a school in Park Lane from 1848, except when the 'way was dangerous' in winter – in summer it would still have been a cross-country trek. The cottages were demolished in c1860.

SEE Coastguards/ Minnis Bay/ Park Lane/ Schools/ Sea wall

POEMS/ POETS

SEE Arnold, Matthew/ Betjeman, Sir John/ Browne, John Collis/ Bryher/ Byron/ Cavendish Baptist Church/ Chariots of Fire/ Coleridge, Samuel Taylor/ Cowper/ Dearmer, Geoffrey/ Eluard, Paul/ George III/ George IV/ Gray, Thomas/ Hardy, Thomas/ Heine, Heinrich/ Henley, WE/ Hood, Thomas/ Horne, RH/ Johnson, Lionel Pigot/ Keats, John/ Kent Hotel/ Lamb, Charles/ Lear, Edward/ Luttrell, Henry/ 'Margate 1940'/ Marsh, Sir Edward/ Milton, John/ 'Misadventures at Margate'/ Munro, Harold/ Nerval, Gerard/ 'Ode to Broadstairs'/ 'Praise of Margate'/ Prince Albert pub/ Ramsgate song/ Rossetti, Christina/ Rossetti, GCD/ St Nicholas Court/ Siddal, Elizabeth/ Smith, Stevie/ Smuggler's Leap/ Standing Stones/ 'Tales of the Hoy'/ Uncle Bones/ 'Westgate on Sea'/ Wilde, Oscar/ Wolcot, John

POETS CORNER, Margate

A pun due to its proximity to streets named after Byron, Milton and Cowper. It was named after the area more accurately known as the South Transept in Westminster Abbey in London where most of the country's greatest poets and writers are either buried or at least remembered. William Caxton, the fifteenth century printer - born in Kent - happened to mention in the inscription that he left on Geoffrey Chaucer's grave in the abbey garden that he had been a poet and started the custom for burying writers and poets in that area.

SEE Byron/ Cowper/ Margate/ Milton/ Poets

POINTER

Mr F W POINTER, Wholesale and Retail Grocer and Tea Merchant,

63 King Street, and 15 Turner Street
Established about ten years ago, this business has made steady headway from the beginning. A speciality is made of choice teas, of which there is a large selection, including blends of the best growths, in addition to which coffees, spices sugars, and generally groceries are well presented. In the hardware department, cutlery, fireirons, brass goods, tinware, brushes, mats, pails, lamps and other general household requisites are stocked. A department is devoted to china and earthenware which include tea sets, dinner services, toilet seats, decanter sand vases of every description.

Ramsgate, by J S Rochard, c1900

SEE King Street, Ramsgate/ Ramsgate/ Shops/ Turner Street

POIROT

Fictional sleuth created by Agatha Christie and played on TV by David Suchet.

SEE Suchet, David and John/ Television

POLICE, Ramsgate

In 1816 the Police force in Ramsgate consisted of just a few constables and watchmen and it was not until 1837 that a sergeant was put in charge, and I was a further seven years until a Head Constable was added.

In 1855 George Pritchard was appointed Superintendent of Ramsgate Harbour Police with an annual salary of £120 plus an allowance for uniform and fuel.

In 1863 The Harbour Police, which comprised a sergeant and five constables, operated out of an office that also had one cell, close to the clock tower in the harbour.

By 1900 the Force comprised a Chief Constable, an inspector, five sergeants, and thirty constables. It was not until the 1930s that the first female joined.

The force merged into the Kent County Constabulary in 1943.

SEE Ramsgate/ Ramsgate Harbour Police/ Town Hall building, Margate

POLICE STATION, Cavendish Street, Ramsgate

The former Police Station was originally built in 1842 as the home for a wealthy local man. It has been a High School for Girls, a lunatic asylum, furniture repository and in 1895 it became a free library and technical institute, before the library moved round the corner into Guildford Lawn in 1904. On 9th May 1929, it became the Police station at a cost of £1,569. The building was also home to the St John's Ambulance Brigade and a mortuary.

In September 2005, permission was granted to convert the building and the old court-house into 82 flats.

SEE Cavendish Street/ Charlotte Court/ Libraries/ Ramsgate/ Schools

POLITICS

The word 'politics' is derived from the word 'poly' meaning 'many', and the word 'ticks',

meaning 'blood sucking parasites.' Larry Hardiman

SEE Aitken, Jonathan/ Any Questions/ Booth, Cherie/ Bulwer-Lytton, Edward/ Callis Court/ Canning, George/ Captain Swing/ Carson, Lord/ Cobbett, William/ Craig, Norman/ Curtis, Sir William/ Disraeli, Benjamin/ Election Results/ Fascists/ Gladstone, William/ Harmsworth, Alfred/ Harmsworth, EC/ Hart, Dr/ Heath, Edward/ Jordan, Sir William/ Layard, Sir Austen/ Lowther, James/ Moseley, Sir Oswald/ Paine, Thomas/ Pankhurst, Christabel/ Pethick-Lawrence, Emmeline/ Salisbury, Lord/ San Clu/ Scanlon, Lord/ Scarman, Lord/ Sheridan, Richard/ Suffragettes/ Thatcher, Margaret/ Tunnels, Ramsgate/ Vogel, Julius

POND – Birchington

On the way into Birchington there used to be a pond on the south side of Canterbury Road opposite Hudson's Mill on Mill Lane. In 1933 the pond was filled in.

East Kent Times, 2nd June 1909: '*Walter Goldsmith, a hawker of no fixed abode, was seen hitting a woman at Birchington. The people who saw him took matters into their own hands: they gave him a black eye and ducked him in the pond. Then about 50 people set about him, hitting and kicking him.*'

SEE Birchington/ Canterbury Road, Birchington/ East Kent Times/ Mill Lane, Birchington

POOLE

Ramsgate, by J S Rochard, c1900:
Messrs POOLE, High class Tailors for Ladies and Gentlemen
54 Queen Street
The business dates back its foundation some 50 years when it was established by a Mr Silver, from whom it was acquired by Mr Poole in 1878. The present building was erected by Mr Poole to accommodate expansion of business. There is a fine stone Gothic front and well finished mahogany door. The premises consist of a spacious single shop, very handsomely filled with cloth racks, shelves etc. for the display of one of the largest stocks of materials in Kent, and all the leading shades and materials produced by the leading manufacturers are always represented. Messrs Poole are able to offer to those who object to the high charges of the exclusive West End tailors and also do not care to wear the cheap and oftentimes somewhat 'nasty' clothing which proceeds from the 'cutting' houses, gentlemanly and fashionable garments at reasonable prices. Their trousers range from 16s 6d [82.5p] and tweed and other suits from 63s [£3.15].

SEE Queen Street, Ramsgate/ Ramsgate/ Shops

'POOR MISS FINCH' by Wilkie Collins

In this novel, published in 1872, Lucilla, the heroine, recovers at Ramsgate following an operation to restore her sight.

East Cliff Ramsgate, August 28th - A fortnight today since my aunt and I arrived at this place. I sent Zillah back to the rectory from London. Her rheumatic infirmities trouble her tenfold, poor old soul, in the moist air of the seaside.

oOo

He considered a little - and then turned the talk to the topic of our residence at Ramsgate next.

'How long do you stay here?' he inquired.

'It depends on Herr Grosse,' I answered. 'I will ask him when he comes next.'

He turned away to the window - suddenly, as if he was a little put out.

'Are you tired of Ramsgate already?' I asked.

He came back to me, and took my hand - my cold insensible hand that won't feel his touch as it ought!

'Let me be your husband, Lucilla,' he whispered; 'and I will live at Ramsgate if you like - for your sake.'

Although there was everything to please me in those words, there was something that startled me - I cannot describe it - in his look and manner when he said them. I made no answer at the moment. He went on.

'Why should we not be married at once?' he asked. We are both of age. We have only ourselves to think of.'

oOo

I proposed returning by the sands. Ramsgate is still crowded with visitors; and the animated scene on the beach in the later part of the day has attractions for me, after my blind life, which it does not (I dare say) possess for people who have always enjoyed the use of their eyes. Oscar, who has a nervous horror of crowds, and who shrinks from contact with people not so refined as himself, was surprised at my wishing to mix with what he called 'the mob on the sands.' However, he said he would go, if I particularly wished it. I did particularly wish it. So we went.

There were chairs on the beach, We hired two, and sat down to look about us.

All sorts of diversions were going on. Monkeys, organs, girls on stilts, a conjurer, and a troop of negro minstrels, were all at work to amuse the visitors. I thought the varied color and bustling enjoyment of the crowd, with the bright blue sea beyond, and the glorious sunshine overhead, quite delightful - I declare I felt as if two eyes were not half enough to see with! A nice old lady, sitting near, entered into conversation with me; hospitably offering me biscuits and sherry out of her own bag. Oscar, to my disappointment, looked quite disgusted with all of us. He thought my nice old lady vulgar; and he called the company on the beach 'a herd of snobs.' While he was still muttering under his breath about the 'mixture of low people,' he suddenly cast a side-look at some person or thing - I could not at the moment tell which - and, rising, placed himself so as to intercept my view of the promenade on the sands immediately before me.

SEE Books/ Collins, Wilkie/ Ramsgate

POORHOLE LANE, Westwood

This lane connects Margate Road, at the junction near the Star Inn, and Westwood Road at the junction by Ballantynes Health Club. In Tudor/medieval times the very poor, plague victims, drowned seamen and so on were buried in mass graves, brickfields or 'potters fields', the latter being ideal since the holes were already there; the name 'poorhole' derives from this usage. This may also explain why it is a bit of a bumpy ride when you drive down there, although it has recently been re-surfaced so I cannot refer to it as pot-hole lane as I used too.

SEE Margate Road, Ramsgate/ Star Inn

POPULATION

The total population of Thanet in 1981 was 115,825 (Margate 54,980; Broadstairs 23,447; Ramsgate 37,398).

Out of a total population of 126,702 in the 2001 census, approximately one half lived in Margate, a third in Ramsgate, and the remaining fifth lived in Broadstairs. There is a total of c55,000 households.

One third of the population is over 65.

Acol

In 1931, Acol had a population of 208 and covered an area of 533 acres.

Birchington

1801	537 in c100 houses
1830s	c800 in c150 houses
1901	2,128
1936	3,756
1980s	12,000

Broadstairs

1801	1,600
1841	1,519
1921	15,465
1931	12,748
1961	15,081
1971	20,048
1981	23,447
1991	22,118

Margate

In 1588 the parish of St John the Baptist had a population of around 700.

In the 1700s the population was thought to increase, with visitors, to around 20,000.

1801	4,766
1851	10,099
1881	18,000 (GB pop 12,552,144)
1901	23,118
1921	46,475
1931	42,259
1961	42,512
1971	50,347
1981	54,980
1991	56,734

Sarre

The population in 1931 was 159, in an area covering 667 acres. The population today is even lower at around 100.

Ramsgate

1801	4,200
1901	27,733
1921	36,560
1931	33,597
1961	35,801
1971	39,561
1981	37,398

St Peter's

In 1563 there were 186 households in St Peter's.

Westgate

1901:	2,738
1936:	4,556

SEE Acol/ Birchington/ Broadstairs/ Jedi/ Margate/ Ramsgate/ St Peter's/ Sarre/ Thanet/ Westgate

PORT AND ANCHOR public house
Albion Hill, Ramsgate

It was called the Royal Standard until the new owners, Thorley Taverns, re-named it in the 1990s. Apparently, it is Cockney rhyming slang for something but I don't know what. . . let's go through the alphabet. A - Banker? Canker – Danker – E – F – G – Hanker – I – J – K – Lanker – M – N – O – P – Q - Ranker – S – Tanker – W . . No I'm never going to get it.

SEE Albion Hill/ Pubs/ Ramsgate

POST BOX

One of the oldest post boxes in England is in Broadstairs' Chandos Square. It is hexagonal in shape, and has 'VR' embossed on the front dating it from the reign of Queen Victoria.

East Kent Times, 4th December 1912: *Tar in pillar boxes in Margate was generally regarded as being the work of the militant suffragettes'*

East Kent Times, 11th December 1912: *A bottle of staining fluid placed in a pillar box outside the Royal Hotel is attributed to the women's suffrage movement.*

SEE Broadstairs/ East Kent Times/ Margate/ Suffragettes

POST OFFICE, Margate

The post office was in Hawley Street in 1790, Charlotte Place in 1802, the High Street in 1815, and then moved to Cecil Square – although not the present site – in 1831; it was to be another thirty years before the public could actually go inside!

Pigot's 1840: *'Cecil Square, Frederick GORE, Post Master – Letters from London & c. arrive (by mail cart from Canterbury) every morning at half past six and are despatched every evening at nine – Letters from Broadstairs and Ramsgate arrive (by penny foot post) three times a day, and are despatched as often. – Letters to St Peter's are despatched every evening at half past six. The office closes for the London mail at half past eight in the evening, but letters are received until nine by paying twopence with each.'*

SEE Charlotte Place/ Hawley Street/ High Street, Margate/ Margate

POST OFFICE, Ramsgate

The Post Office moved from Burgess's Library in 1803 to 82 High Street. James

Ruddick was its postmaster until his death in 1840 and was succeeded by his wife as temporary post mistress. In time, John B Hodgson became postmaster and the Post Office moved back down the road next to his other business, The Isle of Thanet Building Society. Mrs Ruddick, meanwhile, turned the old premises into a pub – The Postman's Arms.

Pigot's 1840: *POST OFFICE 108 High Street, Mary Ruddick, postmistress – letters from London arrive every morning at seven and are despatched every evening at half past eight. Letters arrive from and are despatched to Margate three times daily. The office closes at eight at night, but letters are received until a quarter past eight by payment of 2d with each*

When Mr W G Hogben (the Sub-Postmaster in Queen Street) resigned, the Post Office moved to Mrs Colgate's premises at 52 Queen Street on 10th February 1900.

Two empty shops (42-44 High Street) that had been built in 1865/6 were joined together and The Post Office opened again in 1909.

SEE High Street, Ramsgate/ Libraries/ Queen Street, Ramsgate/ Ramsgate

POSTER

Broadstairs appeared on a Southern Railway poster between the wars designed by Margot Mace.

There is also a poster by Mauzan with 'Ramsgate' emblazoned across it and with the words 'Savon a barbe' (shaving stick) featuring a crazy looking gnome-type figure with his now detached beard in one hand and a shaving stick in the other. The complete wording is 'Savon a barbe Ramsgate. Parfumerie Ramsgate Paris.

SEE Broadstairs/ Mauzan, Achille Luciano/ Ramsgate/ Railway

Oliver POSTGATE
Born 1925

The creator of the children's TV puppet shows, 'The Clangers', 'Ivor the Engine', 'Noggin the Nog' (I used to love that programme!) and 'Bagpuss' apparently lives in Broadstairs.

SEE Broadstairs/ Television

POTATOES

During World War I, potatoes cost 1¾d per pound (you can work out the exact decimal/metric equivalent, but it is less than 1 pence per 454g). Mr Berry and Mrs Caroline Debling of 177 King Street, Ramsgate, and William Daisy of Packers Lane, Ramsgate, were fined £55 (in total) for overcharging their customers for potatoes.

SEE King Street, Ramsgate/ Ramsgate/ World War I

POULTRY FARMS

There were 6 poultry farms in Thanet in 1957. There are none listed in 2005.

SEE Farms/ Thanet/ Tyrrells Farm/ West Dumpton Lane

POWELL ARMS public house
The Square, Birchington

Probably Birchington's oldest inn, having been called the New Inn up until September 1823, when it was re-named in honour of Squire Powell of Quex Park when he became High Sheriff of Kent.

At one time the same room was used for the official meetings of the Parish church and the local smugglers. Not at the same time you understand, but some men could well have been at both meetings!

Near the Powell Arms used to stand the wax-house that made all the candles for All Saints Church.

SEE All Saints' Church/ Birchington/ Pubs/ Quex/ Square, The

POWERBOATS

The Powerboat Grand Prix is held in Ramsgate every June.

SEE Ramsgate/ Sport

'The PRAISE OF MARGATE'
by John Wolcot

Dear Margate, with a tear I quit this isle,
Where all seem happy; sweethearts, husbands, spouses:
On every cheek where pleasure plants a smile,
And plenty furnishes the people's houses.
What's Brighton, when to thee compared? poor thing,
Whose barren hills in mist for ever weep.
Or what is Weymouth; though a Queen and King
Wash, walk, and prattle there, and wake and sleep

Whate'er from dirty Thames to Margate goes,
However foul, immediately turns fair.
Whatever filth offends the London nose,
Acquires a fragrance soon from Margate air.

The Taylor here, the port of Mars assumes;
Who cross-legg'd sat in silence on his board:
Forgets his Goose and Rag-besprinkled rooms,
And Thread and Thimble, and now struts a Lord.
Here Crispin too forgets his End, and Awl.
Here Mistress Cleaver with importance look;
Forgets the Beef and Mutton on her stall,
And Lights and Livers dangling from the hooks.

Here Mistress Tap, from Pewter Pots withdrawn,
Walks forth in all the pride of paunch and geer;
Mounts her swoln heels on Dandelion's lawn,
And at the Ball-room heaves her heavy rear.

SEE Dent-de-lion/ Margate/ Poets/ Wolcot, John

PRAMS

Kent County Council issued an order which came into force on Friday 17th January 1902 saying that all baby perambulators must carry a light after dark, or you could be fined £2.

PREACHER'S KNOLL, Broadstairs

Preacher's Knoll is situated approximately where the shelter now stands in front of Victoria Gardens and the cliff promontory that separates Viking Bay from Louisa Bay. In the nineteenth century there was an archway through the cliff and it was called Arched Rock. The present name derives from outdoor church services that were held here before churches were built – or if it was sunny!

SEE Broadstairs/ Churches/ Jubilee Clock Tower/ Louisa Gap/ Viking Bay

Dr David PRICE

Opposite Hooper's Hill House in Cliftonville was Gloucester Lodge, the early nineteenth-century home of a local doctor and surgeon, Dr David Price. In later years, he had the front windows blocked up so that he could do his dissections of bodies without people looking in - or so that they didn't know what he was doing. The rumour went around that Ben Crouch, who lived at the Crown and Anchor in Zion Place and was notorious for recovering and selling dead bodies, was selling corpses to Dr Price. Like Hooper's Hill House, Gloucester Lodge too was demolished in 1960 along with Flint Row next to it, so named because it had flint walls. The houses were replaced with council flats.

SEE Cliftonville/ Crouch, Ben/ Hooper's Hill House

PRIDE

1643: *It hath been brought to the notice of Crown Commission Officers that the vessel of war 'Pride' which was of late stranded near the hamlet of Bradstow, hath now been all broken up by the inhabitants of that place, and the timber used to repair a ruinous mole; it hath also been noted that the natives are the source of much smuggled goods.*

SEE Bradstow/ Ships

'PRIDE and PREJUDICE'
by Jane Austen

I must now mention a circumstance which I would wish to forget myself, and which no obligation less than the present should induce me to unfold to any human being. Having said thus much, I feel no doubt of your secrecy. My sister, who is more than ten years my junior, was left to the guardianship of my mother's nephew, Colonel Fitzwilliam, and myself. About a year ago she was taken from school, and an establishment formed for her in London; and last summer she went with the lady who presided over it to Ramsgate. And thither also went Mr Wickham, undoubtedly by design, for there proved to have been a prior acquaintance between him and Mrs Younge, in whose character we were most unhappily deceived; and by her connivance and aid he so far recommended himself to Georgiana, whose affectionate heart retained a strong impression of his kindness to her as a child, that she was persuaded to believe herself in love, and to consent to an elopement.

oOo

Lady Catherine seemed resigned. 'Mrs. Collins, you must send a servant with them.

You know I always speak my mind, and I cannot bear the idea of two young women travelling post by themselves. It is highly improper. You must contrive to send somebody. I have the greatest dislike in the world to that sort of thing. Young women should always be properly guarded and attended, according to their situation in life. When my niece Georgiana went to Ramsgate last summer, I made a point of her having two men-servants go with her. Miss Darcy, the daughter of Mr. Darcy, of Pemberley, and Lady Anne, could not have appeared with propriety in a different manner. I am excessively attentive to all those things. You must send John with the young ladies, Mrs. Collins. I am glad it occurred to me to mention it; for it would really be discreditable to You to let them go alone.'

oOo

'Is your master much at Pemberley in the course of the year?'

'Not so much as I could wish, sir; but I dare say he may spend half his time here; and Miss Darcy is always down for the summer months.'

'Except,' thought Elizabeth, 'when she goes to Ramsgate.'

SEE Albion Place/ Austen, Jane/ Books/ Mansfield Park/ Ramsgate

PRIESTLEY'S CYCLE & MACHINE STORES, Ramsgate

Advertisement c1900:

Priestley's Cycle & Machine Stores
1& 6 Turner Street
High-class cycles, mail carts, perambulators, bath chairs, etc for SALE or HIRE. Repairs of every description.
Cycles made to order.
Machines bought or exchanged.
A large assortment of accessories kept in stock.
Official repairer to the C.T.C.

SEE Bicycle/ Ramsgate/ Shops/ Turner Street

PRIME MINISTERS

SEE Addington, Lord/ Asquith, Cynthia/ Booth, Cherie/ Canning, George/ Churchill/ Disraeli/ Fairfield House/ Fig Tree Inn/ Gladstone/ Heath, Edward/ Liverpool, Lord/ Peel, Sir Robert/ Salisbury, Lord/ Thatcher, Margaret/ Wellington, Duke of

PRIMITIVE METHODIST CHAPEL
Albion Road, Birchington

This was part of the Birchington Engineering Works on the north side of Albion Road. Mrs Gray, of Birchington Hall, bought it at the end of the nineteenth century and rented it to the School Authorities for a peppercorn rent so that it could be used as an infants school – which had previously occupied the Institute in the Square – a function it fulfilled until 1926. The building was demolished in 1988, to be replaced with houses and flats.

SEE Albion Road, Birchington/ Birchington/ Churches/ Schools/ Square, The

PRINCE ALBERT public house
High Street, Broadstairs

Originally it had five separate bars but the old pub of this name was demolished in 1910 and replaced in 1911, when the High Street was widened, with the current twin-gabled building which included a butchers shop – originally the London Central Meat Co Ltd. One former landlord, Mr Barnaschina from New South Wales, was nicknamed the Boko Poet of Broadstairs.

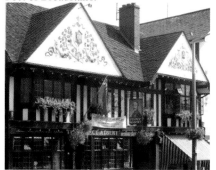

SEE Broadstairs/ High Street, Broadstairs/ Poets/ Pubs

PRINCE COBOURG public house
Ramsgate

This was situated opposite the Plains of Waterloo. The Waterloo Brewery had a malthouse next door.

SEE Breweries/ Plains of Waterloo/ Pubs/ Ramsgate

PRINCE EDWARD PROMENADE
Ramsgate

This runs parallel to the Royal Esplanade and the name commemorates Prince Edward's visit to Thanet on 24th November 1926, when his route was lined with tens of thousands of people – the Prince remarked that he thought every inhabitant had come out to meet him. The streets along the route were festooned with decorations and a giant archway was erected over the spot where the opening ceremony took place. Prince Edward wore an overcoat with a white flower in the button hole and a bowler hat. He, along with the mayor, Alderman Frederick Clive Llewellyn, the deputy mayor and 300 guests attended a luncheon at the Granville Ballroom where apparently the Prince tucked into some chicken and ham, one or two biscuits, and three cups of coffee. The next day he sent a letter:

Dear Mr Mayor,
I hope you will convey to all at Ramsgate my sincere thanks for the splendid welcome which was given me everywhere yesterday. The time spent was most enjoyable and I much appreciate the excellence of the arrangements made throughout.
Yours sincerely
Edward P

SEE Ramsgate

PRINCE HARRY public house
Penshurst Road, Ramsgate

Number 1 Penshurst Road started as a private house, but became a school before World War I – the classrooms were in the hall at the junction of Thanet Road and Dumpton Park Drive. It became a private house again and then a hotel. In 1982 it was pub called the Amber Bar, but soon changed its name to the Prince Harry - almost certainly the first pub in the country to be named after him!

SEE Pubs/ Ramsgate/ Royalty/ Schools

'A PRINCE OF THE CAPTIVITY'
by John Buchan

Although Buchan is best known for his novel 'The Thirty Nine Steps' in which Broadstairs is featured as Bradgate, Broadstairs is mentioned by name in another of his books, 'A Prince of the Captivity' (1933).

'There were . . . too many people at Broadstairs'

SEE Books/ Broadstairs/ Buchan, John/ Thirty Nine Steps

PRINCES AVENUE, Ramsgate

This appears on a 1907 map but with very little housing yet developed.

SEE Ramsgate

PRINCES GARDENS, Cliftonville

A lone German Gotha bomber destroyed the garden and rear of 7 Princes Avenue on 7th July 1917.

SEE Cliftonville/ World War I

PRINCE'S ROAD, Ramsgate

The Corporation Depot provided a base for 40 vehicles and 200 men, when it opened in the summer of 1964.

SEE Ramsgate

PRINCE'S STREET, Ramsgate

This area was called Langley's Place in 1736 and in 1740 it was known as the Hole and Up South End. Nowadays, it is the entrance to a multi-storey car park off Queen Street, but once contained cottages and was the route used by Sir William Curtis to bring his friend, King George IV, to his home.

SEE Curtis, Sir William/ George IV/ Neptune Row/ Queen Street, Ramsgate/ Ramsgate

PRINCES WALK

Running along the clifftop at Cliftonville, Princes Walk was opened in 1926 by the Prince of Wales.

SEE Cliftonville

The PRINCESS OF WALES public house
Tivoli Road, Margate

The public house (on the corner of Tivoli Road and Buckingham Road) was named after the Danish Princess Alexandra, who visited in 1863; after whom also the Alexandra Homes for the elderly are also named (she also had a pub named after her in Ramsgate). The pub dates from 1877 although the building itself dates from around 1850 when it was three terraced houses. It opened just as the Tivoli gardens' popularity was coming to an end and as business there faded, it flourished here. There was an old stable block in the beer garden and what later became a builder's shed was once a coach house.

A recent popular landlady was known as the Duchess. Hilda Cooper had been a leading singer in the West End in her younger days (she had been taught by Dame Clara Butt, the opera singer) and had previously been the landlady of the Elephant in Marine Gardens.

A regular visitor was Hughie Green who was a great friend of Hilda's and he often brought a gift of a doll to add to the collection she kept in glass cases in the bar.

Due to re-numbering and re-classifications, The Princess of Wales address at different times has been 5 Buckingham Terrace, Tivoli Road, 20 Tivoli Road and Buckingham Road.

SEE Buckingham Road/ Green, Hughie/ Margate/ Marine Gardens/ Pubs/ Tivoli Road/ Twelve Nails, The

PRIORY SCHOOL
Cannon Road, Ramsgate
The new Priory School opened in October 1995 with 180 pupils between the ages of 4 and 7. It incorporated the original school plaque and bell in the building.

SEE Cannon Road/ Ramsgate/ Schools

PROMENADES
The promenade from Viking Bay to Dumpton Gap was built in 1965 at a cost of £285,000. It was opened by Lord Cornwallis on 30th June 1965.

The promenade from Broadstairs Harbour to Stone Gap was built in 1971 and cost £375,000.

SEE Broadstairs/ Dumpton Gap/ Stone Bay/ Viking Bay/ Winter Gardens

PROMENADE PIER, Ramsgate
The Promenade Pier Company was formed in 1881, and the Promenade Pier - built by Head Wrightson and Co – was situated at the end of Marina Drive. It was 300ft long by 30ft wide and at the end of the pier was a large shelter and a small theatre, The Pier Hall, which could hold 200 people. Tickets to get on the pier cost 2d, or 1d for a child. The Promenade Pier Company opened it in July 1881 and sold 15,000 shares at £1 each, but it was a financial failure and was sold on 16th March 1884 to the contractors at £2,000; in all making a loss of £1,300 by the time it closed. It did re-open with a switchback to transport paying punters to the end of the pier.

Gales from 29th November to 2nd December 1897 damaged it.

East Kent Times, 17th June 1918: *The Marina or 'Iron' Pier was damaged on Saturday to the tune of several thousand pounds when a fisherman threw a match near to the buildings at the seaward end causing a fire.*

It was further damaged by a World War I mine which exploded later in 1918. It was eventually dismantled in June 1930 after remaining derelict for 12 years.

SEE East Kent Times/ Fires/ Pier, Ramsgate/ Ramsgate/ Royal Victoria Pavilion/ Without Prejudice

PROSPECT HILL, Minster
Evidence of cremations in the Roman era have been found around the Prospect Hill area and in the area to the south of the church.

SEE Minster

PROSPECT INN, Minster

It was built in the late 1930s by Oliver Hill in the International Cunard style. The first fatal car crash happened near the site of the Prospect Inn.

SEE Hill, Vince/ Minster

PROSPECT TERRACE
West Cliff, Ramsgate
At 11am on 20th March 1941, two Messerschmitt fighter-bombers attacked Prospect Terrace.

SEE Ramsgate/ World War II

PROSTITUTES
On one stay at Broadstairs, Charles Dickens wrote to the painter Maclise to suggest that he might like to visit the Margate prostitutes: *'there are conveniences of all kinds at Margate (do you take me?) and I know where they live.'*

SEE Broadstairs/ Dickens, Charles/ Jack the Ripper/ Margate/ Pillow Talk/ Siddal, Elizabeth

PRUSSIA
A leading state in the German Empire, it's territory encompassed parts of modern day Poland, Latvia and Lithuania. Berlin was the last capital of Prussia.

The Queen of Prussia sailed from Ramsgate Harbour to Ostend in 1863.

SEE Blucher, von/ Crampton, Thomas/ Grand Old Duke of York/ Napoleon, Prince/ Harbour, Ramsgate/ Ramsgate/ Royalty/ Tissot/ Waterloo

PRYCE & JUDD
Ramsgate, by J S Rochard, c1900:
Messrs PRYCE & JUDD, Furnishing and General Ironmongers, Ship and Yacht Fitters and Ship Chandlers, Oil Merchants, Gas and Water Fitters, etc, Cutlers, Bell Hangers etc, 24 Queen Street
The business has been in existence since 1830. Previous owners were Mr Elgar (founder) and Mr Cramp. The establishment is handsomely fitted up, and the large stock of brass goods, cutlery, and electroplated ware makes it a very handsome display. Also for sale may be found anchors, ships' lamps, fog horns, compasses, barometers, mast head lights and burglar alarms.

SEE Queen Street, Ramsgate/ Ramsgate/ Shops

PUBS
SEE Acorn Inn/ Addington Street, Ramsgate/ Adelaide Gardens/ Admiral Fox/ Admiral Harvey/ Albion Inn/ Albion Hotel, Broadstairs/ Alexandra Arms/ Anderson's Café, Broadstairs/ Artillery Arms/ Australian Arms/ Bar 26/ Bar Barcelona/ Barnaby Rudge, Broadstairs/ Barnacles/ Bedford Inn/ Bell Inn/ Belle Vue Tavern/ Bellevue Tavern/ Biggs, Ronnie/ Black horse Inn/ Blazing Donkey/ Bowler's Arms/ Bracey's/ Bradstow Mill, Broadstairs/ Breweries/ Britannia/ Brown Jug/ Bulls Head/ Camden Arms/ Captain Digby, Broadstairs/ Charles Dickens, Broadstairs/ Churchill Tavern/ Clifton Arms/ Cottage/ Coxswain/ Cranbourne Alley/ Crown/ Crown & Sceptre/ Crown & Thistle, Northdown/ Crown & Thistle, St Peter's/ Crown Inn/ Dane Valley Arms/ David Copperfield, Broadstairs/ Deal Cutter/ Derby Arms/ Dog & Duck/ Dogget, Coat & Badge/ Dolphin Inn, Broadstairs/ Dover Castle Inn/ Druids Arms/ Duke of Edinburgh/ Duke of York/ Eagle Inn, Ramsgate/ Earl St Vincent/ East Kent Arms/ Elephant & Castle/ Ellingon Arms/ Elms/ Falstaff Inn/ Feeney's/ Fig Tree Inn/ First & Last/ Five Tuns/ Flag & Whistle/ Flying Horse/ Forresters Arms/ Fort Brewery Tap/ Fort House Castle/ Fountain Inn/ Foy Boat Inn/ Frank's/ Garner's Library/ George & Dragon/ Good Intent/ Hare and Hounds/ Harvey's/ High Street, Margate/ High Street, Ramsgate/ Hollicondane/ Honeysuckle Inn/ Horse & Groom/ Hotels/ Hovelling Boat Inn/ Hoy, The/ Hussar/ Jackson's Wharf/ Jazz Room/ Jerrold, Douglas/ Jolly Farmer/ Jolly Sailor Inn/ King of Denmark/ King's Head, Margate/ King's Head, Sarre/ Lanthorne, Broadstairs/ Lester's Bar & Restaurant/ Liverpool Arms/ London Tavern/ Lord Byron/ Lord Nelson, Broadstairs/ Mechanical Elephant/ Montefiore Arms/ Mucky Duck, Broadstairs/ Mulberry Tree/ Neptune's Hall/ New Inn, Birchington/ New Inn, Margate/ North Pole/ Northdown, The/ Northern Belle/ Oak & Shade/ Old Crown, Broadstairs/ Old Margate/ Orb, The, Margate/ Pewter Pot/ Phoenix/ Port & Anchor/ Powell Arms/ Prince Albert, Broadstairs/ Prince Coburg/ Prince Harry/ Princess of Wales/ Punch & Judy/ Quart in a Pint Pot/ Queen's Head, Birchington/ Queen's Head, Margate/ Queen's Head, Ramsgate/ Racing Greyhound/ Railway Tavern/ Red Lion, Ramsgate/ Red Lion, St Peters/ Red Lion, Stonar/ Rising Sun/ Rodney/ Rose, The/ Rose in June/ Royal Exchange Inn/ Saracen's Head/ Shakespeare, Margate/ Shakespeare, Ramsgate/ Ship Inn, Margate/ Ship Inn, Ramsgate/ Sir Francis Drake/ Sir Stanley Grey/ Six Bells/ South Eastern Tavern/ Sportsman Inn/ Spread Eagle Inn/ Star Inn/ Sun Inn/ Swan/ Tartar Frigate, Broadstairs/ Tatnell's Clifton Tavern/ Three Tuns, Broadstairs/ Town of Ramsgate/ Trinity Square, Broadstairs/ Vale Tavern/ Van Gogh/ Victoria/ West Cliff Tavern/ Wheatsheaf, Northdown/ Wheatsheaf, St Lawrence/ White Hart/ White Horse Inn/ White Stag/ White Swan, Broadstairs/ Windmill Inn/ Wishing Well, Broadstairs/ Wrotham Arms, Broadstairs/ Yates' Wine Lodge/ Ye Foy Boat Inn/ Ye Olde Charles/ York Arms/ York Tavern/ Zion Place

Augustus Welby Northmore PUGIN
Born Bloomsbury 1st March 1812
Died Ramsgate 14th September 1852
He was the English-born son of Augustus Charles Pugin, a French-born neo-Gothic architect. He trained as a draughtsman as one of his father's pupils. At the age of 15, he started designing Gothic furniture made by Morel and Seddon for Windsor Castle as well as metalwork for Rundell, Bridge & Co., the Royal goldsmiths. He was able to design pretty much anything – textiles, ceramics, wallpaper, stained glass as well as wood and stone carving.

He converted to Roman Catholicism in 1835 and this, combined with a similar zeal for the Gothic style of architecture which he saw as the only truly Christian style, led him to design many churches.

Amongst his main projects were Scarisbrick Hall, Lancashire (from 1837); Bishop's House, Birmingham (1840); Roman Catholic cathedrals of St Chad, Birmingham (1839-1841) and St George, Southwark, London (1837-1848); St Giles's Church, Cheadle (1841-1846); and St Patrick's College, Maynooth, Ireland (1846-1853); and the Medieval Court at the Great Exhibition of 1851. His best-known work today is the interior of the Houses of Parliament.

Sir Charles Barry employed him to work on the Houses of Parliament after they were

burnt down in 1834 and it must be stressed that he designed everything that was used in the interior, even down to the inkpots.

In Ramsgate, he designed The Grange and St Augustine's Abbey.

He was married three times, widowed twice and had eight children. His first wife was Ann Garnett (1814-1832). The marriage produced one child, Anne (1832-1897). His second wife was Louisa Burton (c1813-1844) and they had five children in nine years: Edward (1834-1875), Agnes (1838-1895), Cuthbert (1840-1928), Katherine (1841-1927) and Mary (1843-1933). It was while he was married to Louisa Burton, his second wife, that he moved to Ramsgate, although Louisa died in 1844 just after The Grange was finished. He was then engaged to Helen Lumsden but her family were against it. He married his third wife, Jane Knill (1825-1909), in 1848 and they had two children, Margaret (1849-1884) and Peter Paul (1851-1904).

There was a large anti-Catholic movement at the time and Jane wrote of how fearful she was in November 1850 because a mob of anti-popery demonstrators were marching to The Grange carrying an effigy of the Pope. Fortunately the police were able to turn them away before they got there.

Pugin died at the age of 40, on the same day as the Duke of Wellington, 14th September 1852. Some say it was due to a 'mental collapse' or exhaustion, which, considering his private life and how much work he packed in would make sense, but there is a school of thought that blames the mercury treatment he had for an eye infection as being the real cause of death.

He is buried with his wife, Jane, and other family members below the floor of chantry in St Augustine's Abbey.

SEE Churches/ Grange, The/ Luck, Alfred/ Lumsden, Helen/ Nelson Crescent/ Pugin, Cuthbert/ Pugin, Edward Welby/ Pugin, Peter Paul/ Ramsgate/ Rose Hill Cottage/ St Augustine's Abbey/ St Augustine's Church/ St Augustine's Road/ Seaman's Infirmary

Cuthbert Welby PUGIN
Born 1840
Died 1928
Cuthbert was the middle one of the Pugin brothers, the sons of Augustus. He was in partnership with Peter Pugin. In 1880 Cuthbert, aged 40, retired to Ramsgate where he ran his father's old workshop.
SEE Pugin, Augustus Welby Northmore/ Pugin, Edward Welby/ Pugin, Peter Paul/ Ramsgate

Edward Welby PUGIN
Born 1834
Died 1875
He was just 18 when his father died, but, as the eldest son, he took over the business and kept most of his clients.
Earl of Shrewsbury: *'His unexpected death did not lead to the banishment of the Gothic and his son Edward proved to be one of the most important Catholic High Victorian architects in the Gothic style from the middle of the century.'*

He built over one hundred Roman Catholic churches in Britain and Ireland, as well as a few in Belgium, Denmark and Canada, and over thirty in the USA where he set up an office on Fifth Avenue, New York after filing for bankruptcy in England in 1873.
SEE Albert Road, Ramsgate/ Churches/ Denmark/ Granville Hotel, Ramsgate/ Hudson's Mill, Ramsgate/ Pugin, Augustus Welby Northmore/ Pugin, Cuthbert/ Pugin, Peter Paul/ Ramsgate

Edward PUGIN – bust

The Dolomite marble bust of Edward Pugin, situated outside the Granville Hotel was commissioned in 1879, a quarter of a century after his death, and sculpted by Owen Hale . It became Grade II listed in 1973 and restored in 2006.
SEE Listed buildings/ Pugin, Edward/ Ramsgate

Peter Paul PUGIN
Born 1851
Died 1904
He was the younger brother of Edward Pugin and designed Catholic churches almost to the exclusion of anything else. Between 1875 and 1880 he was in partnership with his brother Cuthbert and George Coppinger Ashlin (1837-1921), his brother-in-law, and they traded as Pugin, Ashlin & Pugin. George had been a pupil of, and then a partner of Edward Pugin and married Edward's sister, Mary Pugin. Between 1880 and 1884 Peter practised on his own as Pugin & Pugin.

He also designed the lower storeys of Hudson's Flour Mill in Margate Road.
SEE Churches/ Hudson's Mill/ Pugin, Augustus Welby Northmore/ Pugin, Cuthbert Welby/ Pugin, Edward Welby/ Ramsgate/ St Ethelbert & St Gertrude Church

PUGIN in Ramsgate
SEE Albert Road/ Grange, The/ Ramsgate/ St Augustine's Abbey/ St Ethelbert's & St Gertrude Church

PULHAMITE
This was a fake stone made from cement and other secret ingredients known only to Mr Pulham and used by Pulham & Son in the building of Madeira Walk and the Winterstoke Undercliff.
SEE Madeira Walk/ Ramsgate/ Winterstoke Undercliff

PUNCH and JUDY
A very popular puppet show performed on British beaches; Margate, Broadstairs and Ramsgate included. They are as much a part of British seaside tradition as sandcastles, donkey rides, fish and chips, rain and sand in sandwiches.

Mr Punch has been here for about 350 years and his birthday is said to be 9th May 1662 – the day Samuel Pepys recorded in his diary seeing Pietro Gimonde operating as 'Signor Bologna' performing a Punch and Judy marionette (not a glove-puppet) show near St Paul's Church in London. *'Thence to see an Italian puppet play that is within the rayles there, which is very pretty, the best that ever I saw, and great resort of gallants.'* Pepys went back to see the show several more times!

Punch was originally from Italy where he was Pulcinella (because of his beaky nose and squawky voice, in Italian the name means 'little chicken') and was originally part of 'The Commedia Delle Arte' a touring group of minstrels and poets. Groups sprung up all over Europe, a bit like boybands today, but had a different name in each country. France had Polichinelle, Russia had Petrushka, and in Germany it was Hans Wurst (Jack Pudding). In the late seventeenth century they began to appear in England.

Mr Punch and his wife Judy would seem to have moved to an old people's home somewhere because they are becoming a rare sight on Britain's beaches. However, the Broadstairs Punch and Judy got national coverage in 2005 when Brent de Witts included puppets of Osama Bin Laden and Saddam Hussein in his show and was told by the council to stop using them.

Traditionally the stories involved a policeman, the ghost, Toby the dog, the hangman, a sausage eating crocodile, and Punch shouting 'That's the way to do it!' voiced by a puppeteer with a swozzle in his throat to create that distinctive voice. In an age before political correctness, children and adults would laugh their heads off at stories involving wife-beating and murder. Nowadays they watch Eastenders, but there are not so many laughs.
SEE Broadstairs/ Donkeys/ Margate/ Pepys, Samuel/ Ramsgate

PUNCH AND JUDY public house
Marine Terrace, Margate
A pub formerly known as The Cinque Ports.
SEE Cinque Ports, The/ Margate/ Pubs

PUNCH MAGAZINE
It described Broadstairs some years after Dickens holidayed here as *'a shrine to which certain fashionable people make a yearly pilgrimage, in order to take penance'*.
11th July 1891: *I remember some years ago passing a very pleasant half hour on board of a lightship moored in the neighbourhood of Broadstairs. The rum was excellent.*
14th March 1917: *Broadstairs Council has been offered six pounds for a sand-artist's pitch. The advance in price is attributed to the growing attraction of the place for foreigners on a flying visit.*
26th February 1917: *With suitable solemnity Sir Edward Carson gave a brief account of the exploits of the German destroyer squadrons. One of them, comprising several vessels, had engaged a single British destroyer for several minutes before cleverly*

executing a strategic movement in the direction of the German coast; while another had simultaneously bombarded the strongholds of Broadstairs and Margate, completely demolishing two entire houses. The damage would have been still more serious but for the fortunate circumstance that the fortresses erected on the foreshore last summer by an army of youthful workpeople had been subsequently removed.

4th June 1919: *THE GREAT GOLF CRISIS*
A great budget of correspondence from all parts of the country has reached Mr. Punch concerning the suggestions put forward by famous golfers with the view of modifying the predominant influence exercised by putting in golf. A crisis is rapidly being reached and Government intervention may be invoked any day.

Mr. Ludwig Shyster, of the North Boreland Golf Club, suggests that the tin in the hole should be highly magnetised and the ball coated with a metallic substance so that it might be attracted into the hole. Golf, he contends, is a recreation, and the true aim of golf legislation should be to make the game easier, not more difficult; to attract the largest possible number of players and so to keep up the green-fees and pay a decent salary to secretaries and professionals.

Hanusch Kozelik, the famous Czecho-Slovakian amateur, who has recently done some wonderful rounds at Broadstairs, cordially supports George Duncan's advocacy of a larger hole. He sees no reason why it should not be three feet in diameter, provided the greens were reduced to eight feet square and surrounded with a barbed-wire entanglement.

SEE Broadstairs/ Carson, Lord/ Dickens, Charles/ Margate/ North Foreland Golf Club

Q

'QUARANTINE ISLAND' (1888)
by Sir Walter Besant (1836-1901)
Far away on the horizon, like a blue cloud, one could see land; it was the larger island, to which this place belonged. At the south end was a lighthouse, built just like all lighthouses, with low white buildings at its foot, and a flagstaff, and an enclosure which was a feeble attempt at a flower-garden. You may see a lighthouse exactly like it at Broadstairs.
SEE Books/ Broadstairs/ Lighthouse, North Foreland

QUART IN A PINT POT public house
Charlotte Square, Margate
Almost certainly a conversion from a house, to a beer shop, then to a pub, the first mention of The George and the Dragon in Charlotte Place is in an 1839 trade directory. At the end of the nineteenth century, a one-storey extension was added to give an extra

bar and bottle and jug. A flagpole was used to add the final touch to the tower and general medieval castle-look of the place. In 1980, another extension was added and the living quarters were replaced by a games room. There was also a cloistered beer garden overlooked by St Johns Church. The name was changed at this time to The Quart in a Pint Pot. One former landlord was Bill Hamilton who played football for Scotland.
SEE Charlotte Place/ Margate/ Pubs/ St John's Church

QUEEN BERTHA'S SCHOOL
Canterbury Road, Birchington
Founded in 1929 by Miss C M Hunt and Miss E Randall Harris. They bought Fernleigh – once the home of Alderman Robert Grant JP– and in 1934, added Rosebank, the neighbouring property - once the home of Lord and Lady Forrester but then a boys prep school, Birchington House School it had opened at the end of World War I. When the two ladies retired the property was sold and it is now the Queen Bertha estate.
SEE Bertha, Queen/ Birchington/ Canterbury road, Birchington/ Fountain/ Schools/ Square, The, Birchington

QUEEN STREET, Ramsgate
It was originally known as 'West End' and the buildings on the corner of York Street date back to 1866.
The section between York Street and Cliff Street was once a row of private houses, with gardens, but they were soon converted into shops. The last few survived until the area was redeveloped in the 1970s.
The Gym and Fitness Centre used to be the Primitive Methodist Church.
Christ Church, at the top end of Queen Street, was built around 1840-50 of Kentish ragstone brought from Maidstone.
Queen Street was damaged in the same Zeppelin raid (17th May 1915) that destroyed the Bull and George pub in the High Street.
SEE Baldock/ Barclays Bank/ Barnett's/ Blinko's book shop/ Bull & George/ Churches/ Courts Furniture Store/ Drays/ Dunn, E R/ Dunn & Sons/ Gwyn's Clock/ High Street, Ramsgate/ Hodgman/ Lloyds Bank/ Market, Ramsgate/ Obelisk/ One-way system/ Poole/ Post Office, Ramsgate/ Ramsgate/ Queens Cinema/ Tomson & Wotton/ Tunnels, Ramsgate/ Umbrella makers/ Vye and Son/ Vye Brothers/ Wagstall, E G/ Waitrose/ Weller, Sam/ Wiggett/ Zeppelin

QUEEN'S AVENUE, Ramsgate
This avenue appears on a 1907 map but with very little housing yet developed.
SEE Ramsgate

QUEENS CINEMA,
Queen Street,Ramsgate
The Queens Cinema opened in 1911 and operated until 1927. The building became the Ramsgate and District Electric Company's offices, then the Electricity showroom, and is now part of the Argyle Centre approximately where Tescos was, and Wilkinsons are now – are you keeping up with this?
SEE Cinemas/ Queen Street/ Ramsgate

QUEENS COURT, Ramsgate
This is just off Queens Street and Cavendish Street but can be seen from the Cavendish Street car park, and is probably Ramsgate's oldest building, dating from around 1600. Originally thought to be a farmhouse, the foundations are even older – well, they would be wouldn't they? – and suggests that it replaced an older building. It was restored in 1964 by Mrs J Grummant with the help of the Ramsgate Society.
SEE Cavendish Street/ Farms/ Queen Street/ Ramsgate

QUEEN'S GATE ROAD, Ramsgate
When this area was a field, it was the site of Buffalo Bill Cody's Circus in 1904. To give you an idea of the scale of his show, the one he put on in Bradford the previous October attracted a crowd of 28,000 who saw 800 performers and 500 horses. If you are wondering why your roses grow so well there, then you may have found your answer.
SEE Buffalo Bill/ Ramsgate

QUEEN'S HEAD public house
The Square, Birchington
Thought to be the original Acorn Inn, it is mentioned in the Kentish Gazette as far back as 1768. It closed in early 2003 and has been turned into flats.
SEE Birchington/ Square, Birchington/ Pubs

QUEENS HEAD public house
10 Market Place, Margate
This pub was established in 1835 with Isaiah Marsh as both landlord and an auctioneer. Just to confuse everyone, there was a Queens Arms elsewhere in Market Street and a Queens Arms Hotel round the corner in Duke Street. The original small, modest Queens Head was demolished and replaced in 1933 with a very grand building comprising not only a hotel, but also a sweet shop on the corner of Lombard Street complete with a gold vane on top. The hotel had eight rooms from which to choose, stone fireplaces and a very impressive carved wooden dumb waiter that operated from behind the bar.
SEE Margate/ Market Place, Margate/ Pubs

QUEEN'S HEAD public house
Harbour Parade, Ramsgate
The original pub stood out on its own by the pier yard. In 1906-7, as part of a road and sewer improvement programme, it was demolished and re-built further back next door to the Customs House. Its tiling and balconies make it a beautiful building.

SEE Harbour Parade/ Pubs/ Ramsgate

QUEEN'S HIGHCLIFFE HOTEL
Cliftonville

It was a very high class place in between the wars with rooms for guests and their servants and nannies, together with in-house facilities like hairdressing salons. Immaculate manners would be on display as you entered the luxurious surroundings in your evening dress and sat down for an eight-course dinner and, if you could move afterwards, you could dance to the hotel's twelve-piece orchestra in the sumptuous Louis Seize Ballroom.

In 1919, two Royal Navy battleships, the Revenge and Ramillies, anchored offshore allowing the crews to visit the town. The townspeople decorated the buildings and the sailors were given the freedom of the town. The Queens Highcliffe Hotel hosted a banquet for the officers and crew (there was also a smoking concert at the Westbrook Pavilion where *'a nautical dance with racy patter'* was included in the programme – and they talk about youngsters today eh?). The commanding officer, Vice Admiral Sir Sydney Fremantle expressed his delight with the welcome and the mayor thanked them for their protection of the town in the war *'The Germans did not do much damage at Margate, the bracing air was too much for them!'*.

The two wars and change in the social habits meant that trade declined. Butlin's took over six Cliftonville hotels including the Queens Highcliffe between 1955 and 1957 (the Highcliffe and St Georges were both bought in 1957). Out went the formal and in came the communal atmosphere along with the Redcoats. The orchestras were replaced by smaller bands who, in turn, made way for discos. Not one but two fires caused the magnificent building to be demolished and Queens Court (126 'housing units' – or flats) was built in 1993. When Butlin's took over the Princes Hotel – one of 7 Cliftonville hotels that they owned – they put in an indoor swimming pool which later became a dolphinarium.

Queen's Highcliffe Hotel is, at the time of writing, a derelict building site

SEE Bathing/ Butlin, Sir Billy/ Cliftonville/ Fires/ Hotels/ Margate/ 'Margate, 1940' by Betjeman/ Westbrook Pavilion

QUEENS PROMENADE, Cliftonville

Running below the Eastern Esplanade, Queens Promenade was the site of the Koh-i-Noor restaurant which, in time, changed its name to the Bungalow Restaurant. In 1980, it became the site of the Margate Aquarium, but unfortunately that went into liquidation – I'm sorry, I had to – and in 1993, it became a car park.

Between the two World Wars, the whole area would have been seething with people promenading in their finery. It was recommended at the time that ladies staying at the Cliftonville hotels pack a minimum of forty dresses and twelve hats for the duration of their holiday. A change in habits and a decrease in visitors, combined with a large

fire in 1975, has left the previously busy area very open and empty now.

SEE Cliftonville/ Eastern Esplanade, Cliftonville/ Fires/ Koh-i-Noor/ Margate/ Restaurants

QUEX ESTATE & MANSION
Birchington

It was owned by the Queks family in the fifteenth century and through judicious marriages during the sixteenth century the Crispes became the owners. Their guests were the rich and famous, amongst whom was William III (1650-1702. Reigned: 1689-1702) and Mary II who often stayed before they journeyed to and returned from Holland. Visits occurred in 1691, 93, 95, 97, 99 (on three occasions, including the King's birthday!) and in 1700.

The 1st Lord Holland, Henry Fox, bought it in 1776 and when he died it was purchased by John Powell, the Paymaster General. On his death, it passed to his nephew, John Powell Roberts, who changed his name to John Powell Powell. Upon his death, in 1849, it passed to his nephew Henry Perry Cotton and thereafter it passed to sons, not nephews, Henry Horace Powell Cotton and then Percy Powell Cotton who established the museum.

During World War II there was a Red Cross Hospital here.

SEE Acol/ Beacon Road, Broadstairs/ Birchington/ Edward VII/ Kidnapping/ Landy, Jimmy/ National School/ Parks/ Perfects Cottage/ Powell Arms/ Quex Park/ St Nicholas at Stonar Church/ Shakespeare public house/ Spur Railway line/ VAD hospitals/ Wheatley, Dennis/ William III

QUEX PARK, Birchington

Kelly's Directory, 1957: *Quex is a mansion built in the early part of the last century near the site of the ancient mansion. Here is preserved the state chair, used by William III, when he, with Queen Mary, used to stay here on his way to Holland. Adjoining the house is a museum which is open to visitors at stated times. In the park is the Waterloo Tower, containing peel of twelve bells.*

The house is a Victorian mansion, but was originally a gentlemen's country house dating back to Regency times.

A family of the same name originally owned the manor of Quex, although the name has been spelt many different ways over the years. Marriage caused the manor to pass to

the Crispe family and now it is in the Powell-Cotton family.

The Waterloo Tower was built in the middle of the Quex Park Estate in 1812 (the Battle of Waterloo was in 1815 – I know) of red brick, it is around 65 feet tall, with a 65 feet tall cast iron spire on top of the tower. It is unusual in that it is a secular bell tower, and was the first 12-bell tower in Kent.

The museum was founded by Major Percy Horace Gordon Powell-Cotton (1866-1940) an explorer, collector and naturalist and has a collection of local archaeology, armour and arms, as well as stuffed animals from his trips to Africa. His first big trip was in 1887 when he travelled to India, Tibet, the Himalayas and Singapore before crossing to Somalia. Between then and 1939, he travelled all over Africa including Aleriam Morocco, Tunisia, Cameroons, Chad, Nigeria, Zululand, and Tanganyika. In total, his 25 expeditions added up to 26 years spent in Africa.

Stuffed African animals are contained in large dioramas and displayed in different settings. When they were set up, it was the nearest thing to Africa that the average Victorian was able to see. There are 500 stuffed animals including antelope, elephants, giraffes, gorillas, lions, monkeys, tigers, and zebras all stuffed by Rowland Ward who was a celebrated taxidermist of the era. The galleries were built in 1904.

Whilst some might complain of the needless murder of these fine specimens, it should be remembered that it was a different age, and now, ironically, the items stored in the basement are playing a big role in animal conservation. Stored away there are 6,000 animal skins and 4,500 skeletal specimens mostly in their original packaging! The DNA contained in some of these items has enabled breeding programmes to be set up and as a result the quagga and the giant sable have been saved from extinction.

SEE Birchington/ Blake's 7/ Parks/ Quex estate & mansion/ Treasure Hunt/ Waterloo/ William III

R

RACING GREYHOUND public house
Hereson Road, Ramsgate

It was built in 1930 to attract the crowds going to the nearby greyhound track.

SEE Dumpton Greyhound Track/ Hereson Road/ Pubs/ Ramsgate

Ann RADCLIFFE

Born London 9th July 1764
Died 7th February 1823

She was Ann Ward before she was married, but as Ann Radcliffe, she became, for a time, the most popular novelist in England and was partly responsible for popularising the Gothic novel. Her greatest hits were, 'The Romance of the Forest' (1791), 'The Mysteries of Udolpho' (1794), and 'The Italian' (1797).

Sir Walter Scott called her *'the first poetess of Romantic fiction'* and Taylor Coleridge, Christina Rossetti and Lord Byron were all fans. 'The Mysteries of Udolpho' was satirised by Jane Austen in 'Northanger Abbey'.

In 1823 she came to Ramsgate to improve her health but, ironically, caught a chest infection that caused her death.

SEE Austen, Jane/ Authors/ Ramsgate

RADIO

SEE Abrahams, Harold/ Any Questions/ Askey, Arthur/ Blethyn, Brenda/ Corelli, Marie/ d'Abo, Mike/ Grace, Janey Lee/ Hartsdown Park/ Jennings & Darbishire/ Jordan, Sir William/ LeMesurier, John/ Lynn, Dame Vera/ Matthews, Jesse/ Nero's/ Opportunity Knocks/ Rediffusion/ St George's Lawns/ Winter Gardens

RAF MANSTON

SEE Battle of Britain/ Manston airfield

RAILWAY

In January 1960, excursions on the new electrified lines to London were advertised; electrification had taken place on 15th June 1959.

In May 1962 a new service to London Charing Cross via Canterbury and Ashford took 105 minutes. A cheap-day return cost 19/-. (At this time 260 passenger trains went through Ramsgate each day.) By May 1963 a cheap-day return to London via Ashford cost just 14 shillings. In 1988 the cheap-day return to London went up from £10.70 to £11.70. (A 7-day season ticket was £40.80, and an annual ticket £1,632.00)

SEE London Chatham & Dover Railway/ Old Crossing Road, Garlinge/ Railway Stations/ Railway Stations/ Ramsgate/ Snow/ South Eastern and Chatham Railway/ South Eastern Tavern/ Spur railway line/ Transport

RAILWAY FOOTBRIDGE
Birchington
The concrete bridge was put up in 1959.
SEE Birchington

RAILWAY HOTEL
High Street, Broadstairs
The railway came to the town in 1863 and the Railway Hotel, along with the Railway Tavern, was built around 1865. It is now called Crampton's.
SEE Broadstairs/ High Street, Broadstairs/ Hotels

RAILWAY STATIONS

Margate has had six stations in its time, plus two more that were planned but not built.

Ramsgate has had four stations over the years.

SEE Birchington/ Broadstairs/ Dane Valley Arms/ Dumpton Park/ Harbour, Ramsgate/ Margate/ Margate Railway Station/ Margate Sands/ Margate SER/ Margate West/ Minster/ Newington/ Ramsgate/ Ramsgate Sands/ Ramsgate Town/ Richborough Port/ St Lawrence Railway Station/ Tivoli Park/ Westgate

RAILWAY TAVERN, Ramsgate

It stood on the corner of Chatham Street and Shah Place. It became The Rocket in 1961 and closed in 1970.
SEE Chatham Street/ Pubs/ Ramsgate/ Shah Place

RAMSGATE

Ramsgate's name could have come from Hræfn's gate, or gap, in cliff. It has been spelt over the years as Ramisgate, Remmesgate (1225), Ramesgate, Remisgate (1278), and Ramesgate (1357).

In Tudor times, the main sources of income here were shipbuilding and cod fishing.

'The History and Antiquities as well Ecclesiastical as Civil of the Isle of Thanet' 2nd Edition 1736 by John Lewis: *The Vill of Ramsgate was anciently a very small fishing town consisting of only a few houses, and then poorly and meanly built, some of which are still standing. But of late years, since 1688, through successful trade with the inhabitants entered into to Russia and the East country, it is become very much enlarged and improved. The houses are many of them raised and made very convenient dwellings, and abundance of new ones being built after the modern way in a very elegant and beautiful manner.*

'The Penny Cyclopedia' by The Society for the Diffusion of Useful Knowledge: *Ramsgate, a town in the Isle of Thanet in Kent 71 miles from London-bridge, through Dartford, Rochester and Canterbury. The ville of Ramsgate, comprehending 260 acres, was included formerly in the parish of St. Lawrence, in the hundred of Ringslow or Thanet, in the lathe of St. Augustine; but provided separately for its own poor; in 1827 it was made a distinct parish. The ville is a member if the Cinque-Port of Sandwich.*

Ramsgate was anciently a poor fishing-town, consisting of a few meanly-built houses, built on the coast of the Isle of Thanet, which here fronts the south-east: it had a small wooden pier. After the Revolution of 1688, some of the inhabitants engaged in the Russian trade, by which they acquired wealth, and this led to the improvement of the town. When the practice of families from London and elsewhere resorting to the sea-side became general, Ramsgate was one of the earliest frequented spots, though for sometime eclipsed by the superior attractions of Margate.

The improvement of the harbour by the erection of the piers and other works in the middle and latter part of the last century, gave another impulse to the prosperity of the town.

Early in the present century a stone lighthouse was erected on the head of the west pier, a small battery is fixed at the head of the east pier.

The east pier is one of the longest in the kingdom, extending 2,000 feet; the western pier extends about half that length: they are built of Portland and Purbeck stone and Cornish granite. The harbour includes an area of 48 acres, and furnishes a convenient shelter for vessels which are obliged by heavy gales to run from the Downs. It is provided with a basin and floodgates in the upper part of the harbour for scouring it from the drifted sand or mud.

The old part of Ramsgate is situated in one of those natural depressions (called in the Isle of Thanet 'gates', or 'stairs') in the chalk, which open upon the sea. This part of the town is low compared with the higher parts on each side if it. The streets in the old part of the town are narrow and indifferently built.

The newer part of the town, from its elevated site on the cliffs, commands an extensive sea-view, and consists of several streets macadamised and lighted with gas. Many of the houses are very handsome: some are arranged in streets, terraces, or crescents, while others are detached villas. At present (1840) a considerable number of houses are building. There are bathing-rooms, assembly-rooms, boarding and lodging houses, a handsome new church, a chapel-of-ease, and several dissenting meeting-houses.

The population of the ville of Ramsgate, including the town, was, in 1831, 7,985. There is considerable coasting trade; coal is imported in considerable quantity; and ship building and rope-making are carried on. It is observable as indicating the commercial character of the place, that though the population of Margate exceeds that of Ramsgate by 2,300 or 2,400, there are not half as many persons engaged in retail trade or handicraft as at the latter place. The markets are on Wednesday and Saturday. A considerable fishery is carried on ; in the summer steam-boats sail regularly between London and Ramsgate.

The living of Ramsgate is a vicarage, of the clear yearly value of £400, in the gift of the vicar of St. Lawrence, the mother church.

There were, in 1833, two infant schools, with 217 children of both sexes; a national day and Sunday school with 150 boys and 100 girls; twenty day-schools, estimated to contain about 525 children; six boarding-schools, supposed to contain 170 children; and three Sunday-schools, two of them containing 300 children; from the other no return was made.

SEE Abbot's Hill/ Accomodation/ Addington Place/ Addington Road/ Addington Street/ Adelaide Gardens/ Admiral Fox pub/ Admiral Harvey pub/ Ainsworth, WH/ Albert Memorial/ Albert Road/ Albert Street/ Albion Gardens/ Albion House/ Albion Place/ Albion Road/ Albion Street, Broadstairs/ Alexandra Arms/ Alexandra Road/ Alfred Cottages/ Allenby, Viscount/ Alma Road/ Alma Place/ Andersen, Hans Christian/ 'A Passage in the Life of Mr Watkins Tottle'/ Arklow Square/ Armistice Day/ Artillery Arms/ Artillery Road/ Ashburnham Road/ Assembly Rooms/ Augusta Stairs/ Austen, Jane/ Australian Arms/ Bagshaw's/ Baldock/ Ballantyne, RM/ Barclays Bank/ Barnacles/ Barnett's/ Bathing machines & Bathing rooms/ Beach entertainment/ Bedford Inn/ Beeching, Moses & Co/ Belgian soldiers/ Bellevue Garage/ Bellevue Hill/ Bellevue Road/ Belmont House/ Belmont Road/ Belmont Street/ Bethesda Street/ Blackburn's/ Blazing Donkey/ 'Bleak House'/ Blethyn, Brenda/ Blinko's Bookshop/ Bloodless Battle of Harbour Street/ Blucher Villas/ Blythe, Chay/ Booth, General/ Boundary Road/ Bounty/ Bournes/ Bracey's/ Braithwaite, Dame Lilian/ Breweries/ Broad Street/ Brockman, Sarah/ Browne, John Collis/ Buckeridge, Anthony/ Bull & George/ Burges, George/ Burke, James/ Burnand, Sir Francis/ Burton, AH/ Byron, Lord/ 'By Sheer Pluck'/ Caffyns/ Camden Arms/

Camden Square/ Camera Obscura/ Canada/ Canadian Military Hospital/ Cannon Road/ Captain Swing/ Carnegie, Andrew/ Cavendish Baptist Church/ Cavendish Street/ Cecilia Road/ Cemetery Ramsgate/ Cervia/ Chambers Journal/ Chapel Place/ Chapel Road/ Charlotte Court/ Chatham House School/ Chatham Place/ Chatham Street/ Christ Church/ Christ Church School/ Church Road/ Churches/ Churchill, Sir Winston/ Churchill Tavern/ Cinemas/ Cinque Ports/ Clarence, Duke of/ Clarendon Gardens/ Clarendon House School/ Clash, The/ Classic Cinema/ Cliff House/ Cliff Street/ Cliffs/ Cliffs End Hall/ Cliftonville Avenue/ Clock House/ Coastguard Station/ Cobbett, William/ Cockney Rhyming Slang/ Cockerell, Sir Christopher/ Codrington Road/ Coffee Pot/ Coke Riot/ Coleridge/ Collins, Wilkie/ Congregational Church/ Connolly, Billy/ Conyngham School/ Cottage Road/ Courts Furniture/ Cradlecar & Co/ Crescent Road/ Crest & Motto/ Critical Mass/ Cumberland Road/ Curtis, Sir William/ Dame Janet Junior School/ 'David Copperfield'/ Davis, Edmund/ Deal Cutter pub/ Defoe, Daniel/ Derby Arms/ D'Este Road/ Destiny/ Dickens, Charles/ Donkeys/ Dover Castle Inn/ Downs, The/ Drays/ Duke of York pub/ Dull/ Dump Raid/ Dumpton Gap/ Dumpton Park Drive/ Duncan Road/ Dundonald Road/ Dunkirk/ Dunmore, Earl of/ Dunn, ER/ Dunn & Sons/ Dyason's Royal Clarence Baths/ Eagle Café/ Eagle Hill/ Eagle Inn/ Earl St Vincent pub/ East Cliff Lodge/ East Cliff Promenade/ East Court/ East Kent Arms/ Edith Road/ Edward VII/ Effingham Street/ Electric Tramways Co/ Elephant & Castle pub/ Eliot, George/ Ellington Arms/ Ellington Park/ Elms Avenue/ Elms pub/ Eluard, Paul/ Engels, Friedrich/ Evacuation/ 'Fallen Leaves'/ Falstaff Inn/ Farleys/ Faversham & Thanet Co-op/ Feeney's/ Ferranti/ 1566/ Fine Fare/ Fire Station/ Fish/ Fish & Chips/ Fishing Fleet/ Fitzgerald, JP/ Five Pound Note/ 'Floating Light of the Goodwin Sands/ Flora Road/ Flying Horse pub/ Foresters Arms/ Forresters Hall/ Forward, Stephen/ Foster, Herbert/ Fox, Admiral/ Foy Boat Inn/ Friend to all Nations/ Frith, William/ Fry, Elizabeth/ Garwood, WW/ Gas Works/ George & Dragon/ George Street/ Gibbets/ Girl Guides/ Glacco, Mr G/ Goats/ Golden Eagle/ Goodwin Sands/ Gout/ Grand Turk/ Grange, The/ Grange Road/ Grange Road windmill/ Granville Cinema/ Granville Hotel/ Granville Lions/ Granville Theatre/ Green, Hughie/ Grundy Hill/ Guildford Lawn/ Gwyn's Clock/ Gypo/ Gypsy Rose Lee/ Harbour, Ramsgate/ Harbour Lights/ Harbour Parade/ Harbour Street/ Hardres Street/ Harry Potter/ Harveys/ Heath, Sir Edward/ Heine, Heinrich/ Hereson/ Herson Mill/ Hereson Road/ Hereson School/ Hertford Street/ High Sea/ High Street/ High Street, St Lawrence/ HMS Fervant/ HMS Thanet/ Hodgman/ Hollicondane/ Hollicondne pub/ Holy Trinity Church/ Holy Trinity School/ Honeysuckle Inn/ Hood, Thomas/ Horse & Groom/ Hotel de Ville/ Hovelling Boat Inn/ Hovercraft/ Hudson's Mill/ Hugin/ Hurricane Bombardment/ Indian Chief/ Inglis, Sir William/ Isabella Baths/ Italianate Gardens/ Italianate Greenhouse/ Ivy Lane/ Jackson's Wharf/ Jacob's Ladder/ Jazz Room/ Jennings & Darbishire/ Jolly Sailor Inn/ Jones, Henry Arthur/ Jordan, Sir WJ/ Kempe, ABC/ Kent Place/ Kent Steps/ King George VI Park/ King of Denmark pub/ King Street/ Kings Avenue/ Kings Cinema/ Knight, HP/ Knowler/ La Belle Alliance Square/ Laker, Freddie/ Langtry, Lillie/ Lavender/ 'Law and the Lady'/ Lawn Villas/ Layard, Sir AH/ LeMesurier, John/ Leopold' King/ Leopold Street/ Lester's Bar/ Levy, Joseph Moses/ Lewis Hyland & Linom/ Library/ 'Lifeboat'/ Lifeboat, Ramsgate/ Lift/ Lighthouse/ Lillian Road/ Linscott/ Listed Buildings/ Littlewoods/ Liverpool Lawn/ Lloyds Bank/ Logo/ London Road/ Lord of the Manor/

Luck, Alfred/ Luck, JE/ Madeira Walk/ 'Mamsfield Park'/ Margate/ Margate Road/ Marina Bathing Pool/ Marina Esplanade/ Marina Theatre/ Marine Library/ Market/ Marks & Spencer/ Marx, Karl/ Mascall's Mill/ Mayor's Chain/ Meeting Street/ Merrie England/ Methodist Church/ Midland Bank/ Military Road/ Mill Road Birchington/ Miners/ 'Miss Morris and the Stranger'/ Model Village/ Montefiore, Sir Moses/ Montefiore Arms/ Montefiore College/ Moss, Kate/ Motor Museum/ Mount Albion House/ Mouth organs/ 'Mr Jericho'/ Muir, Frank/ Muir Road/ 'Murder Makes an Entrée'/ Mushrooms/ Napoleonic Wars/ National Provincial Bank/ National Union of Women's Suffrage Societies/ Naval Memorial/ Nelson Crescent/ Neptuen Row/ Nero's/ Nerval, Gerard/ Nethercourt Farm/ Nethercourt House/ New Shipwrghts Hotel/ Newcastle Hill/ Newington Estate/ Newington Free Church/ Newington Greyhound Track/ Newington Mill/ Newington Railway Station/ 'Nicholas Nickleby'/ North Pole pub/ Northern Belle/ Northwood/ Obelisk/ Odeon Cinema/ Olby/ Old Customs House/ One way system/ Ozengell/ Ozonic Mineral Water Co/ Palace Theatre/ Pallo, Jackie/ Pankhurst, Christabel/ Pankhurst, Emmeline/ Paradise/ Paragon/ Paragon House Hotel/ Parakeets/ 'Passage in the life of Mr Watkins Tottle'/ Pearks' Stores/ Percy Road/ Pethick-Lawrence, Emmeline/ Picton Road/ Pier/ Pilcher Page & Co/ Plains of Waterloo/ Pleasurama/ Pointer/ Police/ Police Station/ Poole/ 'Poor Miss Finch'/ Population/ Port & Anchor pub/ Post Office/ Poster/ Potatoes/ Powerboats/ 'Pride & Prejudice'/ Priestley's Cycle & Machine Stores/ Prince Coburg pub/ Prince Edward Promenade/ Prince Harry pub/ Princes Avenue/ Princes Gardens/ Princes Road/ Princes Street/ Priory School/ Promenade Pier/ Prospect Terrace/ Prussia/ Pryce & Judd/ Pugin/ Pulhamite/ Punch & Judy/ Queen Street/ Queens Avenue/ Queens Cinema/ Queens Court/ Queens Gate Road/ Queens Head/ Racing Greyhound pub/ Radcliffe, Ann/ Railway/ Railway Stations/ Railway Tavern/ Ramsgatize/ Red Lion Hotel/ Regatta/ Richardson, Alan/ Richmond Road/ Rising Sun pub/ Robey, Sir George/ Rodway's Dining Rooms/ Rose Hill/ Rose Hill Cottage/ Royal Crescent/ Royal Esplanade/ Royal Harbour/ Royal Hotel/ Royal Oak Hotel/ Royal Parade/ Royal Road/ Royal Sailors Rest/ Royal Temple Yacht Club/ Royal Victoria Pavilion/ Russell, William Clarke/ Russia/ Sailors Church/ St Augustine's Abbey/ St Augustine's Road/ St Ethelbert & St Gertrude Church/ St Georges Church/ St Georges Hall/ St Georges School/ St James Avenue/ St Laurence Church/ St Lawrence/ St Lawrence College/ St Lukes area/ St Luke's Avenue/ St Luke's Church/ St Marys Church/ St Mildreds Road/ St Pauls Church/ Sala, George/ Sally the Viking Line/ Salvation Army Citadel/ San Clu Hotel/ Sanger Circus/ Sausages/ Scott, Sir GG/ Sea angling/ Seafield Road/ Seamans Infirmary/ Schools/ Self Service Grocery Shop/ Shackleton, Sir Ernest/ Shah Place/ Shakespeare pub/ Sharps Dairy/ Shelley, Mary/ Ship Inn/ Shipbuilding/ Sion Hill/ Sir Stanley Grey pub/ Slum Clearance/ Smack Boys Home/ Smeatons Dry Dock/ Smuggling/ Smuggling, Ramsgate/ 'Smuggler's Leap'/ Snow/ Snuff/ Sole, The/ South Eastern & Chatham Railway/ South Eastern Road/ South Eastern Tavern/ Southwood/ Southwood House/ Spall, Timothy/ Spencer Square/ Sportsman Inn/ Sprackling, Adam/ Staffordshire Street/ Stancomb-Wills, Dame Janet/ Staner Court/ Star Cinema/ Station Approach Road/ Steam Packets/ Stone House/ Stone, David Lee/ Stray Pony/ Suffragettes/ Summers, Henry/ Sunlight Laundry/ Sunsets/ Superdrug/ Sussex Street/ Synagogue/ Tall Ships/ Television advertising/ Telford, Thomas/ Tesco/ Tester, Dr/ Thanet Technical College/ Thanet Weed/ 'Three

Men in a Boat'/ Thunderstorm/ Timothy Whites/ Tissot, James/ Tobacco/ Toll Gate Kiosk/ Tomson & Wotton/ Tonna, Mrs/ Town of Ramsgate/ Townley Castle/ Townley Castle School/ Townley House/ Townley Street/ Trafalgar Hotel/ Trams/ Transportation/ Truro Lodge/ Truro Road/ Tuckshop murder mystery/ 'Tuggses of Ramsgate'/ Tulips/ Tunnels, Ramsgate/ Turner, JMW/ Turner Street/ Twinning/ U-boat/ Umbrella maker/ Upper Dumpton Park Road/ VAD Hospitals/ Vale Road/ Vale Square/ Vale Tavern/ Van Gogh pub/ Van Gogh, Vincent/ Viaduct/ Victoria/ Victoria Hotel/ Victoria Parade/ Victoria Steps/ Viking Coastal Trail/ Vogel, Julius/ Von Rintelen, Capt/ Vye & Son/ Vye Bros/ Waitrose/ Walcheren Expedition/ Walkway Disaster/ Warre Avenue/ Warre family/ Warren, Sir Charles/ Warten Road/ Wastall, EG/ Waterloo/ Welch/ Wellden/ Weller, Sam/ Wellington Crescent/ West Beach/ West Cliff Bandstand/ West Cliff Hall/ West Cliff Promenade/ West Cliff Road/ West Cliff Tavern/ West Dumpton Lane/ Western Undercliff/ Whitehead, Alfred North/ White Horse Inn/ Whitehall Mineral Water Co/ Whitehall Farms/ Wilde, Oscar/ Wilfred Road/ Wills House/ Willsons Road/ Windmills/ Windmill Inn/ Winstanley Crescent/ Without Prejudice/ Women's Voluntary Service/ Woodford Avenue/ Woodward, James/ 'World of Waters'/ World War I/ World War II/ Wright/ Wrightson/ Yachtsmen, The/ Yeomenry/ York Arms/ York Street/ York Tavern/ Zeppelin raid

RAMSGATE AIRPORT

Despite the name, it was as much in Broadstairs as it was in Ramsgate. In 1881, according to the census, the area bounded by Pysons Road, Rumfields Road, Northwood Road and Hopes Lane was the location of Northwood Dairy Farm which was owned by the Maxted family.

The area had been licensed to Hillmans Airways Ltd as an aerodrome by Ramsgate Borough Council in 1934 for them to operate a Ramsgate to London service. In 1935 British Airways ran a service to Ostend, and by 1936 the first case of smuggling had been detected!

There was a terminal, clubhouse, bar, offices and restaurant. Amy Johnson and Jim Morrison visited in 1934.

Mr Whitney Straight, of Whitney Straight Limited who leased the airport, was the first person to officially land at Ramsgate Aerodrome on 22nd June 1935 when he arrived to consult members of the Corporation about the contract which naturally involved taking the mayor and a few others up for a spin.

The official opening by Sir Francis Skelmerdine the director of Civil Aviation, was on 7th July 1937 when the town was congratulated on *being up-to-date to provide the essential amenity for any seaside or pleasure resort which wished to preserve its popularity and prosperity'*.

The Straight Corporation was run by Mr Whitney Straight from 1935 until the beginning of World War II when it closed, having been damaged by enemy bombing.

During World War II, Mr Whitney Straight was Air Commodore Whitney Straight, and was shot down over France in 1941. He escaped from a prisoner-of-war camp and went on to fight in the Middle East, got mentioned in despatches and was awarded

the Norwegian War Cross by King Haakon of Norway.

After a gap of 12 years, the airport re-opened on 28th July 1951 with flights to Le Touquet. A proposal to extend the airport by nine acres was turned down because it was thought it would have a bad effect on local amenities and agriculture.

It closed in 1968 and was replaced by houses and the industrial estate.

SEE Broadstairs/ Farms/ Johnson, Amy/ Manston Airport/ Northwood/ Restaurants/ World War II

RAMSGATE COUNTY SCHOOL
It opened on 14th October 1909, and cost £11,300 to build and could accommodate 170 boys and 170 girls. In 1921 the boys went off to their new school at Chatham House and this building became Clarendon House Grammar School for girls.

SEE Clarendon House Grammar School/ Schools

RAMSGATE FEATHER
This was a method that Ramsgate smugglers devised for locating hidden contraband left on the beach, when covered by the high tide. It was marked by an innocuous feather floating on the surface that was tied to a thread which, in turn was attached to a rope tied round the goods, allowing the smugglers to find and retrieve the smuggled goods at a later, more convenient time.

RAMSGATE FOOTBALL CLUB
At the latter end of the nineteenth century you could have watched Ramsgate Town – the main team for the town - or Ramsgate St George, Ramsgate Greville or Ramsgate Rovers at various grounds and pitches across the town.

In 1919, Mr Henry and Lady Rose Weigall generously passed the Southwood ground over to Ramsgate Town – although by then they were known as just Ramsgate – and a serious local team began. In their first season they finished 3rd in the league and lost (at Maidstone before a crowd of 10,000) 1-0 to Northfleet in the Kent Senior Cup final.

Meanwhile, Ramsgate Glenville, despite being a good side, had to disband because they did not have a ground to play on (most of their players then joined Ramsgate at Southwood). However, in 1924, Ramsgate Town folded and Ramsgate Glenville, who had recently reformed and were playing at the Warre Recreation Ground, transferred over to Southwood where they continued to play until the outbreak of World War II forced football to cease.

Ramsgate Glenville was a casualty of the war and Southwood instead became home to Ramsgate Athletic – the forerunner of today's club - in 1945. At the same time, the pitch was turned so that it was at right angles to where the old one had been. Until Ramsgate Athletic folded in 1959, they played in the Kent League and won the league and cup double in 1948/9 – there was a crowd of 4,000 at Southwood to see them win the cup. They were champions again in 1956 and 1957. In the latter season a new

attendance record of 5,200 was set for the local derby against Margate.

They have reached the first round of the FA Cup twice; first, in 1955/6 when they lost 5-3 away to Watford; and second, in 2005/6 when they lost 1-0 away to Nuneaton.

The biggest club to play at Southwood is Everton who played a friendly here in November 1959 to mark the installation of the new floodlights. Ramsgate lost 7-1.

SEE Football/ Margate Football club/ Warre family

RAMSGATE HARBOUR POLICE
Employed by the Board of Trade, the Ramsgate Harbour Police consisted of a seargent and five constables, but they had their own office, cell, and a rowing boat! In 1902 they became part of the Ramsgate Borough Force.

SEE Harbour, Ramsgate/ Police, Ramsgate

RAMSGATE HOSPITAL
The foundation stone for the New General Hospital and Seaman's Infirmary was laid on 17th June 1908 at West Cliff Road. The Dame Janet Maternity Wing was opened at Ramsgate Hospital in 1931.

Princess Margaret visited the hospital on Thursday 1st June 1950.

The demolition of the hospital began in December 2003.

SEE Hospitals/ Stancomb-Wills, Dame Janet/

RAMSGATE PAROCHIAL WORK HOUSE or POOR HOUSE
It stood at the end of Portland Court, a through road before it became a cul-de-sac. Zacariah Simmersw and his wife were the managers/overseers on a salary of £10 per annum, when it opened in 1726. It assisted the poor of the parish, as well as some Spanish women and children who had fled from war, for over a century. Parts of the old flint wall were still here in the 1950s.

RAMSGATE PICTURE HOUSE
It closed after 40 years, and the building was put up for sale in September 1959.

SEE Cinemas/ Superdrug

RAMSGATE ROAD, Broadstairs
Wilkie Collins stayed at Church Hill Cottage in Ramsgate Road in 1859 where he was finishing writing 'The Woman in White'.

SEE Broadstairs/ Brown Jug/ Collins, Wilkie/ Pierremont Hall/ Woman in White/ Wrotham Arms/ Yarrow Home

RAMSGATE ROAD, Margate
Eden Villa was a very small school for girls in Ramsgate Road in the late nineteenth century.

SEE B&Q/ Chambers, Frederick/ Crown & Sceptre/ Faversham & Thanet Co-op Society/ First and Last/ Lester's Bar and Restaurant/ Margate/ Orb pub/ Royal Sea Bathing Hospital/ Schools/ Victoria pub

RAMSGATE SANDS RAILWAY STATION
Ramsgate's second railway station was built at the end of a mile-long tunnel through the

chalk cliff, together with a turntable to turn around the engines, in 1862-3 on the site of the old shipbuilders and opened on 5th October 1863.

The chalk that was excavated was used as the base for the esplanade. Thousands of people took the two-hour journey from London.

There was an accident on the 31st August 1891 that killed one person when a train overran across the promenade.

The station closed on 1st July 1926.

The former station became HMS Fervent, a naval base, during World War II, but closed on 15th September 1945.

It was also the site of Merrie England. After being a ballroom, bingo hall, an amusement arcade and, most famously, Pleasurama, a fire on 27th May 1998 destroyed the Pleasurama building. A total of 22 fire engines and 150 firemen attended; crowds of people watched from the cliff top and the flames could be seen for miles. Within hours of the fire being put out, bulldozers flattened the site and is currently the centre of some controversy with regard to its future development.

SEE Fires/ London, Chatham & Dover Railway/ Pleasurama/ Railway Stations/ Shipbuilding/ Tunnels, Ramsgate/ Warten Road/ Without Prejudice/ World War II

RAMSGATE SONG
The song was written for the pageant at the Jubilee of Incorporation, 1934:

Ramsgate Sands, O Ramsgate Sands
Far your sea ribbed stretch expands
Smiling in the noon day bright
Wistful 'neath the shades of night
While its ceaseless melody
Sings upon your beach the sea
Pathway wide to distant lands
O the lore of Ramsgate Sands
Ramsgate Sands, O Ramsgate Sands
Once the goal of fashion bands
Bid once more your sands draw near
Poet, artist, prince and peer
Bid Victorian belle and beau
Sit and flirt as years ago
Breathing sighs and holding hands
Naughty naughty Ramsgate Sands
Ramsgate Sands, O Ramsgate Sands
Take this tribute at our hands
By the breezes soft caress
By each dainty bathing dress
By the boats 'pon your sea
Patient donkeys, shrimps for tea
Pierrot troupes and minstrel bands
Hear us hear us Ramsgate Sands.

SEE Bathing/ Donkeys/ Music/ Poems

RAMSGATE TOWN STATION
The (present) Town (railway) Station opened on 2nd July 1926, the day after the Sands and the Old Town Stations closed on 1st July 1926.

SEE Railway Stations/ Station Approach Road

RAMSGATIZE
Ramsgatize was the word that Samuel Taylor Coleridge created to describe his visits to Ramsgate.

SEE Coleridge, Samuel Taylor/ Ramsgate/ Wellington Crescent

RANELAGH GARDENS & ASSEMBLY ROOMS, St Peter's

The Ranelagh Gardens and Assembly Rooms were created in 1817/18 by Charles Newbolt, the landlord of the Red Lion. They were patronised by the *'nobility, gentry, and public in general'* and opened on 22nd July 1818 on land bought from John Mockett. It covered two and a half acres and could, indeed, regularly did, lavishly entertain up to 1,600 to 2,000 people, depending on the reports that you read. Tickets cost two shillings and sixpence. Breakfast attracted up to 800 people, and 400 in the evening to hear a band and singers - and it was a good sized band judging by the 18ftx55ft dimensions of the stage - playing regularly from late afternoon until sunset, with enough room for 250 couples to dance, so long as they didn't do the jitterbug! Flint Cottage was the entrance. The gardens had a relatively short life though, closing in 1852. The area is now private but The Stewards Cottage, with King Neptune and his attendants on the gable, and the Assembly Rooms still exist.

Pigot's Directory 1840: *The Ranelagh Gardens, the pre-eminent magnet of resort to this village, were fitted up by Mr Newbolt several years since, at a very great expense; and the present proprietor, Mr Hudson unremittingly evinces the most anxious solicitude to promote the enjoyment of visiters to this delightful scene of recreation. The gardens cover an area of about two acres and a half, interspersed with splendid marquees, and a pleasing and beautiful series of cosmoramas; as many as two thousand persons have assembled here in one day. The ordinary price of admission is one shilling, for which refreshments to that amount are supplied. The amusements commence about four o'clock, and last till dusk, during which time an excellent band for quadrilles and country dances is in attendance. In the rear of the principal garden is a bowling green, kept in the best condition. These are the healthful enjoyments that are provided at Saint Peters, Ranelagh – gratuitously, it may be considered. Public breakfasts take place twice a week during the season; and latterly the gardens have been opened and brilliantly illuminated for night galas.*

The gardens here were named after the fashionable Chelsea garden that was named after Richard Jones, third Viscount and first Earl of Ranelagh (1636-1712) – Ranelagh being a district of south Dublin. His house was built in 1690, but after his death the gardens were opened in 1742 and became the fashionable place to be seen at for much of that time. They closed in 1804 and the site is now part of the Chelsea Hospital grounds.
SEE Lovejoy School/ St Peter's

RANELAGH GROVE
SEE Ranelagh Gardens, St Peter's

READ COURT, The Grove, Westgate
The McCarthy & Stone retirement apartment block is named after Arthur Ivor Read, who lived opposite. He was a chartered accountant, a Westgate landowner and owner of the building firm G Lockwood & Co. When he died aged 98, in December 2001, he left £15,000,000 to charities. He owned Westgate and Birchington Golf Club but handed it over to a charity to ensure that the land did not get built on in the future.
SEE Canterbury Road, Westgate/ Westgate-on-Sea

READING STREET
The name 'Reading Street' is said to come from 'Rydding': a clearing in the woods. Or it comes from a corruption of Wrecking Street, due to the number of locals who made their living from salvaging ship wrecks.

Mr and Mrs Morgan were living in Reading Street with their six children when, on 25th February 1917, in the middle of a ten minute long bombardment from German destroyers, Mrs Morgan was killed instantly, followed soon after by her daughter whom she had been holding. Another daughter died later in hospital from wounds and two other children were injured.

White Swan Cottage was built in the style of the Dutch with very attractive gables. In 1792, it was owned by the innkeeper, John Parish, although it was then two cottages. There is a Sun Insurance Company plaque on the outside, No 609586.

Providence Cottages, built in 1873, are so named because the timber used in their construction came from ship wrecks.

The little village green was once known as Kitty's Green.

Convent Cottages were built in 1901. Lavender Cottage next door was built in 1866 and was once the village school.
SEE Beacon Road/ Great Storm, The/ Jersey Cabbage/ St Peter's Mill/ Schools/ Storms/ Trinity Square

RECRUITMENT
Royal Navy battleships and cruisers would often anchor offshore as part of their recruitment drives. The proximity of Chatham Dockyard meant there were often many boats anchored off the Margate coast and many sailors would come ashore for their rest and recreation - in all its varieties! This may have helped or hindered recruitment.
SEE Margate

RECTORY ROAD, Broadstairs
Much of this area was previously part of the Fort House estate.
SEE Broadstairs/ Fort House

RECULVER
The Roman's called it Regulbum, and it guarded the northern end of the Wantsum Channel, with Richborough (or Rutupiae to the Romans) doing the same job at the southern end. The Romans are thought to have constructed a temporary fort here in AD 43 after they had conquered Britain. A new, more substantial, fort was built in the third century and fragments of the massive walls remain. By the fourth century the fort was abandoned.

In AD 669, the King of Kent gave the fort and the land around it to Bassa, a priest, on which he could build a monastery, which he did, only for the Vikings to destroy it towards the end of the ninth century. In 949 it was part of an area of land that included Hoath, Herne and St Nicholas that was given to the Archbishop of Canterbury. By the Middle Ages there was a thriving village to the west of the fort that then surrounded the church. The area began to be eroded by the sea to such an extent, in the early eighteenth century, it began to be abandoned

Built on to the Roman fort was a Saxon church dating back well over sixteen hundred years. It is all that remains of a thriving medieval town that King Ethelbert used as his capital. The sister of an Abbess of Faversham is said to have drowned in a shipwreck here and in her memory, the Abbess built the twin towers. A local farmer sold the stones of the old sea wall here to the builders of Margate pier and after a huge storm in 1807 the old village was washed away. The vicar then ordered that most of the church be pulled down. The two towers did have two spires on them in the 19th century.

These towers the remains of the once venerable church of Reculvers were purchased of the parish by the corporation of Trinity House of Deptford strond in the year of 1810 and groins laid down at their expense to protect the cliff on which the church had stood when the ancient spires were afterwards blown down the present substitutes were erected to render the towers still sufficiently conspicuous to be useful to navigation Capt Joseph Cotton Deputy Master in the year 1819

There is a cross at the Reculver car-park with an inscription on the plinth that reads: *AD2000 This cross was commissioned by Canterbury City Council with the support of the Dean and Chapter of Canterbury Cathedral to commemorate the millennium and two thousand years of Christianity.*
SEE Churches/ Cinque Ports/ Farms/ Jerrold, Douglas/ Pier/ Smuggler's Leap/ Stag Hunt Extraordinary/ Vikings/ Wantsum Channel

RECULVER - JORROCKS
In one adventure, Mr Jorrocks visits Herne Bay and then, with his friend the

Yorkshireman, heads for Reculver: *we struck across a few fields, and soon found ourselves on the sea banks, along which we proceeded at the rate of about two miles an hour, until we came to the old church of Reculvers. Hard by is a public-house, the sign of the 'Two Sisters', where, having each taken a couple of glasses of ale, we proceeded to enjoy one of the (to me at least) greatest luxuries in life - viz. that of lying on the shingle of the beach with my heels just at the water's edge.*

The day was intensely hot, and after occupying this position for about half an hour, and finding the 'perpendicular rays of the sun' rather fiercer than agreeable, we followed the example of a flock of sheep, and availed ourselves of the shade afforded by the Reculvers. Here for a short distance along the beach, on both sides, are small breakwaters, and immediately below the Reculvers is one formed of stake and matting, capable of holding two persons sofa fashion. Into this Jorrocks and I crept, the tide being at that particular point that enabled us to repose, with the water lashing our cradle on both sides, without dashing high enough to wet us.

'Oh, but this is fine!' said J——-, dangling his arm over the side, and letting the sea wash against his hand. 'I declare it comes fizzing up just like soda-water out of a bottle - reminds me of the lush-crib. By the way, Mr Yorkshireman, I heard some chaps in our inn this morning talking about this werry place, and one of them said that there used to be a Roman station, or something of that sort, at it. Did you know anything of them 'ere ancient Romans? Luxterous dogs, I understand. If Mr. Nimrod was here now he could tell us all about them, for, if I mistake not, he was werry intimate with some of them - either he or his father, at least.'
SEE Jorrocks/ Surtees, Robert Smith

RED LION HOTEL
King Street, Ramsgate
It can be traced back as far as 1653 and probably goes back further than that. In 1717, when proper records began it was owned by James Austen, whose family had a brewery in Broad Street; until Fleet & Co took it over in the late 1880s. In the nineteenth century there were weatherboarded houses next to the Red Lion pub where you could get your hair cut at a barbers before going into the offices of the stagecoach company which ran coaches over to Margate, to catch the steamer to London.
There was a big fire at the Red Lion in April 1987.
SEE Breweries/ Fires/ Hotels/ King Street, Ramsgate/ Pubs/ Ramsgate

RED LION public house, St Peter's
Opposite St Peter's Church is the Red Lion public house. The present building replaced a single storey public house which was demolished around 1876. It had been used as a hospital when an outbreak of smallpox killed 5 adults and 5 children.

SEE Pubs/ St Peter's

RED LION public house, Stonar
It opened in 1829. Tomsons of Ramsgate leased it for forty-six years from 1840. At the end of the lease it was bought at auction by the Cobb Brewery of Margate who ran it until World War I. It closed in 1989 and was demolished a year later.
SEE Cobbs/ Pubs/ Stonar/ Tomson & Wotton

REDIFFUSION
In what is now 52 Church Street, St Peter's, Frank Austen experimented with a system that he perfected for transmitting radio, and later television, through a wired system in the 1920s. Eventually it became Rediffusion which had its headquarters at Westwood.
SEE Church Street, St Peter's/ St Peter's/ Radio/ Television/ Westwood

Thomas Dalby REEVE
SEE Dalby Square/ Hall by the Sea

REFUGEES
Refugees from Nazi Germany arrived in England via Stonar in 1938-9
SEE Belgian soldiers/ Stonar/ World War II

REGAL CINEMA
Cecil Square, Margate
On 21st December 1934, the Regal Cinema opened and although it was part of the Odeon group, it never took that name. The front of the building had black terrazzo columns, metal and glass with a tower and a canopy. The auditorium could seat 1,795, and was decorated in gold and black speckle relieved by red. The seats were green with silver festoons, the same as the proscenium curtains. The heavy carpet was an abstract design in grey, green and black. Mahogany handrails completed this epitome of 1930s taste and luxury. On 7th September 1941 a predominately military audience was watching 'Kipps' when an air raid warning prompted them to leave the cinema. The subsequent raid saw the Regal largely destroyed by bombs. After the war a branch of the National Provincial Bank was sited in the still undamaged front part of the building.
SEE Cecil Square/ Cinemas/ Margate

REGATTA
The International Sailing Regatta held at Ramsgate in July each year is the third largest in the world.
SEE Ramsgate/ Royal Temple Yacht Club/ Sport

John RENNIE
Born 7th June 1761
Died 4th October 1821

Margate Harbour was built in 1810 by John Rennie. He also designed London Bridge which was sold in April 1968 and is now in Arizona where it is the state's second biggest tourist attraction after the Grand Canyon.
SEE Harbour, Margate/ Margate

RESTAURANTS
There are over 50 restaurants in Broadstairs.
SEE Bar 26/ Bar Barcelona/ Bobby's Department Store/ Bounty/ Broad Street/ Broadstairs/ Captain Digby/ Cottage, The/ David Copperfield/ Dumpton Park Leisure Centre/ Food/ Hall by the Sea/ Hoy, The/ Isabella Baths/ King of Denmark pub/ Kings Head, Margate/ Lester's Bar and Restaurant/ Libraries/ Lucy the Margate Elephant/ Marchesi's/ Marina Esplanade/ Northumberland Road/ Pegwell Bay Reclaimation Co/ Queens Promenade/ Ramsgate Airport/ Rhodes, Gary/ Royal Victoria Pavilion/ Smugglers, The/ Sportsman Inn/ Spread Eagle Inn/ Wheatsheaf/ Women's Voluntary Service

Cecil John RHODES
Born 5th July 1853
Died 26th March 1902
A statesman, financier and one of the prime promoters of British rule in southern Africa. He originally went, aged 17, to live with his brother in Natal, in what is now South Africa, because of his ill health. Diamond mines were discovered there that same year and he became a diamond prospector. Within two years, he had a large fortune and in 1873 returned to England to study at Oxford. When he got his degree in 1881, he split his time between the university and the diamond mines. He amalgamated a large number of diamond mining claims to form and control the De Beers Mining Company. He became a member of the Cape Colony Parliament in 1881 and was still a member when he died.
In 1885, he was largely responsible for the annexation to the British Empire of Bechuanaland (now Botswana). De Beers Consolidated Mines was founded in 1888 and Rhodes monopolised Kimberley's diamond production, at the same time obtaining exclusive mining rights from the ruler of Matabeleland (now in Zimbabwe), Lobengula. The following year, the British government granted a charter to Rhodes to develop the territory with his British South Africa Company. The area he developed was named Rhodesia in 1894 but it is now Zimbabwe and Zambia, although it remained under the company's control until 1923.
He became the prime minister of Cape Colony in 1890 and five years later supported the British settlers in the Transvaal Republic (now in north-eastern South Africa) who planned to overthrow the Boer government. On 29th December 1895, Sir Leander Starr Jameson, who was later to lead the revolt with the backing of the British South Africa Company, prematurely and unsuccessfully invaded the Transvaal, in what became known as the Jameson Raid. Although acquitted of any responsibility for the raid, Rhodes was censured for his involvement in the plot and the following month he was forced to resign as PM. Thereafter he devoted his time to developing Rhodesia.

There are two versions of his last words. One says they were *'So little done, so much to do.'* The other is *'Turn me over, Jack.'*

His will provided for 200 annual Rhodes scholarships for British Empire, US and German students to go to Oxford University. In 'Following the Equator', Mark Twain (1835-1910) wrote about Cecil Rhodes: *'I admire him, I frankly confess it; and when his time comes I shall buy a piece of the rope for a keepsake.'*

SEE Fildes, Sir Samuel Luke/ Twain, Mark

Gary RHODES
Born 22nd April 1960
He was born in Dulwich, south London and brought up in Gillingham. When he was 14, he made a lemon sponge for his family and it went down so well that he decided he wanted to go to catering college. Three years later, he was attending Thanet Technical College in Broadstairs, travelling from Gillingham every day. After three years he was made Student of the Year and Chef of the Year. His first job was as Commis Chef at the Amsterdam Hilton. Whilst in Amsterdam he was hit by a tram and had to have brain surgery. Happily, he made a complete recovery, proposed to his girlfriend and came back to England.

He was later Sous Chef at the Reform Club in Pall Mall and the Capital Hotel in Knightsbridge. By the time he was 26 he was Head Chef at the Castle Hotel in Somerset where he retained the Michelin Star. In 1990 he was Head Chef at the Greenhouse in Mayfair where he won another Michelin Star in 1996.

His TV career began on BBC2 in May 1994 with 'Rhodes around Britain', followed in April 1995 by 'More Rhodes around Britain' which was followed by 'Yet More . .' no, it was followed by an advertising campaign for Tate & Lyle Sugars. The third TV series in 1996 was called 'Open Rhodes around Britain' ('Yet More Rhodes' would have been better). His restaurant called City Rhodes opened in January 1997 and got a Michelin Star the following January. That year also saw two more TV series 'Rhodes Rides Again' and 'Rhodes to Nowhere' I'm so sorry I'm making them up for myself now, let me try again. 1997 saw two more TV series, 'Roald Dahl's Revolting Recipes' and 'Gary Rhodes' – did they run out of imagination?

He opened a restaurant, Rhodes, in the Square, in Dolphin Square, London in 1998. His TV special 'Gary's Perfect Christmas' was one of BBC2's top 10 most viewed programmes that Yuletide.

He also has two brasseries, in Manchester (opened in 1999) and Gatwick (opened in 2001). He also made sandwiches and soups for Allders – I don't mean he stood there buttering the bread; he had people who did that, but you know what I mean.

He has also hosted Masterchef and Masterchef USA. To accompany the various TV series there have been very successful books. Did I mention that he has other restaurants? There is Rhodes 24 in London, the Rhodes Restaurant in Grenada, and Arcadian Rhodes on the P&O superliner.

How does he manage it all? Well, apparently he gets up at 4:30 in the morning to drive to his London restaurant and does not get home until 11 at night. Personally I prefer getting up at 11 and being home by 4:30.

Gary is married to Jenny; they met at catering college, see above, and have two children, Samuel and George.

SEE Broadstairs/ Restaurants/ Television/ Yarrow Home for Convalescent Children of the Better Classes

Eric RICHARD
Although he grew up in Brixton, Eric Richard was born in Margate. He did not start acting until he was twenty-nine, and as well as stage work he appeared in Shoestring and Juliet Bravo before appearing in The Bill as Bob Cryer. He also writes, directs and has a passion for motor bikes.

SEE Actors/ Margate

Frank RICHARDS
This was the name under which Charles Hamilton wrote the Billy Bunter stories.

SEE Authors/ Billy Bunter/ Hamilton, Charles

Alan RICHARDSON
After being released from an asylum because he was no longer considered dangerous, Alan Richardson used a £2,000 inheritance to buy a house in Duncan Road in 1884. I wouldn't have wanted to be his neighbour, because one of his many eccentricities was to wander the streets firing guns into the air.

At twenty past nine on New Year's Day 1888, standing outside Sanger's Bar on the corner of George Street and Ramsgate High Street, he fired two revolver shots into the air. Four men dashed from the bar to see what was going on, saw Richardson, whom they recognised, running down George Street. They caught up with him in Tomson's Passage and one of the men, Charles Pillow, who lived in Cavendish Street, tackled him. Richardson threw Charles off and shot him in the chest, where the bullet damaged an artery and lodged against his spine (he died in the evening of Thursday 5th January). The three other men, Charles's brother George Pillow, Alfred Hoad of Hardres Street and Alfred Knightly of Boundary Road, left Charles with a passer-by and chased after Richardson who managed to get to his house and lock himself in just before the gang could get hold of him. Here, the men were joined by Constable Sandom, who had heard Knightly shouting for help, and by two other men from Sanger's Bar, William Fox and Alfred Moody. Richardson pointed a double-barrelled shotgun out of an upstairs window and after some shouting, shot Fox in the head and neck (although badly injured, he did recover) and Moody in the head and face (he ended up blind). Police reinforcements arrived, and after knocking down the back door, Richardson was overpowered. Police found a revolver, shotgun and two more pistols, as well as fifty rounds of ammunition inside the house. The injured men were taken to the Seaman's Infirmary at Ramsgate

Harbour to be treated. On 13th February at Maidstone Assizes. Richardson pleaded 'guilty but insane' and was sentenced to life imprisonment.

SEE Boundary Road/ Cavendish Street/ Harbour, Ramsgate/ High Street, Ramsgate/ Murder/ Ramsgate/ Sangar family

Geoffrey RICHARDSON
This singer/songwriter has appeared at the Broadstairs Folk Festival and his song, 'Beauty of Broadstairs' can be found on the album, 'Estella in Lux' by Geoffrey Richardson and Francis Kendall.

SEE Broadstairs/ Music

RICHBOROUGH
In 43AD the Romans used this area as their base camp when they invaded. They called it Rutupiae and it became the military establishment that guarded the southern end of the Wantsum Channel; Reculver guarded the northern end. Within the fort is one of the few remains of a Roman church. Julius Caesar landed nearby in 55BC.

In the Roman world, oysters from here were a great delicacy. They were shipped back packed in snow (OK, I have no idea where they got the snow from. I admit it.)

SEE British Expeditionary Force/ Churches/ Mulberry Harbour/ Snow/ Wantsum Channel

RICHBOROUGH POWER STATION

Complete with its three immense chimneys, it opened in 1964.

RICHBOROUGH SECRET PORT
During World War I, vast amounts of freight and munitions left England for the Western front via Richborough's secret port. It covered 1,500 acres and everything from bullets to ambulances and tanks was shipped out. It was linked to Minster via a railway line. Around 20,000 people were employed here, over 200,000 tons of equipment was shipped out and almost 60,000 tons was received in from Calais and Dunkirk.

SEE Minster/ Stonar/ Tanks

RICHMOND ROAD, Ramsgate
It is named after Henry Fitzroy, the Duke of Richmond, who was Warden of the Cinque Ports in the sixteenth century.

SEE Cinque Ports/ Ramsgate

RIOTS
SEE Captain Swing/ Coke Riot/ Salmestone Grange/ Scarman, Lord/ Square, The, Birchington/ Warren, Sir Charles

RISING SUN public house
SEE Effingham Street, Ramsgate/ Pubs/ Ramsgate

RIVIERA GARDENS
Godwin Road, Cliftonville
In 1911, The Riviera Gardens was an open-air cinema on a tennis court. Although the

films were silent, the neighbours were disturbed by the noise of the generator and the gramophone. Their complaints meant that no music licence was granted and the venture was short-lived.

SEE Cinemas/ Cliftonville/ Godwin Road

RNLI

The Royal National Lifeboat Institution is a charity and the oldest national lifeboat service in the world. It is funded entirely by voluntary contributions. It operates lifeboats to save lives at sea around the coastlines of the United Kingdom as well as the Republic of Ireland.

SEE Hillary, Sir William/ Lifeboat

Sir George ROBEY

Actual name George Edward Wade
Born 20th September 1869
Died 29th November 1954

I will admit that he has only a tenuous link with Ramsgate – he married a Ramsgate girl - but as he is almost forgotten these days, I have included him. In the first half of the twentieth century, George Robey was the funniest comedian in England.

His father was a civil engineer who worked abroad a lot and George spoke German fluently and he even attended Liepzig University. Whilst there he survived a duel!

'I was sent to Cambridge till some of my father's speculations went wrong, and I had to face the facts of life and carve out a career for myself.' George Robey, 'Looking *Back on life' (biography)*

He got a job in Birmingham with the firm who were building the tram system. He took his stage name, originally Roby, from a Birmingham building firm and eventually changed his name by deed poll to Robey.

After starting as an assistant to a stage hypnotist - he sang while pretending to be *'under the influence'* - he was booked in his own right at the music hall in Oxford in June 1891. He made his name before World War I and was still performing up until the 1940s. He wore a seedy clerical costume, a scruffy bowler hat, carried a cane and had huge black eyebrows. Known as The Prime Minister of Mirth, to quell applause he would raise an eyebrow and a hand and say in a powerful voice,

'Desist! Really, I meantosay! Let there be merriment, by all means, let there be merriment, but let it be tempered with dignity and the reserve which is compatible with the obvious refinement of our environment'.

During World War I, he entertained the troops and raised over half a million pounds for war charities. After the war he was offered a knighthood for his services but declined on the basis it was too high an honour for a comedian, but accepted a CBE instcad.

● When he saw a stuffed fish in a glass case he said, *'I am satiated with fishing stories – there's no truth in them! The man who caught that fish is a blasted liar!'*

● *'Complaints should be made to the management in writing and placed in the receptacle installed for that purpose at the Entrance, which is cleared twice weekly by the Dustman.'*

● *'The pleasantry of the Music Hall is to show Father bathing the twins, not seducing the typist.'*

● *'There are two classes of pedestrian – the quick and the dead.'*

● *'The inmate of a lunatic asylum was writing a letter. A man looked over his shoulder and asked. 'To whom are you writing?' The inmate replied, 'I am writing to myself.' 'What are you saying?' asked the other man. 'Oh, I shan't know 'til I get it tomorrow.' said the inmate.*

He was a great pantomime dame *'bonnetted and bridling, at once grotesque and genial, creating out of a termagants tantrums a fountain of geniality'*. He also appeared in comedy drag for some of his other performances. In the revue 'Bits and Pieces' (1926), he was a new bride, *'I've flopped, never to flap again. Oh, and I do feel so funny . . . I feel as if all me past life was running down the back of me neck. I don't know whether to laugh or cry, or mix 'em both up like a Selditz powder. I feel like a potato – I want to be smashed. . . . Mind you, I wasn't sure of him 'til the banns went up three weeks ago. They do say there's always three clear Sundays before the execution takes place. And I don't know whether he's got any money or not, but I do know that he pays Income Tax. I suppose that's why he's taken me on – to get a bit off. Of course, everything's so different now, and so strange. I have to be so careful what I say and do now . . . if ever I mention him to any of my friends I can refer to him as 'Mai Husbarnd!' . . . I can say 'Mai Husbarnd!' without getting funny looks from people. And only a few weeks ago I didn't know whether to look upon him as a gift from heaven or a thundering liar. Mind you, girls, this wedding business is no joke. Oh no. It's a very serious business is marriage, you know. There isn't a word for marriage – it's a sentence.'*

Later in his career, he appeared in light opera and films. He was Falstaff in Laurence Olivier's film of 'Henry V'. He was also in 'Chu Chin Chow'.

His hobby was making violins, at which he was very good - but he was appalling at playing them.

He again entertained the troops during World War II this time raising over £2million for War Savings.

After he retired to Eastbourne, he would sit down in front of a mirror every night at exactly the same time as he had done for the previous sixty-odd years, and put on his stage make up, even though he was no longer performing. He finally accepted a knighthood in 1954 and died soon after on 29th November at Saltdean. Out of all the variety comics, only Harry Lauder and George Robey were knighted.

AND VERY NICE, TOO! By George Robey
I did a silly thing some time ago
I jumped off a tram while in motion

The cab-horse behind me gave me a hard kick
I sat down on what I've no notion
When I came too a doctor was feeling my pulse
In the hospital ward I was staying
The doctor and nurse were discussing my case
You'll not sit down for months, they were saying

Chorus:
And I thought to myself, 'This is nice
Now what am I going to do?'
The nurse said, 'Poor fellow, he seems full of pluck
The horse kicked him hard. You can see where it struck
All his life he'll be marked with a horse-shoe for luck'
I said, 'Shall I? And very nice too.'

Watching the trains from the platforms depart
For me has a great fascination
I've studied the travellers rushing about
To guess each one's destination
I was standing on Waterloo platform one day
A lady I thought such a treasure
Although quite a stranger she rushed up to me
And said, 'Horace, this is such a pleasure.'

Chorus:
And I thought to myself, 'This is nice
Now what am I going to do?'
The lady said, 'Kiss me' I did, bet your life
A fellow rushed up. I thought now they'll be strife
He said, 'Are you aware, Sir, that this lady is my wife?'
I said, 'Is she, and very nice too.'

Now young Lord de Gasha, a dear friend of mine
Has only just recently wed
His wife, truth to tell, is a duck of a gel
In the chorus he found her, 'tis said
I was staying with him at his sea-side abode
We wandered along by the waves
When there on the beach from a bathing machine
A sweet girl came out to bathe.

Chorus:
'Why there goes the wifey' said he
That beautiful girl dressed in blue
And for giving advice you've a jolly fine knack
I would just like to act on your good advice, Jack
Would you give her a yacht?' 'No, I'd give her a smack'
He said, 'Would you?... and very nice too.'

SEE Admiral Harvey pub/ Bathing machines/ Entertainers/ Ramsgate

Bruce ROBINSON
Born 1st May 1946

An actor, writer and director, he was born in Broadstairs. He attended the Central School of Speech and Drama in London and at 21

appeared as Benvolio in the Zeffirelli film of 'Romeo and Juliet'. He also appeared in 'The Music Lovers' directed by Ken Russell, and 'L'Histoire d'Adele H' directed by François Truffaut.

In 1980, after a lean period of acting work, he started to write. He won a BAFTA and was nominated for an Oscar and a Golden Globe for his adaptation of 'The Killing Fields' for the big screen.

The film for which he is most famous, however, is the partly autobiographical 'Withnail & I' which he wrote and directed.

The 'I' was based on Robinson and Withnail was based on Vivian MacKerrall, a friend who had died young. He originally wrote it as a novel which he circulated amongst his friends. The film starred Richard E. Grant as Withnail, Paul McGann as 'I' (Peter Marwood), Richard Griffiths as Monty and Michael Elphick as Jake.

His other films have included the 1989 comedy 'How to get Ahead in Advertising', and the thriller 'Jennifer 8' both of them written and directed by him.

As well as this he has written, 'The Peculiar Memories of Thomas Penman' (a novel), and 'Paranoia in the Launderette' (a novelette), and 'The Obvious Elephant' (a children's picture book illustrated by Sophie Windham, his wife).

SEE Actors/ Broadstairs/ Films

Patricia ROC
Born 1915
Died 30th December 2003
Patricia Roc – her real name was Felicia Miriam Ursula Herold – was the daughter of a paper merchant but was adopted by a Belgian/Dutch stockbroker, Andre Riese: she did not find out that she was adopted until she was 34. She went to school in Switzerland, Regents Park and at Bartram Gables in Broadstairs where she was head girl in 1933. She went on to appear in around 40 films, describing herself as *'the bouncy, sexy girl next door that mothers would like her sons to marry – and the sons wouldn't have minded either.'* Amongst her films were 'Millions Like Us' (1943) and 'The Wicked Lady' (1945).

She married an osteopath in 1939 but the marriage was later dissolved. She was rumoured - and I'm not one to repeat gossip, so I'll only tell you once - to have had a relationship with Ronald Reagan. She married a cinematographer, Andre Thomas, in 1949 and moved to his homeland of France. He could not have children but an affair with actor, Anthony Steel, produced a son, Michael, in 1952 and Thomas accepted paternity. Similar to his mother's circumstances, Michael was not told the truth until he was in his forties. Thomas died in 1957 and after marrying a businessman from Vienna, Walter Reif, Patricia returned to England and retired from films in 1964. Later she lived in Minusio, overlooking Lake Maggiore in Switzerland. At the age of 88, she died of kidney failure in Locarno, Switzerland. Her younger sister married the Wimbledon tennis champion, Fred Perry.

SEE Actors/ Bartram Gables/ Broadstairs

The RODNEY public house
47 High Street, Garlinge
This public house was originally about 50 yards from where it is now, at the end of what is now Welsdene Road. Looking more like a cottage than a pub, it was set in a garden of about half an acre that was used as a tea garden. It dated from around 1814 (that's the earliest mention but it is probably even older) and was named after Admiral George Rodney (whose son, in 1804, visited the nearby Dent-de-lion, then a major attraction). The new pub, originally a Cobb house, was built on the site of an old barn in 1926, eventually becoming a Fremlins house.
SEE Cobbs/ Dent-de-lion/ Garlinge/ High Street, Garlinge/ Rodney, Admiral Lord/ Pubs

Admiral Lord George Brydges RODNEY
Born 1719
Died 1792
The 1st Baron Rodney was born in Walton-on Thames (the family seat was originally Rodney Stoke, Somerset) and was one of the eighteenth century's leading admirals. His family was descended from Jane Seymour, niece of Henry VIII's third wife, Jane Seymour. Their family motto was *Non Generant Aquilae Columbas* 'Eagles Do Not Beget Doves'. He first went to sea in 1732, with the Channel Fleet and within five years, whilst still a teenager, had been promoted to Lieutenant. He was posted to the West Indies and the Mediterranean. He was temporarily in command of the sixty-gun Plymouth that escorted a three hundred vessel convoy back to Britain in 1742. He was promoted to Post Captain the following year and was still only 24. In 1747, as Captain of the Eagle, he fought with characteristic fervour under Admiral Hawke in the victory over de L'Entenduère's French fleet when, out of their eight ships, six were captured. From 1749 to 1752 he was Commodore and Commander-in-Chief of the Newfoundland Station. Most of us would want a rest after all that but he returned home and became an MP. Well, maybe that is a rest. He was busy at sea during the Seven Years War (it did not get that name until it was over!) from 1756 to 1763 including being part of Admiral Hawke's Rochefort expedition of 1757, and he was a commander of a ship in Admiral Boscowen's fleet in the capture of Louisberg and Cape Breton Island. Following the capture of Quebec and the fall of Canada, he became a Rear Admiral in 1759. He then commanded a squadron that attacked the French port of Havre de Grace on 4th July destroying the town's arsenal and most of the flotilla of flat-bottomed boats being readied to invade England; the operation lasted fifty hours.

Following his re-election to Parliament, he set sail on 21st October 1761 as the newly appointed Commander-in-Chief of the Leeward Islands Station in the West Indies. He obviously did not intend to hold many surgeries in his local constituency! With the assistance of troops from New York under Major General Monckton's command, he was under orders to capture the island of Martinique.

They all arrived at Martinique on 7th January 1762 and the French surrendered on 16th February. Grenada, Santa Lucia and St Vincent also soon followed into British hands. After Havana fell in August that year, Rodney had, in effect, got the whole set and his war was over. He saw very little in the way of hostilities for another fifteen years, but when it came it eclipsed even what he had already achieved. During this quieter period, he became Governor of Greenwich Hospital in 1765.

Rodney was appointed to command the Barbados and Leeward Islands Squadron on 1st October 1779 but when he left Plymouth with twenty ships-of-the-line on 29th December that same year, he was ordered to go and relieve Gibralter on his way. By good fortune, on 8th January 1780, the fleet spotted a Spanish convoy of twenty-two vessels, seven of which were warships belonging to the Caracas Company. He captured every one of them and the merchant ships were used as a British convoy to supply the garrison at Gibraltar. Eight days later, they were chasing a further eleven Spanish ships-of-the-line off Cape St Vincent, eventually capturing four of them (including Admiral Langara's flagship) blowing one up and forcing two onto shoals where they were wrecked in a battle that went on until two in the morning and became known as the Moonlight Battle. Confidently using very risky and dangerous tactics, Rodney considered this battle to be his finest victory. He still had not finished though and when he arrived at Martinique on 17th April 1780 he took on Comte de Guichen's twenty-two ship fleet. This descended into more of a skirmish and Rodney put this down to the fact that he had not had enough time to train the men under his command in his methods for this battle. On the death of Admiral Hawke in 1781 Rodney became Vice-Admiral of Great Britain, and you can go no higher than that in the Navy. That same year, saw the American record their famous victory at Yorktown, following which the war effectively moved to the West Indies.

Admiral de Grasse commanded thirty-three French warships that were escorting a further one hundred and fifty ships to Jamaica. When they were between Dominica and Guadelope they came across Rodney's thirty-seven warships. On 9th April, long-range gunning began and went on for three days as both sides tried to manoeuvre themselves into a better position. Finally on 12th April 1782, the wind shifted suddenly and Rodney was able to break through the French line twice; de Grasse could not re-form his fleet in time and after a battle that lasted most of the day, he surrendered his ship, Ville de Paris, to Admiral Lord Hood on HMS Barfleur, becoming the first French naval commander to be taken in combat. Rodney, meanwhile, on his flagship HMS Formidable, gathered some ships and took on four French ships, whilst the rest of their

fleet scattered. (The tactics used here to twice break the line of the enemy were famously used in the Battle of Trafalgar in 1805. It is worthy of note that Nelson and Hardy both served under Rodney.)

By now, Rodney and his fleet were on a roll and they finished by capturing a sloop and seven ships-of-the-line in another battle on 18th August, which saved Jamaica from invasion and wiped out France's naval threat in the West Indies.

During the American War of Independence (1778-1783) the Royal Navy either destroyed or captured twenty-one ships-of-the-line: Rodney was responsible for fifteen of them. During his career, four admirals surrendered to him. Sir John Knox Laughton (1830–1915, expert on the Armada and naval warfare) said of him, *'He never let slip an opportunity to bring opponents to action, or being himself in the thickest of the fight.'* He was afterwards created a peer and hopefully enjoyed his retirement before he died at the age of 73 in May 1792.

SEE Admirals/ Rodney, The

RODWAY'S DINING ROOMS
King Street, Ramsgate

Just one of many dining rooms, cafes and eating houses in the town, this one was in business at 41-45 King Street for 31 years, after it opened in 1924.

SEE King Street, Ramsgate/ Ramsgate

The ROLLING STONES

Rock band formed as long ago as 1962 and still going strong.

SEE Beatles, The/ Music/ Nayland Rock Hotel/ Sea Road, Westgate/ West Cliff Hall

ROMAN CATHOLIC CHURCH of our LADY and St BENEDICT,
Minnis Road, Birchington

Built next to an old malthouse, it was originally, in the eighteenth century, a shed with three fairly low walls, and a side open for farm wagons to back into and park when not in use. In 1908, the open side was walled up using corrugated iron and wood, leaving gaps for doorways and it was transformed into a church with attractive panelling inside. To preserve the panelling the new church was built around it in 1956 with US airmen, stationed at Manston, doing much of the work. It ended up at double the length and a good ten feet taller. It was consecrated in 1962 and the hall was added in 1975.

SEE Birchington/ Churches/ Farms/ Manston Airport/ Minnis Road

ROSE HILL, Ramsgate

A house fire here in 1896 killed Bertrand George (aged 19 months), Grace Mary (aged 3 years) and three others. The blaze was integral to the decision that a fire station should be built in the town.

SEE Fire station, Ramsgate/ Fires/ Ramsgate

ROSE HILL COTTAGE, Ramsgate

Augustus Pugin used to visit his maternal aunt, Selina Welby, at her home at Rose Hill Cottage. She lived here from around 1828 (some say 1832) to 1834 when she died, leaving Pugin a legacy that he used to build a house in Salisbury.

SEE Pugin, Augustus/ Ramsgate

ROSE INN, Albion Street, Broadstairs

This coaching inn was established in 1784. During the nineteenth century a lifeboat was kept mounted on a trailer here – the horses were stabled close by – so that it could be taken as quickly as possible to any part of the nearby coastline to be launched.

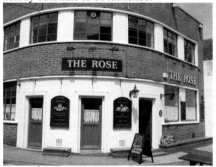

On 23rd January 1857 wood from the wreck of the Northern Belle was presented to John Lang who then had the names of the rescuers painted on it and gave it to the Rose Inn's landlord, who in turn put it on display here. The present building dates from the 1950s and stands further back from the road than the original.

SEE Albion Street/ Broadstairs/ Pubs

The ROSE in JUNE public house
Trinity Square, Margate

A pub which dates back to around 1832 and was named after a boat of the same name that had been berthed in Margate Harbour. Originally, it was the front parlour of a small terraced house in Belmont Cottages but for a small place it had a lot of people working there. The landlady was Sarah Penny, aged 55 in 1841; also living there were a mariner, Edward Hayward (25) and his wife Ann (20) who was a domestic there; and Maria Stannard (15) a lodger of independent means. By 1851, Edward Mariner was the licensee and by 1861, John Duckett was the landlord who also earned a living as a master mason. There was an incident in 1877 when his potboy, aged 15, tried to commit suicide by drinking laudanum in beer. Luckily, Duckett found him in time and forced him to drink a hot water emetic and the poor lad recovered only to face a trial for trying to commit suicide. Fortunately, the courts were lenient. The pub extended into the neighbouring cottage in 1890. In World War I, the entrance to the underground air raid shelters was here.

SEE Harbour, Margate/ Margate/ Pubs/ Trinity Square/ World War I

Christina ROSSETTI

Born London, 5th December 1830
Died 29th December 1894

She was influenced by her mother's devout religious outlook, and her sister who was part of the Anglican sisterhood of All Saints. Her brother was Gabriel Charles Dante Rossetti. Christina was known as Sister Christina when she worked at the Highgate penitentiary, a House of Mercy for Fallen Women

Christina was a lyric poet and her earliest work was published in Germ (in 1850) which was a Pre-Raphaelite journal. Whilst she was a model for a number of paintings by various Pre-Raphaelites, including Rossetti, she was not a member of the movement. Ironically her lasting fame is her face which is probably one of the most famous faces of the Victorian era, as seen in William Holman Hunt's 'The Light of the World'

As a devout Anglican, her work was largely religious, and dealt with death and renouncing earthly love:

'Remember' by Christina Rossetti
'When I am dead, my dearest,
Sing no sad songs for me;
Plant thou no roses at my head,
Nor shady cypress tree:
Be the green grass above me
With showers and dewdrops wet;
And if thou wilt, remember,
And if thou wilt, forget.'
Christina Rossetti, Song: When I am Dead

'Better by far that you should forget and
smile
That you should remember and be sad.'

The rest of of her work was more romantic and less mournful but still not always cheerful:

'Mid-winter' by Christina Rossetti
'In the bleak mid-winter
Frosty wind made moan,
Earth stood hard as iron,
Water like a stone;
Snow had fallen, snow on snow, snow on
snow
In the bleak mid-winter,
Long ago.'
oOo
'In the bleak mid-winter
A stable place sufficed
The Lord God almighty
Jesus Christ.'

She also wrote sonnets, love lyrics, ballads, and even nonsense rhymes for children, many of the latter were written in a fifteen year period in later life when she was a recluse, just like her brother. Among those included in 'Sing-Song: A Nursery Rhyme Book' (1872) is Mice:

The city mouse lives in a house;-
The garden mouse lives in a bower,
He's friendly with the frogs and toads,
And sees the pretty plants in flower.
The city mouse eats bread and cheese;-
The garden mouse eats what he can;
We will not grudge him seeds and stalks,
Poor little timid furry man.

'Goblin Market and Other Poems' (1862) is not only seen as her finest and most important collection of poetry, but 'Goblin Market' itself was much analysed in the latter half of the twentieth century by many feminists:

For there is no friend like a sister
In calm or stormy weather;
To cheer one on the tedious way,
To fetch one if one goes astray,
To lift one if one totters down,

To strengthen whilst one stands.

Despite Christina insisting that it was *'just a fairy story'*, Stanley Weintraub in 'Four Rossettis' (1977) argued that it was *'a Victorian nursery classic, like many works, somehow considered appropriate for children . . . actually full of sinister, subterranean echoes fortunately too sophisticated for their understanding.'*

She never married although she was proposed to more than once. At one time it was thought that she would succeed Alfred, Lord Tennyson as Poet Laureate, but she developed a fatal cancer in 1891 and died three years later. (It was obviously a bad time for poets, because Tennyson himself died 6th October 1892.) She is buried at Highgate Cemetery.

'Silence is more musical than any song.'
Christina Rossetti
'[Spring is] when life's alive in everything.'
Christina Rossetti
SEE Poets

Gabriel Charles Dante ROSSETTI

Born London, 12th May 1828
Died Birchington 10th April 1882

He was the son of an Italian refugee, the poet and Keeper of the Naples Museum, Gabriele Rossetti (born Vaslo, Italy 1783), who came to England in 1821 and became professor of Italian at King's College where his son would later be educated, before attending the Royal Academy. Gabriel was a painter and poet who studied under Ford Maddox Brown and went on to help found the pre-Raphaelite Brotherhood at 7 Gower Street in London in 1848 with John Everett Millais (whom Rossetti had taken under his wing) and William Holman Hunt (Rossetti and Hunt shared a studio).

A buzz-phrase of the time was 'early Christian' and Rossetti wanted the group's name to include it. Hunt did not agree and came up with 'pre-Raphaelite' - because they wanted their work to be similar, in honest simplicity, attention to detail, and colour to the period of Italian painting prior to Raphael Sanzio (1483-1520). Because Rossetti wanted the group to be secret (like the Carboneris, an Italian political group) he suggested adding 'brotherhood' and to that end he signed his painting 'The girlhood of Mary Virgin' 'PRB' in their first exhibition in the summer of 1849.

At a very reactionary time in Victorian art, they were greatly criticised and only when John Ruskin spoke in their favour did it subside. After Millais was elected as an Associate of The Royal Academy, an institution they had previously despised. Hunt went off to Palestine and the brotherhood collapsed.

Rossetti lived at 16 Cheyne Walk, London from 1862 while he was in mourning for his wife Elizabeth Siddal. He turned it into a temple of Aestheticism that included a kangaroo, a zebra, and a racoon in a menagerie.

'I have been at Rossetti's house at Cheyne Walk, and he has been to me in Victoria Street. I liked him on both occasions, but from what I hear he could hardly have been a comfortable man to abide with. He collected Oriental china and bric-à-brac, and had a congregation of queer creatures - a raven, and marmots or wombats, &c. - all in the garden behind his house. I believe he once kept a gorilla. He was much self-absorbed.' F. Locker-Lampson, My Confidences (1896)

Despite his eternal love for Siddal, he turned to William Morris' wife, Jane, and had a long affair with her. In 1871 Morris and Rossetti became joint tenants of a house (Kelscott Manor in Oxfordshire) which Morris described as *'heaven on earth'*. Morris lived there when Rossetti was away.

An article entitled 'The Fleshy School of Poetry' in 'The Contemporary Review' in October 1871 bitterly attacked Rossetti on the morality of his poems. Rossetti's rebuttal 'The Stealthy School of Criticism' was published in the 'Athenaeum' in December 1871.

Whether it was caused by the earlier disinterment, or by the savage criticisms of his poetry, on 8th June 1872 Rossetti reached for the laudanum in an attempt to commit suicide and, whilst he lived, his health never really recovered. Jane stuck by him. In the December of 1881 he had a stroke that left him paralysed on his left side, including his hand.

When Lewis Carrol published 'The Hunting of the Snark' in 1876 - a snark being an imaginary, but elusive beast, that gave the utmost trouble to its hunters and when eventually they tracked it down it proved to be a Boojum – it was widely seen as caricaturing dreamers. Rossetti deluded himself into thinking that Carroll had been thinking of him when he wrote it.

It was therefore for health reasons that he moved, accompanied by Thomas Caine, to Birchington on 4th February 1882, to convalesce in a newly built seaside bungalow lent to him by his friend the architect, John P Seddon. It is now demolished but was situated between Beach Avenue and Rossetti Road.

On first sight of the bungalow, he whispered to the young sister of Hall Caine, *'It's more like another L C and D R station'*. A few days later in an effort to encourage his mother, aged 82, and sister, 52, to visit, he wrote in a letter, *'There is a large garden attached to the house which is in all respects commodious. The journey by 3.15 train is very easy – two hours to Westgate and a quarter of an hour by chaise to come on here.'*

Despite Thomas Caine's long-suffering nature, on one occasion he defended Rossetti's wishes and prevented the local vicar from seeing him!

Birchington was not a holiday resort in those days, it was merely an old fashioned Kentish settlement on the edge of a hungry coast. The village stood back from the shore the better part of a mile, consisting of a quaint old Gothic Church, grey and green, a winding street, a few shops and a wind mill, while the bungalow we were going to live in stood alone on the bare fields to the seaward side. . . . The land around was flat and featureless, unbroken by a tree or a bush and one felt as if the great sea in front, rising up to the horizon in a vast round hill, dominated and threatened to submerge it 'Recollections of Rossetti', by Thomas Caine

A telescope was installed in the bungalow and they were able to view Reculver Towers through it. Rossetti often stood looking out from the cliff tops.

During Rossetti's time here he took a combination of brandy, whisky and claret mixed with chloral, morphia and an old favourite, laudanum. It should be remembered that he had been abusing these substances for a long time.

As his health declined, he got bored, and his moods fluctuated from *'Letters out here must soon come to an end, for nothing happens'* to, *'It is beautiful - the world and life itself. I am glad I have lived.'* He still wrote to Jane Morris and Ford Maddox Brown but was a total recluse and obsessed by a persecution mania.

His friend, Frederick Shields, who later designed the memorial window in the church, came to visit him.

He died on 9th April, Easter Sunday, 1882, and Theodore Watts-Dunton, the author, was at his deathbed.

A later critic observed it was *'A most unlikely spot for a rather improbable life to end'*. He lived here for just sixty-five days and met very few people, yet his name is all over Birchington. Having made it clear that he did not want to be buried next to Elizabeth (Lizzie) Siddal, he was buried in Birchington, a decision made by his brother William, who had also visited him in his last few weeks.

William Sharp (1855-1905) was not only a poet, novelist and biographer (not long after Rossetti's death he wrote his biography), but under the nom-de-plume of Fiona Macleod wrote Celtic romances. He was seen as a protégé of Rossetti's and he came to visit him in Birchington on at least two occasions during his final illness and was at his funeral on 14th April 1882.

Not long after Rossetti's death, the bungalow was bought by Mr F Osbourne O'Hagen, a millionaire who changed its name from Cliffside to Rossetti. He made a few alterations to the property and added carpets, tapestries, and valuable works of art to Rossetti's old studio, which was now his drawing room.

During World War I, the bungalow was a Red Cross Hospital for wounded servicemen. At the same time a 65ft deep air raid shelter was constructed along the length of the grounds between Rossetti Road and Beach Avenue. It was used again in World War II, when the bungalow was occupied by the US Commanding Officer from Manston and after he died, in 1930, his daughter, Miss Agnes Greenwood, lived there until her death in 1952.

The bungalow and its three-quarter acre plot were sold at auction for £4,500. The

bungalows were demolished in 1965 (5 years short of its centenary) and in 1966 town houses were built.

R.E. Francillon, Mid-Victorian Memories (1913): *'I cannot say that Rossetti's presence was enlivening* [in his later years]. *My most representative recollection of him is of his sitting beside Mrs. Morris, who looked as if she had stepped out of any one of his pictures, both wrapped in a motionless silence as of a world where they would have no need of words. And silence, however poetically golden, was a sin in a poet whose voice in speech was so musical as his - hers I am sure I never heard.'*

William Bell Scott, Autobiographical Notes (1892): *'D.G.R., poet and imaginative inventor, who never made a memorandum of anything in the world except the female face between sixteen and twenty-six...'*

The Journal of Beatrix Potter from 1881 to 1897 (1966), ed. by Leslie Linder: '[5th March 1883] *Papa asked Mr Millais yesterday what he thought of the Rossetti pictures. He said they were all rubbish, that the people had goitres - that Rossetti never learnt drawing and could not draw. A funny accusation for one P.R.B. to make at another.'*

Dante Gabriel Rossetti: *'The worst moment for the atheist is when he is really thankful and has nobody to thank.'*

A watercolour portrait by Rossetti. *'One face looks out from all his canvases'*, wrote his sister, Christina. *'Fair as the moon and joyful as the light...Not as she is but as she fills his dream.'*

SEE All Saints Church, Birchington/ Artists/ Birchington/ Bungalows of Birchington/ Manston Airport/ Poets/ Rossetti, Christina/ Rossetti, obituary/ Siddal, Elizabeth/ Westgate-on-Sea/ World War I/ World War II

Gabriel Charles ROSSETTI - obituary

Mr Dante Gabriel Rossetti died on Monday at Birchington-on-Sea, near Margate, where he had been staying for some weeks for the improvement of his health. Mr Rossetti was born in London in May 1828, the son of Mr Gabriel Rossetti, the famous Italian poet, and Dante scholar, who had come to England as a refugee after the Neapolitan revolution in 1821. He showed artistic gifts at a very early age, and for a short time became a pupil of the Royal Academy. His first important picture was entitled 'Mary's Girlhood,' with one exception the only work ever exhibited in London by the painter. Another early work a triptych called 'The Soul of David,' is in the Cathedral of Llandaff.

Mr Rossetti's name became familiar to the public in connection with the so-called Pre-Raphaelite movement, a style of painting founded essentially upon the early Florentine school, in combination with a strict adherence to nature, and strongly opposed to the platitudes of academic art as practised in those days. The revival of medievalism initiated by such men as Mr Madox Brown in whose studio Mr Rossetti worked for some time, Mr Millais, Mr Holman Hunt, and later on Mr Burne-Jones, has exercised a

profound influence on English art. The eccentricities of the school were treated with relentless ridicule by the critics, but the discussion thus raised tended in the end to attract public attention to subjects previously looked upon with indifference, and no amount of abuse was able to crush the fundamental principle of the new movement or the value of the artists, who, as they grew late to maturity, spontaneously abandoned their early mannerisms.

Mr Rossetti's individual bias, his speciality, if the term may be used is traceable partly to his Italian origin, and partly to the associations of his youth. His father, as has already been said, was a lover of Dante, and his curious mystico-political explanation of 'The Divine Commedia,' still boasts some adherents, especially amongst French commentators. The worship of the great Italian poet was with Mr Rossetti hereditary, and from the 'Divine Comedy,' and the 'Vita Nuova,' some of his finest pictorial ideas were derived. The large picture of Dante's vision of the dead Beatrice, recently purchased by the Liverpool Corporation, belongs to this class of subjects, and deserves, by its elaboration, and deep poetic import, to be classed among the artists finest works. Scarcely less beautiful, though less finished, is the early picture which represents the first meeting of the poet with the lady of his love.

Mr Rossetti may be broadly stated to be a colourist rather than a draughtsman. In the former aspect he was, perhaps, unrivalled, certainly unsurpassed by any living painter. There is in his best work a depth and subdued glow of colour which surround his figures with a glow of beauty, whatever the subject may happen to be. Apart from this Mr Rossetti had realised a very high type of female beauty, which, albeit somewhat monotonous, could never fail to rouse the admiration of those not satisfied with the prettiness and cleverness of conventional modern art. Such a picture as the 'Prosperine,' one of the artist's latest works, although consisting only of a single figure, is instinct with all the pathos of antique legend, which would be fully understood without the beautiful Italian sunset which the artist has added by way of explanation. And this leads to the second side of Mr Rossetti's genius, which in him was inseparable from his artistic gift. He was as pictorial a poet as he was poetic painter. His first literary effort was inspired by Dante. It took the form of a collection of translations from the 'Early Italian Poets,' and was published in 1861, and re-issued under the title of 'Dante and His Circle,' in 1874. Both the spirit and the form of the originals are rendered with marvellous fidelity, the translators skill being shown in the prose portions of the 'Vita Nuova,' perhaps even more brilliantly in the sonnets. Mr Rossetti's first volume of poems was published in 1870, and at once established his reputation. The pictorial beauty of 'The Blessed Demozel,' the dramatic force of 'Sister Helen,' a ballad of genuine popular ring, the deep pathos of

'Jenny,' and the profound symbolism of the sonnets, could not fail to impress all lovers of serious poetry, while the rythmical charm of the shorter lyrics was music in the ear.

In addition to this, the absolute originality of these effusions could not be contested by those who were familiar with the history of the Pre-Raphaelite or medieval movement in poetry. Mr Rossetti as we recently pointed out, was the originator of that movement, and his poems were read by the few long before the younger writers who preceded them in date of publication were thought of. That work of this class could not escape adverse criticism of a more or less reasonable kind might have been foreseen, and Mr Rossetti had his full share of both admiration and abuse. He was, and is still, held responsible for the excesses of imitators who have caught his manner without his spirit. Even the vulgarities and affectations of the so-called 'aesthetes', have been gravely cited against him-with what degree of justice students and readers of poetry may decide for themselves. It was, perhaps, partly owing to these misrepresentations that Mr Rossetti waited ten years before publishing a second volume of poems which in many respects evinced even greater and more fully matured powers than the first. Of this book entitled 'Ballads and Sonnets,' we have only recently spoken, and therefore need not return to it, beyond expressing an opinion that the two narrative poems 'Rose Mary,' and A Kings Tragedy,' the short lyric 'Cloud Confines,' and some of the sonnets are likely to take permanent rank with the best poetic work of our time.

Mr Rossetti's death will be deeply felt by the admirers of his art and poetry, and by his personal friends. Although well-read and an excellent talker, he shrank from general society, and in his later years, when ill-health confined him to his house, his circle of acquaintances grew more and more limited. Only a few old friends used to frequent his studio in the quaint Elizabethan house in Cheyne Walk, Chelsea. As an artist he was very sensitive to criticism-favourable or unfavourable-and he seldom exhibited his pictures, although they were occasionally seen in public, chiefly in provincial towns. It is a curious fact that a painter should on this principle have achieved a reputation scarcely inferior to that of the most popular favourites of the day. The Times, Wednesday 12th April 1882.

ROSSETTI ROAD, Birchington

SEE Birchington/ Rossetti

ROVEX/HORNBY

To weave this toy town tale, we need to meet the main players in a complicated story. If I have missed out any twists and turns, or got them wrong, I can only apologise, as I am not good with complicated stories.

Frank Hornby (born 15th May 1868 – died 1936) was the son of a Liverpool provisions merchant. In 1901, he patented his invention, 'Improvements in Toy or Educational Devices for Children and Young People'; a

construction kit called Mechanics Made Easy. In 1907, he thankfully came up with a new name, Meccano, but it was not until 1908 that manufacture of the kits began. He continued manufacturing throughout World War I and later added toy trains. At first, they were clockwork, but in 1925 electric trains joined the range, at first they were powered from the mains at up to 250 volts, but by 1929 it had improved to just 6 volts. Hornby Dubbo ('00') appeared in 1938 at half the size of the original '0' scale, and with diecast trains instead of the pressed metal. In World War II, production did stop but started again soon after. By the fifties, however, rival model train manufacturers were gaining ground, and in 1959 Hornby changed its three-rail system to the more popular two-rail track system. One of Hornby's biggest competitors were Tri-ang who produced plastic bodied trains made in its Margate factory.

The brothers, George and Joseph Lines founded G & J Lines in Victorian times making mainly wooden toys. George later left to become a farmer, and Joe – it's alright, he didn't mind you being informal – had four sons, three of whom, William Lines, Walter Lines and Arthur Edwin Lines joined the firm – and what do three lines make? No, not a parliamentary whip, but a triangle; thus the name 'Tri-ang' was born. Tri-ang trains were very popular, and the business was very efficient. When their factories were taken over in World War II to make munitions, particularly Sten guns, they improved upon the MoD methods.

Lines Brothers acquired Rovex, a plastics firm in Richmond, Surrey.

Rovex was formed in Chelsea in 1946. They made small plastic model cars and other items for Marks and Spencer. By the end of 1950 Rover cars were complaining of the similarity of the names and saying it was causing confusion. Presumably people were buying small plastic toy cars thinking that they were getting a big saloon car they could drive around in. Anyway, they decided to develop a plastic train set. Lines Brothers took them over and in 1952 'Tri-ang Railways' became known as Rovex Scale Models Ltd.

Soon, they had outgrown their premises and moved in 1953 to a new factory at Westwood. The trains were so successful they saw off the competition from Trix Trains and Playcraft and in 1965 they bought out Hornby Dublo.

In 1964, Line Brothers took over Meccano Ltd, merging it with their own Tri-ang Railways, resulting in what became Tri-ang Hornby, with all production located at Margate.

Having been a worldwide success in Canada, South Africa, Australia and New Zealand in the sixties, trade dipped by the seventies when train sets were no longer the most wanted toy for boys.

In 1971 the group was sold and re-named Hornby Railways, the Tri-ang name was lost, and production continued in Thanet. In 1980 the parent company Dunbee Combex Marx went into receivership and Hornby Hobbies Ltd was formed, but later acquired by Wiltminster Ltd who include Hornby Trains, Scalextric, Fairy Dolls, Thomas the Tank Engine – production started in 1985 - Pound Puppies, Boo Boos and Harry Potter's Hogwarts Express are in their range.

Hornby trains, or the old Tri-ang ones were made until 1998.

The site in Hong Kong can apparently employ 1,100 people for the same cost as 500 in Margate.

SEE Harry Potter/ Margate

Arthur Walton ROWE

Born Margate September 1858

Died 17th September 1926

As a GP and surgeon he worked at both the Victoria Road and Royal Sea Bathing Hospitals. He lived in Union Crescent and Cliftonville before having Shottendane House built in which to house his extensive collection of fossils, a field in which he was a world expert. Many of his finds are at the Natural History Museum. Ironically, he died from a tooth infection for which he refused to get medical help.

SEE Cliftonville/ Margate/ Shottendane House/ Union Crescent

ROYAL ADELAIDE

Robert Surtees character Jorrocks took *'an aquatic excursion'* to Margate – *'the most delightful place in the whole world'* on the Royal Adelaide:

Her name was the Royal Adelaide, from which the sagacious reader will infer that this excursion was made during the late reign.

'It was nearly eight o'clock ere the Royal Adelaide touched the point of the far-famed Margate Jetty, a fact that was announced as well by the usual bump, and scuttle to the side to get out first, as by the band striking up God save the King, and the mate demanding the tickets of the passengers. … By a salutary regulation of the sages who watch over the interests of the town, all manner of persons, are prohibited from walking upon the jetty during this ceremony, but the platform of which it is composed being very low, those who stand on the beach outside the rails, are just about on a right level to shoot their impudence cleverly into the ears of the new-comers who are paraded along two lines of gaping, quizzing, laughing, joking, jeering citizens, who fire volleys of wit and satire upon them as they pass. … When they got to the gate at the end, the tide of fashion became obstructed by the kissings of husbands and wives, the greetings of fathers and sons, the officiousness of porters, the cries of flymen, the importunities of innkeepers, the cards of bathing-women, the salutations of donkey drivers, the programmes of librarians, and the rush and push of the inquisitive . . Robert Surtees, 'Jorrocks's Jaunts and Jollities'

SEE Bathing/ Donkeys/ Husbands Boat/ Jorrock's Jaunts and Jollities/ Margate/ Reculver – Jorrocks/ Ships/ Surtees, Robert

ROYAL ALBION HOTEL
Albion Street, Broadstairs

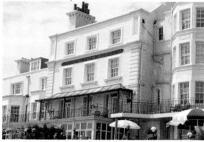

Dating back to 1760, it was originally three buildings – the earliest being the old Phoenix public house – and it fronts onto Albion Street with gardens at the rear extending down to the promenade, giving, *'the most beautiful view of the sea from its bay-windows that you can imagine'*. A plaque on the front of the hotel points out that Dickens stayed there, or in the buildings that now comprise it, for some time during the summers of 1839, 1840, 1845, 1849 and 1859.

On that very first stay in Broadstairs, Dickens visited the Albion (known then as Ballards Hotel, after the owner) with his friend, and biographer, John Forster and recorded that he enjoyed a memorable *'merry night'*. He had the highest regard for the landlord and it would appear that the feeling was mutual, for he wrote, *'Mr. Ballard of the Albion Hotel - one of the best and most respectable tradesmen in England. He has a kind of reverence for me'*.

The novelist, Wilkie Collins, visited Broadstairs in 1859 and stayed at the Albion Hotel with Charles Dickens.

The hotel is now owned by the Roger Family who are descended from Lewis Marchesi, a master baker who settled in Broadstairs in 1884. He was also a founder member of the Round Table, originally set up in Norwich.

SEE Albion Street/ Broadstairs/ Collins, Wilkie/ Dickens, Charles/ Hotels/ Thirty Nine Steps/ Wilde, Oscar

ROYAL ALBION HOTEL, Margate

It opened in 1850 as the Albion Hotel, (although an old print dating from 1779 shows a shop or a pub on the same site) with the White Hart Inn on the opposite corner and a bridge over the creek connecting the two sides of what is now King Street. This was the bridge where George Morland, the artist, had his fight. In 1860, the then very famous Drury Lane clown, Harry Boleno, retired to become the landlord. By 1890, it had become The Royal Albion Hotel, although why the Royal prefix was added is unsure. In its heyday, it was an impressive sight with canopied windows looking down over a very busy area of the town. The hotel survived a big fire in 1909. It stopped being a Tomson and Wotton house in 1969 when it became a free house.

SEE Boleno, Harry/ Fires/ Hotels/ King Street, Margate/ Margate/ Morland, George

ROYAL CRESCENT, Margate

At the end of the nineteenth century, there was a boarding school for around 18 pupils

at 5 Royal Crescent called Royal Crescent College.
SEE Margate/ Schools

ROYAL CRESCENT
West Cliff, Ramsgate
Mary Townley is thought to be the architect of most of the crescent and when it began to be built in 1826, the intention was to build all the way to Government Acre. However, sales were slow. So slow, that after nearly 40 years, in 1865, only one half of the original plans had been completed.
Number 1, fittingly, was the first to be built – I hate it when they start with number 20 – but I mention it particularly, because despite being in a style that Pugin hated, it was the one house that he thought suitable for his patron, the Earl of Shrewsbury, to stay in when he came to Ramsgate.
SEE Burnand, Sir Francis/ Pugin, AWN/ Ramsgate/ Townley, Mary

ROYAL ESPLANADE, Ramsgate
It runs westwards from the end of the West Cliff Promenade and was completed and opened by Dame Janet Stancomb-Wills in 1924. The inland side was set aside for housing; the sea side for a putting green, bowling green, tennis courts, picnic area and a bandstand.
SEE Ramsgate/ Stancomb-Wills, Dame Janet

ROYAL EXCHANGE INN, Monkton
A detached inn with livery stables to the rear, it acted as a post house for carriages travelling between Canterbury and Ramsgate. Thomas Ansley was the landlord here in the 1890s and he was also the Sexton and the Parish Clerk! The inn closed in the 1890s.
SEE Monkton/ Pubs

ROYAL HARBOUR
It covers an area of 42 acres and Ramsgate is the only town in the country to be granted the right to call its harbour a Royal Harbour. George IV gave Ramsgate the right in 1821. The town also has the right to fly the Royal Standard but only on one day per year. Well, it hardly seems worth the bloody effo . . . oops, there goes my knighthood.
SEE George IV/ Harbour, Ramsgate/ Obelisk/ Ramsgate

ROYAL HOTEL, Ramsgate
Advertisement, c1900:
The Royal Hotel
for families and gentlemen (facing the new front road). Good sea view.
A Good Coffee Room, Table d'Hote, and Public Drawing and Smoking Rooms.
Within Five Minutes' walk of the LC&D and South Eastern Railway Stations.
This first class hotel affords every Domestic Comfort, is situated opposite the Royal Harbour, commanding extensive views of the Goodwin Sands, Downs, etc., and is sheltered from the north-east winds.
This Hotel has been used as a Temporary Residence by the late Duc d'Aumale, the French Imperial Family, and other Royal and distinguished personages.

J J Roach, proprieter.
In March 1989, 18 firemen fought a blaze at the empty Royal Hotel.
SEE Downs, The/ Fires/ Goodwin Sands/ Hotels/ Ramsgate

ROYAL NAVY AIR SERVICE STATION
St Mildred's Bay, Westgate
This was sited at St Mildreds Bay until they realised that the stormy weather was not conducive to keeping early aircraft flightworthy. Those were the days of canvas, string and a wing and a prayer. Anyway, when a storm blew several planes, and their hangar, into the sea in March 1916, someone had the bright idea of moving the operation inland and thus RAF Manston was born. The slipways from where the seaplanes were launched are still there.
SEE Manston Airport/ St Luke's area/ Westgate-on-Sea/ World War I

ROYAL OAK HOTEL, Ramsgate
There has been a Royal Oak Hotel since 1690. The 1717 rate book refers to the 'Oak at the Waterside'.
During the years in which he spent holidays at Broadstairs, Dickens often made the six-hour journey from London by Paddle Steamer to Ramsgate, staying overnight on occasion at the Royal Oak Hotel.
The Royal Oak is now Oak and Shade.
SEE Andersen, Hans Christian/ Broadstairs/ Dickens, Charles/ Hotels/ Ramsgate

ROYAL PARADE, Ramsgate
Construction began in 1891.
SEE Ramsgate

ROYAL ROAD, West Cliff, Ramsgate
Designed by Mary Townley in the Regency style. Many of the original occupants were army officers in the Napoleonic Wars.
SEE Napoleonic Wars/ Ramsgate/ Spencer Square/ Townley, Mary/ Trafalgar Hotel/ Van Gogh, Vincent

ROYAL SAILORS' REST
Ramsgate Harbour

The stone-laying ceremony took place on 30th April 1903 with the port missionary, Mr W H Dickinson, presiding. The Rest was to offer temporary accommodation and comfort to visiting sailors. It was turned into a temporary hospital in World War I, initially for Belgian soldiers.

SEE Belgian soldiers/ Harbour, Ramsgate/ Ramsgate

ROYAL SCHOOL FOR DEAF
Victoria Road, Margate
The Royal School for Deaf opened in November 1792 in Grange Road, Bermondsey, East London and was founded by Rev John Townsend, Harry Thornton and Rev Cox-Mason. It was the first school exclusively for the deaf in this country and only the third in the world. In 1875 it moved to Margate where the Royal School for Deaf was built on the site of the old workhouse which was demolished in 1862. The Royal Asylum for the Deaf and Dumb Poor was opened by the Prince of Wales in 1875 in Victoria Road, the name thankfully changed to Royal School for Deaf and Dumb Children – 300 pupils in total. The Queen presented the prizes on Speech Day at the Royal School for Deaf and Dumb Children in 1952. The original building was knocked down in 1971 and over the next 5 years, it was replaced with a modern school. In over 200 years, there have only been 10 headmasters. In its earliest days it had so few staff that some teachers were at times in charge of 250 pupils, these days there are a total of 265 staff and 150 pupils.
SEE Margate/ Schools/ Trinity Square/ Workhouse

ROYAL SEA BATHING HOSPITAL
Canterbury Road, Westbrook

Dr John Coakley Lettson and some other London gentlemen founded the Royal Sea Bathing Hospital to give *'Relief of the Poor whose Diseases require Sea-Bathing'* in *'the extreme Salubrity of that part of the Coast and the ready and cheap Conveyance hither'* on 2nd July 1791 in the then open fields of Westbrook, under the patronage of George III. Designed by Reverend John Pridden, it had 162 beds and the East Wing opened 5 years later with 25 patients. The medical profession, led by people like Dr Richard Russell writing as early as 1750, was convinced of the benefits of breathing *'the sea air over the sea mud'* and saw it as *'a place where poor patients could take the sea water cure in the battle against consumption'*. Dr Lettson wanted a hospital where the patients would be in beds under an open veranda breathing the healthy sea air. Strictly speaking - and this is the science bit – the correct name should have been 'The Royal Thalassotherapy Hospital' but it wasn't as eye-catching, people didn't know what it was, they wouldn't go, relatives of the patients said they didn't know what a 'tha' was let alone understand how the patients were going to lasso one and, even if they could, how was it therapeutic? So in the end, The Royal Sea Bathing was the less

technical name that was chosen but you can only imagine the meetings, reports, think tanks, committees, brain-storming sessions, consultations and public enquiries that were required before this decision was made, or maybe it was different then. Ironically the word 'thalassotherapy' is back in vogue in upmarket health spas, they do say what goes around, comes around, I suppose.

The north wing was built around 1807 and the porch facing the main road was added in 1816.

The Gentleman's Magazine, January 1816: *The late Dr Lettson, whose labours for the benefit of the afflicted poor cannot be too highly estimated, with a few friends, founded in London . . . an Institution, which is the object of this letter to recommend to the notice of a benevolent public. In looking for an eligible spot for the erection of the General Sea Bathing Infirmary, their attention was, in the first instance, called to South-End being a convenient distance from the metropolis; but the difficulty of access from the sea, and the circumstances of vessels sailing constantly to the Isle of Thanet (a passage by water being much cheaper . . . to the Patients than the land-carriage) led them to prefer a part of the coast at Westbrook, near Margate . . . The house was opened for the reception of patients in . . . 1796, when sixteen patients were admitted. From that period to the present 3,756 patients have experienced, in various degrees, the salutary effects of this establishment. . .*

The Rev. Richard Barham, writer of the Ingoldsby Legends, preached sermons at the Sea Bathing Infirmary.

The portico at the entrance to the main building was only added in 1820 having previously stood at the front of Holland House at Kingsgate (at one point the columns were completely clad in ivy). By 1818 the number of patients treated was up to 350, and by 1830 it was 541. It was maintained totally by voluntary subscriptions and donations. Patients were brought down from London by hoys. A special carriageway was made to the sea so patients could be carried to the sea for the beneficial sea bathing. The then Prince Regent (later King George IV) was very interested in the whole venture and in 1821 the hospital was granted a Royal Charter becoming The *Royal* Sea Bathing Hospital.

In 1822, a wing was added that actually looked out to sea - it only took 30-odd years to think of it.

Pigots 1840: *. . .there is a royal sea bathing infirmary, at Westbrook, founded under the patronage of royalty; some years since it received the addition of a wing, appropriated to the accommodation of female patients; and the entire edifice is a proud testimonial of Thanet liberality.*

The hospital was pioneering in the treatment of tuberculosis; in fact, it was the country's first specialist hospital for tuberculosis but, not surprisingly, they realised that bathing in the sea was only suited to the summer months (who could have guessed?). Internal baths were erected in 1858 so that the

treatment could continue through the winter - and probably large chunks of the spring and autumn too. Another part of the treatment was the drinking of two pints of sea water in milk per day. Nowadays, drinking two pints of sea water could put you in hospital - and you would definitely want the skimmed variety. An alternative name for tuberculosis was scrofula.

Meanwhile, back at the hospital, the wounded from World War I battlefields in France and Belgium were brought here to be treated. No more major building took place after 1919. During World War II, the entire hospital was evacuated to Southill Park near Bracknell in Berkshire, and the building was used again by the military medical, particularly following the evacuation from Dunkirk. The number of beds was increased from 324 to 520 to accommodate them. The extra beds were put mainly on the verandas and the pews in the chapel were replaced by beds.

In 1947, the Royal Sea Bathing Hospital joined the newly formed National Health Service but less than 50 years later, in July 1996, it closed - coinciding with the building of the large Queen Elizabeth Queen Mother Hospital on the Ramsgate Road in Margate. The redundant building was a very sad sight for a few years. Various new uses for the site were mooted, from a private hospital, nursing home and hospice, to a Greek Byzantium centre and a football museum. As parts of the site, including the mortuary, were either Grade I, or Grade II listed - that bureaucratic device that often destroys the very buildings it strives to preserve - it became difficult to find a buyer who was allowed to use the building for a future use. Any planning approval also had to take into consideration the curious detail that the grounds are currently a safe haven for the turnstone that flocks to its grounds. It was thought to have been sold in 2001 for c£600,000 when planning permission was given for it to become shops, apartments and parking, but nothing came of it. Finally in 2004 work began on the building.

SEE Barham, Richard Harris/ Canterbury Road, Westbrook/ George III/ Holland House/ Hospital/ Listed buildings/ Margate/ Ramsgate Road, Margate/ Scrofula/ Westbrook/ Wilson, Sir Erasmus

ROYAL TEMPLE YACHT CLUB
Ramsgate

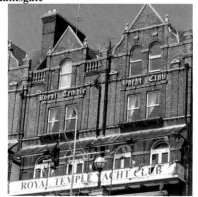

The club was originally formed on 4th March 1857 as the Temple Yacht Club at the Ship

Tavern, Essex Street, Strand, London – actually in the Temple, hence the name – although the Ship has long since been demolished. The members originally cruised and raced in the Thames. A race in 1866, in which only members could steer, started from Charlton and went round the Ovens buoy. The club went on to have temporary quarters at Greenhithe and then Gravesend from where they raced to Ramsgate and back; the last race took place in 1873. In 1888 they rented premises in Ramsgate.

By 1895, permanent quarters in the town were required and the members decided it would be prudent to buy premises rather than rent them. The new clubhouse was opened on the site of Sir William Curtis' house by Lord Charles Beresford on 30th May 1896.

Baron Ferdinand de Rothschild was elected Commodore in 1897 and shortly after it became the Royal Temple Yacht Club. The Prince of Wales, later Edward VII, attended a function here. The admiralty sanctioned the flying of the blue ensign in 1898 and before World War I, the German Kaiser raced here.

During World War I, many members served as officers of the RNVR, and the members of the Dover Patrol frequented the club.

In the years after, yacht racing was slow to recover but in time it did and the club prospered, only for the Second World War to interrupt activities. The Royal Navy took over the premises along with the adjoining ones and it all became part of HMS Fervent until 1945. Despite some difficult times after the war, the club recovered and is still going after almost a century and a half.

The Queen dined here after launching a new lifeboat and she has not been the only royal visitor here. A previous Prince of Wales apparently invited females into the men-only snooker room where he allegedly sank the pink on many occasions.

Ted Heath was a member and current honorary members include Dame Ellen MacArthur (who holds the record for sailing around the world solo) and Steve Fossett (who holds many records including one for sailing around Britain in a sailing yacht).

SEE Curtis, Sir William/ Heath, Edward/ HMS Fervent/ Ramsgate/ Regatta/ Sport

ROYAL VICTORIA PAVILION
Ramsgate

It was built on the site of a mason's yard that had originally been hidden from holiday makers disembarking trains at the Ramsgate Sands Railway Station, by the construction of a Colonnade. As the yard fell into decline, the site was used each summer by the Church of England who erected a marquee where they held mission services. A huge gale on 29th November 1897 and lasted three days (and was the same storm that caused the Friend of All Nations lifeboat disaster at Margate) completely destroyed the Colonnade and damaged the harbour wall, the Promenade Pier and parts of the station.

It took a few years before the council decided that an entertainment venue was needed and chose the site of the old mason's yard.

Designed by Stanley D Adshead, who trained under George Sherrin, it was built on a bed of chalk dug out from the cliff, which had stood 50-60 feet further forward in front of nearby Albion Place and Wellington Crescent. It was able to seat 2,000 people; the large hall was 130ft long and 65ft wide, upholstered and decorated in the style of Louis XVI - or Lawrence Llewellyn-Bowen as some now prefer to call it - and based on the Marie Antoinette Theatre (1770) at Versaille.

HRH Princess Louise of Argyll opened The Royal Victoria Pavilion on 29th June 1904. She stayed at the San Clu Hotel and was escorted down Madeira Walk by members of the East Kent Yeomanry on horseback.

The open area with benches looking out to sea, has stone groynes sloping down to the sands but these have now been covered by the sand.

The Pavilion was used for variety shows and concerts. Bands that were popular here through the decades included the Howard Flynn Band in the 1920s; The Jerry Hoey Band and Al Tabor in the 1930s; and Billy Merrin's Band in the 1940s.

In the winter films were shown in what was known to locals as The Pav.

At each end of the Pavilion were octagonal shaped areas with domed roofs containing buffets and tea rooms. On the outside, facing the sea, is a 180ft long shelter.

Roller skating began here on Boxing Day 1907 and a separate skating rink was added in 1911.

On 24th August 1955 a fire caused the closure of the summer shows and part of the silver dome fell in. After the summer season of 1969, it closed. Now, it houses Grosvenor Casino, but much of the building is empty.

It is one of many buildings in Thanet where ghostly goings-on have been reported.

Advertisement, c1900:

Proprietors –The Corporation of Ramsgate.
Lessee –Mr J Herbert Jay
Acting Manager – Mr N Arthur Hornby.
Refreshment Manager – Mr George B Richter
The band plays from 11 to 1 on Outside Promenade (if wet inside the theatre)
Admission 2d.
3.15 to 4.30 – Grand Variety Entertainment (with change of programme weekly), and Biograph. Admission 6d, 1/-, 1/6; or to Promenade only 2d.
Afternoon teas served on Outer Promenade every afternoon.
7.0 to 11.0 – First class Companies in the latest London successes.
Admission 6d, 1/- to Balcony and Pit Stalls, and Outside Promenade (smoking allowed). Stalls, 2/-, 3/- (seats can be booked).
THE BAND PLAYS ON SATURDAY AFTERNOONS from 3.0 to 4.30 on the

Promenade (if wet inside the theatre).
Admission 2d.
A GRAND CONCERT EVERY SUNDAY EVENING at 8 pm
Admission 6d, 1/-, 1/6
A series of Dances will be given (with lime-light effects) in the Grand Hall during the Summer and Winter months. Admission 1/-.
In the Spacious Restaurant Luncheons and Dinners are served from 12 o'clock to 6pm in high class style, at popular prices.
PRICE LIST
BEVERAGES
Pot of Tea, fresh made, for one 2d, for two 4d, Coffee and Tea, per cup 2d, Milk (cold), per glass, 1d; hot (per cup)1½d, Egg and milk 3d, Milk and soda small 2d large 3d, Cream 1d, Lemonade, Soda water or Ginger Ale small 1d, large 2d, Ginger Beer 2d, Bovril 3d
LIGHT HOT DISHES
Egg, boiled or poached 2d, One egg poached or scrambled on Toast 4d, Two eggs ditto 6d, Ham or Bacon and one egg 6d, two eggs 8d, Sardines on toast 4d
BREAD, PASTRIES, Etc. Bread and Butter (white or brown), per plate 2d, Roll 1d Roll and butter 2d, Toast (dry) 1d (buttered) 2d, Bath, or plain, bun 1d, scone 1d, Biscuits (various) per plate 1d, Butter (per pat) 1d, Jam or marmalade 1d, Cakes and pastries 1d and 2d
LIGHT COLD DISHES Sandwiches each 2d, Sardines 1d, Ham per plate 6d, Pickles 1d, Watercress, lettuce or radishes 1d, Pineapple, Peach, Apricot, Apple etc 1d, Strawberries and cream 4d. Ices 2d & 4d
CHAMPAGNES Bollinger, Extra Dry 11/6 6/-, Pommery and Greno, Ex. Sec 12/- 6/6, Heidsieck, Dry Monopole 12/- 6/6
CLARETS Medoc 2/- 1/3, St Julien 2/6 1/6, Chateaux Margaux, 1894 3/6 2/-
RED BURGUNDY Beaune 3/- 1/9
STILL HOCK Hockheim 4/- 2/3
SPARKLING MOSELLE Klein & Co 3/6 2/-
PORT Fine Old Port 4/- 2/3
SHERRY Amontillado 3/6 2/-
LIQUERS Benedictine per glass 6d, Cherry Brandy per glass 4d, Ginger Brandy per glass 4d, Kummel per glass 6d, Lime Juice per glass 3d, Chartreuse (Yellow and Green) per glass 6d, Peppermint per glass 3d, Vermouth per glass 4d
BOTTLED BEER Bass' Pale Ale per bottle 3d, Worthington's per bottle 3d, Guinness' Stout per bottle 3d, Allsopp's Lager Beer per bottle 3d
SUNDRIES Soda Water large 4d, small 2d, Lemonade large 4d, small 2d, Seltzer 2d, Potass large 2d, Ginger Ale large 6d, small 3d, Ginger Beer 2d, Apollinaris large 6d, split 4d
SALT & CO.'S Pale Ale, TOMSON & WOTTON'S London Stout on Draught
LEMON SQUASH, large 6d small 4d
CIGARS AND CIGARETTES OF THE CHOICEST BRANDS
SEE Booth, General/ Fires/ Friend of All Nations/ Glacco, Mr G/ Madeira Walk/ New Shipwrights Hotel, Ramsgate/ Pankhurst, Christabel/ Pankhurst, Mrs Emmeline/ Promenade Pier/ Ramsgate/ Restaurants/ Royal Victoria Theatre &

Pavilion - advert/ San Clu Hotel, Ramsgate/ Sousa, John Phillip/ Victoria/ Yeomanry

ROYAL YACHT - Victoria & Albert
The second Royal Yacht of this name was built in 1855 and was 360 feet long.

When Princess Alexandra was to marry the Prince of Wales in 1863, the Victoria and Albert, accompianied by the warships Revenge and Warrior, was sent to collect her. Well, if you've got it, flaunt it.

On the evening of the 5th March the yacht unexpectedly had to anchor off Margate. Not one to miss an opportunity, Margate's Mayor, Councillor John Barry Flint went down to the shore and was the first person to welcome the Princess to England. The Princess finally disembarked at Gravesend on 7th March 1863 - and I bet the welcoming committee there were not happy about their thunder being stolen.

Back in Margate, the town was still excited about the unexpected honour. Meetings took place and after the suggestion of building a clock tower on Marine Terrace was turned down, it was decided to commemorate the event by building the Alexandra Homes.
SEE Alexandra Homes/ Margate/ Marine Terrace/ Ships/ Victoria

ROYAL YORK HOTEL, Margate
In the beginning, it was a small tavern called the Black Horse Inn.

When a channel was cut next to Wrights York Hotel in 1736, salt water entered at every high tide and the commercial bath was born.

Widow Barber, the proprietor, built '*a very commodious Assembly Room and salt water baths*' in 1753; and in 1761 she took over the Kings Head. She was succeeded by John Mitchener II who generally enlarged and improved the place adding a coffee room, billiard table and music gallery, and re-named it The New Inn, at 16 New Street.

One guest in 1770 was a Mr Moore who did the 80-mile journey from Cheapside in nine hours on a velocipede - an early bicycle.

Before embarking to Flanders in 1793, The Duke of York, Frederick, the son of George III, stayed here and it was soon renamed the Royal York Hotel. It attracted many members of the gentry and was the terminus for the stagecoaches.

Soon after officers were billeted here in the Napoleanic Wars.

A curious incident occurred in 1814 when Sir Marc Isambard Brunel arrived in one of his early steam ships; such was the strength of feeling against these rivals of the sailing ships of the day, that he was refused a room. In case you were worried, he was allowed to stay when he visited again.

In 1868 the Parade was widened and the channel disappeared.

In 1882 it was completely rebuilt with a grand extension and by the end of Victoria's reign the original coach house and stabling block were being run by Sayer's '*well appointed brakes*' and can still be seen although it is now a residential property.

However, trade dropped so much that in 1909 the hotel was converted into shops and flats, called the Royal York Mansions.

The York Tap bars were renamed The Ruby Lounge with the old hotel reception becoming the games room. The whole place had a huge refurbishment in 1983 and gained the reputation of having a party atmosphere with fancy dress discos. It even won a trophy for best float in the carnival.

The Ruby Lounge is now called Rouge.

Ghostly goings-on have been reported on numerous occasions. Fred, a wizened old man wearing a trench coat and cap, haunted the public bar. The sound of a baby was heard on numerous occasions on the intercom between the bar and a first-floor flat. Lights would turn themselves on and off and plugs were pulled from sockets. It all caused one former landlady to move to the Shakespeare to escape it all.
SEE Bicycle/ George III/ Hotels/ Margate/ New Inn/ Shakespeare/ pub

ROYAL YORK MANSIONS
SEE Royal York Hotel

ROYALTY
SEE Adelaide/ Alexandra/ Anne/ Athelstan/ Canute/ Caroline/ Charles/ Edward III/ Edward VII/ Ethelbert/ Ethelred/ George I/ George II/ George III/ George IV/ George V/ George VI/ George, Prince/ Laking, Sir Francis/ Leopold/ Louise Alberta/ Napoleon/ Prince Harry/ Prussia/ Royal Yacht/ Sweyn/ Victoria/ William III/ William IV/ William & Mary

RUMFIELDS ROAD, Broadstairs
The area between Rumfields Road and Coxes Lane at Northwood had many brickfields and secluded broken ground ideal for holding illicit sporting events like bare-knuckle fights and cock-fighting in the nineteenth century.

On Thursday 20th November 1952, a Tiger Moth plane hit the North Foreland Wireless Station's 120ft tall mast and lost control, eventually landing one yard from the back wall of Mrs W Baxter's house at 94 Rumfields Road.
SEE Broadstairs/ Buffs Cottages/ Cock fighting/ Northwood

William Clark RUSSELL
Born Carlton House Hotel, New York, 24th February 1844
Died 1911
He was the son of Henry Russell who wrote the songs, 'Cheer Boys Cheer' and more famously 'A Life on the Ocean Wave' to which the Royal Marines use to march.

William went to school at Winchester and Boulogne. Aged 13, he joined the merchant navy where he served for the next eight years; his experiences were put to good use later in his novels which were an immediate success. His career in journalism started with the Newcastle Daily Chronicle but he later became a leader writer on the Daily Telegraph. At the same time, he was writing novels, although by 1887, the workload was affecting his health and he resigned from the Telegraph. He used his novels to plead for

better conditions for English seamen, notably for better food in 'The Wreck of the Grosvenor' (1875). He lived in Ramsgate for many years, and he and his father were members of the Ramsgate Royal Oak Glee Club!
SEE Authors/ Music/ Ramsgate

RUSSIA
Ramsgate had a thriving trade with Russia in the early nineteenth century. Chalk was excavated from the local cliffs and used as ballast in the holds of the empty Russian vessels and taken back to Russia where the chalk was burnt for lime.
SEE Alma/ Cochrane, Admiral/ East Cliff Lodge/ 'Last Resort'/ Lonsdale, Gordon/ Montefiore, Sir Moses/ Muir Road/ Ramsgate/ Sanger/ Tester, Dr/ Winter Gardens/

SACKETTS HILL FARM
Dane Court Road, St Peters
It stands back from Dane Court Road, and the original inhabitants, the Sackett family, were yeoman farmers in Thanet for around 500 years. Later owners included Sir Richard Burten, who commanded the Gongreve batteries at the Battle of Waterloo, and a man who even built a light railway to carry his guests between the house and the road!

On the afternoon of 3rd July 1940, a Spitfire, piloted by Sergeant White from 74 Squadron based at Manston, was struck by lightning and crashed at Sacketts Hill. Subsequently the wreckage was bombed by two German aircraft.

The grand old house sadly burnt down in 1944, leaving only the stables.

Back in the 1960s, before the new improved road that is there now, the section of road by Buddles Farm used to have an 's' bend through the farm complete with chickens crossing the road.
SEE Dane Court Road/ Farms/ Manston Airport/ Spitfire/ Waterloo, Battle of

SAILOR'S CHURCH, Ramsgate

Also referred to as the Sailors Home and Harbour Mission, it stands by the west pier and the first stone of the Sailor's Church was

laid by the Marquis of Conyngham on 8th July 1878.

The vicar of Christ Church between 1873 and 1892, the Rev Canon Eustace Brenan, saw a need for a mission church for the smack boys who, until the opening of their own Smack Boys' Home in 1881, were housed above the mission. William Whitmore, Horace Bowler and Edwin Cotton were the harbour missionaries. Edwin Cotton was still there in 1940 when the war forced the closure of the homes for the duration of World War II. After the war, church services resumed, and the harbour men used the room above the church as a canteen. Subsequently the room has been used by Scouts and Sea Cadets.
SEE Churches/ Conyngham/ Ramsgate/ Smack Boys' Home

SAILOR'S HOME and HARBOUR MISSION
SEE Sailor's Church, Ramsgate

SAINSBURY
Sainsbury's are named after John James Sainsbury (1844-1928) whose father was an ornament and frame maker. He married a dairyman's daughter and in 1869 opened a dairy shop in London. By the outbreak of World War I, he had 115 grocery shops in and around London. He and his wife also had twelve children. I am not sure if he ever slept.

Work began on the Sainsbury store in Margate Road in April 1990 with the opening planned for 1991 but it was completed in 44 weeks - two months early, and opened in December 1990. At its opening it carried 12,000 lines in 32,000 square feet, employed 300 staff, had 29 checkouts and parking for 585 cars.
SEE Margate Road, Ramsgate/ Shops

St ANDREW'S CHURCH
Reading Street
The Church Infant School was built in 1868. A few years later it was decided that a church was also needed and, initially, a Church Hall was built and dedicated by the Bishop of Dover in 1907. The foundation stone for St Andrew's Church was consecrated on 11th April 1911, by Dr Randall Davidson, the Archbishop of Canterbury. It was built on a farm previously belonging to Rimpton Court, later the Rimpton Boys Home in Reading Street.

Unfortunately World War I intervened. The clergy from here left to serve in the Armed Forces and the church was closed for the duration.
SEE Churches/ Farms/ Schools/ World War I

St AUGUSTINE
SEE Gregory, Pope

St AUGUSTINE'S
Canterbury Road, Westgate
This Grade II listed building has been a Catholic school, hotel, conference centre, wedding venue – and, at the time of writing, there are plans to turn it into a large-scale residential complex.

SEE Canterbury Road, Westgate/ Listed buildings/ Schools/ Westgate-on-Sea

St AUGUSTINES ABBEY, Ramsgate

Designed and paid for by Augustus Welby Pugin, work began in 1847 and four years later it was open for worship, although the spire in the original design was never built.

The Benedictine monks arrived in 1852, and the monastery was built between 1860 and 1861. Father Wilfred was raised to the position of a mitred abbot in 1871 and St Augustines became an Abbey Church. Pugin originally designed the font for St Georges Cathedral in Southwark but after it was exhibited at the Great Exhibition of 1851, it was presented to Pugin by Mr Myers.

Pugin lies in the abbey, hands clasped in prayer, wrapped in a mantle on a magnificent tomb, showing representations of his children between the marble pillars.

SEE Churches/ Ramsgate/ Salmestone Grange

St AUGUSTINE'S CROSS, Ebbsfleet

In an effort to create a draw for tourists, Earl Granville, Lord Warden of the Cinque Ports at the time, who owned the tea rooms at Ebbsfleet, unveiled the 15ft tall cross in 1884 to mark the spot where it is thought St Augustine landed. Close by are said to have been a well and an oak tree that grew from a staff that St Augustine is supposed to have stuck in the ground.

SEE Cinque Ports/ Ebbsfleet/ St Augustine

St AUGUSTINE'S ROAD, Ramsgate

When Augustus Pugin wanted to recommend somewhere for the Earl of Shrewsbury to stay – he was going to put some work his way! - it was 1 Royal Crescent in St Augustine's Road that he chose. Ironic really, because he hated the Regency style and this is a prime example of it.

Another connection in this road with Pugin is West Cliff Lodge. It was built by a Mr Henry Benson and then called Royal Villa. He and Mrs Benson had a niece, Helen Lumsden, to whom Pugin got engaged (they met at Royal Villa). Unfortunately, her family told her that she should call it off and she did. Pugin, not unnaturally, was upset by this and went to talk to Mr Benson for a bit of comfort. I expect he said that there were plenty more fish in the sea, or something just as trite.

The plot of land occupied by Chartham Terrace was bought by Charles Habershon. He, like Pugin, was an architect, but unlike the strongly Catholic Pugin, he was a staunch Protestant and decided that he would build his house in a totally opposite style to Pugin's. How very grown up eh? He also once described Pugin as *'a repulsive humbug'* following a difference of opinion about the price of his land.

SEE Pugin, Augustus/ Ramsgate

St CHRISTOPHER'S CHURCH
Newington

In 1950, the residents of the newly-built Newington estate decided that they wanted a church of their own; which was unusual because it is usually the church authorities who decide these things. Local pressure soon got going and a 500-signature petition presented to the Archbishop resulted in £9,000 being allocated to the cost of the building which left a shortfall of £5,000. Various fundraising events were organised such as coffee mornings and jumble sales, and the Sunday School organised a farthing collection, and bricks could be 'bought' for 6d. Eventually the money was raised. A fete in Ellington Park on 1st September 1955, raised £1,000 and the following day the church was dedicated by the Archbishop of Canterbury, Dr Geoffrey Fisher. Fifty years later, the Archbishop of Canterbury, by now Rowan Williams, came to re-dedicate the church.

SEE Churches/ Ellington Park/ Newington estate

St ETHELBERT & St GERTRUDE CHURCH, Hereson Road, Ramsgate

Designed by P P Pugin, in a Gothic style, and built by W W Martin, it was opened on Thursday 14th August 1902 by his Lordship, the Right Rev Bishop of Southwark.

SEE Churches/ Hereson Road/ Pugin, PP/ Ramsgate

St GEORGE'S CHURCH, Ramsgate

In 1823, with Ramsgate rapidly expanding to beyond 6,500 inhabitants, a meeting considered, *'the great need and want of church room for the inhabitants of Ramsgate and the necessity for supplying the deficiency'*. Land owned by Mr Townley behind the High Street was bought for £900, and an Act of Parliament, required to form a new parish and the building of a church, was passed. The design of the church was by Mr Hemsley who died before its completion; Mr Kendal then completed it, with only a few alterations to the original plan.

Building commenced in 1824, at a cost of £21,736, 13 shillings, and 2½d. Trinity House donated £1,000 to provide a sea-mark lantern on the tower to assist in the navigation of shipping. Not only did the Archbishop of Canterbury donate £100 but, as he was staying at Albion Place in August 1924, he offered to lay the foundation stone, which he duly did on 30th August 1824 in the presence of the Earl of Liverpool, Lord Warden of the Cinque Ports. The Archbishop returned on 23rd October 1827 to consecrate the church.

It could hold 2,000 people, 1,200 are free sittings. The steeple, which is surrounded by an octagonal lantern (each letter of 'St George' is spelt out on the different faces), is 137ft high, the extreme length of the church is 148ft, the width 68½ft. The first vicar was the Rev Richard Harvey.

Princess Victoria attended a service at St George's on 4th October 1835, and wrote in her journal, *'In all my life I have never heard such a sermon. It was all against the Roman Catholic religion. It was a most impious, un-Christian like and shocking affair. I was quite shocked and ashamed.'*

The war memorial in the churchyard was designed by Sir Herbert Baker and dedicated by Archbishop Davidson on 7th October 1920 and there is also a stained glass window commemorating Dunkirk.

The Archbishop of Canterbury, Dr G Fisher, visited on 4th January 1947.

The sum of £13,000 was spent on repairing and restoring the octagonal lantern in September 1981 and an appeal was launched on 23rd April 1998 for further repairs to the lantern, roof and stone work which had a projected cost of £750,000.

In March 1999, the Heritage Lottery Fund awarded the church £506,000 towards the by now £1,000,000 costs, of which the Restoration Committee had already collected £160,000. In the end, over £1,240,000 was spent on the restoration work which started in January 2001 and finished in September 2004.

As part of the restoration, the Friends of St George's planted 1,000 crocus bulbs. The flagpole was replaced – 65ft of British Colombian pine, if you are wondering. The weather vane was also repaired but the bullet holes – a reminder of the last war – were left in place.

Not only is St George the patron saint of England but also of Canada and Greece. One theory as to why he is England's patron saint is that the old English word for 'bygone days' is 'geogeara'. He is also the patron saint of syphilitics – when you are a saint you can't turn a job down.

SEE Braithwaite, Lillian/ Churches/ Cinque Ports/ Curtis, Sir William/ Dunkirk/ Granville Cinema/ High Street, Ramsgate/ Kent Cyclists Territorial Force/ Ramsgate/ Trinity House/ Tunnels, Ramsgate/ Victoria

St GEORGE'S HALL, Ramsgate
SEE Star Cinema, George Street/ Ramsgate

St GEORGE'S HOTEL - Cliftonville

A bomb from a German seaplane landed on the roof of St Georges Hotel on 23rd October 1916. Two people were injured. The whole area from here (Eastern Esplanade, Empire Terrace and Norfolk Road) round to Broadstairs was the subject of a ten-minute long bombardment on 25th February 1917.

St Georges Hotel is now called St George.

SEE Broadstairs/ Cliftonville/ Eastern Esplanade/ Hotels

St GEORGE'S LAWNS, Cliftonville

The lawns are bowling greens now but before the last war they were croquet lawns. Screens would be put up so that the cricket Test Match scores could be followed ball by ball via the radio commentary.

SEE Cliftonville/ Cricket/ Radio

St GEORGE'S SCHOOL, Broadstairs
SEE Broadstairs/ Schools/ Status Quo/ Westlife

St GEORGE'S SCHOOL, Ramsgate

It was originally called the National School. In October 1940 the headmaster of St Georges School was found in a gas-filled room; he was subsequently charged with the theft of bees and also attempted suicide.

SEE Jordan, Sir William Joseph/ Ramsgate/ Schools/ Tuckshop murder/ Tunnels, Ramsgate

St GILES CHURCH, Sarre

There was probably a chapel at Sarre in Saxon times and although no church is mentioned in the Domesday Book, St Giles Church is thought to have been consecrated sometime a decade or so either side of 1100 – is that vague enough? It was owned by the Crevequer family who were lords of the manor of Sarre. By the 1360s it was pleading poverty and in 1385 it was so poor it was virtually excused from paying any taxes. By the time of the Reformation it was a ruin and the Kent historian, Hasted, thought the Church had stood 30 rods from the village, past the windmill, to the north of the road to Monkton but, in 1863, archaeologists discovered that the site was further out than that, behind a chalk pit.

SEE Churches/ Hasted

St JAMES' CHURCH,
Canterbury Road, Garlinge

It was built to cater for the expansion of the village. The church's foundation stone was laid on the 23rd March 1872, and it was consecrated on 3rd January 1873. It was closed for the duration of the Second World War; a prudent decision in the circumstances, as its walls and windows were damaged by land mines on 17th April 1941. It was damaged again in the October 1987 hurricane and this time the roof suffered also. It was damaged yet again in severe storms in January 1990.
The Church Centre was built and opened in 1971.

SEE Churches/ Garlinge

St JAMES' AVENUE, Ramsgate
St JAMES' AVENUE, St Peter's
St JAMES TERRACE, Birchington

St James is the patron saint of pilgrims - I know it's not relevant but I thought I'd tell you anyway.

SEE Birchington/ Ramsgate/ St Peter's

St JOHN'S CHURCH, Margate

It was first built in 1050 and possibly founded by a monk at Reculver called Ymar who was later murdered by the Vikings.
Unfortunately a fire destroyed it in 1250.
During the Middle ages, the peasants were buried outside, but the local bigwigs were buried under the church floor; there are many brasses still to be seen today commemorating them.
The Wax House that made the candles for St John's Church, burnt down in 1641.
The church had a hard time in the 16th and 17th centuries and there was no money to maintain the building. As the town grew richer in the eighteenth century, so did St John's, although, as soon as the fabric of the church improved, so did the number of people who visited; thus necessitating more repairs. A vicious circle. The Rev W F Bailey suggested another church should be built, and thus Holy Trinity opened in 1825.
Around this time the Tudor vicarage was pulled down.
St Johns Church was restored again in 1876 and the old cottages attached to the church were demolished in the 1960s.

Chambers' Book of Days 1869: *From attaching such importance to the human heart, doubtless arose the practice, which is exemplified in many of our churches, of representing it so freely in sepulchral commemoration. And this occurs, not only where a heart alone is buried, but often the figure of a heart with an inscription is adopted as the sole memorial over the remains of the whole body. An example may be seen in St. John's Church, Margate, Kent. A plate of brass, cut into the shape and size of a human heart, is sunk into the slab which covers the remains of a former vicar of the church. The heart is inscribed with the words 'Credo q',' which begin each inscription on three scrolls that issue from the heart, thus:*
credo qd Redemptor meus vivit
credo qd De terra surrecturus sum
credo qd In carne mea videbo demun Salvatorem meum.
Beneath the heart is a Latin inscription, which shews that the whole body of the deceased was interred below. In English it is as follows: 'Here lies Master John Smyth, formerly vicar of this church. He died the thirtieth day of October, A.D. 1433. Amen.'

SEE Bulls Head/ Churches/ Cottage, The/ Crouch, Ben/ Deller, Alfred/ Dent-de-Lion/ Fires/ First and Last/ Friend to All Nations/ Holy Trinity Church/ Margate/ Morecombe & Wise/ St Peter's Footpath/ Settlement Acre/ Tippledore Lane/ Vikings

St LAURENCE

He was Archdeacon to Pope Sixtus who, in the persecution of Valerian of 258 AD, was martyred. Lashed to a metal frame and barbecued over a raging fire, he is supposed to have uttered as his last words, *'This side is now roasted enough oh tyrant. Do you think roasted meat, or raw the best?'* Strangely, he is the patron saint of curriers (dressers of leather) not barbecues.

St LAURENCE CHURCH, Ramsgate

Founded in 1062 as a chapel of Minster, the original building was oblong in shape, to which the aisles on each side of the nave and the south-west porch were added by Richard Demanston in 1175. Further additions were made in the thirteenth century.
In 1275 it acquired its own parish status and the first vicar was called John. That is all that is known of his name! In 1439 the church was struck by lightning!
In 1658, the Rev Peter Johnson became Vicar of St Laurence. He owned Nethercourt, was very wealthy and was of the belief that having the bishops controlled by the Royalty was stopping the necessary changes in the church. After Cromwell died in 1658, this view did not go down well with the powers that be. He refused to accept, among other things, episcopal ordination, and by 1662 he was no longer vicar. He carried on living at Nethercourt and still had a congregation of fellow dissenters who worshipped in a building thought to be in Charlotte Court. In time, they became the Congregational Church in Ramsgate.
An early vicar of St Laurence Church was the brother of Admiral Harvey, Richard Harvey. The family had a tradition of naming the eldest son in each generation Richard, with no other Christian name to distinguish between them. Thus the first Richard Harvey was vicar here from 1766 until 1793 (he was also a six preacher at Canterbury Cathedral). His son took over from 1793 until 1836 (from 1827-1861 he was the first vicar of Ramsgate) and so on – you get the idea.
The coat of arms of George II is over the south west porch doorway and is dated 1749.
For Queen Victoria's Golden Jubilee in 1888, the church was repaired and spruced up and a four-dial clock was added to the tower. The east window is a memorial to her.

SEE Browne, John Collis/ Charlotte Court/ Churches/ Fox, Admiral/ George II/ Harvey, Admiral/ Minster Abbey/ Ramsgate/ Sprackling, Adam/ Tippledore Lane/ Victoria/ Walcheren Expedition

St LAWRENCE AREA

Although the area around St Laurence Church is called St Lawrence, it is a little local idiosyncrasy that the two are spelt differently.
Originally it was a Saxon settlement. To the north and south of St Laurence Church were two manor houses. One was the home of the de Sandwich and St Nicholas familes, called Nether Court, and the other was home to the St Laurence family (1254-1422) and called Upper Court.
In the seventeenth century, the village of St Lawrence was called Westborough.

The Ramsgate Improvement Act of October 1878 transferred 1,970 acres from the parish of St Lawrence to the district of Ramsgate. The population of St Lawrence was around 6,000 at the time.
SEE Bolaine, Betty/ Ramsgate/ Sandwich/ Vale Tavern

St LAWRENCE COLLEGE
Standing in a 150-acre site, it first opened in 1879. It was evacuated to two Church of England training colleges at Camarthen and Chester during World War I whilst the building was used as a hospital for wounded Canadian troops. The pupils' return was announced in January 1919 but had the war continued, the place was to be converted into a naval barracks for new recruits.
The college was again evacuated during World War II and returned on 30th January 1946.
Tabitha Watling, aged 16, was the BBC Choirgirl of the Year in October 1995, winning £500 for herself and £1,000 for her school chapel choir.
SEE Buckeridge, Anthony/ Canadian Military Hospital/ Jennings and Darbishire/ Ramsgate/ Schools/ World War I

St LAWRENCE FAIR
The St Lawrence Fair was held on St Lawrence's Day, 10th August every year. Incidentally that is how the St Lawrence River in North America got its name, because the French navigator Jacques Cartier first found it on that date in 1534 – it was a Monday in case you were wondering

St LAWRENCE RAILWAY STATION
Now closed, it was next to the first road bridge over the railway line in Newington Road, Ramsgate.
SEE Newington Road/ Railway Stations

St LUKE
He is the patron saint of artists and creatives.

St LUKE'S AREA, Ramsgate
After bombing Dover and Deal, two German seaplanes swooped over Ramsgate on Sunday 22nd March 1916. Although other areas of the town suffered in the attack, it was the devastation in the St Lukes area that was the worst. Whilst on their way to Sunday School, four children were killed; two – a brother and sister James and Gladys Saxby– instantly, and the other two just minutes later after being hit. A car driving by was thrown against a tree and the driver catapulted across the road. The windows in the surrounding houses were smashed. George Philpott, aged 16, was one of nine to be injured. He threw himself on top of his sister to save her but died from his injuries the following year; he was awarded a posthumous award for bravery.
Flight Commander Bone from the Westgate base took off in a FE2b and chased the German planes to the Goodwin Sands. Fifteen-minutes of action resulted in Bone killing the observer and forcing the seaplane down into the minefields that were off the Goodwins.

SEE Goodwin Sands/ Ramsgate/ Royal Navy Air Service Station/ World War I

St LUKE'S AVENUE, Ramsgate
SEE Alexandra Arms/ Harry Potter/ Ramsgate/ Stray pony

St LUKE'S CHURCH
St Luke's Avenue, Ramsgate
When the area was being built up with houses in the 1870s, the Rev Dr Whiting built a small church to the east of St Lukes recreation ground. Imagine his reaction when Archbishop Tait refused to consecrate it on the basis that it was both too near Holy Trinity Church and too small for the local area. That small church is now the Masonic Temple.
After Dr Whiting's death, his nephew, the Rev John Whiting, realised that a church still needed to be built, although there was much discussion about whether the area warranted one. A piece of land given by Mr Farley together with £3,000 from the Whiting family enabled the project to get under way. Designed by local architect, Mr W E South (St Catherines at Manston was also his design), it was consecrated in 1876 by Archbishop Tait.
SEE Churches/ Manston/ Ramsgate/ Sharp's Dairy/ Tait, Archbishop

St MARK'S CHURCH, Northwood
A DREAM COME TRUE –
ST MARK'S OF NORTHWOOD IS
GRANTED PARISH STATUS
The dreams of a nineteenth century vicar became reality this week when St Mark's of Northwood was granted Parish status. When the Rev John Bradford Whiting became the first vicar of St Luke's in 1876 he told parishioners that he had a vision of a hamlet growing up one mile from his church. Eight years later he bought a tin mission hut from Brighton and erected it on land at Pysons Road. This daughter church of St Luke's served the then sparsely populated Northwood area until 1939 when the church hall and chancel were built. In 1967 the nave was added and the building completed. Last week the vision materialised when St Mark's officially became a parish in its own right. On 4 April – Palm Sunday – it will be inaugurated by the Archbishop of Canterbury, Dr Robert Runcie and the Rev Michael Stear will be instituted as the first vicar. The population of Northwood has now reached 7,500 and the congregation has grown significantly over the last few years. Mr Stear is encouraging as much activity in the community as possible. A house in Margate Road is being converted into a vicarage. 9th March 1982
SEE Churches/ Margate Road, Ramsgate/ Northwood

St MARY'S CHURCH
Chapel Place, Ramsgate
SEE Churches/ Chapel Place/ Ramsgate

St MARY'S CHURCH, Minster
The present St Mary's Church has part of an earlier church included within it, but todays

building dates from 1150 and also the 18th centuries. In 1644 Richard Culmer (otherwise known, apparently, as Blue Dick – now stop it) tried unsuccessfully to tear down the cross from the top of the steeple but the locals managed to stop him. The church underwent restorations in 1861, 1863 and in the 1970s.
SEE Churches/ Minster/ Tippledore Lane

St MARY'S CHURCH, Northdown
The windows of St Mary's Church were smashed when a bomb exploded nearby in a raid on the night of 19th May 1918.
SEE Churches/ Northdown

St MARY'S CONVALESCENT HOME, Beach Avenue, Birchington
It was built as a seaside home in 1882 for London mothers and babies. In World War I wounded Belgian soldiers were sent here - the young mums had long gone, so both mums and soldiers were disappointed. It then became St Mary's Diabetic Home for women and girl sufferers and closed in 1971. It was then a private old people's home but is currently closed and boarded up waiting to be transformed into apartments.
SEE Belgian soldiers/ Birchington/ Convalescent Homes/ World War I

St MARY'S CONVALESCENT HOME FOR CHILDREN, Broadstairs
Princesses Christian and Frederica of Hanover (the latter, a granddaughter of Queen Victoria) opened the St Mary's Convalescent Home for Children on the Eastern Esplanade in July 1887. It was built by the Sisters of Kilburn at a cost of £60,000. A tunnel through the chalk direct to the beach was dug so that the children did not have to cross the road to get there. The entrance can still be seen in the cliff in Stone Bay, but the tunnel has been filled in.
SEE Broadstairs/ Convalescent Homes/ Eastern Esplanade, Broadstairs/ Stone Bay/ Tunnels/ Victoria

St MILDRED
St Mildred's Day is July 13th. She is largely remembered for her generosity to the poor and treatment of outcasts after she succeeded to the position of Abbess at Minster on the death of her mother Domneva. In her early days at school in France, it is said that she survived three hours of imprisonment in a hot oven after she refused the entreaties of the convent's abbess to marry! She probably failed Domestic Science as well. There is also a story that says when she returned from school and landed at Ebbsfleet, she disembarked onto a specially placed rock and left her footprint upon it for ever more.
SEE Ebbsfleet/ Minster

St MILDRED'S BAY, Westgate
St Mildred's Bay was once known as Marsh Bay.
SEE Bays/ Lawrence, Carver/ Marsh Bay/ Westgate-on-Sea

St MILDRED'S CHURCH Acol
SEE Acol/ Churches

St MILDRED'S CHURCH, Westgate

Although she was living in the south of France at the time, Mrs Charlotte Rogers donated the land on which to build the church and also a school room. The vicar, Rev. John Alcock, organised collections and donations to pay the £790 building costs. The Dean of Canterbury laid the Foundation Stone, and the Bishop of Dover formally opened the School Church in 1876.
SEE Churches/ Schools/ Westgate-on-Sea

St MILDRED'S ROAD, Ramsgate

Roman urns and pottery have been found in the area between Edith Road and St Mildreds Road.
SEE Ramsgate/ Woodward, James

St MILDRED'S ROAD, Westgate

SEE Carlton Cinema/ Hawtrey's Field/ Town Hall Building/ Westgate-on-Sea

St NICHOLAS

St Nicholas is the patron saint of children and also of sailors.

St NICHOLAS at STONAR CHURCH

This was sited near where the Sandwich to Ramsgate Road and the Stonar Industrial Estate are now. Originally, there was a Saxon church in Stonar. St Nicholas at Stonar Church was built around the eleventh century. As the town declined so did the fortunes of the church and, in 1291, it was valued at £5. The building was still used for many years as a meeting place for the officials of both Stonar and Sandwich. At least they were talking now and not fighting. On 22nd June 1558 it was sold for £637 to Nicholas and John Cryspe of Quex, but that did not include the roof lead, guttering, the bells, or the windows – mainly because most of it had been nicked in the years beforehand. In the 1860s, archaeologists discovered traces of the foundations and more were exposed in 1911.
SEE Churches/ Quex/ Sandwich/ Stonar

St NICHOLAS-at-WADE

The 'wade' part of the name refers to the time when you could indeed wade across the Wantsum Channel at this point.
The Vicarage was destroyed by a fire in 1620.
A windmill appears on a map of St Nicholas in 1719 but on a subsequent map of 1769, it has gone.
A pictorial and descriptive guide to Margate, North-east Kent, and Canterbury, 1905: *(Bell Inn) is a delightful old-world village, where newspapers do not penetrate until 2 p.m., when it is too late to get excited about anything. The inhabitants have in consequence a marvellous reputation for longevity. St. Nicholas enjoys a brief period of excitement in the coursing season, but during the rest of the year its seclusion is rarely disturbed, except by a small carriage party or a casual cyclist. The Church has a lofty embattled tower, and standing as it does on a slight eminence, is seen for miles around. It is reputed to date from the year 1200. A curious feature is the parvise, or priests' chamber over the door, which can only be reached by means of a long wooden ladder. The carving of the Norman columns on the south side of the nave should be noted. The carved oak pulpit bears the date 1615. In the Bridges Chapel is a remarkable sixteenth century brass, and the South Chapel contains an ancient chest. The south chapel and part of the nave were restored in 1898. Some much-worn steps lead to the top of the tower, from which there is a fine view. The Reculver towers are seen across the marshes to the north-west, and in clear weather Canterbury Cathedral is visible to the south-west.*
Late on 26th April 1916, two trees were uprooted in the garden of the vicarage, when a bomb from a German Zeppelin landed there. Bombs were also dropped around St Nicholas and Acol on the night of 19th May 1918, but little damage was done.
Pigots 1936: *The church is in the Norman and Early English styles with tower and additions of a later period. The living is a vicarage net yearly value £357 with residence. It is in the gift of the Archbishop of Canterbury and has been held since 1931 by Rev. Edward Colles Robinson M.A. of Queens College Cambridge. There is also a small Methodist Chapel built in 1882.*
Population in 1931, 578; area, 3,555 acres of land, 8 of water and 158 of foreshore.
Kelly's Directory of The Isle of Thanet, 1957: *St Nicholas-at-Wade is a village and parish, situated 67 miles (by road) from London, 6½ south-west from Margate, 9 north-west from Canterbury, in the Isle of Thanet parliamentary division of the county, lathe of St Augustine, hundred of Ringslow, rural district of Eastry, petty sessional division and county court district of Ramsgate, rural deanery of Thanet and archdeaconry and diocese of Canterbury.*
Water is supplied by The Thanet Water Board.
The church is in the Norman and Early English styles, with tower and additions of a later period. The living is a vicarage, in the gift of the Archbishop of Canterbury and has been held since 1951 by Rev. Joseph Evans Pughe BA of St David's College Lampeter. There is also a small Methodist Chapel built in 1882, a Brethren Meeting Room and a village hall.
Population in 1951, 618; area, 3,555 acres.
Post, M O & T Office- A J Smith sub-postmaster. Postal address, St Nicholas-at-Wade, Birchington, Kent.
St Nicholas & Sarre Joint Burial Board; T West, Albert house, clerk.
Kent County Constabulary; E W Hawkins, constable in charge.
St Nicholas Voluntary Primary School (junior mixed & infants); Frank Baker, headmaster.
A torch-lit procession from St Nicholas to the beach used to be held on 5th November every year.
SEE Acol/ Churches/ Earthquake/ Fires/ Miles, Lord Bernard/ Schools/ Shuart/ Smuggler's Leap/ Stag Hunt Extraordinary/ Sun Inn/ Wantsum Channel/ Windmills/ Zeppelin

St NICHOLAS-at-WADE CHURCH

St Nicholas Church is Norman, although the towers are amongst later additions. The arches in the nave are 12th -13th century.
It is included in Simon Jenkins's 'England's 1000 Best Churches'.
In 1983 a man was up a ladder changing a light bulb in the church when he put his foot through the tiled floor, so he sued them – no he didn't, that was the advert that was on a minute a go. He discovered a hitherto unknown burial chamber containing the bones of around twenty people. They have subsequently been re-buried and the floor made good, so that nobody sues – sorry, that advert again.
SEE Churches/ St Nicholas-at-Wade

St NICHOLAS-at-WADE song

There has even been a song written about the village:
'St Nicholas-at-Wade' lyrics by Royden Barrie, music by Kennedy Russell (1883-1954), published by Boosey & Co., 1924
There's a quaint little sleepy town
Not so far from the sea,
But you'll get no particulars
But the bare name from me,
Or you'd crowd there in millions,
In your best clothes arrayed,
To St Nicholas, St Nicholas, St Nicholas-at-Wade,
St Nicholas-at-Wade

Now the men of St Nicholas
Are the best in the land,
And there ain't much in politics
That they don't understand,
'Twould surprise 'em in parliament
At the wisdom displayed
At St Nicholas, St Nicholas, St Nicholas-at-Wade,
St Nicholas-at-Wade

But as cute as we fellows are,
The maids have us beat,
They're so rosy and cuddlesome,
So winsome and sweet;
Any evening in summer time
It is two in the shade
At St Nicholas, St Nicholas, St Nicholas-at-Wade

Now your London's a finer place,
Aye and smarter, may be,
But altho' it was twice as fine,
You can keep it for me,
All I want is a cottage
And just my own little maid
At St Nicholas, St Nicholas, St Nicholas-at-Wade,
St Nicholas-at-Wade
SEE Music

St NICHOLAS COURT

The St Nicholas family lived at St Nicholas Court from around 1350 until 1589 but it was formerly called Nethercourt and was the home of the Bridges family. A descendent of theirs, Sir Robert Bridges (born Walmer,

1844-1930), was Poet Laureate from 1913 until he died.
SEE Poets

St PAUL'S CHURCH
King Street, Ramsgate
The Rev J M Braithwaite and Rev R Patterson were the two curates at St George's Church largely responsible for the building of St Paul's Church in King Street. At a cost of £1,700, which was raised by public subscription, it was designed by Robert Wheeler of Tunbridge Wells and built by Messrs Smith & Son of Ramsgate. A small church, it was able to seat 250, and was 64 feet by 30, and 33 feet high

Thanet Advertiser, 16th May 1874: *The consecration of St Pauls Church, King Street, Ramsgate, by the Archbishop of Canterbury* (Archbishop Campbell Tait) *will take place on Friday 22nd at 11 o'clock. There will be short service in the church that day at 4, 6.30 and 8pm.*

As the district expanded – there were 4,000 people living in the area – a bigger church was required and on 24th October 1884, the Archbishop received a petition to enlarge St Paul's. Eight cottages, a large yard, a store and an alleyway were included on the new site – bought for £485.

Using the same architects and builders, the old building became the nave and the new church became a larger version of the old one. Colonel King-Harman MP laid the first stone on 29th July 1886. The old columns of the former church were used to make the new baptistry. The enlargements were soon completed at a cost of another £3,100 and on St Paul's Day, 25th January 1887, Archbishop Edward White Benson consecrated the church, which could now seat 507. In April the same year, Rev C E Eastgate became the first vicar of the new separate parish. He was a leading member of the Oxford Movement which aimed to restore high church principles and St Paul's Church was a leading church in this respect for many years. Eastgate remained vicar for 28 years until 1915, when Rev A F Walters took over (1915-19), followed by Rev T Williams (1919-37) and then Rev R C White (1937-40). The church closed in June 1940 ostensibly for the duration of the war but, in fact, it was never to re-open. To much local ill-feeling, the diocese declared St Paul's redundant but it was not until January 1959 that demolition finally began on the 85 year-old church.
SEE Churches/ King Street, Ramsgate/ Ramsgate/ Tait, Archbishop

St PAUL'S ROAD, Cliftonville
Private Benjamin Farnhill died from shrapnel wounds as he sheltered in a doorway in St Paul's Road during the Gotha raid on the night of 30th September 1917.
SEE Cliftonville/ Gotha raid/ World War I

St PETER'S, Broadstairs
In 1791, St Peter's was still surrounded by trees and consisted of 35 houses or groups of houses.

Hasted's History of Kent on St Peter's Village: *It stands on a pleasing eminence, surrounded by trees, which is rather uncommon in these parts.*

St Peter's was once a non-corporate member of the Cinque Port of Dover.
SEE Blagdon Cottages/ Bottle Light Signal/ Broadstairs/ Broadstairs & St Peter's Mail/ Broadstairs Road/ Church Street/ Cinque Ports/ Coves, The/ Crown & Thistle pub x2/ Dane Court Road/ Davis, Edmund/ Edward VII/ Hare & Hounds pub/ Hasted/ High Street, St Peter's/ Livingstone Road/ Lovejoy School/ Oaklands Court/ Percy, Major/ Plane crash/ Population/ Ranelagh Gardens/ Red Lion/ Rediffusion/ St James' Avenue/ Sandwich/ Shallows/ Sickert, Walter/ Sowell Street/ Speke Road/ Stocks/ Tippledore Lane/ Vye & Son/ Wesley, John/ Windmills/ 'World of Waters'/

St PETER'S BAPTIST CHURCH
Vicarage Street, St Peters

It was opened in 1788 by the Reverend John Wesley for his followers who in time became known as Methodists.
At the rear, the church has the only Baptist graveyard in Thanet.
Baptists have been known to worship in St. Peter's since 1653, but it is possible that they were there as much as one hundred years earlier.
SEE Churches/ St Peter's village sign/ Shallows, The/ Wesley, John

St PETER'S CHURCH
Built in the late Norman style in 1070, it was enlarged around 1180/85 – the nave arcade, the Norman pillars in the middle of the nave, date from this period. On the main festival days the congregation, along with those from St John's in Margate and St Laurence in Ramsgate, would walk to their mother church, St Mary's in Minster, although they were all under the jurisdiction of St Augustine's Abbey in Canterbury. St Peter's became a perpetual vicarage and had a vicar from 1291 and the name of every vicar since 1352 is on record at the church. After the dissolution of the abbey by Henry VIII, the patronage of the church transferred to the Archbishop of Canterbury. The recessed container for holy water in the entrance porch is one of the few remaining traces of the pre-Reformation days of the building.
There was a refurbishment of the Church, as well as restoration of the chancel in 1687. The wooden roof dates from then but no further work was done until the mid-eighteenth century, possibly a reflection on the quality of the earlier refurbishment!

In the reign of Henry VIII, archery practice was compulsory and there were butts near St Peter's Church.
The clock was made by William Vale of London, and it took a local carpenter, a bricklayer and just over £100 to install it in 1802.
The church tower is 82ft high and four men kept a daily watch from the top of it during the Napoleonic Wars, using it as a naval signalling station passing information to ships at the Nore, a sandbank at the mouth of the Thames. In recognition of such services the church has the right to fly the white ensign.
There was another renovation between 1859 and 1865 and the church took on the appearance it has today. The inner walls were restored, new pews were added and the brighter stone of the chancel roof, the mosaics behind the altar and the painted figures of the apostles and angels also date from this time. Virtually no changes were made in the twentieth century. Now however, the church has a western tower, a chancel with a north aisle which opens onto a sanctuary via three early English arches on square piers, a south chapel and a nave of five bays with north and south aisles. The doorway on the north side was once blocked up and has become the entry to the modern vestry. The outside of the church is flint and the quoins, windows and doors are cased with ashlar stone – carefully worked stones set with fine close joints.
The War Memorial was unveiled and dedicated by the Bishop of Dover on Wednesday 17th June 1925.
Mollie Blake, daughter of Annette Mills of 'Muffin the Mule' fame, refurbished the Children's Corner of the church in the 1960s in memory of her mother.
Very heavy rains in June 1966 caused around a hundred graves to sink about 18 inches.
St Peter's churchyard is said to be the longest in the country. It is also the location of a gravestone enscribed:

Against his will
Here lies George Hill
Who from a cliff
Fell down quite stiff
When it happen'd is not known
Therefore not mentioned on this stone
SEE Churches/ Crampton, Thomas/ Dane Court/ Eagle House/ Earthquake/ Heath, Edward/ Holy Trinity Church, Broadstairs/ Joy, Richard/ Muffin the Mule/ Napoleonic Wars/ Percy, Major Henry/ Plane crash/ St Mary's Church/ St Peter's Footpath/ Sheridan, Richard/ Star Inn, Westwood/ Tippledore Lane/ Whitehead, Alfred North

St PETER'S COURT PREPARATORY SCHOOL
Opening in 1899 with 30 pupils and Mr A J Richardson as the headmaster, the school stood next to Sowell Street Farm.
It was visited in 1913 by King George V and Queen Mary. Well, to be honest, they were visiting their sons, the Dukes of Kent and Gloucester, who were boarding pupils here at the time but, a royal visit is a royal visit.
That same year, Prince George, the Duke of Kent was given a whack across the backside

with a plimsoll (an early type of trainer for any younger readers) by Mr White, the woodwork and PT master, when he swam too far out to sea one day during a swimming lesson at Joss Bay, despite having been told not to. When the King and Queen later visited the school, Mr White was unsure of the reaction he would get but the King told him 'Well done'. They later sent a him a tiepin. The Prince died on active service with the RAF in World War II.

A later headmaster was the Rev Ridgeway and when he died in 1958, his son Charles took over until bad health saw him step down. The school amalgamated with Wellesley House in 1969 and the old school grounds were sold off and the school demolished.

Another ex-pupil is Lord Montagu of Beaulieu.
SEE Bathing/ Farms/ George V/ George, Prince/ Gloucester, Duke of/ Montagu of Beaulieu, Lord/ Schools/ Sowell Street, St Peters/ Wellesley House

St PETER'S FOOTPATH
This is part of an ancient footpath linking Thanet's churches and this section connects St Peter's Church with St John's Church in Margate.
SEE Churches/ Shallows, The/ St John's Church/ St Peter's Church/ Tippledore Lane

St PETER'S FOOTPATH, Margate
Thanet Collegiate School, later Thanet College, was a boarding school for up to one hundred boys in the second half of the nineteenth century in St Peter's Footpath/St Peter's Road. During the same time there were numerous other schools along St Peter's Road; Bevan House at number 5-7, for around 24 boarding boys; Apsley House a boarding school, at number 28 for a couple of dozen boys; St John's College at number 34, another boys boarding school; Thanet Hall Ladies College, a girls boarding school at Drapers, and a boarding preparatory school for boys called Thanet Lodge School.
SEE College Road/ Margate/ St Peter's Road, Margate/ Schools

St PETER'S MEMORIAL HALL

It was moved here from the 'secret' port of Richborough in 1923. Whilst at Richborough it had been used as a cinema and theatre by the troops stationed there. When World War I was over, the Ministry of Defence sold off the buildings on the site and it was more economical to buy this than build a new hall. A combination of donations from the villagers and fund-raising concerts produced enough money, and the old hall was transported here by horse and cart. Messrs

Larkin and Co of Broadstairs completed the work on 14th January 1922. It has been used for concerts, pantos, and the Broadstairs Horticultural Society has held its flower shows here. During World War II, the Red Cross used the building. It was refurbished in 1974 and again in the 1980s and is still in use today.
SEE Richborough secret port/ World War I/ World War II

St PETER'S MILL
This was a post mill situated near Reading Street from c1695 until the late 1840s.
SEE Reading Street/ Windmills

St PETER'S ORPHANAGE
Designed by J P Seddon in the Decorated Gothic style, it was built in 1869 to the rear of Stone House. There was a large chapel, a refectory, common room and dormitories and could accommodate 60 children plus, at a cost of seven shillings a week, 20 convalescents. Ladies would nominate children at a cost of £12 per year (an early form of today's sponsoring a child in the third world) and also watch out for them in later life.

Thankfully, the children had been evacuated before the building was bombed in World War I. However, what actually finished the building off, was not bombs but dry rot, and it was demolished in 1953. On the site of the orphanage's annexe a private residence, Tait House, was built.
SEE Orphanages/ Stone House, Lanthorne Road/ Tait, Archbishop/ World War I

St PETER'S ROAD, Broadstairs
SEE Albion Inn/ Alexander House School/ Hildersham House School

St PETER'S ROAD, Margate
St Peter's Road suffered damage in an air raid on 1st June 1943.
SEE Dane Court Road/ Hospital/ Margate/ Margate General Hospital/ Oxford Hotel/ St Peter's Footpath/ World War II

St PETER'S VILLAGE HALL
Edward Heath opened the village hall on 14th August 1972. He had learnt to play the organ in St Peter's Church as a boy.
SEE Heath, Edward/ St Peter's Church

St PETER'S - village sign

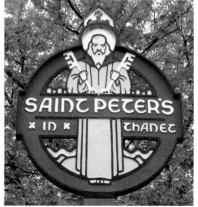

In 1920, the then Duke of York, who later became King George VI, gave a speech on

the revival of the village sign at the Royal Academy. The Daily Mail picked up on the idea and ran a competition and exhibition offering £2,000 in prizes. In all, there were ten awards made, but the outright winner of the £1,000 top prize, out of 525 entries was Mr P H Matthews of Ramsgate for his design that first stood by the church yard wall, near the Baptist Church. Like many other signs, it was taken down in World War II and after the war it was put up by the Red Lion. It took up its present position on the new village green in the 1970s.
SEE Daily Mail/ George VI/ Red Lion/ St Peter's Baptist Church

St SAVIOUR'S CHURCH, Westgate
SEE Churches/ Westgate-on-Sea/ 'Westgate on Sea' by Betjeman

George SALA
Born Manchester 24th November 1828
Died Brighton 8th December 1895
Artist, journalist and critic.
Twice Around the Clock, 1859: *And now we will go out of town. Whithersoever you choose; but by what means of conveyance By water? The penny steamboats have not commenced their journeys yet. The Pride of the Thames is snugly moored at Essex Pier, and Waterman, No. 2, still keeps her head under her wing - or under her funnel, if you will. The omnibuses have not yet begun to roll in any perceptible numbers, and the few stage coaches that are still left (how they linger, those cheerful institutions, bidding yet a blithe defiance to the monopolising and all-devouring rail!) have not put in an appearance at the White Horse Cellar in Piccadilly, the Flower Pot in Bishopsgate Street, or the Catherine Wheel in the Borough. So we must needs quit Babylon by railway. Toss up for a terminus with me. Shall it be London Bridge, Briarean station with arms stretching to Brighton the well-beloved, Gravesend the chalky and periwinkley, Rochester the martial, Chatham the naval, Hastings the saline, Dover the castellated, Tunbridge Wells the genteel, Margate the shrimpy, Ramsgate the asinine, Canterbury the ecclesiastical, or Herne Bay the desolate?*
SEE Artists/ Authors/ Margate/ Ramsgate

Míchel SALGADO
Born 22nd October 1975
He is the left back who plays for Real Madrid Football Club and Spain. His career started with Celta Vigo but he was transferred to Real Madrid for around £4.2million in 1999 where he has won two La Liga titles and the Champions League in 2000 and 2002. When he was 14, he stayed with a local family in Margate to learn English and in an interview in November 2004 he claimed it was the best holiday he has ever had.
'I went to Margate when I was 14 to study English. It was great! I couldn't believe it, there was the beach and then behind it was packed full of amusement arcades.'
'I couldn't take the peanut butter sandwiches, and I couldn't believe you have a big lunch

on a Sunday and nothing else all day. I had
to spend all day in Burger King.'
'It was great fun - I love Margate.'
Now if he had only joined the local football
team . . .
SEE Football/ Margate

Lord SALISBURY
Born 3rd February 1830
Died 22nd August 1903
His full title was Robert Arthur Talbot
Gascoyne-Cecil, 3rd Marquess of Salisbury,
KG, GCVO, PC. Before 1865 he was known
as Lord Robert Cecil, and, until 1868 as
Viscount Cranborne. He was Prime Minister
three times (July 1885 – February 1886;
August 1886 – August 1892; and June 1895
– July 1902). As prime minister, he
appointed his nephew, Arthur Balfour, to be
his private secretary (1878), then made him
President of the Local Government Board
(1885), Secretary for Scotland (1886) and
then, most unexpectedly, Secretary for
Ireland (1887). Such action is thought by
many to be the origin of the phrase, 'and
Bob's your uncle'.
A bishop once said to Lord Salisbury, *'A
judge can do no more than say 'you be
hanged' A bishop has the power to say, 'You
be damned'.'*Salisbury replied, *'That may be
true, but when a judge says 'You be hanged',
you are hanged.'*
SEE Politics/ Prime Ministers

SALISBURY AVENUE, Broadstairs
Named after Lord Salisbury.
Clifford Longley was listed as a rose grower
at Roseacre in Salisbury Avenue in 1936.
SEE Broadstairs/ Salisbury, Lord

SALLY the VIKING LINE
The Finnish company Sally Line is based in
the Aland Islands (Ahvenanmaa) and was
originally founded by Algot Johansson who
merged all his businesses into one in 1937
and named it after the Finnish author Sally
Salminem (born 1906) who was also from
Aland, and whose novel Katrina won many
prizes following its 1936 publication.
It pulled out is ferry service from Ramsgate
Harbour in 1998 after operating from here
for many years.
SEE Harbour, Ramsgate/ Ramsgate/ Vikings

SALMESTONE GRANGE, Margate
Originally part of the manor of Minster and
probably the oldest inhabited building in
Thanet. It is first mentioned when St
Augustine's Abbey in Canterbury acquired it
in 1194. Henry III granted Salmestone the
right to an annual fair in 1224. An 1878
survey concluded that there are four periods
of architecture evident here, late Norman,
early English, Decorated and Perpendicular.
During the fourteenth century, the abbot and
monks of St. Augustine's Abbey at
Canterbury came here for retreats. Although
the two monks who defended the surrounded
grange against rioting peasant tenants in
1318 may have needed a retreat to get over
the ordeal. There was a lot of fire damage

and the people of Thanet were subsequently
fined £600!
The chapel was consecrated in 1326. (The
stained glass windows are by John Trinnick,
an Australian, who completed them after
eighteen years, in 1952. Marriages can now
be held here.)
After St. Augustine's Abbey closed in 1538,
the estate passed to the Crown and in 1559 to
the Dean and Chapter of Canterbury, where
it remained until 1886.
In 1936, the owner, Major H S Hatfield, gave
the chapel, house and land to St Augustine's
Abbey in Ramsgate, who then set about
restoring the place. The Canonesses of St.
Augustine took over in 1950, but it was sold
to William Whelan, in 1984.
SEE Fires/ Margate/ Minster/ Minster Abbey/ St
Augustine's Abbey/ Thanet

SALVATION ARMY CITADEL
High Street, Ramsgate
The citadel building was built in 1885 and
The Young People's Hall was built in 1890
with it entrance in a side road.
SEE Booth, General/ Forresters Hall, Margate/
High Street, Ramsgate/ Lloyd, Marie/ Ramsgate/
Seaman's Infirmary

SAN CLU HOTEL
Victoria Parade, Ramsgate
It was built in 1881, as Granville Terrace, a
row of eight houses. Mr Robert Archibald
Percy Stacey bought five of the houses and
converted them into the Hotel St Cloud in
1897 and it became one of the finest hotels in
the area. The residential area of Paris called
St Cloud is named after King Clodomir's
son, Chodoald, a 6th century saint who
founded a monastery there.
On the 29th June 1904, when Princess Louise
visited to open the Royal Victoria Pavilion,
she and the rest of the party enjoyed an eight-
course meal here courtesy of the head chef,
Mr G Scriven. It was a busy year for Mr
Stacy, because on 15th July he became one of
the first directors of the East Kent Times.
In 1910, the tariff was listed en pension at
2.5 to 4 guineas per week plus servants at 4/6
per day. There was a choice of good stabling
for your own horse and carriage or, fly and
carriages could be supplied without delay.
Those new-fangled motor cars could also be
garaged and petrol supplied. The billiard
room was considered one of the show rooms
of Thanet, decorated with oak panelling and
suits of armour.
When King Manuel of Portugal came to visit
Ramsgate's Canadian Military Hospital on
27th September 1916 in a special coach that
arrived and departed from the Harbour
Station, he was met by the hospital's
commanding officer, Lieutenant-Colonel
Watt. He stayed overnight at the Hotel St
Cloud.
Mr Sugden bought the hotel for £10,000 in
1919 and three years later changed the
spelling of the name to San Clu; a phonetic
spelling of the required French intonation –
he was fed up with people mis-pronouncing
it!
On 25th October 1928, a fire so huge that it
was seen as far away as Dover, killed several

people, and destroyed what had been the first
four houses of the terrace which later had to
be demolished. There were plans to reinstate
the section lost to fire in 1928.
The hotel then occupied just two of the
remaining original four houses. Mrs Elsie
Robson acquired the hotel in 1935.
During the war, troops were billetted here.
When Mrs Robson was able to re-open the
hotel in 1944, she was soon able to buy the
third of the original houses and a few years
later, the fourth house and thus extend the
hotel. There have been many famous guests
here including from the entertainment world
Jimmy Handley, Leon Cortez and Benny
Hill; from the Church of England,
Archbishops Lang, Fisher, Ramsey, and
Coggan; from politics Randolph Churchill
and royalty from Thailand, Belgium and
Denmark.
After 55 years and three generations in the
ownership of the Robson family the San Clu
was sold by Simon Robson to Universal
Projects UK in March 1989, and it is now a
Comfort Inn.
SEE Archbishops/ Cortez, Leon/ Denmark/ East
Kent Times/ Fires/ Garages/ Handley, Jimmy/ Hill,
Benny/ Holy Trinity Church/ Hotels/ Louise,
Princess/ Pankhurst, Christabel/ Politics/
Ramsgate/ Royal Victoria Pavilion

SANDWICH

The toll bridge over the Stour was once the
boundary of the Isle of Thanet.
Collector of Customs at Sandwich, 7th April
1746: *A large gang of smugglers with several
led horses went thro' this town into the Isle
of Thanet, and there is a gang of 200 at St
Peter's, they are so well armed, and we are
in such miserable numbers, that we are
unable to molest them, and beg leave of
assistance from the military.*
The good news: the 4th and 8th Dragoons
were sent to help the Customs men and they
met the smugglers on the Wingham Road.
The bad news: the Dragoons lost. (Well,
whose side where you on?)
SEE Battle of Botany Bay/ Bloodless Battle of
Harbour street/ Crest & Motto/ East Kent Arms/
Forward, Stephen/ Greenstreet, Sydney/ Keble,
TH/ Paine, Thomas/ Perfects Cottage/ Ramsgate/
St Lawrence area/ St Nicholas-at-Stonar Church/
St Peter's/ Sarre/ Saxon Chronicle/ Smuggler's
Leap/ Smuggling/ Sprackling, Adam/ Stonar/
Stone Bay/ Thanet/ Tomson & Wotton

SANGER CIRCUS
The Sanger circus spent the winter in
quarters at Margate, and the Palace Theatre
in the High Street in Ramsgate belonged to
the Sangers.
SEE Entertainers/ Margate/ Palace Theatre/
Ramsgate

The SANGER FAMILY

The family liked to say that they were descended from a jester at the court of King John.

James Sanger had 10 children, three of whom were boys, William, John and George. James started out working on Wiltshire farms but decided that he wanted to do something more exciting so he set off for London. He later said that on the way he was caught by the press gang and ended up serving 10 years with the Royal Navy and fighting at the Battle of Trafalgar. Back in civvy street he joined a travelling fair with a very basic peepshow that included a Battle of Trafalgar display giving a description from his own experience.

William Sanger started out with a waxworks show with different tableaux in six or seven vans, such as 'Moses Striking the Rock in Horeb', 'The Judgement of Soloman' or 'Daniel in the Lions' Den' complete with stuffed lions and sound effects. It was not a big success. In 1885 he had an act comprising six Indian elephants.

The family would later be proud of the fact that there had been a Sanger circus since 1823 (it would even survive World War II). He wife, Mary Rebecca died in 1893, and he died aged 73 in 1901, they had no children. His grave is at Margate cemetery.

John Sanger
Born Somerset 1816
Died Ipswich 22nd August 1889
He and his brother George's first venture together was a successful conjuring exhibition in Birmingham. They went on to tour with a circus comprising a few horses and a handful of human performers As it grew more successful they put on shows at Astley's Amphitheatre in London as well as touring the country.

When James died George and John tossed a coin. The winner kept the circus, valued at the time at £100,000, and the loser got a cheque from the winner for half that amount. George took his circus south and John took his north. John died whilst on tour in Ipswich.

George Sanger
Born Newbury 1825/27
Died 1911
He was the most successful circus entrepreneur and showman of the nineteenth century. He was a snappy dresser, famous for his diamond tie pin and shiny top hat. At the age of 15 he was running a sticky rock concession. In 1853 he and his brother were touring with their own circus that included various performing animals, a conjuring act, and a magic lantern show, and within two years they were performing to large audiences and toured the continent each summer. In 1854 he started his first circus and toured the continent each summer.

It was around this point that he introduced wild animals such as lions into the repertoire. His wife, Mlle Pauline de Vere, had been the Lion Queen at Wombwell's Menagerie and she performed serpent dances in the lions' cages.

He and his wife were accused of being *'rogues and vagabonds and deceivers of the people'*, if you said that now people would think you were talking about politicians, how times change.

He took the title 'Lord' after seeing his showman rival Buffalo Bill Cody referred to as 'The Honourable Bill Cody' in a report of a court case. Apparently, according to his grandson, George said, *'If that Yankee can be an Honourable, then I shall be a ruddy Lord!'* Thereafter that is what he called himself.

'There is not, I believe, a town or village in this United Kingdom, I have not at some time or other visited. So, too, abroad. With the exception of Russia, I have carried my tents into every European Country.' 'Seventy Years a Showman' by George Sanger

Such was his success that in 1871 he could afford to buy Astley's Amphitheatre at Westminster Bridge Road in London and put on productions here and still tour.

Charles Dickens (Jr.), Dickens's Dictionary of London, 1879: *'Sanger's Amphitheatre (late Astley's), Westminster-bridge-road, near Westminster-bridge: A theatre and hippodrome on the Surrey side, about a couple of hundred yards from Westminster-bridge; formerly known as Astley's, now in the hands of Messrs. Sanger, who have introduced a large menagerie element into the performances. NEAREST Railway Station, Westminster-bridge Omnibus Route, Westminster-bridge-road.'* The productions became bigger and bigger with one in particular having a cast of several hundred humans along with 52 horses, 15 elephants, 2 lions and chamois, kangaroos, pelicans and reindeer

It was Sanger who introduced the 3-ring circus so that audiences could watch more than one act at a time and he presented the 'Greatest Show Ever Seen'. The great American circuses, Barnum & Bailey, and the Ringling Brothers would soon imitate!

In July 1889, Queen Victoria saw his show by Royal Command in the grounds of Windsor Castle (he had also performed at Sandringham and Balmoral Castle). Sanger even presented Victoria's eldest daughter, Victoria, with a pony. The Queen gave him a scarf pin set with his birthstone, turquoise and greeted him with *'Why* <u>Lord</u> *George, you are looking younger than ever.'*

At the age of 86 at his house in Finchley he accused Herbert Cooper, his manservant, of stealing £50. Harry Austin, a relation of George, duly sacked Cooper and replaced him with a man called Jackson. A few weeks later, Cooper returned to the house and attacked Jackson with a razor. Austin, who was reading to Sanger in a nearby room, heard the rumpus, and ran to the scene and swiped Cooper with a hatchet (he just happened to have it on his person I assume). Sanger entered the fray with a candelabrum he had snatched from the mantelpiece, but as Cooper pushed past him it was Sanger who got hit on the head with the candelabrum. Cooper then jumped out of the window.

Jackson was not seriously hurt, Austin had to go to hospital but recovered, Sanger seemed to be none the worse, but later that night he died. Cooper's body was found on the railway line between Crouch End and Highgate. He had committed suicide.

George Sanger's funeral was held in Margate in torrential rain. His highly polished oak coffin, covered in Masonic symbols, was placed on a carriage that was followed by another fifty; the first three carried 123 floral tributes. The procession passed through the town along the seafront. The town effectively closed for the day, blinds were drawn and the local cabbies tied black bows to their whips. When the cortege reached the cemetery it was met by the entire town council.

George Sanger's daughter Sarah Harriett, married Arthur Reeve, once the mayor of Margate.

SEE Cemetery, Margate/ Entertainers/ Hall by the Sea/ Margate/ Richardson, Alan/ Russia/ Sanger's Graves/ Victoria

SANGER'S GRAVES

I know it is just personal preference and, possibly, it is strange to like a gravestone, nevertheless I do have a strange liking for the statue of the Mazeppa circus pony that adorns the grave of John Sanger. If ever anyone makes a miniature version of the horse statue to sell, please let me know.

SEE Cemetery, Margate/ Sanger family

SARACEN'S HEAD public house
High Street, Margate

Around 1840, both The Jolly Sailor and The Bell closed in Margate High Street and it has since been assumed that one of these pubs became the Saracens Head. Many pubs across the country were named after artifacts brought back from the Crusades. The Saracens Head was at 55 (then re-numbered 129) High Street from the 1840s. It was rebuilt in 1935.

It is now called Sheldons.

SEE High Street, Margate/ Jolly Sailor/ Margate/ Pubs

SARRE

Sarre was once a port in the narrowest part of the Wantsum Channel before the it silted up. In C800AD it was around 700 yards wide but was a narrow stream by 1500. Roman galleys, Viking longboats, merchant and smugglers' vessels have all sailed through here.

In the eighth century, pilgrims from Canterbury would cross over to Thanet here to visit the tomb of St Mildred at Minster, who was greatly revered at the time. The

Abbess at Minster was granted the ferry tolls by King Eadbert of Kent.

The De Criol family was an important one in Sarre from 1250 until 1471.

Upon the hill, to the eastward of the town . . . on the great road leading from Sarre to Monkton . .

Saxon and other remains have been discovered in Sarre, and there are traces of an ancient Jutish burial place in a field to the east of the mill. A fine gold Jutish brooch, the Sarre Brooch, was discovered here.

In 1910, you could have seen Mr Salmeto do *'wonderful flying'* while carrying a female passenger in his Blierot aeroplane at a Thanet and Herne Harriers meeting in Sarre.

Kelly's Directory of The Isle of Thanet 1957:
Sarre is a civil parish on the river Stour, situated 64 miles (by road) from London, 8 south-west from Margate and 8 west from Ramsgate, in the Isle of Thanet parliamentary division of the county, rural district of Eastry, petty sessional division of Sandwich, lathe of St Augustine, rural deanery of Thanet, archdeaconry and dioceses of Canterbury.

Water is supplied by The Thanet Water Board.

There is no parish church; the living is annexed to that of St Nicholas-at-Wade. There is a Methodist Church.

Saxon and other remains have been discovered here, and there are traces of an ancient burial place in a field near the mill. Sarre bridge is half a mile north.

Population in 1951, 122, area, 667 acres.

Post Office.-Leslie R Parker, sub-postmaster. Postal address, Sarre, Birchington, Kent. The nearest money order & telegraph office is at St Nicholas-at-Wade, about 1 mile distant.

SEE Churches/ Cinque Ports/ Crown Inn/ Hodening/ Minster/ Monkton/ Population, Sarre/ St Giles Church, Sarre/ Sandwich/ Sarre Bridge/ Sarre Windmill/ Sheltering Tree/ Treasure Hunt/ Vikings/ Wantsum Channel

SARRE BRIDGE

This was the first bridge over the Wantsum Channel in 1485, and is half a mile south of the village.

SEE Wantsum Channel

SARRE WINDMILL

Situated between the roads to Ramsgate and Birchington is Sarre's major landmark, the windmill, once described as being *'eight miles from anywhere'* being that distance from the Thanet towns, Sandwich and Canterbury.

If you want to be technical, it is a tarred weather-boarded smock mill, which had a post-mill cap powered by an 8-vane fantail. It carried four white patent sweeps and these drove 2 pairs of stones. These both overdraft (!) and are a pair of Peak gritstone, and a pair of French Burrs. It's alright there is no exam at the end.

It was built in 1820, by John Holman, a Canterbury millwright. In around 1856, a steam engine was installed and the smock mill was also heightened and the base was converted from one storey to two.

By 1920 it was no longer worked by wind but became the first mill in Kent to be worked by gas engine. The sweeps were dismantled in 1922 and taken to Cranbrook's Union Mill. By the 1930s, it was no longer working at all and the old place looked a bit sorry for itself. In the war it was used as an observation post.

The Hobbs family, descended from one of the early millers here, bought it in 1985. The father and son then restored all of it; the brickwork, the cant posts, the weather-boarding, the wind-shaft, the cap, and the curb. Timber from demolished two hundred year-old buildings at Chatham Dockyard was used in some places. The machinery was also restored and once complete, the sails turned again on 12th June 1991.

SEE Treasure Hunt/ Windmills

SAUSAGES

Advertisement, East Kent Times,
16th January 1916:
SEND TO THE SOLDIERS AT THE FRONT ONE OF DAVID GREIG'S 7½d BREAKFAST SAUSAGES
Thousands of these small Breakfast Sausages have already been sent to the Front. They keep absolutely good and sweet for three weeks or longer. They are appreciated by all who desire a change of diet from the ordinary camp ration.
David Greig, 15 High Street, Ramsgate
SEE David Greig/ East Kent Times/ High Street, Ramsgate/ Ramsgate/ World War I

Dominic SAVAGE

He is the son of Tony Savage and, as a boy, he played the piano on the album and television special 'Barbra Streisand and Other Musical Instruments' in 1973. He subsequently appeared in the Stanley Kubric film 'Barry Lyndon' with Ryan O'Neal in the title role and Dominic playing Lyndon's stepson, Young Bullingdon. Dominic went on to direct documentary films including 'Seaside Organist' (Channel 4) about his dad. He has also made films for 'Surely Some Mistake' and 'One Foot in the Past' (both BBC) and won a BAFTA for Best New Director for the first of his trilogy of films dealing with social deprivation and young offenders 'Nice girl' (2000), 'When I was Twelve' (2001) and 'Out of Control' (2002)
SEE Actors/ Films/ Music/ Savage, Tony

Tony SAVAGE

He was the organist at The Lido as well as The Oval for many many years. Born in Winchester in 1922, he played the organ at Winchester Cathedral as a boy. During the war he was an interpreter in France and showed great bravery in the D-day landings.

He became a cinema organist and ran The Friars Cinema at Canterbury.

In the late fifties he moved to Margate, married Marie in 1958 and had two sons, Jason and Dominic.

Whilst at The Lido, in the summer, it entailed Tony playing for seven hours a day, seven days a week to the huge crowds that The Lido attracted.

He also worked on BBC's Crackerjack ('*Crackerjack!*') programme.

SEE Lido/ Music/ Margate/ Oval, The/ Savage, Dominic/ Television

SAXON CHRONICLE

The Saxon Chronicle (no, it was not a popular twelfth century tabloid with articles like 'Hornier Viking have shinier helmets!' but a history of the times) referred to Thanet as Tenet.

A.D. 851. King Athelstan and Alderman Elchere fought in their ships, and slew a large army at Sandwich in Kent, taking nine ships and dispersing the rest. The heathens now for the first time remained over winter in the Isle of Thanet. The same year came three hundred and fifty ships into the mouth of the Thames; the crew of which went upon land, and stormed Canterbury and London; putting to flight Bertulf, king of the Mercians, with his army; and then marched southward over the Thames into Surrey. Here Ethelwulf and his son Ethelbald, at the head of the West-Saxon army, fought with them at Ockley, and made the greatest slaughter of the heathen army that we have ever heard reported to this present day. There also they obtained the victory.

A.D. 853. The same year also Elchere with the men of Kent, and Huda with the men of Surrey, fought in the Isle of Thanet with the heathen army, and soon obtained the victory; but there were many men slain and drowned on either hand, and both the aldermen killed.

A.D. 865. This year sat the heathen army in the isle of Thanet, and made peace with the men of Kent, who promised money therewith; but under the security of peace, and the promise of money, the army in the night stole up the country, and overran all Kent eastward.

A.D. 969. This year King Edgar ordered all Thanet-land to be plundered.

A.D. 1047. This year died Athelstan, Abbot of Abingdon, on the fourth day before the calends of April; and Sparhawk, monk of St. Edmundsbury, succeeded him. Easter day was then on the third day before the nones of April; and there was over all England very great loss of men this year also. The same year came to Sandwich Lothen and Irling, with twenty-five ships, and plundered and took incalculable spoil, in men, and in gold, and in silver, so that no man wist what it all

was; and went then about Thanet, and would there have done the same; but the land-folk firmly withstood, and resisted them both by land and sea, and thence put them to flight withal. They betook themselves thence into Essex, where they plundered and took men, and whatsoever they could find, whence they departed eastward to Baldwin's land, and having deposited the booty they had gained, they returned east to the place whence they had come before.

SEE Athelstan/ Sandwich/ Thanet

SCALEXTRIC

When it was launched in the 1950s the motor-racing game was called 'Scalex', or Scale 'x' because it was of no particular scale, and when the electric version came out in 1957 it became Scale x tric – geddit?

SEE Rovex/Hornby

Lord SCANLON

Born Melbourne, Australia 26th October, 1913
Died Broadstairs 27th January, 2004
Hugh Parr Scanlon worked his way up to become president of the Amalgamated Engineering Union in 1968
He once described the House of Lords as a *'bastion of privilege'* and said he would never enter it but did accept a peerage in 1979 to become Lord Scanlon of Davyhulme, to the anger and incredulity of Labour MPs and the scorn of Conservative MPs.
He retired to a cliff-top bungalow in Broadstairs, dying in 2004 at the age of 90.

SEE Broadstairs/ Politics

Lord SCARMAN

Born Streatham 29th July 1911
Died 8th December 2004
He became a high court judge in 1961 and headed four major inquiries into the troubles in Belfast and Londonderry in 1969, the Red Lion Square riot of 1974, the Grunwicks dispute and, most famously, the Brixton riots of 1981. He retired in 1985 and lived at Monkton.

SEE Monkton/ Politics

SCENIC RAILWAY, DREAMLAND

This roller-coaster and its three-quarter of a mile track opened on 3rd July 1920 and from then until the end of that summer over 500,000 visitors rode on it. The next summer, in its first full season the figure was 1,000,000.
The white-knuckle ride of its day, it is now the only remaining wooden scenic railway in the country (over 120 were built between 1885 and 1960) and the only amusement ride in Britain to be Grade II listed.
On 21st August 1949 the half scenic railway and some show booths were severely damaged in a fire. It was repaired using timber - 30,000 cubic feet of it - from the pier at Lowestoft which had been damaged during the war.

SEE Dreamland/ Fires/ Listed buildings

SCHOOLS/ COLLEGES

It was estimated that there were 2,000 children in private schools in Margate in 1885.
SEE Albion Road, Birchington/ Albion Road, Cliftonville/ Alexander House School/ Arthur Road, Cliftonville/ Athelstan Road, Cliftonville/ Bagshaw's Directory and Gazateer/ Bartram Gables/ Belmont House/ Berkeley Road/ Bettison's Circulating Library/ Billy Bunter/ Blackburn's/ Bradstow Residential School/ Brunswick, Duke & Duchess of/ Callis Court/ Cannon Road/ Canterbury Road, Westbrook/ Cavendish Bptist Church/ Charles Dickens School/ Charlotte Place/ Chatham House School/ Chist Church School/ Chilton Primary School/ Clarendon House School/ Clarendon Road/ Coleman's School/ College Road/ Conyngham School/ Cranbourne Alley/ Dalby Square/ Dame Janet Junior School/ Dane Court School/ Drapers Mill/ East Court/ Eastern Esplanade/ Eaton road/ Edgar Road/ Epple Bay Road/ Evacuation/ Fairfield House/ Fort Crescent/ Garlinge/ Garlinge Junior School/ Godwin Road/ Grange, the/ Grenham House School/ Grosvenor Place/ Grosvenor Road/ Haddon Dene School/ Harold Road/ Hartsdown Park/ Hartsdown Technical College/ Hawley Square/ Hawley Street/ Hawtrey's Field/ Hereson School/ High Street, Margate/ Hildersham House School/ Hilderstone/ Holiday Romance/ Holy Trinity Church, Broadstairs/ Holy Trinity School, Ramsgate/ Home School for Girls/ Honiton House/ Houchin, Alan/ Jennings & Darbishire/ King Ethelbert School/ Laleham School/ Lillian Road/ London Road/ Lord Haw Haw/ Lovejoy School/ Margate College/ Methodist Church, Ramsgate/ Monkton/ Montefiore College/ Mount Albion House/ Mulberry Tree/ National School, Birchington/ Newcastle Hill/ Northdown Road/ Northumberland Road/ Oaklands Court/ Over the River/ Palm Bay Primary School/ Pierremont Hall/ Plum Pudding Island/ Police Station, Ramsgate/ Primitive Methodist Chapel/ Prince Harry pub/ Priory School/ Queen Berta's School/ Ramsgate/ Ramsgate County School/ Ramsgate Road/ Margate/ Reading Street/ Royal Crescent/ Royal School for Deaf/ St Andrew's Church/ St Augustine's/ St George's School/ St Lawrence College/ St Mildred's Church/ St Nicholas-at-Wade/ St Peter's Footpath/ St Peter's Preparatory School/ Sea Point Private School/ Sea Point Road/ Shabby Genteel Story/ Shelley, Mary/ Sickert, Walter/ Spencer Square/ Spread Eagle Inn/ Stone House/ Sunbeam Photos/ Sweyn Road/ Ternan, Nelly/ Thanet Technical College/ Townley House School/ Trinity Square/ Turner, JMW/ Union Crescent/ Upton Primary School/ Ursuline College/ VAD Hospitals/ Van Gogh, Vincent/ Vogel, Julius/ Wellesley House School/ Wesleyan Methodist Church, Birchington/ 'Westgate-on-Sea'/ Wheatley, Dennis/ Whitehead, Alfred North/ Whiteness Manor School/ Woodford Huse School/ Yarrow Home/ Zion Place

SCOTSMAN
Broadstairs Harbour

A figurehead that came off the Highland Chief which was an 854-ton barque that was wrecked on the Goodwin Sands on 12th February 1869. It stood perfectly happily outside the Boathouse in Broadstairs Harbour until the night of 13th July 2004 when it was vandalised and had to be sent off for an extensive stay at a figurehead hospital. It was a private hospital; the operation cost around £700. He returned a new man, and it is good to see him back.

SEE Boathouse/ Broadstairs/ Goodwin Sands/ Harbour, Broadstairs

Clement SCOTT

Born 6th October 1841
Died 25th June 1904
A theatre critic and travel writer.
'Broadstairs is the place for delicious sleep in pure and invigorating air.'

SEE Authors/ Broadstairs

Sir George Gilbert SCOTT

Born 13th July 1811
Died 27th March 1878
He was an architect at the forefront of the Gothic Revival claiming that, *'I was awakened from my slumbers by the thunder of Pugin's writings.'* He designed the Foreign and Commonwealth Office in Whitehall, St Pancras Station in London and, here comes the Ramsgate bit, Christ Church in Vale Square.

SEE Albert Memorial/ Christ Church, Vale Square/ Ramsgate

SCROFULA

Or more accurately 'strumous scrofula' which is caused by the tuberculosis bacillus which enlarges and degenerates the lymph nodes, and often spreads to the bones and their joints, just like other forms of TB. It was called 'king's evil' in the Middle Ages because it was thought that a touch from the king would cure it. During the period when sufferers were treated at the Royal Sea Bathing Hospital, the term 'scruffy', from Scrofula, originated because of the appearance of the victims of the disease. Sometimes, looking around, you could argue that no cure has yet been found.

SEE Royal Sea Bathing Hospital

SEA ANGLING

Broadstairs and Ramsgate were amongst the first places where the sport of sea angling began, after a few Cockney men who had used their rods to catch perch and eels back home in the London docks, then brought them down to Thanet on their holidays.
By 1870, it was an established pursuit locally and it was possible to: *'Buy a pail of bait enough for all day for half a crown (12½p) or rent a sailing boat and crew for the day for five shillings (25p).'* 'Wildfowler' in The Sporting Gazette, 1878.
Within a couple of decades, books were often referring to the fine sea trout that could be caught off Ramsgate, and also tope (a

kind of small shark) that was first fished at Broadstairs.
SEE Broadstairs/ Fishing/ Ramsgate/ Sport

SEA BREEZE CYCLE FACTORY
Advertisement:

SEABREEZE CYCLES
for either sex
The popular exhibit of the Stanley Cycle
Shows.
Geo. Cousins, Patentee and Manufacturer,
Birchington-on-Sea, Kent
The Seabreeze cycles are built on Hygienic
Lines
The Spring Frame obviates the need of
pneumatic tyres.
The Fairy Seabreeze (rigid frame) an Ideal
Lady's Cycle.
The Diamond Frame. Preventative of the
hideous bicycle lamp.

In the 1890s, the Seabreeze Cycle Works - 'The Pioneers of Ladies Bicycling' - was situated where Station Road meets Minnis Road and it was claimed that the ladies' bicycle was invented here.
The owner, George Cousins, was once the chairman of the Parish Council, and ironically, considering his business, the first person in Birchington to own a motor car.
In later years the premises were taken over by Benefield and Cornfords Estate Office, and Fashams the grocers. It is now Christie's Wine Bar.
SEE Bicycle/ Birchington/ Minnis Road/ Shops/ Station Road, Birchington

SEAFIELD ROAD, Ramsgate
SEE Brockman, Sarah/ Ramsgate

SEAMAN'S INFIRMARY
West Cliff Road, Ramsgate
Augustus Welby Pugin paid for the nursing requirements of seamen put ashore at Ramsgate, in two houses that he owned in King Street. This was the forerunner of the Seaman's Infimary in West Cliff Road which opened in 1849 and continued to operate until 1905 when the hospital opened over the road. In 1911, the Salvation Army bought the property, and it later became the Carramore Hotel; then a home for the elderly; and, finally, in 1990, it came full circle, becoming the Grange Medical Centre.
SEE Hospitals/ King Street, Ramsgate/ Pugin, Augustus/ Ramsgate/ Richardson, Alan/ Salvation Army Citadel

SEA POINT PRIVATE SCHOOL
Birchington
Originally a school for girls up to the age of 9, it was established in Epple Bay Road, and moved to Elfin Cottage in Station Approach in the 1930s. Its final move was to Berkeley Road but it closed at the outbreak of World War II.
SEE Birchington/ Epple Bay Road/ Schools/ Station Road, Birchington

SEAPOINT ROAD, Broadstairs
The first houses were built here in 1902 and looked out onto the playing fields of Abbotsford Girls School on the Western Esplanade.

SEE Broadstairs/ Schools/ Western Esplanade

SEA ROAD, Westgate
Ray House was demolished in 1988. Joe Jagger, Mick's father, once lived next door, in fact, he lived in Westgate for twenty years.
SEE Rolling Stones/ Swan, The/ Westgate-on-Sea

SEA VIEW HOTEL
Station Road, Birchington
Originally called the Railway Hotel, it was built in 1865 just after the railway arrived at Birchington. The sea, should you wish to view it, is over a mile away.
SEE Birchington/ Hotels/ Station Road, Birchington

SEA VIEW TERRACE, Margate
There was a wooden bandstand in 1904, opposite Sea View Terrace, but it was replaced by the bandstand previously removed from Fort Green when the Winter Gardens was built. The Westbrook Pavilion was built on the site in 1910 and the bandstand moved again, this time to Queens Lawn in Cliftonville.
SEE Bandstands/ Cliftonville/ Margate/ Westbrook Bathing Pavilion/ Westbrook Pavilion/ Winter Gardens

SEA WALL

A sea wall now protects the drained land behind it from the North Sea and provides a very pleasant 5 mile walk from Reculver to Minnis Bay, although the wall was breached in the great storm of 1st February 1953 when the sea flooded the railway line sweeping the track away.
Inside the sea wall, there are various pleasant footpaths across the marshland along which to walk and spot the many types of butterflies, moths and birds that call the area home, or in some cases, holiday home for the migrating birds that stop off here at different times of the year. This walk, along the wall itself, or even along the shingle beach at low tide, provides one of the few opportunities to experience natural silence (although not in the bitterly cold weather of winter, when the sound of your teeth chattering spoils the effect!). Apart from the odd train in the distance, there is no piped music, no traffic noise, no phones (provided you switch yours off or, and this may be an outrageous suggestion to some, don't take one at all), no-one else's conversation to over-hear, just the sounds of the various flocks of birds (or more correctly, a 'wreck' of seabirds or, a 'colony' of gulls), the wind and the sea. Some people travel halfway round the world for tranquillity like.
In 1746, a gang of around 150 smugglers, although some have reported as over 60 men and 80-90 horses, were reported to have fled

from this area with their cargo to Grove Ferry, Faversham and Whitstable.
Kentish Gazette: *1818 April 20th Found dead on the shore between Birchington and Reculver John Darby of Birchington. It is supposed he was engaged in his occupation of smuggling and that being alone he was brutally murdered by some Frenchman for the sake of his watch and other property which he was known to have had about his person.*
An inquest was held and a verdict brought in as above. His three brothers were lately to the French coast and never returned, and are supposed to have drowned in their nefarious trade.
At the beginning of World War I, Kent Cyclists were ordered to patrol the sea wall and watch out for a German invasion.
At the end of the wall the chalk cliffs of Thanet start, the shingle ends and the sandy beaches begin.
SEE Bicycles/ Birchington/ Dambusters/ Flooding/ Great Storm 1953/ Minnis Bay/ Smuggling/ Storms/ World War I

Sir Harry SECOMBE
Born 8th September 1921
Died 11th April 2001
Actor, singer, comedy entertainer and 'Neddie Seagoon' in The Goons.
Whilst performing at the Theatre Royal, Margate, he stayed at the London Tavern.
SEE Entertainers/ La Rue, Danny/ London Tavern/ Theatre Royal

'The SECOND STAIN'
by Sir Arthur Conan Doyle
This Sherlock Holmes story contains a reference to Margate: *And yet the motives of women are so inscrutable. You remember the woman at Margate whom I suspected for the same reason. No powder on her nose—that proved to be the correct solution. How can you build on such a quicksand? Their most trivial action may mean volumes, or their most extraordinary conduct may depend upon a hairpin or a curling tongs.*
SEE Books/ Doyle, Sir Arthur Conan/ Margate/ Sherlock Holmes

SEDAN CHAIR
Mr Payne offered sedan chairs for hire from his business behind the Royal Hotel (later the site of Lewis & Hyland at 29/39; now replaced by new shops) up until 1866, for 1/6 (7.5p) an hour. The last person to have a sedan chair was Lady Montefiore.
SEE Lewis, Hyland and Linom/ Montefiore, Sir Moses

John Pollard SEDDON
Born 1827
Died 1906
The architect John Pollard Seddon FRIBA had been responsible for restoration work on the cathedrals of Llandaff, Norwich and Rochester; St. Margaret's, Westminster and Lambeth Palace Chapel. He designed the famous Birchington Bungalows in the 1870s and 1880s and was also responsible for the Beresford Hotel.
SEE Beresford Hotel/ Birchington

SELF SERVICE GROCERY SHOP

Mr E Giraud opened a new style of grocery shop in Grange Road, Ramsgate, in April 1960. It was self-service. Well that was never going to catch on was it?

SEE Grange Road, Ramsgate/ Ramsgate/ Shops

SERENE PLACE, Broadstairs

SEE Bradstow House/ Broadstairs/ High Street, Broadstairs/ Milton Place

SETTLEMENT ACRE

If you were a Regency Buck who had fallen out with another Regency Buck over a point of honour sir, you would have no choice but to challenge the dastardly dog to a duel. The top venue in England was Chalk Farm (now swallowed up by London, but then quite rural) and even the Duke of Wellington had a duel there. The number two position in the top duelling venues of the country (and if Channel 4 had been around then, there would have been a programme listing the 100 best I'm sure) was Settlement Acre at North Foreland. There was a duel here in 1789 between a London solicitor, Edward Anderson and 24-year old Thomas Stevens, whose father was the First Secretary of the Admiralty. The night before they'd had a huge argument at the Assembly Rooms in Margate that left them both with no option but to fight to the death. Stevens received a ball from his opponent's pistol in the jugular vein and, *'as a matter of course bled speedily to death'*. His grave is in St Johns churchyard in Margate. The argument had been about whether a window should be open or shut.

Settlement Acre is now part of North Foreland Golf Club and people are challenged to a different type of duel.

SEE Assembly Rooms/ Margate/ North Foreland Golf Club/ St John's Church

SEVEN STONES
South Cliff Parade, Broadstairs

This house on South Cliff Parade, Broadstairs, was designed and built by the architect S H Evans in the 1920s. Now a Grade II listed building, Winston Churchill once stayed here when the Conservative Party had their conference at the Winter Gardens in Margate. It is rumoured he also held meetings here in World War II.

SEE Broadstairs/ Churchill, Winston/ Listed buildings/ South Cliff Parade/ Steenhuis, Wout/ Thatcher, Margaret/ Winter Gardens/ World War II

'A SHABBY GENTEEL STORY'
by William Makepeace Thackeray

This short story is set in Margate (originally published in Fraser's magazine, it is found these days in the book 'Stories and Sketches', if you are interested).

'In the year 1835, when this story begins, there stood in a certain back street in the town of Margate a house, on the door of which might be read, in gleaming brass, the name of Mr. GANN. It was the work of a single smutty servant-maid to clean this brass-plate every morning, and to attend as far as possible to the wants of Mr. Gann, his family, and lodgers; and his house being not very far from the sea, and as you might, by climbing up to the roof, get a sight between two chimneys of that multitudinous element, Mrs. Gann set down her lodgings as fashionable; and declared on her cards that her house commanded 'a fine view of the sea'. . . Mr. Gann . . . always wore a rattling great telescope, with which he might be seen for hours on the sea-shore or the pier, examining the ships, the bathing-machines, the ladies' schools as they paraded up and down the esplanade, and all other objects which the telescopic view might give him.

. . . the silver moon lighted up the bay, and, supported by a numerous and well-appointed train of gas-lamps, illuminated the streets of a town, - of autumn eves so crowded and so gay; of gusty April nights, so desolate. At this still hour (it might be half-past seven) two ladies passed the gates of Wright's Hotel 'in shrouding mantle wrapped, and velvet cap'. Up the deserted High Street toiled they, by gaping rows of empty bathing–houses, by melancholy Jolly's French bazaar, by mouldy pastry-cooks, blank reading-rooms, by fishmongers who never sold a fish, mercers who vended not a yard of riband – because, as yet, the season was not come, … at High Street's corner, near to Hawley Square, they passed the house of Mr. Fincham, chemist, who doth not only healthful drugs supply, but likewise sells cigars – the worst cigars that ever mortal man gave threepence for.'

SEE Bathing machines/ Books/ Snob/ Hawley Square/ High Street, Margate/ Margate/ Schools/ Thackeray, William Makepeace

Sir Ernest SHACKLETON

Born County Clare, 15th February 1874
Died 5th January 1922

A famous explorer who, after attending Dulwich College, became a Merchant Marine Officer, and also tried his hand at politics, journalism, finance and business.

In 1901, he took part in the Royal Geographical Society's National Antarctic Expedition, sometimes called the Discovery Expedition, led by Robert Falcon Scott. Shackleton answered an advert in The Times that apparently read, *'Men wanted for hazardous journey. Small wages. Bitter cold. Long months of complete darkness. Constant danger. Safe return doubtful. Honour and recognition in case of success.'* Scott, Shackleton and Dr Edward Wilson set off on foot to the South Pole in 1902. Unfortunately, they thought that only sheer determination would get them there and they did not take enough food and although they took dogs they did not know how to handle them. They did get further south than anyone had managed, getting to within 857km of the South Pole on 31st December 1902. On the way back, Wilson suffered from snow blindness and Shackleton got scurvy. There was talk of Scott, who was Royal Navy, being jealous of the popularity of Shackleton, who was not, and early in the new year, Scott sent Shackleton home, even though he was virtually fully recovered.

Back home, Shackleton married Emily Dorman in 1904 and they went on to have three children. However, Shackleton was not the most faithful of husbands, having many affairs; most notably from 1910 until his death, with the American actress Rosalind Chetwynd (Rosa Lynd).

Shackleton led the British Antarctic Expedition to Antarctica to try and reach the South Pole in 1907. Having learnt from the previous trip, Shackleton replaced the dogs with ponies, although they were no easier to handle. They took enough food, but only just. They were very fortunate with the weather on the return trip, otherwise they could have been in trouble. The expedition did not reach the South Pole, this time although they did get to within 180km, and they were the first to climb Mount Erebus, Ross Island's active volcano, and the first to cross the Trans-Antarctic mountain range and stand on the South Polar Plateau.

The expedition made Shackleton a hero back home and he was promptly knighted in 1909 becoming a bit of a celebrity. If questioned about failing to reach the South Pole he would say, *'Better a live donkey than a dead lion'*.

Despite receiving £20,000 from the government for his achievements, he still needed money to fund his next expedition and the government was not keen to give him any more. Winston Churchill, First Lord of the Admiralty, 23rd April 1914 *'Enough has been spent on this sterile quest. The Pole has already been discovered. What is the use of another expedition?'*

Shackleton did get funds from Dame Janet Stancomb-Wills. He was 40, she was 60 and was not the first female to fall quietly in love with him. Shackleton knew exactly how to work the situation to his advantage. She gave him money for his expedition and, as he was very low on funds, she promised to support his family while he was away, also paying the school fees for his children.

On 1st August 1914, the Imperial Trans-Antarctic Expedition left from London in their ship Endurance. The mission this time was to cross the Antarctic from the south of the Weddell Sea near Vahsel Bay, reach the South Pole and go on to Ross Island. They

had only got as far as Vahsel Bay when the Endurance was crushed by pack ice and they had to abandon it. The crew of the ship and the members of the expedition then embarked on a truly amazing journey of epic proportions. They crossed the Weddell Sea by sledge, and then by the Endurance's lifeboats, to Elephant Island, just off the Antarctic Peninsula. Here, one of the boats had to be repaired and Shackleton and five others set off to South Georgia, leaving the other 22 men behind. At South Georgia they would get help and return to save the rest. By now it was April/May and winter was setting in. Somehow, in a boat that was only 20 feet long, they made it and landed on the southern side of South Georgia. The only inhabitants were at the whaling station that was on the north side so they had to trek cross country. It took them 36 hours.

After three failed attempts, the men on Elephant Island were rescued by a Chilean ship called Yelcho, on 30th August 1916 – 22 months after they had first left from South Georgia.

Amazingly, everybody survived.

The rest of us would probably have thanked our lucky stars and been afraid of snowmen for the rest of our lives, but not Shackleton. On 17th September 1921, he set off in another ship, Quest, a 125-ton wooden sealer that he had bought in Norway. Shackleton, aboard Quest, visited Ramsgate Harbour the previous year. It was unsuitable, unreliable and uncomfortable. Shackleton had a heart attack on 5th January 1922 whilst anchored off South Georgia and died. He was buried on Grytviken, a South Georgia Island on 5th March.

SEE East Court/ Harbour, Ramsgate/ Ramsgate/ Stancomb-Wills, Dame Janet

SHAFTESBURY HOUSE
Marine Gardens, Margate
This building was presented to the YMCA in 1887 for them to use as a seaside home. Dr Barnado's took it over in 1919 as a home for orphaned East End Children. Over time the seaside souvenir shops and amusement arcades moved into the ground floor and in 1988 a fire destroyed the top three floors. It was restored and is now flats.

SEE Fires/ Margate/ Marine Gardens/ Orphanages

SHAH PLACE, Ramsgate
Thanet Advertiser, 6th January 1906: *Miss Gertrude Pantling, 25, of 1 Shah Place was sent for trial to Maidstone for concealing the birth of an illegitimate daughter between 24th and 26th December 1903.*

Thanet Advertiser, 17th March 1906: *Thomas Harris of Ramsgate was charged with supplying Atiol for the purpose of procuring a miscarriage of Miss Gertrude Pantling, 25, in 1905.*

SEE Railway Tavern/ Ramsgate

William SHAKESPEARE
Born c.26th April 1564
Died 23rd April 1616
Playwright.

SEE Bouchier/ Arthur/ Braithwaite, Dame Lilian/ Falstaff Inn/ Goodwin Sands/ Hicks, Sir Seymour/ Kean, Edmund/ Lamb, Sharles/ Landen, Dinsdale/ London Tavern/ Shakespeare public house/ Shakespeare Road/ Siddons, Mrs Sarah

SHAKESPEARE public house
1 Canterbury Road, Westbrook
The Shakespeare pub was re-named after a locomotive train, not the playwright, but was originally the British Tar, because it was opposite the Margate Watch House in the 19th century; it was re-named when it was rebuilt in around 1870. In World War II, soldiers were billeted there and it was very popular with showbiz people in the middle of the 20th century; the most famous person to drink there being Billy Cotton the bandleader.

SEE Canterbury Road, Westbrook/ Cotton, Billy/ Margate/ Pubs/ South Eastern and Chatham Railway/ Westbrook/ World War II

SHAKESPEARE public house
Margate Road, Ramsgate
It is another pub named after a locomotive not the playwright, although the locomotive was named after the playwright, so, in a way it was named after the playwright, if you are still with me.

'The Shakespeare at Ramsgate had so many [stuffed animals in glass cases] *it was like drinking at Quex Park Museum.'* Comment around 1900.

To make it a top pub for darts, The Shakespeare was re-named The One Hundred and Eighty by its owners Thorley Taverns.

SEE Margate Road, Ramsgate/ Pubs/ Quex/ Ramsgate/ South Eastern & Chatham Railway

SHAKESPEARE ROAD, Birchington
A plaque was put on a house in Shakespeare Road in 1979 to signify that Rossetti once lived nearby

SEE Birchington/ Rossetti/ Shakespeare

The SHALLOWS
St Peter's Footpath, St Peter's
It apparently derives its name from an underground stream that surfaced here. This piece of land, which included a chalk pit, was owned in the late seventeenth century by Richard Mockett, the Churchwarden of St Peters. At this time Baptists were so persecuted in England that they were forced to worship in the middle of woods, or in isolated houses. Stephen Shallows was a local Baptist looking to buy a house with a room large enough in which he and his fellow Baptists could worship in safety. Prompted partly by the coincidence of the name he bought the land from Richard Mockett for ten shillings. Initially, services were held in the chalkpit until he built his house, or more correctly cottage, around 1690.

The rooms are small and the ceilings very low. The walls are formed of large irregular lumps of chalk, not wrought, and covered externally with flint and brick edging. 'Short History of Baptists in the Isle of Thanet' (1876) by Samuel Jones

The cottage served its purpose admirably until 1750, by which time Baptists were more tolerated and could safely build a chapel in the garden of the cottage with room for a congregation of around one hundred. This chapel was used for the next fifty years before the congregation moved to the newly built Salem Baptist Church in St Peter's in 1800. The old chapel, also called Salem Church, continued as a baptistery until 1835, still being seen as the mother church. A special service was held there on the second Sunday in May every year, well into the nineteenth century.

'Short History of Baptists in the Isle of Thanet' (1876) by Samuel Jones: *The house is now very dilapidated, and has been uninhabited almost 20 years. The old chapel having fallen into disuse was pulled down in 1856.*

In the second half of the nineteenth century, the shallow depression in which the chapel had been was laid out as a pleasure garden. On May Day and other holidays, the farm workers, and fishermen would bring their wives or girlfriends (always a mistake to take both – so I've been told) and their children for the day.

In World War II, the Army used the chalk pit as a practice range and after the war, the council used it as a refuse tip until it was finally filled in. The land is now privately owned and only a part of the chapel wall remains. The present house bears no relation to the original house.

SEE Churches/ Farms/ St Peter's/ St Peter's Football/ World War II

Helen SHAPIRO
Born 28th Spetember 1946
Singer, whose first four singles all went to number one – the first when she was only 14-years old. Her best known song is 'Walking Back to Happiness'. When The Beatles did their first national tour, it was as support to Helen Shapiro. In later years she has turned to acting and singing jazz and gospel.

SEE Music/ Winter Gardens

SHARPS DAIRY
Bounday Road, Ramsgate
Mr G Hedgecock started the Thanet Farm Dairy in Boundary Road in 1900, until, in 1906, Mr E Sharp bought the business and Sharps' Dairies went on to be one of the biggest dairies in Ramsgate. The headquarters remained in Bounday Road and the milk came from the outlying farms into Ramsgate by train. One particular Sunday during World War I, troop movements delayed the trains which meant that the dairy was not full when a bomb landed on it. Sadly, other bombs in the same attack hit St Lukes Church killing some children, and naval ratings visiting from a ship in Ramsgate Harbour. The dairy suffered bomb damage on a few occasions in World War I, and also suffered along with houses in the street when the gasworks were damaged one night causing a leak that prompted a big explosion at around noon the next day.

Sharps also had premises at Elgar Place at the top of Boundary Road where they kept their vehicles, some people referred to it as

Sharps Place. A bomb which destroyed the road in World War I caused the discovery of huge, and I mean huge, underground caverns. Eventually they were bricked in, covered with iron girders and the road made good.

Sharps' Dairies moved to Grange Road in 1937 where they opened the most modern pasteurising and bottling plant in Kent. The Sharp family sold the business in 1964.

Unigate is closing its dairy in Grange Road with the loss of 32 jobs. The processing plant is closing but the delivery staff and customers will not be affected. The premises will remain a depot for milkmen and their floats. 23rd January 1987

SEE Boundary Road/ Farms/ Harbour, Ramsgate/ Ramsgate/ Thanet Farm Dairy/ St Luke's Church, Ramsgate/ World War I

George Bernard SHAW
Born 26th July 1856
Died 2nd November 1950
Irish novelist, playwright and critic, and winner of the Nobel prize for literature. As a young man he applied to be the lighthouse keeper at North Foreland, but was rejected due to his inexperience.

In December 1888 George Bernard Shaw came to Thanet (he stayed in Broadstairs) to avoid celebrating Christmas!

'Then, impelled to restless activity by the abominable ozone, I rushed off to the left; sped along the cliffs ; passed a lighthouse, which looked as if it had been turned into a pillar of salt by the sea air; fell presently among stony ground ; passed on into muddy ground; and finally reached Margate, a most dismal hole, where the iodine and ozone were flavoured with lodgings.

I made at once for the railway station and demanded the next train. 'Where to?' said the official. 'Anywhere, 'I replied, 'provided it be far inland. ' 'Train to Ramsgit at two-fifteen,' he said: 'nothing else till six'. I could not conceive Ramsgit as being so depressing, even on Christmas Day, as Margit ; so I got into that train.'

He once received an invitation from a hostess who indicated that she would be '*At home'* on a particular day, GBS replied, '*So will G. Bernard Shaw'*.

Shaw was a virgin until he was 29 when he was seduced by a widow. Apparently, he did not repeat the sexual act for another fifteen years. At the age of 42, he married Charlotte Townsend, apparently a virgin before the wedding, and after. Shaw was far from explicit about sex in his writing; instead of penis he used the word '*manroot'*, and instead of vagina, he used the term '*her sex'*. He left £367,233 when he died.

'*He* [Shaw] *hasn't an enemy in the world, and none of his friends like him.'* Oscar Wilde

SEE Authors/ Broadstairs/ Harmsworth and GBS/ Langty, Lillie/ Margate/ Temple, William/ Theatre Royal/ Wilde, Oscar

Mary SHELLEY
Born London, 30th August 1797
Died London 1st February 1851

Her father, William Godwin, a philosopher and historian, was cold and remote, but loved eating and borrowing money!

Her mother was Mary Wollstonecraft, the influential women's reformer, who, with her sisters, ran a school and was financially independent. She had a fling with a captain in France who deserted her when she got pregnant and produced a daughter, Fanny. Back in England, she attempted suicide. When she recovered, she started writing and her work on women's liberation made her famous.

At a bit of a do at Godwin's house in late 1796, William and Mary found that they shared the same beliefs, and she was soon pregnant again. This prompted a marriage but although in love they kept their separate addresses. When Mary Shelley was just ten days old, on 10th September 1797, her mother died as a result of complications with the birth.

The newly-widowed William could not cope with bringing up his daughter and his step-daughter and immediately went looking for another wife and a mother for the girls. It took a while but Mary Jane Clairmont was the next Mrs Godwin. The girls were looked after in material ways, but Fanny, and particularly young Mary, were treated less well than Mary Jane's own children. Mary was on the receiving end of beatings. The girls were taught every domestic skill, cooking, cleaning and how to run a household but Mary was too interested in reading to pay any attention. She read all her mother's work between the ages of eight and ten. She couldn't stop reading and she couldn't stop talking either! Charles Lamb, Anthony Carlisle, Humphrey Davy, and Samuel Taylor Coleridge were visitors to her father's house and she enjoyed all the adult conversation. She also got into a habit of visiting her mother's grave. Now that is quite normal but in this case it entered the realms of an obsession. She would spend hours and hours there, reading and even eating her meals there. In her defence, she was also using the visits to avoid the atmosphere at home. The grave visiting continued until her teenage years. To combat that, as well as her general frailty, lack of concentration, and eczema (at times her left arm was in a sling because of it) she was sent to Miss Petman's boarding school in Ramsgate where she stayed from May until December 1811.

She met Percy Bysshe Shelley – he was a married man - on 5th May 1814, and apparently they 'made love' in the graveyard at St. Pancras on 27th June 1814 – look, it was meant to be romantic.

On 28th July, Mary, Percy and Jane Clairmont left for France, and then Switzerland - Basle and Lucerne. Not only did Mary's family disown her, but they returned to England with no money left. The following year Mary had a daughter, Clara, on 22nd February who died not long after on 6th March. She later had a son, William Godwin Shelley, on 24th January 1816. Around the same time Claire Clairemont meets Byron, and they accompany Mary and

Shelley to Switzerland in May. Whilst there Byron suggests on 15th June - boredom must have kicked in - that they each write a horror story. We can only hope that Mary got a good prize because she wrote Frankenstein, although she did not actually finish it until the September.

Further tragedy struck when she returned to England; Fanny, her step-sister, committed suicide in October and Shelley's pregnant wife did the same in the Serpentine in London. Mary and Shelley married, and they had a third child, Clara, on 2nd September 1817, who unfortunately died twelve months later; followed, in June 1818, by young William who dies of malaria in Rome. A fourth child, Percy Florence is born, in Florence, on 12th November 1819 and tragedy keeps away until 1822, when Mary nearly dies following a miscarriage and Shelley drowns.

The first signs of menigioma appeared in 1840, and she suffered spells of bad health until 23rd January 1851 when she had a series of fits, fell into a coma and died on 1st February aged 54.

SEE Authors/ Ramsgate/ Schools

SHELL GROTTO, Grotto Hill, Margate
This comprises an Altar Chamber, Serpentine Passage, Rotunda, Dome, a North Passage and a 2,000 square feet mosaic of 4,600,000 shells. That seems too round a number to be absolutely accurate so any volunteers to count them?

The origin of the grotto is still not known. Arguments rage between it being a sun temple built thousands of years ago, a temple connected with the Knights Templar, or simply a folly. I have no definitive answer to the debate, but it is a worthwhile place to pay a visit.

I also know how to get huge crowds to visit the Grotto - persuade Dan Brown to include it in his next novel.

The Grotto was listed as 'Grotto and fancy repository' in 1890.

SEE Corelli, Marie/ Margate

SHELTER, Margate

The recently restored shelter next to the Lifeboatman statue, is Victorian and is now a listed building.

SEE Lifeboat memorial/ Listed Buildings/ Margate

'The SHELTERING TREE'
by Richard Parker
Much of this 1970 novel, currently out of print, is set in Minster and refers to the workhouse (known as the Hill House Hospital in later years, but now demolished) and the Bell public house. Also mentioned are the local wildlife, the Wantsum Channel, Sarre and the Vikings and the Jutes.

SEE Books/ Jutes/ Minster/ Parker, Richard/ Sarre/ Vikings/ Wantsum Channel/ Workhouse

Richard SHERIDAN
Born 30th October 1751
Died 7th July 1816
Having already written 'The Rivals' (1770), 'The School for Scandal' (1777) and 'The Critic' (1779), Richard Sheridan then began enjoying a successful career in politics.
When his father was going to Lisbon for the sake of his health, he stopped off in Margate en route from Dublin, and on 12th August 1788, Richard was called to his bedside in Margate. His father was said to be *'in a melancholy situation'* and two days later he died. He was buried in the north aisle of St Peter's Church in Broadstairs.
SEE Authors/ Margate/ Politics/ St Peter's Church/ Sheridan, Thomas

Thomas SHERIDAN
Born Dublin, 1719
Died Margate 1788
He went to school at Westminster but had to complete his education at Trinity College – gaining a BA in 1739. He became an actor and wrote a play, 'Captain O'Blunder, or the Brave Irishman'. His first appearance in London was in March 1744 at Covent Garden, where he played a variety of parts for three weeks. That October he appeared at Drury Lane. He returned to Dublin, married Frances Chamberlame and became the manager of the Theatre Royal. One day, a young man by the name of Kelly insulted the actresses so Sheridan stepped in. Kelly threatened him and somehow the episode escalated into a riot! Kelly was sent to prison but Sheridan petitioned for his release.
In 1754, he forbade West Digges, an actor, from repeating a passage in 'Mahomet the Impostor', a James Miller tragedy, which did not reflect well on the government. Sheridan left to go to London, but was soon back in Dublin. Just two years later, he returned to London.
He lectured at Oxford and Cambridge for a couple of years from 1758, but by 1760 he has begun acting again at Drury Lane, under Garrick and was also giving lectures on his education system, in which elocution played a major part.
He moved to France in 1764 for three reasons: economic, to study the education system and his wife's health. However, she died in 1766, prompting his return to England.
He published a new updated Plan of Education for the Young Nobility and Gentry in 1769. He sent a copy with a letter to the king, offering to devote the rest of his life to putting his theories into practice in exchange for a pension. No such pension was forthcoming. He moved to Bath and wrote his General Dictionary of the English Language (1780). When his son, Richard Brinsley Sheridan, became a huge success he assisted in managing Drury Lane, and did the odd bit of acting, as well as writing 'Life of Swift' (1784).
He died at Margate on the 14th August 1788.
SEE Authors/ Margate/ Richard, Thomas

SHERLOCK HOLMES
A fictional detective created by Sir Arthur Conan Doyle who wrote about him in four novels and fifty-six short stories.
'When you have eliminated all which is impossible, then whatever remains, however improbable, must be the truth.' 'The Adventure of The Blanched Soldier'
SEE Books/ Doyle, Sir Arthur Conan/ 'Veiled Lodger'/ 'Second Stain'

The SHIP INN, Rendezvous, Margate
It was demolished to make way for the Turner Centre.
SEE Harbour, Margate/ Margate/ Pubs

SHIP INN
Harbour Street, Ramsgate
Now long gone, this inn displayed for many years a sign, showing a picture of a ship in full sail, that read *'Come jolly Tars and lay at anchor here, why go further and drink worse beer?'* It stood at, or near, 31/32 Harbour Street and there is a record of its existence as far back as 1790 when someone called Harvey ran it. The inn looked like a cottage and was built on the chalk of the cliff, higher up than the shops that are now there – indeed, it had many steps up to the entrance. The original building was replaced in c1880 when the steps were turned into a slope.
SEE Harbour Street, Ramsgate/ Pubs/ Ramsgate

SHIPBUILDING
The Culmer-White boatyard closed in Broadstairs in 1824 and the firm of J. Samuel White moved their business to the Isle of Wight where they continued. In the 1841 census there were four boat builders still in business in Broadstairs. There were also nine fishermen included in a total of 44 mariners in the town.
Between 1811 and 1863 in Ramsgate, local fishing smacks were built in the yards of shipbuilders such as Beeching and Moses, William Miller and William Caught.
SEE Beeching, Moses & Co/ Broadstairs/ Deal Cutter/ Fishing/ Friend to All Nations/ Leopold Street/ Pavilion, Broadstairs/ Ramsgate/ Ramsgate Sands Railway Station/ Tunis Row/ Wherry

SHIPS/ SHIPPING
SEE Armada/ Bounty/ Cervia/ Dunkirk/ Foy/ Golden Eagle/ Gand Falconer/ Grand Turk/ Hercules/ HMS Fervant/ HMS Thanet/ Hovelling/ Hoy/ Husbands' boat/ Kooh-i-noor/ Lifeboat/ Lusitania/ 'Margate Hoy'/ Pride/ Royal Adelaide/ Royal Yacht/ Scotsman/ Sloops/ Steam Packets/ Sundowner/ 'Tales of the Hoy'/ Tea Clipper Houses/ Thames Steam Yacht/ Titanic/ U-Boat/ Voss, Captain/ Watt/ Wherry

SHOE REPAIRERS
In 1957 there were 46 listed. In 2005 there were 4.
SEE Shops

SHOPS
SEE Baldock/ Barnett's Radio & electrical/ Blackburns/ Blinko's Bookshop/ Bobby's/ Boots/ Bournes/ Bowketts/ Bradstow House/ Broadway, The/ Butchers/ Centre, The/ Church Street, St Peter's/ Courts/ Cranbourne Alley/ David Greig/ David Potton menswear shop/ Dearden's Picture Gallery/ Derry & Toms/ Drays/ Dunn, ER/ Dunn & Sons/ Farleys/ Faversham & Thanet Co-op Soc/ Fine Fare/ Fishmongers/ Foster, Herbert/ Goodwins/ Grocers/ Harringtons/ Henrys/ Herms/ Hypermarket/ Jebb, JG/ John Bayly's tea dealership/ Kingfisheries/ Knowler/ Lewis, Hyland & Linom/ Linscott/ Littlewoods/ Lovelys/ Marks and Spencer/ MFI/ Minnis Bay Parade/ Munro Cobb/ Olby/ Old Curiosity Shop/ Padgets/ Pearks'/ Pilcher Page/ Pillow Talk/ Pointer/ Poole/ Priestley's Cycles/ Pryce & Judd/ Sainsbury/ Sea Breeze Cycle Factory/ Self Service Grocery/ Shoe repairers/ Street, H/ Sunbeam Photos/ Superdrug/ Tesco/ Timothy Whites/ Vestey, Sir Edmund/ Vye & Sons/ Vye Brothers/ W H Smith & Son/ Waitrose/ Welch/ Wellden/ Westbrook Cycle Stores/ Westwood Cross/ Wiggett/ Woolworths/ Wright/ Wrightson/ Zion Place

SHOTTENDANE HOUSE, Margate
Designed by Hugh Thackeray Turner, it was built by Arthur Walton Rowe. Following Rowe's death it was bought by the Railway Convalescent Homes in 1927. In the 1980s it became the Shottendane Nursing Home.
SEE Convalescent Homes/ Margate/ Rowe, Arthur Walton

SHOTTENDANE ROAD, Margate
SEE Acol/ Green, Napoleon/ Hengrove/ Kings Head/ Margate/ Odell, PC Jon/ Shottendane House/ Spur railway line

SHRINE OF OUR LADY, BRADSTOWE
Albion Street, Broadstairs

The plaque on the wall near the Albion Bookshop for secondhand books, reads:
OLD ST MARY'S
NOW THE PARISH ROOM OF HOLY TRINITY CHURCH. ON THIS SITE STOOD IN OLDEN TIME THE FAMOUS SHRINE OF OUR LADY OF BRADSTOW
Over the years the Chapel was used for worship by Anglicans, Baptists, Catholics, Congregationalists, Methodists, Plymouth Brethren, and the Seaman's Mission.
The first recorded mention of the original Chapel of St Mary and the famous Shrine of Our Ladye Star of the Sea in Bradstowe is in 1070 but it is known that a place of worship existed here for many years prior to this. (There was a replica of the shrine in the old Saxon Church, at St Peter's that the present Norman church replaced.) The shrine faced the sea and was in the shape of a tall column on top of which stood a statue of the Virgin Mary (although it has been suggested that it could have been Pieta 'Our Lady of Pity') in a chapel that was then nearer the clifftop. Pilgrims from all over the country, and even Europe, came to see the shrine and, at that time, there would have been open

countryside virtually all around the chapel. To assist those who wanted to visit the shrine from the sea, steps were cut into the cliff forming a staircase up the cliffs and this could well be where the name Broadstairs originates from.

John Baker 1349: *After the ravages of the Black Death, ye shrine of Our Ladye of Bradstowe, hath lost its brethren to ye plague and is sore decayed after its cometh.*

In medieval times it was called The Chapel of Blue Light because of the lantern that shone through coloured glass to act as a warning to ships: *'Shyppes that lyeth in ye narrow see with marchandyse for Tenet seith at the hedde of the Cliffe ye Shrine of the Bluw Light from many myle off.'* (1451)

Passing ships would lower their top sails to salute the shrine up until 1514 when Trinity House took over the responsibility for showing beacons to warn of hazards. A ship with its sails duly lowered is still shown in the town's coat of arms.

In 1514, a service was held at Bradstow Chapel attended by the crew of the Henry Grace a Dieu, the largest warship built in Tudor times, which was moored nearby on its tour of the country to show the might of the newly formed Royal Navy, and increase the country's morale. The Royal Navy tradition of *'showing the flag'* at seaside towns is said to date from this service.

There was a storm in the 1520s that lasted a few days and was so fierce that a tidal wave swept into Viking Bay badly damaging the chapel and destroying the shrine.

In 1601, Sir John Culmer, who owned the estate that the chapel stood in, set about its restoration: hence the other plaque *'St Mary's Chapel 1601'* which is higher up on the building today. Whilst a lot of the original materials were re-used, only a window, a door and part of a wall remain of the previous, apparently more picturesque building. The shrine was placed in the new chapel and because of the building's high humidity, the Virgin Mary appeared to weep – this was thought to be a bad sign, and ironically it was, as the change in atmospheric pressure that caused the phenomena also meant a change to stormier weather. That year Joel Culmer became the first Pastor.

The Chapel was converted into two cottages for visiting clergy in 1714 and the last burial in the crypt below the chapel took place in 1753. The chapel was further converted into four cottages in 1817, this time for fishermen who kept their boats close by. Three of these cottages were demolished in 1936. Holy Trinity Church sold the building in 1964. It is now a secondhand bookshop.

SEE Albion Street/ Broadstairs/ Churches/ Holy Trinity Church/ Storms/ Viking Bay

SHUART

The sister village to St Nicholas was Shuart which had its own church, All Saints. The remains of the church were excavated by archaeologists in 1978.

SEE All Saints Church, Birchington/ Captain Swing/ Churches/ St Nicholas-at-Wade

Walter Richard SICKERT

Born Munich, 31st May 1860
Died Bath, 22nd January 1942

Walter's family moved to London in 1868 and he went to a school run by a drunken old woman in Reading. When another boy broke Walter's arm, the woman beat him *'and we thirty little wretches lay there cowed.'*

He was the son of an artist and after working as an actor for a while, he turned to art, studying at the Slade School in London. He became the assistant to James McNeill Whistler' – signing his early works *'pupil of Whistler'*. He subsequently worked with Degas in Paris and also lived in Venice and Dieppe. When Oscar Wilde was released from prison, he went to see Sickert who was with Aubrey Beardsley, but they were not happy to see him. Sickert returned to London in 1905 where he painted scenes of music halls and the audiences, and nudes - lower class women in cheap rooms – which he painted with a lack of any sexuality.

'Compositions consisting solely of nudes are usually (I have not forgotten certain exceptional flights of genius, such as the Rubens, in Munich, of the Descent into Hell) not only repellent, but slightly absurd. Even the picture or two (I think there are two) of the master Ingres, which is a conglomeration of nudes, has something absurd and repellent, a suggestion of a dish of macaroni, something wriggling and distasteful.' Sickert, 1910

He married Ellen Melicent Ashburner Cobden, the daughter of the Liberal politican Richard Cobden, in 1885. She was twelve years older than Sickert, they had no children and the marriage was an unhappy one. He was having an affair with Annie Crook a very attractive artist's model, who had a son called Joseph 'Hobo' Sickert, and Walter spent long periods away from home lest his wife found out! She divorced him in 1899 whilst Walter was in France suffering from paranoia – well, that's what he thought people were saying. Sickert was born with a deformed penis and had to undergo traumatic operations in his childhood. Thus there is a theory, amongst those with too much free time, that he was incapable of having an erection. However, he married three times and was supposed to have had an illegitimate son.

In 1908, he painted 'Jack the Ripper's Bedroom', (as in an actual painting, not an odd job) and in 1909, a series of paintings known as the Camden Town Murders, all based on the Jack the Ripper murders which had been carried out in Whitechapel between August and November 1888 – a period when Sickert had a studio close by. Both Patricia Cornwell in 'Portrait of a Killer' and Stephen Knight in 'Jack the Ripper: the Final Solution', claimed that Sickert could well have been, or at least involved with, the killer.

Sickert taught at the Westminster Institute, 1908-10, and subsequently ran Rowlandson House School, and other schools.

'Sickert liked his pupils as the Old Masters, protective, disrespectful, chiding, kind and half contemptuous. 'My flock - poor creatures.' He hammered their heads with his wit... He was such a teacher as would make a kitchen-maid exhibit once.' Enid Bagnold, one of his students

He married his student, Christine Drummond Angus, who was eighteen years younger than him, in 1911. She died in 1920.

In 1911-12 his Camden Town Group, comprised of sixteen artists including Lucien Pisarro, held three exhibitions at the Carfax Gallery.

He lived in Dieppe from 1920-22. In 1926, he married for the third time, to another painter, Thérèse Lessore, and they lived in Islington. By the time he was 74 years old, in 1934, you could have found him either at his studio at 10 Cecil Square, Margate, or his home at Hopeville in Church Street, St Peter's where he lived for 4 years. He also taught at the Thanet School of Art. In 1938 he moved to Bathhampton, Bath, where he died on 23rd January 1942.

Quentin Bell, who once modelled for Sickert: *'the visitor had to make his way between precipitous cliffs of literature which threatened at any moment to fall and leave the painter imprisoned within an impenetrable wilderness of printed matter.'* Sickert was also an art critic in The Speaker, using the pseudonym 'St P' for St Peter. His views started many arguments. He thought Cezanne overrated, and did not like van Gogh: *'I execrate his treatment of the instrument I love, these strips of metallic paint that catch the light like so many dyed straws'*, but he stood up for Degas calling him *'the lighthouse'* of his existence. Roger Fry (another critic and painter), said: *'It took Degas forty years to get rid of his cleverness.'* To which Sickert replied: *'And it will take you eighty years to get it.'*

When Denton Welch once visited him, he was disconcerted by Sickert's odd behaviour during the visit and as he left Sickert told him to *'Come again when you can't stay so long'*.

SEE Artists/ Cecil Square/ Church Street/ Margate/ St Peter's/ Schools

Elizabeth SIDDAL

Born London 25th July 1829
Died 11th February 1862

She was the daughter of a Sheffield cutler and businessman. At the age of twenty she was a milliner and dressmaker but it was as a beautiful red-headed model for Walter Deverill, William Holman Hunt and John Everett Millais that she got to know the Pre-Raphaelite Brotherhood. By 1852, she was studying painting herself, albeit informally, with Dante Gabriel Rossetti who encouraged her naive style.

Meeting Lizzie (Elizabeth Siddal) for the first time in March 1854, Christina Rossetti, his sister, wrote:

'She listened like a cushat dove
That listens to its mate alone;
She listened like a cushat dove
That loves but only one.

And downcast were her dovelike eyes

And downcast was her tender cheek
Her pulses fluttered like a dove
To hear him speak.'

John Ruskin became Lizzie's patron in 1855 and his allowance enabled her to go to Paris and Nice for the sake of her health. The Pre-Raphaelite salon at Russell Place, London, was the venue for her debut exhibition in the summer of 1857 but her reputation as an artist has been overshadowed by her role as model, muse, mistress and wife of Rossetti who immortalised her beauty in many of his best-known paintings, most particularly, 'Mary Magdalene at the House of Simon the Pharisee' (1858).

They married in May 1860, although she was still not in the best of health and they lived in London where she continued to work on watercolours, assisted on the decorating of William Morris's Red House and worked with Georgiana Burne-Jones on illustrations. Post-natal depression followed a stillborn daughter in 1861. Despite regularly seeing prostitutes, Rossetti genuinely loved Lizzie and told her that his love for her could only be more intense if she was dead, which prompted her to deliberately overdose on laudanum and die in February 1862. Grief-stricken, Rossetti buried a book of poems in her grave at Highgate Cemetery. Seven years later being a bit short of money he got official permission to dig up the coffin and untangled the book from her hair. He then had to soak every page in disinfectant before it could be used. You haven't just had your dinner have you?

SEE Artists/ Poems/ Prostitutes/ Rossetti

Mrs Sarah SIDDONS
Born 5th July 1755
Died 1831
She was the outstanding tragic-actress of her time, and her greatest triumph was as Lady 'Macbeth'. She appeared at Margate's Theatre Royal.
SEE Actors/ Shakespeare/ Theatre Royal

Henry SIDMOUTH
He was Home Secretary at the time of Peterloo and later became Lord Addington.
SEE Addington, Lord/ Belvedere House/ Obelisk/ Peterloo

Dorothy SIMPSON
Born 1933
Writer who lives in Maidstone with her husband and three children. She was formerly a French teacher and marriage-guidance counsellor before she began writing full-time. She is the creator of a series of novels involving the character 'Inspector Thanet'.
Titles and year of publication:
1 The Night She Died (1981)
2 Six Feet Under (1982)
3 Puppet for a Corpse (1983)
4 Close Her Eyes (1984)
5 Last Seen Alive (1985 Silver Dagger Award winner)
6 Dead on Arrival (1986)
7 Element of Doubt (1987)
8 Suspicious Death (1988)
9 Dead by Morning (1989)
10 Doomed to Die (1991)
11 Wake the Dead (1992)
12 No Laughing Matter (1993)
13 A Day for Dying (1996)
14 Once Too Often (1998)
15 Dead and Gone (1999)
SEE Authors/ Thanet

SION HILL, Ramsgate
This area was called South Cliff until around 1800.
Elizabeth Fry died in a house here.
Mr Austin fell over the cliff and died in 1841. A fence was soon erected to prevent any more accidents.
Samuel Taylor Coleridge came for dinner at the home here of the physician Sir Thomas Grey and his wife.
SEE Coleridge, Samuel Taylor/ Collins, Wilkie/ Curtis, Sir William/ Fry, Elizabeth/ Ramsgate

SIOUXSIE and the BANSHEES
You may be shocked to learn that Siouxsie Sioux is not the punk singer's real name; and the band members were not actual banshees. Susan Dallion (born 27th May 1957) named her band after the 1970 Vincent Price film 'Cry of the Bansee'.
As a child Siouxsie came on holiday to Broadstairs. I do not know where the Banshees went.
SEE Broadstairs/ Music/ Sunshine Rooms

SIR FRANCIS DRAKE public house
Cliftonville
SEE Cliftonville/ Frank's, Ethelbert Crescent/ Cliftonville Hotel/ Pubs

SIR STANLEY GREY public house
Pegwell Road, Ramsgate
It was once called Moonlighters.
When the Royal Harbour Approach Road underneath the pub was being built, the pub was compulsorily purchased and closed. It was subsequently re-opened by Thorley Taverns.
SEE Pubs/ Ramsgate

SIX BELLS public house
High Street, Margate
The original Six Bells pub at 201 High Street dated from 1722 when it was said to have been called The Five Bells, and named after the number of bells in St John's tower, although it actually had six, but then it was increased to eight! It had a number of buildings in front of it and together it was all collectively known as Jumble Joss Island. It was not an area that you would have entered lightly; Press Gangs were known to operate there – if you went in for a quiet pint you could easily have ended up serving in the Channel Fleet! In theory, you could have escaped if you could distract the press gangers with the cock fighting or nip down one of the smugglers' tunnels to escape, but this was unlikely.
By 1815, it was definitely known as The Six Bells. Further down the High Street was a pub known as The One Bell where, in 1817, a member of staff, Mr Bax, stole some money from a guest who was staying the

night. He was caught and sent off to Dover jail (there was no waiting for psychiatric reports then). During the investigation, a friend of Bax's, Stephen Hughes, was questioned and even though he played no part whatsoever in the crime he was consumed by an irrational guilt over the incident and felt that somehow his evidence had caused his friend's arrest. After blessing his wife and their six children he walked out of his house. The landlord of The Six Bells heard a noise in the yard at about eleven o'clock that night and went out to find that Hughes had cut his own throat. At the inquest his suicide was put down to 'a fit of temporary derangement'.
The landlord in 1840 was a William Young. The police were called by the landlord in December 1877 and arrested 25-year old John Crickett who was subsequently charged with being drunk on a licensed premises. He was sentenced to three weeks in prison. The landlord was Crickett's father!
It was always a popular pub and particularly so during World War II when its social club had 200 members.
In the 1950s, a road widening plan caused the old building to be replaced by the present one, by the then owners, the Cobb Brewery. The demolition work removed four other pubs in the area.
Edwin (Taffy) and Gwyn Thomas were the popular Cobbs tenants and many a coach trip stopped there for their refreshments. They retired in the late sixties.
It later became a Whitbread pub but after it closed in 1987, remained a sad derelict site for decades until Kent County Council bought it and converted it into the SureStart Centre - a day care centre for children.
SEE Cobbs/ High Street, Margate/ Margate/ Pubs/ Tunnels

SKATING RINK
There was a skating rink at Dumpton Park Drive in 1936 which was was the largest in Kent.
SEE Dumpton Park Drive/ Sport

'SKETCHES BY BOZ'
a book by Charles Dickens
The River: *One of the most amusing places we know is the steam-wharf of the London Bridge, or St. Katharine's Dock Company, on a Saturday morning in summer, when the Gravesend and Margate steamers are usually crowded to excess; and as we have just taken a glance at the river above bridge, we hope our readers will not object to accompany us on board a Gravesend packet. Coaches are every moment setting down at the entrance to the wharf, and the stare of bewildered astonishment with which the 'fares' resign themselves and their luggage into the hands of the porters, who seize all the packages at once as a matter of course, and run away with them, heaven knows where, is laughable in the extreme. A Margate boat lies alongside the wharf, the Gravesend boat (which starts first) lies alongside that again; and as a temporary communication is formed between the two,*

by means of a plank and hand-rail, the natural confusion of the scene is by no means diminished.

'Gravesend?' inquires a stout father of a stout family, who follow him, under the guidance of their mother, and a servant, at the no small risk of two or three of them being left behind in the confusion.

'Gravesend?'

'Pass on, if you please, sir,' replies the attendant - 'other boat, sir.'

Hereupon the stout father, being rather mystified, and the stout mother rather distracted by maternal anxiety, the whole party deposit themselves in the Margate boat, and after having congratulated himself on having secured very comfortable seats, the stout father sallies to the chimney to look for his luggage, which he has a faint recollection of having given some man, something, to take somewhere. No luggage, however, bearing the most remote resemblance to his own, in shape or form, is to be discovered; on which the stout father calls very loudly for an officer, to whom he states the case, in the presence of another father of another family - a little thin man - who entirely concurs with him (the stout father) in thinking that it's high time something was done with these steam companies, and that as the Corporation Bill failed to do it, something else must; for really people's property is not to be sacrificed in this way; and that if the luggage isn't restored without delay, he will take care it shall be put in the papers, for the public is not to be the victim of these great monopolies. To this, the officer, in his turn, replies, that that company, ever since it has been St. Kat'rine's Dock Company, has protected life and property; that if it had been the London Bridge Wharf Company, indeed, he shouldn't have wondered, seeing that the morality of that company (they being the opposition) can't be answered for, by no one; but as it is, he's convinced there must be some mistake, and he wouldn't mind making a solemn oath afore a magistrate that the gentleman'll find his luggage afore he gets to Margate.

Here the stout father, thinking he is making a capital point, replies, that as it happens, he is not going to Margate at all, and that 'Passenger to Gravesend' was on the luggage, in letters of full two inches long; on which the officer rapidly explains the mistake, and the stout mother, and the stout children, and the servant, are hurried with all possible despatch on board the Gravesend boat, which they reached just in time to discover that their luggage is there, and that their comfortable seats are not.

SEE Books/ Dickens, Charles/ Margate/ 'Passage in the Life of Mr Watkins Tottle'/ 'Tuggses of Ramsgate'

SKIES
J M W Turrner: *'The loveliest skies in Europe are over the Isle of Thanet'.*
Ruskin, on J M W Turner's love of the North Foreland skies: *'He knew the colours of the clouds over the sea, from the Bay of Naples to the Hebrides and being once asked where in Europe, were to be seen the loveliest skies, answered instantly, in the Isle of Thanet.'*
SEE North Foreland/ Pair of Blue Eyes/ Sunsets/ Thanet/ Turner, J M W

SKY SPORTS
James Nesbitt - of TV comedy/drama 'Cold Feet' fame – filmed an advert for Sky Sports at Viking Bay, Broadstairs on 9th June 2003.
SEE Broadstairs/ Viking Bay/ Sports/ Television

SLOE LANE
SEE Dane Court Road

SLOOPS
A Description of the Isle of Thanet, and particularly of the town of Margate, 1763, J Lyons: *They are sloops of eighty or an hundred tons burden. There are four of them, two of which sail in alternate weeks. Their station in the river is at Wool-Key, near the Custom-house. They usually leave Margate on Friday or Saturday, and London on Wednesday or Thursday. Passengers, of whom there are often sixty or seventy, pay only 2s 6d and the freight of baggage is inconsiderable.*
SEE Margate/ Ships

SLUM CLEARANCE, Ramsgate
In October 1964, a total of around 500 houses were earmarked for demolition under a programme of slum clearance, starting with 123 houses in Hertford Street, Meeting Street, Staffordshire Street and Alfred Cottages, Ramsgate.
SEE Hertford Street/ Meeting Street/ Ramsgate

SMACK BOYS' HOME
Ramsgate Harbour

Orphans and delinquents aged between 14 and 20 (although occasionally some were as young as 11) usually had no choice in life but to be apprenticed to the smack skippers. They signed on for at least five years and some times as long as ten. If you had a bad master then you were in trouble because if you ran away you could be forcibly returned and even imprisoned!
In the 1870s, there were over 400 smack boys. When they were ashore, some slept alongside their skippers or above the Sailor's Church, in very dodgy boarding houses or even slept rough. Described at the time as 'Wild boys' there were numerous arrests for thieving and drunkeness. One boy, Charles Hooper, argued with his skipper and threatened to – well I expect you can guess. When the magistrate told him to keep the peace, he could offer no sureties and was consequently put in jail for 21 days.
The Rev J Eustace Brenan, from Christ Church in Ramsgate, decided to do something to solve the problem, and in June 1880, signed a sixty-year lease on land below Military Road. He set about building the home which included a mess room, wash house, stores, offices and enough berths for 58 boys. The Marchioness of Conyngham officially opend it on 2nd November 1881.
An ex-smack boy, Nathaniel Taylor and his wife, were the first master and matron.
World War I saw many smack boys break their indentures to join up, and when two boys were taken to court over it, the case was won when it was decided that the country needed soldiers more than it needed fishermen. As a consequence of the war, the home closed in 1915 and The Royal Engineers used it from 1917 to 1918. It has subsequently been used as offices.
SEE Boarding houses/ Christ Church/ Harbour, Ramsgate/ Ramsgate/ Sailor's Church/ Summers, Henry/ World War I

SMEATON'S DRY DOCK
Ramsgate Harbour
Smeaton's dry dock was restored in 1981.
SEE Harbour, Ramsgate/ Ramsgate

John SMEATON
Born Austhorpe Lodge, Whitkirk, near Leeds 8th June 1724
Died Austhorpe 28th October 1792. He suffered a stroke walking in his garden.
He was the 'Father of civil engineering' and attended Leeds Grammar School before joining his father's law firm. He soon left and went to work for Henry Hindley (1701-1777) to learn mathematical instrument making (he developed a pyrometer – to study expansion – and a whirling speculum – to aid maritime navigation) before setting up on his own in London in 1748. He was elected to the Royal Society in 1753 and they recommended him to be the civil engineer constructing the Eddystone lighthouse (1755-59). On this project he became the first person since the Romans to use concrete - his was a particular 'hydraulic lime' cement. The lighthouse was the third to be built here, the previous two had been destroyed by the elements. Smeaton's survived until 1877 and had to be replaced only when the rock it was built on cracked; his lighthouse was fine and was dismantled and re-erected at Plymouth Hoe.
He went on to work on the Calder and Hebble Navigation (1758-70); a water engine for the Royal Botanic Gardens at Kew (1761), Coldstream Bridge over the River Tweed (1762-67), Perth Bridge over the River Tay (1766-71), Ripon Canal (1766-1773), a watermill at Alston, Cumbria (1767), the Newark Viaduct over the River Trent in Nottinghamshire (1768-70), the Forth and Clyde Canal from Grangemouth to Glasgow (1768-77), Banff Harbour (1770-75), Aberdeen Bridge (1775-80), Peterhead

Harbour (1775), Harbour works at Ramsgate (retention basin: 1776-83; jetty: 1788-1792), Hexham Bridge (1777-90), the Birmingham and Fazeley Canal (1782-89) and St Austell's Charlestown Harbour, Cornwall (1792).

Although he was a physicist, a mechanical engineer and a civil engineer, it was the latter that was highly lucrative and he was a founder of the Society of Civil Engineers in 1771. In fact, it was he who coined the term 'civil engineer' to differentiate from military engineers that graduated from the Royal Military Academy in Woolwich. On his death the society was re-named the Smeatonian Society – it would evolve into the Institution of Civil Engineers in 1818.

SEE Harbour, Ramsgate

Sir C Aubrey SMITH

Born 21st July 1863
Died 20th December 1948

He was an actor who started in rep at The Theatre Royal in Margate – he was also a cricketer – before going to Hollywood where he was cast as the archetypal Brit. He played the Duke of Wellington a few times in his career.

SEE Actors/ Cricket/ Theatre Royal

Stevie SMITH

Born 20th September 1902
Died 7th March 1971

The novelist and poet was diagnosed with tubercular peritonitis when she was five years old and between 1908 and 1911 she stayed at the Yarrow Home for Convalescent Children of the Better Classes on many occasions for various lengths of times. She was happy there at first, but was later homesick and at one point even suicidal. Even though she was born Florence Margaret Smith, her family called her Peggy, but she got the name Stevie when, on seeing her riding one day, a friend said that she reminded him of Stevie Donaghue, the jockey.

> The Occasional Yarrow
> by Stevie Smith
> It was a mile of greenest grass
> Whereon a little stream did pass,
> The Occasional Yarrow.
> Only in every seventh year
> Did this pretty stream appear,
> The occasional Yarrow.
> Wading and warbling in its beds
> Of grass decked out with daisy heads,
> The Occasional Yarrow.
> There in my seventh year, and this sweet stream's,
> I wandered happily (as happily gleams
> The Occasional Yarrow).
> Though now to memory alone
> I can call up thy lovely form,
> Occasional Yarrow
> I still do bless thy seventh days
> Bless thy sweet name and all who praise
> The Occasional Yarrow.

SEE Poets/ Yarrow Home

SMUGGLERS

Charles Dickens, 1851: *Fancy the Preventative men finding a lot of brandy in barrels on the rocks here (St Mary's Bay) the day before yesterday. Nobody knew anything about the barrels, of course. They were intended to be landed with the next tide, and to have been just covered over at low water. But the water being unusually low, the tops of the barrels became revealed to Preventative telescopes, and descent was made upon the brandy. They are always at it, hereabouts, I have no doubts.*

SEE Landy/ Smuggling/ Snelling, Joss

The SMUGGLERS restaurant
The Square, Birchington

Originally called Evergreen House, and built in the latter 1600s, the building has Dutch gables at each end. A metal rod connected by a 'W' on one gable and a reversed 'N' on the other, not only strengthened the building but also commemorated William Neame who lived there in the 1700s. The Neame family farmed much of the surrounding area and Evergreen House was then a farmhouse. It only became 'The Smugglers' when it was turned into a restaurant in the 1930s.

Ivy Cottages stood where the car park is now.

SEE Birchington/ Coleman's Stairs Road/ Farms/ Restaurants/ Square, The

SMUGGLING

The word comes either from the Germanic verb 'smeugan' or from the Norse 'smjuga' meaning 'to creep into a hole'.

In the 1700s, Thanet's close proximity to Europe, together with its secluded, cave-ridden bays, made it a perfect haven for smuggling. For hundreds of years local men were provided with a livelihood this way.

The golden age of smuggling ended between 1840 and 1850 when the revenue service became increasingly efficient with the addition of steamships, fast cutters and coastguard stations at regular intervals. Most coastguard cottages were built in this era.

Smuggling was a major industry in which all classes of people were involved. Few thought it dishonest and would not betray the smugglers. To this day it is likely that the whole of Thanet still has a network of largely forgotten tunnels hidden from view.

'King's Cutters and Smugglers 1700-1855' by E Kebel-Chatterton: *From the south-east corner of England came reports not much better. Just before the close of the year 1743 the Surveyor at Margate and his men were out on duty along the coast one night when five of them came upon a gang of about twenty-five smugglers. An encounter quickly ensued, and as the latter were well armed they were, by their superior numbers, able to give the officers a severe beating, especially in the case of one unfortunate 'whose head is in such a miserable condition that the Surveyor thought proper to put him under the care of a surgeon.' Both this Surveyor and the one at Ramsgate asserted that the smugglers were accustomed to travel in such powerful gangs, and at the same time were so well armed, that it was impossible to cope with them, there being seldom less than thirty* in a gang 'who bid defiance to all the officers when they met them.'

On the 7th April 1746, the Collector and Controller of the Customs at Sandwich wrote to the Board:

'We further beg leave to acquaint your Honours that yesterday about four o'clock in the afternoon a large gang of near 100 smuglers [sic] with several led horses went thro' this town into the island of Thanet, where we hear they landed their goods, notwithstanding that we took all possible care to prevent them.

'P.S.-This moment we have advice that there is a gang of 200 smugglers more at St. Peter's in the Isle of Thanet.'

Seven months later in that year, at nine o'clock one November morning, a gang of 150 smugglers managed to land some valuable cargo from a couple of cutters on to the Sandwich flats. Several Revenue officers were despatched into the country for the purpose of meeting with some of the stragglers. The officers came into collision with a party of these men and promptly seized two horse-loads of goods consisting of five bags of tea and eight half-ankers of wine. But they were only allowed to retain this seizure for half-an-hour, inasmuch as the smugglers presently overpowered the Revenue men and wrested back their booty. The preventive men were also considerably knocked about, and one of them had his thumb badly dislocated. The officers declared that they knew none of the people, the latter being well supplied not with firearms but with great clubs. A fortnight later, just a few miles farther along the coast, a gang of 150 smugglers succeeded in landing their goods at Reculvers near Birchington; and ten days later still another gang of the same size was able to land their goods near Kingsgate, between the North Foreland and Margate. But it cannot be supposed that the Revenue officers were not aware of the approach of these incidents. The fact was that they were a little lacking in courage to face these problems on every occasion. Indeed, they were candid enough to admit that they dared not venture near these ruffians 'without the utmost hazard of their lives.' But the riding-officers were not solely to blame, for where were the Custom House sloops? How was it they were always absent at these critical times? Indeed, the Collector and Controller informed the Commissioners that not one of these sloops had been seen cruising between Sandwich and Reculvers for some months past.

This complaint about the cruisers was made in March 1747, and in that same month another gang, two hundred strong, appeared on the coast, but this time, after a smart encounter, the officers secured and placed in the King's warehouse a ton of tea as well as other goods, and three horses. A day or two later a gang of smugglers threatened to rescue these goods back again. The property formed a miscellaneous collection and consisted of fifty pieces of cambric, three bags of coffee, some Flemish linen, tea, clothes, pistols, a blunderbuss, and two

musquetoons. *To prevent the smugglers carrying out their intention, however, a strong guard was formed by an amalgamation of all the officers from Sandwich, Ramsgate, and Broadstairs, who forthwith proceeded to Margate. In addition to these, it was arranged that Commodore Mitchell should send ashore from the Downs as many men as he could spare. This united front was therefore successful, and for once the smugglers were overmatched. And but for a piece of bad luck, or sheer carelessness, a couple of years later a smart capture might well have been brought about. It was one day in August when the officers had received information that a gang of twenty men and horses had appeared near Reculvers to receive goods from a cutter that was seen to be hovering near the coast. The smugglers on shore were cute enough to locate the officers, and by some means evidently signaled to the cutter, for the latter now put to sea again and the gang cleared off. Although for some time after this incident both officers and dragoons patrolled the coast in the neighbourhood no one was ever fortunate enough to gather information either as to the cutter or the people who had vanished into the country with such rapidity.*

oOo

Another smuggling device in vogue during this ingenious period had to be employed in such places as Ramsgate Harbour, where it would have been utterly impossible to have employed ordinary methods. It resembled very much the method employed at Dover, mentioned just now. A rowing-boat would come into the harbour, apparently with nothing in her nor anything towing astern. But there were fifteen or so halfankers underneath her hull, spirits of course being contained in these casks. Now the latter were all fastened to a long iron bar, the ropes to the boat being fastened to this bar. Consequently, after the boat had reached her corner of Ramsgate Harbour, all she had to do was to let go the ropes and the iron bar would keep the kegs on the sandy bottom and prevent them from disclosing their identity by floating. At low water the smugglers could have gone to get them up again, for they would not move far even with the ebb tide. Unfortunately, however, the Revenue Tide Surveyor at this port preceded the smugglers, and by creeping for the bar and tubs with grapnels succeeded in locating what he wanted.

SEE Birchington/ Bottle light signal/ Broadstairs/ Coastguards/ Coves, St Peters/ Downs, The/ Pear Tree Cottage/ Ethelred/ Harbour, Ramsgate/ Kingsgate/ Joy, Richard/ Margate/ Ramsgate/ Sandwich/ Sea Wall/ Snelling, Joe/ Thanet/ Tunnels/ Westgate Bay/ Wishing Well

SMUGGLING, Birchington
Kentish Gazette, 26th December 1805: *Any person having gristings of the parish who neglects a day's work on smuggling or wrecking without leave of their master shall have no grist that week.* 3rd December 1804 *'Friday and Saturday, were seized by the revenue officers at Birchington 250 half-*

ankers of brandy and Geneva which were conveyed to H.M. storehouse at Canterbury'.
SEE Landy, Jimmy/ Old Curiosity shop/ Sea Wall

SMUGGLING - Minnis Bay
On Birchington Sands in 1777, a group of 150 smugglers were attacked by six dragoons and two excise men who shot the horses from under the smugglers (the equivalent of shooting the tyres on the getaway car today, although horses don't see it that way). They seized 126 pounds of tea, 96 gallons of Geneva (gin), and 8 gallons of brandy.
On 22nd July 1820, five smugglers, together with their horse and cart, were caught and taken off to the Justice of the Peace (well, not the horse, something about cutting a deal). A large crowd came to support them, but it was not enough to stop them being sent off to Dover jail.
SEE Minnis Bay/ Sea Wall/ Smuggling

SMUGGLING - Ramsgate
Admiral Vernon (1745), '*The town of Ramsgate contains some 300 able young men who were known to have no visible way of earning a living but smuggling.*'
To stop smugglers hauling their goods up from the beach on their pack ponies a wall was built around 1800 from the east pier along the base of the cliff to below Albion House and patrolled by a sentry,.
SEE Smuggling

'The SMUGGLER'S LEAP'
by Richard Harris Barham
*The fire-flash shines from **Reculver** cliff,*
And the answering light burns blue in the skiff,
And there they stand, That smuggling band
Some in the water and some on the sand,
Ready those contraband goods to land:
The night is dark, they are silent and still,
* - At the head of the party is Smuggler Bill.*
Now lower away! Come, lower away!
We must be far ere the dawn of the day.
If Exciseman Gill should get scent of the prey,
And should come and should catch us here, what would he say?
Come, lower away lads – once on the hill,
We'll laugh, ho! Ho! At Exciseman Gill!
The cargo's lower'd from the dark skiff's side,
And the tow-line drags the tubs through the tide,
No trick nor flam, but your real Schiedam.
'Now mount, my merry men, mount and ride!'
Three on ter crupper and one before,
And the led-horse laden with five tubs more;
But the rich point-lace, in the oil-skin case
Of proof to guard its contents from ill,
The 'prime of the swag' is with Smuggler Bill!
Merrily now in a goodly row,
Away and away those smugglers go,
And they laugh at Exciseman Gill, ho! ho!
*When out from the turn of the road to **Herne**,*
Comes Gill, wide awake to the whole concern!
Exciseman Gill, in all his pride,

With his Custom-house officers then
There were no such things as 'Preventative Men'
Sauve qui peut! That lawless crew,
Away, and away, and away they flew!
Some drooping one tub, some drooping two;
Some gallop this way, and some gallop that,
*Through **Fordwich Level** – o'er **Sandwich Flat**,*
Some fly that way, and some fly this,
Like a covey of birds when the sportmen miss;
*These in their hurry, Make for **Sturry**,*
*Down **Rushbourne Lane**, and so by the **Westbere**,*
None of them stopping, but shooting and popping
And many a Custom-house bullet goes slap
Through many a three gallon tub like a tap,
And the gin spurts out. And squirts all about,
And many a heart grew sad that day
That so much good liquor was so thrown away.
Sauve qui peut! That lawless crew,
Away, and away, and away they flew!
*Some seek **Whitstable** – some **Grove Ferry**,*
Spurring and whipping like madmen – very –
For the life! For the life! They ride! They ride!
And the Custom-house officers all divide,
And they gallop on after them far and wide!
All, all, save one – Exciseman Gill, -
He sticks to the skirts of Smuggler Bill!
Smuggler Bill is six feet high,
He has curling locks, and a roving eye,
He has a tongue and he has a smile
Trained the female heart to beguile,
And there is not a farmer's wife on the Isle,
*From **St Nicholas** quite to the **Foreland Light***
But that eye, and that tongue, and that smile will wheedle her
To have done with the Grocer and make him her Tea dealer
There is not a farmer there but he still
Buys gin and tobacco from Smuggler Bill
Smuggler Bill rides gallant and gay
On his dapple-grey mare, away, and away,
And he pats her neck and he seems to say,
'Follow who will, ride after who may,
In sooth he had need, Fodder his stead,
In lieu of Lent-corn, with Quicksilver feed;
- nor oats, nor beans, nor the best of old hay
Will make him a match for my own dapple grey!
Ho! Ho! – ho! ho! says Smuggler Bill –
He draws out a flask and he sips his fill,
And he laughs 'Ho! ho!' at Exciseman Gill.
*Down **Chislet Lane**, so free and so fleet*
*Rides Smuggler Bill, and away to **Up-Street**,*
Sarre bridge is won – Bill thinks it fun;
'Ho! ho! the old tub-guaging son of a gun –
His wind will be thick, and his breeks be thin,
Ere a race like this he may hope to win!'
Away, away Goes the fleet dapple-grey,
Fresh as the breeze and free as the wind,
And Exciseman Gill lags far behind
'I would give my soul', quoth Exciseman Gill,
'For a nag that would catch that Smuggler Bill –
No matter for blood, no matte for bone,

No matter for colour, bay, brown, or roan,
So I had but one!' A voice cried, 'Done!'
'Ay, dun,' said Exciseman Gill, and he spied,
A Custom-house officer close by his side,
On a high trotting horse with a dun-coloured hide, -
'Devil take me,' again quoth Exciseman Gill,
'If I had but that horse, I'd have Smuggler Bill!'
From his using such shocking expressions, it's plain
That Exciseman Gill was rather profane.
He was, it is true, As bad as a Jew,
A sad old scoundrel as ever you knew,
And he rode in his stirrups sixteen stone two,
-He'd just utter'd the words which I mention'd to you,
When his horse coming slap on his knees with him, threw
Him head over heels, and away he flew,
And Exciseman Gill was bruised black and blue,
When he arose His hands and his clothes
Were as filthy as could be, - he'd pitch'd on his nose,
And roll'd over and over again in the mus,
And his nose and his chin were all cove'd with blood,
Yet he screamed with passion, 'I'd rather grill
Than not come up with Smuggler Bill!
-'Mount! Mount!' quoth the the Custom-house officer, 'get
On the back of my Dun, you'll bother him yet,
Your words are plain, though they're somewhat rough,
'Done and done' between gentlemen's always enough!
I'll lend you a lift – there – you're up on him-so,
He's a rum one to look at – a devil to go!'
Exciseman Gill Dash'd up the hill,
And mark'd not, so eager was he in pursuit,
The queer Custom-house officer's queer-looking boot.
Smuggler Bill rides on amain,
He slacks not girth and he draws not rein,
Yet the dapple-grey mare bounds on in vain,
For nearer now – and he hears it plain –
Sounds the tramp of a horse – ''Tis the Gauger again!'
Smuggler Bill Dashes round the mill
That stands near the road upon **Monkton Hill**, -
'Now speed, My dapple-grey steed,
Thou ever, my dapple, went good at need!
Oe'r **Monkton Mead**, and through **Minster Level**,
We'll baffle him yet, be he gouger or devil!
For **Manston Cave**, away! away!
Now speed thee, now speed thee, my good dapple-grey,
It shall never be said that Smuggler Bill
Was run down like a hare by Exciseman Gill!'
Manston Cave was Bill's abode,
A mile to the north of the **Ramsgate** road,
(Of late they say It's been taken away,
That is, levell'd and fill'd up with chalk and clay, By a gentleman there of the name of Day)

Thither he urges his good dapple-grey;
And the dapple-grey steed, Still good at need,
Though her chest it pants, and her flanks they bleed,
Dashes along at the top of her speed;
But nearer and nearer Exciseman Gill,
Cries, 'Yield thee! Now shield thee, thou Smuggler Bill!'
Smuggler Bill, he looks behind,
And he sees a Dun horse come swift as the wind,
And his nostrils smoke, and his eyes they blaze
Like a couple of lamps on a yellow post-chaise!
Every shoe he has got appears red hot;
And sparks round his ears snap, crackle, and play,
And his tail cocks up in a very odd way,
Every hair in his mane seems a porcupine's quill,
And there on his back sits Exciseman Gill,
Crying 'Yield thee! Now yield thee, thou smuggler Bill!'
Smuggler Bill from his holster drew
A large horse-pistol, of which he had two!
Made by Nock; He pull'd back the cock
As far as he could to the back of the lock;
The trigger he touch'd and the welkin rang
To the sound of the weapon, it made such a bang;
Smuggler Bill never missed his aim,
The shot told true on the Dun – but there came
From the hole whereit enter'd – not blood – but flame
He changed his plan, and fired at the man;
But his second horse-pistol flashed in the pan!
And Exciseman Gill with a hearty good-will,
Made a grab at the collar of Smuggler Bill.
The dapple-grey mare made a desperate bound
When that queer Dun horse on her flank she found,
Alack! And alas! On what dangerous ground!
It's enough to make one's flesh to creep
To stand on that fearful verge, and peep
Down the rugged sides so fearfully steep,
Where the chalk-hole yawns full sixty feet deep,
O'er which that steed took that desperate leap!
It was so dark then that under the trees,
No horse in the world could tell chalk from cheese-
Down they went- o'er that terrible fall,-
Horses, Exciseman, Smuggler; and all!!
Below were found next day on the ground
By an elderly gentleman walking his round
(I wouldn't have seen such a sight for a pound)
All smash'd and dash'd, three mangled corpses
Two of them human - the third was a horse's.
That good dapple-grey, and Exciseman Gill
Yet grasping the collar of Smuggler Bill!
But where was the Dun? That terrible dun?
From that terrible night he was seen by none!-

There are, some people think, though I am not one,
That part of the story all nonsense and fun,
But the country-folks there, one and all declare,
When the 'Crownwer's Quest came to sit on the pair,
They heard a loud Horse-laugh up in the air!
If in one of those trips of the steam boat Eclipse
You should go down to Margate to look at the ships,
Or take what the bathing-room people call 'dips'
You may hear old folks talk, Of that quarry of chalk,
Or go over – it's rather too far for a walk,
But a three-shilling drive will give you a peep
At that fearful chalk-pit – so awfully deep,
Which is call'd to this moment 'The Smuggler's Leap'
Nay more, I am told on a moonshiny night,
If you're 'plucky', and not over subject to fright,
You may see, if you will, the Ghost o Old Gill
Grappling the ghost of Smuggler Bill,
And the Ghost of the dapple-grey lying between 'em,
I'm told so – I can't say I know one who's seen 'em!
Moral
And now, gentle Reader, one word are we part,
Just take a friend's counsel and lay it to heart
Imprimis, don't smuggle! – if bent to please Beauty,
You must buy French lace, purchase what has paid duty!
Don't use naughty words in the next place, - and ne'er in
Your language adopt a bad habit of swearing!
Never say 'Devil take me!'
Or 'shake me! – or 'bake me!'
Or such-like expressions – Remember Old Nick
To take folks at their word is remarkably quick,
Another sound maxim I'd wish you to keep,
Is, 'Mind what you're after, and – Look ere you leap!'
Above all, to my last gravest caution attend-
NEVER BORROW A HORSE YOU DON'T KNOW OF A FRIEND!!
SEE Barham, Richard Harris/ Bathing/ Farms/ Lighthouse, North Foreland/ Margate/ Minster/ Manston/ Monkton/ Poets/ Ramsgate/ Sandwich/ Tobacco

George SNELLING
He was Joss Snelling's son and joined the family smuggling firm.
SEE Dumpton Gap/ Snelling, Joss/ Snelling, Jim

Jim SNELLING
He was George Snelling's son and also joined the family smuggling firm.
SEE Snelling, Joss/ Snelling, George

Joss SNELLING
Born 1741

Died 1837

Thanet's most notorious smuggler Joss Snelling (occasionally known as John Sharp) was born at Lanthorne Road in Broadstairs and by the time he died, at the age of 96, he was already a legend. Whilst numerous contemporaries and associates were hanged or deported, Snelling had not only avoided capture but had become such a celebrity that he was introduced as 'The famous smuggler' to the future Queen Victoria when, aged ten, she was staying with her mother at Pierremont Hall in Broadstairs High Street. At a trial following his arrest for the landing and possession of 61 tubs of foreign spirits, 700 people turned up at the court to see him. He was married and had two children, Mary and George; the latter also took up smuggling.

He died, peacefully, in 1837.

John Sharp was a name that Joss Snelling sometimes went by.

SEE Battle of Botany Bay/ Broadstairs/ Farm Cottage/ Joss Bay/ Lanthorne Road/ Marsh Bay/ Mutton, Jeff/ Pierremont Hall/ Smuggling/ Snelling, George/ Snelling, Jim/ Stone Bay/ Victoria

SNOB

William Makepeace Thackeray has been attributed with inventing the word 'snob' – a word he used to describe King George IV but 's.nob' used to be the abbreviation used by colleges to denote students not of noble birth, from *sine nobilitate*. Up t'north, in t'eighteenth century, it was a word meaning cobbler, or cobbler's apprentice. Cambridge University students used the word to describe the locals. In the early 1800s it meant any member of the lower classes, and then a person who associated with those of a higher social standing.

I have long gone about with a conviction on my mind that I had a work to do - a Work, if you like, with a great W; a Purpose to fulfil; a chasm to leap into, like Curtius, horse and foot; a Great Social Evil to Discover and to Remedy. That Conviction Has Pursued me for Years. It has Dogged me in the Busy Street; Seated Itself By Me in The Lonely Study; Jogged My Elbow as it Lifted the Wine- cup at The Festive Board; Pursued me through the Maze of Rotten Row; Followed me in Far Lands. On Brighton's Shingly Beach, or Margate's Sand, the Voice Outpiped the Roaring of the Sea; it Nestles in my Nightcap, and It Whispers, 'Wake, Slumberer, thy Work Is Not Yet Done.' Last Year, By Moonlight, in the Colosseum, the Little Sedulous Voice Came To Me and Said, 'Smith, or Jones' (The Writer's Name is Neither Here nor There), 'Smith or Jones, my fine fellow, this is all very well, but you ought to be at home writing your great work on SNOBS.

SEE Margate/ Shabby Genteel Story/ Thackeray, William Makepeace

SNOW

In the winter of 1793-94 snow covered Thanet for 71 days. I don't know how soon the gritting lorries were sent out.

A blizzard and hurricane-force winds affected the whole of Kent on 19th January 1881. A train was buried under 16 feet of snow at Ramsgate.

SEE Ramsgate/ Richborough/ Thanet/ Weather

SNUFF

Samuel Taylor Coleridge was not impressed with the quality of snuff that was available in Ramsgate describing it as *'vile Ramsgate plug-nostril'* and had some sent down especially from London.

SEE Coleridge, Samuel Taylor/ Ramsgate

The SOLE

The area in Ramsgate where Harbour Street, Queen Street, King Street and the High Street meet.

Ramsgate market returned from Dumpton to The Sole in the late 1990s.

SEE Dumpton Market/ Harbour Street, Ramsgate/ High Street/ King Street, Ramsgate/ Queen Street/ Ramsgate

SOPER'S YARD, King Street, Margate

Soper's Yard contained net lofts and fish-smoking sheds and existed up until the 1950s.

SEE Fishing/ King Street, Margate/ Margate

SOUND LOCATION

After World War I, scientists prepared for the next with 'sound location', the predecessor of radar, which involved a giant dish as tall as the cliffs, and was first tried out at Joss Bay in Broadstairs in 1919.

SEE Broadstairs/ Joss Bay

John Phillip SOUSA

Born 6th November 1854

Died 6th March 1932

The American composer and conductor – famous now as the man who wrote the music used as the theme tune to Monty Python's Flying Circus – performed at the Royal Victoria Pavilion. He invented the sousaphone, an instrument similar to a tuba.

SEE Music/ Royal Victoria Pavilion

SOUTH AFRICA

There is another Margate, also a seaside resort, on the south coast of KwaZulu-Natal.

SEE Australia/ Margate/ USA

SOUTH CLIFF PARADE, Broadstairs

If you enjoy the pleasant walk along the cliff top from Dumpton Gap to what is now King George VI Memorial Park, you are not alone; it has been a popular walk for many years and one that Charles Dickens is known to have partaken of. Along the way, in the hours of darkness it is possible to see the lights from the lightships that mark the Goodwin Sands.

SEE Broadstairs/ Dickens, Charles/ Dumpton Gap/ Goodwin Sands/ King George VI Park/ Seven Stones/ Steenhuis, Wout

SOUTH EAST IN BLOOM COMPETITION

Broadstairs and St. Peters won this competition in 1994, '95 and '96, but were excluded from the 1997 competition because

they had been promoted to the Premier Class for past winners.

SEE Broadstairs

SOUTH EASTERN and CHATHAM RAILWAY

The line opened at Ramsgate on 12th April 1846 with the first train leaving for Canterbury West station. The first train was pulled by a locomotive of the Shakespeare Class and the The Shakespeare pub nearby was named after it – although it is now named the One Hundred and Eighty. Two other pubs were named after the railway, the South Eastern Tavern and the Rocket - now closed.

The South Eastern and Chatham Railway (known to the locals as the 'Slow Easy and Comfortable Railway') was in business for 17 years until, in 1863, the London Chatham and Dover Railway arrived.

SEE Railways/ Ramsgate/ Ramsgate Town Station/ Rocket/ Shakespeare pub/ South Eastern Tavern, Ramsgate

SOUTH EASTERN ROAD, Ramsgate

The road was named after the South Eastern and Chatham Railway Company.

East Kent Times, 28th April 1909: *George Young of 82 South Eastern Road was charged with cruelty to his wife. Among her injuries were a black eye, bruises and kickings. Her doctor testified that this was true. He had also tried to strangle her and had threatened her with a dagger. The housemaid and a neighbour testified to this. The husband promised to be good and the case was dismissed.*

In 1910, the East Kent Times also reported that Frederick Mercer of James Street, and F Atkins of South Eastern Road, were charged with persistent cruelty to their wives; and H Ainsworth and John Collins with neglect of their wives and children.

SEE East Kent Times/ Ramsgate/ South Eastern Tavern

SOUTH EASTERN TAVERN, Ramsgate

The pub was named after the South Eastern and Chatham Railway company.

SEE Pubs/ Railways/ Ramsgate/ South Eastern and Chatham Railway/ South Eastern Road, Ramsgate

SOUTHWOOD, Ramsgate

There were once woods there and the locals apparently hid in them to avoid the Vikings who were pillaging and committing other anti-social behaviour.

SEE Ramsgate/ Ramsgate Football Club/ Vale Square/ Vikings

SOUTHWOOD HOUSE, Ramsgate

The Weigall family lived here for four decades from 1880 and every year a party was held for the children and the elderly of the area. Donkey rides, games and a good tea was laid on and everyone was sent home with a present.

To further the object of establishing a Creche at Ramsgate a meeting was held at Southwood House yesterday. A Creche would be of great benefit to the many poor women who at present had the utmost

214

difficulty in getting their young children looked after while they themselves went to work. 30th June 1906

Lady Rose Weigall and her daughter, Miss Rachel Weigall, nursed many wounded servicemen sent to Southwood House to convalesce in World War I.

The house suffered casualties in the Dump Raid. It is now demolished.

SEE Donkeys/ Dump raid/ Ramsgate/ World War I

SOUTHWOOD ROAD, Ramsgate

As a result of the Hurricane Bombardment on 27th April 1917, James Barnes (73), of Clovelly, 21 Southwood Road, died of shock.

SEE Dump raid/ Faversham & Thanet Co-op Society/ Hurricane Bombardment/ Ramsgate

SOWELL STREET, St Peters

Sowell Street Farm was at the St Peter's Park Road end of Sowell Street.

SEE Davis, Edmund/ Farms/ St Peter's/ St Peter's Court Preparatory School

SPACE SHUTTLE

Although they have never had to take advantage of its facilities, NASA have the right, due to its length, to use the runway at Manston as an emergency landing strip for the space shuttle.

SEE Manston Airport

Timothy SPALL

Born 27th February 1957

The actor, who has appeared in many films ('Topsy Turvy') and TV series (Auf Wiedersehen, Pet'), has a brother who lives in Ramsgate and his mother lives in Cliftonville.

SEE Actors/ Cliftonville/ Films/ Ramsgate

John Hanning SPEKE

Born Bideford, England, 4th May 1827

Died 15th September 1864

He joined Sir Richard Burton's expedition to explore Somaliland in 1854 and two years later The Royal Geographical Society sponsored Burton and Speke's expedition to find the source of the Nile. They found Lake Tanganyika in 1858, and then Speke travelled alone to become the first European to see Lake Victoria. It wasn't called that at the time obviously, but it was so-called from then on. In 1862 Speke went on an expedtion with James Grant and discovered the point where the Nile flows out of the lake and named it Ripon Falls. Speke and Grant travelled along the Nile as far as Juba, where they met Sir Samuel Baker and his wife who were travelling in the opposite direction. Speke had not been able to prove conclusively that Lake Victoria was the source of the Nile; for one thing, he went there alone and therefore had no-one to corroborate his story. He was due to debate the subject with Burton in public, but they had a falling out. Some said it was suicide, but Speke died in a shooting accident before the debate it could take place.

SEE Speke Road, St Peter's

SPEKE ROAD, St Peter's

Named after John Hanning Speke

SEE St Peter's/ Speke, John Hanning

SPENCER ROAD, Birchington

SEE Birchington/ Carmel Court/ Coward, Noel/ Home School for Girls

SPENCER SQUARE, Ramsgate

The building of the square began in 1810 with the houses nearest to Royal Road which were used as officers' quarters for the troops in the Napoleonic Wars who used the area as a parade ground. Nearby were a barracks, stable and brewery. When the army left James Townley bought the land and this Regency square began to emerge around 1826.

Whilst teaching at a school in Royal Road, Vincent van Gogh lodged in a little room at the top of 11 Spencer Square.

In 1921, the Bon Secours Sisters came to Ramsgate and opened a nursing home at St Benets in Spencer Square. It is now demolished.

SEE Breweries/ Napoleonic Wars/ Ramsgate/ Schools/ Tunnels, Ramsgate/ Van Gogh, Vincent

SPITFIRE

Approximately 22,000 Spitfires were built in World War II. Today only 179 remain. The TB752 that is at Manston was in active service at Manston but afterwards fell into disrepair. From 1955 it stood near the station gate. In 1978 the Royal Aeronautical Society's Medway branch restored her – it took 15,000 hours of work – at Rochester and she returned to Manston on 15th September that year and within three years enough money had been raised to provide a suitable building to house her. The Spitfire Memorial Building, Manston, was opened on 13th June 1981.

SEE Hillary, Richard/ Manston airport/ Sacketts Hill Farm/ World War II

SPORT

SEE Abrahams, Harold/ Broadstairs Sailing Club/ Cricket/ Doherty Brothers/ Fishwick, Diane/ Football/ Golf/ Greyhound Racing/ Halfmile Ride/ Harland, Georgina/ Hastings Avenue/ Hengrove/ Jackey Bakers Sports Ground/ Kerly, Sean/ Liddell, Eric/ Pallo, Jackie/ Powerboats/ Regatta/ Royal Temple Yacht Club/ Sea Angling/ Skating rink/ Sky Sports/ Takaloo/ Thanet Tech, Ramsgate/ Wrestling

SPORTSMAN INN
Sandwich Road, Ramsgate

It dates back to 1750 and was popular as a 'stopping-off' place on the journey to Sandwich or what is known today as a 'destination restaurant'. Tomson & Wotton leased the place from 1872 and bought it in 1927.

SEE Pubs/ Ramsgate/ Restaurants

Adam SPRACKLING

The learned Adam Sprackling was master of the large Ellington Estate; his father-in-law was a baronet; he was a man of great dignity and was well known around the pubs of the town - and probably had a fight in most of them. Sometimes just turning over the odd table, other times fisticuffs and, occasionally, the sword would come out and do someone some damage. He lost a brawl in a tap-house in St Peters, but hired a local thug to beat-up his assailant.

Richard Langley, a father of thirteen, was deputy to the mayor of Sandwich and part of his duties was to act as a type of policeman. He had also lent money to Sprackling. In 1648, he and two other deputies, named Pudner and Taddy, went to Ellington House and successfully disarmed Sprackling but before they had left, Sprackling was planning his revenge against all three of them. Once they had gone, he rounded up two of his thugs, gave them guns and horses, and they rode off into Ramsgate. Langley got an inkling that they were on their way, left his house and went to the house of a widow who lent him a horse to get away. He had not long left before the widow saw two armed men gallop past her house. About two miles out of Ramsgate, they fired and Langley was killed. One of the murderers escaped. Sprackling was not punished for his part in the murder, but the other one, named Emerson was caught and eventually hung at Canterbury.

Late one Saturday night, on 11th December 1652, Sprackling's virtuous and pious wife Katherine (daughter of Sir Robert Leukner) was said to be praying for her husband to be forgiven - well, someone had to. It was a pity a lot more people had not done so because when Sprackling returned home he killed her with a meat chopper. He then killed his dogs in an attempt to give the impression that he was mad. It did not work - he was found guilty at his trial in Sandwich and hung on 23rd April 1653. Right up to the end, he swore he was innocent of any part in the earlier Langley murder. After the execution watched by a crowd of 2,000, *'he was coffin'd at the sign of the Three Kings at Sandwich'* and his body brought back by torchlight and buried at St Laurence Church near to the body of his wife.

Sprackling's son sold Ellington House to the Trowards in the mid-eighteenth century.

SEE Ellington Park/ Murder/ Ramsgate/ St Laurence Church/ Sandwich

The SPREAD EAGLE INN
Princes Crescent, Margate

Originally built in 1762 as a boarding school, it was never actually used as one and for a short period it was a lodging house.

In 1830 David Crowe, a pipe-maker, converted the building into a beer shop but it did not become fully licensed until 1838, and it became a Cobb brewery house in 1882.

This pub has, due to streets being re-named and re-numbered, been part of Princess Crescent, 1 Prospect Place and Victoria Road. Its original Georgian façade had a Victorian frontage added.

In the late 19th century, John Pettit decided that he would sort out his wife's excessive spending habits. While she was having a girls' night out in The Spread Eagle, he got the town crier to announce that he would no longer be responsible for any further debts that she incurred. The tactic back-fired somewhat when his wife and all of her friends poured out of the pub and chased

Pettit and the town crier all the way down the street.

In World War II, the caves and tunnels underneath were used as air raid shelters - it is rumoured that one tunnel extends all the way to the local workhouse, now the site of the Royal School for the Deaf. There is also a 75ft deep well. Over the years two adjoining cottages were acquired to provide an extra bar and a restaurant.

SEE Cobbs/ Margate/ Pubs/ Restaurants/ Royal School for the Deaf/ Schools/ Tunnels/ Workhouse/ World War II

SPRINGS, Margate

Serious problems were encountered during the construction of the Stone Pier due to the freshwater springs that bubble up in the area, relics of the Creek and Tivoli Brooks. These springs undermined a 100-yard stretch of the wall and the problem could only be overcome by spreading a bed of clay over the affected area and then laying a timber floor upon it, after which the stone walls were built up on top. The Harbour Wall itself is constructed as a series of compartments filled with rubble and shingle and has now firmly withstood the fury of the sea for 186 years.

SEE Harbour, Margate/ Margate/ Tivoli Brook

SPUR RAILWAY LINE

There was a single track spur railway line that extended from Minnis Bay to Manston from 1916 until 1928. From a long siding at Minnis Bay (carriages were shunted off the main line, but the odd main line engine also travelled on the line) the track crossed the main line near where the footpath is situated at the end of Horsa Road/Old Farm Road/Ingoldsby Road, then across the fields crossing Canterbury Road about 75 metres to the west of King Edward Road, then south of Quex Park, over Shottendane Road near the Sparrow Castle Water Pumping Station down towards Cheesemans Farm and ending near Pouces at a long platform with sidings, workshops and a hangar.

SEE Farms/ Manston airport/ Minnis Bay/ Quex/ Railway/ Shottendane Road/ World War I

SPURGEON'S HOME
Canterbury Road, Birchington

The Spurgeon's Homes bought the building at auction in 1920 and it was the Spurgeons Seaside Homes for Children for many years before it was decided that the building was no longer suitable. It was demolished in 1967 and Birch Hill Park housing estate was later built on the site.

SEE Birchington/ Canterbury Road, Birchington/ Orphanages

The SQUARE, Birchington

The Square grew from the intersection of two ancient roadways, one running from Margate to Canterbury and the other running north to south from the then port of Gore-end to Minster Abbey.

Stocks, a cage and a whipping post were once situated in the Square close to the church yard. (Nowadays you will only find these sorts of things in specialist establishments. So I'm told.) In Elizabethan times it was illegal, for example, to attend any sport - and that included bull baiting! - on a Sunday. The punishment would have been a spell in the stocks. Similarly 'profane swearing' in the reign of William III would entail the same punishment - these days a whole bank of stocks might be required if that law were still enforced. Vagrants were whipped at the whipping post, hence the name, and then sent out of the parish with a couple of pence to help them on their way.

The cage, built in 1788, of brick was used to detain those who had committed a greater, or 'ill behaved or riotous' crime. Church property, and that included coal, was also kept in the cage. It stood on the square for at least 43 years.

There was a maypole here in the seventeenth century, put up to celebrate festivities.

East Kent Times 23rd July 1913: The first Suffragist meeting ever held in Minster took place on Friday (18th). Miss Griffith Jones addressed the crowd. In Birchington Square the local Suffragists held a very successful meeting.

SEE All Saints Church, Birchington/ Birchington/ East Kent Times/ Fountain/ Grove House/ Minnis Bay/ New Inn/ Pewter Pot/ Powell Arms/ Primitive Methodist Church/ Minster Abbey/ Queen's Head/ Smugglers Restaurant/ Stocks/ Wesleyan Methodist Church

SQUASH CLUB, Margate

Built in what had been the old Topspot nightclub, it lasted from July 1977 until November 1990. It originally opened with four courts and a gymnasium, but two more courts were added due to the demand. However, due to lack of demand, after ten years it closed.

SEE Margate/ Topspot

STAFFORDSHIRE STREET, Ramsgate
SEE Ramsgate/ Slum Clearance

STAG HUNT EXTRAORDINARY

Kentish Gazette, 1st November 1825:
On Friday morning last, between the hours of nine and ten o'clock, some labouring men observed near the new Mill at Herne Bay, a fine stag, which, upon their approach, started off towards Mr John Palmer's at Strood Farm, who happened to be in his grounds at the time. No time was lost by this keen sportsman in mounting his horse, unkennelling his hounds and laying them on. This was done so judiciously and speedily that they soon came up to him, although the stag had twenty minutes start. They pursued him at top speed as far as Chislet when they fell in with the pack of Mr E Collard, who also joined heart and soul in the chase and the two packs vieing with each other, pursued him at a slapping pace across the marshes as far as St Nicholas, where they united with Mr Gillow's pack. Thus pursued by his numerous hosts he doubled back to Reculver and then took to the sea, swimming from the shore about a mile and a half. An interested female in her boat, rowed after him and with the aid of the boat's tackle brought him safe to shore. The deer is a red one of great size and is now at Mr Palmer's, where every care is being taken of him with a view to giving the sporting world another sprint. It is conjectured that they ran one better than ten miles without a check in forty minutes.

SEE Farms/ Reculver/ St Nicholas

STAGECOACH

In the 1790s, the single 72-mile stagecoach journey from London to Margate took all day, or all night – depending how muddy the roads were - and cost between 21 and 26 shillings.

SEE Margate/ Transport

Dame Janet STANCOMB-WILLS

Born 1854
Died Ramsgate, 22nd August 1932
She was the niece/adopted daughter of Sir William Henry Wills and moved to Ramsgate, aged 57, in 1911 after inheriting his one million pound fortune.

She was both strong-minded and kind. She was invited to join the town's Education Committee and accepted. She was elected to the Town Council in 1913, winning the Sir Moses Montefiore ward by a walkover when Mr Bradley, the only other candidate, stood down because he thought standing against a woman candidate would be 'ungentlemanly conduct'.

She paid for the local history museum above Ramsgate Library which opened in October 1912 and her generosity also gave the town, amongst other things, a hospital, primary school, an ambulance and, in September 1915, a fire engine! It could climb hills at 30mph! She was created a Dame in 1918 for her war work.

I am perfectly certain she would have had no hesitation in heading a squadron of Amazons on the East Cliff and repelled with her own hands any attempt at a German landing. Rev E L A Hertslet, vicar of Ramsgate

She was also very friendly with Sir Ernest Shackleton and helped to fund his 1916 expedition. One of his boats was named after her – the Stancomb Wills, as was a promontory in the Weddell Sea. In a letter she wrote to Shackleton she told him, Into my life you flashed like a meteor out of the dark, flooding its peaceful dullness, with a splendour of glowing light.

Shackleton died in 1922 and she consoled herself by working on her good causes.

She was made a Freeman of the Borough of Ramsgate on 6th March 1922 and elected mayor in 1923 – the first lady mayor in Kent. She paid for The Winterstoke Gardens to be laid out in 1923 in memory of Lord Winterstoke. The gardens were planted with scented varieties so that servicemen blinded in the war could also enjoy them.

She died aged 78 in August 1932 in the front bedroom of East Court.

SEE Albion Gardens, Hill and Place/ Dame Janet Junior School/ Destiny/ East Court/ Fire Station, Ramsgate/ Jackey Bakers/ Library, Ramsgate/ Paragon/ Ramsgate/ Ramsgate Hospital/ Royal Esplanade/ Shackleton, Sir Ernest/ West beach/ Wills, Sir WH/ Wills House/ Winterstoke Undercliffe/ Zeppelin raid

STANDING STONES

A relatively new addition to Margate's sea front, are the standing stones between the railway station and the sea front. They incurred some criticism at the time but I think they are great! Designed to greet visitors coming from the station, they could easily be missed if you are driving by. If you have not seen them yet, stop the car and have a look.

• *The words on the stones ahead of you arose out of a public art project carried out in 1997. Writer Suzannah Dunn worked with local children at Artwise Youth Club, Ramsgate and other venues to explore ideas and thoughts about Margate, people and feelings in words, stories and poetry. From all the words written down and spoken by the children Suzannah has drawn together a poem, which has been carved into stone by sculptor Paul Wehrle.*

• *I see nothing the sun is in my eyes. Earlier I was watching birds in waves of air and kids yomping ice cream.*

• *Suddenly I am aware of the toffee lolly that I hid from Jim in my pocket and had forgot.*

• *Insects are divebombing me and I am spooked by the crisp sharp sound of leaves creeping over on the ground.*

• *But in the distance is the soothing rustle of the sea. Ssh moan.*

• *My cheese and pickle sandwiches made by Mum are heavy in my lap.*

• *The air is scented with grass damp and sweet and vinegar and chips and candyfloss.*
SEE Margate/ Poems

STANER COURT, Ramsgate

Staner Court and three blocks of 3-storey flats were opened on 24th June 1964.
There was a fatal fire here in July 2001.
SEE Fires/ Newcastle Hill/ Ramsgate

Sir Henry Morton STANLEY

Born 28th January 1841
Died 10th May 1904
A journalist and explorer, although Stanley was not his real name as he was born John Rowlands. When he was eighteen, he went to New Orleans as a cabin boy and worked for an American merchant called Henry Morton Stanley; it was his name that John Rowlands adopted. He served in the Confederate Army during the American Civil War and was captured at the Battle of Shiloh (1862). Whilst working as a special correspondent for the New York Herald, he was with Robert Cornelius Napier of the British army at Magdala and was the first journalist to report the news of his success. In 1869, he was sent by James Gordon Bennett of the American newspaper, The Herald, to find David Livingstone. After a few delays, he arrived at Zanzibar on 26th January 1871, before crossing to the mainland and leaving for the interior with his party of 2,000 on 21st March. He finally said those immortal words *'Dr Livingstone, I presume?'* on 28th October at Ujiji on the shore of Lake Tanganyika. After Livingstone's health improved, the two of them explored the area to the north of Lake Tanganyika.

After Stanley returned to Britain in 1872, the Herald sent him off to what is now Ghana to report on the British campaign against the Asante.

Following Livingstone's death in 1873, The Herald, along with the London Daily Telegraph, funded Stanley's next jaunt to continue the old man's work. By contrast to the 2,000 strong party of 1871, a rather more intimate party of 359 set off in November 1874 to visit King Mutesa of Buganda and circumnavigate Lake Victoria. They were involved in quite a few skirmishes along the way but the expedition did, in May 1875, finally establish that Lake Victoria's only outlet was the Nile, and the Kagera was its only tributary, and therefore the true source of the Nile was the Kagera and its tributaries. After having circumnavigated Lake Victoria, Stanley went west and down the Lualaba River, a headstream of the Congo River, until he discovered and named Livingstone Falls. He then went overland and arrived at the Atlantic coast in August 1877 after travelling for 999 days, and seeing around half of his party die.

Back in London in 1878, he was off again the following year after King Leopold II of Belgium sponsored a five-year trip to the Congo, where he helped lay the foundations for the Independent State of the Congo, as well as constructing a road from the lower Congo to Stanley Pool (it is now named Pool Malebo).

Stanley headed an expedition in January 1887 to assist Mehmed Emin Pasha, the German explorer and governor of the Equatoria Province of the Egyptian Sudan who was surrounded by rebellious Mahdi. When Stanley got to him in 1888, Pasha refused to leave. The journey was not a waste however, because he discovered the Ruwenzori Range (sometimes known as the Mountains of the Moon) and Semliki River which links Lake Albert to Lake Edward. In 1888, he and Pasha finally left for the coast but with a huge loss of lives in their parties. After all that travel and excitement, at the age of 59, it was time for him to settle down, and he married Dorothy Tennant in 1890 (after his death, she edited his autobiography in 1909). In 1885 he had become a naturalized US citizen, but became a British subject again in 1892. He was the Liberal Unionist MP for North Lambeth from 1895 until 1900. He made his last trip to Africa in 1897, was knighted in 1899 and died 10th May 1904 in London. His last words were *'Four o'clock. How strange. So that is the time. Strange. Enough!'*
SEE Livingstone Road, St Peters/ Magdala Road, Broadstairs/ Napier Road, Broadstairs/ Stanley Road, Boadstairs

STANLEY ROAD, Broadstairs

It is named after Sir Henry Morton Stanley of *'Dr Livingstone, I presume'* fame.
A 45 year-old German, Dr Hermann Goertz travelled around the country on his motorbike with 19 year-old Marianne Emig, also German, stopping at airfields to sketch their layouts and defences. When he rented a bungalow called Havelock in Stanley Road and left before the six week tenancy was up, the landlady got suspicious and called the police. They called in Special Branch who found a camera and film with pictures of an airfield. At the Old Bailey trial, Goertz said he had come to England to get material for a novel – yeah, right. He was found guilty of offences under the Official Secrets Act - or spying - and was sentenced to four years in Maidstone prison.
SEE Broadstairs/ Stanley, Sir Henry Morton

STAR CINEMA
George Street, Ramsgate

The St George's Hall was home to a cinema, Stanley's Electric Theatre, but soon changed its name to the Star Cinema. It was damaged in the same air raid that destroyed the Bull and George pub in the High Street – well the bomb bounced off the roof and a chicken house in the next door garden caught fire. Later the building became a store selling furniture. Now it contains a snooker club.
SEE Bull and George/ Cinemas/ George Street, Ramsgate/ Ramsgate

STAR INN
Margate Road, Westwood

This inn dates back to the eighteenth century and is said to have got its name from an old map of Thanet. Apparently, it was on the spot where, in the olden days, cartographers when making their maps, would always place a star in the centre.
A riotous evening was held here in 1825 when the choir and church wardens of St Peter's Church went there for the first time since before the Napoleonic Wars to beat the bounds of the parish. A good time was had by all and the choir boys ended up being thrown into a nearby pond.
SEE Margate Road, Ramsgate/ Napoleonic Wars/ Pubs/ St Peter's Church

STATION APPROACH ROAD
Ramsgate

At the junction of Station Approach Road and Margate Road, the old station wall can still be seen.

The existing station, at the other end of the road, opened in 1924.

The site of the old Town Station was vacant until after World War II when a block of council flats were built upon it.

During an air raid on 24th August 1940, a 16 year-old delivery boy was killed while riding his bike from Station Approach Road into Margate Road. The woman who owned the paper shop was also killed.

SEE Margate Road, Ramsgate/ Railways/ Ramsgate/ Ramsgate Town Station/ World War II

STATION ROAD, Birchington

In 1907, it was a residential road with just two businesses in it. How times have changed.

The Midland Bank and Woolworths replaced the buildings that included the Wayside Café. Woolworths was, in turn, replaced by the Co-op supermarket.

Bath Cottages stood from around 1680 until 1930 at the junction of Station Road and Albion Road. Next door, where the Natwest bank stands now, was a chimney sweep who lived in a thatched cottage and another small cottage where you could get fish and chips and old shops, now gone, that included a bakery with a brick oven.

SEE Albion Road/ Birchington/ Birchington cinema/ Dog Acre/ Faversham & Thanet Co-op Society/ Laburnham House/ Midland Bank/ Sea Breeze Cycle Factory/ Sea Point private school, Birchington/ Sea View Hotel/ Temperance Hotel/ Woodford House School/ Woolworths

STATION ROAD, Westgate

The distinctive canopies that protrude over the pavement in front of the shops date back to the 1870s.

The site of Jackson's Stables in Station Road is now a barbers. If you look up at the roof however, the old sign for Jackson's Stables can be seen hanging between the chimneys. Behind the main building, the old stables have been converted into mews cottages. The entrance to them is through the archway next to Beano's café.

SEE Pancake Day/ Westgate-on-Sea/ 'Westgate-on-Sea'

STATUS QUO

A rock band who wear denim a lot. They are sometimes criticised for only knowing three chords; but they do know them very well.

SEE Music/ St George's School/ Winter Gardens

STEAM PACKETS and STEAMERS

The first steamboats started running between London, Gravesend and Margate in 1813. By 1817 the journey time from London was reduced to 6 or 7 hours. The service became a huge success and within ten years the number of passengers doubled.

The number of passengers landing on the jetty in 1820 was 43,947; by 1836, this figure had leapt to 105,000. The fare in 1821 was five shillings for a return ticket. Local

leaders observed that *'Never mind the quality, the quantity will all leave something behind them'.* Nowadays they can only dream of such numbers visiting.

The Times, 1816: '(The) *introduction of steamboats has given the whole coast of Kent* (and) *the Isle of Thanet in particular, a prodigious lift'.*

The Thanet Itinerary or Steam Yacht Companion (1819): *When the rage for sea bathing became general, the vast metropolis poured forth her smokey thousands, who hastened to the sea coasts of Thanet. . . The natural advantages of Margate, soon obtained for it a decided preference over every other watering place in the kingdom. Its convenient distance from London – its pure air and limpid waters – the delightful level of its fine sandy shore. . . all conduced to make it the favourite summer retreat of nobility, gentry and citizens. Persons of every rank, and of every age, flocked to a place, which promised to afford entertainment. . . and health to all. The effect was astonishing; - squares were laid out – streets built – places of amusement erected – markets established.*

By 1829 Steam packets were replacing the sailing hoys that once plied between Margate and London and the Margate Steam Packet Co. was established. The number of visitors grew from 50,000 in 1825 to 135,000 by 1836.

In 1841, there were six companies offering their services to passengers. The coming of the railways did not see the steamers off and it was 1967 before they finally left.

Steamers brought visitors in such large numbers to the pier from London that there were nearly as many boats as trains. Competition saw the prices fall from 12 shillings, ten years later it was 6/- then another ten years saw it as low as 2/- (1/3 was paid in pier duty so the boat owners were only getting 9d per passenger). Eventually the General Steam Navigation Company saw most of the competition off.

A visitor at the time wrote that *'The inhabitants poured down in such numbers, that they could be compared with nothing better than the savages on Cook's arrival at Otaheire. You could not have a parcel with a single night cap in it that was not immediately seized upon by some kind of ready hand, ready to convey it to your compartment or to their own. If Argos had a thousand eyes he had need of all of them all!'*

The rival steam packets were well known for racing each other from Margate back to London, *'Monday morning drew the cockneys from their roosts betimes, to take their farewell splash and dive in the sea. As the day advanced, the bustle and confusion on the shore and in the town increased, and everyone seemed on the move. The ladies paid their last visits to the bazaars and shell shops, and children extracted the last ounce of exertion from the exhausted leg-weary donkeys. Meanwhile the lords of the creation strutted about, some in dressing -gowns, others, 'full puff', with bags and boxes under their arms – while sturdy porters were*

wheeling barrows full of luggage to the jetty. … At the end of the jetty, on each side, lay the Royal Adelaide and the Magnet, with as fierce a contest for patronage as ever was witnessed. Both decks were crowded with anxious faces – for the Monday's steam-boat race is as great an event as a Derby, and a cockney would as lieve lay on an outside horse as patronise a boat that was likely to let another pass her by. Nay, so high is the enthusiasm carried, that books are regularly made on the occasion, and there is as much clamour for bets as in the ring at Epsom or Newmarket.'

Many boats sailed from Tower Bridge in London to Margate, amongst them the Crested Eagle (it sank when it was dive-bombed in the evacuation from Dunkirk), the Kooh-i-Noor, Royal Eagle, (like all other pleasure steamers, during the Second World War it was requisitioned for Naval duties and brought 3,000 soldiers back from Dunkirk), the Royal Daffodil, the Royal Sovereign (which kept going longer than most), in 1957 it brought 144,000 passengers to Margate - OK there were two Royal Sovereigns, the first operated from 1893 to 1929. The second, with seventy stewards and stewardesses looking after passengers on four decks, and with a dining saloon that could seat 310, was launched on 24th February 1932 by the wife of the chairman of the Port of London, Lady Ritchie, It was probably the most luxurious, and also the most popular ship on the route. At nine o'clock every morning a ticket costing 12/6 got you a trip that left Tower Pier in London, and called in turn at Greenwich, Woolwich and Tilbury before going on to Margate and Ramsgate. The return trip docked back at Tower Pier by eight-thirty. The captain was a large, bright and breezy man who used to lead the passengers in community singing on the journeys, and it was a brave man who did not join in. The Pearly Kings and Queens were regular passengers, as were three Gravesend butchers who never missed a weekly trip. The increasing use and ownership of cars saw off the steamers, and the last one sailed to and from the jetty in 1966.

Apart from the steamers there were also pleasure trips that could be taken on craft such as the sailing boat the Moss Rose.

SEE Bathing/ Broughton, Lord/ Donkeys/ Dunkirk/ Gillray, James/ Grand Falconer/ Hood, Thomas/ Jerrold, Douglas/ Luttrell, Henry/ Margate/ Market Place, Margate/ Passengers by Sea/ Pier/ Ramsgate/ Ships/ Transport

Wout STEENHUIS

In front of the house, Seven Stones, in South Cliff Parade, there is a bench with a plaque that reads:

MAN OF MUSIC

In memory and appreciation of Wout Steenhuis (1922-1985)
greatly talented Hawaiian guitarist, composer, arranger, multi-instrumentalist, popular broadcaster and recording artist.
Placed with fond aloha by friends and fans.
SEE Music/ Seven Stones/ South Cliff Parade

STELLA MARIS

As in Stella Maris Convent for example. It means 'star of the sea', in case you ever wondered.

STOCKS

There are two stocks in Thanet. One is next to St Mary's Church in Monkton and the other is on the green in St Peter's.
The stocks are no longer used for their original purpose, although we could start a campaign. Unused stocks . . . owners who do not clear up their dog's mess . . . isn't it obvious?
SEE Monkton/ St Peter's/ Square, Birchington

STONAR

Originally Stonar was a small island to the south of the Isle of Thanet but the silting up of the Wantsum Channel caused it to become part of Thanet.
As the Wantsum Channel silted up, a small town became established at the southern end called Estonore (from East Stone Shore), Stoner or Stonar. King Canute gave the village to St Augustine's Abbey and both William the Conqueror and William Rufus confirmed the gift. However, over the centuries this action caused a lot of problems between the inhabitants and the church who ruled in such a manner that the inhabitants finally asked *'to be joined with Sandwich'*.
Around the seventh century, Stonar rose to become a prosperous town, larger than Sandwich was at the time.
In 1229, Henry III gave Stonar to Sandwich. Following the dissolution of the monasteries a couple of centuries later, Lord Dudley, the Lord of the Manor, freed Stonar from Sandwich.
In around 1282, the men of Sandwich attacked Stonar and burned down the local mills, damaged the sea defences and beseiged the officials of the Abbot in the church for a day.
However the problems of the past paled into insignificance when during the Hundred Year's War (1337-1453 - I know that totals 116 years, but that is what makes it one of those annoying trivia questions 'how long was the Hundred Year's War?') both Stonar and Sandwich were often attacked and ransacked by French raiders and, in 1385, a French fleet turned up, ransacked Stonar and then burnt it to the ground. It was never re-built. Archbishop Parker (he of the big nose who is the original Nosey Parker – honestly that really is where it comes from!) visited in 1569 and it was recorded that there were no households in Stonar. Ruins were still visible in the seventeenth century, and Dr Plot wrote in 1683 that *'they were lately removed to render the ground fit for tillage.'*

Mrs Rooke was a landowner here in the mid-eighteenth century and was well-known for engaging in law suits. Her other claim to fame was that she planted grape vines in the area that established themselves very successfully.
In the 1890s, local gravel was used to make concrete blocks here for the construction of Dover harbour and a railway was built to transport them there. The production of concrete became a local industry here.
During World War I, the 'Richborough Mystery Port' or 'Secret port' was built around here, as a base to supply the troops in France with ammunition, shells and the new weapon of that war, the tank. It was shipped over first by barge, and then a train-ferry was built. The whole thing was allowed to fall into disrepair after the war and there was much scandal and rumours flying around at the time.
Just before World War II, many refugees from Nazi Germany were housed in temporary accommodation here. During that war, parts of the Mulbery Harbour were built here.
SEE Cinque Ports/ Mulberry Harbour/ Red Lion/ Refugees/ Richborough secret port/ St Nicholas-at-Stonar/ Sandwich/ Tanks/ Wantsum Channel/ World War I/ World War II

STONAR SALT PANS

The Crispe brothers of Birchington, established the enterprise. The salt pans were near the site of the old town and when the sea water receded at low tide through Stonar Cut, it evaporated to leave the salt. A later owner was Baron Greville of Clonyn, who also owned some workers cottages and the lease of the pub - you would want to keep in with him. The salt pans are long gone but lasted well into the twentieth century.

STONE BAY, Broadstairs

This sandy bay is around 200 metres wide and has a promenade.
There was a very bloody battle here in 1803, when the Revenue men and a troop of Dragoons startled a gang of smugglers. Six of the smugglers were killed, several injured and the contraband goods seized. A Revenue man was taken prisoner and covered in tar, but before they could set him alight he was rescued by the dragoons. The leader of the smugglers wrote a letter to the authorities in Sandwich: *The men who perpetrated this outrage were not members of my band, for although we break the law, we are neither cruel or vindictive, for we know that the young officer was only doing his duty to His Majesty, just as we are only doing our duty to our families by earning a livelihood.*
SEE Bays/ Broadstairs/ Green, Napoleon/ Promenades/ St Mary's Convalescent Home for Children/ Sandwich/ Smuggling

STONE FARM
Lanthorne Road, Broadstairs

The farmhouse, with its Flemish gable, was built in 1693 and was used by sailors as a landmark - or is it a seamark if it is on land? I digress. Smuggling happened around here and was facilitated by a tunnel that ran down to the beach and was large enough for a horse pulling a cart carrying two barrels to pass through.
The chapel, barn and stables were demolished in 1965 but the farmhouse survived.
SEE Broadstairs/ Farms/ Lanthorne Road/ Stone House/ Tunnels

STONE HOUSE
Lanthorne Road, Broadstairs

The house was built at a cost of £4,821 in 1764 for Sir Charles Raymond JP who worked for the East India Company. Whilst he was a Justice of the Peace he also funded many a smuggling run. Nearby was Farm Cottage (home of Joss Snelling the infamous smuggler) and Stone Caves (where contraband was stored). A troop of the 17th Lancers was billeted here in 1784 to help combat the amount of local smuggling.
Following Raymond's death in 1783, the house was bought for £5,000 by William Breton who, in turn, sold it to Sir Henry Harpur who died when his carriage overturned in Stone Road. The next owner was Sir John Cuthbert who made quite a few additions to the property, before, three years later, in 1830, Sir James Dupree Alexander bought it for £7,125. He too left his mark on the house by building the flint wall that still surrounds the grounds.
In 1868, Archbishop Tait (the Archbishop of Canterbury and then the Bishop of London) became the owner and gave away five acres of the garden so that Mrs Tait could build an orphanage upon it; the first in Broadstairs. The Taits had seen five of their own children die as a result of Scarlet Fever and the first children here were orphans whose parents had died from cholera in London.
On Archbishop Tait's death, the house passed to his niece, but she sold it in 1883 to the Rev Stone (his son, Christopher Stone, worked for the BBC) who turned it into a school but sold it in 1888 when Stone Farm and 123 acres of land were also sold.
In his autobiography, written when he was in his nineties, the philosopher and mathematician Bertrand Russell recalled the summer of 1877 which he spent at Stone House aged five years old! His grandparents and his aunt rented a holiday home from Archibald Campbell Tait, the then Archbishop of Canterbury.
. . . the time that I spent at Stone House was very delightful. I remember the North Foreland, which I believed to be one of the four corners of England, since I imagined at that time that England was a rectangle. I remember the ruins at Richborough which greatly interested me, and the camera obscura at Ramsgate, which interested me still more. I remember waving corn-fields

219

which, to my regret, had disappeared when I returned to the neighbourhood thirty years later. I remember, of course, all the usual delights of the seaside – limpets, and sea-anemones, and rocks, and sands, and fishermen's boats, and lighthouses. I was impressed by the fact that limpets stick to the rock when one tries to pull them off, and I said to my Aunt Agatha, ' Aunty, do limpets think?' to which she answered, 'I don't know'. 'Then you must learn', I rejoined.

The school closed in 1970 and Stone House is now a listed building divided into apartments. The old farmland became a housing estate in 1965, although the farm house survived.
SEE Broadstairs/ Camera Obscura/ Heseltine/ Lanthorne Road, Broadstairs/ Orphanages/ Ramsgate/ Russell, Bertrand/ St Peter's Orphanage/ Schools/ Stone Road/ Tait, Archbishop

STONE ROAD, Broadstairs
John Buchan and his family stayed at St Ronan in Stone Road in the summer of 1914.
SEE Broadstairs/ Buchan, John/ Chess Board Estate/ Stone House/ Waite, Arthur

David Lee STONE
This author of the Illmoor Chronicles series of books ('The Ratastrophe Catastrophe', 'The Yowler Foul-up', 'The Shadeswell Shenanigans', and 'The Dwellings Debacle') comes from Ramsgate.
SEE Authors/ Ramsgate

STORMS
A great storm on 1st January 1915, resulted in a barge losing all its crew off Margate, and many properties being damaged across the island.
SEE Albert Terrace/ Bathing Machines/ Friend to All Nations/ Great Storm 1703/ Great Storm 1953/ Harbour, Broadstairs/ Hurricane/ Ice/ King's Head/ Lighthouse, Margate/ Margate/ Marine Palace/ Pier, Margate/ Reading Street/ Sea Wall/ Shrine of Our Lady/ Weather/ Westbrook Bathing Pavilion

The STRANGLERS
For any aging punks out there, the Viking ship that appears on the The Stranglers' album The Raven (track one is called 'Longships') is the Hugin. Band member Jet suggested its use after remembering a school trip here.
SEE Hugin/ Music

H STREET & Co
Advertisement c1900
H STREET & Co., 6 Hardres Street & Broad Street
Upholsterers, Cabinet Makers & House Furnitures
Furniture Repaired, Re-covered & Re-polished at Low Prices.
Carpets taken up, beaten and re-laid.
Furniture carefully removed.
SEE Hardres Street/ Shops

STRAY PONY
On 27th January 1900, Frank Penny, who was a fish dealer at 25 Adelaide Gardens, Ramsgate, was given the choice of a 10 shilling (50p) fine, or seven days in prison, for allowing a pony to stray in St Luke's Avenue, Ramsgate.
SEE Adelaide Gardens/ Ramsgate/ St Luke's Avenue

David & John SUCHET
David is the actor who plays Poirot on TV and John is the newsreader. They both attended Grenham Bay School in Birchington.
SEE Actors/ Grenham House School/ Poirot

SUFFRAGETTES
East Kent Times 17th February 1909:
Thanet Suffragettes:
why women should have the vote.
Mrs Philip Snowden, wife of the MP spoke at St. John's Hall, Margate. Mr. G.M. MacFarlane was chairman. Mrs Snowden said: 'Until 1832 there was no law in existence that prevented women from voting. Not many did but it should be borne in mind that at the time the total electorate numbered only 600,000. There was a very high property qualification which very few women could maintain. In 1832 women lost the franchise when men substituted the word 'man' for the word 'person' in the lawbooks. In the North of England, the supporters of women's franchise now outnumber the total electorate.
'Men make laws for women in total ignorance of what women themselves want. There is legislation pending even now which would materially injure the prospects of working women. After an unsuccessful bid to rid the barmaids of their employment, next summer Mr. Burns intends to introduce a Bill to stop ALL married women from working - and all this without even consulting them...'
Mrs Snowden asked her audience to imagine the present situation reversed: women had the vote; men did not. 'Why,' she said, 'their revolution, compared to the Suffragette agitation, would be as sunlight to moonlight. Men had the franchise and what have they done? There were 12 or 13 million people living in, or on the verge of, poverty, and the average wage of a working women is 7 shillings a week! Only minors, criminals, lunatics and women were barred from voting. Women are in an even worse position than the Negro of America.
'It was always said that women could do all that is required by influence. Influence is all very well for the fortunate woman, though undignified; but wholly bad for the working woman. The political inequality of the sexes brought about an atmosphere of domination and from that had sprung the double standard of morals. There are many important state problems that will never be tackled until women had the vote.
'It is argued that womens' place is the home. So is a man's place home. He ought to be there when spending his leisure time in the public house or club... if it were not for the women where would all the soldiers and sailors come from? If they wanted women to fight they are quite capable of fighting. Women beat men every time for endurance.'
In answer to the Rev. Sir C.J.M. Shaw, she
said 'the suffragette agitation in England has given the impetus to similar movements in other countries. In the USA women were beginning to get indignant about their unclean politics.' Further questioned, the speaker admitted she could not condemn the tactics of the militant Suffragettes in their crusade against the Cabinet Minister. She said 'women cannot express their opinions at the ballot box and must necessarily adopt some other method.'
East Kent Times 14th May 1913:
SUFFRAGETTES HOOTED
by Margate visitors
Suffragettes were busy on Whit Monday at Margate selling copies of their newspapers. At Cliftonville, two women bearing suffragette badges were followed by a large crowd which contented itself with hooting.
East Kent Times, 12th March 1913:
WOMEN'S WORK
Activity of Suffragettes in Ramsgate
*The NUWSS branch here now has 125 members. At a meeting held in **York House, Grange Road** by Miss Stokes, the officers were elected. 1911 was said to have been 'a year of promise for suffragettes'. That the second Conciliation Bill had passed its second reading and by a majority of 167 was good news. Asquith had promised to give it its third reading in 1912. The Branch had also managed to influence Ramsgate Town Council to pass the following resolution: 'That this council approves of the Parliamentary Franchise (Women's) Bill for enfranchisement of women householders and urges the government to grant facilities for its passage into law this session.' East Kent Times, 7th February 1912*
*NON MILITANTS NUWSS MEETING HELD AT YORK VILLA, **120 Grange Road** at the invitation of Miss Stokes. Miss Griffith Jones, organiser of the Kent Federation, said they should work at elections to unseat all anti-suffrage Liberals, particularly Asquith and his Cabinet, as he had broken his promises to the suffragists. She spoke of the formation of new branches at Margate, Canterbury and Rochester and said that a new Society had been set up in Ramsgate called Friends of Suffrage for those who did not wish to go so far as to join the NUWSS, and this is to be administered from **19 Royal Crescent**, Miss Poole reported that she held a cake sale at her home at **12 Chapel Place** to raise funds. There were 50 new members.*
SEE Cliftonville/ Craig, Norman/ East Kent Times/ Forresters Hall/ Grange Road, Ramsgate/ Margate/ Margate Sands Railway Station/ Pankhurst, Christabel/ Pankhurst, Mrs Emmeline/ Pethwick-Lawrence/ Politics/ Post Box/ Ramsgate

SUICIDE
One member of a group of patients from an Epsom mental asylum who visited Margate sea front in 1952, paid for ten shots with a Winchester .22 to shoot at moving duck targets. He was not very good. He paid for another ten, fired two more shots before announcing, 'This is my thirteenth shot', and then put the barrel of the gun in his mouth and shot himself.
SEE Margate/ Murder

Barry SULLIVAN
Born Birmingham 1821
Died 1891
He was an actor who played Hamlet at the Haymarket, London in 1852. He also appeared at Margate's Theatre Royal.
SEE Actors/ Theatre Royal

Henry SUMMERS
East Kent Times, 19th July 1916:
DEATH OF MR HENRY SUMMERS - RAMSGATE'S LEADING SMACK OWNER. In the old days of the fleeting system, Summers Fleet, flying the long blue pennants and working with the vessels in which he was also interested from Lowestoft, was a notable feature of the North Sea grounds. For years he acted as treasurer to the Ramsgate Sailors' Home and the Smack Boys' Home. He was, some 43 years ago, one of the founders of the Ramsgate Smackowners' Ice Company and he was associated with the foundation of the Smack-owners' Coal Company.
SEE East Kent Times/ Fishing/ Ramsgate

SUN DECK
SEE Margate Marine Bathing Pavilion

SUN INN
The Street, St Nicholas
It was built in 1900 by the East Kent Brewery on the site of old farm outbuildings.
SEE Breweries/ Farms/ Pubs/ St Nicholas-at-Wade

SUNBEAM PHOTOS
John Milton Worssell set up the business in 1919 when he gained a concession to take photographs on Margate's seafront. Once he had set up his big bulky cameras he employed boys to run the plates back to his premises be be developed. As the business expanded to other Thanet beaches, he improved the method of taking photographs so that he was able to take 100 pictures on one roll of film. People would stroll along the seafront and a photographer would take their picture; they were then given a ticket, and the next day would go to a booth where they could buy the photograph to take home with them. The business was a huge success; in the summer of 1939, there were almost 50 photographers taking up to 35,000 photos a day. After the war it got even better with Sunbeam employing around 300 people.
He had a triangular-shaped headquarters built in Sweyn Road in 1925 costing £5,000 and it still stands today.
John worked until he was aged 80 but after his wife died, his two sons took the business over. By the 1970s, fewer visitors and more privately-owned cameras saw the business decline and in 1976, three years after John's death, Sunbeam was taken over by United Photographic Laboratories; the beach photographer became a thing of the past.
Sunbeam also took many local school photos – notably where the whole school would assemble and the stationary camera would track past the whole group to create a photo about 6in tall and 3ft wide – and young boys would fight the urge not to run round the back of the group and be in the photo twice. Sometimes the fight could not be won. You know who you are.
SEE Cliftonville/ Margate/ Schools/ Shops/ Sweyn Road

SUNDOWNER
C H Lightoller owned this motor yacht which was built in 1912. He had been the second officer on the Titanic and the most senior member of the crew to survive. He insisted on being at the helm of Sundowner during the Dunkirk rescue and in one trip alone brought home 127 men.
SEE Dunkirk/ Titanic

SUNLIGHT LAUNDRY
Willson's Road, Ramsgate
Previously called County Laundry, it was Thanet's biggest laundry before it closed with the loss of 100 jobs in January 1994. There had been a laundry on the site for over a hundred years.
SEE Ramsgate/ Willsons Road, Ramsgate

SUNSETS
What a grand object is a sunset, and what a wonder is an appetite at sea! Lo! the horned moon shines pale over Margate, and the red beacon is gleaming from distant Ramsgate pier.
'Little Travels and Roadside Sketches by Titmarsh'
by William Makepeace Thackeray
SEE Margate/ Ramsgate/ Skies/ Thackeray, William Makepeace/ Turner, JMW

SUNSHINE ROOMS
They were originally built in 1931 as part of the Dreamland Cinema development.
The Sunshine Café ceased to exist in 1955 and was converted into the Sunshine Theatre which was host to the Dreamland Old Time Music Hall which ran until the late 1960s.
In 1978, it briefly became a music venue for punk bands and others. Sham 69 (3rd March), Siouxsie and the Banshees (7th April), Generation X (31st March), Nutz (1st April) and Gong (13th April) all performed here.
SEE Dreamland/ Margate/ Music/ Siouxsie and the Banshees

SUPERDRUG
High Street, Ramsgate
The Ramsgate Picture House closed after 40 years, and the building was put up for sale in September 1959 – the premises are now Superdrug.
SEE Cinemas/ High Street, Ramsgate/ Ramsgate/ Shops

SURREY ROAD, Cliftonville
Number 13 Surrey Road was badly wrecked in a Gotha raid on the night of 4th September 1917, being one of forty houses in the area that were damaged that night in this road and in Cornwall Gardens and the Eastern Esplanade.
SEE Cliftonville/ Eastern Esplanade, Cliftonville/ VAD Hospitals

Robert Smith SURTEES
Born The Riding, Northumberland, 17th May 1803
Died Brighton, Sussex, 16th March 1864
He was a novelist whose greatest creation was Mr Jorrocks, the comical Cockney grocer who loves fox hunting, a passion also shared by his creator. The Sporting Magazine published Surtees' earliest work, but in 1831, Surtees launched the New Sporting Magazine (NSM) published by Rudolph Ackerman and continued to edit it until 1836. Prior to being published in book form, his novels appeared as serials in both the NSM and other periodicals. Mr Jorrocks appears in 'Jorrocks' Jaunts and Jollities' which was a collection of tales (said to be the model for Charles Dickens' 'Pickwick Papers'). Part one appeared in 1831, and as a book in 1838. 'Handley Cross' (1843, then an expanded version 1854) and 'Hillingdon Hall' (1843, 1845). After that came 'Hawbuck Grange' (serial 1846, book 1847), 'Mr. Sponge's Sporting Tour' (serial 1849, book 1853), 'Ask Mamma' (serial 1857, book 1858), 'Plain or Ringlets?' (serial 1858, book 1860) and 'Mr. Romford's Hounds' (published posthumously in 1865).
SEE Jorrocks' Jaunts & Jollities/ Reculver – Jorrocks/ Royal Adelaide

SUSSEX STREET, Ramsgate
Near its junction with Hardres Street, the Ramsgate poorhouse opened in April 1726. It was in use until the 1830s when, due to a change in the law, the residents were transferred to the Union House at Minster.
SEE Hardres Street/ Minster/ Ramsgate

SUSSEX GARDENS, Westgate
Sea Tower was built in 1869 and, although it has three storeys, it is classed as a bungalow.
SEE Westgate-on-Sea

The SWAN public house
Sea Road, Westgate
The Ingleton Hotel, which is now The Swan, was used in World War II by the army until a sea mine exploded on the promenade opposite, bringing down the ceilings and smashing the windows. After this, the Westgate Health and Strength League – gymnastics, running, handball, weightlifting, etc - used the premises as their HQ from 1942 to 1945.
SEE Pubs/ Sea Road/ Westgate-on-Sea/ World War II

King SWEYN
Born 960
Died 12th November 1035
King Sweyn I of Denmark (to the Danish, Svend), whose son was King Canute, was also known as Sweyn Forkbeard, and he became king in 985 at the ripe old age of 15! He led a rebellion against his father Harold Bluetooth and fatally wounded him in the resulting battle. From 994, he was often nipping over to England to earn 'tribute money'. When some Danes were massacred here in 1002, he stepped up the attacks until, in 1013, he actually decided to invade and conquer England. The following year, as London fell, King Ethelred II scarpered to

Normandy and Sweyn became King. He promptly died aged 54 in 1014. We, the English, asked King Ethelred to return and get rid of Sweyn's son, Canute (c994-1035), which he did. His unfortunate title of Ethelred the Unready comes from a corruption of the Old English 'unraed' meaning bad counsel, referring to his misfortunes. Two years later, Canute, obviously refreshed, came back and thrashed us in a battle at Ashingdon on 18th October 1016 and thus, King Canute came to the throne of England, Denmark and Norway. He died at Shaftesbury in Dorset in 1035 and soon after, his North Sea Empire broke up, each country having a separate ruler.
SEE Canute/ Denmark/ Royalty/ Sweyn Road, Cliftonville

SWEYN ROAD, Cliftonville
In the mid-nineteenth century, Mr C Schimmelmann ran a boys school at Albion House School situated in this road.
A cat apparently died of fright when a bomb dropped by a German seaplane exploded in the road on 13th September 1915.
SEE Cliftonville/ Gotha raid/ Hartsdown Park/ Schools/ Sunbeam Photos/ Sweyn

'The SWORD of GANELON'
by Richard Parker (1957)
This novel is set in 851 AD, the period before Alfred becomes King of Kent. The Danes took over the Isle of Sheppey and the rest of the county lived in imminent danger of being invaded.
SEE Books/ Parker, Richard/ Vikings/ Wantsum Channel

SYNAGOGUE, Hereson Road, Ramsgate
The Jewish community in the area had no synagogue until Sir Moses Montefiore moved here. He bought a plot of land and asked David Mocatta, his cousin, to come up with a design. The building was rectangular with a semi-circular apse for the arch. The entrance hall had a marble fountain, and the interior walls were plastered, with the Hebrew words of the Decalogue over the arch. There were no windows, just a skylight or lantern to illuminate the interior. 'Time flies, virtue alone remains' is written on the clock on the north side. The costs were estimated to be £1,500-1,600 for the build plus £3-400 for the interior. Members of the Montefiore family scattered earth from the Holy land at the ceremony to lay the foundation stone on 31st July 1831. The building work continued until 1833 when the Montefiores held the dedication ceremony on their wedding anniversary, 16th June.
SEE Churches/ Hereson Mill/ Hereson Road/ Montefiore, Sir Moses/ Ramsgate

T

Archbishop Archibald Campbell TAIT
Born Edinburgh 21st December 1811

Died 3rd December (Advent Sunday) 1882
The son of Presbyterians, he attended the University of Glasgow before going on to Balliol College, Oxford. After his graduation he became a fellow and tutor and by the age of 26 found himself 'the senior and most responsible of the four Balliol tutors'.
In 1836, aged 25, he became an ordained deacon and in 1838, a priest. In 1842, he followed Arnold as the headmaster of Rugby and the following year, married Catharine Spooner. By 1848, he was struck by a serious illness – after which he continued to suffer from bad health for the rest of his life – and was persuaded to become part of the deanery at Carlisle in 1849. Less stress, apparently, although he seems to have been on every committee, part of the University Commission, out doing pastoral work and even restoring the cathedral. Thank God he decided to take it easy!
He and his wife suffered their greatest tragedy in the spring of 1856 when, within the space of five weeks, scarlet fever killed five of their children.
He was made Bishop of London on 22nd November 1856, but refused the offer of being Bishop of York in 1862. He was made Archbishop of Canterbury in 1868. His son Crauford died in 1878, and Tait was a widower when he died in 1882.
SEE Archbishop of Canterbury/ St Luke's Church/ St Paul'sChurch/ St Peter's Orphanage/ Stone House

TAKALOO
In 1981, when Mehrdud Takalobighashi was six, his family fled to Margate from Iran and the Ayahtollah Khomenei.
His father took him to Margate Amateur Boxing Club so that he could defend himself against bullies. He eventually went on to win the NABC championships and reached the quarter finals of the ABA senior championships.
He turned professional at 21 and Frank Warren became his manager.
He has since won the IBF Intercontinental title and the WBU world title twice.
He lives in Cliftonville with his partner and their two daughters.
SEE Cliftonville/ Margate/ Sport

'TALES OF THE HOY'
by John Wolcot
'Twas in that month when Nature drear,
With sorrow wimpering, drops a tear,
To find that Winter, with a savage sway,
Prepares to leave his hall of storms,
And crush her flowers (delightful forms),
And banish Summer's poor last lingering ray;

'Twas in that season when The Men of Slop,
The Jew and Gentile, turn towards their shop,
In alleys dark of London's ample round ;
From Margate's handsome spot, and Hooper's – hill,
And Dandelion, where, with much good-will,
Of butter'd rolls they swallowed many a pound;

I too, the Bard, from Thanet's pleasant isle,
Where, at a lodging-house, I lived in style,
Prepared with Gentile and with Jew to wander:
So packed up all my little odds and ends,
Took silent leave of all my Margate friends,
And sought a gallant Vessel's great Commander;
Who, proud of empire, ruled with conscious joy
His wooden Kingdom, call'd a Margate Hoy.
SEE Dent-de-lion/ Hoopers mill/ Hoys/ Margate/ Poets/ Ships/ Wolcot, John

'A TALE OF TWO CITIES'
by Charles Dickens
SEE Books/ Collins, Wilkie/ Crouch, Ben/ Dickens, Charles

TALL SHIPS
Ramsgate Harbour has been regularly used as the starting point for the Tall Ships Race.
SEE Harbour, Ramsgate/ Ramsgate

TANKS
They were our new secret weapon in World War I, and most of them were shipped to France via Stonar.
SEE Dent-de-lion/ Richborough Secret Port/ Stonar/ World War I

Jimmy TARBUCK
Born 6th February 1940
The Liverpudlian comedian did the summer season at the Winter Gardens in 1975 along with Arthur Askey.
SEE Askey, Arthur/ Entertainers/ Winter Gardens

TARTAR FRIGATE public house
Harbour Street, Broadstairs

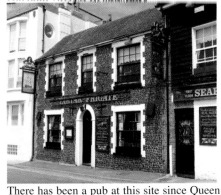

There has been a pub at this site since Queen Elizabeth I was on the throne but the present flint building dates back to the eighteenth century and is named after a locally built naval ship, HMS Tartar. In the 1860s, it was a popular meeting place for fishermen, soldiers and smugglers, although the Five Tuns pub in Union Square tended to be the smugglers' den; however, smugglers did used to meet in a room upstairs at The Tartar Frigate. Nelson is said to have had meetings with them to learn the whereabouts of any French vessels they had met whilst about their business. Tunnels underneath are said to go to Bleak House and the Dolphin public house.
Dickens described The Tartar Frigate as, *the cosiest little sailor's inn, selling the strongest of tobacco and the strongest smelling rum*

that is to be met with around the coast. . . the very walls have long ago learned 'Tom Bowling' and 'The Bay of Biscay' by heart and would be thankful for a fresh song'.

Dickens enjoyed sitting in the bar and listening to the fishermen's tales, whom he immortalised in 'Our English Watering Place'. Could it be coincidence that the name of that handsome sailor who wins Rosa Bud's heart, in The Mystery of Edwin Drood, is Mr Tartar?

SEE Broadstairs/ Dickens, Charles/ Edwin Drood/ Five Tuns/ Green, Napoleon/ Harbour Street, Broadstairs/ Nelson/ Our English Watering Place/ Pubs/ Tobacco/ Tunnels

TATNELL'S CLIFTON TAVERN
Pegwell Bay
Mr Tatnell had been the landlord of the Bellevue Tavern opposite before he opened Tatnell's Clifton Tavern, later becoming Tatnell's Clifton Hotel. It became the Working Mens' Club and Institute Convalescent Home in 1894, before becoming a hotel again. The Home was extended in 1898 and included the Belvedere Tower.

A 100ft cliff fall occurred along Pegwell Road outside the Home on 10th March 1947. The home became the Hovertel in the 1960s but when the Hoverport closed it was re-named The Pegwell Village Hotel. It is now the Pegwell Bay Hotel.

SEE Convalescent Homes/ Hoverport/ Pegwell Bay/ Pubs

TEA CLIPPER HOUSES
Examples of these can be found in Minnis Road, Birchington. They were built around 1870 and have rectangular turrets at the apex of the roof to enable them to see the tea clippers in Minnis Bay and presumably put the kettle on.

SEE Birchington/ Bradstow House/ Minnis Bay/ Minnis Road/ Ships

TEENAGE PREGNANCY
In 2000, Thanet had the highest teenage pregnancy rate in Kent

SEE Illegitimacy/ Infant deaths/ Thanet

TELEPHONE EXCHANGE
In 1955, the country's first cordless telephone exchange opened in Thanet.

SEE Thanet

TELEVISION PROGRAMMES
SEE Actors/ Blake's 7/ Burke, James/ Dads Army/ Diggin' It/ Double Your Money/ Eastenders/ Entertainers/ Fawlty Towers/ Fry, Stephen/ Ivor the Engine/ Mills, Annette/ Noggin the Nog/ Only Fools and Horses/ Opportunity Knocks/ Pallo, Jackie/ Poirot/ Postgate, Oliver/ Rediffusion/ Rhodes, Gary/ Sky Sports/ Treasure Hunt

TELEVISION ADVERTISING
East Kent Times, 4th January 1957: *'Ramsgate is to be first Kent resort to advertise on commercial television.'*

SEE East Kent Times/ Ramsgate

Thomas TELFORD

An 18th century Scottish engineer who worked on some of Ramsgate's drainage systems.

SEE Lester's Bar and Restaurant/ Ramsgate

TEMPERANCE HOTEL
Station Road, Birchington
Built as a hotel where no alcohol was served back in Victorian times the building has since had a number of different uses. It was Willett's Monkton Farm Dairy (it advertised 'Clean milk' - always the best sort), then it became Weston Dairies and is now The Paragon Fish and Chips.

SEE Birchington/ Farms/ Hotels/ Monkton/ Station Road, Birchington

William TEMPLE
Born on 15th October 1881
Died 26th October 1944
He was the son of Frederick Temple, a former Archbishop of Canterbury, and went to school at Rugby (1894-1900) before attending Balliol College, Oxford (1900-1904) where he was president of the student union. Temple became a tutor and later president (1908-1924) of the Workers' Educational Association (WEA). He entered the Church and was ordained on 19th December, 1909. The following year, he became headmaster of Repton School. In World War I, he was the honorary chaplain to George V and became the leader of the Life and Liberty Movement. At the end of the war he joined the Labour Party and in November 1920, David Lloyd George appointed him the Bishop of Manchester. In 1926, he was amongst those who urged the government to negotiate a settlement of the General Strike. He was Archbishop of York (1929-40) and Archbishop of Canterbury (1942-44) speaking for social reform and joined the campaign against unemployment, poverty and poor housing. William Temple died at Westgate-on-Sea.

'To a man of my generation an archbishop of Temple's enlightenment was a realised impossibility.' George Bernard Shaw.

SEE Archbishop of Canterbury/ Shaw, George Bernard/ Westgate-on-Sea

Nelly TERNAN
Born 3rd March 1839
Died 25th April 1914
Ellen Lawless Ternan was an actress and Charles Dickens' mistress; although, some people say they were just good friends - he left her £1,000 in his will.

After Dickens died, she married George Wharton Robinson, a clergyman, in 1876 and he became the co-owner of Margate High School a year later, and then sole owner and headmaster in 1881.

In Margate, she was the dashing, glamourous young wife of a schoolmaster and soon a mother of two children, out doing charitable work. Her past friendships were not known, except to a close friend. In the 1881 census she lowered her age by 14 years!

In 1886, George's health suffered, the school was sold, and they moved to London.

SEE Dickens, Charles/ Margate/ Margate College/ Schools

William TERRISS
Born London, 20th February 1847
Died London, 1897
Born William Charles James Lewin, he was a leading actor of his time, had also worked in the Falklands on a sheep farm and in silver mining in America. He married in 1868 after meeting his wife while on holiday in Margate and they went on to have a daughter.

Terriss established himself as an actor by the time he was in his mid-twenties and started working with Jessie Millward. The two not only became popular romantic leads, but lovers offstage as well, touring in Britain and America.

By 1897 Terriss had got to know Richard Arthur Prince (aka William Archer aka William Archer Flint, real name Richard Millar Archer, born 1858), the son of a ploughman from outside Dundee. As a child he was thought to be *'soft in the head'* and had left school to become an actor. He was appearing in London, albeit in bit parts, from around 1887. Terriss seems to have obtained some small parts in productions that he was employed in, although by now it appeared that Prince's head was getting even softer and was known as 'Mad Archer' and was desperate for work. He appeared well down the cast list in 'Harbour Lights' with Terriss at the Adelphi Theatre in London but said something that offended Terriss who had him sacked. He did however, send Prince money through the Actors' Benevolent Fund and found him other acting jobs although he soon got sacked from these as well. By the December of 1897, Prince had pawned all his clothes apart from the ones he was wearing, and was behind in his rent, and living on a diet of bread and milk. On 13th December he went to the Vaudeville Theatre and tried to get a free ticket by showing a card that read 'Richard Archer Prince. Adelphi Theatre.' When it was pointed out that he was not working there, he got abusive and was slung out. The next night, at the Adelphi, Jessie Millward heard an argument between Terriss and Archer in the former's dressing room. Terriss later told her *'That man's becoming a nuisance'.* Three days later, Archer received a letter from the Actors' Benevolent Fund stating that he would receive no more money from them. When Terriss arrived at the theatre that night he was stabbed in the back, the side and, as he turned, the chest. Jessie Millward, who was already in her dressing room, heard the commotion and ran downstairs with her maid to see Terriss collapse in the doorway. A mutual friend of theirs, Harry Graves, managed to catch hold of the attacker mainly because he did not put up any resistance. It was Archer. He told the police that, *'I did it for revenge. He had kept me out of employment for ten years, and I had either to die in the street or kill him.'* Terriss died in Jessie's arms.

On 13th January 1898, Archer pleaded 'guilty with provocation' at the Old Bailey but was advised to change his plea to 'not guilty'. Not only doctors, but also his mother tried to convince the jury that he was *'of unsound*

mind' and it took the jury half an hour to consider him, *'guilty, but according to the medical evidence, not responsible for his actions.'* Archer was mightily relieved to be sent to Broadmoor asylum, where he busied himself in providing entertainment for the inmates as well as conducting the prison orchestra.

SEE Actors/ Margate

TESCO

The supermarket derives its name from the first two letters of the surname of its founder Sir John Cohen (1898-1979) and from the initials of T E Stockwell, his tea supplier when he started out as a street trader in 1920s London.

The Broadstairs High Street store used to be a cinema.

The Tesco Store at Manston Road opened on 6th April 1998 with 36,000 square feet of shopfloor, 24 checkouts, and 360 jobs. It was the first Thanet superstore to open 24 hours a day.

In 1961, Tesco opened in Ramsgate High Street almost opposite Fine Fare (now Argos). Vye and Son responded to the competition with *'We pioneered self-service in Ramsgate in 1952 and we offer top quality groceries and provisions at competitive prices backed by a free delivery service. We feel our free delivery service and special prices is the answer'*. Vye's announced the opening of a new super self service store at 21-23 High Street on 6th April 1963.

SEE Broadstairs/ Cinemas/ High Street, Broadstairs/ Hypermarket/ Palace Theatre/ Ramsgate/ Shops/ Vye & Son

Dr Arthur TESTER

He lived at Naldera - a mansion on the cliff top below North Foreland lighthouse - for many years with his wife and children. Herr Dr Tester was a well-known figure in the area, especially around Manston, strangely. He was a member of the British Union of Fascists and it has been suggested that he funded Oswald Moseley's (the leader of the BUF) movements from funds he received from the Nazi Propaganda Minister in Germany, Herman Goerring. He also had the reputation of being a conman and a liar.

One of Tester's visitors was William Joyce who went on to become Lord Haw-Haw in the forthcoming war.

Thus, at the outbreak of war, the Police were suspicious of him and when they went to collect him, he had already disappeared - locals reckoned he had rowed out to a waiting German submarine.

In 1945, his car ploughed through a road barrier, swerved and went into a ditch in Castle Mintia, Rumania, and he was shot and killed by advancing Russian troops. The body was confirmed as Tester's when dentist Brigadier J Morley Stebbings of Ramsgate confirmed his identity using dental records.

SEE Fascists/ Joyce, William/ Manston Airport/ Mosely, Oswald/ North Foreland Lighthouse/ Ramsgate/ Russia/ World War II

William Makepeace THACKERAY
Born near Calcutta, 18th July 1811

Died London, 24th December 1863

His father, Richmond Thackeray, worked as a collector for the East India Company, but died when 'Billie Boy' was three years old. At the grand old age of five and a half, William was sent home to England to go to school at Chiswick Mall, shortly after his mother married her first love, Captain Henry Carmichael-Smyth. At six, he went to a Southampton boarding school run by a *'horrible little tyrant'*. His luck did not change when he moved on to Charterhouse, or *'Slaughterhouse'* as he called it, partly because of the brutal regime there but also because it was close to Smithfields market. His nose got broken in a fight there and he was self-conscious about it for the rest of his life. Next stop was Trinity College, Cambridge, where he started a periodical called 'Snob' but left without a degree. He had been left £20,000 but lost most of it gambling at cards and making bad investments. He lived in Paris to study painting, studied law but never practised and it was only when he became the owner of The National Standard - a failing weekly newspaper – in 1833, that his future career as a writer really began - even though it went out of business within a year, taking what was left of his inheritance with it.

Having wanted to be an artist, not a writer, he now found himself writing for various publications using bizarre pen names such as Michael Angelo Titmarsh, George Savage Fitz-Boodle, Théophile Wagstaff, and C.J. Yellowplush, Esq.

He married his teenage bride, Isabella, on 20th August 1836 and they quickly had three daughters; although the second one died after only a few months. Following the birth of their third child, Isabella started to suffer from depression; nowadays, she would have been treated for post-natal depression.

Having holidayed at Margate as a child with his parents, and acting on their doctor's advice, the Thackerays rented rooms at 1 Bridge Terrace, Margate, between 20th August and 6th September 1840 and apparently Isabella's spirits improved.

'We have got a charming green little lodging here, but very dear 2 ½ guineas a week, everybody else asked 3 or 4 for rooms not so good. All our windows look to the sea, if you call this sea. A queer little sitting-room with a glass door that walks straight into the street and two neat smart bed rooms 1 on top of the other. . . .

How delightfully quiet this night is! The ripple of the water is most melodious, the gas lamps round the little bay look as if they were sticking flaming swords into it. . .

We have been out to walk on the sands Missy (their eldest daughter) *famous. Baby ditto. My wife better in health but very low. For the last four days I have not been able to write one line in consequence of her. . .*

Indeed it is a hard matter to resist catching the infection for I am always with her: nor can I get much work done with the pitiful looks always fixed on me . . . of mornings especially her spirits are curiously low, she is so absent that I don't like to trust her.'

Within three weeks Isabella had attempted suicide whilst on board a steamer crossing to Ireland, and suffered a mental breakdown resulting in her having to live in an institution. Charlotte Bronte dedicates 'Jane Eyre' (2nd edition) to Thackeray, suggesting that the character of the mad wife in the novel was based on Isabella.

Their children were packed off to live with his mother in France but returned to live with William in 1846.

He wrote Vanity Fair when he was 35, with much of his early life being reflected in the story. Sadly he is now remembered as a one novel wonder.

The following are quotes from 'Vanity Fair':

Opening lines: *While the present century was in its teens, and on one sunshiny morning in June, there drove up to the great iron gate of Miss Pinkerton's academy for young ladies, on Chiswick Mall, a large family coach, with two fat horses in blazing harness, driven by a fat coachman in a three-cornered hat and wig, at the rate of four miles an hour.*

Title of chapter 36: *'How to live well on nothing a year.'*

Becky Sharp: *'I think I could be a good woman if I had five thousand a year.'*

The world is a looking-glass, and gives back to every man the reflection of his own face. Frown at it and it will in turn look sourly upon you; laugh at it and with it, and it is a jolly kind companion.

This I set down as a positive truth. A woman with fair opportunities and without a positive hump, may marry whom she likes.

Mother is the name for God in the lips and hearts of children

Postscript: *Thackeray: 'Ah! Vanitas Vanitatum! Which of us is happy in this world? Which of us has his desire? Or having it is satisfied?'*

Every time Thackeray passed the house where he wrote 'Vanity Fair' he raised his hat.

He was involved in a row at the Garrick Club which resulted in Thackeray and Dickens falling out and having a sort of ambivalent rivalry. Yeats wrote an article that said Thackeray had got material from the Garrick Club, and Dickens was supposed to have encouraged Yeats. The two did not speak again until very late in life when Dickens went up to Thackeray and shook his hand.

Thackeray suffered from VD - and when I say suffer, I mean suffer - he was in constant pain from his bladder and often vomited but refused an operation in case he died.

He was dead at 52, of a cerebral effusion - a burst blood vessel to most of us – dying on Christmas Eve. Knowing he was about to die, he had visited all his old haunts to say his goodbyes. He was buried at Westminster Abbey, where 2,000 mourners turned up.

Once, he was thought the equal of Dickens, some thought him better; now, only a quarter of his work is still in print.

His eldest daughter, Anne Thackeray Ritchie, (1837-1919) wrote a novel.

His wife outlived him by thirty years.

'Let the man who has to make his fortune in life remember this maxim: Attacking is the

only secret. Dare, and the world always yields. If it beats you sometimes, dare it again and again and it will succumb.
SEE Authors/ Luttrell, Henry/ Margate/ Shabby Genteel Story/ Snob/ Sunsets

THAMES STEAM YACHT
Advertisement,
30th June 1815, Kentish Gazette
A NEW SUPERIOR AND CERTAIN PASSAGE
from
MARGATE to LONDON
in a day
THE THAMES STEAM YACHT will start from Margate every Monday, Wednesday and Friday at 8 o'clock in the morning and leave Wool quay, Customs House, Thames Street to return to Margate on every Tuesday, Thursday and Saturday.
Fares First Cabin 15s., Second Cabin 11s. Pier Duty included. Children under 12, half price.
This rapid, capacious and splendid vessel lately accomplished a voyage of 1,500 miles by sea, has twice crossed the St George's Channel and come round Land's End with a rapidity before unknown in naval history, and is the first Steam Vessel to have ever traversed those seas. She has the peculiar advantage of being able to proceed either by sails or steam, separately or united, by which means the public have the PLEASING CERTAINTY of never being detained on the water after dark, much less one or two nights, which has frequently occurred with the original Packets. Against a gale of wind and tide, or in the most perfect calm, the passage is alike certain and has always been achieved in a day.
Her cabins are spacious, fitted up with all that elegance could suggest and personal comfort require, preventing a choice library, Backgammon Boards, Draughts Tables and other means of amusement.
For the express purpose of combining comfort with delicacy a female servant attends the ladies.
N.B. No articles or goods will be taken except luggage accompanying passengers. The proprietors will not be answerable for any of the above unless delivered into the care of the Steward.
SEE Margate/ Ships/ Transport

THANET
Thanet is one of approximately 402 islands in Great Britain.
The earliest evidence for any settlement in Thanet dates from the Mesolithic Period between 4,000 and 8,500 BC. They walked here - obviously they didn't drive here, the Thanet Way is relatively new - but at that time the land mass was higher and the Wantsum Channel had yet to form.
There are various theories about where the name 'Thanet' derives from. It could come from:
1. The Greek 'thanatos', and the story that the dead were rowed in boats without oarsmen from the coast of Gaul at night to

Thanet and returned the following morning, empty.
2. The Celtic 'teine', meaning fire or bonfire.
3. The Gaelic 'aird' which means a promontory.
4. The Romans called Thanet 'Tanatvs Insvla'. Ptolemy (c100-c170) in his 'Geography' made the first record of the place, Tolianis.
The Venerable Bede refers to Thanet as Tanetos Insula (730AD), sometimes Tane'tus Thanet is called Taniatide in 'The Ravenna Cosmology' (seventh century).
Tened is the name that Simon Dunelmensis calls Thanet in 1164.
Encyclopaedia Britannica 1771: '[Thanet is] *a little island of east Kent, formed by the branches of the Stour and the sea.*'
In 1865, there was a total of 156 miles of road.
SEE Accomodation/ Barricades/ Bays/ Beaches/ Bede, Venerable/ 'Billericay Dickie'/ Birds/ Birmingham Daily Gazette/ Booth, Cherie/ Born out of wedlock/ Bronze Age/ Butchers/ Canada/ Caxton, William/ Charnock, Thomas/ Cinemas/ Coal/ Coastline/ Convalescent Homes/ Crowds/ Dairy Farms/ Development/ Domesday Book/ Dumpton Park/ Earl of/ Ebbsfleet/ Election results/ Electric Tramways Co/ Ellington Park/ Evacuation/ Farms/ Fauna/ Fish/ Fishmongers/ Gas works, Ramsgate/ Gore End/ Great Storm 1703/ Greengrocers/ Grocers/ Hengist & Horsa/ Hill, Sir Rowland/ HMS Thanet/ Hops/ Ice Cream/ Illegitimacy/ Infant Deaths/ Isle of Thanet Gazette/ Jedi/ Loop/ Northdown/ Population/ Poultry farms/ Transport/ Salmestone Grange/ Sandwich/ Saxon Chronicle/ Simpson, Dorothy/ Skies/ Smuggling/ Snow/ Teenage pregnancy/ Telephone Exchange/ Tyler, Wat/ Viking Coastal Trail/ Vikings/ Wantsum Channel/ Weather/ Whales/ Windmills/ 'World of Waters'/ World War I/ World War II/ Yeomenry

THANET HOSPITAL, Margate
It was opened by the Prince and Princess of Cannaught on 3rd July 1930 in front of a crowd of 5,000. Very hi-tech in its day it cost £70,000 to build.
It is now the Queen Elizabeth, the Queen Mother Hospital, or the QEQM.
SEE Hospitals/ Margate/ Thanet

THANET PLACE, Broadstairs
Sir Edmund Vestey lived at Thanet Place, but by 1974, it was the site of The Church of England Children's Society.
SEE Broadstairs/ Vestey

THANET ROAD, Westgate
Thanet Road suffered damage in an air raid on 1st June 1943.
SEE Westgate-on-Sea

THANET TECHNICAL COLLEGE
Broadstairs
SEE Broadstairs/ Schools/ Yarrow Home

THANET TECHNICAL COLLEGE
High Street, Ramsgate
Thomas Abbott built a house in 1733/4 that was the home of Lord and Lady Conyngham from 1777 until 1819, when it became a school known as Conyngham House.
Around 1900, the house, plus two adjoining buildings, were presented as a hospital - St

Catherine's Hospital - to the Daughters of the Cross of Liege for the poor and sick of the Diocese of Southwark. It closed after World War I, when an additional building was erected to create a childrens' convalescent home.
The three-storey building later became Ramsgate Technical College, which, after closing in 1990, was demolished in the summer of 1996 to make way for the new sports centre.
SEE Convalescent Homes/ Conyngham/ High Street, Ramsgate/ Ramsgate/ Schools/ Sport/ Yarrow Home

THANET WEED
Also known as Hoary Cress, or 'cardaria draba', it got the name Thanet Weed because its seeds are supposed to have entered the country via Ramsgate Harbour in the fodder used for the cavalry horses in the Napoleonic Wars. Should have been called fodder weed then shouldn't it?
SEE Harbour, Ramsgate/ Napoleonic Wars/ Ramsgate/ Weed

THATCHED HOUSE
Elmwood Avenue, Broadstairs
This house's design won the £1,000 first prize in the first Daily Mail Ideal Home Competition held in 1919, after which Lord Harmsworth had it dismantled and re-erected here. For a time it was the home of the North Foreland Golf Club's Secretary.
SEE Broadstairs/ Daily Mail/ Elmwood House/ Harmsworth, Lord/ North Foreland Golf Course

Margaret THATCHER
Born 13th October 1925
When Britain's first woman Prime Minister was Education Minister she addressed the Young Conservatives at the Winter Gardens in Margate.
SEE Margate/ Politics/ Prime Ministers/ Seven Stones/ Winter Gardens

THEATRE ROYAL, Margate
It is the second oldest theatre in the UK, but has the oldest stage.
Charles Mate and his business partner Thomas Robson bought the plot of land on which to build their theatre for £80, and it cost another £4,000 to build. The foundation stone was laid on 21st September 1786 with the following inscription:
This is the first stone of the Theatre Royal laid in due form and attended by the brethren of Thanet Lodge, by the proprietors, Thomas Robson and Chas. Mate, on the 21st of September, 1786, on the reign of Geo.Ill
Ship's timbers were used for the flies above the stage and Robson also had a pad built for himself in the theatre, with the parlour used as the box office.
The grand opening was 27th June 1787, and the first productions were 'She Stoops to Conquer' and 'All the World's a Stage' and yes, Robson did star - you don't build a theatre and not use it! Miles Peter Andrews wrote a prologue that was delivered by Mr Booth:
Oh, may you still enjoy,while long you live,

These heartfelt transports which the Muse can give.
May this fair town, where health with roseate charms
Woos pale disease to her refreshing arms,
From whose kind wave life's choicest blessing flows,
Itself feel every comfort it bestows.

Apart from a fire on 15th August 1789 (in which there was only one casualty, an actress named Miss Twiddy who hurt her ankle quite badly jumping from the stage) things trundled along quite nicely, although the working partnership between Mate and Robson was not altogether smooth. Robson sold his share to Thomas King, a London actor, and not long after, Mate sold his share to a man who was already part owner of Drury Lane.

Description of the theatre c1799: *'The wardrobe is barely passable and the dressing room so distant from the stage as to occasion much delay between the acts and pieces, especially when change of dress is requisite. There is now an attempt to rectify this error in a corner of the stage about six to eight feet square but being a thoroughfare for players, scene shifters etc., its utility is rendered ineffectual. The scenery is excellent.'*

The Picturesque Pocket Companion to Margate, Ramsgate, Broadstairs and the Parts Adjacent 1831: *At the north-east end of Hawley Square stands the Theatre Royal, which is exteriorly a neat but unadorned brick building, after the model of old Covent Garden, having, however, its interior fitted up in a chaste and pleasing style, and its scenery painted in a bold and masterly manner by Mr Hodgins. This structure was erected in 1787, at the cost of £4,000; and the present active and indefatigable proprieter spares no expense or labour, to render its amusements attractive and instructing. This house is only open during the season, being limited to that time by its licence.*

For over half a century, the owners changed many times and the theatre closed and re-opened under new management but no-one achieved any real sustained success. It was even used as a chapel in 1841. Robson returned to run the place, albeit for just four weeks, in 1843. The Royal Charter preventing any competition to the theatre was removed by an Act of Parliament in 1843, but the Theatre Royal had been fighting competition from places other than theatres, notably the Assembly Rooms in Cecil Square and then the Tivoli Gardens. At one point, the Assembly Rooms were so popular that many people were turned away because the place was full. In 1799, The Theatre Royal had levelled the stalls area so that it was the same height as the stage and charged five shillings if you wanted to dance, two shillings and sixpence to watch and one shilling and sixpence to watch from the upper circle.

Charles Dickens always enjoyed going to the Margate Theatre, most notably to see the tragedy 'Athenian Captive' (1844), and 'As You Like It' (1847) which he thought excellent.

'He [Charles Dowton] really seems a most respectable man, and he has cleared out this dust hole of a theatre into something like decency.' Charles Dickens, 1847

In 1855, 42 year-old Richard Thorne became the theatre manager. He came from a theatrical family, both acting and managing. Apparently, he liked gambling, was quite effeminate and was known as Gentleman Dick (now stop it). His eldest daughter, Sarah (yes, he and his wife had six boys and four daughters - so leave it) made her debut on stage here aged 18 on 6th August 1855. She was a success and three years later started giving equally successful lectures. Whilst travelling, she met a Scotsman, Thomas McKnight, in Belfast. They never married but Sarah took his name and they had two children named Edmund and Elizabeth. Their relationship is said to have failed because of Sarah's determination to have a stage career. She and her children returned to Margate and when her dad retired in 1861, she took over as theatre manager. One of her first actions was to instal cushioned seats! That was where everyone had been going wrong! At the time, the annual rent, which included the theatre, a shop and Sarah's house came to £135 and 4 shillings. Following her first acting performance as manager, she addressed the audience and likened herself to being *'the captain of a ship that has just left the harbour and was spreading her sail in the breeze.'*

In 1874, a caterer from London called Robert Fort, who also owned a London music hall, bought the theatre at auction and then spent a further £10,000 on a new entrance where the box office is today. He added a bar, a coffee bar in the dress circle and the auditorium was lengthened to 65ft and the depth of the stage to 25ft – ten grand went a long way in those days! J T Robinson was the architect, who had also designed the 'Old Vic'. The new look theatre, looking pretty much as it does today, re-opened on 20th July 1874 with a performance of 'Coals of Fire'.

Daily Telegraph, 21st July 1874: *'With a large ornamental frontage in Addington Street, the present Margate theatre is constructed somewhat in the pattern of the London Vaudeville, and is about the size of the Strand Theatre. It will hold nearly 2,000 persons, and the approaches are roomy and convenient and have had their perfect safety officially certified. Judging from a hot summer's night, the ventilation seems to be excellent.'*

Keble's Margate and Ramsgate Gazette: *'One of the prettiest theatres we have ever seen.'*

The investment did not pay off. Sarah left because she and Mrs Fort could not work together and the audiences did not turn up in sufficient numbers. It was leased out to various people but still was not a success and even a brief change of name to the 'New Theatre and Opera House' did not work. In 1878, Sarah Thorne returned at the ripe old age of 40 - you know, when life begins. She lived at 5, or 38, 'The Towers', Hawley Square and started a School of Acting attended by her *'pupes'*.

At last the theatre saw some success and by 1895, The Sarah Thorne Theatre Company has taken out a seven year lease on a second, the Opera House in Chatham, where she also had a second home. She worked hard for both theatres, despite friends urging her to relax when she suffered from ill health. On 27th February 1899, aged 62, Sarah died in Chatham after catching influenza,.

'To her efforts under her management, we are indebted in this town for the resuscitation of the drama, and the elevation of the public taste. She generally succeeded in giving the confidence and esteem of those with whom she is brought into contact, whilst for candour, probity, and plain dealing, the character of Miss Thorne stands second to none. . . It is the irreproachable private characters of such actresses as the subject of our memoir that have done so much good to remove the social prejudices that have existed for so long against the fair exemplars of Thalia and Melpomene. Miss Thorne has never been assailed by the voice of calumny, and remains firmly seated in our memory as surrounded with 'Honour, love, obedience, and troops of friends'.'

Her son Edmund took over but by 1914 there were only occasional productions being put on and in September 1915 it finally closed as a theatre. Bobby & Co., the department store, used it briefly as a store but for most of the 1920s, it was unused and locked up.

The new owner, Mr. Samuel Wenter, a furniture dealer, re-opened the theatre on 23rd June 1930, with a play called 'Murder on the Second Floor' but he soon leased it to Julian Bainbridge who opened it as a cinema. He lost money. Even All-in Wrestling was staged to get punters in.

From 1934-37 another attempt was made to use it as a theatre, but once again it closed after a performance of 'Night Must Fall' on 4th September 1937. Another attempt to re-open it was thwarted by the outbreak of World War II.

Not even a good luck telegram from King George VI could help when the place re-opened in 1948. Within two years it had closed again. Throughout the fifties and sixties the theatre went through various hands, but by now faced the added competition of television.

The theatre narrowly avoided demolition and became a listed building. It also became a bingo hall for much of the sixties and seventies. In 1987, vandals switched on the fire hoses and flooded the place. It also failed to sell at auction on two separate occasions.

The next owner came from a long line of showbiz folk. Nathan Jackley had his own troupe called The Jackley Wonders who appeared in a circus in America. His son was the comedian George Jackley (1885-1950) who headlined at the Lyceum Theatre in the 1920s and 30s. George's son was Nat Jackley (born Sunderland, 14th July 1909 - died London, 17th September 1988) the 'rubber necked comedian' (he was a very

thin, tall man with a funny walk and a neck jerk, who did a routine dressed either as a girl guide, or an army recruit doing a drill) who appeared in over fifty pantomimes as the Dame, headlined at the London Palladium and in countless summer seasons. He was also in The Beatles' Magical Mystery Tour (1967) as Happy Nat. Nat's son was - I feel like I should have been using the word begat - was Jolyon who played L/Cpl. Browning in The Virgin Soldiers (1969). In 1988, Jolyon Jackley invested over £100,000 in the theatre and put on some good productions but it was not to last.

In 1992, a combined effort involving the Margate Theatre Royal Trust, the Theatres Trust, Equity Trust Fund, Kent County Council, Thanet District Council, and the Castle Trust bought the theatre. In 2007 the theatre was sold to the local council.

The Theatre Royal has the reputation of being haunted. Creepy goings on such as footsteps heard when no-one is there, lights flickering, doors slamming, cloudy floating balls that turn into human heads and balls of fire have all been reported. There is also a story of an actor who was so unhappy at being sacked, that he returned to the theatre the same night, bought a seat in a box and mid-performance jumped to his death into the orchestra pit. His ghost was seen so many times in the box that it was bricked up. The ghost of Sarah Thorne is also said to haunt the theatre.

SEE Addington Street/ Any Questions/ Arliss, George/ Bascomb, A W/ Boucher, Arthur/ Celeste, Madame/ Colman, Ronald/ Craig, Edward Gordon/ Davenport, Bromley/ De Bar, Benedict/ Dickens, Charles/ Dreamland Theatre/ Fires/ Flooding/ Fountain Inn/ George VI/ Greet, Ben/ Hawley Square/ Hicks, Sir Seymour/ Jordan, Mrs/ Kean, Edmund/ Margate/ Mathews, Charles/ Shaw, George Bernard/ Sullivan, Barry/ Tivoli Park/ Tom Thumb Theatre/ Toole, J (John) L (Laurence)/ Vanbrugh, Dame Irene/ Williams, Kenneth

THICKET CONVALESCENT HOME
Cross Road, Birchington

This was situated at the junction of Cross Road, Epple Bay Road and Coleman's Stairs Road. It was built as a convalescent home for the Parish of St Michael's, Chester Square in London by Dr Cross in 1900 and was known for a while as St Michael's Home. Dr Cross's brother was a colonel in the Household Cavalry who consequently took it over so that his men, wounded in the Boer War, could convalesce in the home's thirty beds. They used it again in World War I, although the Imperials used it from 1916 onwards and in World War II many soldiers were billeted here.

In two-thirds of a century only three matrons were employed in the home: Miss Denning (1900-1931), Mrs Hiscocks (1931-48) and Mrs Wiggens (1948-67).

It was demolished in 1967 and replaced with houses.

SEE Birchington/ Convalescent Homes/ Cross Road, Birchington/ Epple Bay Road/ World War I/ World War II

'The THIRTY NINE STEPS'
by John Buchan

There are plenty of local connections in this short novel (c.41,000 words) published in 1915. One of the characters, Franklin P Scudder, uses the alias of Captain Theophilus Digby of the 40th Gurkhas: The Captain Digby is a public house at Kingsgate. The fictional house, Trafalgar Lodge, is the real St Cuby and The Griffin Hotel is the Royal Albion Hotel. I also like to think that the old woman who brings Hannay (the main character in the book) his meal while staying at the Scottish inn, Margit, has a local connection but that might be a bit too whimsical. The climax of the book takes place at Bradgate, which is really Broadstairs.

The steps are still there, although the entrance at the top is gated and locked and the sign at the beach end correctly states that 'This tunnel is dangerous'.

The staircase had 78 steps but Buchan thought that halving the number provided a more effective title, and when he had been in in better health could take them two at a time - it might have made the story twice as long. It was also Buchan's age at the time, 39 that is, not 78. The original steps were an oak staircase but a later owner replaced them with a stone staircase which had 108 steps. Wood salvaged from the original stairs was used to make three pairs of bookends. One was kept by the owner; one was given to John Buchan and one to Alfred Hitchcock.

SEE Books/ Broadstairs/ Buchan, John/ Captain Digby/ Prince of the Captivity/ Royal Albion/ Thirty Nine Steps – films/ Tunnels

'The THIRTY NINE STEPS' - FILMS

There have been three film adaptations of the John Buchan novel, none of which have kept to the original story!

In the 1935 black and white film, directed by Alfred Hitchcock and starring Robert Donat, some of the scenes were filmed at St Cuby's, with the real chauffeur and cook appearing as themselves. This is the version with the scene on stage at the music hall where Mr Memory answers Hannays question 'What are the 39 steps?' with 'The 39 steps are a secret organisation' before he is shot, 'Am I right Sir?'

The other two films, both in colour, are the 1959 version starring Kenneth More and directed by Ralph Thomas, and the 1979 version starring Robert Powell and directed by Don Sharp.

In the 1979 film, the 39 steps are the number of steps to the top of Big Ben where Hannay has to stop the hands reaching 11.45 or a bomb will explode.

SEE Buchan, John/ Films/ St Cuby/ Thirty Nine Steps

Terry THOMAS

Born 14th July 1911
Died 8th January 1990

This comedy actor did a summer season at the Winter Gardens in 1953, during which he was granted free use of the town's deckchairs!

Famous for the gap between his two front teeth and often seen dressed in a silk dressing gown and holding a cigarette holder, his catchphrases included 'Good show!' and 'You're an absolute shower'.

SEE Actors/ Deckchairs/ Entertainers/ Winter Gardens

Dr Spencer THOMSON

'We have committed ourselves to boat-travelling, and though it is not the best way of entering Margate, we must keep to it. Had we come by rail we should have made Ramsgate first, but now we must land on the fine incurved terrace-raised pier of Margate. We do so, at least, if the tide be better than half-full; if not, we look rather blankly at the distant pier, and its expanse of mud on which the boats and small vessels rest as if they had turned on their sides and gone to sleep.

To a stranger, there arise uncomfortable visions of small boats crowded to the gunwhales, and boatmen's shoulders. Quiet yourself as you find the steamer gently easing round to Jarvis's landing-place, at the back of the pier.

Now the necessity which has occasioned the construction of this amphibious jetty – part of its time spent under water – indicates that we must expect a flat shore for bathing, and such we find it. This flatness somewhat of a drawback it may be – is well compensated for by the great extent of sands, by the pleasant facilities for rambles among the cliffs around the town, and by the numerous pretty and interesting walks in the vicinity.

Margate may be taken as the model of a well regulated, not too modish, sea-side watering place, and is admirably calculated for its London visitors, who come down at the rate of 100,000 per annum. In addition to the sands, the cliffs and the walks, the fort and the beautiful pier, constructed specially with a view to promenading, are great attractions; and last, not least, sea breezes of the freshest kind are combined with the comforts and agreeabilities of civilized life, almost too much so, perhaps; for as London, its ways, its shops, its amusements are imported direct, you scarcely lose the flavour of the Great Metropolis sufficiently.

227

It is well that tastes differ, for to some, the loss of town comforts and conveniences – London bread and London meat, for instance – would more than counterbalance the pleasure of the change, were it accompanied with what we call roughing it. Moreover, if our visitor has read our sea-bathing cautions and is afraid of, or has been advised against, bathing in the open sea, he will here find the means of tepid or warm sea-bathing in perfection.

In short, if you are a tired Londoner, not too dignified or distingue, and want a week or more in a cheery, bright, life-loving and not too constrained sea-side resort, with all the materials for healthy enjoyment and abandon, you cannot do better than go to Margate. Four hours' rail, or less, will whisk you back to London Bridge, though how much longer it will take your cab to squeeze through the choked streets you must calculate yourself.' 1855
SEE Bathing/ Jarvis's Landing Place/ Margate

'THREE MEN IN A BOAT'
by Jerome K Jerome
This novel was originally published in August 1889, and Margate gets a couple of mentions:
The blue-and-white mugs of the present-day roadside inn will be hunted up, all cracked and chipped, and sold for their weight in gold, and rich people will use them for claret cups; and travellers from Japan will buy up all the 'Presents from Ramsgate,' and 'Souvenirs of Margate,' that may have escaped destruction, and take them back to Jedo as ancient English curios.

oOo

The blazer is loud. I should not like George to know that I thought so, but there really is no other word for it. He brought it home and showed it to us on Thursday evening. We asked him what colour he called it, and he said he didn't know. He didn't think there was a name for the colour. The man had told him it was an Oriental design. George put it on, and asked us what we thought of it. Harris said that, as an object to hang over a flower-bed in early spring to frighten the birds away, he should respect it; but that, considered as an article of dress for any human being, except a Margate nigger, it made him ill. George got quite huffy; but, as Harris said, if he didn't want his opinion, why did he ask for it?
SEE Books/ Margate/ Ramsgate

The THREE TUNS public house
Broadstairs
This was an old smuggling pub.
A tun is the largest cask in which beer is stored. It holds 216 gallons, 1,728 pints or 982 litres. There are three tuns on the old coat of arms of the vintners, or wine makers, hence the name.
SEE Broadstairs/ Pubs

THUNDERSTORM
A huge thunderstorm over the centre of Ramsgate on Saturday 13th June 1964 caused five manholes to explode sending their covers six feet into the air before they crashed back onto the pavement. It was reported that this caused older people to jump in terror. I can't imagine that many younger people stood there calmly at the time either. Televisions and phones were put out of action and furniture was thrown across rooms. An office block at the end of Boundary Road was struck by lightning and the effects were felt all the way along the road.
SEE Boundary Road/ Ramsgate/ Weather

The TIMES
This newspaper got its nickname, 'The Thunderer', after an earlier editor, Thomas Barnes, during the period 1817 to 1841, called for the people to *'petition, ay, thunder for reform'*. He also used to carry a cudgel when completing an edition in case he was *'set upon by Tory thugs'*.
In 1908, The Times' circulation fell to 38,000 and, not surprisingly, was losing money. There was much talk of a mysterious Mr X who was negotiating to buy The Thunderer. It cost Alfred Harmsworth £320,000 to gain control of the title and there was an outcry immediately. Harmsworth replaced the old-fashioned printing works, appointed Geoffrey Dawson as editor, reduced the number of staff, increased pagination, started a books page and introduced fashion articles. The 'Black Friars', as the old senior editors were referred to, opposed the new ideas but circulation rocketed. Harmsworth also cut the price from 3d to 2d, and in March 1914 reduced it to 1d and consequently sold 278,000 copies a day.
Lord Northcliffe, 'Northcliffe, an Intimate Biography' by Hamilton Fyfe: '*Six hundred years ago, there was near the site of The Times office a monastery, the home of the Blackfriars, recluses who lived remote from the world. The same kind of men inhabit Printing House Square today*'.
Advertisement The Times 11th July 1815: *'Margate Royal Telegraph light 4 inside. Coach every morning at 7 o'clock from the Cross Keys, Woodstreet, two doors from Cheapside. W T Roberts & Co.'*
SEE Harmsworth, Lord/ Newspapers/ Transport

TIMOTHY WHITES
Nationally the 622 Timothy Whites Ltd chemists shops were bought by Boots the chemists in 1968. They had a branch at Harbour Street in Ramsgate.
SEE Boots/ Harbour Street, Ramsgate/ Ramsgate/ Shops

TIPPLEDORE LANE
St Peter's
The alleyway opposite the junction of Fairfield Road and Broadstairs Road was originally called Tipple Dore Lane, or Tipple Door Lane (my spell-check wants it to be 'Tippled ore'!). It was part of an ancient route used by monks for over a thousand years, to walk from Canterbury to St Mary's at Minster, then on to St Laurence Church in Ramsgate, to St Peter's at the end of this footpath and along St Peter's Footpath (still in existence) to St John's in Margate.
SEE Blagdon Cottages/ Broadstairs Road/ St John's church/ St Laurence Church/ St Mary's Church/ St Peter's/ St Peter's Church

James TISSOT
Born Nantes, France, 15th October 1836
Died Buillon, France, 8th August 1902
He was the son of a devout Roman Catholic and a successful, prosperous shopkeeper and was sent away to be educated at a boarding school run by Jesuits. Although his father was far from enthusiastic about his choice, Tissot subsequently went to train as an artist in Paris where he met James McNiell Whistler (1834-1903) and became friends with Degas (1834-1917).
He was handsome, very intelligent, sophisticated, elegantly-dressed and a shrewd businessman as well as a good artist. He travelled in Italy and England and realised that London was where he could make money, although Ruskin described his paintings as *'mere painted photographs of vulgar society.'* Following the Franco-Prussian War (France lost) he fled from occupied Paris in 1871.
He bought a house in St Johns Wood, London in 1873 and became a busy member of London's society, counting Alma Tadema, George du Maurier, Millais and Whistler amongst his dinner guests.
Edmond de Goncourt, 1874: *Today, Duplessis told me that Tissot, that plagiarist painter, has had the greatest success in England. Was it not his idea, this ingenious exploiter of English idiocy, to have a studio with a waiting room where, at all times, there is iced champagne at the disposal of visitors, and around the studio, a garden where, all day long, one can see a footman in silk stockings brushing and shining the shrubbery leaves?* (the last bit is meant to be sarcastic)
He met the beautiful 22 year-old Kathleen Newton (1854-1882) in 1876. She was from Connisborough in Ireland, and her mother had died when Kathleen was only a child. When she was sixteen, she was sent to India, where her brother, an officer in the Indian army, had virtually promised her hand in marriage to a recently widowed Dr Isaac Newton. On the voyage out there, she fell in love with Captain Palliser. *'It is true I have sinned once, and God knows I love that one too deeply to sin with any other.'* She married Newton but abandoned him, virtually as they left the church, to return to Palliser and was soon pregnant. Palliser soon abandoned her and it was Newton who paid for her return voyage to Ireland, where her daughter, Muriel Mary Violet, was born at Kathleen's father's house. Kathleen then went to live in London with her sister, brother-in-law and their four children, just round the corner from Tissot. By the time Tissot, aged 40, met her, she was 22, divorced and the mother of two illegitimate children. She soon became the 3 'm's that every artist needs: muse, model and mistress. To be fair - just this once - he fell completely

in love with her and the two of them (both Catholics so marriage was not an option) lived together openly, meaning that he had to decide between the woman he loved and society. Now, I know what you're thinking. I know exactly what you're thinking: typical artist, love 'em and leave 'em, but you're wrong. He chose Kathleen. They settled into a quieter home life and entertained a few artistic, more bohemian friends. If you are wondering about the children from earlier, both Kathleen's children lived close by with her sister and it is probable that the boy, Cecil George (born 1876), was Tissot's son. Sadly, Kathleen suffered from tuberculosis from the late 1870s and, whilst desperately ill, committed suicide on 9th November 1882 aged just 28. Inside of a week, Tissot had moved out of their home (another artist, Alma-Tadema, bought it), and never really recovered from her death. He continued working in Paris, painting the same style of pictures – graceful, elegant, well-dressed, languorous women in opulent surroundings – until he became a devout Catholic following a religious experience during a visit to a church to `catch the atmosphere for a picture'. His subject matter changed to religious paintings and he even visited the Middle East (1886-87 and 1889) to ensure his backgrounds were accurate. Hugely popular at the time they have lost their appeal today.

His picture, 'A Passing Storm', painted in 1876 (c.30in x 40in), shows the scene from Goldschmid, or Goldsmid Place (previously it had been the Waterside), now Harbour Parade, Ramsgate with Kathleen sprawled out on a sofa wearing a white ruffled dress, with Ramsgate Harbour visible beyond the balcony through the large window.

Another picture, 'July (Specimen of a portrait)', also known as 'July, La Réverie', or 'Ramsgate Harbour', and referred to by Tissot as 'Seaside' was painted in 1878. There are two versions of it, 'Room Overlooking the Harbour' (1876-8) c.10in x 13in has the same view from the same balcony, but this time with a couple, including Kathleen sitting at table.
SEE Artists/ Harbour, Ramsgate/ Harbour Parade/ Prussia/ Ramsgate

TITANIC
The supposedly unsinkable liner sank in the north Atlantic on 14th April 1912. There were over 2,220 people on board, of whom 1,513 died – just over two-thirds.
SEE Craig, Norman/ Lusitania/ Ships/ Sundowner

TIVOLI BROOK, Margate
Before 1808 the sea came up to the area behind the clock tower where it met the marshy Brooks fed by a spring at Tivoli.
SEE Margate/ Springs/ Westbrook

TIVOLI PARK, Margate
There was a time when Tivoli Gardens were Margate's greatest attraction. If you need to go back and read that sentence again, I can wait Honestly, there was such a time, but Tivoli Park looked a lot different then

than it does today and I concede that we have to go back about 170 years, to see how different they were.

Originally, this area was just a *sweet and pleasing dell* between Hartsdown and Salmestone Grange where, up until the 1730s, the sea came up at high tide. In 1829, Mr Sinclair, a singer by trade, opened The Shady Grove Tea Gardens. You would have found refreshments, coffee rooms, arbours, alcoves and *attiring apartments*, a sizeable and stylish concert room, a miniature lake fed by a running spring, a bowling green, Swiss Cottages, a pub called the Kings Arms (Thomas Linger the landlord), a main avenue lined by impressive chestnut trees and winding paths that were illuminated by ornamental lamps held up by sculptured figures. There were very popular public breakfasts (held every Saturday and Wednesday through the season), concerts, musical promenades, firework displays and dances directed by the Master of Ceremonies of the Margate Assembly Rooms.

Kidd's Margate Guide, 1831: *Here may the pensive visitant with pleasure sit beneath the weeping willow's shade, and gaze upon the gentle gliding stream, in which, with blithe security, the finny race their graceful gambols play, and lofty elms their venerable heads reflect, and there may the lovers of melodious sounds their sweetest charms enjoy, while, borne upon the balmy evening breeze, they strike the enraptured ear. In these gardens the migratory nightingale takes up her short abode, and here may the admirer of her varied soft and thrilling melody enjoy her solitary evening chaunt.* (Now there's a word we need to re-introduce; see how many times you can get the word 'chaunt' into conversations.)

Pigot's, 1840: *The 'Tivoli Gardens' opened a few years ago, adjoin the town in a most delightful situation and are ornamented with fine sheets of water and umbrageous* (it means shady – I had to look it up) *plantations.*

Simon Bagshaw, 'History of Kent' 1850: *The Tivoli Gardens, situated in a valley about a half-a-mile from Margate, are interspersed with groves of oak, elms, limes, ash and poplars, and form a beautiful and romantic spot. The embellishments of art have been profusely dispersed and combine every attraction. The pleasure grounds are diversified with rustic chairs, bands, arbours, Swiss Cottages and sheets of water, and contain a spacious bowling green, archery ground and commodious concert room, in which the first metropolitan talent is occasionally engaged. On gala days the gardens are brilliantly illuminated and fireworks on an extensive scale are exhibited. The facility of railway communication has made this one of the most fashionable resorts*

Illustrated Times 13th September 1856: *That Margate is rakishly inclined is evident, for it has gardens where dancing, comic singing and fireworks are nightly indulged in. The Masters of Ceremonies are the most graceful men who ever wore white cravats. It is here that irresistible comic Fulford is engaged*

and sings every night at half-past nine in character. Another professional is the charming Miss Jacobs, who has eyes as black as blots, and often has offers of marriage made to her after warbling one of her ballads – indeed a professor of the German flute is said to have blown out his brains for her sake after 'Yes, Charmer, I will love you then as ever; come out'.

In the 1850s, Tivoli Gardens was so popular that the Tivoli Railway Halt had to be built. The now disused track ran from where Dreamland is sited, over the brick viaduct down the path from Tivoli Park Avenue, on to an iron bridge over Tivoli Road and between Nash Road and Nash Court Gardens and on to Ramsgate.

A visitor to Tivoli Gardens 1856: *We paid our shilling to a gas illuminated man, and walked into the grounds. The footpath seemed to have been cut through a plantation of tall trees, which grew up irregularly on each side and formed a dark tunnel with their branches, making the air so dark that, if it had not been for the gas lights burning at the end, we should have bumped ourselves black and blue against the trunks bout us. There was a pond surrounded by white posts, so completely thatched in with overhanging boughs that it was only by the little speck of moonlight that rested on the centre like a floating lamp that we could tell that there was water. We heard a voice call out, as if it were a warning, 'First train for Ramsgate', and then all became silent again. A desperate man unrestrained might have committed suicide, even in the centre of the principal flower bed. We coughed, and then whistled, but no one appeared; yet the grand illuminations were lighted.*

There was a magnificent star of yellow paint, adorned with eight coloured lamps, and the six yards of various tinted festoons were suspended from tree to tree, like ropes of transparent onions. We grew excessively nervous with the solitude, and felt inclined to run away and give information to the police. Presently a trumpet gave a groan and we hurried in that direction. Now the mystery was solved, for we found the visitors in a dancing hall, which was large enough to hold a thousand. Most of the gentlemen wore straw rowing hats or smoking caps and many of the ladies had taken their mantles and bonnets off, and seemed to be in full dress. There were eight musicians and four masters of ceremonies. We had the great pleasure of hearing Mr Fulford deliver a medley song, at the conclusion of which he danced about the platform, saying, 'Sing li-to-ro, to-ro, ilal, ilal, ilay!'[What do you mean you don't know it?] *He was very much applauded, and on return was so obliging as to give another song. We left Tivoli just as one brilliant display of fireworks was about to let off, for we knew that we should see them just as well outside. We never remembered to have passed a more delightful evening, or one more free from bustle and excitement. We had scarcely passed through the gates before we heard the roar of ascending rockets, and, turning around, we saw the*

golden streak of fire mounting in the air, and beheld it explode with a faint ginger-beer bang, and froth over with a few green stars. There were three of these rockets, and then the entertainment appeared to have ended.

The gardens' popularity began to decline and in 1857, one report described it '*by the low resort of company attending*' and by 1870 decay had set in. A three-day costume fete was held there in 1898 but the grandeur of the place was gone. The Kings Arms Inn was beyond repair and the chocolate or coffee house had half its roof missing, although some of the fresco decorations on the walls remained. Two or three cottages next door were in reasonably good condition but the concert room and old hall at the centre of the park were gone. The bowling green now had trees growing through it, the arbours, alcoves and Swiss Cottage were long gone and the main avenue with its once splendid chestnut trees and winding paths were all being choked by ivy. The lamps were gone although the pedestals were still just about visible. By the outbreak of World War I, only the main entrance remained: two tall flint-built towers with battlements on top and a similar archway over the gates, wide enough to get a carriage through, but that was soon to disappear.

SEE Margate/ Parks/ Theatre Royal/ Tivoli Park Avenue

TIVOLI PARK AVENUE, Westbrook

The remains of a Roman villa were discovered near the tennis courts.
The avenue was constructed in 1926 and cut through the old Tivoli gardens. The whole area now known as Tivoli Park was donated to Margate Corporation.

SEE Margate/ Tivoli Park/ Westbrook

TIVOLI ROAD, Margate

In the 1890s a Mr Perkins kept his bathing machines at Frog Farm, Tivoli.
On Wednesday, 13th June 1917, 22 German Gotha planes set off to bomb London. As they got to North Foreland, one of them - and I do not know why, a diversionary tactic perhaps, the pilot didn't fancy flying all the way to London, or maybe memories of a disappointing holiday in Margate; whatever the cause, - left his mates and attacked Margate, dropping four, possibly five, bombs, each weighing 50kg. They damaged about one hundred homes in the Tivoli Road area but amazingly, just four people were injured.

SEE Alexandra Philanthropic Homes/ Bathing machines/ Farms/ Margate/ Princess of Wales pub/ World War I

TOBACCO

There are mixtures of tobacco called 'Esoterica Margate Pipe Tobacco' and 'Esoterica Ramsgate Pipe Tobacco'.

SEE Five Tuns/ Landy, Jimmy/ Margate/ Ramsgate/ Smuggler's Leap/ Tartar Frigate/ Wills, WD&HO/ Wills, Sir Henry

TOLL GATE KIOSK, Ramsgate

It was built in the 1870s as the entrance to the Victoria Gardens and was where you paid a fee to enter. In later years it has been used to sell ice creams. It was restored in 2000 and is now called the Toll Gate Kiosk.

SEE East Cliff Promenade, Ramsgate/ Ramsgate

TOMSON and WOTTON

Records of the brewery date back to 1554 and refer to '*a piece of land on the road of our Lord the King and our Lady Queen*' – the latter of the two at the time was Mary Tudor who was married to King Philip of Spain.
The date shown on the company's trademark centuries later, 1634, was the year that '*the brewhouse, the malt house and a dwelling house*' were sold for £299.
It was not until 1680 that Thomas Tomson (descended from the Richard Tomson who was responsible for ransoming the Spanish) took over a small brewery and farm at the end of Queen Street.
From c1710-1810, the owners of the brewery were Deputies of the Villa of Ramsgate under the Cinque Port of Sandwich – Deputies were effectively the local government of the time.
In 1854, Thomas Wotton joined and the firm bought the Cannon brewery in 1876.
In 1927, they formed a wine and spirit company and in 1931 added a soft drinks company. The number of licensed premises passed the one hundred mark when they amalgamated with Gardner's Brewery in Ash.
The county's oldest brewery, Tomson & Wotton at Queen Street, was bought by Whitbread for £1,000,000 in May 1968 and the brewery closed at the end of that summer. The equipment was removed in September and the site sold in February 1969 for £80,000. After 300 years of being a brewery, the site became a Waitrose supermarket.
There are tunnels that run for about 200 metres from the site into Elms Avenue.

SEE Admiral Fox public house/ Breweries/ Cannon Road/ Cinque Ports/ Crown & Sceptre/ Elms public house/ Farms/ Flag and Whistle public house/ Fox, Rear Admiral/ Horse and Groom public house/ La Belle Alliance Square/ Lord Nelson public house/ Marina Bathing Pool/ Obelisk/ Ozonic Mineral Water Co/ Phoenix public house/ Queen Street, Ramsgate/ Ramsgate/ Red Lion, Stonar/ Royal Albion Hotel, Margate/ Royal Victoria Theatre & Pav advert/ Sandwich/ Sportsman Inn/ Tunnels, Ramsgate/ Waitrose

TOM THUMB

'General' Tom Thumb and his equally small wife were a huge hit when they performed at the Theatre Royal in Margate in 1865.
SEE Theatre Royal

TOM THUMB THEATRE
Eastern Esplanade, Cliftonville

Built as a coach house in 1896, it was derelict for many years before a former theatrical agent, Lesley Parr-Byrne, and her daughter, Sarah, bought it and converted it into a tiny Victorian theatre called the Tom Thumb Theatre. It can seat 60 and its stage is ten feet by seven feet - which is about the size of two double beds pushed together - and it claims to be the smallest in the world. Sarah Parr Byrne was Miss Broadstairs in 1978 and appeared in the James Bond film 'Moonraker' and on TV in 'Are You Being Served' and 'Don't Wait Up'.

SEE Broadstairs/ Cliftonville/ Eastern Esplanade, Cliftonville/ Moonraker/ Theatre Royal

'TOM TIDDLER'S GROUND'
by Charles Dickens

A Christmas story from 'All the Year Round', a magazine edited by Dickens, in 1861.

Miss Pupford's assistant with the Parisian accent, may be regarded as in some sort an inspired lady, for she never conversed with a Parisian, and was never out of England - except once in the pleasure-boat Lively, in the foreign waters that ebb and flow two miles off Margate at high water.

SEE Books/ Dickens, Charles/ Margate

Mrs TONNA

Chambers' Book of Days 1869: *It is quite possible to be an author and have one's books sold by thousands, and yet only attain a limited and sectional fame. Such was Mrs. Tonna's case. We remember overhearing a conversation between a young lady and a gentleman of almost encyclopaedic information, in which a book by Charlotte Elizabeth was mentioned.*
'*Charlotte Elizabeth!' Exclaimed he; 'who is Charlotte Elizabeth?'*
'*Don't you know Charlotte Elizabeth?' rejoined she; 'the writer of so many very nice books.' She was amazed at his ignorance, and probably estimated his acquirements at a much lower rate afterwards.*
'*Charlotte Elizabeth,' Miss Browne, Mrs Pelhan, finally Mrs. Tonna, was the daughter of the rector of St. Giles, Norwich, and was born in that city on the 1st of October 1790.*

As soon as she could read she became an indiscriminate devourer of books, and when yet a child, once read herself blind for a season. Her favourite volume was Fox's Martyrs, and its spirit may be said to have become her spirit. Shortly after her father's death, she entered into an unhappy marriage with one Captain Pelhan, whose regiment she accompanied to Canada for three years. On her return, she settled on her husband's estate in Kilkenny, and mingling with the peasantry, she came to the conclusion that all their miseries sprang out of their religion. She thereon commenced to write tracts and tales illustrative of that conviction, which attracted the notice and favour of the Orange party, with whom she cordially identified herself.

As her writings became remunerative, her husband laid claim to the proceeds, and to preserve them from sequestration, she assumed the name of 'Charlotte Elizabeth.' Her life henceforward is merely a tale of unceasing literary activity. Having become totally deaf, her days were spent between her desk and her garden. In the editorship of magazines, and in a host of publications, she advocated her religious and Protestant principles with a fervour which it would not be unjust to designate as, occasionally at least, fanatical.

In 1837, Captain Pelhan died, and in 1841 she formed a happier union with Mr Tonna, which terminated with her death at Ramsgate on the 12th of July 1846. Mrs Tonna had a handsome countenance and in its radiance of intelligence and kindliness, a stranger would never imagine that he was in the presence of one whose religion and politics, theoretically, were those of the days of Elizabeth rather than of Victoria, and who was capable of saying in all earnestness, as she once did say to a young Protestant Irish lady of our acquaintance, on their being introduced to each other, 'Well, my dear, I hope you hate the Papists!'
SEE **Authors**/ Ramsgate

J (John) L (Laurence) TOOLE
Born London, 1830
Died Brighton 1906
Charles Dickens encouraged him to take up a career on the stage, and he later played the part of Bob Cratchit in 'A Christmas Carol' (1859). He could probably have been a very good serious actor, but the public loved him in farce. Clement Scott said he was *'one of the kindest and most genial men who ever drew breath. No one acted with more spirit or enjoyed so thoroughly the mere pleasure of acting.'*
He appeared at Margate's Theatre Royal.
SEE Actors/ Dickens/ Charles/ Scott, Clement/ Theatre Royal

TOPSPOT
When Dreamland's ballroom was refurbished in 1973 (it took 2 months, £30,000, 3 miles of cable and almost 2,000 stage lights for various effects) it was renamed The Topspot and lived up to its name for around the next four years. The first night it opened saw Georgie Fame in concert and The Tremeloes on the following night. Some of the bands who subsequently played here were Slade, The Drifters, Marmalade, Suzi Quatro, Alvin Stardust and Bill Haley and the Comets.
'Topspot', a film made by Tracey Emin, was named after the old ballroom and shown on BBC3 during Christmas 2004. It was largely shot on location in Margate and was made for the cinema. However, Emin subsequently withdrew it in protest at the 18-certificate it was given.
SEE Dreamland/ Emin, Tracey/ Films/ Margate/ Squash Club

TOWN HALL BUILDING
Market Street, Margate
It was built in 1820. The ground floor became the police station in 1858. Today it houses the Margate Museum.
SEE Margate/ Old Margate/ Police, Ramsgate

TOWN HALL BUILDING/ CINEMA
St Mildreds Road, Westgate
The large Swiss Gothic building in St Mildred's Road that currently includes the Carlton Cinema was originally built as the Town Hall and opened in March 1910 complete with a rock maple floor for roller skating. Sir William Ingram, the millionaire owner of the London Illustrated News and also the inventor of the rotary printing press, built the building for use as office space and a concert hall for the parochial council He even put their name on a plaque at the front and offered the place to them for a peppercorn rent, but they refused his offer! The next day the plaque came down.
Ingram had an art gallery installed here to show his paintings and, at one point, there was even a rifle range!
SEE Carlton Cinema/ St Mildreds Road, Westgate/ Westgate-on-Sea

TOWN MILL, Margate
This windmill was close to St Johns Church, Margate and is first shown on a 1719 map. It was demolished some time before 1900.
SEE Margate/ St John's Church/ Windmills

TOWN OF RAMSGATE public house
Wapping, London
When Ramsgate fishermen took their catch directly to London, they often did their business deals in a seventeenth century public house at Wapping Old Stairs, before taking the fish onto Billingsgate market. It is still there, called the Town of Ramsgate, at 62 Wapping High Street and has a huge mirror depicting a scene of Ramsgate Harbour engraved on it.
Judge Jeffreys (born 15th May 1648 – died 18th April 1689) was James II's unpopular Lord Chancellor and got the nickname of the 'Hanging Judge' because of his severity in political cases, notably in 1683 in his dealings with the accused in the trial of the Rye House Plot; an assassination attempt against Charles II and the Duke of York. He was arrested at this pub, disguised as a seaman, in December 1688 as he tried to avoid William III's troops and escape abroad. He was taken to the Tower of London where he tried to commit suicide by drinking himself to death. He lived, but apparently could eat nothing but poached eggs for months. It's not funny.
Convicts were also held in the cellars while they awaited transportation to Australia.
SEE Harbour, Ramsgate/ London/ Pubs/ Ramsgate/ Transportation/ William III

Mary TOWNLEY nee Gosling
Born 1753
Died 19th March 1839
The wife of Charles, they had eight children; two girls and six boys, but the oldest and youngest boys predeceased their parents.
She was one of the country's first female architects having studied with Sir Joshua Reynolds and designed Townley House.
SEE Roya Crescent/ Royal Road/ Townley House

TOWNLEY CASTLE, Ramsgate
It is now gone (Chatham House's newer annexe now stands on the plot), but stood opposite Townley House and was used as accommodation for guests. In the early 1900s, an Eastern Prince lived there and caused quite a stir in the town with his large entourage of servants and elephants! Previously the area was a barracks during the Napoleonic Wars.
SEE Chatham House School/ Napoleonic Wars/ Ramsgate

TOWNLEY CASTLE SCHOOL
Ramsgate
Townley Castle was built over the road from Townley House as accomodation for the Townley's guests. Major Faussett bought the place in 1824. When he died in 1832 his niece, who was married to Captain Glass became the new owner. It later became a school but this closed at the outbreak of World War I. It was demolished in 1920/1.
SEE Canadian Military Hospital/ Chatham House School/ Ramsgate/ Schools

TOWNLEY HOUSE
Chatham Street, Ramsgate
It was the home of the Townleys, designed by Mrs Townley and built in 1792.
Princess Victoria stayed here as a child, and William IV was a regular guest of the Townleys. The croquet lawn was opposite Chatham House's top entrance.
Townley House later became a school run by Miss J Kennett, daughter of the first Mayor of Ramsgate, John Kennett.
Townley House was going to be demolished but for the influence of the Ramsgate Society, and the restoration undertaken by Mr H Farley. It became Townley Mansions after being turned into five flats.
SEE Chatham Street/ Farleys/ Ramsgate/ Townley, Mary/ Victoria/ William IV

TOWNLEY STREET, Ramsgate
Originally, this area was used as stabling for the troops involved in the Napoleonic Wars. Some of the houses were originally built for the officers.
SEE Napoleonic Wars/ Ramsgate/ Townley, Mary/ West Cliff Tavern

TRAFALGAR HOTEL

THE 'TRAFALGAR' FAMILY HOTEL.
Royal Road, West Cliff, Ramsgate (Two
minutes from Tram and Grand Promenade)
GRAND BOWLING GREEN,
Finest in Thanet, Free to Visitors.
GARAGE. Hotel tariff strictly moderate.
Proprietor: J A Wright
(From Crown Hotel, Sarre)
SEE Garages/ Hotels/ Ramsgate/ Royal Road

TRAFFIC JAMS

During the 1930s, there were long traffic tailbacks of day trippers on summer evenings through Westgate and Birchington for two reasons; firstly, the Thanet Way and M2 did not then exist and the Canterbury Road was not big enough to take the volume of traffic; and secondly - and you may find this a little difficult to believe – the Margate magistrates insisted that all coach parties, and there were loads of them, had to leave the town by 6pm, when the pubs opened - in case they spent too much money presumably. Nowadays we can't bus them in, never mind ask them to leave early!
SEE Birchington/ Margate/ Transport/ Westgate-on-Sea

TRAMS

Thanet's trams began their journeys from Garlinge, and the tram shed together with the tram rails are still visible today, is located next to the site of the old Westbrook Day Hospital. Sixteen trams could be garaged inside this shed but no tram has been in there since 1937. The building was once used as an electricity substation. In 2005 there was talk of replacing the building with flats.

The tramway system was engineered and built by a Mr Murphy from Ireland – honestly - and opened in 1899 running from here to Margate via Marine Drive, past the Winter Gardens, along part of Northdown Road then through Northdown and across farmland to Broadstairs and then onto Ramsgate. The first tram to Ramsgate ran on 3rd April 1901 when, due to problems with the power, only eight of the trams could run. The first Easter weekend saw 9,000 fares taken; tickets cost a penny a mile, although there was a lot of fare dodging – wouldn't happen now obviously.
On 6th July that year, all the lines were open along with another service which operated from Broadstairs to Ramsgate Harbour.

During the summer season, the maroon and cream coloured cars started running at 5:30 in the morning and continued every 20 minutes until 9.30; then every 10 minutes until 11.30 am when the service ran every few minutes until midnight.
The last tram in Thanet, car number 20, ran on 24th March 1937 with a band playing on board as it travelled and each town's mayor driving the tram through their respective towns.
SEE Broadstairs/ East Kent road Car Co/ Electric Tramways and Lighting Company Ltd, The IoT/ Farms/ Garlinge/ Harbour, Ramsgate/ Madeira Walk/ Margate/ Marine Drive/ Northdown Road/ Ramsgate/ Transport/ Westbrook

TRANSPORT

SEE Bicycle/ Broughton, Lord/ Char-a-bancs/ East Kent Bus Co/ Hoverport/ Husbands' Boat/ Kent International Airport/ Kent Cyclists Territorial force/ Loop/ Manston Airport/ Passengers by Sea/ Railway/ Ramsgate Airport/ Roads in Thanet/ Ships/ Sloops/ Stagecoach/ Steam Packets/ Thames Steam Yacht/ Thanet/ Times, The/ Traffic jams/ Trams

TRANSPORTATION

In the days of transportation of criminals to Australia, convict ships often called in at Ramsgate which was their last port of call in England. If they returned home the convicts faced the death penalty, so Ramsgate was often the last sight they had of their homeland. Obviously the prisoners did not come ashore, and they probably did not get much of a chance to look out the portholes either.
SEE Australia/ Captain/Swing/ Fry, Elizabeth/ Gouger's windmills/ Lawrence, Carver/ Ramsgate/ Town of Ramsgate public house

TREASURE HUNT

Sarre, Sarre Windmill and Quex Park all featured in an edition of the gameshow in 2002. Dermot Murnaghan was the programme's host and Suzi Perry was in the helicopter.
SEE Quex Park/ Sarre/ Sarre Windmill/ Television

TRINITY SQUARE, Broadstairs

The original residents of the square worked for Trinity House. The very small cottage at the end is said to be the second smallest dwelling in England. Originally it was a thatched cottage, but it became a public house called The North Star that was very popular with smugglers. The building burnt down on 22nd July 1909 and No. 5 Trinity Square sits on its old plot.
SEE Broadstairs/ Reading Street

TRINITY SQUARE, Margate

In 1936, the square had a total of twenty-two lodging houses, boarding houses and apartment buildings; two greengrocers, two boot makers, two chimney sweeps and a pub, hotel, newsagent's, butcher, decorator, dressmaker, music dealer, confectioner, dentist, French polisher, builder, electrical engineer, church and a school.
A Gotha raid on the night of 30th September 1917 killed eleven people in Margate after it dropped 13 incendiary bombs and 13 high-

explosive bombs. Mrs Eliza Emptage, the owner of a greengrocer's shop at 82 Trinity Square died when a bomb hit the pavement outside. Her mother suffered two broken legs. Private William Hollins who was standing by the door was also killed. As a result, the top floor of the premises collapsed into the road killing Mr and Mrs Thomas Parker, both 62.
In the early hours of 20th May 1943, one of the German pilots of SKG10, the Fourth Fast Bomber Group, or Gruppe of Schnellkampfgeschwader – if I refer to them again it will be as SKG10! – mistakenly landed his brand new FW190 at Manston airfield because he thought it was St Omer, in France. Don't laugh it was an easy thing to do. The pilot was arrested and the plane was sent down to Boscombe Down where it was incorporated into the RAF's Enemy Aircraft Flight. There is a theory that says the Germans were not as amused as we were about the bungled landing – now I told you not to laugh – and so, on Tuesday 1st June, with no air raid warning, twelve Focke-Wulfs flew across Margate barely above the rooftops, spraying the streets with machine gun fire and dropping fourteen high-explosive bombs in reprisal. Just one minute later they were gone. Even so, the anti-aircraft guns, or ack-ack, on the sea front shot one of them in the fuselage causing him to crash onto a nearby golf course. The pilot died. A second aircraft was brought down at Lydden by Flying Officer I J Davies who had managed to chase it away. The pilot died even though he managed to bale out. The attack on the town had killed ten and seriously injured four people and shops and houses were left damaged. The casualty list would have been higher if children at an infants' school had not been having lunch elsewhere that day. Troops and civilians worked for the next twenty-four hours and the Royal School for the Deaf was turned into a temporary rest centre. Two of the seriously wounded died later that day: John Garland, who was a firewatcher, and Bernard Evans, who was just fourteen years old. Others had a lucky escape; two sisters and their brother saw a bomb come through the first floor of their house bringing down the ceiling and then go out over the front door, bounce in the road and land on the house over the road. Another bomb fell close to Fort Paragon, bounced over some cottages and exploded in Canon Prior's Chapel at Holy Trinity Church that had been there since 1829. It was destroyed beyond repair in the attack. It stood where the car park is now, although it was not until 1959 that the area was completely cleared. The bomb was referred to as 'Bouncing Billy' by locals afterwards.
SEE Boarding houses/ Emin, Tracey/ Gotha raid/ Holy Trinity Church/ Manston Airport/ Margate/ Rose in June pub/ Schools

TRURO LODGE, Ramsgate

Professor Vince built a house in 1799 called Wellington Lodge, at what is the easterly end of Wellington Crescent. He was thought to

be completely mad by the people of Ramsgate for building it so far out of the town! Its garden ran to the cliff top and when Victoria Parade was built in 1862 the road went through the front garden.

It was later the Truro Court Hotel/Truro Lodge Hotel but was demolished after World War II. Homefleet House, built in 1984, now stands on the plot.
SEE Ramsgate/ Wellington Crescent

TRURO ROAD, Ramsgate
SEE Mount Albion House/ Ramsgate

TUCKSHOP MURDER MYSTERY
Next door to a busy soup kitchen, Miss Margery Wren ran a very small general stores in Church Street, Ramsgate (it was converted into a house at a later date) that the pupils of St Georges School referred to, and used as their tuck-shop. She had lived there for fifty years, the last four of which on her own following the death of her sister.

An eleven year-old girl, Ellen Marvel, had been sent down the road by her mother to buy a packet of custard on the afternoon of Saturday, 20th September 1930. When she got there, the door would not open, which was unusual, so she rattled and knocked at the door as well. Eventually Miss Wren opened the door. At the inquest Ellen said, *'She looked terribly ill with blood oozing from under her bonnet and running down her face. Most of the blood seemed to be dry though, When I asked her what had happened she said she had fallen over.'* Ellen got her custard and the correct change, which, considering the severity of Miss Wren's injuries, was surprising. Ellen sprinted home, blurted out her story to her parents and her dad immediately raced to the shop where he found Miss Wren, collapsed on a chair. He ran to the police station in Cavendish Street. The police and the doctor arrived about the same time and Miss Wren was whisked off to hospital where she lay with a policeman at her bedside, ready to take a statement as soon as she came round. Whilst being treated, she told nurses she had fallen and hit her head on some fire tongs but all the medical staff agreed she had been assaulted and was dying.

The local police thought the case important and complex enough to bring in Scotland Yard. On the following Wednesday, Chief Inspector Hambrook (who had been involved in the Sydney Fox case in Margate the previous year) and Detective Sergeant Carson arrived in Ramsgate and went to the scene of the crime. All sorts of theories arose as a result of their interviews. She kept cash in tins all around the premises, so robbery was thought to be the motive, but as plenty of these tins were found with cash still in them this was ruled out. She was going to lend some money to a man in Lowestoft so he could buy a boat but he was never found. A handkerchief marked in ink with the name 'G F Davey' was found on the floor of the shop, but G F Davey was never found. Rumours abounded that she had got hundreds of pounds on the premises and that she owned six houses in London. Suspects as far away as Dover were interviewed. There was even a rumour that it was an illegitimate son who had returned and killed her.

Back at the hospital, Miss Wren was in a bad state and made conflicting and confusing statements to police and medical staff. Very early on the Sunday morning, she kept telling the police that she had fallen after coming over giddy, but about twelve hours later at five o'clock she told them the name of the man who had attacked her. Knowing that she was dying, the vicar was sent for and the sacrament was administered. The police were hopeful that she would make a Dying Declaration, whereby she would state that she knew she was dying and give the events leading up to and including the assault including the name of the man who had assaulted her. Instead she whispered, *'No, I do not wish to make a statement, he tried to borrow ten pounds.'* Shortly after, alone with the matron she whispered, *'I didn't tell them anything did I?'.* When she was asked outright to name him, she just said, *'Let him live in his sins.'*

A distant relative of Miss Wren, and school caretaker, Mr Cook, told reporters, *'I don't think she was the victim of any attack; my view is that she did fall down and I shall stick to that; after all, the Police are only acting on the doctor's evidence and doctors have been known to make mistakes.'* When he got to the inquest, Mr Cook did not repeat any of this and his wife said she was baffled as to how Miss Wren had received her injuries. Mr and Mrs Cook were questioned about the man whom Miss Wren had named and they said he was in business in Kent and had frequently pestered her. The police said that they had interviewed him and were satisfied that he was not involved.

Dr Hardman, the Coroner, told the inquest jury, *'There is no possible doubt that this frail old lady was savagely attacked and murdered by a person she knew but for some reason, known only to her, she refused to name him. Towards the end of her life she was far from coherent and named several persons during her semi-conscious state who could have been responsible for the murder and I am not at all certain that what I heard from several witnesses was entirely truthful. On the other hand, there could have been another person present at the time of the murder as on one occasion during her stay in hospital, she blurted out, 'Stop. Stop. You are hurting me, you are a pair of heartless – You can't take it, you just can't take it.' In addition you must bear in mind that the statements she made in hospital could not be accepted by a Criminal Court as they would be regarded as heresay after the old lady's death. There is no direct evidence to implicate any one person as being the assailant and there is only one verdict you can return.'* The jury returned a verdict of *wilful murder against a person or persons unknown,* without retiring.

The case has never been solved.

SEE Cavendish Street/ Church Street, Ramsgate/ Fox, Sydney/ Murder/ Ramsgate/ St George's School

TUDOR HOUSE
King Street, Margate

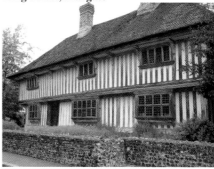

After Salmestone Grange, the Tudor House is the oldest house in Margate and dates back to the late 15th or early 16th century or, in other words, Tudor times, hence the name. When it was built, it was probably a manor house on the banks of the creek which ran down what is now King Street. Back in Roman times, the creek would have been about 150 metres wide and by the 1720s, it was still big enough for small vessels to sail up. An iron bridge over the mouth of the creek was removed by 1809. It is thought that the creek dried up for two reasons: firstly, as Thanet became de-forested, rainfall reduced; and secondly, as the population increased a larger amount of water was removed from the wells that were fed by the springs that had previously fed the Creek directly. Anyway, back to the house. Originally, it had a small entrance hall, with a kitchen on one side and a sitting room with a moulded-plaster ceiling and a frieze of fleur-de-lis and Tudor roses, on the other. The first floor protruded out over the ground floor and there were three main bedrooms with the servants' rooms in the attic above the projecting side wings.

Deeds go back to 1681 when Gregory Philpott was the owner and in his will, dated 1st August 1683, he left the house to his son, Gregory, a mariner.

In 1686, Gregory leased it to Thomas Baker, a cooper, of Margate. By 1711, Gregory has died and his beneficiaries, his wife and daughter, sold it to Valentine Jewell, a grocer *'lately in the occupation of Stephen Baker, and afterwards David Ambrose'.* In a 1743 deed Valentine is described as *'then dead'*, and his widow leases the house to John Sackett, a yeoman of Northdown.

It later passes to William Tibb and in his will in 1750, it is left to his daughter Mary Walton and her children, Robert and John Ladd. It is sold in 1785 by John to Matthias Mummery who leaves it in his will (23rd December 1800) to his wife, Hannah, and then to his son, Matthias.

In 1815, it was split into 3 cottages, involving major alterations. A new front wall was built so that the ground floor walls extended out as far as the first floor rooms. Windows were removed and altered, and the kitchen, sitting room and hall were separated off from each other. Staircases were installed

and the three main bedrooms where divided up

Matthew Eveling was a very poorly young man living in London when two doctors told him he didn't have long to live. One of them suggested moving to Margate as it was healthier. He lodged with Mrs Setterfield in one of the three cottages. Not only did his health improve (he didn't die until he was in his eighties), but so did his finances and he ended up owning the property.

The Corporation bought the neglected property in 1938 but things only got worse when bomb blasts during the war damaged the roof, causing the house to lean into the road,. Thankfully, in 1951, the Mayor, Alderman C B Hosking, took an interest in the building and restoration began. He formed the Beauty of the Borough Committee and under the architect, Mr F M Shea's supervision, at a cost of £4,000, restoration to as near to its original state as possible was achieved.

There is a legend that either William III or George I slept a night here - you wouldn't think that there could be confusion between two kings. Anyway, if it's William III, he stayed the night and travelled to London the next day in a hearse (still alive – if you were worried). The George I story has him stopping off in Margate on the way back from Hanover - he was king over there as well - and this was the only place his servants could find for him to stay, and when his landlady for the night rushed out to meet him she said, *'Oh, Mr King mind the puddle'*. Anyway the next morning all the carriages in Margate were fully booked, even for the King, so he had to travel to London in a hearse pulled by black horses with rope traces. King George was so pleased with his driver Mr Thornton that he commanded his attendance at the palace but Thornton was unsure of the reason why and declined the offer.

SEE George I/ King Street, Margate/ Margate/ Salmestone Grange/ William III

'The TUGGSES OF RAMSGATE'
by Charles Dickens

Short story from 'Sketches by Boz' by Charles Dickens, largely set in Ramsgate and Pegwell Bay.

'What do you think of doing with yourself this morning?' inquired the captain. 'Shall we lunch at Pegwell?'

'I should like that very much indeed,' interposed Mrs. Tuggs. She had never heard of Pegwell; but the word 'lunch' had reached her ears, and it sounded very agreeably.

oOo

. . . 'Hi - hi - hi,' said the boys behind. 'Come up,' expostulated Cymon Tuggs again. 'Hi - hi - hi,' repeated the boys. And whether it was that the animal felt indignant at the tone of Mr. Tuggs's command, or felt alarmed by the noise of the deputy proprietor's boots running behind him; or whether he burned with a noble emulation to outstrip the other donkeys; certain it is that he no sooner heard the second series of 'hi - hi's,' than he started away, with a celerity of pace which jerked

Mr. Cymon's hat off, instantaneously, and carried him to the Pegwell Bay hotel in no time, where he deposited his rider without giving him the trouble of dismounting, by sagaciously pitching him over his head, into the very doorway of the tavern.

SEE Books/ Dickens, Charles/ Donkeys/ Pegwell Bay/ Ramsgate/ Sketches by Boz'

TULIPS

East Kent Times, 6th May 1914: *The tulip fields at Newington, near St Lawrence are one of the sights of Thanet at this time of year. Spring visits have been made to Mr Bull's fields by foreign visitors.*

SEE East Kent Times/ Newington/ Ramsgate

TUNIS ROW, Broadstairs

Albert Cottage and the cottage next to Nelson Cottage date back to when shipbuilding was a local industry.

SEE Broadstairs/ Chippy House/ Shipbuilding

TUNNELS

SEE Britannia/ Cottage/ Crown & Sceptre/ East Cliff Lodge/ Farm Cottage/ First & Last/ Fort Brewery Tap/ Granville Hotel/ Honeysuckle Inn/ London Tavern/ Northern Belle pub/ St Mary's Convalescent Home for Children/ Six Bells/ Smuggling/ Spread Eagle Inn/ Stone Farm/ Tartar Frigate/ Thirty Nine Steps/ Waterloo Steps

TUNNELS, Ramsgate

In what proved to be a brilliant idea prompted by both the inevitability of the Second World War and the fresh-in-the-memory damage done by air raids in World War I – an experience not shared by the whole country due to the lack of distance achievable by the early bombers – a series of tunnels were planned under the town in the late 1930s. Initially, the plan was deferred by the council; then referred to the Home Office who did not approve the idea. The mayor then asked Thanet's MP, Captain H H Balfour, to speak to Sir John Anderson of the Home Office and eventually permission was granted.

Under the direction of the mayor, A B C Kempe 'the top hat mayor', and the borough surveyor, R D Brimmell (who had instigated the idea), the project not only succeeded in providing work for the unemployed (a chronic problem here at that time), but also created shelter and protection from the air-raids of the coming war and, as a bonus, the tunnels could be used as sewers after the war. The first section ran from the harbour up to Queen Street and was opened by Prince George, the Duke of Kent who later came back for a second look at the progress.

There were around fourteen entrances to the tunnels; the first at the western side of Ramsgate Harbour where the tunnel went inland with further tunnels off and entrances at Spencer Square, Liverpool Lawn, Queen Street/Elms Avenue, Ramsgate Hospital and Vale Square. The main tunnel then began its curve eastwards to another entrance at Cannon Road car-park. Here, another tunnel branched off to Ellington Park where there were two separate entrances. The main tunnel continued round to Boundary

Road/Chatham Place, down Boundary Road until a tunnel turned off to an entrance in St George's School. The main tunnel had another entrance at St Lukes recreation ground, then on to Victoria Road, and Victoria Parade until it terminated, aptly at the Railway tunnel adjacent to the old Ramsgate Sands Station. Here another tunnel went off to Dumpton.

The tunnels had many visitors, most notably the Home Secretary, Herbert Morrison, Ernest Brown, the Minister of Health, Miss Ellen Wilkinson MP (she once led the Jarrow March), and Archbishop Cosmo Lang (he visited the tunnels after having dedicated the crypt chapel at St George's Church).

During the Blitz, the tunnels became such a popular place to shelter that a rule had to be made to stop people taking up permanent residence!

On Saturday 24th August 1940 a formation of German bombers were flying across the Channel when a trawler off Ramsgate managed to shoot down its leader. The rest of them then circled Ramsgate and in around three minutes dropped between 250 and 500 high-explosive bombs on the town. A total of 31 people died, 58 were injured and 1200 homes were damaged or destroyed. Thankfully 90% of the population was in the tunnels. Forty-five unexploded bombs were found. In the days following this raid, the Mayor was taken to Manston where he was to 'meet a VIP'. It turned out to be Winston Churchill who went on to compliment the town of Ramsgate on the way it had acted during the blitz and asked to be shown around the town and the tunnels. Churchill had to be shown a 'No Smoking' sign when he lit up one of his trademark cigars, but had the good grace to smile, stub it out and then discard it, prompting a bit of a rush to pick up this sought-after souvenir. It was before the days of Ebay otherwise it would probably have been auctioned off within the hour!

During World War II, over 20,000 people sheltered from the bombs in chalk tunnels.

After the war, one of the Tunnel Railway trains that carried holiday makers to the sands, crashed into the platform, smashing the driver's cab and damaging the carriages. This signalled the end of railway transport in the tunnel. The metal went for scrap, and the sleepers found a new use on the miniature railway at Hythe.

SEE Boundary Road/ Cannon Road/ Churchill, Sir Winston/ East Cliff Lodge/ Dumpton/ Harbour, Ramsgate/ Kempe, A B C/ Manston airfield/ Politics/ Queen Street, Ramsgate/ Ramsgate/ Ramsgate Sands Station/ St George's Church/ Spencer Square/ Victoria Parade/ Warten Road/ World War I/ World War II

J M W TURNER

Born 23rd April 1775
Died 19th December 1851

He was born on St George's Day at his parents' home at 21 Maiden Lane, Covent Garden, London. His father was a barber and wig maker and his mother was a housewife.

He was 11 when he first came to Margate to stay with a fishmonger – a relative of his mother – and attended Thomas Coleman's

234

School on the corner of Love Lane and Hawley Street in Margate from 1785 to 1788 - a blue plaque there commemorates this. A sketch of a Margate street with boats in the sea beyond is one of his earliest surviving works.

A self-taught artist, by the age of fourteen he had begun his lifetime habit of walking up to twenty-five miles a day sketching houses, churches, castles, ruins, trees or landscapes in a 6in x 10in sketchbook. He enrolled at the Royal Academy School in 1789 and the following year his first exhibit was a watercolour. At this point, he specialised in watercolours and sketches but in 1795, he became interested in oil painting and the next year, 'Fishermen at Sea' was hung at the Royal Academy.

When he was 21, he came back to Margate to sketch and paint and fell in love with a former school friend's sister, but whilst off on another sketching tour, she went off with someone else.

In November 1799, when he was twenty four, he was elected an Associate of the Royal Academy of Art and moved from his parents' home to 64 Harley Street London. In 1804, he had a gallery there selling his work.

Amongst all this work, he did find time for some romance. He had already met Mrs Sarah Danby and - her husband having died in 1798 - they became lovers in 1799. They never lived together but he did help to support her children and it is thought that she did bear his first child. As well as being unsocial, Turner was very private so very few details about him are known. The only existing self-portrait dates from when he was 24. He did not like his own appearance and discouraged others from painting his portrait. He was obsessed with his own privacy, and was unwilling to have a conventional family life. Some have linked this to his mother's mental illness. In 1800, when Turner was 25, she was committed to the Bethlehem Hospital for the Insane (Bedlam) where she died in 1804.

The relationship between Turner and his father was a very close one and his passion for art was encouraged by his father from a very young age. His father even sold some of his early work in his barber's shop.

His passion for art took over Turner's whole life leaving him no time for friends, a wife or family, although he did like women - in a sketch book he once wrote, *'There is not a quality or endowment, facility or ability, which is not in a superior degree possesst* (sic) *by women'*. He did make some time for female company and fathered a few children for whom he provided financially. He was also incredibly prolific in his work, producing over 20,000 drawings and paintings in his lifetime which equates to about one per day.

At the ripe old age of 27, the Royal Academy gave Turner full membership in 1802, but his participation was minimal and he failed to show the gratitude that the Academy expected after bestowing on him such an honour. In 1807, Turner was elected Professor of Perspective at the Royal

Academy and would often use the letters 'PP' after his name. He taught this subject here for many years.

A picture entitled 'Margate Harbour' was painted in 1808.

In 1815, he painted 'Dido Building Carthage' and was offered the then huge sum of five thousand guineas (it is a fair sum now) but turned it down and never did sell the painting. When he died, he bequeathed it to the nation.

Possibly because of his volatile nature, he had few friends and was known to have lashed out at his fellow artists. Eugene Delacroix, the French artist, described him as *'Silent, even taciturn, morose at times, close in money matters, shrewd, tasteless, and slovenly in dress'*.

John Constable, the English artist, once sat next to him at a Royal Academy dinner, *'I was a good deal entertained with Turner. I always expected to find him what I did. He was uncouth but has a wonderful range of mind.'*

Richard Redgrave, 1830s: *'His short figure had become corpulent - his face … was unusually red, and a little inclined to blotches, … He generally wore what is called a black dress-coat, which would have been the better for brushing - the sleeves were mostly too long, coming down over his fat and not over-clean hands.'*

Speaking to a young artist, *'What you do not know yet, at your age...is that you ought to paint your impressions.'* and referring to his painting 'Snow Storm', *'I did not paint it to be understood, but I wished to show what such a scene was like.'*

Most Saturdays in 1827 he would travel down by sea from London and lodge with Mr and Mrs Booth at their home in Cold Harbour overlooking the Droit House and the sea.

Letter from Turner to a friend, April 1827: *'What may become of me, I know not, particularly if a lady keep my bed warm and last winter was quite enough to make singles think of doubles. Poor Daddy never felt the cold so much'*.

Turner lived at Sophia Booth's house (she was his landlady and mistress) in Cold Harbour in Margate between 1827 and 1847 and after Mr Booth died in 1833, Turner adopted the name of Booth and lived with Sophia here – off and on, as it were - regularly travelling down on the steam packet from London. He lived with Sophia Booth until his death in 1851.

He drank in all the local pubs. Margate has the rare distinction of having the sun both rise, and set in the sea, which is important to a painter like Turner, and views from Margate Harbour are the subject of over 100 of his paintings.

In 1832, he exhibited 'Fingal's Cave' at the Royal Academy. In later years it was described as *'one of the most perfect expressions of the romanticism style of art'*. It was unsold for thirteen years, but when James Lenox, who bought the painting through a broker, said he was disappointed with his purchase because it was '*indistinct*'

in its execution, Turner's famous reply was, *'You should tell him that indistinctness is my forte.'*

Turner was attracted to nature's violence, whether it was a landscape in the Swiss Alps or a storm at sea and would go to extreme lengths to capture the view, *'I got the sailors to lash me to the mast to observe it; I was lashed for four hours, and I did not expect to escape, but I felt bound to record it, if I did.'*

Once, when he was at Plymouth, he was painting a scene that included a boat with the light behind it when a passing naval officer observed that he had not painted the portholes. Turner said, *'No, of course not. If you climb Mount Edgecumbe and look at the vessels against the light, you'll see that you cannot perceive the portholes'*. The officer replied, *'but you know that the portholes are there?'* To which Turner responded, *'Of course I know that, but my job is to draw what I see, not what I know.'*

At the age of 85, in 1829, Turner's father died. He had given up his barber shop to become Turner's business manager and dealt with both his career and finances. He attended most of the classes that Turner gave at the Academy - some of them were so poorly attended that very often his father was the only one there. Despite his father's age, it was a great blow to Turner who had been close to him all his life; he later said that it felt as though he had lost an only child.

One his most famous paintings 'The Fighting Tameraire' was painted in 1839 when he was aged 64.

Turner travelled on the Great Western Railway train in 1844 which, at 90 mph, was the fastest train in Europe at the time (this was before the days of engineering works, wrong type of snow, etc). During a rain storm, Turner stuck his head out the window for over nine minutes so he could experience the effect of the speed and wind. Thankfully, he chose a stretch without a tunnel. Later that year he exhibited 'Rain, Steam and Speed - The Great Western Railway'.

When the elected President of the Royal Academy was too ill to carry out his duties in July 1845, Turner, as the eldest Academician, was chosen to carry out the duties of President.

In 1846, when he was 71, he bought his first house, and what was to be his last address at 119 Cheyne Walk (although it was 6 Davis Place then) in London. He bought it off Mrs Booth and employed her as his housekeeper. He lived under the name of Mr, or Admiral Booth, and locals naturally thought he was a retired Admiral; the local pubs thought he was impoverished! Well, it probably meant he never had to buy a round. Even Mrs Booth never knew his true identity and had no idea of his wealth, or fame. He built a gallery so that he could watch the sunsets. He let no-one watch him when he painted and stopped going to Royal Academy meetings. Towards the end of his life he existed predominately on a mixture of rum and milk, drinking up to four pints of the stuff a day and he always took a bottle of gin with him when he went out sketching. He would go

weeks, sometimes months, without seeing his friends. After he went missing for many months, his housekeeper eventually found him hiding in a house in Chelsea. He had been very ill and died the next day. His last four paintings were done there and he died there, in a room overlooking the Thames, on 19th December 1851. Shortly before his death he said, *'It is through these eyes, closed forever at the bottom of the tomb, that generations as yet unborn will see nature.'* His last words were *'The sun is God'* although some more devout think he said *'The Son is God'*. The doctor who attended wrote, *'Just before 9 am the sun burst forth and shown directly on him with that brilliancy which he loved to gaze on. He died without a groan.'*

At his own request, he was buried at St Paul's Cathedral and that is where you will find his statue, next to Sir Joshua Reynolds tomb, with these words:

'In habit as he lived' and wrought,
And listened as sweet nature taught,
Turner in simple guise
Upon a rock observant stands;
He pauses as the scene expands
In splendor to his eyes;
Then glancing o'er the land, the sea,
Sets his creative fancy free.
And as the sculptor's lofty reach
Aspires in metaphor to teach,
Thus, in immortal stone,
MacDowell's ready wit suggests
The rock on which great
Turner rests Unshackled and alone.

For a man with very few friends, there was quite a crowd at his funeral.

There were two main provisions in Turner's will. Firstly, he wanted his personal property, valued at nearly £140,000 to be sold and a charitable institution for 'Poor and Decayed Male Artists born in England and of English Parents only and lawful issue' set up. This bequest was hindered by his next of kin on a legal technicality and they were enabled to inherit the entire property. Secondly, he wanted his pictures, sketches and drawings that remained in his studio to be bequeathed to the nation and to be kept together in a special gallery built for the purpose. Well, of course, it did not get built, and after ten years - you can't rush these things - the entire collection of 19,000 drawings and watercolours, and 250 unfinished pictures and oil sketches; otherwise known as the 'Turner Bequest', was put in the charge of the National Gallery. For years, the National Gallery exhibited a small selection of pictures, the Tate Gallery displayed a large selection of the oil paintings, and the British Museum the watercolours and drawings. To celebrate the bi-centenary of his birth in the 1970s, The Royal Academy put on a hugely successful exhibition of his work. Pressure increased for a gallery devoted to Turner's work and in 1987 the Clore Gallery opened on the Tate's Millbank site. It became Tate Britain and houses the entire Turner Bequest. He left 119 Cheyne Walk in London to Mrs Booth. Curiously, years later in 1923, fifteen year-old Ian Fleming lived at 119 Cheyne

Walk with his mother, many years before he wrote the James Bond novels. He was still there when he used the place as a very convenient pied-a-terre for the stockbroker man about town that he became in his late twenties. At number 16 Cheyne Walk, lived Rossetti from 1862 while he was mourning his wife, Elizabeth Siddal. It is strange how one street in London should have connections with two such famous artists with Thanet connections.

Turner often used to depart from Margate when he visited Europe and over 100 of his works, including 30 of the larger canvases stem from his time in Margate where he sketched and developed many of his sea studies. In 1982 at auction in Sotheby's his painting 'Off Margate' fetched £14,000.

He painted two views of Ramsgate Harbour. The first, in the Southern Coast series, shows a view looking into the harbour and the second, painted years later in the Harbours of England series (published posthumously in 1856), shows a brig leaving the harbour. Both paintings include the lighthouse. 'Off Ramsgate' (1840) shows the hulk of a ship off Goodwin Sands.

SEE Artists/ Coleman's School/ Fleming, Ian/ Goodwin Sands/ Harbour, Margate/ Harbour, Ramsgate/ Hawley Street/ Margate/ Ramsgate/ Rossetti/ Sunsets/ Ye Foy Boat Inn

TURNER STREET, Ramsgate

SEE One way system/ Pointer/ Priestley's Cycle & Machine Stores/ Ramsgate/ Umbrella makers

Mark TWAIN

He is alleged to have said about Broadstairs that, *'I could not recommend a finer place for a holiday'*. Although he did live for a time in London, I can find no record of him coming here, but that's not to say . . .

SEE Authors/ Broadstairs/ Rhodes, Cecil

The TWELVE NAILS

This was a mysterious group that met at The Princess of Wales pub in Margate. Just before World War I, a local businessman had a very successful day at the races and pretty much won on every race that he bet on. As he left, the weight of all that money caused him to trip, and looking down, he saw that he had tripped over a horseshoe. It inspired him to start an organisation to do discreet charitable work, and as there were twelve holes for nails on the horseshoe he decided to find eleven other businessmen to form the organisation - although, as they had not won at the races, they may not have been as enthusiastic about the project when he initially approached them.

SEE Margate/ Princess of Wales pub

TWINNING

Margate is twinned with Les Mureaux in France, Idar Oberstein in Germany and Yalta (Ukraine) in the Black Sea. There is no truth in the rumour that it also has a suicide pact with Ramsgate.

Ramsgate is twinned with Conflans-Sainte-Honorine in France, Chimay in Belgium and Frederikssund in Denmark.

Birchington is twinned with la Chapelle d`armentieres in north-west France.

Broadstairs is twinned with Wattignies in northern France.

SEE Birchington/ Denmark/ Margate/ Ramsgate

Wat TYLER
Born unknown
Died 15th June 1381

As part of the rebellion led by Wat Tyler in 1381, Thanet rebels stormed William Menham's house at Manston. He was a tax gatherer for Kent and they destroyed his records. This was a very bad thing to do. Yes it was.

SEE Captain Swing/ Manston/ Thanet

TYRREL'S FARM
High Street, Garlinge

During flooding that followed torrential rain in 1973, a thousand chickens died at Tyrrel's Farm at the top of Garlinge High Street.

SEE Farms/ Flooding/ Garlinge/ High Street, Garlinge

Sir Garrard TYRWHITT-DRAKE
Born 1881
Died 1964

He was mayor of Maidstone twelve times, but also had a travelling show comprising a menagerie and a 'jungle'. It performed in Margate as part of its tour and ten wagons would roll into town full of 'beasts', camels and a large monkey cage.

SEE Entertainers/ Margate

U

U-BOAT

In World War I, three Ramsgate drifters were attacked by U-boat 48, but managed to force the German vessel onto the Goodwin Sands, where she was wrecked. For many years, a gun taken from the U-boat was on display at Nelson Crescent.

East Kent Times, 14th August 1918: *Ramsgate's first war trophy was fixed in the ornamental gardens in Nelson Crescent, West Cliff, this morning. At this present moment we are unable to give full details of the trophy. Sufficient to say that the gun is of fairly heavy calibre, and that its capture was only secured by the heroic conduct of HM Forces.*

SEE East Kent Times/ Goodwin Sands/ Nelson Crescent/ Ramsgate/ Ships/ Woodward, James/ World War I

UMBRELLA MAKER

Robert Collins was an umbrella maker at 54 Queen Street in Ramsgate in 1840 and at 3 York Street, Ramsgate, was another umbrella maker, J A Melen, who was also a hairdresser and an agent for Globe Parcel Express.

W White was an umbrella maker at 4 Turner Street, Ramsgate in 1895 as was Edward Durrant at 58 High Street, St Lawrence.

At number 61 Rancorn Road, Westbrook in 1936, lived Dan Clark junior, who was an umbrella repairer.

Not a career many school leavers are taking up these days, but there is probably a university degree in it somewhere that you can take.

SEE High Street, St Lawrence/ Queen Street, Ramsgate/ Ramsgate/ Turner Street, Ramsgate/ Westbrook/ York Street, Ramsgate

UNCLE BONES

Originally a carpenter, Alfred Bourne, was the seaside entertainer known as Uncle Bones who performed in Minstrel Shows on Margate Sands between 1866 and 1900. His troupe grew from just two members until it had a cast of fifteen, performing three times a day, at 9am, 3pm and 9pm. They had no stage or covering against the weather and would stand in a semi-circle with the children of the audience sitting on the sand in front of them (children loved him – he could even get them to sneeze in unison on his command) and adults sitting on deckchairs behind. There was a lot of audience participation - particularly with the children - riddles, jokes - corny but clean; banjos twanging, tambourines clanking and jangling, and bones rattling and a Mr Interlocutor who would be the straight man and butt of the troupe's jokes; as well as popular songs of the day – 'Come to Martha' was a favourite. So that nobody enjoyed the show for free, a tin or bottle was passed round to collect money; this was known as bottling. People did not always put in money. Jewellery and cigars were sometimes given and Uncle Bones reckoned he had enough French coins to pay for a holiday there.

His troupe, the Royal Margate Minstrels, also played The Prince of Wales Theatre in London.

Alfred Bones lodged with Mrs Berrling at Buckingham Road. When he was found dead in his room here in 1928, they also found this poem:

I was twenty when it struck me
To black my face and hands
To Broadstairs off to sally
And play upon the sands

I bought a concertina
With three bob all I had
But I brought back six for mother
My first not too bad

For forty years in Margate
With young and old I have grown
My games and songs are up to date
This Margate is my own

My little ones around me stand
Still listen to the tone
As when my old friends on the sand
First dubbed me Uncle Bones

Even the great P G Wodehouse mentions him in his writings. What greater honour could a man have asked for?

'The Swoop – How Clarence Saved England' by P G Wodehouse (1909): *In this crisis the trippers of Margate behaved well.*

The Mounted Infantry, on donkeys, headed by Uncle Bones, did much execution.
SEE Broadstairs/ Buckingham Road/ Donkeys/ Entertainers/ Margate/ Poems

UNCLE FRANK

In the 1930s on Margate's seafront, Uncle Frank advertised himself as England's heaviest man. You paid him a penny (an old penny that is) if he guessed your weight correctly, and there was a set of scales there to settle any argument. If his own weight was a reflection of the profit he made, then he was very successful.
SEE Beach entertainment/ Entertainers/ Margate

UNCLE MAC

His real name was James Henry Summerson. He started his theatrical career with G H MacDermott (1845-1901) who was billed as 'The Statesman of the Halls', and was well known for risqué, sensational and political songs which were thought to influence public opinion. Consequently, many music hall managers were reluctant to employ him. When James was seven years old he used to recite the popular ballad The Death of Nelson (*Mourn England mourn, mourn and complain, For the loss of Lord Nelson that died on the main*) whilst sitting on the orchestra rail of the Forester Music Hall in Cambridge East End. MacDermott named him Little Mac, which later became Uncle Mac.

He came to Broadstairs in 1895 with Uncle Godfrey's minstrel troupe that included his friend Fred Hawley. Within a few months, Summerson had joined Uncle Ned's Mohawk Minstrels. These troupes wore baggy costumes and mortar board hats and danced, sang, and played banjos and tambourines. By the early 1900s, he had started his own troupe – Uncle Mac and his Minstrels - and had his own stage by the entrance to the main bay in 1909. With his Minstrels he entertained hundreds on the sands, pier and promenade. In 1911 they were voted the most popular troupe of the British Seaside resorts. Uncle Mac and his minstrels ran singing competitions; one of the winners was a local lad named Frank Muir who sang White Cargo.

After World War I, he held White Nights every Thursday. In World War II, he held fund-raising concerts.

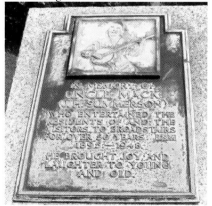

He completed the 1948 season but died of a heart attack in February 1949; his wife died the same year. Apart from the two World

Wars – which we will let him off - Uncle Mac only missed the 1905 season (when Broadstairs Merry Mascots submitted a lower tender to the Broadstairs Pier and Harbour Commissioners) out of the 48 available to him.

The commemorative plaque in the gardens at Victoria Parade reads:
In memory of Uncle Mac (J H Summerson) who entertained the residents of and the visitors to Broadstairs for over 50 years 1895-1948. He brought joy and laughter to young and old.
SEE Broadstairs/ Entertainers/ Muir, Frank/ Nelson/ Victoria Parade/ World War II

UNION CRESCENT, Margate

This crescent was built between 1760 and 1770 originally as *'ten handsome houses for aristocracy and gentry on a road not open to public traffic'* - they should see it now!

Tenants in 1810 included at number 7, Sir Edward Hales; at number 8, Sir Richard Brookes; at number 9, Lord Trunklestown and Sir Horace Mann and at numbers 11 & 12, Lt Col Derby. The third house from the Cecil Square end, was Crescent House, part of Margate College.

At the end of the nineteenth century there were four schools in the street: Crescent Lodge for Ladies; Crescent School for Young Gents at number 12; Ebor House a boarding school for about 7 girls at number 3 (it closed and later re-opened under new ownership) and at number 10 was the Margate and Westgate Government School of Art (a long name for a relatively small school). At number 7 was Clergy Rest a home for adults. At 11 was the Lying in Charity a home for adults.
SEE Forrester's Hall/ Friend to All Nations/ Margate/ Margate College/ Rowe RW/ Schools

UNION SQUARE, Broadstairs

Union Square is named after the 1649 Union of the Commonwealth – Oliver Cromwell had just separated the union of King Charles' body from his head.
SEE Broadstairs/ Five Tons/ Wishing Well

UNITED REFORM CHURCH
(Congregational),
Minnis Road, Birchington

On a piece of land Arthur Haig bought near the coastguard station, he built a wooden church with a slate roof in 1885 using timber from the dismantled Exhibition Building on the Parade. The church was inter-denominational and Mr Haig conducted the services. Farmworkers, men from the local brickworks (at the end of Ingoldsby Road)

and coastguards – who looked after the upkeep of the building – made up the congregation. In 1913 the church joined the Congregational Union and in 1934, following a bequest from the Principal of Woodford House School, Arthur Erlebach, it was replaced by the present brick built-one.
SEE Birchington/ Coastguards/ Churches/ Farms/ Minnis Road

UPPER DUMPTON PARK ROAD
Ramsgate
As a result of the Hurricane Bombardment that occurred on 27th April 1917, Ivy Thorncroft, aged 22, was killed at number 1 Upper Dumpton Park and her sister, Hilda, was very badly wounded. Two years later, she had a 2' piece of shrapnel removed.
SEE Hurricane Bombardment/ Ramsgate

UPTON PRIMARY SCHOOL
Broadstairs
The Holy Trinity Church of England Boys School closed in 1970 with the pupils transferring to Upton Primary School at Edge End Road.
SEE Broadstairs/ Edge End Road, Broadstairs/ Schools

URSULINE COLLEGE, Westgate
The Ursuline Convent in Boulogne dates from 1624, but in 1904, due to anti-clerical laws forcing them out of their convent, the sisters came across the Channel by steamer.
They originally rented four houses in Adrian Square and started a school that soon expanded into the new Hatton House on Canterbury Road, bought by two benefactors for £8,000. Originally most pupils were French.
In the 1920s it was safe for the French nuns to return home. Fortuitously, other nuns from Boulogne who had eventually settled in the West Country bought Hatton House and opened a school with just 23 pupils (6 day girls and 17 boarders).
In 1937, an assembly hall, with classrooms above, and a 4-storey novitiate (where ovices live) were built.
During World War II, the Women's Auxillary Air Force occupied the buildings while the school was evacuated to Berkshire. After their return in 1945, the school gradually went from strength to strength.
In 1979 a small convent was built and Lourdes, an infirmary, was added in 1985.
In 1998, it became co-educational and a new wing, St Ursula's, was added.
Today there are around 775 pupils, just over half of whom are girls.
SEE Schools/ Westgate-on-Sea/ World War I/ World War II

USA
There are three more Margates in the USA; a town in Florida, a town in Maryland and Margate City in New Jersey.
SEE Australia/ Elephant/ Margate/ Newcastle Hill/ Newfoundland/ South Africa

V1 & V2 ROCKETS
The 'V' stood for Vengeance. Also known as 'Buzz bombs' or 'Doodlebugs' they were launched in World War II by the Nazis from France and powered by a jet engine, with a pre-set guidance system. They had a range of around 150 miles, after which the engine cut out, prompting an ominous silence while the missile went into a steep dive, which ended when its 1-tonne high-explosive war head exploded on impact.
The V2 was fuelled by an alcohol/liquid oxygen mixture and was a true ballistic weapon. For the first minute of flight it had a 25,000kg thrust that put it into a trajectory that arched to an altitude of up to 110km and a speed of over a mile a second. The warhead was smaller than the V1 at 730kg, but there was no defence against the V2, except to bomb the mobile launching sites.
The 21st of 130 V2 rockets to land in Kent landed at Birchington at nine minutes past seven in the evening of 11th November 1944.
SEE Birchington/ Manston airfield

VAD HOSPITALS
During World War I there were VAD (Voluntary Aid Detachments), or other voluntary hospitals at the following locations:
Birchington: Beresford Lodge; Fernleigh, Margate Road; Mansford House; Quex Park; Service Club; St Mary's, 3 Beach Avenue; St Saviour's, Minnis Road; The Thicket, Cross Road.
Broadstairs: Beaumont House; Fairfield; Grand Hotel; Overblow House, South Parade; Roseneath; Whittuck Home; Yarrow Home.
Margate: Dunedin, Lewis Avenue, Cliftonville; King's Cliff, Cottage Hospital; Lawn House Sanatorium (convent) Grosvenor Place; Royal Sea Bathing Hospital; The Highlands; Upcott, Surrey Road; Wanstead House; Wavertree, Second Avenue.
Ramsgate: Chatham House School; Hotel St Cloud, Victoria Parade; Granville; Hill House Military Hospital, Minster; Ramsgate Hospital; Royal Sailors' Rest: Nethercourt; Ramsgate General Hospital; St Lawrence College; Townley Castle School.
Westgate-on-Sea: Apsley Rise; Convent des Oiseaux; High Beach; Penrhyn Lodge; St Michael's Home; The Vicarage.
SEE Birchington/ Broadstairs/ Chatham House School/ Cliftonville/ Margate/ Minnis Road/ Minster/ Quex/ Ramsgate/ Ramsgate Hospital/ San Clu/ Schools/ St Lawrence College/ Surrey Road/ Townley Castle School/ Victoria Parade/ Westgate-on-Sea/ World War I

The VALE, Broadstairs
It was once known as The Lynch, or Bradstow Lynch, and was originally a footpath that linked Upton Farm, to what is now, Louisa Bay.
SEE Broadstairs/ Farms/ Louisa Bay

VALE ROAD, Ramsgate
This area on the edge of the Ellington Estate was sold for development in 1866, the building work was completed around a decade later.
SEE Ramsgate/ Vale Tavern, Ramsgate

VALE SQUARE, Ramsgate
A house here used an old Napoleonic cannon as the corner post for a garden fence!
Back in 1822, in the corner of the square near where The Hermitage, a thatched cottage (built in 1818 and the oldest house in the square), stands, there was a footpath that led first to Grange Road, and then onto Southwood; then a separate hamlet.
James Creed Eddels bought a few acres of the area known as The Vale in 1839 and built many large houses that looked out over a garden area.
SEE Christ Church/ Grange Road/ Langtry, Lillie/ Napoleonic Wars/ Ramsgate/ Southwood

VALE TAVERN, Ramsgate
The Vale Tavern was built in 1849 and represented the halfway point between Ramsgate and St Lawrence.
SEE Pubs/ Ramsgate/ St Lawrence area/ Vale Road

Isaac VAN AMBURGH
Born 1800
Died 1868
He was three quarters Dutch and one quarter Cherokee and after successfully touring America with the Titus Menagerie, he arrived in Britain in 1838, and was a huge success – even Queen Victoria was a big fan. She ordered a Command Performance, and even ensured that she had a conversation with Van Amburgh.
He is said to be the first man to have put his head into a lion's mouth. I don't know if it is true or not, but, possibly, he was the first man to get it out again. In his act he was the archetypal lion tamer with top hat and cracking his whip, making a lamb and a lion lay down together and conjuring up images of Eden for the audience - and of takeaway meals for the lion.
His menagerie included a giraffe (said to have been a present from the Pasha of Egypt to King George IV), leopards, tigers, lions and an elephant.
He remained in Britain and toured until around 1848. During this time his show visited Margate with 'his beasts and horses'. Apparently, in the evening he took his elephant down to the sea so that it could bathe. (I hope he had a big pooper-scooper) When the keeper decided that he wanted to leave, the elephant had other ideas and would not budge; it took a boat and forty-five minutes to persuade it. Apparently he was a bit angry for a couple of days. He threw his riders both days and they each suffered

broken bones - I expect the elephant could swim as long as he wanted after that.

A sad postscript to Van Amburgh's story was that in 1883, his daughter was mauled to death in London.

SEE Elephant/ Entertainers/ George IV/ Lion tamer/ Margate/ Victoria

Dame Irene VANBRUGH

Born Exeter 2nd December 1872
Died 30th November 1949

Her stage debut, aged 15, was at Margate in August 1888 playing Phoebe, in 'As You Like It', and then playing Titania. She was mainly a stage actress, appearing in the West End with Sir Henry Irving and J. L. Toole in J. M Barrie's first play, 'Ibsen's Ghost' which opened on 30th May 1891. She created the role of Gwendolen Fairfax in the first performance of Oscar Wilde's 'The Importance of Being Earnest' at the St James's Theatre on 14th February 1895. Her ten films included 'Catherine the Great' (1934 with Douglas Fairbanks Jr, Flora Robson and Gerald du Maurier), 'Wings of the Morning' (1937 with Henry Fonda), and 'Knight without Armour' (1937 with Marlene Dietrich and Robert Donat). For services to the theatre she was made a Dame in 1940.

SEE Actors/ Irving, Sir Henry/ Theatre Royal/ Wilde, Oscar

VAN GOGH public house, Ramsgate

SEE Churchill Tavern/ Pubs/ Ramsgate/ Van Gogh, Vincent

Vincent VAN GOGH

Born 30th March 1853
Died 29th July 1890

In 1876 a 23 year old Vincent Van Gogh wanted to be a Bible teacher and decided to start his teaching career in England. He took a job teaching languages at a private school run by Mr Stokes at 6 Royal Road, Ramsgate, just off Spencer Square, where he taught from 17th April to 12th June. The view from the windows inspired him to take out his pen and ink and sketch them. I suspect that subsequent owners of the building have had the floorboards up a few times in search of any he may have mislaid, so there is not much point going round there now.

When the school moved to Isleworth, re-location costs were not forthcoming, so he walked there via Canterbury and Chatham – it took him three days.

Letter sent to Theo, his brother, from Etten 4th April 1876:

Dear Theo,
On the morning before I left Paris, I received a letter from a schoolmaster in Ramsgate. He proposed that I go there for a month (without salary). At the end of that time he will decide

if I am fit for the position. You can imagine how happy I am to have found something! I will have in any event board and lodging free...

As you know, Ramsgate is a little town by the sea. I saw somewhere that there were 12,000 inhabitants, but I don't know any more about it.

Dear Theo,
I arrived here safely at one o'clock yesterday afternoon, and one of my first impressions was that the window of this not-very-large school looks out on the sea. It is a boarding school, and there are twenty-four boys from ten to fourteen years old. ...Yesterday evening and this morning we all took a walk along the shore. Enclosed is a spray of seaweed.

The houses near the sea are mostly built of yellow brick in the style of those in the Nassaulaan in The Hague, but they are higher and have gardens full of cedars and other dark evergreens. There is a harbour full of ships enclosed by stone jetties on which one can walk. Yesterday everything was gray. ...

The holidays are not yet over, so I have not had to give any lessons so far.

Letter to Theo, Ramsgate 17th April 1876:

Did I tell you about the storm I watched recently? The sea was yellowish, especially near the shore; on the horizon a strip of light, and above it immense dark gray clouds from which the rain poured down in slanting streaks. The wind blew the dust from the little white path on the rocks into the sea and bent the blooming hawthorn bushes and wallflowers that grow on the rocks. To the right were fields of young green corn, and in the distance the town looked like the towns that Albrecht Dürer used to etch. A town with its turrets, mills, slate roofs and houses built in the Gothic style, and below, the harbour between two jetties which project far into the sea. I also saw the sea last Sunday night. Everything was dark and gray, but in the horizon the day began to dawn. It was still very early, but a lark was already singing. So were the nightingales in the gardens near the sea. In the distance shone the light from the lighthouse, the guard ship, etc.

Letter to Theo, Ramsgate 28th April 1876:
Walk to Pegwell Bay:

'Now I am going to tell you about a walk we took yesterday. It was to an inlet of the sea, and the road there led through fields of young corn and along hedges of hawthorn, etc. Once there, we saw to our left a steep two-story-high ridge of sand and stone. On top of it were old gnarled hawthorn bushes – their black and gray moss-covered stems and branches were all bent to one side by the wind; there were also a few elder bushes. The ground we walked on was all covered with big gray stones, chalk and shells. To the right lay the sea as calm as a pond, reflecting the light of the transparent gray sky where the sun was setting. The tide was out and the water very low.'

SEE Artists/ Pegwell Bay/ Ramsgate/ Royal Road/ Schools/ Spencer Square/ Van Gogh pub

VEGETARIAN SOCIETY

Northwood Villa opened as a 'hydropathic infirmary' in 1846 and was the first vegetarian hospital in Britain for people of limited means. At a meeting there, chaired by Joseph Brotherton, MP for Salford, (his wife wrote the first vegetarian cookbook in 1912) on 30th September 1847, the Vegetarian Society was formed and is still going strong.

SEE Northwood

'The VEILED LODGER'
by Sir Arthur Conan Doyle

Published in October 1896 this is the shortest Sherlock Holmes story, at 4,499 words. It not only refers to Sanger but seems to take aspects of his circumstances at Dreamland – a murder, lion tamer, husband and wife etc.. (Leonardo the Strongman drowned there in September 1896.)

They had among their exhibits a very fine North African lion. Sahara King was its name, and it was the habit, both of Ronder and his wife, to give exhibitions inside its cage. Here, you see, is a photograph of the performance by which you will perceive that Ronder was a huge porcine person and that his wife was a very magnificent woman. . .

Ronder, of course, was a household word. He was the rival of Wombwell, and of Sanger, one of the greatest showmen of his day. . .

'But I stood between Leonardo and his fate.'
'And he is dead?'
'He was drowned last month when bathing near Margate. I saw his death in the paper.'

SEE Bathing/ Books/ Doyle, Sir Arthur Conan/ Dreamland/ Margate/ Sanger/ Second Stain, The/ Sherlock Holmes/ Strongman

VERE ROAD, Broadstairs

Cecil Cayzer lived at number 2 in 1936. He was the chauffer/bodyguard of Dr Arthur Tester, the Nazi agent who lived at Kingsgate.

SEE Broadstairs/ Kingsgate/ Tester

Sir Edmund VESTEY

Derek Vestey started out with a family butchery business in Liverpool in the very late part of the nineteenth century. A cold store was opened in London in 1895 and his sons, the Vestey brothers, William (later Sir, and later still, Baron) and Edmund (later Sir), were sent out to the then booming South America to buy game birds, store them in cold stores belonging to American companies and then ship them to Liverpool. Beef was added to the shopping list and soon they owned cattle ranches in Argentina as well as a meat-processing factory in Buenos Aires. On 28th July 1911, they started their own shipping line, the Blue Star Line, to ferry the meat back home. The shipping line ran all over the world carrying passengers as well as freight (it was eventually bought by P&O in 1998 for £60 million). By 1915, the Vestey brothers were earning so much money that they had to move to Buenos Aires to avoid paying income tax. They imported eggs from China and in World War II were the main importer of dried eggs. They bought the Liebig Extract of Meat

Company, which gave them not only the Oxo product but also the Oxo Tower in London. Vestey Brothers grew into The Vestey Group of companies, which included the Dewhurst chain of butcher shops - the first to display meat behind glass. The Dewhurst chain closed in 1995. It is estimated that the current head of the family, William Guy Vestey, is worth around £650million.

Sir Edmund Vestey lived at Thanet Place in Broadstairs.

SEE Broadstairs/ Shops/ Thanet Place/ World War II

VIADUCT, Margate Road, Ramsgate

It was built in 1926 using over 2 million bricks - if you want to do a visual check, please feel free to do so.

On 24th August 1940, in an attempt to destroy the viaduct, the Germans caused major bomb damage to Woodford Avenue - Charles Wesley, aged 16, was killed at number 8.

24th January 1987:

RAIL CARRIAGE SUSPENDED OVER EDGE OF MARGATE ROAD VIADUCT

On Monday night a rail carriage came close to plunging sixty feet from the viaduct in Margate Road. There have been several similar incidents on the same stretch of line in the past. Police evacuated people from their homes after the train went through the brick wall and balanced sixty feet in the air. The train was being shunted up a siding but did not stop, crashed through the buffers, came off the rail and went through the wall ending up suspended from the viaduct. The carriage's bogey, the buffers and tons of brickwork crashed into the goods yard below.

29th January 1993: *In the early hours of yesterday morning a train ploughed through buffers and a wall finishing up hanging eighty feet above gardens near the Margate Road viaduct. Frightened residents in Margate Road had been promised, after a previous incident, that an accident would never happen at the viaduct again. The Health and Safety Executive were called to investigate and found serious deficiencies in the management of shunting activities within the maintenance depot.*

SEE Margate Road, Ramsgate/ Railway/ Ramsgate

Queen VICTORIA

Born 24th May 1819
Died 22nd January 1901

'England's Queen Victoria' is an anagram of 'Governs a nice quiet land' - a handful of useless facts like these, an anorak and a nerdy voice and you will never need to share a seat on public transport again. In case that is not enough though, you can tell people that there were eight assassination attempts on her life; in 1840, 3 in 1842, in 1849, 1850 and, just when she thought she was safe, in 1872 and in 1882.

As a young Princess Victoria, she once gave a few pennies to a blind beggar in Margate.

Back in 1835 she had come ashore at the steps on the East Pier in Ramsgate, and asked for the red carpet that had been put out for her use to be removed so that she could climb them like anyone else. The steps were then re-named Victoria Steps. She and her party which included her mum, her lady-in-waiting, former governess Louise Lehzen and Conroy, her mum's personal advisor, whom Victoria hated, stayed at the Albion Hotel from Monday 28th September. The next day, with thousands out to greet them, the town decorated in flags and bunting and guns saluting them, King Leopold and his wife, Queen Louise, arrived in the town. The royal party watched the ship sail in from the windows of the Albion Hotel. Leopold and Louise arrived at the hotel where Victoria was overjoyed to meet her uncle again after a gap of four years.

'What a happiness it was for me to throw myself in the arms of that dearest of uncles, who has always been to me like a father, and who I love so very dearly.' Victoria's journal, 29th September 1835

When Leopold and Louise departed for Belgium on 7th October, they left from Dover and Victoria went to see them off. On the way back she collapsed in the carriage and when they returned to the hotel, her personal physician, Dr James Clark, was sent for from London. However, it was the Friday before he arrived and, satisfied she was alright, he left the same day. On the Tuesday, Victoria had a terrible fever and Lehzen was nursing her. The next day Victoria was delirious and Dr Clark was called back again although Lehzen had called in a local doctor, Dr Plenderleath, to the immense annoyance of Conroy.

Queen Victoria and Prince Albert visited the Albion Hotel in Ramsgate on 24th November 1842, on a day trip up from Walmer Castle where they were staying. They had a walk along the East Pier - it was a wild and windy day, if you were wondering.

SEE Addington Street, Ramsgate/ Adelaide/ Albion House, Ramsgate/ All Saints Church, Birchington/ Bellevue Tavern, Pegwell/ Belmont House/ Bournes Dept Store/ Brunswick, Duke & Duchess/ Callis Court/ Chatham House School/ Clock Tower/ Corelli, Marie/ Disraeli/ Friend to all Nations/ Hospital/ Frith, William Powell/ Gladstone/ Holy Trinity Church, Broadstairs/ Hospital/ Jubilee Clock Tower, The/ Leopold/ London Road/ Louise Alberta, Princess/ Margate/ Montefiore, Sir Moses/ Pierremont Hall/ Ramsgate/ Royal Victoria Pavilion/ Royal Yacht/ Royalty/ St George's Church/ St Laurence Church/ St Mary's Convalescent Home for Children/ Sanger family/ Snelling, Joss/ Townley House, Ramsgate/ Van Amburgh, Isaac/ Warre/ William IV

VICTORIA HOME for INVALID CHILDREN

SEE Westbrook Day Hospital/ Victoria

VICTORIA HOTEL, Ramsgate

Victoria Hotel, Hardres Street
National Telephone No 10. Telegrams:
'Victoria, Ramsgate'
First class temperance, family and commercial.
Central position. Night porter.
Mrs J C Weeks, manageress
Advertisement c1900

SEE Hardres Street, Ramsgate/ Hotels/ Ramsgate

The VICTORIA public house
Ramsgate Road, Margate

The pub, named after Queen Victoria, at 104 Ramsgate Road was opened by the Thompson Brewery of Deal in 1885. The pub was almost demolished in the 1950s but the then owners, Charrington, managed to successfully oppose the plan to have a roundabout installed at this junction.

SEE Breweries/ Margate/ Pubs/ Ramsgate Road, Margate/ Victoria

VICTORIA PARADE, Broadstairs

SEE Andersons Café/ Bandstand, Broadstairs/ Betsey Trotwood/ Broadstairs/ Carlton Hotel/ Charles Dickens Pub/ Dickens House/ Morelli's/ Uncle Mac/ VAD Hospitals/ Victoria

VICTORIA PARADE, Ramsgate

The road was built in 1862 and the buildings at numbers 3, 4 and 5 were designed by Edward Pugin, and are now Grade II listed.

SEE Coastguard Station/ Granville Hotel/ Listed buildings/ Ramsgate/ San Clu Hotel/ Tunnels, Ramsgate/ Victoria/ VAD Hospitals/ Wellington Crescent

VICTORIA STEPS, Ramsgate

When Princess Victoria visited Ramsgate with her mother, the Duchess of Kent, in the 1830s, she came ashore up the steps at the East Pier. The steps were subsequently named Victoria Steps. Since then, the name has changed to Dover Steps, although no one seems to know why!

SEE Ramsgate/ Victoria

VIKING BAY, Broadstairs

This bay is around 150 metres wide and is connected to Louisa Bay via a promenade.

In 1949 the Main Bay at Broadstairs was re-named Viking Bay after the commemorative (it being 1500 years since the landing of Hengist and Horsa) landing of a Viking ship.

SEE Broadstairs/ Hengist and Horsa/ Hugin/ Jubilee Clock Tower/ Percy, Major/ Promenades/ Sky Sports/ Vikings/ Waterloo Steps

The VIKING COASTAL TRAIL

This 28-mile long cycle track that goes around Thanet is used by 40,000 cyclists each year according to the automated counters that are dotted between Westgate and Ramsgate. That is about one every 12 minutes during daylight! They must form little groups because I rarely see them! I wonder what the ghosts of those long-dead Viking warriors would make of having a cycle track named after them!

SEE Bicycles/ Ramsgate/ Thanet/ Westgate-on-Sea

VIKINGS

Vikings make their first appearance in British history in 789AD although serious attacks did not occur until 838AD. The poor old Isle of Sheppey was attacked in 835AD. Vikings spent the winter of 850AD in Thanet.

SEE Hugin/ Minster Abbey/ Reculver/ St John's Church/ Sally the Viking Line/ Sarre/ Sheltering Tree/ Southwood/ Sword of Ganelon/ Thanet

Julius VOGEL

Born London 24th February 1835
Died East Molesey, 12th March 1899
He boarded at a Jewish school in Ramsgate between the ages of around twelve and fourteen. At different times in his life he was a journalist, writer, politician and the prime minister of New Zealand from April 1873 to July 1875 and again briefly in 1876 (February to August). For three of the seven years he was in power, he was out of the country making two trips to Britain and three to Australia. He also visited the United States.

SEE New Zealand/ Politics/ Ramsgate/ Schools

Captain VON RINTELEN

He was a German spy trying to return home from America on a neutral ship in 1915 when he was captured en route and brought into Ramsgate Harbour by the patrol boat. He later wrote a book called 'The Dark Invader – Wartime Reminiscences of a German Naval Intelligence Officer' that is still in print today.

SEE Harbour, Ramsgate/ Ramsgate

Captain John C VOSS

Born Germany or Denmark, 1858 or 1861
Died 1922
If you are a big film producer and need an idea for a film, what about the story of Captain John (Jack to his friends) Voss? It takes a while but there is a connection to Thanet.

To put his story into context, Voss was inspired by Joshua Slocum (born Nova Scotia 20th February 1844 - 1909) who had rebuilt Spray, a 37ft sloop, from a derelict hull, and at the age of 51, left Boston, USA, on 24th April 1895 and sailed 46,000 miles around the world single-handed. He was the first person to do so and returned to Newport, Rhode Island on 27th June 1898 to fame and fortune. His book, 'Sailing Alone Around the World', became an instant best seller. Arthur Ransome said that, '*boys who do not like this book ought to be drowned at once*'. (In the autumn of 1909 Slocum set off for South America but was never seen again.)

All of this had an impact on John Voss, a professional sailor, who had gone to sea in old square riggers at the age of 19, had been involved in smuggling, sealing, gold prospecting in British Columbia, Nicaragua and Colorado and at this point co-owned a hotel in Victoria.

Norman Kenny Luxton (born 2nd November 1876 Winnipeg, Canada) a slightly-built man who had worked at an Indian agency in Winnipeg, was now working at the Vancouver Sun newspaper. At some point, he and Voss met and between them came up with this adventure. Luxton wanted to write about an adventure but had never sailed; Voss had the seafaring skills to pull it off and Luxton's writings would finance the journey. Luxton described Voss as a hardened seaman, aggressive, provocative and full of bravado, who was subject to black and violent moods when drinking; of which he did a lot.

Voss bought Tilikum (Indian for 'friend'), a red cedar dug-out canoe (thirty eight feet long including the native figure-head, by five feet, that, once fully loaded, only drew 24 inches) on Vancouver Island for $80 from an Nootka Indian, whom he had softened up '*with a drop of old rye*'. He bought it primarily because he wanted to out-do Slocum and circle the globe in an even smaller vessel, and he knew that an unusual one would attract more publicity. He built up the sides by seven inches and fitted it out with a 5ft x 8ft cabin, a cockpit for the helmsman, a small keel weighed down with 300lb of lead, and three short masts with 230 square feet of sail. In two galvanized iron tanks under the cockpit there was a hundred gallons of fresh water. There was three months' supply of tinned goods and a sextant, chronometer, barometer, camera, two rifles, and a double-barrel shotgun.

On 27th May 1901, Voss and Luxton set sail from Oak Bay, Victoria, British Columbia. Well, Luxton was in the cabin sleeping off a hangover after attending an all-night dance at the Palace Hotel and unbeknown to him Voss had had to register the boat as the Pelican to avoid the U.S. Coast Guard – something about drug smuggling and illegal Chinese labour! Within ten miles of the start, the boat began to leak and they had to beach it, by which time Luxton had woken up. Somehow they got on their way again but it was not until 6th July that they really got sailing down the west coast of America. However, within 25 miles, on the way to Pitcairn Island, they were surrounded by a school of whales that threatened to crush the Tilikum. Surviving gales and storms, they had covered 4,000 miles when they arrived at Penrhyn Island on 1st September. They had a huge row because Voss was convinced that the natives would not be friendly and he wanted to continue on to Samoa. But they landed anyway and had an eventful stay. Luxton just about avoided marrying a local princess and Voss later told how two young 'princesses' attended them to wish them bon voyage before they departed for Samoa. It must have been awful. They had another huge row on the voyage during which Voss threatened to throw Luxton overboard. Luxton took a gun and locked Voss in the cabin until they reached Apia where they seemed to have made up and enjoyed their stay, particularly Luxton. He got involved with a Sadie Thompson who asked him to manage her store. He described her as having '*legs like mutton and breasts like huge cabbages*' - the old romantic.

Before they left, Luxton took Voss to a local store where he read a statement in front of a witness, Mr Swan, describing the previous row, stating that if he went missing between Samoa and Australia, Mr. Swan was to take such action as was necessary to make Voss prove he had not killed Luxton.

They continued their journey and along the way met with natives who swam out and demanded tobacco; they were warned off landing on Tonga for fear of being eaten and needed to fire a cannon that they happened to have on board to repel an attack from natives in catamarans. They were then shipwrecked on a reef, where Luxton, who woke up covered in cuts and bruises, claimed he had been left for dead. The boat was patched up and they limped on arriving on 17th October at Suva Harbour in Fiji. Luxton had had enough and took a steamer on to Sydney, Australia.

After Voss met Walter Begent in a bar at Suva, Luxton warned Begent about Voss's character and told him to dump the booze that was on board. During the next passage, Voss claimed that Begent got washed overboard in a storm, taking the only compass with him. Luxton claimed that he later accused Voss of killing Begent in a drunken fight.

Luxton met up with Voss in Sydney to make various public appearances across Australia, but not until after Voss had been hospitalised for some weeks suffering from exposure and the 'sickness he contracted through the women on the islands'.

The two went their separate ways in Melbourne, never to meet again. Luxton went back to Canada, married and started a trading post, tourist, haberdashery and taxidermist shop called 'The Sign of the Goat Trading Post' in Banff. He died on 26th October 1962.

In time, Voss made it to Hobart, Tasmania where he met Begent's sister, Jemima Clay, who apparently bore him no ill-will.

Voss went on to New Zealand, where he gave lectures and met up with Horace Buckridge, fresh from Captain Scott's South Pole expedition, who joined him as mate for a while. He left New Zealand on 17th August 1902 and headed, with another crew member, MacMillan, a refined well-educated man, to the New Hebrides and the Great Barrier Reef, Indian Ocean and on to Durban, South Africa. MacMillan was replaced and Voss and the new recruit set off for St Helena and then Brazil where they stayed for two weeks, leaving on 4th June 1904 for the Azores and then England.

After sailing 40,000 miles over three oceans Voss arrived with, by now, his tenth different crew member – and here comes the Thanet connection:

The westerly breeze kept fresh and the Tilikum sailed through the English Channel, passing one lighthouse after another until on on 2nd September [1904], at four o'clock, with a very light breeze we rounded the jetty at Margate, where thousands of people crowded to watch our approach. When we were within speaking distance a voice from the jetty called out, 'Where are you from?'

'Victoria, British Columbia,' was my reply.

'How long have you been on the voyage?' the questioner enquired.

'Three years, three months, and twelve days!'

A loud applause followed. When we were inside we tied the Tilikum up to a fishing vessel called the Sunbeam. Thereupon I stepped on the jetty and at once became very busy shaking hands. While this was going on I suddenly felt myself lifted from the ground. Some gentlemen had got hold of me from behind and carried me over the heads of the cheering crowds, finally dropping me into a carriage. We soon arrived at a hotel, where our successful arrival from the long voyage was celebrated with champagne. '40,000 Miles in a Canoe' by John C Voss (and still in print)

In England he became a bit of a celebrity for a while and was elected to the Royal Geographical Society.

Voss went back to British Columbia and in 1907 sold his share in the hotel. He went to Japan to work in the sealing industry until this industry was made illegal for 15 years from 1911.

In 1912 he planned a world cruise in The Sea Queen, but a typhoon ended that voyage. Voss died, on 27th February 1922 in Tracy, California of pneumonia.

The Tilikum was exhibited at Earls Court in 1905 and then went through various owners until it was discovered in disrepair in the Thames in 1929. It was then sent out to Canada and can be seen today in the Maritime Museum in Victoria, British Columbia.
SEE Denmark/ Harbour, Margate/ Margate/ Ships/ New Zealand

VYE and SON
At one time Vye and Son were the major grocery stores within Thanet.
When Ramsgate Harbour was being built, much of the stone was brought up from the Isle of Purbeck in Dorset. The moderately wealthy Vye family from Dorset was involved in this business and Sarah Vye moved to Ramsgate from Dorset in 1814, and later opened, with the help of a King Street grocer, Mr Ramnell, a tea-packing store in Queen Street on 1st June 1817. Until the law was abolished in 1835, shops had to buy all tea from the East India Company or pay a £100 fine. From 1835 the age of the tea clippers began.
The business grew, and grew, and er grew. They had 47 branches all across Kent including 11 in Thanet.
They had a warehouse in Archway Road. The Ramsgate branch was the first shop in Ramsgate to have electric lighting.
In 1932 the silver Vye Cup was awarded to the winer of the annual international Thanet Air Race.
In 1957, their shops are listed in Broadstairs at 20 & 22 High Street; 1 & 3 Church Street, St Peter's; 36 Percy Avenue, King Street; and a stores at Thanet Road.
Eventually the chain was sold to Lipton's supermarkets in 1970.
SEE Broadstairs/ Church Street, St Peter's/ Harbour, Ramsgate/ High Street, St Peter's/ King Street, Ramsgate/ Queen Street, Ramsgate/ Ramsgate/ St Peter's/ Shops

VYE and SON – Queen Street, Ramsgate
The premises of Vye and Son were destroyed in air raids on Saturday 24th August 1940 and again on 4th January 1941.
In the 1940 raid over 100 aircraft flew over Ramsgate at around 10 o'clock in the morning dropping over 500 bombs on the town. The gas works and area around Margate Road and Camden Square were badly damaged. Members of the Auxiliary Fire Service had the double danger of trying to fight the fires and avoid machine gun fire from the aircraft.
A total of 29 civilians and 2 soldiers died, 10 people were seriously injured and another 49 were slightly injured.
Another bomb landed on the Vye site in 1941 killing Clara Gladys Kay (of 6 Effingham Street).
The Queen Street site of Vye and Son grocers is now 66 McCarthy & Stone retirement flats (opened 2004). There was a local competition to come up with a suitable name for the flats.
SEE Margate Road, Ramsgate/ Queen Street, Ramsgate/ Ramsgate/ Shops

VYE BROTHERS, Ramsgate
Advertisement c1900:
VYE BROTHERS – Home and Colonial Outfitters.
44 Queen Street
Hosiers, Hatters, Tailors and Shirt Makers.
The 'Royal Spa' Raincoats – Newest materials and styles.
Speciality: JUVENILE SUITS, Choice Designs.
Mens suits to measure, 30/-, 34/6, 42/6, 52/-, 62/-.
SEE Queen Street, Ramsgate/ Ramsgate/ Shops

W D & H O Wills
Henry Overton Wills (1761-1826) was a partner in a tobacco business in Bristol. He had two sons, William Day Wills (1797-1865), and Henry Overton Wills (1800-1871) whose names were reflected in the company's name of W D & H O Wills. Their Woodbine cigarette first appeared in 1888 and by the turn of the century it was the biggest cigarette manufacturer in the country.
SEE East Court/ Tobacco/ Wills, Sir William Henry

W H SMITH & SON
Henry Walton Smith was a London Custom House official who opened a newsagents in Mayfair in 1792 and introduced the equivalent of a paper round that he called a 'newswalk'. Unfortunately, that same year, he died, aged 54. His wife kept the business going until she died in 1816, when their younger son, William Henry Smith took it over along with his elder brother, Henry Edward Smith. William was the dominant

partner and the partnership dissolved in 1828 with William continuing the business as a stationers and wholesale newsagents. When his son, who shared the same name, reached 21 in 1846, the firm became W H Smith & Son. It was the son who was responsible for the famous railway bookstalls, the first being at Euston in 1848.
The old Cliftonville branch of W H Smith, now an empty shop at 182 Northdown Road, still has the old tiled sign there, albeit covered in white paint.
SEE Cliftonville/ Northdown Road/ Shops

Miss WAGRAM
She was a dancer who had what was described as an '*indelicate*' style. When she appeared at the Theatre Royal, Margate, in 1816, the management said that they would not be inviting her back! Today she would be a reality TV star.
SEE Entertainers/ Theatre Royal

Louis WAIN
Born London 1860
Died Napsbury Hospital 4th June 1939
Louis was born with a cleft lip, was very often ill, had terrible nightmares and was prone to wander the streets of London on his own as a child. The Westgate newspaper magnate, Sir William Ingram, employed him on The Illustrated London News. In 1884 aged 24, he got married to a woman 10 years his senior, who was also his youngest sister's governess. His mother did not approve and there was a major falling out between them. Just three years later his new wife died of cancer. Whilst she was in bed, Louis had amused her by doing drawings of her cat, Peter, in various poses and situations. When his boss, Sir William, got to see them, he immediately asked Louis to do a two-page spread depicting a cats' Christmas Party for the forthcoming December issue. It was a huge success. Sir William offered Louis' family a home in Adrian Square, Westgate, in 1894 and the rift was healed as Louis, his mum and five sisters (Caroline, Josephine, Marie, Claire and Felicie) moved in. At first, Louis was thought of locally as an eccentric. He would dance on the top of tables, both at home and at friend's houses; he would often turn up in white tie and tails at the Westgate Tennis Club and go into a dance routine; his four cats, Peter, Bigit, Minna and Leo, would follow him as he danced along the seafront; when he came back from business trips to London, he would get off at Margate and dance all the way home – well we've all done that haven't we? – No? OK, just me and Louis then.
Meanwhile, Wain's drawings of cats were everywhere. You could find them playing golf on a mug, smoking cigars in adverts, playing cards in books, dressing up in any costume you can think of (well, nearly any costume for those of you with too vivid an imagination) in collectable cards. They even became popular in the USA where Wain went for a tour in 1907, taking a job at one point with the New York Journal. It must have been a successful tour because he was

still there when his mother died in 1910 (she is buried in the Catholic section of Margate Cemetery).

The next few years were not good for Louis; in 1913 his sister Marie died in the Kent Lunatic Asylum; World War I meant a paper shortage and the public had become less interested in comical cats. Westgate had an influx of military personnel to the seaplane base on the seafront. As Wain's financial circumstances plunged, his schizophrenia worsened. In 1917, he and his four remaining sisters returned to London.

In 1925, Louis was a pauper and entered a lunatic asylum himself, where he remained until his death 14 years later. During these years, he continued to draw his cats, but strangely they too became madder-looking as his mental health deteriorated. They started with wider, madder eyes but then became more jagged around the edges, and eventually became almost psychedelic. The books written about his mental health show the difference in his pictures to illustrate his decline, but they describe the early ones with cats folding their arms, dressing up, or playing games, as 'normal'!
SEE Adrian Square, Westgate/ Artists/ Cemetery, Margate/ Westgate-on-Sea

Arthur WAITE

Born 2nd October 1857
Died 19th May 1942
Originally from New York, Arthur came to Britain as a young boy and developed a great interest and authority on the occult, mysticism, alchemy and even freemasonry, writing over sixty books on these subjects, many of which are still available. He is best-remembered for creating the 78-card Rider-Waite Tarot deck, as opposed to the 22-card packs. Illustrated by Pamela Colman Smith, the cards first appeared in 1910.

A very affable man with long white hair, he lived at one point at Betsy Cottage in Stone Road, Broadstairs.
SEE Authors/ Broadstairs/ Stone Road

WAITROSE, Queen Street, Ramsgate

Wallace Wyndham Waite (1881-1971) and Arthur Rose (1881-1949) were two grocery store assistants in London, who opened their own store at 263 Acton Hill, West London in 1904 with a third colleague, David Taylor (who left soon afterwards). By 1914 they had 25 stores. The business was acquired by the John Lewis Partnership in 1937 and the first Waitrose supermarket opened in 1955. Now there are over 140 stores employing 27,000 people.
SEE Queen Street, Ramsgate/ Ramsgate/ Shops/ Tomson and Wotton

WALCHEREN EXPEDITION

In July 1809, under the command of the Earl of Chatham, 40,000 troops left on 35 ships, escorted by 200 transports, from Ramsgate – what a sight that must have been – to sail to Holland and Belgium to destroy Napoleon's Antwerp naval base. They took Flushing, on the island of Walcheren off south west Holland, but unfortunately, they took so long that they gave the enemy a chance to re-inforce. They got no further and consequently suffered heavy losses, not just military casualties but also from malaria caught from the mosquitoes that infested the area. After Chatham left behind a garrison of 15,000 men on Walcheren Island, 7,000 died of malaria. The expedition achieved nothing.

Great Chatham with his sabre drawn
Stood waiting for Sir Richard Strachan;
Sir Richard, longing to be at 'em,
Stood waiting for the Earl of Chatham.
Anon

In December of that year they returned to Ramsgate where scores more soldiers died from the disease, many of whom were buried behind St Laurence Church.
SEE Harbour, Ramsgate/ Napoleonic Wars/ Ramsgate/ St Laurence Church

Jeremiah WALKER

He had been highly praised for his efforts in saving the crew of the Northern Belle when, in 1859, as part of the crew of the lugger 'Petrel' they rescued the crew of Julia, a Spanish vessel. He became the first man to receive medals from two different countries for the same rescue when Queen Donna Isabella II of Spain authorised a medal for him.
SEE Northern Belle

WALKWAY DISASTER, Ramsgate

In Thanet's worst peacetime disaster six people died and seven were seriously injured around 1am on Wednesday 14th September 1994 when the boarding walkway, built only eight months previously, to the 29,000-ton Prins Filip ferry to Ostend collapsed as the last passenger boarded, catapulting the thirteen people in the covered walkway forward, as the other end crashed down 40ft to a floating concrete pontoon below, resulting in what eye witnesses described as bodies 'piled up, tangled with each other'.
SEE Harbour, Ramsgate/ Ramsgate

Barnes WALLIS

Born Ripley, Derbs. 26th September 1887
Died 30th October 1979.
The son of a doctor, Neville Barnes Wallis was born, ironically considering his future achievements, sixteen years before man's first flight. He left school at 16 and became a marine engineer apprentice. At 26, he joined Vickers in their airship design department and was responsible for the design of the R100 airship. When the R101 crashed, killing all 48 crew in 1930, airships were understandably thought to be too dangerous and they immediately became a thing of the past.

In the 1930s, he invented the Geodetic form of aircraft design and included it in the Wellesley aircraft which gained the world's non-stop distance record of 7,158 miles in 1938. The Wellington Bomber which had a huge coil that could detonate magnetic mines from the air, was also designed by Wallis and became an integral part of RAF Bomber Command in the war. If this was not enough, the design of the ten-tonne Grand Slam and five-tonne Tallboy bombs were his inventions as well. These used a spin to enable them to penetrate through reinforced concrete several metres thick, deep into buildings before exploding. The RAF used them to great effect to blow up U-boat pens - they were used to destroy the Tirpitz, a battleship that had been causing major problems to allied shipping whilst it sheltered in a Norwegian fjord.

After the war, Wallis worked successfully for the British Aircraft Corporation being heavily involved in the development of variable geometry aircraft, sometimes known as 'swing-wing'.

He was knighted in 1968, having already been awarded the CBE in 1943, prior to the Dambusters raid.
SEE Bouncing Bomb/ Dambusters/ Gibson, Guy

WALPOLE BAY, Cliftonville

A German Gotha was brought down in Walpole Bay on 22nd August 1917; two of the three crewmen died and the third was picked up by HMS Kestrel.

The three-sided bathing pool that is open on the side nearest to the cliff was officially opened in 1937 (at the same time as the pool in front of the Sun Deck) to enable people to bathe in sea water without having a long walk when the tide was out. It took 150 men working day and night, because of the tides, using 6,000 tons of inter-connecting concrete blocks that were put onto solid chalk foundations. Standing on the side nearest to the cliff, and with four bathing belles courtesy of Bobby's department store to add a bit of glamour next to him, the mayor said, *'Margate has always been in the van for bathing. The clear water is changed twice twenty four hours. I hope it will provide added means for increasing the happiness and abundant health for the many who will use them year by year'.*

In 1953, it was estimated that 6,000 herrings were trapped in the bathing pool after the pool had been drained for maintenance work. Many free dinners were had that week by the locals.
SEE Bathing/ Bays/ Bobby's department store/ Cemetery, Margate/ Chatham House School/ Cliftonville/ Gotha/ Hengrove/ Margate/ Military Road, Ramsgate/ Picton Road, Ramsgate/ Sun Deck

WALPOLE BAY HOTEL, Cliftonville

It was built by Louisa Budge in 1914 and remained in the Budge family until 1995 when the present owners took over.

The hotel retains many original features and there is a museum incorporated within.

Tracey Emin held part of her 40th birthday party here. Amongst the guests were the model Kate Moss and the designers Stella MacCartney, Vivienne Westwood and Laurence Llewelyn-Bowen.
SEE Cliftonville/ Emin, Tracey/ Hotels/ Moss, Kate

WANTSUM CHANNEL

The Venerable Bede AD 597: *'Thanet is separated from the mainland by a waterway about three furlongs* (about a third of a mile) *broad called the Wantsum, which joins the*

sea at either end and is fordable only in two places.'

These days, the Wantsum Channel is a small stream but is still the western boundary of the Isle of Thanet. In Roman times and through the Anglo Saxon times, it was broad and up to 13 metres deep and the double tides met at Sarre. Not only Roman galleys but also Viking longboats sailed through, some more friendly than others. A ferry ran from the mainland to Thanet. Opposite Sarre was the estuary of the River Stour hence the name of the village of Stourmouth today.

The high tide covered large areas of salt marsh on both sides of the channel which from the eleventh-century onwards was gradually drained and early sea walls were built to protect it. Only a narrow channel with two high sea walls protecting the land from the high tides remained of the great channel by the thirteenth-century. Coinciding with man's attempt to reclaim the land was Mother Nature silting up the channel as well, which caused - and here is a nice bit of irony - man-made channels to be dug to facilitate shipping once more up the channel. The first channel was the work of the Archbishop of Canterbury, John Morton, in the late fifteenth century, which ran from Sarre to Northmouth, known as New Stour or nowadays as Little Stour, from near Wickambreaux to Plucks Gutter in 1582. The channel had narrowed so much that by 1485 the ferry was replaced by a bridge. Back in its heyday Sarre was a limb of the Cinque Ports through Sandwich.

SEE Bede, Venerable/ Cinque Ports/ Hengist & Horsa/ Parker, Richard/ Reculver/ Richborough/ St Nicholas-at-Wade/ Sandwich/ Sarre/ Sarre bridge/ Sheltering Tree/ Stonar/ Sword of Ganelion/ Thanet

'The WAR OF THE WORLDS'
by H G Wells

Had the Martians aimed only at destruction, they might on Monday have annihilated the entire population of London but also south of the Thames to Deal and Broadstairs, poured the same frantic rout.
SEE Books/ Broadstairs

WARDOUR CLOSE,
Broadstairs

Just off Crofts Place is Wardour Close. David Mason, the owner of the Cherry Blossom Shoe Shine Company, once lived at The Maisonette.
SEE Broadstairs/ Mason, David

Jack WARNER

Born London, 24th October 1896
Died 24th May 1981
His real name was John Waters, the brother of fellow entertainers Elsie and Doris Waters, and he was an actor in film and television. The 1947 Gainsborough film 'Holiday Camp' saw him as the dad in the the Huggetts family. Three more films were made in 1950s involving the Huggetts - one was partly filmed in Broadstairs – as well as a radio series. Warner played a nasty piece of work in the 1948 film 'My Brother's Keeper', and PC Dixon who was murdered

in the film 'The Blue Lamp' (1950), but the character was somehow resurrected in 1955 for the long-running Saturday night television series 'Dixon of Dock Green', which was opened and closed with Dixon talking direct to camera 'Evening all'. It ran until 1976.

Prior to all this, he had been a big star in variety reciting self written works as 'A fumper and flattener of fevvers', 'A caster up of alabaster plaster', 'Bunger-up o' rat-'oles', 'The turkish bath attendant', 'A poker in o' peas for p'licemen's whistles', 'A slapper-up o' shapeless sloppy slippers', 'A fly exterminator at the fish shop', 'A do'er-up o' dirty, damaged door-knobs', 'A rubber-up and rounder-off o' rissoles', 'The chap who chops the chillis', 'A puller-out o' bee-stings', 'A whelk uncurler in a fish bar', 'A ladder holder-upper for a painter', 'The man who fans the females', 'A posher-up o' poodles', 'The bloke that puts the cuck in cuckoo clocks', 'I didn' orta a ett it!', 'If i'd only put an 'x' instead of '1''.

His catchphrase in Garrison Theatre during World War II was, 'Mind my bike!'
SEE Actors/ Broadstairs/ Entertainers/ Belle Vue Tavern/ Hanley, Jimmy/ World War II

WARRE AVENUE, Ramsgate

This avenue is named after the Warre family. Thaneholme in Warre Avenue was built to the highest standards by Cecil Banting. After he died in 1949, and before his body was removed, the house was robbed and vandalised throughout. His widow was understandably upset by this and left the house fully-furnished and unoccupied for fifteen years. Although she returned to the town – she thought the sea air did her good - she never went back to the house. It became known as the 'House of Secrets' and was a bit of a local mystery. Eventually, the contents were auctioned off for £1,800 in 1964.
SEE Warre family

WARRE family

Queen Victoria stayed with the Warre family in St Lawrence when she was a young girl.
SEE Holy Trinity Church, Ramsgate/ London Road/ Pegwell Bay/ Ramsgate/ Ramsgate FC/ St Laurence Church, Ramsgate/ Victoria/ Warre Avenue

Sir Charles WARREN

Born Bangor, 7th February 1840
Died 1927
He went to school in Cheltenham, and in 1857 he was commissioned in the Royal Engineers, serving in Gibralter (1858-65) surveying the Rock. He went on to serve at Chatham, Jerusalem (1867-70), Dover and Shoeburyness (1871-76), South Africa (1876-79), Chatham (1880-82), Egypt and Arabia Petriea (1882-83), Chatham (1883-84), and Bechuanaland Expedition (1884-85).

The now Colonel Sir Charles Warren was appointed Commissioner of the Metropolitan Police in 1885, a position which he held until he resigned in 1888.

He was given the task of organising much of the 1887 Jubilee celebrations during which it was he who sent in troops to suppress and clear rioters from Trafalgar Square. They opened fire. He also had to deal with the muzzling of dogs, an increase in the number of burglaries and the Jack the Ripper murders in Whitechapel. The public did not hold the police in high esteem at this time, nor did he feel that the Home Secretary was giving him his full support, or even allowing him to do his job properly. He resigned in 1888 but his resignation was not accepted and he carried on until the November when he resigned for good.

He received complimentary letters, from Henry Mathews (the Home Secretary), Salisbury (the Prime Minister), the Prince of Wales and the Duke of Cambridge and his resignation was debated in the House of Commons.

Henry Mathews, House of Commons debate, 14th November 1888: *'Sir Charles was a man not only of the highest character, but of great ability. . . By his vigour and firmness he had restored that confidence in the police which had been shaken after the regrettable incident of 1886. . .Sir Charles Warren had shown conspicuous skill and firmness in putting an end to disorder in the metropolis, and for that he deserves the highest praise.'*

A cartoon in Punch called 'Extremes Meet' showed Sir Charles Warren talking to his predecessor:

Sir Edmund Henderson: 'My dear Warren, you did too much.'
Sir Charles Warren: 'And you, my dear Henderson, did too little.'
Mr Punch: 'H'm! Sorry for the new man.'

He returned to his previous career dealing with the Straits Settlements (1889-94), and serving the Thames District (1895-98).

Finding himself at a bit of a hiatus, he lived at Wellington Crescent, Ramsgate, until his country called on him again and appointed him the Commander of the 5th Division under Sir Redvers Buller. They embarked for South Africa on 25th November 1899, to assist in the relief of Ladysmith. Warren commanded the troops that were involved in the futile attack on Spion Kop in 1900 (The area at Liverpool FC's Anfield ground called The Kop was named after this battle when it was built in 1906, because many of the troops involved were local lads in the 2nd Royal Lancaster Regiment or the 2nd Royal Lancaster Fusiliers). He further fought in the Boer War and returned home in August 1900. By 1905 he had reached the rank of General. Sir Charles Warren died in 1927 at the age of 87.
SEE Jack the Ripper/ Ladysmith, Relief of/ Ramsgate/ Wellington Crescent

WARTEN ROAD,
Ramsgate

A railway tunnel ran between Ramsgate Sands Station to an area behind Warten Road that had a 1 in 75 gradient along its 1,640 yard length.
SEE Ramsgate/ Tunnels, Ramsgate

WARWICK ROAD, Cliftonville

In 1936 there were 16 boarding houses, 6 apartment buildings and 2 lodging houses listed here.
SEE Boarding houses/ Cliftonville

E G WASTALL

Ernest Wastall opened the Thanet Brewery on the East Cliff in 1851, with the expensive Pale Ale - using the best barley - a speciality. The brewery supplied public houses as far out as St Nicholas and Sarre and in 1890, they opened offices opposite Cliff Street in Queen Street, Ramsgate. Behind the offices, in Archway Road, was their warehouse, with a spirit store, bottle store and a sample room – calm yourself. Wastall's made three whiskies called Lifeboat, Two Anchor and Three Anchor and they also made mineral waters under the brand name of Marble.
They also claimed to be the first company to use electricity in their premises.
SEE Breweries/ Cottage/ Queen Street, Ramsgate/ Ramsgate

'WASTE LAND' by T S Eliot

This was partly written in Margate.
SEE Books/ Eliot, T S/ Margate

Battle of WATERLOO 1815

British and Prussian troops under Wellington and Blucher beat the French under Napoleon. The battle took place near Waterloo, a village, now a town, in the centre of Belgium. (The name Waterloo comes from the Flemish 'water' and 'loo' meaning sacred wood.)
Ten thousand soldiers left through Ramsgate on the way to the Battle of Waterloo.
SEE Battles/ Blucher/ Eagle House/ Hawley Street/ La Belle Alliance/ Napoleonic Wars/ Percy, Major Henry/ Plains of Waterloo/ Prussia/ Quex Park/ Ramsgate/ Sacketts Hill Farm/ Waterloo Place/ Wellesley/ Wellington

WATERLOO STEPS, Broadstairs

A stairway-come-tunnel through the chalk, now gone, at Broadstairs seafront. It stood approximately near where the lift is now.
SEE Broadstairs/ Tunnels/ Viking Bay/ Waterloo

WATT

'The inhabitants of Margate ought to eulogize the name of Watt, as the founder of their good fortune; and Steam vessels as the harbingers of their prosperity' Unknown 1820
SEE Margate/ Ships

WEATHER

Thanet towns have coastlines facing three different directions; Margate faces north and is in an almost direct line to the North Pole (alright, I know if you go directly north you will clip East Anglia). Consequently, Thanet can experience some harsh weather conditions in the winter months. It can seem to have its own climate, as the rest of the county sometimes has completely different weather. In fact some go so far as saying that it is like a different planet here, hence the 'Planet-Thanet' nickname – I think that is the reason.

In June 1795, sixty newly-shorn sheep died of cold at St Nicholas - and we moan about summers now!
In June 1989 no rain fell on Margate. Back in 1921, Margate had 236mm (9.29inches) making it the driest ever year in Kent - and nobody mentioned global warming.
'When England wrings, the Island sings.'
This old rhyme about Thanet refers to how low the rainfall is here.
In October 1939, 261mm (10.28 inches) of rain fell – an inch more than in the whole of 1921.
SEE Blizzard/ Great Storm/ Hot weather/ Hurricane/ Margate/ Pegwell Bay/ Pancake ice/ Storms/ Thanet/ Thunderstorm

WEED

As in unwanted plant, not the other sort – just what sort of a book do you think this is?
SEE Thanet Weed

Kurt WEILL

Born 1900
Died 1950
He wrote the song 'Die Muschel von Margate (Petroleum Song)'.
SEE Margate/ Music

WELCH

High Street, Ramsgate

Ramsgate by J S Rochard, c1900:
Mr F H WELCH, Grocer
53 High Street
Originally founded by Mr Emmerson about 35 years ago the premises occupies an advantageous situation on the corner of the High Street and Hardres Street. The interior is divided up into grocery and provision sides, a special department also being provided for the sale of bottled wines and spirits and cigar. Mr Welch also offers an Apartments Register used by those seeking rooms and having rooms to let.
SEE High Street, Ramsgate/ Ramsgate/ Shops

WELLDEN

High Street, Ramsgate

Advertisement, c1900:
Geo. Wellden, The Tailor,
40 High Street next the post office
High class tailoring in all its branches.
Liveries, ladies' garments etc.
Agent for Henry Heath's silk and felt hats.
Shirt tailoring.
Hosiery and gloves by best makers.
No pains are spared to ensure satisfaction of all orders entrusted to me.
Regd. Specialities:- 'Sea serge' and 'N B Tweeds'
SEE High Street, Ramsgate/ Ramsgate/ Shops

Sam WELLER

When writing 'The Pickwick Papers', it is said that Charles Dickens named his character Sam Weller after a hatter at 35 Queen Street in Ramsgate. However, other, more convincing, theories are available.
SEE Dickens, Charles/ Pickwick Papers/ Ramsgate/ Queen Street, Ramsgate

WELLESLEY HOUSE SCHOOL

Situated on the corner of Gladstone Road and Bromstone Road, Broadstairs, it was established in 1899/1900.
An early headmaster, Leonard J Moon, played football for the Corinthians and cricket for England against South Africa in 1905. He joined the Devonshire Regiment in 1914 and died two years later at Salonika.
In 1969 the school merged with St Peter's Preparatory School, and a new building was built to accommodate the increase in numbers. The new school was opened by Princess Alice, Duchess of Gloucester, whose two sons Princes William and Richard were pupils here. She lived to the ripe old age of 102. The present Duke of Gloucester opened the new computer suite in 1999.
Lord Lichfield, Mike d'Abo, Lord Kingsdown, Christopher Cowdrey and William Fox-Pitt are all ex pupils.
SEE Broadstairs/ Cowdrey, Christopher/ Cricket/ d'Abo, Mike/ Fox-Pitt, William/ Gladstone Road/ Lichfield, Lord/ St Peter's Preparatory School/ Schools/ William, Prince of Gloucester

Duke of WELLINGTON

Born Arthur Wellesley, 1st September 1769
Died 14th September 1852
Although born in Ireland, he thought of himself as British, explaining that Jesus was born in a stable but he was not a horse.
As a military man, he defeated Napoleon at the Battle of Waterloo and as a statesman, he was Prime Minister from 1828 until 1830.
The Duke of Wellington did so badly at Eton that his mother took him out of school so that the money saved could be spent on his younger brother's education. Instead, she sent him to study with a barrister but he only showed a talent for fiddling. In desperation, she sent him off for a military career although she thought that he would only be 'fit food for [cannon] powder'.
A totally useless bit of trivia for you - the Duke of Wellington always wore six watches, and was very proud of never being late for an appointment in his life.
Apparently he was not a great success on the sexual front. Harriette Wilson, a well-known and notorious whore with whom he had a well-publicised affair, described his performance as 'most unentertaining'. Well, this was her area of expertise after all. She threatened him with including details of their affair in her memoirs unless he paid her off. He told her to 'Publish and be damned!'
He died on the same day as Augustus Pugin, 14th September 1852.
SEE Addington Place, Ramsgate/ Chatham Place, Ramsgate/ East Cliff Lodge/ Inglis, Sir William/ La Belle Alliance/ Napoleonic Wars/ Prime Ministers/ Pugin, Augustus/ Waterloo, Battle of/ Wellington Crescent, Ramsgate

WELLINGTON CRESCENT, Ramsgate

During the Napoleonic Wars, this area was used by the military who often held manoeuvres on the open cliff top. There was also a battery, guns and an ammunition store and the only access was by two footpaths. Once the soldiers left, the area became a building site.

A consortium to develop the area was set up comprising Mr Miller a shipright, Mr Pilcher Langley a carpenter, Mr Smith a builder and Mr Underwood a smith although the latter was soon declared bankrupt. The crescent of 29 houses was built between 1817 and 1824, but not finished until 1834.

Originally the houses in the crescent had their own gardens in front surrounded by railings.

Samuel Taylor Coleridge spent holidays with the Gillmans here in 1821 (at No 7), 1824 (at No 29), 1825 (at No 3), and 1827 (at No 28).

I was myself very unwell on Monday & Yesterday – but this morning I have cleared up again, and had such a Trio of Plunges into the very Heart, Liver and Lights of three towering Billows this morning, the last of which fairly hurried me back, I might almost say, into the Machine – but actually, to the topmost step of the Ladder – so that I narrowly escaped a bruise – The wave set the Carpet afloat, and had I not instantly called out to Philpott, that his Pot was over-full, I should have had had my outsides, . . alias Cloathes, seized by the grim old Surgeon

. . It was glorious! I watched each time from the top-step for a high Wave coming, and then with my utmost power of projection shot myself off into it, for all the world like a Congreve Rocket into a Whale.

. . .The Weather still goes on, just as if it were made according to order – just often enough beclouded & pretending to be going to rain, to make a variety, & surprize us with the fine weather an hour after. – O I wish, you were here, and that we could all Ramsgatize till the middle of December! Letter from Samuel Coleridge Taylor sent from 7 Wellington Crescent to James Gillman, 31st October 1821

A favourite phrase of Coleridges's was *'Audi alteram partem'* which he used to look at things in an alternative way. Here in a letter sent from 29 Wellington Crescent to James Gillman on 26th November 1824, he is writing about a storm that was so fierce that he kept interrupting his work to run to the window every few minutes to watch it:

Audi alteram partem was most amusingly exemplified to me this morning by Mr Philpot, (the Bathing –machinist) who in a strain of eloquence & with an animation of Tone & Gesture which I never could have supposed him capable of, set forth to me the delights & great advantages of a good Wreck – which he euphoniously entitled 'a diffusion of Property' – and again - 'a providential multiplication of Properties' (meaning, I suppose, of Proprietors or Appropriators) – 'For, Sir! There is a Providence in all these things – It is a loss to the Underwriters, I don't deny that – but it is a great thing for the Poor Folks and for our town of Ramsgate'. On my honor, these were his very words: I could not mistake – for he repeated 'Diffusion, & 'multiplication' half a dozen times as if proud of their fineness. 'What is dispersed, Sir! isn't always lost, you know!'

. . . It particularly amused me to observe the very comprehensive List of Articles, he

deemed too trifling to be trusted to the Salvage remuneration – Telescopes, Spies-glass, Barrels of Brandy and Wine – when there was no sharp ones at the Preventive Barrack on the Beach, &c. I am not ashamed to say, that it had the effect on my mind of an excellent Farce after a deep Tragedy.

In 1825, a wooden statue honouring the Duke of Wellington was erected by William Miller whose shipyard was at the base of the adjacent cliff. Whilst he could defeat Napoleon, Wellington's statue was no match for a drunken Irishman - some reports refer to a mob - who objected to his policies. A Grecian statue took its place until the bandstand was moved here from Granville Gardens, further along the cliff, in 1914.

In 1862, what had been a cul-de-sac became the access to the new Victoria Parade.

Wilkie Collins stayed with Martha Rudd here in the 1870s. At the same time he was staying with Caroline Graves in Nelson Crescent. Whilst staying at number 9 or 10 he wrote 'The Woman in White'.

The council took over the gardens in 1890 and in 1901 tramlines were put in and the road was widened. In 1937, when the tramlines were removed, the road was widened again.

The Royal Artillery had a battery observation post, pillbox and two six-inch naval guns, first used on ships during World War I, installed on the garden area in front of Wellington Crescent around the then fortified band stand in July 1940.

When a German plane was brought down on 14th October 1942, the pilot bailed out and the plane went through an empty boarding house in Wellington Crescent.

In 1949 the houses in the crescent were amongst the first buildings in Thanet to be listed.

The Wellington Crescent Residents' Association was formed in 2000. In 2003 £200,000 was spent on restoring the crescent – balconies and canopies were strengthened - funded by Thanet Council, KCC and the Heritage Lottery Fund.

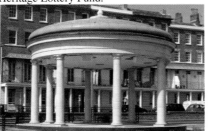

What do you need if you have a bandstand? A band; and if you have a band, what do you want to do? Dance; and what is essential to have a dance? A dancefloor. That is why around this bandstand is the only open-air polished dance floor that you will find on a cliff top anywhere in the world. When the new bandstand, designed by the borough engineer R D Brimmell, was opened, it was reported that the dancefloor was *'specially prepared concrete polished to a mirror-like surface'* (Kent Times, 1st March 1939) and had to be re-waxed every spring. Dances that attracted big crowds were held here after the war and throughout the fifties, indeed right

up until the 1970s, but it was to be September 2005 before the next entertainment was put on here.

Underneath the bandstand are two changing rooms.

SEE Boarding houses/ Coleridge, Samuel Taylor/ Collins, Wilkie/ Napoleonic Wars/ Nelson Crescent, Ramsgate/ Pier/ Plains of Waterloo/ Ramsgate/ Ramsgatize/ Snuff/ Trams/ Truro Lodge, Ramsgate/ Victoria Parade, Ramsgate/ Warren, Sir Charles/ Wellington, Duke of/ Woman in White

WELLINGTON HOTEL, Margate

The market was established in 1776 and parts of the building that houses the Wellington in Duke Street, Margate dates back to then. A butcher's shop and a baker's were converted to make the pub although the old ovens were not removed from the cellars. With its classic Georgian frontage it was named after the Duke of Wellington who was then Lord Warden of the Cinque Ports. The pub's existence first occurs in the local directory in 1841. When it was the Wellington Hotel, most of the guests arrived on the Eagle steamers and before World War I, it had a 5.00am licence but there was rarely any trouble, possibly because the flint-built police station and town gaol were opposite. At one time, there was a cage where petty criminals were placed before going to the sessions - and there are some who say 'bring it back'. Market House was a hotel in the latter part of the nineteenth century at 4 Duke Street and the site of The Wellington's beer garden.

SEE Bathing machines/ Cinque Ports/ Hotels/ Margate/ Market Place, Margate/ Old Margate/ Wellington, Duke of

John WESLEY
Born 17th June 1703
Died 2nd March 1791
A Methodist preacher - *'I look upon the whole world as my parish'* – his Rule of Conduct read,

> *'Do all the good you can,*
> *By all the means you can,*
> *In all the ways you can,*
> *In all the places you can,*
> *At all the times you can,*
> *To all the people you can,*
> *As long as ever you can.*

As an old man of 85, he stopped at St Peter's on a very snowy Thursday, 28th November 1788, on his journey from Margate and preached to the locals. I wonder if he quoted Psalms 51:7 *Purge me with hyssop, and I shall be clean: wash me, and I shall be whiter than snow.* Or Psalms 147:16 *He giveth snow like wool: he scattereth the hoarfrost like ashes.* Or Proverbs 25:13 *As the cold of snow in the time of harvest, so is a faithful messenger to them that send him: for he refresheth the soul of his masters.* OK I'll stop, but did you know that the word 'snow' occurs 25 times in the Bible? - I must get out more.

One of his obituaries read: *'When at length he came to die he left only a knife, a fork, two spoons and the Methodist Church.'*

SEE Baptist Church, St Peters/ Margate/ Newcastle Hill, Ramsgate/ St Peter's/ Wesleyan Methodist Church, Birchington/ Wesleyan Church, Westgate

WESLEYAN CHURCH, Westgate
Built in 1867 where Plumstone Road and Minster Road meet, it was more recently taken over and used as an undertaker's chapel of rest.
SEE Churches/ Wesley, John/ Westgate-on-Sea

WESLEYAN METHODIST CHURCH
The Square, Birchington
This church is in Chapel Place just off the south side of The Square, and was built in 1830. The clock is said to have come from the old Margate Pier and was restored in 1902, as part of the Edward VII coronation celebrations, and again in 1976. The church was restored and re-dedicated in 1966.
The Wesleyan schoolroom dates from 1928.
SEE Birchington/ Churches/ Edward VII/ Pier/ Schools/ Square, The/ Wesley, John

WEST BEACH, Ramsgate
Dame Janet Stancomb-Wills supplied much of the £7,000 needed to move 14,000 tons of sand from the eastern foreshore to create a beach here. The first section was completed on 3rd August 1935.
SEE Beaches/ Ramsgate/ Stancomb-Wills, Dame Janet

WEST CLIFF BANDSTAND, Ramsgate
It was taken down in February 1961 and the area turned into the boating pool.
SEE Bandstands/ Ramsgate

WEST CLIFF HALL, Ramsgate
During the Napoleonic Wars, a French privateer craftily attempted to attack a British ship anchored off Ramsgate by coming between the Downs and the coast. Once she had been discovered, she tried to escape by sailing towards Ramsgate Harbour. As she passed the battery, on the site of the West Cliff Hall, she was fired upon with the first shot dropping right in front of her. The French ship immediately lowered her sail as a sign of surrender. The French Captain said afterwards, 'that the first that was fired was so well aimed I could not wait for the second to sink me.'
Sir John Hunt, leader of the 1953 Everest expedition addressed a huge youth rally at West Cliff Hall on 20th January 1954 and The Rolling Stones appeared on 9th April 1964.
After 50 years the West Cliff Hall closed on 4th February 1966 because it was feared that the building was unsafe and could fall into the sea. It didn't and The West Cliff Hall became the Motor Museum.
SEE Downs, The/ Harbour, Ramsgate/ Hunt, Sir John/ Italiante Greenhouse/ Motor Museum/ Napoleonic Wars/ Ramsgate/ Rolling Stones

WEST CLIFF PROMENADE, Ramsgate
Up until the 1920s, an 1884 Victorian shelter marked the end of the West Cliff Promenade, beyond which were cornfields. The shelter lasted until the 1960s when it was re-built.

The area is known as Government Acre, a name that dates back to the Napoleonic Wars, when the harbour was defended by a large cannon sited here. The government paid a rent for the area for many years. Screaming Alley which runs from here is said to get its name because local girls would sneak down to check out the soldiers and when they were seen would run screaming down the alley.
SEE Napoleonic Wars/ Ramsgate

WEST CLIFF ROAD, Broadstairs
The houses on the southern side are built on a site previously used by the Yarrow Home's dairy cow herd.
SEE Broadstairs/ Yarrow Home

WEST CLIFF ROAD, Ramsgate
It was originally called Sacketts Hill.
SEE Ramsgate/ Ramsgate Hospital/ Seaman's Infirmary

WEST CLIFF TAVERN, Ramsgate
Edith Evans, the landlady of the West Cliff Tavern in Townley Street, Ramsgate, was one of eight people who died when two German Junkers bombed both Townley Street and Adelaide Gardens on 8th September 1941.
Now closed.
SEE Adelaide Gardens/ Pubs/ Ramsgate/ Townley Street/ World War II

WEST DUMPTON LANE, Ramsgate
German seaplanes dropped over twenty bombs across Broadstairs and Dumpton on the night of 19th May 1916 but the only casualty was a chicken at Pear Tree Cottage.
SEE Broadstairs/ Dumpton/ Poultry Farms/ Ramsgate/ World War I

WEST HAM CONVALESCENT HOME
Built in 1882 on the corner of Zion Place and Northdown Road was The West Ham Convalescent Home *'for illegitimate fatherless boys under twelve to take advantage of open air bathing and healthy bracing sea breezes'*. It was later the site of a garage, but this too has been demolished.
SEE Bathing/ Convalescent Homes/ Garages/ Northdown Road/ Zion Place

WESTBROOK
The area only started to be developed in the 1860s. A combination of a sea wall and promenade being built along the coast beyond the farmland between Garlinge and the sea, and the Royal Esplanade being improved, meant that, in 1913, Garlinge became part of the Borough of Margate prompting roads and housing to be built. Westbrook, however, remained mainly open farmland until the 1930s when the present housing was developed. The name Garlinge was not deemed acceptable, whether because it was not good enough or was not geographically accurate, is debatable, but a new name was sought. In the end, it came down to Westonville or Westbrook, with the latter winning, possibly because Westonville was too similar in sound to Cliftonville or

because the area is west of the old Tivoli Brook, hence Westbrook.
SEE All Saints Service Station/ All Saints Church War Memorial/ Beach Entertainment/ Canterbury Road, Westbrook/ Dog & Duck/ Farms/ Friend to all Nations/ Garlinge/ Goodwins/ Hartsdown Road/ Marine Terrace Margate/ Royal Sea Bathing Hospital/ Shakespeare pub/ Tivoli Brook/ Tivoli Park Avenue/ Trams/ Umbrella maker

WESTBROOK BATHING PAVILION
As they entered the 20th century, the public got more and more daring and started - and I'm sorry to even mention it - but they started to, well, they went into the sea straight from the beach. Yes, you're right, disgusting. Bathing Pavilions were built by the Corporation to provide cubicles to change in; The Westbrook Bathing Pavilion was built in 1914 and another was built a mile eastwards on Marine Terrace in 1926; a bathing pool was added in 1938.
The Pavilion welcomed many dance bands and variety stars between the wars, but following the neglect caused by wartime evacuation and damage from the odd passing floating mine, the 1953 great storm finally demolished it. The Pavilion was eventually replaced by Leisure Time's children's amusement centre and café in the 1980s.
SEE Bathing/ Marine Terrace/ Queens Highcliffe Hotel/ Sea View Terrace/ Storms

WESTBROOK BAY

SEE Bays/ Westbrook Bathing Pavilion

WESTBROOK CYCLE STORE
Advertisement, 1957:
 WESTBROOK CYCLE STORE
 Proprietor: W T STEVENS
 Cycle and Cycle Motor Specialists
DISTRIBUTORS FOR: CYCLEMASTER, BERINI, POWER PAK, FIRE-FLY
AGENTS FOR: PHILLIPS GADABOUT, NSU QUICKLY
150 CYCLES ALWAYS IN STOCK
REPAIRS & SPARES OF EVERY DESCRIPTION
CYCLES FOR HIRE
H.P. AND EASY PAYMENTS
34 & 36 CANTERBURY ROAD, WESTBROOK, MARGATE
TEL.: THANET 22481
SEE Bicycles/ Canterbury Road, Westbrook/ Shops

WESTBROOK DAY HOSPITAL
Canterbury Road, Westbrook
The Victoria Home for Invalid Children (Incorporated) 1892-1963, then became the Victoria Hospital Westbrook and later, the Westbrook Day Hospital. The building was demolished in the early part of 2004.
SEE Canterbury Road, Westbrook/ Hospitals

WESTBROOK MILL
In the years before the twentieth-century development of the area, Westbrook once had a windmill called Westbrook Mill.
SEE Windmills

WESTERN ESPLANADE, Broadstairs
SEE Broadstairs/ Buckmaster House/ Seapoint Road

WESTERN UNDERCLIFF, Ramsgate
Ramsgate Corporation acquired the area to the west of Grange Road before World War I. It had previously been the Murray-Smith estate.
SEE Grange Road/ Ramsgate

WESTGATE BAY
Four smugglers from the North Kent Gang were hung on 4th April 1822 after a battle with custom officers at Westgate.
SEE Bays/ Smuggling/ Westgate-on-Sea

WESTGATE BAY AVENUE, Westgate
Tanks were stationed here in World War II as part of the D-day preparations in April 1943. Camouflage nets were thrown over them at night to add to the cover that the trees on either side of the street gave them.
SEE Westgate-on-Sea/ World War II

WESTGATE-ON-SEA
All the land in this area was once owned by the Leybourn Family and was known as the Manor of Westgate. The family name died out when Juliana De Leybourn, having outlived her two husbands, died. The land then passed to the Abbey of St Augustine at Canterbury. When Henry VIII dissolved the Abbey the land became the property of the Crown. In time Henry granted the land to Sir Thomas Moile, who soon after ceded it to the Bere family with whom it remained up until the reign of Elizabeth I. It was then sold to the Denne family and eventually passed down the family tree via inheritances and marriages to Nicholas Crispe. Now, at the latter end of the eighteenth century *'The (manor) house is now a farmhouse and not a very good one. It stands pretty near the cliff, and is not out of danger of being destroyed sometime or other, by the encroachment of the sea.'* (John Lewis, antiquarian). He was right, because a century later no trace of the Manor House remained (1869 is thought to be about the last time it is recorded as still standing) and the land had been sold off in small chunks by previous owners. All the buildings in Westgate date from after this time.
In the 1830s, Westgate consisted of a coastguard station and two farms.
The London Chatham and Dover Railway arrived in 1863. Sir Erasmus Wilson, the influential medical man who was a huge fan of the benefits of Thanet's air, encouraged Edmund Davis to build an exclusive estate.
Westgate-on-sea was the first place in England to test electric street lighting.
SEE Accomodation/ Belmont Road/ Beresford Hotel/ Bull & George/ Bungalows/ Bungalows of Birchington/ Canterbury Road, Westgate/ Carlton Cinema/ Cinemas/ Coastguards/ Davis, Edmund/ Domneva/ Earthquake/ Farms/ Friend to all Nations/ Hawtrey's Field/ Hussar/ Leybourn/ Manston Airfield/ Marsh Bay/ Old Boundary Road/ Pancake Race/ Population, Westgate/ Read Court/ Rossetti/ Royal Navy Air Service Station/ St Augustine's/ St Mildred's Bay/ St Mildred's Church/ St Mildred's Road/ St Saviour's Church/ Sea Road/ Smuggling, Westgate Bay/ Station Road/ Sussex Gardens/ Swan pub/ Temple, William/ Thanet Road/ Town Hall Building/ Traffic jams/ Ursuline Convent/ VAD Hospitals/ Viking Coastal Trail/ Wain, Louis/ Wesleyan Church/ Westgate Bay Avenue/ Wheatley, Dennis/ Wherry

'WESTGATE ON SEA'
by Sir John Betjeman
The future Poet Laureate was probably staying at Birchington when he wrote 'Westgate-on-Sea' in the early 1930s. The Church of England bells he refers to must belong to St Saviours, the only Anglican church in Westgate, even though it only had one high-pitched bell. Blame either poetic licence or that he included all the bells in the area, especially those belonging to the many schools whose pupils he describes. The shops on the parade are also mentioned.
SEE Betjeman/ Birchington/ Churches/ Schools/ Station road, Westgate/ Poems

WESTLIFE
This boyband played a concert at St George's School in Broadstairs in July 2004.
SEE Broadstairs/ Music/ St Georges School

WESTWOOD
With great ceremony, traffic lights were installed at Westwood, on the junction of Westwood Road, Margate Road and Haine Road, on Thursday 5th March 1964, by Councillor E E Bing, Chairman of the Broadstairs and St Peter's Urban District Council, Councillor A T Tucker, the chairman of the Building and Works Committee, Mr Roy Plackett, the Surveyor, and Police Inspector W Beton. The junction had been one of the worst traffic blackspots with 51 accidents in the previous three years.
SEE Bowketts Bakery/ Hypermarket/ Margate Road, Ramsgate/ Rediffusion/ Star Inn

WESTWOOD CROSS SHOPPING CENTRE
Where Margate, Broadstairs and Ramsgate all meet, is the site of the Westwood Cross shopping centre. During the building, there was a banner that proclaimed it as 'Westwood's new town centre' – a town centre with no town, it is amazing what they can do nowadays.
The original planning application was received by Thanet Council in May 1997, work began in November 2003, and the centre comprising nearly 35 shops, opened on 8th June 2005.
Some of the centre is situated on the plot of the old Haine Isolation Hospital. Part of the hospital's wall and a plaque remain in the car park.
SEE Haine Hospital/ Marks and Spencers/ Shops

WHALES

It has not been uncommon for whales to be washed up on Thanet's shores. The jaw bone of one was used to make an archway over the entrance to Ellington Park in Ramsgate.
On the beach below the old Grand Hotel at Broadstairs, a whale was stranded on 9th July 1754. Apparently it was twenty-two yards long, his *nether jaw opening twelve feet*, and three men could stand in its mouth. A cart pulled by six horses could not take one of his eyes away (you're not eating while you read this are you?), a man could stand upright in the eye socket and a man also crept into a nostril (why would anyone want to do that?). Its ribs were up to 14ft long, he measured 14ft from his back to his belly, his tail measured the same, the distance between his eyes was 12ft and the tongue was 14ft long. It took two carts to take away the liver (you've stopped eating now haven't you?) and its cry could be heard a mile away (if that is what whales do, when they are happy they sing, when they are stranded I would think they probably cry, or even blubber).
On 2nd July 1762 another whale got washed up at Broadstairs, measuring 62ft long.
In April 1995 an 18ft long female killer whale was washed up at Pegwell Bay. Despite the efforts of rescuers who worked on her for ten hours and guided her out to sea late on the night of Tuesday, 25th April, she came ashore again and had to be put down.
SEE Boathouse, Broadstairs Harbour/ Broadstairs/ Ellington Park/ Grenham Bay/ Lamb, Charles/ Pegwell Bay/ Thanet/ Voss, Captain John C

Dennis WHEATLEY
Born South London, 8th January 1897
Died 10th November 1977
From the age of 8 until he was 12 he attended Skelsmergh School in Dalby Square in Cliftonville. His grandparents lived in Westgate.
His thrillers and occult novels were hugely popular in the 1960s and 70s but have now fallen out of favour, possibly because of their anti-semetic and racist undertones.
Birchington, Quex Park, Margate and Pegwell Bay are all written about in his 1936 novel 'Contraband' about the, then, contemporary smuggling.
SEE Authors/ Birchington/ Cliftonville/ Dalby Square/ Margate/ Pegwell Bay/ Schools/ Quex/ Westgate-on-Sea

WHEATSHEAF public house
Northdown Park Road
Formerly known as the Waterloo Tea and Pleasure Gardens. The ex-landlord of the Rose and Crown, William Armstrong, bought *'this fine commodious new built house with a pleasant prospect of the sea'* in 1733 and decided to run it as a pub. In many ways a strange choice as it was miles from anywhere then, but that was maybe what he wanted as it became a pub that people travelled to as an excursion and not a place they just dropped into. The Waterloo Tea and Pleasure Gardens were incredibly popular in the 19th century with horse-drawn carriages regularly visiting. In later years, the trams and then buses would transport the customers here. A Beefeater Restaurant and bar were

added in 1975, and a fireplace was built over the old well. It was a Beefeater Restaurant for many years, and is currently a Hungry Horse. It is reputed to be haunted.
SEE Ghosts/ Pubs/ Restaurants

WHEATSHEAF public house
High Street, St Lawrence
This pub goes back to 1833 although the present building is a replacement for the original. The pub is currently closed.
SEE High Street, St Lawrence/ Pubs

WHERRY
With a clinker-built, varnished wooden hull, they were boats similar to a Deal galley or a Thames waterman's skiff, and were essentially beach boats, although you could have had a Wherry (high sides) or a Wherry Punt (low sides). Around 30 were in use from around 1890 up to 1939. Brockman of Margate built many Thanet wherries in the years up to World War I. The last one in service here was Dusty Miller's of Westgate, built by an apprentice at Brockmans in 1939, *'She was only about 12 ft long and being small was sometimes called a skiff'*.
Eight wherries were towed behind Margate lifeboats in the evacuation of Dunkirk in 1940.
SEE Dunkirk/ Margate/ Shipbuilding/ Ships/ Westgate-on-Sea

WHITE HART public house, Margate
It was the scene of Surtee's Jorrocks humiliation when he went bathing and lost his breeches to the tide, and a mob hunted him back to the inn.
SEE Bathing/ Jorrocks/ Margate/ Pubs/ Surtees

Alfred North WHITEHEAD
Born 29 Chatham Street, Ramsgate, 15th February 1861
Died Cambridge, Mass. USA 30th December 1947
He was one of the greatest minds of the 20th century, both as a mathematician and philosopher. As the former, he collaborated with Bertrand Russell on 'Principia Mathematica' (1903); as the latter, he wrote many works including 'Adventures of Ideas', and 'Process and Reality'.
His grandfather, Thomas Whitehead, was a self-made man who had bought a school on the site of the present Chatham House School in Ramsgate, and his father, Alfred Whitehead, an Anglican clergyman, became the headmaster. He was later vicar of St Peter's in Broadstairs from 1871 until he died in 1898. Alfred's uncles were also members of the clergy, as was his brother, Henry, who went on to become the Bishop of Madras. His mother, Maria Sarah Buckmaster, was the daughter of a prosperous military tailor.
Alfred spent his early childhood in St Peter's and was educated at home on account of his delicate health, until he was sent, aged 14, to a public school at Sherborne in Dorset where he received a classical education and excelled at maths. He became head prefect - meaning he was responsible for all discipline outside of the classroom – and captain of

games. Not bad for a kid who was previously taught at home because he was thought to be too frail for school or sports. He went to Trinity College, Cambridge on a scholarship in 1880 where he only attended mathematics lectures, but on mixing socially, his interest in religion, philosophy, politics and literature grew. In May 1884, he was eventually elected to the 'Apostles', an elite discussion society, and won a Trinity fellowship, and - it was a busy year – he got a job on the teaching staff there.
Evelyn Willoughby Wade, the daughter of Irish landed gentry, albeit down on their luck, who was born in France and educated in a convent, married Alfred in December 1890; the start of a happy marriage.
Although brought up and surrounded by members of the Church of England, Alfred was also strongly influenced by Cardinal Newman and for around eight years he immersed himself in reading theology, considered joining the Roman Catholic church, but then suddenly sold all his theology books, gave up religion and became an agnostic. Although World War I restored some of his some beliefs, he never again joined any church.
He started work on his Treatise on Universal Algebra in January 1891 and it was published seven years later in 1898. He started work on Universal Algebra, Part Two – not yet out on dvd – in 1898 and worked on it until 1893 when he started working with a young Bertrand Russell whose brilliance he had discovered during Russell's entrance examinations for Trinity College. The two progressed from being tutor and freshman, into being good friends and together they went to the First International Congress of Philosophy in Paris in July 1890 – OK, it was hardly Glastonbury, but they enjoyed it. They were impressed by the work of the mathematician, Giuseppe Peano, whose work and methods Russell extended, and his first draft of 'Principals of Mathematics' was completed by 1900 and published three years later. Alfred agreed with the thesis and in 1901 the two decided that Part Two should be a joint effort and separate from Russell's original work, thus it was entitled 'Principia Mathematica' and kept the two of them out of mischief for years. Part One, of three ('builds week by week . . .' no it didn't) came out in 1910, the rest following over the next three years (see, it could have). Whilst Russell appears to have spent more time on the project, Alfred having his teaching commitments, was happy to share the credit. He was awarded the Order of Merit in 1945.
'If a dog jumps in your lap, it is because he is fond of you; but if a cat does the same thing, it is because your lap is warmer.'
Alfred North Whitehead
SEE Chatham House/ Chatham Street/ Ramsgate/ Russell, Bertrand/ St Peter's Church/ Schools

WHITE HORSE INN
High Street, St Lawrence
The old White Horse Inn was pulled down just after the war to enable the St Lawrence church junction to be widened. Other

buildings had been demolished in 1938, also to enable roads to be widened.
The present White Horse opened in the summer of 1969 on a site just up the road replacing a temporary prefabricated building. The *'new building attractively styled after a Kentish oast house . . . bar snacks are a special feature of the house.'*
It is now the St Lawrence Tavern.
SEE High Street, St Lawrence/ Pubs/ Ramsgate

WHITEHALL MINERAL WATER Co (Ramsgate) Ltd
This business was listed in Whitehall Road in 1957.
SEE Cradlecar & Co/ Ozonic/ Ramsgate

WHITEHALL FARM, Ramsgate
Benjamin Cowell was listed as a poultry farmer there, in Whitehall Road in 1936.
SEE Farms/ Ramsgate

WHITENESS MANOR SCHOOL FOR CRIPPLED BOYS, Kingsgate
It was listed there in 1961.
SEE Kingsgate/ Schools

WHITE STAG public house, Monkton
Not named after a deer, but after a local turkey farm - a stag is also the name for a male turkey! Up until the 1970s it was the New Inn and in the 1920s, the village horses often entered the public bar. Slow to buy a round though. They went through the bar because it was the only route to the stables at the rear.
SEE Farms/ Monkton/ Pubs

WHITE SLAVE TRADE
East Kent Times, 2nd April 1913: *Mrs Despard addressed a meeting in Margate and spoke against women's sweated labour and the white slave trade.*
SEE East Kent Times/ Margate

WHITE SWAN public house
Reading Street
The original White Swan pub, referred to by some as the Mucky Duck, was built in 1760 and demolished in 1913 when the present White Swan was built.
SEE Pubs/ Reading Street

WIGGETT
Queen Street, Ramsgate
Advertisement, c1900:
T J Wiggett, 8 Queen Street
(Stores at 19 Cottage Mews)
Glass and China rooms
Sole agent for W T Copeland & Sons' Royal
Worcester and Minton China.
Goods lent on hire. Largest stock in Thanet
of Fancy and Useful Goods.
SEE Queen Street, Ramsgate/ Shops

Oscar WILDE
Born 16th October 1864
Died 30th November 1900
The wit, playwright, author, and poet stayed at the Albion Hotel, Broadstairs on 3rd September 1888.
'I am very glad you went to Margate, which, I believe, is the nom-de-plume of Ramsgate.

It is a nice quiet spot not vulgarised by crowds of literary people.'

Incidently, Wilde's famous quote:

'There is only one thing worse than being talked about and that is not being talked about'

is an anagram of:

'Hate being sunk in that rotten gaol. Wilde died broken, beaten 'n' total nut. Shh gay is taboo.'

(I don't waste my evenings!)

SEE Authors/ Broadstairs/ Carson, Lord/ Hildersham House School/ Langty, Lily/ Margate/ Poets/ Ramsgate/ Royal Albion Hotel/ Shaw, George Bernard/ Sickert, Walter Richard/ Vanbrugh, Dame Irene

WILDERNESS HILL, Cliftonville

Opposite St Paul's Church in Fairview Close there was a building, originally part of the Chateau Belle Vue Pleasure Gardens, which, in 1860, became the East Cliff Sanitorium for Tuberculosis, and in 1876, The Wilderness Convalescent Home – named after Wilderness Hill on which it sits, but sounding more like a home for the bewildered. In 1915, it was a Seaside Home for the Poor Waifs of London. The Metropolitan Asylum Board took it over in the 1930s and turned it into St Mary's, a tuberculosis hospital. Following the war, it was Princess Mary's Rehabilitation and Convalescent Centre and in the 1980s, became the Dane Park Centre, a private health centre.

A picture of Pinocchio adorns the front of a house in Wilderness Hill, Cliftonville.

SEE Cliftonville/ Convalescent Homes

WILFRED ROAD, Ramsgate

In World War I, a lone German aircraft dropped a parachute mine that destroyed a house in Wilfred Road killing James Holt and his wife Sarah at number 26 and Godfrey and Clifford Aste at number 28.

SEE Ramsgate/ World War I

King WILLIAM III

Born 14th November 1650
Died 8th March 1702

He died from pneumonia, a complication following a fall from his horse which broke his collar-bone.

SEE Quex estate and mansion/ Royalty/ Tudor House/ William & Mary

King WILLIAM IV

Born Buckingham House 21st August 1765
Died 20th June 1837

As he was the third son of George III, he was not expected to be king and so was sent off to the navy at the age of 13. He was treated, and wanted to be treated, as any other sailor and was known as William Guelph (his family name).

From Midshipman on The Prince George, he worked his way up to be captain of a frigate by the time he was 21 and eventually became Admiral of the Fleet. He was a friend of Nelson and even gave away the bride at his wedding.

He became Duke of Clarence and St. Andrews and Earl of Munster in 1789.

After he retired from active service, he lived with his mistress, Mrs Jordan, and their ten children who took Fitzclarence as their surname.

As his brother, George IV's, only child, Charlotte, had died and the next in line, Frederick, the Grand Old Duke of York, had also died, William was unexpectedly in the frame for the job of king. Therefore, after a long search, a marriage to Princess Adelaide was arranged for him, although he was in love with another of his mistresses. In a letter to his eldest illegitimate son he wrote, *The Princess of Saxe-Meiningen is doomed, poor, dear innocent young creature, to be my wife. I cannot, I will not, I must not ill use her . . . what time may produce in my heart, I cannot tell, but at present I think and exist only for Mrs Wykeham. But enough of your father's misery.*

His marriage to Adelaide was a surprisingly happy one, although they had no children.

In early April 1837, after suffering a bad asthma attack, and realising that he was dying, he wanted wanted to hang on long enough to see his niece, Princess Victoria, turn 18, which she did on 24th April. This meant that her mother, the Duchess of Kent (the widow of his brother Edward), whom William hated, would not become Regent.

His other wish was to see the anniversary of the Battle of Waterloo on the 18th June. He asked his doctor *'try if you cannot tinker me up to last over that date.'* Duly tinkered, he died on the 20th with Adelaide and his son Fitzclarence at his bedside.

SEE Adelaide, Queen/ Admirals/ Clarence, Duke of/ Cochrane, Admiral/ Fox, Rear Admiral William/ Grand Old Duke of York/ George III/ Jordan, Mrs/ Pegwell Cottage/ Royalty/ Townley House/ Victoria

WILLIAM and MARY

Following their marriage on 4th November 1677, bad weather prevented them from leaving England until: *William remained at the inn* [in Canterbury] *four days longer, and then left for Margate, where he embarked on the 28th of November* [1677]*; and after a short but stormy passage, the only lady on board unaffected by sea-sickness being the princess, he arrived safely in Holland.*

Chambers' Book of Days 1869

SEE Margate/ Royalty/ William III

Kenneth WILLIAMS

Born 22nd February 1926
Died 15th April 1988

The comedy actor appeared at the Theatre Royal, Margate in various plays in the early 1950s.

SEE Actors/ Theatre Royal

Sir William Henry WILLS

William Henry Wills became the chairman of the Imperial Tobacco Company; he was also the Liberal MP for Coventry, and later Bristol. In 1853 he married Elizabeth Stancomb and they had two daughters who both died young. They adopted Elizabeth's brother's daughter, Janet, when both her parents died and she took Stancomb-Wills as her surname. She was brought up in Blagdon

– Wills's country home in Somerset. Lady Elizabeth was in poor health later in life and it it probable that East Court was built so that the healthy sea air would help her. In 1893 Wills became a Baronet. In 1896 Elizabeth died and at her funeral, her body was borne by six guards from the Great Western Railway (where Sir William was a director) to Holy Trinity Church where the east window is a memorial to her.

In 1906, Wills became 1st Baron Winterstoke of Blagdon. He died in 1911, leaving his fortune of around a million pounds to his 57 year-old niece/adopted daughter, Janet Stancomb-Wills.

SEE East Court/ Holy Trinity Church, Ramsgate/ Stancomb-Wills, Dame Janet/ Tobacco/ W D & H O Wills

WILLS HOUSE, Ramsgate

Once the residence of Dame Janet Stancomb-Wills, it is now a home for children.

SEE Ramsgate/ Stancomb-Wills, Dame Janet

WILLSON'S ROAD, Ramsgate

It is named after Mr Willson who lived at Dudley House (later the Savoy Hotel) in Grange Road.

Bathing machines were stored at a site in Willson's Road.

The Drill Hall opened amongst great pomp on 23rd May 1912.

Recently the derelict site of a laundry here was declared one of the UK's worst wasted spaces.

SEE Bathing Machines/ Ramsgate/ Sunlight Laundry

Sir William James Erasmus WILSON

Born London, 1809
Died 1884

The son of a naval surgeon, he expanded the Royal Sea Bathing Hospital in 1881, and added the north wing. It is a statue of him that now stands in the grounds between the portico and the main entrance on the Canterbury Road. I always felt that this was stealing the glory away from Dr Lettson who actually built the place. Along comes old Erasmus in typical Victorian manner and plonks a statue of himself out front when all he had done was added a few extensions. Well, alright, he paid for a lot of them, to the tune of £30,000 which is a fair amount now, and was a huge fortune then, and included the four wards in the west wing and the chapel, which has a beautiful tiled floor, or encaustic pavement if you prefer.

In fact, Erasmus was a great philanthropist both here and in other areas of the country; he gave money to Epsom College, the Egypt Exploration Society; established a chair and a department of Pathology at Aberdeen University and gave a generous bequest to re-organise and refurbish the library of the Royal College of Surgeons. Professionally, he was and still is regarded as the father of modern dermatology and was a professor at Oxford University. It was he who, largely, established the modern habit of having a daily shower or bath, if you want somebody to blame. So I take it all back, he deserves his statue.

Apropos of nothing, our Erasmus, was also responsible for one of the worst predictions of all time, *'When the Paris Exhibition (1878) closes, electric light will close with it and no more be heard of it'*. Other contenders for similar quotes are Lord Kelvin who came out with two, *'Radio has no future'* (1897), and *'Heavier than air flying machines are impossible'* (1895). My particular favourite is the then chairman of IBM, Thomas Watson, who said in 1943 *'I think there is a world market for maybe five computers'*.

Finally, before we leave Erasmus, he, like all other Erasmuses, occurs in a very popular palindrome: 'Sums are not set as a test on Erasmus'. Now how that is relevant, I do not know, but I thought I would include it for you and I haven't charged you any extra.

SEE Royal Sea Bathing Hospital/ Cleopatra's Needle

WINDMILLS

Windmills were first used by the Arabs and introduced into Europe in the 12th century.

In 1596, there were five windmills in Thanet at Minster, Monkton, Birchington, St Peter's and St Lawrence. There was also a windmill at Dent-de-lion, Garlinge in 1610.

Ramsgate has had eight windmills, including the Coffee Pot in Margate Road, Grange Road Mill, Mascall's Mill in Newington Road, Hereson Mill near the synagogue and two near the old town station.

SEE Birchington-on-Sea railway station/ Coffee Pot/ Dent-de-lion/ Drapers Mills/ Eagle Hill, Ramsgate/ Garlinge/ Gouger's windmills/ Grange Road Windmill, Ramsgate/ Hereson Mill, Ramsgate/ Hooper's Horizontal/ Humbers Mill/ Lawrence, Carver/ Margate/ Mascall's Mill, Ramsgate/ Mill Lane, Birchington/ Mill Lane, Margate/ Minster/ Monkton/ Nayland Rock Hotel/ Northdown Road/ Pierremont Mill/ Sarre Windmill/ St Giles Church, Sarre/ St Nicholas-at-Wade/ St Peter's/ St Peter's Mill/ Town Mill/ Westbrook Mill

WINDMILL INN public house, Ramsgate

Listed in Newington Road, St Lawrence, Ramsgate in 1936 and 1957.

SEE Newington/ Newington Road/ Pubs/ Ramsgate

WINDSOR CINEMA
Harbour Street, Broadstairs

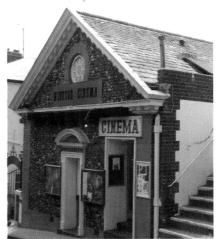

York Gate Hall was built in 1906 so that Dr Larkin could store his collection of Napoleonic War memorabilia, but after another war, World War I, it became a council storeroom holding a variety of things including deckchairs. In World War II, soldiers were billeted there.

A puppet show started there in 1950 but in 1961 it became a cartoon cinema. Three years later, the owner of the Carlton Cinema in Westgate, and the Regal in Birchington, Jack Field, bought it and it became solely a cinema. In 1987, Brian Stout took it over and, in 2006 the cinema was put up for sale - I was tempted . . .

It has recently been re-named the Palace Cinema.

SEE Broadstairs/ Cinemas/ Granville Cinema/ Harbour Street, Broadstairs/ Napoleonic Wars/ World War I/ World War II

WINSTANLEY CRESCENT, Ramsgate

A high-explosive bomb damaged most of the houses in Winstanley Crescent on 18th March 1941, leaving the majority of the rooves without tiles and the windows without glass. Amazingly, the only casualty was a warden, Albert Wood.

SEE Ramsgate/ World War II

WINTER GARDENS, Margate

In 1900, realising that the town needed an entertainment venue larger than any private enterprise could provide, the Council and the Chamber of Commerce formed a Fetes Committee. They wanted to build and run venues to provide the highest-quality entertainment for visitors and residents alike. The pinnacle of their achievement was The Winter Gardens, a type of municipal entertainment venue that would be copied in towns all over the country.

In 1901 the Fetes Committee appointed John Saxby as its secretary. He had previously been working in an accountancy office and became the driving force behind the building, in every sense, of the Winter Gardens. He went on to become the first Municipal Entertainments Manager retiring in 1941; he died in 1951.

The site of the Winter Gardens took the committee years to find but, by the end of the season in 1910, they had found the central site that was required, Fort Green, where the Bandstand held concerts given by both visiting military bands and also the Town Band. The main reason for the proposed Pavilion and Winter Gardens being situated in an artificial hollow at Fort Green was that the existing buildings around Fort Green had a covenant which did not allow the erection of any building on the green that could obscure the view or light of the ground floors of these buildings.

Originally called Fort Pavilion, the plan was approved in September 1910. The first sod was cut in December 1910, the foundation stone was laid on 15th March 1911, and by July the whole building was completed.

The estimated cost was £22,000 and the work had to be completed in 20 weeks. Only local labour was used, and there was no mechanical equipment, just picks and shovels; tragically one workman died in a fall. In total, 58,000 cubic yards of chalk was dug out, and taken away on horse-drawn carts. It was then used as the foundations for the promenades.

At midday on 7th August 1911 the whole corporation assembled for The Opening ceremony and led by mounted police, they proceeded to the main entrance. A sumptuous banquet was held in the Louis XVI ballroom and by the look of my last council tax bill, we may still be paying for it. The mayor, Alderman W. B. Reeve, came up with a cracker of a speech: *'While not a matter to be discussed at lunch, I am proud to say that the death rate is the lowest for thirty two years. So you only have to come to Margate to practically live for ever!'* - or does it just feel like it sometimes?

With four entrance halls, The Concert Hall was 140ft long by 95ft wide, had two side wings and an amphitheatre and internally, was decorated in a Neo-Grecian style. Audiences of 2,500 could view the stage from the main hall, as they can now, and a further 2,000 from the open-air amphitheatre. Over the years, the Winter Gardens have attracted a whole range of performers, from all areas of theatre, some of them legendary.

In the early 1920s, the 36-piece Margate Municipal Orchestra performed both classical and operatic works in the Main Hall with the leading guest vocalists of the day, from Covent Garden and the Paris Opera including Harry Dearth and Carrie Tubb. In 1923 Claude Hulbert with the Cigarettes Concert Company, Sybil Thorndyke, Will Evans, and the Imperial Russian Ballet and Anna Pavlova (31st July), Madame Melba (the dessert Peach Melba is named after her) all included dates here as part of their world tours.

Ivan Kalchinsky's Blue Slavonic Company presented a cabaret show here (sadly not available on DVD) for summer seasons of around six weeks up to the outbreak of World War II.

The Winter Gardens was not an entertainment venue during World War II (the chandeliers were put in storage for the duration) but was used as a receiving station for many of the 46,000 troops that landed at Margate from Dunkirk, and as an Air Raid Precaution and Food Rationing Centre. Troops attended Brighten-Up Dances on Saturdays and Thursdays and concerts on Sundays.

A sea-mine exploded in January 1941 breaking most of the windows and later that year it was considerably damaged by a direct hit. Plans for the repairs were drawn up in 1943, but work could not start until February 1946. Costing £40,000, it re-opened on 3rd August.

The following year, Vera Lynn, Webster Booth and Anne Zieglar appeared and there was a performance of the hit radio show 'ITMA' ('Its That Man Again') on 17th August. Stan Laurel and Oliver Hardy were there for the week of 18th August and were the biggest names of their time.

A young Julie Andrews gave a performance there in 1949.

A stage version of Hughie Green's TV quiz show 'Double your Money' had a ten-week season there in 1962 and his talent show 'Opportunity Knocks' was also staged here. In the 1960s Helen Shapiro, and Lenny the Lion (well, I liked him!) performed here and Adam Faith did a, brief, summer season.

Although not the headline act, The Beatles performed here between the 8th and the 13th July 1963. Billy J Kramer and the Dakotas and the Lana Sisters were also on the same bill.

Coinciding with the formation of Thanet District Council in 1974, Peter Roberts became Entertainments and Arts Officer. Under his control, the venue was completely re-furbished at cost of £125,000, with new seats and new carpet. New entrances were created on the sea side enabling greater access, most importantly vehicular, and therefore flexibility for exhibitions, which has been an important part of its history as has its importance as a conference centre.

In the 1970s, Larry Grayson, Mike and Bernie Winters, Tommy Cooper, The Bachelors, Morecambe and Wise, Roger Whittaker, Cilla Black, Lena Zavaroni, Arthur Askey and Jimmy Tarbuck all performed there.

In the 1980s, Boy George's Culture Club (1st November 1978), Jerry Lee Lewis and Duane Eddy (9th November 1978), Jasper Carrott (16th February 1981), Rik Mayal supported by Ben Elton (30th November 1984, and Michael Barrymore (29th August 1985).

Comedians Jim Davidson and Graham Norton as well as musicians like Ocean Colour Scene, Status Quo, and David Essex all appeared in the 1990s.

SEE Askey, Arthur/ Bachelors, The/ Beach Entertainment/ Beatles, The/ Billy J Kramer and the Dakotas/ Cooper, Tommy/ Culture Club/ Davidson, Jim/ Double your Money/ George, Boy/ Grayson, Larry/ Helen Shapiro/ Laurel and Hardy/ Lewis, Jerry Lee/ Lynn, Vera/ Margate/ Mike and Bernie Winters/ Miners/ Morecambe and Wise/ Music/ Norton, Graham/ Opportunity Knocks/ Promenades/ Radio/ Russia/ Seven Stones/ Status Quo/ Tarbuck, Jimmy/ Thatcher, Margaret/ Thomas, Terry/ World War II/ Zavaroni, Lena

Mike and Bernie WINTERS
Mike: Born 15th November 1930)
Bernie: Born 6th September 1932
Died 4th May 1991)
They changed their name for the stage from Weinstein and became a popular comedy double act of the 1960s and 70s. They broke up in 1978 with Bernie continuing in a double act with his pet St Bernard dog, Schnorbitz. Bernie died at the age of 58 from stomach cancer.
SEE Entertainers/ Winter Gardens

WINTERSTOKE
SEE Stancomb-Wills, Dame Janet/ East Court

WINTERSTOKE UNDERCLIFFE and ROCK GARDENS, Ramsgate
The landscaping took two years and cost £10,000; paid for by Dame Janet Stancomb-Wills. Opened by the Mayor, Alderman H Stead on 10th July 1936.

SEE Stancomb-Wills, Dame Janet

WISHING WELL public house
Broadstairs
Popular with the local smugglers back in the seventeenth century, it stood in the area in front of Union Square. The actual well was used for hiding and storing contraband.
SEE Broadstairs/ Pubs/ Smuggling/ Union Square

WITHNAIL & I
SEE Films/ Robinson, Bruce

'WITHOUT PREJUDICE'
by I Zangwill (1864-1926)
*A story is current in the Clubs that Mr. Henry James innocently went to Ramsgate, in order to possess his soul in peace. 'T was the height of the rougher Ramsgate season, and there is something irresistibly incongruous in the juxtaposition of the rarefied American novelist and the roaring sands of Albion. In the which juxtaposition the story leaves him; and we are ignorant of whether he turned tail and fled back to quieter London, or whether he stayed on to collect unexpected material. Our analytical cousin's stippling methods are, it is to be feared, but poorly adapted for the painting of holiday crowds, which require the scene-painter's brush, and lend themselves reluctantly to nuances. The colours have not that dubiety so dear to the artist of the penumbra; the sands are as yellow as the benches are red; and the niggers are quite as black as they are burnt-corked. The love-making, too, is devoid of subtlety. When you see - as I saw last Bank Holiday on Ramsgate beach - Edwin and Angelina asleep in each other's arms, the situation strikes you as too simple for analysis. It is like the loves of the elements, or the propensity of carbon to combine with oxygen. An even more idyllic couple I came upon prone amid the poppies on the cliff hard by, absorbing the peace and the sunshine, steeping themselves in the calm of Nature after the finest Wordsworthian manner. But presently there is the roll of a drum, and the scream of a fife in distress rises from below, and Angelina pricks up her ears. 'I wish they'd come up 'ere,' she murmurs wistfully; 'I'd jump up like steam; I could just do a dance.'
Yet all the same their seclusion among the wild flowers on the edge of the cliff showed a glimmering of soul. Not theirs the hankering for that strip of sand near the stone pier,*

*which a worthy dame of my acquaintance once compared to a successful fly-paper. Scientific investigation shows the congestion at this particular spot to be due to the file of bathing-machines which blocks the view of the sea from half the beach. To the bulk of the visitors this yellow patch IS Ramsgate, just as a small, cocoanut-bearing area of Hampstead woodland is the Heath, most of whose glorious acres have never felt the tread of a donkey or a cheap tripper. Not that there are many other attractions in Ramsgate, which is administered by councillors more sleepy than sage. Having literally defaced their town by a railway-station, built a harbour which will not hold water, constructed a promenade pier in the least accessible quarter, and provided a band which plays mainly 'intervals,' they naturally refuse to venture on further improvements, such as refuges on the parade, or trees in the shadeless streets, and, in the excess of their zeal, have even, so I hear, declined the railway company's offer to give them a lift (from sands to cliff), and Mr. Sebag Montefiore's offer to allow the public gardens to be continued right through his estate on towards Dumpton. Even so, these worthy burghers have more of my regard than their brethren of Margate, who have sacrificed their trust to the Moloch of advertisement. Stand on Margate Parade and look seaward, and the main impression is Pills. Sail towards Margate Pier and look landward, and the main impression is Disinfectant Powder.
Baby Broadstairs has known better how to guard its dignity and its beauty; so that Dickens might still look from Bleak House on as dainty a scene as in the days when he lounged on the dear old, black, weather-beaten pier. I spent a week at Broadstairs in the height of a Dynamite Mystery. We were very proud of the Mystery, we of Broadstairs, and of the space we filled in the papers. Ramsgate, with its contemporaneous murder sensation, we turned up our noses at, till Ramsgate had a wreck and redressed the balance. For the rest, we made sand-pies, and bathed and sailed, and listened to a band that went wheezy on Bank Holiday. Broadstairs boasts of one drunkard, who does odd jobs as well. He is tall, venerable, and melancholy, and has the air of a temperance orator. 'Joe's one of the best chaps on the pier when he's sober,' said his mate to me sorrowfully; 'but when he's drunk he makes a fool of himself.' This was not quite true; for Joe was not always foolish. Why, when two gentlemen came down from London in a gipsy caravan to teach us Theosophy, and all Broadstairs fluttered towards their oil-lamp, leaving the band to tootle to the sad sea waves, I could not get him to mount the Cheap Jack rostrum in opposition! The most I could spur him to was an indignant defence of London against the lecturer's denunciation of it as an immoral city, a pit of unrighteousness. ''T ain't true!' he thundered raucously. 'Many's the gent from Lunnon as has behaved most liberal to me.' One day there was an attempt to disturb*

Joe's monopoly as drunkard, and I am afraid I had a hand in it. A human caricature in broken boots addressed me as I lay on the beach (writing with a stylographic pen and blotting the sheets with the sand), and besought me to buy sprigs of lavender. He proved to me by ocular demonstration that he had no money in his pockets; whereupon I proved to him by parity of reasoning that I had none in mine either. However, I remembered me of a penny postage-stamp (unlicked), and tendered it diffidently, and he received it with disproportionate benedictions. Later in the day he reappeared under my window, hurling up maudlin abuse. He had got drunk on my postage-stamp!

I told him to get along with him, which he did. For some time he staggered about Broadstairs in search of its policeman. He came across him at last, and was straightway clapped into an open victoria and driven across the sunny fields to Ramsgate. Meantime, Broadstairs was left unprotected - perhaps Joe kept an eye on it.

Broadstairs has also a jolly old waterman, who paddles about apparently to pick up exhausted bathers. One morning as I was swimming past his boat he warned me back. 'Any danger?' I asked. 'Ladies,' he replied, ambiguously enough. It thus transpired that his function is to preserve a scientific frontier between the sexes. Considering that the ladies one meets at sea are much more clothed than the ladies whose diaphanous drapery one engirdles in ball-rooms, this prudery is amusing. It is consoling to remember that the Continental practice prevails in many a quaint nook along our coasts, and that the ladies are sensible enough to walk to and from their bathing tents, clothed and unashamed. Strange to say, Broadstairs has placed its ladies' machines nearest the pier, for the benefit of loungers armed with glasses; and I must not forget to mention that the boatman himself holds a daily 'levée' of mermaidens, who make direct for his boat and gambol around the prow. If anything needs reforming in our marine manners, it is rather the male costume. Why we men are allowed to go about like savages, clothed only in skins (and those our own), is to me one of the puzzles of popular ethics. What is sauce for the gander is sauce for the goose. At Folkestone, where the machine-people are dreadfully set against ladies and gentlemen using the same water, promiscuous bathing flourishes more nakedly than anywhere on the Continent; and the gentlemen have neither tents nor costumes. In Margate and Deal the machines are of either sex, and the gentlemen are clad in coloured pocket-handkerchiefs. At Birchington I bathed from a boat which was besieged by a bevy of wandering water-nymphs, begging me to let them dive from it. And they dived divinely!

SEE Albion/ Bathing/ Bathing machines/ Birchington/ Books/ Broadstairs/ Dickens, Charles/ Donkeys/ Dumpton/ East Cliff Lodge/ Fort House/ Harbour, Broadstairs/ Harbour, Ramsgate/ Lavender/ Margate/ Pier, Margate/ Promenade Pier/ Ramsgate Sands Station

'WITH WOLFE IN CANADA
Or The Winning of a Continent'
by G. A. Henty (1894)

The squire wasn't an hour in the house afore the carriage was round to the door, and we posted as hard as horses could take us right across England to Broadstairs, never stopping a minute except to change horses; and when we got there it was a month too late, and there was nothing to do but to go to the churchyard, and to see the stone under which Master Herbert and his young wife was laid.

SEE Books/ Broadstairs

John WOLCOT

Born Dodbroke, Devon, 9th May 1738
Died London, 14th January 1819

He was a man who qualified as a physician, then took holy orders, and gave that up when his writing career became successful. He wrote, under the name Peter Pindar, a great deal of witty satirical verse, particularly targeting academics, Boswell, Pitt, George III and the royal family. He was criticised for his work being *'generally coarse and not infrequently profane'* (I like him already) but his work was the talk of the town in fashionable London. Sadly, in later life he went blind.

He wrote 'Tales of the Hoy' and 'The Praise of Margate' both about the town.

SEE Dent-de-lion/ George III/ Tales of the Hoy/ Poets/ Praise of Margate, The

'The WOMAN IN WHITE'
by Wilkie Collins

Dickens's serial in Household Words, A Tale of Two Cities, was relatively short and he needed something to follow it. Collins, employed on the staff of Dickens magazine 'All The Year Round', was asked to contribute a serial. *'I must stagger the public into attention, if possible, at the outset.'* (August 1859) He did. He wrote 'The Woman in White'.

Collins, his brother Charles and Millais, the artist, had been walking home one night in 1858 when they saw, *'a woman dressed in flowing white robes escaping from a villa in Regent's Park where she had been kept prisoner under mesmeric influence'* and this inspired the 'woman in white' of the title, and not the North Foreland lighthouse that is so often given as the muse.

'I began this story [The Woman in White] *on the 15th of August 1859, at Broadstairs and finished it on the 26 July 1860, at 12 Harley Street, London.'*

Originally it was serialised in 'All the Year Round', a magazine edited by his friend Charles Dickens. The serialisation began on 26th November and circulation increased When it came out in book form in 1860, it was a bestseller here, in America and, when translated, in Europe. It sold eight editions of an expensive three-volume format in three months in 1860, and the following year 10,000 copies of a one-volume edition sold out.

Charles Dickens, on The Woman in White, January 1860: *'There cannot be a doubt that it is a very great advance on all your former writing, ...In character it is excellent...I know that this is an admirable book, and that it grips the difficulty of the weekly portion and throws them in a masterly style. No one else could do it half so well.'*

We think that merchandising is a modern thing but there was a plethora of Woman in White items available, from perfumes to bonnets, as well as Waltzes and Quadrilles written.

Punch parodied it, Thackeray read it from morning until sunset and Gladstone was so engrossed that he missed a trip to the theatre.

SEE Books/ Broadstairs/ Collins, Wilkie/ Dickens, Charles/ Gladstone/ Lighthouse, North Foreland/ Ramsgate Road, Broadstairs

'WOMEN IN LOVE'
by D H Lawrence

From the Prologue to 'Women in Love' although subsequently abandoned: *How vividly, months afterwards, he would recall. . . a young man in flannels on the sands at Margate, flaxen and ruddy, like a Viking of twenty-three, with clean, rounded contours, pure as the contours of snow, playing with some young children, building a castle in sand, intent and abstract, like a seagull or a keen, white bear.*

SEE Books/ Lawrence, D H/ Margate

WOMEN'S VOLUNTARY SERVICE RAMSGATE 1939-1945

The WVS was set up in 1938 mainly to help with air raid precautions. The Ramsgate WVS numbered one hundred and fifteen and did magnificent work in the town.

They provided meals for the homeless and the first mobile canteen which arrived in Ramsgate in 1940. It was well used until January 1942 when it was sent to Herne Bay as Ramsgate now had a new larger one that could provide hot food!

For twelve days following the attack on 24th August 1940, the WVS, from their rest centre in Cliff Street, cooked 3,000 meals on just 6 Primus stoves for the resultant homeless for whom they also provided clothing, where necessary. They moved into the larger Merrie England premises where they also began tending to any stretcher cases, accompanying the walking and wheelchair-wounded to the railway station and sending hundreds of postcards and telegrams to the families and next of kin. Throughout the war, they ran three British restaurants and three clothing depots – they also darned 13,830 pairs of socks for troops between March 1942 and November 1943! Throughout the country the WVS ran a book drive that acquired 24,000 books!

Mrs F C L Sutton was the borough organiser who was awarded the MBE for her work in the Dunkirk evacuation; Mrs Blinko was in charge of the WVS for most of the war; Mrs Holthouse died by enemy action in 1943.

The WVS became the WRVS (Women's Royal Voluntary Service) in 1949.

SEE Cliff Street/ Ramsgate/ Restaurants/ World War II

WOODFORD AVENUE, Ramsgate
SEE Ramsgate/ Viaduct/ World War II

WOODFORD HOUSE SCHOOL
Station Road, Birchington
A and H A Erlebach left a school in Woodford, Essex, and took over the Kent County School in Birchington whose pupils then formed Woodford House School in 1892 (the house was built in 1865) with a few day pupils and 40 boarders. The playing fields extended back to Albion Road.

Mr Erlebach and his wife lost their three sons in World War I and in their memory they presented the Memorial Ground to the village in 1924. Woodford House was the only school in Thanet to remain open throughout Word War II.

The school was later sold and in 1961, demolished and replaced by Woodford Court and shops.

SEE Bath Cottages/ Birchington/ Schools/ Station Road, Birchington/ World War I/ World War II

James WOODWARD
Born Ramsgate 1851
Died 1933

Woodward died, at the age of 82, in a house called Everest, at 16 St Mildreds Road in Ramsgate. The Woodward family was well-known in the circus and music hall world for having an internationally famous sea lion act. In the 1870s, he had been employed by Captain Joseph Catt, his father-in-law, as the superintendent of the aquarium at Ramsgate Harbour and it was here that the idea of training seals came to him. He asked his son, Joseph (born 1872, Canada – died 5th December 1945), to get him a sea-lion when he was in San Francisco. He named it Frisco and it was soon able to perform *'equilibrium defying'* tricks - juggling and balancing - right across the world, from the Hippodrome in London, to the USA. By his early thirties, Joseph Woodward and the sea lion had earned enough to think about retiring. Whilst Joseph was performing in America, his brother William toured Europe, until he died, aged 27, in 1903. During World War I, Joseph and his other brother, Fred, worked with the Board of Invention and Research to see if it was possible to train sea lions to track German U-boats. Sadly, they could not.

SEE Entertainers/ Harbour, Ramsgate/ Ramsgate/ St Mildreds Road/ U-boats/ World War I

WOOLWORTHS
The son of a farmer, Franklin Winfield Woolworth (1852-1919) started his working life as an apprentice clerk in a New York corner store, but by 1879 had set up 'The Great Five-Cent Store' in Utica, New York, where everything cost five cents as the name implied. We all know what happened next; it was a failure, the location was all wrong. Undeterred, he opened another store, this time in a better location, in Lancaster, Pennsylvania, and sold a greater range of goods. It was a success. The next step was to add a ten cent range. This too was a success and more stores opened. The first one with 'F W Woolworth' above the door (red background, gold letters) was in Scranton, Pennsylvania and this is where the chain really begins. The first UK store was in Liverpool in 1909. The listings in the local 1936 directories still referred to it as the *'3d & 6d stores'*.

SEE Bull and George Hotel, Ramsgate/ Gouger's Windmills/ High Street, Margate/ Shops/ Station Road, Birchington

WORKHOUSE
Around 1820, The Margate Parochial Workhouse, with its extensive gardens, was located on the eastern side of Victoria Road, just north of Princess Crescent.

SEE Captain Swing/ Lavender/ Margate/ Nuckell's Almshouses, St Peter's/ Royal School for Deaf/ Sheltering Tree/ Spread Eagle Inn

WORKING MEN'S CLUB and INSTITUTE UNION, Reading Street
The first sod for the new convalescent home was cut by the then President of the Working Men's Club and Institute Union in the spring of 1969. In October 1970, the home, which overlooked the golf course, was virtually finished.

SEE Convalescent Homes/ Reading Street

'THE WORLD OF WATERS or A Peaceful Progress o'er the Unpathed Sea' by Mrs David Osborne.
MRS. WILTON. 'The Isle of Thanet forms the north-east angle of the county of Kent: from north to south it is five miles, and rather more than ten from east to west. It contains many beautiful watering places, - Margate, Ramsgate, and Broadstairs on the sea; St Lawrence, Birchington, and St Peter's, inland. The whole of the district is in a very high state of cultivation and remarkable for its fertility; the first market-garden in England was planted in the Isle of Thanet There is a little place called Fishness, not far from Broadstairs, which derived its name from the following circumstance: On the 9th of July, 1574, a monstrous fish shot himself on shore, where, for want of water, he died the next day; before which time, his roaring was heard above a mile: his length was twenty-two yards, the nether jaw opening twelve feet; one of his eyes was more than a cart and six horses could draw; a man stood upright in the place from whence his eye was taken; his tongue was fifteen feet long; his liver two cart-loads; and a man might creep into his nostrils.' All this, and a great deal more, is asserted by Kilburne, in his 'Survey of Kent;' and Stowe, in his Annals, under the same date, in addition to the above, informs us, that this 'whale of the sea' came on shore under the cliff, at six o'clock at night, 'where, for want of water beating himself on the sands, it died about the same hour next morning.'

CHARLES. 'The size and other particulars seem probable enough, with the exception of the eye, which certainly must be an exaggeration; one such an eye would be large enough for any animal, were he as monstrous as the wonderful Mammoth of antediluvian days. Do not you think, madam, that the account is a little preposterous?'

MRS. WILTON. 'I think it is very likely, my dear, because there were so few persons to write descriptions of these wonderful creatures, that those who undertook the task were seldom content with the bare truth, no matter how extraordinary, but generally increased the astonishment of their readers by almost incredible accounts, which they were quite aware would never be contradicted. We live in a more inquiring age, and do not so readily give credence to all we hear, without ascertaining the probabilities of such descriptions; and exaggerated accounts are now merely regarded as 'travellers' wonders,' and only partially believed.'

SEE Birchington/ Books/ Broadstairs/ Margate/ Ramsgate/ St Peter's/ Thanet/ Whales

WORLD WAR I (1914-18)
As a result of air raids in World War I, 18 people died in Margate, 3 in Broadstairs and 25 in Ramsgate.

There were 42 enemy raids on Margate by either Zeppelins or Gothas dropping bombs from the air, or by destroyers shelling from the sea. Not surprisingly, Margate's population dropped from 31,000 to 12,000 by September 1917.

On 16th March 1917 two German seaplanes dropped 7 bombs on Garlinge.

Other raids occurred on 17th May 1916, 18th March 1917, 22nd August 1917, 17th May 1918,

The message that the war was to cease at 11:00am on 11th November 1918 was sent from Dover to the naval base at Ramsgate Harbour at 9:45am that morning. The townspeople were informed by ships' sirens, fog horns and whistles all making one a hell of a din!

SEE Albion Gardens/ All Saints Church war memorial/ Allenby, Viscount/ Armistice Day/ Belgian soldiers/ Belmont Road, Ramsgate/ Belmont Road, Westgate/ Beresford Hotel/ Britannia pub/ British Expeditionary Force/ Broadstairs/ Buchan, John/ Bull & George Hotel/ Camera Obscura/ Cavendish Baptist Chuch/ Craig, Norman/ Dearmer, Geoffrey/ Destiny/ Dreamland/ Elmwood House/ Evacuation/ Fishing Fleet/ Golden Eagle/ Gordon Road/ Gotha/ Granville Hotel/ Grosvenor Road, Broadstairs/ Harbour, Ramsgate/ Hartsdown Road/ Lewis Crescent/ Lillian Road/ Lusitania/ Manston Airfield/ Mutrix/ Norfolk Road/ Orchardson, Sir William Quiller/ Oxford Street/ Paragon/ Pluck's Gutter/ Potatoes/ Rose in June/ Royal Navy Air Service Station/ Princes Gardens/ Ramsgate/ Rossetti/ Sausages/ Sea Wall/ Sharps Dairy/ Smack Boys' Home/ Spur Railway Line/ St Andrew's Church/ St Lawrence College/ St Luke's area/ St Mary's Convalescent home, Birchington/ St Paul's Road/ St Peter's Memorial Hall/ St Peter's Orphanage/ Stonar/ Tanks/ Temple, William/ Thanet/ Thicket Convalescent Home/ Tivoli Road/ Tunnels, Ramsgate/ U-Boat/ Ursuline Convent/ VAD Hospital/ West Dumpton Lane/ Wilfred Road/ Windsor Cinema/ Woodford House School/ Woodward, James/ Yarrow Home/ Zeppelin/ Zion Place

WORLD WAR II (1939-45)
Owing to invasion fears during World War II, The Isle of Thanet was made a restricted

area, and entry was prohibited for any leisure or pleasure purposes.

Friday 6th October 1944
BY BOMB AND SHELL
Record of Thanet Casualties and Damage
Now that the statistics of other front-line towns have been disclosed, it is interesting to record how Thanet fared in enemy attacks. Here are the details of Thanet's grim but glorious five years:
RAMSGATE CIVILIAN CASUALTIES KILLED OR DIED OF WOUNDS 84
INJURED 262
Number of air raid warnings (including 1,193 imminent danger warnings) 3,655
Shelling warnings 86
Aircraft attacks 53
High explosive bombs dropped 693
Other bombs 381
Shells 42
Buildings demolished 373
Severely damaged 340
Total damaged (apart from damage to glass) 8,891
War damage claims 12,700
Of the 340 houses and business premises badly damaged, 300 have already been restored. Many buildings suffered more than once and this accounts for the high total of war damage claims, the number of which is higher than the total of 11,500 premises in the borough.
In addition to the 53 aircraft attacks on the town, 25 sweeps on Allied shipping in the Channel were watched by people on the sea front.

During World War II, 35 people were killed in air raids in Margate, with 40 seriously injured; and 201 slightly injured; 206 properties were wrecked; 592 severely damaged; 584 high-explosive bombs, and 2,489 incendiary bombs landed.

Broadstairs' first air raid of the war occurred on Sunday 3rd August 1941 when Morrisson's Garage (The Broadway), the library, the fire station and several shops were damaged. The manager of the Electricity Company, Joseph Forde, was killed and two firemen were injured.

In Broadstairs people were killed in 52 air attacks, mainly air raids, but including two shells from France, with 6 seriously injured, and 48 slightly injured; 18 properties were wrecked; 163 severely damaged; 278 (some reports state 262) high explosive bombs landed, along with 300 incendiary bombs, and 3 flying bombs. The population of Broadstairs dropped from 13,000 to 2,000.

After the war, out of a total of around 4,500 houses in the town, 900 were empty, but prices were shooting up; houses that were on the market for £1,950 were, within months, being sold for £33,500.

SEE Barricades/ Battle of Britain/ Belmont House/ Bevin Boys/ Britannia public house/ Broadstairs/ Catholic Church/ Chatham House School/ Cliffs End Hall/ D-Day/ Dambusters/ Dent-de-Lion/ Evacuation/ Galland, William/ Goodwins/ Granville Hotel/ Harbour, Ramsgate/ Harley's Tower/ Hastings Avenue/ High Street, Broadstairs/ Hodge's Flagstaff/ Hoy public house/ Libraries/ Lord Haw-Law/ Manston Airfield/ Minster/ Morrison Bell Hotel/ Mulberry Harbour/ Pegwell Bay/ Prospect Terrace/ Ramsgate/ Ramsgate Sands Railway Station/ Refugees/ Restricted area/ Rossetti/ St Peter's Road/ Seven Stones/ Shakespeare public house/ Shallows/ Spitfire/ Spread Eagle Inn/ St Peter's Memorial Hall/ Station Approach Road, Ramsgate/ Stonar/ Swan public house/ Tester, Dr Arthur/ Thanet/ Thicket Convalescent Home/ Uncle Mac/ Ursuline Convent/ Vestey, Sir Edmund/ Warner, Jack/ West Cliff Tavern/ Westgate Bay Avenue/ Windor Cinema/ Winstanley Crescent/ Winter Gardens/ Woodford Avenue/ Woodford House School/ WVS

WORLDS WONDER, Manston
This building was partly flint but mainly brick built. The old lady who owned it up until her death in 1999 was a great animal lover and left it to the RSPCA. They intended to sell it and use the proceeds to establish a local sanctuary, however just before Bonfire night, the place burnt down.
SEE Fires/ Manston

Sir William WRATTON
An old boy of Chatham House Grammar School who led the RAF in the first Gulf War.
SEE Chatham House Grammar School

WRESTLING
Wrestling was extremely popular in the 1960s and 70s due largely to ITV's World of Sport. They showed it every Saturday afternoon at four o'clock, and it was introduced by Kent Walton - *'Good afternoon grapple fans'.*
All the stars of the time including Jackie Pallo, Mick McManus, Johnny Kwango, Jon Cortez wrestled in Margate at the Winter Gardens, Dreamland and The Oval.
SEE Dreamland/ Margate/ Oval, The/ Pallo, Jackie/ Sport/ Winter Gardens

WROTHAM ARMS public house
Ramsgate Road, Broadstairs
Once upon a time it was two cottages, but became a pub in the 1850s, named after nearby Wrotham House.
SEE Broadstairs/ Pubs/ Ramsgate Road, Broadstairs/ Yarrow Home

WROTHAM ROAD, Broadstairs
SEE Broadstairs/ Yarrow Home

WRIGHT
High Street, Ramsgate
Ramsgate by J S Rochard, c1900:
MR JAMES WRIGHT,
General and Fancy Draper
21 and 23 High Street
One window is bright with laces, flowers, gloves and handkerchiefs, another with ladies' blouses and skirts; whilst a third contains a fine assortment of ladies underclothing and corsets. The window at 21 High Street which has been recently added, exhibits a nice selection of black and coloured dress materials, over which is shown a variety of skirts, with sunshades in the centre and a background of lace curtains. For many years Mr Wright was with Messrs Marshall and Snelgrove, London.
SEE High Street, Ramsgate/ Ramsgate/ Shops

WRIGHTS YORK HOTEL
SEE Hotels/ Shabby Genteel Story, A

WRIGHTSON
High Street, Ramsgate
Ramsgate by J S Rochard, c1900:
L Wrightson, Fancy Bread and Biscuit Baker, Pastrycook, and Confectioner, 78 High Street
A well known shop where high class business was conducted for 27 years by Mr Wrightson and now carried out by his widow. Wedding, christening and birthday cakes of delicious flavour are a speciality. The shop also sells Horniman's pure tea.
SEE High Street, Ramsgate/ Ramsgate/ Shops

XYZ

The YACHTSMEN
Advertisement 1920:
'THE YACHTSMEN' CONCERT PARTY
proprietors: Messrs Gold & Ellison
Also at MARGATE, BRIGHTON, ABERYSTWYTH etc
DAILY at 11.0, 3.0 and 7.0
Special Engagement of New Artistes and Old Favourites
THIS CONCERT PARTY IS NOW BETTER THAN ITS PRE-WAR STANDARD
EVERY EVENING
VALUABLE PRIZES will be presented by MR 'TIT BITS' to patrons who are holders of a current issue of 'Tit Bits' or 'Woman's Life.' Secure a copy of either of these two publications and take a sporting chance of gaining one of these Handsome Presents.
Thursday Afternoon –
LOVE LETTER WRITING for GENTS
Friday Afternoon -
BOYS' BOOT LACING COMPETITION
Competitions Every Afternoon. Prizes by 'Tit Bits.'
SPECIAL COSTUME CONCERTS –
Tuesday and Thursday Evenings
SEATS 3d., 5d. & 9d.
'The Yachtsmen' – Ramsgate Sands
SEE Beach Entertainment/ Margate/ Ramsgate

Sir Alfred YARROW
Born 1842
Died 24th January 1932
Educated at University College School, he served an apprenticeship at Stepney and in 1865 opened a yard at Folly Wall, Poplar, on the Isle of Dogs, in partnership (Yarrow & Hedley) initially building steam river launches. Within a few years, he was building torpedo boats for the Japanese and Argentine Navies. In 1875, his partnership with Hedley was dissolved and it became Yarrow & Co from then on. In 1892, he built two destroyers, Havock and Hornet, for the Royal Navy. In 1898 he moved his shipyards to London Yard, but in 1906-8 he moved again to larger premises, this time at

Scotstoun on the River Clyde; subsequently closing his London operation. He also started a yard in Vancouver.

A very philanthropic man, he gave money to medical research, set up a scholarship at University College in London, built homes for the widows of soldiers at Hampstead and built the Yarrow Home for Convalescent Children of the Better Classes at Broadstairs.

He was knighted in 1916.

His firm was eventually bought by GEC in 1974.

SEE Broadstairs/ Yarrow Home for Convalescent Children of the Better Classes

YARROW CLOSE, Broadstairs

SEE Broadstairs/ Yarrow, Sir Alfred/ Yarrow Home for Convalescent Children of the Better Classes

YARROW HOME for CONVALESCENT CHILDREN of the BETTER CLASSES
Ramsgate Road, Broadstairs

It was built on the site of Mr Richardson's Wrotham House – hence the name of the nearby Wrotham Arms public house.

In 1895 Sir Alfred Yarrow, using money he had amassed from his Yarrow Shipyards built the home. It grew its own fruit and vegetables and had its own dairy herd that grazed where Yarrow Close is now - and a dairy.

In World War I, it was used as a military hospital and became a home again in 1919.

In 1936, it was listed as The Alfred Yarrow Home & Hospital for Children but in 1957 it was listed as The Yarrow Home of Westminster Technical College. It is now Thanet Technical College.

SEE Broadstairs/ Canadian Military Hospital/ Convalescent Homes/ Ramsgate Road, Broadstairs/ Schools/ Smith, Stevie/ Thanet Technical College/ VAD hospitals/ West Cliff Road, Broadstairs/ World War I

YATES' WINE LODGE
Cecil Square, Margate

It opened in 2000 in what was once Bobby's Department store and the old Jobcentre.

SEE Cecil Square/ Margate/ Pubs

YE FOY BOAT INN, Margate

Right opposite the entrance to the pier and jetty was the Ye Foy Boat Inn which according to the deeds dates back to 1726. 'Foying' was the practice carried out by local sailing boats that took fresh water and victuals out to passing shipping. It is a common pub name in local coastal towns. It was J M W Turner's favourite pub, where, if he said 'Usual, landlord', he got a beer mulled by a red hot poker.

The inn was replaced by the Grand or Pier Hotel, built in 1833. It also took over the adjacent Dukes Head Tavern in 1878. A fire completely destroyed it in 1890 and it was replaced by the Hotel Metropole in 1891.

SEE Fires/ Foy/ Margate/ Metropole Hotel/ Pubs/ Turner, J M W

YE OLDE CHARLES public house
Northdown Road, Cliftonville

Russell's of Gravesend was the brewery who built the mock Tudor Ye Olde Charles public house on what was open countryside in 1926. It had 36-gallon wooden barrels on tap behind the bar. Beer used to be stored either in the bar, or in outhouses at the same level as it meant that no pumps were necessary. Spirits were kept in the cellar instead. It is now a Chef and Brewer house.

SEE Breweries/ Cliftonville/ Northdown Road/ Pubs

YEOMANRY

The Isle of Thanet Yeomanry was founded in 1794 under Captain Garrett of Nethercourt. It consisted of 60 farmers and gentlemen. The Cinque Ports Volunteers was for more lowly citizens without horses. With the threat of invasion high in 1803 they were to muster as follows: Margate men at Nash Down; Broadstairs men at Rumfields; Ramsgate men at Upper Court Field near Nethercourt and Sarre men at Mount Pleasant.

They disbanded in 1828 having never seen any action.

SEE Broadstairs/ Cinque Ports/ Ellington Arms/ Farms/ Margate/ Nethercourt House/ Ramsgate/ Royal Victoria Pavilion

YEW TREE CLOSE/ESTATE
Canterbury Road, Birchington

The Yew Tree Estate was built in the 1960s on the site of Yew Tree House which stood here from 1830 until 1963.

SEE Birchington/ Canterbury Road, Birchington

Michael YOAKLEY

A Margate man, who made his fortune as a merchant. On his death he left enough money in his will to build ten houses for Quaker ladies. They were built in 1709 at a cost of £74 (many additions have been made over the years at a total cost of over £5,000,000). To provide themselves with an income, the Quaker ladies wove garters, knitted and made pin cushions together with other similar items to sell to the holiday makers. In the 18th and 19th centuries, it was very popular to take a walk out to the Drapers Almshouses as they became known. By the beginning of the 20th century, there were 40 cottages there.

Benjamin Beale, the bathing machine inventor, is buried there.

SEE Bathing machines/ Beale, Benjamin/ Margate

YOAKLEY SQUARE, Margate

Named after Michael Yoakley.

SEE Margate/ Yoakley, Michael

YORK ARMS, King Street, Ramsgate

It has also been known as Scotts and The Warehouse, and it was even closed for a year but is now back in business.

SEE King Street, Ramsgate/ Ramsgate/ Pubs

YORK HOTEL
Marine Parade, Margate

The Picturesque Pocket Companion to Margate, Ramsgate, Broadstairs, and the Parts Adjacent (1831): *THE YORK HOTEL is situate on the Marine Parade: the accommodations here are of a very superior*

and satisfactory kind, and the proprietor, Mr James Wright, is well known to, and highly respected by, the many families and individuals, of the first respectability and distinction, by whom this hotel is frequented; and his polite attention, and perservering endevours to ensure their comfort, during their stay at his house, is sufficiently evidenced by the large share of patronage with which he is honoured.

SEE Hotels/ Margate/ Marine Parade

YORK MANSIONS, Margate

SEE Grand Old Duke of York/ Margate/

YORK GATE
Harbour Street, Broadstairs

It was originally called Flint Gate but was renamed York Gate after the Grand Old Duke of York.

Sir John Henneker paid for repairs to the arch out of his own pocket.

The original road was cut through the chalk by the shipwright George Culmer to gain access to the sea in 1538. Two years later he built Flint Gate, originally with two large wooden gates that could be closed to protect any attack to the town from the sea and, yes, they were needed. In 1795, with threat from the Napoleonic Wars at its height, the gate needed repairing and Lord Henneker undertook the job.

The Bell Inn used to be next to it with its sign hanging in the middle of the arch and it is now York Gate House. Opposite were fishermen's cottages which are still there although the fishermen have gone.

York Gate is represented in the town's coat of arms.

SEE Broadstairs/ Harbour Street, Broadstairs/ Napoleonic Wars

YORK STREET, Broadstairs

Many years ago, fed up with what she saw as the endless references to Charles Dickens in Broadstairs, a resident of York Street put up a plaque which read, 'Charles Dickens did not live here'.

SEE Blackburn's/ Broadstairs/ Dickens, Charles/ Harringtons

YORK STREET, Ramsgate

The Fire Brigade had their premises in York Street at the end of the nineteenth century. The horses were stabled in a building in King Street, where the Classic Cinema was later situated. Have you spotted what the problem was?

In September 1995, it was announced that Island Cards would be the first shop to be renovated in the original Victorian style in the street.

SEE Foster, Herbert/ Hovelling Boat Inn/ Horse and Groom, Ramsgate/ Jackson's Wharf pub, Ramsgate/ King Street, Ramsgate/ Market, Ramsgate/ Ramsgate/ Umbrella makers

YORK TAVERN, York Street, Ramsgate

The York Tavern was previously the Vine Inn but was demolished along with the Fountain to make way for the Argyle Centre in the 1970s.

SEE Pubs/ Ramsgate/ York Street

Lena ZAVARONI

Born 4th November 1963
Died 1st October 1999
Teenage singing sensation who died tragically young after suffering fron anorexia for many years.

SEE Entertainers/ Granville Theatre/ Opportunity Knocks/ Winter Gardens

ZEPPELIN

Graf (meaning Count) Ferdinand von Zeppelin (1838-1917) was a German airship pioneer. From 1900, he constructed rigid-bodied airships, known as Zeppelins, or Zepps, and in World War I, they were used as a means for dropping bombs.

SEE Albert Road, Ramsgate/ Albert Street, Ramsgate/ Albion Gardens, Hill, Place/ Bull & George Hotel/ Chapel Place, Ramsgate/ Chapel Road, Ramsgate/ Dump Raid/ Ellington Park/ Manston Airfield/ Nethercourt Farm/ Queen Street, Ramsgate/ St Nicholas-at-Wade/ World War I

ZEPPELIN RAID

On 16th June 1917, a German Lz42 Zeppelin dropped a 650lb bomb on Ramsgate. It landed on the fishmarket, near the harbour Clock Tower, which the Royal Navy was using as an ammunition store. When a 650lb bomb meets shells, depth charges and German mines that had been recovered and stored out of harms way, it causes a massive explosion. Consequently, 700 houses were damaged and 10,000 windows were shattered across the town. Royal Navy personnel and local firemen fought the resulting blaze for many hours and men and equipment from Margate and Broadstairs had to be brought in to help. In 1920, at a dinner in Maidstone, sixteen Ramsgate men who fought the fire were awarded the OBE, and at another dinner at the Granville, they were given £5 each by Dame Janet Stancomb-Wills.

SEE Albion Gardens, Hill and Place/ Albert Road/ Broadstairs/ Fires/ Granville Hotel/ Ramsgate/ Stancomb-Wills, Dame Janet/ Zeppelin

ZION PLACE, Cliftonville

Albany House in Prospect Place (Zion Place) was a boys' school in the mid-eighteenth century. In the same period, there was Bath House, a boarding school for around 40 boys at number 12 Zion Place, which, by 1936 was the address of Albert Peters' boarding house.

From 1792 and throughout the nineteenth century The Prospect Tavern, which had also been the Prospect Coffee House, was at Zion Place. Now, a supermarket sits on the site.

The Crown and Anchor in nineteenth century Zion Place became the Randolph Hotel in the 1880s and was still there in 1936.

A German bomber, a Heinkel HE111 dropped twelve 55 pound bombs across Margate Harbour in the first few minutes after midnight on 14th July 1941 hitting Droit House – some of which also hit Zion Place.

After the war, the whole area was compulsorily purchased and redeveloped. Nowadays Zion Place is essentially a road with the Quarterdeck on one side and an Aldi supermarket (opened in 1997 – virtually on the site of the old Prospect Inn) on the other; not the flourishing community of small businesses that it once was.

SEE Boarding houses/ Cliftonville/ Harbour, Margate/ Hoopers Horizontal Mill/ Pubs/ Schools/ Shops/ West Ham Convalescent Home/ World War II

SELECT BIBLIOGRAPHY

'Ramsgate in old picture postcards' by Charles E Busson
'Historic Margate' by G E Clarke
'Wish You Were Here – Coleridge's Holidays at Ramsgate' by Allan Clayson
'Images of England – Ramsgate & St Lawrence' by Don Dimond
'A Glint in the Sky' by Martin Easdown with Thomas Genth
'Dreamland Remembered' by Nick Evans
'Francis Frith's Pocket Album Thanet'
'Then & Now Margate' by Alan and Ian Kay
'Kelly's Directory of the Isle of Thanet' – in particular 1936 and 1957
'Margate Pubs Past & Present' by John Land
'Smugglers' Broadstairs' by William H Lapthorne
'Historic Broadstairs' by William H Lapthorne
'Discover Ramsgate' by Don Long
'Discover Ramsgate Volume II' by Don Long
'Hasted's History of Birchington'
'Kent – A Chronicle of the Century' Volumes 1 – 4 by Bob Ogley
'Kent 1800-1899' by Bob Ogley
'The Kent Weather Book' by Bob Ogley
'Kent at War' by Bob Ogley
'Sketches of Historic Thanet' by D Perkins
'The Ville of Birchington' by Alfred T Walker
'Britain in Old Photographs – Images of Thanet' by Barrie Whooton
'Ramsgate Photographic Memories' by Barrie Whooton
'Britain in Old Photographs – Broadstairs & St Peter's' by John Whyman
'The Green Island at the End of the World'
'Birchington, Now, Then and Gone Forever'
'Margate – A Resort History'
plus
Various editions of Bygone Kent;
many and assorted websites;
disparate newspapers and magazines,
and a motley collection of memories –
both mine and those of others recounted to me over the years!

ACKNOWLEDGEMENTS

I would like to thank Chas and Dave for their permission to reproduce the lyrics to 'Down to Margate'. Every effort has been made to trace and contact copyright holders. I will be pleased to make good any omissions, or rectify any mistakes brought to my attention, at the earliest opportunity.

Since writing this book, once-derelict buildings have been transformed; some have been demolished and replaced; pubs have closed, opened or changed their names. So I apologise if this book is already out of date, but the nature of the subject is that things change and the area moves on. It just means that there more things to be written about in the future!